Cover Image:
Iranian, illustrated manuscript,
Mantiq at-Tayr: Concourse of the Birds
(c. 1600) by Farid-al-din 'Attar. Painted
by Habib Allah. Colors, gold, and silver
on paper, 10 in. x 4-1/2 in.

The Metropolitan Museum of Art,
Fletcher Fund, 1963 (63.210.11)

Adventures in Appreciation

ATHENA EDITION

HOLT, RINEHART AND WINSTON

Harcourt Brace & Company

Austin • **New York** • Orlando • Atlanta • San Francisco • Boston • Dallas • Toronto • London

Staff Credits

EDITORIAL
Project Director: Fannie Safier
Editorial Coordinator: Katie Vignery
Editorial Staff: Lynda Abbott, Sally Ahearn, Judith Austin-Mills, Laura Baci, Amanda Beard, Richard Blake, Susan Britt, Robert Carranza, Daniela Guggenheim, Scott Hall, Bobbi Hernandez, Constance D. Israel, Susan Lynch, Mary Malone, Jennifer Osborne, Marie Hoffman Price, Sara Schroeder, Amy D.D. Simpson, Atietie O. Tonwe
Editorial Support: Carla M. Beer, Ruth Hooker, Margaret Guerrero
Editorial Permissions: Carrie Jones
Software Development: Armin Gutzmer, Lydia Doty

DESIGN AND PHOTO RESEARCH
Design: Pun Nio, *Senior Art Director;* Richard Metzger, *Design Supervisor;* Diane Motz, *Senior Designer;* Clair LaVaye Doluisio, *Designer*
Photo: Debra Saleny, *Photo Research Manager;* V. Sing Griffin Bitzer, Yvonne Gerin, Karen Grandfield, Jeannie Taylor, *Photo Researchers*

PRODUCTION
Beth Prevelige, *Senior Production Manager;* Simira Davis, *Production Assistant;* Sergio Durante, *Secretary;* George Prevelige, *Production Manager;* Rose Degollado, *Production Coordinator*
Electronic Publishing: Carol Martin, *Electronic Publishing Manager;* Kristy Sprott, *Electronic Publishing Supervisor;* Debra Schorn, *Electronic Publishing Senior Coordinator;* Lana Castle, Denise Haney, David Hernandez, Maria Homic, Barbara Hudgens, Mercedes Newman, Monica Shomos, *Electronic Publishing Staff*

Cover Design: Design 5

Acknowledgments appear on pages iv–vii, which are an extension of the copyright page.

Printed in the United States of America

ISBN 0-03-098634-6

4 5 6 041 00

Curriculum AND Writing

Glenda Zumwalt
Southeastern Oklahoma
Durant, Oklahoma

William Bassell
Long Island City High School
Long Island City, New York

Carroll Moulton
Formerly of Duke University
Durham, North Carolina

Contributors AND Critical Readers

Gail M. Brown
McDonogh 35 High School
New Orleans, Louisiana

Jan Freeman
Florence, Massachusetts

Janice Bell Ollarvia
Fenger Academy for
African American Studies
Chicago, Illinois

Jeanne S. Provencher
Nashua Senior High School
Nashua, New Hampshire

Carolyn P. Rea
Chattahoochee High School
Alpharetta, Georgia

Faye E. Smith
Colquitt County High School
Moultrie, Georgia

Gwendolyn L. Smith
Yucaipa High School
Yucaipa, California

Linda A. Young
Thomas Jefferson High School
Dallas, Texas

Acknowledgments

For permission to reprint copyrighted material, grateful acknowledgment is made to the following sources:

American Council for Nationalities Service: "Chee's Daughter" by Juanita Platero and Siyowin Miller from *Common Ground,* vol. 8, Winter 1948.

Robert Anderson: *I Never Sang for My Father* by Robert Anderson. Copyright © 1966, 1968 and renewed © 1994 by Robert Anderson.

Appletree Press Ltd., Belfast Ireland: "The Quiet Man" by Maurice Walsh. Copyright 1933 by Curtis Publishing Company; copyright renewed © 1960 by Maurice Walsh.

Elizabeth Barnett, Literary Executor: "Autumn Chant," "I Shall Go Back Again to the Bleak Shore," from "On Hearing a Symphony of Beethoven," and "Recuerdo" from *Collected Poems* by Edna St. Vincent Millay. Copyright © 1922, 1923, 1928, 1950, 1951, 1955 by Edna St. Vincent Millay and Norma Millay Ellis. Published by HarperCollins.

BOA Editions, Ltd., 92 Park Avenue, Brockport, NY 14420: "miss rosie" from *good woman: poems and a memoir 1969–1980* by Lucille Clifton. Copyright © 1987 by Lucille Clifton.

Gwendolyn Brooks: From "The Ballad of Rudolph Reed" and "The Sonnet-Ballad" from *Blacks* by Gwendolyn Brooks. Copyright © 1991 by Gwendolyn Brooks. Published by Third World Press, Chicago.

Chronicle Books: "Oranges" from *New and Selected Poems* by Gary Soto. Copyright © 1995 by Gary Soto.

Eugenia Collier and Negro Digest: "Marigolds" by Eugenia Collier from *Negro Digest,* November 1969. Copyright © 1969 by Johnson Publishing Company, Inc.

Don Congdon Associates, Inc.: "Contents of a Dead Man's Pockets" by Jack Finney (Retitled: "Contents of the Dead Man's Pockets") from *Colliers,* October 1956. Copyright © 1956 and renewed © 1984 by Jack Finney.

Delacorte Press/Seymour Lawrence, a division of Bantam Doubleday Dell Publishing Group, Inc.: "Harrison Bergeron" from *Welcome to the Monkey House* by Kurt Vonnegut, Jr. Copyright © 1961 by Kurt Vonnegut, Jr.

Devin-Adair, Publishers, Inc., Old Greenwich, Connecticut 06870: "The Trout" by Sean O'Faolain. Copyright 1948 and renewed © 1976 by Devin-Adair, Publishers, Inc. All rights reserved.

Sandra Dijkstra Literary Agency: "North County" from *Some One Sweet Angel Chile* by Sherley Anne Williams. Copyright © 1976, 1982 by Sherley Anne Williams.

Anne Dillard: Comment on "In the Jungle" by Annie Dillard. Copyright © 1996 by Anne Dillard.

Doubleday, a division of Bantam Doubleday Dell Publishing Group, Inc.: "The Rockpile" from *Going to Meet the Man* by James Baldwin. Copyright 1948, 1951, © 1957, 1958, 1960, 1965 by James Baldwin. "Big Wind" from *The Collected Poems of Theodore Roethke.* Copyright 1947 by The United Chapters of Phi Beta Kappa.

Rita Dove: From "November for Beginners" from *Selected Poems* by Rita Dove. Copyright © 1983, 1993 by Rita Dove.

Dutton Signet, a division of Penguin Books USA Inc.: "The Tale of Sir Gareth" and "The Tale of Sir Launcelot du Lake" from *Le Morte D'Arthur* by Sir Thomas Malory, translated by Keith Baines. Translation copyright © 1962 by Keith Baines; copyright renewed © 1990 by Francesca Evans. Introduction copyright © 1962 by Robert Graves; copyright renewed © 1990 by Beryl Graves.

Ann Elmo Agency, Inc.: "Leiningen Versus the Ants" by Carl Stephenson (slightly abridged) from *Esquire,* vol. 10, no. 6, December 1938. Copyright 1938 by Esquire-Coronet, Inc.; copyright renewed © 1966 by Esquire, Inc.

Mari Evans: From "When in Rome" from *I Am a Black Woman* by Mari Evans. Copyright © 1970 by Mari Evans.

Faber and Faber Ltd.: "The Lake" by Ted Hughes. Copyright © 1961, 1963, 1965 by Ted Hughes. Originally appeared in *The New Yorker.*

Farrar, Straus & Giroux, Inc.: From "Invitation to Miss Marianne Moore," "One Art" and from "Varick Street" from *Complete Poems 1927–1979* by Elizabeth Bishop. Copyright © 1979, 1983 by Alice Helen Methfessel. From "Vint" by Anton Chekhov from *The Unknown Chekhov,* translated by Avrahm Yarmolinsky. Copyright © 1954 by Avrahm Yarmolinsky; copyright renewed © 1982 by Babette Deutsch Yarmolinsky. "Introduction" from *The Acts of King Arthur and His Noble Knights* by John Steinbeck. Copyright © 1976 by Elaine Steinbeck. Adapted from "The Track Meet" (Retitled: "The Beginning of Grief") from *Beyond the Bedroom Wall* by Larry Woiwode. Copyright © 1975 by Larry Woiwode. Adapted from "Clean Fun at Riverhead" from *The Kandy-Kolored Tangerine-Flake Streamline Baby* by Tom Wolfe. Copyright © 1965 by Thomas K. Wolfe.

GRM Associates, Inc., Agents for the Estate of Ida M. Cullen: "For My Grandmother" from *Color* by Countee Cullen. Copyright © 1925 by Harper & Brothers; copyright renewed © 1953 by Ida M. Cullen. "Sonnet" from *The Medea and Some Poems* by Countee Cullen. Copyright © 1935 by Harper & Brothers; copyright renewed © 1963 by Ida M. Cullen.

Contents

NONFICTION

POETRY

Types of Poetry

DRAMA

THE LEGEND
OF KING ARTHUR

THE NOVEL

WRITING ABOUT LITERATURE

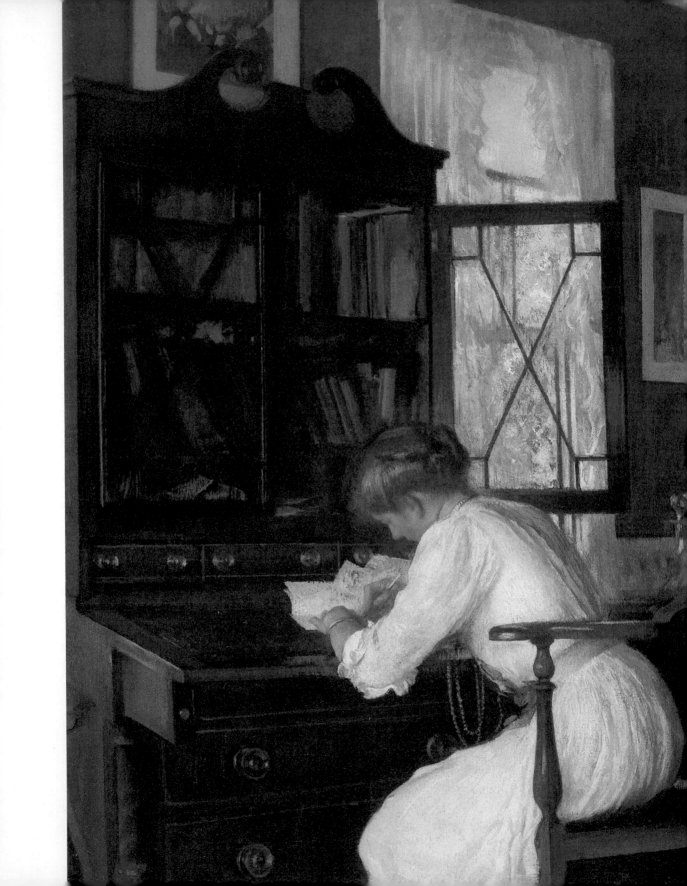

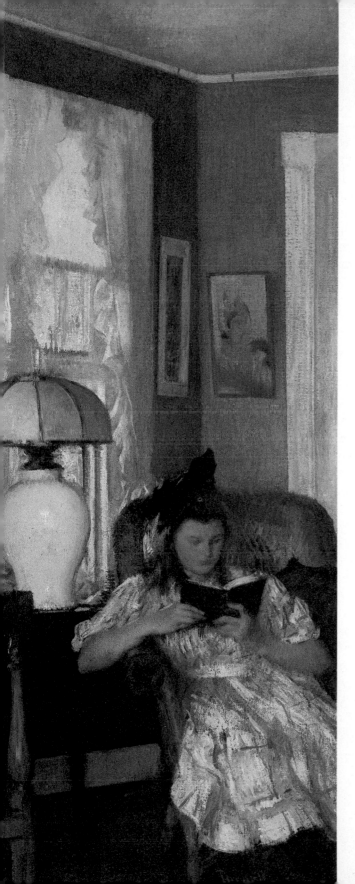

SHORT STORIES

It's been said that a picture is worth a thousand words. In fact, in some ways, a picture is like a short story. Paintings like the one to the left contain a great deal of detail to spark the imagination. Study the painting carefully, either alone or with classmates. Create a story about the two girls. The following questions will help you develop your story.

1. Who are the girls in the room? Are they sisters? friends? roommates?
2. What do the furniture and the paintings in the room suggest?
3. What is the girl in the armchair reading?
4. Why is the girl at the desk writing?
5. What has just happened? What might be about to happen?

Share your story with other members of the class. Find out how many different stories can grow out of clues in the painting.

Josephine and Mercie (1908) by Edmund Charles Tarbell (1862–1938). Oil on canvas, 28 1/4 x 32 1/4 in.
In the Collection of the Corcoran Gallery of Art, Museum Purchase, Gallery Fund, 1909

1

*T*here are two reasons for reading imaginative literature and two tests for judging it: pleasure and insight. The first and most important test of a story, poem, or play is, "Does it bring enjoyment?" If it doesn't, we want no more of it. But we must also ask, "Enjoyment to whom?" The best story in the world will bring no enjoyment to a person who doesn't know how to respond to it. Many excellent stories bring no enjoyment to us because we are unskilled as responders. Thus, in order to enjoy literature, we need to practice asking ourselves key questions as we read and making ourselves conscious of our reactions to what we read.

The second test for the worth of imaginative literature is, "Does it yield insight? Do we know more, after reading it, about the world we live in, about our fellow human beings, about ourselves?" The paradox of imaginative literature is that, though it deals with imaginary events and imaginary people, it can communicate real truth—not just facts but essential truths about living, delivered whole to our senses, our emotions, our imaginations and our minds.

Reading and responding to good literature can not only provide enjoyment but also enlarge our experience, extend our sympathies, and deepen our understanding. Though we read and respond to imaginative literature for enjoyment, we also read and respond to it to make ourselves more fully human.

A reader who enters imaginatively into a story responds to several elements that are interdependent: plot (the sequence of related events); characters (persons, animals, or things presented as persons); point of view (the vantage point of the narrative); setting (the time and place of the action); and theme (the underlying idea about human life). The better you understand how these elements work together, the better you will understand and appreciate the author's intent and meaning and your own response to the story.

Guidelines for Close Reading

1. Read actively for both pleasure and insight, asking yourself questions as you read. Respond to clues and draw inferences about the events and people in the story. The imaginary events and people in short stories can be enjoyed in their own right and can also provide us with greater awareness of ourselves and others.

2. Ask questions about unfamiliar words and references. If you feel uncertain about the meaning of a word and cannot get the meaning from context clues, be sure to check in a standard dictionary or other reference work.

3. React to how the plot unfolds and make predictions as you read. Note the sequence of events and the logic with which the action develops. Ask yourself, "What will happen next?" Be aware of your response to plot developments.

4. Ask yourself how characters are presented and how they develop. Watch for details that directly or indirectly reveal characters and their values. The author often does not tell us things directly but wants readers to draw inferences from evidence in the story.

5. Be aware of the time and place of the story, and look for the effect of setting on plot and characters. The opening paragraph of a story sometimes gives a detailed description of a setting, a clue that this place will play an important role in the story. Ask yourself what significance there might be to details the author gives you.

6. Take note of the story's point of view. Ask yourself about the author's purpose in choosing to have a story told by a character in the story or by an outside voice.

7. Don't accept everything in a story at face value. Ask yourself questions and be alert to the author's use of irony and symbolism. The central characters, objects, and actions of a story sometimes represent more than they appear to be on the surface. Familiar objects of real life are often used as symbols in fiction.

8. Ask yourself about the central idea or point, the underlying meaning of the work. State this central idea or theme in a sentence. For example: The story makes me think about the way the worlds of fantasy and reality blend as a child grows up.

Here is a brief story that has been read carefully by one reader. The comments in the margin show how this reader has responded to the story. If you would like, make notes of your own on a separate sheet of paper, covering up the printed notes as you read. You may wish to compare your responses with these printed comments at a later point.

The Trout

SEAN O'FAOLAIN°

ONE READER'S RESPONSE

This sounds very mysterious. Words like dark, midnight, wild, *and* damp *make me feel like I'm part of something mysterious.*

I think Julia enjoys racing through the Dark Walk.

Does this mean that she gets scared and likes it?

Julia likes scaring her little brother, too.

Why are they arguing?

One of the first places Julia always ran to when they arrived in G———— was The Dark Walk. It is a laurel walk, very old; almost gone wild, a lofty midnight tunnel of smooth, sinewy branches. Underfoot the tough brown leaves are never dry enough to crackle: there is always a suggestion of damp and cool trickle.

She raced right into it. For the first few yards she always had the memory of the sun behind her, then she felt the dusk closing swiftly down on her so that she screamed with pleasure and raced on to reach the light at the far end; and it was always just a little too long in coming so that she emerged gasping, clasping her hands, laughing, drinking in the sun. When she was filled with the heat and glare she would turn and consider the ordeal again.

This year she had the extra joy of showing it to her small brother, and of terrifying him as well as herself. And for him the fear lasted longer because his legs were so short and she had gone out at the far end while he was still screaming and racing.

When they had done this many times they came back to the house to tell everybody that they had done it. He boasted. She mocked. They squabbled.

"Cry babby!"

"You were afraid yourself, so there!"

° **Sean O'Faolain** (shôn ō-fǝ-lôn′, -līn).

Children by a Brook (c. 1822) by Francis Danby (1793–1861).
Tate Gallery, London, Great Britain.
Tate Gallery, London/Art Resource, NY

"I won't take you anymore."
"You're a big pig."
"I hate you."

Tears were threatening so somebody said, "Did you see the well?" She opened her eyes at that and held up her long, lovely neck suspiciously and decided to be incredulous. She was twelve and at that age little girls are beginning to suspect most stories: they have already found out too many, from Santa Claus to the Stork. How could there be a well! In The Dark Walk? That she had visited year after year? Haughtily, she said, "Nonsense."

Why are they fighting?

She's going to act like she doesn't believe it.

Her curiosity gets the best of her.

What an incredible image!! What does the author want me to feel?

How did it get there?

Julia really feels strongly about this fish.

I don't think she accepts her parents' theories.

But she went back, pretending to be going somewhere else, and she found a hole scooped in the rock at the side of the walk, choked with damp leaves, so shrouded by ferns that she only uncovered it after much searching. At the back of this little cavern there was a quart of water. In the water she suddenly perceived a panting trout. She rushed for Stephen and dragged him to see, and they were both so excited that they were no longer afraid of the darkness as they hunched down and peered in at the fish panting in his tiny prison, his silver stomach going up and down like an engine.

Nobody knew how the trout got there. Even old Martin in the kitchen garden laughed and refused to believe that it was there, or pretended not to believe, until she forced him to come down and see. Kneeling and pushing back his tattered old cap he peered in.

"You're right. How did that fella get there?"

She stared at him suspiciously.

"You knew?" she accused; but he said, "The divil a know"; and reached down to lift it out. Convinced she hauled him back. If she had found it, then it was her trout.

Her mother suggested that a bird had carried the spawn. Her father thought that in the winter a small streamlet might have carried it down there as a baby, and it had been safe until the summer came and the water began to dry up. She said, "I see," and went back to look again and consider the matter in private. Her brother remained behind, wanting to hear the whole story of the trout, not really interested in the actual trout but much interested in the story which his mummy began to make up for him on the lines of, "So one

The Abandoned Pond by Vasily Polenov. Tretyakov Gallery, Moscow, Russia.
Scala/Art Resource, NY

day Daddy Trout and Mammy Trout . . ." When he retailed[1] it to her she said, "Pooh."

It troubled her that the trout was always in the same position; he had no room to turn; all the time the silver belly went up and down; otherwise he was motionless. She wondered what he ate and in between visits to Joey Pony, and the boat and a bathe to get cool, she thought of his hunger. She brought him down bits of dough; once she brought him a worm. He ignored the food. He just went on panting. Hunched over him she thought how, all the winter, while she was at school he had been in there. All the winter, in The Dark Walk, all day, all night, floating around alone. She drew the leaf of her hat down around her ears and chin and stared. She was thinking of it as she lay in bed.

1. **retailed** (rī-tāld'): told and retold.

She keeps brushing her brother off.

She feels sorry for the poor trout. So do I.

She's got a good heart.

This is scary and sad. It makes me feel lonely too.

This sentence really captures the heat.

I like how she makes believe that she's not listening.

Finally, she reacts strongly. I've been waiting for this.

What's going on? Who are the beasts?

The author really contrasts her with Stephen here.

What does ewer mean?

Wow!! This is both mysterious and exciting. What words will the author use to make me feel more involved?

It was late June, the longest days of the year. The sun had sat still for a week, burning up the world. Although it was after ten o'clock it was still bright and still hot. She lay on her back under a single sheet, with her long legs spread, trying to keep cool. She could see the D of the moon through the fir tree—they slept on the ground floor. Before they went to bed her mummy had told Stephen the story of the trout again, and she, in her bed, had resolutely presented her back to them and read her book. But she had kept one ear cocked.

"And so, in the end, this naughty fish who would not stay at home got bigger and bigger and bigger, and the water got smaller and smaller. . . ."

Passionately she had whirled and cried, "Mummy, don't make it a horrible old moral story!" Her mummy had brought in a Fairy Godmother, then, who sent lots of rain, and filled the well, and a stream poured out and the trout floated away down to the river below. Staring at the moon she knew that there are no such things as Fairy Godmothers and that the trout, down in The Dark Walk, was panting like an engine. She heard somebody unwind a fishing reel. Would the *beasts* fish him out!

She sat up. Stephen was a hot lump of sleep, lazy thing. The Dark Walk would be full of little scraps of moon. She leaped up and looked out the window, and somehow it was not so lightsome now that she saw the dim mountains far away and the black firs against the breathing land and heard a dog say bark-bark. Quietly she lifted the ewer of water, and climbed out the window and scuttled along the cool but cruel gravel down to the maw[2] of the tunnel. Her pajamas were very short so that when she splashed water it wet her ankles. She peered into the tunnel. Something alive rustled inside there. She raced in, and up and down she raced, and flurried, and cried aloud, "Oh, gosh, I can't find it," and then at last she did. Kneeling down in the damp she put her hand into the slimy hole. When the body lashed they were both mad with fright. But she gripped him and shoved him into the ewer and raced, with her teeth ground, out to the other end of the tunnel and down the steep paths to the river's edge.

All the time she could feel him lashing his tail against the

2. **maw** (mô): here, a large opening.

side of the ewer. She was afraid he would jump right out. The gravel cut into her soles until she came to the cool ooze of the river's bank where the moonmice on the water crept into her feet. She poured out watching until he plopped. For a second he was visible in the water. She hoped he was not dizzy. Then all she saw was the glimmer of the moon in the silent-flowing river, the dark firs, the dim mountains, and the radiant pointed face laughing down at her out of the empty sky.

She saves the trout.

She scuttled up the hill, in the window, plonked down the ewer and flew through the air like a bird into bed. The dog said bark-bark. She heard the fishing reel whirring. She hugged herself and giggled. Like a river of joy her holiday spread before her.

What an amazing contrast. It's all so peaceful now.

In the morning Stephen rushed to her, shouting that "he" was gone, and asking "where" and "how." Lifting her nose in the air she said superciliously,[3] "Fairy Godmother, I suppose?" and strolled away patting the palms of her hands.

I love this image. It reminds me of how I feel when I'm happy because I've done something.

Julia is pleased with herself, but she'll keep her secret.

3. **superciliously** (sōō′pər-sĭl′ē-əs-lē). disdainfully.

© Chris Hackett/The Image Bank

Looking at Yourself as a Reader

Compare your own notes with the notes that appear alongside the selection. How are the two sets of responses similar? How are they different? What do these similarities and differences tell you about the way different readers respond to short stories?

Review your responses carefully. What aspects of the story had the greatest effect on you? Why? What was your reaction to the scene? the characters? the action? Meet with several of your classmates and compare responses. Put together a group response to the story and present it to the class.

Consider the following statements about "The Trout." Which statement, if any, do you think presents the best interpretation of the story? Are there any statements you disagree with? Give reasons for your answers.

1. The story is called "The Trout" because a fish is its most important character.
2. The events of this story show that as children mature, they lose interest in make-believe games and stories and become interested in real problems and challenges.
3. As "The Trout" shows, children who grow up in the country feel a great attachment to nature and its creatures.
4. The story suggests that the games we play and the stories we read as children are a necessary preparation for the serious business of life.

PLOT

Plot is the sequence of incidents or actions in a story. Whatever the characters do, or whatever happens to them, constitutes *plot.*

The most important element in plot is usually *conflict.* Conflict may be *external* or *internal;* it may be physical, intellectual, emotional, or moral. A story may pit a character against the environment, against another person, or against some inner impulses or desires. Many stories have more than one conflict. A story ordinarily ends when its main conflict is *resolved,* that is, when one side or the other triumphs, and the main character either succeeds or fails. In some stories, however, the conflict is left unresolved, just as conflicts in real life often have no definite conclusions.

A plot may be realistic or fantastic. It may start from an ordinary, everyday situation or from a strange, even supernatural one. All the succeeding events should proceed logically from that initial situation, and all the characters' actions should be consistent with their personalities. A good plot is governed by an inner logic. It may begin with a far-fetched coincidence, but it will not ordinarily end with one.

As you read, note how your enjoyment of a story can be enhanced by a better understanding of plot development.

Leiningen Versus the Ants

CARL STEPHENSON

The title of this story tells you that a human being will be pitted against a force of nature. How does the author maintain your interest and keep you uncertain about the outcome of the struggle?

"Unless they alter their course, and there's no reason why they should, they'll reach your plantation in two days at the latest."

Leiningen sucked placidly at a cigar about the size of a corncob and for a few seconds gazed without answering at the agitated District Commissioner. Then he took the cigar from his lips, and leaned slightly forward. With his bristling gray hair, bulky nose, and lucid eyes, he had the look of an aging and shabby eagle.

"Decent of you," he murmured, "paddling all this way just to give me the tip. But you're pulling my leg of course when you say I must do a bunk. Why, even a herd of saurians[1] couldn't drive me from this plantation of mine."

The Brazilian official threw up lean and lanky arms and clawed the air with wildly distended fingers. "Leiningen!" he shouted. "You're insane! They're not creatures you can fight—they're an elemental—an 'act of God'! Ten miles long, two miles wide—ants, nothing but ants! And every single one of them a fiend from hell; before you can spit three times they'll eat a full-grown buffalo to the bones. I tell you if you don't clear out at once there'll be nothing left of you but a skeleton picked as clean as your own plantation."

Leiningen grinned. "Act of God, my eye! Anyway, I'm not going to run for it just because an elemental's on the way. And don't think I'm the kind of fathead who tries to fend off lightning with his fists, either. I use my intelligence, old man. With me, the brain isn't a second blind gut;[2] I know what it's there for. When I began this model farm and plantation three years ago, I took into account all that could conceivably happen to it. And now I'm ready for anything and everything—including your ants."

The Brazilian rose heavily to his feet. "I've done my best," he gasped. "Your obstinacy endangers not only yourself, but the lives of your four hundred workers. You don't know these ants!"

1. **saurians** (sôr′ē-əns): lizards, crocodiles, and other reptiles.

2. **blind gut:** an allusion to the appendix, for which there is no known function.

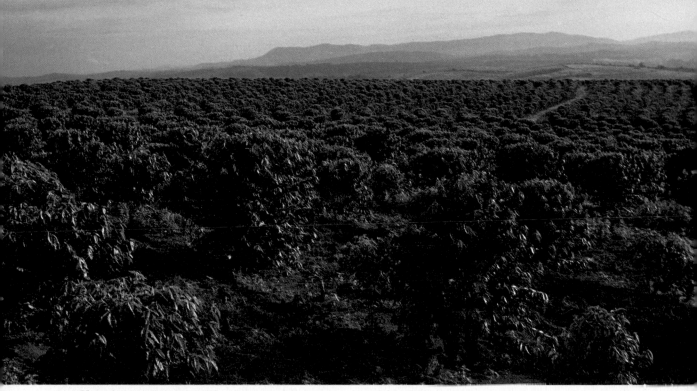

A coffee plantation in Brazil.

Leiningen accompanied him down to the river, where the government launch was moored. The vessel cast off. As it moved downstream, the exclamation mark neared the rail and began waving his arms frantically. Long after the launch had disappeared round the bend, Leiningen thought he could still hear that dimming, imploring voice. "You don't know them, I tell you! *You don't know them!*"

But the reported enemy was by no means unfamiliar to the planter. Before he started work on his settlement, he had lived long enough in the country to see for himself the fearful devastations sometimes wrought by these ravenous insects in their campaigns for food. But since then he had planned measures of defense accordingly, and these, he was convinced, were in every way adequate to withstand the approaching peril.

Moreover, during his three years as a planter, Leiningen had met and defeated drought, flood, plague, and all other "acts of God" which had come against him—unlike his fellow settlers in the district, who had made little or no resistance. This unbroken success he attributed solely to the observance of his lifelong motto: *The human brain needs only to become fully aware of its powers to conquer even the elements.* Dullards reeled senselessly and aimlessly into the abyss; cranks, however brilliant, lost their heads when circumstances suddenly altered or accelerated and ran into stone walls; sluggards drifted with the current until they were caught in whirlpools and dragged under. But such disasters, Leiningen contended, merely strengthened his argument that intelligence, directed aright, invariably makes man the master of his fate.

Yes, Leiningen had always known how to grapple with life. Even here, in this Brazilian wilderness, his brain had triumphed over every difficulty and danger it had so far en-

Leiningen Versus the Ants **13**

countered. First he had vanquished primal forces by cunning and organization, then he had enlisted the resources of modern science to increase miraculously the yield of his plantation. And now he was sure he would prove more than a match for the "irresistible" ants.

That same evening, however, Leiningen assembled his workers. He had no intention of waiting till the news reached their ears from other sources. Most of them had been born in the district; the cry "The ants are coming!" was to them an imperative signal for instant, panic-stricken flight, a spring for life itself. But so great was the Indians' trust in Leiningen, in Leiningen's word, and in Leiningen's wisdom, that they received his curt tidings, and his orders for the imminent struggle, with the calmness with which they were given. They waited, unafraid, alert, as if for the beginning of a new game or hunt which he had just described to them. The ants were indeed mighty, but not so mighty as the boss. Let them come!

They came at noon the second day. Their approach was announced by the wild unrest of the horses, scarcely controllable now either in stall or under rider, scenting from afar a vapor instinct with horror.

It was announced by a stampede of animals, timid and savage, hurtling past each other; jaguars and pumas flashing by nimble stags of the pampas;[3] bulky tapirs, no longer hunters, themselves hunted, outpacing fleet kinkajous;[4] maddened herds of cattle, heads lowered, nostrils snorting, rushing through tribes of loping monkeys, chattering in a dementia of terror; then followed the creeping and springing denizens of bush and steppe, big and little rodents, snakes, and lizards.

Pell-mell the rabble swarmed down the hill to the plantation, scattered right and left before the barrier of the water-filled ditch, then sped onwards to the river, where, again hindered, they fled along its bank out of sight.

This water-filled ditch was one of the defense measures which Leiningen had long since prepared against the advent of the ants. It encompassed three sides of the plantation like a huge horseshoe. Twelve feet across, but not very deep, when dry it could hardly be described as an obstacle to either man or beast. But the ends of the "horseshoe" ran into the river which formed the northern boundary, and fourth side, of the plantation. And at the end nearer the house and outbuildings in the middle of the plantation, Leiningen had constructed a dam by means of which water from the river could be diverted into the ditch.

So now, by opening the dam, he was able to fling an imposing girdle of water, a huge quadrilateral with the river as its base, completely around the plantation, like the moat encircling a medieval city. Unless the ants were clever enough to build rafts, they had no hope of reaching the plantation, Leiningen concluded.

The twelve-foot water ditch seemed to afford in itself all the security needed. But while awaiting the arrival of the ants, Leiningen made a further improvement. The western section of the ditch ran along the edge of a tamarind[5] wood, and the branches of some great trees reached over the water. Leiningen now had them lopped so that ants could not descend from them within the "moat."

The women and children, then the herds of cattle, were escorted by peons on rafts over the river, to remain on the other side in absolute safety until the plunderers had departed. Leiningen gave this instruction, not because he believed the noncombatants were in any danger, but in order to avoid hampering the efficiency of the defenders.

3. **pampas** (păm′pəz): vast treeless plains.
4. **kinkajous** (kīng′kə-jōōz′): three-foot-long mammals with long tails, which live in South America.

5. **tamarind** (tăm′ə-rīnd′): tropical tree with featherlike leaves.

Finally, he made a careful inspection of the "inner moat"—a smaller ditch lined with concrete, which extended around the hill on which stood the ranch house, barns, stables, and other buildings. Into this concrete ditch emptied the inflow pipes from three great petrol[6] tanks. If by some miracle the ants managed to cross the water and reach the plantation, this "rampart of petrol" would be an absolutely impassable protection for the besieged and their dwellings and stock. Such, at least, was Leiningen's opinion.

He stationed his men at irregular distances along the water ditch, the first line of defense. Then he lay down in his hammock and puffed drowsily away at his pipe until a peon came with the report that the ants had been observed far away in the south.

Leiningen mounted his horse, which at the feel of its master seemed to forget its uneasiness, and rode leisurely in the direction of the threatening offensive. The southern stretch of ditch—the upper side of the quadrilateral—was nearly three miles long; from its center one could survey the entire countryside. This was destined to be the scene of the outbreak of war between Leiningen's brain and twenty square miles of life-destroying ants.

It was a sight one could never forget. Over the range of hills, as far as eye could see, crept a darkening hem, ever longer and broader, until the shadow spread across the slope from east to west, then downwards, downwards, uncannily swift, and all the green herbage of that wide vista was being mown as by a giant sickle, leaving only the vast moving shadow, extending, deepening, and moving rapidly nearer.

When Leiningen's men, behind their barrier of water, perceived the approach of the long-expected foe, they gave vent to their suspense in screams and imprecations. But as the distance began to lessen between the "sons of hell" and the water ditch, they relapsed into silence. Before the advance of that awe-inspiring throng, their belief in the powers of the boss began to steadily dwindle.

Even Leiningen himself, who had ridden up just in time to restore their loss of heart by a display of unshakable calm, even he could not free himself from a qualm of malaise. Yonder were thousands of millions of voracious jaws bearing down upon him and only a suddenly insignificant, narrow ditch lay between him and his men and being gnawed to the bones "before you can spit three times."

Hadn't his brain for once taken on more than it could manage? If the blighters decided to rush the ditch, fill it to the brim with their corpses, there'd still be more than enough to destroy every trace of that cranium[7] of his. The planter's chin jutted; they hadn't got him yet, and he'd see to it they never would. While he could think at all, he'd flout both death and the devil.

The hostile army was approaching in perfect formation; no human battalions, however well-drilled, could ever hope to rival the precision of that advance. Along a front that moved forward as uniformly as a straight line, the ants drew nearer and nearer to the water ditch. Then, when they learned through their scouts the nature of the obstacle, the two outlying wings of the army detached themselves from the main body and marched down the western and eastern sides of the ditch.

This surrounding maneuver took rather more than an hour to accomplish; no doubt the ants expected that at some point they would find a crossing.

During this outflanking movement by the wings, the army on the center and southern front remained still. The besieged were there-

6. **petrol** (pĕt′rəl): a British term for gasoline.

7. **cranium** (krā′nē-əm): skull.

fore able to contemplate at their leisure the thumb-long, reddish-black, long-legged insects; some of the Indians believed they could see, too, intent on them, the brilliant, cold eyes, and the razor-edged mandibles,[8] of this host of infinity.

It is not easy for the average person to imagine that an animal, not to mention an insect, can *think*. But now both the brain of Leiningen and the brains of the Indians began to stir with the unpleasant foreboding that inside every single one of that deluge of insects dwelled a thought. And that thought was: Ditch or no ditch, we'll get to your flesh!

Not until four o'clock did the wings reach the "horseshoe" ends of the ditch, only to find these ran into the great river. Through some kind of secret telegraphy, the report must then have flashed very swiftly indeed along the entire enemy line. And Leiningen, riding—no longer casually—along his side of the ditch, noticed by energetic and widespread movements of troops that for some unknown reason the news of the check had its greatest effect on the southern front, where the main army was massed. Perhaps the failure to find a way over the ditch was persuading the ants to withdraw from the plantation in search of spoils more easily obtainable.

An immense flood of ants, about a hundred yards in width, was pouring in a glimmering black cataract down the far slope of the ditch. Many thousands were already drowning in the sluggish creeping flow, but they were followed by troop after troop, who clambered over their sinking comrades, and then themselves served as dying bridges to the reserves hurrying on in their rear.

Shoals of ants were being carried away by the current into the middle of the ditch, where gradually they broke asunder and then, exhausted by their struggles, vanished below the surface. Nevertheless, the wavering, floundering hundred-yard front was remorselessly if slowly advancing towards the besieged on the other bank. Leiningen had been wrong when he supposed the enemy would first have to fill the ditch with their bodies before they could cross; instead, they merely needed to act as steppingstones, as they swam and sank, to the hordes ever pressing onwards from behind.

Near Leiningen a few mounted herdsmen awaited his orders. He sent one to the weir[9]— the river must be dammed more strongly to increase the speed and power of the water coursing through the ditch.

A second peon was dispatched to the outhouses to bring spades and petrol sprinklers. A third rode away to summon to the zone of the offensive all the men, except the observation posts, on the nearby sections of the ditch, which were not yet actively threatened.

The ants were getting across far more quickly than Leiningen would have deemed possible. Impelled by the mighty cascade behind them, they struggled nearer and nearer to the inner bank. The momentum of the attack was so great that neither the tardy flow of the stream nor its downward pull could exert its proper force; and into the gap left by every submerging insect, hastened forward a dozen more.

When reinforcements reached Leiningen, the invaders were halfway over. The planter had to admit to himself that it was only by a stroke of luck for him that the ants were attempting the crossing on a relatively short front: had they assaulted simultaneously along the entire length of the ditch, the outlook for the defenders would have been black indeed.

Even as it was, it could hardly be described as rosy, though the planter seemed quite un-

8. **mandibles** (măn′də-bəls): jaws.

9. **weir** (wîr): dam on a river or stream.

aware that death in a gruesome form was drawing closer and closer. As the war between his brain and the "act of God" reached its climax, the very shadow of annihilation began to pale to Leiningen, who now felt like a champion in a new Olympic game, a gigantic and thrilling contest, from which he was determined to emerge victor. Such, indeed, was his aura of confidence that the Indians forgot their fear of the peril only a yard or two away; under the planter's supervision, they began fervidly digging up to the edge of the bank and throwing clods of earth and spadefuls of sand into the midst of the hostile fleet.

The petrol sprinklers, hitherto used to destroy pests and blights on the plantation, were also brought into action. Streams of evil-reeking oil now soared and fell over an enemy already in disorder through the bombardment of earth and sand.

The ants responded to these vigorous and successful measures of defense by further developments of their offensive. Entire clumps of huddling insects began to roll down the opposite bank into the water. At the same time, Leiningen noticed that the ants were now attacking along an ever-widening front. As the numbers both of his men and his petrol sprinklers were severely limited, this rapid extension of the line of battle was becoming an overwhelming danger.

To add to his difficulties, the very clods of earth they flung into that black floating carpet often whirled fragments toward the defenders' side, and here and there dark ribbons were already mounting the inner bank. True, wherever a man saw these they could still be driven back into the water by spadefuls of earth or jets of petrol. But the file of defenders was too sparse and scattered to hold off at all points these landing parties, and though the peons toiled like madmen, their plight became momently more perilous.

One man struck with his spade at an enemy clump, did not draw it back quickly enough from the water; in a trice the wooden haft swarmed with upward scurrying insects. With a curse, he dropped the spade into the ditch; too late, they were already on his body. They lost no time; wherever they encountered bare flesh they bit deeply; a few, bigger than the rest, carried in their hindquarters a sting which injected a burning and paralyzing venom. Screaming, frantic with pain, the peon danced and twirled like a dervish.[10]

Realizing that another such casualty, yes, perhaps this alone, might plunge his men into confusion and destroy their morale, Leiningen roared in a bellow louder than the yells of the victim: "Into the petrol, idiot! Douse your paws in the petrol!" The dervish ceased his pirouette as if transfixed, then tore off his shirt and plunged his arm and the ants hanging to it up to the shoulder in one of the large open tins of petrol. But even then the fierce mandibles did not slacken; another peon had to help him squash and detach each separate insect.

Distracted by the episode, some defenders had turned away from the ditch. And now cries of fury, a thudding of spades, and a wild trampling to and fro, showed that the ants had made full use of the interval, though luckily only a few had managed to get across. The men set to work again desperately with the barrage of earth and sand. Meanwhile an old Indian, who acted as medicine man to the plantation workers, gave the bitten peon a drink he had prepared some hours before, which, he claimed, possessed the virtue of dissolving and weakening ants' venom.

Leiningen surveyed his position. A dispassionate observer would have estimated the

10. **dervish** (dûr′vĭsh): member of a Moslem sect. Some dervishes use whirling movements as part of their religious rituals.

odds against him at a thousand to one. But then such an onlooker would have reckoned only by what he saw—the advance of myriad battalions of ants against the futile efforts of a few defenders—and not by the unseen activity that can go on in a man's brain.

For Leiningen had not erred when he decided he would fight elemental with elemental. The water in the ditch was beginning to rise; the stronger damming of the river was making itself apparent.

Visibly the swiftness and power of the masses of water increased, swirling into quicker and quicker movement its living black surface, dispersing its pattern, carrying away more and more of it on the hastening current.

Victory had been snatched from the very jaws of defeat. With a hysterical shout of joy, the peons feverishly intensified their bombardment of earth clods and sand.

And now the wide cataract down the opposite bank was thinning and ceasing, as if the ants were becoming aware that they could not attain their aim. They were scurrying back up the slope to safety.

All the troops so far hurled into the ditch had been sacrificed in vain. Drowned and floundering insects eddied in thousands along the flow, while Indians running on the bank destroyed every swimmer that reached the side.

Not until the ditch curved towards the east did the scattered ranks assemble again in a coherent mass. And now, exhausted and half-numbed, they were in no condition to ascend the bank. Fusillades of clods drove them round the bend towards the mouth of the ditch and then into the river, wherein they vanished without leaving a trace.

The news ran swiftly along the entire chain of outposts, and soon a long scattered line of laughing men could be seen hastening along the ditch towards the scene of victory.

For once they seemed to have lost all their native reserve, for it was in wild abandon now they celebrated the triumph—as if there were no longer thousands of millions of merciless, cold, and hungry eyes watching them from the opposite bank, watching and waiting.

The sun sank behind the rim of the tamarind wood and twilight deepened into night. It was not only hoped but expected that the ants would remain quiet until dawn. But to defeat any forlorn attempt at a crossing, the flow of water through the ditch was powerfully increased by opening the dam still further.

In spite of this impregnable barrier, Leiningen was not yet altogether convinced that the ants would not venture another surprise attack. He ordered his men to camp along the bank overnight. He also detailed parties of them to patrol the ditch in two of his motor cars and ceaselessly to illuminate the surface of the water with headlights and electric torches.

After having taken all the precautions he deemed necessary, the farmer ate his supper with considerable appetite and went to bed. His slumbers were in no wise disturbed by the memory of the waiting, live, twenty square miles.

Dawn found a thoroughly refreshed and active Leiningen riding along the edge of the ditch. The planter saw before him a motionless and unaltered throng of besiegers. He studied the wide belt of water between them and the plantation, and for a moment almost regretted that the fight had ended so soon and so simply. In the comforting, matter-of-fact light of morning, it seemed to him now that the ants hadn't the ghost of a chance to cross the ditch. Even if they plunged headlong into it on all three fronts at once, the force of the now powerful current would inevitably sweep them away. He had got quite a thrill out of the fight—a pity it was already over.

He rode along the eastern and southern sections of the ditch and found everything in order. He reached the western section, opposite the tamarind wood, and here, contrary to the other battle fronts, he found the enemy very busy indeed. The trunks and branches of the trees and the creepers of the lianas,[11] on the far bank of the ditch, fairly swarmed with industrious insects. But instead of eating the leaves there and then, they were merely gnawing through the stalks, so that a thick green shower fell steadily to the ground.

No doubt they were victualing columns sent out to obtain provender[12] for the rest of the army. The discovery did not surprise Leiningen. He did not need to be told that ants are intelligent, that certain species even use others as milch cows, watchdogs, and slaves. He was well aware of their power of adaptation, their sense of discipline, their marvelous talent for organization.

His belief that a foray to supply the army was in progress was strengthened when he saw the leaves that fell to the ground being dragged to the troops waiting outside the wood. Then all at once he realized the aim that rain of green was intended to serve.

Each single leaf, pulled or pushed by dozens of toiling insects, was borne straight to the edge of the ditch. Even as Macbeth watched the approach of Birnam Wood in the hands of his enemies,[13] Leiningen saw the tamarind wood move nearer and nearer in the mandibles of the ants. Unlike the fey Scot, however, he did not lose his nerve; no witches had prophesied his doom, and if they had, he

11. **lianas** (lē-ăn′əs): tropical climbing vines that root in the ground.
12. **provender** (prŏv′ən-dər): food.
13. **Macbeth . . . enemies:** a reference to William Shakespeare's play *Macbeth*. Macbeth's enemies disguise themselves with boughs from Birnam Wood and creep up to his castle. From Macbeth's vantage point, it looks as if the forest is moving. This event fulfills a prophecy made by three witches.

would have slept just as soundly. All the same, he was forced to admit to himself that the situation was now far more ominous than that of the day before.

He had thought it impossible for the ants to build rafts for themselves—well, here they were, coming in thousands, more than enough to bridge the ditch. Leaves after leaves rustled down the slope into the water, where the current drew them away from the bank and carried them into midstream. And every single leaf carried several ants. This time the farmer did not trust to the alacrity of his messengers. He galloped away, leaning from his saddle and yelling orders as he rushed past outpost after outpost: "Bring petrol pumps to the southwest front! Issue spades to every man along the line facing the wood!" And arrived in the eastern and southern sections, he dispatched every man except the observation posts to the menaced west.

Then, as he rode past the stretch where the ants had failed to cross the day before, he witnessed a brief but impressive scene. Down the slope of the distant hill there came toward him a singular being, writhing rather than running, an animallike blackened statue with a shapeless head and four quivering feet that knuckled under almost ceaselessly. When the creature reached the far bank of the ditch and collapsed opposite Leiningen, he recognized it as a pampas stag, covered over and over with ants.

It had strayed near the zone of the army. As usual, they had attacked its eyes first. Blinded, it had reeled in the madness of hideous torment straight into the ranks of its persecutors, and now the beast swayed to and fro in its death agony.

With a shot from his rifle Leiningen put it out of its misery. Then he pulled out his watch. He hadn't a second to lose, but for life itself he could not have denied his curiosity the sat-

isfaction of knowing how long the ants would take—for personal reasons, so to speak. After six minutes the white polished bones alone remained. That's how he himself would look before you can—Leiningen spat once, and put spurs to his horse.

The sporting zest with which the excitement of the novel contest had inspired him the day before had now vanished; in its place was a cold and violent purpose. He would send these vermin back to the hell where they belonged, somehow, anyhow. Yes, but how was indeed the question; as things stood at present, it looked as if the devils would raze him and his men from the earth instead. He had underestimated the might of the enemy; he really would have to bestir himself if he hoped to outwit them.

The biggest danger now, he decided, was the point where the western section of the ditch curved southwards. And arrived there, he found his worst expectations justified. The very power of the current had huddled the leaves and their crews of ants so close together at the bend that the bridge was almost ready.

True, streams of petrol and clumps of earth still prevented a landing. But the number of floating leaves was increasing ever more swiftly. It could not be long now before a stretch of water a mile in length was decked by a green pontoon over which the ants could rush in millions.

Leiningen galloped to the weir. The damming of the water was controlled by a wheel on its bank. The planter ordered the man at the wheel first to lower the water in the ditch almost to vanishing point, next to wait a moment, then suddenly to let the river in again. This maneuver of lowering and raising the surface, of decreasing then increasing the flow of water through the ditch was to be repeated over and over again until further notice.

This tactic was at first successful. The water in the ditch sank, and with it the film of leaves. The green fleet nearly reached the bed and the troops on the far bank swarmed down the slope to it. Then a violent flow of water at the original depth raced through the ditch, overwhelming leaves and ants, and sweeping them along.

Army ants foraging.

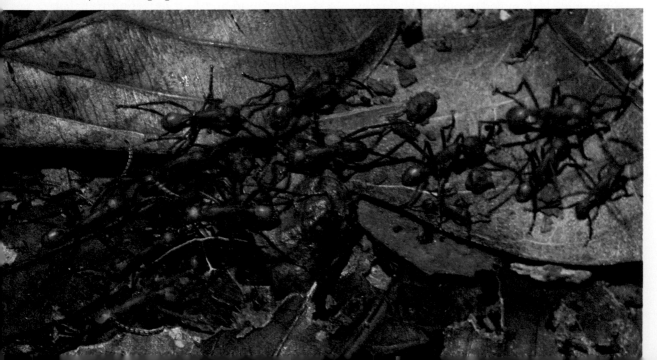

This intermittent rapid flushing prevented just in time the almost completed fording of the ditch. But it also flung here and there squads of the enemy vanguard simultaneously up the inner bank. These seemed to know their duty only too well, and lost no time accomplishing it. The air rang with the curses of bitten Indians. They had removed their shirts and pants to detect the quicker the upward-hastening insects; when they saw one, they crushed it; and fortunately the onslaught as yet was only by skirmishers.

Again and again, the water sank and rose, carrying leaves and drowned ants away with it. It lowered once more nearly to its bed; but this time the exhausted defenders waited in vain for the flush of destruction. Leiningen sensed disaster; something must have gone wrong with the machinery of the dam. Then a sweating peon tore up to him—

"They're over!"

While the besieged were concentrating upon the defense of the stretch opposite the wood, the seemingly unaffected line beyond the wood had become the theater of decisive action. Here the defenders' front was sparse and scattered; everyone who could be spared had hurried away to the south.

Just as the man at the weir had lowered the water almost to the bed of the ditch, the ants on a wide front began another attempt at a direct crossing like that of the preceding day. Into the emptied bed poured an irresistible throng. Rushing across the ditch, they attained the inner bank before the Indians fully grasped the situation. Their frantic screams dumbfounded the man at the weir. Before he could direct the river anew into the safeguarding bed he saw himself surrounded by raging ants. He ran like the others, ran for his life.

When Leiningen heard this, he knew the plantation was doomed. He wasted no time bemoaning the inevitable. For as long as there was the slightest chance of success, he had stood his ground, and now any further resistance was both useless and dangerous. He fired three revolver shots into the air—the prearranged signal for his men to retreat instantly within the "inner moat." Then he rode towards the ranch house.

This was two miles from the point of invasion. There was therefore time enough to prepare the second line of defense against the advent of the ants. Of the three great petrol cisterns near the house, one had already been half emptied by the constant withdrawals needed for the pumps during the fight at the water ditch. The remaining petrol in it was now drawn off through underground pipes into the concrete trench which encircled the ranch house and its outbuildings.

And there, drifting in twos and threes, Leiningen's men reached him. Most of them were obviously trying to preserve an air of calm and indifference, belied, however, by their restless glances and knitted brows. One could see their belief in a favorable outcome of the struggle was already considerably shaken.

The planter called his peons around him.

"Well, lads," he began, "we've lost the first round. But we'll smash the beggars yet, don't you worry. Anyone who thinks otherwise can draw his pay here and now and push off. There are rafts enough and to spare on the river, and plenty of time still to reach 'em."

Not a man stirred.

Leiningen acknowledged his silent vote of confidence with a laugh that was half a grunt. "That's the stuff, lads. Too bad if you'd missed the rest of the show, eh? Well, the fun won't start till morning. Once these blighters turn tail, there'll be plenty of work for everyone and higher wages all round. And now run along and get something to eat; you've earned it all right."

In the excitement of the fight the greater part of the day had passed without the men once pausing to snatch a bite. Now that the ants were for the time being out of sight, and the "wall of petrol" gave a stronger feeling of security, hungry stomachs began to assert their claims.

The bridges over the concrete ditch were removed. Here and there solitary ants had reached the ditch; they gazed at the petrol meditatively, then scurried back again. Apparently they had little interest at the moment for what lay beyond the evil-reeking barrier; the abundant spoils of the plantation were the main attraction. Soon the trees, shrubs, and beds for miles around were hulled with ants zealously gobbling the yield of long weary months of strenuous toil.

As twilight began to fall, a cordon of ants marched around the petrol trench, but as yet made no move towards its brink. Leiningen posted sentries with headlights and electric torches, then withdrew to his office, and began to reckon up his losses. He estimated these as large, but, in comparison with his bank balance, by no means unbearable. He worked out in some detail a scheme of intense cultivation which would enable him, before very long, to more than compensate himself for the damage now being wrought to his crops. It was with a contented mind that he finally betook himself to bed where he slept deeply until dawn, undisturbed by any thought that next day little more might be left of him than a glistening skeleton.

He rose with the sun and went out on the flat roof of his house. And a scene like one from Dante[14] lay around him; for miles in every direction there was nothing but a black, glittering multitude, a multitude of rested,

sated, but nonetheless voracious ants: yes, look as far as one might, one could see nothing but that rustling black throng, except in the north, where the great river drew a boundary they could not hope to pass. But even the high stone breakwater, along the bank of the river, which Leiningen had built as a defense against inundations, was, like the paths, the shorn trees and shrubs, the ground itself, black with ants.

So their greed was not glutted in razing that vast plantation? Not by a long chalk; they were all the more eager now on a rich and certain booty—four hundred men, numerous horses, and bursting granaries.

At first it seemed that the petrol trench would serve its purpose. The besiegers sensed the peril of swimming it, and made no move to plunge blindly over its brink. Instead they devised a better maneuver; they began to collect shreds of bark, twigs, and dried leaves and dropped this into the petrol. Everything green, which could have been similarly used, had long since been eaten. After a time, though, a long procession could be seen bringing from the west the tamarind leaves used as rafts the day before.

Since the petrol, unlike the water in the outer ditch, was perfectly still, the refuse stayed where it was thrown. It was several hours before the ants succeeded in covering an appreciable part of the surface. At length, however, they were ready to proceed to a direct attack.

Their storm troops swarmed down the concrete side, scrambled over the supporting surface of twigs and leaves, and impelled these over the few remaining streaks of open petrol until they reached the other side. Then they began to climb up this to make straight for the helpless garrison.

During the entire offensive, the planter sat peacefully, watching them with interest, but not stirring a muscle. Moreover, he had or-

14. **Dante** (dän'tā): Dante Alighieri (ä'lē-gyä'rē) (1265–1321), author of *The Divine Comedy*. This allusion is to Dante's description of the horrors of the inferno, or hell.

dered his men not to disturb in any way whatever the advancing horde. So they squatted listlessly along the bank of the ditch and waited for a sign from the boss.

The petrol was now covered with ants. A few had climbed the inner concrete wall and were scurrying towards the defenders.

"Everyone back from the ditch!" roared Leiningen. The men rushed away, without the slightest idea of his plan. He stooped forward and cautiously dropped into the ditch a stone which split the floating carpet and its living freight, to reveal a gleaming patch of petrol. A match spurted, sank down to the oily surface—Leiningen sprang back; in a flash a towering rampart of fire encompassed the garrison.

This spectacular and instant repulse threw the Indians into ecstasy. They applauded, yelled, and stamped. Had it not been for the awe in which they held the boss, they would infallibly have carried him shoulder high.

It was some time before the petrol burned down to the bed of the ditch, and the wall of smoke and flame began to lower. The ants had retreated in a wide circle from the devastation, and innumerable charred fragments along the outer bank showed that the flames had spread from the holocaust in the ditch well into the ranks beyond, where they had wrought havoc far and wide.

Yet the perseverance of the ants was by no means broken; indeed, each setback seemed only to whet it. The concrete cooled, the flicker of the dying flames wavered and vanished, petrol from the second tank poured into the trench—and the ants marched forward anew to the attack.

The foregoing scene repeated itself in every detail, except that on this occasion less time was needed to bridge the ditch, for the petrol was now already filmed by a layer of ash. Once again they withdrew; once again petrol flowed into the ditch. Would the creatures never learn that their self-sacrifice was utterly senseless? It really was senseless, wasn't it? Yes, of course it was senseless—provided the defenders had an *unlimited* supply of petrol.

When Leiningen reached this stage of reasoning, he felt for the first time since the arrival of the ants that his confidence was deserting him. His skin began to creep; he loosened his collar. Once the devils were over the trench, there wasn't a chance for him and his men. What a prospect, to be eaten alive like that!

For the third time the flames immolated the attacking troops, and burned down to extinction. Yet the ants were coming on again as if nothing had happened. And meanwhile Leiningen had made a discovery that chilled him to the bone—petrol was no longer flowing into the ditch. Something must be blocking the outflow pipe of the third and last cistern—a snake or a dead rat? Whatever it was, the ants could be held off no longer, unless petrol could by some method be led from the cistern into the ditch.

Then Leiningen remembered that in an outhouse nearby were two old disused fire engines. The peons dragged them out of the shed, connected their pumps to the cistern, uncoiled and laid the hose. They were just in time to aim a stream of petrol at a column of ants that had already crossed and drive them back down the incline into the ditch. Once more an oily girdle surrounded the garrison, once more it was possible to hold the position—for the moment.

It was obvious, however, that this last resource meant only the postponement of defeat and death. A few of the peons fell on their knees and began to pray; others, shrieking insanely, fired their revolvers at the black, advancing masses, as if they felt their despair was pitiful enough to sway fate itself to mercy.

Leiningen Versus the Ants **23**

At length, two of the men's nerves broke: Leiningen saw a naked Indian leap over the north side of the petrol trench, quickly followed by a second. They sprinted with incredible speed towards the river. But their fleetness did not save them; long before they could attain the rafts, the enemy covered their bodies from head to foot.

In the agony of their torment, both sprang blindly into the wide river, where enemies no less sinister awaited them. Wild screams of mortal anguish informed the breathless onlookers that crocodiles and sword-tooth piranhas[15] were no less ravenous than ants, and even nimbler in reaching their prey.

In spite of this bloody warning, more and more men showed they were making up their minds to run the blockade. Anything, even a fight midstream against alligators, seemed better than powerlessly waiting for death to come and slowly consume their living bodies.

Leiningen flogged his brain till it reeled. Was there nothing on earth could sweep this devils' spawn back into the hell from which it came?

Then out of the inferno of his bewilderment rose a terrifying inspiration. Yes, one hope remained, and one alone. It might be possible to dam the great river completely, so that its water would fill not only the water ditch but overflow into the entire gigantic "saucer" of land in which lay the plantation.

The far bank of the river was too high for the waters to escape that way. The stone breakwater ran between the river and the plantation; its only gaps occurred where the "horseshoe" ends of the water ditch passed into the river. So its waters would not only be forced to inundate into the plantation, they would also be held there by the breakwater until they rose to its own high level. In half an hour,

15. **piranhas** (pī-rän′yəz): meat-eating South American fish. A school of piranhas can devour a human or an animal in a matter of minutes.

perhaps even earlier, the plantation and its hostile army of occupation would be flooded.

The ranch house and outbuildings stood upon rising ground. The foundations were higher than the breakwater, so the flood would not reach them. And any remaining ants trying to ascend the slope could be repulsed by petrol.

It was possible—yes, if one could only get to the dam! A distance of nearly two miles lay between the ranch house and the weir—two miles of ants. Those two peons had managed only a fifth of that distance at the cost of their lives. Was there an Indian daring enough after that to run the gauntlet five times as far? Hardly likely; and if there were, his prospect of getting back was almost nil.

No, there was only one thing for it, he'd have to make the attempt himself; he might just as well be running as sitting still, anyway, when the ants finally got him. Besides, there was a bit of a chance. Perhaps the ants weren't so almighty, after all; perhaps he had allowed the mass suggestion of that evil black throng to hypnotize him, just as a snake fascinates and overpowers.

The ants were building their bridges. Leiningen got up on a chair. "Hey, lads, listen to me!" he cried. Slowly and listlessly, from all sides of the trench, the men began to shuffle towards him, the apathy of death already stamped on their faces.

"Listen, lads!" he shouted. "You're frightened of those beggars, but I'm proud of you. There's still a chance to save our lives—by flooding the plantation from the river. Now one of you might manage to get as far as the weir—but he'd never come back. Well, I'm not going to let you try it; if I did, I'd be worse than one of those ants. No. I called the tune, and now I'm going to pay the piper.

"The moment I'm over the ditch, set fire to the petrol. That'll allow time for the flood to

do the trick. Then all you have to do is to wait here all snug and quiet till I'm back. Yes, I'm coming back, trust me"—he grinned—"when I've finished my slimming cure."

He pulled on high leather boots, drew heavy gauntlets over his hands, and stuffed the spaces between breeches and boots, gauntlets and arms, shirt and neck, with rags soaked in petrol. With close-fitting mosquito goggles he shielded his eyes, knowing too well the ants' dodge of first robbing their victims of sight. Finally, he plugged his nostrils and ears with cotton wool, and let the peons drench his clothes with petrol.

He was about to set off, when the old Indian medicine man came up to him; he had a wondrous salve, he said, prepared from a species of chafer whose odor was intolerable to ants. Yes, this odor protected these chafers from the attacks of even the most murderous ants. The Indian smeared the boss's boots, his gauntlets, and his face over and over with the extract.

Leiningen then remembered the paralyzing effect of ants' venom, and the Indian gave him a gourd full of the medicine he had administered to the bitten peon at the water ditch. The planter drank it down without noticing its bitter taste; his mind was already at the weir.

He started off towards the northwest corner of the trench. With a bound he was over—and among the ants.

The beleaguered garrison had no opportunity to watch Leiningen's race against death. The ants were climbing the inner bank again— the lurid ring of petrol blazed aloft. For the fourth time that day the reflection from the fire shone on the sweating faces of the imprisoned men, and on the reddish-black cuirasses[16] of their oppressors. The red and blue, dark-edged flames leaped vividly now,

16. **cuirasses** (kwĭ-răs'əs): originally, close-fitting armor for the back and chest; here, bony plates protecting the bodies of the ants.

celebrating what? The funeral pyre of the four hundred, or of the hosts of destruction?

Leiningen ran. He ran in long equal strides, with only one thought, one sensation, in his being—he *must* get through. He dodged all trees and shrubs; except for the split seconds his soles touched the ground, the ants should have no opportunity to alight on him. That they would get to him soon, despite the salve on his boots, the petrol in his clothes, he realized only too well, but he knew even more surely that he must, and that he would, get to the weir.

Apparently the salve was some use after all; not until he had reached halfway did he feel ants under his clothes, and a few on his face. Mechanically, in his stride, he struck at them, scarcely conscious of their bites. He saw he was drawing appreciably nearer the weir—the distance grew less and less—sank to five hundred—three—two—one hundred yards.

Then he was at the weir and gripping the ant-hulled wheel. Hardly had he seized it when a horde of infuriated ants flowed over his hands, arms, and shoulders. He started the wheel—before it turned once on its axis the swarm covered his face. Leiningen strained like a madman, his lips pressed tight; if he opened them to draw breath. . . .

He turned and turned; slowly the dam lowered until it reached the bed of the river. Already the water was overflowing the ditch. Another minute, and the river was pouring through the nearby gap in the breakwater. The flooding of the plantation had begun.

Leiningen let go the wheel. Now, for the first time, he realized he was coated from head to foot with a layer of ants. In spite of the petrol, his clothes were full of them, several had got to his body or were clinging to his face. Now that he had completed his task, he felt the smart raging over his flesh from the bites of sawing and piercing insects.

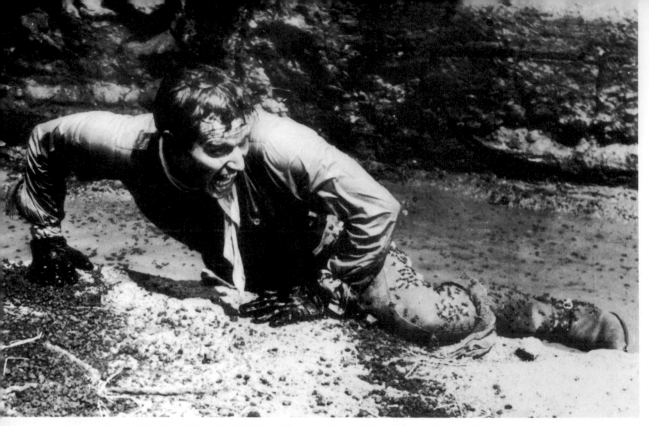

A scene from *The Naked Jungle* (1953), a film version of "Leiningen Versus the Ants."
The Museum of Modern Art Film Stills Archive

Frantic with pain, he almost plunged into the river. To be ripped and slashed to shreds by piranhas? Already he was running the return journey, knocking ants from his gloves and jacket, brushing them from his bloodied face, squashing them to death under his clothes.

One of the creatures bit him just below the rim of his goggles; he managed to tear it away, but the agony of the bite and its etching acid drilled into the eye nerves; he saw now through circles of fire into a milky mist, then he ran for a time almost blinded, knowing that if he once tripped and fell. . . . The old Indian's brew didn't seem much good; it weakened the poison a bit, but didn't get rid of it. His heart pounded as if it would burst; blood roared in his ears; a giant's fist battered his lungs.

Then he could see again, but the burning girdle of petrol appeared infinitely far away; he could not last half that distance. Swift-changing pictures flashed through his head, episodes in his life, while in another part of his brain a cool and impartial onlooker informed this ant-blurred, gasping, exhausted bundle named Leiningen that such a rushing panorama of scenes from one's past is seen only in the moment before death.

A stone in the path . . . too weak to avoid it . . . the planter stumbled and collapsed. He tried to rise . . . he must be pinned under a rock. . . . It was impossible . . . the slightest movement was impossible. . . .

Then all at once he saw, starkly clear and huge, and, right before his eyes, furred with ants, towering and swaying in its death agony, the pampas stag. In six minutes—gnawed to

the bones. He *couldn't* die like that! And something outside him seemed to drag him to his feet. He tottered. He began to stagger forward again.

Through the blazing ring hurtled an apparition which, as soon as it reached the ground on the inner side, fell full length and did not move. Leiningen, at the moment he made that leap through the flames, lost consciousness for the first time in his life. As he lay there, with glazing eyes and lacerated face, he appeared a man returned from the grave. The peons rushed to him, stripped off his clothes, tore away the ants from a body that seemed almost one open wound; in some places the bones were showing. They carried him into the ranch house.

As the curtain of flames lowered, one could see in place of the illimitable host of ants an extensive vista of water. The thwarted river had swept over the plantation, carrying with it the entire army. The water had collected and mounted in the great "saucer," while the ants had in vain attempted to reach the hill on which stood the ranch house. The girdle of flames held them back.

And so imprisoned between water and fire, they had been delivered into the annihilation that was their god. And near the farther mouth of the water ditch, where the stone mole had its second gap, the ocean swept the lost battalions into the river, to vanish forever.

The ring of fire dwindled as the water mounted to the petrol trench and quenched the dimming flames. The inundation rose higher and higher: because its outflow was impeded by the timber and underbrush it had carried along with it, its surface required some time to reach the top of the high stone breakwater and discharge over it the rest of the shattered army.

It swelled over ant-stippled shrubs and bushes, until it washed against the foot of the knoll whereon the besieged had taken refuge. For a while an alluvial[17] of ants tried again and again to attain this dry land, only to be repulsed by streams of petrol back into the merciless flood.

Leiningen lay on his bed, his body swathed from head to foot in bandages. With fomentations[18] and salves, they had managed to stop the bleeding, and had dressed his many wounds. Now they thronged around him, one question in every face. Would he recover? "He won't die," said the old man who had bandaged him, "if he doesn't want to."

The planter opened his eyes. "Everything in order?" he asked.

"They're gone," said his nurse. "To hell." He held out to his master a gourd full of a powerful sleeping draught. Leiningen gulped it down.

"I told you I'd come back," he murmured, "even if I am a bit streamlined." He grinned and shut his eyes. He slept.

17. **alluvial** (ə-lōō′vē-əl): deposit left by a flood.
18. **fomentations** (fō′mən-tā′shəns): lotions or warm compresses.

Reading Check

1. How does Leiningen know the ants are approaching his plantation, even though he cannot see them?
2. What part of their victim's body do the ants always attack first?
3. How do the ants get through the barrier of the water-filled ditch?
4. What is Leiningen's second line of defense?
5. How does Leiningen destroy the army of ants?

Analyzing and Interpreting the Story

1. This story is narrated as a series of major battles between an army of ants and a group of beleaguered humans. **a.** Describe each battle. **b.** What is the critical decision Leiningen must make to defeat the invaders?

2. Find some of the words and phrases in the story that characterize the ants as "demons." **a.** How does this characterization affect your feelings as you read the story? **b.** Does the author ever lead you to feel sympathy or admiration for the ants? Explain.

3. After the first day, Leiningen "almost regretted that the fight had ended so soon and so simply. . . . He had got quite a thrill out of the fight—a pity it was already over." **a.** When does Leiningen first lose this feeling of superiority? **b.** When does he realize that the ants may indeed succeed?

4. The men who work on the plantation are critical to Leiningen's various defenses; in fact, several lose their lives defending the land. What do you think of Leiningen's treatment of his workers? Is it demeaning, or is Leiningen simply acting decisively to save the plantation? Give reasons for your answer.

5. At the beginning of the story, Leiningen's lifelong motto is quoted. **a.** What is this motto? **b.** Do the events of this story support the motto, or do they reveal that it is not necessarily true? Explain.

6. Since this story was written, we have learned a great deal about the necessity of caring for our environment. Consider the tactics Leiningen uses to combat the ants: trenches of gasoline, fire, and deliberate flooding of the plantation. **a.** How might an environmental activist criticize Leiningen's motto and his resolve to "fight elemental with elemental"? **b.** Do you agree or disagree with this criticism?

Conflict, Climax, Resolution

In most short stories, the main character undergoes a **conflict,** or a struggle of some kind. The conflict may be internal or external. An external conflict may involve the main character in a struggle against another character or against a force of nature. An internal conflict may take the form of a mental struggle, in which the main character tries to make a difficult decision or overcome a fear.

The nature of Leiningen's external conflict is clear from the title: "Leiningen Versus the Ants." At what point in the story does Leiningen also wage a mental battle?

The point at which the outcome of the conflict is decided is called the **climax.** The climax is usually the most exciting and tense part of the story. When does the climax occur in "Leiningen Versus the Ants"?

A story ordinarily ends when its main conflict is **resolved**—that is, when one side or the other finally triumphs. When are the conflicts of this story resolved? Would you describe this resolution as satisfying, or would you describe its effect in some other way?

How would you evaluate the resolution of this plot—is it believable? Explain.

Language and Vocabulary

Building Vocabulary

One of the best ways to extend your vocabulary is through wide reading. You meet many new words that become familiar to you, and gradually these words become part of your own speaking and writing.

You can also increase your vocabulary by making a conscious effort to learn the meanings of unfamiliar words. Throughout this textbook you will be guided in vocabulary-building techniques such as using context

clues, studying synonyms and antonyms, analyzing word structure and origins, recognizing multiple meanings, and using the parts of a dictionary.

At the back of this textbook, you will find a glossary of vocabulary. Get into the habit of using this glossary to check the pronunciation and meaning of unfamiliar vocabulary.

Use the glossary to determine the pronunciation and meaning of each of the following words in the story. Then use each word in a sentence of your own.

abyss	myriad	beleaguer
malaise	foray	lacerate

Creative Writing

Using Metaphor in Description

The ants in this story are presented as an army on the march. All their maneuvers are described in military terms. They advance like well-drilled battalions. They mass in ranks, squads, and columns. Some of the troops are scouts, others reserves.

You may recognize that in drawing a comparison between insects and an army, Stephenson is using a form of figurative language known as **metaphor.** Metaphor can be an effective device in descriptive writing. At one point, the author describes the "outflanking movement" of the two wings of the ant army, detaching themselves from the main army to find a crossing over the ditch (page 15). Locate other passages in the story where Stephenson identifies the action of the ants with some military stratagem.

Think of some other creatures that might be described in military terms. For example, how might an attack of locusts be like the invasion of an air force? Write a paragraph describing the similarities. If you wish, state your comparison in your opening sentence.

Focus on Narrative Writing

Developing a Plot

At the beginning of "Leiningen Versus the Ants," Carl Stephenson uses dialogue to involve readers in the tale. The district commissioner's brief speech establishes the principal **conflict** of the story. With the reference to "two days at the latest," Stephenson also starts to build **suspense.**

Try using this speech as a model for beginning a story of your own. Experiment with some "What if?" questions to brainstorm story ideas. For example, "What if I were a member of the first colony to live on the moon?" or "What if I had the ability to read people's thoughts?" Fill in some ideas for basic story elements on a chart like the one below.

```
┌──────────────────────────────────────────────┐
│           Prewriting Chart for a Story         │
│  What if _____? │
│  Conflict: _____ vs. _____  │
│  Climax: _____ │
│                                                │
│  Resolution: _____ │
│  _____│
└──────────────────────────────────────────────┘
```

When you have finished writing, exchange papers with a classmate and discuss each other's story ideas. Save your writing.

About the Author

Carl Stephenson (1893–1954)

Carl Stephenson was born in Germany and lived there all of his life, working in the publishing business. His classic adventure story, "Leiningen Versus the Ants," first published in *Esquire* magazine in 1938, has since been reprinted in many anthologies and has been made into a motion picture called *The Naked Jungle.*

The Monkey's Paw

W. W. JACOBS

The element of suspense—*"What will happen next?"—dominates this compelling story. Stories of the supernatural need not have ghosts or monsters or strange alien beings to be effective. How is an eerie, uncanny atmosphere created in this story through the power of suggestion?*

I

Without, the night was cold and wet, but in the small parlor of Laburnam Villa the blinds were drawn and the fire burned brightly. Father and son were at chess, the former, who possessed ideas about the game involving radical changes, putting his king into such sharp and unnecessary perils that it even provoked comment from the white-haired old lady knitting placidly by the fire.

"Hark at the wind," said Mr. White, who, having seen a fatal mistake after it was too late, was amiably desirous of preventing his son from seeing it.

"I'm listening," said the latter, grimly surveying the board as he stretched out his hand. "Check."[1]

"I should hardly think that he'd come to-night," said his father, with his hand poised over the board.

"Mate," replied the son.

"That's the worst of living so far out," bawled Mr. White, with sudden and unlooked-for violence; "of all the beastly, slushy, out-of-the-way places to live in, this is the worst. Pathway's a bog, and the road's a torrent. I don't know what people are thinking about. I suppose because only two houses in the road are let, they think it doesn't matter."

"Never mind, dear," said his wife, soothingly; "perhaps you'll win the next one."

Mr. White looked up sharply, just in time to intercept a knowing glance between mother and son. The words died away on his lips, and he hid a guilty grin in his thin gray beard.

"There he is," said Herbert White, as the gate banged to loudly and heavy footsteps came toward the door.

The old man rose with hospitable haste, and opening the door, was heard condoling with

1. **Check:** in chess, a move directly attacking the king. *Mate* (checkmate) means the end of the game, when the king is unable to move.

the new arrival. The new arrival also condoled with himself, so that Mrs. White said, "Tut, tut!" and coughed gently as her husband entered the room, followed by a tall, burly man, beady of eye and rubicund of visage.[2]

"Sergeant Major Morris," he said, introducing him.

The sergeant major shook hands, and taking the proffered seat by the fire, watched contentedly while his host got out whiskey and tumblers and stood a small copper kettle on the fire.

At the third glass his eyes got brighter, and he began to talk, the little family circle regarding with eager interest this visitor from distant parts, as he squared his broad shoulders in the chair and spoke of wild scenes and doughty deeds; of wars and plagues and strange peoples.

"Twenty-one years of it," said Mr. White, nodding at his wife and son. "When he went away he was a slip of a youth in the warehouse. Now look at him."

"He don't look to have taken much harm," said Mrs. White, politely.

"I'd like to go to India myself," said the old man, "just to look round a bit, you know."

"Better where you are," said the sergeant major, shaking his head. He put down the empty glass, and sighing softly, shook it again.

"I should like to see those old temples and fakirs[3] and jugglers," said the old man. "What was that you started telling me the other day about a monkey's paw or something, Morris?"

"Nothing," said the soldier, hastily. "Leastways nothing worth hearing."

"Monkey's paw?" said Mrs. White, curiously.

"Well, it's just a bit of what you might call magic, perhaps," said the sergeant major, offhandedly.

His three listeners leaned forward eagerly. The visitor absent-mindedly put his empty glass to his lips and then set it down again. His host filled it for him.

"To look at," said the sergeant major, fumbling in his pocket, "it's just an ordinary little paw, dried to a mummy."

He took something out of his pocket and proffered it. Mrs. White drew back with a grimace, but her son, taking it, examined it curiously.

"And what is there special about it?" inquired Mr. White as he took it from his son, and having examined it, placed it upon the table.

"It had a spell put on it by an old fakir," said the sergeant major, "a very holy man. He wanted to show that fate ruled people's lives, and that those who interfered with it did so to their sorrow. He put a spell on it so that three separate men could each have three wishes from it."

His manner was so impressive that his hearers were conscious that their light laughter jarred somewhat.

"Well, why don't you have three, sir?" said Herbert White, cleverly.

The soldier regarded him in the way that middle age is wont to regard presumptuous youth. "I have," he said, quietly, and his blotchy face whitened.

"And did you really have the three wishes granted?" asked Mrs. White.

"I did," said the sergeant major, and his glass tapped against his strong teeth.

"And has anybody else wished?" persisted the old lady.

"The first man had his three wishes. Yes," was the reply; "I don't know what the first two were, but the third was for death. That's how I got the paw."

His tones were so grave that a hush fell upon the group.

2. **rubicund** (rōō′bə-kənd) **of visage** (vĭz′ĭj): red-faced.
3. **fakirs** (fə-kîrs′): Moslem or Hindu holy men, some of whom claim the ability to perform miracles.

"He took something out of his pocket and proffered it." A scene from a film version of "The Monkey's Paw."
Museum of Modern Art Film Stills Archive

"If you've had your three wishes, it's no good to you now, then, Morris," said the old man at last. "What do you keep it for?"

The soldier shook his head. "Fancy, I suppose," he said, slowly. "I did have some idea of selling it, but I don't think I will. It has caused enough mischief already. Besides, people won't buy. They think it's a fairy tale; some of them, and those who do think anything of it want to try it first and pay me afterward."

"If you could have another three wishes," said the old man, eyeing him keenly, "would you have them?"

"I don't know," said the other. "I don't know."

He took the paw, and dangling it between his forefinger and thumb, suddenly threw it upon the fire. White, with a slight cry, stooped down and snatched it off.

"Better let it burn," said the soldier, solemnly.

"If you don't want it, Morris," said the other, "give it to me."

"I won't," said his friend, doggedly. "I threw it on the fire. If you keep it, don't blame me for what happens. Pitch it on the fire again like a sensible man."

The other shook his head and examined his new possession closely. "How do you do it?" he inquired.

"Hold it up in your right hand and wish aloud," said the sergeant major, "but I warn you of the consequences."

"Sounds like the *Arabian Nights*,"[4] said Mrs.

4. *Arabian Nights:* a collection of tales from ancient India, Persia, and Arabia.

White, as she rose and began to set the supper. "Don't you think you might wish for four pairs of hands for me?"

Her husband drew the talisman[5] from his pocket, and then all three burst into laughter as the sergeant major, with a look of alarm on his face, caught him by the arm.

"If you must wish," he said, gruffly, "wish for something sensible."

Mr. White dropped it back in his pocket, and placing chairs, motioned his friend to the table. In the business of supper the talisman was partly forgotten, and afterward the three sat listening in an enthralled fashion to a second installment of the soldier's adventures in India.

"If the tale about the monkey's paw is not more truthful than those he has been telling us," said Herbert, as the door closed behind their guest, just in time for him to catch the last train, "we shan't make much out of it."

"Did you give him anything for it, father?" inquired Mrs. White, regarding her husband closely.

"A trifle," said he, coloring slightly. "He didn't want it, but I made him take it. And he pressed me again to throw it away."

"Likely," said Herbert, with pretended horror. "Why, we're going to be rich, and famous and happy. Wish to be an emperor, father, to begin with; then you can't be henpecked."

He darted round the table, pursued by the maligned Mrs. White armed with an antimacassar.[6]

Mr. White took the paw from his pocket and eyed it dubiously. "I don't know what to wish for, and that's a fact," he said, slowly. "It seems to me I've got all I want."

"If you only cleared the house, you'd be quite happy, wouldn't you?" said Herbert, with his hand on his shoulder. "Well, wish for two

hundred pounds,[7] then; that'll just do it."

His father, smiling shamefacedly at his own credulity, held up the talisman, as his son, with a solemn face, somewhat marred by a wink at his mother, sat down at the piano and struck a few impressive chords.

"I wish for two hundred pounds," said the old man distinctly.

A fine crash from the piano greeted the words, interrupted by a shuddering cry from the old man. His wife and son ran toward him.

"It moved," he cried, with a glance of disgust at the object as it lay on the floor.

"As I wished, it twisted in my hand like a snake."

"Well, I don't see the money," said his son as he picked it up and placed it on the table, "and I bet I never shall."

"It must have been your fancy, father," said his wife, regarding him anxiously.

He shook his head. "Never mind, though; there's no harm done, but it gave me a shock all the same."

They sat down by the fire again while the two men finished their pipes. Outside, the wind was higher than ever, and the old man started nervously at the sound of a door banging upstairs. A silence unusual and depressing settled upon all three, which lasted until the old couple rose to retire for the night.

"I expect you'll find the cash tied up in a big bag in the middle of your bed," said Herbert, as he bade them good night, "and something horrible squatting up on top of the wardrobe watching you as you pocket your ill-gotten gains."

He sat alone in the darkness, gazing at the dying fire, and seeing faces in it. The last face was so horrible and so simian[8] that he gazed at it in amazement. It got so vivid that, with a

5. **talisman** (tăl′ĭs-mən): an object with magic powers.
6. **antimacassar** (ăn′tĭ-mə-kăs′ər): a small covering to protect the back or arms of a chair.

7. **two hundred pounds:** English money equal to about a thousand dollars at the time of this story.
8. **simian** (sĭm′ē-ən): resembling an ape or monkey.

little uneasy laugh, he felt on the table for a glass containing a little water to throw over it. His hand grasped the monkey's paw, and with a little shiver he wiped his hand on his coat and went up to bed.

II

In the brightness of the wintry sun next morning as it streamed over the breakfast table he laughed at his fears. There was an air of prosaic wholesomeness about the room which it had lacked on the previous night, and the dirty, shriveled little paw was pitched on the sideboard with a carelessness which betokened no great belief in its virtues.

"I suppose all old soldiers are the same," said Mrs. White. "The idea of our listening to such nonsense! How could wishes be granted in these days? And if they could, how could two hundred pounds hurt you, father?"

"Might drop on his head from the sky," said the frivolous Herbert.

"Morris said the things happened so naturally," said his father, "that you might if you so wished attribute it to coincidence."

"Well, don't break into the money before I come back," said Herbert as he rose from the table. "I'm afraid it'll turn you into a mean, avaricious man, and we shall have to disown you."

His mother laughed, and following him to the door, watched him down the road; and returning to the breakfast table, was very happy at the expense of her husband's credulity. All of which did not prevent her from scurrying to the door at the postman's knock, nor prevent her from referring somewhat shortly to retired sergeant majors of bibulous[9] habits when she found that the post brought a tailor's bill.

"Herbert will have some more of his funny

9. **bibulous** (bĭb′yə-ləs): drinking.

remarks, I expect, when he comes home," she said, as they sat at dinner.

"I dare say," said Mr. White, pouring himself out some beer; "but for all that, the thing moved in my hand; that I'll swear to."

"You thought it did," said the old lady soothingly.

"I say it did," replied the other. "There was no thought about it; I had just——What's the matter?"

His wife made no reply. She was watching the mysterious movements of a man outside, who, peering in an undecided fashion at the house, appeared to be trying to make up his mind to enter. In mental connection with the two hundred pounds, she noticed that the stranger was well dressed, and wore a silk hat of glossy newness. Three times he paused at the gate, and then walked on again. The fourth time he stood with his hand upon it, and then with sudden resolution flung it open and walked up the path. Mrs. White at the same moment placed her hands behind her, and hurriedly unfastening the strings of her apron, put that useful article of apparel beneath the cushion of her chair.

She brought the stranger, who seemed ill at ease, into the room. He gazed at her furtively, and listened in a preoccupied fashion as the old lady apologized for the appearance of the room, and her husband's coat, a garment which he usually reserved for the garden. She then waited patiently for him to broach his business, but he was at first strangely silent.

"I—was asked to call," he said at last, and stooped and picked a piece of cotton from his trousers. "I come from 'Maw and Meggins.' "

The old lady started. "Is anything the matter?" she asked, breathlessly. "Has anything happened to Herbert? What is it? What is it?"

Her husband interposed. "There, there, mother," he said, hastily. "Sit down, and don't jump to conclusions. You've not brought bad

news, I'm sure, sir," and he eyed the other wistfully.

"I'm sorry—" began the visitor.

"Is he hurt?" demanded the mother, wildly.

The visitor bowed in assent. "Badly hurt," he said, quietly, "but he is not in any pain."

"Oh, thank God!" said the old woman, clasping her hands. "Thank God for that! Thank——"

She broke off suddenly as the sinister meaning of the assurance dawned upon her and she saw the awful confirmation of her fears in the other's averted face. She caught her breath, and turning to her slower-witted husband, laid her trembling old hand upon his. There was a long silence.

"He was caught in the machinery," said the visitor at length in a low voice.

"Caught in the machinery," repeated Mr. White, in a dazed fashion, "yes."

He sat staring blankly out at the window, and taking his wife's hand between his own, pressed it as he had been wont to do in their old courting days nearly forty years before.

"He was the only one left to us," he said, turning gently to the visitor. "It is hard."

The other coughed, and rising, walked slowly to the window. "The firm wished me to convey their sincere sympathy with you in your great loss," he said, without looking round. "I beg that you will understand I am only their servant and merely obeying orders."

There was no reply; the old woman's face was white, her eyes staring, and her breath inaudible; on the husband's face was a look such as his friend the sergeant might have carried into his first action.

"I was to say that Maw and Meggins disclaim all responsibility," continued the other. "They admit no liability at all, but in consideration of

". . . they wish to present you with a certain sum as compensation."

your son's services, they wish to present you with a certain sum as compensation."

Mr. White dropped his wife's hand, and rising to his feet, gazed with a look of horror at his visitor. His dry lips shaped the words, "How much?"

"Two hundred pounds," was the answer.

Unconscious of his wife's shriek, the old man smiled faintly, put out his hands like a sightless man, and dropped, a senseless heap, to the floor.

III

In the huge new cemetery, some two miles distant, the old people buried their dead, and came back to a house steeped in shadow and silence. It was all over so quickly that at first they could hardly realize it, and remained in a state of expectation as though of something else to happen—something else which was to lighten this load, too heavy for old hearts to bear.

But the days passed, and expectation gave place to resignation—the hopeless resignation of the old, sometimes miscalled apathy. Sometimes they hardly exchanged a word, for now they had nothing to talk about, and their days were long to weariness.

It was about a week after that the old man, waking suddenly in the night, stretched out his hand and found himself alone. The room was in darkness, and the sound of subdued weeping came from the window. He raised himself in bed and listened.

"Come back," he said, tenderly. "You will be cold."

"It is colder for my son," said the old woman, and wept afresh.

The sound of her sobs died away on his ears. The bed was warm, and his eyes heavy with sleep. He dozed fitfully, and then slept until a sudden wild cry from his wife awoke him with a start.

"*The paw!*" she cried wildly. "The monkey's paw!"

He started up in alarm. "Where? Where is it? What's the matter?"

She came stumbling across the room toward him. "I want it," she said, quietly. "You've not destroyed it?"

"It's in the parlor, on the bracket,"[10] he replied, marveling. "Why?"

She cried and laughed together, and bending over, kissed his cheek.

"I only just thought of it," she said, hysterically. "Why didn't I think of it before? Why didn't *you* think of it?"

"Think of what?" he questioned.

"The other two wishes," she replied, rapidly. "We've only had one."

"Was not that enough?" he demanded, fiercely.

"No," she cried, triumphantly; "we'll have one more. Go down and get it quickly, and wish our boy alive again."

The man sat up in bed and flung the bedclothes from his quaking limbs. "Good God, you are mad!" he cried, aghast.

"Get it," she panted; "get it quickly, and wish—— Oh, my boy, my boy!"

Her husband struck a match and lit the candle. "Get back to bed," he said, unsteadily. "You don't know what you are saying."

"We had the first wish granted," said the old woman, feverishly; "why not the second?"

"A coincidence," stammered the old man.

"Go and get it and wish," cried his wife, quivering with excitement.

The old man turned and regarded her, and his voice shook. "He has been dead ten days, and besides he—I would not tell you else, but—I could only recognize him by his clothing. If he was too terrible for you to see then, how now?"

"Bring him back," cried the old woman, and

10. **bracket:** shelf.

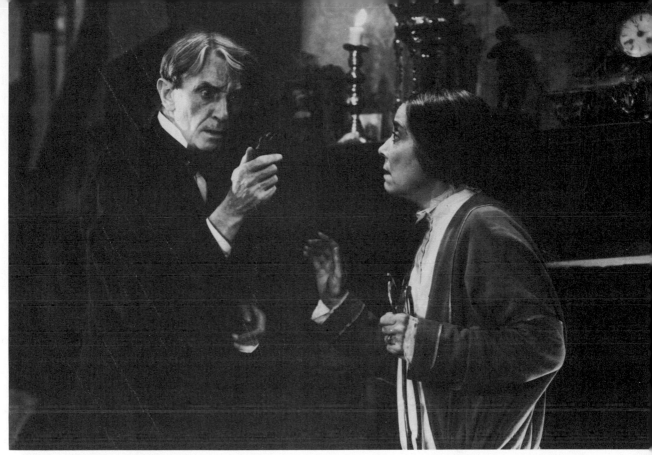

"I wish my son alive again."

dragged him toward the door. "Do you think I fear the child I have nursed?"

He went down in the darkness, and felt his way to the parlor, and then to the mantelpiece. The talisman was in its place, and a horrible fear that the unspoken wish might bring his mutilated son before him ere he could escape from the room seized upon him, and he caught his breath as he found that he had lost the direction of the door. His brow cold with sweat, he felt his way round the table, and groped along the wall until he found himself in the small passage with the unwholesome thing in his hand.

Even his wife's face seemed changed as he entered the room. It was white and expectant, and to his fears seemed to have an unnatural look upon it. He was afraid of her.

"*Wish!*" she cried, in a strong voice.

"It is foolish and wicked," he faltered.

"*Wish!*" repeated his wife.

He raised his hand. "I wish my son alive again."

The talisman fell to the floor, and he regarded it fearfully. Then he sank trembling into a chair as the old woman, with burning eyes, walked to the window and raised the blind.

He sat until he was chilled with the cold, glancing occasionally at the figure of the old woman peering through the window. The candle-end, which had burned below the rim of the china candlestick, was throwing pulsating shadows on the ceiling and walls, until, with a flicker larger than the rest, it expired. The old man, with an unspeakable sense of relief at the

The Monkey's Paw **37**

failure of the talisman, crept back to his bed, and a minute or two afterward the old woman came silently and apathetically beside him.

Neither spoke, but lay silently listening to the ticking of the clock. A stair creaked, and a squeaky mouse scurried noisily through the wall. The darkness was oppressive, and after lying for some time screwing up his courage, he took the box of matches, and striking one, went downstairs for a candle.

At the foot of the stairs the match went out, and he paused to strike another; and at the same moment a knock, so quiet and stealthy as to be scarcely audible, sounded on the front door.

The matches fell from his hand and spilled in the passage. He stood motionless, his breath suspended until the knock was repeated. Then he turned and fled swiftly back to his room, and closed the door behind him. A third knock sounded through the house.

"*What's that?*" cried the old woman, starting up.

"A rat," said the old man in shaking tones— "a rat. It passed me on the stairs."

His wife sat up in bed listening. A loud knock resounded through the house.

"It's Herbert!" she screamed. "It's Herbert!"

She ran to the door, but her husband was before her, and catching her by the arm, held her tightly.

"What are you going to do?" he whispered hoarsely.

"It's my boy; it's Herbert!" she cried, struggling mechanically. "I forgot it was two miles away. What are you holding me for? Let go. I must open the door."

"Don't let it in," cried the old man, trembling.

"You're afraid of your own son," she cried, struggling. "Let me go. I'm coming, Herbert; I'm coming."

There was another knock, and another. The old woman with a sudden wrench broke free and ran from the room. Her husband followed to the landing, and called after her appealingly as she hurried downstairs. He heard the chain rattle back and the bottom bolt drawn slowly and stiffly from the socket. Then the old woman's voice, strained and panting.

"The bolt," she cried, loudly. "Come down. I can't reach it."

But her husband was on his hands and knees groping wildly on the floor in search of the paw. If he could only find it before the thing outside got in. A perfect fusillade of knocks reverberated through the house, and he heard the scraping of a chair as his wife put it down in the passage against the door. He heard the creaking of the bolt as it came slowly back, and at the same moment he found the monkey's paw, and frantically breathed his third and last wish.

The knocking ceased suddenly, although the echoes of it were still in the house. He heard the chair drawn back, and the door opened. A cold wind rushed up the staircase, and a long loud wail of disappointment and misery from his wife gave him courage to run down to her side, and then to the gate beyond. The street lamp flickering opposite shone on a quiet and deserted road.

Reading Check

1. How did Sergeant Major Morris get the monkey's paw?
2. Why does Herbert suggest that his father wish for two hundred pounds?
3. How is Mr. White's first wish granted?
4. What is the second wish?
5. What is the result of Mr. White's final wish?

For Study and Discussion

Analyzing and Interpreting the Story

1. Horror stories are usually rich in **atmosphere,** a word used for the general emotional effect of a literary work. **a.** How does the opening scene of this story help to create a mood of mystery and uneasiness? **b.** How is this mood sustained throughout the first part of the story?

2. At the beginning of a story, an author often provides important information about what is to come and about what has already happened. **a.** What does Sergeant Major Morris reveal concerning the history of the monkey's paw? **b.** How does his story suggest that its powers are evil?

3a. The sergeant major had told Mr. White that the wishes were granted so naturally that it could seem like coincidence. How is this shown to be true with the first wish? **b.** Could the "granting" of the second and third wishes also be attributed to coincidence, and not to the supernatural? Why, or why not?

4. How does the monkey's paw change the relationship between the husband and wife?

5. What point in the story would you identify as the **climax**—that intense moment when you finally realize how the plot will turn out?

6. Do you think Mr. White could have rephrased his first and second wishes so that he could have gotten what he really wanted? Explain your answer.

7. How do the events of the story bear out the old fakir's belief about the danger of tampering with fate?

8. Note that Jacobs divides his story into three sections. **a.** What scenes and actions make up each of these three sections? **b.** What do you think is the logic behind the structure of the story?

Literary Elements

Foreshadowing and Suspense

Foreshadowing is the use of clues that hint at what will happen later in a story. A skillful writer can provide such clues without giving the plot away, and sometimes a reader does not even recognize the foreshadowing until after the story is finished. Look back at the first part of "The Monkey's Paw." Where does the author foreshadow the fact that the monkey's paw will bring horror with it? Look at the game of chess that opens the story. How does Mr. White's "fatal mistake" foreshadow his later actions?

How can each of these statements be considered examples of foreshadowing?

> Mr. White says, "I don't know what to wish for, and that's a fact. . . . It seems to me I've got all I want."

> Herbert says, "Well, I don't see the money . . . and I bet I never shall."

> Mrs. White says, "How could wishes be granted in these days? And if they could, how could two hundred pounds hurt you, father?"

> "Morris said the things happened so naturally . . . that you might if you so wished attribute it to coincidence."

Every horror story depends on **suspense** for part of its effect. Suspense is usually greatest when we are curious or worried about a character whom we like or admire. How does the fact that the monkey's paw can grant *three* wishes keep you in suspense right up until the end of this story? Did your feelings for Herbert and for his parents increase your sense of anxiety? Explain.

The moment of greatest suspense probably comes between the making of the second wish and the making of the third. How do the setting and the dialogue heighten the suspense of this scene?

Language and Vocabulary

Analyzing Word Structure

Many words in our language are made up of different parts. For example, the word *condole* has two parts. The first part, *con-*, is a prefix that comes to us from the Latin *com-*, meaning "with." The second part, *dole*, is a root or stem that comes from the Latin *dolere*, meaning "to grieve."

The word *doleful* comes from the same Latin root meaning "to grieve." The suffix *-ful* means "full of." The word *doleful* means "full of grief or sad."

Knowing the meaning of individual word parts can help you unlock the meaning of many words.

The prefix *inter-* means "among or between." The root *pose* means "to place." What is the meaning of *interpose?*

The prefix *re-* means "back or again." What is the meaning of *resound?* of *reverberate?*

The suffix *-ly,* meaning "in the manner of," changes adjectives to adverbs. What is the meaning of each of these adverbs: *doggedly, dubiously, furtively?*

The suffix *-ous* means "full of or characterized by." What is the meaning of *avaricious?* of *presumptuous?*

Check your answers in the glossary or in a dictionary.

Focus on Narrative Writing

Considering Repetition and Variation

The three wishes in "The Monkey's Paw" illustrate two important elements in plot structure: **repetition** and **variation.** Much of the story's **suspense** comes from our expectation that each wish will be granted. The surprise and horror come from the fulfillment of the wishes in unexpected ways.

Experiment with these aspects of plot structure by listing three wishes of your own. The wishes should be in a sequential order: that is, the second should logically grow out of a situation resulting from the first, and the third should build on the second. The wishes do not have to produce a horror tale; feel free to make them humorous if you wish.

1. _____
2. _____
3. _____

Now write a paragraph in which you summarize the story outline that these wishes suggest. When you have finished, trade papers with a partner and give each other some suggestions. Save your writing.

About the Author

W. W. Jacobs (1863–1943)

The Granger Collection, New York

William Wymark Jacobs was born and grew up near the shipping area on the Thames River in London, where his father worked on the docks. As a young man, Jacobs passed a Civil Service exam and worked for the government's Savings Bank Department and later for the General Post Office. Jacobs never enjoyed this work; storytelling was more to his liking. Jacobs' experiences on the docks and his interest in the tales of seafarers are reflected in the titles of his books, such as *Many Cargoes, Deep Water, Captains All, More Cargoes,* and *Snug Harbor.* "The Monkey's Paw," his most famous story, has been dramatized as a one-act play.

The Demon Lover

ELIZABETH BOWEN

The word demon *has more than one meaning. It can refer to an evil spirit, or it can refer to a personal obsession—something within a person that drives him or her to do dangerous things. Who or what is the demon in this tale?*

Towards the end of her day in London Mrs. Drover went round to her shut-up house to look for several things she wanted to take away. Some belonged to herself, some to her family, who were by now used to their country life. It was late August; it had been a steamy, showery day: at the moment the trees down the pavement glittered in an escape of humid yellow afternoon sun. Against the next batch of clouds, already piling up ink-dark, broken chimneys and parapets stood out. In her once familiar street, as in any unused channel, an unfamiliar queerness had silted up; a cat wove itself in and out of railings, but no human eye watched Mrs. Drover's return. Shifting some parcels under her arm, she slowly forced round her latchkey in an unwilling lock, then gave the door, which had warped, a push with her knee. Dead air came out to meet her as she went in.

The staircase window having been boarded up, no light came down into the hall. But one door, she could just see, stood ajar, so she went quickly through into the room and unshuttered the big window in there. Now the prosaic woman, looking about her, was more per-plexed than she knew by everything that she saw, by traces of her long former habit of life—the yellow smoke-stain up the white marble mantelpiece, the ring left by a vase on the top of the escritoire;[1] the bruise in the wallpaper where, on the door being thrown open widely, the china handle had always hit the wall. The piano, having gone away to be stored, had left what looked like claw-marks on its part of the parquet.[2] Though not much dust had seeped in, each object wore a film of another kind; and, the only ventilation being the chimney, the whole drawing-room smelled of the cold hearth. Mrs. Drover put down her parcels on the escritoire and left the room to proceed upstairs; the things she wanted were in a bed-room chest.

She had been anxious to see how the house was—the part-time caretaker she shared with some neighbours was away this week on his holiday, known to be not yet back. At the best of times he did not look in often, and she was never sure that she trusted him. There were

1. **escritoire** (ĕs'krĭ-twär'): a writing table.
2. **parquet** (pär-kā'): wood worked into patterns, used for floors.

The Demon Lover **41**

some cracks in the structure, left by the last bombing, on which she was anxious to keep an eye. Not that one could do anything——

A shaft of refracted daylight now lay across the hall. She stopped dead and stared at the hall table—on this lay a letter addressed to her.

She thought first—then the caretaker *must* be back. All the same, who, seeing the house shuttered, would have dropped a letter in at the box? It was not a circular, it was not a bill. And the post office redirected, to the address in the country, everything for her that came through the post. The caretaker (even if he *were* back) did not know she was due in London today—her call here had been planned to be a surprise—so his negligence in the manner of this letter, leaving it to wait in the dusk and the dust, annoyed her. Annoyed, she picked up the letter, which bore no stamp. But it cannot be important, or they would know . . . She took the letter rapidly upstairs with her, without a stop to look at the writing till she reached what had been her bedroom, where she let in light. The room looked over the garden and other gardens: the sun had gone in; as the clouds sharpened and lowered, the trees and rank lawns seemed already to smoke with dark. Her reluctance to look again at the letter came from the fact that she felt intruded upon—and by someone contemptuous of her ways. However, in the tenseness preceding the fall of rain she read it: it was a few lines.

Dear Kathleen: You will not have forgotten that today is our anniversary, and the day we said. The years have gone by at once slowly and fast. In view of the fact that nothing has changed, I shall rely upon you to keep your promise. I was sorry to see you leave London, but was satisfied that you would be back in time. You may expect me, therefore, at the hour arranged. Until then . . . K.

Entity #3 (1986) by Fritz Scholder.
Acrylic on canvas, 40 x 30 in.
Fritz Scholder

Mrs. Drover looked for the date: it was today's. She dropped the letter on to the bed-springs, then picked it up to see the writing again—her lips, beneath the remains of lipstick, beginning to go white. She felt so much the change in her own face that she went to the mirror, polished a clear patch in it and looked at once urgently and stealthily in. She was confronted by a woman of forty-four, with eyes starting out under a hat-brim that had been rather carelessly pulled down. She had not put on any more powder since she left the shop where she ate her solitary tea. The pearls her husband had given her on their marriage hung loose round her now rather thinner throat, slipping in the V of the pink wool jumper her sister knitted last autumn as they sat round the fire. Mrs. Drover's most normal expression was

one of controlled worry, but of assent. Since the birth of the third of her little boys, attended by a quite serious illness, she had had an intermittent muscular flicker to the left of her mouth, but in spite of this she could always sustain a manner that was at once energetic and calm.

Turning from her own face as precipitately as she had gone to meet it, she went to the chest where the things were, unlocked it, threw up the lid and knelt to search. But as rain began to come crashing down she could not keep from looking over her shoulder at the stripped bed on which the letter lay. Behind the blanket of rain the clock of the church that still stood struck six—with rapidly heightening apprehension she counted each of the slow strokes. "The hour arranged . . . My God," she said, "*what* hour? How should I . . . ? After twenty-five years . . ."

The young girl talking to the soldier in the garden had not ever completely seen his face. It was dark; they were saying goodbye under a tree. Now and then—for it felt, from not seeing him at this intense moment, as though she had never seen him at all—she verified his presence for these few moments longer by putting out a hand, which he each time pressed, without very much kindness, and painfully, on to one of the breast buttons of his uniform. That cut of the button on the palm of her hand was, principally what she was to carry away. This was so near the end of a leave from France that she could only wish him already gone. It was August 1916. Being not kissed, being drawn away from and looked at intimidated Kathleen till she imagined spectral glitters in the place of his eyes. Turning away and looking back up the lawn she saw, through branches of trees, the drawing-room window alight: she caught a breath for the moment when she could go running back there into the

safe arms of her mother and sister, and cry: "What shall I do, what shall I do? He has gone."

Hearing her catch her breath, her fiancé said, without feeling: "Cold?"

"You're going away such a long way."

"Not so far as you think."

"I don't understand?"

"You don't have to," he said. "You will. You know what we said."

"But that was—suppose you—I mean, suppose."

"I shall be with you," he said, "sooner or later. You won't forget that. You need do nothing but wait."

Only a little more than a minute later she was free to run up the silent lawn. Looking in through the window at her mother and sister, who did not for the moment perceive her, she already felt that unnatural promise drive down between her and the rest of all humankind. No other part of having given herself could have made her feel so apart, lost and foresworn. She could not have plighted a more sinister troth.[3]

Kathleen behaved well when, some months later, her fiancé was reported missing, presumed killed. Her family not only supported her but were able to praise her courage without stint because they could not regret, as a husband for her, the man they knew almost nothing about. They hoped she would, in a year or two, console herself—and had it been only a question of consolation things might have gone much straighter ahead. But her trouble, behind just a little grief, was a complete dislocation from everything. She did not reject other lovers, for these failed to appear: for years she failed to attract men—and with the approach of her thirties she became natural enough to share her family's anxiousness

3. **plighted . . . troth:** To plight one's troth is to become engaged.

on this score. She began to put herself out, to wonder; and at thirty-two she was very greatly relieved to find herself being courted by William Drover. She married him, and the two of them settled down in this quiet, arboreal part of Kensington:[4] in this house the years piled up, her children were born and they all lived till they were driven out by the bombs of the next war. Her movements as Mrs. Drover were circumscribed, and she dismissed any idea that they were still watched.

As things were—dead or living the letter-writer sent her only a threat. Unable, for some minutes, to go on kneeling with her back exposed to the empty room, Mrs. Drover rose from the chest to sit on an upright chair whose back was firmly against the wall. The desuetude[5] of her former bedroom, her married London home's whole air of being a cracked cup from which memory, with its reassuring power, had either evaporated or leaked away, made a crisis—and at just this crisis the letter-writer had, knowledgeably, struck. The hollowness of the house this evening cancelled years on years of voices, habits and steps. Through the shut windows she only heard rain fall on the roofs around. To rally herself, she said she was in a mood—and for two or three seconds shutting her eyes, told herself that she had imagined the letter. But she opened them—there it lay on the bed.

On the supernatural side of the letter's entrance she was not permitting her mind to dwell. Who, in London, knew she meant to call at the house today? Evidently, however, this had been known. The caretaker, *had* he come back, had had no cause to expect her: he would have taken the letter in his pocket, to forward it, at his own time, through the post. There was no other sign that the caretaker had been

in—but, if not? Letters dropped in at doors of deserted houses do not fly or walk to tables in halls. They do not sit on the dust of empty tables with the air of certainty that they will be found. There is needed some human hand—but nobody but the caretaker had a key. Under circumstances she did not care to consider, a house can be entered without a key. It was possible that she was not alone now. She might be being waited for, downstairs. Waited for—until when? Until "the hour arranged." At least that was not six o'clock: six has struck.

She rose from the chair and went over and locked the door.

The thing was, to get out. To fly? No, not that: she had to catch her train. As a woman whose utter dependability was the keystone of her family life she was not willing to return to the country, to her husband, her little boys and her sister, without the objects she had come up to fetch. Resuming work at the chest she set about making up a number of parcels in a rapid, fumbling-decisive way. These, with her shopping parcels, would be too much to carry; these meant a taxi—at the thought of the taxi her heart went up and her normal breathing resumed. I will ring up the taxi now; the taxi cannot come too soon: I shall hear the taxi out there running its engine, till I walk calmly down to it through the hall. I'll ring up—But no: the telephone is cut off . . . She tugged at a knot she had tied wrong.

The idea of flight . . . He was never kind to me, not really. I don't remember him kind at all. Mother said he never considered me. He was set on me, that was what it was—not love. Not love, not meaning a person well. What did he do, to make me promise like that? I can't remember—But she found that she could.

She remembered with such dreadful acuteness that the twenty-five years since then dissolved like smoke and she instinctively looked for the weal left by the button on the palm of

4. **Kensington:** a borough of London.
5. **desuetude** (dĕs′wĭ-tōōd′, -tyōōd′): disuse.

her hand. She remembered not only all that he said and did but the complete suspension of *her* existence during that August week. I was not myself—they all told me so at the time. She remembered—but with one white burning blank as where acid has dropped on a photograph: *under no conditions* could she remember his face.

So, wherever he may be waiting, I shall not know him. You have no time to run from a face you do not expect.

The thing was to get to the taxi before any clock struck what could be the hour. She would slip down the street and round the side of the square to where the square gave on the main road. She would return in the taxi, safe, to her own door, and bring the solid driver into the house with her to pick up the parcels from room to room. The idea of the taxi driver made her decisive, bold: she unlocked her door, went to the top of the staircase and listened down.

She heard nothing—but while she was hearing nothing the *passé*[6] air of the staircase was disturbed by a draught that travelled up to her face. It emanated from the basement: down there a door or window was being opened by someone who chose this moment to leave the house.

The rain had stopped; the pavements steamily shone as Mrs. Drover let herself out by inches from her own front door into the empty street. The unoccupied houses opposite continued to meet her look with their damaged stare. Making towards the thoroughfare and the taxi, she tried not to keep looking behind. Indeed, the silence was so intense—one of those creeks of London silence exaggerated this summer by the damage of war—that no tread could have gained on hers unheard. Where her street debouched[7] on the square

where people went on living, she grew conscious of, and checked, her unnatural pace. Across the open end of the square two buses impassively passed each other: women, a perambulator,[8] cyclists, a man wheeling a barrow signalized, once again, the ordinary flow of life. At the square's most populous corner should be—and was—the short taxi rank.[9] This evening, only one taxi—but this, although it presented its blank rump, appeared already to be alertly waiting for her. Indeed, without looking round the driver started his engine as she panted up from behind and put her hand on the door. As she did so, the clock struck seven. The taxi faced the main road: to make the trip back to her house it would have to turn—she had settled back on the seat and the taxi *had* turned before she, surprised by its knowing movement, recollected that she had not "said where." She leaned forward to scratch at the glass panel that divided the driver's head from her own.

The driver braked to what was almost a stop, turned round and slid the glass panel back: the jolt of this flung Mrs. Drover forward till her face was almost into the glass. Through the aperture driver and passenger, not six inches between them, remained for an eternity eye to eye. Mrs. Drover's mouth hung open for some seconds before she could issue her first scream. After that she continued to scream freely and to beat with her gloved hands on the glass all round as the taxi, accelerating without mercy, made off with her into the hinterland of deserted streets.

6. *passé*: here, motionless; stale.
7. **debouched** (dĭ-bouchd′, -bo͞oshd′): opened out.

8. **perambulator:** a baby carriage, also called a "pram."
9. **taxi rank:** a taxi stand.

For Study and Discussion

Analyzing and Interpreting the Story

1. What mood is created by the opening passages of the story? Support your answer by referring to specific words and phrases.

2. We are told that "Mrs. Drover's most normal expression was one of controlled worry, but of assent." What impression do you have of her character from her thoughts and actions?

3. The author creates suspense by making the reader curious about how the letter came to be on the table. What explanations does Kathleen Drover consider and reject before she is forced to accept the identity of the letter writer?

4. Carefully reread the passages that describe the lovers' last meeting in August 1916. What details foreshadow a disastrous reunion?

5. Is it significant that Mrs. Drover encounters her demon lover only during wartime? Why or why not?

6. Kathleen cannot remember the face of her fiancé. How does this detail intensify the atmosphere of dread and doom?

7. Do you think there is a realistic explanation for the events in this story, or do you believe there is a "supernatural side"?

Focus on Narrative Writing

Using Chronological Order

Most narratives use **chronological** or **time order.** Sometimes, however, storytellers vary this order with a **flashback**—a scene that interrupts the present action to tell about earlier events. Elizabeth Bowen uses a flashback in "The Demon Lover" to tell about Kathleen's engagement to the soldier.

Bowen also uses **transitional words and phrases,** as well as **verb tenses,** to signal the order of actions and events. In the third paragraph, for example, notice the past perfect verb *had been,* as well as time order words like *yet, often, never,* and *last.*

Write a paragraph or two telling about a recent occasion when you were disappointed, either in yourself or in someone else. Use time order and transitions to show the sequence of events. If possible, build in a brief flashback to show how you had expected things to turn out before the disappointment occurred. Save your writing.

About the Author

Elizabeth Bowen (1899–1973)

Elizabeth Bowen was born in Dublin, Ireland, and grew up on her family's country estates in County Cork and southern England. *Encounters,* her first volume of short stories, was published in 1923. In addition to being a short-story writer, she was a novelist and is best known for *The Death of the Heart* (1938). Her other novels include *The Last September* (1929) and *The Heat of the Day* (1949).

CHARACTER

One of the greatest pleasures of reading fiction is getting acquainted with a wider range and variety of people than we could ever know in life. Often the characters in fiction seem more interesting than the people we meet in life because we can know them better. Fiction, for two reasons, allows us to see more deeply into the inner nature of a character than we usually can in life. First, fiction places characters in crucial situations, which test them and expose their natures. Second, fiction can take us inside a character's mind and let us experience inner thoughts and feelings that in life we could only guess at. Of course, fictional characters are imaginary people and have only imaginary existence. Yet, if their author has made them seem believable, they can help us to understand something about real people, including ourselves.

To be believable, characters cannot be either all good or all bad; we know that real people are not like that. To be believable, characters must also be consistent: they must not act one way on one occasion and an entirely different way on another, unless there is a clear reason for the change. Sudden changes of heart for no apparent reason should be no more common in literature than they are in life.

A writer may present characters ("characterize" them) directly or indirectly. In *direct characterization,* the writer explicitly tells us what a character is like (for example, stupid, silly, kind). In *indirect characterization,* the writer shows us what the character does or says or thinks or feels, and lets us draw our own conclusions about what the character is like. Most writers use both forms of characterization. What we are *told* about a character will have little force unless we are also *shown* the character in action.

Neighbor Rosicky

WILLA CATHER

Willa Cather might have chosen to call her story "Anton Rosicky," but she decided to call it "Neighbor Rosicky." Why is the word neighbor *an appropriate word to use in the title?*

One

When Doctor Burleigh told neighbor Rosicky he had a bad heart, Rosicky protested.

"So? No, I guess my heart was always pretty good. I got a little asthma, maybe. Just a awful short breath when I was pitchin' hay last summer, dat's all."

"Well now, Rosicky, if you know more about it than I do, what did you come to me for? It's your heart that makes you short of breath, I tell you. You're sixty-five years old, and you've always worked hard, and your heart's tired. You've got to be careful from now on, and you can't do heavy work any more. You've got five boys at home to do it for you."

The old farmer looked up at the Doctor with a gleam of amusement in his queer triangular-shaped eyes. His eyes were large and lively, but the lids were caught up in the middle in a curious way, so that they formed a triangle. He did not look like a sick man. His brown face was creased but not wrinkled, he had a ruddy color in his smooth-shaven cheeks and in his lips, under his long brown mustache. His hair was thin and ragged around his ears, but very little gray. His forehead, naturally high and crossed by deep parallel lines, now ran all the way up to his pointed crown. Rosicky's face had the habit of looking interested—suggested a contented disposition and a reflective quality that was gay rather than grave. This gave him a certain detachment, the easy manner of an onlooker and observer.

"Well, I guess you ain't got no pills fur a bad heart, Doctor Ed. I guess the only thing is fur me to git me a new one."

Doctor Burleigh swung round in his desk chair and frowned at the old farmer. "I think if I were you I'd take a little care of the old one, Rosicky."

Rosicky shrugged. "Maybe I don't know how. I expect you mean fur me not to drink my coffee no more."

"I wouldn't, in your place. But you'll do as you choose about that. I've never yet been able to separate a Bohemian[1] from his coffee or his pipe. I've quit trying. But the sure thing is you've got to cut out farm work. You can feed the stock and do chores about the barn, but you can't do anything in the fields that makes you short of breath."

1. **Bohemian** (bō-hē′mē-ən): a native of Bohemia, a region in western Czechoslovakia.

"How about shelling corn?"

"Of course not!"

Rosicky considered with puckered brows.

"I can't make my heart go no longer'n it wants to, can I, Doctor Ed?"

"I think it's good for five or six years yet, maybe more, if you'll take the strain off it. Sit around the house and help Mary. If I had a good wife like yours, I'd want to stay around the house."

His patient chuckled. "It ain't no place fur a man. I don't like no old man hanging round the kitchen too much. An' my wife, she's a awful hard worker her own self."

"That's it; you can help her a little. My Lord, Rosicky, you are one of the few men I know who has a family he can get some comfort out of; happy dispositions, never quarrel among themselves, and they treat you right. I want to see you live a few years and enjoy them."

"Oh, they're good kids, all right," Rosicky assented.

The Doctor wrote him a prescription and asked him how his oldest son, Rudolph, who had married in the spring, was getting on. Rudolph had struck out for himself, on rented land. "And how's Polly? I was afraid Mary mightn't like an American daughter-in-law, but it seems to be working out all right."

"Yes, she's a fine girl. Dat widder woman bring her daughters up very nice. Polly got lots of spunk, an' she got some style, too. Da's nice, for young folks to have some style." Rosicky inclined his head gallantly. His voice and

his twinkly smile were an affectionate compliment to his daughter-in-law.

"It looks like a storm, and you'd better be getting home before it comes. In town in the car?" Doctor Burleigh rose.

"No, I'm in de wagon. When you got five boys, you ain't got much chance to ride round in de Ford. I ain't much for cars, noway."

"Well, it's a good road out to your place; but I don't want you bumping around in a wagon much. And never again on a hayrake, remember!"

Rosicky placed the Doctor's fee delicately behind the desk telephone, looking the other

way, as if this were an absent-minded gesture. He put on his plush cap and his corduroy jacket with a sheepskin collar, and went out.

The Doctor picked up his stethoscope and frowned at it as if he were seriously annoyed with the instrument. He wished it had been telling tales about some other man's heart, some old man who didn't look the Doctor in the eye so knowingly, or hold out such a warm brown hand when he said goodbye. Doctor Burleigh had been a poor boy in the country before he went away to medical school; he had known Rosicky almost ever since he could remember, and he had a deep affection for Mrs. Rosicky.

Only last winter he had had such a good breakfast at Rosicky's, and that when he needed it. He had been out all night on a long, hard confinement case at Tom Marshall's—a big rich farm where there was plenty of stock and plenty of feed and a great deal of expensive farm machinery of the newest model, and no comfort whatever. The woman had too many children and too much work, and she was no manager. When the baby was born at last, and handed over to the assisting neighbor woman, and the mother was properly attended to, Burleigh refused any breakfast in that slovenly house, and drove his buggy—the snow was too deep for a car—eight miles to Anton Rosicky's place. He didn't know another farmhouse where a man could get such a warm welcome, and such good strong coffee with rich cream. No wonder the old chap didn't want to give up his coffee!

He had driven in just when the boys had come back from the barn and were washing up for breakfast. The long table, covered with a bright oilcloth, was set out with dishes waiting for them, and the warm kitchen was full of the smell of coffee and hot biscuit and sausage. Five big handsome boys, running from twenty to twelve, all with what Burleigh called natural

good manners—they hadn't a bit of the painful self-consciousness he himself had to struggle with when he was a lad. One ran to put his horse away, another helped him off with his fur coat and hung it up, and Josephine, the youngest child and the only daughter, quickly set another place under her mother's direction.

With Mary, to feed creatures was the natural expression of affection—her chickens, the calves, her big hungry boys. It was a rare pleasure to feed a young man whom she seldom saw and of whom she was as proud as if he belonged to her. Some country housekeepers would have stopped to spread a white cloth over the oilcloth, to change the thick cups and plates for their best china, and the wooden-handled knives for plated ones. But not Mary.

"You must take us as you find us, Doctor Ed. I'd be glad to put out my good things for you if you was expected, but I'm glad to get you any way at all."

He knew she was glad—she threw back her head and spoke out as if she were announcing him to the whole prairie. Rosicky hadn't said anything at all; he merely smiled his twinkling smile, put some more coal on the fire, and went into his own room to pour the Doctor a little drink in a medicine glass. When they were all seated, he watched his wife's face from his end of the table and spoke to her in Czech. Then, with the instinct of politeness which seldom failed him, he turned to the Doctor and said slyly: "I was just tellin' her not to ask you no questions about Mrs. Marshall till you eat some breakfast. My wife, she's terrible fur to ask questions."

The boys laughed, and so did Mary. She watched the Doctor devour her biscuit and sausage, too much excited to eat anything herself. She drank her coffee and sat taking in everything about her visitor. She had known him when he was a poor country boy, and was boastfully proud of his success, always saying: "What do people go to Omaha for, to see a doctor, when we got the best one in the state right here?" If Mary liked people at all, she felt physical pleasure in the sight of them, personal exultation in any good fortune that came to them. Burleigh didn't know many women like that, but he knew she was like that.

When his hunger was satisfied, he did, of course, have to tell them about Mrs. Marshall, and he noticed what a friendly interest the boys took in the matter.

Rudolph, the oldest one (he was still living at home then), said: "The last time I was over there, she was lifting them big heavy milk cans, and I knew she oughtn't to be doing it."

"Yes, Rudolph told me about that when he came home, and I said it wasn't right," Mary put in warmly. "It was all right for me to do them things up to the last, for I was terrible strong, but that woman's weakly. And do you think she'll be able to nurse it, Ed?" She sometimes forgot to give him the title she was so proud of. "And to think of your being up all night and then not able to get a decent breakfast! I don't know what's the matter with such people."

"Why, Mother," said one of the boys, "if Doctor Ed had got breakfast there, we wouldn't have him here. So you ought to be glad."

"He knows I'm glad to have him, John, any time. But I'm sorry for that poor woman, how bad she'll feel the Doctor had to go away in the cold without his breakfast."

"I wish I'd been in practice when these were getting born." The doctor looked down the row of close-clipped heads. "I missed some good breakfasts by not being."

The boys began to laugh at their mother because she flushed so red, but she stood her ground and threw up her head. "I don't care, you wouldn't have got away from this house without breakfast. No doctor ever did. I'd have

had something ready fixed that Anton could warm up for you."

The boys laughed harder than ever, and exclaimed at her: "I'll bet you would!" "She would, that!"

"Father, did you get breakfast for the doctor when we were born?"

"Yes, and he used to bring me my breakfast, too, mighty nice. I was always awful hungry!" Mary admitted with a guilty laugh.

While the boys were getting the Doctor's horse, he went to the window to examine the house plants. "What do you do to your geraniums to keep them blooming all winter, Mary? I never pass this house that from the road I don't see your windows full of flowers."

She snapped off a dark red one, and a ruffled new green leaf, and put them in his buttonhole. "There, that looks better. You look too solemn for a young man, Ed. Why don't you git married? I'm worried about you. Settin' at breakfast, I looked at you real hard, and I seen you've got some gray hairs already."

"Oh, yes! They're coming. Maybe they'd come faster if I married."

"Don't talk so. You'll ruin your health eating at the hotel. I could send your wife a nice loaf of nut bread, if you only had one. I don't like to see a young man getting gray. I'll tell you something, Ed; you make some strong black tea and keep it handy in a bowl, and every morning just brush it into your hair, an' it'll keep the gray from showin' much. That's the way I do!"

Sometimes the Doctor heard the gossipers in the drugstore wondering why Rosicky didn't get on faster. He was industrious, and so were his boys, but they were rather free and easy, weren't pushers, and they didn't always show good judgment. They were comfortable, they were out of debt, but they didn't get much ahead. Maybe, Doctor Burleigh reflected, peo-ple as generous and warm-hearted and affectionate as the Rosickys never got ahead much; maybe you couldn't enjoy your life and put it into the bank, too.

Two

When Rosicky left Doctor Burleigh's office he went into the farm implement store to light his pipe and put on his glasses and read over the list Mary had given him. Then he went into the general merchandise place next door and stood about until the pretty girl with the plucked eyebrows, who always waited on him, was free. Those eyebrows, two thin India-ink strokes, amused him, because he remembered how they used to be. Rosicky always prolonged his shopping by a little joking; the girl knew the old fellow admired her, and she liked to chaff[2] with him.

"Seems to me about every other week you buy ticking, Mr. Rosicky, and always the best quality," she remarked as she measured off the heavy bolt with red stripes.

"You see, my wife is always makin' goose-fedder pillows, an' de thin stuff don't hold in dem little down fedders."

"You must have lots of pillows at your house."

"Sure. She makes quilts of dem, too. We sleeps easy. Now she's makin' a fedder quilt for my son's wife. You know Polly, that married my Rudolph. How much my bill, Miss Pearl?"

"Eight eighty-five."

"Chust make it nine, and put in some candy fur de women."

"As usual. I never did see a man buy so much candy for his wife. First thing you know, she'll be getting too fat."

"I'd like dat. I ain't much fur all dem slim women like what de style is now."

"That's one for me, I suppose, Mr. Bo-

2. **chaff** (chăf): joke in a good-natured way.

hunk!"[3] Pearl sniffed and elevated her India-ink strokes.

When Rosicky went out to his wagon, it was beginning to snow—the first snow of the season, and he was glad to see it. He rattled out of town and along the highway through a wonderfully rich stretch of country, the finest farms in the county. He admired this High Prairie, as it was called, and always liked to drive through it. His own place lay in a rougher territory, where there was some clay

3. **Bohunk** (bō′hŭngk): a slang word derived from *Bohemian* and *Hungarian*, referring to someone from east-central or southeastern Europe.

in the soil and it was not so productive. When he bought his land, he hadn't the money to buy on High Prairie; so he told his boys, when they grumbled, that if their land hadn't some clay in it, they wouldn't own it at all. All the same, he enjoyed looking at these fine farms, as he enjoyed looking at a prize bull.

After he had gone eight miles, he came to the graveyard, which lay just at the edge of his own hayland. There he stopped his horses and sat still on his wagon seat, looking about at the snowfall. Over yonder on the hill he could see his own house, crouching low, with the clump of orchard behind and the windmill before,

and all down the gentle hillslope the rows of pale gold cornstalks stood out against the white field. The snow was falling over the cornfield and the pasture and the hayland, steadily, with very little wind—a nice dry snow. The graveyard had only a light wire fence about it and was all overgrown with long red grass. The fine snow, settling into this red grass and upon the few little evergreens and the headstones, looked very pretty.

It was a nice graveyard, Rosicky reflected, sort of snug and homelike, not cramped or mournful—a big sweep all round it. A man could lie down in the long grass and see the complete arch of the sky over him, hear the wagons go by; in summer the mowing machine rattled right up to the wire fence. And it was so near home. Over there across the cornstalks his own roof and windmill looked so good to him that he promised himself to mind the Doctor and take care of himself. He was awful fond of his place, he admitted. He wasn't anxious to leave it. And it was a comfort to think that he would never have to go farther than the edge of his own hayfield. The snow, falling over his barnyard and the graveyard, seemed to draw things together like. And they were all old neighbors in the graveyard, most of them friends; there was nothing to feel awkward or embarrassed about. Embarrassment was the most disagreeable feeling Rosicky knew. He didn't often have it—only with certain people whom he didn't understand at all.

Well, it was a nice snowstorm; a fine sight to see the snow falling so quietly and graciously over so much open country. On his cap and shoulders, on the horses' backs and manes, light, delicate, mysterious it fell; and with it a dry cool fragrance was released into the air. It meant rest for vegetation and men and beasts, for the ground itself; a season of long nights for sleep, leisurely breakfasts, peace by the fire. This and much more went through Rosicky's mind, but he merely told himself that winter was coming, clucked to his horses, and drove on.

When he reached home, John, the youngest boy, ran out to put away his team for him, and he met Mary coming up from the outside cellar with her apron full of carrots. They went into the house together. On the table, covered with oilcloth figured with clusters of blue grapes, a place was set, and he smelled hot coffeecake of some kind. Anton never lunched in town; he thought that extravagant, and anyhow he didn't like the food. So Mary always had something ready for him when he got home.

After he was settled in his chair, stirring his coffee in a big cup, Mary took out of the oven a pan of *kolache*[4] stuffed with apricots, examined them anxiously to see whether they had got too dry, put them beside his plate, and then sat down opposite him.

Rosicky asked her in Czech if she wasn't going to have any coffee.

She replied in English, as being somehow the right language for transacting business: "Now what did Doctor Ed say, Anton? You tell me just what."

"He said I was to tell you some compliments, but I forgot 'em." Rosicky's eyes twinkled.

"About you, I mean. What did he say about your asthma?"

"He says I ain't got no asthma." Rosicky took one of the little rolls in his broad brown fingers. The thickened nail of his right thumb told the story of his past.

"Well, what is the matter? And don't try to put me off."

"He don't say nothing much, only I'm a little older, and my heart ain't so good like it used to be."

Mary started and brushed her hair back from her temples with both hands as if she

4. *kolache* (kə-läch′ē): pastry filled with fruit or jam.

were a little out of her mind. From the way she glared, she might have been in a rage with him.

"He says there's something the matter with your heart? Doctor Ed says so?"

"Now don't yell at me like I was a hog in de garden, Mary. You know I always did like to hear a woman talk soft. He didn't say anything de matter wid my heart, only it ain't so young like it used to be, an' he tell me not to pitch hay or run de corn sheller."

Mary wanted to jump up, but she sat still. She admired the way he never under any circumstances raised his voice or spoke roughly. He was city-bred, and she was country-bred; she often said she wanted her boys to have their papa's nice ways.

"You never have no pain there, do you? It's your breathing and your stomach that's been wrong. I wouldn't believe nobody but Doctor Ed about it. I guess I'll go see him myself. Didn't he give you no advice?"

"Chust to take it easy like, an' stay round de house dis winter. I guess you got some carpenter work for me to do. I kin make some new shelves for you, and I want dis long time to build a closet in de boys' room and make dem two little fellers keep dere clo'es hung up."

Rosicky drank his coffee from time to time, while he considered. His mustache was of the soft long variety and came down over his mouth like the teeth of a buggy rake over a bundle of hay. Each time he put down his cup, he ran his blue handkerchief over his lips. When he took a drink of water, he managed very neatly with the back of his hand.

Mary sat watching him intently, trying to find any change in his face. It is hard to see anyone who has become like your own body to you. Yes, his hair had got thin, and his high forehead had deep lines running from left to right. But his neck, always clean shaved except in the busiest seasons, was not loose or baggy.

It was burned a dark reddish brown, and there were deep creases in it, but it looked firm and full of blood. His cheeks had a good color. On either side of his mouth there was a half-moon down the length of his cheek, not wrinkles, but two lines that had come there from his habitual expression. He was shorter and broader than when she married him; his back had grown broad and curved, a good deal like the shell of an old turtle, and his arms and legs were short.

He was fifteen years older than Mary, but she had hardly ever thought about it before. He was her man, and the kind of man she liked. She was rough, and he was gentle—city-bred, as she always said. They had been shipmates on a rough voyage and had stood by each other in trying times. Life had gone well with them because, at bottom, they had the same ideas about life. They agreed, without discussion, as to what was most important and what was secondary. They didn't often exchange opinions, even in Czech—it was as if they had thought the same thought together. A good deal had to be sacrificed and thrown overboard in a hard life like theirs, and they had never disagreed as to the things that could go. It had been a hard life, and a soft life, too. There wasn't anything brutal in the short, broad-backed man with the three-cornered eyes and the forehead that went on to the top of his skull. He was a city man, a gentle man, and though he had married a rough farm girl, he had never touched her without gentleness.

They had been at one accord not to hurry through life, not to be always skimping and saving. They saw their neighbors buy more land and feed more stock than they did, without discontent. Once when the creamery agent came to the Rosickys to persuade them to sell them their cream, he told them how much money the Fasslers, their nearest neighbors, had made on their cream last year.

"Yes," said Mary, "and look at them Fassler children! Pale, pinched little things, they look like skimmed milk. I'd rather put some color into my children's faces than put money into the bank."

The agent shrugged and turned to Anton.

"I guess we'll do like she says," said Rosicky.

Three

Mary very soon got into town to see Doctor Ed, and then she had a talk with her boys and set a guard over Rosicky. Even John, the youngest, had his father on his mind. If Rosicky went to throw hay down from the loft, one of the boys ran up the ladder and took the fork from him. He sometimes complained that though he was getting to be an old man, he wasn't an old woman yet.

That winter he stayed in the house in the afternoons and carpentered, or sat in the chair between the window full of plants and the wooden bench where the two pails of drinking water stood. This spot was called "Father's corner," though it was not a corner at all. He had a shelf there, where he kept his Bohemian papers and his pipes and tobacco, and his shears and needles and thread and tailor's thimble. Having been a tailor in his youth, he couldn't bear to see a woman patching at his clothes, or at the boys'. He liked tailoring, and always patched all the overalls and jackets and work shirts. Occasionally he made over a pair of pants one of the older boys had outgrown, for the little fellow.

While he sewed, he let his mind run back over his life. He had a good deal to remember, really; life in three countries. The only part of his youth he didn't like to remember was the two years he had spent in London, in Cheapside, working for a German tailor who was wretchedly poor. Those days, when he was nearly always hungry, when his clothes were dropping off him for dirt, and the sound of a strange language kept him in continual bewilderment, had left a sore spot in his mind that wouldn't bear touching.

He was twenty when he landed at Castle Garden in New York, and he had a protector

The Port of New York, Birds-eye View from the Battery Looking South (1872).
Currier and Ives lithograph.
Courtesy of The New-York Historical Society, New York

who got him work in a tailor shop in Vesey Street, down near the Washington Market. He looked upon that part of his life as very happy. He became a good workman, he was industrious, and his wages were increased from time to time. He minded his own business and envied nobody's good fortune. He went to night school and learned to read English. He often did overtime work and was well paid for it, but somehow he never saved anything. He couldn't refuse a loan to a friend, and he was self-indulgent. He liked a good dinner, and a little went for beer, a little for tobacco; a good deal went to the girls. He often stood through an opera on Saturday nights; he could get standing room for a dollar. Those were the great days of opera in New York, and it gave a fellow something to think about for the rest of the week. Rosicky had a quick ear, and a childish love of all the stage splendor; the scenery, the costumes, the ballet. He usually went with a chum, and after the performance they had beer and maybe some oysters somewhere. It was a fine life; for the first five years or so it satisfied him completely. He was never hungry or cold or dirty, and everything amused him: a fire, a dogfight, a parade, a storm, a ferry ride. He thought New York the finest, richest, friendliest city in the world.

Moreover, he had what he called a happy home life. Very near the tailor shop was a small furniture factory, where an old Austrian, Loeffler, employed a few skilled men and made unusual furniture, most of it to order, for the rich German housewives uptown. The top floor of Loeffler's five-story factory was a loft, where he kept his choice lumber and stored the odd pieces of furniture left on his hands. One of the young workmen he employed was a Czech, and he and Rosicky became fast friends. They persuaded Loeffler to let them have a sleeping room in one corner of the loft. They bought good beds and bedding and had their pick of the furniture kept up there. The loft was low-pitched, but light and airy, full of windows, and good-smelling by reason of the fine lumber put up there to season. Old Loeffler used to go down to the docks and buy wood from South America and the East from the sea captains. The young men were as foolish about their house as a bridal pair. Zichec, the young cabinetmaker, devised every sort of convenience, and Rosicky kept their clothes in order. At night and on Sundays, when the quiver of machinery underneath was still, it was the quietest place in the world, and on summer nights all the sea winds blew in. Zichec often practiced on his flute in the evening. They were both fond of music and went to the opera together. Rosicky thought he wanted to live like that for ever.

But as the years passed, all alike, he began to get a little restless. When spring came round, he would begin to feel fretted, and he got to drinking. He was likely to drink too much of a Saturday night. On Sunday he was languid and heavy, getting over his spree. On Monday he plunged into work again. So he never had time to figure out what ailed him, though he knew something did. When the grass turned green in Park Place, and the lilac hedge at the back of Trinity churchyard put out its blossoms, he was tormented by a longing to run away. That was why he drank too much; to get a temporary illusion of freedom and wide horizons.

Rosicky, the old Rosicky, could remember as if it were yesterday the day when the young Rosicky found out what was the matter with him. It was on a Fourth of July afternoon, and he was sitting in Park Place in the sun. The lower part of New York was empty. Wall Street, Liberty Street, Broadway, all empty. So much stone and asphalt with nothing going on, so many empty windows. The emptiness was intense, like the stillness in a great factory when

the machinery stops and the belts and bands cease running. It was too great a change, it took all the strength out of one. Those blank buildings, without the stream of life pouring through them, were like empty jails. It struck young Rosicky that this was the trouble with big cities; they built you in from the earth itself, cemented you away from any contact with the ground. You lived in an unnatural world, like the fish in an aquarium, who were probably much more comfortable than they ever were in the sea.

On that very day he began to think seriously about the articles he had read in the Bohemian papers, describing prosperous Czech farming communities in the West. He believed he would like to go out there as a farmhand; it was hardly possible that he could ever have land of his own. His people had always been workmen; his father and grandfather had worked in shops. His mother's parents had lived in the country, but they rented their farm and had a hard time to get along. Nobody in his family had ever owned any land—that belonged to a different station of life altogether. Anton's mother died when he was little, and he was sent into the country to her parents. He stayed with them until he was twelve, and formed those ties with the earth and the farm animals and growing things which are never made at all unless they are made early. After his grandfather died, he went back to live with his father and stepmother, but she was very hard on him, and his father helped him to get passage to London.

After that Fourth of July day in Park Place, the desire to return to the country never left him. To work on another man's farm would be all he asked; to see the sun rise and set and to plant things and watch them grow. He was a very simple man. He was like a tree that has not many roots, but one taproot that goes down deep. He subscribed for a Bohemian paper printed in Chicago, then for one printed in Omaha. His mind got farther and farther west. He began to save a little money to buy his liberty. When he was thirty-five, there was a great meeting in New York of Bohemian

A Burlington and Missouri Railroad advertisement in Czech for 600,000 acres of land in Nebraska. It offers "the longest terms, the lowest interest rates, and the most liberal conditions ever offered by any company."
Nebraska State Historical Society

athletic societies, and Rosicky left the tailor shop and went home with the Omaha delegates to try his fortune in another part of the world.

Four

Perhaps the fact that his own youth was well over before he began to have a family was one reason why Rosicky was so fond of his boys. He had almost a grandfather's indulgence for them. He had never had to worry about any of them—except, just now, a little about Rudolph.

On Saturday night the boys always piled into the Ford, took little Josephine, and went to town to the moving-picture show. One Saturday morning they were talking at the breakfast table about starting early that evening, so that they would have an hour or so to see the Christmas things in the stores before the show began. Rosicky looked down the table.

"I hope you boys ain't disappointed, but I want you to let me have de car tonight. Maybe some of you can go in with de neighbors."

Their faces fell. They worked hard all week, and they were still like children. A new jack-knife or a box of candy pleased the older ones as much as the little fellow.

"If you and Mother are going to town," Frank said, "maybe you could take a couple of us along with you, anyway."

"No, I want to take de car down to Rudolph's, and let him an' Polly go in to de show. She don't git into town enough, an' I'm afraid she's gettin' lonesome, an' he can't afford no car yet."

That settled it. The boys were a good deal dashed. Their father took another piece of applecake and went on: "Maybe next Saturday night de two little fellers can go along wid dem."

"Oh, is Rudolph going to have the car every Saturday night?"

Rosicky did not reply at once; then he began to speak seriously: "Listen, boys; Polly ain't lookin' so good. I don't like to see nobody lookin' sad. It comes hard fur a town girl to be a farmer's wife. I don't want no trouble to start in Rudolph's family. When it starts, it ain't so easy to stop. An American girl don't git used to our ways all at once. I like to tell Polly she and Rudolph can have the car every Saturday night till after New Year's, if it's all right with you boys."

"Sure it's all right, Papa," Mary cut in. "And it's good you thought about that. Town girls is used to more than country girls. I lay awake nights, scared she'll make Rudolph discontented with the farm."

The boys put as good a face on it as they could. They surely looked forward to their Saturday nights in town. That evening Rosicky drove the car the half-mile down to Rudolph's new, bare little house.

Polly was in a short-sleeved gingham dress, clearing away the supper dishes. She was a trim, slim little thing, with blue eyes and shingled yellow hair, and her eyebrows were reduced to a mere brushstroke, like Miss Pearl's.

"Good evening, Mr. Rosicky. Rudolph's at the barn, I guess." She never called him father, or Mary mother. She was sensitive about having married a foreigner. She never in the world would have done it if Rudolph hadn't been such a handsome, persuasive fellow and such a gallant lover. He had graduated in her class in the high school in town, and their friendship began in the ninth grade.

Rosicky went in, though he wasn't exactly asked. "My boys ain't goin' to town tonight, an' I brought de car over fur you two to go in to de picture show."

Polly, carrying dishes to the sink, looked over her shoulder at him. "Thank you. But I'm late with my work tonight, and pretty tired. Maybe Rudolph would like to go in with you?"

"Oh, I don't go to de shows! I'm too old-fashioned. You won't feel so tired after you ride in de air a ways. It's a nice clear night, an' it ain't cold. You go an' fix yourself up, Polly, an' I'll wash de dishes an' leave everything nice fur you."

Polly blushed and tossed her bob. "I couldn't let you do that, Mr. Rosicky. I wouldn't think of it."

Rosicky said nothing. He found a bib apron on a nail behind the kitchen door. He slipped it over his head and then took Polly by her two elbows and pushed her gently toward the door of her own room. "I washed up de kitchen many times for my wife, when de babies was sick or somethin'. You go an' make yourself look nice. I like you to look prettier'n any of dem town girls when you go in. De young folks must have some fun, an' I'm goin' to look out fur you, Polly."

That kind, reassuring grip on her elbows, the old man's funny bright eyes, made Polly want to drop her head on his shoulder for a second. She restrained herself, but she lingered in his grasp at the door of her room, murmuring tearfully: "You always lived in the city when you were young, didn't you? Don't you ever get lonesome out here?"

As she turned round to him, her hand fell naturally into his, and he stood holding it and smiling into her face with his peculiar, knowing, indulgent smile without a shadow of reproach in it. "Dem big cities is all right fur de rich, but dey is terrible hard fur de poor."

"I don't know. Sometimes I think I'd like to take a chance. You lived in New York, didn't you?"

"An' London. Da's bigger still. I learned my trade dere. Here's Rudolph comin', you better hurry."

"Will you tell me about London sometime?"

"Maybe. Only I ain't no talker, Polly. Run an' dress yourself up."

The bedroom door closed behind her, and Rudolph came in from the outside, looking anxious. He had seen the car and was sorry any of his family should come just then. Supper hadn't been a very pleasant occasion. Halting in the doorway, he saw his father in a kitchen apron, carrying dishes to the sink. He flushed crimson and something flashed in his eye. Rosicky held up a warning finger.

"I brought de car over fur you an' Polly to go to de picture show, an' I made her let me finish here so you won't be late. You go put on a clean shirt, quick!"

"But don't the boys want the car, Father?"

"Not tonight dey don't." Rosicky fumbled under his apron and found his pants pocket. He took out a silver dollar and said in a hurried whisper: "You go an' buy dat girl some ice cream an' candy tonight, like you was courtin'. She's awful good friends wid me."

Rudolph was very short of cash, but he took the money as if it hurt him. There had been a crop failure all over the county. He had more than once been sorry he'd married this year.

In a few minutes the young people came out, looking clean and a little stiff. Rosicky hurried them off, and then he took his own time with the dishes. He scoured the pots and pans and put away the milk and swept the kitchen. He put some coal in the stove and shut off the drafts, so the place would be warm for them when they got home late at night. Then he sat down and had a pipe and listened to the clock tick.

Generally speaking, marrying an American girl was certainly a risk. A Czech should marry a Czech. It was lucky that Polly was the daughter of a poor widow woman; Rudolph was proud, and if she had a prosperous family to throw up at him, they could never make it go. Polly was one of four sisters, and they all worked; one was bookkeeper in the bank, one taught music, and Polly and her younger sister

had been clerks, like Miss Pearl. All four of them were musical, had pretty voices, and sang in the Methodist choir, which the eldest sister directed.

Polly missed the sociability of a store position. She missed the choir, and the company of her sisters. She didn't dislike housework, but she disliked so much of it. Rosicky was a little anxious about this pair. He was afraid Polly would grow so discontented that Rudy would quit the farm and take a factory job in Omaha. He had worked for a winter up there, two years ago, to get money to marry on. He had done very well, and they would always take him back at the stockyards. But to Rosicky that meant the end of everything for his son. To be a landless man was to be a wage earner, a slave, all your life; to have nothing, to be nothing.

Rosicky thought he would come over and do a little carpentering for Polly after the New Year. He guessed she needed jollying. Rudolph was a serious sort of chap, serious in love and serious about his work.

Rosicky shook out his pipe and walked home across the fields. Ahead of him the lamplight shone from his kitchen windows. Suppose he were still in a tailor shop on Vesey Street, with a bunch of pale, narrow-chested sons working on machines, all coming home tired and sullen to eat supper in a kitchen that was a parlor also; with another crowded, angry family quarreling just across the dumbwaiter[5] shaft, and squeaking pulleys at the windows where dirty washings hung on dirty lines above a court full of old brooms and mops and ashcans. . . .

He stopped by the windmill to look up at the frosty winter stars and draw a long breath before he went inside. That kitchen with the shining windows was dear to him; but the sleeping fields and bright stars and the noble darkness were dearer still.

Five

On the day before Christmas the weather set in very cold; no snow, but a bitter, biting wind that whistled and sang over the flat land and lashed one's face like fine wires. There was baking going on in the Rosicky kitchen all day, and Rosicky sat inside, making over a coat that Albert had outgrown into an overcoat for John. Mary had a big red geranium in bloom for Christmas, and a row of Jerusalem cherry trees, full of berries. It was the first year she had ever grown these; Doctor Ed brought her the seeds from Omaha when he went to some medical convention. They reminded Rosicky of plants he had seen in England; and all afternoon, as he stitched, he sat thinking about those two years in London, which his mind usually shrank from even after all this while.

He was a lad of eighteen when he dropped down into London, with no money and no connections except the address of a cousin who was supposed to be working at a confectioner's. When he went to the pastry shop, he found that the cousin had gone to America. Anton tramped the streets for several days, sleeping in doorways and on the Embankment,[6] until he was in utter despair. He knew no English, and the sound of the strange language all about him confused him. By chance he met a poor German tailor who had learned his trade in Vienna, and could speak a little Czech. This tailor, Lifschnitz, kept a repair shop in a Cheapside basement, underneath a cobbler. He didn't much need an apprentice, but he was sorry for the boy and took him in for no wages but his keep and what he could pick up. The pickings were supposed to be coppers given you when you took work home to a cus-

5. **dumbwaiter:** a small elevator used to carry food or trash from one floor to another.

6. **Embankment:** the Victoria Embankment along the Thames River.

Bishopsgate Street, London by Gustave Doré (1832–1883). Engraving.

From *London. A Pilgrimage* (1872) by Gustave Doré and Blanchard Jerrold. Courtesy The Lundoff Collection

tomer. But most of the customers called for their clothes themselves, and the coppers that came Anton's way were very few. He had, however, a place to sleep. The tailor's family lived upstairs in three rooms; a kitchen, a bedroom, where Lifschnitz and his wife and five children

slept, and a living room. Two corners of this living room were curtained off for lodgers; in one Rosicky slept on an old horsehair sofa, with a feather quilt to wrap himself in. The other corner was rented to a wretched, dirty boy, who was studying the violin. He actually practiced there. Rosicky was dirty, too. There was no way to be anything else. Mrs. Lifschnitz got the water she cooked and washed with from a pump in a brick court, four flights down. There were bugs in the place, and multitudes of fleas, though the poor woman did the best she could. Rosicky knew she often went empty to give another potato or a spoonful of dripping to the two hungry, sad-eyed boys who lodged with her. He used to think he would never get out of there, never get a clean shirt to his back again. What would he do, he wondered, when his clothes actually dropped to pieces and the worn cloth wouldn't hold patches any longer?

It was still early when the old farmer put aside his sewing and his recollections. The sky had been a dark gray all day, with not a gleam of sun, and the light failed at four o'clock. He went to shave and change his shirt while the turkey was roasting. Rudolph and Polly were coming over for supper.

After supper they sat round in the kitchen, and the younger boys were saying how sorry they were it hadn't snowed. Everybody was sorry. They wanted a deep snow that would lie long and keep the wheat warm, and leave the ground soaked when it melted.

"Yes, sir!" Rudolph broke out fiercely; "if we have another dry year like last year, there's going to be hard times in this country."

Rosicky filled his pipe. "You boys don't know what hard times is. You don't owe nobody, you got plenty to eat an' keep warm, an' plenty water to keep clean. When you got them, you can't have it very hard."

Rudolph frowned, opened and shut his big right hand, and dropped it clenched upon his knee. "I've got to have a good deal more than that, Father, or I'll quit this farming gamble. I can always make good wages railroading, or at the packing house, and be sure of my money."

"Maybe so," his father answered dryly.

Mary, who had just come in from the pantry and was wiping her hands on the roller towel, thought Rudy and his father were getting too serious. She brought her darning basket and sat down in the middle of the group.

"I ain't much afraid of hard times, Rudy," she said heartily. "We've had a plenty, but we've always come through. Your father wouldn't never take nothing very hard, not even hard times. I got a mind to tell you a story on him. Maybe you boys can't hardly remember the year we had that terrible hot wind, that burned everything up on the Fourth of July? All the corn an' the gardens. An' that was in the days when we didn't have alfalfa yet—I guess it wasn't invented.

"Well, that very day your father was out cultivatin' corn, and I was here in the kitchen makin' plum preserves. We had bushels of plums that year. I noticed it was terrible hot, but it's always hot in the kitchen when you're preservin', an' I was too busy with my plums to mind. Anton come in from the field about three o'clock, an' I asked him what was the matter.

"'Nothin',' he says, 'but it's pretty hot, an' I think I won't work no more today.' He stood round for a few minutes, an' then he says: 'Ain't you near through? I want you should git up a nice supper for us tonight. It's Fourth of July.'

"I told him to git along, that I was right in the middle of preservin', but the plums would taste good on hot biscuit. 'I'm goin' to have fried chicken, too,' he says, and he went off an' killed a couple. You three oldest boys was

little fellers, playin' round outside, real hot an' sweaty, an' your father took you to the horse tank down by the windmill an' took off your clothes an' put you in. Them two box elder trees was little then, but they made shade over the tank. Then he took off all his own clothes, an' got in with you. While he was playin' in the water with you, the Methodist preacher drove into our place to say how all the neighbors was goin' to meet at the schoolhouse that night, to pray for rain. He drove right to the windmill, of course, and there was your father and you three with no clothes on. I was in the kitchen door, an' I had to laugh, for the preacher acted like he ain't never seen a naked man before. He surely was embarrassed, an' your father couldn't git to his clothes; they was all hangin' up on the windmill to let the sweat dry out of 'em. So he laid in the tank where he was, an' put one of you boys on top of him to cover him up a little, an' talked to the preacher.

"When you got through playin' in the water, he put clean clothes on you and a clean shirt on himself, an' by that time I'd begun to get supper. He says: 'It's too hot in here to eat comfortable. Let's have a picnic in the orchard. We'll eat our supper behind the mulberry hedge, under them linden trees.'

"So he carried our supper down, an' a bottle of my wild-grape wine, an' everything tasted good, I can tell you. The wind got cooler as the sun was goin' down, and it turned out pleasant, only I noticed how the leaves was curled up on the linden trees. That made me think, an' I asked your father if that hot wind all day hadn't been terrible hard on the gardens an' the corn.

"'Corn,' he says, 'there ain't no corn.'

"'What you talkin' about?' I said. 'Ain't we got forty acres?'

"'We ain't got an ear,' he says, 'nor nobody else ain't got none. All the corn in this country

was cooked by three o'clock today, like you'd roasted it in an oven.'

"'You mean you won't get no crop at all?' I asked him. I couldn't believe it, after he'd worked so hard.

"'No crop this year,' he says. 'That's why we're havin' a picnic. We might as well enjoy what we got.'

"An' that's how your father behaved, when all the neighbors was so discouraged they couldn't look you in the face. An' we enjoyed ourselves that year, poor as we was, an' our neighbors wasn't a bit better off for bein' miserable. Some of 'em grieved till they got poor digestions and couldn't relish what they did have."

The younger boys said they thought their father had the best of it. But Rudolph was thinking that, all the same, the neighbors had managed to get ahead more, in the fifteen years since that time. There must be something wrong about his father's way of doing things. He wished he knew what was going on in the back of Polly's mind. He knew she liked his father, but he knew, too, that she was afraid of something. When his mother sent over coffee-cake or prune tarts or a loaf of fresh bread, Polly seemed to regard them with a certain suspicion. When she observed to him that his brothers had nice manners, her tone implied that it was remarkable they should have. With his mother she was stiff and on her guard. Mary's hearty frankness and gusts of good humor irritated her. Polly was afraid of being unusual or conspicuous in any way, of being "ordinary," as she said!

When Mary had finished her story, Rosicky laid aside his pipe.

"You boys like me to tell you about some of dem hard times I been through in London?" Warmly encouraged, he sat rubbing his forehead along the deep creases. It was bothersome to tell a long story in English (he nearly

always talked to the boys in Czech), but he wanted Polly to hear this one.

"Well, you know about dat tailor shop I worked in in London? I had one Christmas dere I ain't never forgot. Times was awful bad before Christmas; de boss ain't got much work, an' have it awful hard to pay his rent. It ain't so much fun, bein' poor in a big city like London, I'll say! All de windows is full of good t'ings to eat, an' all de pushcarts in de streets is full, an' you smell 'em all de time, an' you ain't got no money—not a damn bit. I didn't mind de cold so much, though I didn't have no overcoat, chust a short jacket I'd outgrowed so it wouldn't meet on me, an' my hands was chapped raw. But I always had a good appetite, like you all know, an' de sight of dem pork pies in de windows was awful fur me!

"Day before Christmas was terrible foggy dat year, an' dat fog gits into your bones and makes you all damp like. Mrs. Lifschnitz didn't give us nothin' but a little bread an' drippin' for supper, because she was savin' to try for to give us a good dinner on Christmas Day. After supper de boss say I can go an' enjoy myself, so I went into de streets to listen to de Christmas singers. Dey sing old songs an' make very nice music, an' I run round after dem a good ways, till I got awful hungry. I t'ink maybe if I go home, I can sleep till morning an' forget my belly.

"I went into my corner real quiet, and roll up in my fedder quilt. But I ain't got my head down, till I smell somet'ing good. Seem like it git stronger an' stronger, an' I can't git to sleep noway. I can't understand dat smell. Dere was a gas light in a hall across de court, dat always shine in at my window a little. I got up an' look round. I got a little wooden box in my corner fur a stool, 'cause I ain't got no chair. I picks up dat box, and under it dere is a roast goose on a platter! I can't believe my eyes. I carry it to de window where de light comes in, an' touch it and smell it to find out, an' den I taste it to be sure. I say, I will eat chust one little bite of dat goose, so I can go to sleep, and tomorrow I won't eat none at all. But I tell you, boys, when I stop, one half of dat goose was gone!"

The narrator bowed his head, and the boys shouted. But little Josephine slipped behind his chair and kissed him on the neck beneath his ear.

"Poor little Papa, I don't want him to be hungry!"

"Da's long ago, child. I ain't never been hungry since I had your mudder to cook fur me."

"Go on and tell us the rest, please," said Polly.

"Well, when I come to realize what I done, of course, I felt terrible. I felt better in de stomach, but very bad in de heart. I set on my bed wid dat platter on my knees, an' it all come to me; how hard dat poor woman save to buy dat goose, and how she get some neighbor to cook it dat got more fire, an' how she put it in my corner to keep it away from dem hungry children. Dey was a old carpet hung up to shut my corner off, an' de children wasn't allowed to go in dere. An' I know she put it in my corner because she trust me more'n she did de violin boy. I can't stand it to face her after I spoil de Christmas. So I put on my shoes and go out into de city. I tell myself I better throw myself in de river; but I guess I ain't dat kind of a boy.

"It was after twelve o'clock, an' terrible cold, an' I start out to walk about London all night. I walk along de river awhile, but dey was lots of drunks all along; men, and women too. I chust move along to keep away from de police. I git onto de Strand, an' den over to New Oxford Street, where dere was a big German restaurant on de ground floor, wid big windows all fixed up fine, an' I could see de people havin' parties inside. While I was lookin' in,

two men and two ladies come out, laughin' and talkin' and feelin' happy about all dey been eatin' an' drinkin', and dey was speakin' Czech—not like de Austrians, but like de home folks talk it.

"I guess I went crazy, an' I done what I ain't never done before nor since. I went right up to dem gay people an' begun to beg dem: 'Fellow countrymen, for God's sake give me money enough to buy a goose!'

"Dey laugh, of course, but de ladies speak awful kind to me, an' dey take me back into de restaurant and give me hot coffee and cakes, an' make me tell all about how I happened to come to London, an' what I was doin' dere. Dey take my name and where I work down on paper, an' both of dem ladies give me ten shillings.

"De big market at Covent Garden ain't very far away, an' by dat time it was open. I go dere an' buy a big goose an' some pork pies, an' potatoes and onions, an' cakes an' oranges fur de children—all I could carry! When I git home, everybody is still asleep. I pile all I bought on de kitchen table, an' go in an' lay down on my bed, an' I ain't waken up till I hear dat woman scream when she come out into her kitchen. My goodness, but she was surprise! She laugh an' cry at de same time, an' hug me and waken all de children. She ain't stop fur no breakfast; she git de Christmas dinner ready dat morning, and we all sit down an' eat all we can hold. I ain't never seen dat violin boy have all he can hold before.

"Two three days after dat, de two men come to hunt me up, an' dey ask my boss, and he give me a good report an' tell dem I was a steady boy all right. One of dem Bohemians was very smart an' run a Bohemian newspaper in New York, an' de odder was a rich man, in de importing business, an' dey been traveling togedder. Dey told me how t'ings was easier in New York, an' offered to pay my passage when

dey was goin' home soon on a boat. My boss say to me: 'You go. You ain't got no chance here, an' I like to see you git ahead, fur you always been a good boy to my woman, and fur dat fine Christmas dinner you give us all.' An' da's how I got to New York."

That night when Rudolph and Polly, arm in arm, were running home across the fields with the bitter wind at their backs, his heart leaped for joy when she said she thought they might have his family come over for supper on New Year's Eve. "Let's get up a nice supper, and not let your mother help at all; make her be company for once."

"That would be lovely of you, Polly," he said humbly. He was a very simple, modest boy, and he, too, felt vaguely that Polly and her sisters were more experienced and worldly than his people.

Six

The winter turned out badly for farmers. It was bitterly cold, and after the first light snows before Christmas there was no snow at all—and no rain. March was as bitter as February. On those days when the wind fairly punished the country, Rosicky sat by his window. In the fall he and the boys had put in a big wheat planting, and now the seed had frozen in the ground. All that land would have to be plowed up and planted over again, planted in corn. It had happened before, but he was younger then, and he never worried about what had to be. He was sure of himself and of Mary; he knew they could bear what they had to bear, that they would always pull through somehow. But he was not so sure about the young ones, and he felt troubled because Rudolph and Polly were having such a hard start.

Sitting beside his flowering window while the panes rattled and the wind blew in under the door, Rosicky gave himself to reflection as he

had not done since those Sundays in the loft of the furniture factory in New York, long ago. Then he was trying to find what he wanted in life for himself; now he was trying to find what he wanted for his boys, and why it was he so hungered to feel sure they would be here, working this very land, after he was gone.

They would have to work hard on the farm, and probably they would never do much more than make a living. But if he could think of them as staying here on the land, he wouldn't have to fear any great unkindness for them. Hardships, certainly; it was a hardship to have the wheat freeze in the ground when seed was so high; and to have to sell your stock because you had no feed. But there would be other years when everything came along right, and you caught up. And what you had was your own. You didn't have to choose between bosses and strikers, and go wrong either way. You didn't have to do with dishonest and cruel people. They were the only things in his experience he had found terrifying and horrible; the look in the eyes of a dishonest and crafty man, of a scheming and rapacious woman.

In the country, if you had a mean neighbor, you could keep off his land and make him keep off yours. But in the city, all the foulness and misery and brutality of your neighbors was part of your life. The worst things he had come upon in his journey through the world were human—depraved and poisonous specimens of man. To this day he could recall certain terrible faces in the London streets. There were mean people everywhere, to be sure, even in their own country town here. But they weren't tempered, hardened, sharpened, like the treacherous people in cities who live by grinding or cheating or poisoning their fellowmen. He had helped to bury two of his fellow workmen in the tailoring trade, and he was distrustful of the organized industries that see one out of the world in big cities. Here, if you

were sick, you had Doctor Ed to look after you; and if you died, fat Mr. Haycock, the kindest man in the world, buried you.

It seemed to Rosicky that for good, honest boys like his, the worst they could do on the farm was better than the best they would be likely to do in the city. If he'd had a mean boy, now, one who was crooked and sharp and tried to put anything over on his brothers, then town would be the place for him. But he had no such boy. As for Rudolph, the discontented one, he would give the shirt off his back to anyone who touched his heart. What Rosicky really hoped for his boys was that they could get through the world without ever knowing much about the cruelty of human beings. "Their mother and me ain't prepared them for that," he sometimes said to himself.

These thoughts brought him back to a grateful consideration of his own case. What an escape he had had, to be sure! He, too, in his time, had had to take money for repair work from the hand of a hungry child who let it go so wistfully; because it was money due his boss. And now, in all these years, he had never had to take a cent from anyone in bitter need—never had to look at the face of a woman become like a wolf's from struggle and famine. When he thought of these things, Rosicky would put on his cap and jacket and slip down to the barn and give his workhorses a little extra oats, letting them eat it out of his hand in their slobbery fashion. It was his way of expressing what he felt, and made him chuckle with pleasure.

The spring came warm, with blue skies—but dry, dry as a bone. The boys began plowing up the wheat fields to plant them over in corn. Rosicky would stand at the fence corner and watch them, and the earth was so dry it blew up in clouds of brown dust that hid the horses and the sulky plow and the driver. It was a bad outlook.

The big alfalfa field that lay between the home place and Rudolph's came up green, but Rosicky was worried because during that open windy winter a great many Russian thistle plants had blown in there and lodged. He kept asking the boys to rake them out; he was afraid their seed would root and "take the alfalfa." Rudolph said that was nonsense. The boys were working so hard planting corn, their father felt he couldn't insist about the thistles, but he set great store by that big alfalfa field. It was a feed you could depend on—and there was some deeper reason, vague, but strong. The peculiar green of that clover woke early memories in old Rosicky, went back to something in his childhood in the old world. When he was a little boy, he had played in fields of that strong blue-green color.

One morning, when Rudolph had gone to town in the car, leaving a work team idle in his barn, Rosicky went over to his son's place, put the horses to the buggy rake, and set about quietly raking up those thistles. He behaved with guilty caution, and rather enjoyed stealing a march on Doctor Ed, who was just then taking his first vacation in seven years of practice and was attending a clinic in Chicago. Rosicky got the thistles raked up, but did not stop to burn them. That would take some time, and his breath was pretty short, so he thought he had better get the horses back to the barn.

He got them into the barn and to their stalls, but the pain had come on so sharp in his chest that he didn't try to take the harness off. He started for the house, bending lower with every step. The cramp in his chest was shutting him up like a jackknife. When he reached the windmill, he swayed and caught at the ladder. He saw Polly coming down the hill, running with the swiftness of a slim greyhound. In a flash she had her shoulder under his armpit.

"Lean on me, Father, hard! Don't be afraid. We can get to the house all right."

Somehow they did, though Rosicky became blind with pain; he could keep on his legs, but he couldn't steer his course. The next thing he

was conscious of was lying on Polly's bed, and Polly bending over him wringing out bath towels in hot water and putting them on his chest. She stopped only to throw coal into the stove, and she kept the teakettle and the black pot going. She put these hot applications on him for nearly an hour, she told him afterwards, and all that time he was drawn up stiff and blue, with the sweat pouring off him.

As the pain gradually loosed its grip, the stiffness went out of his jaws, the black circles round his eyes disappeared, and a little of his natural color came back. When his daughter-in-law buttoned his shirt over his chest at last, he sighed.

"Da's fine, de way I feel now, Polly. It was a awful bad spell, an' I was so sorry it all come on you like it did."

Polly was flushed and excited. "Is the pain really gone? Can I leave you long enough to telephone over to your place?"

Rosicky's eyelids fluttered. "Don't telephone, Polly. It ain't no use to scare my wife. It's nice and quiet here, an' if I ain't too much trouble to you, just let me lay still till I feel like myself. I ain't got no pain now. It's nice here."

Polly bent over him and wiped the moisture from his face. "Oh, I'm so glad it's over!" she broke out impulsively. "It just broke my heart to see you suffer so, Father."

Rosicky motioned her to sit down on the chair where the teakettle had been, and looked up at her with that lively affectionate gleam in his eyes. "You was awful good to me, I won't never forget dat. I hate it to be sick on you like dis. Down at de barn I say to myself, dat young girl ain't had much experience in sickness, I don't want to scare her, an' maybe she's got a baby comin' or somet'ing."

Polly took his hand. He was looking at her so intently and affectionately and confidingly; his eyes seemed to caress her face, to regard it with pleasure. She frowned with her funny streaks of eyebrows, and then smiled back at him.

"I guess maybe there is something of that kind going to happen. But I haven't told anyone yet, not my mother or Rudolph. You'll be the first to know."

His hand pressed hers. She noticed that it was warm again. The twinkle in his yellow-brown eyes seemed to come nearer.

"I like mighty well to see dat little child, Polly," was all he said. Then he closed his eyes and lay half-smiling. But Polly sat still, thinking hard. She had a sudden feeling that nobody in the world, not her mother, not Rudolph, or anyone, really loved her as much as old Rosicky did. It perplexed her. She sat frowning and trying to puzzle it out. It was as if Rosicky had a special gift for loving people, something that was like an ear for music or an eye for color. It was quiet, unobtrusive; it was merely there. You saw it in his eyes—perhaps that was why they were merry. You felt it in his hands, too. After he dropped off to sleep, she sat holding his warm, broad, flexible brown hand. She had never seen another in the least like it. She wondered if it wasn't a kind of gypsy hand, it was so alive and quick and light in its communications—very strange in a farmer. Nearly all the farmers she knew had huge lumps of fists, like mauls, or they were knotty and bony and uncomfortable-looking, with stiff fingers. But Rosicky's was like quicksilver, flexible, muscular, about the color of a pale cigar, with deep, deep creases across the palm. It wasn't nervous, it wasn't a stupid lump; it was a warm brown human hand, with some cleverness in it, a great deal of generosity, and something else which Polly could only call "gypsy-like"— something nimble and lively and sure, in the way that animals are.

Polly remembered that hour long afterwards; it had been like an awakening to her. It seemed to her that she had never learned

so much about life from anything as from old Rosicky's hand. It brought her to herself; it communicated some direct and untranslatable message.

When she heard Rudolph coming in the car, she ran out to meet him.

"Oh, Rudy, your father's been awful sick! He raked up those thistles he's been worrying about, and afterwards he could hardly get to the house. He suffered so I was afraid he was going to die."

Rudolph jumped to the ground. "Where is he now?"

"On the bed. He's asleep. I was terribly scared, because, you know, I'm so fond of your father." She slipped her arm through his and they went into the house. That afternoon they took Rosicky home and put him to bed, though he protested that he was quite well again.

The next morning he got up and dressed and sat down to breakfast with his family. He told Mary that his coffee tasted better than usual to him, and he warned the boys not to bear any tales to Doctor Ed when he got home. After breakfast he sat down by his window to do some patching and asked Mary to thread several needles for him before she went to feed her chickens—her eyes were better than his, and her hands steadier. He lit his pipe and took up John's overalls. Mary had been watching him anxiously all morning, and as she went out of the door with her bucket of scraps, she saw that he was smiling. He was thinking, indeed, about Polly, and how he might never have known what a tender heart she had if he hadn't got sick over there. Girls nowadays didn't wear their heart on their sleeve. But now he knew Polly would make a fine woman after the foolishness wore off. Either a woman had that sweetness at her heart or she hadn't. You couldn't always tell by the look of them; but if they had that, everything came out right in the end.

After he had taken a few stitches, the cramp began in his chest, like yesterday. He put his pipe cautiously down on the windowsill and bent over to ease the pull. No use—he had better try to get to his bed if he could. He rose and groped his way across the familiar floor, which was rising and falling like the deck of a ship. At the door he fell. When Mary came in, she found him lying there, and the moment she touched him she knew that he was gone.

Doctor Ed was away when Rosicky died, and for the first few weeks after he got home he was hard driven. Every day he said to himself that he must get out to see that family that had lost their father. One soft, warm moonlight night in early summer he started for the farm. His mind was on other things, and not until his road ran by the graveyard did he realize that Rosicky wasn't over there on the hill where the red lamplight shone, but here, in the moonlight. He stopped his car, shut off the engine, and sat there for a while.

A sudden hush had fallen on his soul. Everything here seemed strangely moving and significant, though signifying what, he did not know. Close by the wire fence stood Rosicky's mowing machine, where one of the boys had been cutting hay that afternoon; his own workhorses had been going up and down there. The new-cut hay perfumed all the night air. The moonlight silvered the long, billowy grass that grew over the graves and hid the fence; the few little evergreens stood out black in it, like shadows in a pool. The sky was very blue and soft, the stars rather faint because the moon was full.

For the first time it struck Doctor Ed that this was really a beautiful graveyard. He thought of city cemeteries; acres of shrubbery and heavy stone, so arranged and lonely and unlike anything in the living world. Cities of the dead, indeed; cities of the forgotten, of the

The graveyard in Catherton, Nebraska, where Willa Cather's grandparents are buried.

"put away." But this was open and free, this little square of long grass which the wind for ever stirred. Nothing but the sky overhead, and the many-colored fields running on until they met that sky. The horses worked here in summer; the neighbors passed on their way to town; and over yonder, in the cornfield, Rosicky's own cattle would be eating fodder as winter came on. Nothing could be more un-deathlike than this place; nothing could be more right for a man who had helped to do the work of great cities and had always longed for the open country and had got to it at last. Rosicky's life seemed to him complete and beautiful.

For Study and Discussion

Analyzing and Interpreting the Story

1. In the first sentence of the story, you learn that Rosicky has a bad heart. **a.** How does Rosicky react to this diagnosis? **b.** What does this reaction show about Rosicky's character?

2. In Part One Dr. Burleigh remembers a day from the previous winter when he had breakfast at the Rosicky farm. **a.** What do you learn about the Rosicky family through the flashback? **b.** What other scenes are revealed through flashbacks? **c.** How do the flashbacks add to your appreciation of Rosicky's life and character?

3. In Part Three you learn about the conflicts in Rosicky's early life. **a.** What similar conflicts are now troubling Rudolph and Polly? **b.** What evidence is there that the couple's conflicts will be resolved? **c.** Why is it appropriate that you learn Polly's secret at this time?

4. Many details in the story reveal contrasting attitudes and life styles. **a.** What do the contrasts between Rosicky and other farmers imply? **b.** What do you learn from Rosicky's comparison of city life to country life? **c.** What other contrasts can you find in the story? **d.** What is the effect of each one?

5. The story begins in early winter when "the first snow of the season" is falling. **a.** How is

Pavelka home, the model for Rosicky's house.

Pavelka family. John Pavelka (seated) was the model for Anton Rosicky.
Willa Cather Pioneer Memorial Collection, Nebraska State Historical Society

the oncoming of winter related to Rosicky's time of life? **b.** Why is spring a fitting season for the end of the story?

6. Reread the last sentence of the story. **a.** What makes Rosicky's life "complete and beautiful"? **b.** Why do you think Cather ends the story, not with Rosicky's death, but with Dr. Burleigh's reflections on Rosicky's life?

Literary Elements

Direct and Indirect Characterization

A writer can create characters in two ways: by **direct presentation** and by **indirect presentation.** When characters are presented directly, the writer tells us explicitly what they are like, or what motivates them. Willa Cather uses direct characterization in the opening scene of

the story, when she *tells* us what Rosicky looks like:

> His eyes were large and lively. . . . His brown face was creased but not wrinkled, he had a ruddy color in his smooth-shaven cheeks and in his lips, under his long brown mustache. His hair was thin and ragged around his ears, but very little gray (page 48).

She also uses direct characterization when she tells us what she thinks of Rosicky:

> "He was a very simple man. He was like a tree that has not many roots, but one taproot that goes down deep" (page 58).

In indirect characterization, the writer *shows* us the characters in action, lets us hear them speaking, reveals their thoughts, and lets us know how other characters feel about the kinds of people they are. We form a very strong impression of Rosicky in the opening

Neighbor Rosicky **73**

scene by observing his actions and by noticing how he affects Dr. Burleigh. We discover that he has an easy manner, a sense of humor, and pride in his family. We also learn that Dr. Burleigh likes him very much.

Find other examples of direct and indirect characterization of Rosicky. Locate passages that tell directly what kind of person Rosicky is or what his qualities are, and passages that indirectly reveal his character through actions, words, thoughts, and other people's reactions.

Language and Vocabulary

Noting Multiple Meanings of Words

At the opening of the story, we learn that Rosicky has a contented *disposition*. In this context, *disposition* means "one's nature or temperament."

Like many words in our language, *disposition* has several different meanings. In the phrase "the disposition of troops," the word means "arrangement." The disposition of property refers to its transfer by gift or by sale. Can you give additional meanings of the word? Check your answers in a dictionary.

We are told that Mary *started* when she heard the news about her husband's bad heart. What is the meaning of *start* in this context? Check your answer in a dictionary.

Writing About Literature

Writing a Character Analysis

Analyzing fictional characters forces us to look closely at their personalities, to discover their weaknesses and strengths, to look for underlying causes for their behavior, and finally to appreciate each character for what he or she is. Character analysis often helps us better understand real people and the conflicts of our own lives.

Write an essay analyzing the character of Anton Rosicky. Consider answers to these questions: Why did he prefer country life? Why was he such a good father? Why was he able to live with so little worry or fear? Do you feel that the characterization of Rosicky is realistic, given your own experience of human behavior?

See *Writing About Literature* for assistance in developing your paper.

About the Author

Willa Cather (1873–1947)

Willa Cather, who from the age of ten grew up on the frontier in Nebraska, admired people like the pioneers who lived in sod huts and plain frame farmhouses and who fought to preserve their traditional spiritual values. Some of Cather's most famous novels were inspired by her romantic memories of her Nebraska girlhood. *My Ántonia,* for example, is the story of a Bohemian immigrant girl who triumphs over hardships and disappointments because of her vibrant strength of character. In some stories—especially those that show the lonely world of farm women—Cather suggests a less idealistic attitude. She won the Pulitzer Prize for fiction in 1922 for *One of Ours.* "Neighbor Rosicky," which first appeared in the popular magazine *Woman's Home Companion* in 1930, was included in a collection of stories called *Obscure Destinies,* published in 1932.

Marigolds

EUGENIA W. COLLIER

Sometimes an experience is so important that it changes forever the way we feel or think about ourselves or about something in our lives. Such an experience is called a turning point. *What causes the narrator's life to change in one bewildering and frightening moment?*

When I think of the home town of my youth, all that I seem to remember is dust—the brown, crumbly dust of late summer—arid, sterile dust that gets into the eyes and makes them water, gets into the throat and between the toes of bare brown feet. I don't know why I should remember only the dust. Surely there must have been lush green lawns and paved streets under leafy shade trees somewhere in town; but memory is an abstract painting[1]—it does not present things as they are, but rather as they *feel*. And so when I think of that time and that place, I remember only the dry September of the dirt roads and grassless yards of the shanty-town[2] where I lived. And one other thing I remember, another incongruency[3] of memory—a brilliant splash of sunny yellow against the dust—Miss Lottie's marigolds.

Whenever the memory of those marigolds flashes across my mind, a strange nostalgia comes with it and remains long after the picture has faded. I feel again the chaotic emotions of adolescence, illusive as smoke, yet as real as the potted geranium before me now. Joy and rage and wild animal gladness and shame become tangled together in the multicolored skein of 14-going-on-15 as I recall that devastating moment when I was suddenly more woman than child, years ago in Miss Lottie's yard. I think of those marigolds at the strangest times; I remember them vividly now as I desperately pass the time waiting for you, who will not come.

I suppose that futile waiting was the sorrowful background music of our impoverished little community when I was young. The Depression that gripped the nation was no new thing to us, for the black workers of rural Maryland had always been depressed. I don't know what it was that we were waiting for; certainly not for the prosperity that was "just around the corner," for those were white folks' words, which we never believed. Nor did we wait for hard work and thrift to pay off in shining success as the American Dream promised, for

1. **abstract painting:** a work that does not show things as they are but rather uses forms and colors suggested by natural objects.
2. **shanty-town:** a run-down section of a town.
3. **incongruency** (ĭn′kŏn-grōō′ən-sē): something that is not consistent or compatible.

we knew better than that, too. Perhaps we waited for a miracle, amorphous[4] in concept but necessary if one were to have the grit to rise before dawn each day and labor in the white man's vineyard until after dark, or to wander about in the September dust offering one's sweat in return for some meager share of bread. But God was chary with miracles in those days, and so we waited—and waited.

We children, of course, were only vaguely aware of the extent of our poverty. Having no radios, few newspapers, and no magazines, we were somewhat unaware of the world outside our community. Nowadays we would be called "culturally deprived" and people would write books and hold conferences about us. In those days everybody we knew was just as hungry and ill-clad as we were. Poverty was the cage in which we all were trapped, and our hatred of it was still the vague, undirected restlessness of the zoo-bred flamingo who knows that nature created him to fly free.

As I think of those days I feel most poignantly the tag-end of summer, the bright dry times when we began to have a sense of shortening days and the imminence of the cold.

By the time I was 14 my brother Joey and I were the only children left at our house, the other ones having left home for early marriage or the lure of the city, and the two babies having been sent to relatives who might care for them better than we. Joey was three years younger than I, and a boy, and therefore vastly inferior. Each morning our mother and father trudged wearily down the dirt road and around the bend, she to her domestic job, he to his daily unsuccessful quest for work. After our few chores around the tumble-down shanty, Joey and I were free to run wild in the sun with other children similarly situated.

For the most part, those days are ill-defined in my memory, running together and combining like a fresh water-color painting left out in the rain. I remember squatting in the road drawing a picture in the dust, a picture which Joey gleefully erased with one sweep of his dirty foot. I remember fishing for minnows in a muddy creek and watching sadly as they eluded my cupped hands, while Joey laughed uproariously. And I remember, that year, a strange restlessness of body and spirit, a feeling that something old and familiar was ending, and something unknown and therefore terrifying was beginning.

One day returns to me with special clarity for some reason, perhaps because it was the beginning of the experience that in some inexplicable[5] way marked the end of innocence. I was loafing under the great oak tree in our yard, deep in some reverie which I have now forgotten except that it involved some secret, secret thoughts of one of the Harris boys across the yard. Joey and a bunch of kids were bored now with the old tire suspended from an oak limb which had kept them entertained for awhile.

"Hey, Lizabeth," Joey yelled. He never talked when he could yell. "Hey, Lizabeth, let's go somewhere."

I came reluctantly from my private world. "Where you want to go? What you want to do?"

The truth was that we were becoming tired of the formlessness of our summer days. The idleness whose prospect had seemed so beautiful during the busy days of spring now had degenerated to an almost desperate effort to fill up the empty midday hours.

"Let's go see can we find some locusts on the hill," someone suggested.

Joey was scornful. "Ain't no more locusts

4. **amorphous** (ə-môr′fəs): without form; shapeless.

5. **inexplicable** (ĭn-ĕk′splĭ-kə-bəl): not capable of being explained.

there. Y'all got 'em all while they was still green."

The argument that followed was brief and not really worth the effort. Hunting locust trees wasn't fun any more by now.

"Tell you what," said Joey finally, his eyes sparkling. "Let's go over to Miss Lottie's."

The idea caught on at once, for annoying Miss Lottie was always fun. I was still child enough to scamper along with the group over rickety fences and through bushes that tore our already raggedy clothes, back to where Miss Lottie lived. I think now that we must have made a tragicomic spectacle, five or six kids of different ages, each of us clad in only one garment—the girls in faded dresses that were too long or too short, the boys in patchy pants, their sweaty brown chests gleaming in the hot sun. A little cloud of dust followed our thin legs and bare feet as we tramped over the barren land.

When Miss Lottie's house came into view we stopped, ostensibly[6] to plan our strategy, but actually to reinforce our courage. Miss Lottie's house was the most ramshackle of all our ramshackle homes. The sun and rain had long since faded its rickety frame siding from white to a sullen gray. The boards themselves seemed to remain upright not from being nailed together but rather from leaning together like a house that a child might have constructed from cards. A brisk wind might have blown it down, and the fact that it was still standing implied a kind of enchantment that was stronger than the elements. There it stood, and as far as I know is standing yet—a gray rotting thing with no porch, no shutters, no steps, set on a cramped lot with no grass, not even any weeds—a monument to decay.

In front of the house in a squeaky rocking chair sat Miss Lottie's son, John Burke, com-pleting the impression of decay. John Burke was what was known as "queer-headed." Black and ageless, he sat, rocking day in and day out in a mindless stupor, lulled by the monotonous squeak-squawk of the chair. A battered hat atop his shaggy head shaded him from the sun. Usually John Burke was totally unaware of everything outside his quiet dream world. But if you disturbed him, if you intruded upon his fantasies, he would become enraged, strike out at you, and curse at you in some strange enchanted language which only he could understand. We children made a game of thinking of ways to disturb John Burke and then to elude his violent retribution.

But our real fun and our real fear lay in Miss Lottie herself. Miss Lottie seemed to be at least a hundred years old. Her big frame still held traces of the tall, powerful woman she must have been in youth, although it was now bent and drawn. Her smooth skin was a dark reddish-brown, and her face had Indian-like features and the stern stoicism[7] that one associates with Indian faces. Miss Lottie didn't like intruders either, especially children. She never left her yard, and nobody ever visited her. We never knew how she managed those necessities which depend on human interaction—how she ate, for example, or even whether she ate. When we were tiny children, we thought Miss Lottie was a witch and we made up tales, that we half believed ourselves, about her exploits. We were far too sophisticated now, of course, to believe the witch-nonsense. But old fears have a way of clinging like cobwebs, and so when we sighted the tumble-down shack, we had to stop to reinforce our nerves.

"Look, there she is," I whispered, forgetting that Miss Lottie could not possibly have heard me from that distance. "She's fooling with

6. **ostensibly** (ŏ-stĕn′sə-blē): seemingly.

7. **stoicism** (stō′ĭ-sĭz′əm): repression of feeling.

Maudell Sleet's Magic Garden (1978) by Romare Bearden. Collage from the *Profile/Part 1: The Twenties* series.

them crazy flowers."

"Yeh, look at 'er."

Miss Lottie's marigolds were perhaps the strangest part of the picture. Certainly they did not fit in with the crumbling decay of the rest of her yard. Beyond the dusty brown yard, in front of the sorry gray house, rose suddenly and shockingly a dazzling strip of bright blossoms, clumped together in enormous mounds, warm and passionate and sun-golden. The old black witch-woman worked on them all summer, every summer, down on her creaky knees, weeding and cultivating and arranging, while the house crumbled and John Burke rocked.

For some perverse reason, we children hated these marigolds. They interfered with the perfect ugliness of the place; they were too beautiful; they said too much that we could not understand; they did not make sense. There was something in the vigor with which the old woman destroyed the weeds that intimidated us. It should have been a comical sight—the old woman with the man's hat on her cropped white head, leaning over the bright mounds, her big backside in the air—but it wasn't comical, it was something we could not name. We had to annoy her by whizzing a pebble into her flowers or by yelling a dirty word, then dancing away from her rage, revelling in our youth and mocking her age. Actually, I think it was the flowers we wanted to destroy, but nobody had the nerve to try it, not even Joey, who was usually fool enough to try anything.

"Y'all git some stones," commanded Joey now, and was met with instant giggling obedience as everyone except me began to gather pebbles from the dusty ground. "Come on, Lizabeth."

I just stood there peering through the bushes, torn between wanting to join the fun and feeling that it was all a bit silly.

"You scared, Lizabeth?"

I cursed and spat on the ground—my favorite gesture of phony bravado.[8] "Y'all children get the stones, I'll show you how to use 'em."

I said before that we children were not consciously aware of how thick were the bars of our cage. I wonder now, though, whether we were not more aware of it than I thought. Perhaps we had some dim notion of what we were, and how little chance we had of being anything else. Otherwise, why would we have been so preoccupied with destruction? Any-

8. **bravado** (brə-vä′dō): a show of courage.

way, the pebbles were collected quickly, and everybody looked at me to begin the fun.

"Come on, y'all."

We crept to the edge of the bushes that bordered the narrow road in front of Miss Lottie's place. She was working placidly, kneeling over the flowers, her dark hand plunged into the golden mound. Suddenly, "zing"—an expertly-aimed stone cut the head off one of the blossoms.

"Who out there?" Miss Lottie's backside came down and her head came up as her sharp eyes searched the bushes. "You better git!"

We had crouched down out of sight in the bushes, where we stifled the giggles that insisted on coming. Miss Lottie gazed warily across the road for a moment, then cautiously returned to her weeding. "Zing"—Joey sent a pebble into the blooms, and another marigold was beheaded.

Miss Lottie was enraged now. She began struggling to her feet, leaning on a rickety cane and shouting, "Y'all git! Go on home!" Then the rest of the kids let loose with their pebbles, storming the flowers and laughing wildly and senselessly at Miss Lottie's impotent rage. She shook her stick at us and started shakily toward the road crying, "Git 'long! John Burke! John Burke, come help!"

Then I lost my head entirely, mad with the power of inciting such rage, and ran out of the bushes in the storm of pebbles, straight toward Miss Lottie chanting madly, "Old witch, fell in a ditch, picked up a penny and thought she was rich!" The children screamed with delight, dropped their pebbles and joined the crazy dance, swarming around Miss Lottie like bees and chanting, "Old lady witch!", while she screamed curses at us. The madness lasted only a moment, for John Burke, startled at last, lurched out of his chair, and we dashed for the bushes just as Miss Lottie's cane went whizzing at my head.

I did not join the merriment when the kids gathered again under the oak in our bare yard. Suddenly I was ashamed and I did not like being ashamed. The child in me sulked and said it was all in fun, but the woman in me flinched at the thought of the malicious attack that I had led. The mood lasted all afternoon. When we ate the beans and rice that was supper that night, I did not notice my father's silence, for he was always silent these days, nor did I notice my mother's absence, for she always worked until well into the evening. Joey and I had a particularly bitter argument after supper; his exuberance[9] got on my nerves. Finally I stretched out upon the pallet in the room we shared and fell into a fitful doze.

When I awoke, somewhere in the middle of the night, my mother had returned, and I vaguely listened to the conversation that was audible through the thin walls that separated our rooms. At first I heard no words, only voices. My mother's voice was like a cool, dark room in summer—peaceful, soothing, quiet. I loved to listen to it; it made things seem all right somehow. But my father's voice cut through hers, shattering the peace.

"Twenty-two years, Maybelle, 22 years," he was saying, "and I got nothing for you, nothing, nothing."

"It's all right, honey, you'll get something. Everybody's out of work now, you know that."

"It ain't right. Ain't no man ought to eat his woman's food year in and year out, and see his children running wild. Ain't nothing right about that."

"Honey, you took good care of us when you had it. Ain't nobody got nothing nowadays."

"I ain't talking about nobody else, I'm talking about *me*. God knows I try." My mother said something I could not hear, and my father

9. **exuberance** (ĭg-zōō′bər-əns): unrestrained enthusiasm; high spirits.

cried out louder, "What must a man do, tell me that?"

"Look, we ain't starving. I git paid every week, and Mrs. Ellis is real nice about giving me things. She's gonna let me have Mr. Ellis's old coat for you this winter—"

"Damn Mr. Ellis's coat! And damn his money! You think I want white folks' leavings? Damn, Maybelle"—and suddenly he sobbed, loudly and painfully, and cried helplessly and hopelessly in the dark night. I had never heard a man cry before. I did not know men ever cried. I covered my ears with my hands but could not cut off the sound of my father's harsh, painful, despairing sobs. My father was a strong man who would whisk a child upon his shoulders and go singing through the house. My father whittled toys for us and laughed so loud that the great oak seemed to laugh with him, and taught us how to fish and hunt rabbits. How could it be that my father was crying? But the sobs went on, unstifled, finally quieting until I could hear my mother's voice, deep and rich, humming softly as she used to hum to a frightened child.

The world had lost its boundary lines. My mother, who was small and soft, was now the strength of the family; my father, who was the rock on which the family had been built, was sobbing like the tiniest child. Everything was suddenly out of tune, like a broken accordion. Where did I fit into this crazy picture? I do not remember my thoughts, only a feeling of great bewilderment and fear.

Long after the sobbing and humming had stopped, I lay on the pallet, still as stone with my hands over my ears, wishing that I too could cry and be comforted. The night was silent now except for the sound of the crickets and of Joey's soft breathing. But the room was too crowded with fear to allow me to sleep, and finally, feeling the terrible aloneness of 4 A.M., I decided to awaken Joey.

"Ouch! What's the matter with you? What you want?" he demanded disagreeably when I had pinched and slapped him awake.

"Come on, wake up."

"What for? Go 'way."

I was lost for a reasonable reply. I could not say, "I'm scared and I don't want to be alone," so I merely said, "I'm going out. If you want to come, come on."

The promise of adventure awoke him. "Going out now? Where to, Lizabeth? What are you going to do?"

I was pulling my dress over my head. Until now I had not thought of going out. "Just come on," I replied tersely.

I was out the window half-way down the road before Joey caught up with me.

"Wait, Lizabeth, where you going?"

I was running as if the Furies[10] were after me, as perhaps they were—running silently and furiously until I came to where I had half-known I was headed: to Miss Lottie's yard.

The half-dawn light was more eerie than complete darkness, and in it the old house was like the ruin that my world had become—foul and crumbling, a grotesque[11] caricature. It looked haunted, but I was not afraid because I was haunted too.

"Lizabeth, you lost your mind?" panted Joey.

I had indeed lost my mind, for all the smoldering emotions of that summer swelled in me and burst—the great need for my mother who was never there, the hopelessness of our poverty and degradation, the bewilderment of being neither child nor woman and yet both at once, the fear unleashed by my father's tears. And these feelings combined in one great impulse toward destruction.

"Lizabeth!"

I leaped furiously into the mounds of mar-

10. **Furies:** In Greek mythology, three spirits that pursued and punished wrongdoers.
11. **grotesque** (grō-tĕsk′): bizarre.

igolds and pulled madly, trampling and pulling and destroying the perfect yellow blooms. The fresh smell of early morning and of dew-soaked marigolds spurred me on as I went tearing and mangling and sobbing while Joey tugged my dress or my waist crying, "Lizabeth stop, please stop!"

And then I was sitting in the ruined little garden among the uprooted and ruined flowers, crying and crying, and it was too late to undo what I had done. Joey was sitting beside me, silent and frightened, not knowing what to say. Then, "Lizabeth, look."

I opened my swollen eyes and saw in front of me a pair of large calloused feet; my gaze lifted to the swollen legs, the age-distorted body clad in a tight cotton night dress, and then the shadowed Indian face surrounded by stubby white hair. And there was no rage in the face now, now that the garden was destroyed and there was nothing any longer to be protected.

"M-miss Lottie!" I scrambled to my feet and just stood there and stared at her, and that was the moment when childhood faded and womanhood began. That violent, crazy act was the last act of childhood. For as I gazed at the immobile face with the sad, weary eyes, I gazed upon a kind of reality which is hidden to childhood. The witch was no longer a witch but only a broken old woman who had dared to create beauty in the midst of ugliness and sterility. She had been born in squalor and lived in it all her life. Now at the end of that life she had nothing except a falling-down hut, a wrecked body, and John Burke, the mindless son of her passion. Whatever verve there was left in her, whatever was of love and beauty and joy that had not been squeezed out by life, had been there in the marigolds she had so tenderly cared for.

Of course I could not express the things that I knew about Miss Lottie as I stood there awkward and ashamed. The years have put words to the things I knew in that moment, and as I look back upon it, I know that that moment marked the end of innocence. People think of the loss of innocence as meaning the loss of virginity, but this is far from true. Innocence involves an unseeing acceptance of things at face value, an ignorance of the area below the surface. In that humiliating moment I looked beyond myself and into the depths of another person. This was the beginning of compassion, and one cannot have compassion and innocence.

The years have taken me worlds away from that time and that place, from the dust and squalor of our lives and from the bright thing that I destroyed in a blind childish striking out at God-knows-what. Miss Lottie died long ago and many years have passed since I last saw her hut, completely barren at last, for despite my wild contrition[12] she never planted marigolds again. Yet, there are times when the image of those passionate yellow mounds returns with a painful poignancy.[13] For one does not have to be ignorant and poor to find that his life is barren as the dusty yards of our town. And I too have planted marigolds.

12. **contrition:** repentance.
13. **poignancy** (poin′yən-sē): sharp distress.

Reading Check

1. Where and when does the story take place?
2. What two things does Lizabeth remember about her hometown?
3. How do the children annoy Miss Lottie?
4. Why is Lizabeth's father angry and unhappy?
5. How does Miss Lottie react to the destruction of her garden?

For Study and Discussion

Analyzing and Interpreting the Story

1. Why do you think the children in this story are "so preoccupied with destruction"?

2. Make a list of the conflicts in the story. Which conflict do you believe is most important? Why?

3. Why does Lizabeth destroy something beautiful instead of something ugly?

4. Why does the memory of Miss Lottie remain important to the narrator?

5. The narrator concludes that we cannot have both compassion and innocence. What do you think she means by this?

Literary Elements

Dynamic and Static Characters

In many stories, a character will change in some important way. Usually the change is an inner change—a change in attitude toward self or others, a new confidence, a sudden awareness. A character who undergoes such a change is called a **dynamic character.** A character who stays the same throughout the story is called a **static character.**

At the opening of "Marigolds," we learn that Lizabeth became "more woman than child" the summer she was fourteen. What causes her to grow up? Describe the change in her.

Reread the descriptions of Miss Lottie. Is she a static or dynamic character? Explain.

Focus on Narrative Writing

Building Dynamic Characters

The narrator in Eugenia Collier's "Marigolds" is an example of a **dynamic character**—a character who undergoes a change in personality and attitude. Brainstorm your own memories for some examples of changes in your feelings, attitudes, and thoughts. What personal experiences caused these changes? Could you use one of these experiences as a basis for developing a dynamic fictional character? Jot down some notes on a chart like the one below.

```
Name of Character: _____

Age and Appearance: _____

Important Experience/Turning Point: _____

_____

_____

Outlook/Personality

  Before the Experience: _____

  After the Experience: _____
```

When you have finished writing, get together with a small group of classmates and discuss each other's ideas for dynamic characters.

About the Author

Eugenia W. Collier (1928–)

Charles S. Collier

The daughter of a physician and an educator, Collier was born in Baltimore, Maryland. She attended Howard and Columbia universities and completed her doctoral work at the University of Maryland. She worked for several years in the Baltimore Department of Public Welfare. During this period she began writing stories and poems that reflect her appreciation of her heritage. In 1969 "Marigolds" won the Gwendolyn Brooks Award for Fiction. *Breeder and Other Stories* (1994) is a collection of stories about African American experiences.

The Beginning of Grief

L. WOIWODE°

Characters in fiction can be complex and puzzling, and they can evoke mixed responses from the reader. Consider your reactions to the characters in this story. How do you think the author wants you to perceive them?

From the way his five children gathered around him at the dinner table Stanion could tell something was wrong. He put his silverware down beside his plate, leaving untouched the food he had prepared and heaped there, and leaned his forehead on clasped hands as if to say grace. He was reaching his limit. Beneath his closed eyelids, inflamed by lime burns and bits of sand, he saw pulsing networks, as though his vessels were of neon, and then the substance and strength of his muscles and long limbs seemed to move upward, pulsing, and he felt weak, out of touch with the big bulk of his body, reduced to less than he was, less than he'd ever been, trapped within the small sphere of his eye. The size of his world now.

He would quit work late, drive from whatever part of the county his job, plastering, had taken him to that day, back to Minneapolis,

and pick up the little ones, the two girls, at the baby sitter's, and then drive back home, to the outskirts of St. Paul, and cook dinner and call the three boys in to the table—now that it was summer, they spent the day at home alone— only to see in their attitudes that they were trying to conceal something. Then another circuit, familiar as the first, began. He would have to travel through the events of their day, prying his way into them, find out what the trouble was, find out who had caused it, and set right the one who was at fault, or, if there had been fighting, punish him. He hated it. It was difficult for him to pass judgment on anyone, much less his own children, and even harder for him to see them hurt. His wife had always handled the discipline.

She was prudent and judicious, and had no patience with any kind of wrongdoing. For years she tried to persuade him to give up his job, because she felt his employers were taking advantage of him. They went on long vacations

° **Woiwode** (woi′wōōd-ē).

Distressed Man (1963) by Ben Shahn (1898–1969). Watercolor.
Private Collection

and left the business in his hands. They showed up for work irregularly, at their leisure, knowing that he would keep things in order, and never increased his wages. But they were well-meaning and young, and he stayed on with them, in spite of her disapproval, because he liked them and knew that without him they wouldn't have a business. The memory of it, along with a thousand other memories, tormented him now. A year ago she died. The torment was more than grief. It grew, linking one memory to another, linking networks of them together, and would not let her go.

"Dad? Are you all right?"

He let his arms drop beside his plate. "Yes. Just tired."

She was the periphery of everything, closing around his vision, his mind, his actions, like a second conscience. His ideas, before he could speak them, were observed by her and he gave them up. The sheen of her hair was in the hair of the older girl, who was only five, and to run his hand over the girl's hair was excruciating, almost a sin. Her indignation was in his voice when he began arguing bitterly with his employers and when, ten months ago, he gave them final notice. He mortgaged the house, sold the car, hired a laborer, and started a business of his own. *Wm. Stanion & Sons, Plastering,* he hand-painted on the doors and tailgate of an old pickup he bought.

All they had for transportation was the pickup. In the winter and when it was raining, the six of them rode in the cab, the boys holding the girls on their laps, an acrid smell of rubber and gasoline enwrapping them, the bags of plaster color breaking and spilling and staining the floorboards, then merging into a muddy gray. In good weather the boys rode in the bed of the truck, and at first they liked it so much that they sang and shouted, they stood and made wings like birds, they held their arms like Superman, and he had to keep knocking on the rear window and signaling them to sit. But lately when they went anywhere the boys huddled down with their backs against the cab, and Stanion could see, as they climbed out over the tailgate at their destination, her gestures and her averted eyes when she was suffering silent humiliation.

He would have taken his life just to end the torment, just to be at peace, and maybe to be with her (who could say?), if it hadn't been for the children. And when they were bad or unhappy he felt there was no use. He looked across the table at his middle son, Kevin, aged

ten, who sat with his elbows on the tabletop and his eyes lowered, forking food into his mouth as fast as he could. Kevin's large skull had a bluish tint to it. A few days ago, for some unaccountable reason, he had taken out the electric razor and shaved off all his hair.

"Well, what kind of trouble did you cause today?" Stanion asked, and his words made him feel weary and resentful. He was being unjust. He couldn't help it. It seemed Kevin was always the guilty one. He had a bad temper, a savage energy, and was unpredictable. When she was alive, she seemed to favor Kevin, yet he was the only one she lost her temper with. Once she caught him striking matches along the foundation of the house and came up behind him, grabbed him by the arm, grabbed up a bundle of the matches, set the matches ablaze, and held them under his hand until he understood what it felt like to be burned.

Kevin couldn't stand to lose. When the simplest game or argument didn't go in his favor, he started a fight, and if he was left alone with the younger ones he set up strict rules, such as no singing or talking, no TV, no dinner, or he made them march in unison around the room, and if they violated the rules or disobeyed his commands he hit them or shoved them into a closet and held the door shut.

Kevin looked up, gave an impatient scowl, and said, "What did I *do*? Nothing." His gray eyes looked even larger now that he had no hair, and his long eyelashes, catching the light of the bare bulb overhead, sparkled as he blinked several times. He was also a practiced liar.

"*Nothing*? Then what's the matter? Why do you act so guilty? Why are you all so quiet?"

"We're eating," Kevin said.

Stanion turned to his eldest son, who sat next to Kevin, and said in a restrained and altered tone, as though speaking to an arbiter,

"Carl, what is this?" Carl was twelve but could be left alone with the girls, the youngest of whom was only three, in complete trust. He understood them, sensed their needs, anticipated their whims, was gentle, and so could care for them better than most adults. He was straightforward and truthful unless he was protecting one of the others, in which case, with his intelligence, he could make himself a blank.

"Carl," Stanion said, placing both fists, broad as saucers, on the tabletop. "I asked you a question. What's been going on here?"

"I don't know."

"You don't know?"

"I don't think I really saw it."

"Saw what?"

"Anything that happened."

"Then something did happen."

"I don't know."

"You just said it did."

"I didn't see it."

"Ach!"

It was futile. The two girls, sitting along the side of the table to his left, their wide eyes fastened on him, went pale at the sound of his voice. It angered him to keep at it this way, to give it such importance, but his interrogating and lecturing were becoming harder to control, obsessive, and more involved and emotional. He rarely lifted a hand against the children, as she sometimes had; he felt it was unnecessary and wrong, and, besides, he feared the strength of an adult against a child, especially his own strength. He stared for a long time at the open lime burns on his knuckles, clenching his fists, angered even more by his indecisiveness, and then reached for his fork. He stopped. His youngest son, Jim, who sat across from the girls, alone at that side of the table, looked anxiously at Stanion, then at his brothers, and then at his food, which he had hardly touched.

This boy, changed so by her death, had become Stanion's favorite. He was no longer exuberant and cheerful. He woke at night and wandered through the bedrooms trailing a blanket, saying her name, and if his wanderings and the sound of his voice didn't wake Stanion so that he could take the boy into bed with him, he searched through all the rooms of the house, went out the door into the backyard, went to the plot where she had had her garden, and lay down there and slept until morning. He was old enough to know his mother as his sisters would never know her, but too young to be a companion to his brothers, who became close after her death. When he approached them, shy and ill at ease, they sent him to play with the girls. For a while he had quietly accepted this. But since he started school he had been bringing home his own playmates—a procession of the most reticent, underfed, tattered, backward boys in his class. He invited them in for meals, offered them the pick of his toys, and attached himself to them, feeding off their presence, praising them, devoting himself to them, until they became bored with his passive reverence and worshipful stare and stopped coming to the house. Now the boy's eyes, light green, large and seductive, were traveling around the table with a harried look.

With his lime-burned hand, Stanion reached out and touched the boy's shoulder. "You didn't do anything, did you, Jim?" he asked, and the boy, shrugging off Stanion's hand, turned clear around and took hold of the back of his chair and broke into tears.

"Carl! What's this about? Answer me!"

"I don't know how to," Carl said, and looked aside at Kevin, who was still eating as fast as he could.

"Did he hurt Jim?" Stanion demanded. "Is Kevin the cause of this?"

Carl lowered his eyes.

"Jim, you can tell me," Stanion said. "You don't have to be afraid now."

"I'm done," Kevin said, and scraped back his chair. "I'm going out."

"You sit right where you are till I'm through with you."

Kevin sat, piled more food on his plate, and started eating again.

"And if we have to sit here all night till I find out what's been going on," Stanion said, "we will."

Jim shifted his weight restlessly, his eyes made an anxious circuit of the table, and then, shrinking back in his chair, he cried out, "He kicked Marvin!"

"Who did?"

"Kevin!"

"*Kicked* him?"

"Then Marvin went home! He was crying!" Marvin, a frail boy who had just moved up from Kentucky, was Jim's most recent and most enduring friend.

"What is this? Carl!"

Carl kept his eyes down, picking at his food, then murmured, "We were having a track meet over at the school and Marvin was on Kevin's side. Jim and I were on the other. Marvin got tired toward the end and didn't want to run, so maybe Kevin did something. I don't know. I didn't see it. I was running."

Realizing that Carl had said all he was going to say, Stanion moved his eyes to Kevin. "Is this true?"

"No."

"Don't lie to me."

"Marvin just started crying and wanted to go home, that's all. He's a baby."

"Quit eating and look at me when I speak to you. Now nobody just starts crying for no reason—I know that and you know it too."

"I told him to play right. He wasn't playing right."

"Wasn't playing 'right.' What's right?"

Sensing he had exposed himself, brought out something that had caused trouble in the past, Kevin's face lost its color and he seemed breathless, as though he were running again, circling something dangerous. "We were way ahead in points," he said, "and then Marvin faked like he was tired. He wouldn't do anything any more. Then when we were all running the mile he just walked along. He could have got second or third, at least, and we score 5, 3, 1. He didn't care whether we got those last points. We needed them."

"You mean you hurt him just because you were worried about losing?"

"Who says I hurt him?"

"Jim said you kicked him."

"If I had to run every race, Marvin could run at least one. He was just in the field events."

"How could you do such a thing?"

"What?"

"Whatever you did."

"Well, what would you do if you were all tired out and came around the track about the third time and there your teammate was, just walking along just like an old lady."

"So you kicked him."

"I brushed against him. Maybe I nicked him with my foot."

"Can't you leave other people alone? Don't you realize he's one of the few friends Jim's got? Let him run or walk or crawl or sit on his can or do what he wants. You hear me!" Silverware jumped as Stanion hit the tabletop. "What's the matter with you? What makes you think you're a judge of others?"

"I know I was running and he wasn't."

"He's not you. He's——"

"He was on my side!"

"Will you *listen* to me!"

Stanion started to rise, and his belt caught on the edge of the table, upsetting his coffee and a carton of milk. Kevin pushed himself back from the table and tipped over his chair, and the slap that was meant for him carried past and struck the youngest girl. She went back off her stool neatly as a bundle and dropped to the floor. When she realized where she was, she started wailing, and her sister joined in.

"Now look! Look what you made me do," Stanion said, and started around the table with all the galling details—the girl on the floor, the puddle of coffee and milk beside her, Jim with his hands over his face—streaming along the edge of his vision, sharpening his outrage. Kevin hadn't got to his feet, and was maneuvering around among the chairs on his hands and knees, trying to make it to a safe spot, his rump raised. Stanion came up behind him and kicked hard and struck bone, and Kevin, his limbs splaying out, hit flat on his stomach. Stanion lifted him to his feet. "Now get upstairs," he said. "Get upstairs before something worse happens."

Kevin gave him a furious going over with his eyes before he turned and ran up the steps. And then, as Kevin disappeared around the corner, Stanion realized what he had done and started trembling. He sent Jim and Carl outside, took the girls, one in each arm, and carried them into the bedroom and tried to comfort them. Their eyes were wide with terror, and the youngest girl didn't want to be touched.

When they were calmed, he undressed them and put them to bed, hardly aware of what he was doing. The presence in the upstairs room demanded all his attention. He went into the kitchen and sat at the table, his broad workman's knees bending with effort. He ached from balancing on a springy scaffold the whole day, all the while carrying a hawk of heavy plaster and reaching overhead to skim a finish coat on the ceiling. He felt too old to go on with the work. Tonight brought it to an end.

The Beginning of Grief **87**

No. There was bookwork to do, orders to call in, material to get, his lunch to pack.

He wanted to go upstairs but wasn't sure it was the right thing to do. He didn't want his thoughts to focus. He was afraid of what he'd done. He started eating, but the food was chilly and he had no appetite.

He gathered up the dishes, carried them to the sink, shook detergent over them, adjusted the temperature of the water, and let it run while he took a rag from the S-trap under the sink and wiped off the table. Then he got down on his hands and knees, and as he was mopping up the milk and coffee his vision narrowed, the patch of linoleum he was staring at darkened, and he felt faint. He stood up and leaned against the table. An even, abrasive sound was traveling through his consciousness as though it meant to erode it. He hurried over to the sink and shut off the water. The sound stayed.

He dipped a plate in and out of the water, rinsing off the grease, and his sight fastened on the soapy rainbow sliding along the plate's rim. He let it slip beneath the suds. He had an image of her turning from the sink, inclining her head to one side and lifting the hair from her cheek with the back of her hand, her face flushed, her eyes traveling around the room restlessly, but with an abstract look, as though there was no name for what she was searching for.

He went up the steps. Kevin was lying face down on the unmade bed, his back heaving, his exclamations and sobs muted by a pillow he held clasped over his head. Stanion eased himself onto the edge of the bed and lifted the pillow away. "Listen. Listen, now. I've tried——"

The boy grabbed at the loose bedclothes and tucked them around his face.

"How many times have I told you——" Stanion began, then stopped. He couldn't stand being sanctimonious. He looked away and saw the bed—with Kevin's legs, Kevin's body half covered with a sheet stretched out on it—and part of his own shoulder enclosed in a mirror, and it was as though he were looking through to the past. The scene, scaled down, dimmer than in hospital light, was a scene he had lived through once, with her, and it was the same. Those close to you showed up well and were solid and understandable, were fixed for good in your mind—but only in your mind. Their real selves were at a distance, a part of the world, and the world opened up, took them without reason; was opening up just as before, the body beside him falling away, while he sat off to the side, his shoulder showing in the tilted mirror, helpless.

Then he felt himself being drawn down too. He searched for something outside him to hold to. Wadded socks lay on the floor, gathering tufts of dust. Tubes and coils of a dismantled radio were strewn in one corner along with a model pistol of plastic, model ships, and a Boy Scout neckerchief. Dirty clothes were spread over the top of the dresser, trailing down its front, and more clothes were draped over the back of a chair.

"If your mother——" Stanion stopped. The words only took him down deeper. He put his hands on the boy's shoulders and tried to lift him up, but Kevin struggled free and dropped back onto the mattress.

"Don't now," Stanion said. "Don't carry on so. Please. Sit up."

"I'm sorry!"

"I know. Now don't."

"I can't stop!"

"Try to look at it——"

"My head hurts! It feels like something wants to come out of it!"

Stanion passed his hand over Kevin's skull, and the sensation of stiff stubble rubbing across the palm of his hand—what led the boy

to do this? what did this hark back to?—made him feel even more helpless and afraid. "Don't now," he said, and his being closed around the words. Father, mother, nurse, teacher, arbiter, guardian, judge—all the roles were too much. He no longer had the power to reach through to his children as the person he was, their father, the man who loved them, and let them know he loved them, and that inability, more than anything else, was the thing breaking him.

He heard a muffled sound, regular and tense, and at first he thought it was a summons, a last thing he would have to face up to, and when nothing came he believed it was the labored beating of his own heart. He turned. Kevin was lying in the same position, face down, but his hand was tapping over the covers in a widening arc, feeling its way toward Stanion; it touched him tentatively, backed away, and then came down, damp and hot with perspiration, on his thigh. Stanion took the hand in his and an order came over the room.

"I'm sorry," Kevin said in a muffled voice. "Forgive me."

"Did I hurt you?"

"No."

"Do you want to come downstairs?"

"No."

"Do you feel any better?"

"Yes."

"I've sent Jim and Carl outdoors. The girls are in bed. I'm sorry they had to see it."

"I didn't mean to do it. He wasn't playing right."

"I know. Here," he said, and raised Kevin and arranged him so they were sitting next to one another. "Let's go downstairs and do the dishes," Stanion said. "Then we'll both feel better." He put his arm around his son's waist. "Will you come downstairs and help me do the dishes?"

Reading Check

1. Who takes care of the children while Stanion is working?
2. Which of the children has become Stanion's favorite?
3. Why is Kevin difficult to play with?
4. How does Stanion punish Kevin?
5. How are father and son reconciled?

For Study and Discussion

Analyzing and Interpreting the Story

1. The main characters in this story are William Stanion and his son Kevin. The father's character is well defined because we are able to share his inner thoughts and feelings. Using details from the story, tell what kind of person William Stanion is.

2. We can watch Kevin and listen to him, and we know how other people feel about him, but his inner thoughts and feelings are not directly revealed. Using clues you are given in the story, tell what kind of person you think Kevin is.

3. Stanion's dead wife is an important presence in this story. **a.** How has her death affected the entire family? **b.** In what specific ways do memories of his wife "torment" Stanion?

4. Kevin, who has shaved his head, cries out, "My head hurts! It feels like something wants to come out of it!" What do you think Kevin is trying to release?

5. The climax of this story occurs when Stanion takes Kevin's outstretched hand. **a.** What comes "over the room" when this happens? **b.** What changes do you think are taking place in Kevin and his father?

Literary Elements

Complex Characterization

In simple forms of fiction—such as in some mystery and adventure stories—the characters are "all good" or "all bad." But in serious fiction, we find that characters cannot be so easily pigeonholed. These characters are complex. We find there is more than one side to them, just as there is more than one side to us all. At times, the central characters in such stories do things we admire a great deal, but they also do things that are not so admirable. It is important in such stories to understand the characters' **motivations**—the reasons they act as they do.

The character of William Stanion in this story is a complex one. We are told in the opening paragraph that Stanion is "reaching his limit," that he feels "weak" and "out of touch." When we learn that his wife has died, we feel great sympathy for him. But then he tangles with a difficult son. What other side of Stanion do we see when he strikes out at Kevin? What are his motives for acting so impulsively, even cruelly?

Kevin is also a complex character. How would you explain Kevin's cruelty to a younger child?

Language and Vocabulary

Determining Precise Meanings

When Stanion recalls his wife, he thinks of her as "*prudent* and *judicious*." The words *prudent* and *judicious* are close in meaning, but they are not exact synonyms. The word *prudent* means "careful" or "cautious," while *judicious* means "wise" or "sound in judgment." One could be prudent without being judicious.

Using a college or unabridged dictionary, determine the precise meanings of the following pairs of italicized words:

He understood them, *sensed* their needs, *anticipated* their whims . . .

He was *straightforward* and *truthful* . . .

He was no longer *exuberant* and *cheerful*.

"Father, mother, nurse, teacher, *arbiter*, guardian, *judge* . . .

Writing About Literature

Expressing an Opinion

Stories like "The Beginning of Grief," which trace the pattern of an internal conflict, are different in many ways from stories like "Leiningen Versus the Ants," which trace the pattern of an exciting external conflict. In a paragraph, tell which kind of story you prefer to read, and why. If you enjoy both kinds of stories, state your reasons and tell what effect each kind of story has on you.

About the Author

Larry Woiwode (1941–)

Larry Woiwode was born in Carrington, North Dakota. He has said: "In the novel we want to see dramatic interaction among people, building up, we hope, to a climax, or a denouement, and that's what I attempt to do. . . ." Woiwode's first novel, *What I'm Going to Do (I Think)*, won the 1969 William Faulkner Foundation Award for best first novel. His second novel, *Beyond the Bedroom Wall*, published in 1975, also earned much critical praise. A book of poems, *Even Tide*, appeared in the same year. In 1981 Woiwode published his novel *Poppa John*. His most recent novels are *Indian Affairs* (1992) and *Silent Passengers* (1993).

The Rifles of the Regiment

ERIC KNIGHT

Throughout literature there are certain characters called stock characters, who appear with regularity. These characters conform to a conventional pattern and tend to be types rather than individuals. One of these stock characters is the British officer who is a stickler for the rules and for tradition. As you read, note how Eric Knight transforms this stock character into an individual.

Colonel Heathergall has become a bit of a regimental legend already. In the mess[1] of the Loyal Rifles, they say, "Ah, but old Glass-eye! He was a one for one. A pukka sahib![2] I'll never forget once . . ."

Then off they go on some story or other about "Old Glass-eye."

But the regiment doesn't know the finest and truest story of all: when he fought all night with Fear—and won.

Colonel Heathergall met Fear in a little shack atop a cliff near the French village of Ste. Marguerite-en-Vaux.[3] He had never met Fear before—not on the Somme[4] nor in India nor in Palestine—because he was the type brought up not to know Fear. Fear is a cad—you just don't recognize the bounder.

The system has its points. Not being even on nodding acquaintance with Fear had allowed the colonel to keep the Loyal Rifle Regiment going in France long after all other British troops had gone—they were still fighting, working their way westward toward the Channel,[5] nearly two weeks after Dunkirk[6] was all over.

The men—those that were left—were drunk with fatigue. When they marched between fights, they slept. When they rested, they went into a sort of coma, and the sergeants had to slap them to waken them.

1. **mess:** the place where soldiers eat meals together.
2. **pukka sahib:** In Anglo-Indian, *pukka* means "genuine or good." *Sahib* is a respectful title formerly used by Indians in addressing Europeans.
3. **Ste. Marguerite-en-Vaux** (săɴt mär′gə-rēt′-äɴ-vō).
4. **Somme** (sôm): a river in northern France. A major battle was fought there during World War I. The French and British tried to break through the German line along the Somme River. They lost over half a million men.

5. **Channel:** The English Channel, which lies between England and France.
6. **Dunkirk** (dŭn′kûrk′): a seaport in northern France. In May of 1940, the British army was trapped at Dunkirk by Hitler's armies. English civilians sent their boats across the English Channel to help evacuate the British troops.

Cliffs of Étretat, France, on the Channel coast.

"They're nearly done," the adjutant[7] said. "Shouldn't we jettison equipment?"

"All right," the colonel said, finally. "Equip-ment can be destroyed and left behind. But not rifles! Regiment's never failed to carry its rifles in—and carry 'em out. We'll take our rifles with us—every last single rifle."

The adjutant saluted.

7. **adjutant** (ăj′ōō-tənt): officer who serves as an assistant to a commanding officer.

"Er—and tell 'em we'll cut through soon," the colonel added. "Tell 'em I say we'll find a soft spot and cut through soon."

But the Loyal Rifles never did cut through. For there was then no British Army left in France to cut through to. But the regiment didn't know that. It marched west and north and attacked, and went west and north again. Each time it brought out its rifles and left its dead. First the sergeants were carrying two rifles, and then the men, and then the officers.

The Loyal Rifles went on until—they could go no farther. For they had reached the sea. It was on a headland looking out over the Channel, beside the fishing port of Ste. Marguerite-en-Vaux.

In the late afternoon the colonel used the regiment's last strength in an attempt to take Ste. Marguerite, for there might be boats there, fishing smacks,[8] something that could carry them all back to England. He didn't find boats. He found the enemy with tanks and artillery, and the regiment withdrew. They left their dead, but they left no rifles.

The colonel sent out scouts. They brought him the report. They were cut off by the Germans—ringed about with their backs to the sea; on a cliff top with a two-hundred-foot drop to the beach below.

The regiment posted pickets, and dug foxholes,[9] and fought until darkness came. Then they waited through the night for the last attack that was sure to come.

And it was that night, in his headquarters at the cliff top shack, that Colonel Heathergall, for the first time in his well-bred, British, military life, met Fear.

Fear had a leprous face. Its white robes were damp, and it smelled of stale sweat.

Colonel Heathergall, who had not heard the door close, saw the figure standing there in the darkness.

"Who—who is it?"

Fear bowed and said, "You know me, really, Colonel. All your arrogant, aristocratic, British life you've snubbed me and pretended you didn't know me, but really you do, don't you? Let us be friends."

The colonel adjusted his monocle. "What do you want?" he asked.

"I've come to tell you," Fear said, "that it's time for you to surrender the regiment. You're finished."

"You're a slimy brute," the colonel said. "I won't surrender. There must be some way out! That R.A.F.[10] plane this morning! I'm sure it saw us—the way the chap waggled[11] his wings. He'd go get help. The navy—they'll come!"

Fear laughed. "And if they come, then what? How would you get down that cliff? . . . You *can't* get down—and you know it!"

"We could cut south and find a better spot— the men still have fight left," the colonel said desperately.

"The men," Fear said, "they'll leave their broken bodies wherever you choose. They've got the stuff. And oh, yes, you, too, have courage, in your way. The huntin'-shootin'-fishin' sort of courage. The well-bred polo-field kind of courage. But that's got nothing to do with *this* kind of war. You haven't the right to ask your men to die to preserve that sort of record. Have you?"

The colonel sat still, not answering.

Fear spoke again. "The enemy will be here soon. Your men are exhausted. They can't do any more. Really, you'd be saving their lives if you surrender. No one would blame you. . . ."

The colonel shook his head, "No," he said. "We can't do that. You see—we never have

8. **smacks:** boats used to transport live fish to market.
9. **foxholes:** shallow pits dug in the ground for shelter against enemy gunfire.

10. **R.A.F.:** Royal Air Force.
11. **waggled** (wăg′əld): moved rapidly up and down.

done that. And we can't now. Perhaps we are outmoded. I and my kind may be out-of-date—incompetent—belonging to a bygone day. But . . ." He looked around him as if for help. Then he went on desperately: "But—we've brought out all the rifles."

"Is that all?" mocked Fear.

"All?" the colonel echoed. "Is that all?"

Then at last he squared his shoulders. "All? Why, you bloody civilian, it's everything! I may die—and my men may die—but the regiment! It doesn't. The regiment goes on living. It's bigger than me—it's bigger than the men. Why, you slimy dugout king of a base-wallah[12]—it's bigger than you!"

And exactly as he said that, Fear fled. And there came a rap on the door, and the adjutant's voice sounded.

"Come in," the colonel said quietly.

"Are you alone, sir?" the adjutant asked.

"Yes," the colonel said. "Quite alone. What is it?"

"Report from the signal officer, sir. He has carried an ordinary torch with him, and he feels the colonel will be interested to know that he's in visual communication with the navy—destroyers or something. They say they're ready to put off boats to take us off."

"Tell him my thanks to C.O.[13] of whatever naval force there is there. Message to company commanders: Withdraw pickets quietly. Rendezvous[14] cliff top north of this H.Q.[15] at three-fifty-five ack emma.[16] Er—pretty good chaps in the navy—I've heard."

"Indeed, sir," the adjutant said.

So they assembled the men of the Loyal Rifle Regiment on the cliff top, where they could see out and below them the brief dots and dashes of light that winked.[17] And there, too, in the night wind, they could feel the space and know the vast drop to the beach. Some of the men lay flat and listened for the sound of the sailors two hundred feet below them.

The officers waited, looking toward the colonel. It was the major who spoke: "But—how on earth are we going to get down there, Colonel?"

Colonel Heathergall smiled privately within himself. "The rifles," he said softly. "The rifles, of course. I think we'll just about have enough."

And that's how the regiment escaped. They made a great chain of linked rifle slings, and went down it one at a time. The colonel came last, of course, as custom dictated.

Below, they picked up the rifles, whole and shattered, that they had thrown from the cliff top, and wading out into the sea, carried them to the boats.

By this time the Germans were awake, and they let loose with everything they had. The sailors used fine naval language, and said that Dunkirk was a picnic compared to this so-and-so bloody mess. But they got the men into the boats. The navy got in and got them out.

That's the way the Loyal Rifle Regiment came home nearly two weeks after the last troops from Dunkirk had landed in Blighty.[18]

In the mess they still talk of the colonel. "Old Glass-eye," they say. "Ah, there was a colonel for you. Saved the outfit, he did. Knew the only way it'd ever get out would be down a cliff—so he made 'em carry all the rifles half-way across France. Knew he'd need the slings for that cliff. Foresight, eh? . . . Great Chap, Old Glass-eye. Never knew the meaning of Fear."

12. **wallah:** Anglo-Indian for someone who is associated with a particular occupation or function.
13. **C.O.:** Commanding Officer.
14. **Rendezvous** (rän′dā-vōō′, rän′də-): Assemble troops.
15. **H.Q.:** Headquarters.
16. **ack emma:** A.M.
17. **dots . . . winked:** The message was transmitted in Morse code.
18. **Blighty:** British slang for "England."

1. Identify the Loyal Rifles.
2. How are the colonel's men trapped?
3. Why does the colonel refuse to surrender?
4. How does the navy communicate with the colonel's men?
5. How do the men of the regiment escape?

For Study and Discussion

Analyzing and Interpreting the Story

1. In what ways is Colonel Heathergall a familiar character type? Consider the characteristics of English officers as they are often depicted in films and in stories.

2. We are told that Colonel Heathergall has never before experienced fear. What is different about the situation in which he now finds himself?

3. Knight represents an emotion—fear—as a character. The presentation of an idea or an abstract quality as a human being is called **personification.** **a.** What physical characteristics are attributed to Fear? **b.** How does the characterization of Fear convey the colonel's experience of terror?

4a. How does the colonel resolve his inner conflict? **b.** Is this resolution consistent with his character?

5a. Explain the colonel's strategy for evacuating his men. **b.** How does his plan make him a regimental legend?

Literary Elements

Stock Characters

If you have read "Rip Van Winkle," you will recall that Dame Van Winkle is cast in the role of a shrew, a type of character that recurs throughout literature with little or no variation. If you have seen a great many Westerns, you will readily identify the lawman and the villain by a few familiar characteristics. These character types are known as **stock characters** or **stereotypes** (stĕr′ē-ə-tīps′, stîr′-).

As a rule, stock characters are a product of commercial fiction written to a ready-made formula. Sometimes, however, a writer will deliberately choose to use a stock character in order to create a new personality out of familiar materials. Charles Dickens does this when he transforms the stereotype of the miser into Ebenezer Scrooge, the famous character in "A Christmas Carol."

The colonel in Knight's story is depicted as a stock character. His background, education, and military career are typical. Above all else he adheres to tradition and to his duty. He is not expected to show fear or any emotion. Even the monocle, which earns him the nickname "Old Glass-eye," is part of the pattern.

When the colonel confronts his own fears, he is transformed from a stock character into an individual who for the first time in his life has doubts about his principles and his abilities as a commanding officer. Why do you suppose Knight chose to dramatize the colonel's experience of fear? What details make the scene with Fear effective and convincing?

Writing About Literature

Comparing Personification Techniques

A famous example of personification occurs in this short story by W. Somerset Maugham.

Appointment in Samarra

DEATH SPEAKS: There was a merchant in Baghdad who sent his servant to market to buy provisions, and in a little while the servant came back, white and trembling, and said, "Master, just now when

I was in the marketplace I was jostled by a woman in the crowd, and when I turned I saw it was Death that jostled me. She looked at me and made a threatening gesture; now lend me your horse, and I will ride away from this city and avoid my fate. I will go to Samarra, and there Death will not find me." The merchant lent him his horse, and the servant mounted it, and he dug his spurs in its flanks, and as fast as the horse could gallop he went. Then the merchant went down to the marketplace and he saw me standing in the crowd and he came to me and said, "Why did you make a threatening gesture to my servant when you saw him this morning?" "That was not a threatening gesture," I said, "it was only a start of surprise. I was astonished to see him in Baghdad, for I had an appointment with him tonight in Samarra."

Compare the personification of Death in this tale with that of Fear in Knight's story. What characteristics does each writer use to present an abstract quality as a human being?

About the Author

Eric Knight (1897–1943)

Eric Knight was born in Yorkshire, England, which is the setting for "Lassie Come-Home," his best-known work. This story has also appeared as a novel, a movie, and a television series. Another well-known work, *The Flying Yorkshireman,* is about a colorful character, Sam Small, who is sometimes called the Yorkshire Paul Bunyan. During World War II, Knight was a major in the United States Army. He was killed in an airplane crash while he was on a mission to Africa. "The Rifles of the Regiment" appeared the year before his death.

Focus on Narrative Writing

Building Round Characters

Flat characters are merely sketched in one dimension. They are not fully developed. By contrast, **round characters** are complex, more lifelike figures. In Colonel Heathergall, Eric Knight gives us a fascinating glimpse of the transformation of a flat character into a round character. The device that makes this possible is a "behind-the-scenes" look at the colonel's inner emotions.

Write a paragraph about a familiar stereotype, such as a "hard-boiled" private investigator or an "egghead" student. Then, in a second paragraph, describe how you might transform this figure into a round character in a story. What personality traits would you add? What hidden emotions might you explore? Save your writing.

Tracing Word Origins

During the days when India was part of the British Empire, many words from Indian languages found their way into the English language. The men in Colonel Heathergall's regiment refer to him as a *pukka sahib.* The word *pukka* comes from a Hindi word which means "ripe." In English it has the meaning "first-rate." *Sahib* comes from a word that means "master."

Making Connections: Activities

Here are some other words that come from the languages of India. Using a college or an unabridged dictionary, find the origin of each word.

avatar	juggernaut	pariah
dinghy	jungle	pundit
gunny	khaki	thug

SETTING

Edgar Allan Poe opens "The Fall of the House of Usher," one of his famous horror stories, with this scene:

> During the whole of a dull, dark, and soundless day in the autumn of the year, when the clouds hung oppressively low in the heavens, I had been passing alone, on horseback, through a singularly dreary tract of country, and at length found myself, as the shades of the evening drew on, within view of the melancholy House of Usher. I know not how it was—but, with the first glimpse of the building, a sense of insufferable gloom pervaded my spirit.

Clearly, the *setting* of this story—the time and place of its action—is significant. The author tells us what the day is like (dull, dark, and soundless), what time of year it is (autumn), what time of day it is (evening), and what the surroundings are like (dreary and melancholy). This description not only gives us a vivid picture of a setting, but it also creates an atmosphere, or emotional climate. It is hard to read about dull, dark days in the autumn of the year at evening in a dreary country without feeling a sense of uneasiness and gloom.

In Poe's story, setting is used to create atmosphere. Setting can also have other functions in fiction. Setting may be a significant element in the plot. In Carl Stephenson's story "Leiningen Versus the Ants" (page 12), for example, a vast horde of ravenous ants, native to a South American setting, must be overcome by the main character. Setting can be used to reveal something about character. In "Neighbor Rosicky" (page 48) the description of Rosicky's home conveys the warmth and generosity of his character. "The long table, covered with a bright oilcloth, was set out with dishes waiting for them, and the warm kitchen was full of the smell of coffee and hot biscuit and sausage."

Setting is an important element in the stories that follow.

Contents of the Dead Man's Pockets

JACK FINNEY

There are two settings in this story. What is the function of each one? Can you see the relation of setting to the plot?

At the little living-room desk Tom Benecke rolled two sheets of flimsy[1] and a heavier top sheet, carbon paper sandwiched between them, into his portable. *Interoffice Memo*, the top sheet was headed, and he typed tomorrow's date just below this; then he glanced at a creased yellow sheet, covered with his own handwriting, beside the typewriter. "Hot in here," he muttered to himself. Then, from the short hallway at his back, he heard the muffled clang of wire coat hangers in the bedroom closet, and at this reminder of what his wife was doing he thought: Hot, no—guilty conscience.

He got up, shoving his hands into the back pockets of his gray wash slacks, stepped to the living-room window beside the desk, and stood breathing on the glass, watching the expanding circlet of mist, staring down through the autumn night at Lexington Avenue,[2] eleven stories below. He was a tall, lean, dark-haired young man in a pullover sweater, who looked as though he had played not football, probably, but basketball in college. Now he placed the heels of his hands against the top edge of the lower window frame and shoved upward. But as usual the window didn't budge, and he had to lower his hands and then shoot them upward to jolt the window open a few inches. He dusted his hands, muttering.

But still he didn't begin his work. He crossed the room to the hallway entrance and, leaning against the doorjamb, hands shoved into his back pockets again, he called, "Clare?" When his wife answered, he said, "Sure you don't mind going alone?"

"No." Her voice was muffled, and he knew her head and shoulders were in the bedroom closet. Then the tap of her high heels sounded on the wood floor and she appeared at the end of the little hallway, wearing a slip, both hands raised to one ear, clipping on an earring. She smiled at him—a slender, very pretty girl with light brown, almost blonde, hair—her prettiness emphasized by the pleasant nature that showed in her face. "It's just that I hate you to miss this movie; you wanted to see it too."

1. **flimsy:** thin paper used for typing carbon copies.
2. **Lexington Avenue:** one of the main streets in New York City.

"Yeah, 1 know." He ran his fingers through his hair. "Got to get this done though."

She nodded, accepting this. Then, glancing at the desk across the living room, she said, "You work too much, though, Tom—and too hard."

He smiled. "You won't mind though, will you, when the money comes rolling in and I'm known as the Boy Wizard of Wholesale Groceries?"

"I guess not." She smiled and turned back toward the bedroom.

At his desk again, Tom lighted a cigarette; then a few moments later as Clare appeared, dressed and ready to leave, he set it on the rim of the ashtray. "Just after seven," she said. "I can make the beginning of the first feature."

He walked to the front-door closet to help her on with her coat. He kissed her then and, for an instant, holding her close, smelling the

New York City at night.

perfume she had used, he was tempted to go with her; it was not actually true that he had to work tonight, though he very much wanted to. This was his own project, unannounced as yet in his office, and it could be postponed. But then they won't see it till Monday, he thought once again, and if I give it to the boss tomorrow he might read it over the weekend. . . . "Have a good time," he said aloud. He gave his wife a little swat and opened the door for her, feeling the air from the building hallway, smelling faintly of floor wax, stream past his face.

He watched her walk down the hall, flicked a hand in response as she waved, and then he started to close the door, but it resisted for a moment. As the door opening narrowed, the current of warm air from the hallway, channeled through this smaller opening now, suddenly rushed past him with accelerated force. Behind him he heard the slap of the window curtains against the wall and the sound of paper fluttering from his desk, and he had to push to close the door.

Turning, he saw a sheet of white paper drifting to the floor in a series of arcs, and another sheet, yellow, moving toward the window, caught in the dying current flowing through the narrow opening. As he watched, the paper struck the bottom edge of the window and hung there for an instant, plastered against the glass and wood. Then as the moving air stilled completely, the curtains swinging back from the wall to hang free again, he saw the yellow sheet drop to the window ledge and slide over out of sight.

He ran across the room, grasped the bottom edge of the window, and tugged, staring through the glass. He saw the yellow sheet, dimly now in the darkness outside, lying on the ornamental ledge a yard below the window. Even as he watched, it was moving, scraping slowly along the ledge, pushed by the breeze that pressed steadily against the building wall. He heaved on the window with all his strength and it shot open with a bang, the window weight rattling in the casing. But the paper was past his reach and, leaning out into the night, he watched it scud steadily along the ledge to the south, half-plastered against the building wall. Above the muffled sound of the street traffic far below, he could hear the dry scrape of its movement, like a leaf on the pavement.

The living room of the next apartment to the south projected a yard or more farther out toward the street than this one; because of this the Beneckes paid seven and a half dollars less rent than their neighbors. And now the yellow sheet, sliding along the stone ledge, nearly invisible in the night, was stopped by the projecting blank wall of the next apartment. It lay motionless, then, in the corner formed by the two walls—a good five yards away, pressed firmly against the ornate corner ornament of the ledge by the breeze that moved past Tom Benecke's face.

He knelt at the window and stared at the yellow paper for a full minute or more, waiting for it to move, to slide off the ledge and fall, hoping he could follow its course to the street, and then hurry down in the elevator and retrieve it. But it didn't move, and then he saw that the paper was caught firmly between a projection of the convoluted corner ornament and the ledge. He thought about the poker from the fireplace, then the broom, then the mop—discarding each thought as it occurred to him. There was nothing in the apartment long enough to reach that paper.

It was hard for him to understand that he actually had to abandon it—it was ridiculous—and he began to curse. Of all the papers on his desk, why did it have to be this one in particular! On four long Saturday afternoons he had stood in supermarkets counting the

people who passed certain displays, and the results were scribbled on that yellow sheet. From stacks of trade publications, gone over page by page in snatched half-hours at work and during evenings at home, he had copied facts, quotations, and figures onto that sheet. And he had carried it with him to the Public Library on Fifth Avenue, where he'd spent a dozen lunch hours and early evenings adding more. All were needed to support and lend authority to his idea for a new grocery-store display method; without them his idea was a mere opinion. And there they all lay in his own improvised shorthand—countless hours of work—out there on the ledge.

For many seconds he believed he was going to abandon the yellow sheet, that there was nothing else to do. The work could be duplicated. But it would take two months, and the time to present this idea was *now,* for use in the spring displays. He struck his fist on the window ledge. Then he shrugged. Even though his plan were adopted, he told himself, it wouldn't bring him a raise in pay—not immediately, anyway, or as a direct result. It won't bring me a promotion either, he argued—not of itself.

But just the same, and he couldn't escape the thought, this and other independent projects, some already done and others planned for the future, would gradually mark him out from the score of other young men in his company. They were the way to change from a name on the payroll to a name in the minds of the company officials. They were the beginning of the long, long climb to where he was determined to be, at the very top. And he knew he was going out there in the darkness, after the yellow sheet fifteen feet beyond his reach.

By a kind of instinct, he instantly began making his intention acceptable to himself by laughing at it. The mental picture of himself sidling along the ledge outside was absurd—it was actually comical—and he smiled. He imagined himself describing it; it would make a good story at the office and, it occurred to him, would add a special interest and importance to his memorandum, which would do it no harm at all.

To simply go out and get his paper was an easy task—he could be back here with it in less than two minutes—and he knew he wasn't deceiving himself. The ledge, he saw, measuring it with his eye, was about as wide as the length of his shoe, and perfectly flat. And every fifth row of brick in the face of the building, he remembered—leaning out, he verified this—was indented half an inch, enough for the tips of his fingers, enough to maintain balance easily. It occurred to him that if this ledge and wall were only a yard above ground—as he knelt at the window staring out, this thought was the final confirmation of his intention—he could move along the ledge indefinitely.

On a sudden impulse, he got to his feet, walked to the front closet, and took out an old tweed jacket; it would be cold outside. He put it on and buttoned it as he crossed the room rapidly toward the open window. In the back of his mind he knew he'd better hurry and get this over with before he thought too much, and at the window he didn't allow himself to hesitate.

He swung a leg over the sill, then felt for and found the ledge a yard below the window with his foot. Gripping the bottom of the window frame very tightly and carefully, he slowly ducked his head under it, feeling on his face the sudden change from the warm air of the room to the chill outside. With infinite care he brought out his other leg, his mind concentrating on what he was doing. Then he slowly stood erect. Most of the putty, dried out and brittle, had dropped off the bottom edging of the window frame, he found, and the flat wooden edging provided a good gripping sur-

face, a half-inch or more deep, for the tips of his fingers.

Now, balanced easily and firmly, he stood on the ledge outside in the slight, chill breeze, eleven stories above the street, staring into his own lighted apartment, odd and different-seeming now.

First his right hand, then his left, he carefully shifted his fingertip grip from the putty-less window edging to an indented row of bricks directly to his right. It was hard to take the first shuffling sideways step then—to make himself move—and the fear stirred in his stomach, but he did it, again by not allowing himself time to think. And now—with his chest, stomach, and the left side of his face pressed against the rough cold brick—his lighted apartment was suddenly gone, and it was much darker out here than he had thought.

Without pause he continued—right foot, left foot, right foot, left—his shoe soles shuffling and scraping along the rough stone, never lifting from it, fingers sliding along the exposed edging of brick. He moved on the balls of his feet, heels lifted slightly; the ledge was not quite as wide as he'd expected. But leaning slightly inward toward the face of the building and pressed against it, he could feel his balance firm and secure, and moving along the ledge was quite as easy as he had thought it would be. He could hear the buttons of his jacket scraping steadily along the rough bricks and feel them catch momentarily, tugging a little, at each mortared crack. He simply did not permit himself to look down, though the compulsion to do so never left him; nor did he allow himself actually to think. Mechanically—right foot, left foot, over and again—he shuffled along crabwise, watching the projecting wall ahead loom steadily closer. . . .

Then he reached it and, at the corner—he'd decided how he was going to pick up the pa-per—he lifted his right foot and placed it carefully on the ledge that ran along the projecting wall at a right angle to the ledge on which his other foot rested. And now, facing the building, he stood in the corner formed by the two walls, one foot on the ledging of each, a hand on the shoulder-high indentation of each wall. His forehead was pressed directly into the corner against the cold bricks, and now he carefully lowered first one hand, then the other, perhaps a foot farther down, to the next indentation in the rows of bricks.

Very slowly, sliding his forehead down the trough of the brick corner and bending his knees, he lowered his body toward the paper lying between his outstretched feet. Again he lowered his fingerholds another foot and bent his knees still more, thigh muscles taut, his forehead sliding and bumping down the brick V. Half squatting now, he dropped his left hand to the next indentation and then slowly reached with his right hand toward the paper between his feet.

He couldn't quite touch it, and his knees now were pressed against the wall; he could bend them no farther. But by ducking his head another inch lower, the top of his head now pressed against the bricks, he lowered his right shoulder and his fingers had the paper by a corner, pulling it loose. At the same instant he saw, between his legs and far below, Lexington Avenue stretched out for miles ahead.

He saw, in that instant, the Loew's theater sign, blocks ahead past Fiftieth Street; the miles of traffic signals, all green now; the lights of cars and street lamps; countless neon signs; and the moving black dots of people. And a violent instantaneous explosion of absolute terror roared through him. For a motionless instant he saw himself externally—bent practically double, balanced on this narrow ledge, nearly half his body projecting out above the street far below—and he began to tremble vi-

olently, panic flaring through his mind and muscles, and he felt the blood rush from the surface of his skin.

In the fractional moment before horror paralyzed him, as he stared between his legs at that terrible length of street far beneath him, a fragment of his mind raised his body in a spasmodic jerk to an upright position again, but so violently that his head scraped hard against the wall, bouncing off it, and his body swayed outward to the knife edge of balance, and he very nearly plunged backward and fell. Then he was leaning far into the corner again, squeezing and pushing into it, not only his face but his chest and stomach, his back arching; and his fingertips clung with all the pressure of his pulling arms to the shoulder-high half-inch indentation in the bricks.

He was more than trembling now; his whole body was racked with a violent shuddering beyond control, his eyes squeezed so tightly shut it was painful, though he was past awareness of that. His teeth were exposed in a frozen grimace, the strength draining like water from his knees and calves. It was extremely likely, he knew, that he would faint, slump down along the wall, his face scraping, and then drop backward, a limp weight, out into nothing. And to save his life he concentrated on holding on to consciousness, drawing deliberate deep breaths of cold air into his lungs, fighting to keep his senses aware.

Then he knew that he would not faint, but he could not stop shaking nor open his eyes. He stood where he was, breathing deeply, trying to hold back the terror of the glimpse he had had of what lay below him; and he knew he had made a mistake in not making himself stare down at the street, getting used to it and accepting it, when he had first stepped out onto the ledge.

It was impossible to walk back. He simply could not do it. He couldn't bring himself to make the slightest movement. The strength was gone from his legs; his shivering hands—numb, cold, and desperately rigid—had lost all deftness; his easy ability to move and balance was gone. Within a step or two, if he tried to move, he knew that he would stumble and fall.

Seconds passed, with the chill faint wind pressing the side of his face, and he could hear the toned-down volume of the street traffic far beneath him. Again and again it slowed and then stopped, almost to silence; then presently, even this high, he would hear the click of the traffic signals and the subdued roar of the cars starting up again. During a lull in the street sounds, he called out. Then he was shouting *"Help!"* so loudly it rasped his throat. But he felt the steady pressure of the wind, moving between his face and the blank wall, snatch up his cries as he uttered them, and he knew they must sound directionless and distant. And he remembered how habitually, here in New York, he himself heard and ignored shouts in the night. If anyone heard him, there was no sign of it, and presently Tom Benecke knew he had to try moving; there was nothing else he could do.

Eyes squeezed shut, he watched scenes in his mind like scraps of motion-picture film—he could not stop them. He saw himself stumbling suddenly sideways as he crept along the ledge and saw his upper body arc outward, arms flailing. He saw a dangling shoestring caught between the ledge and the sole of his other shoe, saw a foot start to move, to be stopped with a jerk, and felt his balance leaving him. He saw himself falling with a terrible speed as his body revolved in the air, knees clutched tight to his chest, eyes squeezed shut, moaning softly.

Out of utter necessity, knowing that any of these thoughts might be reality in the very next seconds, he was slowly able to shut his mind against every thought but what he now began

to do. With fear-soaked slowness, he slid his left foot an inch or two toward his own impossibly distant window. Then he slid the fingers of his shivering left hand a corresponding distance. For a moment he could not bring himself to lift his right foot from one ledge to the other; then he did it, and became aware of the harsh exhalation of air from his throat and realized that he was panting. As his right hand, then, began to slide along the brick edging, he was astonished to feel the yellow paper pressed to the bricks underneath his stiff fingers, and he uttered a terrible, abrupt bark that might have been a laugh or a moan. He opened his mouth and took the paper in his teeth, pulling it out from under his fingers.

By a kind of trick—by concentrating his entire mind on first his left foot, then his left hand, then the other foot, then the other hand—he was able to move, almost imperceptibly, trembling steadily, very nearly without thought. But he could feel the terrible strength of the pent-up horror on just the other side of the flimsy barrier he had erected in his mind; and he knew that if it broke through he would lose this thin artificial control of his body.

During one slow step he tried keeping his eyes closed; it made him feel safer, shutting him off a little from the fearful reality of where he was. Then a sudden rush of giddiness swept over him and he had to open his eyes wide, staring sideways at the cold rough brick and angled lines of mortar, his cheek tight against the building. He kept his eyes open then, knowing that if he once let them flick outward, to stare for an instant at the lighted windows across the street, he would be past help.

He didn't know how many dozens of tiny sidling steps he had taken, his chest, belly, and face pressed to the wall; but he knew the slender hold he was keeping on his mind and body was going to break. He had a sudden mental picture of his apartment on just the other side of this wall—warm, cheerful, incredibly spacious. And he saw himself striding through it, lying down on the floor on his back, arms spread wide, reveling in its unbelievable security. The impossible remoteness of this utter safety, the contrast between it and where he now stood, was more than he could bear. And the barrier broke then, and the fear of the awful height he stood on coursed through his nerves and muscles.

A fraction of his mind knew he was going to fall, and he began taking rapid blind steps with no feeling of what he was doing, sidling with a clumsy desperate swiftness, fingers scrabbling along the brick, almost hopelessly resigned to the sudden backward pull and swift motion outward and down. Then his moving left hand slid onto not brick but sheer emptiness, an impossible gap in the face of the wall, and he stumbled.

His right foot smashed into his left anklebone; he staggered sideways, began falling, and the claw of his hand cracked against glass and wood, slid down it, and his fingertips were pressed hard on the puttyless edging of his window. His right hand smacked gropingly beside it as he fell to his knees; and, under the full weight and direct downward pull of his sagging body, the open window dropped shudderingly in its frame till it closed and his wrists struck the sill and were jarred off.

For a single moment he knelt, knee bones against stone on the very edge of the ledge, body swaying and touching nowhere else, fighting for balance. Then he lost it, his shoulders plunging backward, and he flung his arms forward, his hands smashing against the window casing on either side; and—his body moving backward—his fingers clutched the narrow wood stripping of the upper pane.

For an instant he hung suspended between balance and falling, his fingertips pressed onto the quarter-inch wood strips. Then, with ut-

most delicacy, with a focused concentration of all his senses, he increased even further the strain on his fingertips hooked to these slim edgings of wood. Elbows slowly bending, he began to draw the full weight of his upper body forward, knowing that the instant his fingers slipped off these quarter-inch strips he'd plunge backward and be falling. Elbows imperceptibly bending, body shaking with the strain, the sweat starting from his forehead in great sudden drops, he pulled, his entire being and thought concentrated in his fingertips. Then suddenly, the strain slackened and ended, his chest touching the windowsill, and he was kneeling on the ledge, his forehead pressed to the glass of the closed window.

Dropping his palms to the sill, he stared into his living room—at the red-brown davenport across the room, and a magazine he had left there; at the pictures on the walls and the gray rug; the entrance to the hallway; and at his papers, typewriter, and desk, not two feet from his nose. A movement from his desk caught his eye and he saw that it was a thin curl of blue smoke; his cigarette, the ash long, was still burning in the ashtray where he'd left it—this was past all belief—only a few minutes before.

His head moved, and in faint reflection from the glass before him he saw the yellow paper clenched in his front teeth. Lifting a hand from the sill he took it from his mouth; the moistened corner parted from the paper, and he spat it out.

For a moment, in the light from the living room, he stared wonderingly at the yellow sheet in his hand and then crushed it into the side pocket of his jacket.

He couldn't open the window. It had been pulled not completely closed, but its lower edge was below the level of the outside sill; there was no room to get his fingers underneath it. Between the upper sash and the lower was a gap not wide enough—reaching up, he tried—to get his fingers into; he couldn't push it open. The upper window panel, he knew from long experience, was impossible to move, frozen tight with dried paint.

Very carefully observing his balance, the fingertips of his left hand again hooked to the narrow stripping of the window casing, he drew back his right hand, palm facing the glass, and then struck the glass with the heel of his hand.

His arm rebounded from the pane, his body tottering. He knew he didn't dare strike a harder blow.

But in the security and relief of his new position, he simply smiled; with only a sheet of glass between him and the room just before him, it was not possible that there wasn't a way past it. Eyes narrowing, he thought for a few moments about what to do. Then his eyes widened, for nothing occurred to him. But still he felt calm. the trembling, he realized, had stopped. At the back of his mind there still lay the thought that once he was again in his home, he could give release to his feelings. He actually *would* lie on the floor, rolling, clenching tufts of the rug in his hands. He would literally run across the room, free to move as he liked, jumping on the floor, testing and reveling in its absolute security, letting the relief flood through him, draining the fear from his mind and body. His yearning for this was astonishingly intense, and somehow he understood that he had better keep this feeling at bay.

He took a half-dollar from his pocket and struck it against the pane, but without any hope that the glass would break and with very little disappointment when it did not. After a few moments of thought he drew his leg onto the ledge and picked loose the knot of his shoelace. He slipped off the shoe and, holding it across the instep, drew back his arm as far as he dared and struck the leather heel against

New York City at dusk.

the glass. The pane rattled, but he knew he'd been a long way from breaking it. His foot was cold and he slipped the shoe back on. He shouted again, experimentally, and then once more, but there was no answer.

The realization suddenly struck him that he might have to wait here till Clare came home, and for a moment the thought was funny. He could see Clare opening the front door, withdrawing her key from the lock, closing the door behind her, and then glancing up to see him crouched on the other side of the window. He could see her rush across the room, face astounded and frightened, and hear himself shouting instructions: "Never mind how I got here! Just open the wind——" She couldn't

open it, he remembered, she'd never been able to; she'd always had to call him. She'd have to get the building superintendent or a neighbor, and he pictured himself smiling, and answering their questions as he climbed in. "I just wanted to get a breath of fresh air, so——"

He couldn't possibly wait here till Clare came home. It was the second feature she'd wanted to see, and she'd left in time to see the first. She'd be another three hours or—— He glanced at his watch; Clare had been gone eight minutes. It wasn't possible, but only eight minutes ago he had kissed his wife goodbye. She wasn't even at the theater yet!

It would be four hours before she could possibly be home, and he tried to picture him-

self kneeling out here, fingertips hooked to these narrow strippings, while first one movie, preceded by a slow listing of credits, began, developed, reached its climax, and then finally ended. There'd be a newsreel next, maybe, and then an animated cartoon, and then interminable scenes from coming pictures. And then, once more, the beginning of a full-length picture—while all the time he hung out here in the night.

He might possibly get to his feet, but he was afraid to try. Already his legs were cramped, his thigh muscles tired; his knees hurt, his feet felt numb, and his hands were stiff. He couldn't possibly stay out here for four hours, or anywhere near it. Long before that his legs and arms would give out; he would be forced to try changing his position often—stiffly, clumsily, his coordination and strength gone— and he would fall. Quite realistically, he knew that he would fall; no one could stay out here on this ledge for four hours.

A dozen windows in the apartment building across the street were lighted. Looking over his shoulder, he could see the top of a man's head behind the newspaper he was reading; in another window he saw the blue-gray flicker of a television screen. No more than twenty-odd yards from his back were scores of people, and if just one of them would walk idly to his window and glance out. . . . For some moments he stared over his shoulder at the lighted rectangles, waiting. But no one appeared. The man reading his paper turned a page and then continued his reading. A figure passed another of the windows and was immediately gone.

In the inside pocket of his jacket he found a little sheaf of papers, and he pulled one out and looked at it in the light from the living room. It was an old letter, an advertisement of some sort; his name and address, in purple ink, were on a label pasted to the envelope. Gripping one end of the envelope in his teeth,

he twisted it into a tight curl. From his shirt pocket he brought out a book of matches. He didn't dare let go the casing with both hands but, with the twist of paper in his teeth, he opened the matchbook with his free hand; then he bent one of the matches in two without tearing it from the folder, its red-tipped end now touching the striking surface. With his thumb, he rubbed the red tip across the striking area.

He did it again, then again, and still again, pressing harder each time, and the match suddenly flared, burning his thumb. But he kept it alight, cupping the matchbook in his hand and shielding it with his body. He held the flame to the paper in his mouth till it caught. Then he snuffed out the match flame with his thumb and forefinger, careless of the burn, and replaced the book in his pocket. Taking the paper twist in his hand, he held it flame down, watching the flame crawl up the paper, till it flared bright. Then he held it behind him over the street, moving it from side to side, watching it over his shoulder, the flame flickering and guttering in the wind.

There were three letters in his pocket and he lighted each of them, holding each till the flame touched his hand and then dropping it to the street below. At one point, watching over his shoulder while the last of the letters burned, he saw the man across the street put down his paper and stand—even seeming to glance toward Tom's window. But when he moved, it was only to walk across the room and disappear from sight.

There were a dozen coins in Tom Benecke's pocket and he dropped them, three or four at a time. But if they struck anyone, or if anyone noticed their falling, no one connected them with their source.

His arms had begun to tremble from the steady strain of clinging to this narrow perch, and he did not know what to do now and was

terribly frightened. Clinging to the window stripping with one hand, he again searched his pockets. But now—he had left his wallet on the dresser when he'd changed clothes—there was nothing left but the yellow sheet. It occurred to him irrelevantly that his death on the sidewalk below would be an eternal mystery; the window closed—why, how, and from where could he have fallen? No one would be able to identify his body for a time, either— the thought was somehow unbearable and increased his fear. All they'd find in his pockets would be the yellow sheet. *Contents of the dead man's pockets*, he thought, *one sheet of paper bearing penciled notations—incomprehensible.*

He understood fully that he might actually be going to die; his arms, maintaining his balance on the ledge, were trembling steadily now. And it occurred to him then with all the force of a revelation that, if he fell, all he was ever going to have out of life he would then, abruptly, have had. Nothing, then, could ever be changed; and nothing more—no least experience or pleasure—could ever be added to his life. He wished, then, that he had not allowed his wife to go off by herself tonight— and on similar nights. He thought of all the evenings he had spent away from her, working; and he regretted them. He thought wonderingly of his fierce ambition and of the direction his life had taken; he thought of the hours he'd spent by himself, filling the yellow sheet that had brought him out here. *Contents of the dead man's pockets,* he thought with sudden fierce anger, *a wasted life.*

He was simply not going to cling here till he slipped and fell; he told himself that now. There was one last thing he could try; he had been aware of it for some moments, refusing to think about it, but now he faced it. Kneeling here on the ledge, the fingertips of one hand pressed to the narrow strip of wood, he could, he knew, draw his other hand back a yard

perhaps, fist clenched tight, doing it very slowly till he sensed the outer limit of balance, then, as hard as he was able from the distance, he could drive his fist forward against the glass. If it broke, his fist smashing through, he was safe; he might cut himself badly, and probably would, but with his arm inside the room, he would be secure. But if the glass did not break, the rebound, flinging his arm back, would topple him off the ledge. He was certain of that.

He tested his plan. The fingers of his left hand clawlike on the little stripping, he drew back his other fist until his body began teetering backward. But he had no leverage now— he could feel that there would be no force to his swing—and he moved his fist slowly forward till he rocked forward on his knees again and could sense that this swing would carry its greatest force. Glancing down, however, measuring the distance from his fist to the glass, he saw it was less than two feet.

It occurred to him that he could raise his arm over his head, to bring it down against the glass. But, experimenting in slow motion, he knew it would be an awkward blow without the force of a driving punch, and not nearly enough to break the glass.

Facing the window, he had to drive a blow from the shoulder, he knew now, at a distance of less than two feet; and he did not know whether it would break through the heavy glass. It might; he could picture it happening, he could feel it in the nerves of his arm. And it might not; he could feel that too—feel his fist striking this glass and being instantaneously flung back by the unbreaking pane, feel the fingers of his other hand breaking loose, nails scraping along the casing as he fell.

He waited, arm drawn back, fist balled, but in no hurry to strike; this pause, he knew, might be an extension of his life. And to live even a few seconds longer, he felt, even out here on this ledge in the night, was infinitely

better than to die a moment earlier than he had to. His arm grew tired, and he brought it down.

Then he knew that it was time to make the attempt. He could not kneel here hesitating indefinitely till he lost all courage to act, waiting till he slipped off the ledge. Again he drew back his arm, knowing this time that he would not bring it down till he struck. His elbow protruding over Lexington Avenue far below, the fingers of his other hand pressed down bloodlessly tight against the narrow stripping, he waited, feeling the sick tenseness and terrible excitement building. It grew and swelled toward the movement of action, his nerves tautening. He thought of Clare—just a wordless, yearning thought—and then drew his arm back just a bit more, fist so tight his fingers pained him, and knowing he was going to do it. Then with full power, with every last scrap of strength he could bring to bear, he shot his arm forward toward the glass, and he said, *"Clare!"*

He heard the sound, felt the blow, felt himself falling forward, and his hand closed on the living-room curtains, the shards and fragments of glass showering onto the floor. And then, kneeling there on the ledge, an arm thrust into the room up to the shoulder, he began picking away the protruding slivers and great wedges of glass from the window frame, tossing them in onto the rug. And, as he grasped the edges of the empty window frame and climbed into his home, he was grinning in triumph.

He did not lie down on the floor or run through the apartment, as he had promised himself; even in the first few moments it seemed to him natural and normal that he should be where he was. He simply turned to his desk, pulled the crumpled yellow sheet from his pocket, and laid it down where it had been, smoothing it out; then he absently laid a pencil across it to weight it down. He shook his head wonderingly, and turned to walk toward the closet.

There he got out his topcoat and hat and, without waiting to put them on, opened the front door and stepped out, to go find his wife. He turned to pull the door closed and the warm air from the hall rushed through the narrow opening again. As he saw the yellow paper, the pencil flying, scooped off the desk and, unimpeded by the glassless window, sail out into the night and out of his life, Tom Benecke burst into laughter and then closed the door behind him.

Reading Check

1. How does the sheet of yellow paper get onto the ledge below the window?
2. What keeps the sheet of paper from sliding off the edge and falling to the street?
3. What makes the piece of paper so valuable to Tom?
4. How does Tom signal to others that he needs help?
5. What happens to the sheet of yellow paper at the end of the story?

For Study and Discussion

Analyzing and Interpreting the Story

1. The main character of this story, Tom, makes a number of important choices that directly affect the story's plot. **a.** What choice has he already made when the story opens? **b.** Why does he risk his life to retrieve the paper?

2. The two settings—ledge and apartment— are important in this story. **a.** How does Finney set up a contrast between them? **b.** How does he make you feel about each setting?

3a. Describe four crises that hold us in suspense while Tom is on the ledge. **b.** Why does the last crisis seem the worst?

4. How does the title of this story help to intensify our feelings of suspense?

5a. How do Tom's actions at the end of the story show that the experience has changed him? **b.** How would you describe this change?

6. What do you think this story says about work, ambition, and human relationships? Cite specific details to support your answer.

Literary Elements

Setting and Plot

Every story has a **setting,** both a time when and a place where the action occurs. Setting is not always a controlling element in a story, but when the conflict involves a person against a force of nature or against the environment, setting becomes a powerful force.

If setting is presented effectively, it helps readers believe in fictional characters and events. In Finney's story, the major part of the action takes place on a ledge eleven stories above the ground. The setting is depicted in vivid detail:

He saw, in that instant, the Loew's theater sign, blocks ahead past Fiftieth Street; the miles of traffic signals, all green now; the lights of cars and street lamps; countless neon signs; and the moving black dots of people.

Locate details of the setting that you found most effective in creating suspense.

Language and Vocabulary

Using Context Clues

The words and sentences surrounding a word are called its **context.** At times, you can determine the meaning of an unfamiliar word by looking closely at its context. Use context clues to determine the meanings of the italicized words below. Check your guesses in the glossary at the back of this textbook or in a dictionary.

Again he lowered his fingerholds another foot and bent his knees still more, thigh muscles *taut* . . .

The strength was gone from his legs; his shivering hands—numb, cold, and desperately rigid—had lost all *deftness*; his easy ability to move and balance was gone.

. . . by concentrating his entire mind on first his left foot, then his left hand, then the other foot, then the other hand—he was able to move, almost *imperceptibly* . . .

There'd be a newsreel next, maybe, and then an animated cartoon, and then *interminable* scenes from coming pictures.

. . . he saw the yellow paper, the pencil flying, scooped off the desk and, *unimpeded* by the glassless window, sail out into the night and out of his life . . .

Writing About Literature

Discussing Setting

Discuss the setting of one of the stories you read earlier, such as "Leiningen Versus the Ants," "The Monkey's Paw," or "Neighbor Rosicky." Tell how setting affects the action and characters.

Focus on Narrative Writing

Listing Details of Setting

Jack Finney uses specific **details of setting** very effectively in "Contents of the Dead Man's Pockets." Notice, for example, the details about what Tom feels and hears on the ledge in the paragraph on page 103 beginning "Seconds passed."

Suppose that you were writing a story about a person in a tight spot. List as many specific details as you can about what the character does for a few minutes of time. Besides details of setting, include specific details on your list about the person's sensations, actions, and thoughts. Save your notes.

About the Author

Jack Finney (1911–1995)

Jack Finney was born Walter Braden Finney in Milwaukee and lived for a time in New York City, where he worked in an advertising agency. His most famous novel, *The Body Snatchers,* was first published in 1955; then, in 1973, it was reprinted with the title *The Invasion of the Body Snatchers.* Several of his novels were made into films. Although he was known for his captivating thrillers and science fiction, Finney also wrote detective mysteries and general fiction. Many of his plots reflected his interest in time travel. The novels *Time and Again* (1970) and *About Time* (1986) were well received, as were his short stories, which are collected in *The Third Level* (1957) and *I Love Galesburg in the Springtime* (1963). Like Tom Benecke in "Contents of the Dead Man's Pockets," Finney's heroes often find themselves trapped in the modern, technological world but leave it behind for a simpler, more natural life.

The Rockpile

JAMES BALDWIN

Children who grow up in areas where there are no playgrounds often create their own makeshift playgrounds in unsafe places, against their parents' wishes. As you read, ask yourself why the children in this story are fascinated by the rockpile in their neighborhood.

Across the street from their house, in an empty lot between two houses, stood the rockpile. It was a strange place to find a mass of natural rock jutting out of the ground; and someone, probably Aunt Florence, had once told them that the rock was there and could not be taken away because without it the subway cars underground would fly apart, killing all the people. This, touching on some natural mystery concerning the surface and the center of the earth, was far too intriguing an explanation to be challenged, and it invested the rockpile, moreover, with such mysterious importance that Roy felt it to be his right, not to say his duty, to play there.

Other boys were to be seen there each afternoon after school and all day Saturday and Sunday. They fought on the rockpile. Sure footed, dangerous, and reckless, they rushed each other and grappled on the heights, sometimes disappearing down the other side in a confusion of dust and screams and upended, flying feet. "It's a wonder they don't kill themselves," their mother said, watching sometimes from the fire escape. "You children stay away from there, you hear me?" Though she said "children" she was looking at Roy, where he sat beside John on the fire escape. "The good Lord knows," she continued, "I don't want you to come home bleeding like a hog every day the Lord sends." Roy shifted impatiently, and continued to stare at the street, as though in this gazing he might somehow acquire wings. John said nothing. He had not really been spoken to: he was afraid of the rockpile and of the boys who played there.

Each Saturday morning John and Roy sat on the fire escape and watched the forbidden street below. Sometimes their mother sat in the room behind them, sewing, or dressing their younger sister, or nursing the baby, Paul. The sun fell across them and across the fire escape with a high, benevolent indifference; below them, men and women, and boys and girls, sinners all, loitered; sometimes one of the church-members passed and saw them and waved. Then, for the moment that they waved decorously back, they were intimidated. They watched the saint, man or woman, until he or she had disappeared from sight. The passage of one of the redeemed made them consider, however vacantly, the wickedness of the street,

their own latent wickedness in sitting where they sat; and made them think of their father, who came home early on Saturdays and who would soon be turning this corner and entering the dark hall below them.

But until he came to end their freedom, they sat, watching and longing above the street. At the end of the street nearest their house was the bridge which spanned the Harlem River and led to a city called the Bronx;[1] which was where Aunt Florence lived. Nevertheless, when they saw her coming, she did not come from the bridge, but from the opposite end of the street. This, weakly, to their minds, she explained by saying that she had taken the subway, not wishing to walk, and that, besides, she did not live in *that* section of the Bronx. Knowing that the Bronx was across the river, they did not believe this story ever, but, adopting toward her their father's attitude, assumed that she had just left some sinful place which she dared not name, as, for example, a movie palace.

In the summertime boys swam in the river, diving off the wooden dock, or wading in from the garbage-heavy bank. Once a boy, whose name was Richard, drowned in the river. His mother had not known where he was; she had even come to their house, to ask if he was there. Then, in the evening, at six o-clock, they had heard from the street a woman screaming and wailing; and they ran to the windows and looked out. Down the street came the woman, Richard's mother, screaming, her face raised to the sky and tears running down her face. A woman walked beside her, trying to make her quiet and trying to hold her up. Behind them walked a man, Richard's father, with Richard's body in his arms. There were two white policemen walking in the gutter, who did not

1. **Harlem River . . . Bronx:** The Harlem River separates two of New York City's boroughs: Manhattan and the Bronx.

seem to know what should be done. Richard's father and Richard were wet, and Richard's body lay across his father's arms like a cotton baby. The woman's screaming filled all the street; cars slowed down and the people in the cars stared; people opened their windows and looked out and came rushing out of doors to stand in the gutter, watching. Then the small procession disappeared within the house which stood beside the rockpile. Then, *"Lord, Lord, Lord!"* cried Elizabeth, their mother, and slammed the window down.

One Saturday, an hour before his father would be coming home, Roy was wounded on the rockpile and brought screaming upstairs. He and John had been sitting on the fire escape and their mother had gone into the kitchen to sip tea with Sister McCandless. By and by Roy became bored and sat beside John in restless silence; and John began drawing into his schoolbook a newspaper advertisement which featured a new electric locomotive. Some friends of Roy passed beneath the fire escape and called him. Roy began to fidget, yelling down to them through the bars. Then a silence fell. John looked up. Roy stood looking at him.

"I'm going downstairs," he said.

"You better stay where you is, boy. You know Mama don't want you going downstairs."

"I be right *back*. She won't even know I'm gone, less you run and tell her."

"I ain't *got* to tell her. What's going to stop her from coming in here and looking out the window?"

"She's talking," Roy said. He started into the house.

"But Daddy's going to be home soon!"

"I be back before *that*. What you all the time got to be so *scared* for?" He was already in the house and he now turned, leaning on the windowsill, to swear impatiently, "I be back in *five* minutes."

John watched him sourly as he carefully unlocked the door and disappeared. In a moment he saw him on the sidewalk with his friends. He did not dare to go and tell his mother that Roy had left the fire escape because he had practically promised not to. He started to shout, *Remember, you said five minutes!* but one of Roy's friends was looking up at the fire escape. John looked down at his schoolbook: he became engrossed again in the problem of the locomotive.

When he looked up again he did not know how much time had passed, but now there was a gang fight on the rockpile. Dozens of boys fought each other in the harsh sun: clambering up the rocks and battling hand to hand, scuffed shoes sliding on the slippery rock; fill-

ing the bright air with curses and jubilant cries. They filled the air, too, with flying weapons: stones, sticks, tin cans, garbage, whatever could be picked up and thrown. John watched in a kind of absent amazement—until he remembered that Roy was still downstairs, and that he was one of the boys on the rockpile. Then he was afraid; he could not see his brother among the figures in the sun; and he stood up, leaning over the fire-escape railing. Then Roy appeared from the other side of the rocks; John saw that his shirt was torn; he was laughing. He moved until he stood at the very top of the rockpile. Then, something, an empty tin can, flew out of the air and hit him on the forehead, just above the eye. Immediately, one side of Roy's face ran with blood, he fell and rolled on his face down the rocks. Then for a moment there was no movement at all, no sound, the sun, arrested,[2] lay on the street and the sidewalk and the arrested boys. Then someone screamed or shouted; boys began to run away, down the street, toward the bridge. The figure on the ground, having caught its breath and felt its own blood, began to shout. John cried, "Mama! Mama!" and ran inside.

"Don't fret, don't fret," panted Sister Mc-Candless as they rushed down the dark, narrow, swaying stairs, "don't fret. Ain't a boy been born don't get his knocks every now and again. *Lord!*" they hurried into the sun. A man had picked Roy up and now walked slowly toward them. One or two boys sat silent on their stoops; at either end of the street there was a group of boys watching. "He ain't hurt bad," the man said, "wouldn't be making this kind of noise if he was hurt real bad."

Elizabeth, trembling, reached out to take Roy, but Sister McCandless, bigger, calmer, took him from the man and threw him over her shoulder as she once might have handled

2. **arrested:** motionless.

a sack of cotton. "God bless you," she said to the man, "God bless you, son." Roy was still screaming. Elizabeth stood behind Sister McCandless to stare at his bloody face.

"It's just a flesh wound," the man kept saying, "just broke the skin, that's all." They were moving across the sidewalk, toward the house. John, not now afraid of the staring boys, looked toward the corner to see if his father was yet in sight.

Upstairs, they hushed Roy's crying. They bathed the blood away, to find, just above the left eyebrow, the jagged, superficial scar. "Lord, have mercy," murmured Elizabeth, "another inch and it would've been his eye." And she looked with apprehension toward the clock. "Ain't it the truth," said Sister Mc-Candless, busy with bandages and iodine.

"When did he go downstairs?" his mother asked at last.

Sister McCandless now sat fanning herself in the easy chair, at the head of the sofa where Roy lay, bound and silent. She paused for a moment to look sharply at John. John stood near the window, holding the newspaper advertisement and the drawing he had done.

"We was sitting on the fire escape," he said. "Some boys he knew called him."

"When?"

"He said he'd be back in five minutes."

"Why didn't you tell me he was downstairs?"

He looked at his hands, clasping his notebook, and did not answer.

"Boy," said Sister McCandless, "you hear your mother a-talking to you?"

He looked at his mother. He repeated:

"He said he'd be back in five minutes."

"He said he'd be back in five minutes," said Sister McCandless with scorn, "don't look to me like that's no right answer. You's the man of the house, you supposed to look after your baby brothers and sisters—you ain't supposed to let them run off and get half-killed. But I

expect," she added, rising from the chair, dropping the cardboard fan, "your Daddy'll make you tell the truth. Your Ma's way too soft with you."

He did not look at her, but at the fan where it lay in the dark red, depressed seat where she had been. The fan advertised a pomade for the hair and showed a brown woman and her baby, both with glistening hair, smiling happily at each other.

"Honey," said Sister McCandless, "I got to be moving along. Maybe I drop in later to-night. I don't reckon you going to be at Tarry Service tonight?"

Tarry Service was the prayer meeting held every Saturday night at church to strengthen believers and prepare the church for the coming of the Holy Ghost on Sunday.

"I don't reckon," said Elizabeth. She stood up; she and Sister McCandless kissed each other on the cheek. "But you be sure to re-member me in your prayers."

"I surely will do that." She paused, with her hand on the door knob, and looked down at Roy and laughed. "Poor little man," she said, "reckon he'll be content to sit on the fire escape *now.*"

Elizabeth laughed with her. "It sure ought to be a lesson to him. You don't reckon," she asked nervously, still smiling, "he going to keep that scar, do you?"

"Lord, no," said Sister McCandless, "ain't nothing but a scratch. I declare, Sister Grimes, you worse than a child. Another couple of weeks and you won't be able to *see* no scar. No, you go on about your housework, honey, and thank the Lord it weren't no worse." She opened the door; they heard the sound of feet on the stairs. "I expect that's the Reverend," said Sister McCandless, placidly, "I *bet* he going to raise cain."[3]

<hr/>

3. **raise cain:** to make trouble (slang).

"Maybe it's Florence," Elizabeth said. "Some-times she get here about this time." They stood in the doorway, staring, while the steps reached the landing below and began again climbing to their floor. "No," said Elizabeth then, "that ain't her walk. That's Gabriel."

"Well, I'll just go on," said Sister McCandless, "and kind of prepare his mind." She pressed Elizabeth's hand as she spoke and started into the hall, leaving the door behind her slightly ajar. Elizabeth turned slowly back into the room. Roy did not open his eyes, or move; but she knew that he was not sleeping; he wished to delay until the last possible moment any contact with his father. John put his newspaper and his notebook on the table and stood, lean-ing on the table, staring at her.

"It wasn't my fault," he said. "I couldn't stop him from going downstairs."

"No," she said, "you ain't got nothing to worry about. You just tell your Daddy the truth."

He looked directly at her, and she turned to the window, staring into the street. What was Sister McCandless saying? Then from her bed-room she heard Delilah's thin wail and she turned, frowning, looking toward the bed-room and toward the still open door. She knew that John was watching her. Delilah continued to wail, she thought, angrily, *Now that girl's getting too big for that,* but she feared that De-lilah would awaken Paul and she hurried into the bedroom. She tried to soothe Delilah back to sleep. Then she heard the front door open and close—too loud, Delilah raised her voice, with an exasperated sigh Elizabeth picked the child up. Her child and Gabriel's, her children and Gabriel's: Roy, Delilah, Paul. Only John was nameless and a stranger, living, unalter-able testimony to his mother's days in sin.

"What happened?" Gabriel demanded. He stood, enormous, in the center of the room, his black lunchbox dangling from his hand,

staring at the sofa where Roy lay. John stood just before him, it seemed to her astonished vision just below him, beneath his fist, his heavy shoe. The child stared at the man in fascination and terror—when a girl down home she had seen rabbits stand so paralyzed before the barking dog. She hurried past Gabriel to the sofa, feeling the weight of Delilah in her arms like the weight of a shield, and stood over Roy, saying:

"Now, ain't a thing to get upset about, Gabriel. This boy sneaked downstairs while I had my back turned and got hisself hurt a little. He's alright now."

Roy, as though in confirmation, now opened his eyes and looked gravely at his father. Gabriel dropped his lunchbox with a clatter and knelt by the sofa.

"How you feel, son? Tell your Daddy what happened?"

Roy opened his mouth to speak and then, relapsing into panic, began to cry. His father held him by the shoulder.

"You don't want to cry. You's Daddy's little man. Tell your Daddy what happened."

"He went downstairs," said Elizabeth, "where he didn't have no business to be, and got to fighting with them bad boys playing on that rockpile. That's what happened and it's a mercy it weren't nothing worse."

He looked up at her. "Can't you let this boy answer me for hisself?"

Ignoring this, she went on, more gently: "He got cut on the forehead, but it ain't nothing to worry about."

"You call a doctor? How you know it ain't nothing to worry about?"

"Is you got money to be throwing away on doctors? No, I ain't called no doctor. Ain't nothing wrong with my eyes that I can't tell whether he's hurt bad or not. He got a fright more'n anything else, and you ought to pray God it teaches him a lesson."

"You got a lot to say *now,*" he said, "but I'll have *me* something to say in a minute. I'll be wanting to know when all this happened, what you was doing with your eyes *then.*" He turned back to Roy, who had lain quietly sobbing eyes wide open and body held rigid: and who now, at his father's touch, remembered the height, the sharp, sliding rock beneath his feet, the sun, the explosion of the sun, his plunge into darkness and his salty blood; and recoiled, beginning to scream, as his father touched his forehead. "Hold still, hold still," crooned his father, shaking, "hold still. Don't cry. Daddy ain't going to hurt you, he just wants to see this bandage, see what they've done to his little man." But Roy continued to scream and would not be still and Gabriel dared not lift the bandage for fear of hurting him more. And he looked at Elizabeth in fury: "Can't you put that child down and help me with this boy? John, take your baby sister from your mother—don't look like neither of you got good sense."

John took Delilah and sat down with her in the easy chair. His mother bent over Roy, and held him still, while his father, carefully—but still Roy screamed—lifted the bandage and stared at the wound. Roy's sobs began to lessen. Gabriel readjusted the bandage. "You see," said Elizabeth, finally, "he ain't nowhere near dead."

"It sure ain't your fault that he ain't dead." He and Elizabeth considered each other for a moment in silence. "He came mighty close to losing an eye. Course, his eyes ain't as big as your'n, so I reckon you don't think it matters so much." At this her face hardened; he smiled. "Lord, have mercy," he said, "you think you ever going to learn to do right? Where was you when all this happened? Who let him go downstairs?"

"Ain't nobody let him go downstairs, he just went. He got a head just like his father, it got

to be broken before it'll bow. I was in the kitchen."

"Where was Johnnie?"

"He was in here?"

"Where?"

"He was on the fire escape."

"Didn't he know Roy was downstairs?"

"I reckon."

"What you mean, you reckon? He ain't got your big eyes for nothing, does he?" He looked over at John. "Boy, you see your brother go downstairs?"

"Gabriel, ain't no sense in trying to blame Johnnie. You know right well if you have trouble making Roy behave, he ain't going to listen to his brother. He don't hardly listen to me."

"How come you didn't tell your mother Roy was downstairs?"

John said nothing, staring at the blanket which covered Delilah.

"Boy, you hear me? You want me to take a strap to you?"

"No, you ain't," she said. "You ain't going to take no strap to this boy, not today you ain't. Ain't a soul to blame for Roy's lying up there now but you—you because you done spoiled him so that he thinks he can do just anything and get away with it. I'm here to tell you that ain't no way to raise no child. You don't pray to the Lord to help you do better than you been doing, you going to live to shed bitter tears that the Lord didn't take his soul today." And she was trembling. She moved, unseeing, toward John and took Delilah from his arms. She looked back at Gabriel, who had risen, who stood near the sofa, staring at her. And she found in his face not fury alone, which would not have surprised her; but hatred so deep as to become insupportable in its lack of personality. His eyes were struck alive, unmoving, blind with malevolence—she felt, like the pull of the earth at her feet, his longing to witness

her perdition.[4] Again, as though it might be propitiation,[5] she moved the child in her arms. And at this his eyes changed, he looked at Elizabeth, the mother of his children, the help-meet given by the Lord. Then her eyes clouded; she moved to leave the room; her foot struck the lunchbox lying on the floor.

"John," she said, "pick up your father's lunchbox like a good boy."

She heard, behind her, his scrambling movement as he left the easy chair, the scrape and jangle of the lunchbox as he picked it up, bending his dark head near the toe of his father's heavy shoe.

4. **perdition:** eternal damnation.
5. **propitiation** (prō-pĭsh′ē-ā′shən): an act that appeases or soothes.

<hr>

Reading Check

1. Where do John and Roy sit on Saturday mornings?
2. How do the boys in the neighborhood use the rockpile?
3. Why doesn't John tell his mother that Roy is on the rockpile?
4. What does John do while his brother plays on the rockpile?
5. Whom does Gabriel blame for the accident?

For Study and Discussion

Analyzing and Interpreting the Story

1. Roy is attracted to the rockpile whereas John is afraid of it. What does this contrast reveal about the two boys?

2. Why is the street "forbidden" to the children in the family?

3a. What is the boys' attitude toward their

father? **b.** What do you think causes them to feel as they do about him?

4. John is expected to be responsible for Roy. Do you think this is a reasonable expectation?

5. How does the accident on the rockpile bring the conflicts in the family to a head?

6. The rockpile is an important symbol in the story. It stands for something in itself and for a broader meaning as well. **a.** How does the rockpile emphasize the threatening nature of the setting? **b.** How does it also reveal the helplessness of the characters in the story?

Focus on Narrative Writing

Using Sensory Images

Sensory images are words or phrases that appeal to one or more of the five senses: sight, hearing, smell, taste, and touch. In the fifth paragraph of "The Rockpile," for example, James Baldwin uses vivid sensory images that appeal to sight, hearing, and touch in order to describe the young boy Richard's death by drowning (see page 113).

Choose an exciting moment from a concert or sports event you attended recently. Shut your eyes and try to visualize this moment. On a chart like the one below, make a list of concrete, sensory images that you could use in a paragraph to re-create the moment for readers. Try to include images that appeal to all five senses. Save your notes.

Sensory Images				
Sight	Hearing	Smell	Taste	Touch

About the Author

James Baldwin (1924–1987)

After James Baldwin's death in St. Paul de Vence, France, a memorial service was held for him in New York City. Thousands of mourners attended, and eulogies were given by a number of renowned African American writers, including Maya Angelou, Toni Morrison, and Amiri Baraka. Baldwin had been not only an important voice for the African American community but also one of the nation's most influential writers.

Baldwin was born and raised in a Harlem neighborhood much like the one described in "The Rockpile." He began writing at an early age but worked at several jobs before becoming a professional writer. He found employment as a handyman, dishwasher, waiter, and factory worker. By 1947 he had begun attracting attention as a writer, and within a few years, he would become a major figure in American literature. African American family life is the subject for much of his work and Harlem is often the setting.

Baldwin's novels include *Go Tell It on the Mountain* (1953), *Tell Me How Long the Train's Been Gone* (1968), and *If Beale Street Could Talk* (1974). In addition, Baldwin is well known for his nonfiction, such as *Notes of a Native Son* (1955) and *The Fire Next Time* (1962), and for plays, such as *The Amen Corner* (1968) and *Blues for Mister Charlie* (1964).

The Masque°
of the Red Death

EDGAR ALLAN POE

Atmosphere is the overall mood or feeling established in a work of art. In literature, atmosphere is most often produced by descriptions of setting. As you read this story, note how Poe uses setting to create a mood of nightmarish horror.

The "Red Death" had long devastated the country. No pestilence had ever been so fatal, or so hideous. Blood was its Avatar[1] and its seal—the redness and the horror of blood. There were sharp pains, and sudden dizziness, and then profuse bleeding at the pores, with dissolution. The scarlet stains upon the body and especially upon the face of the victim were the pest ban which shut him out from the aid and from the sympathy of his fellow men. And the whole seizure, progress, and termination of the disease were the incidents of half an hour.

But the Prince Prospero was happy and dauntless and sagacious. When his dominions were half depopulated, he summoned to his presence a thousand hale and lighthearted friends from among the knights and dames of his court, and with these retired to the deep seclusion of one of his castellated[2] abbeys. This was an extensive and magnificent structure, the creation of the prince's own eccentric yet august taste. A strong and lofty wall girdled it in. This wall had gates of iron. The courtiers, having entered, brought furnaces and massy[3] hammers and welded the bolts. They resolved to leave means neither of ingress or egress to the sudden impulses of despair or of frenzy from within. The abbey was amply provisioned. With such precautions the courtiers might bid defiance to contagion. The external world could take care of itself. In the meantime it was folly to grieve, or to think. The prince had provided all the appliances of pleasure. There were buffoons, there were im-

° **Masque** (măsk): a masked ball; a masquerade.
1. **Avatar** (ăv′ə-tär′): a sign or an embodiment of an invisible force.

2. **castellated** (kăs′tə-lā′tĭd): having towers like those of a castle.
3. **massy:** here: massive.

provisatori,[4] there were ballet dancers, there were musicians, there was Beauty, there was wine. All these and security were within. Without was the "Red Death."

It was toward the close of the fifth or sixth month of his seclusion, and while the pestilence raged most furiously abroad, that the Prince Prospero entertained his thousand friends at a masked ball of the most unusual magnificence.

It was a voluptuous scene, that masquerade. But first let me tell of the rooms in which it was held. There were seven—an imperial suite. In many palaces, however, such suites form a long and straight vista, while the folding doors slide back nearly to the walls on either hand, so that the view of the whole extent is scarcely impeded. Here the case was very different; as might have been expected from the duke's love of the *bizarre*. The apartments were so irregularly disposed that the vision embraced but little more than one at a time. There was a sharp turn at every twenty or thirty yards, and at each turn a novel effect. To the right and left, in the middle of each wall, a tall and narrow Gothic window looked out upon a closed corridor which pursued the windings of the suite. These windows were of stained glass whose color varied in accordance with the prevailing hue of the decorations of the chamber into which it opened. That at the eastern extremity was hung, for example, in blue—and vividly blue were its windows. The second chamber was purple in its ornaments and tapestries, and here the panes were purple. The third was green throughout, and so were the casements. The fourth was furnished and lighted with orange—the fifth with white—the sixth with violet. The seventh apartment was closely shrouded in black velvet tapestries that

hung all over the ceiling and down the walls, falling in heavy folds upon a carpet of the same material and hue. But in this chamber only, the color of the windows failed to correspond with the decorations. The panes here were scarlet—a deep blood color. Now in no one of the seven apartments was there any lamp or candelabrum, amid the profusion of golden ornaments that lay scattered to and fro or depended from the roof. There was no light of any kind emanating from lamp or candle within the suite of chambers. But in the corridors that followed the suite, there stood, opposite to each window, a heavy tripod, bearing a brazier of fire that projected its rays through the tinted glass and so glaringly illumined the room. And thus were produced a multitude of gaudy and fantastic appearances. But in the western or black chamber the effect of the firelight that streamed upon the dark hangings through the blood-tinted panes was ghastly in the extreme, and produced so wild a look upon the countenances of those who entered that there were few of the company bold enough to set foot within its precincts at all.

It was in this apartment, also, that there stood against the western wall a gigantic clock of ebony. Its pendulum swung to and fro with a dull, heavy, monotonous clang; and when the minute hand made the circuit of the face, and the hour was to be stricken, there came from the brazen lungs of the clock a sound which was clear and loud and deep and exceedingly musical, but of so peculiar a note and emphasis that, at each lapse of an hour, the musicians of the orchestra were constrained to pause momentarily in their performance to hearken to the sound; and thus the waltzers perforce ceased their evolutions; and there was a brief disconcert of the whole gay company; and, while the chimes of the clock yet rang, it was observed that the giddiest grew pale, and the more aged and sedate passed their hands over

4. **improvisatori** (ĭm′prə-vē′zə-tôr′ē): actors who make up scenes at the suggestions of onlookers.

their brows as if in confused reverie or meditation. But when the echoes had fully ceased, a light laughter at once pervaded the assembly; the musicians looked at each other and smiled as if at their own nervousness and folly, and made whispering vows, each to the other, that the next chiming of the clock should produce in them no similar emotion; and then, after the lapse of sixty minutes (which embrace three thousand and six hundred seconds of the Time that flies), there came yet another chiming of the clock, and then were the same disconcert and tremulousness and meditation as before.

But in spite of these things, it was a gay and magnificent revel. The tastes of the duke were peculiar. He had a fine eye for colors and effects. He disregarded the *decora*[5] of mere fashion. His plans were bold and fiery, and his conceptions glowed with barbaric luster. There are some who would have thought him mad. His followers felt that he was not. It was necessary to hear and see and touch him to be *sure* that he was not.

He had directed, in great part, the movable embellishments of the seven chambers, upon occasion of this great *fête;* and it was his own guiding taste which had given character to the masqueraders. Be sure they were grotesque. There were much glare and glitter and piquancy and phantasm—much of what has been since seen in *Hernani*.[6] There were arabesque figures with unsuited limbs and appointments. There were delirious fancies such as the madman fashions. There was much of the beautiful, much of the wanton, much of the *bizarre,* something of the terrible, and not a little of that which might have excited disgust. To and fro in the seven chambers there stalked, in fact, a multitude of dreams. And

these—the dreams—writhed in and about, taking hue from the rooms, and causing the wild music of the orchestra to seem as the echo of their steps. And, anon, there strikes the ebony clock which stands in the hall of the velvet. And then, for a moment, all is still, and all is silent save the voice of the clock. The dreams are stiff-frozen as they stand. But the echoes of the chime die away—they have endured but an instant—and a light, half-subdued laughter floats after them as they depart. And now again the music swells, and the dreams live, and writhe to and fro more merrily than ever, taking hue from the many-tinted windows through which stream the rays from the tripods. But to the chamber which lies most westwardly of the seven, there are now none of the maskers who venture; for the night is waning away; and there flows a ruddier light through the blood-colored panes; and the blackness of the sable drapery appals; and to him whose foot falls upon the sable carpet, there comes from the near clock of ebony a muffled peal more solemnly emphatic than any which reaches *their* ears who indulge in the more remote gaieties of the other apartments.

But these other apartments were densely crowded, and in them beat feverishly the heart of life. And the revel went whirlingly on, until at length there commenced the sounding of midnight upon the clock. And then the music ceased, as I have told; and the evolutions of the waltzers were quieted; and there was an uneasy cessation of all things as before. But now there were twelve strokes to be sounded by the bell of the clock; and thus it happened, perhaps, that more of thought crept, with more of time, into the meditations of the thoughtful among those who reveled. And thus, too, it happened, perhaps, that before the last echoes of the last chime had utterly sunk into silence, there were many individuals in the crowd who had found leisure to become

5. *decora:* Latin for "dictates."
6. *Hernani:* a romantic tragedy of 1830 by the French author Victor Hugo (1802–1885).

The Masque of the Red Death (1883) by Odilon Redon (1840–1916). Charcoal
on brown paper.

aware of the presence of a masked figure which had arrested the attention of no single individual before. And the rumor of this new presence having spread itself whisperingly around, there arose at length from the whole company a buzz, or murmur, expressive of disapprobation and surprise—then, finally, of terror, of horror, and of disgust.

In an assembly of phantasms such as I have painted, it may well be supposed that no ordinary appearance could have excited such sensation. In truth the masquerade license of the night was nearly unlimited; but the figure in question had out-Heroded Herod,[7] and gone beyond the bounds of even the prince's indefinite decorum. There are chords in the hearts of the most reckless which cannot be touched without emotion. Even with the utterly lost, to whom life and death are equally jests, there are matters of which no jest can be made. The whole company, indeed, seemed now deeply to feel that in the costume and bearing of the stranger neither wit nor propriety existed. The figure was tall and gaunt, and shrouded from head to foot in the habiliments of the grave. The mask which concealed the visage was made so nearly to resemble the countenance of a stiffened corpse that the closest scrutiny must have had difficulty in detecting the cheat. And yet all this might have been endured, if not approved, by the mad revelers around. But the mummer[8] had gone so far as to assume the type of the Red Death. His vesture was dabbled in *blood*— and his broad brow, with all the features of the face, was besprinkled with the scarlet horror.

When the eyes of Prince Prospero fell upon this spectral image (which with a slow and solemn movement, as if more fully to sustain its *rôle,* stalked to and fro among the waltzers) he was seen to be convulsed, in the first moment with a strong shudder either of terror or distaste; but, in the next, his brow reddened with rage.

"Who dares?" he demanded hoarsely of the courtiers who stood near him—"who dares insult us with this blasphemous mockery? Seize him and unmask him—that we may know whom we have to hang at sunrise from the battlements!"

It was in the eastern or blue chamber in which stood the Prince Prospero as he uttered these words. They rang throughout the seven rooms loudly and clearly—for the prince was a bold and robust man, and the music had become hushed at the waving of his hand.

It was in the blue room where stood the prince with a group of pale courtiers by his side. At first, as he spoke, there was a slight rushing movement of this group in the direction of the intruder, who at the moment was also near at hand, and now, with deliberate and stately step, made closer approach to the speaker. But from a certain nameless awe with which the mad assumptions of the mummer had inspired the whole party, there were found none who put forth hand to seize him; so that, unimpeded, he passed within a yard of the prince's person; and, while the vast assembly, as if with one impulse, shrank from the centers of the rooms to the walls, he made his way uninterruptedly, but with the same solemn and measured step which had distinguished him from the first, through the blue chamber to the purple—through the purple to the green—through the green to the orange— through this again to the white—and even thence to the violet, ere a decided movement had been made to arrest him. It was then, however, that the Prince Prospero, maddening

7. **out-Heroded Herod:** overplayed his part. Herod, the king of Judea, ordered the slaughter of all babies in Bethlehem in hopes of destroying the infant Jesus. He is usually depicted as a raging, demented figure. Shakespeare uses the phrase in *Hamlet* (III, 2) for overacting.
8. **mummer:** masked figure.

with rage and the shame of his own momentary cowardice, rushed hurriedly through the six chambers, while none followed him on account of a deadly terror that had seized upon all. He bore aloft a drawn dagger, and had approached, in rapid impetuosity, to within three or four feet of the retreating figure, when the latter, having attained the extremity of the velvet apartment, turned suddenly and confronted his pursuer. There was a sharp cry—and the dagger dropped gleaming upon the sable carpet, upon which, instantly afterwards, fell prostrate in death the Prince Prospero. Then, summoning the wild courage of despair, a throng of the revelers at once threw themselves into the black apartment and, seizing the mummer, whose tall figure stood erect and motionless within the shadow of the ebony clock, gasped in unutterable horror at finding the grave cerements[9] and corpselike mask, which they handled with so violent a rudeness, untenanted by any tangible form.

And now was acknowledged the presence of the Red Death. He had come like a thief in the night.[10] And one by one dropped the revelers in the blood-bedewed halls of their revel, and died each in the despairing posture of his fall. And the life of the ebony clock went out with that of the last of the gay. And the flames of the tripods expired. And Darkness and Decay and the Red Death held illimitable dominion over all.

9. **cerements** (sîr′mənts): burial clothes; shroud.
10. **a thief in the night:** a Biblical reference to 1 Thessalonians 5:2–3, which suggests sudden and swift destruction: "For yourselves know perfectly that the day of the Lord so cometh as a thief in the night."

"For when they shall say, Peace and safety; then sudden destruction cometh upon them, as travail upon a woman with child; and they shall not escape."

Reading Check

1. Why is the plague known as the "Red Death"?
2. What is Prince Prospero's plan for survival?
3. What entertainment does he provide for his friends?
4. Which room contains the ebony clock?
5. At what time does the uninvited guest appear?

For Study and Discussion

Analyzing and Interpreting the Story

1. This story takes place in a country devastated by the plague. What kind of life do Prince Prospero and his friends lead in their world apart?

2. Describe the seven rooms of the prince's suite. What is significant about the number seven, about the colors of the rooms, and about their progression from east to west?

3. Why do you think the masqueraders avoid the seventh room—the black room with the blood-red windows?

4. Many readers consider the ebony clock to be especially significant in this story. What do you think it stands for?

5. In the paragraph that describes the masquerade (page 122), find words and phrases that suggest nightmare and madness.

6. Who or what do you assume the masked figure to be and what does his arrival at the party signify?

7. Poe believed that every detail in a short story should contribute to a single emotional effect. Explain the "single emotional effect" you think is conveyed by this story.

Literary Elements

Setting and Atmosphere

In "The Masque of the Red Death" all the details of setting add up to a fictional world of nightmarish horror. Consider this passage in which the narrator describes the seventh chamber:

> The seventh apartment was closely shrouded in black velvet tapestries that hung all over the ceiling and down the walls, falling in heavy folds upon a carpet of the same material and hue. But in this chamber only, the color of the windows failed to correspond with the decorations. The panes here were a scarlet—a deep blood color.

Find other passages that emphasize the nightmarish setting in which Prince Prospero and his friends hold their masquerade.

Language and Vocabulary

Understanding Denotation and Connotation

All words have **denotations,** which are their strict dictionary meanings or definitions. The denotative meaning of *blood,* for example, is "a red fluid that circulates through the heart, veins, and arteries of vertebrates." Many words also have **connotations,** feelings and associations that have come to be attached to the words in addition to their strict, literal meanings. The word *blood,* for example, is especially rich in connotations. Blood is often associated with thoughts of death, wounds, and pain.

Poe, of course, was aware of these two aspects of the meanings of words. Reread the paragraph beginning "In an assembly of phantasms" (page 124). Explain the denotative and the connotative meanings of the following words:

phantasms	gaunt	corpse
license	shrouded	horror
jest		

How do words like these affect your feelings as you read this paragraph?

Focus on Narrative Writing

Creating Atmosphere

In "The Masque of the Red Death," Poe uses many details of setting—for example, in the description of the plague at the outset and in the description of the gigantic ebony clock—to create an ominous **atmosphere,** or mood. This atmosphere, in turn, contributes to maintaining suspense until the climax of the story.

Choose a story idea you have developed earlier in this unit, or brainstorm a new idea for a narrative. Explore the use of setting to create atmosphere by filling out an outline like the one below. Focus on identifying details of setting that contribute to a single overall atmosphere or mood. Save your notes.

Story Outline

Story Idea: _____

Overall Atmosphere/Mood: _____

Present/Past/or Future: _____

Season of Year: _____

Time of Day/Night: _____

Outside/Inside: _____

Weather Conditions: _____

Sensory Images: _____

About the Author

Edgar Allan Poe (1809–1849)

The Granger Collection, New York

The son of traveling actors, Poe was orphaned at an early age. Shortly after Poe's birth, his father deserted the family and his mother died within two years. Poe went to live in Richmond, Virginia, with a wealthy couple named John and Frances Allan. Mrs. Allan loved the boy as her own, but Poe and John Allan would always have a troubled relationship. Poe was an excellent athlete and a brilliant student, but his guardian disapproved of his literary ambitions and sent him to the University of Virginia on a small allowance. Poe eventually left school because of gambling debts. He joined the army and served for two years. He entered West Point to make peace with Allan but deliberately got himself expelled after realizing that a reconciliation was impossible. Cast off by Allan, Poe went to live with a poor aunt and later married her thirteen-year-old daughter, Virginia Clemm. In Richmond, New York, Baltimore, and Philadelphia, Poe tried to support his household by working as a magazine editor and newspaper writer. When his young wife died of tuberculosis, Poe was driven deeper into despair. Showing signs of mental illness, he died a few years later on a rainy Baltimore sidewalk.

Poe is famous for his tales of horror and suspense. Many modern detective stories have been modeled after Poe's, and his techniques have greatly influenced writers and thrilled readers for well over a century. Among his most admired stories are "The Tell-Tale Heart," "The Pit and the Pendulum," "The Fall of the House of Usher," "The Murders in the Rue Morgue," "Ligeia," and "The Purloined Letter."

Poe is also known for his poetry and literary criticism. Among his best-known poems are "The Raven," "Annabel Lee," and "The Bells."

Literature and the Arts

Interpretations of Poe's Work

Many artists have interpreted Poe's stories and poems. The French Impressionist Edouard Manet made a series of lithographs for a French edition of "The Raven." Edmund Dulac made colored lithographs for an edition of "The Bells." Arthur Rackham created watercolors to accompany "The Fall of the House of Usher." The charcoal illustrations for "The Masque of the Red Death" shown on pages 120 and 123 were done by Odilon Redon.

Poe has also inspired a number of filmmakers. Among the works that have been adapted for movies are "The Masque of the Red Death," "The Raven," "The Murders in the Rue Morgue," and "The Fall of the House of Usher."

Making Connections: Activities

1. Locate illustrations for some of Poe's stories and poems. Choose several illustrations to evaluate. How does the individual artist interpret the details in Poe's prose or verse?

2. Consider writing a TV script for "The Masque of the Red Death" or another Poe work. What dialogue would you have to add? How would you adapt the story so that it would be suitable for television?

3. If you have studied dance or know someone who choreographs dance, consider a ballet based on "The Masque of the Red Death." What kinds of sets would you need? Who would be the principal dancers? What dance movements would be appropriate?

The Masque of the Red Death **127**

POINT OF VIEW

When writers set out to tell their stories, they must immediately decide on a point of view. *Point of view* simply means the vantage point from which the story is told. The most familiar point of view is the *omniscient point of view.* The word *omniscient* means "all-knowing." In a story told from an omniscient point of view, there is no identifiable narrator. In such a story we tend to think of the writer—not any of the characters—as the storyteller. The omniscient point of view enables the writer to look into the hearts of all of the characters in the story and to reveal their thoughts and feelings to us. With an omniscient narrator, a writer can tell us as much or as little about the characters as he or she wants to. This is how the familiar story of Cinderella might begin if told from the omniscient point of view:

> Once upon a time there was a girl named Cinderella. Cinderella got her name because she was forced to work as a servant and sleep near the cinders. Cinderella was treated cruelly by her wicked stepmother, who was jealous of the girl's good looks and sweet temper because her own daughters were ugly and mean.

A story can also be told from a *limited third-person point of view.* This means that the story is narrated by someone who stands outside the story, but who sees everything from the limited vantage point of only one character. With such a point of view, we feel as if we are taken inside one character's head, for all of our attention is riveted on this one person. With this point of view, we usually do not know much of what the other characters are thinking and feeling. This is how Cinderella's story might begin if told from a limited third-person point of view:

> Once upon a time there was a girl named Cinderella, who was treated cruelly by her stepmother. Cinderella often wept bitterly in her ashy corner. Nightmares haunted her, and she feared the darkened scullery when the rats came out and played about her feet. At times, she wondered if her goodness would ever be rewarded.

Finally, a writer can use the *first-person point of view.* This simply means that the writer lets one of the characters tell the story. This narrator can be the hero or heroine of the story, or a minor character who is observing the action. This person speaks as "I," which is how the

point of view got its name. In the first-person point of view, we might hear the story told in the diction of the narrator. When a story is told in the first person, by a character in the story, we know only what the character reports to us. The advantage of this point of view is that it creates immediacy and intimacy. If Cinderella's story were told in a first-person point of view, this is what we might get:

> I had spent sixteen years sitting in the cinders of the kitchen. My stepmother must have hated me, because she made me do the dirty work. I could not understand the reasons for her feelings, for I had always treated her with respect. I slept in the ashes, and was tortured by nightmares and fear of rats.

It is important to remember that the narrator of a story is different from the author of the story. Sometimes, for example, women write stories that are narrated by men and vice versa. Sometimes stories are told by animals.

To analyze the point of view of a story, ask these questions: Who is the narrator of this story? Is this narrator a character in the story, or does the narrator stand outside the story? Does the narrator know about all the action and characters in the story, or is the narrator's view limited to one character only? How does the point of view affect my reaction to the story's characters and events?

The Quiet Man

MAURICE WALSH

The author who chooses an all-knowing point of view can control the response of readers by revealing or withholding information. In the following story, how much does the author allow you to know about the thoughts, feelings, and experiences of his characters? What does he choose to withhold?

Shawn Kelvin, a blithe young lad of twenty, went to the States to seek his fortune. And fifteen years thereafter he returned to his native Kerry,[1] his blitheness sobered and his youth dried to the core, and whether he had made his fortune or whether he had not, no one could be knowing for certain. For he was a quiet man, not given to talking about himself and the things he had done. A quiet man, under middle size, with strong shoulders and deep-set blue eyes below brows darker than his dark hair—that was Shawn Kelvin. One shoulder had a trick of hunching slightly higher than the other, and some folks said that came from a habit he had of shielding his eyes in the glare of an open-hearth furnace in a place called Pittsburgh, while others said it used to be a way he had of guarding his chin that time he was a sort of sparring-partner punching bag at a boxing camp.

Shawn Kelvin came home and found that he was the last of the Kelvins and that the farm of his forefathers had added its few acres to the ranch of Big Liam O'Grady of Moyvalla. Shawn took no action to recover his land,

though O'Grady had got it meanly. He had had enough of fighting, and all he wanted now was peace. He quietly went amongst the old and kindly friends and quietly looked about him for the place and peace he wanted; and when the time came, quietly produced the money for a neat, handy, small farm on the first warm shoulder of Knockanore Hill below the rolling curves of heather. It was not a big place but it was in good heart, and it got all the sun that was going; and, best of all, it suited Shawn to the tiptop notch of contentment; for it held the peace that tuned to his quietness, and it commanded the widest view in all Ireland—vale and mountain and the lifting green plain of the Atlantic Sea.

There, in a four-roomed, lime-washed, thatched cottage, Shawn made his life, and, though his friends hinted his needs and obligations, no thought came to him of bringing a wife into the place. Yet Fate had the thought and the dream in her loom for him. One middling imitation of a man he had to do chores for him, an ex-navy pensioner handy enough about house and byre,[2] but with no relish for

1. **Kerry:** a county in southwestern Ireland.

2. **byre** (bīr): cow barn.

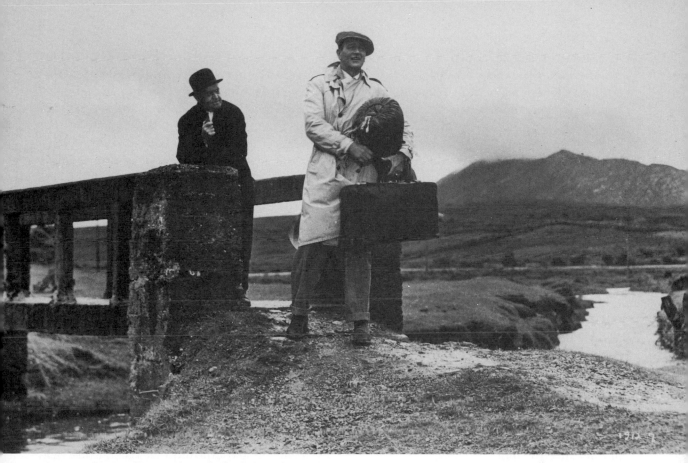

A scene from a film version of *The Quiet Man*.

the sustained work of the field—and, indeed, as long as he kept house and byre shipshape, he found Shawn an easy master.

Shawn himself was no drudge toiler. He knew all about drudgery and the way it wears out a man's soul. He plowed a little and sowed a little, and at the end of a furrow he would lean on the handles of the cultivator, wipe his brow, if it needed wiping, and lose himself for whole minutes in the great green curve of the sea out there beyond the high black portals of Shannon mouth. And sometimes of an evening he would see, under the glory of the sky, the faint smoke smudge of an American liner. Then he would smile to himself—a pitying smile—thinking of the poor devils, with dreams of fortune luring them, going out to

sweat in Ironville or to stand in a breadline.[3] All these things were behind Shawn forever.

Market days he would go down and across to Listowel town, seven miles, to do his bartering; and in the long evenings, slowly slipping into the endless summer gloaming, his friends used to climb the winding lane to see him. Only the real friends came that long road, and they were welcome—fighting men who had been out in the "Sixteen";[4] Matt Tobin the thresher, the schoolmaster, the young curate—men like that. A stone jar of malt whiskey would appear on the table, and there would

3. **breadline:** During the Great Depression in America in the 1930s, people waited in lines for free food.
4. **the "Sixteen":** the unsuccessful Irish rebellion against English rule in 1916.

be a haze of smoke and a maze of warm, friendly disagreements.

"Shawn, old son," one of them might hint, "aren't you sometimes terrible lonely?"

"Never!" might retort Shawn derisively. "Why?"

"Nothing but the daylight and the wind and the sun setting with the wrath o' God."

"Just that! Well?"

"But after stirring times beyond in the States——"

"Ay! Tell me, fine man, have you ever seen a furnace in full blast?"

"A great sight."

"Great surely! But if I could jump you into a steel foundry this minute, you would be sure that God had judged you faithfully into the very hob[5] of hell."

And then they would laugh and have another small one from the stone jar.

And on Sundays Shawn used to go to church, three miles down to the gray chapel above the black cliffs of Doon Bay. There Fate laid her lure for him.

Sitting quietly on his wooden bench or kneeling on the dusty footboard, he would fix his steadfast, deep-set eyes on the vestmented celebrant and say his prayers slowly or go into that stranger trance, beyond dreams and visions, where the soul is almost at one with the unknowable.

But after a time, Shawn's eyes no longer fixed themselves on the celebrant. They went no farther than two seats ahead. A girl sat there, Sunday after Sunday she sat in front of him, and Sunday after Sunday his first casual admiration grew warmer.

She had a white nape to her neck and short red hair above it, and Shawn liked the color and wave of that flame. And he liked the set of her shoulders and the way the white neck

had of leaning a little forward and she at her prayers—or her dreams. And the service over, Shawn used to stay in his seat so that he might get one quick but sure look at her face as she passed out. And he liked her face, too—the wide-set gray eyes, cheekbones firmly curved, clean-molded lips, austere yet sensitive. And he smiled pityingly at himself that one of her name should make his pulses stir—for she was an O'Grady.

One person, only, in the crowded chapel noted Shawn's look and the thought behind the look. Not the girl. Her brother, Big Liam O'Grady of Moyvalla, the very man who as good as stole the Kelvin acres. And that man smiled to himself, too—the ugly, contemptuous smile that was his by nature—and, after another habit he had, he tucked away his bit of knowledge in his mind corner against a day when it might come in useful for his own purposes.

The girl's name was Ellen—Ellen O'Grady. But in truth she was no longer a girl. She was past her first youth into that second one that had no definite ending. She might be thirty— she was no less—but there was not a lad in the countryside would say she was past her prime. The poise of her and the firm set of her bones below clean skin saved her from the fading of mere prettiness. Though she had been sought in marriage more than once, she had accepted no one, or rather, had not been allowed to encourage anyone. Her brother saw to that.

Big Liam O'Grady was a great rawboned, sandy-haired man, with the strength of an ox and a heart no bigger than a sour apple. An overbearing man given to berserk rages. Though he was a churchgoer by habit, the true god of that man was Money—red gold, shining silver, dull copper—the trinity[6] that he worshiped in degree. He and his sister Ellen lived

5. **hob:** ledge inside a fireplace, used for keeping food warm.

6. **trinity:** Big Liam's trinity of money is compared to the Christian Trinity of Father, Son, and Holy Spirit.

on the big ranch farm of Moyvalla, and Ellen was his housekeeper and maid of all work. She was a careful housekeeper, a good cook, a notable baker, and she demanded no wage. All that suited Big Liam splendidly, and so she remained single.

Big Liam himself was not a marrying man. There were not many spinsters with a dowry big enough to tempt him, and the few there were had acquired expensive tastes—a convent education, the deplorable art of hitting jazz out of a piano, the damnable vice of cigarette smoking, the purse-emptying craze for motor cars—such things.

But in due time, the dowry and the place—with a woman tied to them—came under his nose, and Big Liam was no longer tardy. His neighbor, James Carey, died in March and left his fine farm and all on it to his widow, a youngish woman without children, a woman with a hard name for saving pennies. Big Liam looked once at Kathy Carey and looked many times at her broad acres. Both pleased him. He took the steps required by tradition. In the very first week of the following Shrovetide,[7] he sent an accredited emissary to open formal negotiations, and that emissary came back within the hour.

"My soul," said he, "but she is the quick one! I hadn't ten words out of me when she was down my throat. 'I am in no hurry,' says she, 'to come wife to a house with another woman at the fire corner. When Ellen is in a place of her own, I will listen to what Liam O'Grady has to say.' "

"She will, I say!" Big Liam stopped him. "She will so."

There, now, was the right time to recall Shawn Kelvin and the look in his eyes. Big Liam's mind corner promptly delivered up its memory. He smiled knowingly and contemp-

7. **Shrovetide:** the three days before Ash Wednesday.

tuously. Shawn Kelvin daring to cast sheep's eyes at an O'Grady! The undersized chicken heart, who took the loss of the Kelvin acres lying down! The little Yankee runt hidden away on the shelf of Knockanore! But what of it? The required dowry would be conveniently small, and the girl would never go hungry, anyway. There was Big Liam O'Grady, far descended from many chieftains.

The very next market day at Listowel he sought out Shawn Kelvin and placed a huge, sandy-haired hand on the shoulder that hunched to meet it.

"Shawn Kelvin, a word with you! Come and have a drink."

Shawn hesitated. "Very well," he said then. He did not care for O'Grady, but he would hurt no man's feelings.

They went across to Sullivan's bar and had a drink, and Shawn paid for it. And Big Liam came directly to his subject—almost patronizingly, as if he were conferring a favor.

"I want to see Ellen settled in a place of her own," said he.

Shawn's heart lifted into his throat and stayed there. But that steadfast face with the steadfast eyes gave no sign and, moreover, he could not say a word with his heart where it was.

"Your place is small," went on the big man, "but it is handy, and no load of debt on it, as I hear. Not much of a dowry ever came to Knockanore, and not much of a dowry can I be giving with Ellen. Say two hundred pounds at the end of harvest, if prices improve. What do you say, Shawn Kelvin?"

Shawn swallowed his heart, and his voice came slow and cool: "What does Ellen say?"

"I haven't asked her," said Big Liam. "But what would she say, blast it?"

"Whatever she says, she will say it herself, not you, Big Liam."

But what could Ellen say? She looked within

her own heart and found it empty; she looked at the granite crag of her brother's face and contemplated herself a slowly withering spinster at his fire corner; she looked up at the swell of Knockanore Hill and saw the white cottage among the green small fields below the warm brown of the heather. Oh, but the sun would shine up there in the lengthening spring day and pleasant breezes blow in sultry summer; and finally she looked at Shawn Kelvin, that firmly built, small man with the clean face and the lustrous eyes below steadfast brow. She said a prayer to her God and sank head and shoulders in a resignation more pitiful than tears, more proud than the pride of chieftains. Romance? Welladay!

Shawn was far from satisfied with that resigned acceptance, but then was not the time to press for a warmer one. He knew the brother's wizened soul, guessed at the girl's clean one, and saw that she was doomed beyond hope to a fireside sordidly bought for her. Let it be his own fireside then. There were many worse ones—and God was good.

Ellen O'Grady married Shawn Kelvin. One small statement; and it holds the risk of tragedy, the chance of happiness, the probability of mere endurance—choices wide as the world.

But Big Liam O'Grady, for all his resolute promptness, did not win Kathy Carey to wife. She, foolishly enough, took to husband her own cattleman, a gay night rambler, who gave her the devil's own time and a share of happiness in the bygoing. For the first time, Big Liam discovered how mordant the wit of his neighbors could be, and to contempt for Shawn Kelvin he now added an unreasoning dislike.

Shawn Kelvin had got his precious, red-haired woman under his own roof now. He had no illusions about her feelings for him. On himself, and on himself only, lay the task of mold-

ing her into a wife and lover. Darkly, deeply, subtly, away out of sight, with gentleness, with restraint, with a consideration beyond kenning,[8] that molding must be done, and she that was being molded must never know. He hardly knew himself.

First he turned his attention to material things. He hired a small servant maid to help her with the housework. Then he acquired a rubber-tired tub cart and half-bred gelding[9] with a reaching knee action. And on market days, husband and wife used to bowl down to Listowel, do their selling and their buying, and bowl smoothly home again, their groceries in the well of the cart and a bundle of secondhand American magazines on the seat at Ellen's side. And in the nights, before the year turned, with the wind from the plains of the Atlantic keening[10] above the chimney, they would sit at either side of the flaming peat fire, and he would read aloud strange and almost unbelievable things out of the high-colored magazines. Stories, sometimes, wholly unbelievable.

Ellen would sit and listen and smile and go on with her knitting or her sewing; and after a time it was sewing she was at mostly—small things. And when the reading was done, they would sit and talk quietly in their own quiet way. For they were both quiet. Woman though she was, she got Shawn to do most of the talking. It could be that she, too, was probing and seeking, unwrapping the man's soul to feel the texture thereof, surveying the marvel of his life as he spread it diffidently before her. He had a patient, slow, vivid way of picturing for her the things he had seen and felt. He made her see the glare of molten metal, lambent[11] yet searing, made her feel the sucking heat,

8. **kenning:** understanding.
9. **gelding** (gĕl′dĭng): horse.
10. **keening:** moaning; wailing.
11. **lambent:** glowing.

made her hear the clang; she could see the roped square under the dazzle of the hooded arcs with the curling smoke layer above it, understand the explosive restraint of the game, thrill when he showed her how to stiffen wrist for the final devastating right hook. And often enough the stories were humorous, and Ellen would chuckle, or stare, or throw back her red, lovely curls in laughter. It was grand to make her laugh.

Shawn's friends, in some hesitation at first, came in ones and twos up the slope to see them. But Ellen welcomed them with her smile that was shy and, at the same time, frank, and her table was loaded for them with scones and crumpets and cream cakes and heather honey; and at the right time it was she herself that

brought forth the decanter of whiskey—no longer the half-empty stone jar—and the polished glasses. Shawn was proud as sin of her. She would sit then and listen to their discussions and be forever surprised at the knowledgeable man her husband was—the way he would discuss war and politics and making of songs, the turn of speech that summed up a man or a situation. And sometimes she would put in a word or two and he listened too, and they would look to see if her smile commended them, and be a little chastened by the wisdom of that smile—the age-old smile of the matriarch from whom they were all descended. In no time at all, Matt Tobin the thresher, who used to think, "Poor old Shawn! Lucky she was to get him," would whisper to the schoolmas-

A scene from *The Quiet Man*.

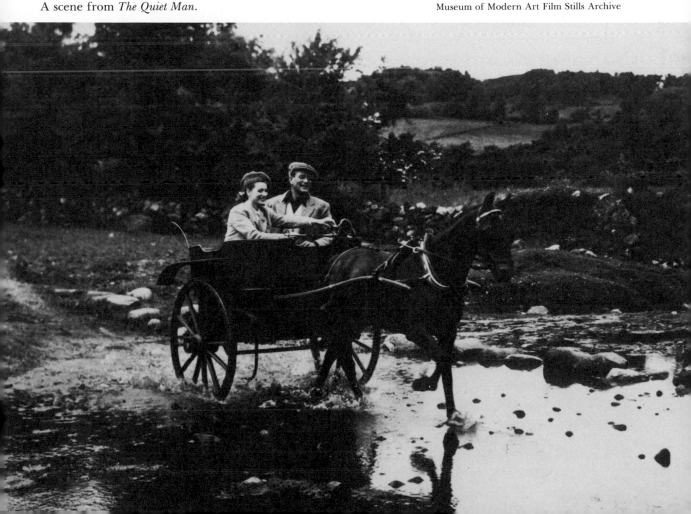

ter: "Herrin's alive! That fellow's luck would astonish nations."

Women, in the outside world, begin by loving their husbands; and then, if Fate is kind, they grow to admire them; and, if Fate is not unkind, may descend no lower than liking and enduring. And there is the end of lawful romance. Look now at Ellen O'Grady. She came up to the shelf of Knockanore and in her heart was only a nucleus of fear in a great emptiness, and that nucleus might grow into horror and disgust. But, glory of God, she, for reason piled on reason, presently found herself admiring Shawn Kelvin; and with or without reason, a quiet liking came to her for this quiet man who was so gentle and considerate; and then, one great heart-stirring dark o'night, she found herself fallen head and heels in love with her own husband. There is the sort of love that endures, but the road to it is a mighty chancy one.

A woman, loving her husband, may or may not be proud of him, but she will fight like a tiger if anyone, barring herself, belittles him. And there was one man that belittled Shawn Kelvin. Her brother, Big Liam O'Grady. At fair or market or chapel that dour giant deigned not to hide his contempt and dislike. Ellen knew why. He had lost a wife and farm; he had lost in herself a frugally cheap housekeeper; he had been made the butt of a sly humor; and for these mishaps, in some twisted way, he blamed Shawn. But—and there came in the contempt—the little Yankee runt, who dared say nothing about the lost Kelvin acres, would not now have the gall or guts to demand the dowry that was due. Lucky the hound to stean[12] an O'Grady to hungry Knockanore! Let him be satisfied with that luck!

One evening before a market day, Ellen spoke to her husband: "Has Big Liam paid you my dowry yet, Shawn?"

12. **stean:** bring.

"Sure there's no hurry, girl," said Shawn.

"Have you ever asked him?"

"I have not. I am not looking for your dowry, Ellen."

"And Big Liam could never understand that." Her voice firmed. "You will ask him tomorrow."

"Very well, so, *agrah*,"[13] agreed Shawn easily.

And the next day, in that quiet diffident way of his, he asked Big Liam. But Big Liam was brusque and blunt. He had no loose money and Kelvin would have to wait till he had. "Ask me again, Shawneen,"[14] he finished, his face in a mocking smile, and turning on his heel, he plowed his great shoulders through the crowded market.

His voice had been carelessly loud and people had heard. They laughed and talked amongst themselves. "Begogs! The devil's own boy, Big Liam! What a pup to sell! Stealing the land and keeping a grip on the fortune! Ay, and a dangerous fellow, mind you, the same Big Liam! He would smash little Shawn at the wind of a word. And devil the bit his Yankee sparring tricks would help him!"

A friend of Shawn's, Matt Tobin the thresher, heard that and lifted his voice: "I would like to be there the day Shawn Kelvin loses his temper."

"A bad day for poor Shawn!"

"It might then," said Matt Tobin, "but I would come from the other end of Kerry to see the badness that would be in it for someone."

Shawn had moved away with his wife, not heeding or not hearing.

"You see, Ellen?" he said in some discomfort. "The times are hard on the big ranchers, and we don't need the money, anyway."

"Do you think Big Liam does?" Her voice

13. *agrah:* "my love," in Irish.
14. **Shawneen:** little Shawn; here, a term of mockery. The speaker may be making a pun on the word *shoneen*, "an upstart."

had a cut in it. "He could buy you and all Knockanore and be only on the fringe of his hoard. You will ask him again."

"But, girl dear, I never wanted a dowry with you."

She liked him to say that, but far better would she like to win for him the respect and admiration that was his due. She must do that now at all costs. Shawn, drawing back now, would be the butt of his fellow men.

"You foolish lad! Big Liam would never understand your feelings, with money at stake." She smiled and a pang went through Shawn's breast. For the smile was the smile of an O'Grady, and he could not be sure whether the contempt in it was for himself or for her brother.

Shawn asked Big Liam again, unhappy in his asking, but also dimly comprehending his woman's object. And Shawn asked again a third time. The issue was become a famous one now. Men talked about it, and women too. Bets were made on it. At fair or market, if Shawn was seen approaching Big Liam, men edged closer and women edged away. Someday the big fellow would grow tired of being asked, and in one of his terrible rages half kill the little lad as he had half killed the other men. A great shame! Here and there, a man advised Shawn to give up asking and put the matter in a lawyer's hands. "I couldn't do that," was Shawn's only answer. Strangely enough, none of these prudent advisers were amongst Shawn's close friends. His friends frowned and said little, but they were always about, and always amongst them was Matt Tobin.

The day at last came when Big Liam grew tired of being asked. That was the big October cattle fair at Listowel, and he had sold twenty head of fat Polled Angus beeves at a good price. He was a hard dealer and it was late in the day before he settled at his own figure, so that the banks were closed and he was not able to make a lodgment.[15] He had, then, a great roll of bills in an inner vest pocket when he saw Shawn and Ellen coming across to where he was bargaining with Matt Tobin for a week's threshing. Besides, the day being dank, he had had a drink or two more than was good for him and the whiskey had loosened his tongue and whatever he had of discretion. By the powers!—it was time and past time to deal once and for all with this little gadfly of a fellow, to show him up before the whole market. He strode to meet Shawn, and people got out of his savage way and edged in behind to lose nothing of this dangerous game.

He caught Shawn by the hunched shoulder—a rending grip—and bent down to grin in his face.

"What is it, little fellow? Don't be ashamed to ask!"

Matt Tobin was probably the only one there to notice the ease with which Shawn wrenched his shoulder free, and Matt Tobin's eyes brightened. But Shawn did nothing further and said no word. His deep-set eyes gazed steadily at the big man.

The big man showed his teeth mockingly. "Go on, you whelp! What do you want?"

"You know, O'Grady."

"I do. Listen, Shawneen!" Again he brought his handclap on the little man's shoulder. "Listen, Shawneen! If I had a dowry to give my sister, 'tis not a little shrimp like you would get her!"

His great hand gripped and he flung Shawn backward as if he were only the image of a man filled with chaff.

Shawn went backward, but he did not fall. He gathered himself like a spring, feet under him, arms half raised, head forward into hunched shoulder. But as quickly as the spring coiled, as quickly it slackened, and he turned away to his wife. She was there facing him,

15. **lodgment:** deposit.

tense and keen; her face pale and set, and a gleam of the race in her eyes.

"Woman, woman!" he said in his deep voice. "Why would you and I shame ourselves like this?"

"Shawn!" she cried. "Will you let him shame you now?"

"But your own brother, Ellen—before them all?"

"And he cheating you——"

"Glory of God!" His voice was distressed. "What is his dirty money to me? Are you an O'Grady, after all?"

That stung her and she stung him back in one final effort. She placed a hand below her breast and looked *close* into his face. Her voice was low and bitter, and only he heard: "I am an O'Grady. It is a great pity that the father of this my son is a Kelvin and a coward."

The bosses[16] of Shawn Kelvin's cheekbones were like hard marble, but his voice was as soft as a dove's.

"Is that the way of it? Let us be going home then, in the name of God!"

He took her arm, but she shook his hand off; nevertheless, she walked at his side, head up, through the people that made way for them. Her brother mocked them with his great, laughing bellow.

"That fixes the pair of them!" he cried, brushed a man who laughed with him out of his way, and strode off through the fair.

There was talk then—plenty of it. "Murder, but Shawn had a narrow squeak that time! Did you see the way he flung him? I wager he'll give Big Liam a wide road after this. And he by way of being a boxer! That's a pound you owe me, Matt Tobin."

"I'll pay it," said Matt Tobin, and that is all he said. He stood, wide-legged, looking at the ground, his hand ruefully rubbing the back of his head and dismay and gloom on his face.

16. **bosses:** knobs.

His friend had failed him in the face of the people.

Shawn and Ellen went home in their tub cart and had not a single word or glance for each other on the road. And all that evening, at table or fireside, a heart-sickening silence held them in its grip. And all that night they lay side by side, still and mute. There was only one subject that possessed them and on that they dared speak no longer. They slept little. Ellen, her heart desolate, lay on her side, staring into the dark, grieving for what she had said and unable to unsay it. Shawn, on his back, contemplated things with a cold clarity. He realized that he was at the fork of life and that a finger pointed unmistakably. He must risk the very shattering of all happiness, he must do a thing so final and decisive that, once done, it could never again be questioned. Before morning he came to his decision, and it was bitter as gall. He cursed himself. "Oh, you fool! You might have known that you should never have taken an O'Grady without breaking the O'Gradys."

He got up early in the morning at his usual hour and went out, as usual, to his morning chores—rebedding and foddering the cattle, rubbing down the half-bred, helping the servant maid with the milk in the creaming pans—and, as usual, he came in to his breakfast, and ate it unhungrily and silently, which was not usual. But, thereafter he again went out to the stable, harnessed his gelding and hitched him to the tub cart. Then he returned to the kitchen and spoke for the first time.

"Ellen, will you come with me down to see your brother?"

She hesitated, her hands thrown wide in a helpless, hopeless gesture. "Little use you going to see my brother, Shawn. 'Tis I should go and—not come back."

"Don't blame me now or later, Ellen. It has been put on me and the thing I am going to

do is the only thing to be done. Will you come?"

"Very well," she agreed tonelessly. "I will be ready in a minute."

And they went the four miles down into the vale to the big farmhouse of Moyvalla. They drove into the great square of cobbled yard and found it empty.

On one side of the square was the long, low, lime-washed dwelling house; on the other, fifty yards away, the two-storied line of steadings[17] with a wide arch in the middle; and through the arch came the purr and zoom of a threshing machine. Shawn tied the half-bred to the wheel of a farm cart and, with Ellen, approached the house.

A slattern servant girl leaned over the kitchen half-door and pointed through the arch. The master was out beyond in the haggard[18]—the rickyard—and would she run across for him?

"Never mind, *achara*,"[19] said Shawn, "I'll get him. . . . Ellen, will you go in and wait?"

"No," said Ellen, "I'll come with you." She knew her brother.

As they went through the arch, the purr and zoom grew louder and, turning the corner, they walked into the midst of activity. A long double row of cone-pointed cornstacks stretched across the yard and, between them, Matt Tobin's portable threshing machine was busy. The smooth-flying, eight-foot driving wheel made a sleepy purr and the black driving belt ran with a sag and heave to the red-painted thresher. Up there on the platform, bare-armed men were feeding the flying drum with loosened sheaves, their hands moving in a rhythmic sway. As the toothed drum bit at the corn sheaves it made an angry snarl that changed and slowed into a satisfied zoom. The

wide conveying belt was carrying the golden straw up a steep incline to where other men were building a long rick; still more men were attending to the corn shoots, shoulders bending under the weight of the sacks as they ambled across to the granary. Matt Tobin himself bent at the face of his engine, feeding the fire box with sods of hard black peat. There were not less than two score men about the place, for, as was the custom, all Big Liam's friends and neighbors were giving him a hand with the threshing—"the day in harvest."

Big Liam came round the flank of the engine and swore. He was in his shirt sleeves, and his great forearms were covered with sandy hair.

"Look who's here!"

He was in the worst of tempers this morning. The stale dregs of yesterday's whiskey were still with him, and he was in the humor that, as they say, would make a dog bite its father. He took two slow strides and halted, feet apart and head truculently forward.

"What is it this time?" he shouted. That was the un-Irish welcome he gave his sister and her husband.

Shawn and Ellen came forward steadily, and, as they came, Matt Tobin slowly throttled down his engine. Big Liam heard the change of pitch and looked angrily over his shoulder.

"What do you mean, Tobin? Get on with the work!"

"Big Liam, this is my engine, and if you don't like it, you can leave it!" And at that he drove the throttle shut and the purr of the flywheel slowly sank.

"We will see in a minute," threatened Big Liam, and turned to the two now near at hand.

"What is it?" he growled.

"A private word with you. I won't keep you long." Shawn was calm and cold.

"You will not—on a busy morning," sneered the big man. "There is no need for private words between me and Shawn Kelvin."

17. **steadings:** farm buildings.
18. **haggard** (hăg′ərd): hay yard. Ricks are stacks of hay.
19. *achara:* "dear friend," in Irish.

The Quiet Man **139**

"There is need," urged Shawn. "It will be best for us all if you hear what I have to say in your own house."

"Or here on my own land. Out with it! I don't care who hears!"

Shawn looked round him. Up on the thresher, up on the straw rick, men leaned idle on fork handles and looked down at him; from here and there about the stackyard, men moved in to see, as it might be, what had caused the stoppage, but only really interested in the two brothers-in-law. He was in the midst of Clan O'Grady, for they were mostly O'Grady men—big, strong, blond men, rough, confident, proud of their breed. Matt Tobin was the only man he could call a friend. Many of the others were not unfriendly, but all had contempt in their eyes, or, what was worse, pity. Very well! Since he had to prove himself, it was fitting that he do it here amongst the O'Grady men.

Shawn brought his eyes back to Big Liam—deep, steadfast eyes that did not waver. "O'Grady," said he—and he no longer hid his contempt—"you set a great store by money."

"No harm in that. You do it yourself, Shawneen."

"Take it so! I will play that game with you as long as you like. You would bargain your sister and cheat; I will sell my soul. Listen, you big brute! You owe me two hundred pounds. Will you pay it?" There was an iron quality in his voice that was somehow awesome. The big man, about to start forward overbearingly, restrained himself to a brutal playfulness.

"I will pay it when I am ready."

"Today."

"No; nor tomorrow."

"Right. If you break your bargain, I break mine."

"What's that?" shouted Big Liam.

"If you keep your two hundred pounds, you keep your sister."

"What is it?" shouted Big Liam again, his voice breaking in astonishment. "What is that you say?"

"You heard me. Here is your sister Ellen! Keep her!"

He was completely astounded out of his truculence. "You can't do that!"

"It is done," said Shawn.

Ellen O'Grady had been quiet as a statue at Shawn's side, but now, slow like doom, she faced him. She leaned forward and looked into his eyes and saw the pain behind the strength.

"To the mother of your son, Shawn Kelvin?" she whispered that gently to him.

His voice came cold as a stone out of a stone face: "In the face of God. Let Him judge me."

"I know—I know!" That was all she said, and walked quietly across to where Matt Tobin stood at the face of his engine.

Matt Tobin placed a hand on her arm.

"Give him time, *acolleen*,"[20] he whispered urgently. "Give him his own time. He's slow but he's deadly as a tiger when he moves."

Big Liam was no fool. He knew exactly how far he could go. There was no use, at this juncture, in crushing the runt under a great fist. There was some force in the little fellow that defied dragooning.[21] Whatever people might think of Kelvin, public opinion would be dead against himself. Worse, his inward vision saw eyes leering in derision, mouths open in laughter. The scandal on his name would not be bounded by the four seas of Erin. He must change his stance while he had time. These thoughts passed through his mind while he thudded the ground three times with iron-shod heel. Now he threw up his head and bellowed his laugh.

"You fool! I was only making fun of you. What are your dirty few pounds to the likes of me. Stay where you are."

20. *acolleen:* "dear girl," in Irish.
21. **dragooning:** forcing someone to do something.

He turned, strode furiously away, and disappeared through the arch.

Shawn Kelvin was left alone in that wide ring of men. The hands had come down off the ricks and thresher to see closer. Now they moved back and aside, looked at one another, lifted eyebrows, looked at Shawn Kelvin, frowned, and shook their heads. They knew Big Liam. They knew that, yielding up the money, his savagery would break out into something little short of killing. They waited, most of them, to prevent that savagery going too far.

Shawn Kelvin did not look at anyone. He stood still as a rock, his hands deep in his pockets, one shoulder hunched forward, his eyes on the ground, and his face strangely calm. He seemed the least perturbed man there. Matt Tobin held Ellen's arm in a steadying grip and whispered in her ear: "God is good, I tell you."

Big Liam was back in two minutes. He strode straight to Shawn and halted within a pace of him.

"Look, Shawneen!" In his raised hand was a crumpled bundle of greasy bank notes. "Here is your money. Take it, and then see what will happen to you. Take it!" He thrust it into Shawn's hand. "Count it. Make sure you have it all—and then I will kick you out of this haggard—and look"—he thrust forward a hairy fist—"if ever I see your face again, I will drive that through it. Count it, you spawn."

Shawn did not count it. Instead he crumpled it into a ball in his strong fingers. Then he turned on his heel and walked, with surprising slowness, to the face of the engine. He gestured with one hand to Matt Tobin, but it was Ellen, quick as a flash, who obeyed the gesture. Though the hot bar scorched her hand, she jerked open the door of the firebox and the leaping peat flames whispered out at her. And forthwith, Shawn Kelvin, with one easy sweep, threw the crumpled ball of notes into the heart of the flame. The whisper lifted one tone and one scrap of burned paper floated out of the funnel top. That was all the fuss the fire made of its work.

But there was fuss enough outside.

Big Liam O'Grady gave one mighty shout. No, it was more an anguished scream than a shout:

"My money! My good money!"

He gave two furious bounds forward, his great arms raised to crush and kill. But his hands never touched the small man.

"You dumb ox!" said Shawn Kelvin between his teeth. That strong, hunched shoulder moved a little, but no one there could follow the terrific drive of that hooked right arm. The smack of bone on bone was sharp as whip crack, and Big Liam stopped dead, went back on his heel, swayed a moment, and staggered back three paces.

"Now and forever! Man of the Kelvins!" roared Matt Tobin.

But Big Liam was a man of iron. That blow should have laid him out on his back—blows like it had tied men to the ground for the full count. But Big Liam only shook his head, grunted like a boar, and drove in at the little man. And the little man, instead of circling away, drove in at him, compact of power.

The men of the O'Gradys saw then an exhibition that they had not knowledge enough to appreciate fully. Thousands had paid as much as ten dollars each to see the great Tiger Kelvin in action, his footwork, his timing, his hitting; and never was his action more devastating than now. He was a thunderbolt on two feet and the big man a glutton.

Big Liam never touched Shawn with clenched fist. He did not know how. Shawn, actually forty pounds lighter, drove him by sheer hitting across the yard.

Men for the first time saw a two-hundred-

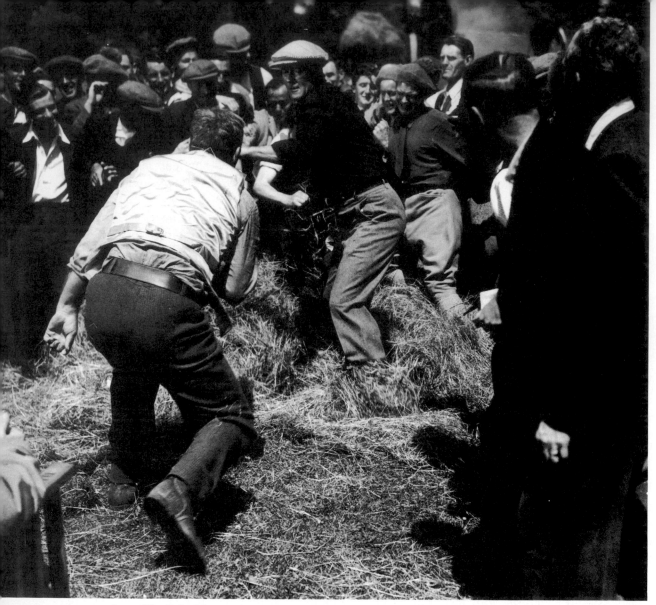

A scene from *The Quiet Man*.

pound man knocked clean off his feet by a body blow. They saw for the first time the deadly restraint and explosion of skill.

Shawn set out to demolish his enemy in the briefest space of time, and it took him five minutes to do it. Five, six, eight times he knocked the big man down, and the big man came again, staggering, slavering, raving, vainly trying to rend and smash. But at last he stood swaying and clawing helplessly, and Shawn finished him with his terrible double hit—left below the breastbone and right under the jaw.

Big Liam lifted on his toes and fell flat on his back. He did not even kick as he lay.

Shawn did not waste a glance at the fallen giant. He swung full circle on the O'Grady men and his voice of iron challenged them:

"I am Shawn Kelvin, of Knockanore Hill. Is there an O'Grady amongst you thinks himself a better man? Come then."

His face was deep-carved stone, his great chest lifted, the air whistled through his nostrils; his deep-set flashing eyes dared them.

No man came.

He swung around then and walked straight to his wife. He halted before her.

His face was still of stone, but his voice quivered and had in it all the dramatic force of the Celt:

"Mother of my son, will you come home with me?"

She lifted to the appeal, voice and eye:

"Is it so you ask me, Shawn Kelvin?"

His face of stone quivered at last, "As my wife only—Ellen Kelvin!"

"Very well, heart's treasure." She caught his arm in both of hers. "Let us be going home."

"In the name of God," he finished for her.

And she went with him, proud as the morning, out of that place. But a woman, she would have the last word.

"Mother of God!" she cried. "The trouble I had to make a man of him!"

"God Almighty did that for him before you were born," said Matt Tobin softly.

Reading Check

1. What kind of work did Shawn do in America?
2. Why does Big Liam O'Grady want to marry Kathy Carey?
3. Why is Ellen O'Grady willing to marry Shawn?
4. Why are so many men gathered at Big Liam's farm when Shawn and Ellen arrive?
5. What does Shawn do with the dowry money?

For Study and Discussion

Analyzing and Interpreting the Story

1. It is obvious early in the story that the author is setting up a contrast between Shawn Kelvin and Big Liam. **a.** What does Shawn seem to value most? **b.** What does Big Liam value more than anything else?

2. Shawn Kelvin and Liam O'Grady differ in more than values. How does the author also contrast their appearances?

3a. How does Ellen intensify the conflict between the two men? **b.** How does Ellen change after she marries Shawn Kelvin?

4. To Shawn, Ellen, and Big Liam, Ellen's unpaid dowry comes to mean something different. What is each character's attitude toward this money?

5. We are held in suspense by several conflicts in this story. There are external conflicts between Shawn and Big Liam and between Shawn and Ellen. There is as well an inner conflict that Shawn himself must overcome. How would you describe each one of these conflicts?

6. What would you say is the **climax** of this story—that point of greatest emotional intensity when we finally know what will happen to the characters and their conflicts?

7. At the end of the story, Ellen states that *she* had made "a man" out of her quiet husband. Why is she mistaken?

Literary Elements

Omniscient Point of View

Maurice Walsh tells his story from the **omniscient point of view.** He is the all-knowing narrator who allows us to share the private, unspoken thoughts and feelings of his three main characters: Shawn, Ellen, and Big Liam. For

example, he tells us exactly what Ellen thinks and feels when she considers Shawn's proposal:

> She looked within her own heart and found it empty; she looked at the granite crag of her brother's face and contemplated herself a slowly withering spinster at his fire corner . . .

What does the narrator tell us about Shawn's private reactions to her acceptance? What are we told about Big Liam's motivations when he suggests that Shawn marry his sister?

In any point of view, the author may withhold information for effect. What important information does the author of "The Quiet Man" save until the end of the story? Where in the story does he foreshadow his surprising news about Shawn's background?

Figurative Language

Big Liam thinks that Shawn Kelvin cast "sheep's eyes" at Ellen. Liam's face, in turn, is described as a "granite crag." We know that these expressions are not literally true. They are **figures of speech,** in which one thing is compared to some other, different thing. Such figures of speech can tell a great deal about a character. What does the first figure of speech reveal about the way Big Liam sees Shawn Kelvin? What does the second one reveal about Big Liam himself?

What are the figures of speech in each of the following sentences? What comparisons are being made in each one? What does each tell you about the character involved?

> Big Liam O'Grady was a great rawboned, sandy-haired man, with the strength of an ox and a heart no bigger than a sour apple.

> The bosses of Shawn Kelvin's cheekbones were like hard marble, but his voice was as soft as a dove's.

> Ellen O'Grady had been quiet as a statue at Shawn's side, but now, slow like doom, she faced him.

Language and Vocabulary

Finding Word Histories

On page 135, Walsh refers to "the age-old smile of the *matriarch*." If you consult a dictionary, you will find that the word *matriarch* is derived from the Latin word *mater,* meaning "mother," and -*arch,* a suffix meaning "ruler." A *matriarch* is a woman who is head of a family or a tribe. A *matriarchy* is a kind of society dominated or ruled by women.

The term used by language experts for the study of the origin and development of words is *etymology* (et′ə-mŏl′ə-jē). In dictionaries the etymology of a word is generally given in brackets. According to one dictionary, this is the etymology of the word *brusque:*

> [Fr. < It. *brusco* < ML *bruscus,* brushwood; prob. akin to BRUSH, but infl. by It. *rusco* < L. *ruscum,* butcher's broom]

This entry tells us that the word came into our language from French (Fr.), and that the French word was derived from Italian. The symbol < means "derived from." The Italian word *brusco* itself was derived from the Medieval Latin (ML) word for "brushwood." Scholars believe that somewhere in its history the word was influenced by a different Italian word, *rusco,* which came from a Latin word meaning "butcher's broom."

Use a college or unabridged dictionary to find the etymologies of the following words:

gloaming deign
austere whelp
patronize (patron)

If you have questions about the abbreviations in the etymologies, check the list of abbreviations and symbols usually located in the front matter of the dictionary.

Writing About Literature

Analyzing the Appeal of a Story

"The Quiet Man" is a story that has endured for many years and has been a favorite with readers of all ages. In an essay, analyze what you think is the basic appeal of the story. Is it the old conflict between the bully and the little guy? Is it the interesting characterizations of Big Liam, Ellen, and the Quiet Man? Or is it the appeal of the love story? Do you know other stories or films that have been popular because they have the same appeal? Be specific in your answers.

Focus on Narrative Writing

Experimenting with Point of View

Point of view in a narrative is the vantage point from which the story is told. When you tell a story, you may use one of the following three points of view:

First-person: one of the characters tells the story in his or her own words. The character may be a major person in the story or a relatively minor eyewitness.

Third-person limited: the writer uses the vantage point of a single character in the story. We see everything through that person's eyes.

Third-person omniscient: the writer is an all-knowing narrator who allows us to share the thoughts and feelings of a number of characters. This is the point of view of Maurice Walsh's "The Quiet Man."

Experiment with different points of view by writing the opening paragraph for a story in two ways. In the first version, use first-person point of view; in the second, use third-person point of view. After you have finished writing, exchange papers with a classmate and offer each other suggestions. Which version seems more effective for the story you are telling?

About the Author

Maurice Walsh (1879–1964)

Maurice Walsh described himself as "the son and the grandson and the great-great-grandson of farmers and rebels." He was born in Kerry, the county that provides the setting for "The Quiet Man." Walsh said that his earliest stories were about "Australian bush-ranging, and Klondike gold-digging, and the Boer War, and other subjects with which I was closely acquainted at a distance." In his twenties he became an employee of the British Customs Excise Service and traveled throughout Ireland, Wales, and England, and often to Scotland, where he fell in love with and married a red-haired Scottish woman. In Dublin during the Irish Civil War, confined indoors at night because of sniping and separated from his family, Walsh resumed his writing. "Up to then," he said, "I had scarcely written a thing—too busy living."

Blues Ain't No Mockin Bird

TONI CADE BAMBARA

A story told in the first-person point of view has the advantage of immediacy because someone involved in the action, a character or an observer, is reporting directly to us. This point of view, however, has intentional limitations, for the narrator may be unreliable or may have a narrow perception of what is going on. When the narrator is a child, as in this story, a great deal of our interest lies in recognizing the difference between the child's interpretation of events and our own.

The puddle had frozen over, and me and Cathy went stompin in it. The twins from next door, Tyrone and Terry, were swingin so high out of sight we forgot we were waitin our turn on the tire. Cathy jumped up and came down hard on her heels and started tap-dancin. And the frozen patch splinterin every which way underneath kinda spooky. "Looks like a plastic spider web," she said. "A sort of weird spider, I guess, with many mental problems." But really it looked like the crystal paperweight Granny kept in the parlor. She was on the back porch, Granny was, making the cakes drunk. The old ladle dripping rum into the Christmas tins, like it used to drip maple syrup into the pails when we lived in the Judson's woods, like it poured cider into the vats when we were on the Cooper place, like it used to scoop buttermilk and soft cheese when we lived at the dairy.

"Go tell that man we ain't a bunch of trees."

"Ma'am?"

"I said to tell that man to get away from here with that camera." Me and Cathy look over toward the meadow where the men with the station wagon'd been roamin around all mornin. The tall man with a huge camera lassoed to his shoulder was buzzin our way.

"They're makin movie pictures," yelled Tyrone, stiffenin his legs and twistin so the tire'd come down slow so they could see.

"They're makin movie pictures," sang out Terry.

"That boy don't never have anything original to say," say Cathy grown-up.

By the time the man with the camera had cut across our neighbor's yard, the twins were out of the trees swingin low and Granny was onto the steps, the screen door bammin soft

and scratchy against her palms. "We thought we'd get a shot or two of the house and everything and then—"

"Good mornin," Granny cut him off. And smiled that smile.

"Good mornin," he said, head all down the way Bingo does when you yell at him about the bones on the kitchen floor. "Nice place you got here, Aunty. We thought we'd take a —"

"Did you?" said Granny with her eyebrows. Cathy pulled up her socks and giggled.

"Nice things here," said the man, buzzin his camera over the yard. The pecan barrels, the sled, me and Cathy, the flowers, the printed stones along the driveway, the trees, the twins, the toolshed.

"I don't know about the thing, the it, and the stuff," said Granny, still talkin with her eyebrows. "Just people here is what I tend to consider."

Camera man stopped buzzin. Cathy giggled into her collar.

"Mornin, ladies," a new man said. He had come up behind us when we weren't lookin. "And gents," discoverin the twins givin him a nasty look. "We're filmin for the county," he said with a smile. "Mind if we shoot a bit around here?"

"I do indeed," said Granny with no smile. Smilin man was smiling up a storm. So was Cathy. But he didn't seem to have another word to say, so he and the camera man backed on out the yard, but you could hear the camera buzzin still. "Suppose you just shut that machine off," said Granny real low through her teeth, and took a step down off the porch and then another.

"Now, Aunty," Camera said, pointin the thing straight at her.

"Your mama and I are not related."

Smilin man got his notebook out and a chewed-up pencil. "Listen," he said movin back into our yard, "we'd like to have a statement from you . . . for the film. We're filmin for the county, see. Part of the food-stamp campaign. You know about the food stamps?"

Granny said nuthin.

"Maybe there's somethin you want to say for the film. I see you grow your own vegetables," he smiled real nice. "If more folks did that, see, there'd be no need—"

Granny wasn't sayin nuthin. So they backed on out, buzzin at our clothesline and the twins' bicycles, then back on down to the meadow. The twins were danglin in the tire, lookin at Granny. Me and Cathy were waitin, too, cause Granny always got somethin to say. She teaches steady with no letup. "I was on this bridge one time," she started off. "Was a crowd cause this man was goin to jump, you understand. And a minister was there and the police and some other folks. His woman was there, too."

"What was they doin?" asked Tyrone.

"Tryin to talk him out of it was what they was doin. The minister talkin about how it was a mortal sin, suicide. His woman takin bites out of her own hand and not even knowin it, so nervous and cryin and talkin fast."

"So what happened?" asked Tyrone.

"So here comes . . . this person . . . with a camera, takin pictures of the man and the minister and the woman. Takin pictures of the man in his misery about to jump, cause life so bad and people been messin with him so bad. This person takin up the whole roll of film practically. But savin a few, of course."

"Of course," said Cathy, hatin the person. Me standin there wonderin how Cathy knew it was "of course" when I didn't and it was *my* grandmother.

After a while Tyrone say, "Did he jump?"

"Yeh, did he jump?" say Terry all eager.

And Granny just stared at the twins till their faces swallow up the eager and they don't even care any more about the man jumpin. Then she goes back onto the porch and lets the

screen door go for itself. I'm lookin to Cathy to finish the story cause she knows Granny's whole story before me even. Like she knew how come we move so much and Cathy ain't but a third cousin we picked up on the way last Thanksgivin visitin. But she knew it was on account of people drivin Granny crazy till she'd get up in the night and start packin. Mumblin and packin and wakin everybody up sayin, "Let's get on away from here before I kill me somebody." Like people wouldn't pay her for things like they said they would. Or

Jennie (1943) by Lois M. Jones (1905–)
The Howard University Gallery of Art,
Permanent Collection, Washington, D.C.

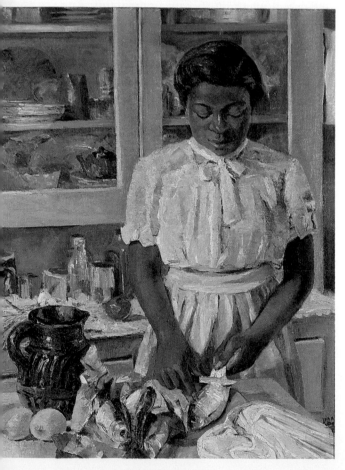

Mr. Judson bringin us boxes of old clothes and raggedy magazines. Or Mrs. Cooper comin in our kitchen and touchin everything and sayin how clean it all was. Granny goin crazy, and Granddaddy Cain pullin her off the people, sayin, "Now, now, Cora." But next day loadin up the truck, with rocks all in his jaw, madder than Granny in the first place.

"I read a story once," said Cathy soundin like Granny teacher. "About this lady Goldilocks who barged into a house that wasn't even hers. And not invited, you understand. Messed over the people's groceries and broke up the people's furniture. Had the nerve to sleep in the folks' bed."

"Then what happened?" asked Tyrone. "What they do, the folks, when they come in to all this mess?"

"Did they make her pay for it?" asked Terry, makin a fist. "I'd've made her pay me."

I didn't even ask. I could see Cathy actress was very likely to just walk away and leave us in mystery about this story which I heard was about some bears.

"Did they throw her out?" asked Tyrone, like his father sounds when he's bein extra nasty-plus to the washin-machine man.

"Woulda," said Terry. "I woulda gone upside her head with my fist and—"

"You woulda done whatcha always do—go cry to Mama, you big baby," said Tyrone. So naturally Terry starts hittin on Tyrone, and next thing you know they tumblin out the tire and rollin on the ground. But Granny didn't say a thing or send the twins home or step out on the steps to tell us about how we can't afford to be fightin amongst ourselves. She didn't say nuthin. So I get into the tire to take my turn. And I could see her leanin up against the pantry table, starin at the cakes she was puttin up for the Christmas sale, mumblin real low and grumpy and holdin her forehead like it wanted to fall off and mess up the rum cakes.

Behind me I hear before I can see Granddaddy Cain comin through the woods in his field boots. Then I twist around to see the shiny black oilskin cuttin through what little left there was of yellows, reds, and oranges. His great white head not quite round cause of this bloody thing high on his shoulder, like he was wearin a cap on sideways. He takes the shortcut through the pecan grove, and the sound of twigs snapping overhead and underfoot travels clear and cold all the way up to us. And here comes Smilin and Camera up behind him like they was going to do somethin. Folks like to go for him sometimes. Cathy say it's because he's so tall and quiet and like a king. And people just can't stand it. But Smilin and Camera don't hit him in the head or nuthin. They just buzz on him as he stalks by with the chicken hawk slung over his shoulder, squawkin, drippin red down the back of the oilskin. He passes the porch and stops a second for Granny to see he's caught the hawk at last, but she's just starin and mumblin, and not at the hawk. So he nails the bird to the toolshed door, the hammerin crackin through the eardrums. And the bird flappin himself to death and droolin down the door to paint the gravel on the driveway red, then brown, then black. And the two men movin up on tiptoe like they was invisible or we were blind, one.

"Get them persons out of my flower bed, Mister Cain," say Granny moanin real low like at a funeral.

"How come your grandmother calls her husband 'Mister Cain' all the time?" Tyrone whispers all loud and noisy and from the city and don't know no better. Like his mama, Miss Myrtle, tell us never mind the formality as if we had no better breeding than to call her Myrtle, plain. And then this awful thing—a giant hawk—come wailin up over the meadow, flyin low and tilted and screamin, zigzaggin through the pecan grove, breakin branches and hollerin, snappin past the clothesline, flyin every which way, flyin into things reckless with crazy.

"He's come to claim his mate," say Cathy fast, and ducks down. We all fall quick and flat into the gravel driveway, stones scrapin my face. I squinch my eyes open again at the hawk on the door, tryin to fly up out of her death like it was just a sack flown into by mistake. Her body holdin her there on that nail, though. The mate beatin the air overhead and clutchin for hair, for heads, for landin space.

The camera man duckin and bendin and runnin and fallin, jigglin the camera and scared. And Smilin jumpin up and down swipin at the huge bird, tryin to bring the hawk down with just his raggedy ole cap. Granddaddy Cain straight up and silent, watchin the circles of the hawk, then aimin the hammer off his wrist. The giant bird fallin, silent and slow. Then here comes Camera and Smilin all big and bad now that the awful screechin thing is on its back and broken, here they come. And Granddaddy Cain looks up at them like it was the first time noticin, but not payin them too much mind cause he's listenin, we all listenin, to that low groanin music comin from the porch. And we figure any minute, somethin in my back tells me any minute now, Granny gonna bust through that screen with somethin in her hand and murder on her mind. So Granddaddy say above the buzzin, but quiet, "Good day, gentlemen." Just like that. Like he'd invited them in to play cards and they'd stayed too long and all the sandwiches were gone and Reverend Webb was droppin by and it was time to go.

They didn't know what to do. But like Cathy say, folks can't stand Granddaddy tall and silent and like a king. They can't neither. The smile the men smilin is pullin the mouth back and showin the teeth. Lookin like the wolf man, both of them. Then Granddaddy holds

his hand out—this huge hand I used to sit in when I was a baby and he'd carry me through the house to my mother like I was a gift on a tray. Like he used to on the trains. They called the other men just waiters. But they spoke of Granddaddy separate and said, The Waiter. And said he had engines in his feet and motors in his hands and couldn't no train throw him off and couldn't nobody turn him round. They were big enough for motors, his hands were. He held that one hand out all still and it gettin to be not at all a hand but a person in itself.

"He wants you to hand him the camera," Smilin whispers to Camera, tiltin his head to talk secret like they was in the jungle or somethin and come upon a native that don't speak the language. The men start untyin the straps, and they put the camera into that great hand speckled with the hawk's blood all black and crackly now. And the hand don't even drop with the weight, just the fingers move, curl up around the machine. But Granddaddy lookin straight at the men. They lookin at each other and everywhere but at Granddaddy's face.

"We filmin for the county, see," say Smilin. "We puttin together a movie for the food-stamp program . . . filmin all around these parts. Uhh, filmin for the county."

"Can I have my camera back?" say the tall man with no machine on his shoulder, but still keepin it high like the camera was still there or needed to be. "Please, sir."

Then Granddaddy's other hand flies up like a sudden and gentle bird, slaps down fast on top of the camera and lifts off half like it was a calabash cut for sharing.

"Hey," Camera jumps forward. He gathers up the parts into his chest and everything unrollin and fallin all over. "Whatcha tryin to do? You'll ruin the film." He looks down into his chest of metal reels and things like he's protectin a kitten from the cold.

"You standin in the misses' flower bed," say Granddaddy. "This is our own place."

The two men look at him, then at each other, then back at the mess in the cameraman's chest, and they just back off. One sayin over and over all the way down to the meadow, "Watch it, Bruno. Keep ya fingers off the film." Then Granddaddy picks up the hammer and jams it into the oilskin pocket, scrapes his boots, and goes into the house. And you can hear the squish of his boots headin through the house. And you can see the funny shadow he throws from the parlor window onto the ground by the string-bean patch. The hammer draggin the pocket of the oilskin out so Granddaddy looked even wider. Granny was hummin now—high, not low and grumbly. And she was doin the cakes again, you could smell the molasses from the rum.

"There's this story I'm goin to write one day," say Cathy dreamer. "About the proper use of the hammer."

"Can I be in it?" Tyrone say with his hand up like it was a matter of first come, first served.

"Perhaps," say Cathy, climbin onto the tire to pump us up. "If you there and ready."

Reading Check

1. What are the two men filming?
2. Why has the family moved so often?
3. What does Granny ask Granddaddy Cain to do?
4. How does Granddaddy kill the hawk's mate?
5. What does Granddaddy do to the camera?

For Study and Discussion

Analyzing and Interpreting the Story

1. The narrator of this story watches a conflict between her grandparents and two men who intrude on their land. **a.** What do the men want? **b.** What is their attitude?

2. The narrator says, "Granny always got somethin to say. She teaches steady with no letup." What story does the grandmother tell to explain her feelings about the cameramen?

3. Cathy seems to understand Granny better than the narrator does. **a.** What story does Cathy tell to support the grandmother's story? **b.** What is the main point of both of these "teaching stories"?

4. Cathy says that Granddaddy Cain is "like a king." How does the grandfather's way of dealing with the intruders seem "kingly" or majestic?

5. In the midst of this human conflict, the giant hawk comes to the rescue of his suffering mate. How could these great birds remind you of the older couple themselves?

6. The unusual title of this story seems to suggest that some people cannot understand the "blues." The "blues," of course, is a kind of slow, sad music that expresses suffering or unhappiness. Which characters in this story know what the "blues" really are?

and help to make her story enjoyable. What original way does the narrator have of describing Cathy, whom she seems to envy a bit? What funny names does she give the cameramen? What other comical remarks does she make as she tells her story?

This young narrator makes humorous remarks that might make us smile, but she also makes it clear that this conflict is anything but comical to the older people. The narrator cannot tell us the unspoken thoughts and feelings of her grandparents, but she does report on what they say and do. She also helps us to see these two people through the eyes of a child who loves and admires them. Notice what she tells us about her grandfather—this man who held a bloodied hawk is remembered in a tender moment by his young granddaughter:

> Then Granddaddy holds his hand out—this huge hand I used to sit in when I was a baby and he'd carry me through the house to my mother like I was a gift on a tray.

What other details does the young narrator tell us about her grandparents as she knows and remembers them? How do these descriptions affect your feelings for these characters?

While the tense confrontation takes place between the adults, the children are playing in the yard. Where does the narrator make it clear that the children—all except Cathy—do not fully understand what is happening?

Literary Elements

First-Person Point of View

"Blues Ain't No Mockin Bird" is told from the **first-person point of view.** It is a story about a conflict between adults that is narrated by a young character who is an observer of the action. This first-person narrator has a sense of humor and a highly individual way of speaking. These qualities make her seem real to us

Language and Vocabulary

Understanding the Role of Dialect

Throughout American cities and towns and in the countryside many varieties of our language can be heard. **Dialect** is the term language experts use to describe the variety of language used in a geographical region or by a particular group of people. Dialects ring with original expressions, colorful metaphors, and

ear-catching pronunciations. The American language is a melting pot of dialects, each one adding to our language the special flavor of a region, a culture, or a profession.

"Blues Ain't No Mockin Bird" is written in a style that reproduces faithfully the way the narrator's language sounds. Notice that the speaker often uses incomplete sentences or strings her ideas together in lengthy sentences. Note also how rhythmically effective this style can be:

> And then this awful thing—a giant hawk—come wailin up over the meadow, flyin low and tilted and screamin, zigzaggin through the pecan grove, breakin branches and hollerin, snappin past the clothesline, flyin every which way, flyin into things reckless with crazy.

To discover how enriching dialect is to the story, rewrite one of the passages in standard, formal English. What must be changed besides the spelling and grammar? Why is Bambara's telling of the story in dialect more effective?

Creative Writing

Writing from Another Point of View

At the end of the story, Granddaddy Cain goes back into the house. In a paragraph, write what he might be thinking about the incident that has just occurred with the cameramen. Write from the first-person point of view, as if Granddaddy Cain himself is speaking. Before you write, review the characterization of the grandfather, especially the paragraph on page 149 beginning "They didn't know what to do." What would be the tone of this paragraph written from the grandfather's point of view—would he feel bitter, angry, sad, triumphant, compassionate?

About the Author

Toni Cade Bambara (1939–1995)

Toni Cade Bambara (bäm-bä′rä) took her last name from a signature on a sketchbook she found in her great-grandmother's trunk. (Bambara is the name of a people of northwest Africa who are noted for their delicate wood carvings.) Cade Bambara was a New Yorker who went to schools in New York City, in the South, in Paris, and in Florence, Italy. She was a social investigator, a recreation director, a film writer and producer, and taught English in college. She edited *The Black Woman* (1970) and *Tales and Stories for Black Folks* (1971), and published two collections of her own short stories: *Gorilla, My Love* (1972), from which "Blues Ain't No Mockin Bird" is taken, and *The Sea Birds Are Still Alive* (1977). Poet Lucille Clifton said of the stories in *Gorilla, My Love:* "She has captured it all, how we really talk, how we really are; and done it with love and respect. I laughed until I cried, then laughed again." Bambara's first novel, *The Salt Eaters* (1980), uses many dialects to tell the story of a depressed woman who seeks help from a healer.

A Pair of Silk Stockings

KATE CHOPIN

Sometimes a story is told from the point of view of a single character. This point of view is chosen when the author wishes to bring us close to a particular character so that we experience what the character sees, thinks, or feels. As you read ask yourself how this limited third-person point of view affects the telling of the story. What would the story lose if it were told in the first person?

Little Mrs. Sommers one day found herself the unexpected possessor of fifteen dollars. It seemed to her a very large amount of money, and the way in which it stuffed and bulged her worn old *porte-monnaie*[1] gave her a feeling of importance such as she had not enjoyed for years.

The question of investment was one that occupied her greatly. For a day or two she walked about apparently in a dreamy state, but really absorbed in speculation and calculation. She did not wish to act hastily, to do anything she might afterward regret. But it was during the still hours of the night when she lay awake revolving plans in her mind that she seemed to see her way clearly toward a proper and judicious use of the money.

A dollar or two should be added to the price usually paid for Janie's shoes, which would insure their lasting an appreciable time longer than they usually did. She would buy so and so many yards of percale for new shirtwaists for the boys and Janie and Mag. She had intended to make the old ones do by skillful

patching. Mag should have another gown. She had seen some beautiful patterns, veritable bargains in the shop windows. And still there would be left enough for new stockings—two pairs apiece—and what darning that would save for a while! She would get caps for the boys and sailor hats for the girls. The vision of her little brood looking fresh and dainty and new for once in their lives excited her and made her restless and wakeful with anticipation.

The neighbors sometimes talked of certain "better days" that little Mrs. Sommers had known before she had ever thought of being Mrs. Sommers. She herself indulged in no such morbid retrospection.[2] She had no time—no second of time to devote to the past. The needs of the present absorbed her every faculty. A vision of the future like some dim, gaunt monster sometimes appalled her, but luckily tomorrow never comes.

Mrs. Sommers was one who knew the value of bargains, who could stand for hours making her way inch by inch toward the desired object

1. *porte-monnaie* (pôrt′ môn-nĕ′): a small pocketbook.

2. **morbid retrospection:** looking back on the past in a way that is unwholesome or psychologically unhealthy.

that was selling below cost. She could elbow her way if need be; she had learned to clutch a piece of goods and hold it and stick to it with persistence and determination till her turn came to be served, no matter when it came.

But that day she was a little faint and tired. She had swallowed a light luncheon—no! when she came to think of it, between getting the children fed and the place righted, and preparing herself for the shopping bout, she had actually forgotten to eat any luncheon at all!

She sat herself upon a revolving stool before a counter that was comparatively deserted, trying to gather strength and courage to charge through an eager multitude that was besieging breastworks[3] of shirting and figured lawn.[4] An all-gone limp feeling had come over her and she rested her hand aimlessly upon the counter. She wore no gloves. By degrees she grew aware that her hand had encountered something very soothing, very pleasant to touch. She looked down to see that her hand lay upon a pile of silk stockings. A placard nearby announced that they had been reduced in price from two dollars and fifty cents to one dollar and ninety-eight cents; and a young girl who stood behind the counter asked her if she wished to examine their line of silk hosiery. She smiled, just as if she had been asked to inspect a tiara of diamonds with the ultimate view of purchasing it. But she went on feeling the soft, sheeny luxurious things—with both hands now, holding them up to see them glisten, and to feel them glide serpentlike through her fingers.

Two hectic blotches came suddenly into her pale cheeks. She looked up at the girl.

"Do you think there are any eights-and-a-half among these?"

There were any number of eights-and-a-half. In fact, there were more of that size than

3. **breastworks:** low walls, here used metaphorically.
4. **figured lawn:** fine fabric decorated with a pattern.

any other. Here was a light-blue pair; there were some lavender, some all black and various shades of tan and gray. Mrs. Sommers selected a black pair and looked at them very long and closely. She pretended to be examining their texture, which the clerk assured her was excellent.

"A dollar and ninety-eight cents," she mused aloud. "Well, I'll take this pair." She handed the girl a five-dollar bill and waited for her change and for her parcel. What a very small parcel it was! It seemed lost in the depths of her shabby old shopping bag.

Mrs. Sommers after that did not move in the direction of the bargain counter. She took the elevator, which carried her to an upper floor into the region of the ladies' waiting rooms. Here, in a retired corner, she exchanged her cotton stockings for the new silk ones which she had just bought. She was not going through any acute mental process or reasoning with herself, nor was she striving to explain to her satisfaction the motive of her action. She was not thinking at all. She seemed for the time to be taking a rest from that laborious and fatiguing function and to have abandoned herself to some mechanical impulse that directed her actions and freed her of responsibility.

How good was the touch of the raw silk to her flesh! She felt like lying back in the cushioned chair and reveling for a while in the luxury of it. She did for a little while. Then she replaced her shoes, rolled the cotton stockings together and thrust them into her bag. After doing this she crossed straight over to the shoe-department and took her seat to be fitted.

She was fastidious. The clerk could not make her out; he could not reconcile her shoes with her stockings, and she was not too easily pleased. She held back her skirts and turned her feet one way and her head another as she

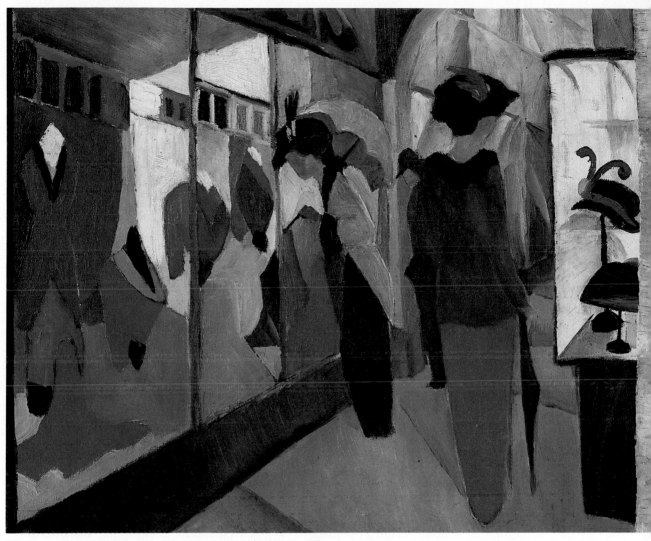

The Dress Shop (1913) by Auguste Macke (1887–1914). Oil on canvas.

glanced down at the polished, pointed-tipped boots. Her foot and ankle looked very pretty. She could not realize that they belonged to her and were a part of herself. She wanted an excellent and stylish fit, she told the young fellow who served her, and she did not mind the difference of a dollar or two more in the price so long as she got what she desired.

It was a long time since Mrs. Sommers had been fitted with gloves. On rare occasions when she had bought a pair they were always "bargains," so cheap that it would have been preposterous and unreasonable to have expected them to be fitted to the hand.

Now she rested her elbow on the cushion of the glove counter, and a pretty, pleasant young creature, delicate and deft of touch, drew a long-wristed "kid" over Mrs. Sommers' hand. She smoothed it down over the wrist and buttoned it neatly, and both lost themselves for a

second or two in admiring contemplation of the little symmetrical gloved hand. But there were other places where money might be spent.

There were books and magazines piled up in the window of a stall a few paces down the street. Mrs. Sommers bought two high-priced magazines such as she had been accustomed to read in the days when she had been accustomed to other pleasant things. She carried them without wrapping. As well as she could she lifted her skirts at the crossings. Her stockings and boots and well-fitting gloves had worked marvels in her bearing—had given her a feeling of assurance, a sense of belonging to the well-dressed multitude.

She was very hungry. Another time she would have stilled the cravings for food until reaching her own home, where she would have brewed herself a cup of tea and taken a snack of anything that was available. But the impulse that was guiding her would not suffer her to entertain any such thought.

There was a restaurant at the corner. She had never entered its doors; from the outside she had sometimes caught glimpses of spotless damask and shining crystal, and soft-stepping waiters serving people of fashion.

When she entered her appearance created no surprise, no consternation, as she had half feared it might. She seated herself at a small table alone, and an attentive waiter at once approached to take her order. She did not want a profusion; she craved a nice and tasty bite—a half dozen bluepoints,[5] a plump chop with cress, a something sweet—a crème-frappée,[6] for instance; a glass of Rhine wine, and after all a small cup of black coffee.

While waiting to be served she removed her gloves very leisurely and laid them beside her.

5. **bluepoints:** oysters from the south shore of Long Island.
6. **crème-frappée** (krĕm fră-pā′): a chilled dessert.

Then she picked up a magazine and glanced through it, cutting the pages with a blunt edge of her knife. It was all very agreeable. The damask was even more spotless than it had seemed through the window, and the crystal more sparkling. There were quiet ladies and gentlemen, who did not notice her, lunching at the small tables like her own. A soft, pleasing strain of music could be heard, and a gentle breeze was blowing through the window. She tasted a bite, and she read a word or two, and she sipped the amber wine and wiggled her toes in the silk stockings. The price of it made no difference. She counted the money out to the waiter and left an extra coin on his tray, whereupon he bowed before her as before a princess of royal blood.

There was still money in her purse, and her next temptation presented itself in the shape of a matinée poster.

It was a little later when she entered the theater, the play had begun and the house seemed to her to be packed. But there were vacant seats here and there, and into one of them she was ushered, between brilliantly dressed women who had gone there to kill time and eat candy and display their gaudy attire. There were many others who were there solely for the play and acting. It is safe to say there was no one present who bore quite the attitude which Mrs. Sommers did to her surroundings. She gathered in the whole—stage and players and people in one wide impression, and absorbed it and enjoyed it. She laughed at the comedy and wept—she and the gaudy woman next to her wept over the tragedy. And they talked a little together over it. And the gaudy woman wiped her eyes and sniffled on a tiny square of filmy, perfumed lace and passed little Mrs. Sommers her box of candy.

The play was over, the music ceased, the crowd filed out. It was like a dream ended. People scattered in all directions. Mrs. Som-

mers went to the corner and waited for the cable car.

A man with keen eyes, who sat opposite to her, seemed to like the study of her small, pale face. It puzzled him to decipher what he saw there. In truth, he saw nothing—unless he were wizard enough to detect a poignant wish, a powerful longing that the cable car would never stop anywhere, but go on and on with her forever.

Reading Check

1. At first, what does Mrs. Sommers plan to do with the fifteen dollars?
2. After purchasing the silk stockings what other things does she buy?
3. What would she normally have for lunch?
4. What is the last temptation she yields to?

For Study and Discussion

Analyzing and Interpreting the Story

1. What impression do you form of Mrs. Sommers' day-to-day life from the opening paragraphs of the story?

2. What need is awakened in her by the pair of silk stockings?

3. Mrs. Sommers spends all of the precious money on herself. Given the responsible nature of her character, what do you think accounts for this self-indulgence?

4. Early in the story we are told that Mrs. Sommers is not in the habit of dwelling on the "better days" she had once known. At the end of the story, is she ready to resume her practical attitude toward the deprivations of her life, or has she changed in some way?

Literary Elements

Limited Third-Person Point of View

"A Pair of Silk Stockings" is told from the **limited third-person point of view.** A story told from this point of view is narrated by someone who stands outside the action, but who sees almost everything from the vantage point of one character. The narrator takes us inside the mind of the main character and lets us see the world chiefly through his or her eyes. The narrator also reveals what the character thinks or feels:

> Her stockings and boots and well-fitting gloves had worked marvels in her bearing—had given her a feeling of assurance, a sense of belonging to the well-dressed multitude.

By adopting the limited third-person point of view, the author rivets our attention to her main character. Why is the private, quiet world of little Mrs. Sommers best revealed through limited third-person narration? How do you think the story would have changed if it had been told from an omniscient point of view or from a first-person point of view, with Mrs. Sommers herself narrating?

Language and Vocabulary

Determining Precise Meanings

Using a college or unabridged dictionary, determine the precise meanings of the italicized pairs of words in the following passages from the story:

> For a day or two she walked about . . . absorbed in *speculation* and *calculation*.

> . . . she seemed to see her way clearly toward a *proper* and *judicious* use of the money.

> The vision of her little brood . . . made her *restless* and *wakeful* with anticipation.

> She seemed for the time to be taking a rest from that *laborious* and *fatiguing* function . . .

Writing About Literature

Interpreting the Author's Attitude

In this story Kate Chopin tells about a woman's self-indulgence. Instead of using her extra money to buy necessary things for her children, Mrs. Sommers uses it on small luxuries for herself.

Is the author's attitude toward her character critical, or is it compassionate? How do you know? Write an essay in which you present your interpretation.

Prewriting Suggestions: Find passages of direct description and look at the *connotative* meanings of words used to describe Mrs. Sommers. Note how other people in the story react to her.

Focus on Narrative Writing

Using Anecdotes in a Narrative

An **anecdote** is a very brief story about an interesting or humorous incident. Kate Chopin's story derives its effect from a cumulative series of related anecdotes about a special day in the life of Mrs. Sommers. These incidents are relatively minor in themselves; it is their combination that makes Chopin's story effective.

Write some notes for an anecdote about something humorous, surprising, or strange that happened to you. Then use these guidelines to organize your notes:

1. Use first-person point of view.
2. Use your own "voice": the speech mannerisms and colloquial expressions that you would use to tell a story to a good friend.
3. Follow chronological order.

Join with a small group of classmates and trade anecdotes with them. After each person tells an anecdote, hold a short group discussion. In the discussion, give each other suggestions about ways to make your anecdotes clearer, funnier, or more meaningful. Save your notes.

About the Author

Kate Chopin (1850–1904)

Kate Chopin was born in St. Louis, Missouri. After graduating from school she became part of the fashionable social scene in St. Louis, although she did not relish the role of society belle. She married in 1870 and settled in Louisiana, which became the setting for many of her stories. After her husband's death she took over the management of the family plantation and the village store. In 1884 she returned to St. Louis with her children and began her literary career. Her first collection of stories, *Bayou Folk,* appeared in 1894. Kate Chopin valued spontaneity in literature and tended to write quickly, with a minimum of revision. In addition to short stories she wrote poems and novels.

IRONY

All irony involves a difference, or discrepancy, between what appears to be and what really is—that is, between appearance and reality. The simplest kind of irony is *verbal irony*. In verbal irony, a speaker or writer says the opposite of what he or she means; such a person speaks "tongue in cheek," as we say. Verbal irony is common in everyday conversation. When someone describes a ten-course meal as a "light snack," the speaker is being ironic. Leiningen is being ironic when he tells his men, "Too bad if you'd missed the rest of the show, eh? Well, the fun won't start till morning" (page 21). He is talking about a life-and-death struggle as if it were a party.

Another, usually more important, kind of irony is *dramatic irony*. In dramatic irony, the discrepancy is between what a character says (or thinks) and what the reader knows is true. In dramatic irony, a character is not aware of something the reader is aware of. Maurice Walsh uses dramatic irony in his story "The Quiet Man" (page 130). If we read that story carefully, we find hints that Shawn Kelvin, the "quiet man," was really a prizefighter in the United States. Thus, we have guessed at something that Shawn's enemy, the bully Big Liam O'Grady, does not know.

A third kind of irony often used in fiction is *irony of situation*. Irony of situation occurs when a situation turns out to be different from what we had expected. A famous example of irony of situation occurs in O. Henry's story "The Gift of the Magi." In that story, a young husband and wife are nearly penniless, and it is Christmas. Out of love for her husband, the wife cuts off and sells her long hair to buy him a watch chain. At the end of the story, however, she discovers that her husband has sold his watch to buy her a set of combs for her long hair. This situation is ironic because the characters' actions bring about results that are the opposite of what they had expected.

Irony is an important element in fiction because it drives home the truth that human life itself is unpredictable. In fiction, just as in life, our words and our actions do not always have the meanings or results we expect them to have.

The Bet

ANTON CHEKHOV°

Translated from the Russian by

Constance Garnett

Are you prepared for the outcome of the bet? What does this story tell you about Chekhov's view of human beings and of life?

I

It was a dark autumn night. The old banker was walking up and down his study and remembering how, fifteen years before, he had given a party one autumn evening. There had been many clever men there, and there had been interesting conversations. Among other things, they had talked of capital punishment. The majority of the guests, among whom were many journalists and intellectual men, disapproved of the death penalty. They considered that form of punishment out of date, immoral, and unsuitable for Christian states. In the opinion of some of them the death penalty ought to be replaced everywhere by imprisonment for life.

"I don't agree with you," said their host the banker. "I have not tried either the death penalty or imprisonment for life, but if one may judge *a priori*,[1] the death penalty is more moral and more humane than imprisonment for life. Capital punishment kills a man at once, but lifelong imprisonment kills him slowly. Which executioner is the more humane, he who kills you in a few minutes or he who drags the life out of you in the course of many years?"

"Both are equally immoral," observed one of the guests, "for they both have the same object—to take away life. The state is not God. It has not the right to take away what it cannot restore when it wants to."

Among the guests was a young lawyer, a young man of five-and-twenty. When he was asked his opinion, he said:

"The death sentence and the life sentence are equally immoral, but if I had to choose between the death penalty and imprisonment for life, I would certainly choose the second. To live anyhow is better than not at all."

A lively discussion arose. The banker, who was younger and more nervous in those days, was suddenly carried away by excitement; he struck the table with his fist and shouted at the young man:

"It's not true! I'll bet you two millions you wouldn't stay in solitary confinement for five years."

"If you mean that in earnest," said the young man, "I'll take the bet, but I would stay not five but fifteen years."

°**Chekhov** (chĕk'ôf').
1. *a priori* (ä'prē-ôr'ē, ā'prī-ôr'ī): based on theory.

"Fifteen? Done!" cried the banker. "Gentlemen, I stake two millions!"

"Agreed! You stake your millions and I stake my freedom!" said the young man.

And this wild, senseless bet was carried out! The banker, spoiled and frivolous, with millions beyond his reckoning, was delighted at the bet. At supper he made fun of the young man, and said:

"Think better of it, young man, while there is still time. To me two millions are a trifle, but you are losing three or four of the best years of your life. I say three or four, because you won't stay longer. Don't forget either, you unhappy man, that voluntary confinement is a great deal harder to bear than compulsory. The thought that you have the right to step out in liberty at any moment will poison your whole existence in prison. I am sorry for you."

And now the banker, walking to and fro, remembered all this, and asked himself: "What was the object of that bet? What is the good of that man's losing fifteen years of his life and my throwing away two millions? Can it prove that the death penalty is better or worse than imprisonment for life? No, no. It was all nonsensical and meaningless. On my part it was the caprice of a pampered man, and on his part simple greed for money. . . ."

Then he remembered what followed that evening. It was decided that the young man should spend the years of his captivity under the strictest supervision in one of the lodges in the banker's garden. It was agreed that for fifteen years he should not be free to cross the threshold of the lodge, to see human beings, to hear the human voice, or to receive letters and newspapers. He was allowed to have a musical instrument and books, and was allowed to write letters, to drink wine, and to smoke. By the terms of the agreement, the only relations he could have with the outer world were by a little window made purposely for that object. He might have anything he wanted—books, music, wine, and so on—in any quantity he desired, by writing an order, but could receive them only through the window. The agreement provided for every detail and every trifle that would make his imprisonment strictly solitary, and bound the young man to stay there *exactly* fifteen years, beginning from twelve o'clock of November 14, 1870, and ending at twelve o'clock of November 14, 1885. The slightest attempt on his part to break the conditions, if only two minutes before the end, released the banker from the obligation to pay him two millions.

For the first year of his confinement, as far as one could judge from his brief notes, the prisoner suffered severely from loneliness and depression. The sounds of the piano could be heard continually day and night from his lodge. He refused wine and tobacco. Wine, he wrote, excites the desires, and desires are the worst foes of the prisoner; and besides, nothing could be more dreary than drinking good wine and seeing no one. And tobacco spoiled the air of his room. In the first year the books he sent for were principally of a light character; novels with a complicated love plot, sensational and fantastic stories, and so on.

In the second year the piano was silent in the lodge, and the prisoner asked only for the classics. In the fifth year music was audible again, and the prisoner asked for wine. Those who watched him through the window said that all that year he spent doing nothing but eating and drinking and lying on his bed, frequently yawning and talking angrily to himself. He did not read books. Sometimes at night he would sit down to write; he would spend hours writing, and in the morning tear up all that he had written. More than once he could be heard crying.

In the second half of the sixth year the prisoner began zealously studying languages, phi-

The House of Mystery (1892) by William Degouve de Nuncques (1867–1935).
Oil on canvas.

losophy, and history. He threw himself eagerly into these studies—so much so that the banker had enough to do to get him the books he ordered. In the course of four years some six hundred volumes were procured at his request. It was during this period that the banker received the following letter from his prisoner:

"My dear Jailer, I write you these lines in six languages. Show them to people who know the languages. Let them read them. If they find not one mistake I implore you to fire a shot in the garden. That shot will show me that my efforts have not been thrown away. The geniuses of all ages and of all lands speak different languages, but the same flame burns in them all. Oh, if you only knew what unearthly happiness my soul feels now from being able to understand them!" The prisoner's desire was fulfilled. The banker ordered two shots to be fired in the garden.

Then, after the tenth year, the prisoner sat immovably at the table and read nothing but the Gospel. It seemed strange to the banker that a man who in four years had mastered six hundred learned volumes should waste nearly a year over one thin book easy of comprehension. Theology and histories of religion followed the Gospels.

In the last two years of his confinement the prisoner read an immense quantity of books quite indiscriminately. At one time he was busy with the natural sciences, then he would ask for Byron[2] or Shakespeare. There were notes in which he demanded at the same time books on chemistry, and a manual of medicine, and a novel, and some treatise on philosophy or theology. His reading suggested a man swimming in the sea among the wreckage of his ship, and trying to save his life by greedily clutching first at one spar and then at another.

2. **Byron:** George Gordon, Lord Byron (1788–1824), English Romantic poet.

II

The old banker remembered all this, and thought:

"Tomorrow at twelve o'clock he will regain his freedom. By our agreement I ought to pay him two millions. If I do pay him, it is all over with me: I shall be utterly ruined."

Fifteen years before, his millions had been beyond his reckoning; now he was afraid to ask himself which were greater, his debts or his assets. Desperate gambling on the Stock Exchange, wild speculation, and the excitability which he could not get over even in advancing years, had by degrees led to the decline of his fortune, and the proud, fearless, self-confident millionaire had become a banker of middling rank, trembling at every rise and fall in his investments. "Cursed bet!" muttered the old man, clutching his head in despair. "Why didn't the man die? He is only forty now. He will take my last penny from me, he will marry, will enjoy life, will gamble on the Exchange; while I shall look at him with envy like a beggar, and hear from him every day the same sentence: 'I am indebted to you for the happiness of my life, let me help you!' No, it is too much! The one means of being saved from bankruptcy and disgrace is the death of that man!"

It struck three o'clock. The banker listened; everyone was asleep in the house, and nothing could be heard outside but the rustling of the chilled trees. Trying to make no noise, he took from a fireproof safe the key of the door which had not been opened for fifteen years, put on his overcoat, and went out of the house.

It was dark and cold in the garden. Rain was falling. A damp, cutting wind was racing about the garden, howling and giving the trees no rest. The banker strained his eyes, but could see neither the earth nor the white statues, nor the lodge, nor the trees. Going to the spot

where the lodge stood, he twice called the watchman. No answer followed. Evidently the watchman had sought shelter from the weather, and was now asleep somewhere either in the kitchen or in the greenhouse.

"If I had the pluck to carry out my intention," thought the old man, "suspicion would fall first upon the watchman."

He felt in the darkness for the steps and the door, and went into the entry of the lodge. Then he groped his way into a little passage and lighted a match. There was not a soul there. There was a bedstead with no bedding on it, and in the corner there was a dark cast-iron stove. The seals on the door leading to the prisoner's rooms were intact.

When the match went out the old man, trembling with emotion, peeped through the little window. A candle was burning dimly in the prisoner's room. He was sitting at the table. Nothing could be seen but his back, the hair on his head, and his hands. Open books were lying on the table, on the two easy chairs, and on the carpet near the table.

Five minutes passed and the prisoner did not once stir. Fifteen years' imprisonment had taught him to sit still. The banker tapped at the window with his finger, and the prisoner made no movement whatever in response. Then the banker cautiously broke the seals off the door and put the key in the keyhole. The rusty lock gave a grating sound and the door creaked. The banker expected to hear at once footsteps and a cry of astonishment, but three minutes passed and it was as quiet as ever in the room. He made up his mind to go in.

At the table a man unlike ordinary people was sitting motionless. He was a skeleton with the skin drawn tight over his bones, with long curls like a woman's, and a shaggy beard. His face was yellow with an earthy tint in it, his cheeks were hollow, his back long and narrow, and the hand on which his shaggy head was propped was so thin and delicate that it was dreadful to look at it. His hair was already streaked with silver, and seeing his emaciated, aged-looking face, no one would have believed that he was only forty. He was asleep. . . . In front of his bowed head there lay on the table a sheet of paper, on which there was something written in fine handwriting.

"Poor creature!" thought the banker, "he is asleep and most likely dreaming of the millions. And I have only to take this half-dead man, throw him on the bed, stifle him a little with the pillow, and the most conscientious expert would find no sign of a violent death. But let us first read what he has written here. . . ."

The banker took the page from the table and read as follows:

"Tomorrow at twelve o'clock I regain my freedom and the right to associate with other men, but before I leave this room and see the sunshine, I think it necessary to say a few words to you. With a clear conscience I tell you, as before God, who beholds me, that I despise freedom and life and health, and all that in your books is called the good things of the world.

"For fifteen years I have been intently studying earthly life. It is true I have not seen the earth nor men, but in your books I have drunk fragrant wine, I have sung songs, I have hunted stags and wild boars in the forests, have loved women. . . . Beauties as ethereal as clouds, created by the magic of your poets and geniuses, have visited me at night, and have whispered in my ears wonderful tales that have set my brain in a whirl. In your books I have climbed to the peaks of Elburz and Mont Blanc,[3] and from there I have seen the sun rise and have watched it at evening flood the sky, the ocean, and the mountaintops with gold

3. **Elburz** (ĕl-bo͞orz′) **and Mont Blanc** (môN bläN′): Elburz is a mountain range in northern Iran; Mont Blanc, in France, is the highest peak in the Alps.

and crimson. I have watched from there the lightning flashing over my head and cleaving the storm clouds. I have seen green forests, fields, rivers, lakes, towns. I have heard the singing of the sirens,[4] and the strains of the shepherds' pipes; I have touched the wings of comely devils who flew down to converse with me of God. . . . In your books I have flung myself into the bottomless pit, performed miracles, slain, burned towns, preached new religions, conquered whole kingdoms. . . .

"Your books have given me wisdom. All that the unresting thought of man has created in the ages is compressed into a small compass in my brain. I know that I am wiser than all of you.

"And I despise your books, I despise wisdom and the blessings of this world. It is all worthless, fleeting, illusory, and deceptive, like a mirage. You may be proud, wise, and fine, but death will wipe you off the face of the earth as though you were no more than mice burrowing under the floor, and your posterity, your history, your immortal geniuses will burn or freeze together with the earthly globe.

"You have lost your reason and taken the wrong path. You have taken lies for truth, and hideousness for beauty. You would marvel if, owing to strange events of some sorts, frogs and lizards suddenly grew on apple and orange trees instead of fruit, or if roses began to smell like a sweating horse; so I marvel at you who exchange heaven for earth. I don't want to understand you.

"To prove to you in action how I despise all that you live by, I renounce the two millions of which I once dreamed as of paradise and which now I despise. To deprive myself of the right to the money I shall go out from here five minutes before the time fixed, and so break the compact. . . ."

4. **sirens:** in Greek mythology, sea nymphs who had beautiful unearthly voices.

When the banker had read this he laid the page on the table, kissed the strange man on the head, and went out of the lodge, weeping. At no other time, even when he had lost heavily on the Stock Exchange, had he felt so great a contempt for himself. When he got home he lay on his bed, but his tears and emotion kept him for hours from sleeping.

Next morning the watchmen ran in with pale faces, and told him they had seen the man who lived in the lodge climb out of the window into the garden, go to the gate, and disappear. The banker went at once with the servants to the lodge and made sure of the flight of his prisoner. To avoid arousing unnecessary talk, he took from the table the writing in which the millions were renounced, and when he got home locked it up in the fireproof safe.

Reading Check

1. How long does the banker predict the young lawyer will remain in the lodge?
2. What kind of books does the prisoner ask for at first?
3. What happens to the banker's fortune?
4. Why does the banker enter the prisoner's lodge?
5. What is the outcome of the bet?

For Study and Discussion

Analyzing and Interpreting the Story

1. A **flashback** is a narrative device in which past events and conversations are recalled. What essential information is provided by the two flashbacks at the beginning of this story?

2. What is about to happen in the present?

The Bet **165**

3. During the fifteen years, the banker and the lawyer have changed in important ways. How has the banker changed?

4. This story is told from the limited point of view of one character, the banker. How does the narrator reveal the prisoner's state of mind?

5a. Why does the prisoner deliberately forfeit the money? **b.** How would you describe his view of human life?

6a. Has the prisoner's letter changed the banker's view of himself? Explain. **b.** Why does the banker put the letter in the safe?

7. The bet was made to test certain views about human life. In your opinion, whose viewpoint was proved valid—the prisoner's or the banker's?

Literary Elements

Irony of Situation

In "The Bet" Chekhov uses **irony of situation,** the kind of irony in which what happens is the opposite of what we expect will happen. The basis of the bet itself provides part of the irony in this story. Look back at the conversation at the opening of the story in which the banker talks of such things as morality and humaneness. Why is it ironic that this particular bet should lead the banker to decide to murder his prisoner?

Because we have not had a chance to know the prisoner's thoughts, we are as much surprised as the banker is by the letter. Like the banker, we expect that the prisoner would, after fifteen years, look forward to his release and the two million which would help him achieve his "life's happiness." Ironically, the bet has proved something different to the prisoner. What did he expect it to prove? What has it actually proved to him?

Writing About Literature

Explaining the Tone of a Story

Tone is the attitude a writer takes toward a subject or an audience. Two writers can write on the same subject and convey entirely different tones: one might view a topic with great sympathy and compassion, whereas the other might take a cynical and pessimistic approach. In a brief essay, discuss the tone revealed in "The Bet." What attitude toward life, happiness, wealth, wisdom, and death does the author convey? Support your opinion by quoting passages from the story.

About the Author

Anton Chekhov (1860–1904)

Anton Chekhov, a Russian, was the grandson of a serf and the son of a shopkeeper. While a medical student, he supported himself and his family by writing short stories for comic magazines. After the publication of his first book, he gave up medicine to become a writer. A master of the short-story form, Chekhov is also one of the most important modern dramatists, known for such plays as *The Cherry Orchard, Uncle Vanya, The Three Sisters,* and *The Sea Gull.* In a letter written in 1889, Chekhov said of his work: "I weave in the life of good people, their fate, deeds, words, ideas, and hopes. My goal is to kill two birds with one stone: to paint life in its true aspects, and to show how far this life falls short of the ideal life. I don't know what this ideal life is, just as it is unknown to all of us."

Harrison Bergeron

KURT VONNEGUT

A handicap is a contest or race in which some contestants are given advantages or disadvantages so that the chances of winning are equalized. Note how Vonnegut makes use of the word in this science-fiction fantasy.

The year was 2081, and everybody was finally equal. They weren't only equal before God and the law. They were equal every which way. Nobody was smarter than anybody else. Nobody was better looking than anybody else. Nobody was stronger or quicker than anybody else. All this equality was due to the 211th, 212th, and 213th Amendments to the Constitution, and to the unceasing vigilance of agents of the United States Handicapper General.

Some things about living still weren't quite right, though. April, for instance, still drove people crazy by not being springtime. And it was in that clammy month that the H-G men took George and Hazel Bergeron's fourteen-year-old son, Harrison, away.

It was tragic, all right, but George and Hazel couldn't think about it very hard. Hazel had a perfectly average intelligence, which meant she couldn't think about anything except in short bursts. And George, while his intelligence was way above normal, had a little mental-handicap radio in his ear. He was required by law to wear it at all times. It was tuned to a government transmitter. Every twenty seconds or so, the transmitter would send out some sharp noise to keep people like George from taking unfair advantage of their brains.

George and Hazel were watching television. There were tears on Hazel's cheeks, but she'd forgotten for the moment what they were about.

On the television screen were ballerinas.

A buzzer sounded in George's head. His thoughts fled in panic, like bandits from a burglar alarm.

"That was a real pretty dance, that dance they just did," said Hazel.

"Huh?" said George.

"That dance—it was nice," said Hazel.

"Yup," said George. He tried to think a little about the ballerinas. They weren't really very good—no better than anybody else would have been, anyway. They were burdened with sash weights and bags of birdshot, and their faces were masked, so that no one, seeing a free and graceful gesture or a pretty face, would feel like something the cat drug in. George was toying with the vague notion that maybe dancers shouldn't be handicapped. But he didn't

Nervosa (1980) by Ed Paschke (1939–). Oil on canvas.

Courtesy Phyllis Kind Gallery, New York and Chicago

get very far with it before another noise in his ear radio scattered his thoughts.

George winced. So did two out of the eight ballerinas.

Hazel saw him wince. Having no mental handicap herself, she had to ask George what the latest sound had been.

"Sounded like somebody hitting a milk bottle with a ball-peen hammer," said George.

"I'd think it would be real interesting, hearing all the different sounds," said Hazel, a little envious. "All the things they think up."

"Um," said George.

"Only, if I was Handicapper General, you know what I would do?" said Hazel. Hazel, as a matter of fact, bore a strong resemblance to the Handicapper General, a woman named Diana Moon Glampers. "If I was Diana Moon Glampers," said Hazel, "I'd have chimes on Sunday—just chimes. Kind of in honor of religion."

"I could think, if it was just chimes," said George.

"Well—maybe make 'em real loud," said Hazel. "I think I'd make a good Handicapper General."

"Good as anybody else," said George.

"Who knows better'n I do what normal is?" said Hazel.

"Right," said George. He began to think glimmeringly about his abnormal son who was now in jail, about Harrison, but a twenty-one-gun salute in his head stopped that.

"Boy!" said Hazel, "that was a doozy, wasn't it?"

It was such a doozy that George was white and trembling, and tears stood on the rims of his red eyes. Two of the eight ballerinas had collapsed to the studio floor, were holding their temples.

"All of a sudden you look so tired," said Hazel. "Why don't you stretch out on the sofa, so's you can rest your handicap bag on the pillows, honeybunch." She was referring to the forty-seven pounds of birdshot in a canvas bag, which was padlocked around George's neck. "Go on and rest the bag for a little while," she said. "I don't care if you're not equal to me for a while."

George weighed the bag with his hands. "I don't mind it," he said. "I don't notice it any more. It's just a part of me."

"You been so tired lately—kind of wore out," said Hazel. "If there was just some way we could make a little hole in the bottom of the bag, and just take out a few of them lead balls. Just a few."

"Two years in prison and two thousand dollars fine for every ball I took out," said George. "I don't call that a bargain."

"If you could just take a few out when you came home from work," said Hazel. "I mean— you don't compete with anybody around here. You just set around."

"If I tried to get away with it," said George, "then other people'd get away with it—and pretty soon we'd be right back to the dark ages again, with everybody competing against everybody else. You wouldn't like that, would you?"

"I'd hate it," said Hazel.

"There you are," said George. "The minute people start cheating on laws, what do you think happens to society?"

If Hazel hadn't been able to come up with an answer to this question, George couldn't have supplied one. A siren was going off in his head.

"Reckon it'd fall all apart," said Hazel.

"What would?" said George blankly.

"Society," said Hazel uncertainly. "Wasn't that what you just said?"

"Who knows?" said George.

The television program was suddenly interrupted for a news bulletin. It wasn't clear at first as to what the bulletin was about, since the announcer, like all announcers, had a serious speech impediment. For about half a minute, and in a state of high excitement, the announcer tried to say, "Ladies and gentlemen——"

He finally gave up, handed the bulletin to a ballerina to read.

"That's all right—" Hazel said of the announcer, "he tried. That's the big thing. He tried to do the best he could with what God gave him. He should get a nice raise for trying so hard."

"Ladies and gentlemen—" said the ballerina, reading the bulletin. She must have been extraordinarily beautiful, because the mask she wore was hideous. And it was easy to see that she was the strongest and most graceful of all the dancers, for her handicap bags were as big as those worn by two-hundred-pound men.

And she had to apologize at once for her voice, which was a very unfair voice for a woman to use. Her voice was a warm, luminous, timeless melody. "Excuse me—" she said, and she began again, making her voice absolutely uncompetitive.

"Harrison Bergeron, age fourteen," she said in a grackle squawk, "has just escaped from jail, where he was held on suspicion of plotting to overthrow the government. He is a genius and an athlete, is underhandicapped, and should be regarded as extremely dangerous."

A police photograph of Harrison Bergeron was flashed on the screen—upside down, then sideways, upside down again, then right side up. The picture showed the full length of Harrison against a background calibrated in feet and inches. He was exactly seven feet tall.

The rest of Harrison's appearance was Halloween and hardware. Nobody had ever borne heavier handicaps. He had outgrown hindrances faster than the H-G men could think them up. Instead of a little ear radio for a mental handicap, he wore a tremendous pair of earphones, and spectacles with thick wavy lenses. The spectacles were intended to make him not only half blind, but to give him whanging headaches besides.

Scrap metal was hung all over him. Ordinarily, there was a certain symmetry, a military neatness to the handicaps issued to strong people, but Harrison looked like a walking junkyard. In the race of life, Harrison carried three hundred pounds.

And to offset his good looks, the H-G men required that he wear at all times a red rubber ball for a nose, keep his eyebrows shaved off, and cover his even white teeth with black caps at snaggle-tooth random.

"If you see this boy," said the ballerina, "do not—I repeat, do not—try to reason with him."

There was the shriek of a door being torn from its hinges.

Screams and barking cries of consternation came from the television set. The photograph of Harrison Bergeron on the screen jumped again and again, as though dancing to the tune of an earthquake.

George Bergeron correctly identified the earthquake, and well he might have—for many was the time his own home had danced to the same crashing tune. "That must be Harrison!"

The realization was blasted from his mind instantly by the sound of an automobile collision in his head.

When George could open his eyes again, the photograph of Harrison was gone. A living, breathing Harrison filled the screen.

Clanking, clownish, and huge, Harrison stood in the center of the studio. The knob of the uprooted studio door was still in his hand. Ballerinas, technicians, musicians, and announcers cowered on their knees before him, expecting to die.

"I am the Emperor!" cried Harrison. "Do you hear? I am the Emperor! Everybody must do what I say at once!" He stamped his foot and the studio shook.

"Even as I stand here—" he bellowed, "crippled, hobbled, sickened—I am a greater ruler than any man who ever lived! Now watch me become what I *can* become!"

Harrison tore the straps of his handicap harness like wet tissue paper, tore straps guaranteed to support five thousand pounds.

Harrison's scrap-iron handicaps crashed to the floor.

Harrison thrust his thumbs under the bar of the padlock that secured his head harness. The bar snapped like celery. Harrison smashed his headphones and spectacles against the wall.

He flung away his rubber-ball nose, revealed a man that would have awed Thor, the god of thunder.

"I shall now select my Empress!" he said, looking down on the cowering people. "Let the first woman who dares rise to her feet claim her mate and her throne!"

A moment passed, and then a ballerina arose, swaying like a willow.

Harrison plucked the mental handicap from her ear, snapped off her physical handicaps with marvelous delicacy. Last of all, he removed her mask.

She was blindingly beautiful.

"Now—" said Harrison, taking her hand, "shall we show the people the meaning of the word *dance?* Music!" he commanded.

The musicians scrambled back into their chairs, and Harrison stripped them of their handicaps, too. "Play your best," he told them, "and I'll make you barons and dukes and earls."

The music began. It was normal at first—cheap, silly, false. But Harrison snatched two musicians from their chairs, waved them like batons as he sang the music as he wanted it played. He slammed them back into their chairs.

The music began again and was much improved.

Harrison and his Empress merely listened to the music for a while—listened gravely, as though synchronizing their heartbeats with it.

They shifted their weights to their toes.

Harrison placed his big hands on the girl's tiny waist, letting her sense the weightlessness that would soon be hers.

And then, in an explosion of joy and grace, into the air they sprang!

Not only were the laws of the land abandoned, but the law of gravity and the laws of motion as well.

They reeled, whirled, swiveled, flounced, capered, gamboled, and spun.

They leaped like deer on the moon.

The studio ceiling was thirty feet high, but

each leap brought the dancers nearer to it.

It became their obvious intention to kiss the ceiling.

They kissed it.

And then, neutralizing gravity with love and pure will, they remained suspended in air inches below the ceiling, and they kissed each other for a long, long time.

It was then that Diana Moon Glampers, the Handicapper General, came into the studio with a double-barreled ten-gauge shotgun. She fired twice, and the Emperor and the Empress were dead before they hit the floor.

Diana Moon Glampers loaded the gun again. She aimed it at the musicians and told them they had ten seconds to get their handicaps back on.

It was then that the Bergerons' television tube burned out.

Hazel turned to comment about the blackout to George. But George had gone out into the kitchen for a can of beer.

George came back in with the beer, paused while a handicap signal shook him up. And then he sat down again. "You been crying?" he said to Hazel.

"Yup," she said.

"What about?" he said.

"I forget," she said. "Something real sad on television."

"What was it?" he said.

"It's all kind of mixed up in my mind," said Hazel.

"Forget sad things," said George.

"I always do," said Hazel.

"That's my girl," said George. He winced. There was the sound of a riveting gun in his head.

"Gee—I could tell that one was a doozy," said Hazel.

"You can say that again," said George.

"Gee—" said Hazel, "I could tell that one was a doozy."

Reading Check

1. Why does George Bergeron have a mental-handicap radio in his ear, but his wife does not?
2. Why have the H-G men taken away Harrison?
3. What is the penalty for tampering with a handicap bag?
4. What handicaps have been issued to Harrison?
5. Who is in charge of seeing that the laws of equality are carried out?

For Study and Discussion

Analyzing and Interpreting the Story

1. "Harrison Bergeron" is a **satire,** a form of writing that attacks and ridicules some social evil or human weakness. **a.** On what principle is the society in this satire based? **b.** What aspects of actual societies is the author mocking?

2. In traditional stories, the hero is a superhuman figure, superior to ordinary people. Usually this hero "saves" the people from an enemy. **a.** In what passages of the story does Harrison Bergeron remind you of this superhuman kind of hero? **b.** How is the result of Harrison's efforts an ironic reversal of what happens in the traditional heroic stories?

3a. What is the conflict in this story? **b.** Did the climax surprise you? Why, or why not?

4. Like all satires, this one has a serious point to make. What do you think Vonnegut is saying about equality in this story?

Literary Elements

Verbal Irony

Verbal irony is a way of saying something and intending something quite different. It is clear in the first paragraph of the story that Vonnegut is using the words *equal* and *equality* ironically. What do these words ordinarily suggest? What do they mean in Vonnegut's story? How are the words *normal* and *abnormal* used?

Find other examples of verbal irony in the story. What does this use of language suggest about the society in Vonnegut's story?

About the Author

Kurt Vonnegut (1922–)

Vonnegut was born in Indianapolis, Indiana. Unlike many writers, Vonnegut received a technical education. Rather than studying literature, he studied biochemistry and then anthropology. He has expressed his amusement at critics who assume "that anybody who understands how a refrigerator works couldn't possibly be an artist."

While Vonnegut was once identified as a science-fiction writer, he is now recognized chiefly for his social satire. His work often combines technology and ideas about the future with an understanding of human nature and experience. He is the author of numerous novels, books of short fiction, and plays, several of which have been turned into films. One of Vonnegut's best-known novels, *Slaughterhouse-Five* (1969), is based on his experiences as a German prisoner of war during World War II. Vonnegut was being held in an abandoned slaughterhouse in Dresden in eastern Germany at the time the city was firebombed by the Allies.

Recent works include *Slapstick; or Lonesome No More!* (1976), *Fates Worse Than Death* (1985), and *Hocus Pocus* (1990).

The Piece of Yarn

GUY DE MAUPASSANT

The plot of this story hinges on several ironies of situation. What are they?
What do you think is the author's attitude toward his characters?

On all the roads around Goderville, farmers and their wives were streaming into town, for this was market day. The men strode calmly along, their bodies hunching forward with each movement of their long, crooked legs, misshapen from hard labors—from leaning on the plow, which simultaneously elevated the left shoulder and threw the back out of line; from swinging the scythe, in which the need for a solid stance bowed the legs at the knees; from all the slow and laborious tasks of work in the field. Their blue smocks, starched until they glistened like varnish, embroidered at neck and wrist with a small design in white thread, puffed out around their bony chests like balloons about to take flight with a head, two arms, and two feet attached.

The men tugged after them, at the end of a rope, a cow or a calf. And their wives, behind the animal, tried to hasten it on by flicking its rump with a small branch still bearing leaves. In the crook of their arms they carried large covered baskets from which heads of chickens and ducks protruded here and there. They walked with shorter and more lively steps than their husbands; their figures lean, erect, and wrapped in a tightfitting shawl pinned together over their flat chests; their hair swathed in a piece of white linen and topped off by a tight brimless cap.

Now and then a farm wagon would overtake them, drawn at a brisk trot by a small sturdy horse, grotesquely jouncing two men side by side, and a woman in the back clinging to the frame to cushion the rough jolts.

What a milling around, what a jostling mob of people and animals there was on Goderville square! Above the surface of the assemblage protruded the horns of cattle, the high-crowned, long-furred hats of wealthy farmers, and the headdresses of their ladies. The bawling, shrill, piercing voices raised a continuous din, above which echoed an occasional hearty laugh from the robust lungs of a merrymaking farmhand or the long lowing of a cow tied to a house wall.

Everything smelled of the stable, milk and manure, hay and sweat, and gave off the pungent, sour odor of man and beast so characteristic of those who work in the fields.

Maître Hauchecorne, of Bréauté,[1] had just reached Goderville and was making his way toward the square when he glimpsed a piece of yarn on the ground. Maître Hauchecorne,

1. **Maître ... Bréauté** (mā′trə ōsh′kôrn of brā′ō-tā′). *Maître* was used as a title for shopkeepers and farmers.

Poultry Market at Gisors (1885) by Camille Pissarro (1830–1903).
Gouache and black chalk on paper mounted on canvas.

thrifty like the true Norman he was, thought it worthwhile to pick up anything that could be useful; and he stooped down painfully, for he suffered from rheumatism. He plucked up the thin piece of yarn and was just starting to wind it up carefully when he caught sight of

Maître Malandain,[2] the harness maker, eyeing him from his doorstep. They had once disagreed over the price of a harness, and since both had a tendency to hold grudges, they had remained on bad terms with each other. Maître Hauchecorne felt a bit humiliated at having been seen by his enemy scrabbling in the dirt for a bit of yarn. He quickly thrust his find under his smock, then into his trousers pocket; afterwards he pretended to search the ground for something he had lost, and at last he went off toward the marketplace with his head bent forward and his body doubled over by his aches and pains.

He lost himself at once in the shrill and slow-moving crowd, keyed up by long-drawn-out bargaining. The farmers would run their hands over the cows, go away, come back, undecided, always in fear of being taken in, never daring to commit themselves, slyly watching the seller's eye, endlessly hoping to discover the deception in the man and the defect in the beast.

The women, after placing their baskets at their feet, had drawn out their poultry, which sprawled on the ground, their feet tied together, with fear-glazed eyes and scarlet combs.

Standing rigidly, their faces giving away nothing, the women would listen to offers and hold to their prices; or else, on impulse deciding to accept an offer, would shout after a customer who was slowly moving off: "All right, Maît' Anthime.[3] It's yours."

Then, little by little, the square emptied, and as the bells rang the noonday angelus,[4] those who lived too far away scattered to the inns.

At Jourdain's the large hall was filled with diners just as the great courtyard was filled with vehicles of all descriptions: two-wheeled carts, buggies, farm wagons, carriages, nameless carryalls, yellow with mud, battered, patched together, with shafts raised heavenward like two arms or with front down and rear pointing upward.

Next to the seated diners the immense fireplace, flaming brightly, cast a lively warmth on the backs of the right-hand row. Three spits were turning, loaded with chickens, pigeons, and legs of mutton, and a delectable aroma of roasting meat and of juices trickling over the heat-browned skin wafted from the hearth, making hearts gay and mouths drool.

All the carriage aristocracy was eating here at the table of Maît' Jourdain, innkeeper and horse dealer, a sly man who had a knack for making money.

The dishes were passed and emptied, along with jugs of yellow cider. Each man told of his dealings, what he had bought and sold. They asked one another about how they thought the crops would do. The weather was fine for hay, but a bit damp for grain.

All of a sudden the rolling beat of a drum echoed in the courtyard before the inn. At once all the diners, except a few indifferent ones, leaped to their feet, and with mouths still full and napkins in hand, rushed to the door and windows.

When the drum roll ended, the town crier announced in a jerky voice, breaking his sentences in the wrong places:

"It is made known to the inhabitants of Goderville, and in general to all—the persons attending the market fair, that there was lost this morning, on the Beuzeville[5] road, between—nine and ten o'clock, a black leather pocketbook containing five hundred francs[6] and some business documents. It is requested that

2. **Malandain** (mȧl′ȧN-dāN′).
3. **Maît' Anthime** (māt′ȧN-tēm′).
4. **angelus** (ăn′jə-ləs): a prayer said at morning, noon, and night.

5. **Beuzeville** (bœz′vēl′).
6. **five hundred francs:** about one hundred dollars, a considerable sum at that time.

the finder return it—to the town hall, at once, or to Maître Fortuné Houlbrèque[7] of Manneville. There will be a reward of twenty francs."

The man then went off. Once more in the distance the beat of the drum rolled out hollowly, followed by the receding voice of the crier.

Now everyone began to discuss the announcement, weighing the chance Maître Houlbrèque had of getting his pocketbook back.

And the meal came to an end.

They were finishing coffee when the police sergeant appeared in the doorway.

He asked: "Is Maître Hauchecorne, of Bréauté, here?"

Maître Hauchecorne, sitting at the far end of the table, spoke up: "That's me!"

And the sergeant continued: "Maître Hauchecorne, please be good enough to come with me to the town hall. The mayor wants to talk with you."

The farmer, surprised and uneasy, gulped down his after-dinner glass of brandy, got up, and more stooped over than earlier in the morning, because his first steps after each meal were especially painful, started on his way, saying over and over:

"That's me! That's me!"

And he followed the sergeant out.

The mayor was waiting for him, presiding in an armchair. He was the local notary, a large man, grave in manner and given to pompous phrases.

"Maître Hauchecorne," he said, "you were seen this morning on the Beuzeville road picking up the pocketbook lost by Maître Houlbrèque, of Manneville."

The old farmer, struck speechless, in a panic over being suspected and not understanding why, stared at the mayor:

"Me? Me? Me pick up that pocketbook?"

7. **Fortuné Houlbrèque** (fôr-tü-nā′ōōl′brĕk′).

"Yes, you are indeed the one."

"I swear! I don't know anything at all about it."

"You were seen."

"Seen? Me? Who says he saw me?"

"Monsieur[8] Malandain, the harness maker."

Then the old man remembered, understood, and flushing with anger, said: "Hah! He saw me, that old good-for-nothing! He saw me pick up this bit of yarn. Look, Mr. Mayor." And, fumbling in the depths of his pocket, he pulled out the little piece of yarn.

But the mayor, incredulous, shook his head: "You would have me to believe, Maître Hauchecorne, that Monsieur Malandain, who is a trustworthy man, mistook that piece of yarn for a pocketbook?"

The farmer, enraged, raised his hand, spit to one side to reinforce his word, and said again: "But it's God's honest truth, the sacred truth, Mister Mayor. There! On my soul and salvation, I swear."

The mayor resumed his accusation: "After having picked up the article, you kept on searching in the mud for some time to see if some coin might have slipped out."

The old man was choking with indignation and fear.

"How can anyone say such things! . . . How can anyone say such lies to ruin a man's good name! How can anyone . . ."

No matter how much he protested, no one believed him.

He was confronted by Monsieur Malandain, who repeated his statement under oath. They hurled insults at each other for a full hour. Maître Hauchecorne was searched at his own request. They found nothing on him.

Finally the mayor, completely baffled, sent him away with the warning that he was going to inform the public prosecutor and ask what should be done.

8. **Monsieur** (mə-syœ′): French title equivalent to "Mr."

The news had spread. On leaving the town hall, the old man was surrounded and questioned with serious or good-humored curiosity, but without any hint of blame. He began to tell the story of the piece of yarn. They didn't believe him. They laughed.

He went here and there, stopped by everyone, buttonholing his acquaintances, beginning over and over again his story and his protestations, turning his pockets inside out to prove that he had nothing in them.

People said to him: "You sly old rascal, you!"

He got more and more annoyed, upset, feverish in his distress because no one believed him, not knowing what to do, and always telling his story.

Night came. It was time to go home. He set off with his three neighbors, showed them the place where he had picked up the piece of yarn, and all the way talked about his experience.

That evening he made the rounds of the village of Bréauté, telling his tale to everyone. He met no one who believed him.

He was sick about it all night.

The next day, about one in the afternoon, Marius Paumelle,[9] a farmhand working for Maître Breton, a landowner of Ymauville,[10] returned the pocketbook and its contents to Maître Houlbrèque, of Manneville.

This man claimed he had actually found the article on the highway, but being unable to read, he had taken it home and given it to his employer.

The news spread through the neighborhood. Maître Hauchecorne was informed. He began immediately to make the rounds, telling his story all over again, including the ending. He was exultant.

"What made me mad," he said, "wasn't so much the accusation, you know; it was all that lying. Nothing burns you up as much as being hauled into court on the word of a liar."

All day he kept talking about his experience, retelling it on the street to passersby, in the tavern to people having a drink, outside the church on the following Sunday. He would stop complete strangers to tell them. He felt calm about it now, but something still bothered him that he could not quite figure out. People listening to him seemed to be amused. They didn't appear to be convinced. He sensed that they were making remarks behind his back.

On Tuesday of the following week he returned to the marketplace in Goderville, driven by his need to state his case.

Malandain, standing in his doorway, began to laugh when he saw him going by. Why?

He accosted a farmer from Criquetot,[11] who didn't let him finish but punched him in the pit of the stomach and shouted in his face: "Knock it off, you old rascal!" Then he turned on his heel and walked away.

Maître Hauchecorne was struck speechless and grew more and more upset. Why would anyone call him an "old rascal"?

When he had taken his usual place at Jourdain's table, he launched into another explanation of the incident.

A horse dealer of Montivilliers[12] shouted at him: "Oh, come off it! I'm wise to that old trick. We know all about your yarn!"

Hauchecorne stammered: "But they found the pocketbook!"

"Sure old man! Somebody found it, and somebody took it back. Seeing is believing. A real pretty tangle to unsnarl!"

The farmer was stunned. At last he understood. People were accusing him of having gotten an accomplice to return the pocketbook.

He tried to deny it. The whole table burst into laughter.

9. **Marius Paumelle** (mà-rē-üs′pō-mĕl′).
10. **Breton . . . Ymauville** (brĕ-tôɴ′ē′môv-vēl′).

11. **Criquetot** (krĭk′tō′).
12. **Montivilliers** (môɴ′tē-vēl-yā′).

Unable to finish his dinner, he left, the butt of jokes and mockery.

He went home, feeling humiliated and indignant, strangled with anger and mental confusion, especially crushed because, as a shrewd Norman, he knew himself capable of doing what he was accused of, and even boasting about it as a good trick. In his confusion, he could not see how he could prove his innocence, since he was well known for driving a sharp bargain. He was heartsick over the injustice of being suspected.

He set about telling his experience all over again, each day embroidering his recital, with each retelling adding new reasons, more vigorous protestations, more solemn vows that he dreamed up and repeated during his hours alone, his whole mind occupied with the yarn. He was believed less and less as his defense became more and more intricate and his explanations more and more involved.

"Ha! With such an explanation, he must be lying!" they said behind his back. He sensed this, ate his heart out, and exhausted his strength in useless efforts. He visibly began to weaken.

Jokers now encouraged him, for their amusement, to tell "The Yarn" as one encourages a soldier back from the wars to tell about his battles. His mind, hurt to the depths, began to weaken.

Toward the end of December he took to his bed.

He died during the early days of January, and, in his dying delirium, kept protesting his innocence, repeating:

"Just a bit of yarn . . . a little bit of yarn . . . see, Mr. Mayor, there it is!"

Reading Check

1. Why does Maître Hauchecorne pick up the yarn?
2. Why have Maître Hauchecorne and Maître Malandain quarreled?
3. How do the villagers react to the story about the piece of yarn?
4. After the pocketbook is returned to its owner, why are the villagers still skeptical?

For Study and Discussion

Analyzing and Interpreting the Story

1. Besides giving us the setting of the story, the opening paragraphs also reveal important aspects of the villagers' characters. **a.** How does de Maupassant emphasize the peasants' frugality? **b.** How does he show their suspicion of one another? **c.** How do these details prepare us for their behavior later in the story?

2a. Why does Hauchecorne attempt to conceal the yarn he has picked up? **b.** What does this incident reveal about his character?

3a. Does Malandain believe that Hauchecorne found the pocketbook or is he deliberately lying? **b.** Is either answer reasonable, given the character of the peasants?

4. Why do the peasants refuse to believe that Hauchecorne is innocent?

5. Irony of situation occurs when events turn out to be quite different from what we expected. **a.** Discuss the ironies that occur in this story. **b.** What are these ironies intended to reveal about human nature?

Analyzing Sentence Structure

The following sentence has several words that look like verbs. Read the sentence aloud and identify the main clause and subordinate constructions.

> Their blue smocks, starched until they glistened like varnish, embroidered at neck and wrist with a small design in white thread, puffed out around their bony chests like balloons about to take flight with a head, two arms, and two feet attached.

The complete subject of this sentence consists of a subject word, *smocks*, and a number of modifying constructions. *Their* and *blue* are single-word modifiers. The construction *starched until they glistened like varnish* modifies *smocks*. The long phrase *embroidered at neck and wrist with a small design in white thread* also modifies the word *smocks*. The rest of the sentence is the predicate.

Identify the subject and predicate in this sentence:

> Above the surface of the assemblage protruded the horns of cattle, the high-crowned, long-furred hats of wealthy farmers, and the headdresses of their ladies.

Focus on Narrative Writing

Using Reversals

As the chart below shows, **irony** depends for its effect on a reversal or on a pointed contrast:

Verbal Irony	Situational Irony
What is said ⟶	What we expect ⟶
What is meant ←	What happens ←

Jot down some notes on how you might use verbal irony, situational irony, or both in a story of your own. Remember that the tone of irony can vary widely: from humorous to bitter, from light to tragic. Save your notes.

About the Author

Guy de Maupassant (1850–1893)

Guy de Maupassant (gē də mō-pä-säɴ′) was born and grew up in Normandy, a province in northwest France. When he was twenty, he enlisted in the French army and served in the Franco-Prussian War. After the war he worked as a government clerk in Paris. His first published story, *Boule de suif* ("Ball of Fat"), was hailed as a masterpiece. Although he wrote novels, travel sketches, and poems, he is best known as a short-story writer. His most famous story is "The Necklace." Maupassant's fame rests on his close and accurate observation of human life. Many of his tales, like "The Piece of Yarn," have an ironic ending.

SYMBOL

A *symbol* is something that stands for itself and for something broader than itself as well. In literature, a symbol may be an object, a person, a situation, or an action that suggests or represents a wider meaning. A simple example is name symbolism. Usually a name simply identifies a person. But if a name also tells us something *about* the person, then the name also has a symbolic meaning. Mistress Slipslop, for example, is a comic character in Henry Fielding's novel *Joseph Andrews*. Her name is symbolic, because she uses words as sloppily as her name suggests.

In Jack Finney's story "Contents of the Dead Man's Pockets" (page 98), a sheet of yellow paper covered with facts and figures comes to symbolize an absurd and meaningless way of life. It does so when the hero imagines his dead body lying on the sidewalk eleven stories below:

> All they'd find in his pockets would be the yellow sheet. *Contents of the dead man's pockets,* he thought, *one sheet of paper bearing penciled notations—incomprehensible.*

Finney explains the symbolism for us a few sentences later:

> *Contents of the dead man's pockets,* he thought with sudden fierce anger, *a wasted life.*

Symbolism is an extraordinarily rich fictional device. It also places a large responsibility on the reader. We must be careful not to let our imaginations run away with us and see symbols everywhere. Symbols do not occur in all stories, and they cannot mean just anything.

Love

WILLIAM MAXWELL

*Flowers appear throughout this story, in both literal and figurative ways.
Determine what symbolic meaning these flowers have.*

Miss Vera Brown, she wrote on the blackboard, letter by letter in flawlessly oval Palmer method.[1] Our teacher for the fifth grade. The name might as well have been graven in stone.

As she called the roll, her voice was as gentle as the expression in her beautiful dark brown eyes. She reminded me of pansies. When she called on Alvin Ahrens to recite and he said, "I know but I can't say," the class snickered but she said, "Try," encouragingly, and waited, to be sure that he didn't know the answer, and then said, to one of the hands waving in the air, "Tell Alvin what one-fifth of three-eighths is." If we arrived late to school, red faced and out of breath and bursting with the excuse we had thought up on the way, before we could speak she said, "I'm sure you couldn't help it. Close the door, please, and take your seat." If she kept us after school it was not to scold us but to help us past the hard part.

Somebody left a big red apple on her desk for her to find when she came into the classroom, and she smiled and put it in her desk, out of sight. Somebody else left some purple asters, which she put in her drinking glass. After that the presents kept coming. She was the only pretty teacher in the school. She never

had to ask us to be quiet or to stop throwing erasers. We would not have dreamed of doing anything that would displease her.

Somebody wormed it out of her when her birthday was. While she was out of the room the class voted to present her with flowers from the greenhouse. Then they took another vote and sweet peas won. When she saw the florist's box waiting on her desk, she said, "Oh?"

"Look inside," we all said.

Her delicate fingers seemed to take forever to remove the ribbon. In the end, she raised the lid of the box and exclaimed.

"Read the card!" we shouted.

Many Happy Returns to Miss Vera Brown, from the Fifth Grade, it said.

She put her nose in the flowers and said, "Thank you all very, very much," and then turned our minds to the spelling lesson for the day.

After school we escorted her downtown in a body to a special matinée of D. W. Griffith's[2] "Hearts of the World." She was not allowed to buy her ticket. We paid for everything.

We meant to have her for our teacher forever. We intended to pass right up through the sixth, seventh, and eighth grades and on into

1. **Palmer method:** a method of teaching handwriting, popular earlier in this century.

2. **D. W. Griffith:** a pioneer in the motion-picture industry (1875–1948).

The Country School (1871) by Winslow Homer (1836–1910). Oil on canvas.

St. Louis Art Museum,
Museum Purchase

high school taking her with us. But that isn't what happened. One day there was a substitute teacher. We expected our real teacher to be back the next day but she wasn't. Week after week passed, and the substitute continued to sit at Miss Brown's desk, calling on us to recite and giving out tests and handing them back with grades on them, and we went on acting the way we had when Miss Brown was there because we didn't want her to come back and find we hadn't been nice to the substitute. One Monday morning she cleared her throat and said that Miss Brown was sick and not coming back for the rest of the term.

In the fall we had passed on into the sixth grade and she was still not back. Benny Irish's mother found out that she was living with an aunt and uncle on a farm a mile or so beyond the edge of town, and told my mother, who told somebody in my hearing. One afternoon after school Benny and I got on our bikes and rode out to see her. At the place where the road turned off to go to the cemetery and the Chautauqua[3] grounds, there was a red barn with a huge circus poster on it, showing the entire inside of the Sells-Floto Circus tent and everything that was going on in all three rings. In the summertime, riding in the back seat of my father's open Chalmers,[4] I used to crane my neck as we passed that turn, hoping to see every last tiger and flying-trapeze artist, but it was never possible. The poster was weather-beaten now, with loose strips of paper hanging down.

It was getting dark when we wheeled our bikes up the lane of the farmhouse where Miss Brown lived.

"You knock," Benny said as we started up on the porch.

"No, you do it," I said.

3. **Chautauqua** (shə-tô′kwə): a program of educational assemblies which flourished during the late nineteenth and early twentieth centuries.
4. **Chalmers:** an automobile. The last year of production of Chalmers cars was 1923.

We hadn't thought ahead to what it would be like to see her. We wouldn't have been surprised if she had come to the door herself and thrown up her hands in astonishment when she saw who it was, but instead a much older woman opened the door and said, "What do you want?"

"We came to see Miss Brown," I said.

"We're in her class at school," Benny explained.

I could see that the woman was trying to decide whether she should tell us to go away, but she said, "I'll find out if she wants to see you," and left us standing on the porch for what seemed like a long time. Then she appeared again and said, "You can come in now."

As we followed her through the front parlor I could make out in the dim light that there was an old-fashioned organ like the kind you used to see in country churches, and linoleum on the floor, and stiff uncomfortable chairs, and family portraits behind curved glass in big oval frames.

The room beyond it was lighted by a coal-oil lamp but seemed ever so much darker than the unlighted room we had just passed through. Propped up on pillows in a big double bed was our teacher, but so changed. Her arms were like sticks, and all the life in her seemed concentrated in her eyes, which had dark circles around them and were enormous. She managed a flicker of recognition but I was struck dumb by the fact that she didn't seem glad to see us. She didn't belong to us anymore. She belonged to her illness.

Benny said, "I hope you get well soon."

The angel who watches over little boys who know but they can't say it saw to it that we didn't touch anything. And in a minute we were outside, on our bicycles, riding through the dusk toward the turn in the road and town.

A few weeks later I read in the Lincoln *Evening Courier* that Miss Vera Brown, who taught the fifth grade in Central School, had died of tuberculosis, aged twenty-three years and seven months.

Sometimes I went with my mother when she put flowers on the graves of my grandparents. The cinder roads wound through the cemetery in ways she understood and I didn't, and I would read the names on the monuments: Brower, Cadwallader, Andrews, Bates, Mitchell. In loving memory of. Infant daughter of. Beloved wife of. The cemetery was so large and so many people were buried there, it would have taken a long time to locate a particular grave if you didn't know where it was already. But I know, the way I sometimes know what is in wrapped packages, that the elderly woman who let us in and who took care of Miss Brown during her last illness went to the cemetery regularly and poured the rancid water out of the tin receptacle that was sunk below the level of the grass at the foot of her grave, and filled it with fresh water from a nearby faucet and arranged the flowers she had brought in such a way as to please the eye of the living and the closed eyes of the dead.

Reading Check

1. Why did Miss Brown sometimes keep children after school?
2. What gifts did she receive from the children in her class?
3. Where did the children take Miss Brown on her birthday?
4. Why did the class behave for the substitute teacher?

For Study and Discussion

Analyzing and Interpreting the Story

1. In this story the narrator recalls how a teacher made an unforgettable impression on her students. Why were the children so deeply touched by Miss Brown?

2. What characteristics of Miss Brown led the children to associate her with flowers?

3. In the opening paragraph of the story, the narrator says that the teacher's name "might as well have been graven in stone." In the light of later events, why is this statement tragically ironic?

4. At the conclusion of the story, the narrator has an image of someone placing fresh flowers on Miss Brown's grave. Why does he find comfort in this thought?

Writing About Literature

Discussing Tone

You have learned that **tone** is the attitude a writer takes toward a subject or an audience. In a brief essay discuss the tone of "Love." Take into account matters of language, events, and feelings.

Explaining the Title

Write a brief essay explaining the title of the story. In what way does it pinpoint the meaning of the story? How do the characters and actions in the story help us define *love*?

About the Author

William Maxwell (1908–)

William Maxwell was born in Lincoln, Illinois. He attended the University of Illinois and after graduation received a scholarship to Harvard. He taught at the University of Illinois until 1933, when he decided to become a novelist. In 1936, two years after the publication of his first novel, *Bright Center of Heaven,* Maxwell joined the editorial staff of *The New Yorker* magazine, where he played an essential role for forty years. Explaining why he writes about the past, Maxwell said: "I write about the past not because I think it is better than the present but because of things that happened that I do not want to be forgotten."

Maxwell's work shows a deep understanding of young people. His third novel, *The Folded Leaf* (1945), is about the friendship between two boys growing up in the Midwest in the 1920s. The story "Love," which appeared in *The New Yorker,* is based on an incident in Maxwell's childhood. His most recent book is *Billie Dyer and Other Stories* (1992).

The Alligator War

HORACIO QUIROGA°

Translated by
Arthur Livingston

The beast fable, *in which animal characters speak and behave as humans do, is common to most cultures. Often, the stories satirize the follies or weaknesses of human beings.*

This story was first published in 1918. As you read, think about what has happened to rain forests and jungles around the globe during this century. Does Quiroga's satire have as much meaning today as it had in his own time?

It was a very big river in a region of South America that had never been visited by white men; and in it lived many, many alligators—perhaps a hundred, perhaps a thousand. For dinner they ate fish, which they caught in the stream, and for supper they ate deer and other animals that came down to the waterside to drink. On hot afternoons in summer they stretched out and sunned themselves on the bank. But they liked nights when the moon was shining best of all. Then they swam out into the river and sported and played, lashing the water to foam with their tails, while the spray ran off their beautiful skins in all the colors of the rainbow.

These alligators had lived quite happy lives for a long, long time. But at last one afternoon,

° **Quiroga** (kē-rō′gä).

when they were all sleeping on the sand, snoring and snoring, one alligator woke up and cocked his ears—the way alligators cock their ears. He listened and listened, and, to be sure, faintly, and from a great distance, came a sound: *Chug! Chug! Chug!*

"Hey!" the alligator called to the alligator sleeping next to him, "Hey! Wake up! Danger!"

"Danger of what?" asked the other, opening his eyes sleepily and getting up.

"I don't know!" replied the first alligator. "That's a noise I never heard before. Listen!"

The other alligator listened: *Chug! Chug! Chug!*

In great alarm the two alligators went calling up and down the riverbank: "Danger! Danger!" And all their sisters and brothers and mothers and fathers and uncles and aunts woke up and began running this way and that with their tails curled up in the air. But the excitement did not serve to calm their fears. *Chug! Chug! Chug!* The noise was growing louder every moment; and at last, away off down the stream, they could see something moving along the surface of the river, leaving a trail of gray smoke behind it and beating the water on either side to foam: *Chush! Chush! Chush!*

The alligators looked at each other in the greatest astonishment: "What on earth is that?"

But there was one old alligator, the wisest and most experienced of them all. He was so old that only two sound teeth were left in his jaws—one in the upper jaw and one in the lower jaw. Once, also, when he was a boy, fond of adventure, he had made a trip down the river all the way to the sea.

"I know what it is," said he. "It's a whale. Whales are big fish, they shoot water up through their noses, and it falls down on them behind."

At this news, the little alligators began to scream at the top of their lungs, "It's a whale! It's a whale! It's a whale!" and they made for the water intending to duck out of sight.

But the big alligator cuffed with his tail a little alligator that was screaming nearby with his mouth open wide. "Dry up!" said he. "There's nothing to be afraid of! I know all about whales! Whales are the afraidest people there are!" And the little alligators stopped their noise.

But they grew frightened again a moment afterward. The gray smoke suddenly turned to an inky black, and the *Chush! Chush! Chush!* was now so loud that all the alligators took to the water, with only their eyes and the tips of their noses showing at the surface.

Cho-ash-h-h! Cho-ash-h-h! Cho-ash-h-h! The strange monster came rapidly up the stream. The alligators saw it go crashing past them, belching great clouds of smoke from the middle of its back and splashing into the water heavily with the big revolving things it had on either side.

It was a steamer, the first steamer that had ever made its way up to the Parana.[1] *Chush! Chush! Chush!* It seemed to be getting farther away again. *Chug! Chug! Chug!* It had disappeared from view.

One by one, the alligators climbed up out of the water onto the bank again. They were all quite cross with the old alligator who had told them wrongly that it was a whale.

"It was not a whale!" they shouted in his ear—for he was rather hard of hearing. "Well, what was it that just went by?"

The old alligator then explained that it was a steamboat full of fire and that the alligators would all die if the boat continued to go up and down the river.

The other alligators only laughed, however. Why would the alligators die if the boat kept

1. **Parana:** a river rising in Brazil and flowing for more than 2,000 miles into Argentina.

going up and down the river? It had passed by without so much as speaking to them! That old alligator didn't really know so much as he pretended to! And since they were very hungry they all went fishing in the stream. But alas! There was not a fish to be found! The steamboat had frightened every single one of them away.

"Well, what did I tell you?" said the old alligator. "You see, we haven't anything left to eat! All the fish have been frightened away! However—let's just wait till tomorrow. Perhaps the boat won't come back again. In that case, the fish will get over their fright and come back so that we can eat them." But the next day the steamboat came crashing by again on its way back down the river, spouting black smoke as it had done before, and setting the whole river boiling with its paddle wheels.

"Well!" exclaimed the alligators. "What do you think of that? The boat came yesterday. The boat came today. The boat will come tomorrow. The fish will stay away and nothing will come down here at night to drink. We are done for!"

But an idea occurred to one of the brighter alligators: "Let's dam the river!" he proposed. "The steamboat won't be able to climb a dam!"

"That's the talk! That's the talk! A dam. A dam! Let's build a dam!" And the alligators all made for the shore as fast as they could.

They went up into the woods along the bank and began to cut down trees of the hardest wood they could find—walnut and mahogany, mostly. They felled more than ten thousand of them altogether, sawing the trunks through with the kind of saw that alligators have on the tops of their tails. They dragged the trees down into the water and stood them up about a yard apart, all the way across the river, driving the pointed ends deep into the mud and weaving the branches together. No steamboat, big or little, would ever be able to pass that dam! No one would frighten the fish away again! They would have a good dinner the following day and every day! And since it was late at night by the time the dam was done, they all fell sound asleep on the riverbank.

Chug! Chug! Chug! Chush! Chush! Chush! Cho-ash-h-h-h! Cho-ash-h-h-h! Cho-ash-h-h-h!

They were still asleep, the next day, when the boat came up; but the alligators barely opened their eyes and then tried to go to sleep again. What did they care about the boat? It could make all the noise it wanted, but it would never get by the dam!

And that is what happened. Soon the noise from the boat stopped. The men who were steering on the bridge took out their spyglasses and began to study the strange obstruction that had been thrown up across the river. Finally a small boat was sent to look into it more closely. Only then did the alligators get up from where they were sleeping, run down into the water, and swim out behind the dam, where they lay floating and looking downstream between the piles. They could not help laughing, nevertheless, at the joke they had played on the steamboat!

The small boat came up, and the men in it saw how the alligators had made a dam across the river. They went back to the steamer but

soon after came rowing up toward the dam again.

"Hey, you alligators!"

"What can we do for you?" answered the alligators, sticking their heads through between the piles in the dam.

"That dam is in our way!" said the men.

"Tell us something we don't know!" answered the alligators.

"But we can't get by!"

"I'll say so!"

"Well, take the old thing out of the way!"

"Nosireesir!"

The men in the boat talked it over for a while and then they called: "Alligators!"

"What can we do for you?"

"Will you take the dam away?"

"No!"

"No?"

"No!"

"Very well! See you later!"

"The later the better," said the alligators.

The rowboat went back to the steamer, while the alligators, as happy as could be, clapped their tails as loud as they could on the water. No boat could ever get by that dam and drive the fish away again!

But the next day the steamboat returned; and when the alligators looked at it, they could not say a word from their surprise: it was not the same boat at all but a larger one, painted gray like a mouse! How many steamboats were there, anyway? And this one probably would want to pass the dam! Well, just let it try! No, sir! No steamboat, little or big, would ever get through that dam!

"They shall not pass!" said the alligators, each taking up his station behind the piles in the dam.

The new boat, like the other one, stopped some distance below the dam; and again a little boat came rowing toward them. This time there were eight sailors in it, with one officer.

The officer shouted: "Hey, you alligators!"

"What's the matter?" answered the alligators.

"Going to get that dam out of there?"

"No!"

"No?"

"No!"

"Very well!" said the officer. "In that case, we shall have to shoot it down!"

"Shoot it up if you want to!" said the alligators.

And the boat returned to the steamer.

But now, this mouse-gray steamboat was not an ordinary steamboat: it was a warship with armor plate and terribly powerful guns. The old alligator who had made the trip to the river mouth suddenly remembered, and just in time to shout to the other alligators: "Duck for your lives! Duck! She's going to shoot! Keep down deep under water."

The alligators dived all at the same time and headed for the shore, where they halted, keeping all their bodies out of sight except for their noses and their eyes. A great cloud of flame and smoke burst from the vessel's side, followed by a deafening report. An immense solid shot hurtled through the air and struck the dam exactly in the middle. Two or three tree trunks were cut away into splinters and drifted off downstream. Another shot, a third, and finally a fourth, each tearing a great hole in the dam. Finally the piles were entirely destroyed; not a tree, not a splinter, not a piece of bark was left; and the alligators, still sitting with their eyes and noses just out of water, saw the warship come steaming by and blowing its whistle in derision at them.

Then the alligators came out on the bank and held a council of war. "Our dam was not strong enough," said they; "we must make a new and much thicker one."

So they worked again all that afternoon and night, cutting down the very biggest trees they

could find and making a much better dam than they had built before. When the gunboat appeared the next day, they were sleeping soundly and had to hurry to get behind the piles of the dam by the time the rowboat arrived there.

"Hey, alligators!" called the same officer.

"See who's here again!" said the alligators, jeeringly.

"Get that new dam out of there!"

"Never in the world!"

"Well, we'll blow it up, the way we did the other!"

"Blaze away, and good luck to you!"

You see, the alligators talked so big because they were sure the dam they had made this time would hold up against the most terrible cannonballs in the world. And the sailors must have thought so, too; for after they had fired the first shot a tremendous explosion occurred in the dam. The gunboat was using shells, which burst among the timbers of the dam and broke the thickest trees into tiny, tiny bits. A second shell exploded right near the first, and a third near the second. So the shots went all along the dam, each tearing away a long strip of it till nothing, nothing, nothing was left. Again the warship came steaming by, closer in toward shore on this occasion, so that the sailors could make fun of the alligators by putting their hands to their mouths and holloing.

"So that's it!" said the alligators, climbing up out of the water. "We must all die, because the steamboats will keep coming and going, up and down, and leaving us not a fish in the world to eat!"

The littlest alligators were already whimpering, for they had had no dinner for three days; and it was a crowd of very sad alligators that gathered on the river shore to hear what the old alligator now had to say.

"We have only one hope left," he began. "We must go and see the Sturgeon! When I was a boy, I took that trip down to the sea along with him. He liked the salt water better than I did and went quite a way out into the ocean. There he saw a sea fight between two of these boats; and he brought home a torpedo that had failed to explode. Suppose we go and ask him to give it to us. It is true the Sturgeon has never liked us alligators; but I got along with him pretty well myself. He is a good fellow, at bottom, and surely he will not want to see us all starve!"

The fact was that some years before an alligator had eaten one of the Sturgeon's favorite grandchildren, and for that reason the Sturgeon had refused ever since to call on the alligators or receive visits from them. Nevertheless, the alligators now trouped off in a body to the big cave under the bank of the river where they knew the Sturgeon stayed, with his torpedo beside him. There are sturgeons as much as six feet long, you know, and this one with the torpedo was of that kind.

"Mr. Sturgeon! Mr. Sturgeon!" called the alligators at the entrance of the cave. No one of them dared go in, you see, on account of that matter of the Sturgeon's grandchild.

"Who is it?" answered the Sturgeon.

"We're the alligators," the latter replied in a chorus.

"I have nothing to do with alligators," grumbled the Sturgeon crossly.

But now the old alligator with the two teeth stepped forward and said: "Why, hello, Sturgy. Don't you remember Ally, your old friend that took that trip down the river when we were boys?"

"Well, well! Where have you been keeping yourself all these years?" said the Sturgeon, surprised and pleased to hear his old friend's voice. "Sorry I didn't know it was you! How goes it? What can I do for you?"

"We've come to ask you for that torpedo you found, remember? You see, there's a warship keeps coming up and down our river scaring

all the fish away. She's a whopper, I'll tell you, armor plate, guns, the whole thing! We made one dam and she knocked it down. We made another and she blew it up. The fish have all gone away and we haven't had a bite to eat in near onto a week. Now you give us your torpedo and we'll do the rest!"

The Sturgeon sat thinking for a long time, scratching his chin with one of his fins. At last he answered: "As for the torpedo, all right! You can have it in spite of what you did to my eldest son's first-born. But there's one trouble: who knows how to work the thing?"

The alligators were all silent. Not one of them had ever seen a torpedo.

"Well," said the Sturgeon proudly, "I can see I'll have to go with you myself. I've lived next to that torpedo a long time. I know all about torpedoes."

The first task was to bring the torpedo down to the dam. The alligators got into line, the one behind taking in his mouth the tail of the one in front. When the line was formed it was fully a quarter of a mile long. The Sturgeon pushed the torpedo out into the current and got under it so as to hold it up near the top of the water on his back. Then he took the tail of the last alligator in his teeth and gave the signal to go ahead. The Sturgeon kept the torpedo afloat, while the alligators towed him along. In this way they went so fast that a wide wake followed on after the torpedo, and by the next morning they were back at the place where the dam was made.

As the little alligators who had stayed at home reported, the warship had already gone by upstream. But this pleased the others all the more. Now they would build a new dam, stronger than ever before, and catch the steamer in a trap, so that it would never get home again.

They worked all that day and all the next night, making a thick, almost solid dike, with

barely enough room between the piles for the alligators to stick their heads through. They had just finished when the gunboat came into view.

Again the rowboat approached with the eight men and their officer. The alligators crowded behind the dam in great excitement, moving their paws to hold their own with the current, for this time they were downstream.

"Hey, alligators!" called the officer.

"Well?" answered the alligators.

"Still another dam?"

"If at first you don't succeed, try, try, again!"

"Get that dam out of there!"

"No, sir!"

"You won't?"

"We won't!"

"Very well! Now you alligators just listen! If you won't be reasonable, we are going to knock this dam down, too. But to save you the trouble of building a fourth, we are going to shoot every blessed alligator around here. Yes, every single last alligator, women and children, big ones, little ones, fat ones, lean ones, and even that old codger sitting there with only two teeth left in his jaws!"

The old alligator understood that the officer was trying to insult him with that reference to his two teeth, and he answered: "Young man, what you say is true. I have only two teeth left, not counting one or two others that are broken off. But do you know what those two teeth are going to eat for dinner?" As he said this the old alligator opened his mouth wide, wide, wide.

"Well, what are they going to eat?" asked one of the sailors.

"A little dude of a naval officer I see in a boat over there!"—and the old alligator dived under water and disappeared from view.

Meantime the Sturgeon had brought the torpedo to the very center of the dam, where four alligators were holding it fast to the river bottom waiting for orders to bring it up to the top of the water. The other alligators had gathered along the shore, with their noses and eyes alone in sight as usual.

The rowboat went back to the ship. When he saw the men climbing aboard, the Sturgeon went down to his torpedo.

Suddenly there was a loud detonation. The warship had begun firing, and the first shell struck and exploded in the middle of the dam. A great gap opened in it.

"Now! Now!" called the Sturgeon sharply, on seeing that there was room for the torpedo to go through. "Let her go! Let her go!"

As the torpedo came to the surface, the Sturgeon steered it to the opening in the dam, took aim hurriedly with one eye closed, and pulled at the trigger of the torpedo with his teeth. The propeller of the torpedo began to revolve, and it started off upstream toward the gunboat.

And it was high time. At that instant a second shot exploded in the dam, tearing away another large section.

From the wake the torpedo left behind it in the water the men on the vessel saw the danger they were in, but it was too late to do anything about it. The torpedo struck the ship in the middle, and went off.

You can never guess the terrible noise that torpedo made. It blew the warship into fifteen thousand million pieces, tossing guns and smokestacks and shells and rowboats—everything—hundreds and hundreds of yards away.

The alligators all screamed with triumph and made as fast as they could for the dam. Down through the opening bits of wood came floating, with a number of sailors swimming as hard as they could for the shore. As the men passed through, the alligators put their paws to their mouths and holloed, as the men had done to them three days before. They decided not to eat a single one of the sailors, though some of them deserved it without a doubt. Except that when a man dressed in a blue uniform with gold braid came by, the old alligator jumped into the water off the dam and snap! snap! ate him in two mouthfuls.

"Who was that man?" asked an ignorant young alligator, who never learned his lessons in school and never knew what was going on.

"It's the officer of the boat," answered the

Sturgeon. "My old friend, Ally, said he was going to eat him, and eaten him he has!"

The alligators tore down the rest of the dam, because they knew that no boats would be coming by that way again.

The Sturgeon, who had quite fallen in love with the gold lace of the officer, asked that it be given him in payment for the use of his torpedo. The alligators said he might have it for the trouble of picking it out of the old alligator's mouth, where it had caught on the two teeth. They also gave him the officer's belt and sword. The Sturgeon put the belt on just behind his front fins and buckled the sword to it. Thus togged out, he swam up and down for more than an hour in front of the assembled alligators, who admired his beautiful spotted skin as something almost as pretty as the coral snake's, and who opened their mouths wide at the splendor of his uniform. Finally they escorted him in honor back to his cave under the riverbank, thanking him over and over again and giving him three cheers as they went off.

When they returned to their usual place they found the fish had already returned. The next day another steamboat came by; but the alligators did not care, because the fish were getting used to it by this time and seemed not to be afraid. Since then the boats have been going back and forth all the time, carrying oranges. And the alligators open their eyes when they hear the *chug! chug! chug!* of a steamboat and laugh at the thought of how scared they were the first time and of how they sank the warship.

But no warship has ever gone up the river since the old alligator ate the officer.

Reading Check

1. What happens to interfere with the alligators' "quite happy lives"?
2. Why are the alligators threatened by the steamer?
3. How many dams do the alligators build?
4. How do the alligators destroy the warship?

For Study and Discussion

Analyzing and Interpreting the Story

1. In beast fables animals often take on certain characteristics of human beings while retaining many recognizable animal characteristics. How is this true of the alligators in the story?

2. Should we read this story as a tale about alligators or humans? Explain.

The Alligator War **193**

3. On one level this story is a simple and entertaining tale. How can the story also be interpreted as a serious statement about the destruction of the balance of nature?

4. Think of some well-known fables by Aesop, James Thurber, or other fabulists. Why do you think writers choose animals as characters?

Literary Elements

Allegory

In an **allegory** characters stand for something other than themselves, usually some abstract quality. In the beast tale, a special form of allegory with animals as characters, the animals usually represent human characteristics. For example, in "The Alligator War," the old alligator might represent the human tendency to make generalizations based on limited experience or insufficient information. As a result of his one trip to the sea, the alligator assumes at first that the steamer must be a whale. What other human characteristics do you see in the animal characters?

The beast fable usually teaches a moral or a lesson. What do you think is the moral or lesson of Quiroga's fable?

Creative Writing

Writing a Beast Fable

Choose an issue or problem that is important to you and write a beast fable illustrating that problem. Remember that your characters should speak and behave as humans do. If you wish, take a well-known fable such as "The Country Mouse and the City Mouse" or "Belling the Cat" and give it a modern setting.

About the Author

Horacio Quiroga (1878–1937)

Horacio Quiroga's life was haunted by tragedy. Shortly after Quiroga's birth, his father, an Argentine diplomat, was killed in a hunting accident. His mother soon remarried, but his stepfather, depressed over ill-health, later committed suicide. Many critics believe that these grim events were partially responsible for Quiroga's sense of the macabre.

Quiroga spent much of his youth in Uruguay, where he was born. After an expedition to Argentina in 1903, he came to prefer northern Argentina's tropical forests. Later, Quiroga settled there, frequently struggling against harsh conditions to sustain his family. Argentina's lush and untamed territories provide the setting for some of his best fiction.

Quiroga was influenced by a number of authors. His tales of the unusual and grotesque reflect the influence of Edgar Allan Poe's writing. Some readers also compare Quiroga's animal stories with Rudyard Kipling's *The Jungle Book*. The French story writer Guy de Maupassant and the Russian author Anton Chekhov were literary models as well. Most critics agree, however, that Quiroga's style, shaped by his Latin American heritage, is unique. Many of his works have been translated into English, including *South American Jungle Tales* (1922), *The Decapitated Chicken and Other Stories* (1974), and *The Exiles and Other Stories* (1987).

Shaving

LESLIE NORRIS

As you read, keep these questions in mind: How do the opening and closing scenes of the story frame the main action of the narrative? In what way are both scenes essential to the story's meaning?

Earlier, when Barry had left the house to go to the game, an overnight frost had still been thick on the roads, but the brisk April sun had soon dispersed it, and now he could feel the spring warmth on his back through the thick tweed of his coat. His left arm was beginning to stiffen up where he'd jarred it in a tackle, but it was nothing serious. He flexed his shoulders against the tightness of his jacket and was surprised again by the unexpected weight of his muscles, the thickening strength of his body. A few years back, he thought, he had been a small, unimportant boy, one of a swarming gang laughing and jostling to school, hardly aware that he possessed an identity. But time had transformed him. He walked solidly now, and often alone. He was tall, strongly made, his hands and feet were adult and heavy, the rooms in which all his life he'd moved had grown too small for him. Sometimes a devouring restlessness drove him from the house to walk long distances in the dark. He hardly understood how it had happened. Amused and quiet, he walked the High Street among the morning shoppers.

He saw Jackie Bevan across the road and remembered how, when they were both six

years old, Jackie had swallowed a pin. The flustered teachers had clucked about Jackie as he stood there, bawling, cheeks awash with tears, his nose wet. But now Jackie was tall and suave, his thick, pale hair sleekly tailored, his gray suit enviable. He was talking to a girl as golden as a daffodil.

"Hey, hey!" called Jackie. "How's the athlete, how's Barry boy?"

He waved a graceful hand at Barry.

"Come and talk to Sue," he said.

Barry shifted his bag to his left hand and walked over, forming in his mind the answers he'd make to Jackie's questions.

"Did we win?" Jackie asked. "Was the old Barry Stanford magic in glittering evidence yet once more this morning? Were the invaders sent hunched and silent back to their hovels in the hills? What was the score? Give us an epic account, Barry, without modesty or delay. This is Sue, by the way."

"I've seen you about," the girl said.

"You could hardly miss him," said Jackie. "Four men, roped together, spent a week climbing him—they thought he was Everest. He ought to carry a warning beacon, he's a danger to aircraft."

"Silly," said the girl, smiling at Jackie. "He's not much taller than you are."

She had a nice voice too.

"We won," Barry said. "Seventeen points to three, and it was a good game. The ground was hard, though."

He could think of nothing else to say.

"Let's all go for a frivolous cup of coffee," Jackie said. "Let's celebrate your safe return from the rough fields of victory. We could pour libations[1] all over the floor for you."

"I don't think so," Barry said. "Thanks. I'll go straight home."

"Okay," said Jackie, rocking on his heels so that the sun could shine on his smile. "How's your father?"

"No better," Barry said. "He's not going to get better."

"Yes, well," said Jackie, serious and uncomfortable, "tell him my mother and father ask about him."

"I will," Barry promised. "He'll be pleased."

Barry dropped the bag in the front hall and moved into the room which had been the dining room until his father's illness. His father lay in the white bed, his long body gaunt, his still head scarcely denting the pillow. He seemed asleep, thin blue lids covering his eyes, but when Barry turned away he spoke.

"Hullo, Son," he said. "Did you win?"

His voice was a dry, light rustling, hardly louder than the breath which carried it. Its sound moved Barry to a compassion that almost unmanned him, but he stepped close to the bed and looked down at the dying man.

"Yes," he said. "We won fairly easily. It was a good game."

His father lay with his eyes closed, inert, his breath irregular and shallow.

1. **pour libations** (lī-bā′shənz): When a warrior in ancient Greece returned home victorious, he would pour libations, or offerings of wine, onto the ground as a ritual of thanksgiving to the gods.

"Did you score?" he asked.

"Twice," Barry said. "I had a try in each half."

He thought of the easy certainty with which he'd caught the ball before his second try; casually, almost arrogantly he had taken it on the tips of his fingers, on his full burst for the line, breaking the fullback's tackle. Nobody could have stopped him. But watching his father's weakness he felt humble and ashamed, as if the morning's game, its urgency and effort, was not worth talking about. His father's face, fine-skinned and pallid, carried a dark stubble of beard, almost a week's growth, and his obstinate, strong hair stuck out over his brow.

"Good," said his father, after a long pause. "I'm glad it was a good game."

Barry's mother bustled about the kitchen, a tempest of orderly energy.

"Your father's not well," she said. "He's down today, feels depressed. He's a particular man, your father. He feels dirty with all that beard on him."

She slammed shut the stove door.

"Mr. Cleaver was supposed to come up and shave him," she said, "and that was three days ago. Little things have always worried your father, every detail must be perfect for him."

Barry filled a glass with milk from the refrigerator. He was very thirsty.

"I'll shave him," he said.

His mother stopped, her head on one side.

"Do you think you can?" she asked. "He'd like it if you can."

"I can do it," Barry said.

He washed his hands as carefully as a surgeon. His father's razor was in a blue leather case, hinged at the broad edge and with one hinge broken. Barry unfastened the clasp and took out the razor. It had not been properly cleaned after its last use and lather had stiffened into hard yellow rectangles between the teeth of the guard. There were water-shaped

rust stains, brown as chocolate, on the surface of the blade. Barry removed it, throwing it in the wastebin. He washed the razor until it glistened, and dried it on a soft towel, polishing the thin handle, rubbing its metal head to a glittering shine. He took a new blade from its waxed envelope, the paper clinging to the thin metal. The blade was smooth and flexible to the touch, the little angles of its cutting clearly defined. Barry slotted it into the grip of the razor, making it snug and tight in the head.

The shaving soap, hard, white, richly aromatic, was kept in a wooden bowl. Its scent was immediately evocative and Barry could almost see his father in the days of his health, standing before his mirror, thick white lather on his face and neck. As a little boy Barry had loved the generous perfume of the soap, had waited for his father to lift the razor to his face, for one careful stroke to take away the white suds in a clean revelation of the skin. Then his father would renew the lather with a few sweeps of his brush, one with an ivory handle and the bristles worn, which he still used.

His father's shaving mug was a thick cup, plain and serviceable. A gold line ran outside the rim of the cup, another inside, just below the lip. Its handle was large and sturdy, and the face of the mug carried a portrait of the young Queen Elizabeth II, circled by a wreath of leaves, oak perhaps, or laurel. A lion and unicorn balanced precariously on a scroll above her crowned head, and the Union Jack, the Royal Standard, and other flags were furled each side of the portrait. And beneath it all, in small black letters, ran the legend: "Coronation June 2nd 1953." The cup was much older than Barry. A pattern of faint translucent cracks, fine as a web, had worked itself haphazardly, invisibly almost, through the white glaze. Inside, on the bottom, a few dark bristles were lying, loose and dry. Barry

shook them out, then held the cup in his hand, feeling its solidness. Then he washed it ferociously, until it was clinically clean.

Methodically he set everything on a tray, razor, soap, brush, towels. Testing the hot water with a finger, he filled the mug and put that, too, on the tray. His care was absorbed, ritualistic. Satisfied that his preparations were complete, he went downstairs, carrying the tray with one hand.

His father was waiting for him. Barry set the tray on a bedside table and bent over his father, sliding an arm under the man's thin shoulders, lifting him without effort so that he sat against the high pillows.

"By God, you're strong," his father said. He was as breathless as if he'd been running.

"So are you," said Barry.

"I was," his father said. "I used to be strong once."

He sat exhausted against the pillows.

"We'll wait a bit," Barry said.

"You could have used your electric razor," his father said. "I expected that."

"You wouldn't like it," Barry said. "You'll get a closer shave this way."

He placed the large towel about his father's shoulders.

"Now," he said, smiling down.

The water was hot in the thick cup. Barry wet the brush and worked up the lather. Gently he built up a covering of soft foam on the man's chin, on his cheeks and his stark cheekbones.

"You're using a lot of soap," his father said.

"Not too much," Barry said. "You've got a lot of beard."

His father lay there quietly, his wasted arms at his sides.

"It's comforting," he said. "You'd be surprised how comforting it is."

Barry took up the razor, weighing it in his

hand, rehearsing the angle at which he'd use it. He felt confident.

"If you have prayers to say . . ." he said.

"I've said a lot of prayers," his father answered.

Barry leaned over and placed the razor delicately against his father's face, setting the head accurately on the clean line near the ear where the long hair ended. He held the razor in the tips of his fingers and drew the blade sweetly through the lather. The new edge moved light as a touch over the hardness of the upper jaw and down to the angle of the chin, sliding away the bristles so easily that Barry could not feel their release. He sighed as he shook the razor in the hot water, washing away the soap.

"How's it going?" his father asked.

"No problem," Barry said. "You needn't worry."

It was as if he had never known what his father really looked like. He was discovering under his hands the clear bones of the face and head, they became sharp and recognizable under his fingers. When he moved his father's face a gentle inch to one side, he touched with his fingers the frail temples, the blue veins of his father's life. With infinite and meticulous care he took away the hair from his father's face.

"Now for your neck," he said. "We might as well do the job properly."

"You've got good hands," his father said. "You can trust those hands, they won't let you down."

Barry cradled his father's head in the crook of his left arm, so that the man could tilt back his head, exposing the throat. He brushed fresh lather under the chin and into the hollows alongside the stretched tendons. His father's throat was fleshless and vulnerable, his head was a hard weight on the boy's arm. Barry was filled with unreasoning protective love. He lifted the razor and began to shave.

"You don't have to worry," he said. "Not at all. Not about anything."

He held his father in the bend of his strong arm and they looked at each other. Their heads were very close.

"How old are you?" his father said.

"Seventeen," Barry said. "Near enough seventeen."

"You're young," his father said, "to have this happen."

"Not too young," Barry said. "I'm bigger than most men."

"I think you are," his father said.

He leaned his head tiredly against the boy's shoulder. He was without strength, his face was cold and smooth. He had let go all his authority, handed it over. He lay back on his pillow, knowing his weakness and his mortality, and looked at his son with wonder, with a curious humble pride.

"I won't worry then," he said. "About anything."

"There's no need," Barry said. "Why should you worry?"

He wiped his father's face clean of all soap with a damp towel. The smell of illness was everywhere, overpowering even the perfumed lather. Barry settled his father down and took away the shaving tools, putting them by with the same ceremonial precision with which he'd prepared them: the cleaned and glittering razor in its broken case; the soap, its bowl wiped and dried, on the shelf between the brush and the coronation mug; all free of taint. He washed his hands and scrubbed his nails. His hands were firm and broad, pink after their scrubbing. The fingers were short and strong, the little fingers slightly crooked, and soft dark hair grew on the backs of his hands and his fingers just above the knuckles. Not long ago they had been small bare hands, not very long ago.

Barry opened wide the bathroom window.

Already, although it was not yet two o'clock, the sun was retreating and people were moving briskly, wrapped in their heavy coats against the cold that was to come. But now the window was full in the beam of the dying sunlight, and Barry stood there, illuminated in its golden warmth for a whole minute, knowing it would soon be gone.

Reading Check

1. What does the scene with Jackie Bevan reveal about Barry as an athlete?
2. Where has Barry's father been moved during his illness?
3. Why does Barry offer to shave his father?
4. Why doesn't he use his electric razor?
5. How old is Barry?

For Study and Discussion

Analyzing and Interpreting the Story

1. The two main characters in this story are at different stages of life. **a.** In what ways is Barry contrasted with his father? **b.** How does this contrast between the two characters make you feel about each of them?

2. The act of shaving is important because it is the act by which Barry "comes of age." During the shaving ritual, he takes on the authority and responsibilities once held by his father. **a.** Which passages indicate that Barry has taken up his father's authority? **b.** What passages make Barry seem like a parent, and his father like a trusting child? **c.** Why is the razor an appropriate symbol of their changing roles?

3a. At what point in this story do you realize that Barry's father accepts his own death?

b. What details in the last two paragraphs indicate that Barry accepts the fact that someday his own youth will be gone? **c.** What do sunlight, cold, and warmth each symbolize in the final paragraph of the story?

4. Consider the opening scene in which Barry meets Jackie Bevan and the closing scene, where Barry puts away the shaving tools and looks out of the bathroom window. What is the connection between these scenes?

5. "Shaving" is clearly concerned with more than shaving. How would you state the central idea or truth about life that the author expresses in this story?

Literary Elements

Simile and Metaphor

Figurative language is so much a part of our everyday speech that we are generally unaware that we are speaking figuratively. If you have ever said "It's raining cats and dogs" or "I'm as hungry as a bear," you have used some common figures of speech.

Two important forms of figurative language are **simile** and **metaphor**. A simile draws a comparison between two unlike things by using a word such as *like, as,* or *than.* When Leslie Norris says that Jackie "was talking to a girl as golden as a daffodil," he is using simile.

A metaphor identifies two things. When Jackie says that four players were "climbing" Barry—"they thought he was Everest," Norris is using metaphor. If Norris had chosen to express this comparison as a simile, he might have said "Barry was *like* Mount Everest."

Very often figurative meaning can be carried by a single word. Barry's mother is described as a "tempest of orderly energy." The word *tempest* suggests the vigorous activity and commotion in the kitchen.

Identify the figures of speech in these sentences. Explain what each one means.

The flustered teachers had clucked about Jackie as he stood there, bawling, cheeks awash with tears, his nose wet (page 195).

Were the invaders sent hunched and silent back to their hovels in the hills (page 195)?

He ought to carry a warning beacon, he's a danger to aircraft (page 195).

A pattern of faint translucent cracks, fine as a web, had worked itself haphazardly, invisibly almost, through the white glaze (page 197).

Focus on Narrative Writing

Creating Dialogue

Dialogue is conversation or speech among two or more characters. Storytellers use dialogue to reveal character, to establish a conflict, to build suspense, and to advance the action. Here are some guidelines you may find helpful when you write dialogue:

1. Make sure the words are appropriate for the character who speaks them.
2. Use language from real life: short sentences, phrase fragments, slang, and contractions.
3. Use speaker tags—phrases like "she murmured" or "he joked"—to show who is speaking and how.
4. Make sure the dialogue moves the plot along.

Choose a narrative passage involving at least two characters from one of your favorite short stories. Rewrite the passage by turning the narrative into dialogue. When you have finished work, get together with a small group of classmates and use the guidelines above to evaluate your writing. Save your notes.

About the Author

Leslie Norris (1921–)

Leslie Norris was born in Merthyr Tydfil, Wales. His work has appeared in many journals. He lives in Utah and is Humanities Professor of Creative Writing at Brigham Young University.

The Author Comments on His Story

"Shaving" is one of a number of stories in which I have explored the relationship of children and parents. . . . I hope you can see that the boy who walked home from the game is a different person from the young man who completes the ceremony of shaving his father. He has changed significantly, grown in understanding and maturity. The story is really a kind of Greek myth in which the young prince ceremonially ascends the throne on the approaching death of his father. There are many hints of this: the joking reference made early in the story by Jackie Bevan to the pouring of "libations"; the preparation of the shaving materials as if for some important occasion; the almost ritual conversation between the boy and his father, like statement and response, as each recognizes and formalizes the exchange of power; and of course the symbolic fact of shaving, in which the son removes the strong beard from the father. And other things, too, which you will easily recognize. In this case, though, the young hero is not a prince returning victorious from battle but a young man coming home to his dying father after playing football. I just hope the situation is seen to be a common one, and that heroes rise to the occasion wherever they happen to live. The game, by the way, is rugby football, which is very popular in Wales.

THEME

The *theme* of a story is its controlling idea—the central insight that the story gives us about human life.

A theme is not necessarily an idea that a writer consciously decides to focus on before beginning a story. Writers do not, as a rule, tell a story in order to illustrate a particular idea. Rather, they try to write truthfully about life, and their particular way of looking at people and events gives their stories a central focus. We must not expect to find a theme stated outright in the story. Sometimes it may be, but more often we must state it for ourselves after we have thought about the characters and what has happened to them.

The theme of a story is not the same as a "moral." A moral is a practical bit of advice about how to conduct our lives. Morals usually instruct us to "do" something or "not to do" something: "A stitch in time saves nine," or "There's no use crying over spilt milk," or "Waste not, want not." Stories are not sermons, and most short-story writers are not interested in "preaching" to their readers. In attempting to determine the theme of a story, we should ask not what it *teaches,* but what it *reveals* about human experience.

There is no single "right" way to state the theme of a story. We should simply be sure that our statement of theme truly expresses the story's underlying idea. The theme of Jack Finney's story "Contents of the Dead Man's Pockets" (page 98) might be stated in several ways: "What is truly important in life is easier to see when we face the possibility of death." Or, "When one's life is in danger, it becomes apparent that money and position are not worth risking life and love." Notice, by the way, that a statement of theme is not very exciting. A statement of theme merely sums up dryly to our conscious mind what the story makes us deeply feel.

Through the Tunnel

DORIS LESSING

As you read, ask yourself how the author makes Jerry's motivation believable. How does she draw you into the story so that you live through Jerry's experience?

Going to the shore on the first morning of the vacation, the young English boy stopped at a turning of the path and looked down at a wild and rocky bay, and then over to the crowded beach he knew so well from other years. His mother walked on in front of him, carrying a bright striped bag in one hand. Her other arm, swinging loose, was very white in the sun. The boy watched that white, naked arm, and turned his eyes, which had a frown behind them, toward the bay and back again to his mother. When she felt he was not with her, she swung around. "Oh, there you are, Jerry!" she said. She looked impatient, then smiled. "Why, darling, would you rather not come with me? Would you rather—" She frowned, conscientiously worrying over what amusements he might secretly be longing for, which she had been too busy or too careless to imagine. He was very familiar with that anxious, apologetic smile. Contrition sent him running after her. And yet, as he ran, he looked back over his shoulder at the wild bay; and all morning, as he played on the safe beach, he was thinking of it.

Next morning, when it was time for the routine of swimming and sunbathing, his mother said, "Are you tired of the usual beach, Jerry? Would you like to go somewhere else?"

"Oh, no!" he said quickly, smiling at her out of that unfailing impulse of contrition—a sort of chivalry. Yet, walking down the path with her, he blurted out, "I'd like to go and have a look at those rocks down there."

She gave the idea her attention. It was a wild-looking place, and there was no one there; but she said, "Of course, Jerry. When you've had enough, come to the big beach. Or just go straight back to the villa, if you like." She walked away, that bare arm, now slightly reddened from yesterday's sun, swinging. And he almost ran after her again, feeling it unbearable that she should go by herself, but he did not.

She was thinking. Of course, he's old enough to be safe without me. Have I been keeping him too close? He mustn't feel he ought to be with me. I must be careful.

He was an only child, eleven years old. She was a widow. She was determined to be neither possessive nor lacking in devotion. She went worrying off to her beach.

As for Jerry, once he saw that his mother had gained her beach, he began the steep de-

scent to the bay. From where he was, high up among red-brown rocks, it was a scoop of moving bluish green fringed with white. As he went lower, he saw that it spread among small promontories and inlets of rough, sharp rock, and the crisping, lapping surface showed stains of purple and darker blue. Finally, as he ran sliding and scraping down the last few yards, he saw an edge of white surf and the shallow, luminous movement of water over white sand, and, beyond that, a solid, heavy blue.

He ran straight into the water and began swimming. He was a good swimmer. He went out fast over the gleaming sand, over a middle region where rocks lay like discolored monsters under the surface, and then he was in the real sea—a warm sea where irregular cold currents from the deep water shocked his limbs.

When he was so far out that he could look back not only on the little bay but past the promontory that was between it and the big beach, he floated on the buoyant surface and looked for his mother. There she was, a speck of yellow under an umbrella that looked like a slice of orange peel. He swam back to shore, relieved at being sure she was there, but all at once very lonely.

On the edge of a small cape that marked the side of the bay away from the promontory was a loose scatter of rocks. Above them, some boys were stripping off their clothes. They came running, naked, down to the rocks. The Eng-

Cliffs of the Petites Dalles 1880, by Oscar Claude Monet (1840–1926). Oil on canvas.
Denman Waldo Ross Collection, Courtesy, Museum of Fine Arts, Boston

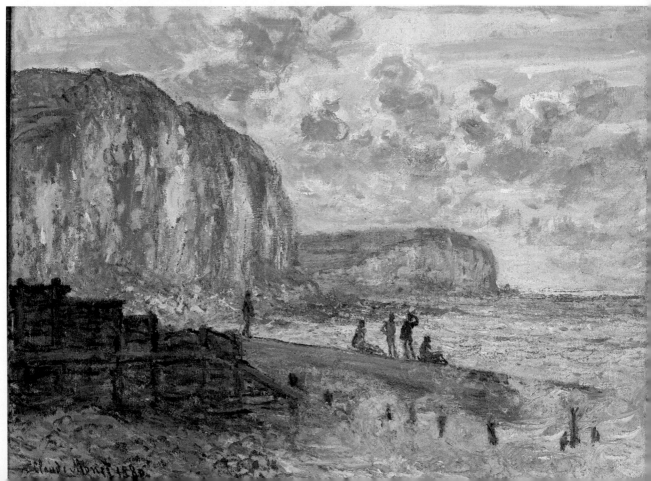

lish boy swam toward them, but kept his distance at a stone's throw. They were of that coast; all of them were burned smooth dark brown and speaking a language he did not understand. To be with them, of them, was a craving that filled his whole body. He swam a little closer; they turned and watched him with narrowed, alert dark eyes. Then one smiled and waved. It was enough. In a minute, he had swum in and was on the rocks beside them, smiling with a desperate, nervous supplication. They shouted cheerful greetings at him; and then, as he preserved his nervous, uncomprehending smile, they understood that he was a foreigner strayed from his own beach, and they proceeded to forget him. But he was happy. He was with them.

They began diving again and again from a high point into a well of blue sea between rough, pointed rocks. After they had dived and come up, they swam around, hauled themselves up, and waited their turn to dive again. They were big boys—men, to Jerry. He dived, and they watched him; and when he swam around to take his place, they made way for him. He felt he was accepted and he dived again, carefully, proud of himself.

Soon the biggest of the boys poised himself, shot down into the water, and did not come up. The others stood about, watching. Jerry, after waiting for the sleek brown head to appear, let out a yell of warning; they looked at him idly and turned their eyes back toward the water. After a long time, the boy came up on the other side of a big dark rock, letting the air out of his lungs in a spluttering gasp and a shout of triumph. Immediately the rest of them dived in. One moment, the morning seemed full of clattering boys; the next, the air and the surface of the water were empty. But through the heavy blue, dark shapes could be seen moving and groping.

Jerry dived, shot past the school of under-water swimmers, saw a black wall of rock looming at him, touched it, and bobbed up at once to the surface, where the wall was a low barrier he could see across. There was no one visible; under him, in the water, the dim shapes of the swimmers had disappeared. Then one, and then another of the boys came up on the far side of the barrier of rock, and he understood that they had swum through some gap or hole in it. He plunged down again. He could see nothing through the stinging salt water but the blank rock. When he came up the boys were all on the diving rock, preparing to attempt the feat again. And now, in a panic of failure, he yelled up, in English. "Look at me! Look!" and he began splashing and kicking in the water like a foolish dog.

They looked down gravely, frowning. He knew the frown. At moments of failure, when he clowned to claim his mother's attention, it was with just this grave, embarrassed inspection that she rewarded him. Through his hot shame, feeling the pleading grin on his face like a scar that he could never remove, he looked up at the group of big brown boys on the rock and shouted, *"Bonjour! Merci! Au revoir! Monsieur, monsieur!"* while he hooked his fingers round his ears and waggled them.

Water surged into his mouth; he choked, sank, came up. The rock, lately weighted with boys, seemed to rear up out of the water as their weight was removed. They were flying down past him, now, into the water; the air was full of falling bodies. Then the rock was empty in the hot sunlight. He counted one, two, three. . . .

At fifty, he was terrified. They must all be drowning beneath him, in the watery caves of the rock! At a hundred, he stared around him at the empty hillside, wondering if he should yell for help. He counted faster, faster, to hurry them up, to bring them to the surface quickly, to drown them quickly—anything

rather than the terror of counting on and on into the blue emptiness of the morning. And then, at a hundred and sixty, the water beyond the rock was full of boys blowing like brown whales. They swam back to the shore without a look at him.

He climbed back to the diving rock and sat down, feeling the hot roughness of it under his thighs. The boys were gathering up their bits of clothing and running off along the shore to another promontory. They were leaving to get away from him. He cried openly, fists in his eyes. There was no one to see him, and he cried himself out.

It seemed to him that a long time had passed, and he swam out to where he could see his mother. Yes, she was still there, a yellow spot under an orange umbrella. He swam back to the big rock, climbed up, dived into the blue pool among the fanged and angry boulders. Down he went, until he touched the wall of rock again. But the salt was so painful in his eyes that he could not see.

He came to the surface, swam to shore, and went back to the villa to wait for his mother. Soon she walked slowly up the path, swinging her striped bag, the flushed, naked arm dangling beside her. "I want some swimming goggles," he panted, defiant and beseeching.

She gave him a patient, inquisitive look as she said casually, "Well, of course, darling."

But now, now, now! He must have them this minute, and no other time. He nagged and pestered until she went with him to a shop. As soon as she had bought the goggles, he grabbed them from her hand as if she were going to claim them for herself, and was off, running down the steep path to the bay.

Jerry swam out to the big barrier rock, adjusted the goggles, and dived. The impact of the water broke the rubber-enclosed vacuum, and the goggles came loose. He understood that he must swim down to the base of the rock from the surface of the water. He fixed the goggles tight and firm, filled his lungs, and floated, face down on the water. Now, he could see. It was as if he had eyes of a different kind—fish eyes that showed everything clear and delicate and wavering in the bright water.

Under him, six or seven feet down, was a floor of perfectly clean, shining white sand, rippled firm and hard by the tides. Two grayish shapes steered there, like long, rounded pieces of wood or slate. They were fish. He saw them nose toward each other, poise motionless, make a dart forward, swerve off, and come around again. It was like a water dance. A few inches above them the water sparkled as if sequins were dropping through it. Fish again myriads of minute fish, the length of his fingernail, were drifting through the water, and in a moment he could feel the innumerable tiny touches of them against his limbs. It was like swimming in flaked silver. The great rock the big boys had swum through rose sheer out of the white sand—black, tufted lightly with greenish weed. He could see no gap in it. He swam down to its base.

Again and again he rose, took a big chestful of air, and went down. Again and again he groped over the surface of the rock, feeling it, almost hugging it in the desperate need to find the entrance. And then, once, while he was clinging to the black wall, his knees came up and he shot his feet out forward and they met no obstacle. He had found the hole.

He gained the surface, clambered about the stones that littered the barrier rock until he found a big one, and, with this in his arms, let himself down over the side of the rock. He dropped, with the weight, straight to the sandy floor. Clinging tight to the anchor of stone, he lay on his side and looked in under the dark shelf at the place where his feet had gone. He could see the hole. It was an irregular, dark gap; but he could not see deep into it. He let

go of his anchor, clung with his hands to the edges of the hole, and tried to push himself in.

He got his head in, found his shoulders jammed, moved them in sidewise, and was inside as far as his waist. He could see nothing ahead. Something soft and clammy touched his mouth; he saw a dark frond moving against the grayish rock, and panic filled him. He thought of octopuses, of clinging weed. He pushed himself out backward and caught a glimpse, as he retreated, of a harmless tentacle of seaweed drifting in the mouth of the tunnel. But it was enough. He reached the sunlight, swam to shore, and lay on the diving rock. He looked down into the blue well of water. He knew he must find his way through that cave, or hole, or tunnel, and out the other side.

First, he thought, he must learn to control his breathing. He let himself down into the water with another big stone in his arms, so that he could lie effortlessly on the bottom of the sea. He counted. One, two three. He counted steadily. He could hear the movement of blood in his chest. Fifty-one, fifty-two. . . . His chest was hurting. He let go of the rock and went up into the air. He saw that the sun was low. He rushed to the villa and found his mother at her supper. She said only "Did you enjoy yourself?" and he said "Yes."

All night the boy dreamed of the water-filled cave in the rock, and as soon as breakfast was over he went to the bay.

That night, his nose bled badly. For hours he had been underwater, learning to hold his breath, and now he felt weak and dizzy. His mother said, "I shouldn't overdo things, darling, if I were you."

That day and the next, Jerry exercised his lungs as if everything, the whole of his life, all that he would become, depended upon it. Again his nose bled at night, and his mother insisted on his coming with her the next day. It was a torment to him to waste a day of his careful self-training, but he stayed with her on that other beach, which now seemed a place for small children, a place where his mother might lie safe in the sun. It was not his beach.

He did not ask for permission, on the following day, to go to his beach. He went, before his mother could consider the complicated rights and wrongs of the matter. A day's rest, he discovered, had improved his count by ten. The big boys had made the passage while he counted a hundred and sixty. He had been counting fast, in his fright. Probably now, if he tried, he could get through that long tunnel, but he was not going to try yet. A curious, most unchildlike persistence, a controlled impatience, made him wait. In the meantime, he lay underwater on the white sand, littered now by stones he had brought down from the upper air, and studied the entrance to the tunnel. He knew every jut and corner of it, as far as it was possible to see. It was as if he already felt its sharpness about his shoulders.

He sat by the clock in the villa, when his mother was not near, and checked his time. He was incredulous and then proud to find he could hold his breath without strain for two minutes. The words *two minutes*, authorized by the clock, brought close the adventure that was so necessary to him.

In another four days, his mother said casually one morning, they must go home. On the day before they left, he would do it. He would do it if it killed him, he said defiantly to himself. But two days before they were to leave—a day of triumph when he increased his count by fifteen—his nose bled so badly that he turned dizzy and had to lie limply over the big rock like a bit of seaweed, watching the thick red blood flow onto the rock and trickle slowly down to the sea. He was frightened. Supposing he turned dizzy in the tunnel? Sup-

posing he died there, trapped? Supposing—his head went around in the hot sun, and he almost gave up. He thought he would return to the house and lie down, and next summer, perhaps, when he had another year's growth in him—*then* he would go through the hole.

But even after he had made the decision, or thought he had, he found himself sitting up on the rock and looking down into the water; and he knew that now, this moment, when his nose had only just stopped bleeding, when his head was still sore and throbbing—this was the moment when he would try. If he did not do it now, he never would. He was trembling with fear that he would not go; and he was trembling with horror at that long, long tunnel under the rock, under the sea. Even in the open sunlight, the barrier rock seemed very wide and very heavy; tons of rock pressed down on where he would go. If he died there, he would lie until one day—perhaps not before next year—those big boys would swim into it and find it blocked.

He put on his goggles, fitted them tight, tested the vacuum. His hands were shaking. Then he chose the biggest stone he could carry and slipped over the edge of the rock until half of him was in the cool, enclosing water and half in the hot sun. He looked up once at the empty sky, filled his lungs once, twice, and then sank fast to the bottom with the stone. He let it go and began to count. He took the edges of the hole in his hands and drew himself into it, wriggling his shoulders in sidewise as he remembered he must, kicking himself along with his feet.

Soon he was clear inside. He was in a small rockbound hole filled with yellowish-gray water. The water was pushing him up against the roof. The roof was sharp and pained his back. He pulled himself along with his hands—fast, fast—and used his legs as levers. His head knocked against something; a sharp pain diz-zied him. Fifty, fifty-one, fifty-two. . . . He was without light, and the water seemed to press upon him with the weight of rock. Seventy-one, seventy-two. . . . There was no strain on his lungs. He felt like an inflated balloon, his lungs were so light and easy, but his head was pulsing.

He was being continually pressed against the sharp roof, which felt slimy as well as sharp. Again he thought of octopuses, and wondered if the tunnel might be filled with weed that could tangle him. He gave himself a panicky, convulsive kick forward, ducked his head, and swam. His feet and hands moved freely, as if in open water. The hole must have widened out. He thought he must be swimming fast, and he was frightened of banging his head if the tunnel narrowed.

A hundred, a hundred and one. . . . The water paled. Victory filled him. His lungs were beginning to hurt. A few more strokes and he would be out. He was counting wildly; he said a hundred and fifteen, and then, a long time later, a hundred and fifteen again. The water was a clear jewel-green all around him. Then he saw, above his head, a crack running up through the rock. Sunlight was falling through it, showing the clean, dark rock of the tunnel, a single mussel shell, and darkness ahead.

He was at the end of what he could do. He looked up at the crack as if it were filled with air and not water, as if he could put his mouth to it to draw in air. A hundred and fifteen, he heard himself say inside his head—but he had said that long ago. He must go on into the blackness ahead, or he would drown. His head was swelling, his lungs cracking. A hundred and fifteen, a hundred and fifteen pounded through his head, and he feebly clutched at rocks in the dark, pulling himself forward, leaving the brief space of sunlit water behind. He felt he was dying. He was no longer quite conscious. He struggled on in the darkness

between lapses into unconsciousness. An immense, swelling pain filled his head, and then the darkness cracked with an explosion of green light. His hands, groping forward, met nothing; and his feet, kicking back, propelled him out into the open sea.

He drifted to the surface, his face turned up to the air. He was gasping like a fish. He felt he would sink now and drown; he could not swim the few feet back to the rock. Then he was clutching it and pulling himself up onto it. He lay face down, gasping. He could see nothing but a red-veined, clotted dark. His eyes must have burst, he thought; they were full of blood. He tore off his goggles and a gout of blood went into the sea. His nose was bleeding, and the blood had filled the goggles.

He scooped up handfuls of water from the cool, salty sea, to splash on his face, and did not know whether it was blood or salt water he tasted. After a time, his heart quieted, his eyes cleared, and he sat up. He could see the local boys diving and playing a half mile away. He did not want them. He wanted nothing but to get back home and lie down.

In a short while, Jerry swam to shore and climbed slowly up the path to the villa. He flung himself on his bed and slept, waking at the sound of feet on the path outside. His mother was coming back. He rushed to the bathroom, thinking she must not see his face with bloodstains, or tearstains, on it. He came out of the bathroom and met her as she walked into the villa, smiling, her eyes lighting up.

"Have a nice morning?" she asked, laying her hand on his warm brown shoulder a moment.

"Oh, yes, thank you," he said.

"You look a bit pale." And then, sharp and anxious, "How did you bang your head?"

"Oh, just banged it," he told her.

She looked at him closely. He was strained; his eyes were glazed-looking. She was worried.

And then she said to herself, Oh, don't fuss! Nothing can happen. He can swim like a fish.

They sat down to lunch together.

"Mummy," he said, "I can stay under water for two minutes—three minutes, at least." It came bursting out of him.

"Can you, darling?" she said. "Well, I shouldn't overdo it. I don't think you ought to swim any more today."

She was ready for a battle of wills, but he gave in at once. It was no longer of the least importance to go to the bay.

<table>
<tr><td>

Reading Check

1. How does Jerry try to get the attention of the boys after he fails to follow them through the tunnel?
2. What is the first thing Jerry needs to begin his training?
3. Why does Jerry carry a big rock into the water?
4. How does he learn to control his breathing?
5. When does Jerry decide the time has come for him to swim through the tunnel?

</td></tr>
</table>

For Study and Discussion

Analyzing and Interpreting the Story

1. Near the beginning of this story, the author writes of Jerry's feelings about the boys on the rocks: "To be with them, of them, was a craving that filled his whole body." Why do you think Jerry feels it is so important to join the group of divers?

2a. Why does swimming through the tunnel become important to Jerry? b. What details in the description of his preparations suggest that he is undergoing some change?

3. Describe Jerry's passage through the tunnel. What physical and mental conflicts must Jerry face during his ordeal?

4. At the end of the story, we are told that Jerry felt it was "no longer of the least importance to go to the bay" with the older boys. **a.** What accounts for this change in Jerry's attitude? **b.** What details show that his attitude toward his mother has also changed?

5. The author suggests that passage through the tunnel is more than just a test of physical stamina for Jerry. What do you think his passage through the tunnel could represent?

6. How does the author make Jerry's story credible? Consider whether you know anyone who might have acted similarly in Jerry's position.

Literary Elements

Theme

The **theme** of a story is its controlling idea, the central insight that it presents about life or human behavior. Theme is usually implied, though in some stories it is directly stated. Not every story will have a theme. The purpose of many mystery stories, for example, is simply to pose a problem for the reader to solve. Theme exists only in those stories that attempt to make a serious statement about life.

Discovering and stating the theme of a story is sometimes a difficult task. The best way to begin looking for theme in many stories is to focus on the story's main character. Ask yourself what conflicts this character has faced. Determine what changes he or she has undergone and what is the significance of these changes. The answers to these questions should help you understand what is most important in the story and what it says about life or about human behavior.

Here are two statements about "Through the Tunnel." Which do you think is the better statement of the theme, and why?

1. Young people sometimes feel the need to perform daring stunts, just to experience the thrill of danger.

2. By overcoming great obstacles and facing danger alone, a young person may acquire greater maturity and independence.

Language and Vocabulary

Distinguishing Meanings

Each of the following excerpts from the story contains an italicized word. Explain how the word in brackets would change the meaning of the italicized word. What is lost as a result of the substitution?

> . . . he saw an edge of white surf and the shallow, *luminous* [shining] movement of water over white sand . . .

> He *plunged* [dived] down again.

> He got his head in, found his shoulders *jammed* [stuck], moved them in sidewise . . .

> In the meantime, he lay underwater on the white sand, *littered* [covered] now by stones . . .

> His hands, *groping* [reaching] forward, met nothing . . .

Writing About Literature

Analyzing a Setting

This story has two settings: the "safe beach" and the "wild bay." The setting of the wild bay is where the boy undergoes the ordeal that changes him. In a brief essay, explain how Lessing uses imagery and figures of speech to make the bay seem fearful and threatening. What details make the underwater tunnel seem like a place of entombment or burial? Use specific quotations from the story in your discussion.

Focus on Narrative Writing

Focusing on the Climax

The **climax** of a narrative is the moment of highest emotional intensity in the plot, when the outcome of the conflict is finally made clear. In Lessing's "Through the Tunnel," the climax occurs when Jerry succeeds in meeting the challenge he has set for himself.

Identify a real or imaginary event that could serve as the climax for a story of your own. Make sure that this event could be a turning point: for example, a child's first swimming lesson, the final moments of a close game, a breakthrough in a science lab, or a moment of revelation about your own emotions. Freewrite about the event you have chosen for five minutes, adding plot details, characters, and setting. Then get together with a small group of classmates to discuss your story ideas. Save your writing.

About the Author

Doris Lessing (1919–)

Doris Lessing, who was born to British parents living in Iran (then known as Persia), grew up on a plantation in southern Africa. She started writing when she was eighteen but destroyed her first six novels. When she was thirty, she moved to England, where she continued to write while supporting herself with a variety of odd jobs. Now she is considered one of the foremost writers of fiction in this century. Africa provides the setting for many of her early stories and novels. She has said that writers brought up on that continent have many advantages, "being at the center of a modern battlefield, part of a society in rapid, dramatic change." Her most famous novel, *The Golden Notebook*, is a long experimental work that examines the life of a woman struggling to find self-fulfillment. *Shikasta*, a science-fiction novel, appeared in 1979.

"Through the Tunnel" is from her collection of stories called *The Habit of Loving*. Though many writers have given up writing short stories because of a dwindling market, Doris Lessing says she would go on writing stories even if there were no home for them but a private drawer. *The Real Thing* (1992) is a recent collection of Lessing's short stories.

Chee's Daughter

JUANITA PLATERO AND SIYOWIN MILLER

You have seen that setting may have several different functions in a story. Setting may be an important element in plot, it may help to establish mood, or it may reflect a character's state of mind. As you read, consider how the contrasting settings in this story represent contrasting values. How does the contrast underscore the theme of the story?

The hat told the story, the big, black, drooping Stetson. It was not at the proper angle, the proper rakish angle for so young a Navajo. There was no song, and that was not in keeping either. There should have been at least a humming, a faint, all-to-himself "he he he heya," for it was a good horse he was riding, a slender-legged, high-stepping buckskin that would race the wind with light knee-urging. This was a day for singing, a warm winter day, when the touch of the sun upon the back belied the snow high on distant mountains.

Wind warmed by the sun touched his high-boned cheeks like flicker[1] feathers, and still he rode on silently, deeper into Little Canyon, until the red rock walls rose straight upward from the stream bed and only a narrow piece of blue sky hung above. Abruptly the sky widened where the canyon walls were pushed back to make a wide place, as though in ancient times an angry stream had tried to go all ways at once.

1. **flicker:** woodpecker.

This was home—this wide place in the canyon—levels of jagged rock and levels of rich red earth. This was home to Chee, the rider of the buckskin, as it had been to many generations before him.

He stopped his horse at the stream and sat looking across the narrow ribbon of water to the bare-branched peach trees. He was seeing them each springtime with their age-gnarled limbs transfigured beneath veils of blossom pink; he was seeing them in autumn laden with their yellow fruit, small and sweet. Then his eyes searched out the indistinct furrows of the fields beside the stream, where each year the corn and beans and squash drank thirstily of the overflow from summer rains. Chee was trying to outweigh today's bitter betrayal of hope by gathering to himself these reminders of the integrity of the land. Land did not cheat! His mind lingered deliberately on all the days spent here in the sun caring for the young plants, his songs to the earth and to the life springing from it— ". . . In the middle of the

Staff Bearer II (1981) by Ed Singer (1951–).
Mixed media on paper.
Courtesy of the Museum of the American Indian.
Heye Foundation, gift of Mr. and Mrs. L. D.
Horodenski, Smithsonian Institution #25/2533

wide field . . . Yellow Corn Boy . . . He has started both ways . . . ," then the harvest and repayment in full measure. Here was the old feeling of wholeness and of oneness with the sun and earth and growing things.

Chee urged the buckskin toward the family compound where, secure in a recess of overhanging rock, was his mother's dome-shaped hogan,[2] red rock and red adobe like the ground on which it nestled. Not far from the

hogan was the half-circle of brush like a dark shadow against the canyon wall—corral for sheep and goats. Farther from the hogan, in full circle, stood the horse corral made of heavy cedar branches sternly interlocked. Chee's long thin lips curved into a smile as he passed his daughter's tiny hogan squatted like a round Pueblo oven beside the corral. He remembered the summer day when together they sat back on their heels and plastered wet adobe all about the circling wall of rock and the woven dome of piñon[3] twigs. How his family laughed when the Little One herded the bewildered chickens into her tiny hogan as the first snow fell.

Then the smile faded from Chee's lips and his eyes darkened as he tied his horse to a corral post and turned to the strangely empty compound. "Someone has told them," he thought, "and they are inside weeping." He passed his mother's deserted loom on the south side of the hogan and pulled the rude wooden door toward him, bowing his head, hunching his shoulders to get inside.

His mother sat sideways by the center fire, her feet drawn up under her full skirts. Her hands were busy kneading dough in the chipped white basin. With her head down, her voice was muffled when she said, "The meal will soon be ready, son."

Chee passed his father sitting against the wall, hat over his eyes as though asleep. He passed his older sister who sat turning mutton ribs on a crude wire grill over the coals, noticed tears dropping on her hands. "She cared more for my wife than I realized," he thought.

Then because something must be said sometime, he tossed the black Stetson upon a bulging sack of wool and said, "You have heard, then." He could not shut from his mind how confidently he had set the handsome new hat

2. **hogan:** traditional Navajo house, usually made of earth walls supported by timber.

3. **piñon** (pĭn′yōn′): small pine tree.

on his head that very morning, slanting the wide brim over one eye: he was going to see his wife and today he would ask the doctors about bringing her home; last week she had looked so much better.

His sister nodded but did not speak. His mother sniffled and passed her velveteen sleeve beneath her nose. Chee sat down, leaning against the wall. "I suppose I was a fool for hoping all the time. I should have expected this. Few of our people get well from the coughing sickness.[4] But *she* seemed to be getting better."

His mother was crying aloud now and blowing her nose noisily on her skirt. His father sat up, speaking gently to her.

Chee shifted his position and started a cigarette. His mind turned back to the Little One. At least she was too small to understand what had happened, the Little One who had been born three years before in the sanitarium where his wife was being treated for the coughing sickness, the Little One he had brought home to his mother's hogan to be nursed by his sister, whose baby was a few months older. As she grew fat-cheeked and sturdy-legged, she followed him about like a shadow; somehow her baby mind had grasped that of all those at the hogan who cared for her and played with her, he—Chee—belonged most to her. She sat cross-legged at his elbow when he worked silver at the forge; she rode before him in the saddle when he drove the horses to water; often she lay wakeful on her sheep pelts until he stretched out for the night in the darkened hogan and she could snuggle warm against him.

Chee blew smoke slowly and some of the sadness left his dark eyes as he said, "It is not as bad as it might be. It is not as though we are left with nothing."

Chee's sister arose, sobs catching in her throat, and rushed past him out the doorway. Chee sat upright, a terrible fear possessing him. For a moment his mouth could make no sound. Then: "The Little One! Mother, where is she?"

His mother turned her stricken face to him. "Your wife's people came after her this morning. They heard yesterday of their daughter's death through the trader at Red Sands."

Chee started to protest but his mother shook her head slowly. "I didn't expect they would want the Little One either. But there is nothing you can do. She is a girl child and belongs to her mother's people; it is custom."

Frowning, Chee got to his feet, grinding his cigarette into the dirt floor. "Custom! When did my wife's parents begin thinking about custom? Why, the hogan where they live doesn't even face the east!"[5] He started toward the door. "Perhaps I can overtake them. Perhaps they don't realize how much we want her with us. I'll ask them to give my daughter back to me. Surely, they won't refuse."

His mother stopped him gently with her outstretched hand. "You couldn't overtake them now. They were in the trader's car. Eat and rest, and think more about this."

"Have you forgotten how things have always been between you and your wife's people?" his father said.

That night, Chee's thoughts were troubled—half-forgotten incidents became disturbingly vivid—but early the next morning he saddled the buckskin and set out for the settlement of Red Sands. Even though his father-in-law, Old Man Fat, might laugh, Chee knew that he must talk to him. There were some things to which Old Man Fat might listen.

Chee rode the first part of the fifteen miles to Red Sands expectantly. The sight of sand-

4. **coughing sickness:** tuberculosis.

5. **east:** according to Navajo custom, the door of a hogan faces the east.

Chee's Daughter **213**

stone buttes[6] near Cottonwood Spring reddening in the morning sun brought a song almost to his lips. He twirled his reins in salute to the small boy herding sheep toward many-colored Butterfly Mountain, watched with pleasure the feathers of smoke rising against tree-darkened western mesas from the hogans sheltered there. But as he approached the familiar settlement sprawled in mushroom growth along the highway, he began to feel as though a scene from a bad dream was becoming real.

Several cars were parked around the trading store which was built like two log hogans side by side, with red gas pumps in front and a sign across the tar-paper roofs: *Red Sands Trading Post—Groceries Gasoline Cold Drinks Sandwiches Indian Curios.* Back of the trading post an unpainted frame house and outbuildings squatted on the drab, treeless land. Chee and the Little One's mother had lived there when they stayed with his wife's people. That was according to custom—living with one's wife's people—but Chee had never been convinced that it was custom alone which prompted Old Man Fat and his wife to insist that their daughter bring her husband to live at the trading post.

Beside the post was a large hogan of logs, with brightly painted pseudo-Navajo[7] designs on the roof—a hogan with smoke-smudged windows and a garish blue door which faced

6. **buttes** (byōōts): steep, flat-topped hills rising above a plain.

7. **pseudo-Navajo** (sōō'dō-năv'ə-hō'): fake or imitation Navajo.

Trading Post (1946) by Beatien Yazz (1931?–). Watercolor on paper.
Courtesy of the School of American Research, Santa Fe, New Mexico

north to the highway. Old Man Fat had offered Chee a hogan like this one. The trader would build it if he and his wife would live there and Chee would work at his forge, making silver jewelry where tourists could watch him. But Chee had asked instead for a piece of land for a cornfield and help in building a hogan far back from the highway and a corral for the sheep he had brought to this marriage.

A cold wind blowing down from the mountains began to whistle about Chee's ears. It flapped the gaudy Navajo rugs which were hung in one long bright line to attract tourists. It swayed the sign *Navajo Weaver at Work* beside the loom where Old Man Fat's wife sat hunched in her striped blanket, patting the colored thread of a design into place with a wooden comb. Tourists stood watching the weaver. More tourists stood in a knot before the hogan where the sign said: *See Inside a Real Navajo Home 25¢.*

Then the knot seemed to unravel as a few people returned to their cars; some had cameras; and there against the blue door Chee saw the Little One standing uncertainly. The wind was plucking at her new purple blouse and wide green skirt; it freed truant strands of soft dark hair from the meager queue[8] into which it had been tied with white yarn.

"Isn't she cunning!" one of the women tourists was saying as she turned away.

Chee's lips tightened as he began to look around for Old Man Fat. Finally he saw him passing among the tourists collecting coins.

Then the Little One saw Chee. The uncertainty left her face and she darted through the crowd as her father swung down from his horse. Chee lifted her in his arms, hugging her tight. While he listened to her breathless chatter, he watched Old Man Fat bearing down on them, scowling.

8. **queue** (kyoō): braid.

As his father-in-law walked heavily across the graveled lot, Chee was reminded of a statement his mother sometimes made: "When you see a fat Navajo, you see one who hasn't worked for what he has."

Old Man Fat was fattest in the middle. There was indolence in his walk even though he seemed to hurry, indolence in his cheeks so plump they made his eyes squint, eyes now smoldering with anger.

Some of the tourists were getting into their cars and driving away. The old man said belligerently to Chee, "Why do you come here? To spoil our business? To drive people away?"

"I came to talk with you," Chee answered, trying to keep his voice steady as he faced the old man.

"We have nothing to talk about," Old Man Fat blustered and did not offer to touch Chee's extended hand.

"It's about the Little One." Chee settled his daughter more comfortably against his hip as he weighed carefully all the words he had planned to say. "We are going to miss her very much. It wouldn't be so bad if we knew that *part* of each year she could be with us. That might help you too. You and your wife are no longer young people and you have no young ones here to depend upon." Chee chose his next words remembering the thriftlessness of his wife's parents, and their greed, "Perhaps we could share the care of this little one. Things are good with us. So much snow this year will make lots of grass for the sheep. We have good land for corn and melons."

Chee's words did not have the expected effect. Old Man Fat was enraged. "Farmers, all of you! Long-haired farmers! Do you think everyone must bend his back over the short-handled hoe in order to have food to eat?" His tone changed as he began to brag a little. "We not only have all the things from cans at the trader's, but when the Pueblos come past here

on their way to town we buy their salty jerked[9] mutton, young corn for roasting, dried sweet peaches."

Chee's dark eyes surveyed the land along the highway as the old man continued to brag about being "progressive." *He* no longer was tied to the land. He and his wife made money easily and could *buy* all the things they wanted. Chee realized too late that he had stumbled into the old argument between himself and his wife's parents. They had never understood his feeling about the land—that a man took care of his land and it in turn took care of him. Old Man Fat and his wife scoffed at him, called him a Pueblo farmer, all during that summer when he planted and weeded and harvested. Yet they ate the green corn in their mutton stews, and the chili paste from the cornmeal his wife ground. None of this working and sweating in the sun for Old Man Fat, who talked proudly of his easy way of living—collecting money from the trader who rented this strip of land beside the highway, collecting money from the tourists.

Yet Chee had once won that argument. His wife had shared his belief in the integrity of the earth, that jobs and people might fail one but the earth never would. After that first year she had turned from her own people and gone with Chee to Little Canyon.

Old Man Fat was reaching for the Little One. "Don't be coming here with plans for my daughter's daughter," he warned. "If you try to make trouble, I'll take the case to the government man in town."

The impulse was strong in Chee to turn and ride off while he still had the Little One in his arms. But he knew his time of victory would be short. His own family would uphold the old custom of children, especially girl children, belonging to the mother's people. He would have

9. **jerked:** preserved by being cut into strips and dried in the sun.

to give his daughter up if the case were brought before the headman of Little Canyon, and certainly he would have no better chance before a strange white man in town.

He handed the bewildered Little One to her grandfather who stood watching every movement suspiciously. Chee asked, "If I brought you a few things for the Little One, would that be making trouble? Some velvet for a blouse, or some of the jerky she likes so well . . . this summer's melon?"

Old Man Fat backed away from him. "Well," he hesitated, as some of the anger disappeared from his face and beads of greed shone in his eyes. "Well," he repeated. Then as the Little One began to squirm in his arms and cry, he said, "No! No! Stay away from here, you and all your family."

The sense of his failure deepened as Chee rode back to Little Canyon. But it was not until he sat with his family that evening in the hogan, while the familiar bustle of meal preparing went on about him, that he began to doubt the wisdom of the things he'd always believed. He smelled the coffee boiling and the oily fragrance of chili powder dusted into the bubbling pot of stew; he watched his mother turning round crusty fried bread in the small black skillet. All around him was plenty—a half of mutton hanging near the door, bright strings of chili drying, corn hanging by the braided husks, cloth bags of dried peaches. Yet in his heart was nothing.

He heard the familiar sounds of the sheep outside the hogan, the splash of water as his father filled the long drinking trough from the water barrel. When his father came in, Chee could not bring himself to tell a second time of the day's happenings. He watched his wiry, soft-spoken father's queue of graying hair quiver as he nodded his head with sympathetic exclamations.

Chee's doubting, acrid thoughts kept form-

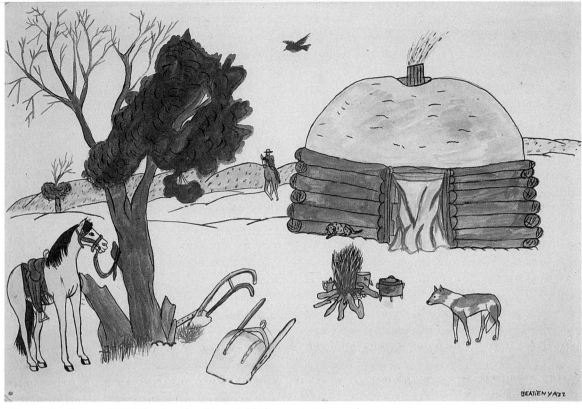

Hogan of a Farmer (1942) by Beatien Yazz (1931?–). Watercolor on paper.
Courtesy of the School of American Research, Santa Fe, New Mexico

ing: Was it wisdom his father had passed on to him, or was his inheritance only the stubbornness of a long-haired Navajo resisting change? Take care of the land and it will take care of you. True, the land had always given him food, but now food was not enough. Perhaps if he had gone to school he would have learned a different kind of wisdom, something to help him now. A schoolboy might even be able to speak convincingly to this government man whom Old Man Fat threatened to call, instead of sitting here like a clod of earth itself—Pueblo farmer indeed. What had the land to give that would restore his daughter?

In the days that followed, Chee herded sheep. He got up in the half-light, drank the hot coffee his mother had ready, then started the flock moving. It was necessary to drive the sheep a long way from the hogan to find good winter forage. Sometimes Chee met friends or relatives who were on their way to town or to the road camp where they hoped to get work; then there was friendly banter and an exchange of news. But most of the days seemed endless; he could not walk far enough or fast enough from his memories of the Little One or from his bitter thoughts. Sometimes it seemed his daughter trudged beside him, so real he could almost hear her footsteps—the muffled pad-pad of little feet clad in deerhide.

Chee's Daughter **217**

In the glare of a snowbank he would see her vivid face, brown eyes sparkling. Mingling with the tinkle of sheep bells he heard her laughter.

When, weary of following the small sharp hoof marks that crossed and recrossed in the snow, he sat down in the shelter of a rock, it was only to be reminded that in his thoughts he had forsaken his brotherhood with the earth and sun and growing things. If he remembered times when he had flung himself against the earth to rest, to lie there in the sun until he could no longer feel where he left off and the earth began, it was to remember also that now he sat like an alien against the same earth; the belonging-together was gone. The earth was one thing and he was another.

It was during the days when he herded sheep that Chee decided he must leave Little Canyon. Perhaps he would take a job silver smithing for one of the traders in town. Perhaps, even though he spoke little English, he could get a job at the road camp with his cousins; he would ask them about it.

Springtime transformed the mesas. The peach trees in the canyon were shedding fragrance and pink blossoms on the gentled wind. The sheep no longer foraged for the yellow seeds of chamiso[10] but ranged near the hogan with the long-legged new lambs, eating tender young grass.

Chee was near the hogan on the day his cousins rode up with the message for which he waited. He had been watching with mixed emotions while his father and his sister's husband cleared the fields beside the stream.

"The boss at the camp says he needs an extra hand, but he wants to know if you'll be willing to go with the camp when they move it to the other side of the town?" The tall cousin shifted his weight in the saddle.

10. **chamiso** (chə-mē′sō): shrub that forms dense thickets.

The other cousin took up the explanation. "The work near here will last only until the new cutoff beyond Red Sands is finished. After that, the work will be too far away for you to get back here often."

That was what Chee had wanted—to get away from Little Canyon—yet he found himself not so interested in the job beyond town as in this new cutoff which was almost finished. He pulled a blade of grass, split it thoughtfully down the center, as he asked questions of his cousins. Finally he said: "I need to think more about this. If I decide on this job, I'll ride over."

Before his cousins were out of sight down the canyon Chee was walking toward the fields, a bold plan shaping in his mind. As the plan began to flourish, wild and hardy as young tumbleweed, Chee added his own voice softly to the song his father was singing: ". . . In the middle of the wide field . . . Yellow Corn Boy . . . I wish to put in."

Chee walked slowly around the field, the rich red earth yielding to his footsteps. His plan depended upon this land and upon the things he remembered most about his wife's people.

Through planting time Chee worked zealously and tirelessly. He spoke little of the large new field he was planting because he felt so strongly that just now this was something between himself and the land. The first days he was ever stooping, piercing the ground with the pointed stick, placing the corn kernels there, walking around the field and through it, singing, ". . . His track leads into the ground . . . Yellow Corn Boy . . . his track leads into the ground." After that, each day Chee walked through his field watching for the tips of green to break through; first a few spikes in the center and then more and more until the corn in all parts of the field was above ground. Surely, Chee thought, if he sang the proper songs, if he cared for this land faith-

fully, it would not forsake him now, even though through the lonely days of winter he had betrayed the goodness of the earth in his thoughts.

Through the summer Chee worked long days, the sun hot upon his back, pulling weeds from around young corn plants; he planted squash and pumpkin; he terraced a small piece of land near his mother's hogan and planted carrots and onions and the moisture-loving chili. He was increasingly restless. Finally he told his family what he hoped the harvest from this land would bring him. Then the whole family waited with him, watching the corn: the slender graceful plants that waved green arms and bent to embrace each other as young winds wandered through the field, the maturing plants flaunting their pollen-laden tassels in the sun, the tall and sturdy parent corn with new-formed ears and a froth of purple, red, and yellow corn beards against the dusty emerald of broad leaves.

Summer was almost over when Chee slung the bulging packs across two pack ponies. His mother helped him tie the heavy rolled pack behind the saddle of the buckskin. Chee knotted the new yellow kerchief about his neck a little tighter, gave the broad black hat brim an extra tug, but these were only gestures of assurance and he knew it. The land had not failed him. That part was done. But this he was riding into? Who could tell?

When Chee arrived at Red Sands, it was as he had expected to find it—no cars on the highway. His cousins had told him that even the Pueblo farmers were using the new cutoff to town. The barren gravel around the Red Sands Trading Post was deserted. A sign banged against the dismantled gas pumps: *Closed until further notice.*

Old Man Fat came from the crude summer shelter built beside the log hogan from a few branches of scrub cedar and the sides of wooden crates. He seemed almost friendly when he saw Chee.

"Get down, my son," he said, eyeing the bulging packs. There was no bluster in his voice today and his face sagged, looking somewhat saddened; perhaps because his cheeks were no longer quite full enough to push his eyes upward at the corners. "You are going on a journey?"

Chee shook his head. "Our fields gave us so much this year, I thought to sell or trade this to the trader. I didn't know he was no longer here."

Old Man Fat sighed, his voice dropping to an injured tone. "He says he and his wife are going to rest this winter; then after that he'll build a place up on the new highway."

Chee moved as though to be traveling on, then jerked his head toward the pack ponies. "Anything you need?"

"I'll ask my wife," Old Man Fat said as he led the way to the shelter. "Maybe she has a little money. Things have not been too good with us since the trader closed. Only a few tourists come this way." He shrugged his shoulders. "And with the trader gone—no credit."

Chee was not deceived by his father-in-law's unexpected confidences. He recognized them as a hopeful bid for sympathy and, if possible, something for nothing. Chee made no answer. He was thinking that so far he had been right about his wife's parents: their thriftlessness had left them with no resources to last until Old Man Fat found another easy way of making a living.

Old Man Fat's wife was in the shelter working at her loom. She turned rather wearily when her husband asked with noticeable deference if she would give him money to buy supplies. Chee surmised that the only income here was from his mother-in-law's weaving.

She peered around the corner of the shelter at the laden ponies, and then she looked at

Chee. "What do you have there, my son?"

Chee smiled to himself as he turned to pull the pack from one of the ponies, dragged it to the shelter where he untied the ropes. Pumpkins and hard-shelled squash tumbled out, and the ears of corn—pale yellow husks fitting firmly over plump ripe kernels, blue corn, red corn, yellow corn, many-colored corn, ears and ears of it—tumbled into every corner of the shelter.

"Yooooh," Old Man Fat's wife exclaimed as she took some of the ears in her hands. Then she glanced up at her son-in-law. "But we have no money for all this. We have sold almost everything we own—even the brass bed that stood in the hogan."

Old Man Fat's brass bed. Chee concealed his amusement as he started back for another pack. That must have been a hard parting. Then he stopped, for, coming from the cool darkness of the hogan was the Little One, rubbing her eyes as though she had been asleep. She stood for a moment in the doorway and Chee saw that she was dirty, barefoot, her hair uncombed, her little blouse shorn of all its silver buttons. Then she ran toward Chee, her arms outstretched. Heedless of Old Man Fat and his wife, her father caught her in his arms, her hair falling in a dark cloud across his face, the sweetness of her laughter warm against his shoulder.

It was the haste within him to get this slow waiting game played through to the finish that made Chee speak unwisely. It was the desire to swing her before him in the saddle and ride fast to Little Canyon that prompted his words. "The money doesn't matter. You still have something. . . ."

Chee knew immediately that he had overspoken. The old woman looked from him to the corn spread before her. Unfriendliness began to harden in his father-in-law's face. All the old arguments between himself and his

wife's people came pushing and crowding in between them now.

Old Man Fat began kicking the ears of corn back onto the canvas as he eyed Chee angrily. "And you rode all the way over here thinking that for a little food we would give up our daughter's daughter?"

Chee did not wait for the old man to reach for the Little One. He walked dazedly to the shelter, rubbing his cheek against her soft dark hair and put her gently into her grandmother's lap. Then he turned back to the horses. He had failed. By his own haste he had failed. He swung into the saddle, his hand touching the roll behind it. Should he ride on into town?

Then he dismounted, scarcely glancing at Old Man Fat, who stood uncertainly at the corner of the shelter, listening to his wife. "Give me a hand with this other pack of corn, Grandfather," Chee said, carefully keeping the small bit of hope from his voice.

Puzzled, but willing, Old Man Fat helped carry the other pack to the shelter, opening it to find more corn as well as carrots and round pale yellow onions. Chee went back for the roll behind the buckskin's saddle and carried it to the entrance of the shelter where he cut the ropes and gave the canvas a nudge with his toe. Tins of coffee rolled out, small plump cloth bags; jerked meat from several butcherings spilled from a flour sack; and bright red chilis splashed like flames against the dust.

"I will leave all this anyhow," Chee told them. "I would not want my daughter nor even you old people to go hungry."

Old Man Fat picked up a shiny tin of coffee, then put it down. With trembling hands he began to untie one of the cloth bags—dried sweet peaches.

The Little One had wriggled from her grandmother's lap, unheeded, and was on her knees, digging her hands into the jerked meat.

"There is almost enough food here to last

all winter." Old Man Fat's wife sought the eyes of her husband.

Chee said, "I meant it to be enough. But that was when I thought you might send the Little One back with me." He looked down at his daughter noisily sucking jerky. Her mouth, both fists were full of it. "I am sorry that you feel you cannot bear to part with her."

Old Man Fat's wife brushed a straggly wisp of gray hair from her forehead as she turned to look at the Little One. Old Man Fat was looking too. And it was not a thing to see. For in that moment the Little One ceased to be their daughter's daughter and became just another mouth to feed.

"And why not?" the old woman asked wearily.

Chee was settled in the saddle, the barefooted Little One before him. He urged the buckskin faster, and his daughter clutched his shirt-front. The purpling mesas flung back the echo: ". . . My corn embrace each other. In the middle of the wide field . . . Yellow Corn Boy embrace each other."

Reading Check

1. At the opening of the story, where has the Little One, Chee's daughter, been taken?
2. Why does Old Man Fat think that his way of life is better than Chee's?
3. How does the trading post change by the end of the summer?
4. Why do Old Man Fat and his wife give the Little One to Chee?

For Study and Discussion

Analyzing and Interpreting the Story

1. Find passages in this story that describe the traditional Navajo belief about the land and about people's relationship to it. Why does Chee begin to doubt his beliefs about the land?

2. Chee refers to "the old arguments" between himself and his wife's parents. **a.** What is the basis of this old conflict? **b.** What new conflict between Chee and his in-laws is the basis of this story?

3. How does the land itself finally help solve Chee's conflicts?

4. This story is basically about a clash between two cultures and two sets of values. **a.** How are the contrasting values represented by the contrasting settings: the trading post and Chee's home in Little Canyon? **b.** Which setting and set of values are sterile and destructive? **c.** Which are fruitful and supporting?

Language and Vocabulary

Finding Word Origins

You probably know that a number of words in English are derived from American Indian languages. The word *hogan*, for example, comes from *goghan*, the Navajo word for house. Using a college or unabridged dictionary, determine the origin of each of the following words:

Cayuse	skunk
hickory	squash
Mackinaw	succotash
persimmon	totem
raccoon	woodchuck

Writing About Literature

Expressing the Theme of the Story

In a short composition explain how the plot, settings, and characters in "Chee's Daughter" all lead to unmistakable conclusions about which way of living is superior—Old Man Fat's "progressive" way or Chee's traditional way. Conclude your essay with a sentence directly expressing the theme of the story.

Focus on Narrative Writing

Making a Story Map

A **story map** is an outline that shows all the important elements of a narrative. Here is a sample story map:

Story Map

Story Title: _____

Point of View: _____

Characters

 1: _____

 2: _____

 3: _____

Setting

 Time: _____

 Place: _____

Plot

 Exposition: _____

 Conflict: _____

Complications:

 Climax: _____

 Resolution: _____

Create a story map for a narrative of your own. When you have finished work, get together with a partner and offer each other suggestions. Save your writing.

About the Authors

Juanita Platero and Siyowin Miller

Juanita Platero (plä-tâ′rō) and Siyowin (sē′ə wēn′) Miller were introduced to each other in California in 1929 by Chief Standing Bear. Since that time they have collaborated on several stories about the conflict between traditional Navajo values and middle-class American values. Platero lived for many years in New Mexico with her husband's people, while Miller shuttled between her home in California and the Plateros' home on the Navajo reservation. "Chee's Daughter" was first published in *Common Ground* in 1948.

Connecting Cultures

Corn as a Symbol

While Chee is planting his field, he sings a song about Yellow Corn Boy. Throughout the ages, corn has been used in the legends of many cultures as a symbol of nourishment, fertility, strength, and a successful harvest. For example, many ancient ancestors of Europeans believed in a Corn-mother goddess. According to American Indian legends, maize was formed from a drop of the mythical Corn Woman's blood. The Berbers of Morocco regarded the corn as a bride, and practiced an elaborate ceremony in which the corn plant, dressed as a woman, was kidnapped and rescued. Corn myths may be found in the cultures of India, Egypt, and Burma, among others.

Making Connections: Activities

Using reference materials available to you, such as *North American Indian Mythology* (1965) or *Corn Is in Our Blood* (1991), explore a culture in which corn plays a symbolic role. Describe the legends, customs, and rituals surrounding it. You may wish to expand your written work into illustrations or dramatic presentations.

The Handsomest Drowned Man in the World

A Tale for Children

GABRIEL GARCÍA MÁRQUEZ°

Translated by
Gregory Rabassa

The intriguing title of this story suggests the "magical realism" that mixes the "marvelous" with the commonplace. Note that the subtitle of this story is "A Tale for Children." As you read, consider how this tale resembles a creation myth.

The first children who saw the dark and slinky bulge approaching through the sea let themselves think it was an enemy ship. Then they saw it had no flags or masts and they thought it was a whale. But when it was washed up on the beach, they removed the clumps of seaweed, the jellyfish tentacles, and the remains of fish and flotsam, and only then did they see that it was a drowned man.

They had been playing with him all afternoon, burying him in the sand and digging him up again, when someone chanced to see them and spread the alarm in the village. The men who carried him to the nearest house noticed that he weighed more than any dead man they had ever known, almost as much as a horse, and they said to each other that maybe he'd been floating too long and the water had got into his bones. When they laid him on the floor they said he'd been taller than all other men because there was barely enough room for him in the house, but they thought that maybe the ability to keep on growing after death was part of the nature of certain drowned men. He had the smell of the sea about him and only his shape gave one to suppose that it was the corpse of a human being, because the skin was covered with a crust of mud and scales.

They did not even have to clean off his face to know that the dead man was a stranger. The village was made up of only twenty-odd

° **García Márquez** (gär-sē'ä mär'kĕs).

wooden houses that had stone courtyards with no flowers and which were spread about on the end of a desertlike cape. There was so little land that mothers always went about with the fear that the wind would carry off their children and the few dead that the years had caused among them had to be thrown off the cliffs. But the sea was calm and bountiful and all the men fit into seven boats. So when they found the drowned man they simply had to look at one another to see that they were all there.

That night they did not go out to work at sea. While the men went to find out if anyone was missing in neighboring villages, the women stayed behind to care for the drowned man. They took the mud off with grass swabs, they removed the underwater stones entangled in his hair, and they scraped the crust off with tools used for scaling fish. As they were doing that they noticed that the vegetation on him came from faraway oceans and deep water and that his clothes were in tatters, as if he had sailed through labyrinths of coral. They noticed too that he bore his death with pride, for he did not have the lonely look of other drowned men who came out of the sea or that haggard, needy look of men who drowned in rivers. But only when they finished cleaning him off did they become aware of the kind of man he was and it left them breathless. Not only was he the tallest, strongest, most virile, and best built man they had ever seen, but even though they were looking at him there was no room for him in their imagination.

They could not find a bed in the village large enough to lay him on nor was there a table solid enough to use for his wake. The tallest men's holiday pants would not fit him, not the fattest ones' Sunday shirts, nor the shoes of the one with the biggest feet. Fascinated by his huge size and his beauty, the women then decided to make him some pants from a large piece of sail and a shirt from some bridal brabant linen[1] so that he could continue through his death with dignity. As they sewed, sitting in a circle and gazing at the corpse between stitches, it seemed to them that the wind had never been so steady nor the sea so restless as on that night and they supposed that the change had something to do with the dead man. They thought that if that magnificent man had lived in the village, his house would have had the widest doors, the highest ceiling, and the strongest floor, his bedstead would have been made from a midship frame held together by iron bolts, and his wife would have been the happiest woman. They thought that he would have had so much authority that he could have drawn fish out of the sea simply by calling their names and that he would have put so much work into his land that springs would have burst forth from among the rocks so that he would have been able to plant flowers on the cliffs. They secretly compared him to their own men, thinking that for all their lives theirs were incapable of doing what he could do in one night, and they ended up dismissing them deep in their hearts as the weakest, meanest, and most useless creatures on earth. They were wandering through that maze of fantasy when the oldest woman, who as the oldest had looked upon the drowned man with more compassion than passion, sighed:

"He has the face of someone called Esteban."[2]

It was true. Most of them had only to take another look at him to see that he could not have any other name. The more stubborn among them, who were the youngest, still lived for a few hours with the illusion that when

1. **brabant** (brə-bänt′, -bänt′) **linen:** Brabant, a district in the lowlands of the Netherlands and Belgium, is known for its fine lace and cloth.
2. **Esteban** (ĕs-tä′bän): the Spanish name for Stephen.

they put his clothes on and he lay among the flowers in patent leather shoes his name might be Lautaro.[3] But it was a vain illusion. There had not been enough canvas, the poorly cut and worse sewn pants were too tight, and the hidden strength of his heart popped the buttons on his shirt. After midnight the whistling of the wind died down and the sea fell into its Wednesday drowsiness. The silence put an end to any last doubts: he was Esteban. The women who had dressed him, who had combed his hair, had cut his nails and shaved him were unable to hold back a shudder of pity when they had to resign themselves to his being dragged along the ground. It was then that they understood how unhappy he must have been with that huge body since it bothered him even after death. They could see him in life, condemned to going through doors sideways, cracking his head on crossbeams, remaining on his feet during visits, not knowing what to do with his soft, pink, sea lion hands while the lady of the house looked for her most resistant chair and begged him, frightened to death, sit here, Esteban, please, and he, leaning against the wall, smiling, don't bother, ma'am, I'm fine where I am, his heels raw and his back roasted from having done the same thing so many times whenever he paid a visit, don't bother, ma'am, I'm fine where I am, just to avoid the embarrassment of breaking up the chair, and never knowing perhaps that the ones who said don't go, Esteban, at least wait till the coffee's ready, were the ones who later on would whisper the big boob finally left, how nice, the handsome fool has gone. That was what the women were thinking beside the body a little before dawn. Later, when they covered his face with a handkerchief so that the light would not bother him, he looked so forever dead, so de-

Blue Profile (Profil bleu) by Odilon Redon. Pastel, 30.2 x 24.7 cm.
Copyright British Museum

fenseless, so much like their men that the first furrows of tears opened in their hearts. It was one of the younger ones who began the weeping. The others, coming to, went from sighs to wails, and the more they sobbed the more they felt like weeping, because the drowned man was becoming all the more Esteban for them, and so they wept so much, for he was the most destitute, most peaceful, and most obliging man on earth, poor Esteban. So when the men returned with the news that the drowned man was not from the neighboring villages either, the women felt an opening of jubilation in the midst of their tears.

"Praise the Lord," they sighed, "he's ours!"

The men thought the fuss was only womanish frivolity. Fatigued because of the difficult nighttime inquiries, all they wanted was to get rid of the bother of the newcomer once and

3. **Lautaro** (lou-tär′ō).

for all before the sun grew strong on that arid, windless day. They improvised a litter with the remains of foremasts and gaffs,[4] tying it together with rigging so that it would bear the weight of the body until they reached the cliffs. They wanted to tie the anchor from a cargo ship to him so that he would sink easily into the deepest waves, where fish are blind and divers die of nostalgia, and bad currents would not bring him back to shore, as had happened with other bodies. But the more they hurried, the more the women thought of ways to waste time. They walked about like startled hens, pecking with the sea charms[5] on their breasts, some interfering on one side to put a scapular[6] of the good wind on the drowned man, some on the other side to put a wrist compass on him, and after a great deal of *get away from there, woman, stay out of the way, look, you almost made me fall on top of the dead man*, the men began to feel mistrust in their livers and started grumbling about why so many main-altar decorations for a stranger, because no matter how many nails and holy-water jars he had on him, the sharks would chew him all the same, but the women kept piling on their junk relics, running back and forth, stumbling, while they released in sighs what they did not in tears, so that the men finally exploded with *since when has there ever been such a fuss over a drifting corpse, a drowned nobody, a piece of cold Wednesday meat.*[7] One of the women, mortified by so much lack of care, then removed the handkerchief from the dead man's face and the men were left breathless too.

He was Esteban. It was not necessary to repeat it for them to recognize him. If they had been told Sir Walter Raleigh,[8] even they might have been impressed with his gringo[9] accent, the macaw on his shoulder, his cannibal-killing blunderbuss, but there could be only one Esteban in the world and there he was, stretched out like a sperm whale, shoeless, wearing the pants of an undersized child, and with those stony nails that had to be cut with a knife. They only had to take the handkerchief off his face to see that he was ashamed, that it was not his fault that he was so big or so heavy or so handsome, and if he had known that this was going to happen, he would have looked for a more discreet place to drown in, seriously, I[10] even would have tied the anchor off a galleon around my neck and staggered off a cliff like someone who doesn't like things in order not to be upsetting people now with this Wednesday dead body, as you people say, in order not to be bothering anyone with this filthy piece of cold meat that doesn't have anything to do with me. There was so much truth in his manner that even the most mistrustful men, the ones who felt the bitterness of endless nights at sea fearing that their women would tire of dreaming about them and begin to dream of drowned men, even they and others who were harder still shuddered in the marrow of their bones at Esteban's sincerity.

That was how they came to hold the most splendid funeral they could conceive of for an abandoned drowned man. Some women who had gone to get flowers in the neighboring villages returned with other women who could not believe what they had been told, and those women went back for more flowers when they saw the dead man, and they brought more and more until there were so many flowers and so

4. **gaffs:** A gaff is a pole attached at the upper edge of a mast to support a sail.
5. **sea charms:** amulets supposed to have special powers of protection against the sea.
6. **scapular** (skăp′yə-lər): a garment worn under the clothes as a mark of religious devotion.
7. *Wednesday meat:* meat left over from the Sunday meal.

8. **Sir Walter Raleigh** (rôl′ē): an English explorer (c. 1552–1618) who attempted to establish a colony in America.
9. **gringo:** foreign; here, English.
10. **I:** The point of view shifts here and the dead man speaks for himself.

many people that it was hard to walk about. At the final moment it pained them to return him to the waters as an orphan and they chose a father and mother from among the best people, and aunts and uncles and cousins, so that through him all the inhabitants of the village became kinsmen. Some sailors who heard the weeping from a distance went off course and people heard of one who had himself tied to the mainmast, remembering ancient fables about sirens.[11] While they fought for the privilege of carrying him on their shoulders along the steep escarpment by the cliffs, men and women became aware for the first time of the desolation of their streets, the dryness of their courtyards, the narrowness of their dreams as they faced the splendor and beauty of their drowned man. They let him go without an anchor so that he could come back if he wished and whenever he wished, and they all held their breath for the fraction of centuries the body took to fall into the abyss. They did not need to look at one another to realize that they were no longer all present, that they would never be. But they also knew that everything would be different from then on, that their houses would have wider doors, higher ceilings, and stronger floors so that Esteban's memory could go everywhere without bumping into beams and so that no one in the future would dare whisper the big boob finally died, too bad, the handsome fool has finally died, because they were going to paint their house fronts gay colors to make Esteban's memory eternal and they were going to break their backs digging for springs among the stones and planting flowers on the cliffs so that in future years at dawn the passengers on great liners would awaken, suffocated by the smell

11. **sirens:** In Greek mythology the Sirens were beautiful but destructive creatures that lured sailors to their death on rocky coasts by singing seductive songs. In Homer's *Odyssey*, Odysseus has his crew stop up their ears with wax, then has himself tied to the mast of his ship so that he can listen to the song of the Sirens.

Sea, Fish, and Constellation (1943)
by Morris Graves

The Seattle Art Museum, Gift of Mrs. Thomas D. Stimson

of gardens on the high seas, and the captain would have to come down from the bridge in his dress uniform, with his astrolabe,[12] his pole star,[13] and his row of war medals and, pointing to the promontory of roses on the horizon, he would say in fourteen languages, look there, where the wind is so peaceful now that it's gone to sleep beneath the beds, over there, where the sun's so bright that the sunflowers don't know which way to turn, yes, over there, that's Esteban's village.

12. **astrolabe** (ăs′trə-lāb′): an instrument once used to find a star's altitude, now replaced by the sextant.
13. **pole star:** Polaris, the North Star, used by navigators because it remains almost fixed throughout the night.

Reading Check

1. When and where does the story take place?
2. What superstitions do the people associate with the dead man?
3. How is the body prepared for its water burial?
4. What changes does Esteban bring about in the life of the village?

For Study and Discussion

Analyzing and Interpreting the Story

1. The people give the drowned man an identity, choose relatives for him from the village's inhabitants, and fantasize his former life among them. What does he represent for them?

2. On page 226 the narrative point of view shifts so that the dead man speaks for himself. **a.** Why do you suppose the author does this? **b.** How do the villagers respond to this speech?

3. In some cultures superstition is viewed as backward and inconsistent with what is considered true and rational. **a.** What perspective does this story offer on the superstitions of the villagers? **b.** Does García Márquez suggest that something is lost in a total reliance on reason?

4. What has been missing from the life of the village and how does Esteban fill that need?

5. Locate instances of "magical realism," in which García Márquez mixes the marvelous with the commonplace.

6. Some readers believe that the theme of this story is about people's need for heroic ideals. Other readers believe that the theme is about the power of the imagination to transform the ordinary into the marvelous. How would you state the theme?

7. Consider the effectiveness of the title and subtitle of the story. In what sense is this tale a story for children?

Literary Elements

Allusions

An **allusion** is a reference to a work of literature, a well-known historical event, person, place, or work of art. Allusion can be used equally well in prose and poetry. It is used most effectively when the reference calls up appropriate associations. Literature contains many allusions to the Bible and to the literature of ancient Greece and Rome.

On page 226 García Márquez alludes to Sir Walter Raleigh in a way that suggests Esteban is even more remarkable than the British adventurer, whose name is often associated with boldness and gallantry. García Márquez also alludes to ancient fables about sirens (page 227). Find the source of this allusion by reading the adventure of Odysseus in Book 12 of the *Odyssey*. Then explain its meaning in the story.

Exploring Theme and Tone

The **theme** of a literary work is its central insight about life or human nature. A work's **tone** is the attitude that the writer expresses or implies toward the subject, the characters, and the audience. In "The Handsomest Drowned Man in the World," Gabriel García Márquez uses a conversational tone to tell a story with a serious theme about people's need for heroes.

The tone of a narrative is usually related to its theme. A story with a serious theme, for example, often has a serious tone. García Márquez's method of "magical realism," however, shows that writers sometimes employ a light or humorous tone in narratives whose underlying theme is serious.

Make some notes about a movie or television drama that you have seen recently and enjoyed. Freewrite about the plot, characters, and setting for five to ten minutes. Then write a statement of the story's theme in one or two sentences. In another sentence or two, describe the story's tone. Save your writing.

About the Author

Gabriel García Márquez (1928–)

Gabriel García Márquez was born in Aracataca, Colombia. He has said that his grandmother was a very important influence on his writing: "She was a fabulous storyteller who told wild tales of the supernatural with a most solemn expression on her face. Now, as a writer, I do the same thing: I say extraordinary things in a serious tone. It's possible to get away with *anything* as long as you make it believable."

Combining politics, folklore, history, and an astute understanding of human weaknesses and strengths, García Márquez creates incredible environments for readers to enter and amazing people for them to meet. *One Hundred Years of Solitude* (1970) (*Cien Años de Soledad*) has sold over ten million copies, been translated into thirty-two languages, and created worldwide interest in Latin American literature. His books include *Innocent Erendira and Other Stories* (1978) (*La Candida Erendira*); *Love in the Time of Cholera* (1988) (*El Amor en Los Tiempos del Cólera*); *The General in His Labyrinth* (1990) (*El General en Su Laberinto*); and *Strange Pilgrims* (1993) (*Doce Cuentos Peregrinos*), a collection of short stories. In 1982 García Márquez received the Nobel Prize for literature.

EVALUATING NARRATIVE WRITING

\mathcal{S}tudying the major elements of narrative can enrich your appreciation of short stories. Below are some criteria you can use to *evaluate* the merits of stories. Use a separate sheet of paper to answer the questions marked with a symbol (■).

Plot

1. *Is the main conflict developed well?* Do the episodes grow logically out of the conflict? Is the resolution acceptable or is it improbable?

Are the elements of suspense and foreshadowing handled skillfully? Is your interest sustained?

■ How does the story "Through the Tunnel" (page 202) show skillful use of all these plot elements?

Character

2. *Are the characters credible and consistent?* Are their actions well motivated? Are they revealed through their actions, thoughts, and words rather than merely through direct comment? Are they individualized or are they stereotypes?

■ How do these criteria apply to the characters in "Shaving" (page 195)?

Setting

3. *What function does setting have?* Does it have important links to the plot? Does the setting help to create atmosphere or delineate character?

■ Apply the two criteria above to "The Rockpile" (page 112) and "The Masque of the Red Death" (page 120).

Point of View

4. *What point of view is used and what is its purpose?* How does the point of view control your reactions to characters and events?

■ How does the first-person point of view affect the impact of characters and events in "Blues Ain't No Mockin Bird" (page 146)?

Irony and Symbol

5. *What is the significance of ironic and symbolic elements?* What kinds of irony are used, and how does irony affect the tone of the story? Do symbols add meaning to the story?

■ How does the author use irony in "The Monkey's Paw" (page 30)? What different use of irony is shown in "The Bet" (page 160)? What meanings might the symbol of corn have in "Neighbor Rosicky" (page 48)?

Theme

6. *Does the story offer some insight into human experience?* Does the story have a theme, or does it exist chiefly for entertainment? Is the theme expressed directly or indirectly?

■ What is the theme of "The Handsomest Drowned Man in the World" (page 223)? Test your statement by seeing if it includes all the important aspects of the story.

Use the questions on page 230 to evaluate the following short story by Leo Rosten.

Cemetery Path

Ivan was a timid little man—so timid that the villagers called him "Pigeon" or mocked him with the title, "Ivan the Terrible."[1] Every night Ivan stopped in at the saloon which was on the edge of the village cemetery. Ivan never crossed the cemetery to get to his lonely shack on the other side. That path would save many minutes, but he had never taken it—not even in the full light of noon.

Late one winter's night, when bitter wind and snow beat against the saloon, the customers took up the familiar mockery. "Ivan's mother was scared by a canary when she carried him." "Ivan the Terrible—Ivan the Terribly Timid One."

Ivan's sickly protest only fed their taunts, and they jeered cruelly when the young Cossack[2] lieutenant flung his horrid challenge at their quarry.

"You are a pigeon, Ivan. You'll walk all around the cemetery in this cold—but you dare not cross it."

Ivan murmured, "The cemetery is nothing to cross, Lieutenant. It is nothing but earth, like all the other earth."

The lieutenant cried, "A challenge, then! Cross the cemetery tonight, Ivan, and I'll give you five rubles—five gold rubles!"

Perhaps it was the vodka. Perhaps it was the temptation of the five gold rubles. No one ever knew why Ivan, moistening his lips, said suddenly: "Yes, Lieutenant, I'll cross the cemetery!"

The saloon echoed with their disbelief. The lieutenant winked to the men and unbuckled his saber. "Here Ivan. When you get to the center of the cemetery, in front of the biggest tomb, stick the saber into the ground. In the morning

1. **Ivan the Terrible:** Ivan IV (1530–1584), the first czar of Russia, was noted for his cruelty and ferocity.
2. **Cossack** (kŏs´ăk): a cavalryman from southern Russia.

we shall go there. And if the saber is in the ground—five gold rubles to you!"

Ivan took the saber. The men drank a toast: "To Ivan the Terrible!" They roared with laughter.

The wind howled around Ivan as he closed the door of the saloon behind him. The cold was knife-sharp. He buttoned his long coat and crossed the dirt road. He could hear the lieutenant's voice, louder than the rest, yelling after him, "Five rubles, pigeon! *If you live!*"

Ivan pushed the cemetery gate open. He walked fast. "Earth, just earth . . . like any other earth." But the darkness was a massive dread. "Five gold rubles . . ." The wind was cruel and the saber was like ice in his hands. Ivan shivered under the long, thick coat and broke into a limping run.

He recognized the large tomb. He must have sobbed—that was the sound that was drowned in the wind. And he kneeled, cold and terrified, and drove the saber through the crust into the hard ground. With all his strength, he pushed it down to the hilt. It was done. The cemetery . . . the challenge . . . five gold rubles.

Ivan started to rise from his knees. But he could not move. Something held him. Something gripped him in an unyielding and implacable hold. Ivan tugged and lurched and pulled—gasping in his panic, shaken by a monstrous fear. But something held Ivan. He cried out in terror, then made senseless gurgling noises.

They found Ivan, next morning, on the ground in front of the tomb that was in the center of the cemetery. He was frozen to death. The look on his face was not that of a frozen man, but of a man killed by some nameless horror. And the lieutenant's saber was in the ground where Ivan had pounded it—through the dragging folds of his long coat.

Focus on Reading and Critical Thinking **231**

THE WRITING PROCESS AND WRITING A NARRATIVE

The Writing Process

*T*he *process* of writing may be divided into four key stages:

- Prewriting
- Writing a First Draft
- Evaluating and Revising
- Proofreading and Publishing

Much of the most important work in the writing process occupies the first stage. In **prewriting,** you make decisions about what to say and how to say it. Prewriting activities include the following:

- choosing and limiting a topic
- identifying your purpose
- thinking about the needs of your audience
- gathering ideas and information
- identifying your thesis or main idea
- organizing your material into an outline

These activities are not always carried out in the order listed above. Just like the broader phases of the writing process, these prewriting steps may overlap, and a writer may move back and forth between them.

In the **writing** stage, you use an outline or working plan to write a first draft of your project. New ideas and better ways of ordering your material may often occur to you while you write, and you should revise your working plan accordingly.

After you have finished your first draft, put it aside for a while. Try to look at it again with a fresh pair of eyes in the **evaluating and revising** stage. Consider how you might improve content, organization, and style. Here

are some of the ways writers revise their first drafts:

- adding or deleting ideas
- rearranging sentences
- making words or phrases more vivid and precise
- rephrasing for clarity and coherence

The final stage of the writing process is **proofreading and publishing.** Although they may not strike to the heart of your theme or the power of your reasoning, sloppy spelling, grammar, mechanics, and usage create a bad first impression. Therefore, good writers always proofread their semifinal drafts to correct any errors. After you proofread your writing, make a clean copy of the paper—and proofread again, just to make sure your new draft is free from errors.

Your final task is to decide how you will publish or share your writing. How you share it will depend on the nature of your project, on your audience, and on opportunities in your local area. Here are some ideas you may find helpful:

- enter a writing contest
- send your piece to a newspaper or magazine
- send your writing to an organization interested in the topic
- use your writing as the basis for an illustrated presentation to your class
- make a class anthology
- adapt your writing into a presentation for younger students

Writing A Narrative

Narration is storytelling. If we may judge by some of the oldest cave paintings yet discovered, human beings have loved to share stories with one another since prehistoric times. Narratives range from book-length novels and epics to the length of a paragraph, as in anecdotes and brief fables. Other kinds of narrative include short stories, movie screenplays, comic strips, ballads, histories, and journals. In this unit you have seen many of the important elements and techniques of storytelling: plot, character, setting, point of view, irony, symbol, and theme. Now you will have the chance to write your own narrative.

Prewriting

1. Explore story ideas for a narrative by using a "What if?" scenario. For example, ask questions like these:

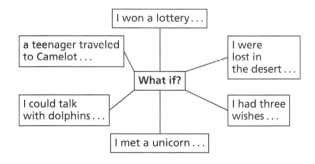

Freewrite for five or ten minutes about one or two of these or similar ideas. Also explore story plots by brainstorming with a small group of classmates about recent news stories. Finally, you may want to review the notes you have made for the writing assignments in this unit.

2. Explore a **plot** for a story in more detail.

Remember the key plot elements in a narrative:

- **Exposition:** background information
- **Conflict:** main struggle
- **Complications:** additional difficulties
- **Climax:** point of greatest intensity
- **Resolution:** outcome or falling action

Focus on introducing a **conflict** for your main character(s) at the very beginning of your story to capture the reader's interest. Below are four types of conflict to consider. The first three types are **external conflicts.** The fourth is **internal conflict.**

- a person versus another person
- a person versus society
- a person versus a force of nature
- two forces struggling within a person

[See Focus assignments on pages 29 and 40.]

3. Decide on a **point of view** for your narrative. There are three vantage points from which you can choose:

- **first person:** one of the characters tells the story in his/her own words, as in Toni Cade Bambara's "Blues Ain't No Mockin Bird"
- **third-person limited:** the writer uses the vantage point of one character, as in Kate Chopin's "A Pair of Silk Stockings"
- **third-person omniscient:** an all-knowing narrator allows us to share the thoughts of many characters, as in Maurice Walsh's "The Quiet Man"

Each point of view has advantages and drawbacks. For example, first-person point of view can give readers an intimate impression of a storyteller, but it restricts the tale to incidents or dialogue that the storyteller witnesses. Whatever point of view you choose, remem-

ber to use it consistently. [See **Focus** assignment on page 145.]

4. Start to flesh out your **characters.** You may want to fill out a chart like the one below for each character you create:

Name: _____
Age: _____
Appearance: _____
Habits: _____
Likes and Dislikes: _____
Personality Traits: _____

Way of Speaking: _____

Remember that it is generally more effective to **show** your characters through **indirect characterization** than to **tell** about them in **direct characterization.** Some methods of indirect characterization include the following:

- showing the character acting and speaking
- revealing the character's thoughts
- revealing what other characters think about the character

Here, for example, is the final impression Kate Chopin gives us of Mrs. Sommers in "A Pair of Silk Stockings":

> In truth, he saw nothing—unless he were wizard enough to detect a poignant wish, a powerful longing that the cable car would never stop anywhere, but go on and on with her forever. (page 157).

[See **Focus** assignments on pages 82 and 96.]

5. Make some notes about the **setting,** or the time and place of your narrative. Think about how you could use **sensory details** to describe the setting. For example, Edgar Allan Poe describes Prince Prospero's seventh chamber this way in "The Masque of the Red Death":

> The seventh apartment was closely shrouded in black velvet tapestries that hung all over the ceiling and down the walls, falling in heavy folds upon a carpet of the same material and hue (page 121).

Notice that Poe's details not only help you to visualize the scene but also help to establish a sinister **atmosphere** or **mood.** [See **Focus** assignments on pages 111, 119, and 126.]

6. Use the notes you have made up to this point to create a **story map,** a plan for all the essential elements of your narrative. [For an example, see **Focus** assignment on page 222.]

Writing

1. Use **chronological** or **time order** to narrate actions and events. You may also want to vary time order with one or more **flashbacks.** Remember to use **transitional words and phrases** to make the sequence of events clear. [See **Focus** assignment on page 46.]

2. **Dialogue** can help you to make your story more lively and interesting. Here are some guidelines to use when you create dialogue:

- Make the words fit the character.
- Use language from real life.
- Use speaker tags ("she cried," "he asked").
- Use dialogue to advance the action.

[See **Focus** assignment on page 200.]

3. The **climax** of a narrative is its point of highest interest or suspense: for example, Tom's breaking the glass of his apartment window in Jack Finney's "Contents of the Dead Man's Pockets" (see p. 109), or Jerry's successful swim in Doris Lessing's "Through the Tunnel" (see pages 207–208). As you write your first draft, make sure that events in your narrative lead up to a genuine turning point. If there is no clear climax in your story, go

back and reconsider the events and actions on your story map.

Evaluating and Revising

1. Put your first draft aside for a while so that you can come back to it with a fresh perspective. After you take a new look at your story, consider trading papers with a classmate and offering each other some suggestions. Pay special attention to the beginning and the end of your narrative. Do you capture the reader's interest right away? Is the resolution of your story satisfying and appropriate for your story's **theme** and **tone?** [See **Focus** assignments on pages 179 and 229.]

Below is an example of the opening paragraph of a narrative. Notice the revisions that the writer made.

Writer's Model

"That man is ~~crazy~~," ~~said~~ the *a lunatic growled*
General, ~~whose~~ teeth ~~bit deeply into~~ *while his* *chomped even more*
on
his cigar.

"I wouldn't be too sure, sir," ~~said~~ *replied*
Hawks respectfully. "Foster knows *the senior aide*
every ~~part~~ of this galaxy. If there's *warp*
a ~~chance~~ of finding The Mushroom, *prayer* *then*
Foster's our man."

2. As you revise your first draft, you will find the following checklist helpful.

Checklist for Evaluation and Revision

✓ Do I open the story with a strong conflict?
✓ Do I use a consistent point of view?
✓ Is the order of events clear?
✓ Are the characters lifelike? Have I created any round, dynamic characters?
✓ Does the dialogue sound like speech in real life? Does it fit the characters who speak it?
✓ Have I used sensory images to describe the setting?
✓ Does the story build to a clear turning point?
✓ Have I used irony and/or symbol if appropriate?
✓ Is the ending appropriate to my theme and tone?

Proofreading and Publishing

1. Proofread your narrative to identify and correct any errors in grammar, usage, capitalization, and punctuation. (You may find it helpful to refer to the **Handbook for Revision** on pages 928–971.) Prepare a final version of your narrative by making a clean copy.
2. Here are some publication ideas for sharing your story:

- read your narrative aloud as a radio broadcast
- enter your story in a contest
- create a class anthology of stories
- illustrate your story or ask a friend in art class to do it for you
- prepare a comic book version

Portfolio If your teacher approves, you may wish to keep a copy of your work in your writing folder or portfolio.

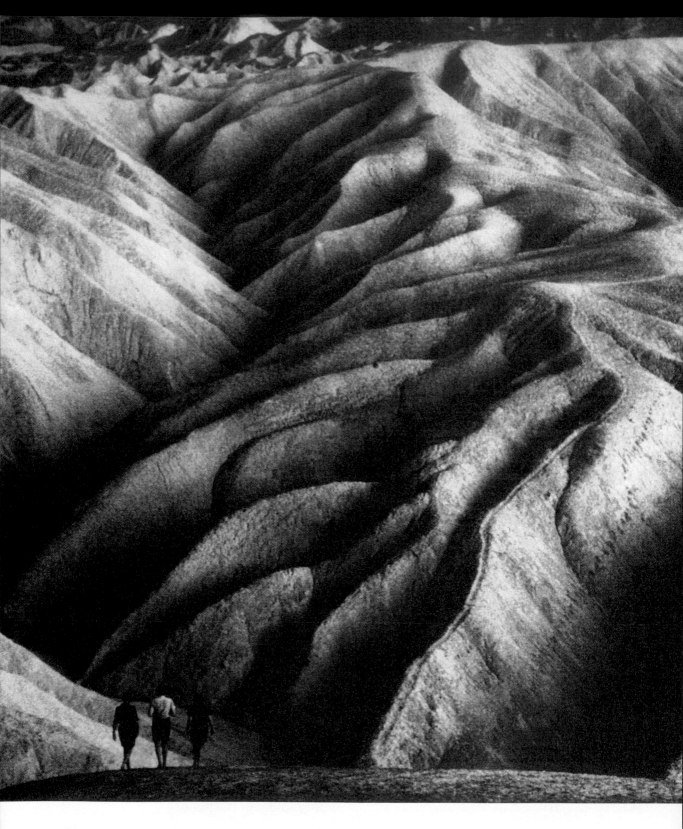

NONFICTION

Nonfiction tells about things that are real. Much of the time, nonfiction is inspired by a writer's excitement about his or her subject.

At first glance, the illustration at the left may look like a painting, but it is actually a photograph. Why do you think the photographer was inspired to take this photograph? If you were to "read" this photograph, what would it tell you about the setting and the photographer's feeling for his subject?

Think of a place, an experience, or an idea that affected you strongly. Freewrite for about ten minutes, trying to get your feelings on paper. Then exchange papers with a classmate and respond to each other's writing, asking yourself these questions:

1. What does the writer want me to know?
2. How does the writing make me feel?
3. How does the writer feel about the topic?
4. What is my reaction to the writer's point of view?

After sharing responses, review your work and keep it in your journal or writing folder for reference.

Zabriskie Point, Death Valley, California.

ESSAYS

The word *essay* dates back to a sixteenth-century French writer named Montaigne. Montaigne liked to jot down his thoughts on a wide variety of subjects—from the joys of the countryside to the evils of government. When he decided to publish his informal compositions, he called them *Essais,* the French word for "attempts." Since Montaigne's time, essays have been written by countless writers on nearly every conceivable subject. Essays have been written to entertain, to inform, to explain, and to persuade, and have made use of *description,* which presents a picture or an impression of a subject; *narration,* which relates a series of events; *exposition,* which explains a subject; and *argument* or *persuasion,* which attempts to influence people's ideas or actions. Whatever its form, the essay has remained essentially what it was for Montaigne: a play of the mind on a subject, an "attempt" to say something about a subject, but not everything. Whenever you read a feature article, a sports column, a movie review, or an editorial, you are reading an essay.

All of the essays included here show the play of the writer's mind on a subject—whether it be Annie Dillard's impressions of the Ecuadorian jungle or Harry Crews's serious thought about birds of prey. Through each of these essays we see the writer's personality, the individual mind that selects the subject of the essay, shapes its organization, and selects those details that this particular writer has noticed and wants to report. The essays you will read here, and probably most of the ones you read every day, are *informal* or *familiar* essays: they have an informal tone, as if the author were speaking directly to you. Other essays are classified as *formal.* They are serious in tone and subject, and more objective in point of view. One of the rewards of reading any kind of essay is meeting people—the essayists—through the ideas that interest them.

*W*hen you read an essay, whether it is in a book, on the editorial page of a newspaper, or in a magazine, you need to be an active reader, aware of what the author is saying, how the author is using language, and why. You also need to be aware of how you are responding to the essay. As you read you should pay close attention not only to the subject of the essay but also to its style—the choice of words and the ways in which they have been arranged. You should remember that the author has had to make many decisions—deleting and substituting words, rewriting phrases and sentences, perhaps rearranging entire sections of the essay in order to inform, entertain, or persuade the reader. In reading, ask yourself how elements of style like imagery, figures of speech, and diction work together to convey the author's meaning and to affect your response. It is a good idea to read an essay more than once. In your first reading you can be thinking about what the author has to say. In your rereading pay closer attention to the union of style and subject as well as to your own response to the writing.

Guidelines for Close Reading

1. Determine the purpose of the essay. Is the object to entertain, to inform, to explain, to persuade, or some combination of purposes?

2. Determine the tone of the essay. Is it formal or informal? Is it serious or light? Does it combine approaches?

3. How do you respond to the personality of the writer? What impressions do you get and why?

4. How do you respond to what the writer does with language? Be aware of elements of style and their effect on you.

5. After clarifying your personal response to the essay, determine its main idea and state it in your own words.

An East Prospect of the City of Philadelphia from the Jersey Shore by George Heap.
Historical Society of Pennsylvania

Here is a brief informal essay, "The Whistle," written by Benjamin Franklin in 1779. Franklin's purpose is to teach a lesson he has learned from his own experience and from observing the experiences of others. Read the essay first to understand what Franklin is saying. On the second reading think about the choices Franklin has made in order to influence you. How do you think Franklin wants his readers to respond to the essay? The notes in the margin show how one reader has responded to this essay. If you wish, take notes of your own on a separate sheet of paper, covering up the printed notes as you read. Then compare your responses with these printed comments.

The Whistle

BENJAMIN FRANKLIN

When I was a child of seven years old, my friends, on a holiday, filled my pockets with coppers. I went directly to a shop where they sold toys for children; and, being charmed with the sound of a *whistle,* that I met by the way in the hands of another boy, I voluntarily offered and gave all my money for one. I then came home, and went whistling all over the house, much pleased with my *whistle,* but disturbing all the family. My brothers, and sisters, and cousins, understanding the bargain I had made, told me I had given four times as much for it as it was worth; put me in mind what good things I might have bought with the rest of the money; and laughed at me so much for my folly, that I cried with vexation; and the reflection gave me more chagrin[1] than the *whistle* gave me pleasure.

This however was afterwards of use to me, the impression continuing on my mind; so that often, when I was tempted to buy some unnecessary thing, I said to myself, *Don't give too much for the whistle;* and I saved my money.

As I grew up, came into the world, and observed the actions of men, I thought I met with many, very many, who *gave too much for the whistle.*

When I saw one too ambitious of court favor, sacrificing his time in attendance on levees,[2] his repose, his liberty, his virtue, and perhaps his friends, to attain it, I have said to myself, *This man gives too much for his whistle.*

When I saw another fond of popularity, constantly employing himself in political bustles, neglecting his own affairs, and ruining them by that neglect, *He pays, indeed,* said I, *too much for his whistle.*

If I knew a miser, who gave up every kind of comfortable living, all the pleasure of doing good to others, all the esteem of his fellow citizens, and the joys of benevolent friendship, for the sake of accumulating wealth, *Poor man,* said I, *you pay too much for your whistle.*

1. **chagrin** (shə-grīn'): humiliation.
2. **levees** (lĕv'ēz, lə-vēz'): receptions at court or at the homes of great aristocrats.

ONE READER'S RESPONSE

What are coppers?

That's a careless thing to do.

It figures that they would make him feel bad about it.

Now he realizes that he got ripped off.

I see his point. The whistle represents the prize, or what someone wants.

He thinks that many people give too much for what they want.

Politicians give up too much for success.

People can be ruined by neglecting their own businesses.

Misers give up too much. People need friendship and other people.

Men who care only for physical pleasure give up too much.

Being a show-off can require too great a sacrifice.

Married women may also pay too high a price.

I wonder why he repeats this phrase so many times.

Franklin thinks people create a lot of their own unhappiness because they don't set things at their real value. They need to see what's really important in life.

When I met with a man of pleasure, sacrificing every laudable improvement of the mind, or of his fortune, to mere corporeal[3] sensations, and ruining his health in their pursuit, *Mistaken man,* said I, *you are providing pain for yourself, instead of pleasure; you give too much for your whistle.*

If I see one fond of appearance, or fine clothes, fine horses, fine furniture, fine equipages,[4] all above his fortune, for which he contracts debts, and ends his career in a prison, *Alas!* say I, *he has paid dear, very dear, for his whistle.*

When I see a beautiful, sweet-tempered girl married to an ill-natured brute of a husband, *What a pity,* say I, *that she should pay so much for a whistle!*

(Detail) "The Whistle" from Holley's *Life of Franklin.*
Franklin Collection, Yale University Library

In short, I conceive that great part of the miseries of mankind are brought upon them by the false estimates they have made of the value of things, and by their *giving too much for their whistles.*

3. **corporeal** (kôr-pôr′ē-əl, -pō′rē-əl): physical.
4. **equipages** (ĕk′wə-pĭj-əs): elegant carriages, usually equipped with footmen.

Looking at Yourself as a Reader

Compare your own responses with those in the notes alongside the essay. What similarities and differences are there? How did you feel after reading the essay? How did the tone of the essay affect your response? What impression did you receive of Franklin's personality?

Form a small group and have members share their responses to Franklin's essay. Then have the group compose a modern version of Franklin's essay. Think of a catchy title, and present your group's essay to the class.

In the Jungle

ANNIE DILLARD

*"In the Jungle" describes an extraordinary place, a jungle in Ecuador near
a tributary of the Amazon. Annie Dillard feels at home in this jungle despite
boas and crocodiles and lakes alive with eels and piranha. She has written:
"In nature I find grace tangled in a rapture with violence; I find an intricate
landscape whose forms are fringed in death; I find mystery, newness, and a
kind of exuberant, spendthrift energy." As you read, look for examples that
support her statements.*

Like any out-of-the-way place, the Napo River
in the Ecuadorian jungle seems real enough
when you are there, even central. Out of the
way of *what?* I was sitting on a stump at the
edge of a bankside palm-thatch village, in the
middle of the night, on the headwaters of the
Amazon. Out of the way of human life, ten-
derness, or the glance of heaven?

A nightjar[1] in deep-leaved shadow called
three long notes, and hushed. The men with
me talked softly in clumps: three North Amer-
icans, four Ecuadorians who were showing us
the jungle. We were holding cool drinks and
idly watching a hand-sized tarantula seize
moths that came to the lone bulb on the gen-
erator shed beside us.

It was February, the middle of summer.
Green fireflies spattered lights across the air
and illumined for seconds, now here, now
there, the pale trunks of enormous, solitary
trees. Beneath us the brown Napo River was

rising, in all silence; it coiled up the sandy
bank and tangled its foam in vines that trailed
from the forest and roots that looped the
shore.

Each breath of night smelled sweet, more
moistened and sweet than any kitchen, or gar-
den, or cradle. Each star in Orion seemed to
tremble and stir with my breath. All at once,
in the thatch house across the clearing behind
us, one of the village's Jesuit[2] priests began
playing an alto recorder, playing a wordless
song, lyric, in a minor key, that twined over
the village clearing, that caught in the big trees'
canopies, muted our talk on the bankside, and
wandered over the river, dissolving down-
stream.

This will do, I thought. This will do, for a
weekend, or a season, or a home.

Later that night I loosed my hair from its
braids and combed it smooth—not for myself,

1. **nightjar:** a nocturnal bird. Its name derives from the
whirring sound made by the male.

2. **Jesuit** (jĕzh′o͞o-ĭt, jĕz′yo͞o-): of the Society of Jesus, a
Roman Catholic religious order.

but so the village girls could play with it in the morning.

We had disembarked at the village that afternoon, and I had slumped on some shaded steps, wishing I knew some Spanish or some Quechua[3] so I could speak with the ring of little girls who were alternately staring at me and smiling at their toes. I spoke anyway, and fooled with my hair, which they were obviously dying to get their hands on, and laughed, and soon they were all braiding my hair, all five of them, all fifty fingers, all my hair, even my bangs. And then they took it apart and did it again, laughing, and teaching me Spanish nouns, and meeting my eyes and each other's with open delight, while their small brothers in blue jeans climbed down from the trees and began kicking a volleyball around with one of the North American men.

Now, as I combed my hair in the little tent, another of the men, a free-lance writer from Manhattan, was talking quietly. He was telling us the tale of his life, describing his work in Hollywood, his apartment in Manhattan, his house in Paris. . . . "It makes me wonder," he said, "what I'm doing in a tent under a tree in the village of Pompeya, on the Napo River, in the jungle of Ecuador." After a pause he added, "It makes me wonder why I'm going *back*."

The point of going somewhere like the Napo River in Ecuador is not to see the most spectacular anything. It is simply to see what is there. We are here on the planet only once, and might as well get a feel for the place. We might as well get a feel for the fringes and hollows in which life is lived, for the Amazon basin, which covers half a continent, and for the life that—there, like anywhere else—is al-ways and necessarily lived in detail: on the tributaries, in the riverside villages, sucking this particular white-fleshed guava[4] in this particular pattern of shade.

What is there is interesting. The Napo River itself is wide (I mean wider than the Mississippi at Davenport) and brown, opaque, and smeared with floating foam and logs and branches from the jungle. White egrets hunch on shoreline deadfalls[5] and parrots in flocks dart in and out of the light. Under the water in the river, unseen, are anacondas—which are reputed to take a few village toddlers every year—and water boas, stingrays, crocodiles, manatees,[6] and sweet-meated fish.

Low water bares gray strips of sandbar on which the natives build tiny palm-thatch shelters, arched, the size of pup tents, for overnight fishing trips. You see these extraordinarily clean people (who bathe twice a day in the river, and whose straight black hair is always freshly washed) paddling down the river in dugout canoes, hugging the banks.

Some of the Indians of this region, earlier in the century, used to sleep naked in hammocks. The nights are cold. Gordon Mac-Creach, an American explorer in these Amazon tributaries, reported that he was startled to hear the Indians get up at three in the morning. He was even more startled, night after night, to hear them walk down to the river slowly, half asleep, and bathe in the water. Only later did he learn what they were doing: they were getting warm. The cold woke them; they warmed their skins in the river, which was always ninety degrees; then they returned to their hammocks and slept through the rest of the night.

3. **Quechua** (kĕch′wə,-wä′): a language spoken by several Indian peoples in Peru, Ecuador, and other South American countries.

4. **guava** (gwä′və): the pear-shaped fruit of a tropical tree, often used to make preserves or jelly.
5. **deadfalls:** fallen trees or branches that form tangled masses.
6. **manatees** (măn′ə-tēz′): large mammals that live in coastal waters in the tropics.

Village of Napo in the Upper Amazon Basin.

The riverbanks are low, and from the river you see an unbroken wall of dark forest in every direction, from the Andes to the Atlantic. You get a taste for looking at trees: trees hung with the swinging nests of yellow troupials,[7] trees from which ant nests the size of grain sacks hang like black goiters,[8] trees from which seven-colored tanagers flutter, coral trees, teak, balsa and breadfruit, enormous emergent silk-cotton trees, and the pale-barked *samona* palms.

When you are inside the jungle, away from the river, the trees vault out of sight. It is hard to remember to look up the long trunks and see the fans, strips, fronds, and sprays of glossy leaves. Inside the jungle you are more likely to notice the snarl of climbers and creepers round the trees' boles,[9] the flowering brome-

7. **troupials** (trōō′pē-əlz): tropical birds related to black-birds and orioles.
8. **goiters** (goi′tərz): swellings or enlargements of the thy-roid gland.

9. **boles** (bōlz): trunks.

liads and epiphytes[10] in every bough's crook, and the fantastic silk-cotton tree trunks thirty or forty feet across, trunks buttressed in flanges of wood whose curves can make three high walls of a room—a shady, loamy-aired room where you would gladly live, or die. Butterflies, iridescent blue, striped, or clear-winged, thread the jungle paths at eye level. And at your feet is a swath of ants bearing triangular bits of green leaf. The ants with their leaves look like a wide fleet of sailing dinghies—but they don't quit. In either direction they wobble over the jungle floor as far as the eye can see. I followed them off the path as far as I dared, and never saw an end to ants or to those luffing[11] chips of green they bore.

Unseen in the jungle, but present, are tapirs, jaguars, many species of snake and lizard, ocelots, armadillos, marmosets, howler monkeys, toucans and macaws and a hundred other birds, deer, bats, peccaries, capybaras, agoutis,[12] and sloths. Also present in this jungle, but variously distant, are Texaco derricks and pipelines, and some of the wildest Indians in the world, blowgun-using Indians, who killed missionaries in 1956 and ate them.

Long lakes shine in the jungle. We traveled one of these in dugout canoes, canoes with two inches of freeboard, canoes paddled with machete-hewn oars chopped from buttresses of silk-cotton trees, or poled in the shallows with peeled cane or bamboo. Our part-Indian guide had cleared the path to the lake the day before; when we walked the path we saw where he had impaled the lopped head of a boa, open-mouthed, on a pointed stick by the canoes, for decoration.

10. **bromeliads** (brō-mē′lē-ădz′): plants of the pineapple family; **epiphytes** (ĕp′ə-fīts′): plants that grow on other plants but produce their own food.
11. **luffing:** flapping, as sails flap.
12. **peccaries** (pĕk′ə-rēz): piglike mammals; **capybaras** (kăp′ĭ-bä′rəz, -băr′əz): largest known rodents, often over four feet long; **agoutis** (ə-gōō′tēz): rodents related to guinea pigs.

This lake was wonderful. Herons, egrets, and ibises plodded the sawgrass shores, kingfishers and cuckoos clattered from sunlight to shade, great turkeylike birds fussed in dead branches, and hawks lolled overhead. There was all the time in the world. A turtle slid into the water. The boy in the bow of my canoe slapped stones at birds with a simple sling, a rubber thong and leather pad. He aimed brilliantly at moving targets, always, and always missed; the birds were out of range. He stuffed his sling back in his shirt. I looked around.

The lake and river waters are as opaque as rain-forest leaves; they were veils, blinds, painted screens. You see things only by their effects. I saw the shoreline water roil and the sawgrass heave above a thrashing *paichi*,[13] an enormous black fish of these waters; one had been caught the previous week weighing 430 pounds. Piranha fish live in the lakes, and electric eels. I dangled my fingers in the water, figuring it would be worth it.

We would eat chicken that night in the village, and rice, yucca, onions, beets, and heaps of fruit. The sun would ring down, pulling darkness after it like a curtain. Twilight is short, and the unseen birds of twilight wistful, uncanny, catching the heart. The two nuns in their dazzling white habits—the beautiful-boned young nun and the warm-faced old—would glide to the open cane-and-thatch schoolroom in darkness, and start the children singing. The children would sing in piping Spanish, high-pitched and pure; they would sing "Nearer My God to Thee" in Quechua, very fast. (To reciprocate, we sang for them "Old MacDonald Had a Farm"; I thought they might recognize the animal sounds. Of course they thought we were out of our minds.) As the children became excited by their own singing, they left their log benches and swarmed around the nuns, hopping, smiling at us, everyone smiling, the nuns' faces bursting in

13. *paichi* (pī′chē).

their cowls, and the clear-voiced children still singing, and the palm-leafed roofing stirred.

The Napo River: it is not out of the way. It is *in* the way, catching sunlight the way a cup catches poured water; it is a bowl of sweet air, a basin of greenness, and of grace, and, it would seem, of peace.

Reading Check

1. Where is the village of Pompeya located?
2. How does Annie Dillard make friends with the village children?
3. What activities make up the day-to-day life of the natives who live close to the water?
4. What types of wildlife does Dillard see on her canoe trip around the lake?
5. Which songs become a way for the children of the village and the Americans to communicate?

For Study and Discussion

Analyzing and Interpreting the Essay

1. At the end of the first paragraph, the author asks a question that guides us toward the main idea of the essay. **a.** In your own words tell what the question means. **b.** How is the question answered by the last paragraph in the essay?

2a. What might be the author's purpose in describing both violent and peaceful scenes? **b.** What is the author's reaction toward these scenes? **c.** Which words help reveal her attitude?

3. An essayist often places important words at strategic points—at the ends of sentences and paragraphs, and even at the end of the essay.

a. What examples can you find of key words placed at the ends of paragraphs? **b.** Why is this method effective? **c.** Why is *peace* an appropriate word for the end of this essay?

4. In paragraphs 6, 7, and 8 Dillard contrasts the life of the village children with the life of a free-lance writer from Manhattan, but she draws no conclusions. **a.** Which life is apparently better? **b.** What makes it better?

5. Annie Dillard once wrote that the artist's "face is a flame like a seraph's, lighting the kingdom of God for the people to see." From reading her essay, what do you see more brightly or clearly?

Language and Vocabulary

Analyzing Effective Sentences

All good writers look for the most effective arrangement of sentence parts to create interest and emphasis. Listen to the rhythm of this description:

> Green fireflies spattered lights across the air and illumined for seconds, now here, now there, the pale trunks of enormous, solitary trees.

Notice how the pauses before, after, and within the phrase "now here, now there" make those words flash on and off like the fireflies. That is an effective use of **syntax**, the order and arrangement of words in a sentence.

Find and explain other examples of effective syntax in the essay.

Focus on Expository Writing

Organizing Information

"We are here on the planet only once, and might as well get a feel for the place," writes Annie Dillard. In "In the Jungle," Dillard skillfully organizes information to present a

graphic picture of a place that is unfamiliar to most of her audience: the Amazon in Ecuador.

The purpose of **expository writing** is to explain a subject or provide information. Dillard's picture of the Amazon is vivid and coherent because she has organized specific details into a series of descriptive scenes: the village, the river, the jungle, the lake.

Make notes for a description of a place that is special to you—for example, your room at home or a favorite outdoor landscape. Assume that your audience has never seen this place before. Visualize the place in your mind's eye as concretely and vividly as possible. When you have finished brainstorming and organizing details, get together with a partner to offer each other suggestions. Save your writing.

About the Author

Annie Dillard (1945–)

"After a trip to the Amazon tributary the Napo River, in eastern Ecuador, I found myself haunted by the apparently simple lives of the people who lived on the river's banks." Her essay "In the Jungle" tells how much Dillard was moved by that experience.

An observer of nature, an essayist, and a poet, Annie Dillard grew up in Pittsburgh. She now lives in Middletown, Connecticut, with her husband and daughter. In 1975 she was awarded a Pulitzer Prize for her first book of prose, *Pilgrim at Tinker Creek*. While writing that book Dillard worked in a library carrel fifteen hours a day, seven days a week for eight months. Her recent books include *An American Childhood* (1987), a memoir, and *The Living*

(1992), a novel. "In the Jungle" is from a collection of essays called *Teaching a Stone to Talk* (1982).

Literature and the Environment

Jungles and the Ecosystem

Jungles, with their rich foliage and wide variety of animal life, are an important part of the earth's ecosystem. In some parts of the world, jungles are being leveled to create open land for industry and housing. Many people support this development, but many others claim that destroying jungles eradicates a precious resource and disrupts the earth's ecological balance.

Making Connections: Activities

1. Learn more about jungles or rainforests by consulting a reference work such as *The Rainforest Book* by Scott Lewis, *The Decade of Destruction* by Adrian Cowell, or *Conserving Rainforests* by Martin Banks. Then write a public-service advertisement that will encourage people to help protect tropical forests. Your ad may be for a magazine, a billboard, radio, or television. Use one or more illustrations or photographs to accompany your text, and make sure all your facts are correct. Remember to write an arresting headline to attract attention and support. If you like your ad, copy it and display it on the class bulletin board.

2. Choose one lesser-known species, plant or animal, that lives in the jungle. You might find some ideas in *Portraits of the Rainforest* (1990). Research its habitat, physical characteristics, and way of life. How does it figure into the cycle and balance of life in the jungle and on the earth as a whole? How might the destruction of this species throw off the balance of nature? See if you can locate any photographs. Plan a presentation to discuss the unique qualities of this species.

Cold Weather

E. B. WHITE

Essays are written about out-of-the way places like the Ecuadorian jungle, and they are also written about everyday places and ordinary experiences like cold weather. As you read this essay, try to get a sense of the author's personality. Is he discussing topics in a random way, or is there a plan to the essay?

There has been more talk about the weather around here this year than common, but there has been more weather to talk about. For about a month now we have had solid cold—firm, businesslike cold that stalked in and took charge of the countryside as a brisk housewife might take charge of someone else's kitchen in an emergency. Clean, hard, purposeful cold, unyielding and unremitting. Some days have been clear and cold, others have been stormy and cold. We have had cold with snow and cold without snow, windy cold and quiet cold, rough cold and indulgent peace-loving cold. But always cold. The kitchen dooryard is littered with the cylinders of ice from frozen water buckets that have been thawed out in the morning with hot water. Storm windows weren't enough this winter—we resorted to the simplest and best insulating material available, the daily newspaper applied to north windows with thumbtacks. Mornings the thermometer would register ten or twelve below. By noon it would have zoomed up to zero. As the night shut in, along about four-thirty, it would start dropping again. Even in the tight barn, insu-lated with tons of hay, the slobber from the cow's nose stiffened in small icicles, and the vapor rose from the warm milk into the milker's face. If you took hold of a latch with ungloved hands, the iron seized you by the skin and held on.

There is a fraternity of the cold, to which I am glad I belong. Nobody is kept from joining. Even old people sitting by the fire belong, as the floor draft closes in around their ankles. The members get along well together: extreme cold when it first arrives seems to generate cheerfulness and sociability. For a few hours all life's dubious problems are dropped in favor of the clear and congenial task of keeping alive. It is rather soothing when existence is reduced to the level of a woodbox that needs filling, a chink that needs plugging, a rug that needs pushing against a door.

I remember that first morning. It was twelve below just before daylight. Most of us had realized the previous afternoon that we were in for a cold night. There is something about the way things look that tells you of approaching cold—a tightening, a drawing in. Acting on

It Snows, Oh It Snows by Grandma Moses (1860–1961). Oil on pressed wood.
Anna Mary Robertson Moses began painting when she was in her seventies
and became internationally famous as "Grandma Moses." She was particularly
well known for her depictions of old-fashioned New England winters, which
were frequently reproduced on seasonal greeting cards.

this tip, I had laid a fire in the old drum stove in the garage, a few feet from the car's radiator. Before I went to bed I lit it and threw in another stick of wood. Then I went down to the sheep shed, whose door ordinarily stands open night and day, winter and summer, and kicked the snow away with my boot and closed the door. Then I handed the cow a forkful of straw instead of her usual teaspoonful of sawdust, and also threw some straw down through the hatch to the hog. (The windows in this house have to be propped up with a window stick, and on nights like this we don't use the window stick; we just take a piece of stove wood and lay it flat on the sill and let the window down on that.)

Morning comes and bed is a vise from which it is almost impossible to get free. Once up,

things seem very fine and there are fires to be made all over the house, and the old dog has to be wrapped in a wool throw because of his rheumatism. (He and I have about the same amount of this trouble, but he makes more fuss about it than I do and is always thinking about wool throws.) Then everybody compares notes, each reads the thermometer for himself, and wonders whether the car will start. From the gray waters of the bay the vapor rises. In the old days when the vapor used to rise from the sea people would wink and say: "Farmer Jones is scalding his hog."

The phone jingles. It's the mailman. He can't start his car. I'm to pick him up if my car will start and carry him to the town line. The phone rings again (cold weather stirs up the telephone). It's Mrs. Dow. I am to pick her up on my way back from the store because it's most too cold to walk it this morning. Thanks to my all-night fire in the drum stove my car starts easily, third time over. The garage is still comfortably warm from the night before and there are embers in the stove.

The question of clothes becomes a topic for everybody. The small boy, who has relied thus far on a hunting cap with flaps down, digs up an old stocking cap as midwinter gear. I exhume my Army underdrawers, saved from the little war of 1918. The snow squeaks under the rubber tread of the boot, and the windows of the car frost up immediately. The geese, emerging from their hole in the barn, trample a yard for themselves in the deep drift. They complain loudly about a frozen water pan, and their cornmeal mash is golden-yellow against the blue snow.

The mailman is full of charitable explanations about his car—he thinks it was sediment in the carburetor. The general cheerfulness is in part surprise at discovering that it is entirely possible to exist in conditions that would appear, offhand, to be fatal. The cold hasn't a chance really against our club, against our walls, our wool, the blaze in the stove, the clever mitten, the harsh sock, the sound of kindling, the hot drink, the bright shirt that matches the bright cap. A truck driver, through the slit in his frosted windshield, grins at me and I grin back through the slit in mine. This interchange, translated means: "Some cold, Bud, but nothing but what your buggy and my buggy can handle." Words get round that the school bus won't start. Children wait, chilly but busy, along the route, testing surfaces for skis and runners, some of them waiting indoors and peering out the windows. A truckman has to go down and tow the bus to get it started. Scholars will be tardy today. This makes *them* cheerful. It is a fine thing to be late for school all together in one vast company of mass delinquency, with plenty of support and a cold bus for alibi.

If a man were in any doubt as to whether it is a cold day or not there is one way he can always tell. On a really cold day the wooden handle of a pitchfork is as cold as a pinch bar.[1] And when he picks up a scrubbing brush to clean out a water pail the brush has turned to stone. I don't know any object much colder than a frozen brush.

1. **pinch bar:** a kind of crowbar.

Reading Check

1. According to White, what is the best insulating material for windows?
2. How much variation in temperature has he recorded?
3. What precautions does White take so that his car will start?
4. Why is the opening of school delayed?
5. What is the coldest object White reports handling?

Analyzing and Interpreting the Essay

1. Personification is a kind of figurative language in which something nonhuman is given human characteristics or feelings. **a.** How does White personify the cold in his opening paragraph? **b.** What characteristics does he attribute to the cold? **c.** What examples does he use to illustrate the effects of the cold?

2a. What is the main idea of White's second paragraph? **b.** What words does White use to give the reader a different feeling about the cold weather?

3. White says in his second paragraph that "all life's dubious problems are dropped in favor of the clear and congenial task of keeping alive." **a.** What examples of these "clear and congenial" tasks does he give? **b.** How is the rest of the essay organized to support this idea?

4. Toward the end of the essay White shares with the reader a discovery about the effect of cold weather on people. **a.** What is his discovery? **b.** What reasons has he given to support his conclusion?

5a. How is the final paragraph of the essay connected to the introductory paragraph? **b.** Why do you suppose White chooses to end the essay in this way? **c.** What would you say is the main idea of White's essay?

Literary Elements

Personification

In the opening paragraph of the essay, White uses a special kind of metaphor, **personification,** when he attributes to the cold such actions as *stalking* and *taking charge* of the countryside. White imaginatively transforms an everyday natural phenomenon into something that has purpose and personality. Where in the

essay is the cold depicted as an opponent or adversary? Note the last sentence of the opening paragraph. How is iron personified? What makes White's use of language so effective?

Language and Vocabulary

Determining Precise Meanings

At the opening of his essay, E. B. White describes the cold as *unyielding* and *unrelenting.* In this context the word *unyielding* means "stubborn or harsh." The word *unrelenting* means "not slackening or lessening in intensity." The words are close in meaning but not exact synonyms. Used in combination within the same sentence, the words have the effect of emphasizing the severity of the cold weather.

Consider the following pairs of italicized words which appear on page 249. What is the exact meaning of each one? What is gained by using the words in combination?

"... *firm, businesslike* cold ..."
"... *indulgent peace-loving* cold."
"... *cheerfulness* and *sociability*."
"... a *tightening*, a *drawing in*."

Focus on Expository Writing

Developing a Thesis Statement

A **thesis statement** is a summary in one or two sentences of the writer's main idea in an essay or other piece of expository writing. The thesis statement usually comes in the introduction of an essay. For example, E. B. White begins the second paragraph of "Cold Weather" with a sentence that sums up his main idea: "There is a fraternity of the cold, to which I am glad I belong" (see page 249).

Make some notes for an expository essay in which you explain how the weather affects people. Like White, you will want to use specific incidents and examples to illustrate your ideas. Using White's thesis statement as a model, develop a one- or two-sentence summary of your main idea for the essay: for example, "Heat waves seem to bring out the worst in people." Try to make your thesis statement as clear and specific as you can. Save your writing.

About the Author

E. B. White (1899–1985)

Elwyn Brooks White grew up and attended school in Mount Vernon, New York. After graduating from Cornell University in 1921, he worked for a few years as a journalist and in an advertising agency. From 1926 until his death, he was a regular contributor to *The New Yorker* magazine, and his essays, editorials, and anonymous features for "The Talk of the Town" were read and enjoyed by many people. He also wrote the children's classics *Stuart Little* and *Charlotte's Web,* and was coauthor of *The Elements of Style,* possibly the best known of all manuals on the subject of writing.

E. B. White's readers know him through his essays as a person of wisdom and abiding good humor. On July 4, 1963, President Kennedy named White in the first group of Americans to receive the Presidential Medal for Freedom, with a citation that called him "an essayist whose concise comment on men and places has revealed to yet another age the vigor of the English sentence."

The Hawk Is Flying

HARRY CREWS

An essay may have more than one purpose. In this essay, narration is combined with exposition, *the kind of writing that explains a subject or provides information about something. Note how Harry Crews explains a particular process step by step. After reading this essay, you should have a better understanding of what good expository writing can do.*

I was jogging between Lake Swan and Lake Rosa on the ridge full of blackjack oak when I saw the hawk, tail feathers fanned and wings half spread, beside a dump of palmetto[1] about twenty yards off the dim path. From the attitude of her wings and tail I first thought she was sitting on a kill, maybe a rabbit or a rat, but then she turned her wild dandelion eyes toward me and I knew that she was there in the sand not because of something she had killed but because she herself had almost been killed. Blood was dark and clotted on the trailing edge of her right wing. Someone had brought her down with a gun and then not had the decency to find where she fell.

I stood there in the path for a long time, deciding whether or not to kill her. I knew the chances of keeping her alive were slim after

1. **palmetto:** a palm tree with fan-shaped leaves. The action of this narrative takes place in southern Georgia.

she'd been hurt. But leaving her wing-shot in the dirt like that would take more meanness than I thought I could manage. At the same time, though, I knew the right thing to do would be to step quickly across the sand and kick her to death. I watched her where she sat quietly, feathers ruffled now and unafraid, and I knew I was not going to find it in myself either to leave her or kill her. There was nothing to do but take her up and try to save her.

Because the direct stare of a man is terrifying to a hawk, I kept my eyes averted and slowly circled to the edge of the palmetto, where I knelt in the sand. Her sharp, hooked beak was open from heat and exhaustion and her peach-colored tongue beat like a pulse with her rapid breathing. From her size and plumage she was obviously a red-tailed hawk, less than two years old and in her prime, but even so she would have a nervous system as fine and as delicate as a Swiss watch and be subject to death by heart attack or apoplexy if she was not handled carefully. I would need not only whatever skill I might have but also enormous luck, since she would rather die than submit to me. Moving very slowly so as not to disturb her any more than was absolutely necessary, I took off one of my Adidas shoes and rolled down a long one-size-fits-all sweat sock I was wearing. Then, moving the hand that held the sock out in front of her so that she would follow it with her eyes, I eased my other hand over her back and pinned her wings down so she could not beat them against the ground. Her shallow, rapid heart trembled under the fine bright feathers of her breast. I tore the toe out of the sock and put it around her neck like a collar and rolled it down until she was encased in a tight tube of elastic cotton. All that was visible was her head at one end of the sock and talons at the other.

On the long slow walk back home, the only sound she made was a soft clucking very much like that of a chicken. I held her as loosely as I could because I was worried about the heat of my hands and the way she was wrapped. I really expected her to die, but apparently she was not hurt as badly as I thought. By the time I put her on my bed, her breathing had slowed and she had grown calm under the tight sock.

I sat down and opened my desk and there, nearly filling the bottom drawer, was leather from all the years I had kept and trained and flown hawks. On top was a pair of leather welder's gloves, the right one bloodstained between the thumb and forefinger. And under the gloves were several pairs of eighteen-inch jesses[2] and two four-foot leashes and fifteen hoods, each one with the size and date it was made cut into the top of it, and finally four tiny brass falcon bells and as many shark swivels, used to join the jesses to the leashes.

I took the hoods out of the drawer and arbitrarily selected number seven to fit to the hawk's head to see if it was lighttight. It was too big so I tried the next one down, number six, which was nearly right. When I went to number five the fit was perfect, so I drew the leather hood strings, and the hawk, in total darkness now, lay utterly still. With a pair of scissors I carefully cut away the sock. I put on the leather gloves and with my right hand under her breast lifted her to stand on the floor. In the darkness and confusion of the lighttight hood, she stood without moving while I looped the leather jesses around her legs and attached one of the bells to a tail feather. I then attached the ends of the two jesses to the shark swivel and hooked the other end of the swivel to a leash. Her blood-clotted wing hung half spread from her body. I ran my fingers gently along the leading edge to see whether or not the bone was broken. It was not. The flesh was torn, but not badly and I was able to remove

2. **jesses:** straps that are fastened around a hawk's leg, with a ring at one end for attaching a leash.

four tiny birdshot from the wound with a pair of tweezers without cutting away any of her feathers. With the leather glove covering my wrist I touched her legs from behind, and as all hawks will do, she immediately stepped up and back, her talons gripping my arm tightly enough to hurt through the quarter-inch leather.

It has always seemed an awesome mystery to me that any hooded hawk anywhere in the world will step in precisely the same way if the backs of its legs are touched. It was true when Attila the Hun[3] carried hawks on his wrist and it is still true. Presumably it is something that will be true forever. It is part of the reason men have been fascinated with the art of falconry through all the centuries of recorded history.

The hood was the only way I could possibly keep her while her wing healed because without the hood she would beat herself to death at the end of the jesses. A hood makes a hawk's movements and reactions predictable, but there is something about it that is disgusting, too. To make a hawk as docile as a kitten, to reduce even the biggest and most magnificent raptor[4] in the world to something any child can carry, has always caused a sour ball of shame to settle solid as bone inside me.

I made a perch for her out of a broomstick attached to the top of a ladder-back chair and put her on it. She gripped the perch and sat as still as if she had been killed and stuffed. Eventually she would move, but only a little. She would lower her head and rake at the hood with her talons, but not for long, and the period of quietness would give her some chance of staying alive until she healed. I drew the blinds on the windows and stood watching her in the darkened room, thinking again of the perverse pleasure and unreasonable joy, dating all the way back to my childhood, that I have found in meat-eating birds.

One of my most vivid memories is of riding bareback on a mule in the pinewoods of south Georgia and seeing a buzzard walk out of the stomach of a dead and bloated cow, a piece of putrid flesh caught in its stinking beak. And right behind that memory is a hawk swinging into our farmyard and driving its talons into the back of a screaming chicken and flying toward the darkened tree line on the horizon. And necessarily linked to that memory is my grandmother immediately cooping up all the chickens except one puny biddy[5] left unprotected in the yard with arsenic on its head for the same hawk to come back later and take away toward the same dark tree line, never to be seen again. A bird that drinks blood and eats flesh seemed to me then, and seems to me now, an aberration of nature, and I have always thought it must be for this very reason that I have been driven to capture, train, and fly hawks, to participate in the thing that I find so abhorrently and consistently beautiful.

I left the room and let the hawk sit in silence for the rest of the day and that night. I knew there was some danger she might die of shock or thirst. But unless she was kept still so the damaged wing could start to heal, she would surely die from exertion.

Toward the end of the next day I went down to a feedstore and bought a biddy and carried it dead into the room where the hawk sat on her perch, more alert now, shaking the bell with her tail feathers and holding the damaged wing closer to her body and turning her hooded head toward me as I came to the perch. The blinds were still drawn and I knew after the long blind night of the hood she would not be afraid of me if I did not look directly at her and made no sudden move-

3. **Attila the Hun:** barbarian chieftain (406?–453) whose armies overran most of central Europe in the fifth century.
4. **raptor:** a bird of prey, such as the eagle or hawk.

5. **biddy:** a chicken or chick, especially a hen.

ments. I held the biddy between the thumb and forefinger of my right hand while I slipped the strings at the back of the hood and drew it away from her head.

I held the biddy about six inches away from the perch and stood very still while the hawk raised the feathers on her head and looked from the glove to my averted face and back again. She had to be hungry, perhaps dangerously so, but I was not going to feed her unless she stepped to my hand. I was not surprised when she had not taken that step after I had held the food in front of her for nearly an hour.

Finally I backed quietly to the door and left her sitting unhooded in the darkened room. I didn't know how long it would take before she stepped to my glove to eat. But she had to do it or I could never release her and let her fly free again. The problem was simple enough and even easy to solve if she would just cooperate. If she did not lose her fear of me and step to my glove to eat, I would not be able to work her to a lure. And if I could not work her to a lure, I'd never be able to strengthen her wing enough so she could hunt for herself again, because it would take from three weeks to a month of inactivity for her wing to heal, and after she sat on a perch for a month she wouldn't even be able to fly to the top of a tree, much less catch a darting rabbit. The choice was brutally necessary: either she lost her fear of me and ate off my glove or I would starve her to death.

Fortunately, most birds of prey—except owls, which are too dumb to do much with—react favorably to patience and calm persistence. After two days on the perch without food, half the time wearing the hood I put on her to accustom her to it, the hawk stepped to my glove and ate the biddy right down to the feet. The next day I gave her strips of beef heart and began taking her outside and fas-

tening her leash to a block of wood where she could weather in the sun and bathe from time to time in a shallow pan of water. There are few things in the world more beautiful to me than a hawk rising from the water and slowly turning in the sun, wings stretched and fanning on the air.

There was no infection, and even though the red-tailed hawk did finally lose two of her flight feathers, she was soon flying the length

Red-tailed hawk with hood.

of her leash to my glove. But her eyes and feathers were dull and she was extremely weak. With no work, her appetite had gotten smaller and smaller until she was eating barely enough to stay alive.

Twenty days after I brought her home, I decided to start flying her to a lure. I didn't think she was ready for it, but I was afraid she was going to die if she didn't start taking more food, and the only way she was going to do that was if I worked her.

The lure is a pillow-shaped piece of leather with a freshly killed chicken's head tied to it along with a nice bit of bloody meat. I introduced her to the lure in the room where I kept her, letting her fly to it and eat with it caught between the thumb and forefinger of my glove. When she had become thoroughly accustomed to it, I let her go entirely without food for thirty hours and then took her into a wide, empty field and set her on a portable perch. I fastened her jesses to a twenty-foot length of light but very strong nylon cord. From a distance of about seven feet, I showed her the lure, swung it round and round before finally offering it to her on the glove. Her bobbing head followed the bloody meat, and then, giving a short startled cry, she flew to it, her talons stretched and ready.

By the end of two weeks I had lengthened the nylon cord to sixty yards. At first there were a few lapses when she swerved away from the lure and headed straight up. But she didn't have to be jerked out of the air many times by the cord before she was convinced she was somehow irrevocably joined to me and the lure.

Five weeks after I took her crippled and bleeding out of the sand, she was flying free, diving at the lure as I swung it in long arcs over my head, finally catching it high in the air and powering to the ground with it. As she sat on the lure eating, I would quietly walk to her and touch the backs of her legs with the glove and she would step up and back, finishing her meal on my arm.

I kept her longer than I needed to because I had come to love her, probably because she did not love me, and never would. She was as wild the day I flew her free as she was the day I found her. Hawks are not your friend and do not want to be. They are incapable of love and I have for a long time thought that was precisely why I so much loved them.

One Sunday morning, trying to do it mechanically and without thought, I drove sixty miles to the Okefenokee Swamp with the hawk hooded so she would stay quiet. When I had taken the canoe five hours deep into the blackwater cypress, I unclipped the falconer's bell, slipped her jesses, removed the hood, and threw her from my wrist toward the bright blue sky. I had taken her as deep into the swamp as I could because she had lost her fear of man and at least here she would have some chance of survival. But given the number of fools with guns, I did not think that chance very good, even though she had been freed in the middle of a national preserve.

For a long time I heard her high trailing cry above me. But I never looked up. I felt bad enough as it was.

Reading Check

1. How is the hawk injured?
2. What three choices does Crews have when he finds the injured bird?
3. Why does he leave the hawk in a room without food?
4. How long does it take for the hawk to recover and fly free?
5. Where does Crews choose to let the hawk go?

For Study and Discussion

Analyzing and Interpreting the Essay

1. What specific details in this essay show that Crews is knowledgeable about hawks and is skilled in handling them?

2. This essay tells a great deal about hawks, but it also reveals something about Crews himself. For example, Crews must make a decision when he finds the wounded hawk. **a.** What do you think his decision reveals about Crews? **b.** What else does the essay reveal about him?

3a. Why does Crews find the process of hooding a hawk disgusting? **b.** Why must he hood this hawk?

4. Crews says that he finds birds of prey "abhorrently beautiful." **a.** What do you think this means? **b.** What other aspects of nature could also be seen in this way?

5. Why do you think Crews feels bad at the end of the essay?

6. State the main idea of the essay in your own words.

Focus on Expository Writing

Explaining a Process

In "The Hawk Is Flying," Harry Crews presents a detailed explanation of how he was able to nurse an injured hawk back to health. In a **process explanation** you use parts, steps, or stages of a process to explain how to do something or how something works or happens.

When you choose a topic for a process explanation, you may find these hints helpful:

1. Make a list of your interests.
2. Think about the value to your audience of the information you will share.

3. Consider how much your audience may already know about the topic.
4. Evaluate the extent of the topic: is it suitable for a short essay?

Choose *two* topics for expository essays. One topic should be on how to do something, whereas the other should be on how something works or happens. For each topic, make a prewriting chart like the one below:

Topic: _____
Value: _____
Audience: _____
Steps/Stages in Process
 1: _____
 2: _____
 3: _____
 4: _____

When you have finished making notes, join with a small group of classmates to share topics and discuss ideas. Save your notes.

About the Author

Harry Crews (1935–)

Harry Crews has said that his vision as a writer comes from experiencing childhood poverty in rural Georgia: "It was a world in which survival depended on . . . a courage born out of desperation. . . ." In *A Childhood: The Biography of a Place* (1978), Crews describes growing up on a sharecropper's farm. His recent novels include *Body* (1988), *The Knockout Artist* (1989), and *Scar Lover* (1992). Crews teaches writing at the University of Florida.

The Hawk Is Flying **259**

FROM
Desert Images

EDWARD ABBEY

The following selection is an example of speculative writing. *The purpose of speculative writing is to search for answers to questions for which there are as yet no answers. The speculative writer is like an explorer charging into the frontier of knowledge, searching for meaning and understanding. Edward Abbey will not stop at simply showing you some "desert images." Note how he takes you much farther than a tour guide.*

Everywhere you go in the southwestern deserts you come across drawings on the rocks, on the canyon walls. Some are inscribed into the rock—*petroglyphs.* Some are painted on the rock—*pictographs.* All of them, pictographs and petroglyphs alike, present an odd and so-far-untranslated language. If it is a language.

Not that the pictures are always hard to understand. Most consist of recognizable figures: deer, bighorn sheep, antelope, sometimes a

Shield figures, Galisteo Basin, New Mexico. Petroglyph.

Deer and hunters panel, Nine-Mile Canyon, Utah. Petroglyph.

mastodon (extinct no more than ten thousand years in North America), serpents, centipedes, rain clouds, the sun, dancing humans, warriors with shields and lances, even men on horseback—representations that cannot be more than four hundred years old, when the Spaniards introduced the horse to North America.

Some of the pictures, however, are disturbingly strange. We see semihuman figures with huge blank eyes, horned heads. Ghostly shapes resembling men, but without feet or legs, float on the air. Humanlike forms with helmets and goggles wave tentacles at us. What can they be? Gods? Goddesses? Cosmonauts from the Betelgeuse[1] neighborhood? Here's a fighter with shield painted red, white and blue—the all-American man. And still other forms appear; completely nonrepresentational, totally abstract symbols of . . . of what? Nobody knows. The American Indians of today, if they know, aren't telling. Probably they are as mystified by them as we are. In any case the culture of the modern Native Americans has little con-

1. **Betelgeuse** (bĕt′l-jōōz′, bĕt′l-jœz′): a bright-red star in the constellation Orion.

nection with the culture of the vanished rock artists. The continuity was broken long ago.

But still we ask, what does the rock art mean? Unlike the story of the cliff ruins, fairly coherent to archaeologists, we know little of the significance of this ancient work. Perhaps it was only doodling of a sort. A bunch of Stone Age deer hunters sit in camp day after day with nothing to do (the game is gone), telling lies, chipping arrowheads, straightening arrow shafts with their doughnutlike straightener stones. One of them, wanting to record his lies for posterity, begins to chisel the image of a six-point buck on the overhanging cliff wall. I killed that animal, he boasts, with my bare hands.

Another liar takes up the challenge, I killed six bighorn rams, he claims, in this very canyon, only fourteen years ago. And he tallies the total on the soft sandstone with a hard-edged chunk of agate or basalt or flint.

These shallow scratchings may have been the beginning. Inevitably the power of art took over. Most hunter-warriors were artists. They had to be. They made their own weapons. A

Great Panel, Barrier Canyon, Canyonlands National Park, Utah. Pictograph.

Fluteplayer, Galisteo Basin, New Mexico. Petroglyph.

weapon, to be useful, has to be well made. A well-made weapon or any well-made tool, when crafted by hand, becomes a work of art.

Perhaps the rock art was created by specialists. By shamans[2] and wizards, evoking sympathetic magic to aid the hunt. Portraying a deer slain by an arrow, the medicine man would believe that his wishes would serve as efficient cause in producing the desired result. Imitative magic: life imitates art. Thus the pictographs and petroglyphs may have had a religious denotation, hunting being central to any hunter's religion.

The art served as a record. As practical magic. And as communication between wanderers. Water around the next bend, a certain zigzag sign might mean. We killed eleven bighorn here, only two hundred years ago, says a second. *We were here, say the hunters. We were here, say the artists.*

What about the spectral forms—the ghosts, ghouls, gods? Supernatural beings are fished from dreams. From the caves of Altamira[3] to the base of Ayers Rock in central Australia, all original, aboriginal people have believed in the power of dreams. In the Dream Time, say the wise old men of the outback, we made our beginning; from the Dream Time we come; into the Dream Time, after death, we shall return. The dream is the real; waking life is only a dream within a greater dream.

These are speculations. Only a few anthropologists, like New Mexico's Dr. Polly Schaafsma, have given the Indian rock art serious attention. Most have observed the drawings, recorded them, but made no further study. At this time there is no method known by which the pictographs and petroglyphs can be dated accurately; dendrochronology (tree rings) and the carbon-14 technique[4] cannot be applied here. Nor can the art be correlated with other archaeological data—cliff dwellings, burial sites, the various styles of pottery-, basket-, and toolmaking. In the absence of verifiable scientific information, the interpretation of rock art has been left by default to popular fancy: thus the early and premature labeling of this art as a form of "writing" or "hieroglyphs." Not surprising. The first reaction of anyone seeing these strange pictures for the first time is the naturally human: what do they *mean?*

Perhaps meaning is not of primary importance here. What is important is the recognition of art, wherever we may discover it, in whatever form. These canyon paintings and canyon inscriptions are valuable for their own sake, as works of elegance, freshness, originality (in the original sense of the word), economy of line, precision of point, integrity of materials. They are beautiful. And all of them are hundreds of years old—some may be much, much older.

The artist Paul Klee, whose surreal work resembles some of this desert rock art, wrote in his *Diaries 1898–1918:* "There are two mountains on which the weather is bright and clear, the mountain of the animals and the mountain of the gods. But between lies the shadowy valley of men." How's that for meaning?

On many walls in the desert we find the figure of the humpbacked flute player, Kokopelli (a Hopi name). A wanderer, for sure, and a man of strange powers, Kokopelli may have been the Pied Piper[5] who led the cliff dwellers out of the canyons, out of their fear, and down to the high, open country to the south, where

2. **shaman** (shä′mən, shä′-, shăm′ən): a medicine man.
3. **Altamira** (äl′tä-mē′rä): caverns in northern Spain where prehistoric drawings and paintings of animals were discovered in 1879.

4. **carbon-14 technique:** a method of dating ancient objects by determining how much their carbon isotopes have broken down over time.
5. **Pied Piper:** in German legend, a piper who got rid of Hamelin's rats by leading them to the river to be drowned.

the people could live more like humans and less like bats. Maybe he was a nomadic witch doctor, a healer of bodies and curer of feverishly imaginative savage souls. Nobody knows. The memory of the actual Kokopelli, if he was an actual person, has been lost. Only the outline of Kokopelli, his image chiseled into rock, has survived. Too bad. Many of us would like very much to hear the music that he played on that flute of his.

The American desert was discovered by an unknown people. They tried its deepest secrets. Now they have vanished, extinct as the tapir and the coryphodon.[6] But the undeciphered message that they left us remains, written on the walls. A message preserved not in mere words and numbers but in the durable images of line on stone. *We were here.*

Language, in the mind of a poet, seeks to transcend itself, "to grasp the thing that has no name." It seems reasonable to suppose that the unknown people who left this record of their passage felt the same impulse toward permanence, the same longing for communion

with the world that we feel today. To ask for any more meaning may be as futile as to ask for a meaning in the desert itself. What does the desert mean? It means what it is. It is there, it will be there when we are gone. But for a while we living things—men, women, birds, that coyote howling far off on yonder stony ridge—we were a part of it all. That should be enough.

6. **tapir** (tā′pər, tə-pîr′) . . . **coryphodon** (kə-rĭf′ə-dän).

Reading Check

1. Where in the United States are petroglyphs and pictographs found?
2. How do the pictures of men on horseback help us know the age of those pictures?
3. What recognizable figures and objects are depicted in the pictures?
4. Which pictures apparently came from dreams?
5. What musical instrument did the humpbacked figure named Kokopelli play?

For Study and Discussion

Analyzing and Interpreting the Essay

1. Abbey suggests several possible explanations of the rock art found in the Southwest. **a.** According to the author, what types of men could have made the pictures? **b.** What other possible explanation for their origin and meaning can you provide?

2. Abbey says that early hunter-warriors were artists. **a.** How is a well-made weapon or tool a work of art? **b.** What artistic qualities does it have?

3. What explanation is offered for the origin of the supernatural, ghostly pictures?

4. A **paradox** is a statement that appears to be contradictory, yet contains some element of truth. **a.** What does Abbey mean by the paradox "The dream is real"? **b.** How can waking life be seen as "only a dream within a greater dream"?

5a. What is Abbey's purpose in quoting Paul Klee's statement? **b.** In what way are human beings *between* the animals and the gods? **c.** Why is that position a shadowy one?

6. This essay is speculative: it is looking at questions that so far have no absolute answers. What qualifying words and phrases (like "perhaps" or "if he was an actual person") does Abbey use to remind his readers that his statements are guesses, not facts?

7. The last paragraph of the essay does more than close the essay; it draws conclusions. **a.** How do the phrases "communion with the world" and "a part of it all" help explain the importance of the drawings? **b.** How would you state the main idea of the essay?

8. Examine the photographs of rock art on pages 260–261. **a.** What do the images suggest to you? **b.** Which figures are representational and which appear to be symbolic?

Literary Elements

Recognizing Cause and Effect

Studying both the causes and the effects of something is one of the most basic and most important methods of thinking, writing, and learning. In the first three paragraphs of this essay, Abbey simply describes desert images. Which paragraphs attempt to explain the causes of these images? Which paragraphs explain the effects or the significance of the pictures?

Why is this cause and effect method of writing important to scientific writing? How is it helpful in understanding a fictional character or even a real person?

Language and Vocabulary

Analyzing Word Structure

1. Use your dictionary to explain the etymology of *petroglyph* and *pictograph*.

2. Find out the relationship between these words and *hieroglyph*.

Creative Writing

Interpreting a Work of Art

According to Edward Abbey, works of art leave only this message: "We were here." Notice that other kinds of art, perhaps a cathedral or the Great Wall of China or even graffiti drawings, also say "We were here." The work that an artist leaves behind helps us know something about the character of the individual who produced it.

Find a reproduction of a work of art in this textbook and try to draw conclusions about the character of the artist who created it. What does the art suggest about the artist's values, concerns, dreams, or fears? Point out details in the work which support your conclusions.

Thinking About Purpose and Audience

Because the **purpose** of all expository writing is to share information, you have to consider the needs of your **audience** with special care. How much do they already know about the topic? What do they need to know as background? Should you define any unfamiliar terms? Notice that Edward Abbey provides definitions and other background information at several points in the excerpt from *Desert Images*. For example, in the opening paragraph Abbey tells his audience the meaning of the terms *petroglyph* and *pictograph* (see page 260). He uses an appositive to identify Paul Klee as an artist (see page 262).

There are several ways you can provide important definitions or background material for your audience. You can use one or more of the following methods:

> appositives visual aids
> parentheses footnotes

Select a newspaper or magazine article about a topic in science, technology, or economics that interests you. Read the article carefully. Make a list of the ways in which the author helps you understand the material by providing definitions, explanations, or visual aids. Save your notes.

About the Author
Edward Abbey (1927–1989)

Edward Abbey was born in Home, Pennsylvania. Growing up on his family's farm, Abbey learned to love the land. After graduating from the University of New Mexico in 1956, he worked in the National Park Service as a forest ranger and fire fighter. As a writer and an environmentalist, he tried to defend the desert from invasion by corporations, the military, and tourists. Abbey admired Native Americans and Australian Aborigines who live in harmony with the land. Abbey's books include *Desert Solitaire* (1968), *The Brave Cowboy* (1971), and *Beyond the Wall* (1984), where the essay "Desert Images" originally appeared.

Learn with BOOK

R. J. HEATHORN

Humor is often the essayist's way of getting readers to look at something serious. What point is this writer making about our society?

A new aid to rapid—almost magical—learning has made its appearance. Indications are that if it catches on, all the electronic gadgets will be so much junk. The new device is known as Built-in Orderly Organized Knowledge. The makers generally call it by its initials, BOOK.

Many advantages are claimed over the old-style learning and teaching aids on which most people are brought up nowadays. It has no wires, no electric circuits to break down. No connection is needed to an electricity power point. It is made entirely without mechanical parts to go wrong or need replacement.

Anyone can use BOOK, even children, and it fits comfortably into the hands. It can be conveniently used sitting in an armchair by the fire.

How does the revolutionary, unbelievably easy invention work? Basically BOOK consists only of a large number of paper sheets. These may run to hundreds where BOOK covers a lengthy program of information. Each sheet bears a number in sequence, so that the sheets cannot be used in the wrong order. To make it even easier for the user to keep the sheets in the proper order, they are held firmly in place by a special locking device called a "binding."

Each sheet of paper presents the user with an information sequence in the form of symbols, which he absorbs optically for automatic registration on the brain. When one sheet has been assimilated, a flick of the finger turns it over and further information is found on the other side. By using both sides of each sheet in this way a great economy is effected, thus reducing both the size and cost of BOOK. No buttons need to be pressed to move from one sheet to another, to open or close BOOK, or to start it working.

BOOK may be taken up at any time and used by merely opening it. Instantly it is ready for use. Nothing has to be connected up or switched on. The user may turn at will to any sheet, going backwards or forwards as he pleases. A sheet is provided near the beginning as a location finder for any required information sequence.

A small accessory, available at trifling extra cost, is the BOOKmark. This enables the user to pick up his program where he left off on the previous learning session. BOOKmark is versatile and may be used in any BOOK.

The initial cost varies with the size and subject matter. Already a vast range of BOOKs is available, covering every conceivable subject

and adjusted to different levels of aptitude. One BOOK, small enough to be held in the hands, may contain an entire learning schedule. Once purchased, BOOK requires no further cost; no batteries or wires are needed, since the motive power, thanks to the ingenious device patented by the makers, is supplied by the brain of the user.

BOOKs may be stored on handy shelves, and for ease of reference the program schedule is normally indicated on the back of the binding.

Altogether the Built-in Orderly Organized Knowledge seems to have great advantages with no drawbacks. We predict a big future for it.

For Study and Discussion

Analyzing and Interpreting the Essay

1. In this essay, the writer seems to be saying: if books were introduced today, into a society addicted to electronic gadgets, this is how they would be advertised. Although he is talking about books, Heathorn is really poking fun at our addiction to electronic gadgets. **a.** Name some of the gadgets that are the targets of his satire. **b.** How is BOOK superior to them?

2. By describing BOOK in mechanical terms, Heathorn is also making fun of a kind of **jargon**—in this case, the specialized vocabulary used to describe electronic gadgets. **a.** How does he describe binding, table of contents, and title? **b.** What words does he use when he's talking about the contents of BOOK?

Literary Elements

Satire

Any kind of writing that pokes fun at some aspect of human behavior is called **satire**. The ridicule in satire can be bitter, or it can be gentle and humorous. "Learn with BOOK" is an example of genial satire. Its mockery is meant not to insult or hurt, but to point out the foolishness of some of our attitudes and practices.

One of the tools of the satirist is the absurd comparison. Throughout his essay Heathorn compares books to electronic gadgets. The absurdity of this comparison dramatizes our addiction to gadgets. It makes us realize how much simpler it is to read a book than it is to plug ourselves into a computer.

Satirists criticize society in the hope of bringing about some change. In your opinion, what changes would Heathorn like to bring about in our society?

Not everyone agrees with a satirist, of course. How would you respond to Heathorn?

Language and Vocabulary

Noting Meanings of Different Terms

The term **satire** is a general word for any work that holds up to ridicule the shortcomings of human nature. The word is a useful catchall for many different kinds of composition.

The word **caricature** is used in art for a portrait that humorously exaggerates or distorts a person's features. A caricature can exist in literature as well. The works of William Shakespeare and Charles Dickens contain many such exaggerated character portraits.

The term **burlesque** usually refers to a drama that ridicules the style of a serious literary or musical work through exaggeration or comic imitation. John Gay's *The Beggar's Opera* was written in the eighteenth century as a burlesque of Italian opera. The word can also be used to describe a poem, story, or other work that makes fun of some literary genre.

In an unabridged dictionary or a dictionary

of literary terms, find the meanings of these terms: **parody, travesty, farce,** and **invective.** Explain how each term is related to the general meaning of **satire.**

Creative Writing

Writing a Satire

Heathorn takes something that is familiar (a book) and describes it as if it is a great new invention. Think of some other thing or activity that has been around for a long time, and write a brief announcement of it, as if it is a brand new invention. (You might try an ordinary activity like walking or talking.) Describe several "advantages" that this "new invention" has over other gadgets or activities. Before you write, decide what the target of your satire will be.

About the Author

R. J. Heathorn (1914–)

R. J. Heathorn was born in England and writes for British and American periodicals. In this essay, the voice we hear is an ironic one. It says to us: "I mean more than I am saying." Though we know by the end of the first paragraph that Heathorn is writing satirically, his targets may not be immediately evident. The fun of reading the essay is discovering what they are.

Literature and Technology

A World Without Bound Books

We take books for granted now, but some science-fiction writers have predicted a future without them. For example, Isaac Asimov's short story "The Fun They Had" describes a world where children have computerized teachers and have never read books. While such predictions are fictional, they do contain the seeds of truth. For years, books on tape and Braille books have provided an alternative to traditional bound books. Computer software programs already exist that store entire books such as the complete works of Shakespeare. There is even a computer program that can create a formulaic plot for writing your own novel. While these advances do not foretell the death of books as we know them, they do broaden the definition of a "book." Can you imagine a future where bound books no longer exist? What would cause such a change, and how would it be made possible with regard to libraries, schools, and bookstores?

Making Connections: Activities

In your school or library, see if you can locate any computer programs that store books. What can the program accomplish? What advantage does the computer program have over a bound book? What disadvantages? If you don't have access to a computer, use your imagination to invent a program that could replace bound books. What features would it ideally have? How might it teach you? Would it use illustrations? sound? Present your findings and ideas to the class.

Clean Fun at Riverhead

TOM WOLFE

In this description of the demolition derby, Wolfe is concerned with a subculture of American society. He invites the reader to make a judgment with him about the values of participants and spectators. This essay is to be enjoyed for Wolfe's keen observations and acute ear for language. In recalling the sights and sounds of the derby, Wolfe evokes the volatile world of the early 1960s.

The inspiration for the demolition derby came to Lawrence Mendelsohn one night in 1958 when he was nothing but a spareribbed twenty-eight-year-old stock-car driver halfway through his tenth lap around the Islip, L.I., Speedway and taking a curve too wide. A lubberly young man with a Chicago boxcar haircut came up on the inside of a 1949 Ford and caromed him twelve rows up into the grandstand, but Lawrence Mendelsohn and his entire car did not hit one spectator.

"That was what got me," he said. "I remember I was hanging upside down from my seat belt like a side of Jersey bacon and wondering why no one was sitting where I hit. 'Lousy promotion,' I said to myself.

"Not only that, but everybody who *was* in the stands forgot about the race and came running over to look at me gift-wrapped upside down in a fresh pile of junk."

At that moment occurred the transformation of Lawrence Mendelsohn, racing driver, into Lawrence Mendelsohn, promoter, and, a few transactions later, owner of the Islip Speedway, where he kept seeing more of this same underside of stock-car racing that everyone in the industry avoids putting into words. Namely, that for every purist who comes to see the fine points of the race, such as who is going to win, there are probably five waiting for the wrecks to which stock-car racing is so gloriously prone.

The pack will be going into a curve when suddenly two cars, three cars, four cars tangle, spinning and splattering all over each other and the retaining walls, upside down, right side up, inside out and in pieces, with the seams bursting open and disks, rods, wires, and gasoline spewing out and yards of sheet metal shearing off like Reynolds Wrap and crumpling into the most baroque shapes, after which an ash-blue smoke starts seeping up from the ruins and a thrill begins to spread over the stands like Newburg sauce.[1]

So why put up with the monotony between crashes?

Such, in brief, is the early history of what is culturally the most important sport ever orig-

1. **Newburg sauce:** a rich, creamy sauce.

inated in the United States, a sport that ranks with the gladiatorial games of Rome as a piece of national symbolism. Lawrence Mendelsohn had a vision of an automobile sport that would be all crashes. Not two cars, not three cars, not four cars, but 100 cars would be out in an arena doing nothing but smashing each other into shrapnel. The car that outrammed and outdodged all the rest, the last car that could still move amid the smoking heap, would take the prize money.

So at 8:15 at night at the Riverhead Raceway, just west of Riverhead, L.I., on Route 25, amid the quaint tranquillity of the duck and turkey farm flatlands of eastern Long Island, Lawrence Mendelsohn stood up on the back of a flat truck in his red neon warm-up jacket and lectured his 100 drivers on the rules and niceties of the new game, the "demolition derby." And so at 8:30 the first 25 cars moved out onto the raceway's quarter-mile stock-car track. There was not enough room for 100 cars to mangle each other. Lawrence Mendelsohn's dream would require four heats. Now the 25 cars were placed at intervals all about the circumference of the track, making flatulent revving noises, all headed not around the track but toward a point in the center of the infield.

Then the entire crowd, about 4,000, started chanting a countdown. "Ten, nine, eight, seven, six, five, four, three, two," but it was impossible to hear the rest, because right after "two" half the crowd went into a strange whinnying wail. The starter's flag went up, and the 25 cars took off, roaring into second gear with no mufflers, all headed toward that same point in the center of the infield, converging nose on nose.

The effect was exactly what one expects that many simultaneous crashes to produce: the unmistakable tympany of automobiles colliding and cheap-gauge sheet metal buckling; front ends folding together at the same cock-eyed angles police photographs of nighttime wreck scenes capture so well on grainy paper; smoke pouring from under the hoods and hanging over the infield like a howitzer cloud; a few of the surviving cars lurching eccentrically on bent axles. At last, after four heats, there are only two cars moving through the junk, a 1953 Chrysler and a 1958 Cadillac. In the Chrysler a small fascia[2] of muscles named Spider Ligon, who smoked a cigar while he drove, had the Cadillac cornered up against a guard rail in front of the main grandstand. He dispatched it by swinging around and backing full throttle through the left side of its grille and radiator.

By now the crowd was quite beside itself. Spectators broke through a gate in the retaining screen. Some rushed to Spider Ligon's car, hoisted him to their shoulders and marched off the field, howling. Others clambered over the stricken cars of the defeated, enjoying the details of their ruin, and howling. The good, full cry of triumph and annihilation rose from Riverhead Raceway, and the demolition derby was over.

That was the 154th demolition derby in two years. Since Lawrence Mendelsohn staged the first one at Islip Speedway in 1961, they have been held throughout the United States at the rate of one every five days, resulting in the destruction of about 15,000 cars. The figures alone indicate a gluttonous appetite for the sport. Sportswriters, of course, have managed to ignore demolition derbies even more successfully than they have ignored stock-car racing and drag racing. All in all, the new automobile sports have shown that the sports pages, which on the surface appear to hum with life and earthiness, are at bottom pillars of gentility. This drag racing and demolition derbies and things, well, there are too many

2. **fascia** (făsh′ē-ə): a layer of connective tissue that covers muscles.

kids in it with sideburns, tight Levis, and winkle-picker boots.[3]

Yet the demolition derbies keep growing on word-of-mouth publicity. The "nationals" were held last month at Langhorne, Pa., with 50 cars in the finals, and demolition-derby fans everywhere know that Don McTavish, of Dover, Mass., is the new world's champion. About 1,250,000 spectators have come to the 154 contests held so far. More than 75 percent of the derbies have drawn full houses.

The nature of their appeal is clear enough. Since the onset of the Christian era, i.e., since about A.D. 500, no game has come along to fill the gap left by the abolition of the purest of all sports, gladiatorial combat. As late as A.D. 300 these bloody duels, usually between men but sometimes between women and dwarfs, were enormously popular not only in Rome but throughout the Roman Empire. Since then no game, not even boxing, has successfully acted out the underlying motifs of most sport, that is, aggression and destruction.

Boxing, of course, is an aggressive sport, but one contestant has actually destroyed the other in a relatively small percentage of matches. Other games are progressively more sublimated[4] forms of sport. Often, as in the case of football, they are encrusted with oddments of passive theology and metaphysics[5] to the effect that the real purpose of the game is to foster character, teamwork, stamina, physical fitness, and the ability to "give-and-take."

But not even those wonderful clergymen who pray in behalf of Congress, expressway ribbon-cuttings, urban renewal projects, and testimonial dinners for ethnic aldermen would pray for a demolition derby. The demolition derby is, pure and simple, a form of gladiatorial combat for our times.

As hand-to-hand combat has gradually disappeared from our civilization, even in wartime, and competition has become more and more sophisticated and abstract, Americans have turned to the automobile to satisfy their love of direct aggression. The mild-mannered man who turns into a bear behind the wheel of a car—i.e., who finds in the power of the automobile a vehicle for the release of his inhibitions—is part of American folklore. Among teenagers, the automobile has become the symbol, and in part the physical means, of triumph over family and community restrictions. Seventy-five percent of all car thefts in the United States are by teenagers out for "joy rides."

The symbolic meaning of the automobile tones down but by no means vanishes in adulthood. Police traffic investigators have long been convinced that far more accidents are purposeful crashes by belligerent drivers than they could ever prove. One of the heroes of the era was the Middle Eastern diplomat who rammed a magazine writer's car from behind in the Kalorama embassy district of Washington two years ago. When the American bellowed out the window at him, he backed up and smashed his car again. When the fellow leaped out of his car to pick a fight, he backed up and smashed his car a third time, then drove off. He was recalled home for having "gone native."

The unabashed, undisguised, quite purposeful sense of destruction of the demolition derby is its unique contribution. The aggression, the battering, the ruination are there to be enjoyed. The crowd at a demolition derby seldom gasps and often laughs. It enjoys the same full-throated participation as Romans at the Colosseum. After each trial or heat at a demolition derby, two drivers go into the fi-

3. **winkle-picker boots:** boots with narrow, sharply pointed toes.
4. **sublimated:** containing a hidden impulse—usually one that is socially unacceptable.
5. **metaphysics:** a branch of highly speculative philosophy; popularly, any deep or mysterious reasoning.

nals. One is the driver whose car was still going at the end. The other is the driver the crowd selects from among the 24 vanquished on the basis of his courage, showmanship, or simply the awesomeness of his crashes. The numbers of the cars are read over loudspeakers, and the crowd chooses one with its cheers. By the same token, the crowd may force a driver out of competition if he appears cowardly or merely cunning. This is the sort of driver who drifts around the edge of the battle avoiding crashes with the hope that the other cars will eliminate one another. The umpire waves a yellow flag at him and he must crash into someone within 30 seconds or run the risk of being booed off the field in dishonor and disgrace.

The frank relish of the crowd is nothing, however, compared to the kick the contestants get out of the game. It costs a man an average of $50 to retrieve a car from a junkyard and get it running for a derby. He will only get his money back—$50—for winning a heat. The chance of being smashed up in the madhouse first 30 seconds of a round are so great, even the best of drivers faces long odds in his shot at the $500 first prize. None of that matters to them.

Tommy Fox, who is nineteen, said he entered the demolition derby because, "You know, it's fun. I like it. You know what I mean?" What was fun about it? Tommy Fox had a way of speaking that was much like the early Marlon Brando. Much of what he had to say came from the trapezii,[6] which he rolled quite a bit, and the forehead, which he cocked, and the eyebrows, which he could bring together expressively from time to time. "Well," he said, "you know, like when you hit 'em, and all that. It's fun."

Tommy Fox had a lot of fun in the first heat. Nobody was bashing around quite like he was in his old green Hudson. He did not win, chiefly because he took too many chances, but the crowd voted him into the finals as the best showman.

"I got my brother," said Tommy. "I came in from the side and he didn't even see me."

His brother is Don Fox, thirty-two, who owns the junkyard where they both got their cars. Don likes to hit them, too, only he likes it almost too much. Don drives with such abandon, smashing into the first car he can get a shot at and leaving himself wide open, he does not stand much chance of finishing the first three minutes.

For years now sociologists have been calling upon one another to undertake a serious study of America's "car culture." No small part of it is the way the automobile has, for one very large segment of the population, become the focus of the same sort of quasi-religious dedication as art is currently for another large segment of a higher social order. Tommy Fox is unemployed, Don Fox runs a junkyard, Spider Ligon is a maintenance man for Brookhaven Naval Laboratory, but to categorize them as such is getting no closer to the truth than to

have categorized William Faulkner in 1926 as a clerk at Lord & Taylor, although he was.

Tommy Fox, Don Fox, and Spider Ligon are acolytes[7] of the car culture, an often esoteric world of arts and sciences that came into its own after World War II and now has believers of two generations. Charlie Turbush, thirty-five, and his son, Buddy, seventeen, were two more contestants, and by no stretch of the imagination can they be characterized as bizarre figures or cultists of the death wish. As for the dangers of driving in a demolition derby, they are quite real by all physical laws. The drivers are protected only by crash helmets, seat belts, and the fact that all glass, interior handles, knobs, and fixtures have been removed. Yet Lawrence Mendelsohn claims that there have been no serious injuries in 154 demolition derbies and now gets his insurance at a rate below that of stock-car racing.

The sport's future may depend in part on word getting around about its relative safety. Already it is beginning to draw contestants here and there from social levels that could give the demolition derby the cachet[8] of respectability. In Eastern derbies so far two doctors and three young men of more than passable connections in Eastern society have entered under whimsical *noms de combat*[9] and emerged neither scarred nor victorious. Bullfighting had to win the same social combat.

All of which brings to mind that fine afternoon when some highborn Roman women were out in Nero's box at the Colosseum watching this Thracian carve an ugly little Samnite up into prime cuts, and one said, darling, she had an inspiration, and Nero, needless to say, was all for it. Thus began the new vogue of Roman socialites fighting as gladia-

6. **trapezii** (tră-pē′zē-ī): muscles on each side of the upper back. Rolling them would involve hunching the shoulders.

7. **acolytes** (ăk′ə-līts′): attendants; followers; helpers.
8. **cachet** (kă-shā′): a sign of official approval.
9. *noms de combat* (nōm′də kŏm′bä): French for "fighting names."

tors themselves, for kicks. By the second century A.D. even the Emperor Commodus was out there with a tiger's head as a helmet hacking away at some poor dazed fall guy. He did a lot for the sport. Arenas sprang up all over the empire like shopping-center bowling alleys.

The future of the demolition derby, then, stretches out over the face of America. The sport draws no lines of gender, and post-debs[10] may reach Lawrence Mendelsohn at his office in Deer Park.

10. **post-debs:** young women who have made their debuts, or entrances into high society.

Reading Check

1. What event inspired Lawrence Mendelsohn to promote his idea for a demolition derby?
2. How is the winner of the demolition derby determined?
3. How many cars can be entered in a derby and how are they eliminated?
4. What other modern sport is aggressive, according to Wolfe?
5. Why are there no serious injuries during the derby?

For Study and Discussion

Analyzing and Interpreting the Essay

1. Tom Wolfe's essays have made him well known as a social critic. In your opinion, is Wolfe's attitude throughout this essay critical of the demolition derby and of certain aspects of society? Support your answer with quotations from the essay.

2. Does Wolfe intend the title of his essay to be taken seriously, or is the title ironic—that is, does Wolfe say one thing but mean something else? Explain.

3. Wolfe compares the demolition derby to the gladiatorial games of Rome. **a.** What similarities does Wolfe see between the derby and the Roman games? **b.** The crowd at the Roman games often decided whether the gladiator lived or died. What role does the crowd play in deciding the outcome of the derby?

4. Wolfe calls the derby "the most important sport ever originated in the United States, a sport that ranks with the gladiatorial games of Rome as a piece of national symbolism." **a.** Do you agree with this statement, or do you think Wolfe is exaggerating? **b.** Are there other places in this essay where you think Wolfe exaggerates to make his points?

5. On page 273 Wolfe mentions America's "car culture." What do you think he means by this?

Literary Elements

Style and Purpose

Tom Wolfe is known for his fast-paced, free-wheeling style, which is often characterized by a piling up of metaphors and whatever colloquial vocabulary is suited to his subject. A good example is found in the paragraph beginning "All of which brings to mind" on page 273. Wolfe is talking here about the gladiatorial games of Rome, but he describes them in lively, colloquial language: the Thracian "carves up" an opponent into "prime cuts." One woman says "darling." Nero is "all for it." The socialites are fighting "for kicks." The emperor is "hacking away" at some "fall guy." The arenas spring up over the empire "like shopping-center bowling alleys."

Look at the paragraph on page 269 beginning "The pack will be going into a curve." How many sentences are in this fast-moving passage? What strongly visual similes are used

here? What verbs create a sense of rapid, often violent action?

A writer as skilled as Wolfe knows how to suit his style to his subject matter. Wolfe's style, for example, would hardly be appropriate in Harry Crews's thoughtful essay on hawks. Look at how the founder of the derby speaks (page 269). How does Wolfe's style match the speech of Lawrence Mendelsohn?

Underneath Wolfe's seemingly casual style is a serious intent. Wolfe always tries to answer the question: "What does it all mean?" What meaning do you think he sees in the demolition derby?

Language and Vocabulary

Analyzing Sentence Structure

In the following sentence from Wolfe's essay, the main clause appears in italics:

> *The mild-mannered man* who turns into a bear behind the wheel of a car—i.e., who finds in the power of the automobile a vehicle for the release of his inhibitions—*is part of American folklore.*

The two subordinate *who* clauses are adjective clauses modifying the subject word *man.* There are additional levels of modification in the sentence. For example, the compound adjective *mild-mannered* also modifies the subject word *man.* What effect is achieved by this sentence structure? What does Wolfe emphasize by playing off the modifier *mild-mannered* against the ideas in both subordinate clauses?

Choose another sentence in the essay for analysis. Determine how sentence structure is related to Wolfe's purpose.

About the Author

Tom Wolfe (1931–)

Tom Wolfe was born in Richmond, Virginia, and attended Washington and Lee and Yale universities. He is known as a writer and social commentator. Wolfe's freewheeling use of language is shown in the title of the book this essay comes from: *The Kandy-Kolored Tangerine-Flake Streamline Baby* (1965), which refers to a personally customized car. In his introduction to the book, Wolfe describes how he found his distinctive style. After deciding that he could not complete a magazine article he had researched for *Esquire,* he phoned his editor and agreed to type up his notes so that another writer could complete the article. Wolfe says, "About 8 o'clock that night I started typing the notes out in the form of a memorandum. . . . I started typing away, starting right with the first time I saw any custom cars in California. . . . I wrapped up the memorandum about 6:15 A.M., and this time it was 49 pages long." Wolfe's editor was so impressed that he decided to run the notes as an article.

The "memorandum" writing style, which is a form of "New Journalism," became Wolfe's trademark. In 1980 he received the American Book Award for *The Right Stuff* (1979). His novel *The Bonfire of the Vanities* (1987) was made into a film.

BIOGRAPHY AND AUTOBIOGRAPHY

Biography and autobiography try to capture the qualities of character that define a person's life. All sorts of people have been the subjects of biography and autobiography—from men and women who have changed the world, to ordinary people whose lives may be like our own. The approaches to biography and autobiography are many. Some biographers present the facts and documents objectively and let us interpret for ourselves the life and personality of the individual. Most biographers, however, and all autobiographers, make subjective connections for us. These writers interpret and sort out the evidence themselves.

Biographical and autobiographical articles may be organized around one or two major episodes to which other experiences and impressions are linked, or they may present a series of events and episodes without making any single one the focus of interest. Writers may use one part of a life to say something about the whole, or they may give us an overview, a sense of a life from the beginning to the end.

Biography and autobiography are like history: in them we discover a point of view, a philosophy of people and life. This is one important interest of biography—to understand the meaning of human life and perhaps the secret of success and failure in living.

FROM
Peter the Great

ROBERT K. MASSIE

Peter the Great ruled Russia from 1682 to 1725. Massie's biography recounts Peter's efforts to modernize Russia in the late seventeenth and early eighteenth centuries. In 1696 Peter began sending Russians to Western Europe to study and learn more about shipbuilding, government, and the social customs of Europe. Peter accompanied this Great Embassy incognito. He returned to Russia determined to change his country. As Massie explains: "He would try to lead; but where education and persuasion were not enough, he would drive—and if necessary flog—the backward nation forward."

As you read, think about the kinds of evidence Massie must have consulted to create his portrait of Peter the Great and his times.

That very day, even as one grandee[1] was elbowing the next aside to come closer to the Tsar, the warmth of their welcome was put to an extraordinary test. After passing among them and exchanging embraces, Peter suddenly produced a long, sharp barber's razor and with his own hands began shaving off their beards. He began with Shein, the commander of the army, who was too astonished to resist. Next came Romodanovsky, whose deep loyalty to Peter surmounted even this affront to his Muscovite[2] sensibility. The others were forced, one by one, to submit until every boyar[3] present was beardless and none could laugh and point a shocked finger at the others. Only

three were spared: the Patriarch,[4] watching the proceedings with horror, in respect for his office; Prince Michael Cherkassky, because of his advanced age; and Tikhon Streshnev, in deference to his role as guardian of the Tsaritsa.[5]

The scene was remarkable: at a stroke the political, military and social leaders of Russia were bodily transformed. Faces known and recognized for a lifetime suddenly vanished. New faces appeared. Chins, jaws, cheeks, mouths, lips, all hidden for years, emerged, giving their owners a wholly new look. It was comical, but the humor of it was mixed with nervousness and dread. For most Orthodox

1. **grandee** (grăn-dē'): a person of high rank.
2. **Muscovite** (mŭs'kə-vīt'): referring to someone from Moscow.
3. **boyar** (bō-yär'): an aristocrat.

4. **Patriarch** (pā'trē-ärk'): in the Eastern Orthodox Church, the title of the highest-ranking bishop at Moscow.
5. **Tsaritsa** (zä-rīt'sə): Peter's wife.

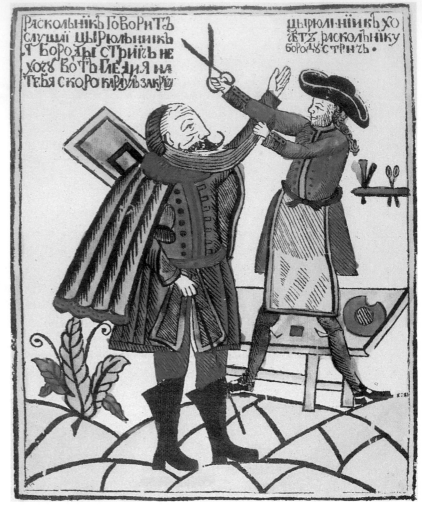

A Russian cartoon showing Peter's decree being carried out. A boyar protests that he doesn't want to have his beard cut and says he will yell for help. The barber snipping off the beard replies that he is following Peter's orders.
Slavonic Division, New York Public Library

Russians, the beard was a fundamental symbol of religious belief and self-respect. It was an ornament given by God, worn by the prophets, the apostles and by Jesus himself. Ivan the Terrible[6] expressed the traditional Muscovite feeling when he declared, "To shave the beard is a sin that the blood of all the martyrs cannot cleanse. It is to deface the image of man created by God." Priests generally refused to bless men without beards; they were considered shameful and beyond the pale of Christendom. Yet, as more beardless foreign mer-

chants, soldiers and engineers arrived in Moscow in the mid-seventeenth century, Peter's father, Tsar Alexis, had relaxed the rule, declaring that Russians might shave if they wished. Few did so, and even those drove the Patriarch Adrian to fresh condemnation: "God did not create men beardless, only cats and dogs. Shaving is not only foolishness and dishonor; it is a mortal sin." Such sentiments rang in the boyars' ears even as they obeyed the Tsar's command.

Peter, beardless himself, regarded beards as unnecessary, uncivilized and ridiculous. They made his country a subject of mirth and mock-

6. **Ivan the Terrible:** first tsar of Russia (1547–1584).

ery in the West. They were a visible symbol of all he meant to change, and, typically, he attacked, wielding the razor himself. Thereafter, whenever Peter attended a banquet or ceremony, those who arrived with beards departed without them. Within a week of his return, he went to a banquet given by Shein and sent his court fool, Jacob Turgenev, around the room in the role of barber. The process was often uncomfortable; shaving long, thick beards with a dry razor left many gouges and cuts where the sharp blade came too close. But no one dared object; Peter was there to box the ears of any who showed reluctance.

Although the cutting of beards began in Peter's intimate circle to ridicule the old Russian way and to show that those who wished the Tsar's favor would thereafter appear beardless in his presence, the ban against beards soon became serious and general. By decree, all Russians except the clergy and the peasants were ordered to shave. To ensure that the order was carried out, officials were given the power to cut the beard off any man, no matter how important, whom they encountered. At first, horrified and desperate Russians bribed these officials to let them go, but as soon as they did, they would fall into the hands of another official. Before long, wearing a beard became too expensive a luxury.

Eventually those who insisted on keeping their beards were permitted to do so on paying an annual tax. Payment entitled the owner to a small bronze medallion with a picture of a beard on it and the words TAX PAID, which was worn on a chain around the neck to prove to any challengers that his beard was legal. The tax was graduated;[7] peasants paid only two kopeks a year, wealthy merchants paid as much as a hundred roubles.[8] Many were willing to pay this tax to keep their beards, but few who came near Peter were willing to risk his wrath with a chin that was not hairless. Finding men in his presence still bearded, Peter sometimes, "in a merry humor, pulled out their beards by the roots or took if off so roughly [with a razor] that some of the skin went with it." . . .

Not long after Peter compelled his boyars to shave their beards, he also began to insist they change from traditional Russian clothing to Western dress. Some had already done so; Polish costume had appeared at court and was regularly worn by progressive figures such as Vasily Golitsyn. In 1681, Tsar Fedor had insisted that his courtiers shorten their long robes so as to permit them to walk. But most continued to wear the traditional Russian national costume: embroidered shirt, wide breeches tucked into floppy boots brilliantly colored in red or green with turned-up toes and gold trim, and on top of that a caftan

Medallion indicating that the annual tax had been paid and that the wearer could keep his beard.

7. **graduated:** The tax rate increased with income.
8. **kopeks** (kō-pĕks′); **roubles** (rōō′bəlz); There were 100 kopeks to the rouble.

reaching to the ground with a straight collar of velvet, satin or brocade and sleeves of exaggerated length and width. To go outdoors, another long garment was added, light in summer, fur-lined in winter, with high, square collar and even longer sleeves which fell to the bottom of the heels. Walking in procession in Moscow in their long, flowing robes and tall, fur-lined hats, a group of Russian boyars made an opulent, almost Oriental picture.

Peter detested this national dress because it was impractical. In his own active life, working in a shipyard, sailing, marching with his soldiers, the long, bulky robes got in the way and he could scarcely walk. Nor did he like the expressions of curiosity, amusement and contempt which he saw on Western faces when a group of Russians in national costumes walked through the streets of a Western town. Back in Moscow, he resolved on change. Among the most persistent wearers of the old dress was the stern Prince Romodanovsky. When Romodanovsky was told that Fedor Golovin, an ambassador of the Great Embassy, had taken off his Russian clothes in the West and put on fashionable foreign garments, Romodanovsky said, "I do not believe Golovin to be such a brainless ass as to despise the dress of his fatherland." Yet on October 30, when Peter ordered that Golovin and Lefort be received in state[9] to acknowledge the Embassy's return, and that only those in Western dress be allowed to appear, Romodanovsky himself was obliged to conform.

That winter, in the course of a two-day banquet and celebration to dedicate Lefort's new palace, Peter took a pair of long cutting shears and clipped the wide sleeves of the boyars around him at the table. "See," he said, "these things are in your way. You are safe nowhere with them. At one moment you upset a glass, then you forgetfully dip them in the sauce."

9. **in state:** with great ceremony.

He handed the sheared-off sleeves to the astonished guests, suggesting, "Get gaiters made of them."

A year later, in January 1700, Peter transformed persuasion into decree. With rolling drums in the streets and squares, it was proclaimed that all boyars, government officials and men of property, both in Moscow and in the provinces, were to abandon their long robes and provide themselves with Hungarian or German-style caftans. The following year, a new decree commanded men to wear a waistcoat, breeches, gaiters, boots and a hat in the French or German style, and women to put on petticoats, skirts, bonnets and Western shoes. Later decrees prohibited the wearing of high Russian boots and long Russian knives. Models of the new approved costumes were hung at Moscow's gates and in public places in the city for people to observe and copy. All who arrived at the gates in traditional dress except peasants were permitted to enter only after paying a fine. Subsequently, Peter instructed the guards at the city gates to force to their knees all visitors arriving in long, traditional coats and then to cut off the coats at the point where the lowered garment touched the ground. "Many hundreds of coats were cut accordingly," says Perry, "and being done with good humor it occasioned mirth among the people and soon broke the custom of wearing long coats, especially in places near Moscow and those towns wherever the Tsar came."

Not surprisingly, Peter's sartorial[10] transformation was much more readily accepted by women than by men. His sister Natalya and his widowed sister-in-law, Praskovaya, were the first to set the example, and many Russian noblewomen hurried to follow. Seeing great possibilities in foreign dress, anxious to be à la mode,[11] they sent to the West for examples of

10. **sartorial** (sär-tôr′ē-əl, -tōr′ē-əl): relating to clothes.
11. **à la mode** (ä′ lə-mōd′): in fashion.

the gowns, shoes and hats being worn at Versailles.[12]

As time passed, subsequent decrees further extended and refined Peter's will that the new clothes be worn "for the glory and comeliness of the state and the military profession." Resistance was never so strong as that which had greeted his condemnation of beards; priests might still berate clean-shaven men, but the church did not rise to the defense of the traditional robes. Fashion has its own authority, and lesser men scurried to adopt the dress of their superiors. Within five years, Whitworth, the English ambassador, reported from Moscow that "in all this great city not a single person of importance is to be met dressed otherwise than in the German manner."

In the country, however, fashion still bowed to age-old habit. Those of the nobility, the bureaucracy and the merchants who fell under Peter's eye dressed as he desired, but other gentry living on their far-off estates still serenely wore their long robes. In a way, this first and most obvious of Peter's reforms on his return from the West was typical of what followed. In his impatience to apply Western customs to Russian society, he jettisoned Russian habits whose existence was based on common sense. It was true that the old Russian clothing was bulky and made walking difficult; limbs were certainly freer once the long robes and coats were cast off. But in the rigorous cold of Russian winter, the freer limbs were also more likely to be frostbitten. When the temperature sank to twenty or thirty below zero, the old Russian in his warm boots, his greatcoat rising above his ears and reaching down to the ground, with his bushy beard protecting his mouth and cheeks, could look with satisfaction at that poor Westernized fellow whose face was purple in the cold and whose knees, showing

beneath his shortened coat, knocked together in a futile effort to keep warm. . . .

In the months that followed Peter's return from the West, he imposed other changes on Russian life. Most were superficial and symbolic; like the cutting of beards and the trimming of clothes, they were harbingers of the deeper institutional reforms to come in the decades ahead. These early transformations really changed nothing fundamental in Russian society. Yet, to Russians they seemed very strange, for they had to do with the commonest ingredients of everyday life.

One of these changes had to do with the calendar. Since the earliest times, Russians had calculated the year not from the birth of Christ but from the moment when they believed the world had been created. Accordingly, by their reckoning, Peter returned from the West not in the year 1698 but in the year 7206. Similarly, Russians began the New Year not on January 1, but on September 1. This stemmed from their belief that the world was created in autumn when the grain and other fruits of the earth had ripened to perfection and were ready to pluck, rather than in the middle of winter when the earth was covered with snow. Traditionally, New Year's Day, September 1, was celebrated with great ceremony, with the tsar and the patriarch seated on two thrones in a courtyard of the Kremlin surrounded by crowds of boyars and people. Peter had suspended these rites as obsolete, but September 1 still remained the beginning of the New Year.

Anxious to bring both the year and New Year's Day into line with the West, Peter decreed in December 1699 that the next year would begin on January 1 and that the coming year would be numbered 1700. In his decree, the Tsar stated frankly that the change was made in order to conform to Western practice. But to blunt the argument of those who said

12. **Versailles** (vər-sī', vĕr-): the palace of Louis XIV, King of France.

FROM

The Life of Caesar

PLUTARCH

Translated from the Greek by
Rex Warner

The first modern biographer and the greatest biographer of the ancient world was Plutarch, who wrote The Life of Caesar *more than a century after Caesar's death. Julius Caesar (102?–44 B.C.) was a dazzling military genius. After his victories in the Gallic Wars and the defeat of his rival, Pompey, in a civil war, Caesar became ruler of the Roman world. He had himself appointed dictator for life. This selection from Plutarch opens with Caesar's victorious return to Rome after crushing the last resistance to his power. However, as Caesar enters the city in triumph, a conspiracy to overthrow him is already under way.*

As you read, ask yourself what interpretation Plutarch brings to the events he recounts. Can you determine his attitude toward his subject?

What made Caesar most openly and mortally hated was his passion to be made King. It was this which made the common people hate him for the first time, and it served as a most useful pretext for those others who had long hated him but had up to now disguised their feelings. Yet those who were trying to get this honor conferred on Caesar actually spread the story among the people that it was foretold in the Sibylline books[1] that Parthia[2] could only be conquered by the Romans if the Roman army was led by a king; and as Caesar was coming down from Alba to Rome, they ventured to salute him as "King," which caused a disturbance among the people. Caesar, upset by this himself, said that his name was not King but Caesar. These words were received in total silence, and he went on his way looking far from pleased. Then there was an occasion when a number of extravagant honors had been voted for him in the senate, and Caesar happened to be sitting above the rostra. Here he was approached by the consuls and the praetors[3] with the whole senate following behind; but instead of rising to receive them, he behaved

1. **Sibylline books:** nine ancient prophetic books, supposed to reveal the destiny of Rome.
2. **Parthia:** ancient country southeast of the Caspian Sea, in what is now northeast Iran.

3. **consuls:** the two chief magistrates of the Roman republic; **praetors** (prē′tərz): A praetor was a magistrate with judicial duties, ranking just below consul.

to them as though they were merely private individuals and, after receiving their message, told them that his honors ought to be cut down rather than increased. This conduct of his offended not only the senate but the people as well, who felt that his treatment of the senators was an insult to the whole state. There was a general air of the deepest dejection, and everyone who was in a position to do so went away at once. Caesar himself realized what he had done and immediately turned to go home. He drew back his toga and, uncovering his throat, cried out in a loud voice to his friends that he was ready to receive the blow from anyone who liked to give it to him. Later, however, he excused his behavior on account of his illness,[4] saying that those who suffer from it are apt to lose control of their senses if they address a large crowd while standing; in these circumstances they are very subject to fits of giddiness and may fall into convulsions and insensibility. This excuse, however, was not true. Caesar himself was perfectly willing to rise to receive the senate; but, so they say, one of his friends, or rather his flatterers, Cornelius Balbus, restrained him from doing so. "Remember," he said, "that you are Caesar. You are their superior and ought to let them treat you as such."

Another thing which caused offense was his insulting treatment of the tribunes.[5] The feast of the Lupercalia[6] was being celebrated. Caesar, sitting on a golden throne above the rostra and wearing a triumphal robe, was watching this ceremony; and Antony, who was consul at the time, was one of those taking part in the sacred running. When he came running into the forum, the crowd made way for him. He

Julius Caesar by a fifteenth-century sculptor. Bas-relief. Caesar is shown crowned with a laurel wreath, the symbol of victory.
Louvre, Paris

was carrying a diadem[7] with a wreath of laurel tied round it, and he held this out to Caesar. His action was followed by some applause, but it was not much and it was not spontaneous. But when Caesar pushed the diadem away from him, there was a general shout of applause. Antony then offered him the diadem for the second time, and again only a few applauded, though, when Caesar again rejected it, there was applause from everyone. Caesar, finding that the experiment had proved a fail-

4. **illness:** Caesar suffered from epilepsy.
5. **tribunes:** in ancient Rome, city officials responsible for guarding the interests of the common people.
6. **Lupercalia** (loo′pər-kā′lē-ə): a Roman religious festival held on February 15, during which priests, magistrates, and young noblemen held races through the streets of Rome.

7. **diadem:** a crown, the symbol of royalty.

The Life of Caesar **291**

ure, rose from his seat and ordered the wreath to be carried to the Capitol. It was then discovered that his statues had been decorated with royal diadems, and two of the tribunes, Flavius and Marullus, went round the statues and tore down the decorations. They then found out who had been the first to salute Caesar as King, and led them off to prison. The people followed the tribunes and were loud in their applause, calling them Brutuses—because it was Brutus[8] who first put an end to the line of Kings in Rome and gave to the senate and the people the power that had previously been in the hands of one man. This made Caesar angry. He deprived Marullus and Flavius of their tribuneship and in speaking against them he insulted the people at the same time.

It was in these circumstances that people began to turn their thoughts toward Marcus Brutus. He was thought to be, on his father's side, a descendant of the Brutus who had abolished the monarchy; on his mother's side he came from another famous family, the Servilii; and he was a son-in-law and a nephew of Cato.[9] But his own zeal for destroying the new monarchy was blunted by the honors and favors which he had received from Caesar. It was not only that at Pharsalus[10] after Pompey's flight his own life had been spared and the lives of many of his friends at his request; he was also a person in whom Caesar had particular trust. He had been given the most important of the praetorships for this very year and was to be consul three years later. For this post he had been preferred to Cassius, who had been the rival candidate. Caesar, indeed, is said to have admitted that Cassius had the better

claims of the two for the office. "But," he added, "I cannot pass over Brutus." And once, when the conspiracy was already formed and some people were actually accusing Brutus to Caesar of being involved in it, Caesar laid his hand on his body and said to the accusers: "Brutus will wait for this skin of mine"—implying that Brutus certainly had the qualities which would entitle him to power, but that he would not, for the sake of power, behave basely and ungratefully.

However, those who were eager for the change and who looked to Brutus as the only, or at least the most likely, man to bring it about, used, without venturing to approach him personally, to come by night and leave papers all over the platform and the chair where he sat to do his work as praetor. Most of the messages were of this kind: "You are asleep, Brutus" or "You are no real Brutus." And when Cassius observed that they were having at least something of an effect on Brutus' personal pride, he redoubled his own efforts to incite him further. Cassius, as I have mentioned in my *Life of Brutus,* had reasons of his own for hating Caesar; moreover, Caesar was suspicious of him, and once said to his friends: "What do you think Cassius is aiming at? Personally I am not too fond of him; he is much too pale." And on another occasion it is said that, when Antony and Dolabella were accused to him of plotting a revolution, Caesar said: "I'm not much afraid of these fat, long-haired people. It's the other type I'm more frightened of, the pale thin ones"—by which he meant Brutus and Cassius.

Fate however, seems to be not so much unexpected as unavoidable. Certainly, before this event, they say that strange signs were shown and strange apparitions were seen. As for the lights in the sky, the crashing sounds heard in all sorts of directions by night, the solitary specimens of birds coming down into the

8. **Brutus:** an earlier Brutus who was thought to be an ancestor of Caesar's friend Marcus Brutus.
9. **Cato:** Marcus Porcius Cato (95–46 B.C.), famous for his courage and honor. He supported Pompey against Caesar.
10. **Pharsalus:** a city in Greece, near which Caesar defeated Pompey in 48 B.C.

forum, all these, perhaps, are scarcely worth mentioning in connection with so great an event as this. But the philosopher Strabo says that a great crowd of men all on fire were seen making a charge; also that from the hand of a soldier's slave a great flame sprang out so that the hand seemed to the spectators to be burning away; but when the flame died out, the man was uninjured. He also says that when Caesar himself was making a sacrifice, the heart of the animal being sacrificed was missing—a very bad omen indeed, since in the ordinary course of nature no animal can exist without a heart. There is plenty of authority too for the following story:

A soothsayer[11] warned Caesar to be on his guard against a great danger on the day of the month of March which the Romans call the Ides;[12] and when this day had come, Caesar, on his way to the senate house, met the soothsayer and greeted him jestingly with the words: "Well, the Ides of March have come," to which the soothsayer replied in a soft voice: "Yes, but they have not yet gone." And on the previous day Marcus Lepidus was entertaining Caesar at supper and Caesar, according to his usual practice, happened to be signing letters as he reclined at table. Meanwhile the conversation turned to the question of what sort of death was the best, and, before anyone else could express a view on the subject, Caesar cried out: "The kind that comes unexpectedly." After this, when he was sleeping as usual by the side of his wife, all the doors and windows of the bedroom flew open at once; Caesar, startled by the noise and by the light of the moon shining down on him, noticed that Calpurnia was fast asleep, but she was saying something in her sleep which he could not make out and was groaning in an inarticulate way. In fact she was dreaming at that time that she was holding his murdered body in her arms and was weeping over it. Though some say that it was a different dream which she had. They say that she dreamed that she saw the gable ornament[13] of the house torn down and for this reason fancied that she was weeping and lamenting. In any case, when it was day, she implored Caesar, if it was possible, not to go out and begged him to postpone the meeting of the senate; or if, she said, he had no confidence in her dreams, then he ought to inquire about the future by sacrifices and other methods of divination.[14] Caesar himself, it seems, was affected and by no means easy in his mind; for he had never before noticed any superstition in Calpurnia and now he could see that she was in very great distress. And when the prophets, after making many sacrifices, told him that the omens were unfavorable, he decided to send for Antony and to dismiss the senate.

At this point Decimus Brutus, surnamed Albinus, intervened. Caesar had such confidence in him that he had made him the second heir in his will, yet he was in the conspiracy with the other Brutus and Cassius. Now, fearing that if Caesar escaped this day the whole plot would come to light, he spoke derisively of the prophets and told Caesar that he ought not to give the senate such a good opportunity for thinking that they were being treated discourteously; they had met, he said, on Caesar's instructions, and they were ready to vote unanimously that Caesar should be declared King of all the provinces outside Italy with the right of wearing a diadem in any other place except

11. **soothsayer:** literally, truth-sayer, one who claims to be able to foretell events.
12. **Ides:** the 15th of March in the ancient Roman calendar. The Romans called the day that fell in the middle of the month "the Ides."

13. **gable ornament:** This ornament was put up by decree of the senate as a mark of honor and distinction.
14. **divination:** the act of trying to foretell the future or penetrate the unknown, using magic or other special rites.

Italy, whether on sea or land; but if, when they were already in session, someone were to come and tell them that they must go away for the time being and come back again when Calpurnia had better dreams, it would be easy to imagine what Caesar's enemies would have to say themselves and what sort of a reception they would give to Caesar's friends when they tried to prove that Caesar was not a slave master or a tyrant. If, however, he had really made up his mind to treat this day as inauspicious, then, Decimus Brutus said, it would be better for him to go himself to the senate, speak personally to the senators, and adjourn the meeting.

While he was speaking, Brutus took Caesar by the hand and began to lead him toward the door. And before he had gone far from the door a slave belonging to someone else tried to approach him, but being unable to get near him because of the crowds who pressed round him, forced his way into the house and put himself into the hands of Calpurnia, asking her to keep him safe until Caesar came back, since he had some very important information to give him.

Then there was Artemidorus, a Cnidian by birth, and a teacher of Greek philosophy, who, for that reason, had become acquainted with Brutus and his friends. He had thus acquired a very full knowledge of the conspiracy and he came to Caesar with a small document in which he had written down the information which he intended to reveal to him. But when he saw that Caesar took each document that was given to him and then handed it to one of his attendants, he came close up to him and said: "Read this one, Caesar, and read it quickly and by yourself. I assure you that it is important and that is concerns you personally." Caesar then took the document and was several times on the point of reading it, but was prevented from doing so by the numbers of people who came to speak to him. It was the only document which he did keep with him and he was still holding it in his hand when he went on into the senate.

It may be said that all these things could have happened as it were by chance. But the place where the senate was meeting that day and which was to be the scene of the final struggle and of the assassination made it perfectly clear that some heavenly power was at work, guiding the action and directing that it should take place just here. For here stood a statue of Pompey, and the building had been erected and dedicated by Pompey as one of the extra amenities attached to his theater. Indeed it is said that, just before the attack was made on him, Caesar turned his eyes toward the statue of Pompey and silently prayed for its good will. This was in spite of the fact that Caesar was a follower of the doctrines of Epicurus;[15] yet the moment of crisis, so it would seem, and the very imminence of the dreadful deed made him forget his former rationalistic views and filled him with an emotion that was intuitive or divinely inspired.

Now Antony, who was a true friend of Caesar's and also a strong man physically, was detained outside the senate house by Brutus Albinus, who deliberately engaged him in a long conversation. Caesar himself went in and the senate rose in his honor. Some of Brutus' party took their places behind his chair and others went to meet him as though they wished to support the petition being made by Tillius Cimber on behalf of his brother who was in exile. So, all joining in with him in his entreaties, they accompanied Caesar to his chair. Caesar took his seat and continued to reject their request; as they pressed him more and more urgently, he began to grow angry with them.

15. **Epicurus:** a Greek philosopher who taught that happiness is achieved through the pursuit of honor, prudence, and peace of mind. The Epicureans did not believe in an afterlife, nor in divine intervention in human affairs.

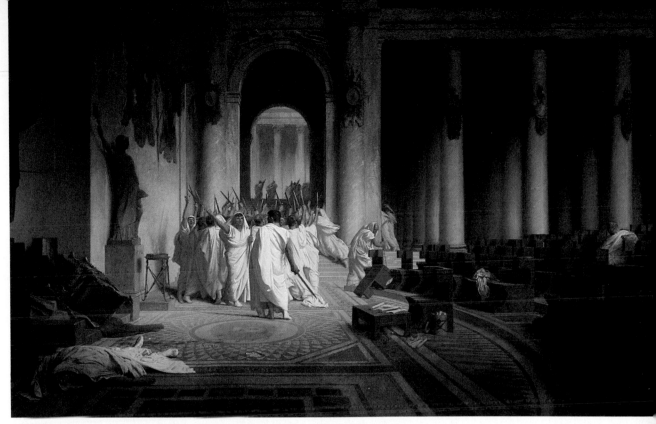

The Death of Caesar (1859) by Jean-Léon Gérôme (1824–1904). Oil on canvas.
Caesar's body lies at the base of Pompey's statue.
The Walter Art Gallery, Baltimore

Tillius then took hold of his toga with both hands and pulled it down from his neck. This was the signal for the attack. The first blow was struck by Casca, who wounded Caesar in the neck with his dagger. The wound was not mortal and not even a deep one, coming as it did from a man who was no doubt much disturbed in mind at the beginning of such a daring venture. Caesar, therefore, was able to turn round and grasp the knife and hold on to it. At almost the same moment the striker of the blow and he who was struck cried out together—Caesar, in Latin, "Casca, you villain, what are you doing?" while Casca called to his brother in Greek: "Help, brother."

So it began, and those who were not in the conspiracy were so horror-struck and amazed at what was being done that they were afraid to run away and afraid to come to Caesar's help; they were too afraid even to utter a word. But those who had come prepared for the murder all bared their daggers and hemmed Caesar in on every side. Whichever way he turned he met the blows of daggers and saw the cold steel aimed at his face and at his eyes. So he was driven this way and that, and, like a wild beast in the toils,[16] had to suffer from the hands of each one of them; for it had been agreed that they must all take part in this sacrifice and all flesh themselves with his blood. Because of this compact Brutus also gave him one wound in the groin. Some say that Caesar fought back against all the rest, darting this way and that to avoid the blow and crying out for help, but when he saw that Brutus had

16. **in the toils:** at bay, in a net or trap.

drawn his dagger, he covered his head with his toga and sank down to the ground. Either by chance or because he was pushed there by his murderers, he fell down against the pedestal on which the statue of Pompey stood, and the pedestal was drenched with his blood, so that one might have thought that Pompey himself was presiding over this act of vengeance against his enemy, who lay there at his feet struggling convulsively under so many wounds.[17]

So Caesar was done to death and, when it was over, Brutus stepped forward with the intention of making a speech to explain what had been done. The senators, however, would not wait to hear him. They rushed out through the doors of the building and fled to their homes, thus producing a state of confusion, terror, and bewilderment amongst the people. Some bolted their doors; others left their counters and shops and could be observed either running to see the place where Caesar had been killed or, once they had seen it, running back again. Antony and Lepidus, who were Caesar's chief friends, stole away and hid in houses belonging to other people. Brutus and his party, on the other hand, just as they were, still hot and eager from the murder, marched all together in one body from the senate house to the Capitol, holding up their naked daggers in front of them and, far from giving the impression that they wanted to escape, looking glad and confident. They called out to the people that liberty had been restored, and they invited the more distinguished persons whom they met to join in with them. Some of these did join in the procession and go up with them to the Capitol, pretending that they had taken part in the deed and thus claiming their share in the glory of it.

Among these were Caius Octavius and Lentulus Spinther who suffered later for their imposture. They were put to death by Antony and young Caesar, and did not even have the satisfaction of enjoying the fame which caused their death, since no one believed that they had taken part in the action. Even those who inflicted the death penalty on them were punishing them not for what they did but for what they would have liked to have done.

Next day Brutus and his party came down from the Capitol and Brutus made a speech. The people listened to what he said without expressing either pleasure or resentment at what had been done. Their complete silence indicated that they both pitied Caesar and respected Brutus. The senate passed a decree of amnesty[18] and tried to reconcile all parties. It was voted that Caesar should be worshiped as a god and that there should be no alteration made, however small, in any of the measures passed by him while he was in power. On the other hand, provinces and appropriate honors were given to Brutus and his friends. Everyone thought, therefore, that things were not only settled but settled in the best possible way.

But when Caesar's will was opened and it was discovered that he had left a considerable legacy to each Roman citizen, and when the people saw his body, all disfigured with its wounds, being carried through the forum, they broke through all bounds of discipline and order. They made a great pile of benches, railings, and tables from the forum and, placing the body upon this, burned it there. Then, carrying blazing brands, they ran to set fire to the houses of the murderers, while others went up and down through the city trying to find the men themselves to tear them to pieces. They, however, were well barricaded and not one of them came in the way of the mob. But

17. **wounds:** Caesar is said to have received twenty-three wounds, and many of his assailants were wounded by one another in the confusion.

18. **amnesty:** general pardon.

The Roman Forum.

there was a man called Cinna, one of Caesar's friends, who, they say, happened to have had a strange dream during the previous night. He dreamed that Caesar invited him to supper and he declined the invitation; Caesar then led him along by the hand, though he did not want to go and was pulling in the opposite direction. Now when Cinna heard that they were burning Caesar's body in the forum he got up and went there out of respect for his memory, though he felt a certain amount of misgiving as a result of his dream and was also suffering from a fever. One of the crowd who saw him there asked who he was and, when he had learned the name, told it to another. So the name was passed on and it was quickly accepted by everyone that here was one of the men who had murdered Caesar, since among the conspirators there was in fact a man with this same name of Cinna. The crowd, thinking that this was he, rushed on him and tore him limb from limb on the spot. It was this more than anything else which frightened Brutus

and Cassius, and within a few days they withdrew from the city. What they did and what happened to them before they died has been related in my *Life of Brutus*.

Caesar was fifty-six years old when he died.[19] He had survived Pompey by not much more than four years. As for the supreme power which he had pursued during the whole course of his life throughout such dangers and which at last and with such difficulty he had achieved, the only fruit he reaped from it was an empty name and a glory which made him envied by his fellow citizens. But that great divine power or genius, which had watched over him and helped him in his life, even after his death remained active as an avenger of his murder, pursuing and tracking down the murderers over every land and sea until not one of them was left and visiting with retribution all, with-

19. **Caesar . . . died:** According to Plutarch, Caesar was born in 100 B.C., but modern scholars believe that he was actually born in 102 B.C. Thus he was fifty-eight, not fifty-six, when he died.

out exception, who were in any way concerned either with the death itself or with the planning of it.

So far as human coincidences are concerned, the most remarkable was that which concerned Cassius. After his defeat at Philippi he killed himself with the very same dagger which he had used against Caesar. And of supernatural events there was, first, the great comet, which shone very brightly for seven nights after Caesar's murder and then disappeared; and also the dimming of the sun. For the whole of that year the sun's orb rose dull and pale; the heat which came down from it was feeble and ineffective, so that the atmosphere, with insufficient warmth to penetrate it, lay dark and heavy on the earth and fruits and vegetables never properly ripened, withering away and falling off before they were mature because of the coldness of the air.

But, more than anything else, the phantom which appeared to Brutus made it clear that the murder of Caesar was not pleasing to the gods. The story is as follows: Brutus was about to take his army across from Abydos[20] to the mainland on the other side of the straits, and one night was lying down, as usual, in his tent, not asleep, but thinking about the future. He fancied that he heard a noise at the entrance to the tent and, looking toward the light of the lamp which was almost out, he saw a terrible figure, like a man, though unnaturally large and with a very severe expression. He was frightened at first, but, finding that this apparition just stood silently by his bed without doing or saying anything, he said: "Who are you?" Then the phantom replied: "Brutus, I am your evil genius. You shall see me at Philippi." On this occasion Brutus answered courageously: "Then I shall see you," and the supernatural visitor at once went away. Time

20. **Abydos:** an ancient town on the Dardanelles, in Asia Minor.

passed and he drew up his army against Antony and Caesar[21] near Philippi. In the first battle he conquered the enemy divisions that were opposed to him, and, after routing them, broke through and sacked Caesar's camp. But in the night before the second battle the same phantom visited him again. It spoke no word, but Brutus realized that his fate was upon him and exposed himself to every danger in the battle. He did not die, however, in the fighting. It was after his troops had been routed that he retired to a steep rocky place, put his naked sword to his breast and with the help of a friend, so they say, who assisted him in driving the blow home, killed himself.

21. **Caesar:** Gaius Octavius (63 B.C.–A.D. 14), the nephew of Julius Caesar, who, in 27 B.C., under the title of Augustus Caesar, became the first Roman emperor.

Reading Check

1. Why did Caesar deprive the tribunes Marullus and Flavius of their office?
2. How had Caesar treated Marcus Brutus so that he was reluctant at first to join the conspiracy?
3. Who were the two men that Caesar feared the most?
4. What was the soothsayer's warning?
5. How did Decimus convince Caesar to go to the senate?
6. What was the signal for the conspirators to attack Caesar?
7. How did the people respond to Brutus' speech?
8. What caused the people to turn against the conspirators?
9. Why did the mob kill an innocent man named Cinna?
10. How did Cassius and Brutus die?

Analyzing and Interpreting the Selection

1. Historians often do more than report the events of a person's life: they also may state or imply explanations for those events. One historian might show that people shape their own lives. Another historian might show that a force outside the control of a person—upbringing, environment, "fate"—is the shaping influence. **a.** Do you think Plutarch shows that Caesar was in control of his destiny? **b.** Does he suggest that if Caesar had been a different kind of man, he might have avoided being killed? Cite passages from the text to support your answers.

2. Plutarch implies certain truths—lessons to be drawn from Caesar's life and death. **a.** Where, for example, does he imply that a divine justice punishes the guilty? **b.** What lesson about the use of power does he want you to draw from Caesar's assassination?

3. Plutarch was inclined toward mysticism in religion and he served as a priest in the Temple of Apollo in Greece. Look back at his narrative of the events that followed Caesar's death. What details show that Plutarch believed that supernatural forces caused the natural world to respond to human events?

4. Has Plutarch presented a favorable portrayal of Caesar, or is he neutral in his feelings about him? Explain.

5a. Does Plutarch present Brutus in a more positive light than the other conspirators? Explain. **b.** What do you think is Plutarch's attitude toward Brutus?

About the Author

Plutarch (46?–120?)

Plutarch was born in central Greece about a hundred years after the death of Julius Caesar. Plutarch's main interest was the characters of famous men and how these men shaped history. He was particularly interested in the story of the collapse of the Roman Republic between about 100 and 30 B.C. After much reading and research, he wrote biographies of ten important Romans who lived during the decline of Rome. Among them are Pompey, Caesar, Cicero, Brutus, and Antony, all of whom figure, in one way or another, in Shakespeare's play *The Tragedy of Julius Caesar*. Shakespeare, in fact, read Plutarch in a translation that was published in England in 1579, and he based his play on Plutarch's biography.

The Car
We Had to Push

JAMES THURBER

James Thurber's memoir is written in a conversational style, with humorous anecdotes, most of them involving members of his eccentric family. Note that Thurber often wanders from his subject. These digressions, as you will see, are quite skillful and reveal a great deal about the personality of their writer.

Many autobiographers, among them Lincoln Steffens and Gertrude Atherton,[1] describe earthquakes their families have been in. I am unable to do this because my family was never in an earthquake, but we went through a number of things in Columbus that were a great deal like earthquakes. I remember in particular some of the repercussions of an old Reo[2] we had that wouldn't go unless you pushed it for quite a way and suddenly let your clutch out. Once, we had been able to start the engine easily by cranking it, but we had had the car for so many years that finally it wouldn't go unless you pushed it and let your clutch out. Of course, it took more than one person to do this; it took sometimes as many as five or six, depending on the grade of the roadway and the conditions underfoot. The car was unusual in that the clutch and brake were on the same pedal, making it quite easy to stall the engine after it got started, so that the car would have to be pushed again.

My father used to get sick at his stomach pushing the car, and very often was unable to go to work. He had never liked the machine, even when it was good, sharing my ignorance and suspicion of all automobiles of twenty years ago and longer. The boys I went to school with used to be able to identify every car as it passed by: Thomas Flyer, Firestone-Columbus, Stevens Duryea, Rambler, Winton, White Steamer, etc. I never could. The only car I was really interested in was one that the Get-Ready Man, as we called him, rode around town in: a big Red Devil with a door in the back. The Get-Ready Man was a lank unkempt elderly gentleman with wild eyes and a deep voice who used to go about shouting at people

1. **Lincoln . . . Atherton:** Lincoln Steffens (1866–1936) wrote *The Autobiography of Lincoln Steffens;* Gertrude Atherton (1857–1948), *Adventures of a Novelist.*
2. **Reo:** an early car named for Ransom Eli Olds.

through a megaphone to prepare for the end of the world. "GET READY! GET READ-Y!" he would bellow. "THE WORLLLD IS COMING TO AN END!" His startling exhortations would come up, like summer thunder, at the most unexpected times and in the most surprising places. I remember once during Mantell's production of *King Lear*[3] at the Colonial Theater, that the Get-Ready Man added his bawlings to the squealing of Edgar and the ranting of the King and the mouthing of the Fool, rising from somewhere in the balcony to join in. The theater was in absolute darkness and there were rumblings of thunder and flashes of lightning offstage. Neither father nor I, who were there, ever completely got over the scene, which went something like this:

Edgar: Tom's a-cold.—O, do de, do de, do de!—Bless thee from whirlwinds, star-blasting, and taking . . . the foul fiend vexes!

 (*Thunder off.*)

Lear: What! Have his daughters brought him to this pass?—

3. ***King Lear:*** a tragedy by William Shakespeare. Lear is driven mad by the ingratitude and cruelty of his daughters. During a storm he takes refuge in a hovel with his jester, the Fool. Edgar, another character, assumes the disguise of a madman.

Get-Ready Man: Get ready! Get ready!

Edgar: Pillicock sat on Pillicock-hill:—

 Halloo, halloo, loo, loo!

 (*Lightning flashes.*)

Get-Ready Man: The Worllld is com-ing to an End!

Fool: This cold night will turn us all to fools and madmen!

Edgar: Take heed o' the foul fiend: obey thy paren——

Get-Ready Man: Get *Rea*-dy!

Edgar: Tom's a-*cold*!

Get-Ready Man: The *Worr*-uld is coming to an end! . . .

They found him finally, and ejected him, still shouting. The Theater, in our time, has known few such moments.

But to get back to the automobile. One of my happiest memories of it was when, in its eighth year, my brother Roy got together a great many articles from the kitchen, placed them in a square of canvas, and swung this under the car with a string attached to it so that, at a twitch, the canvas would give way and the steel and tin things would clatter to the street. This was a little scheme of Roy's to

It Took Sometimes as Many as Five or Six.

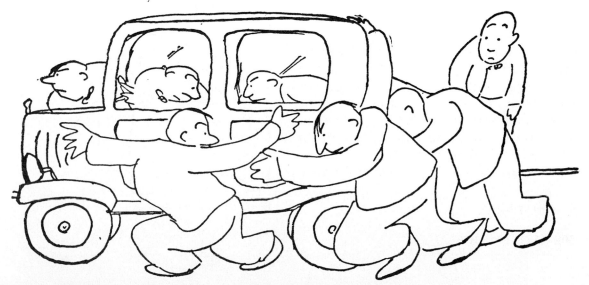

frighten father, who had always expected the car might explode. It worked perfectly. That was twenty-five years ago, but it is one of the few things in my life I would like to live over again if I could. I don't suppose that I can, now. Roy twitched the string in the middle of a lovely afternoon, on Bryden Road near Eighteenth Street. Father had closed his eyes and, with his hat off, was enjoying a cool breeze. The clatter on the asphalt was tremendously effective: knives, forks, can openers, pie pans, pot lids, biscuit cutters, ladles, eggbeaters fell, beautifully together, in a lingering, clamant crash. "Stop the *car*!" shouted father. "I can't," Roy said. "The engine fell out." "God Almighty!" said father, who knew what *that* meant, or knew what it sounded as if it might mean.

It ended unhappily, of course, because we finally had to drive back and pick up the stuff and even father knew the difference between the works of an automobile and the equipment of a pantry. My mother wouldn't have known, however, nor *her* mother. My mother, for instance, thought—or, rather knew—that it was dangerous to drive an automobile without gasoline: it fried the valves, or something. "Now don't you dare drive all over town without gasoline!" she would say to us when we started off. Gasoline, oil, and water were much the same to her, a fact that made her life both confusing and perilous. Her greatest dread, however, was the Victrola[4]—we had a very early one, back in the "Come Josephine in My Flying Machine" days. She had an idea that the Victrola might blow up. It alarmed her, rather than reassured her, to explain that the phonograph was run neither by gasoline nor by electricity. She could only suppose that it was propelled by some newfangled and untested apparatus which was likely to let go at

4. **Victrola:** an early phonograph. The phonograph was invented by Edison.

any minute, making us all the victims and martyrs of the wild-eyed Edison's dangerous experiments. The telephone she was comparatively at peace with, except, of course, during storms, when for some reason or other she always took the receiver off the hook and let it hang. She came naturally by her confused and groundless fears, for her own mother lived the latter years of her life in the horrible suspicion that electricity was dripping invisibly all over the house. It leaked, she contended, out of empty sockets if the wall switch had been left on. She would go around screwing in bulbs, and if they lighted up she would hastily and fearfully turn off the wall switch and go back to her *Pearson's* or *Everybody's*, happy in

Electricity Was Leaking All Over the House.

the satisfaction that she had stopped not only a costly but a dangerous leakage. Nothing could ever clear this up for her.

Our poor old Reo came to a horrible end, finally. We had parked it too far from the curb on a street with a car line. It was late at night and the street was dark. The first streetcar that came along couldn't get by. It picked up the tired old automobile as a terrier might seize a rabbit and drubbed it unmercifully, losing its hold now and then but catching a new grip a second later. Tires booped and whooshed, the fenders queeled and graked, the steering wheel rose up like a specter and disappeared in the direction of Franklin Avenue with a melancholy whistling sound, bolts and gadgets flew like sparks from a Catherine wheel.[5] It was a splendid spectacle but, of course, saddening to everybody (except the motorman of the streetcar, who was sore). I think some of us broke down and wept. It must have been the weeping that caused grandfather to take on so terribly. Time was all mixed up in his mind; automobiles and the like he never remembered having seen. He apparently gathered, from the talk and excitement and weeping, that somebody had died. Nor did he let go of this delusion. He insisted, in fact, after almost a week in which we strove mightily to divert him, that it was a sin and a shame and a disgrace on the family to put the funeral off any longer. "Nobody is dead! The automobile is smashed!" shouted my father, trying for the thirtieth time to explain the situation to the old man. "Was he drunk?" demanded grandfather, sternly. "Was who drunk?" asked father. "Zenas," said grandfather. He had a name for the corpse now: it was his brother Zenas, who, as it happened, *was* dead, but not from driving an automobile while intoxicated. Zenas had died in 1866. A sensitive, rather poetical boy

of twenty-one when the Civil War broke out, Zenas had gone to South America—"just," as he wrote back, "until it blows over." Returning after the war had blown over, he caught the same disease that was killing off the chestnut trees in those years, and passed away. It was the only case in history where a tree doctor had to be called in to spray a person, and our family had felt it very keenly; nobody else in the United States caught the blight. Some of us have looked upon Zenas' fate as a kind of poetic justice.[6]

Now that grandfather knew, so to speak, who was dead, it became increasingly awkward to go on living in the same house with him as if nothing had happened. He would go into towering rages in which he threatened to write to the Board of Health unless the funeral were held at once. We realized that something had to be done. Eventually, we persuaded a friend of father's, named George Martin, to dress up in the manner and costume of the eighteen-sixties and pretend to be Uncle Zenas, in order to set grandfather's mind at rest. The impostor looked fine and impressive in sideburns and a high beaver hat, and not unlike the daguerreotypes[7] of Zenas in our album. I shall never forget the night, just after dinner, when this Zenas walked into the living room. Grandfather was stomping up and down, tall, hawk-nosed, round-oathed. The newcomer held out both his hands. "Clem!" he cried to grandfather. Grandfather turned slowly, looked at the intruder, and snorted. "Who air *you?*" he demanded in his deep, resonant voice. "I'm Zenas!" cried Martin. "Your brother Zenas, fit as a fiddle and sound as a dollar!" "Zenas, my foot!" said grandfather. "Zenas died of the chestnut blight in '66!"

5. **Catherine wheel:** a firework that throws out colored lights.

6. **poetic justice:** That is, good is rewarded and evil is punished.

7. **daguerreotypes** (də-gâr′ə-tīps′): photographs made from a process using a chemically treated metal or glass plate.

Grandfather was given to these sudden, unexpected, and extremely lucid moments; they were generally more embarrassing than his other moments. He comprehended before he went to bed that night that the old automobile had been destroyed and that its destruction had caused all the turmoil in the house. "It flew all to pieces, Pa," my mother told him, in graphically describing the accident. "I knew 'twould," growled grandfather. "I allus told ye to git a Pope-Toledo."[8]

8. **Pope-Toledo:** an early gasoline-powered car.

Reading Check

1. What was the major problem the family had with their old Reo?
2. What was the only car Thurber had any interest in?
3. What modern inventions were considered dangerous by Thurber's mother and grandmother?
4. How did the old Reo meet an untimely and accidental end?
5. What did Thurber's grandfather conclude from all the talk, excitement, and crying in the family?

For Study and Discussion

Analyzing and Interpreting the Selection

1. Thurber begins his narrative by talking about the family's problem with the old Reo, but it soon becomes apparent that the experiences with the Reo become a way of revealing the humorous quirks of people. **a.** How does Thurber make the transition from the description of the Reo to the Get-Ready Man? **b.** How does he tie in the eccentricities of his mother and grandmother with the family car?

c. How is the entire incident of grandfather's delusion connected to the old Reo?

2. One element in humor is **incongruity** (ĭn′kŏng-grōō′ə-tē), the joining of things that normally do not go together or are not appropriate. One scene in Thurber's narrative that illustrates comic incongruity is the sudden appearance of the Get-Ready Man in the theater during a performance of Shakespeare's tragedy. What other examples of incongruity can you find in the selection?

3. Thurber chooses his details carefully when creating a scene of situational humor that we can visualize. **a.** Which events would be good for a silent movie scene or a cartoon? **b.** What about Thurber's use of language makes the scenes memorable?

4a. What is Thurber's attitude toward the characters in his narrative? Is his humor cynical and biting, or is it affectionate and good-natured? **b.** What insight do you gain into Thurber's personality after reading this memoir? Support your answers with evidence from the selection.

5. Thurber's line drawings are often as witty as his essays. How do the drawings on pages 301 and 302 capture the comic mood of the essay?

Literary Elements

Onomatopoeia

Onomatopoeia (ŏn′ə-măt′ə-pē′ə), a musical device often used by poets, occurs when the sound of a word suggests or imitates its meaning. The word *buzz*, for instance, sounds like the droning noise a bee makes. Thurber makes use of onomatopoeia when he describes the destruction of the old Reo on page 303. Locate the onomatopoeic words and tell what sounds they imitate.

Language and Vocabulary

Recognizing Precise Meanings of Words

When Thurber relates the scene in the theater, he writes "the Get-Ready Man added his *bawlings* to the *squealing* of Edgar and the *ranting* of the King and the *mouthing* of the Fool, rising from somewhere in the balcony to join in." All of the italicized words refer to a kind of exaggerated speech, but note that Thurber differentiates the sounds made by each speaker. Check the meanings of *bawl*, *squeal*, *rant*, and *mouth* in a dictionary. Give the precise meaning of each word. Then tell how the combination of sounds adds to the hilarity of the scene.

Focus on Expository Writing

Using Anecdotes

An **anecdote** is a mini-story about an interesting or humorous incident. In "The Car We Had to Push," James Thurber tells a number of amusing anecdotes about various members of his family. Anecdotes are often useful in expository writing, especially in **biography** and **autobiography.**

Make a list of favorite anecdotes about your own experiences or about other family members or friends. Then jot down some notes about how you might develop one of these anecdotes in an essay of biography or autobiography. Remember that good anecdotes generally use dialogue to make the action come alive. Anecdotes also usually follow chronological order. When you have finished writing, get together with a partner and trade anecdotes orally. Save your writing.

About the Author

James Thurber (1894–1961)

The American humorist James Thurber was born and raised in Columbus, Ohio. Thurber later used Columbus as a setting for a series of stories about his family and boyhood called *My Life and Hard Times*, in which "The Car We Had to Push" appears. In 1927 Thurber began his association with *The New Yorker* magazine, where most of his witty essays, fables, stories, satires, and unforgettable line drawings subsequently appeared. Thurber was also a dramatist. He adapted some of the narratives and sketches in his collection *The Thurber Carnival* for a stage production, which ran for a successful season in New York and then on tour through the United States. Thurber's works include *Fables for Our Times* and *Further Fables for Our Times, My World and Welcome to It, The Beast in Me and Other Animals,* and *Men, Women, and Dogs.* Thurber once defined humor as "a kind of emotional chaos told about calmly and quietly in retrospect."

A Child's Christmas in Wales

DYLAN THOMAS

In this autobiographical essay, Dylan Thomas moves between the past and the present, from the point of view of a child to the point of view of an adult, from the real world into an imaginary one. Be alert to these subtle shifts as you read.

One Christmas was so much like another, in those years around the sea-town corner now and out of all sound except the distant speaking of the voices I sometimes hear a moment before sleep, that I can never remember whether it snowed for six days and six nights when I was twelve or whether it snowed for twelve days and twelve nights when I was six. All the Christmases roll down toward the two-tongued sea, like a cold and headlong moon bundling down the sky that was our street; and they stop at the rim of the ice-edged, fish-freezing waves, and I plunge my hands in the snow and bring out whatever I can find. In goes my hand into that wool-white bell-tongued ball of holidays resting at the rim of the carol-singing sea, and out come Mrs. Prothero and the firemen.

It was on the afternoon of the day of Christmas Eve, and I was in Mrs. Prothero's garden, waiting for cats, with her son Jim. It was snowing. It was always snowing at Christmas. De-cember, in my memory, is white as Lapland, though there were no reindeer. But there were cats. Patient, cold, and callous, our hands wrapped in socks, we waited to snowball the cats. Sleek and long as jaguars and horrible-whiskered, spitting and snarling, they would slink and sidle over the white back-garden walls, and the lynx-eyed hunters, Jim and I, fur-capped and moccasined trappers from Hudson Bay, off Mumbles Road, would hurl our deadly snowballs at the green of their eyes. The wise cats never appeared. We were so still, Eskimo-footed arctic marksmen in the muffling silence of the eternal snows—eternal, ever since Wednesday—that we never heard Mrs. Prothero's first cry from her igloo at the bottom of the garden. Or, if we heard it at all, it was, to us, like the far-off challenge of our enemy and prey, the neighbor's polar cat. But soon the voice grew louder.

"Fire!" cried Mrs. Prothero, and she beat the dinner gong.

Dylan Thomas by **Augustus John** (1879–1961).
National Museum of Wales, Cardiff

And we ran down the garden, with the snowballs in our arms, toward the house; and smoke, indeed, was pouring out of the dining room, and the gong was bombilating,[1] and Mrs. Prothero was announcing ruin like a town crier in Pompeii.[2] This was better than all the cats in Wales standing on the wall in a row. We bounded into the house, laden with snowballs, and stopped at the open door of the smoke-filled room. Something was burning all right; perhaps it was Mr. Prothero, who always slept there after midday dinner with a newspaper over his face. But he was standing in the middle of the room, saying, "A fine Christmas!" and smacking at the smoke with a slipper.

"Call the fire brigade," cried Mrs. Prothero as she beat the gong.

"They won't be there," said Mr. Prothero, "it's Christmas."

There was no fire to be seen, only clouds of smoke and Mr. Prothero standing in the middle of them, waving his slipper as though he were conducting.

"Do something," he said.

And we threw all our snowballs into the smoke—I think we missed Mr. Prothero—and ran out of the house to the telephone box.

"Let's call the police as well," Jim said.

"And the ambulance."

"And Ernie Jenkins, he likes fires."

But we only called the fire brigade, and soon the fire engine came and three tall men in helmets brought a hose into the house and Mr. Prothero got out just in time before they turned it on. Nobody could have had a noisier Christmas Eve. And when the firemen turned off the hose and were standing in the wet, smoky room, Jim's aunt, Miss Prothero, came downstairs and peered in at them. Jim and I

waited, very quietly, to hear what she would say to them. She said the right thing, always. She looked at the three tall firemen in their shining helmets, standing among the smoke and cinders and dissolving snowballs, and she said: "Would you like anything to read?"

Years and years and years ago, when I was a boy, when there were wolves in Wales, and birds the color of red-flannel petticoats whisked past the harp-shaped hills, when we sang and wallowed all night and day in caves that smelt like Sunday afternoons in damp front farmhouse parlors, and we chased, with the jawbones of deacons, the English and the bears, before the motor car, before the wheel, before the duchess-faced horse, when we rode the daft and happy hills bareback, it snowed and it snowed. But here a small boy says: "It snowed last year, too. I made a snowman and my brother knocked it down and I knocked my brother down and then we had tea."

"But that was not the same snow," I say. "Our snow was not only shaken from whitewash buckets down the sky, it came shawling[3] out of the ground and swam and drifted out of the arms and hands and bodies of the trees; snow grew overnight on the roofs of the houses like a pure and grandfather moss, minutely white-ivied the walls and settled on the postman, opening the gate, like a dumb, numb thunderstorm of white, torn Christmas cards."

"Were there postmen then, too?"

"With sprinkling eyes and wind-cherried noses, on spread, frozen feet they crunched up to the doors and mittened on them manfully. But all that the children could hear was a ringing of bells."

"You mean that the postman went rat-a-tat-tat and the doors rang?"

"I mean that the bells that the children could hear were inside them."

1. **bombilating:** This word means "buzzing" or "humming," but Thomas has invented a new meaning for it, something like "clanging."

2. **Pompeii** (pŏm-pā′): an ancient Italian city buried by an eruption of Mount Vesuvius in A.D. 79.

3. **shawling:** a word that Thomas invented. The snow acts like a shawl, blanketing the ground.

"I only hear thunder sometimes, never bells."

"There were church bells, too."

"Inside them?"

"No, no, no, in the bat-black, snow-white belfries, tugged by bishops and storks. And they rang their tidings over the bandaged town, over the frozen foam of the powder and ice-cream hills, over the crackling sea. It seemed that all the churches boomed for joy under my window; and the weathercocks crew for Christmas, on our fence."

"Get back to the postmen."

"They were just ordinary postmen, fond of walking and dogs and Christmas and the snow. They knocked on the doors with blue knuckles. . . ."

"Ours has got a black knocker. . . ."

"And then they stood on the white Welcome mat in the little, drifted porches and huffed and puffed, making ghosts with their breath, and jogged from foot to foot like small boys wanting to go out."

"And then the Presents?"

"And then the Presents, after the Christmas box. And the cold postman, with a rose on his button nose, tingled down the tea-tray-slithered run of the chilly glinting hill. He went in his icebound boots like a man on fishmonger's slabs. He wagged his bag like a frozen camel's hump, dizzily turned the corner on one foot, and was gone."

"Get back to the Presents."

"There were the Useful Presents: engulfing mufflers of the old coach days, and mittens made for giant sloths; zebra scarfs of a substance like silky gum that could be tug-o'-warred down to the galoshes; blinding tam-o'-shanters like patchwork tea cozies[4] and bunny-suited busbies[5] and balaclavas[6] for victims of

Dylan Thomas as a child, shown with his mother *(right)*, his sister Nancy, and a family friend.

headshrinking tribes; from aunts who always wore wool next to the skin there were mustached and rasping vests that made you wonder why the aunts had any skin left at all; and once I had a little crocheted nose bag from an aunt now, alas, no longer whinnying with us. And pictureless books in which small boys, though warned with quotations not to, *would* skate on Farmer Gile's pond and did and drowned; and books that told me everything about the wasp, except why."

"Go on to the Useless Presents."

"Bags of moist and many-colored jelly babies and a folded flag and a false nose and a tram

4. **tea cozies:** padded covers used to keep teapots hot.
5. **busbies:** tall fur hats.
6. **balaclavas:** knitted caps that cover most of the face.

A Child's Christmas in Wales **309**

conductor's cap and a machine that punched tickets and rang a bell; never a catapult;[7] once, by mistake that no one could explain, a little hatchet; and a celluloid duck that made, when you pressed it, a most unducklike sound, a mewing moo that an ambitious cat might make who wished to be a cow; and a painting book in which I could make the grass, the trees, the sea and the animals any color I pleased, and still the dazzling sky-blue sheep are grazing in the red field under the rainbow-billed and pea-green birds. Hard-boileds, toffee, fudge and all-sorts, crunches, cracknels, humbugs, glaciers, marzipan, and butterwelsh[8] for the Welsh. And troops of bright tin soldiers who, if they could not fight, could always run. And Snakes-and-Families and Happy Ladders. And Easy Hobbi-Games for Little Engineers, complete with instructions. Oh, easy for Leonardo![9] And a whistle to make the dogs bark to wake up the old man next door to make him beat on the wall with his stick to shake our picture off the wall. And a packet of cigarettes: you put one in your mouth and you stood at the corner of the street and you waited for hours, in vain, for an old lady to scold you for smoking a cigarette, and then with a smirk you ate it. And then it was breakfast under the balloons."

"Were there uncles, like in our house?"

"There are always uncles at Christmas. The same uncles. And on Christmas mornings, with dog-disturbing whistle and sugar fags,[10] I would scour the swatched town for the news of the little world, and find always a dead bird by the white post office or by the deserted swings; perhaps a robin, all but one of his fires

out. Men and women wading or scooping back from chapel, with taproom noses[11] and wind-bussed cheeks, all albinos, huddled their stiff black jarring feathers against the irreligious snow. Mistletoe hung from the gas brackets in all the front parlors; there was sherry and walnuts and bottled beer and crackers by the dessertspoons; and cats in their furabouts watched the fires; and the high-heaped fire spat, all ready for the chestnuts and the mulling pokers. Some few large men sat in the front parlors, without their collars, uncles almost certainly, trying their new cigars, holding them out judiciously at arms' length, returning them to their mouths, coughing, then holding them out again as though waiting for the explosion; and some few small aunts, not wanted in the kitchen, nor anywhere else for that matter, sat on the very edges of their chairs, poised and brittle, afraid to break, like faded cups and saucers."

Not many those mornings trod the piling streets: an old man always, fawn-bowlered,[12] yellow-gloved and, at this time of year, with spats of snow, would take his constitutional to the white bowling green and back, as he would take it wet or fire on Christmas Day or Doomsday; sometimes two hale young men, with big pipes blazing, no overcoats and windblown scarfs, would trudge, unspeaking, down to the forlorn sea, to work up an appetite, to blow away the fumes, who knows, to walk into the waves until nothing of them was left but the two curling smoke clouds of their inextinguishable briars.[13] Then I would be slapdashing home, the gravy smell of the dinners of others, the bird smell, the brandy, the pudding and mince, coiling up to my nostrils, when out

7. **catapult:** a toy model of an ancient weapon that hurls stones or toy spears.

8. **Hard-boileds . . . butterwelsh:** kinds of candy.

9. **Leonardo:** Leonardo da Vinci (1452–1519), the famous fifteenth-century Italian painter, architect, and sculptor, who was also an engineer.

10. **sugar fags:** candy cigarettes.

11. **taproom noses:** A taproom is a barroom. Thomas means that their noses were red as if they'd been drinking too much.

12. **fawn-bowlered:** wearing a bowler, or derby hat, of fawn color—a pale, yellowish brown.

13. **briars:** tobacco pipes made of briarroot.

Cwmdonkin Drive, Swansea, where Dylan Thomas lived as a child.

of a snow-clogged side lane would come a boy the spit of myself, with a pink-tipped cigarette and the violet past of a black eye, cocky as a bullfinch, leering all to himself. I hated him on sight and sound, and would be about to put my dog whistle to my lips and blow him off the face of Christmas when suddenly he, with a violet wink, put *his* whistle to *his* lips and blew so stridently, so high, so exquisitely loud that gobbling faces, their cheeks bulged with goose, would press against their tinseled windows, the whole length of the white echoing street. For dinner we had turkey and blazing pudding, and after dinner the uncles sat in front of the fire, loosened all buttons, put their large moist hands over their watch chains, groaned a little, and slept. Mothers, aunts, and sisters scuttled to and fro, bearing tureens. Auntie Bessie, who had already been frightened, twice, by a clock-work mouse, whimpered at the sideboard and had some elderberry wine. The dog was sick. Auntie Dosie had to have three aspirins, but Auntie Hannah, who liked port,[14] stood in the middle of the snowbound backyard, singing like a big-bosomed thrush. I would blow up balloons to see how big they would blow up to; and, when they burst, which they all did, the uncles jumped and rumbled. In the rich and heavy afternoon, the uncles breathing like dolphins and the snow descending, I would sit among festoons and Chinese lanterns and nibble dates and try to make a model man-o'-war, following the Instructions for Little Engineers, and produce what might be mistaken for a seagoing tram-car. Or I would go out, my bright new boots squeaking, into the white world, onto the seaward hill, to call on Jim and Dan and Jack and to pad through the still streets, leaving huge deep footprints on the hidden pavements.

"I bet people will think there's been hippos."

"What would you do if you saw a hippo coming down our street?"

"I'd go like this, bang! I'd throw him over the railings and roll him down the hill and then I'd tickle him under the ear and he'd wag his tail."

"What would you do if you saw *two* hippos?"

Iron-flanked and bellowing he-hippos clanked and battered through the scudding snow toward us as we passed Mr. Daniel's house.

"Let's post Mr. Daniel a snowball through his letter box."

"Let's write things in the snow."

"Let's write, 'Mr. Daniel looks like a spaniel' all over his lawn."

Or we walked on the white shore. "Can the fishes see it's snowing?"

The silent one-clouded heavens drifted on to the sea. Now we were snow-blind travelers lost on the north hills, and vast dewlapped dogs, with flasks round their necks, ambled and shambled up to us, baying "Excelsior."[15] We returned home through the poor streets where only a few children fumbled with bare red fingers in the wheel-rutted snow and cat-called after us, their voices fading away, as we trudged uphill, into the cries of the dock birds and the hooting of ships out in the whirling bay. And then, at tea the recovered uncles would be jolly; and the ice cake loomed in the center of the table like a marble grave. Auntie Hannah laced her tea with rum, because it was only once a year.

Bring out the tall tales now that we told by the fire as the gaslight bubbled like a diver. Ghosts whooed like owls in the long nights when I dared not look over my shoulder; animals lurked in the cubbyhole under the stairs where the gas meter ticked. And I re-

14. **port:** a sweet, dark-red wine, originally made only in Portugal.

15. **"Excelsior"** (ĕk-sĕl′sē-ər): "higher, always upward." The imagined dogs (St. Bernards) are urging them to keep on going.

member that we went singing carols once, when there wasn't the shaving of a moon to light the flying streets. At the end of a long road was a drive that led to a large house, and we stumbled up the darkness of the drive that night, each one of us afraid, each one holding a stone in his hand in case, and all of us too brave to say a word. The wind through the trees made noises as of old and unpleasant and maybe webfooted men wheezing in caves. We reached the black bulk of the house.

"What shall we give them? Hark the Herald?"

"No," Jack said, "Good King Wenceslas. I'll count three."

One, two, three, and we began to sing, our voices high and seemingly distant in the snow-felted darkness round the house that was occupied by nobody we knew. We stood close together, near the dark door.

"Good King Wenceslas looked out
On the Feast of Stephen . . ."

And then a small, dry voice, like the voice of someone who has not spoken for a long time, joined our singing: a small, dry, eggshell voice from the other side of the door: a small dry voice through the keyhole. And when we stopped running we were outside our house; the front room was lovely; balloons floated under the hot-water-bottle-gulping gas; everything was good again and shone over the town.

"Perhaps it was a ghost," Jim said.

"Perhaps it was trolls," Dan said, who was always reading.

"Let's go in and see if there's any jelly left," Jack said. And we did that.

Always on Christmas night there was music. An uncle played the fiddle, a cousin sang "Cherry Ripe," and another uncle sang "Drake's Drum." It was very warm in the little house. Auntie Hannah, who had got on to the parsnip wine, sang a song about Bleeding Hearts and Death, and then another in which she said her heart was like a Bird's Nest; and then everybody laughed again; and then I went to bed. Looking through my bedroom window, out into the moonlight and the unending smoke-colored snow, I could see the lights in the windows of all the other houses on our hill and hear the music rising from them up the long, steadily falling night. I turned the gas down, I got into bed. I said some words to the close and holy darkness, and then I slept.

Reading Check

1. How did Mrs. Prothero attempt to summon the fire brigade?
2. How did the narrator and his friend, Jim, try to help put out the fire?
3. What two kinds of presents were there?
4. What frightened the boys when they were singing carols?
5. On Christmas night, what activities did the adults and children share?

Analyzing and Interpreting the Essay

1. An autobiographical essay sometimes tries to give an objective account of the writer's own life, a straightforward report of events and people. Thomas is not interested in objective truth; he wants to evoke the world of the past, to re-create it in concrete detail and image. How does Thomas indicate in the first paragraph that his essay will be very subjective and personal?

2a. How does Thomas establish the point of view of a child at the beginning of the essay? **b.** What is gained by introducing another child on page 308, who asks the grown man about his childhood?

3. Find two points where the boy passes from the real world into an imaginary one.

4. Children are often amused by events and behavior that adults miss. What in the adult world does Thomas as a boy find amusing?

5a. What are some of the differences between the child's and the adult's Christmas? **b.** What in Christmas do child and adult share?

6a. Why do you think Thomas calls the darkness "holy" in his last sentence? **b.** What does this word tell about Thomas' attitude toward his childhood?

7. What impression do you get of Thomas as a man from the way he tells about Christmas in Wales?

Literary Elements

Style and Purpose

Thomas is a poet, and like all poets he uses **figures of speech,** in which one thing is compared to some other, different thing. Figures of speech are not literally true, but they help us to see similarities between things that seem to be completely different. For example, here is how Thomas describes the ringing of the church bells over the snowy town:

> . . . in the bat-black, snow-white belfries, tugged by bishops and storks. And they rang their tidings over the bandaged town, over the frozen foam of the powder and ice-cream hills, over the crackling sea. It seemed that all the churches boomed for joy under my window; and the weathercocks crew for Christmas, on our fence.

Thomas uses figures of speech in saying that the bells are pulled by bishops "and storks," that the snowy town is "bandaged," that the snowy hills are "powder" and "ice-cream," that the icy sea is "crackling," that the churches are booming "for joy" (churches are inanimate objects and cannot feel anything).

Notice how Thomas also creates a musical quality, especially by using **alliteration** (the repetition of consonant sounds): "bat-black," "frozen foam," "weathercocks crew for Christmas."

Find the figurative language in the following passages from this essay. Look also for the use of alliteration. How do these passages give you the sense that you are seeing the world through the eyes of an imaginative child?

> In goes my hand into that wool-white bell-tongued ball of holidays resting at the rim of the carol-singing sea, and out come Mrs. Prothero and the firemen.

> We were so still, Eskimo-footed arctic marksmen in the muffling silence of the eternal snows—eternal, ever since Wednesday—that we never heard Mrs. Prothero's first cry from her igloo at the bottom of the garden.

> And then, at tea the recovered uncles would be jolly; and the ice cake loomed in the center of the table like a marble grave.

> And then a small, dry voice, like the voice of someone who has not spoken for a long time, joined our singing: a small, dry, eggshell voice from the other side of the door: a small dry voice through the keyhole.

Language and Vocabulary

Defining Hyphenated Adjectives

Following an old tradition in English poetry, Thomas frequently creates original and sometimes elaborate hyphenated adjectives. For instance, "fish-freezing waves" is a vivid and original way of saying "waves so cold they would freeze even the fish." Below are more of Thomas' hyphenated adjectives. Locate each one in its context, and write out what you think it means:

horrible-whiskered (page 306)
wind-cherried (page 308)
tea-tray-slithered (page 309)
rainbow-billed (page 310)
dog-disturbing (page 310)
one-clouded (page 312)
snow-felted (page 313)
hot-water-bottle-gulping (page 313)

For Oral Reading

Preparing a Passage for Recitation

Those who have had the pleasure of hearing Dylan Thomas' own recording of "A Child's Christmas in Wales" can never read the essay again without hearing the cadences of Thomas' voice. Select a passage of the essay and prepare it for your own oral reading. Watch for Thomas' chantlike rhythms. Note also where his memories speed up (as in the tongue-twisting "wool-white bell-tongued ball of holidays resting at the rim of the carol-singing sea"), and where they take on a slower pace (as in "and out come Mrs. Prothero and the firemen").

About the Author

Dylan Thomas (1914–1953)

Dylan Thomas was born in Swansea, a seaport town in southern Wales. Here he spent a happy childhood, and here, at the local grammar school, he received all his formal education. Upon leaving school, he worked for a while as a newspaper reporter, but soon turned to writing poetry full time. The brilliance of Thomas' poetry, which is full of vigor and unusual imagery, was recognized with the publication of his first book, which appeared when he was only twenty. His prose, however, was not widely read until after his death in New York at the age of thirty-nine. Thomas' reputation had grown enormously through his poetry readings for British and American audiences. By the time of his death, he had become a celebrated figure. Many consider him one of the greatest poets of his age.

A Genuine Mexican Plug

MARK TWAIN

Roughing It is an account of Mark Twain's experiences in the Far West and in Hawaii during the period between July, 1861, and spring of 1867, before he became famous as a writer. Twain gives us an unforgettable picture of the American frontier and his own adventures as a prospector, a speculator, a reporter, and a lecturer. Twain called Roughing It a "personal narrative," but the narrator is clearly a fictionalized creation, an innocent tenderfoot who has to be initiated into the institutions of the Wild West. One of the best-known narratives in the book is included here.

I resolved to have a horse to ride. I had never seen such wild, free, magnificent horsemanship outside of a circus as these picturesquely clad Mexicans, Californians, and Mexicanized Americans displayed in Carson[1] streets every day. How they rode! Leaning just gently forward out of the perpendicular, easy and nonchalant, with broad slouch-hat brim blown square up in front, and long riata[2] swinging above the head, they swept through the town like the wind! The next minute they were only a sailing puff of dust on the far desert. If they trotted, they sat up gallantly and gracefully, and seemed part of the horse; did not go jiggering up and down after the silly Miss Nancy fashion of the riding schools. I had quickly learned to tell a horse from a cow, and was full of anxiety to learn more. I resolved to buy a horse.

While the thought was rankling in my mind, the auctioneer came scurrying through the plaza on a black beast that had as many humps and corners on him as a dromedary,[3] and was necessarily uncomely; but he was "going, going, at twenty-two!—horse, saddle and bridle at twenty-two dollars, gentlemen!" and I could hardly resist.

A man whom I did not know (he turned out to be the auctioneer's brother) noticed the wistful look in my eye, and observed that that was a very remarkable horse to be going at such a price; and added that the saddle alone was worth the money. It was a Spanish saddle, with

1. **Carson:** Carson City, Nevada.
2. **riata** (rē-ä′tə): a lasso or lariat.

3. **dromedary** (drŏm′ə-dĕr′ē): a camel with one hump.

ponderous *tapaderos*,[4] and furnished with the ungainly sole-leather covering with the unspellable name. I said I had half a notion to bid. Then this keen-eyed person appeared to me to be "taking my measure"; but I dismissed the suspicion when he spoke, for his manner was full of guileless candor and truthfulness. Said he:

"I know that horse—know him well. You are a stranger, I take it, and so you might think he was an American horse, maybe, but I assure you he is not. He is nothing of the kind; but— excuse my speaking in a low voice, other people being near—he is, without the shadow of a doubt, a Genuine Mexican Plug!"

I did not know what a Genuine Mexican Plug was, but there was something about this man's way of saying it, that made me swear inwardly that I would own a Genuine Mexican Plug, or die.

"Has he any other—er—advantages?" I inquired, suppressing what eagerness I could.

He hooked his forefinger in the pocket of my army shirt, led me to one side, and breathed in my ear impressively these words:

"He can outbuck anything in America!"

"Going, going, going—at *twen-ty*-four dollars and a half, gen—" "Twenty—seven!" I shouted, in a frenzy.

"And sold!" said the auctioneer, and passed over the Genuine Mexican Plug to me.

I could scarcely contain my exultation. I paid the money, and put the animal in a neighboring livery stable to dine and rest himself.

In the afternoon I brought the creature into the plaza, and certain citizens held him by the head, and others by the tail, while I mounted him. As soon as they let go, he placed all his feet in a bunch together, lowered his back, and then suddenly arched it upward, and shot me straight into the air a matter of three or four

feet! I came as straight down again, lit in the saddle, went instantly up again, came down almost on the high pommel, shot up again, and came down on the horse's neck—all in the space of three or four seconds. Then he rose and stood almost straight up on his hind feet, and I, clasping his lean neck desperately, slid back into the saddle, and held on. He came down, and immediately hoisted his heels into the air, delivering a vicious kick at the sky, and stood on his forefeet. And then down he came once more, and began the original exercise of shooting me straight up again.

An illustration from *Roughing It* (1872).
Courtesy of the Mark Twain House, Hartford, CT

UNEXPECTED ELEVATION.

4. *tapaderos:* leather guards worn in front of stirrups.

The third time I went up I heard a stranger say: "Oh *don't* he buck, though!"

While I was up, somebody struck the horse a sounding thwack with a leathern strap, and when I arrived again the Genuine Mexican Plug was not there. A Californian youth chased him up and caught him, and asked if he might have a ride. I granted him that luxury. He mounted the Genuine, got lifted into the air once, but sent his spurs home as he descended, and the horse darted away like a telegram. He soared over three fences like a bird, and disappeared down the road toward the Washoe Valley.[5]

I sat down on a stone with a sigh, and by a natural impulse one of my hands sought my forehead, and the other the base of my stomach. I believe I never appreciated, till then, the poverty of the human machinery—for I still needed a hand or two to place elsewhere. Pen cannot describe how I was jolted up. Imagination cannot conceive how disjointed I was—how internally, externally, and universally I was unsettled, mixed up, and ruptured. There was a sympathetic crowd around me, though.

One elderly-looking comforter said:

"Stranger, you've been taken in. Everybody in this camp knows that horse. Any child, any Injun, could have told you that he'd buck; he is the very worst devil to buck on the continent of America. You hear *me*. I'm Curry. *Old* Curry. Old *Abe* Curry. And moreover, he is a simonpure, out-and-out, genuine d—d Mexican plug, and an uncommon mean one at that, too. Why, you turnip, if you had laid low and kept dark, there's chances to buy an *American* horse for mighty little more than you paid for that bloody old foreign relic."

I gave no sign; but I made up my mind that if the auctioneer's brother's funeral took place while I was in the territory I would postpone all other recreations and attend it.

5. **Washoe Valley:** in northwestern Nevada.

After a gallop of sixteen miles the Californian youth and the Genuine Mexican Plug came tearing into town again, shedding foam flakes like the spume spray that drives before a typhoon, and, with one final skip over a wheelbarrow, cast anchor in front of the "ranch."

Such panting and blowing! Such spreading and contracting of the red equine nostrils, and glaring of the wild equine eye! But was the imperial beast subjugated? Indeed, he was not. His lordship the Speaker of the House thought he was, and mounted him to go down to the Capitol; but the first dash the creature made was over a pile of telegraph poles half as high as a church; and his time to the Capitol—one mile and three-quarters—remains unbeaten to this day. But then he took an advantage—he left out the mile, and only did the three-quarters. That is to say, he made a straight cut across lots, preferring fences and ditches to a crooked road; and when the Speaker got to the Capitol he said he had been in the air so much he felt as if he had made the trip on a comet.

In the evening the Speaker came home afoot for exercise, and got the Genuine towed back behind a quartz wagon. The next day I loaned the animal to the Clerk of the House to go down to the Dana silver mine, six miles, and *he* walked back for exercise, and got the horse towed. Everybody I loaned him to always walked back; they never could get enough exercise any other way. Still, I continued to loan him to anybody who was willing to borrow him, my idea being to get him crippled, and throw him on the borrower's hands, or killed, and make the borrower pay for him. But somehow nothing ever happened to him. He took chances that no other horse ever took and survived, but he always came out safe. It was his daily habit to try experiments that had always before been considered impossible, but he al-

ways got through. Sometimes he miscalculated a little, and did not get his rider through intact, but *he* always got through himself. Of course I had tried to sell him; but that was a stretch of simplicity which met with little sympathy. The auctioneer stormed up and down the streets on him for four days, dispersing the populace, interrupting business, and destroying children, and never got a bid—at least never any but the eighteen-dollar one he hired a notoriously substanceless bummer to make. The people only smiled pleasantly, and restrained their desire to buy, if they had any. Then the auctioneer brought in his bill, and I withdrew the horse from the market. We tried to trade him off at private vendue[6] next, offering him at a sacrifice for secondhand tombstones, old iron, temperance tracts[7]—any kind of property. But holders were stiff, and we retired from the market again. I never tried to ride the horse any more. Walking was good enough exercise for a man like me, that had nothing the matter with him except ruptures, internal injuries, and such things. Finally I tried to *give* him away. But it was a failure. Parties said earthquakes were handy enough on the Pacific coast—they did not wish to own one. As a last resort I offered him to the Governor for the use of the "Brigade." His face lit up eagerly at first, but toned down again, and he said the thing would be too palpable.

Just then the livery-stable man brought in his bill for six weeks' keeping—stall room for the horse, fifteen dollars; hay for the horse, two hundred and fifty! The Genuine Mexican Plug had eaten a ton of the article, and the man said he would have eaten a hundred if he had let him.

6. **vendue** (vĕn-do͞o′, -dyo͞o′): a public sale.
7. **temperance tracts:** pamphlets urging abstinence from alcoholic liquors.

I will remark here, in all seriousness, that the regular price of hay during that year and a part of the next was really two hundred and fifty dollars a ton. During a part of the previous year it had sold at five hundred a ton, in gold, and during the winter before that there was such scarcity of the article that in several instances small quantities had brought eight hundred dollars a ton in coin! The consequence might be guessed without my telling it: people turned their stock loose to starve, and before the spring arrived Carson and Eagle valleys were almost literally carpeted with their carcasses! Any old settler there will verify these statements.

I managed to pay the livery bill, and that same day I gave the Genuine Mexican Plug to a passing Arkansas emigrant whom fortune delivered into my hand. If this ever meets his eye, he will doubtless remember the donation.

Now whoever has had the luck to ride a real Mexican plug will recognize the animal depicted in this chapter, and hardly consider him exaggerated—but the uninitiated will feel justified in regarding his portrait as a fancy sketch, perhaps.

Reading Check

1. How did Twain come to buy the Genuine Mexican Plug?
2. What did the Mexican Plug do when Twain mounted him?
3. What happened each time the horse was borrowed?
4. How did Twain try to make good his loss?
5. Which of the plans for getting rid of the horse finally worked?

For Study and Discussion

Analyzing and Interpreting the Selection

1a. At the beginning of this narrative, how does Twain show that he is a newcomer to the West? **b.** Why is he so easily duped? **c.** At what point does he seem to be changing and learning from his experience? How do you know?

2. Twain's comic technique involves the use of exaggeration and humorous figures of speech. **a.** How are both combined in this passage?

> After a gallop of sixteen miles the Californian youth and the Genuine Mexican Plug came tearing into town again, shedding foam flakes like the spume spray that drives before a typhoon. . . .

b. Find other passages that show exaggeration or humorous figures of speech.

3. In what way does the character of the Mexican Plug add humor to the narrative?

4a. What elements in Twain's narrative have become **stereotypes,** or fixed conceptions, in Western fiction? Consider the Western films you have seen in which a "tenderfoot" is initiated by being tricked into buying a worthless mine or riding an untamed horse. **b.** Why do you think writers use "stereotypes"?

Literary Elements

Irony

You have seen that there are three kinds of irony: **dramatic irony,** in which the reader perceives something that a character does not know; **irony of situation,** in which the writer shows a discrepancy between the expected result of some action and its actual result; and **verbal irony,** in which a writer says one thing and means something entirely different. Twain uses all three kinds of irony in "A Genuine Mexican Plug."

Dramatic irony occurs when we can tell that Twain is being tricked before he catches on. *Irony of situation* occurs when Twain, having resolved to buy a horse and to emulate the "magnificent horsemanship" of the riders in Carson City, mounts the Mexican Plug. Contrary to his expectations, he makes a comic spectacle of himself before he is thrown by the horse. When someone asks to borrow his horse, Twain responds with *verbal irony:* "I granted him that *luxury.*" He considers a trip on the Genuine anything but a pleasure and comfort.

Find other examples of irony in the story and identify each instance.

Creative Writing

Writing an Anecdote

An anecdote is a brief entertaining story about some happening. Unlike a short story, an anecdote does not have a complicated plot or well-developed characters, but it can make a point. Both Thurber and Twain use anecdotes frequently.

Write a short, humorous anecdote of your own. Make your anecdote show something about human nature.

For Oral Reading

Dramatizing a Passage of the Essay

Mark Twain performed many of his own works on the lecture platform, and he was a master entertainer who suited his readings to the moods of his audience.

Prepare a section of "A Genuine Mexican Plug" for oral delivery. How will you read the narrator's part? How will you show the change he undergoes? How will you use your voice to indicate the different speakers?

Using Transitional Words

You can help your reader to follow the organization and relationships of ideas in your writing by using **transitional words and phrases.** In the last paragraph on page 317, for example, Mark Twain uses a number of transitions to indicate chronological order: *In the afternoon, while, as soon as, then, again, immediately, once more.*

The chart below lists transitions you will find helpful in expository writing:

Transitional Words and Phrases

Showing Time/Narration

after	eventually	first	then
before	finally	next	when

Showing Place/Description

above	before	here	over
across	behind	inside	there
around	down	into	under

Showing Importance/Evaluation

first	mainly	then
last	more important	to begin with

Showing Cause and Effect/Narration

as a result	for	so that
because	since	therefore
consequently	so	

Browse through an encyclopedia and locate a brief article that interests you: for example, an article on some aspect of transportation, industry, or the natural world. Read the article carefully and make a list of transitional words and phrases that the writer uses. Share your list with a small group of classmates. Save your notes.

About the Author

Mark Twain (1835–1910)

Mark Twain, or—to call him by the name his parents gave him—Samuel Langhorne Clemens, is perhaps America's most widely read writer. He grew up near the Mississippi, a river that dominated the lives of people who lived along its banks. Twain worked on the river as a young man and wrote about it for years afterward. He took his pen name, Mark Twain, from the cry of the leadsman who measured the depth of the river waters. "By the mark, twain!" indicated a depth of two fathoms. This depth made a river pilot feel comfortable, Clemens once said, which is why he chose Mark Twain for his pen name.

Mark Twain first received popular recognition as a writer in 1869 with the publication of *The Innocents Abroad,* a humorous travelogue based on his experiences as a tourist in Europe, Egypt, and the Near East. After the success of this book, Twain published many more works of nonfiction and fiction, including *Life on the Mississippi, The Adventures of Tom Sawyer,* and his masterpiece, *Adventures of Huckleberry Finn.* These books depict America in its exuberant youth, and develop themes that are typically American: the struggle between freedom and bondage; the search for identity; the lure of the frontier. In *Roughing It,* Twain, as narrator, depicts the variety of people who sought a new life in the West: reckless speculators, brash politicians, and brutal desperados. Twain loved the Western brand of humor with its practical jokes and extravagant tales. In *Roughing It,* he preserves these stories and fictional characters as well as Western dialect.

The Autobiography of Malcolm X

MALCOLM X

with

Alex Haley

This selection is taken from a chapter called "Saved" in Malcolm X's auto-biography. Why did he choose that title for this episode in his life?

Many who today hear me somewhere in person, or on television, or those who read something I've said, will think I went to school far beyond the eighth grade. This impression is due entirely to my prison studies.

It had really begun back in the Charlestown Prison, when Bimbi[1] first made me feel envy of his stock of knowledge. Bimbi had always taken charge of any conversation he was in, and I had tried to emulate him. But every book I picked up had few sentences which didn't contain anywhere from one to nearly all of the words that might as well have been in Chinese. When I just skipped those words, of course, I really ended up with little idea of what the book said. So I had come to the Norfolk Prison Colony still going through only book-reading motions. Pretty soon, I would have quit even these motions, unless I had received the motivation that I did.

1. **Bimbi:** a fellow inmate Malcolm X met in Charlestown State Prison.

I saw that the best thing I could do was get hold of a dictionary—to study, to learn some words. I was lucky enough to reason also that I should try to improve my penmanship. It was sad. I couldn't even write in a straight line. It was both ideas together that moved me to request a dictionary along with some tablets and pencils from the Norfolk Prison Colony school.

I spent two days just riffling uncertainly through the dictionary's pages. I'd never realized so many words existed! I didn't know *which* words I needed to learn. Finally, just to start some kind of action, I began copying.

In my slow, painstaking, ragged handwriting, I copied into my tablet everything printed on that first page, down to the punctuation marks.

I believe it took me a day. Then, aloud, I read back, to myself, everything I'd written on the tablet. Over and over, aloud, to myself, I read my own handwriting.

I woke up the next morning, thinking about those words—immensely proud to realize that not only had I written so much at one time, but I'd written words that I never knew were in the world. Moreover, with a little effort, I also could remember what many of these words meant. I reviewed the words whose meanings I didn't remember. Funny thing, from the dictionary first page right now, that "aardvark" springs to my mind. The dictionary had a picture of it, a long-tailed, long-eared, burrowing African mammal, which lives off termites caught by sticking out its tongue as an anteater does for ants.

The Autobiography of Malcolm X **323**

I was so fascinated that I went on—I copied the dictionary's next page. And the same experience came when I studied that. With every succeeding page, I also learned of people and places and events from history. Actually the dictionary is like a miniature encyclopedia. Finally the dictionary's A section had filled a whole tablet—and I went on into the B's. That was the way I started copying what eventually became the entire dictionary. It went a lot faster after so much practice helped me to pick up handwriting speed. Between what I wrote in my tablet, and writing letters, during the rest of my time in prison I would guess I wrote a million words.

I suppose it was inevitable that as my word-base broadened, I could for the first time pick up a book and read and now begin to understand what the book was saying. Anyone who has read a great deal can imagine the new world that opened. Let me tell you something: from then until I left that prison, in every free moment I had, if I was not reading in the library, I was reading on my bunk. You couldn't have gotten me out of books with a wedge. Between Mr. Muhammad's teachings, my correspondence, my visitors—usually Ella and Reginald[2]—and my reading of books, months passed without my even thinking about being imprisoned. In fact, up to then, I never had been so truly free in my life.

The Norfolk Prison Colony's library was in the school building. A variety of classes was taught there by instructors who came from such places as Harvard and Boston universities. The weekly debates between inmate teams were also held in the school building. You would be astonished to know how worked up convict debaters and audiences would get over subjects like "Should Babies Be Fed Milk?"

Available on the prison library's shelves were books on just about every general subject. Much of the big private collection that Parkhurst[3] had willed to the prison was still in crates and boxes in the back of the library—thousands of old books. Some of them looked ancient: covers faded, old-time parchment-looking binding. Parkhurst, I've mentioned, seemed to have been principally interested in history and religion. He had the money and the special interest to have a lot of books that you wouldn't have in general circulation. Any college library would have been lucky to get that collection.

As you can imagine, especially in a prison where there was heavy emphasis on rehabilitation, an inmate was smiled upon if he demonstrated an unusually intense interest in books. There was a sizable number of well-read inmates, especially the popular debaters. Some were said by many to be practically walking encyclopedias. They were almost celebrities. No university would ask any student to devour literature as I did when this new world opened to me, of being able to read and *understand*.

I read more in my room than in the library itself. An inmate who was known to read a lot could check out more than the permitted maximum number of books. I preferred reading in the total isolation of my own room.

When I had progressed to really serious reading, every night at about ten P.M. I would be outraged with the "lights out." It always seemed to catch me right in the middle of something engrossing.

Fortunately, right outside my door was a corridor light that cast a glow into my room. The glow was enough to read by, once my eyes adjusted to it. So when "lights out" came, I would sit on the floor where I could continue reading in that glow.

2. **Ella and Reginald:** his sister and brother.

3. **Parkhurst:** a millionaire interested in prison reform.

At one-hour intervals the night guards paced past every room. Each time I heard the approaching footsteps, I jumped into bed and feigned sleep. And as soon as the guard passed, I got back out of bed onto the floor area of that light-glow, where I would read for another fifty-eight minutes—until the guard approached again. That went on until three or four every morning. Three or four hours of sleep a night was enough for me. Often in the years in the streets I had slept less than that.

Reading Check

1. What were Malcolm X's two reasons for requesting a dictionary?
2. What did he learn from the dictionary besides the meanings of words?
3. How did the prison library acquire many of its books?
4. How did Malcolm X manage to read after "lights out"?

For Study and Discussion

Analyzing and Interpreting the Selection

1. Malcolm X distinguishes "book-reading motions" from "being able to read and *understand*." What is the difference?

2. What was Malcolm X's approach to educating himself?

3. What does this episode in Malcolm X's life reveal about his character?

4. A **paradox** is a statement that seems to contradict itself but is true nevertheless. Despite being imprisoned Malcolm X felt that learning to read had freed him. Explain what he means by this paradox.

5. Why might reading be considered an important part of rehabilitation?

Language and Vocabulary

Using Context Clues

Although a dictionary is an invaluable tool in determining the meanings of words, a dictionary may not be handy when you are reading. Sometimes you can figure out the meaning of a word that you don't recognize by examining the words and phrases that surround it. It's always best to confirm your guesses when you can, so after you have attempted to define the following italicized words, check your answers in the glossary at the back of this textbook or in a dictionary.

I spent two days just *riffling* uncertainly through the dictionary's pages.

I suppose it was *inevitable* that as my word-base broadened, I could for the first time pick up a book and read and now begin to understand what the book was saying.

At one-hour intervals the night guards paced past every room. Each time I heard the approaching footsteps, I jumped into bed and *feigned* sleep.

Focus on Expository Writing

Understanding Cause and Effect

A **cause-and-effect explanation** focuses on a situation or event and answers one or both of these questions: Why did it happen? What were the effects?

When you explore cause and effect, it is important to remember that a single event may have more than one cause and may lead to

more than one effect. Causes and effects may also be linked in a **cause-and-effect chain,** where an event or situation causes an effect, which in turn becomes a cause for an additional effect, and so on. For example:

Malcolm X's envy of Bimbi →
 his attempt to read books →
 his copying dictionary entries →
 his broadening of his vocabulary →
 his dedication to reading

When you write a cause-and-effect essay, you should use a **thesis statement** early in the essay to identify your main idea. You should also use **evidence** such as facts, statistics, and examples to clarify the relationships between causes and effects.

What are some puzzles about the world that you would like to explore? Make notes for a cause-and-effect essay on a topic that interests you. Be sure to include a thesis statement as well as a list of sources you will consult to gather specific evidence for your essay. Save your notes.

About the Author

Malcolm X (1925–1965)

Malcolm X was born Malcolm Little in Omaha, Nebraska. Malcolm's father, a Baptist minister, introduced him to the teachings of Marcus Garvey, an influential African American activist. After his father's death, Malcolm's mother became ill and was institutionalized.

Malcolm X turned to crime at an early age and in 1946 was sentenced to ten years in prison for burglary. In prison he began to ed-ucate himself on a wide range of topics from philosophy to politics. He also became a Black Muslim, changing his name to Malcolm X. After leaving prison in 1952, Malcolm X became an important leader in the African American community, advocating black pride and black economic independence. In 1964 he went on a pilgrimage to Mecca. His experience led him to embrace the orthodox Muslim faith and establish his own Muslim association. In 1965 he was assassinated as he was about to speak to an audience in New York City. He was buried as El Hajj Malik El-Shabazz, the Muslim name he adopted after his visit to Mecca.

In addition to his autobiography, a collection of his speeches has been published in *Malcolm X: The Man and His Times.* Film director Spike Lee released a movie about his life in 1992.

West with the Night

BERYL MARKHAM

In September, 1936, Beryl Markham became the first person to fly alone across the Atlantic from east to west. In this selection from her autobiography, she re-creates her dangerous solo flight from England to Nova Scotia, across a cold and stormy Atlantic Ocean. Note how she uses flashback *in her account to connect the events of the past and the present.*

I have seldom dreamed a dream worth dreaming again, or at least none worth recording. Mine are not enigmatic[1] dreams; they are peopled with characters who are plausible[2] and who do plausible things, and I am the most plausible amongst them. All the characters in my dreams have quiet voices like the voice of the man who telephoned me at Elstree[3] one morning in September of nineteen-thirty-six and told me that there was rain and strong head winds over the west of England and over the Irish Sea, and that there were variable winds and clear skies in mid-Atlantic and fog off the coast of Newfoundland.

"If you are still determined to fly the Atlantic this late in the year," the voice said, "the Air Ministry suggests that the weather it is able to forecast for tonight, and for tomorrow morning, will be about the best you can expect."

The voice had a few other things to say, but not many, and then it was gone, and I lay in

Beryl Markham.

1. **enigmatic** (ĕn'ĭg-măt'ĭk): mysterious.
2. **plausible** (plô'zə-bəl): credible.
3. **Elstree** (ĕl'strē): a parish located northeast of London.

bed half-suspecting that the telephone call and the man who made it were only parts of the mediocre dream I had been dreaming. I felt that if I closed my eyes the unreal quality of the message would be reestablished, and that, when I opened them again, this would be another ordinary day with its usual beginning and its usual routine.

But of course I could not close my eyes, nor my mind, nor my memory. I could lie there for a few moments—remembering how it had begun, and telling myself, with senseless repetition, that by tomorrow morning I should either have flown the Atlantic to America—or I should not have flown it. In either case this was the day I would try.

I could stare up at the ceiling of my bedroom in Aldenham House, which was a ceiling undistinguished as ceilings go, and feel less resolute than anxious, much less brave than foolhardy. I could say to myself, "You needn't do it, of course," knowing at the same time that nothing is so inexorable[4] as a promise to your pride.

I could ask, "Why risk it?" as I have been asked since, and I could answer, "Each to his element." By his nature a sailor must sail, by his nature a flyer must fly. I could compute that I had flown a quarter of a million miles; and I could foresee that, so long as I had a plane and the sky was there, I should go on flying more miles.

There was nothing extraordinary in this. I had learned a craft and had worked hard learning it. My hands had been taught to seek the controls of a plane. Usage had taught them. They were at ease clinging to a stick, as a cobbler's fingers are in repose grasping an awl.[5] No human pursuit achieves dignity until it can be called work, and when you can experience a physical loneliness for the tools of your trade, you see that the other things—the experiments, the irrelevant vocations, the vanities you used to hold—were false to you.

Record flights had actually never interested me very much for myself. There were people who thought that such flights were done for admiration and publicity, and worse. But of all the records—from Louis Blériot's first crossing of the English Channel in nineteen hundred and nine, through and beyond Kingsford Smith's[6] flight from San Francisco to Sydney, Australia—none had been made by amateurs, nor by novices, nor by men or women less than hardened to failure, or less than masters of their trade. None of these was false. They were a company that simple respect and simple ambition made it worth more than an effort to follow.

The Carberrys (of Seramai) were in London and I could remember everything about their dinner party—even the menu. I could remember June Carberry and all her guests, and the man named McCarthy, who lived in Zanzibar, leaning across the table and saying, "J. C., why don't you finance Beryl for a record flight?"

I could lie there staring lazily at the ceiling and recall J. C.'s dry answer: "A number of pilots have flown the North Atlantic, west to east. Only Jim Mollison has done it alone the other way—from Ireland. Nobody has done it alone from England—man or woman. I'd be interested in that, but nothing else. If you want to try it, Burl, I'll back you. I think Edgar Percival could build a plane that would do it, provided you can fly it. Want to chance it?"

"Yes."

I could remember saying that better than I could remember anything—except J. C.'s al-

4. **inexorable** (ĭn-ĕk′sər-ə-bəl): unyielding; inflexible.
5. **awl** (ôl): a tool for making holes in leather.

6. **Louis Blériot** (blā-ryō′): French engineer and aviator (1872–1936), the first person to fly the English Channel; **Kingsford Smith:** Charles Kingsford-Smith, an Australian flier who flew a distance of 1,762 miles, from Oakland, California, to Hawaii, to the Fiji Islands, and then to Australia, in June 1928.

most ghoulish grin, and his remark that sealed the agreement: "It's a deal, Burl. I'll furnish the plane and you fly the Atlantic—but, gee, I wouldn't tackle it for a million. Think of all that black water! Think how cold it is!"

And I had thought of both.

I had thought of both for a while, and then there had been other things to think about. I had moved to Elstree, half-hour's flight from the Percival Aircraft Works at Gravesend,[7] and almost daily for three months now I had flown down to the factory in a hired plane and watched the Vega Gull they were making for me. I had watched her birth and watched her growth. I had watched her wings take shape, and seen wood and fabric molded to her ribs to form her long, sleek belly, and I had seen her engine cradled into her frame, and made fast.

The Gull had a turquoise-blue body and silver wings. Edgar Percival had made her with care, with skill, and with worry—the care of a veteran flyer, the skill of a master designer, and the worry of a friend. Actually the plane was a standard sport model with a range of only six hundred and sixty miles. But she had a special undercarriage built to carry the weight of her extra oil and petrol tanks. The tanks were fixed into the wings, into the center section, and into the cabin itself. In the cabin they formed a wall around my seat, and each tank had a petcock[8] of its own. The petcocks were important.

"If you open one," said Percival, "without shutting the other first, you may get an airlock.[9] You know the tanks in the cabin have no gauges, so it may be best to let one run completely dry before opening the next. Your motor might go dead in the interval—but she'll start again. She's a De Havilland Gipsy—and Gipsys never stop."

I had talked to Tom.[10] We had spent hours going over the Atlantic chart, and I had realized that the tinker of Molo,[11] now one of England's great pilots, had traded his dreams and had got in return a better thing. Tom had grown older too; he had jettisoned a deadweight of irrelevant hopes and wonders, and had left himself a realistic code that had no room for temporizing or easy sentiment.

"I'm glad you're going to do it, Beryl. It won't be simple. If you can get off the ground in the first place, with such an immense load of fuel, you'll be alone in that plane about a night and a day—mostly night. Doing it east to west, the wind's against you. In September, so is the weather. You won't have a radio. If you misjudge your course only a few degrees, you'll end up in Labrador or in the sea—so don't misjudge anything."

Tom could still grin. He had grinned; he had said: "Anyway, it ought to amuse you to think that your financial backer lives on a farm called 'Place of Death' and your plane is being built at 'Gravesend'. If you were consistent, you'd christen the Gull 'The Flying Tombstone.'"

I hadn't been that consistent. I had watched the building of the plane and I had trained for the flight like an athlete. And now, as I lay in bed, fully awake, I could still hear the quiet voice of the man from the Air Ministry intoning, like the voice of the dispassionate court clerk: ". . . the weather for tonight and tomorrow . . . will be about the best you can expect." I should have liked to discuss the flight once more with Tom before I took off, but he was on a special job up north. I got out of bed and bathed and put on my flying clothes and took

7. **Gravesend** (grāvz′ĕnd′): a town east of London.
8. **petcock** (pĕt′kŏk′): a valve used to reduce pressure.
9. **airlock:** a bubble or pocket of air that stops the flow of fuel.

10. **Tom:** Tom Black, who taught the author to fly.
11. **tinker of Molo:** Tom had come from Molo.

some cold chicken packed in a cardboard box and flew over to the military field at Abingdon, where the Vega Gull waited for me under the care of the R.A.F.[12] I remember that the weather was clear and still.

Jim Mollison lent me his watch. He said: "This is not a gift. I wouldn't part with it for anything. It got me across the North Atlantic and the South Atlantic too. Don't lose it—and, for God's sake, don't get it wet. Salt water would ruin the works."

Brian Lewis gave me a lifesaving jacket. Brian owned the plane I had been using between Elstree and Gravesend, and he had thought a long time about a farewell gift. What could be more practical than a pneumatic jacket that could be inflated through a rubber tube?

"You could float around in it for days," said Brian. But I had to decide between the lifesaver and warm clothes. I couldn't have both, because of their bulk, and I hate the cold, so I left the jacket.

And Jock Cameron, Brian's mechanic, gave me a sprig of heather. If it had been a whole bush of heather, complete with roots growing in an earthen jar, I think I should have taken it, bulky or not. The blessing of Scotland, bestowed by a Scotsman, is not to be dismissed. Nor is the well-wishing of a ground mechanic to be taken lightly, for these men are the pilot's contact with reality.

It is too much that with all those pedestrian centuries behind us we should, in a few decades, have learned to fly; it is too heady a thought, too proud a boast. Only the dirt on a mechanic's hands, the straining vise, the splintered bolt of steel underfoot on the hangar floor—only these and such anxiety as the face of a Jock Cameron can hold for a pilot and his

plane before a flight, serve to remind us that, not unlike the heather, we too are earthbound. We fly, but we have not "conquered" the air. Nature presides in all her dignity, permitting us the study and the use of such of her forces as we may understand. It is when we presume to intimacy, having been granted only tolerance, that the harsh stick falls across our impudent knuckles and we rub the pain, staring upward, startled by our ignorance.

"Here is a sprig of heather," said Jock, and I took it and pinned it into a pocket of my flying jacket.

There were press cars parked outside the field at Abingdon, and several press planes and photographers, but the R.A.F. kept everyone away from the grounds except technicians and a few of my friends.

The Carberrys had sailed for New York a month ago to wait for me there. Tom was still out of reach with no knowledge of my decision to leave, but that didn't matter so much, I thought. It didn't matter because Tom was unchanging—neither a fair-weather pilot nor a fair-weather friend.[13] If for a month, or a year, or two years we sometimes had not seen each other, it still hadn't mattered. Nor did this. Tom would never say, "You should have let me know." He assumed that I had learned all that he had tried to teach me, and for my part, I thought of him, even then, as the merest student must think of his mentor. I could sit in a cabin overcrowded with petrol tanks and set my course for North America, but the knowledge of my hands on the controls would be Tom's knowledge. His words of caution and words of guidance, spoken so long ago, so many times, on bright mornings over the veldt or over a forest, or with a far mountain visible at the tip of our wing, would be spoken again, if I asked.

12. **R.A.F.:** Royal Air Force.

13. **fair-weather . . . friend:** dependable only when there is "fair weather," or no trouble.

So it didn't matter, I thought. It was silly to think about.

You can live a lifetime and, at the end of it, know more about other people than you know about yourself. You learn to watch other people, but you never watch yourself because you strive against loneliness. If you read a book, or shuffle a deck of cards, or care for a dog, you are avoiding yourself. The abhorrence of loneliness is as natural as wanting to live at all. If it were otherwise, men would never have bothered to make an alphabet, nor to have fashioned words out of what were only animal sounds, nor to have crossed continents—each man to see what the other looked like.

Being alone in an aeroplane for even so short a time as a night and a day, irrevocably alone, with nothing to observe but your instruments and your own hands in semi-darkness, nothing to contemplate but the size of your small courage, nothing to wonder about but the beliefs, the faces, and the hopes rooted in your mind—such an experience can be as startling as the first awareness of a stranger walking by your side at night. You are the stranger.

It is dark already and I am over the south of Ireland. There are the lights of Cork and the lights are wet; they are drenched in Irish rain, and I am above them and dry. I am above them and the plane roars in a sobbing world, but it imparts no sadness to me. I feel the security of solitude, the exhilaration of escape. So long as I can see the lights and imagine the people walking under them, I feel selfishly triumphant, as if I have eluded care and left even the small sorrow of rain in other hands.

It is a little over an hour now since I left Abingdon. England, Wales, and the Irish Sea are behind me like so much time used up. On a long flight distance and time are the same. But there had been a moment when Time stopped—and Distance too. It was the moment I lifted the blue-and-silver Gull from the aerodrome, the moment the photographers aimed their cameras, the moment I felt the craft refuse its burden and strain toward the earth in sullen rebellion, only to listen at last to the persuasion of stick and elevators, the dogmatic argument of blueprints that said she *had* to fly because the figures proved it.

So she had flown, and once airborne, once she had yielded to the sophistry[14] of a draftsman's board, she had said, "There: I have lifted the weight. Now, where are we bound?"—and the question had frightened me.

"We are bound for a place thirty-six hundred miles from here—two thousand miles of it unbroken ocean. Most of the way it will be night. We are flying west with the night."

So there behind me is Cork; and ahead of me is Berehaven Lighthouse. It is the last light, standing on the last land. I watch it, counting the frequency of its flashes—so many to the minute. Then I pass it and fly out to sea.

The fear is gone now—not overcome nor reasoned away. It is gone because something else has taken its place; the confidence and the trust, the inherent belief in the security of land underfoot—now this faith is transferred to my plane, because the land has vanished and there is no other tangible thing to fix upon. Flight is but momentary escape from the eternal custody of earth.

Rain continues to fall, and outside the cabin it is totally dark. My altimeter[15] says that the Atlantic is two thousand feet below me, my Sperry artificial horizon[16] says that I am flying level. I judge my drift at three degrees more than my weather chart suggests, and fly ac-

14. **sophistry** (sŏf′əs-trē): clever reasoning.
15. **altimeter** (ăl-tĭm′ə-tər): an instrument for measuring elevation.
16. **artificial horizon:** an instrument for measuring dipping and tilting movements of an airplane.

Course of Markham's flight, from *The New York Times*, September 6, 1936.

cordingly. I am flying blind. A beam to follow would help. So would a radio—but then, so would clear weather. The voice of the man at the Air Ministry had not promised storm.

I feel the wind rising and the rain falls hard. The smell of petrol in the cabin is so strong and the roar of the plane so loud that my senses are almost deadened. Gradually it becomes unthinkable that existence was ever otherwise.

At ten o'clock P.M. I am flying along the Great Circle Course for Harbour Grace, Newfoundland, into a forty-mile headwind at a speed of one hundred and thirty miles an hour. Because of the weather, I cannot be sure of how many more hours I have to fly, but I think it must be between sixteen and eighteen.

At ten-thirty I am still flying on the large cabin tank of petrol, hoping to use it up and put an end to the liquid swirl that has rocked the plane since my takeoff. The tank has no gauge, but written on its side is the assurance: "This tank is good for four hours."

There is nothing ambiguous about such a guaranty. I believe it, but at twenty-five minutes to eleven, my motor coughs and dies, and the Gull is powerless above the sea.

I realize that the heavy drone of the plane has been, until this moment, complete and comforting silence. It is the actual silence following the last splutter of the engine that stuns me. I can't feel any fear; I can't feel anything. I can only observe with a kind of stupid disinterest that my hands are violently active and know that, while they move, I am being hypnotized by the needle of my altimeter.

I suppose that the denial of natural impulse is what is meant by "keeping calm," but impulse has reason in it. If it is night and you are sitting in an aeroplane with a stalled motor, and there are two thousand feet between you and the sea, nothing can be more reasonable than the impulse to pull back your stick in the hope of adding to that two thousand, if only by a little. The thought, the knowledge, the law that tells you that your hope lies not in this, but in a

contrary act—the act of directing your impotent craft toward the water—seems a terrifying abandonment, not only of reason, but of sanity. Your mind and your heart reject it. It is your hands—your stranger's hands—that follow with unfeeling precision the letter of the law.

I sit there and watch my hands push forward on the stick and feel the Gull respond and begin its dive to the sea. Of course it is a simple thing; surely the cabin tank has run dry too soon. I need only to turn another petcock . . .

But it is dark in the cabin. It is easy to see the luminous dial of the altimeter and to note that my height is now eleven hundred feet, but it is not easy to see a petcock that is somewhere near the floor of the plane. A hand gropes and reappears with an electric torch, and fingers moving with agonizing composure, find the petcock and turn it; and I wait.

At three hundred feet the motor is still dead, and I am conscious that the needle of my altimeter seems to whirl like the spoke of a spindle winding up the remaining distance between the plane and the water. There is some lightning, but the quick flash only serves to emphasize the darkness. How high can waves reach—twenty feet, perhaps? Thirty?

It is impossible to avoid the thought that this is the end of my flight, but my reactions are not orthodox; the various incidents of my entire life do not run through my mind like a motion-picture film gone mad. I only feel that all this has happened before—and it has. It has all happened a hundred times in my mind, in my sleep, so that now I am not really caught in terror; I recognize a familiar scene, a familiar story with its climax dulled by too much telling.

I do not know how close to the waves I am when the motor explodes to life again. But the sound is almost meaningless. I see my hand easing back on the stick, and I feel the Gull climb up into the storm, and I see the altimeter whirl like a spindle again, paying out the distance between myself and the sea.

The storm is strong. It is comforting. It is like a friend shaking me and saying, "Wake up! You were only dreaming."

But soon I am thinking. By simple calculation I find that my motor had been silent for perhaps an instant more than thirty seconds.

I ought to thank God—and I do, though indirectly. I thank Geoffrey De Havilland who designed the indomitable Gipsy, and who, after all, must have been designed by God in the first place.

A lighted ship—the daybreak—some steep cliffs standing in the sea. The meaning of these will never change for pilots. If one day an ocean can be flown within an hour, if men can build a plane that so masters time, the sight of land will be no less welcome to the steersman of that fantastic craft. He will have cheated laws that the cunning of science has taught him how to cheat, and he will feel his guilt and be eager for the sanctuary of the soil.

I saw the ship and the daybreak, and then I saw the cliffs of Newfoundland wound in ribbons of fog. I felt the elation I had so long imagined, and I felt the happy guilt of having circumvented the stern authority of the weather and the sea. But mine was a minor triumph; my swift Gull was not so swift as to have escaped unnoticed. The night and the storm had caught her and we had flown blind for nineteen hours.

I was tired now, and cold. Ice began to film the glass of the cabin windows and the fog played a magician's game with the land. But the land was there. I could not see it, but I had seen it. I could not afford to believe that it was any land but the land I wanted. I could not afford to believe that my navigation was at fault, because there was no time for doubt.

South to Cape Race, west to Sydney on Cape Breton Island. With my protractor,[17] my map, and my compass, I set my new course, humming the ditty that Tom had taught me: "Variation West—magnetic best. Variation East—magnetic least." A silly rhyme, but it served to placate, for the moment, two warring poles[18]—the magnetic and the true. I flew south and found the lighthouse of Cape Race protruding from the fog like a warning finger. I circled twice and went on over the Gulf of Saint Lawrence.

After a while there would be New Brunswick, and then Maine—and then New York. I could anticipate. I could almost say, "Well, if you stay awake, you'll find it's only a matter of time now"—but there was no question of staying awake. I was tired and I had not moved an inch since that uncertain moment at Abingdon when the Gull had elected to rise with her load and fly, but I could not have closed my eyes. I could sit there in the cabin, walled in glass and petrol tanks, and be grateful for the sun and the light, and the fact that I could see the water under me. They were almost the last waves I had to pass. Four hundred miles of water, but then the land again—Cape Breton. I would stop at Sydney to refuel and go on. It was easy now. It would be like stopping at Kisumu and going on.

Success breeds confidence. But who has a right to confidence except the gods? I had a following wind, my last tank of petrol was more than three-quarters full, and the world was as bright to me as if it were a new world, never touched. If I had been wiser, I might have known that such moments are, like innocence, short-lived. My engine began to

shudder before I saw the land. It died, it spluttered, it started again and limped along. It coughed and spat black exhaust toward the sea.

There are words for everything. There was a word for this—airlock, I thought. This had to be an airlock because there was petrol enough. I thought I might clear it by turning on and turning off all the empty tanks, and so I did that. The handles of the petcocks were sharp little pins of metal, and when I had opened and closed them a dozen times, I saw that my hands were bleeding and that the blood was dropping on my maps and on my clothes, but the effort wasn't any good. I coasted along on a sick and halting engine. The oil pressure and the oil temperature gauges were normal, the magnetos[19] working, and yet I lost altitude slowly while the realization of failure seeped into my heart. If I made the land, I should have been the first to fly the North Atlantic from England, but from my point of view, from a pilot's point of view, a forced landing was failure because New York was my goal. If only I could land and then take off, I would make it still . . . if only, if only . . .

The engine cuts again, and then catches, and each time it spurts to life I climb as high as I can get, and then it splutters and stops and I glide once more toward the water, to rise again and descend again, like a hunting sea bird.

I find the land. Visibility is perfect now and I see land forty or fifty miles ahead. If I am on my course, that will be Cape Breton. Minute after minute goes by. The minutes almost materialize; they pass before my eyes like links in a long slow-moving chain, and each time the engine cuts, I see a broken link in the chain and catch my breath until it passes.

The land is under me. I snatch my map and

17. **protractor:** an instrument for measuring angles.
18. **poles:** There are two "norths"; the magnetic north where the compass is pointing (and which is influenced by local metallic deposits) and the true geographic north, which is constant.

19. **magnetos** (măg-nē′tōz): small generators used in engines.

stare at it to confirm my whereabouts. I am, even at my present crippled speed, only twelve minutes from Sydney Airport, where I can land for repairs and then go on.

The engine cuts once more and I begin to glide, but now I am not worried; she will start again, as she has done, and I will gain altitude and fly into Sydney.

But she doesn't start. This time she's dead as death; the Gull settles earthward and it isn't any earth I know. It is black earth stuck with boulders and I hang above it, on hope and on a motionless propeller. Only I cannot hang above it long. The earth hurries to meet me, I bank,[20] turn, and side slip to dodge the boulders, my wheels touch, and I feel them submerge. The nose of the plane is engulfed in

20. **bank:** tilt the plane sideways.

mud, and I go forward striking my head on the glass of the cabin front, hearing it shatter, feeling blood pour over my face.

I stumble out of the plane and sink to my knees in muck and stand there foolishly staring, not at the lifeless land, but at my watch.

Twenty-one hours and twenty-five minutes.

Atlantic flight. Abingdon, England, to a nameless swamp—nonstop.

A Cape Breton Islander found me—a fisherman trudging over the bog saw the Gull with her tail in the air and her nose buried, and then he saw me floundering in the embracing soil of his native land. I had been wandering for an hour and the black mud had got up to my waist and the blood from the cut in my head had met the mud halfway.

The Vega Gull after Markham's crash at Cape Breton.

From a distance, the fisherman directed me with his arms and with shouts toward the firm places in the bog, and for another hour I walked on them and came toward him like a citizen of Hades[21] blinded by the sun, but it wasn't the sun; I hadn't slept for forty hours.

He took me to his hut on the edge of the coast and I found that built upon the rocks there was a little cubicle that housed an ancient telephone—put there in case of ship wrecks.

I telephoned to Sydney Airport to say that I was safe and to prevent a needless search being made. On the following morning I did step out of a plane at Floyd Bennett Field and there was a crowd of people still waiting there to greet me, but the plane I stepped from was not the Gull, and for days while I was in New York I kept thinking about that and wishing over and over again that it had been the Gull, until the wish lost its significance, and time moved on, overcoming many things it met on the way.

21. **Hades** (hā′dēz): in Greek mythology, the world below the earth, always in darkness.

Reading Check

1. Where did the idea for Beryl Markham's flight first come up?
2. What kind of plane was built for the flight?
3. What provision was made to give the Vega Gull a greater flying range?
4. Why did Markham leave the life-saving jacket behind?
5. What did the mechanic give her for luck?
6. What was Markham's intended destination?
7. When the first gas tank ran dry, why did she have difficulty finding the petcock?
8. What land did she see at daybreak?
9. Why was she forced to land at Cape Breton?
10. How many hours did she spend in the air?

For Study and Discussion

Analyzing and Interpreting the Selection

1. In this account of her solo transatlantic flight, Markham reveals that she made a number of important choices. **a.** List the choices she made and the consequences of each one. **b.** What does this list of decisions reveal about her character? **c.** Why did she risk her life to make the flight?

2a. Explain how the Vega Gull was adapted for the transatlantic flight. **b.** What were the dangers in this adaptation? **c.** Describe some of the other dangers Markham knew were part of the night flight.

3. What important background information is supplied by Markham's flashbacks?

4. Markham tells us that the total flying distance from Abingdon, England, to New York is 3,600 miles. Using the information on the map which appears on page 332, tell how far she had gone before crashing.

5. On page 330, Markham writes, "We fly, but we have not 'conquered' the air. Nature presides in all her dignity, permitting us the study and the use of such of her forces as we may understand." **a.** How is her view of flying borne out by the experience of her flight? **b.** Do you think her statement is relevant today?

Language and Vocabulary

Recognizing Specific Words

To re-create her struggle in "flying blind," Beryl Markham chooses specific words to convey exactly what she hears. For example, the first time the plane's engine stops, she hears it "cough," then misses its "drone," and finally hears it give a "last splutter." What is the exact meaning of each of these words? Later in the narrative, when the engine fails again, she

Headlines from *The New York Times*, September 6–7, 1936.

West with the Night **337**

writes, "My engine began to shudder before I saw the land" (page 334). Find three more words that Markham uses to describe what she heard when the engine died. How does each word help to re-create what she experienced?

Writing About Literature

Explaining the Use of Flashback

One of a writer's privileges is to reorder time, to rearrange events by using a technique called **flashback.** A flashback is a section of narrative that interrupts the action in the present to tell about events that happened earlier. In using this device in her narrative, Markham provides the reader with an insight into her present plans by showing what happened in the past. Flashbacks let the reader discover the link between past actions and present actions.

In a brief essay discuss how Beryl Markham uses the technique of flashback in her narrative. What important information does she give the reader about earlier events in her life? How do these flashbacks also serve to reveal her character?

About the Author

Beryl Markham (1902–1986)

In 1904 English-born Beryl Markham was taken by her father to East Africa, where he hoped to establish a farm in the wilderness. Beryl spent her childhood playing with native Murani children, learning to hunt wild animals and watching her father build a farm and a horse-training business "out of labor and out of patience." In her autobiography, *West with the Night,* Markham retells the adventures of her childhood, which included a narrow escape from a lion attack and an unsuccessful attempt to rescue her dog from a wild boar's anger. The stories of her apprenticeship as a horse trainer make up the middle part of the book. When she was thirty, Tom Black, one of the first commercial pilots in Africa, offered to teach her how to fly. Like other pilots at this time, she learned to fly without radios, radar, or the paved runways of more civilized airports. She became a licensed bush pilot and in her book recounts stories of the rescues, dangers, and discoveries that were part of her job. After reading her book, Ernest Hemingway said that she "can write rings around all of us who consider ourselves as writers."

FROM
Aké

WOLE SOYINKA°

In his autobiography, Aké: The Years of Childhood, *Soyinka recalls not only the small town in Nigeria where he grew up but also his family, friends, and first years of school with the imagination and creativity of a poet and dramatist. In this selection, which is Chapter 2 of the autobiography, he recreates for us a child's view of such events as the first day of school, a birthday party, and an accident. In reading this selection, look for clues that help you understand the point of view of a very young child responding to happenings important to him. What types of experiences are mysterious to him? How does he apply what he has learned to new situations? How does Wole discover whom he can trust?*

Every morning before I woke up, Tinu[1] was gone. She returned about midday carrying a slate with its marker attached to it. And she was dressed in the same khaki uniform as the hordes of children, of different sizes, who milled around the compound from morning till afternoon, occupied in a hundred ways.

At a set hour in the morning one of the bigger ones seized the chain which dangled from the bellhouse, tugged at it with a motion which gave the appearance of a dance and the bell began pealing. Instantly, the various jostling, tumbling, racing and fighting pupils rushed in different directions around the school buildings, the smaller in size towards the schoolroom at the further end of the compound where I could no longer see them. The bigger pupils remained within sight, near the main building. They split into several groups, each group lined up under the watchful eye of a teacher. When all was orderly, I saw father[2] appear from nowhere at the top of the steps. He made a speech to the assembly, then stood aside. One member of the very biggest group stepped forward and raised a song. The others took it up and they marched into the school building in twos, in the rhythm of the song.

The song changed every day, chosen from the constant group of five or six. That I came to have a favorite among them was because this was the same one which they sang with more zest than others. I noticed that on the days when it was the turn of this tune, they

° **Wole Soyinka** (wōl soi-ĭn′kə).
1. **Tinu:** Wole's older sister.

2. **father:** Wolc's father, also called Essay, is headmaster of the school.

The Compound at Aké.

danced rather than marched. Even the teachers seemed affected, they had an indulgent smile on their faces and would even point out a pupil who on a certain charged beat in the tune would dip his shoulders in a most curious way, yet march without breaking the rhythm. It was an unusual song too, since the main song was in English but the chorus was sung in Yoruba;[3] I could only catch the words of the latter:

> B'ina njo ma je'ko
> B'ole nja, ma je'ko
> Eni ebi npa, omo wi ti're[4]

I never heard any such lively singing from the other school, indeed that group simply vanished from sight, yet this was where my sister went. I never saw her anywhere among the marching group; in any case, there was nobody her size in that section. My curiosity grew every day. She sensed this and played on it, refusing to answer my questions or else throwing off incomplete fragments which only fed my curiosity.

"I am going to school," I announced one day. It became a joke to be passed from mouth to mouth, producing instant guffaws. Mother appeasingly said, "Wait till you are as old as your sister."

The hum of voices, once the pupils were within the buildings, took mysterious overtones. Through the open windows of the schoolroom I saw heads in concentration, the majestic figure of a teacher who passed in and out of vision, mumbling incantations over the heads of his attentive audience. Different

3. **Yoruba** (yō′rō̄o-bä): a language spoken by the people in southwestern Nigeria.
4. **B'ina . . . ti're:** These lines are translated
If the house is on fire, I must eat
If the house is being robbed, I must eat
The child who is hungry, let him speak.

chants broke out from different parts of each building, sometimes there was even direct singing, accompanied by a harmonium. When the indoor rites were over, they came out in different groups, played games, ran races, they spread over the compound picking up litter, sweeping the paths, clipping lawns and weeding flower beds. They roamed about with hoes, cutlasses, brooms and sticks, retired into open workshop sheds where they wove baskets, carved bits of wood and bamboo, kneaded clay and transformed them into odd-shaped objects.

Under the anxious eyes of "Auntie" Lawanle, I played by myself on the pavement of our house and observed these varied activities. The tools of the open air were again transformed into books, exercise books, slates, books under armpits, in little tin or wooden boxes, books in raffia bags, tied together with string and carried on the head, slung over shoulders in cloth pouches. Directly in front of our home was the lawn which was used exclusively by girls from the other school. They formed circles, chased one another in and out of the circles, struggled for a ball and tossed it through an iron hoop stuck on a board. Then they also vanished into classrooms, books were produced and they commenced their own observances of the mystery rites.[5]

Tinu became even more smug. My erstwhile playmate had entered a new world and, though we still played together, she now had a new terrain to draw upon. Every morning she was woken earlier than I, scrubbed, fed and led to school by one of the older children of the house. My toys and games soon palled but the laughter still rankled, so I no longer demanded that I join Tinu in school.

Instead, I got up one morning as she was

5. **mystery rites:** secret ceremonies, such as those practiced by ancient religious cults, here used figuratively.

being woken up, demanded my bath at the same time, ate, selected the clothing which I thought came closest to the uniforms I had seen, and insisted on being dressed in them. I had marked down a number of books on father's table but did not yet remove them. I waited in the front room. When Tinu passed through with her escort, I let them leave the house, waited a few moments, then seized the books I had earlier selected and followed them. Both parents were still in the dining room. I followed at a discreet distance, so I was not noticed until we arrived at the infant school. I waited at the door, watched where Tinu was seated, then went and climbed on to the bench beside her.

Only then did Lawanle, Tinu's escort that day, see me. She let out a cry of alarm and asked me what I thought I was doing. I ignored her. The teachers heard the commotion and came into the room. I appeared to be everybody's object of fun. They looked at me, pointed and they held their sides, rocked forwards and backwards with laughter. A man who appeared to be in charge of the infant section next came in, he was also our father's friend and came often to the house. I recognized him, and I was pleased that he was not laughing with the others. Instead he stood in front of me and asked,

"Have you come to keep your sister company?"

"No. I have come to school."

Then he looked down at the books I had plucked from father's table.

"Aren't these your father's books?"

"Yes. I want to learn them."

"But you are not old enough, Wole."

"I am three years old."

Lawanle cut in, "Three years old *wo*? Don't mind him sir, he won't be three until July."

"I am nearly three. Anyway, I have come to school. I have books."

He turned to the class teacher and said, "Enter his name in the register." He then turned to me and said, "Of course you needn't come to school every day—come only when you feel like it. You may wake up tomorrow morning and feel that you would prefer to play at home. . . ."

I looked at him in some astonishment. Not feel like coming to school! The colored maps, pictures and other hangings on the walls, the colored counters, markers, slates, inkwells in neat round holes, crayons and drawing books, a shelf laden with modeled objects—animals, human beings, implements—raffia and basketwork in various stages of completion, even the blackboards, chalk and duster. . . . I had yet to see a more inviting playroom! In addition, I had made some vague, intuitive connection between school and the piles of books with which my father appeared to commune so religiously in the front room, and which had constantly to be snatched from me as soon as my hands grew long enough to reach them on the table.

"I shall come every day" I confidently declared.

Mr. Olagbaju's bachelor house behind the school became a second lunch-hour home. His favorite food appeared to be the pounded yam, *iyan,* at which I soon became his keen accomplice. Through the same *iyan,* I made my first close school friend, Osiki, simply by

Ibo school north of Port Harcourt, Nigeria.

discovering that he was an even more ardent lover of the pounded yam than either Mr. Olagbaju or I. It seemed a simple matter of course that I should take him home or to Mr. Olagbaju's whenever the meal was *iyan;* moreover, Mr. Olagbaju was also teaching me to play *ayo,*[6] and this required a partner to play with. It was with some surprise that I heard my mother remark:

"This one is going to be like his father. He brings home friends at mealtimes without any notice."

I saw nothing to remark in it at all; it was the most natural thing in the world to bring a friend home at his favorite mealtime. So Osiki became an inseparable companion and a regular feature of the house, especially on *iyan* days. One of the house helps composed a song on him:

> Osiki oko oniyan
> A ti nwa e, a ko ri e[7]

which she began singing as soon as we appeared, hand in hand, on the path leading from the school. But the pounded yam was also to provide the first test of our friendship.

There were far too many aspects of the schoolroom and the compound to absorb in the regular school hours, moreover, an empty schoolroom appeared to acquire a totally different character which changed from day to day. And so, new discoveries began to keep me behind at lunchtime after everyone had gone. I began to stay longer and longer, pausing over objects which became endowed with new meanings, forms, even dimensions as soon as silence descended on their environment. Sometimes I simply wandered off among the rocks intending merely to climb a challenging

surface when no one was around. Finally, Osiki lost patience. He would usually wait for me at home even while Tinu had her own food. On this day however, being perhaps more hungry than usual, Osiki decided not to wait. Afterwards he tried to explain that he had only meant to eat half of the food but had been unable to stop himself. I returned home to encounter empty dishes and was just in time to see Osiki disappearing behind the croton bush in the backyard, meaning no doubt to escape through the rear gate. I rushed through the parlor and the front room, empty dishes in hand, hid behind the door until he came past, then pelted him with the dishes. A chase followed, with Osiki instantly in front by almost the full length of the school compound while I followed doggedly, inconsolable at the sight of the increasing gap, yet unable to make my legs emulate Osiki's pace.

Finally, I stopped. I no longer saw Osiki but—Speed, Swiftness! I had not given any thought before then to the phenomenon of human swiftness and Osiki's passage through the compound seemed little short of the magical. The effect of his *dansiki*[8] which flowed like wings from his sides also added to the illusion of him flying over the ground. This, more than anything else, made it easy enough for the quarrel to be settled by my mother. It was very difficult to cut oneself off from a school friend who could fly at will from one end of the compound to the other. Even so, some weeks elapsed before he returned to the pounded-yam table, only to follow up his perfidy by putting me out of school for the first time in my career.

There was a birthday party for one of the Canon's[9] children. Only the children of the parsonage were expected but I passed the secret to Osiki and he turned up at the party in

6. *ayo:* a game played on a wooden board with dug-out holes, and seeds.
7. **Osiki . . . ri e:** These lines are translated
Osiki, lord of the pounded-yam seller
we have sought you everywhere but failed to find you.

8. *dansiki:* a long, loose-fitting shirt open at the sides.
9. **Canon:** a clergyman.

his best *buba*.[10] The entertainments had been set up out of doors in front of the house. I noticed that one of the benches was not properly placed, so that it acted like a seesaw when we sat on it close to the two ends. It was an obvious idea for a game, so, with the help of some of the other children, we carried it to an even more uneven ground, rested its middle leg on a low rock outcrop and turned it into a proper seesaw. We all took turns to ride on it.

For a long time it all went without mishap. Then Osiki got carried away. He was a bigger boy than I, so that I had to exert a lot of energy to raise him up, lifting myself on both hands and landing with all possible weight on my seat. Suddenly, while he was up in his turn, it entered his head to do the same. The result was that I was catapulted up very sharply while he landed with such force that the leg of the bench broke on his side. I was flung in the air, sailed over his head and saw, for one long moment, the Canon's square residence rushing out to meet me.

It was only after I had landed that I took much notice of what I had worn to the party. It was a yellow silk *dansiki,* and I now saw with some surprise that it had turned a bright crimson, though not yet entirely. But the remaining yellow was rapidly taking on the new color. My hair on the left side was matted with blood and dirt and, just before the afternoon was shut out and I fell asleep, I wondered if it was going to be possible to squeeze the blood out of the *dansiki* and pump it back through the gash which I had located beneath my hair.

The house was still and quiet when I woke up. One moment there had been the noise, the shouts and laughter and the bumpy ride of the seesaw, now silence and semidarkness and the familiar walls of mother's bedroom. Despite mishaps, I reflected that there was something

10. *buba:* a shirt with tailored sleeves.

to be said for birthdays and began to look forward to mine. My only worry now was whether I would have recovered sufficiently to go to school and invite all my friends. Sending Tinu seemed a risky business, she might choose to invite all her friends and pack my birthday with girls I hardly even knew or played with. Then there was another worry. I had noticed that some of the pupils had been kept back in my earlier class and were still going through the same lessons as we had all learned during my first year in school. I developed a fear that if I remained too long at home, I would also be sent back to join them. When I thought again of all the blood I had lost, it seemed to me that I might actually be bedridden for the rest of the year. Everything depended on whether or not the blood on my *dansiki* had been saved up and restored to my head. I raised it now and turned towards the mirror; it was difficult to tell because of the heavy bandage but, I felt quite certain that my head had not shrunk to any alarming degree.

The bedroom door opened and mother peeped in. Seeing me awake she entered, and was followed in by father. When I asked for Osiki, she gave me a peculiar look and turned to say something to father. I was not too sure, but it sounded as if she wanted father to tell Osiki that killing me was not going to guarantee him my share of *iyan.* I studied their faces intently as they asked me how I felt, if I had a headache or a fever and if I would like some tea. Neither would touch on the crucial question, so finally I decided to put an end to my suspense. I asked them what they had done with my *dansiki.*

"It's going to be washed," mother said, and began to crush a half-tablet in a spoon for me to take.

"What did you do with the blood?"

She stopped, they looked at each other.

Father frowned a little and reached forward to place his hand on my forehead. I shook my head anxiously, ignoring the throb of pain this provoked.

"Have you washed it away?" I persisted.

Again they looked at each other. Mother seemed about to speak but fell silent as my father raised his hand and sat on the bed, close to my head. Keeping his eyes on me he drew out a long, "No-o-o-o-o."

I sank back in relief. "Because, you see, you mustn't. It wouldn't matter if I had merely cut my hand or stubbed my toe or something like that—not much blood comes out when that happens. But I saw this one, it was too much. And it comes from my head. So you must squeeze it out and pump it back into my head. That way I can go back to school at once."

My father nodded agreement, smiling. "How did you know that was the right thing to do?"

I looked at him in some surprise, "But everybody knows."

Then he wagged his finger at me, "Ah-ha, but what you don't know is that we have already done it. It's all back in there, while you were asleep. I used Dipo's[11] feeding-bottle to pour it back."

I was satisfied. "I'll be ready for school tomorrow" I announced.

I was kept home another three days. I resumed classes with my head still swathed in a bandage and proceeded to inform my favorite classmates that the next important event in the parsonage was going to be my birthday, still some months away. Birthdays were not new. I had shared one with Tinu the previous year and even little Dipo had had his first year of existence confirmed a few weeks before the fateful one at the Canon's house. But now, with the daily dressing of my head prolonging the

aura of the last, the Birthday acquired a new status, a special and personal significance which I assumed was recognized by everyone. Indeed I thought that this was a routine knowledge into which one entered in the normal way of growing up. Understanding the functioning of the calendar became part of the order of birthdays and I dutifully watched Essay cancel one date after the other on the IBUKUN OLU STORES 1938 Almanac alias The Blessed Jacob, the alias of which was printed, for some reason, in a slanting form, rather like my father's handwriting.

All was ready on the thirteenth of July. I headed home after school with about a dozen of the favored friends, led by Osiki. They all stacked their slates in the front room and took over the parlor. On the faces of the guests, everyone on his best behavior, was a keen anticipation of food and drinks, of some music from the gramophone and games and excitement. Now that they were home, I became a little uncertain of my role as celebrant and host; still, I took my place among the others and awaited the parade of good things.

We had settled down for a while before I noticed the silence of the house. Essay was still at school, mother was obviously at her shop with Dipo who would probably be strapped to the back of Auntie Lawanle. But where were the others? Come to think of it I had expected mother to be home to welcome my friends even if she had to go back to the shop to attend to her customers. It occurred to me also that Tinu had not come home at all, perhaps she went straight to the shop—she was considered old enough by now to do this on her own. That looked promising; any moment now I expected our mother to rush through the doors, making up for the delay with all sorts of unexpected delights.

I went out to the backyard, expecting to find at least one of our cousins or detect signs of

11. **Dipo:** the youngest child.

preparations for the Birthday. There was nobody. The kitchen was empty and there was no aroma from recent cooking. I called out, announcing that I was home with guests and where was everybody? Really puzzled now, I returned to the dining room, inspected the cupboards, the table—beyond the usual items there was nothing at all, no jars of *chin-chin*, no *akara*, no glasses or mugs obviously set aside, no pancakes, jollof rice . . . there was simply nothing out of the ordinary. This was not how Birthdays normally behaved but, there did not seem to be any cause for alarm. I checked the date on Ibukun Olu Stores once more, satisfied myself that there was no mistake, then settled down with my guests to wait for Birthday to happen.

My mother rushed in long afterwards, Dipo strapped to her back, Auntie Lawanle and others following, carrying the usual assorted items which accompanied them to the shop every morning. This was impressive because it meant that the shop had been closed for the day and it was still early afternoon—obviously Birthday was really about to happen in earnest. But she came in shaking her head and casting up her eyes in a rather strange manner. She stopped in the parlor, took a long look at my friends, looked at me again, shook her head repeatedly and passed through to the kitchen from where I heard her giving rapid orders to the welcome ring of pots and pans and the creak of the kitchen door. I nodded with satisfaction to the guests and assured them.

"The Birthday is beginning to come."

A moment later Tinu came in to say I was wanted by mother in the kitchen. I found her with her arms elbow deep in flour which she was kneading as if possessed. Without taking her eye off the dough she began.

"Now Wole, tell me, what have your friends come for?"

It was a strange question but I replied,

"We've come to eat Birthday."

"You came to eat Birthday" she repeated. For some reason, Lawanle and the others had already burst out laughing. Mother continued, "Do you realize that you and your friends would still be sitting in that parlor, waiting to 'eat your birthday' if Tinu hadn't come and told me?"

"But today is my birthday" I pointed out to her.

Patiently she explained, "No one is denying that. I had planned to cook something special tonight but . . . look, you just don't invite people home without letting us know. How was I to know you were bringing friends? Now look at us rushing around, your friends have been sitting there, nearly starving to death, and you say you've brought them to eat birthday. You see, you have to let people know. . . ."

The Birthday proved to be all that was expected once it had got over the one disappointing limitation—Birthday did not just happen but needed to be reminded to happen. That aspect of its character bothered me for a while, it was a shortcoming for which I tried to find excuses, without success. The Birthday lost a lot in stature after this, almost as if it had slid down from the raised end of that fateful seesaw to the lower end and landed in a heap, among other humdrum incidents in the parsonage. Still, it had added the calendar to my repertoire of knowledge. When it came to my turn to entertain the gathering, I sang:

> Ogbon'jo ni September
> April, June ati November
> February ni meji din l'ogbon
> Awon iyoku le okan l'ogbon*

The others took it up, Osiki supplying a ko-ko-ti-ko-ko . . . ko-ko-ti-ko-ko beat on the table so fluently that my mother asked him jokingly if he had been drumming for the masqueraders. To everybody's surprise he said, Yes.

* See page 351.

Large group of *egúngún* preparing to perform in front of the king's palace during the annual festival.

Their *agbole*,[12] he revealed, even possessed its own mask which paraded the town with others at the yearly festival of the *egúngún*. When Osiki promised to lead their *egúngún* on a visit to our house at the next festival, I could not help feeling that the Birthday had more than made up for its earlier shortcoming. I had watched them before over the wall of the backyard, seated on Joseph's shoulders. I knew that the *egúngún* were spirits of the dead. They spoke in guttural voices and were to be feared even more than kidnappers. And yet I had noticed that many of them were also playful and would joke with children. I had very nearly been startled off Joseph's shoulders once when one of them passed directly beneath the wall, looked up and waved, calling out in the familiar throaty manner,

"Nle o, omo Tisa Agba."[13]

But Joseph explained that it was only natural that the dead should know all about the living ones. After all, they once lived like us and that friendly one might even have been in the compound before. Now, discovering that Osiki had an *egúngún* which emerged from their compound every year was almost the same as if we

12. *agbole:* family compound.

13. **Nle . . . Agba:** Greetings, son of the Senior Teacher.

Aké **347**

also had one of our own. We crowded round him and I asked if he knew which of his dead ancestors it was.

He shook his head. "I only know it is one of our ancient people."

"Are you actually there when he emerges from the bottom of the earth?"

He nodded yes. "Any of us can watch. As long as you are male of course. Women mustn't come near."

"Then you must come and call me the next time" I said. "I want to watch."

"You want to what?" It was mother, her voice raised in alarm. "Did I hear you say you want to go and watch *egúngún* in his compound?"

"Osiki will take me" I said.

"Osiki is taking you nowhere. Better not even let your father hear you."

"Why not?" I said, "he can come too. Osiki, we can take him can't we? He is not like Mama, he is a man too."

My mother gave a sigh, shook her head and left us to listen to Osiki's tales of the different kinds of *egúngún*, the dangerous ones with bad charms who could strike a man with epilepsy and worse, the violent ones who had to be restrained with powerful ropes, the *opidan* with their magical tricks. They would transform themselves into alligators, snakes, tigers and rams and turn back again into *egúngún*. Then there were the acrobats—I had seen those myself over the wall, performing in a circle of spectators near the cenotaph.[14] They did forward and backward somersaults, doubled up their limbs in the strangest manner, squeezed their lower trunks into mortars and then bounced up and down in the mortar along short distances as if they were doing a mortar race. Apart from Giro, the crippled contortionist to whose performance we had once been taken in the palace compound, only these

14. **cenotaph** (sĕn′ə-tăf′, -täf′): a monument for a dead person who is buried somewhere else.

egúngún appeared to be able to tie up their limbs in any manner they pleased.

"Can I come back as an *egúngún* if I die?" I asked Osiki.

"I don't think so" he said. "I've never heard of any Christian becoming an *egúngún*."

"Do they speak English in the *egúngún* world?" I now wanted to know.

Osiki shrugged. "I don't know. Our own *egúngún* doesn't speak English."

It seemed important to find out. The stained-glass windows behind the altar of St. Peter's church displayed the figures of three white men, dressed in robes which were very clearly *egúngún* robes. Their faces were exposed, which was very unlike our own *egúngún*, but I felt that this was something peculiar to the country from which those white people came. After all, Osiki had explained that there were many different kinds of *egúngún*. I sought his opinion on the three figures only to have Tinu interrupt.

"They are not *egúngún*" she said, "those are pictures of two missionaries and one of St. Peter himself."

"Then why are they wearing dresses like *egúngún*?"

"They are Christians, not masqueraders. Just let Mama hear you."

"They are dead aren't they? They've become *egúngún*, that is why they are wearing those robes. Let's ask Osiki."

Osiki continued to look uncertain. "I still haven't heard of any Christian becoming *egúngún*. I've never heard of it." Then he suddenly brightened. "Wait a minute, I've just remembered. My father told me that some years ago, they carried the *egúngún* of an *ajele*, you know, the District Officer who was here before."

I rounded on Tinu triumphantly. "You see. Now I can speak to those *egúngún* in the church window whenever they come. I am sure they only speak English."

"You don't know what you are talking about. You are just a child." She turned scornfully away and left us alone.

"Don't mind her" I told Osiki. "She knows I've always liked the one in the middle, the St. Peter. I've told her before that he is my special egúngún. If I come first to your compound, perhaps we can go next to the church cemetery and make him come out of the ground in the same way."

"With his face bared like that?" Osiki sounded scandalized.

(Left) Egúngún who have changed their shapes into animals—a hyena and a civet cat; (right) Hunter's egúngún with a carving of a hunter's head surrounded by carvings of monkey and hornbill skulls; (below) egúngún who has changed into a tiger.

"Of course not" I assured him. "That is only his picture. When he comes out of the ground he will be properly dressed. And I'll be able to talk to him."

Osiki looked troubled. "I don't know. I don't really know if he will be a real *egúngún*."

"But you've just said that the *egúngún* of the District Officer came out in procession before."

"It is not the same thing. . . ." Osiki tried to explain, but finally admitted that he did not really understand. Somehow, it was not going to be possible but, why it should be that way, he didn't know. I reminded him that the District Officer was both white and Christian, that St. Peter's had the advantage because he was near a cemetery. In addition, anyone with eyes could see that he was already in his *egúngún* robes, which meant that he had joined in such festivals before. Osiki continued to be undecided, to my intense disappointment. Without his experience, I did not even know how to begin to bring out *egúngún* St. Peter without whom, from then on, the parade of ancestral masquerades at Aké would always seem incomplete.

When I again lay bleeding on the lawns of the infant school, barely a year later, I tried to see myself as a one-eyed masquerade, led by Osiki along the paths of the parsonage to visit my old home and surprise Tinu and Dipo by calling out their names. The accident occurred during a grass-cutting session by the bigger boys. The rest of us simply played around the school grounds or went home for the rest of the day. Osiki should have been cutting grass with the others but he had become my unofficial guardian, taking me home or to Mr. Olagbaju's house after school or fetching me from home, as if I had not walked to school all by myself nearly two years before. On that afternoon we were playing together, he chasing me round and round the infant school building. I was already developing a sense of

speed, nothing to match his, but could dodge faster than he could run whenever his arms reached out to grab me. I had just rounded the corner of the schoolroom when I saw, through the corner of my eye, the upward flash of a blade. Beneath it was a crouching form, its back turned towards me. That was all I had time to see. The next instant I felt the blade bite deep into the corner of my eye, the day was blotted out in a flush of redness and I collapsed forward on my face, blinded. I heard screams from everywhere. When I rolled over and put my hands to my face they were instantly drenched in the same warm thick flood which had accompanied my somersault in the Canon's garden.

I lay still, unaware of any pain. My only thought was that if I did not remain like that, on my back, my eye would fall out on to the ground. Then I thought perhaps I would actually die this time; since I had obviously lost an eye, I tried to recall if I had ever seen a one-eyed masquerade among the *egúngún* whom we watched over the wall. There were sounds of heavier feet running towards me. I recognized the voices of teachers, felt myself raised up and carried into the schoolroom, then laid on a table. I heard Mr. Olagbaju send someone to fetch my father.

Through the noise and confusion I gathered that I had run straight into the upward stroke of a cutlass wielded by a pupil who was busy cutting grass, his back turned to me. I heard the confused boy calling on God to save him from the stigma of becoming a murderer in his lifetime. One of the teachers told him to shut up and eventually pushed him out. When I heard my father's voice, it occurred to me to open the undamaged eye—I had not, until then, acted on the fact that I was only hit in one eye, not both. Wiping the blood from the left eye, I blinked it open. Standing round the table was a semicircle of teachers, looking at

me as if I was already a masquerade, the *opidan* type, about to transform himself into something else. I touched myself to ensure that this had not already happened, so strangely watchful were all the pairs of eyes.

"How did it happen?" my father demanded even as he examined the wound. A babble of voices rose in explanation.

I asked him, "Am I blind?"

Everyone shouted at once, "Keep still, Wole. Don't move!"

I repeated my question, feeling now that I was not dying but wondering if I would be obliged to become a beggar like those blind men who sometimes came into the parsonage, led by a small child, sometimes no bigger than I. It occurred to me then that I had never seen a small child leading a blind child.

Someone asked, "Where is that Osiki?"

But Osiki was gone. Osiki, when I was struck down, had simply continued running in the direction which he was facing at the time. He ran, I was sure, at a speed which surpassed even his usual phenomenal swiftness. Some of the bigger boys had tried to catch him—why, I did not know—but Osiki outstripped them running lean and light in the wind. I could see him, and the sight brought a smile to my face. It also made me open the injured eye and, to my surprise, I could see with it. There were loud gasps from the anxious faces who now crowded closer to see for themselves. The skin was split right into the corner of the eye but the eyeball itself was unscathed. Even the bleeding appeared to have stopped. I heard one teacher breathe "Impossible!" while another shouted, "Olorun ku ise!"[15] My father simply stood back and stared, his mouth agape in disbelief.

And then I felt very tired, a mist appeared to cover my eyes, and I fell asleep.

15. **Olorun ku ise:** God's work be praised.

Reading Check

1. How does Wole decide which of the school songs he likes the best?
2. What mysterious sounds does Wole hear as he watches and waits outside the school?
3. What special preparations does Wole make to get ready for school?
4. What answer does Wole give when questioned by the principal about his age?
5. When his new school friend, Osiki, eats his food, how does Wole get even?
6. How is Wole injured at the party for one of the Canon's children?
7. How is Wole's birthday party almost spoiled?
8. In Aké there is a yearly festival of *egúngún*. Who or what are they?
9. Why does Wole believe that the Christian figures are *egúngún*?
10. How is Wole injured while playing on the school grounds?

* The song on page 346 is equivalent to

Thirty days hath September,
April, June, and November,
February has twenty-eight alone,
All the rest have thirty-one.

For Study and Discussion

Analyzing and Interpreting the Selection

1a. What hints do you get at the start of this account as to the size, age, and personality of Wole? **b.** When do you find out exactly how old Wole was when these events occurred? **c.** Does how you feel about him change when you learn his exact age?

2a. What are some of Wole's likes and dislikes? **b.** How do these things help to individualize him? **c.** Where does he show that he is curious? impetuous? impatient? clever? **d.** What other modifiers can you suggest to describe his personality?

3. Wole learns from a variety of experiences about getting along with adults and other children. **a.** Using Wole's and others' actions, thoughts, and speech as evidence, indicate how he gets along with his sister, his parents, and his friends. **b.** What does he learn about trust? **c.** What does he learn about responsibility? **d.** What types of things does he learn from experience and from what others tell him?

About the Author

Wole Soyinka (1934–)

Soyinka was born and raised in the western Nigerian town of Aké. He left home when he was eleven and attended the University College in Ibadan and then the University of Leeds in England. During the 1960s the Nigerian government arrested Soyinka several times. He was opposed to Nigeria's civil war and the government's brutal policies toward the Ibo people who were trying to form their own country, Biafra. His longest stay in prison, spent in solitary confinement, lasted over two years. Although denied reading and writing materials, he was able to make ink and keep a diary written on any paper products he could find, including toilet paper and cigarette packages. Soyinka's diary was published a few years after his release as *The Man Died: Prison Notes of Wole Soyinka* (1972).

Soyinka again dramatized historical events in *Isara: A Voyage Around "Essay,"* a biography of his father (1989). In 1986 Soyinka received the Nobel Prize for literature. The Swedish Academy especially praised his two plays *A Dance of the Forests* (1962) and *Death and the King's Horseman* (1975). Soyinka's recent works include a collection of poems, *Mandela's Earth* (1988).

Reading and Critical Thinking

UNDERSTANDING CAUSE AND EFFECT

*E*xpository writers often use cause-and-effect relationships to develop their ideas. In the passage below, Dr. Lewis Thomas uses causes and effects to discuss education in science. Read the passage carefully and then answer the questions that follow.

The worst thing that has happened to science education is that the great fun has gone out of it. A very large number of good students look at it as slogging work to be got through on the way to medical school. Others look closely at the premedical students themselves, embattled and bleeding for grades and class standing, and are turned off. Very few see science as the high adventure it really is, the wildest of all explorations ever undertaken by human beings, the chance to catch close views of things never seen before, the shrewdest maneuver for discovering how the world works. Instead, they become baffled early on, and they are misled into thinking that bafflement is simply the result of not having learned all the facts. They are not told, as they should be told, that everyone else—from the professor in his endowed chair to the platoons of post-doctoral students in the laboratory all night— is baffled as well. Every important scientific advance that has come in looking like an answer has turned, sooner or later—usually sooner—into a question. And the game is just beginning. . . .

Maybe, just maybe, a new set of courses

dealing systematically with ignorance in science might take hold. The scientists might discover in it a new and subversive technique for catching the attention of students driven by curiosity, delighted and surprised to learn that science is . . . an "endless frontier." The humanists, for their part, might take considerable satisfaction watching their scientific colleagues confess openly to not knowing everything about everything. And the poets, on whose shoulders the future rests, might, late nights, thinking things over, begin to see some meanings that elude the rest of us. It is worth a try.

—from "Humanities and Science"

Understanding Cause and Effect

1. According to Thomas, what are some of the causes for the great fun having gone out of science? Review the first paragraph of the excerpt and list three causes that have produced this effect.

C1 _____

C2 _____

C3 _____

2. What does the author say might be the effects of a new set of courses dealing with ignorance in science? Reread the second paragraph and list three effects.

E1 _____

E2 _____

E3 _____

WRITING AN EXPOSITORY ESSAY

*I*n **expository writing** your purpose is to explain a subject or provide information. The following are some examples of this kind of writing:

- process explanation
- biographical sketch
- autobiographical essay
- cause-and-effect essay
- speculative essay
- scientific report
- historical article
- news story

In this unit you have investigated some of the major elements of expository writing. Now you will have the chance to write an expository essay on a topic of your choice.

Prewriting

1. Begin by making a list or inventory of your interests. You may want to fill out a chart like the one below.

What do I know how to do well?	_____ _____
Who are some people I admire?	_____ _____
What interesting facts, trends, or events have I read about lately?	_____ _____ _____ _____
What natural processes am I curious about?	_____ _____ _____

Write some notes about one or two topics on your list. Keep in mind that a suitable topic for an expository essay should

- have value and interest to others
- be neither too broad nor too narrow

To limit your topic, draw a diagram like the following one. Keep narrowing the topic until you feel it is about right for an essay of two or three pages.

LASERS

Lasers in Medicine

Use of Lasers in Eye Surgery

2. Before you share information in an expository essay, you must consider the needs of your **audience.** Try to gauge how much your audience may already know about the topic and how much background you will need to supply. Also consider how to "hook" your audience on your topic right at the beginning of your essay. Here are some useful techniques to capture your readers' attention in your introduction:

- begin with a striking fact or statistic
- use a pointed quotation or comment
- address your audience directly with a statement, a question, or a command

Notice how Edward Abbey directly addresses the audience in the first sentence of the excerpt from *Desert Images* on page 260.

3. The introduction to your essay should con-

tain a **thesis statement** of one or two sentences in which you identify your topic and clearly express your focus or main idea. Review your notes and write a thesis statement that will help you to unify your essay. For example, if you plan to write a process explanation, you might state a thesis this way: "The use of lasers in cataract surgery has revolutionized treatment of one of the commonest eye disorders in older people."

A thesis statement for a biographical sketch might run as follows: "Pompey may not have achieved as much fame as Julius Caesar, but his career had a major impact on politics in the late Roman Republic."

A thesis statement for a cause-and-effect essay might be stated in this way: "In his desire to modernize Russia, Peter the Great decreed far-reaching political, military, and social changes."

[See **Focus** assignments on pages 247, 253, and 265.]

4. Make an **outline** in which you show your thesis and your supporting details in a logical order. Below are some sample outlines for three different kinds of expository essay: a process explanation, a biographical sketch, and a cause-and-effect explanation.

Process Explanation

Introduction:
 grab reader's attention
 identify topic/state thesis
Body:
 list essential materials
 define unfamiliar terms
 explain each step in order
Conclusion:
 discuss advantages of process
 include further hints/advice

Biographical Sketch

Introduction:
 grab reader's attention
 identify person/state thesis
Body:
 present facts/anecdotes logically
Conclusion:
 restate thesis
 sum up significance of person

Cause-and-Effect Explanation

Introduction:
 grab reader's attention
 identify topic
 state thesis, focusing on causes,
 effects, or both
Body:
 discuss cause/effect A
 discuss cause/effect B
 discuss cause/effect C
Conclusion:
 summarize main points
 add a final comment or prediction

[See **Focus** assignments on pages 259, 289, and 325.]

Writing ✎

1. Use your outline as a guide to write the **first draft** of your essay. Be sure to include all the information your readers need to understand your main idea. For example, in a process explanation, listing steps or stages in the wrong order or leaving out any steps will confuse your readers. If you are writing a cause-and-effect essay, remember that a single event can have more than one cause. Likewise, a single event can lead to more than one significant effect. In this type of essay,

also watch out for logical **fallacies,** or errors in reasoning, such as the following:

- **false cause and effect:** assuming that one event caused another just because the first occurred before the second
- **oversimplification:** identifying a single cause or effect and ignoring all others

2. Clarify the relationships of ideas and details in your essay by using appropriate **transitions.** Transitional words and phrases can show the following relationships:

- time
- place
- order of importance
- cause and effect

You will find a chart of useful transitions in the **Focus** assignment on page 321.

3. You may find some of these methods helpful for defining unfamiliar terms or providing other background in an expository essay:

- using an appositive (such as "the painter Picasso") to identify or define a name or term
- using parentheses to include informative material of lesser importance
- using visual aids to make relationships like cause and effect clear
- using footnotes to credit sources and to provide supplementary information

Evaluating and Revising

1. When you have finished writing your first draft, put your essay aside for a while. Then try to evaluate it as critically and objectively as you can. Pay special attention to your thesis statement. Does it clearly express your main idea and give readers a sharp focus for what follows? Also be sure you have arranged your ideas and details in a logical, coherent order.

The following example shows how one writer revised an opening paragraph for a cause-and-effect essay.

Writer's Model

The Florida Everglades ~~may or may not~~ ^{Can} be saved~~.~~? Believing that a national ~~landmark~~ *treasure* is at stake, government officials are launching ~~a~~ *an* ~~late~~ *eleventh-hour* campaign to reverse the destruction of this ~~most~~ unique habitat. In order to ~~see~~ *evaluate* their chances for success, it is important to understand the causes that have ~~made~~ *combined to create* the crisis.

2. After making changes that may be necessary in your draft, consider trading papers with a classmate. Then you can both use the checklist below to offer each other suggestions on your writing.

Checklist for Evaluation and Revision

✓ Do I capture the reader's interest in the introduction?

✓ Have I stated my thesis clearly at the beginning of the essay?

✓ Do I define unfamiliar terms, explain any materials that may be needed, and supply any necessary background?

✓ Do I discuss the steps of a process, the facts/anecdotes about a person, or the causes and effects of an event in a clear, logical order?

✓ Do I end with a strong conclusion that restates my main idea and wraps up my paper appropriately?

Proofreading and Publishing

1. Proofread your essay to find and correct any errors in grammar, usage, and mechanics. (You may find it helpful at this stage to refer to the **Handbook for Revision** on pages 928–971.) Check facts, statistics, and quotations you have included to be sure that they are accurate. Then prepare a final version of your paper by making a clean copy

2. Consider some of the following publication methods for sharing your essay:

- organize a "how to" day in class and make your process essay the basis for a demonstration
- send your essay to a newspaper or magazine
- send your essay to an organization that is interested in the topic
- join with classmates to create a class anthology called "Profiles of Famous People"
- share your essay with a social studies or science class if appropriate

Portfolio If your teacher approves, you may wish to make a copy of your work for your writing folder or portfolio.

POETRY

Poetry is a way of expressing thoughts and feelings in imaginative, suggestive language. Poets often try to capture in words what painters and photographers can achieve with shapes and colors.

The photograph at the left was taken as the last rays of the sun faded, creating a silhouette image of a gnarled tree. Imagine yourself in the scene. How would you respond? Would you feel like celebrating the awesome beauty of nature? Would the darkness make you think about sadness?

List some of the words or phrases you could use to describe what you see and what you feel. Some things you may wish to consider are light and shadow, color, shape, and mood. Then try writing a poem about your response. Use language that will stir emotion and put readers in touch with your feelings.

In the nineteenth century people were fond of defining poetry in such terms as "Lofty thoughts expressed in noble language" and "Beauty dressed out in melodious words." Anyone who has read much poetry knows better. There is nothing lofty about the thoughts of the speaker in Dorothy Parker's "One Perfect Rose" (page 371), who wishes her admirer would send her a limousine every once in a while. The subject matter of poetry is all of life, just as it is in other forms of literature.

If we do not limit the subject matter of poetry to the lofty and the beautiful, we need not put any such limitations on its language. There is nothing noble about the language in Ted Hughes's "The Lake" (page 390): "[It] Snuffles at my feet for what I might drop or kick up,/Sucks and slobbers the stones, snorts through its lips."

What kind of language, then, is used in poetry? The answer is that a poet seeks the most meaningful words—those that are most expressive, most suggestive, and most precise for the poet's purpose.

And what is the poet's purpose? Like many simple questions, this one is hard to answer, though it's an important question to ask. Poetry, like other forms of literature, communicates feelings and experiences rather than objective facts. Poetry "says more and talks less" than other forms of expression, and it does this mainly by using a number of language resources not ordinarily used in strictly factual prose. These language "resources" include imagery, figurative language, rhythm, and sometimes, rhyme.

Consider the differences between a factual inning-by-inning summary of a baseball game and an account written by a good sportswriter. (Sportswriters resemble poets: they want to give us the facts of the game, but they also want to make us feel as if we were watching it.) The factual summary might run like this: "Johnson hit a single to left. Calvetti hit a double to right, allowing Johnson to score." But the sportswriter writes: "Johnson smoked a grass-cutter between short and third. Calvetti, after taking two strikes, drove a screaming double off the right-field wall. Johnson took off like a frightened rabbit at the crack of the bat, rounded third with a full head of steam, and slid home in a cloud of dust." The sportswriter's

account differs from the factual summary in a number of ways. First, it appeals to our senses; it allows us to hear "the crack of the bat" and see "a cloud of dust." Second, it uses figurative language: "smoked a grass-cutter," "screaming double," "like a frightened rabbit," "with a full head of steam." Third, its sentences are more rhythmical than those of the factual summary, and the rhythm helps suggest the speed and excitement of the play. Like this sports story, poetry communicates vividly through the deliberate use of certain language "resources."

To respond to a poem fully, you need to understand and react to its special language and structure. It is a good idea to read a poem several times and aloud at least once. Often it is helpful to write a prose paraphrase of a poem (see page 391). A paraphrase is no substitute for the poem itself, but it helps you clarify and simplify the author's ideas and language.

Guidelines for Close Reading

1. Read the poem aloud at least once, following the punctuation for phrasing. Commas, semicolons, periods, and other marks of punctuation tell you where to pause. Poets do not expect the reader to pause at the end of each line.

2. Respond thoughtfully to key words and references. Many words have both denotative and connotative meanings. Denotative meaning is the dictionary definition, whereas connotative meaning carries emotional associations. In poetry a word often has special connotations.

3. Write a paraphrase of any lines that need clarification or simplification. A paraphrase helps a reader respond more fully to the poem and to understand imagery and figurative language. It also puts inverted word order into normal word order.

4. Using your own response to the poem, write a statement clarifying its central idea or meaning. Try to state this idea in one or two sentences. In this way you can use your own reactions as a means of exploring the poet's meaning.

Read the following poem several times. The notes alongside the poem represent one reader's responses. Compare these responses with your own.

Autumn Chant

EDNA ST. VINCENT MILLAY

Now the autumn shudders
 In the rose's root.
Far and wide the ladders
 Lean among the fruit.

The word shudders is so powerful. The ladders remind me of the autumn harvest.

Now the autumn clambers 5
 Up the trellised frame,°
And the rose remembers
 The dust from which it came.

It seems like the poet wants me to think of autumn and roses as people. In autumn flowers ripen and die.

Brighter than the blossom
 On the rose's bough 10
Sits the wizened,° orange,
 Bitter berry now;

This seems dry, sad, and empty. The rose hips are prettier than what is left of the rose.

Beauty never slumbers;
 All is in her name;
But the rose remembers 15
 The dust from which it came.

Beauty is always there. However, beauty and youth always lead to decay and death.

6. **trellised** (trĕl'īsd) **frame:** an open framework used for training vines. 11. **wizened** (wĭz'ənd): shriveled.

Looking at Yourself as a Reader

How did you respond to Millay's poem? What did the images make you think of? What emotions did the poem produce in you? How did the poet's use of language influence your response?

Write a paragraph describing your response and your thoughts about the poem's meaning. Share your reactions with your classmates. Did they enjoy the poem? How did it make them feel?

THE SPEAKER

An important question to ask yourself when you read a poem is, Who is speaking? While the speaker in a poem may be the poet, the voice in the poem is often that of a fictional character or even an object. In a dramatic poem there may be more than one speaker.

Running

RICHARD WILBUR

1933
(North Caldwell, New Jersey)

What were we playing? Was it prisoner's base?
I ran with whacking keds
Down the cart-road past Rickard's place,
And where it dropped beside the tractor-sheds

Leapt out into the air above a blurred 5
Terrain, through jolted light,
Took two hard lopes, and at the third
Spanked off a hummock-side exactly right,

And made the turn, and with delighted strain
Sprinted across the flat 10
By the bull-pen, and up the lane.
Thinking of happiness, I think of that.

For Study and Discussion

Analyzing and Interpreting the Poem

1a. Who is the speaker in this poem? **b.** How do you know?

2. The subtitle of the poem is "1933 (North Caldwell, New Jersey)." Given the fact that Richard Wilbur was born in 1921 and grew up in New Jersey, what assumptions might you make from the subtitle?

3. The poet uses language that helps you share his experience. **a.** What words and phrases create vivid and specific pictures of motion? **b.** What physical setting do you see? **c.** What sounds do you hear?

4a. Why do you think this particular run makes the speaker think of happiness? **b.** What reasons can you give for the fact that people often think of happiness in connection with childhood?

Mirror

SYLVIA PLATH

*The speaker in this poem claims to be truthful. What is the truth
the speaker is concerned with?*

I am silver and exact. I have no preconceptions.°
Whatever I see I swallow immediately
Just as it is, unmisted by love or dislike.
I am not cruel, only truthful—
The eye of a little god, four-cornered. 5
Most of the time I meditate on the opposite wall.
It is pink, with speckles. I have looked at it so long
I think it is a part of my heart. But it flickers.
Faces and darkness separate us over and over.

Now I am a lake. A woman bends over me, 10
Searching my reaches for what she really is.
Then she turns to those liars, the candles or the moon.
I see her back, and reflect it faithfully
She rewards me with tears and an agitation of hands.
I am important to her. She comes and goes. 15
Each morning it is her face that replaces the darkness.
In me she has drowned a young girl, and in me an old
 woman
Rises toward her day after day, like a terrible fish.

1. **preconceptions:** prejudices; ideas or opinions formed in advance.

Photograph by Gordon Parks

For Study and Discussion

Analyzing and Interpreting the Poem

1. If this poem had no title, what clues would
reveal that the speaker is a mirror?

2. In the first stanza, the mirror is personified,
or given human qualities. **a.** What specific
human characteristics does it have? **b.** In
what ways is the mirror *not* fully human?

3. What does the mirror mean when it says it
is not cruel, only truthful?

4. What words in the second stanza extend the
comparison of the mirror to a lake?

5. Why does the mirror call the moon and
candles "liars"?

6a. How would you explain what is happening
in the last two lines? **b.** What emotional im-
pact is created in these lines?

Literary Elements

The Speaker of a Poem

One of the first things you should do when you read a poem is look for clues that identify its speaker. Sometimes the speaker will seem to be the poet, but at other times the speaker will be someone or something altogether different. Speakers in poems have been rivers, ghosts, children, imaginary characters, and so on. Some poems have more than one speaker. In this poem, the speaker is a mirror, and what the mirror says reveals something about its particular character. How would you describe the kind of "person" this mirror is?

Focus on Descriptive Writing

Finding a Focus

In **descriptive writing** you use precise words and sensory details to re-create in the mind of your reader a person, place, thing, or event. You will find these guidelines helpful when you explore subjects for your own descriptive writing:

1. Choose someone or something familiar as your focus.
2. If possible, select a subject you can observe directly.
3. Limit your subject to one you can cover in a few paragraphs.

Focus on three familiar inanimate objects either from the list below or of your own choice.

a clock	a door	a television
a mailbox	a lamp	a phone booth

For each object, freewrite some notes for a description. Think about personifying one or two of the objects to get a fresh perspective. Save your writing.

About the Authors

Richard Wilbur (1921–)

Richard Wilbur grew up in New Jersey. He began writing poetry while serving in the army during World War II and has continued to write poetry, literary criticism, and children's books for more than forty years. When asked to describe his early interest in language, he replied: "I've always been crazy about words, and I suppose that one really wouldn't consider trying to be a poet if that weren't a continual delight and obsession." In 1957 Wilbur was awarded the Pulitzer Prize in poetry. He served as the second poet laureate of the United States from 1987 to 1988. His collections of poetry include *Things of This World* (1956) and *New and Collected Poems* (1988).

Sylvia Plath (1932–1963)

Sylvia Plath was born in Boston and graduated from Smith College. Her first volume of poetry was published when she was still in her twenties. *The Bell Jar* (1963), an autobiographical novel about a young girl's breakdown, appeared under a pseudonym, partly because Plath didn't consider it a serious work and partly because she felt too many people would be hurt by its details. The novelist Joyce Carol Oates has called Sylvia Plath "our acknowledged Queen of Sorrows, the spokeswoman for our most private, most helpless nightmares. . . ."

DICTION

The words a poet chooses and the way he or she arranges the words to express a thought are referred to as the poet's *diction*. Every writer and every speaker has a personal diction—one chooses, either consciously or unconsciously, to use one word over many others that have similar meanings. In poetry, diction is especially important because every word must relay exactly the right connotation, or emotional meaning. When Edna St. Vincent Millay uses the word *shudders* in the first line of "Autumn Chant," she suggests the fearful anticipation of death. In "Running," Richard Wilbur uses precise words to describe his movements: *lopes, spanked, sprinted.* Poets also make use of inverted order for the sake of rhythm and for emphasis. In the third stanza of "Autumn Chant," the subject and predicate are inverted:

> Brighter than the blossom
> On the rose's bough
> Sits the wizened, orange,
> Bitter berry now . . .

Poets often invent, or coin, words to relay an intended meaning. We refer to the poet's freedom to use language creatively as *poetic license*—the freedom to change words or invent new ones, rearrange the normal order of words, and omit understood phrases in order to create a certain mood or create a special meaning.

Women

ALICE WALKER

Although this poem contains very little punctuation, what clues are there to the way the lines should be phrased? Where should you pause in your reading? What words should be emphasized?

They were women then
My mama's generation
Husky of voice—Stout of
Step
With fists as well as 5
Hands
How they battered down
Doors
And ironed
Starched white 10
Shirts
How they led
Armies
Headragged Generals
Across mined 15
Fields
Booby-trapped
Ditches
To discover books
Desks 20
A place for us
How they knew what we
Must know
Without knowing a page
Of it 25
Themselves.

For Study and Discussion

Analyzing and Interpreting the Poem

1. The first five lines of the poem contain words that are often used to describe men. What words does the poet choose to convey the strength of the women in her mother's generation?

2a. Find the verbs in lines 7–14. **b.** What kind of movement does the poet suggest with these verbs?

3a. What words and phrases in the poem suggest war? **b.** Why was the "war" in the poem fought?

4. What feeling does the poet suggest through the use of word emphasis?

Mother Courage II (1974) by Charles White (1918–1979). Oil on canvas.
Collection The National Academy of Design, New York, Courtesy Heritage Gallery, Los Angeles

A Birthday

CHRISTINA ROSSETTI

As you read, note how Rossetti creates pictures of both natural beauty and oriental splendor through her diction.

My heart is like a singing bird
 Whose nest is in a watered shoot;
My heart is like an apple tree
 Whose boughs are bent with thickset fruit;
My heart is like a rainbow shell 5
 That paddles in a halcyon sea;
My heart is gladder than all these
 Because my love is come to me.

Raise me a dais of silk and down;
 Hang it with vair° and purple dyes; 10
Carve it in doves and pomegranates,
 And peacocks with a hundred eyes;
Work it in gold and silver grapes,
 In leaves and silver fleurs-de-lys;°
Because the birthday of my life 15
 Is come, my love is come to me.

10. vair (vâr): a kind of fur used in medieval times.

14. fleur-de-lys (flûr′də-lēz′): three-petaled iris flower, used as an emblem.

For Study and Discussion

Analyzing and Interpreting the Poem

1. The poet compares the feelings in her heart to those of a bird, a tree, and a shellfish when they are in perfect settings. In what ways do the ending words of lines 2, 4, and 6 capture the ideal settings for these things?

2. In the second stanza, the poet paints a word-picture of riches and royalty, suggesting that she is as happy as a princess or a queen, who might order a *dais* (a throne). Which words suggest royalty and riches?

3. Why is the word *birthday* appropriate to describe the arrival of the poet's love?

Language and Vocabulary

Finding Word Origins

In line 6 of "A Birthday," Rossetti uses the phrase "a halcyon sea." The word *halcyon*, which means "calm" or "peaceful," comes from an ancient Greek myth about a pair of lovers, Ceyx and Alcyone, who were changed into birds. Locate the story in a book of mythology and explain how the phrase "halcyon days" came to have its meaning.

One Perfect Rose

DOROTHY PARKER

A single flow'r he sent me, since we met.
 All tenderly his messenger he chose;
Deep-hearted, pure, with scented dew still wet—
 One perfect rose.

I knew the language of the floweret; 5
 "My fragile leaves," it said, "his heart enclose."
Love long has taken for his amulet
 One perfect rose.

Why is it no one ever sent me yet
 One perfect limousine, do you suppose? 10
Ah no, it's always just my luck to get
 One perfect rose.

For Study and Discussion

Analyzing and Interpreting the Poem

1. In the first two stanzas, this poet's diction—or choice of words—is the standard diction of romantic old-fashioned poetry. The shortened form of the word *flower* clues us in to this right away. What other words and phrases in these stanzas strike you as "poetic" or "romantic"?

2. How does the speaker's diction change in the third stanza?

3. The speaker says she'd prefer a limousine to a rose. **a.** What is the meaning of the word *limousine*? **b.** What associations does it have?

4. How would you read this poem aloud to convey the speaker's change of tone from romantic tenderness to cynical humor?

Literary Elements

Poetic Inversion

At times, poets *invert,* or reverse, standard English word order. Sometimes this is done for emphasis, sometimes to make rhythms or rhymes work out. In the past, inversion was more common because poets worked under stricter metrical rules. Excessive inversion is often what makes those older poems sound artificial and old-fashioned today.

Dorothy Parker deliberately uses inversion in the first two stanzas to suggest an old-fashioned artificial style. For example, in the first line she says:

> A single flow'r he sent me

In standard English we'd get rid of the poetic *flow'r* and say:

> He sent me a single flower.

What words are inverted in lines 2, 3, and 6? Rephrase these lines in standard English word order. What happens to the tone of the poem when this is done?

Focus on Descriptive Writing

Thinking About Your Purpose

Your **purpose** is linked to the tone and point of view of the description you write. In **subjective description** you use first-person point of view and an informal tone to express your thoughts and feelings. Rossetti's "A Birthday" and Parker's "One Perfect Rose" are both examples of this kind of description, which is common in letters, poems, and stories.

In **objective description** your purpose is to inform rather than to express yourself. This type of description, which stresses factual details, uses third-person point of view and a formal tone. It is common in reports and articles.

Choose two subjects, one for each type of description. Freewrite for five minutes about each subject. When you have finished, exchange papers with a classmate and compare notes. Save your writing.

Ornamental Sketch with Verbs

MAY SWENSON

You have seen that poets can coin words and reverse standard word order.
What kind of poetic license is evident in this poem?

Sunset runs in a seam
over the brows of buildings
 dropping west to the river,
turns the street to a gilded stagger,
makes the girl on skates, 5
 the man with the block of ice,
 the basement landlady calling her cat
 creatures in a dream,

scales with salamander-red
 the window-pitted walls, 10
hairs the gutters with brindled° light,
helmets cars and boys on bikes
and double-dazzles
 the policeman's portly coat,
halos the coal truck where 15
 nuggets race from a golden sled,

11. **brindled:** spotted and streaked.

festoons lampposts to fantastic trees.
lacquers sooty roofs and pavements,
floats in every puddle
 pinks of cloud,
flamingos all the pigeons,
grands all dogs to chows,
enchants the ash cans into urns°
 and fire-escapes to Orleans balconies.

20

23. **urns:** decorative vases.

For Study and Discussion

Analyzing and Interpreting the Poem

1. The poet describes how a sunset transforms the ordinary things and people of the city into something beautiful, as if the sunlight were alive. **a.** Which words in the first stanza show the sunlight's movement? **b.** What does the phrase "gilded stagger" suggest about the light?

2. The poet announces in her title that this will be a sketch with "verbs." Note that from line 4 to the end of the poem, most lines begin with a verb. But in this poem, words that are normally nouns function as verbs. **a.** How would you explain the meaning of *scales* (line 9), *hairs* (line 11), *helmets* (line 12), *halos* (line 15), and *flamingos* (line 21)? **b.** What is the subject of all these verbs?

3. In lines 13 and 14, the sun "double-dazzles" the policeman's coat. What does this word combination suggest?

Language and Vocabulary

Understanding Connotations

All words have **denotations**—that is, explicit meanings you find listed in a dictionary. Many words also have **connotations**—that is, suggestive meanings and associations that go beyond their strict dictionary definitions.

In line 22 of "Ornamental Sketch with Verbs," the poet says that the sun "grands" all the dogs to "chows." This image makes us see dogs, probably mongrels, being magically transformed into chows, valuable members of a pure breed. But the word *chow* has certain connotations, too. Chows are of ancient lineage and were originally bred in China. They also have extraordinary blue-black tongues, and are often associated with fierceness. Thus the word *chow* not only puts a specific picture in our minds, but it also suggests, or connotes, something exotic. (How would the effect differ if the dogs had been turned into "Labrador retrievers"?)

What does each of the following words mean? Do any of them have connotations— that is, do they call forth associations or feelings?

salamander	lacquers	flamingos
festoons	pinks	urns

Focus on Descriptive Writing

Considering Your Audience

When you plan a description, give some thought to your **audience.** Who is going to read your description, and why? What do your readers need to know to understand it?

Practice your audience awareness by making a chart like the one below. In the blanks list a different subject for description for each audience. Then get together with a small group of classmates to compare notes. Discuss any special needs that the audience for each description might have. Save your notes.

Subject	Audience
1. _____	Sixth-graders
2. _____	Classmates
3. _____	Senior citizens
4. _____	Entire community

About the Authors

Alice Walker (1944–)

Alice Walker was born in rural Georgia and educated at Spelman College and Sarah Lawrence. The primary themes found in her poetry, short stories, and novels revolve around the sacredness of family life and the oppression of black women. Her third collection of poems, *Good Night Willie Lee, I'll See You in the Morning,* was critically acclaimed, and her novel *The Color Purple* won a Pulitzer Prize and an American Book Award in 1983. *In Search of Our Mothers' Gardens* is a collection of Walker's essays.

Christina Rossetti (1830–1894)

Christina Rossetti was born in London, the daughter of an Italian political exile. Her brother was the equally famous poet and painter Dante Gabriel Rossetti. Many of Rossetti's finest poems reflect her feelings about love; she was deeply religious, however, and twice for religious reasons she broke off plans to marry.

Dorothy Parker (1893–1967)

Dorothy Parker, a famous wit, said that she was "one of those awful children who write verse." At nineteen she was a member of *Vogue*'s editorial board, then a writer for *Vanity Fair* magazine and *The New Yorker.* During the Spanish Civil War, she served as an American correspondent in Spain. She also spent many years in Hollywood, where she wrote screenplays.

May Swenson (1919–1989)

May Swenson was born in Logan, Utah, but lived in New York most of her life. She is known for her playful use of language, sense of humor, and keen observation of nature. She once said her poems come "from the organic, the inorganic, and the psychological world." *The Love Poems of May Swenson* was published posthumously in 1991.

IMAGERY

To help us participate in certain experiences, poets will create *images*—that is, they use words that put our senses to work. Images are chiefly visual, but some images can also help us hear something, smell it, taste it, even feel its texture or temperature. In these lines from his poem called "Give Me the Splendid Silent Sun," Walt Whitman uses a series of images so that we can imaginatively share certain sensations:

> Give me the splendid silent sun with all his beams full-dazzling,
> Give me juicy autumnal fruit ripe and red from the orchard,
> Give me a field where the unmowed grass grows,
> Give me an arbor, give me the trellised grape,
> Give me fresh corn and wheat, give me serene-moving animals teaching content,
> Give me nights perfectly quiet as on high plateaus west of the Mississippi, and I looking up at the stars . . .

The Lake Isle of Innisfree

WILLIAM BUTLER YEATS

Innisfree is an island in Lough (Lake) Gill in western Ireland. Yeats was inspired to write this poem while he was walking along a crowded street in London. He thought of Innisfree when he heard the sound of water falling from a small fountain that was part of a window display.

I will arise and go now, and go to Innisfree,
And a small cabin build there, of clay and wattles° made:
Nine bean-rows will I have there, a hive for the honeybee,
And live alone in the bee-loud glade.

And I shall have some peace there, for peace comes drop-
 ping slow, 5
Dropping from the veils of the morning to where the
 cricket sings;
There midnight's all a glimmer, and noon a purple glow,
And evening full of the linnet's° wings.

I will arise and go now, for always night and day
I hear lake water lapping with low sounds by the shore; 10
While I stand on the roadway, or on the pavements gray,
I hear it in the deep heart's core.

2. **wattles:** poles intertwined with twigs.

8. **linnet's:** songbird's.

For Study and Discussion

Analyzing and Interpreting the Poem

1a. What specific images help you visualize what this speaker is longing for? **b.** The next-to-last line describes the speaker's present surroundings. How do these images contrast with the others in the poem?

2. What images help you hear the sounds the speaker longs to hear?

3. The speaker says that he wants peace. **a.** In which line does he compare the coming of peace to the dropping of dew? **b.** What other images suggest peacefulness?

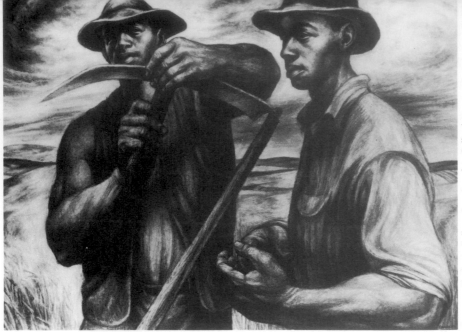

The Harvest (1953) by Charles White. Charcoal.

Reapers

JEAN TOOMER

Black reapers with the sound of steel on stones
Are sharpening scythes. I see them place the hones
In their hip-pockets as a thing that's done,
And start their silent swinging, one by one.
Black horses drive a mower through the weeds,
And there, a field rat, startled, squealing bleeds,
His belly close to ground. I see the blade,
Blood-stained, continue cutting weeds and shade.

For Study and Discussion

Analyzing and Interpreting the Poem

1. What images in this poem help you see and hear what the reapers and mower are doing?

2a. What details suggest that the mower is impersonal—with no feeling for the life around it? **b.** What images in the poem help create a sense of menace?

North County

SHERLEY ANNE WILLIAMS

*Note how the poet uses images of sight and sound to give you an impression
of the setting.*

The freeway is a river
of light rounding the base of
Mt. Soledad, its distant
drone a part of the night. I've
watched in the darkness as the 5
river dimmed to the fitful
passing of solitary
cars and heard the coyotes
in the canyon crying their
survival to the strange land. 10

I booted up one day, walked
out across the mesa that
fronts along my place till the
land was a shallow cup around
me and the houses were lost 15
in the distance on its
rim. The plants were the only

life I saw—muted greens dry
browns bursts of loud purple and
lighter blues, brilliant in the 20
spring light; something rustled the
undergrowth; a jet murmured
in the softly clabbered° sky.

The Indian dead are here
buried beneath Spanish place 25
names and the cities of the
pioneers and the droning
silence is witness to what
each has claimed, what each owned.
My father's grave is here some 30
where his tale lost like that jet
in clabber his children
scattered along the river
voices singing to the night.

23. **clabbered:** like curdled milk.

For Study and Discussion

Analyzing and Interpreting the Poem

1. The freeway is described as a river in the
poem. How does the image of the river change
in the first stanza of the poem?

2. In Spanish the word *mesa* means "table." In
English we have adopted the word and use it
for high, flat, tablelike land with sides that
drop off sharply. Williams describes the mesa
as a "shallow cup." What makes the high mesa
seem to become a "shallow cup"?

3. The word *droning* literally means "making
a low, humming sound." Sound cannot be a
part of silence, yet the poet uses the words
"droning silence." When words with opposing
or contradictory meanings are linked together,
we call the combination an **oxymoron.**
a. What feelings are suggested by this oxy-
moron? **b.** What "silent" sounds might the
poet be suggesting?

North County **379**

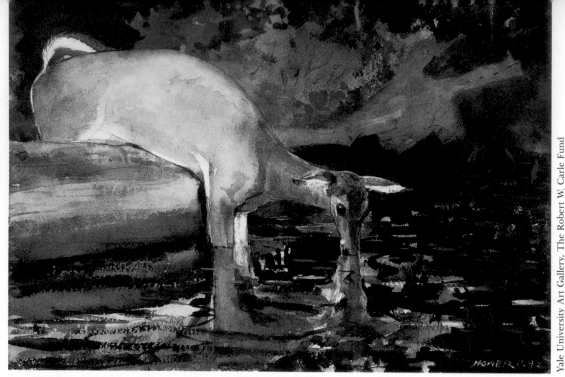

Deer Drinking (1892) by Winslow Homer (1836–1910). Watercolor.

Above Pate Valley

GARY SNYDER

*In this poem note how the speaker's thoughts are revealed chiefly through a
series of vivid impressions rather than through complete sentences. Does this
technique give you a more direct experience of the setting?*

We finished clearing the last
Section of trail by noon,
High on the ridge-side
Two thousand feet above the creek—
Reached the pass, went on 5
Beyond the white pine groves,
Granite shoulders, to a small
Green meadow watered by the snow,
Edged with Aspen—sun
Straight high and blazing 10
But the air was cool.
Ate a cold fried trout in the
Trembling shadows. I spied
A glitter, and found a flake

Black volcanic glass—obsidian— 15
By a flower. Hands and knees
Pushing the Bear grass, thousands
Of arrowhead leavings over a
Hundred yards. Not one good
Head, just razor flakes 20
On a hill snowed all but summer,
A land of fat summer deer,
They came to camp. On their
Own trails. I followed my own
Trail here. Picked up the cold-drill, 25
Pick, singlejack, and sack
Of dynamite.
Ten thousand years.

Analyzing and Interpreting the Poem

1a. What specific images help you experience the setting of "Above Pate Valley"? **b.** How do the images make you feel about this setting?

2. How do you suppose the speaker's trails contrast with "their" trails?

3. The speaker talks about his tools in lines 25–27. How do these tools contrast with the remains he finds in the Bear grass?

4. The poet emphasizes *dynamite* by putting it on a separate line. **a.** What does dynamite suggest to you? **b.** How could dynamite and the speaker's other tools affect this valley that has remained the same for ten thousand years?

Writing About Literature

Comparing Treatments of a Theme

Both "North County" and "Above Pate Valley" are about alterations of the natural landscape by human beings. Williams reflects on the disappearance of her ancestors from the North County around Mt. Soledad, and Snyder thinks about the effects of civilization on a wilderness ridge above Pate Valley, an area that had remained the same for ten thousand years—until man appeared with his dynamite. Write a composition in which you compare the treatment of this theme in the two poems.

Focus on Descriptive Writing

Identifying Sensory Details

Words and phrases that appeal to the five senses—sight, hearing, touch, taste, and smell—are called **sensory details.** Sensory details play an important role in making descriptions vivid and interesting. Notice, for example, that Gary Snyder uses details of sight (lines 5–8, 13–15), touch (line 11), and taste (line 12) in "Above Pate Valley."

Select one of the following four subjects. Think of as many sensory details as you can to describe the subject you have chosen. Fill in your details on an observation chart like the one below. Save your notes.

an old easy chair peanut butter
a desktop computer snow

Observation Chart				
Subject: _____				
Sight	Sound	Touch	Smell	Taste

Recuerdo

EDNA ST. VINCENT MILLAY

Recuerdo means "memory" or "remembrance" in Spanish. Why might the poet have chosen this word as the title of her poem?

We were very tired, we were very merry—
We had gone back and forth all night on the ferry.
It was bare and bright, and smelled like a stable—
But we looked into a fire, we leaned across a table,
We lay on the hill-top underneath the moon; 5
And the whistles kept blowing, and the dawn came soon.

We were very tired, we were very merry—
We had gone back and forth all night on the ferry;
And you ate an apple, and I ate a pear,
From a dozen of each we had bought somewhere; 10
And the sky went wan, and the wind came cold,
And the sun rose dripping, a bucketful of gold.

We were very tired, we were very merry—
We had gone back and forth all night on the ferry.
We hailed, "Good morrow, mother!" to a shawl-covered head, 15
And bought a morning paper, which neither of us read;
And she wept, "God bless you!" for the apples and pears,
And we gave her all our money but our subway fares.

For Study and Discussion

Analyzing and Interpreting the Poem

1a. What images in this poem help create a sense of romance and enchantment? **b.** Does the use of the past tense lend an edge of sadness to the poem? Explain.

2. This poet helps us share her experience by using images that appeal to all the senses. What specific images appeal to your senses of taste, touch, smell, sight, and hearing?

3. Line 15 contains an example of a figure of speech called **synecdoche** (sĭ-něk′də-kē). In a synecdoche, a part of something is used to refer to or imply a whole. **a.** What does the "shawl-covered head" refer to? **b.** How does the shawl-covered head contrast with the other people in the poem?

4. Why do you think the speaker and her friend gave away their fruit and money?

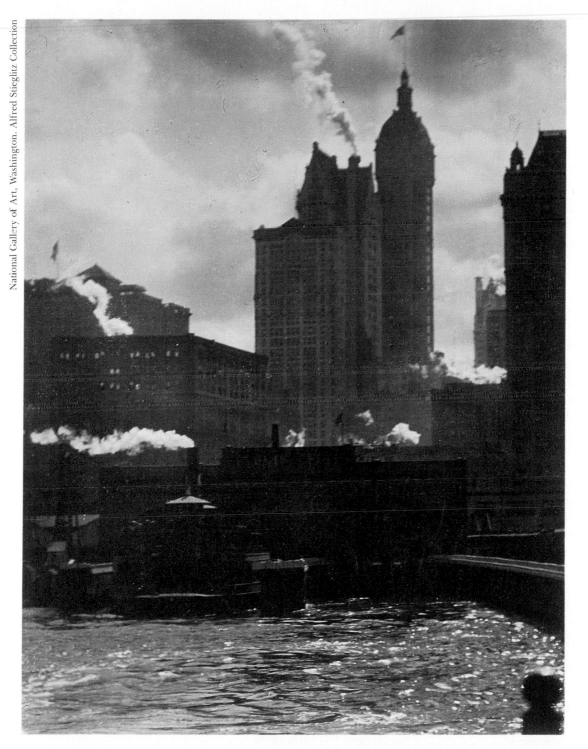

City of Ambition (1910) by Alfred Stieglitz (1864–1946). Gelatin silver print.

Boy with His Hair Cut Short

MURIEL RUKEYSER

How does the poet use imagery to create a contrast between vulnerable human beings and an overpowering, indifferent world?

Sunday shuts down on this twentieth-century evening.
The L° passes. Twilight and bulb define 2. **L:** elevated train.
the brown room, the overstuffed plum sofa,
the boy, and the girl's thin hands above his head.
A neighbor's radio sings stocks, news, serenade. 5

He sits at the table, head down, the young clear neck exposed,
watching the drugstore sign from the tail of his eye;
tattoo, neon, until the eye blears, while his
solicitous tall sister, simple in blue, bending
behind him, cuts his hair with her cheap shears. 10

The arrow's electric red always reaches its mark,
successful neon! He coughs, impressed by that precision.
His child's forehead, forever protected by his cap,
is bleached against the lamplight as he turns head
and steadies to let the snippets drop. 15

Erasing the failure of weeks with level fingers,
she sleeks the fine hair, combing: "You'll look fine tomorrow!
You'll surely find something, they can't keep turning you down;
the finest gentleman's not so trim as you!" Smiling, he raises
the adolescent forehead wrinkling ironic now. 20

He sees his decent suit laid out, new-pressed,
his carfare on the shelf. He lets his head fall, meeting
her earnest hopeless look, seeing the sharp blades splitting,
the darkened room, the impersonal sign, her motion,
the blue vein, bright on her temple, pitifully beating. 25

Analyzing and Interpreting the Poem

1. During the Great Depression millions of people could not find work. **a.** What details reveal that this boy is looking for work? **b.** What details suggest that the boy and his sister do not have much money?

2. The sister speaks cheerfully in stanza 4. **a.** What words in stanza 5 reveal that she does not believe what she says? **b.** How does the poet make you aware that the boy is feeling hopeless and despairing?

3. What specific words and images reveal that the poet sympathizes with these people and wants us to see their dignity?

Focus on Descriptive Writing

Making a Description Chart

Explore ideas for descriptive writing by looking through some recent issues of illustrated magazines on sports, travel, nature, and hobbies. When you have identified a subject for a description, freewrite about it for ten minutes or so. Then make a chart like the one below to organize your notes. Save your writing.

Description Chart
Subject: _____
Purpose: _____ (creative or informative)
Type of Description: _____ (subjective or objective)
Audience: _____
Point of View: _____ (first or third person)
Tone: _____ (personal or formal)

About the Authors

William Butler Yeats (1865–1939)

The Granger Collection, New York

William Butler Yeats was, more than any other individual, responsible for the revival of Irish literature at the turn of the century. Born in Ireland, the son of a well-known painter, Yeats divided his time between Dublin, London, and Sligo, a county in the west of Ireland where his grandparents lived. Poet, playwright, and editor, Yeats is regarded as one of the greatest poets writing in the English language in this century. This reputation was built on such poems as "Easter 1916," "The Second Coming," and "Among School Children." Yeats was a leader in the Modernist movement in poetry, which sought fresh approaches to language and to poetic subjects. In 1923 Yeats received the Nobel Prize for literature.

Jean Toomer (1894–1967)

Jean Toomer grew up in the home of his grandfather, who had been acting governor of Louisiana during the Reconstruction period following the Civil War. After high school, Toomer restlessly wandered from one city and one college to another. He settled for a time in Georgia, where he was superintendent of a rural black school. With the publication of *Cane* (1923)—a collection of stories, sketches, and poems about Southern black life—Toomer became one of the leaders of the Harlem Renaissance of the 1920s.

Sherley Anne Williams (1944–1999)

Sherley Anne Williams was born in Bakersfield, California, and educated at California State University and Brown University. Williams wrote poetry about the black cultural experience, exploring the tradition of black heroes and the black women "blues" theme. Her focus was on the "small" themes, the things that she felt are at the heart of the black experience, where life and movement exist. Her books include *The Peacock Poems* (1975) and the novel *Dessa Rose* (1986).

Gary Snyder (1930–)

Gary Snyder was born in San Francisco and educated at Reed College, Indiana University, and the University of California. His poetry reflects his diverse experiences as a seaman on a tanker, a logger, a Forest Service crew member, and a serious student of Zen Buddhism. Snyder has said of his poetry: "I try to hold both history and wilderness in mind, that my poems may approach the true measure of things and stand against the unbalance and ignorance of our times." In addition to more than eighteen books of poetry, Snyder has produced several collections of essays and contributed to numerous anthologies. In 1974 his collection *Turtle Island* was awarded the Pulitzer Prize for poetry. Recent works include *The Practice of the Wild* (1990) and *No Nature* (1992).

Edna St. Vincent Millay (1892–1950)

The Granger Collection, New York

Edna St. Vincent Millay began writing poetry as a child and had her first poems published in the "club page" of *St. Nicholas,* a children's magazine. "Renascence," a long poem written when she was nineteen, established her as an important American poet, and in 1923 she won the Pulitzer Prize for a collection called *The Harp-Weaver.* The themes that dominate Millay's most famous poems are a romantic celebration of youth and a concern with love, death, and the self.

Muriel Rukeyser (1913–1980)

The Granger Collection, New York

Muriel Rukeyser's poetry reflects her deep emotional involvement in the social and political events of our times. She believed the modern world to be characterized by a widespread alienation and a loss of personal direction, and her poems illustrate these concerns. She was born in New York City and worked as a reporter for a time, often covering controversial events.

FIGURATIVE LANGUAGE

At the heart of poetry is *figurative language*—the use of language to describe one thing in terms of something else. Poets can make us see lips as cherries, the sun as the eye of heaven, the world as a stage, or a lake as a slurping monster. Figurative language is not literally true, but it contains a kind of imaginative truth. Robert Burns tells us, "my Luve's like a red, red rose." We're fairly certain that his love does not have thorns, a green stem, and petals. But his figure of speech makes us think of all the ways the girl might be like a flower: fresh, soft, sweet, and maybe just as rosy.

People who study such things have categorized over a hundred different figures of speech. In this unit, we'll look at four: simile, metaphor, personification, and symbol.

The main thing to remember about figurative language is that it is always helping us to see comparisons and relationships. A *simile*, for example, is a straightforward comparison of two unlike things, using a word such as *like* or *as*. Burns uses a simile in saying his love is "like" a rose.

A *metaphor* is a more powerful figure of speech: it omits the specific word of comparison and directly identifies the two unlike things. If Burns had been in a metaphorical frame of mind, he could have said "my Luve *is* a red, red rose."

Personification is a special form of metaphor. In personification, an inanimate thing or an animal is given human qualities. Homer, writing centuries ago, described "rosy-fingered dawn," making us think of a woman with rosy fingers.

A *symbol* is an object, a person, an action, or an event that stands for itself and for something more than itself as well. A common symbol in literature is night, which often stands for death. Another is spring, which often symbolizes rebirth.

Figurative language comes as naturally to us as breathing. If you doubt it, look at your newspaper. You will probably find at least fifty figures of speech that are used every day.

The Base Stealer

ROBERT FRANCIS

Poised between going on and back, pulled
Both ways taut like a tightrope-walker,
Fingertips pointing the opposites,
Now bouncing tiptoe like a dropped ball
Or a kid skipping rope, come on, come on, 5
Running a scattering of steps sidewise,
How he teeters, skitters, tingles, teases,
Taunts them, hovers like an ecstatic bird,
He's only flirting, crowd him, crowd him,
Delicate, delicate, delicate, delicate—now! 10

Dreams

LANGSTON HUGHES

Hold fast to dreams
For if dreams die
Life is a broken-winged bird
That cannot fly.

Hold fast to dreams
For when dreams go
Life is a barren field
Frozen with snow.

For Study and Discussion

Analyzing and Interpreting the Poem

1. The simile in lines 1–3 says the base stealer is like a tightrope walker. Why is this an appropriate comparison?

2. Find three other similes in the poem—comparisons between two unlike things using words such as *like* or *as*. In each of these, what is the movement of the base stealer compared to?

3. Stealing bases involves complicated and unusual kinds of movement. What verbs does the poet use to create vivid images of motion?

4. Even the rhythm of the poem suggests motion. **a.** Why is *delicate* repeated four times in the last line? **b.** What action is signaled by the word *now*?

For Study and Discussion

Analyzing and Interpreting the Poem

1. A simile compares two unlike things, using a specific word such as *like* or *as*. A metaphor, on the other hand, does not use *like* or *as*, but makes its comparison directly. **a.** What is life compared to in the two metaphors in this poem? **b.** How do the metaphors suggest a life that is not free, or that is empty and dead?

2. Explain what you think this poet means by the word *dreams*.

Literary Elements

Metaphors

A metaphor lets us see certain specific ways in which two unlike things are similar. When the poet says that life is "a broken-winged bird," he does not want us to think of life as having feathers and eating worms. He wants us to think of how life can be free, as a bird is when

Boy on Roof (1967) by Hughie Lee-Smith (1915–). Oil on canvas.
Collection David Randolph, Jr., Philadelphia

it's flying. What specific points of comparison does Hughes want us to see with his second metaphor?

Suppose Hughes had wanted to describe life *with* dreams. What metaphors might be used to express this idea?

Look at Edna St. Vincent Millay's poem "Recuerdo" on page 382. What metaphor does she use in line 12 to describe the rising sun? What specific points of comparison does she want us to see in this metaphor?

Metaphors can arouse strong feeings. What feelings would you say are aroused by Hughes's metaphors? What feelings do you think Millay wants to arouse with her description of the sun?

The Lake

TED HUGHES

Why does Hughes think that the lake in this poem has an effective disguise?
What does he see as its real nature?

Better disguised than the leaf insect,

A sort of subtler armadillo,
The lake turns with me as I walk,

Snuffles at my feet for what I might drop or kick up,
Sucks and slobbers the stones, snorts through its lips 5

Into broken glass, smacks its chops.
It has eaten several my size

Without developing a preference—
Prompt, with a splash, to whatever I offer.

It ruffles in its wallow, or lies sunning, 10
Digesting old, senseless bicycles

And a few shoes. The fish down there
Do not know they have been swallowed,

Any more than the girl out there, who over the stern
 of a rowboat
Tests its depth with her reflection. 15

How the outlet fears it—dragging it out,
Black and yellow, a maniac eel,

Battering it to death with sticks and stones!

For Study and Discussion

Analyzing and Interpreting the Poem

1. Throughout this poem, the speaker describes the lake as if it were a hungry creature. We get this impression through a series of metaphors. How do the verbs in lines 4–11 make you think of the lake as a living, hungry creature?

2. The poet says that the lake has eaten several of his size. **a.** How has it "swallowed" the girl in lines 14–15? **b.** What else has it eaten?

3. An outlet is a stream or river that flows out from a lake. What happens in lines 16–18 when this "creature" reaches the outlet?

4. Consider carefully the words used to describe the lake, and then tell how you think the speaker feels about it. Does he look at it with affection, fear, loathing, dislike, humor, fascination?

Literary Elements

Implied Metaphors

Many metaphors are **implied**—that is, they are not directly stated. In this poem, Hughes uses a string of verbs in lines 4–11 to *imply*, or suggest, comparisons between a lake and some living creature. Notice that he never once directly says that the lake *is* a creature; his words imply the comparison. Lakes, for example, do not do things like "smack their chops," but animals do.

What metaphor does Hughes employ to describe the lake in line 17? Why is this metaphor an appropriate way to describe the lake as it reaches the outlet?

Dead Metaphors

Many metaphors have been part of our common speech for so long that they have lost their force. We call these **dead metaphors**. There are hundreds of examples: the leg of the chair, the head of the bed, and the foot of the table are a few that apply to furniture alone. What dead metaphor can you spot in the title of the poem "The Base Stealer" (page 388)?

Here are some other commonly used expressions that contain dead metaphors. What comparisons are being made in each one? Perhaps you can add to the list.

a cold shoulder	hounded by fear
a toadstool	consumed by jealousy
a fishy story	plagued by bad luck

Writing About Literature

Paraphrasing a Poem

A **paraphrase** is a retelling of a piece of literature in simpler words. A good paraphrase of a poem will do the following: restate all metaphors in literal language, replace difficult words with simpler ones, and make clear what the poet suggests but does not actually state. A paraphrase of a poem will usually run longer than the poem itself. Here is a paraphrase of the first four lines of "The Lake." Using this paragraph as a beginning, paraphrase the rest of the poem, making clear all the poet is trying to say.

> This lake hides its true nature as if it were disguised. It is better disguised than a leaf insect. It is more subtle in its disguise than an armadillo. As I walk around the lake, it seems to turn with me. It is like a snuffling beast, waiting at my feet for me to drop or kick up something for it to devour.

She Sweeps with Many-Colored Brooms

EMILY DICKINSON

Sometimes a poem consists of one sustained metaphor. What is the comparison that underlies this entire poem?

She sweeps with many-colored brooms,
And leaves the shreds behind;
Oh, housewife in the evening west,
Come back, and dust the pond!

You dropped a purple raveling in, 5
You dropped an amber thread;
And now you've littered all the East
With duds° of emerald! 8. **duds:** clothes or belongings.

And still she plies her spotted brooms,
And still the aprons fly, 10
Till brooms fade softly into stars—
And then I come away.

Analyzing and Interpreting the Poem

1. This poet uses a metaphor and talks about the sun as if it were a housewife. **a.** What words reveal that the subject is the setting sun? **b.** What do you think the "brooms" are?

2. Look at what the speaker says to the "housewife." Is this a careful housekeeper, or is she somewhat untidy? Explain.

3. Which metaphors here are based on the ordinary details of domestic life?

Literary Elements

Extended Metaphor

Many times a poet will extend a metaphor throughout several lines of a poem or even throughout an entire poem. Dickinson extends her metaphor comparing the sunset to a housewife throughout the whole poem, and she finds many points of comparison between the two. For example, the streaks of light in the sky become raveled threads and bits of cloth, and the flying clouds become her aprons, which fly about as she works.

Look back at Ted Hughes's poem "The Lake" (page 390). Hughes extends a metaphor throughout his poem. How many points of comparison does he find between the lake and a hungry creature?

She Sweeps with Many-Colored Brooms **393**

Big Wind

THEODORE ROETHKE°

Where were the greenhouses going,
Lunging into the lashing
Wind, driving water
So far down the river
All the faucets stopped?— 5
So we drained the manure-machine
For the steam plant,
Pumping the stale mixture
Into the rusty boilers,
Watching the pressure gauge 10
Waver over to red,
As the seams hissed
And the live steam
Drove to the far
End of the rose-house, 15
Where the worst wind was,
Creaking the cypress window-frames,
Cracking so much thin glass
We stayed all night,
Stuffing the holes with burlap; 20
But she rode it out,
That old rose-house,
She hove into the teeth of it,
The core and pith of that ugly storm,
Ploughing with her stiff prow, 25
Bucking into the wind-waves
That broke over the whole of her,
Flailing her sides with spray,
Flinging long strings of wet across the roof-top,
Finally veering, wearing themselves out, merely 30
Whistling thinly under the wind-vents;
She sailed until the calm morning,
Carrying her full cargo of roses.

°**Roethke** (rĕt′kē).

For Study and Discussion

Analyzing and Interpreting the Poem

1a. What images does the poet use to help you see the storm? **b.** What images help you hear it?

2. This poem contains an extended metaphor. **a.** To what are the greenhouses compared throughout the poem? **b.** What verbs does the poet use to make this comparison?

3. What wider meaning can you see in the fact that this "cargo" of roses conquers an "ugly" storm?

4. How would you describe the poet's feeling for the rose-house?

Creative Writing

Creating Images

Write a poem or a prose paragraph that creates images of some kind of movement. Use precise verbs that will give your reader an impression of what you see and feel, perhaps even of what you hear. Try to use figurative language—perhaps an extended metaphor—to let your reader know what the action reminds you of and how you feel about it.

The Long Hill

SARA TEASDALE

What does each stanza add to your understanding of this poem's symbolic meaning?

I must have passed the crest a while ago
 And now I am going down—
Strange to have crossed the crest and not to know,
 But the brambles were always catching the hem of my gown.

All the morning I thought how proud I should be 5
 To stand there straight as a queen,
Wrapped in the wind and the sun with the world under me—
 But the air was dull, there was little I could have seen.

It was nearly level along the beaten track
 And the brambles caught in my gown— 10
But it's no use now to think of turning back,
 The rest of the way will be only going down.

For Study and Discussion

Analyzing and Interpreting the Poem

1. What three reasons does the speaker give for not noticing when she reached the crest of the hill?

2. How was crossing the crest different from what she thought it would be?

3. This poem can be read on a simple literal level as being about a walk over a long hill. But usually people are not as serious and melancholy about a mere walk as this poet is. Thus, we can guess that the poem should also be read on another, deeper level. How can the "long hill" in the poem be seen as a symbol of life itself?

4. What is symbolized by the "crest" of the hill and by the "brambles" that catch in the speaker's gown?

5. What details in the poem suggest that the speaker is disappointed and regretful about her experience?

First Lesson

PHILIP BOOTH

Lie back, daughter, let your head
be tipped back in the cup of my hand.
Gently, and I will hold you. Spread
your arms wide, lie out on the stream
and look high at the gulls. A dead- 5
man's-float is face down. You will dive
and swim soon enough where this tidewater
ebbs to the sea. Daughter, believe
me, when you tire on the long thrash
to your island, lie up, and survive. 10
As you float now, where I held you
and let go, remember when fear
cramps your heart what I told you:
lie gently and wide to the light-year
stars, lie back, and the sea will hold you. 15

For Study and Discussion

Analyzing and Interpreting the Poem

1. On a literal level, this father is giving his daughter advice about floating, but the poem can also be interpreted on another, symbolic level. Everything that the father says can be understood as advice about becoming an adult. With this interpretation in mind, explain the following phrases: "the long thrash to your island," "lie up, and survive," "when fear cramps your heart."

2. When people take swimming lessons, often the first thing they learn is how to float. How would you explain the "first lesson" that this father is teaching his daughter?

3a. How is "floating" a good symbol for the lesson the girl is learning? **b.** What is symbolized by the tidewater and by the sea?

Literary Elements

Symbols

On one level, Teasdale's poem is about a climb up a hill. On a deeper level, it is about a journey toward a crucial event. Symbols do not exist in every poem, and it would be a mistake to look for them all the time. But when you suspect that a poem is about more than appears on the surface, you can be fairly certain that the poem is also operating on a deeper, symbolic level.

Some symbols are common in literature and are used over and over again. Many writers, however, invent their own symbols, as Booth does in his poem. Booth teaches his daughter to float in the tidewater before she goes out to the sea. What symbolic meaning can you find in the words "dive and swim" (lines 6–7)?

That Gentleman (1960) by Andrew Wyeth (1917–). Tempera on panel.
Dallas Museum of Art, Dallas Art Association Purchase

A Black Man Talks of Reaping

ARNA BONTEMPS°

This poem is best understood if we realize that it is a comment on a line
from the Bible: "whatsoever a man soweth, that shall he also reap"
(Galatians 6:7).

I have sown beside all waters in my day.
I planted deep, within my heart the fear
That wind or fowl would take the grain away.
I planted safe against this stark, lean year.

I scattered seed enough to plant the land 5
In rows from Canada to Mexico
But for my reaping only what the hand
Can hold at once is all that I can show.

Yet what I sowed and what the orchard yields
My brother's sons are gathering stalk and root, 10
Small wonder then my children glean in fields
They have not sown, and feed on bitter fruit.

° **Bontemps** (bäwn′tämp).

For Study and Discussion

Analyzing and Interpreting the Poem

1. In lines 1–6, the speaker describes what he has sown, or planted. According to lines 7–8, what is he allowed to reap, or harvest?

2. How is this situation different from what is stated in the Biblical passage?

3. What do you think the speaker means in lines 9–10 when he says that his "brother's sons" gather what he has sown?

4a. What might "all waters" in line 1 be?
b. What do you think the "bitter fruit" stands for in the final line?

5. This poem seems to be about sowing and reaping, but it is about much more than that. What is the real subject of the poem?

6. What words reveal the speaker's bitter tone? How does the poem suggest a sense of **irony**—that is, that a situation is entirely different from what was expected, or what seemed appropriate?

Literary Elements

Allusions

An **allusion** is a reference to a person, a place, an event, or a literary work that the writer expects the reader to recognize and respond to. An allusion can call to the reader's mind a whole series of associations and feelings. Bontemps, for example, bases his poem on an allusion to the Bible.

Because of the central place they occupy in Western literature, the Bible and the myths of Greece and Rome are alluded to frequently. Each of the following excerpts contains one or more allusions to Greek or Roman mythology. Find and explain each allusion. If you can't recognize the allusion, look up the unfamiliar name in a good dictionary or encyclopedia.

Better yet, read about the character in a mythology book.

> So might I, standing on this pleasant lea,
> Have glimpses that would make me less forlorn;
> Have sight of Proteus rising from the sea;
> Or hear old Triton blow his wreathèd horn.
> William Wordsworth
> from "The World Is Too Much with Us"

> Earth outgrows the mythic fancies
> Sung beside her in her youth;
> And those debonair romances
> Sound but dull beside the truth.
> Phoebus' chariot is run!
> Look up, poets, to the sun!
> Pan, Pan is dead.
> Elizabeth Barrett Browning
> from "The Dead Pan"

> Sacred Goddess, Mother Earth,
> Thou from whose immortal bosom,
> Gods, and men, and beasts have birth,
> Leaf and blade, and bud and blossom,
> Breathe thine influence most divine
> On thine own child Proserpine.
> Percy Bysshe Shelley
> from "Hymn to Proserpine" (prō-sûr′pə-nē)

Writing About Literature

Analyzing Figures of Speech

Review the four figures of speech you have studied in this unit: simile, metaphor, personification, and symbol. Choose one of the poems in this textbook and analyze the different figures of speech used by the poet. In your essay tell in what way the poet's use of figurative language appeals to your imagination.

A Black Man Talks of Reaping **399**

About the Authors

Robert Francis (1901–1987)

Robert Francis was born in Pennsylvania and grew up in Massachusetts. After he graduated from Harvard University, he chose to spend most of his time in solitude, finding nature a better companion than the social world. His love of nature and appreciation of the simple things in life are reflected in his poetry. He referred to his style as "neither avant-garde nor traditional." He did not purposely invent new structures, nor did he feel restricted to what had been most popular in the past. His books include *Collected Poems: 1937–1976* and an autobiography, *The Trouble with Francis.*

Langston Hughes (1902–1967)

Langston Hughes, born in Joplin, Missouri, was one of the key figures of the Harlem Renaissance of the 1920s, a cultural awakening that expressed the diversity and vitality of the black experience in America. Hughes got his start as a poet through a stroke of luck. When he was working in a Washington hotel, he left some of his poems beside the plate of poet Vachel Lindsay. Lindsay recognized the young poet's talent and introduced Hughes to the literary world. Hughes's poems were among the first to express the spirit of the blues in words.

Ted Hughes (1930–1998)

Ted Hughes grew up in a half-rural, half-industrial area of Yorkshire, England. Many of Hughes's poems, such as "The Lake," depict nature as wild and brutal, but this poet had a lyrical side, too, as seen in his books for children. A prolific writer, Hughes published more than seventy works, including poetry collections, plays, and books of children's poems and plays. He also wrote radio plays and recorded poetry. He received several awards, including the Guinness Award, the Guggenheim Fellowship, and the Queen's Gold medal for Poetry. In 1984 he was named poet laureate of England.

Emily Dickinson (1830–1886)

The Granger Collection, New York

Emily Dickinson was born in Amherst, Massachusetts, where she lived her entire life. Though she wrote more than 1,700 poems—on bits of wrapping paper, envelopes, and old grocery bills—not more than seven of her poems were published during her lifetime. As critic Van Wyck Brooks says, Dickinson "domesticated the universe," often drawing metaphors from the details of ordinary life.

Theodore Roethke (1908–1963)

Theodore Roethke grew up "in and around a beautiful greenhouse" owned by his father and uncle in Saginaw, Michigan. "Big Wind" is one of several poems Roethke wrote about the greenhouse, which, he said, had a profound effect on his childhood. Roethke once wrote that "Big Wind" shows how a poet writing in free verse can use a formal device—in this case, repetition of participial and verbal forms—to keep the action going and give energy to the poem. Roethke sold his first poems when he was a graduate student at Harvard University. His collection called *The Waking* earned him the Pulitzer Prize in 1954. At the time of his death, Roethke was poet-in-residence at the University of Washington in Seattle.

Sara Teasdale (1884–1933)

Sara Teasdale was born in St. Louis and lived most of her adult life there and in New York City. Though wooed by the poet Vachel Lindsay, she married a St. Louis businessman instead. She was a victim of ill health and often withdrew into her own private world. She is remembered chiefly for a few graceful, simple lyrics.

Philip Booth (1925–)

Philip Booth was born in Hanover, New Hampshire. After graduating from Dartmouth College and Columbia University, Booth taught literature and writing. He is now a professor of English and poet-in-residence at Syracuse University and has written several collections of poetry, including *Available Light* (1976) and *Before Sleep* (1980). His poems are noted for their powerful images and intensely personal themes. Booth has received many awards, including the Guggenheim Fellowship, the American Academy Award, and the Academy of American Poets Fellowship. A recent collection of poetry is *Selves* (1990)

Arna Bontemps (1902–1973)

Arna Bontemps was born in Alexandria, Louisiana, and educated at Pacific Union College and at the University of Chicago. As a young writer, Bontemps was a leader of the Harlem Renaissance, a literary movement of the 1920s. With Langston Hughes he compiled *The Poetry of the Negro,* an anthology that covers two hundred years of black poetry.

TONE

Think of all the ways "Good morning" can be spoken. A person may say it cheerfully or sullenly, cordially or grudgingly, stiffly or warmly, courteously or contemptuously, proudly or eagerly, with stiff politeness or with boisterous good will. In short, the words "Good morning" can be uttered so as to mean almost anything from "I love you" to "I don't really care to speak to you." The manner in which the words are spoken is as important as their dictionary definition.

Poets, too, communicate meaning through *tone*—that is, through the attitudes they take toward their subject matter or audience. Three poets can write on the same topic: one might be serious, one might be sarcastic, and one might be light and humorous. Thus, it is important to recognize a poet's tone, because if we misread the tone, we might badly misread the entire work.

Unlike vocal communications, poems cannot express tone through inflection, volume, and pitch. Tone is indicated in a poem by other methods: by the particular words chosen, by the arrangement of the words, by rhythm, sound, images, and figures of speech.

Miss Rosie

LUCILLE CLIFTON

It is possible to go astray in reading a poem if we do not grasp its tone. How do you think the poet wants you to respond to the subject of this poem?

When I watch you
wrapped up like garbage
sitting, surrounded by the smell
of too old potato peels
or 5
when I watch you
in your old man's shoes
with the little toe cut out
sitting, waiting for your mind
like next week's grocery 10
I say
when I watch you
you wet brown bag of a woman
who used to be the best looking gal
 in Georgia
used to be called the Georgia Rose 15
I stand up
through your destruction
I stand up

For Study and Discussion

Analyzing and Interpreting the Poem

1. The "smell of too old potato peels" in lines 3–4 is an image that arouses unpleasant associations. What unpleasant metaphors and similes are used to describe Miss Rosie?

2. The poem shifts suddenly at line 14. How do the details in lines 14–15 change your perception of Miss Rosie?

3a. Why do you suppose the speaker would "stand up" for this "wet brown bag of a woman"? **b.** What does this reveal about the poet's tone—the way she feels toward Miss Rosie?

4a. How does repetition create rhythm here? **b.** What ideas are emphasized by the repetition?

Creative Writing

Writing a Poem

Imitate the conversational style of this poem and write a poem in which you describe someone or something that you would "stand up" for. Open with the words "When I" and close with the words "I stand up." Do not attempt rhyme or a regular rhythm. Make your poem sound as if you were speaking naturally.

Focus on Descriptive Writing

Gathering Descriptive Details

You can use one or more of the following strategies to gather details for a description:

Observing Use all your senses to observe your subject directly. Freewrite about your subject while you observe it.

Recalling Shut your eyes and tap into your memory. Call up a mental picture of your subject and take notes about it.

Researching Gather details from books, magazines, pictures, or interviews.

Imagining Make up realistic or fantastic details of your own.

Choose a person whom you admire. Using the strategies listed above, write a list of details for a description of this person. Try to make your details as specific and vivid as possible. When you have finished writing, get together with a partner to compare lists. Save your notes.

A Blessing

JAMES WRIGHT

The tone of a poem is affected by its subject matter as well as by its style. How is the attitude of the speaker in this poem expressed through details and words?

Just off the highway to Rochester, Minnesota,
Twilight bounds softly forth on the grass.
And the eyes of those two Indian ponies
Darken with kindness.
They have come gladly out of the willows 5
To welcome my friend and me.
We step over the barbed wire into the pasture
Where they have been grazing all day, alone.
They ripple tensely, they can hardly contain their happiness
That we have come. 10
They bow shyly as wet swans. They love each other.
There is no loneliness like theirs.
At home once more,
They begin munching the young tufts of spring in the darkness.
I would like to hold the slenderer one in my arms, 15
For she has walked over to me
And nuzzled my left hand.
She is black and white,
Her mane falls wild on her forehead,
And the light breeze moves me to caress her long ear 20
That is delicate as the skin over a girl's wrist.
Suddenly I realize
That if I stepped out of my body I would break
Into blossom.

For Study and Discussion

Analyzing and Interpreting the Poem

1a. What images describe the setting and the horses? **b.** What experience is central to the poem?

2. What metaphor at the end of the poem tells how the speaker feels about the experience?

3. The tone of this poem is joyful. It expresses the pleasure that comes from springtime and love. What images in the poem help to suggest this tone?

Focus on Descriptive Writing

Identifying a Special Emphasis

Sometimes completeness may be your goal in descriptive writing. At other times, however, you may want to focus on a **special emphasis,** or impression. For example, in "A Blessing" James Wright carefully selects details that contribute to a single, overall impression: the experience of joy in sharing love.

Make a list of details for a description of an animal, such as a giraffe, an elephant, a lion, or a coyote. Then choose details from your list that all contribute to a special emphasis. You may want to fill out a diagram like the one below. Save your notes.

Detail 1: _____ Detail 2: _____

Special Emphasis: _____

Detail 5: _____ Detail 3: _____

Detail 4: _____

Tableau at Twilight

OGDEN NASH

Ogden Nash is well known for his imaginative and humorous use of language. What examples can you find of invented words and ingenious rhymes in this poem?

I sit in the dusk. I am all alone.
Enter a child and an ice-cream cone.

A parent is easily beguiled
By sight of this coniferous° child.

4. **coniferous** (kō-nĭf′ər-əs): bearing cones, used of a cone-bearing tree.

The friendly embers warmer gleam, 5
The cone begins to drip ice cream.

Cones are composed of many a vitamin.
My lap is not the place to bitamin.

Although my raiment is not chinchilla,°
I flinch to see it become vanilla. 10

9. **chinchilla** (chĭn-chĭl′ə): a pale-gray fur.

Coniferous child, when vanilla melts
I'd rather it melted somewhere else.

Exit child with remains of cone.
I sit in the dusk. I am all alone,

Muttering spells like an angry Druid,° 15
Alone, in the dusk, with the cleaning fluid.

15. **Druid** (drōo′ĭd): a priest in ancient Britain.

For Study and Discussion

Analyzing and Interpreting the Poem

1. The tone of "Tableau at Twilight" is light-hearted and humorous. **a.** Why does the first line of the poem give a false impression about the poem? **b.** What words make the tone of the poem shift with the second line?

2. How does the word *parent* help establish the tone of the poem?

3. What humorous meaning does Nash give to the word *coniferous*?

4. Nash is known for his creative play with words. **a.** What does he use to rhyme with *vitamin*? **b.** What is the meaning of the word?

5. Part of the humor in Nash's poem comes from the contrast in diction. Compare the choice of words in these pairs of lines: 5–6, 9–10, 15–16. What is the effect of rhyming a word like *chinchilla* with *vanilla*?

6. Although the speaker says in line 15 that he is angry, why does his tone come through as amused rather than angry?

Tableau at Twilight **407**

Transit

ADRIENNE RICH

The word transit *means "a passage across or through something." It also means "a change or transition from one place or situation to another." What do you think the word means in the title of this poem?*

When I meet the skier she is always
walking, skis and poles shouldered, toward the mountain
knee-swinging in worn boots
over the path new-sifted with fresh snow
over graying dark hair almost hidden by 5
a cap of many colors
her fifty-year-old, strong, impatient body
dressed for cold and speed
her eyes level with mine

And when we pass each other I look into her face 10
wondering what we have in common
where our minds converge
for we do not pass each other, she passes me
as I halt beside the fence tangled in snow,
she passes me as I shall never pass her 15
in this life

Yet I remember us together
climbing Chocorua,° summer nineteen-forty-five 18. **Chocorua** (shə-kôr′ə-wə):
details of vegetation beyond the timberline Mount Chocorua in the White
lichens, wildflowers, birds, Mountains, New Hampshire.
amazement when the trail broke out onto the granite ledge 20
sloped over blue lakes, green pines, giddy air
like dreams of flying

When sisters separate they haunt each other
as she, who I might once have been, haunts me 25
or is it I who do the haunting
halting and watching on the path
how she appears again through lightly-blowing
crystals, how her strong knees carry her,
how unaware she is, how simple 30
this is for her, how without let or hindrance
she travels in her body
until the point of passing, where the skier
and the cripple must decide
to recognize each other? 35

For Study and Discussion

Analyzing and Interpreting the Poem

1a. Which words in the first stanza are associated with the skier's age? **b.** Which words and phrases in the first stanza convey an image of the skier's movement and energy?

2. What is the speaker's attitude toward the skier?

3. The word *pass* appears five times in the second stanza. **a.** Why does the speaker give this word so much emphasis? **b.** Explain the meaning of lines 15–16.

4. Why does the shift in time in the third stanza also create a shift in mood?

5a. Why does the speaker say that the image of the skier haunts her? **b.** The speaker adds that perhaps she is the one that haunts the skier. Can you explain this?

Ex-Basketball Player

JOHN UPDIKE

Pearl Avenue runs past the high-school lot,
Bends with the trolley tracks, and stops, cut off
Before it has a chance to go two blocks,
At Colonel McComsky Plaza. Berth's Garage
Is on the corner facing west, and there, 5
Most days, you'll find Flick Webb, who helps Berth out.

Flick stands tall among the idiot pumps—
Five on a side, the old bubble-head style,
Their rubber elbows hanging loose and low.
One's nostrils are two S's, and his eyes 10 **10-11. two S's . . . E and O:**
An E and O.° And one is squat, without ESSO, a former trademark for
A head at all—more of a football type. Standard Oil.

The Diner (1964–1966) by George
Segal (1924–). Plaster,
wood, chrome, formica, mason-
ite, fluorescent lamp.

Once Flick played for the high-school team, the Wizards.
He was good: in fact, the best. In '46
He bucketed three hundred ninety points, 15
A county record still. The ball loved Flick.
I saw him rack up thirty-eight or forty
In one home game. His hands were like wild birds.

He never learned a trade, he just sells gas,
Checks oil, and changes flats. Once in a while, 20
As a gag, he dribbles an inner tube,
But most of us remember anyway.
His hands are fine and nervous on the lug wrench.
It makes no difference to the lug wrench, though.

Off work, he hangs around Mae's Luncheonette, 25
Grease-grey and kind of coiled, he plays pinball,
Sips lemon cokes, and smokes those thin cigars;
Flick seldom speaks to Mae, just sits and nods
Beyond her face towards bright applauding tiers
Of Necco Wafers, Nibs, and Juju Beads. 30

For Study and Discussion

Analyzing and Interpreting the Poem

1. The poem is a character study. It contrasts Flick Webb's past glories with his present life. What specific lines present this contrast?

2. How does Flick himself contrast with his setting, as described in the second stanza?

3. Except for the last lines, Flick is described from the outside, from the point of view of the speaker. Yet at the end of the poem we are given a glimpse into Flick's mind. Why does this image make such a powerful comment on Flick's life?

4a. How would you describe the tone of the poem: that is, what is the speaker's attitude toward the ex-basketball player? **b.** How does the title itself suggest an attitude toward Flick? (Suppose, for example, the title were "Flick Webb" or "Gas-Station Attendant." What attitudes would these titles suggest?)

Focus on Descriptive Writing

Using Factual Details

Factual details are realistic details or items that can be measured or checked: for example, the geographical details (lines 1–5) and the details about Flick's record (lines 14–18) in Updike's "Ex-Basketball Player." Although factual details are especially important in scientific writing, you can use them in both objective and subjective descriptions.

Locate an encyclopedia article about a machine, a musical instrument, or a plant. Read the article carefully and make a list of all the factual details you discover. Then make notes on how you could classify these details, using categories such as size, color, shape, weight, and sound. Save your writing.

About the Authors

Lucille Clifton (1936 –)

Lucille Clifton was born in Depew, New York, and educated at Howard University and Fredonia State Teachers' College. In addition to her career as a claims clerk, literature assistant, visiting writer, and poet-in-residence, Clifton has raised six children and published more than twenty books of poetry, fiction, and children's literature. She was awarded a National Endowment for the Arts grant, received the Juniper Prize in 1980, and was named Maryland's official poet laureate. She says of her work, "I am a black woman poet, and I sound like one."

James Wright (1927–1980)

James Wright said: "I have written about things I am deeply concerned with—crickets outside my window, cold and hungry old men, ghosts in the twilight, horses in a field, a red-haired child in her mother's arms, a feeling of desolation in the fall, some cities I have known." He was born in Martin's Ferry, Ohio, and lived in New York City. Like many poets, Wright earned his living as a college professor. In 1972 he was awarded the Pulitzer Prize.

Ogden Nash (1902–1971)

Ogden Nash was born in Rye, New York, attended Harvard University, and lived in Baltimore, Maryland. During Nash's varied career, he worked as a school teacher, advertising writer, editor, and television panelist on "Masquerade Party."

He wrote volumes of light verse and is considered America's foremost humorous poet. Nash is known for his outrageous play with the English language in creating rhymes and puns that are both wise and witty.

Adrienne Rich (1929–)

Adrienne Rich grew up in Baltimore, Maryland. When she graduated from Radcliffe College, she was awarded the prestigious Yale Younger Poets Prize for her first collection of poems, *A Change of World* (1951). A renowned feminist leader and teacher, Rich is considered one of the most important writers of the twentieth century. Her poetry and prose reflect her interest in the personal and political plights of oppressed people. She has published several collections of essays and more than twenty books of poetry.

John Updike (1932–)

John Updike grew up in a small town in Pennsylvania. He won highest honors at Harvard before beginning a career as a novelist, poet, critic, essayist, and dramatist. He is best known for his novels, which often portray the average American family-man in a search for meaning and morality. His best-known novels have depicted the life of the fictional "Rabbit" Angstrom, and Updike received many honors, including the Pulitzer Prize, for the third book in the series, *Rabbit Is Rich*. His poetry, like his novels, treats the plight of the American male with both humor and seriousness.

MUSICAL DEVICES

One of the chief characteristics of poetry is its use of language to create musical effects. Some of the earliest known poems, the Greek *lyrikoi* and the Hebrew psalms, were, in fact, written to be accompanied by music, which was usually produced by a lyre or other stringed instrument. In choosing their words, poets always consider musical quality as well as meaning, and they often use sound to reinforce meaning. Edgar Allan Poe described poetry as "music . . . combined with a pleasurable idea." You can hear Poe's "music" in this first stanza of his poem "Annabel Lee":

> It was many and many a year ago,
> In a kingdom by the sea,
> That a maiden there lived whom you may know
> By the name of Annabel Lee;
> And this maiden she lived with no other thought
> Than to love and be loved by me.

The principal device that Poe employs to make this stanza musical is *rhyme*—the repetition of accented vowel sounds and all succeeding sounds in words that appear close to each other. The words *ago / know* and *sea / Lee / me* are *end rhymes*—rhyming words that occur at the end of a poetic line. They are also *exact rhymes*—words that exactly repeat a sound. Other forms of rhyme that you will encounter in this section are *internal rhyme*—rhyme occurring within a line, and *approximate rhyme*—rhyme in which the final sounds of words are similar but not identical.

Poets make use of other forms of repetition besides rhyme. *Alliteration* is the repetition of consonant sounds, usually at the beginnings of words. *Assonance* is the repetition of vowel sounds. Another common form of repetition is the *refrain,* which is the recurring use of a phrase, an entire line, or a stanza. Refrains are especially popular in ballads, which are story poems that are often meant to be sung.

Onomatopoeia (ŏn′ə-măt′ə-pē′ə) is another musical device often used by poets. Onomatopoeia occurs when the sound of a word imitates or suggests its meaning. In this quotation from *The Princess* by Alfred, Lord Tennyson, the musical quality of the lines is enhanced by the onomatopoetic words *moan* and *murmuring:*

> The moan of doves in immemorial elms,
> And murmuring of innumerable bees.

In the poems to come, you will see how musical devices are used by many different poets to achieve widely different effects. If you look closely enough, you should be able to find music in all poetry. Beautiful or harsh, flowing or staccato, each poem plays a distinct tune.

Once by the Pacific

ROBERT FROST

Sometimes a poet uses understatement, *deliberately holding back or saying less than the truth. What momentous event is Frost speaking about in the last five lines of this poem?*

The shattered water made a misty din.
Great waves looked over others coming in,
And thought of doing something to the shore
That water never did to land before.
The clouds were low and hairy in the skies, 5
Like locks blown forward in the gleam of eyes.
You could not tell, and yet it looked as if
The shore was lucky in being backed by cliff,
The cliff in being backed by continent;
It looked as if a night of dark intent 10
Was coming, and not only a night, an age.
Someone had better be prepared for rage.
There would be more than ocean-water broken
Before God's last *Put out the Light* was spoken.

For Study and Discussion

Analyzing and Interpreting the Poem

1a. How does the poet personify the clouds and waves? **b.** What details in the first six lines suggest violence and destruction?

2. From this specific natural scene, the poet goes on to talk about a much broader scene or situation. **a.** What does this setting make him think of? **b.** Whose "rage" is he talking about in line 12?

3. In Genesis, the Creator uses the words "Let there be light." How does Frost picture the end of the world in the last two lines?

Literary Elements

Rhyme

Rhyme is the repetition of accented vowel sounds and all succeeding sounds in words that appear close to each other. Rhyme is one of the chief ways by which a poet creates verbal music. Most rhymes are **end rhymes**; they occur at the ends of lines. Poets also can use **internal rhymes**, rhymes which occur within a line.

This poem is written in pairs of rhyming lines called **couplets**. If you look at the poem, you'll see that the last words in each pair of lines rhyme. All of the rhymes are **exact rhymes**. This means that the sounds of the accented vowels correspond exactly: *din/in; age/rage; broken/spoken*. Notice that spelling has nothing to do with rhyme; it is the sound of the words that counts. *Skies* and *eyes* are spelled differently, yet they are exact rhymes.

It is difficult to write an entire poem in couplets and not have it become monotonous. Frost has skillfully constructed this poem so that the rhymes contribute to the music but do not interfere with the meaning. To prevent a singsong effect, he has often used punctuation to force us to pause in unexpected places. We would not make a full pause at the end of the third line, for example. Instead, we must keep on reading until we come to the period at the end of line 4. Where are we forced to make pauses in reading lines 7–11?

The Splendor Falls

ALFRED, LORD TENNYSON

In 1848, when Tennyson visited the lakes of Killarney in Ireland, he heard the echoes of the boatsman's bugle over the water. The experience inspired this famous poem, which is sometimes called "The Bugle Song." When Tennyson visited Killarney much later, another boatsman said, "So you're the gentleman that brought the money to the place"—suggesting that this poem had bolstered the tourist trade.

The splendor falls on castle walls
 And snowy summits old in story;
The long light shakes across the lakes,
 And the wild cataract° leaps in glory. 4. **cataract:** waterfall.
Blow, bugle, blow, set the wild echoes flying, 5
Blow, bugle; answer, echoes, dying, dying, dying.

O, hark, O, hear! how thin and clear,
 And thinner, clearer, farther going!
O, sweet and far from cliff and scar° 9. **scar:** rocky place.
 The horns of Elfland faintly blowing! 10
Blow, let us hear the purple glens replying,
Blow, bugle; answer, echoes, dying, dying, dying.

O love, they die in yon rich sky,
 They faint on hill or field or river;
Our echoes roll from soul to soul, 15
 And grow for ever and for ever.
Blow, bugle, blow, set the wild echoes flying,
And answer, echoes, answer, dying, dying, dying.

Analyzing and Interpreting the Poem

1a. What images in the first stanza help you see what the speaker sees? **b.** What images in the second stanza help you hear what he hears?

2. What images in the first two stanzas suggest that the speaker sees this setting as romantic, like something in a fairy tale?

3a. How do the last two lines of each stanza help you hear the echoes of the bugle? **b.** What line makes the bugle and its echoes seem farther and farther away?

4. In the last stanza, Tennyson uses the echoes to make a point. Here the speaker addresses his love. **a.** What does the speaker say their "echoes" will do that the bugle's echoes do not do? **b.** What do you think he means by "echoes" in line 15?

Literary Elements

Rhyme

The music in this poem is achieved in two ways: Tennyson repeats words that help us hear the sound of the bugle and its dying echoes; and he uses end rhyme and internal rhyme.

Rhyme not only lends musical quality to a poem, but also gives it structure. End rhymes are often arranged in a certain pattern, called a **rhyme scheme**. Here is the rhyme scheme of the first stanza of "The Splendor Falls." Notice that a new letter of the alphabet is used to indicate each new end rhyme:

The splendor falls on castle walls	*a*
And snowy summits old in story;	*b*
The long light shakes across the lakes,	*c*
And the wild cataract leaps in glory.	*b*
Blow, bugle, blow, set the wild echoes flying,	*d*
Blow, bugle; answer, echoes, dying, dying,	
dying.	*d*

What is the rhyme scheme of the other stanzas? Is the pattern of end rhymes the same in each stanza?

This poem is famous for its internal rhymes. The first example is in line 1:

> The splendor *falls* on castle *walls*

What lines in each stanza contain internal rhymes? Is there a pattern to these internal rhymes?

Writing About Literature

Discussing Musical Devices

Write a short essay in which you discuss the musical devices used in the last stanza of "The Splendor Falls." When preparing to write your paper, look for answers to the following questions: What sound is used to start the stanza? What words create the assonance in the third line of the stanza? What is the repeated vowel sound? Are the repetitions of the long *o* sounds and the unstressed vowel sounds in a regular pattern? Does the combination of the long *o* sounds and the surrounding unstressed vowel sounds sometimes create the effect of an echo? How does the word *echo* itself remind us of the thing it identifies? In which lines do you find internal rhyme? What examples of alliteration do you find in the stanza? What vowel sounds does the poet use in the last words of the stanza? What effect is created by the repetition at the end of the stanza? (Is the last syllable stressed or unstressed?) Be sure to use specific examples from the poem and punctuate direct quotations with quotation marks.

Blue Girls

JOHN CROWE RANSOM

Twirling your blue skirts, traveling the sward°
Under the towers of your seminary,°
Go listen to your teachers old and contrary
Without believing a word.

Tie the white fillets° then about your hair
And think no more of what will come to pass
Than bluebirds that go walking on the grass
And chattering on the air.

Practice your beauty, blue girls, before it fail;
And I will cry with my loud lips and publish
Beauty which all our power shall never establish,
It is so frail.

For I could tell you a story which is true;
I know a lady with a terrible tongue,
Blear eyes fallen from blue,
All her perfections tarnished—yet it is not long
Since she was lovelier than any of you.

1. **sward** (swôrd): grass.
2. **seminary:** private school.

5

5. **fillets:** ribbons.

10

15

For Study and Discussion

Analyzing and Interpreting the Poem

1. How do you know that the speaker is older and wiser than the girls being addressed?

2a. To what are the girls compared in lines 6–8? **b.** What does this comparison emphasize?

3a. What advice does the speaker give the girls in the first three stanzas? **b.** According to stanzas 3 and 4, why is he telling them to do these things?

4. How does the image of "blear" blue eyes in the last stanza contrast with the images of blue in the rest of the poem?

5a. Describe the tone in the first two stanzas. **b.** How does the tone change in the last two stanzas? **c.** What specific words and images establish the change in tone?

Literary Elements

Approximate Rhyme

Approximate rhyme is rhyme in which the final vowel sounds are similar but not identical. The words *sward/word* in lines 1 and 4 are approximate rhymes. Modern poets make extensive use of approximate rhymes. Find two more examples of approximate rhymes in the poem. What effect do these rhymes have on the way you read the poem?

Summer Remembered

ISABELLA GARDNER

The poet recalls and re-creates the sounds of summer. What clues are there to the setting of the poem?

Sounds sum and summon the remembering of summers.
The humming of the sun
The mumbling in the honey-suckle vine
The whirring in the clovered grass
The pizzicato° plinkle of ice in an auburn 5
uncle's amber glass.
The whing of father's racquet and the whack
of brother's bat on cousin's ball
and calling voices call-
ing voices spilling voices . . . 10
The munching of saltwater at the splintered dock
The slap and slop of waves on little sloops
The quarreling of oarlocks hours across the bay
The canvas sails that bleat as they
are blown. The heaving buoy bell- 15
ing HERE I am
HERE you are HEAR HEAR

listen listen listen
The gramophone is wound
the music goes round and around 20
BYE BYE BLUES LINDY'S COMING
voices calling calling calling
"Children! Children! Time's Up
Time's Up"
Merrily sturdily wantonly the familial voices 25
cheerily chidingly call to the children TIME'S UP
and the mute children's unvoiced clamor sacks° the summer air
crying Mother Mother are you there?

5. **pizzicato:** the sound made by plucking a string on a violin or other stringed instrument.

27. **sacks:** ravages or destroys.

Analyzing and Interpreting the Poem

1. Line 1 of this poem introduces its subject, just as a topic sentence introduces the subject of a paragraph. **a.** What is the poem's subject? **b.** What is the function of lines 2–26?

2. Many of the sounds in this poem are described by means of metaphors. For example, in line 3 the sound of the wind in the honeysuckle is compared to the sound made by a person mumbling. What metaphors are used to describe sounds in lines 11, 13, and 14?

3. The images in the last two lines provide a sharp contrast to those in the rest of the poem. **a.** What images in lines 1–26 suggest a mood of peace, innocence, and fun? **b.** What images in lines 27–28 suggest anxiety and a threat of some kind?

Literary Elements

Onomatopoeia, Alliteration, and Assonance

The speaker of this poem recalls the "sounds" of summer, so it is appropriate that the poem uses a number of sound effects. To be appreciated fully, the poem should really be read aloud. The most obvious sound device used in the poem is **onomatopoeia**, the use of a word whose sound imitates or suggests its meaning. The word *humming* in line 2 is a good example of onomatopoeia. What onomatopoetic words are used to describe the sounds of bees in the grass, of the ice, of the games, and of the waves?

Another sound device used in the poem is **alliteration**, the repetition of consonant sounds, usually at the beginning of words. Alliteration seems to have a special appeal for the ear and is found in many familiar expressions: "a dime a dozen," "bigger and better," and "jump for joy." Alliteration is often used to reinforce meaning or to create a mood. In line 1, for example, the repeated *s* sounds suggest a quiet, hushed mood, as if someone is saying "Sh-h-h, listen." But often alliteration is simply used for pleasure. Where is alliteration used in lines 5, 7, 8, 12, 15, and 26? Is alliteration used to reinforce the meaning of any of these lines?

Related to alliteration is **assonance**—the repetition of vowel sounds in words. Lines 1–3 provide an example of assonance. How many times is the vowel sound *u* repeated in these lines? What vowel sound is repeated in line 5?

Focus on Descriptive Writing

Organizing Descriptive Details

Isabella Gardner helps you to hear the sounds of summer by organizing her details into clusters. You will help your audience to follow your description if you organize your details in a logical way. Here are three methods that may be helpful:

Spatial Order Arrange details from top to bottom, from side to side, or from near to far.
Order of Importance Place the most important details either first or last.
Order of Impression Start with the most important detail and move on to other details in chronological or time order.

Review the lists of details for the **Focus** assignments on pages 403, 405, and 411, or compile a different list on a new subject. Use one of the methods above to organize your details in a logical order. Save your writing.

Two Bodies

OCTAVIO PAZ°

Two bodies face to face
are at times two waves
and night is an ocean.

Two bodies face to face
are at times two stones 5
and night a desert.

Two bodies face to face
are at times two roots
laced into night.

Two bodies face to face 10
are at times two knives
and night strikes sparks.

Two bodies face to face
are two stars falling
in an empty sky. 15

° **Octavio Paz** (ôk-tä′vyō päz).

Double Star.
© 1992 F. Reginato/The Image Bank

For Study and Discussion

Analyzing and Interpreting the Poem

1. Repetition is the reappearance of a word, phrase, stanza, or structure in a literary work. **a.** What examples of repetition do you find in this poem? **b.** What emphasis is achieved by this repetition?

2. Each of the stanzas uses a different metaphor. What does each metaphor say about human relationships?

3. What do you consider to be the theme or main idea of this poem?

Fifteen

WILLIAM STAFFORD

South of the Bridge on Seventeenth
I found back of the willows one summer
day a motorcycle with engine running
as it lay on its side, ticking over
slowly in the high grass. I was fifteen. 5

I admired all that pulsing gleam, the
shiny flanks, the demure headlights
fringed where it lay; I led it gently
to the road and stood with that
companion, ready and friendly. I was fifteen. 10

We could find the end of a road, meet
the sky on out Seventeenth. I thought about
hills, and patting the handle got back a
confident opinion. On the bridge we indulged
a forward feeling, a tremble. I was fifteen. 15

Thinking, back farther in the grass I found
the owner, just coming to, where he had flipped
over the rail. He had blood on his hand, was pale—
I helped him walk to his machine. He ran his hand
over it, called me good man, roared away. 20

I stood there, fifteen.

For Study and Discussion

Analyzing and Interpreting the Poem

1a. What details in the second and third stanzas personify the motorcycle—that is, describe it as if it were a person? **b.** What kind of person does the boy think the machine is?

2. The word *thinking* in the last stanza marks a turning point in the poem. **a.** What word in this stanza indicates that the boy no longer sees the motorcycle as a person, but sees it for what it is? **b.** What accounts for the change in his thinking?

3. In your opinion, what does this poem say about youthful fantasies and adult realities?

Literary Elements

Refrain

One form of repetition often used by poets is the **refrain**—a line or group of lines repeated

Yamaha (1973) by David Parrish (1939–). Oil on canvas.
Wadsworth Atheneum, Hartford, The Ella Gallup Sumner and Mary Catlin Sumner Collection

Creative Writing

Using a Refrain

Write a brief poem of your own in which you use a refrain for emphasis and for setting a mood. You might imitate Stafford's poem and narrate an incident from your life. Your refrain might then begin with the words "I was_____" and give the age at which the incident took place. Do not attempt to use rhyme and rhythm; try to imitate the conversational style of Stafford's poem.

About the Authors

Robert Frost (1874–1963)

Robert Frost wrote of the birch trees, the stone walls, the white churches, the mountains, and the snowfalls of New England, and of the region's farmers, wanderers, and hired men. Frost moved to New England when he was a child, and as a young man he attempted farming and poetry writing. Neither venture met with much success. Discouraged, Frost moved with his family to England, and there published his first two books of poetry: *A Boy's Will* (1913) and *North of Boston* (1914). The books were immediate successes and Frost was soon one of America's most revered poets. He eventually won four Pulitzer Prizes and numerous other awards. Though he is beloved for his simple language and familiar country settings, Frost also reveals images of the tragic and disturbing side of human life. In one of his poems, Frost said that if an epitaph were to sum up his story, he had one ready: "I had a lover's quarrel with the world."

throughout a poem. What is the refrain in this poem? What does the poet want to emphasize with this refrain?

In line 20, the owner of the motorcycle calls the boy a "good man." How does the final refrain show that the poet sees irony in this remark—that is, that he wants us to realize that the opposite is actually true?

Alfred, Lord Tennyson (1809–1892)

Alfred, Lord Tennyson was England's chief poetic spokesman during the age of Queen Victoria. Tennyson attended Cambridge University, but he was not an exceptional student and never received a degree. He read widely, though, and devoted his life to poetry. Tennyson is famous for such long poems as *Idylls of the King*, *In Memoriam*, and "The Lady of Shalott." He is also known for numerous short lyrics, many of which are found in a long collection called *The Princess*. Tennyson was England's poet laureate for over forty years.

John Crowe Ransom (1888–1974)

John Crowe Ransom was an eminent poet, a teacher of eminent poets, and a leading figure in American literary criticism. Born in Pulaski, Tennessee, he was educated at Vanderbilt University, and, as a Rhodes scholar, at Oxford University. Ransom was a principal member of the Southern Agrarians, a group who wanted to preserve certain values and traditions of the old South. In 1937 he founded the important literary magazine *The Kenyon Review*. Ransom's poetry explores with wit and irony the traditional themes of love, death, and change. In 1964 he won a National Book Award for his *Selected Poems*.

Isabella Gardner (1915 –1981)

Isabella Gardner was born in Newton, Massachusetts, and for a time was a professional actress. From 1952 to 1956 she was an editor, with the poet Karl Shapiro, of the influential literary magazine *Poetry*. She gave poetry readings in many parts of the world.

Octavio Paz (1914–)

Octavio Paz, a famed poet, literary critic, and social philosopher, was born in Mexico City. He developed a talent for writing at an early age and published his first volume of poems when he was nineteen. His poetry usually focuses on one of two themes: human relationships and Mexico's heritage. In 1990 Paz was awarded the Nobel Prize for literature.

William Stafford (1914–1993)

William Stafford was born in Kansas and lived in Oregon for much of his life. He published more than twenty-eight collections of poetry during his lifetime. His many awards included the National Book Award for *Traveling Through the Dark* in 1963 and the American Academy and Institute of Arts and Letters Award in Literature in 1981. In 1975 he was named poet laureate of Oregon. His last book, *The Long Sigh the Wind Makes*, was published in 1991.

RHYTHM AND METER

Closely associated with the "music" of poetry is rhythm. The term *rhythm* refers to any regularly recurrent flow of motion or sound. In music, we recognize rhythm as the regular "beat" of a song. If we look closely, we can also observe a regular pattern in the way we breathe, or walk, or swim, or plow our fields. There is also rhythm in the way we talk.

In speech, rhythm is the natural rise and fall of language—the alternation between the stressed and unstressed syllables of words. Poets plot these alternations consciously, using rhythm, as they do musical devices, to enhance the meaning of what they write. When a line of poetry has a regularized rhythmic pattern, we say it has a *meter*. Poetry in meter is poetry in which we can detect a more or less regular "beat."

Poets writing in English have long recognized that writing with a "beat" makes an emotional impact on readers and listeners. In the poems to come, you will explore one of the most popular metrical forms in English—*iambic pentameter*. In the past century, many poets have experimented with an important departure from meter—*free verse*. This poetry, an example of which you will also read, is not controlled by any regular metrical pattern. Nevertheless, it uses strong rhythms, much as we use them in our natural speech.

Like musical devices, rhythm is best appreciated when you hear a poem read aloud. Try reading the following poems aloud as you study them, and discover for yourself the pleasure of rhythm in language.

Sea Fever

JOHN MASEFIELD

We use the term spring fever *to refer to a feeling of laziness and dreaminess.
How would you define what Masefield means by "sea fever"?*

I must go down to the seas again, to the lonely sea and the sky,
And all I ask is a tall ship and a star to steer her by;
And the wheel's kick and the wind's song and the white sail's
 shaking,
And a gray mist on the sea's face and a gray dawn breaking.

I must go down to the seas again, for the call of the running tide 5
Is a wild call and a clear call that may not be denied;
And all I ask is a windy day with the white clouds flying,
And the flung spray and the brown spume,° and the sea gulls
 crying.

8. **spume** (spyo͞om): foam.

I must go down to the seas again, to the vagrant gypsy life,
To the gull's way and the whale's way where the wind's like a
 whetted knife; 10
And all I ask is a merry yarn from a laughing fellow-rover,
And quiet sleep and a sweet dream when the long trick's° over.

12. **trick:** sailor's turn of duty.

For Study and Discussion

Analyzing and Interpreting the Poem

1. What specific images help you see, hear, and feel what life on the sea is like?

2. How does Masefield use repetition to suggest the urgency of the sea's call and of the speaker's needs?

3. Masefield has used words that suggest certain sounds. What repeated consonant sound in lines 3, 7, and 10 might suggest the sound of wind?

4. Details in the last stanza suggest that Masefield is talking not only about life at sea, but about something broader as well. Suppose he has used the words "long trick" to mean life itself. **a.** What images in the last line could refer to death and to life after death? **b.** What sort of life does the speaker look for after his exciting "sea life" is over?

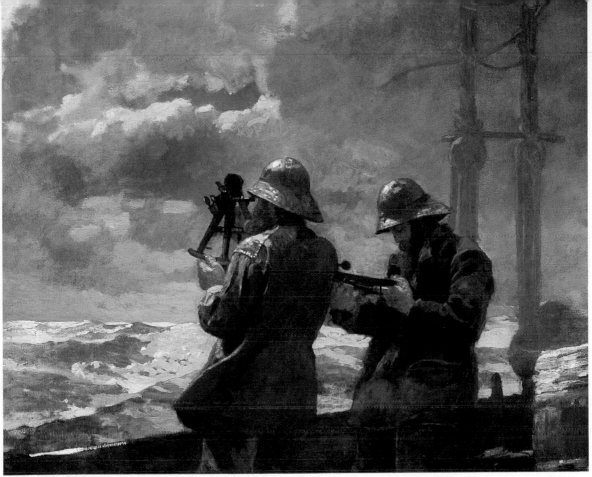

Eight Bells (1886) by Winslow Homer. Oil on canvas.
Courtesy of the Addison Gallery of American Art, Phillips Academy, Andover, Massachusetts. All Rights Reserved.

Literary Elements

Rhythm and Meter

If you read Masefield's poem aloud, you will notice its steady beat. The poem has a lilt and a kick to it, like the roll and toss of waves at sea. We call this the poem's **rhythm**. When rhythm follows a certain pattern, we call it **meter**. Meter is a regularized pattern of stressed and unstressed syllables. Poets vary the meter of a poem from time to time, usually for emphasis. This is how the metrical pattern of "Sea Fever" works out. The stressed syllables are marked (′) and the unstressed syllables are marked (�‿).

Ĭ mŭst gŏ dówn tŏ thĕ seás ăgaín, tŏ thĕ lónelў
 seá ănd thĕ skу́,
Ănd áll Ĭ aśk iš ă táll shiṕ ănd ă staŕ tŏ steér hĕr
 bу́;
Ănd thĕ wheél's kićk ănd thĕ wińd's sońg ănd thĕ
 white saiĺ's shaḱing,
Ănd ă graý mist oň thĕ sea's faće ănd ă graý dawń
 breáking.

Masefield groups the stressed syllables together in line 3. Does he do this in any other lines?

Notice that there are seven heavily accented syllables in each line of the first stanza of the poem. Is this pattern followed throughout the other stanzas as well?

Birches

ROBERT FROST

*In Frost's poetry, a road or a stone wall can become a symbol of
an attitude toward life. As you read, consider what it means to be "a swinger
of birches."*

When I see birches bend to left and right
Across the lines of straighter darker trees,
I like to think some boy's been swinging them.
But swinging doesn't bend them down to stay
As ice storms do. Often you must have seen them 5
Loaded with ice a sunny winter morning
After a rain. They click upon themselves
As a breeze rises, and turn many-colored
As the stir cracks and crazes° their enamel.
Soon the sun's warmth makes them shed crystal shells 10
Shattering and avalanching on the snow crust—
Such heaps of broken glass to sweep away
You'd think the inner dome of heaven had fallen.
They are dragged to the withered bracken° by the load,
And they seem not to break; though once they are bowed 15
So low for long, they never right themselves:
You may see their trunks arching in the woods
Years afterwards, trailing their leaves on the ground
Like girls on hands and knees that throw their hair
Before them over their heads to dry in the sun. 20
But I was going to say when Truth broke in
With all her matter of fact about the ice storm,
I should prefer to have some boy bend them
As he went out and in to fetch the cows—
Some boy too far from town to learn baseball, 25
Whose only play was what he found himself,
Summer or winter, and could play alone.
One by one he subdued his father's trees
By riding them down over and over again
Until he took the stiffness out of them, 30
And not one but hung limp, not one was left

9. **crazes:** cracks into networks of tiny lines. 14. **bracken:** large coarse ferns.

For him to conquer. He learned all there was
To learn about not launching out too soon
And so not carrying the tree away
Clear to the ground. He always kept his poise 35
To the top branches, climbing carefully
With the same pains you use to fill a cup
Up to the brim, and even above the brim.
Then he flung outward, feet first, with a swish,
Kicking his way down through the air to the ground. 40
So was I once myself a swinger of birches.
And so I dream of going back to be.
It's when I'm weary of considerations,
And life is too much like a pathless wood
Where your face burns and tickles with the cobwebs 45
Broken across it, and one eye is weeping
From a twig's having lashed across it open.
I'd like to get away from earth awhile
And then come back to it and begin over.
May no fate willfully misunderstand me 50
And half grant what I wish and snatch me away
Not to return. Earth's the right place for love:
I don't know where it's likely to go better.
I'd like to go by climbing a birch tree,
And climb black branches up a snow-white trunk 55
Toward heaven, till the tree could bear no more,
But dipped its top and set me down again.
That would be good both going and coming back.
One could do worse than be a swinger of birches.

For Study and Discussion

Analyzing and Interpreting the Poem

1. This poem can be divided into three nearly equal parts. In lines 1–20 the speaker describes the birches and tells how ice storms must have bent them. He calls this the Truth. What images and figures of speech does he use to help you experience this scene?

2. In lines 21–40, what does the speaker say he likes to imagine has bent the birches?

3. In lines 41–59, the speaker says he dreams of going back one day to be "a swinger of birches" again. Look at the way he describes the boy's climb up a birch in lines 28–38. How could climbing a birch, swinging, and coming down again symbolize the ways young people learn about life?

4a. What simile in lines 44–47 describes the times when the speaker would "like to get away from earth awhile," and then "come back to it and begin over"? **b.** Where does the speaker show that he does not want us to misunderstand what he means by getting away from earth? **c.** What do you think he does mean by the word *earth* here?

5. The speaker says he'd like to climb "*toward* heaven, till the tree could bear no more." **a.** What do you think he means by the word *heaven*? **b.** What kind of experience do you think he is talking about in lines 54–59?

Literary Elements

Blank Verse

Blank verse is unrhymed iambic pentameter, which means that each line has five iambs. An **iamb** is an unaccented syllable followed by an accented syllable. *Blank* verse is so called because the ends of the lines are "blank" of rhyme. Some of the greatest English poetry is written in blank verse, including much of the poetry in Shakespeare's plays, as in these lines from *Julius Caesar*:

> Yŏnd Cás ‖ sĭus hás ‖ ˘a leán ‖ ǎnd hún ‖ gry loók.
> Hĕ thinks ‖ tŏo múch, ‖ sŭch mén ‖ ăre
> dán ‖ gĕrŏus.

Here each iamb is marked off by the double lines. Each line has five unstressed syllables alternating with five stressed syllables.

"What we have in English is mostly iambic," Frost once said, and others have agreed that iambic rhythm comes closest to the ordinary rhythm of spoken English. "Birches" provides a good example of Frost's use of blank verse and of his occasional variations on that meter. This is how the meter of the first two lines of "Birches" works out:

> Whĕn Í sĕe bírchĕs bénd tŏ léft ănd ríght
> Ăcróss thĕ línes ŏf stráightĕr dárkĕr treés

Continue marking the stressed and unstressed syllables in the first nine lines. Where does Frost depart from strict iambic pentameter? Does he ever depart from having five stressed syllables per line? How does the variation make the lines sound more natural?

Writing About Literature

Analyzing a Poem

Robert Frost first makes an observation, then tells about an incident, and finally applies the incident to some universal truth about life. Write a paragraph in which you explain clearly what the observation is, what the incident is, and what truth about life concludes the poem. Frost once said that a poem "begins in delight and ends in wisdom." In a second paragraph, discuss whether this poem begins in "delight" and ends in "wisdom."

Eleven

ARCHIBALD MACLEISH

And summer mornings the mute child, rebellious,
Stupid, hating the words, the meanings, hating
The Think now, Think, the O but Think! would leave
On tiptoe the three chairs on the verandah
And crossing tree by tree the empty lawn 5
Push back the shed door and upon the sill
Stand pressing out the sunlight from his eyes
And enter and with outstretched fingers feel
The grindstone and behind it the bare wall
And turn and in the corner on the cool 10
Hard earth sit listening. And one by one,
Out of the dazzled shadow in the room,
The shapes would gather, the brown plowshare, spades,
Mattocks, the polished helves of picks, a scythe
Hung from the rafters, shovels, slender tines 15
Glinting across the curve of sickles—shapes
Older than men were, the wise tools, the iron
Friendly with earth. And sit there, quiet, breathing
The harsh dry smell of withered bulbs, the faint
Odor of dung, the silence. And outside 20
Beyond the half-shut door the blind leaves
And the corn moving. And at noon would come,
Up from the garden, his hard crooked hands
Gentle with earth, his knees still earth-stained, smelling
Of sun, of summer, the old gardener, like 25
A priest, like an interpreter, and bend
Over his baskets.
 And they would not speak:
They would say nothing. And the child would sit there
Happy as though he had no name, as though
He had been no one: like a leaf, a stem, 30
Like a root growing——

For Study and Discussion

Analyzing and Interpreting the Poem

1. In the first line the boy is described as "mute." **a.** What clues let you know that he remains silent by choice? **b.** Is his silence a part of his rebellion? Explain.

2. The shed is a kind of sanctuary for the boy. **a.** What sights and smells does he find there? **b.** Why do they make him happy?

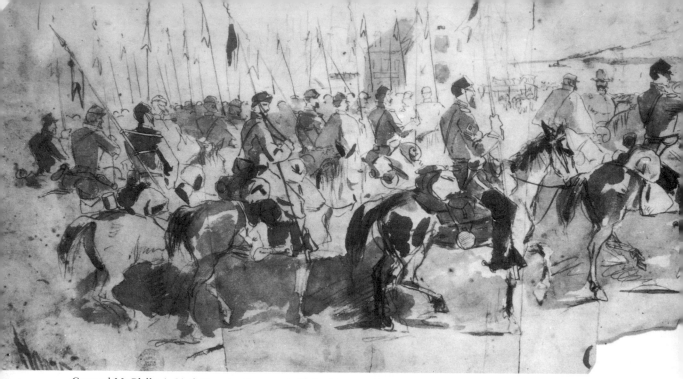

General McClellan's Sixth Cavalry Regiment, Embarking at Alexandria for Old Point Comfort (1862) by Winslow Homer (1836–1910).

Cavalry Crossing a Ford

WALT WHITMAN

Whitman's verse does not rely on rhyme, uniform stanzas, or regularity of meter, but upon other poetic elements, especially variety of rhythm and parallelism. Note how these characteristics are used here.

A line in long array where they wind betwixt green islands,
They take a serpentine course, their arms flash in the sun—
 hark to the musical clank,
Behold the silvery river, in it the splashing horses loitering
 stop to drink,
Behold the brown-faced men, each group, each person a
 picture, the negligent rest on the saddles,
Some emerge on the opposite bank, others are just entering
 the ford—while, 5
Scarlet and blue and snowy white,
The guidon° flags flutter gaily in the wind.

7. **guidon** (gī′dŏn′): small flag.

Analyzing and Interpreting the Poem

1a. What images does the poet use to help you see and hear the cavalry as it crosses a ford in the river? **b.** How many colors are used in this poem?

2. How are the images in the poem arranged to help you see the far-off line of cavalry move nearer and nearer?

3. Though Whitman describes a military scene, the effect is peaceful. What images help create a sense of peacefulness?

Literary Elements

Free Verse

Walt Whitman was the first American poet to break free from the notion that iambic pentameter was the proper and greatest meter for verse written in English. In doing this, Whitman declared a second American "independence" from England—this time, a literary one.

The form of verse that Whitman used is called **free verse**. Free verse is so called because it is not controlled by any definite metrical pattern, nor by any definite pattern of rhyme, though it makes use of various rhythms and it often uses rhymes. Many of the poems in this book, in addition to Whitman's, are written in free verse. For other examples, look at Muriel Rukeyser's "Boy with His Hair Cut Short" (page 384) and Isabella Gardner's "Summer Remembered" (page 419). Notice how the loosely organized rhythms of these poems contrast with the meters and rhymes of Edna St. Vincent Millay's "Recuerdo" (page 382) and Alfred, Lord Tennyson's "The Splendor Falls" (page 416).

Free verse looks easy to write, but it isn't. Read Whitman's poem aloud and note how the poet has used many strong beats in each line. Notice also that the poem gains force because Whitman has ended many of its lines with strongly accented syllables.

Whitman also deliberately varies the length of his lines, which is a characteristic of free verse. Why are the long lines appropriate to describe the "serpentine" course of the army?

Where does Whitman repeat words and sentence patterns to create rhythm? What consonant sounds are alliterated in the first line to slow down the line and to suggest the length of the cavalry line? What two consonant sounds are alliterated in the last line, perhaps to suggest movement?

Literature and the Arts

Portraying the Civil War

Whitman's poem vividly describes a cavalry regiment crossing a ford in a river. Memorable scenes of the Civil War were also recorded by photographers and illustrators. Their photographs, sketches, and paintings capture the movements of battle, crucial decisions, and the faces of those who died in the struggle.

Making Connections: Activities

Using the illustration on page 432 as a starting point, research one or more Civil War photographers and artists. You could consult the works of Mathew Brady, Edwin Forbes, Andrew Joseph Russell, and Winslow Homer. A source such as *The American Heritage Picture History of the Civil War* (1988), by Bruce Catton, might be a good place to begin your research. Prepare an oral report and exhibit samples of the artist's work. Analyze the composition and style of the works and any changes you see over time. What was this artist or photographer trying to convey? What emotions or ideas do you experience looking at the works?

My Mother Pieced Quilts

TERESA PALOMO ACOSTA

they were just meant as covers
in winters
as weapons
against pounding january winds

but it was just that every morning I awoke to these 5
october ripened canvases
passed my hand across their cloth faces
and began to wonder how you pieced
all these together
these strips of gentle communion cotton and flannel nightgowns 10
wedding organdies
dime store velvets

how you shaped patterns square and oblong and round
positioned
balanced 15
then cemented them
with your thread
a steel needle
a thimble

how the thread darted in and out 20
galloping along the frayed edges, tucking them in
as you did us at night
oh how you stretched and turned and rearranged
your michigan spring faded curtain pieces
my father's santa fe work shirt 25
the summer denims, the tweeds of fall

in the evening you sat at your canvas
—our cracked linoleum floor the drawing board
me lounging on your arm
and you staking out the plan: 30
whether to put the lilac purple of easter against the red plaid of
 winter-going-
into-spring

whether to mix a yellow with blue and white and paint the
corpus christi noon when my father held your hand
whether to shape a five-point star from the 35
somber black silk you wore to grandmother's funeral

you were the river current
carrying the roaring notes . . .
forming them into pictures of a little boy reclining
a swallow flying 40
you were the caravan master at the reins
driving your threaded needle artillery across the mosaic cloth
 bridges
delivering yourself in separate testimonies

oh mother you plunged me sobbing and laughing
into our past 45
into the river crossing at five
into the spinach fields
into the plainview cotton rows
into tuberculosis wards
into braids and muslin dresses 50
sewn hard and taut to withstand the thrashings of twenty-five
 years

stretched out they lay
armed / ready / shouting / celebrating

knotted with love
the quilts sing on 55

For Study and Discussion

Analyzing and Interpreting the Poem

1. This poem does not have a regular metrical pattern, but it has a strong rhythm. The use of strong verbs helps give the poem movement. Which of the verbs or verb forms might be applied to painting or to music?

2. Repetition is often used to create rhythm in a poem. What words and phrases are used repeatedly at the beginnings or near the beginnings of lines?

3a. What mood is created by the rhythm in the poem? **b.** How does the last line of the poem add to the mood?

4. What image is created by the repetition of the descriptive words near the end of the poem?

5. In line 6 the speaker refers to the quilts as "ripened canvases." What does her mother do that is similar to what a painter of pictures might do?

6. What is the speaker's attitude toward her mother?

About the Authors

John Masefield (1878–1967)

John Masefield was poet laureate of England for thirty-seven years. Orphaned at an early age, Masefield went off to sea at fifteen as an apprentice on a sailing ship. He jumped ship in New York City, and worked for three years in America before returning to England. He became a journalist, and eventually began writing poetry. His first collection of poems, *Salt-Water Ballads* (1902), launched his career as a poet. Another of his popular lyrics is "Cargoes."

Archibald MacLeish (1892–1982)

Archibald MacLeish wrote some deeply personal poems, and he also wrote poems expressing the dreams and aspirations of the nation. MacLeish was born in Illinois. He served as an ambulance driver and artillery captain in World War I, and was, at different times in his life, a lawyer, a Librarian of Congress, an Assistant Secretary of State, and an adviser to President Franklin D. Roosevelt. MacLeish won the Pulitzer Prize in 1933 for *Conquistador,* a long poem about Cortes' conquest of Mexico, and in 1953 for *Collected Poems: 1917–1952.* MacLeish was also a dramatist, and in 1959 he won his third Pulitzer Prize—for *J.B.,* his modernization of the Book of Job.

Walt Whitman (1819–1892)

Walt Whitman was born on Long Island, New York, and he worked for years as a printer, reporter, and newspaper editor. Not until he was thirty-six did he publish his revolutionary and controversial *Leaves of Grass,* the collection of poems he revised and added to for the rest of his life. During the American Civil War, Whitman served as a volunteer nurse. Some of his most famous poems deal with his wartime experiences.

Teresa Palomo Acosta (1949–)

Teresa Palomo Acosta was born and grew up in McGregor, Texas. She was educated at the University of Texas and Columbia University, where she received a Master of Science degree in journalism. Her poems and short stories depict Mexican American traditions and culture and the history of the Southwest. She is a cofounder of the National Institute of Chicana Writers. She has produced bilingual educational videos and recordings that teach children about their environment through the poems, short stories, and legends of the Southwest. Acosta currently works as a research associate at the Texas State Historical Association and teaches at the University of Texas at Austin.

STRUCTURES

A poem's structure is the form or pattern a poet chooses for the arrangement of thoughts. A poet may choose a particular kind of stanzaic form. A *stanza* is any group of related lines that forms a division of a poem. Stanzas are usually used to mark divisions of thought in a poem, and so they function somewhat as paragraphs do.

A poet may choose to work in a fixed form such as a *sonnet*. A sonnet has fourteen lines, and the lines are usually written in iambic pentameter (that is, each line has ten syllables with every second syllable accented). There are two traditional rhyme schemes of a sonnet—the English (or Shakespearean) and the Italian (or Petrarchan). An English sonnet has three *quatrains* (groups of four lines) followed by a concluding *couplet* (two rhyming lines). The Petrarchan sonnet consists of two parts—an *octave* of eight lines and a *sestet* of six lines.

Sometimes a poet chooses to divide units of thought into *verse paragraphs* of varying length rather than fixed stanzas. This is particularly true of long poems such as "The Creation" (page 449).

When you analyze the structure of a poem, you find out how its parts are related to the whole.

Sonnet 71

WILLIAM SHAKESPEARE

In the opening lines of this poem, Shakespeare refers to the custom of ringing a bell in a solemn way to announce a person's death.

No longer mourn for me when I am dead
Than you shall hear the surly sullen bell
Give warning to the world that I am fled
From this vile world with vilest worms to dwell.
Nay, if you read this line, remember not 5
The hand that writ it, for I love you so
That I in your sweet thoughts would be forgot
If thinking on me then should make you woe.
O if, I say, you look upon this verse
When I perhaps compounded am with clay, 10
Do not so much as my poor name rehearse,
But let your love even with my life decay,
 Lest the wise world should look into your moan
 And mock you with me after I am gone.

For Study and Discussion

Analyzing and Interpreting the Poem

1. A sonnet often presents a carefully reasoned argument. **a.** What idea is presented in each quatrain of the poem? **b.** What conclusion is drawn in the couplet?

2. When Shakespeare refers to "world," or society, as "vile" in line 4, he is merely using an expression that was common in his time, rather than trying to emphasize the bad things about society. What clue in line 13 gives the reader another image of society?

3a. What is the speaker's tone in the poem? **b.** Does the speaker really believe the world is "wise"?

Focus on Descriptive Writing

Using Precise Words

You can create sharp, clear images for your readers by using **precise words**—nouns, verbs, adjectives, and adverbs—in your descriptive writing. Here are some examples of precise words from Shakespeare's sonnet:

 surly versus hostile (line 2)
 sullen versus gloomy (line 2)
 woe versus pain (line 8)
 compounded versus combined (line 10)
 rehearse versus mention (line 11)

Read a letter that you have written recently. Make a list of words to revise so that they are sharper and more precise. Use a dictionary or thesaurus if you wish. Try rewriting your letter as a poem in free verse. Save your writing.

Sonnet

COUNTEE CULLEN

In some sonnets the thought is organized so that the first eight lines state a problem, ask a question, or meditate on some subject, and the final six lines provide a solution to the problem, an answer to the question, or a conclusion of some kind. What does Cullen describe in the first eight lines of this sonnet? What conclusion does he draw in the final six lines?

Some for a little while do love, and some for long;
And some rare few forever and for aye;
Some for the measure of a poet's song,
And some the ribbon width of a summer's day.
Some on a golden crucifix do swear, 5
And some in blood do plight a fickle troth;
Some struck divinely mad may only stare,
And out of silence weave an iron oath.

So many ways love has none may appear
The bitter best, and none the sweetest worst; 10
Strange food the hungry have been known to bear,
And brackish° water slakes an utter thirst. 12. **brackish:** salty.
It is a rare and tantalizing fruit
Our hands reach for, but nothing absolute.

For Study and Discussion

Analyzing and Interpreting the Poem

1a. What metaphors in lines 3 and 4 dramatize the poet's ideas about how long love lasts? **b.** What point about love is made in lines 5–8?

2a. What analogies does the poet make in lines 11–12? **b.** What metaphor describes love in line 13? **c.** How does the final couplet sum up the idea of this poem?

One Art

ELIZABETH BISHOP

*Hyperbole is a figure of speech that uses exaggeration for special effect.
How does the poet use hyperbole here?*

The art of losing isn't hard to master;
so many things seem filled with the intent
to be lost that their loss is no disaster.

Lose something every day. Accept the fluster
of lost door keys, the hour badly spent. 5
The art of losing isn't hard to master.

Then practice losing farther, losing faster:
places, and names, and where it was you meant
to travel. None of these will bring disaster.

I lost my mother's watch. And look! my last, or 10
next-to-last, of three loved houses went.
The art of losing isn't hard to master.

I lost two cities, lovely ones. And, vaster,
some realms I owned, two rivers, a continent.
I miss them, but it wasn't a disaster. 15

—Even losing you (the joking voice, a gesture
I love) I shan't have lied. It's evident
the art of losing's not too hard to master
though it may look like (*Write* it!) like disaster.

For Study and Discussion

Analyzing and Interpreting the Poem

1. An art is a skill acquired by experience or training. According to the speaker, how does one master the "art of losing"?

2a. What examples does the speaker give of her own experiences of loss? **b.** Which of these are metaphorical rather than literal?

3. Study the last stanza of the poem carefully. Does the speaker really believe that practicing the "art of losing" things prepares one for the disastrous loss of someone dear?

4. This poem is a modified **villanelle** (vĭl′ ə-nĕl′), an intricate 19-line poem of French origin. Only two rhymes are allowed in the villanelle, and 8 lines are refrains. How does repetition gain emphasis for the poet's ideas?

5a. What do you think the title refers to? **b.** Does the speaker believe there is "One Art," or is the title ironic?

About the Authors

William Shakespeare (1564–1616)

For close to four hundred years, William Shakespeare has been regarded as the greatest writer in the English language. He was born in Stratford-on-Avon. After a grammar-school education and an early marriage to Anne Hathaway, Shakespeare went to London and became, by 1592, a renowned playwright. In addition to his plays, Shakespeare also wrote a brilliant series of sonnets. Around 1610 he left London and spent the rest of his life in Stratford as a respected citizen and country gentleman.

Countee Cullen (1903–1946)

Winold Reiss, The Granger Collection, New York

Countee Cullen was born in New York City, the son of a minister. He began writing poetry while in his teens and published his first book of poems, *Color,* when he was in college. In a brief writing career, Cullen published several volumes of verse, a translation of the classical Greek play *Medea,* and an original play written in collaboration with Arna Bontemps. His poems are largely traditional in form and concerned with universal themes—death, love, and human relationships. Along with Bontemps, Jean Toomer, and Langston Hughes, Cullen was a leader of the Harlem Renaissance of the 1920s.

Elizabeth Bishop (1911–1979)

Elizabeth Bishop was born in Worcester, Massachusetts. She was raised in Nova Scotia and in Boston. She attended Vassar College. In 1934 she met Marianne Moore, whose poetry was an important influence on her own work. Bishop traveled widely and lived for periods in Key West, Florida, in Mexico, and in Brazil. Her first volume of verse was published in 1946. She received a number of awards and grants for her poetry, including the Pulitzer Prize in 1955 and the National Book Award in 1970. Her poetry is characterized by detailed observation and a disciplined technique. Among her collections of poetry are *Poems: North and South—A Cold Spring, Questions of Travel, Selected Poems,* and *Complete Poems.*

Types Of Poetry

NARRATIVE POETRY

A *narrative poem* tells a story. Early storytellers, who entertained people in a time when hardly anyone could read or write, found that regular meter and rhyme helped them to remember the story and to hold their listeners' attention. Recitations of stories in verse took the place now held by books, radio, and television, and were a principal form of entertainment.

One kind of narrative poem is the *epic*—a long poem celebrating the deeds of a society's hero. Most epics are lofty poems, concerned with heroes and heroines who are larger-than-life, and told in stately and dignified language. The most famous epics are the *Iliad* and *Odyssey* by the Greek poet Homer, the *Aeneid* by the Roman poet Virgil, and *The Divine Comedy* by the Italian poet Dante. The greatest epic in English is *Paradise Lost* by John Milton.

An entirely different kind of narrative poem is the *ballad*—a relatively short poem originally meant for singing. The oldest ballads, known as *folk* or *popular ballads*, arose among the common people and were passed on by word of mouth for generations. Most ballads are tragic in mood and are concerned largely with sensational stories of murder, love, treachery, and the supernatural.

Literary ballads, unlike folk ballads, are written by known writers. Literary ballads sometimes try to imitate the style of folk ballads, but in general they tend to be more elaborate, both in language and in form.

Johnny Armstrong

This folk ballad comes from the Border country, the region between Scotland and England that was once wild and lawless. Like all true Border ballads, this one celebrates an outlaw. It is based on an actual incident that took place about 1530. The Armstrongs were a powerful clan who made so many armed raids against the English that the Scottish king was forced to take action. The ballad would originally have been sung in a Scottish dialect.

There dwelt a man in fair Westmorland,
 Johnny Armstrong men did him call,
He had neither lands nor rents coming in,
 Yet he kept eight score men in his hall.

He had horse and harness for them all, 5
 Goodly steeds were all milk-white;
O the golden bands about their necks,
 And their weapons, they were all alike.

News then was brought unto the king
 That there was such a one as he, 10
That lived like a bold outlaw,
 And robbed all the north country.

The king he wrote out a letter then,
 A letter which was large and long;
He signed it with his own hand, 15
 And he promised to do him no wrong.

When this letter came Johnny unto,
 His heart it was as blithe as birds on the tree.
"Never was I sent for before any king,
 My father, my grandfather, nor none but me. 20

"And if we go the king before,
 I would we went most orderly;
Every man of you shall have his scarlet cloak,
 Laced with silver laces three.

"Every one of you shall have his velvet coat,　　　　　　　25
　　Laced with silver lace so white;
O the golden bands about your necks,
　　Black hats, white feathers, all alike."

By the morrow morning at ten of the clock,
　　Toward Edinborough gone was he,　　　　　　　　　30
And with him all his eight score men;
　　Good Lord, it was a goodly sight for to see!

When Johnny came before the king,
　　He fell down on his knee,
"O pardon, my sovereign liege,"° he said,　　　　　　　35　　　　　　　35. **liege** (lēj): lord.
　　"O pardon my eight score men and me!"

"Thou shalt have no pardon, thou traitor strong,
　　For thy eight score men nor thee;
For tomorrow morning by ten of the clock,
　　Both thou and them shall hang on the gallows tree."　　40

But Johnny looked over his left shoulder,
　　Good Lord, what a grievous look looked he!
Saying, "Asking grace of a graceless face—
　　Why there is none for you nor me."

But Johnny had a bright sword by his side,　　　　　　　45
　　And it was made of the metal so free,°　　　　　　　　　　　46. **free:** here, pure.
That had not the king stepped his foot aside,
　　He had smitten his head from his fair body.

Saying, "Fight on, my merry men all,
　　And see that none of you be ta'en;　　　　　　　　　50
For rather than men shall say we were hanged,
　　Let them report how we were slain."

Then, God wot,° fair Edinborough rose,　　　　　　　　　　53. **wot:** knows.
　　And so beset poor Johnny round,
That fourscore and ten of Johnny's best men　　　　　　55
　　Lay gasping all upon the ground.

Then like a mad man Johnny laid about,
　　And like a mad man then fought he,
Until a false Scot came Johnny behind,
　　And run him through the fair body.　　　　　　　　　60

Saying, "Fight on, my merry men all,
 And see that none of you be ta'en;
For I will stand by and bleed but awhile,
 And then I will come and fight again."

News then was brought to young Johnny Armstrong, 65
 As he stood by his nurse's knee,
Who vowed it e'er he lived for to be a man,
 On the treacherous Scots revenged he'd be.

For Study and Discussion

Analyzing and Interpreting the Poem

1. Although Johnny is an outlaw, the ballad singer shows him to be more honorable and more likable than the king. **a.** What promise does the king break? **b.** What details in this song glorify Johnny?

2. Irony of situation occurs when what happens is the opposite of what is expected. What ironic situation is the basis of the tragedy in this ballad?

3. Folk ballads generally take their subject matter from sensational happenings. The most popular subjects of ballads are disappointed love, jealousy, betrayal, revenge, and sudden death. **a.** Which of these do you find in "Johnny Armstrong"? **b.** Which specific subject is introduced in the last stanza?

Writing About Literature

Analyzing a Ballad

Folk ballads often use certain **conventions**, or widely accepted techniques and ways of saying things. Here are some of these conventions:

1. Ballads usually dramatize their action quickly, omitting unnecessary scenes or details.

2. Ballads often heighten the drama by using dialogue.

3. Suspense is often created in ballads by giving out information a little at a time.

4. Folk ballads have their favorite colors: we often find milk-white steeds, lily-white skin, golden hair, or ruby lips. Often the colors suggest certain things. White and gold, for example, usually suggest purity and perfection, and red can suggest blood.

5. Folk ballads often use stock phrases. The singers, relying only on their memories, could resort to a whole repertoire of stock phrases.

6. In structure, ballads usually use what we call the **ballad stanza**, a four-line stanza with the second and fourth lines rhyming. Usually the first and third lines contain four heavily accented syllables, and the second and fourth lines contain three.

Write an essay in which you analyze "Johnny Armstrong," noting which of these conventions are followed in that ballad. Cite lines from the poem to illustrate your findings.

La Belle Dame sans Merci

JOHN KEATS

This poem is based on an older ballad called "True Thomas," which tells of a knight who was lured away by the Queen of Elfland and forced to serve her for seven years. Keats's poem takes up the story after the knight has reappeared in the world of mortals. The poem's title means "the beautiful lady without pity." The story is told as a dialogue between the returned knight and a passer-by.

"O, what can ail thee, knight-at-arms,
 Alone and palely loitering?
The sedge° has withered from the lake,
 And no birds sing.

"O, what can ail thee, knight-at-arms, 5
 So haggard and so woebegone?
The squirrel's granary is full,
 And the harvest's done.

"I see a lily on thy brow,
 With anguish moist and fever dew, 10
And on thy cheeks a fading rose
 Fast withereth too."

"I met a lady in the meads,°
 Full beautiful—a faery's child,
Her hair was long, her foot was light, 15
 And her eyes were wild.

"I made a garland for her head,
 And bracelets too, and fragrant zone;°
She looked at me as she did love,
 And made sweet moan. 20

"I set her on my pacing steed,
 And nothing else saw all day long,
For sidelong would she bend and sing
 A faery's song.

"She found me roots of relish sweet, 25
 And honey wild, and manna dew,°
And sure in language strange she said
 'I love thee true.'

"She took me to her elfin grot,°
 And there she wept and sighed full sore, 30
And there I shut her wild wild eyes
 With kisses four.

"And there she lulled me asleep,
 And there I dreamed—Ah! woe betide!
The latest dream I ever dreamed 35
 On the cold hill side.

"I saw pale kings and princes too,
 Pale warriors, death-pale were they all;
They cried, 'La Belle Dame sans Merci
 Hath thee in thrall!'° 40

3. **sedge** (sĕj): marsh grass. 13. **meads** (mēdz): meadows. 18. **fragrant zone:** belt of flowers.

26. **manna dew:** moist (dewy) substance in the stems of plants. 29. **grot:** cave. 40. **in thrall** (thrôl): enslaved.

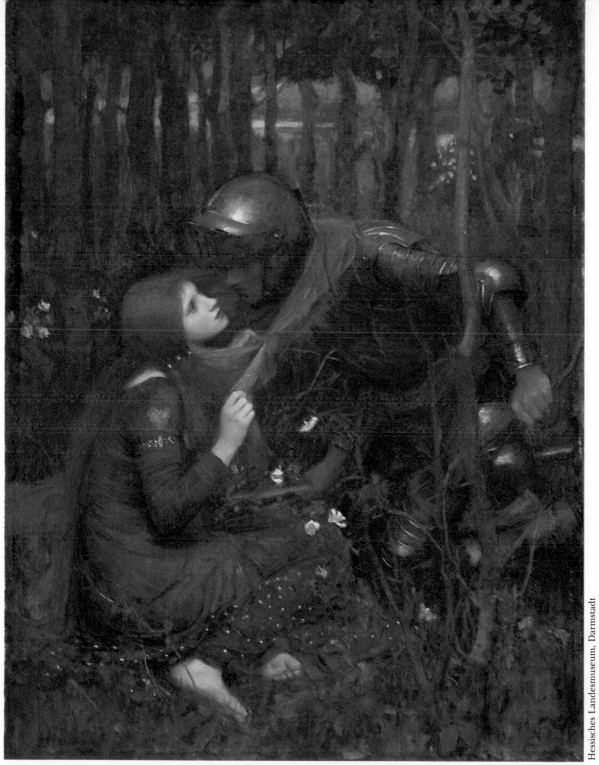

La Belle Dame sans Merci (1893) by John William Waterhouse (1849–1917).
Oil on canvas.

"I saw their starved lips in the gloam,°
 With horrid warning gaped wide,
And I awoke, and found me here,
 On the cold hill's side.

41. **gloam:** twilight

"And this is why I sojourn here, 45
 Alone and palely loitering,
Though the sedge is withered from the lake,
 And no birds sing."

For Study and Discussion

Analyzing and Interpreting the Poem

1. This poem tells a story entirely through dialogue. **a.** What question does the passerby ask the knight? **b.** What images help you visualize the knight's sickly appearance?

2a. What images help you visualize the setting? **b.** How does the setting help create a mood of gloom and loss?

3. Beginning with line 13, the knight speaks. **a.** What images in lines 13–32 create an atmosphere of romance and enchantment? **b.** What images in lines 35–44 help you experience the horror of the knight's dream?

4. La Belle Dame is a supernatural figure with whom the knight, a mortal, has fallen hopelessly in love. **a.** Is La Belle Dame totally sinister? Explain. **b.** Do you know of other stories of mortals who suffer when they love unattainable supernatural figures or figures from another world?

Focus on Descriptive Writing

Exploring Connotations

A word's **denotations** are its literal, dictionary meanings. A word's **connotations** are its suggestive meanings and associations that go beyond literal definitions (see pages 126 and 374). The connotations of words and phrases can be extremely effective in descriptive writ-ing because they often act powerfully on people's memories, thoughts, and emotions.

On a chart like the one below, explore the connotations of words by listing your associations with each phrase from "La Belle Dame sans Merci." When you have finished writing, join with a small group of classmates to share and discuss your associations with each phrase. Save your writing.

Connotations Chart	
Word or Phrase	**Associations**
palely loitering	_____

sweet moan	_____

elfin grot	_____

cold hill side	_____

horrid	_____

sojourn	_____

The Creation

JAMES WELDON JOHNSON

*In what way is this poem like a sermon? What is the speaker's tone toward
the events described in the Creation?*

And God stepped out on space,
And he looked around and said:
I'm lonely—
I'll make me a world.

And far as the eye of God could see 5
Darkness covered everything,
Blacker than a hundred midnights
Down in a cypress swamp.

Then God smiled,
And the light broke, 10
And the darkness rolled up on one side,
And the light stood shining on the other,
And God said: That's good!

Then God reached out and took the light in his hands,
And God rolled the light around in his hands 15
Until he made the sun;
And he set that sun a-blazing in the heavens.
And the light that was left from making the sun
God gathered it up in a shining ball
And flung it against the darkness, 20
Spangling the night with the moon and stars.
Then down between
The darkness and the light
He hurled the world;
And God said: That's good! 25

Then God himself stepped down—
And the sun was on his right hand,
And the moon was on his left;
The stars were clustered about his head,
And the earth was under his feet. 30

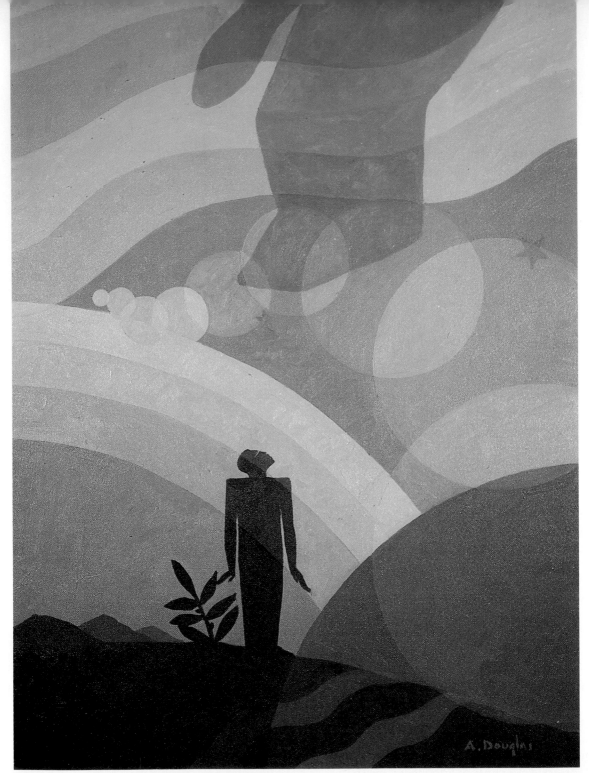

The Creation (1935) by Aaron Douglas (1899–1979). Oil on masonite.
The Howard University Gallery of Art,
Permanent Collection, Washington, D.C.

And God walked, and where he trod
His footsteps hollowed the valleys out
And bulged the mountains up.

Then he stopped and looked and saw
That the earth was hot and barren. 35
So God stepped over to the edge of the world
And he spat out the seven seas—
He batted his eyes, and the lightnings flashed—
He clapped his hands, and the thunders rolled—
And the waters above the earth came down, 40
The cooling waters came down.

Then the green grass sprouted,
And the little red flowers blossomed,
The pine tree pointed his finger to the sky,
And the oak spread out his arms, 45
The lakes cuddled down in the hollows of the ground,
And the rivers ran down to the sea;
And God smiled again,
And the rainbow appeared,
And curled itself around his shoulder. 50

Then God raised his arm and he waved his hand
Over the sea and over the land,
And he said: Bring forth! Bring forth!
And quicker than God could drop his hand,
Fishes and fowls 55
And beasts and birds
Swam the rivers and the seas,
Roamed the forests and the woods,
And split the air with their wings.
And God said: That's good! 60

Then God walked around,
And God looked around
On all that he had made.
He looked at his sun,
And he looked at his moon, 65
And he looked at his little stars;
He looked on his world
With all its living things,
And God said: I'm lonely still.

Then God sat down— 70
On the side of a hill where he could think;
By a deep, wide river he sat down;
With his head in his hands,
God thought and thought,
Till he thought: I'll make me a man! 75

Up from the bed of the river
God scooped the clay;
And by the bank of the river
He kneeled him down;
And there the great God Almighty 80
Who lit the sun and fixed it in the sky,
Who flung the stars to the most far corner of the night,
Who rounded the earth in the middle of his hand;
This Great God,
Like a mammy bending over her baby, 85
Kneeled down in the dust
Toiling over a lump of clay
Till he shaped it in his own image;

Then into it he blew the breath of life,
And man became a living soul. 90
Amen. Amen.

For Study and Discussion

Analyzing and Interpreting the Poem

1. This poem retells the Biblical account of Creation given in Genesis 1 and 2. What vivid images and figures of speech help you visualize the Creation, particularly the creation of light, the sun, the moon and the stars, the world, and human beings?

2. How does the poet emphasize that God's creation is "good"?

3a. According to the poem, why does God create "man," or the human race? **b.** The poet says that God created man "in his own image." What specific details reveal that this poet has given the Creator very human characteristics?

For Oral Reading

Preparing a Presentation

Prepare this poem for an oral reading. Note that the poem is written in free verse. It does not use rhyme but it uses strong rhythms, which are often created by repetition. Which words, phrases, and sentence structures are repeated over and over again as the poet tells the account of Creation? This poem evokes many feelings, which you should note. For example, where would you use your voice to convey feelings of power, action, and strength? Where would you change your tone to suggest tenderness, love, and awe?

Oranges

GARY SOTO

*Note how Soto uses color in this poem to make a special childhood memory vivid
for the reader.*

The first time I walked
With a girl, I was twelve,
Cold, and weighted down
With two oranges in my jacket.
December. Frost cracking 5
Beneath my steps, my breath
Before me, then gone,
As I walked toward
Her house, the one whose
Porch light burned yellow 10
Night and day, in any weather.
A dog barked at me, until
She came out pulling
At her gloves, face bright
With rouge, I smiled, 15
Touched her shoulder, and led
Her down the street, across
A used car lot and a line
Of newly planted trees,
Until we were breathing 20
Before a drugstore. We
Entered, the tiny bell
Bringing a saleslady
Down a narrow aisle of goods.

I turned to the candies 25
Tiered like bleachers,
And asked what she wanted—
Light in her eyes, a smile

Starting at the corners
Of her mouth. I fingered 30
A nickel in my pocket,
And when she lifted a chocolate
That cost a dime,
I didn't say anything.
I took the nickel from 35
My pocket, then an orange,
And set them quietly on
The counter. When I looked up,
The lady's eyes met mine,
And held them, knowing 40
Very well what it was all
About.

　　　Outside,
A few cars hissing past,
Fog hanging like old
Coats between the trees. 45
I took my girl's hand
In mine for two blocks,
Then released it to let
Her unwrap the chocolate.
I peeled my orange 50
That was so bright against
The gray of December
That, from some distance
Someone might have thought
I was making a fire in my hands. 55

For Study and Discussion

Analyzing and Interpreting the Poem

1. The speaker is recalling a dramatic and important experience of growing up. What was special about this incident?

2. What contrast does the poet create between the setting and the actions and emotions of the characters?

3. How does the vivid imagery of the poem underscore the speaker's feelings for the girl?

Creative Writing

Writing a Poem

Write a short poem in which you describe a simple but memorable event. Try to remember specific details, the season and things you might have seen, heard, smelled, tasted, and touched. Also consider your general mood at the time. Think about descriptive techniques that will make these details vivid for your readers.

About the Authors

John Keats (1795–1821)

John Keats, who saw his mother and brother die of tuberculosis, knew when he was only twenty-four years old that he was also dying of the disease. Keats's anguish over his illness was made more acute by the fact that he had fallen deeply in love with a young woman named Fanny Brawne, whom he knew he would never live to marry. Keats, who had studied medicine, also knew that he would never live to write the poetry he dreamed of writing. At the age of twenty-five, Keats died in Rome, where he had gone for the warmer climate. Keats's own sad epitaph was "Here lies one whose name is writ on water." His prediction proved untrue. In his few years, Keats produced some of the finest poems ever written in the English language.

James Weldon Johnson (1871–1938)

Winold Reiss, The Granger Collection, New York

James Weldon Johnson, American poet and essayist, received his B.A. and M.A. from Atlanta University and studied for three years at Columbia University. Johnson had an exceptionally versatile career, being at various times a high-school principal, an attorney, a songwriter, a United States consul in Venezuela and Nicaragua, secretary of the N.A.A.C.P., and a professor of literature. "The Creation" is one of seven old-time "sermons" that Johnson published in a book called *God's Trombones* (1927).

Gary Soto (1952–)

Gary Soto's first book of poems, *The Elements of San Joaquin*, explores, among other subjects, the exhausting life of the migrant farm worker. As a child, he worked as a migrant laborer and experienced firsthand the hardship he has written about. Besides poetry, he has written short stories and novels. *Living Up the Street* (1985), which is based on his memories of a poor but whimsical family, won the American Book Award.

DRAMATIC POETRY

A *dramatic poem* presents one or more characters speaking, usually to each other, but sometimes to themselves or directly to the reader. A dramatic poem has many of the characteristics of a play: a definite setting, a dramatic situation, emotional conflict, vigorous speech, and natural language rhythms. The more dramatic a poem becomes, the more it reminds us of a play. In fact, the purest example of dramatic poetry is in verse plays, such as those written by William Shakespeare.

The *dramatic monologue* is a special kind of dramatic poem. In a dramatic monologue one character speaks to one or more other characters, whose replies are not given in the poem. The speaker, in a moment of great personal crisis, reveals his or her deepest thoughts and feelings. Reading a dramatic monologue is like listening to one end of a telephone conversation: from what is said at your end you must imagine what is said at the other.

The most famous dramatic monologue in English is "My Last Duchess," by Robert Browning. "The Laboratory," also by Browning, is another excellent example of this intensely dramatic kind of poem.

The Laboratory

ROBERT BROWNING

Ancien Régime

The phrase Ancien Régime (äN-syăN′rā-zhēm′), *which means "the old order" in French, places this poem in France during the century or so before the French Revolution, when aristocrats involved in the whirl of court life had very little on their minds besides gossip, rivalries, and intrigue.*

Now that I, tying thy glass mask° tightly,
May gaze through these faint smokes curling whitely,
As thou pliest thy trade in this devil's smithy—
Which is the poison to poison her, prithee?°

He is with her; and they know that I know 5
Where they are, what they do. They believe my tears flow
While they laugh, laugh at me, at me fled to the drear
Empty church, to pray God in, for them!—I am here.

Grind away, moisten and mash up thy paste,
Pound at thy powder—I am not in haste! 10
Better sit thus, and observe thy strange things,
Than go where men wait me and dance at the King's.

That in the mortar°—you call it a gum?
Ah, the brave tree whence such gold oozings come!
And yonder soft phial,° the exquisite blue, 15
Sure to taste sweetly—is that poison too?

Had I but all of them, thee and thy treasures,
What a wild crowd of invisible pleasures!
To carry pure death in an earring, a casket,°
A signet,° a fan mount, a filigree basket. 20

Soon, at the King's, a mere lozenge° to give,
And Pauline° should have just thirty minutes to live!
But to light a pastille,° and Elise, with her head
And her breast and her arms and her hands, should drop dead!

1. **glass mask:** a face mask worn for protection against poisonous fumes.

4. **prithee:** I pray thee.

13. **mortar:** a hard bowl for grinding substances to a powder.

15. **phial** (fī′əl): a small glass bottle.

19. **casket:** jewelry box.

20. **signet:** seal, probably on a ring.

21. **lozenge** (lŏz′ĭnj): piece of candy.

22. **Pauline:** The speaker would also like to murder Pauline and Elise (line 23).

23. **pastille:** a small candle.

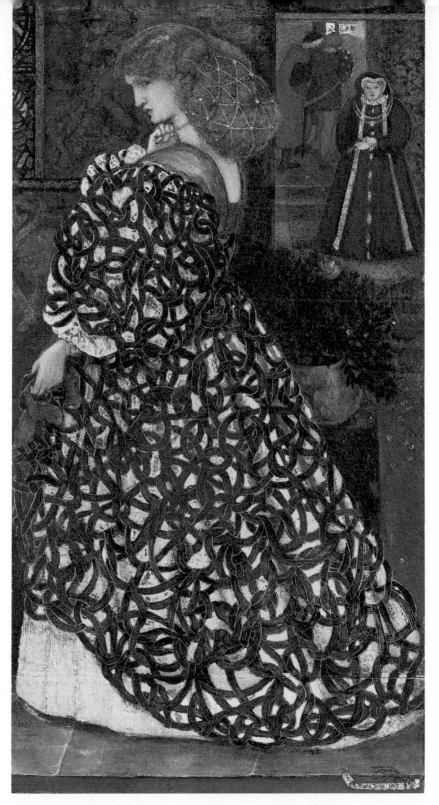

Sidonia Von Bork (1860) by Sir Edward Burne-Jones (1833–1898). Gouache. Tate Gallery, London

Quick—is it finished? The color's too grim!
Why not soft like the phial's, enticing and dim?
Let it brighten her drink, let her turn it and stir,
And try it and taste, ere she fix and prefer!

What, a drop? She's not little, no minion° like me! 29. **minion:** here, a small per-
That's why she ensnared him; this never will free 30 son.
The soul from those masculine eyes—say, "no!"
To that pulse's magnificent come and go.

For only last night, as they whispered, I brought
My own eyes to bear on her so, that I thought
Could I keep them one half minute fixed, she would fall, 35
Shriveled; she fell not; yet this does it all!

Not that I bid you spare her the pain!
Let death be felt and the proof remain;
Brand, burn up, bite into its grace—
He is sure to remember her dying face! 40

Is it done? Take my mask off! Nay, be not morose;
It kills her, and this prevents seeing it close:
The delicate droplet, my whole fortune's fee!
If it hurts her, beside, can it ever hurt me?

Now, take all my jewels, gorge gold to your fill, 45
You may kiss me, old man, on my mouth if you will!
But brush this dust off me, lest horror it brings
Ere I know it—next moment I dance at the King's!

For Study and Discussion

Analyzing and Interpreting the Poem

1a. Which lines in this dramatic poem reveal that the speaker is a woman? **b.** To whom is she speaking?

2. What is the speaker planning to do with the poison?

3a. How would you describe the passions that are driving this woman to commit murder? **b.** Which lines reveal that she is gloating over the murder, rather than feeling remorse?

4a. What morbid fantasies about the poison does the speaker reveal in lines 17–24? **b.** What anxieties does she express in lines 25–32?

5. In the final stanza, the speaker pays for the poison. **a.** What has it cost her? **b.** What do you think her offer in line 46 reveals about her character?

6. There is great irony in this poem—a contrast between what seems to be true on the surface of things, and what actually *is* true. For example, this speaker probably is beautifully dressed, as she is on her way to a ball; she is certainly rich and bejeweled. **a.** How is her heart exactly the opposite of her beautiful appearance? **b.** At the end of the poem, the speaker asks that the dust of the chemist's shop be brushed from her clothing. What "horror" can she never "brush" from her heart?

Writing About Literature

Analyzing a Poem

In the best dramatic monologues, we have a speaker, an audience, a setting, an interplay or a conflict between characters, action, and revelation of character. In a brief essay, analyze "The Laboratory" in terms of these characteristics. Use specific details from the poem to illustrate your analysis.

About the Author

Robert Browning (1812–1889)

The name Robert Browning is practically synonymous with the dramatic monologue, a form which he brought to a peak of perfection. Browning's poems shocked many readers with their objective treatment of the relationships between men and women, and some of Browning's contemporaries disapproved of his common, everyday language—he put into his verse such unpoetic things as vials of poison and aching corns. Browning eloped with Elizabeth Barrett. His "rescue" of the poet from her tyrannical father was one of the great love stories of the age.

Fear

HART CRANE

*In this dramatic poem, what do you learn about the
setting, the situation, and the speaker's conflict?*

The host, he says that all is well
And the firewood glow is bright;
The food has a warm and tempting smell—
But on the window licks the night.

Pile on the logs. . . . Give me your hands,
Friends! No—it is not fright. . . .
But hold me . . . somewhere I heard demands . . .
And on the window licks the night.

For Study and Discussion

Analyzing and Interpreting the Poem

1a. What images in this poem suggest com-
fort, security, and companionship? **b.** What
images suggest fear, loneliness, and forebod-
ing?

2a. To what is the poet comparing night
when he says night "licks" the window?
b. How would the emotional impact differ if
the speaker had merely said "it is growing
dark"?

3. When the speaker says he heard "de-
mands," we begin to guess that this situation
might symbolize something broader than itself.
a. What could the bright, warm, well-provi-
sioned room symbolize? **b.** What could the
night symbolize?

4. This is a dramatic poem. What action does
the poet help you visualize in the second
stanza?

About the Author

Hart Crane (1899–1932)

Hart Crane, who had a troubled and unhappy
childhood, left his home in Ohio at sixteen to
wander about the country and write poetry.
He turned down a chance to go to college,
worked at various jobs, and ended up in New
York where he spent ten furious years on his
best-known work, *The Bridge*, a long poem
about America. Finally, worn down by work
and the feeling that his best years were behind
him, Crane threw himself off a ship that was
bringing him back to New York from Mexico.

LYRIC POETRY

At times, poets wish to tell a story in poetic form, and they write what we call narrative poems. You have already seen how John Keats told a story in "La Belle Dame sans Merci," and James Weldon Johnson in "The Creation." At other times, a poet's principal aim is not to tell a story, but to express personal thoughts or emotions—about the serenity of an autumn day, for example, or the grace of a beautiful woman, or the remorse that follows the death of a friend. We call such poems *lyric* poems.

The word *lyric* is derived from the ancient Greek *lyrikos*, a short poem that was sung to the accompaniment of a lyre, a stringed instrument. Over the centuries, the lyric has lost its musical accompaniment, but it still is concerned with expressing personal thoughts and emotions. A lyric may reveal a moment of beauty or horror, joy or grief; it may present a rosy reminiscence of the past or a gloomy prediction for the future.

Lyric poetry often is rich in musical devices. Note how Carl Sandburg uses alliteration and assonance in his flawless lyric "Splinter":

> *The voice of the last cricket*
> *across the first frost*
> *is one kind of goodbye.*
> *It is so thin a splinter of singing.*

Over the centuries, certain forms of lyric poems have become particularly popular. Among these are the sonnet and the elegy. Most lyrics, however, do not fall easily into categories. The forms of the lyric are as varied as its infinite subjects and treatments.

A Red, Red Rose

ROBERT BURNS

What are the connotations or emotional overtones of the words Burns uses to characterize the woman in this poem?

O my Luve's like a red, red rose,
 That's newly sprung in June:
O my Luve's like the melodie
 That's sweetly played in tune.

As fair art thou, my bonnie lass, 5
 So deep in luve am I;
And I will luve thee still, my dear,
 Till a' the seas gang° dry.

Till a' the seas gang dry, my dear,
 And the rocks melt wi' the sun: 10
O I will luve thee still, my dear,
 While the sands o' life shall run.

And fare thee weel, my only Luve!
 And fare thee weel, a while!
And I will come again, my Luve, 15
 Though it ware ten thousand mile!

8. **gang:** go.

For Study and Discussion

Analyzing and Interpreting the Poem

1. Lines 1–2 of this love song contain one of the most famous similes in English poetry. **a.** Try to express in literal language the ideas and feelings suggested by this figure of speech. **b.** Would the effect have been different if Burns had written, "O my Luve's like a *violet*"?

2. What does the simile in lines 3–4 add to the characterization of the woman?

3. Hyperbole (hī-pûr′bə-lē) is a figure of speech that uses exaggeration for special effect. **a.** Where does the speaker use hyperboles to express the duration of his love? **b.** What images do these hyperboles create?

4a. What details in the last stanza reveal that the speaker and his love are parting? **b.** What is the mood of the poem?

word may be pronounced differently in various parts of the country. **Dialect** is the term language experts use to describe a regional vocabulary and a regional way of speaking.

"A Red, Red Rose" is written in a Scottish dialect. Which words in the poem are different from words you would use?

Other words in the song are *archaic*—that is, they are not in common use today. Which words are these?

Try translating the poem into standard Modern English. What is lost? How do the dialect and archaic usage affect the musical qualities of the poem?

Literature and the Arts

The Rose as a Symbol

The rose is a common symbol in many forms of the arts. It is used as a symbol of beauty in *Romeo and Juliet* (II, 2, 43–44). The rose may be treated satirically, as in Dorothy Parker's "One Perfect Rose" (page 371), or used to allude to youth, as in Robert Herrick's "Gather ye rosebuds while ye may." Popular songs that refer to the rose include "The Rose," "The Yellow Rose of Texas," "Love Is a Rose," and "L'important c'est la Rose." The rose also plays a role in many fairy tales; in the animated movie *Beauty and the Beast,* the beast is kept alive by a magic rose under glass.

Making Connections: Activities

1. Pick one instance in which a rose is used symbolically and analyze its meaning in comparison with other rose metaphors and similes. Is the rose still a powerful symbol? Why or why not? Why do you think the rose acquired its evocative qualities, and not some other flower?

2. If you write music, try writing a melody for "A Red, Red Rose."

Language and Vocabulary

Recognizing Dialect and Archaic Words

If you have traveled from one part of the United States to another, you know that names for objects may differ regionally. A milkshake, for example, means one kind of drink in Cleveland and another in Boston. People talk about Southern accents and Western drawls when they want to point out that the same

A Red, Red Rose **463**

i thank You God for most this amazing

E. E. CUMMINGS

Cummings is well known for his experiments with language and with capitalization and punctuation. What gives this poem a fresh and original look? What imaginative use does Cummings make of the words yes *and* no?

i thank You God for most this amazing
day:for the leaping greenly spirits of trees
and a blue true dream of sky;and for everything
which is natural which is infinite which is yes

(i who have died am alive again today, 5
and this is the sun's birthday;this is the birth
day of life and love and wings:and of the gay
great happening illimitably earth)

how should tasting touching hearing seeing
breathing any—lifted from the no 10
of all nothing—human merely being
doubt unimaginable You?

(now the ears of my ears awake and
now the eyes of my eyes are opened)

For Study and Discussion

Analyzing and Interpreting the Poem

1. This poem contains approximate rhyme but the pattern is very definite. Do you see a similarity between this poem and Shakespeare's "Sonnet 71" (page 438)?

2. Cummings is known for his unusual arrangement of words. Which word combinations in the poem are arranged differently from what we would think of as "natural order"?

3. What images from the world of nature does Cummings use in his celebration of God?

4. Cummings ends the first stanza with the word *yes*, as another of the things he thanks God for. **a.** Why do you suppose he used the word? **b.** What does the word mean in this poem?

The Sonnet-Ballad

GWENDOLYN BROOKS

The title tells us that this poem is both a sonnet and a ballad. How does the poem combine the characteristics of the lyric and narrative forms?

Oh mother, mother, where is happiness?
They took my lover's tallness off to war,
Left me lamenting. Now I cannot guess
What I can use an empty heart-cup for.
He won't be coming back here any more. 5
Some day the war will end, but, oh, I knew
When he went walking grandly out that door
That my sweet love would have to be untrue.
Would have to be untrue. Would have to court
Coquettish death, whose impudent and strange 10
Possessive arms and beauty (of a sort)
Can make a hard man hesitate—and change.
And he will be the one to stammer, "Yes."
Oh mother, mother, where is happiness?

For Study and Discussion

Analyzing and Interpreting the Poem

1a. What has happened to make the speaker ask, "where is happiness"? **b.** What does the speaker predict will happen to her lover?

2. What metaphor does the speaker use in line 4 to help you visualize her feeling of loss?

3a. According to lines 9–12, how does the speaker know her lover will be "untrue"? **b.** In what unusual way does the speaker personify her rival, death? **c.** What do you think the speaker means by death's "beauty (of a sort)"?

4. How would you describe the emotion expressed in this lyric?

Writing About Literature

Analyzing a Poem

Brooks calls her poem "The Sonnet-Ballad." In a brief essay, discuss how the poem meets the requirements of both a sonnet and a ballad. Is it a fourteen-line poem written in iambic pentameter? Does each group of rhyming lines develop the thought of the poem? How does the poem use repetition as a ballad does? Be specific, and use lines from the poem to illustrate your analysis.

Little Elegy

X. J. KENNEDY

for a child who skipped rope

Here lies resting, out of breath,
Out of turns, Elizabeth
Whose quicksilver toes not quite
Cleared the whirring edge of night.

Earth whose circles round us skim
Till they catch the lightest limb,
Shelter now Elizabeth
And for her sake trip up Death.

For Study and Discussion

Analyzing and Interpreting the Poem

1. An **elegy** is a poem of mourning for a person who has died. What reasons would the poet have for calling this a "little" elegy?

2. Remember that Elizabeth skipped rope. **a.** What phrases in the poem are associated with skipping rope? **b.** What does the poet suggest about the timing of Elizabeth's death with the phrase "out of turns" in line 2?

3. Where does the poet use *night* as a metaphor for death?

4. The second verse is a prayer. **a.** What two things does the speaker ask Earth to do? **b.** What might the poet mean by the "circles" of Earth in line 5?

Writing About Literature

Analyzing Techniques in a Lyric Poem

The poet's aim in writing lyric poetry is to express a personal thought or emotion. Choose one of the poems in this unit, and write an essay in which you identify the thought or emotion expressed and point out examples of how the poet uses figurative language (metaphors, similes, symbols, etc.), invented language, or images to reveal his or her feelings. For instance, Robert Burns expresses his love for a girl in "A Red, Red Rose." You might discuss his use of metaphor and of hyperbole. He uses the rose as a symbol for his love: The color red is associated with blood (which is necessary to life) and passion; the rose is an especially beautiful flower that has long been associated with love. The poet also uses exaggeration (hyperbole) to show the intensity of his emotion.

About the Authors

Robert Burns (1759–1796)

Robert Burns, born in Scotland, spent much of his life as a farmer. At the age of twenty-six, in order to earn enough money to marry the woman he loved and leave the country, he published his first book of poetry, *Poems: Chiefly in Scottish Dialect*. This book was an immediate success, Burns married his love, and he decided to remain in Scotland. Burns's last years were marked by poverty, yet when he died at thirty-seven, he was hailed as the national poet of Scotland. Many of his lyrics have been set to music. "Auld Lang Syne" and "Flow Gently, Sweet Afton" are two examples.

E. E. Cummings (1894–1962)

E. E. Cummings once said that "poetry and every other art was and is and forever will be strictly and distinctly a question of individuality." Before the United States entered World War I, Cummings volunteered as an ambulance driver in the French army. A letter expressing disenchantment with the war landed him in a French detention camp, an experience he described in his first book, *The Enormous Room* (1922). Cummings is famous for his poetic experiments with punctuation, sentence structure, and the arrangement of words on the page.

Gwendolyn Brooks (1917–)

Gwendolyn Brooks was born in Topeka, Kansas, and grew up in Chicago. A graduate of Wilson Junior College, she has taught poetry at colleges and universities all over the country. In 1950 she was the first African American to win the Pulitzer Prize. She was named poet laureate of Illinois in 1968 and was appointed poetry consultant to the Library of Congress in 1985, the first African American woman to hold that position. "My aim," she once said, ". . . is to write poems that will somehow successfully 'call' . . . all black people . . . I wish to teach black people in pulpits, black people in mines, on farms, on thrones." Among her recently published books are *Blacks* (1987) and *The Near-Johannesburg Boy* (1986).

X. J. Kennedy (1920–)

In addition to poetry, Kennedy has written children's books and coedited literature anthologies with his wife, Dorothy. He has said of his craft: "Many today dismiss the sonnet and other traditional forms as drab boxes for cramming with words. But to me the old forms are where the primitive and surprising action is. Writing in rhythm and rhyme, a poet is involved in an enormous, meaningful game. . . . He is a mere mouse in the lion's den of the language—but with any luck, at times he can get the lion to come out." A recent work is *Dark Horses* (1992).

RELATING SOUND TO MEANING

Reading the poems in this unit has shown you that the sounds of words, as well as their meanings, can contribute effectively to description. Sound patterns include rhythm, meter, rhyme, alliteration, assonance, onomatopoeia, parallelism, and refrain. Writers use many of these devices in prose as well as in poetry.

Read aloud the two short passages below. Then get together with a small group of classmates for the activity that follows.

1. Snow would be the easy
 way out—that softening
 sky like a sigh of relief
 at finally being allowed
 to yield. No dice.
 We stack twigs for burning
 in glistening patches
 but the rain won't give.
 So we wait, breeding
 mood, making music
 of decline. We sit down
 in the smell of the past
 and rise in a light
 that is already leaving.

 —Rita Dove,
 from "November for Beginners"

2. I am in our walled yard, standing beside the swimming pool. The moon shines down on me from a polished black sky, and shines up at me from black water. I have been hearing the screech of a hunting owl, and now I see him on the telephone wire, a Halloween silhouette, cat-size and cat-eared. A moment only, and then he is not there, gone as soundlessly as a falling feather. The moon stares back at me from the pool.

 Then it cracks, crazes, shivers, spreads on tiny, almost imperceptible ripples. Some moth or night-flying beetle has blundered into it, I think. But when I put my flashlight on the spot from which the ripples seem to emanate . . . I see that a mouse is drowning there. He is a very small mouse, hardly bigger or heavier than a grasshopper, and he apparently cannot sink. But he must have been in the water for some time, for his struggles are feeble, and as I watch, they stop completely. He lies on the surface, his ripples spread out and dissipate and smooth out. . . .

 Generally when I find mice in the pool they are dead, and I can scoop them out with the net. . . . I lay the net on the pavement and turn the light on it close. . . . Then miracle. The fur stirs, finds itself on dry ground. In a scurry of legs it disappears among the grass and weeds.

 —Wallace Stegner,
 from *Crossing to Safety*

Relating Sound to Meaning

- Working in small groups, make a list of sound devices that contribute to the vivid description in each passage above. List one or more specific examples from the texts for each sound device.

WRITING A DESCRIPTIVE ESSAY

*I*n **descriptive writing** you use precise words and sensory details to re-create in the mind of your reader a person, place, object, or event. Your primary purpose in description can be to inform, to persuade, or to express your own feelings. This kind of writing appears in a wide variety of forms, including poetry, novels, short stories, biographies, ads, letters, and articles. In this unit you have explored some of the key elements of descriptive writing. Now you will have the chance to write a description on a subject of your own choice.

Prewriting

1. You may find these strategies helpful for choosing a subject:

- Think of a familiar person, place, or thing.
- Choose a subject you can observe directly.
- Limit your subject to one that you can cover in a few paragraphs.

[See **Focus** assignment on page 366.]

2. Decide whether your **purpose** is to write a **subjective** or an **objective description**. In a subjective description, the writer uses a first-person point of view and an informal tone to express thoughts and feelings. In an objective description, the writer's purpose is to provide information. This type of description, which is common in reports and articles, uses third-person point of view and a formal tone. The following chart lists some of the features of these two types.

	Subjective	Objective
Point of View	First-person	Third-person
Tone	Informal	Formal
Type of Writing	Letters, poems, stories, essays, journals	Reports, articles, speeches
Details	Factual and sensory; writer's thoughts and feelings; figures of speech	Factual and sensory

Also consider your **audience.** What background information might they need to understand your description? Will you need to define any unfamiliar terms for your readers? [See **Focus** assignments on pages 372 and 375.]

3. Summarize your planning so far by filling out a **description chart** like the one below.

Subject: _____
Type of Description: _____
Purpose: _____
Audience: _____
Point of View: _____
Tone: _____

[See **Focus** assignment on page 385.]

4. Effective descriptions contain a variety of sharp, carefully selected details. Here are three types of details you can use:

- **sensory details:** appeal to sight, sound, taste, touch, smell
- **factual details:** can be measured or checked

- **figures of speech:** words or phrases that are not meant literally
 —simile: comparison with *like* or *as*
 —metaphor: direct comparison
 —personification: giving human features to something nonhuman
 —symbol: using something to stand both for itself and for something broader than itself

The diagram below shows four methods of gathering details:

Sometimes you may wish to create a **special emphasis** or impression in your description. For example, if you were writing a tourist ad to promote travel to a foreign city, you would probably include details about the friendliness of the people, the hotel facilities, the shopping opportunities, and the exotic sights. You would probably not mention traffic problems, unpleasant weather patterns, or crime. [See **Focus** assignments on pages 381, 403, 405, and 411.]

5. Organize your details in a way that makes sense. Three ways to present your material are listed below:

- **spatial order:** arranging details from top to bottom, from side to side, or from near to far
- **order of importance:** placing the most important details either first or last
- **order of impression:** starting with the most important detail and moving on to other details in chronological order

[See **Focus** assignment on page 420.]

Writing

1. Capture your audience's attention by beginning your description with an especially vivid or unusual detail. By the end of the first paragraph, your focus and tone should be clear to the audience.

2. As you write, use the criteria below to **evaluate** the details you include:

- Is each detail sharp and vivid?
- Are factual details accurate?
- Do some details identify unique or especially notable features of the subject?

If you are trying to create a special emphasis, also ask yourself whether each detail contributes to a single, overall impression. [See **Focus** assignment on page 438.]

3. Use **transitions** to clarify relationships in your description. Below is a list of useful transitions:

above	first	outside
across	here	over
around	inside	then
before	into	there
behind	last	under
below	mainly	up
down	most important	

Evaluating and Revising

1. After you have written your first draft, put it aside for a while. Then evaluate it as objectively as you can. Specifically, focus on your use of **precise words.** Do your nouns, verbs, adjectives, and adverbs create sharp, clear images? Watch out for vague words like *go, move, some, interesting,* or *thing.* Check to see that your figures of speech are vivid and fresh. Have you avoided clichés? Finally, be sensitive to the **connotations,** or emotional overtones, of words and phrases. [See **Focus** assignments on pages 438 and 448.]

Below is an example of how one writer revised the opening paragraph of a descriptive essay.

Writer's Model

In the ~~late~~ *gathering twilight of* fall afternoons, our group would ~~meet~~ *hang around* at ~~the grocery~~ *Ted's Market* ~~store~~, just two blocks from school. The market was really a ~~small~~ *narrow-aisled* sandwich shop, into which we'd ~~go~~ *jostle loudly* just after 3:00 P.M. The owner sat ~~there~~ *like a Buddha*, ~~smiling~~ *philosophically* behind the cash register, as we ~~bought~~ *stocked up on* his staple ~~items:~~ *5* gum, comics, and sodas.

2. You may find the following checklist helpful as you revise your essay.

Checklist for Evaluation and Revision

✓ Do I capture the reader's interest?
✓ Are my subject and focus clear?
✓ Do I present sensory and factual details?
✓ Have I organized details logically?
✓ Do I create a special emphasis or impression?

✓ Are figures of speech fresh and imaginative?
✓ If my description is subjective, have I included my own thoughts and feelings?
✓ Are the tone and point of view consistent?

Proofreading and Publishing

1. Proofread your writing to correct errors in grammar, usage, and mechanics. (You may find it helpful to refer to the **Handbook for Revision** on pages 928–971.) Then prepare a final version of your essay by making a clean copy.

2. Consider some of the following ways to publish and share your essay:

- illustrate your essay with photographs or drawings and post it on the class bulletin board
- join with students who have written on similar or related subjects and create a portfolio of essays
- submit your essay to the school newspaper or literary magazine
- trade essays with a partner and use each other's paper as the springboard for writing a short poem in free verse

Portfolio If your teacher approves, you may wish to keep a copy of your work in your writing folder or portfolio.

DRAMA

Drama, like all other forms of literature, appeals to the imagination. While some drama is realistic and draws upon ordinary people experiencing common problems, audiences have always enjoyed dramas that extend the limits of their world. How many television programs and movies can you think of that deal with fantastic, legendary, or symbolic subjects?

In the photograph to the left, a modern actor is re-creating a role in an ancient Greek drama, where characters wore masks. Why might masks be effective in a large theater?

With a group of three or four other classmates, adapt one of the poems you have read as a short play for radio or television. Create dialogue that will reveal characters' thoughts and feelings. Some poems you might use are

"Boy with His Hair Cut Short"	(page 384)
"Ex-Basketball Player"	(page 410)
"Johnny Armstrong"	(page 443)
"La Belle Dame sans Merci"	(page 446)
"The Laboratory"	(page 456)

Practice your lines before presenting the play to the class.

A scene from *The House of Atreus,* adapted by John Lewin from Aeschylus' *Oresteia* for the Tyrone Guthrie Theater, Minneapolis, in 1967. Production designed by Tanya Moiseiwitsch.

History of the Drama

The origins of drama are obscure, but the form is probably as old as language itself. The first theater might have been a Stone Age campfire; the first actor-playwright, a person retelling the story of a hunt to other members of the tribe. All the ingredients were probably there: the suspenseful story, the conflict between hero and enemy, the tense hush in the audience, the climax, the satisfying ending.

Drama evolved through the ages. The drama of the early Greeks began as simple religious celebrations, but by the sixth and fifth centuries B.C., the Greeks were presenting their plays in huge, open-air amphitheaters. Costumed performers acted out the old Greek myths and legends, and the large audience spent all day at the theater, viewing a series of tragedies interspersed with comedies. When the center of Mediterranean civilization shifted from Greece to Rome, there was a decline in the range and scope of the drama. Although the Romans enjoyed comedies and some tragedies, many of their plays were copied from those of the Greeks.

During the Middle Ages, drama was for a while confined to strolling minstrels and players, who sang or mimed their tales to small groups in marketplaces, fairs, or courts. Gradually, from the rich ceremonies of the medieval church grew another form of drama. Bible stories were acted out, first by priests before the altar and later by actors on the steps of the cathedral. Biblical plays gave way to what were called "morality plays," in which actors pretended to be abstract qualities, such as vice, greed, or charity. These plays were enacted to teach certain morals or lessons. Eventually, as Greek and Roman manuscripts began to be rediscovered, the classical dramas were copied and restaged. By the end of the sixteenth century, the folk, religious, and classical elements of the theater had culminated in the dramas of William Shakespeare.

Since Shakespeare's time, drama has continued to take on varied forms, and certain forms have been associated with particular countries. Ever since the seventeenth century, the English have often used the stage to laugh at themselves and to criticize their own society. The Italians have produced grand opera. The French have produced plays that are, for the most part, cool, objective, and ironic—a theater of the mind. Toward the end of the nineteenth century, the Scandinavians produced a series of "social" dramas that were angry, hard-headed attacks on middle-class society. Americans became famous for the development of musical comedies and movies, which made Broadway and Hollywood practically household terms.

Rehearsal for a Satyr Play. Mosaic from the House of the Tragic Poet, Pompeii. The satyr play developed when the followers of Dionysus dressed as satyrs, animals that were part man and part goat, and sang songs about the god. Shown here are young chorus members dressed in goatskins and practicing the satyr dances. A wreathed musician plays the double flute. Conducting the rehearsal is the old man, right of center, who may be the dramatist. At his feet and on the table at the right can be seen the masks that were used in the drama.
Museo Nazionale, Naples

A conjectural representation of a medieval mystery play. Engraving by David Jee. The mystery plays dramatized scenes from the Bible. Shown here is Jesus before Pilate. Each scene of the play was built on a wagon stage. While the audience stood in the town square, the wagons moved around. Each wagon performed its part of the play before a group of spectators, then moved on.

Scene from a modern production of *Jedermann* (*Everyman*) at the Salzburg Festival. Medieval morality plays were concerned with human beings' salvation. Everyman, summoned by Death, asks his Good Works to accompany him on his journey, but since he has led a sinful life, Good Works is too weak to rise.

Scene from a modern production of Shakespeare's *Two Gentlemen of Verona* at the Oregon Shakespeare Festival in Ashland. This is an example of how directors, set designers, and costume designers give Elizabethan drama a new look.

Interior of the Royal Theater, Turin by Domenico Oliviero.
Museo Civico, Turin

An Italian Comedy in Verona (1772) by Marco
Marcola. Oil on canvas, 115.3 × 84.2 cm (oval).
The artist depicts an open-air commedia dell'arte
performance with Arlecchino (Harlequin) bowing
before his *innamorata* (loved one).
Courtesy of the Art Institute of Chicago,
gift of Emily Crane Chadbourne 1922.4790

A Broadway production of
Candide, a musical drama
based on an eighteenth-cen-
tury work by Voltaire.

Tragedy and Comedy

Over the centuries, plays have generally clustered around two poles: tragedy and comedy. These terms were first established by the Greeks. *Tragos* in Greek means "goat," and *oide,* "song," thus "goatsong." This suggests a primitive play in which an actor, dressed in goatskin, sang his lines. We do not know much about these ancient "goatsongs," but we do know that as Greek drama developed, the word *tragedy* came to be applied to serious plays that depicted the fall and death of a noble character in conflict with forces beyond his or her control. It is not easy to say exactly what tragedy is, but it is clear that tragedy must have something to do with thought, with human decisions. A person who makes a series of foolish decisions and gets into trouble doesn't seem tragic. Tragedy requires that the hero or heroine make choices that lead to a situation from which there is no escape. Tragedy is the confrontation of human intelligence with forces that intelligence cannot cope with. We admire the tragic heroes and heroines for their struggles; we feel that perhaps we might do the same things; and we weep when we see them fall. When we leave a tragic play, our feeling is one of profound sadness. Yet we also feel our hearts lifted, because we have been reminded of the fact that people are capable of nobility of spirit, even in the face of overwhelming disaster.

A relief showing the Greek dramatist Euripides handing a tragic mask to a figure representing *skene*. (The *skene* was a structure on the stage through which actors made their entrances.) At the right is a statue of the god Dionysus. Tragedy developed out of a ritual observance in honor of Dionysus.

The Greek word *komos* suggests a festive procession, and *oide*, as already mentioned, is a song. Most likely, in ancient Greece, this song was sung by a daring peasant who, with temporary immunity, poked fun at his ruler and let him know a few of his faults. It is thought that classical Greek comedy rose from these primitive beginnings, and eventually developed into a special form of theater in which a comic hero acted out a story that mocked social customs and procedures. The best comedy of all ages seems to have continued in this tradition. Comedy usually takes aim at society, advocates changes, and makes us laugh at its boldness and truthfulness. Both tragic and comic figures struggle against authority of some sort. In tragedy, the odds are usually unconquerable; in comedy, the hero or heroine is usually able to overthrow the authority figure and the play ends happily. One of the most popular comic plots is the one involving two lovers. In this plot, one of the lovers must overcome some obstacle—social or personal—to their marriage. Hollywood has been capable of finding endless variations on this popular comic plot.

In this unit you will find two tragedies: Sophocles' *Antigone,* first performed around 440 B.C. in Athens, and William Shakespeare's *Julius Caesar,* first performed in 1599 in London. Two contemporary dramas are also included: Robert Anderson's realistic American drama *I Never Sang for My Father,* which opened on Broadway in January 1968, and the screenplay of *The Third Man,* which was shot in 1949.

Close Reading OF A PLAY

*W*hile many of the elements you re-
sponded to in connection with short
stories and poetry are relevant to the
study of drama, there are several ad-
ditional elements that need to be
taken into account. Drama has its own
conventions, or practices. Classical
Greek drama, for example, makes use
of a chorus, a choragos, and odes (see
page 490). Elizabethan drama makes use of asides and soliloquies (see
page 541). Sometimes a character will step out of the play to address
the audience, as Gene does in I Never Sang for My Father (page 640).
The screenplay, a comparatively recent form of drama, has conven-
tions of its own, including the voice-over and dissolve (see page 688).
Dramatists frequently make use of stage directions to create setting
and to give players instructions for acting. Generally, however, dia-
logue is the dramatist's most important device for presenting char-
acter and for moving the action along.

Guidelines for Close Reading

1. Note any information that establishes the setting or explains the
 situation.
2. Note clues that tell you what the players are doing or how the
 lines are spoken.
3. Be alert to shifts in tone. Whereas farce tends to be uniformly
 comic and classical tragedies tend to be consistently serious, the
 tone in most dramas will vary to some degree. In Shakespeare's
 tragedies, for example, there are clowns who provide comic relief;
 and in his sunniest comedies, there are scenes of serious and noble
 grandeur. Consider how these shifts in tone affect your response.
4. Be aware of dramatic conventions and their functions as well as
 your response to them. Many modern plays are written in a realistic
 style. The dialogue is colloquial, and the main action takes place
 in full view of the audience. By contrast, classical Greek drama is
 written in verse, and much of the action takes place offstage and
 is reported by messengers. Elizabethan drama uses both prose and
 verse and special kinds of speeches known as soliloquies and asides.

Screenplays make use of dissolves, montages, and other visual effects.

5. Using your responses to the play, write a statement of its theme or underlying meaning. Most drama, like most narrative fiction, has something to say about the human condition that helps give us insight into ourselves and others. Distill your response into a written statement of what the play is all about.

The following one-act play is by David Mamet (măm′ət), a Pulitzer prize-winning American playwright who writes screenplays and teleplays as well as stage plays. This work is a dramatization of the short story "Vint" by Anton Chekhov. Vint is a card game for four players, with similarities to bridge.

Mamet's play is a *farce*—a kind of comedy that depends on exaggerated characters and actions and improbable or absurd situations. As you read, imagine the facial expressions, the gestures, and the tone of voice each actor would use. Note how economically the characters, the situation, and the dialogue are handled.

Vint

DAVID MAMET

Characters

Porter
Commissioner Persolin
 (pâr-tsô′lĭn)
Zvisdulin (zvîs-dōō′lyĭn)

Kulakevitch (kōō-lä-kâ′vĭch)
Nedkudov (nyĕd-kōō-dôv′)
Psiulin (pē-sōō′lyĭn)

A Porter *and* Commissioner Persolin, *walking down the corridors of power, late at night.*

Porter. You wish the coach to wait, your Excellency?
Persolin. I've told him to. I just need the one file.

ONE READER'S RESPONSE

I need to take time to learn how to pronounce these Russian names.

If he took a coach, then this must take place a long time ago.

Close Reading of a Play **481**

What must this be?

Porter. I may say so, sir. It must be important, to drag you in so late.

Persolin. It is, yes. It's for the Quarterly Report.

Porter. Oh, yes, sir. Tomorrow's the day.

Persolin. What's that I hear? (*Pauses*)

Porter. Clerks, sir.

Persolin. Clerks. (*Pauses*)

Porter. Your clerks.

Persolin. They're still here?

Porter. Yessir.

Persolin. They stayed to work on the report. God bless *them*. What is a man without his staff?

Porter. As you say, Commissioner Persolin.

He is so happy.

Persolin. I think a commendation is in order here. (*Hands a slip of paper to* Porter) Fetch me this file. (Porter *goes off.* Persolin *goes up to a door behind which we hear the clerks muttering. Speaks to himself.*) My bully, bully boys . . .

Zvisdulin (*behind the door*). My bid. An Interoffice Clerk.

Kulakevitch. Two Treasury.

Persolin (*to himself*). Two Treasury what?

Nedkudov. No, may we stop a moment, please?

Zvisdulin. Finish the bidding. Eh?

It sounds like they're playing cards.

Persolin (*to himself*). The bidding?

Nedkudov. Finish it *nothing*. Not at all. My partner leads an Interoffice Clerk, and then two *Treasury* . . . ?

Kulakevitch. It was my bid.

Persolin (*to himself*). What's going on here?

Nedkudov. All that I . . .

Psiulin. It's his *bid*. Let it stand. When it's *your* bid, then *you* bid.

Nedkudov. All right . . . all right . . .

[*Pause*]

Psiulin. It's your bid.

Nedkudov. All right . . . two Treasury, and I raise . . . Vrazhansky.[1]

Kulakevitch. Fine. Vrazhansky.

Nedkudov. Your bid . . . ?

Psiulin. Madame Persolin.

They're bidding people and ranks, not cards. How weird!

1. **Vrazhansky** (vrä-zhän'skē).

[Persolin *bursts in*.]

Persolin. What's going on here? (*Pauses*) I said, what's going on here?
Kulakevitch. Sir . . .
Persolin. Yes. Sir. What? Come on. . . . Surprised to find you here, thought you were for once doing the work you're *paid* to, what do I . . . bandying[2] the name of my wife. (*Pauses*) Now.

[*Pause*]

Nedkudov. Commissioner Persolin.
Persolin. Now: What does this mean?

2. **bandying:** tossing back and forth casually.

A scene from David Mamet's *Vint,* one of seven short plays based on stories by Anton Chekhov in The Acting Company's 1985–86 production of *Orchards,* directed by Robert Falls. (From left to right: Joel Miller as Zvisdulin, Aled Davies as Psiulin, Kevin Jackson as Nedkudov, Terrence Caza as Commissioner Persolin, Craig Bryant as the Porter and Phil Meyer as Kulakevitch.)

[*Pause*]

Zvisdulin. We . . .
Persolin. Yes. What what what? Up all night . . . finish the report—I come in. I . . . *What are you doing?*
Kulakevitch. We were playing cards.

[*Pause*]

Now he's angry, particularly because he thinks they're insulting his wife.

Persolin. Playing cards. And bandying the name of my wife.
Zvisdulin. Yes. As you see . . . playing cards and . . .
Persolin. Ignorant as I am it seems to me those are not cards but Identity Dossiers.[3]

[*Pause*]

They're playing cards with the files. This is really strange!

Nedkudov. Yes, sir, that's what they are.
Persolin. That's what they are.
Nedkudov. Yes. Sir.
Persolin. So what is it I'm privy to? In this perversion? In this . . . this unauthorized use of . . . Treason? I would have thought you lacked the initiative. But. No. Unauthorized files, you . . .
Kulakevitch. We assure you, sir. We. We were only playing vint.
Persolin. Playing vint.
Kulakevitch. Yessir.

[*Pause*]

He's being skeptical and a little sarcastic.

Persolin. With Identity Dossiers.
Kulakevitch. Yes, sir.
Persolin. And how *is* that? Well. Let me *profit* from it, *please.*

[*Pause*]

Nedkudov (*to* Kulakevitch). *You* go.

[*Pause*]

3. **Dossier** (dŏs′ē-ā′, dôs′yā): a file of documents about a person.

Kulakevitch. Um. Each name, you see, your Excellency . . .

Persolin. Yes . . .

Kulakevitch. Each name is like a card. Just like a regular deck. Four suits. Fifty-two cards. Men of the Treasury are hearts, the Provincial Administrators clubs, the State Bank spades, the Ministry of Education . . . and so on, you see . . . State Councilors are aces, Assistant State Councilors . . .

Nedkudov. It's very easy, sir . . . and down the line. Collegiate Councilors jacks, their wives are queens . . .

Persolin. . . . wives of the Collegiate Councilors . . .

Kulakevitch. . . . are queens . . . Court Councilors are tens, and so on. I . . . here's *my* card: Stepan Kulakevitch: three.

Persolin. You're a three.

Kulakevitch. Three of, yessir, the three of clubs. And Zvisdulin, here, he's a—

Persolin. What am I?

[*Pause*]

Zvisdulin. Ace of clubs.

[*Pause*]

Persolin. I'm the ace of clubs.

Kulakevitch. Yessir.

Persolin. And my wife?

Kulakevitch. Is the queen of clubs.

Persolin. You said the queen was the spouse of the jack.

Zvisdulin. As the jack in Provincial has no wife . . .

Persolin. Ah.

Kulakevitch (*confidentially*). It's Mosischev[4] . . .

Persolin. Yes, I know.

Zvisdulin. . . . and neither the king, we took the liberty . . .

Kulakevitch. . . . and meant no disre—

Persolin. Yes, yes, yes, and so my wife's the queen of clubs.

[*Pause*]

Nedkudov. Yessir.

4. **Mosischev** (môʹsĭs-chĕv).

What a strange way to play cards—with people's file folders.

All of a sudden he's interested!

He's happy that he and his wife have high ranks.

I feel like I'm in the middle of an explanation that should make complete sense but doesn't.

Persolin. And as I came in she'd just—
Psiulin. I'd had the honor to *bid* her.
Nedkudov. As you came in she'd just taken a trick over two Treasury half-councilors.
Persolin. She did.
Nedkudov. Yes.
Persolin. And who were they?
Kulakevitch (*checks*). Ostopchin and Brot.[5]

[*Pause*]

Persolin. And she took that trick.
Kulakevitch. Yes.

5. **Ostopchin** (ô-stôp′chĭn); **Brot** (brôt).

A scene from David Mamet's *Vint*, one of seven short plays based on stories by Anton Chekhov in The Acting Company's 1985-86 production of *Orchards*, directed by Robert Falls. (From left to right: Aled Davies as Psiulin, Kevin Jackson as Nedkudov, Terrence Caza as Commissioner Persolin, and Phil Meyer as Kulakevitch.)

Photo: Diane Gorodnitzki ©

Nedkudov. You see, he led the Interoffice Clerk. Why? *Why,* I said . . .

Kulakevitch. I countered with the Treasury.

Persolin. Why make the diamonds vulnerable?

Nedkudov. That's what *I* said. That's what *I* said!

Persolin. And so you've got to come back with my wife.

Nedkudov. Wasted a perfectly good queen. With all resp—

Persolin. No, you're quite right. Wasted. Yes. Who taught you to play? He leads who? The Interoffice . . . ?

Zvisdulin. Brulin and Baschenko.[6]

Persolin. He leads Brulin. Brulin *and* Baschenko?

Zvisdulin. Yes.

Persolin. *Why?*

Zvisdulin. To force—

Persolin. You know . . . you're laying the whole Ministry open to—

Nedkudov. That's what *I* said.

Persolin. Look—look—can I get in?

Kulakevitch. Sir, we'd be honored to—

Nedkudov. Give him the cards.

Zvisdulin. Deal him in.

[Persolin *is dealt in.*]

Persolin. All right. Now: let's go back to *you.*

Psiulin. I bid your wife.

Persolin. My bid?

Psiulin. Yes.

Persolin. All right. Grand Court Councilor, I give you: Ivan Dimich Grelandsky.[7]

[*Pause*]

Nedkudov. Brilliant.

Persolin. Well, you *see* . . . ?

Nedkudov. Brilliant.

Persolin. If he comes out with Education . . .

Kulakevitch. Yes . . .

Now he's so interested that he wants to play also.

6. **Brulin** (broo′lyĭn); **Baschenko** (bäs-chyĕn′kō).
7. **Ivan Dimich Grelandsky** (ē-vän′ dē′mĭch gryĕ-län′skē).

Close Reading
OF A PLAY

He is no longer interested in what he came for.

This is ironic. He has become completely involved in the game.

Persolin. What do I have? Look: let's play this hand open. I have *Grelandsky* . . . Paschin . . .
Nedkudov. Yes.

[*The* Porter *sticks his head in.*]

Porter. Excellency, I have the file.
Persolin. (*brushing him off*). Just . . . just . . . just . . .
Nedkudov. Finish the hand: the man bid Grelandsky.
Kulakevitch. All right. Grelandsky, and . . . has Potkin fallen?
Psiulin. No, we're void[8] in Education.
Porter. Excellency . . .?
Persolin (*sternly*): Will you *please* . . . ?
Kulakevitch. All right. Grelandsky and . . . um . . . um . . .
Nedkudov. No prompting.
Kulakevitch. And . . . um . . .
Persolin. Just bid, will you?
Kulakevitch. All right, I . . .
Persolin. What are you, working by the *hour?* Come *on.* Come on!

8. **void:** To be void means to hold no cards in a particular suit.

Looking at Yourself as a Reader

Compare your own notes with the notes alongside the selection. How are the two sets of responses similar? How are they different? What do these similarities and differences reveal about the way readers respond to plays?

Review your responses carefully. What aspects of the play had the greatest effect on you? Why? What was your reaction to the setting? the writer's language? the characters? the plot? Meet with several of your classmates in a small group and compare responses. Assemble a group response to the play and present it to the class. Then arrange your group notes into a formal essay about the play.

A modern performance in the restored theater at Epidaurus. The flat circular area, called the *orchestra*, was the dancing place used by the chorus. The audience sat around the orchestra, first on the bare hillside, and later on wooden benches and stone steps.

ANTIGONE

Sophocles and His Theater

The theater for which *Antigone* was written was very different from the one we attend today. It resembled more what we would call a stadium. It was outdoors, and plays were presented during the daylight hours only. The Greeks were careful in choosing sites for their theaters, which were built on hillsides, preferably on those with a slight inward slope. This provided a natural semicircle, or amphitheater. Seats were built up in rows, either of earth and stone or of wood, to provide an arena, at the base of which plays could be performed. The area at the base was called the *orchestra*. The orchestra (so named because it was the place where the chorus changed and danced) was also the place where the actors performed. There was no raised stage as there was later in Roman times.

The acoustics in these theaters were usually very fine, and people had little trouble hearing even in the highest rows of seats. The sound was also amplified by the large masks the actors wore. The chanting of the chorus also helped to carry the sound further. To aid viewing, the actors wore oversized, well-padded costumes, and boots with raised soles to add to their height. The masks not only were oversized but also had exaggerated features so that they could be seen clearly at large distances. Behind the orchestra was a painted wall called a *skene* (our word *scenery* comes from this word), through which the actors entered and exited. The actors, all of whom were men, masked and padded, moved in a stately and controlled fashion. We might think these actors were performing some stately ritual if we compared their acting to the realistic acting style of today's theater. The chorus would also strike us as artificial, and their chanting and dancing would add to our feeling of ritual. The chorus consisted of fifteen men with one spokesman, or leader, called the *choragos*. The chorus,

A modern production of Sophocles' *Oedipus Rex* at the Landestheater, Darmstadt, Germany.

usually representing the city elders, took part in the action of the play, reacting to what was happening as citizens might. But the chorus also commented on the action of the play and interpreted its meaning for the audience in a series of chanted poems, or odes.

The Greeks took their theater very seriously, and we would be right to see it as part of a religious ritual. In fact, the plays were written for performance at great festivals held seasonally in honor of the god Dionysos (dī′ə-nī′səs), whose altar stood in the orchestra. New plays were written specifically for these festivals, competitions were held, and prizes awarded. Many playwrights entered the competitions, and plays were performed continuously for several days.

Sophocles (496?–406 B.C.) first competed for the prize in tragedy when he was twenty-seven; he won, defeating the great Aeschylus (ĕs′kə-ləs), then the most famous playwright in Athens. Sophocles is said to have had a fortunate life. He was born at Colonus (kə-lō′nəs) of a wealthy family. He was given a traditional education in music, dancing, and gymnastics. When the Greeks defeated the Persians in 480 B.C., young Sophocles led the chorus in singing and dancing at the victory celebration. He is said to have been graceful and handsome, and to have had musical as well as dramatic gifts. Sophocles was also active in public life. He was twice elected general, served as a priest of the god Asclepius, and at eighty-three was appointed to a commission studying a revision of Athens' constitution.

It is probable that Sophocles wrote over one hundred twenty tragedies in his lifetime. Only seven remain to us today, but they are among the greatest plays ever written. Sophocles won many contests with his plays and was greatly respected by his fellow citizens; at his death he was given the honors of a hero. It is hard to imagine, given his tranquil and successful life, how Sophocles came by his great and deep understanding of human grief and suffering. It may be that the ancient myths of his people provided him with insight into the depths of human nature and its relationship to fate and to the gods.

A statue of Sophocles from the fourth century B.C.
Vatican Museum

Background of the Play

The story of the ill-fated royal house of Thebes is one of the mythical stories that Sophocles looked into most deeply. Three of his surviving plays are based on this tragic story: *Oedipus* (ĕd′ə-pəs) *the King*, *Oedipus at Colonus*, and *Antigone* (ăn-tĭg′ə-nē′).

The story begins when Laios (lā′əs), grandson of the founder of Thebes, is king, and Iocaste (yō-kăs′tə) the queen. Because of an

Oedipus visits the Sphinx. Base of an Attic cup.
The Vatican Museum

impiety Laios has committed, an oracle proclaims that he will be slain by his own son. In an attempt to avoid this fate, Laios pierces and binds the feet of his infant son and abandons him on a nearby mountain. But the child is found by the shepherds of King Polybus (pä′lə-bəs) of Corinth. They bring the baby to their master who adopts him as his own son and names him Oedipus, which means "swollen foot." Polybus raises Oedipus as his heir. When Oedipus grows to manhood, he is told by another oracle that he is destined to slay his own father and marry his mother. As Laios had done, Oedipus attempts to avoid this fate. He leaves Corinth, but at a crossroads he meets a stranger; they quarrel, and Oedipus kills the man, not realizing that the stranger is his father, Laios.

In the meantime, a celebrated Sphinx has appeared at Thebes. This winged monster with the body of a lion and the face of a woman has been preying on travelers whom she challenges with a riddle. If they are unable to answer the riddle, they are thrown into the sea. The riddle goes like this: What creature has four feet, two feet, then three feet, but only one voice, and when it has the most feet, it is the

weakest? Oedipus' answer (the correct one) is "man," who crawls on all fours as an infant, walks on two feet when grown, and needs a cane when old. Defeated by Oedipus, the Sphinx throws herself into the sea, and the Theban people welcome Oedipus as their savior. He learns that their king has recently died. They offer to make him king and give him Iocaste, their queen, for his wife. Thus Oedipus unknowingly marries his own mother, and the oracles he and Laios had tried to avoid are fulfilled.

Iocaste and Oedipus have four children—two daughters, Antigone and Ismene (ĭs-mē′nē), and two sons, Eteocles (ĭ-tē′ə-klēz′) and Polyneices (päl′ə-nī′sēz). They reign in Thebes in harmony for many years until a plague strikes the city. Oedipus sends his wife's brother, Creon, to consult the oracle to discover the cause of the plague. Creon brings word that Thebes is unclean because the murderer of the former king still lives there. Oedipus rashly promises that he will again make hidden things known, assuming that he can solve this problem as easily as he solved the riddle of the Sphinx. The blind Teiresias (tī-rē′sē-əs), a seer (or prophet), advises Oedipus not to seek for the murderer lest he discover that it is himself.

But Oedipus goes ahead with the investigation anyway, and gradually he learns the truth: that he has indeed murdered his father and married his own mother. Iocaste, in horror, commits suicide, and Oedipus blinds himself because he has failed to see the truth that could have saved him. Oedipus then asks to be sent into exile, but Creon says he must stay until the will of the gods has been revealed. Oedipus remains in Thebes for some years until Creon and the Theban elders decide he should be exiled. By this time, Oedipus wants to remain in Thebes, but his sons do nothing to help him. Oedipus goes off with his two daughters to wander as a beggar, cursing his ungrateful sons. The old man finally dies at peace in Colonus. When his daughters are assured that no mortal may approach the hidden tomb of their father, they return to Thebes.

Creon rules in Thebes until Oedipus' sons decide that they should have their father's throne. Creon sides with Eteocles, and Polyneices is exiled. But he raises a force among the Argives (är′jīvz′), his wife's people. These troops storm the seven gates of Thebes. At one of the gates, the brothers meet and slay each other, fulfilling their father's curse. Creon has Eteocles buried with full state honors. But he decrees that Polyneices shall go unburied as an enemy of the state. This was a very harsh sentence in the eyes of the ancient Greeks because their holiest law required the performance of certain burial rites.

As the play begins, it is the day after the battle. Antigone decides to defy Creon's decree and bury her brother.

Antigone

SOPHOCLES

Translated by
Dudley Fitts and Robert Fitzgerald

Characters

Antigone (ăn-tĭg′ə-nē′)⎫
Ismene (ĭs-mē′nē) ⎭ daughters of Oedipus, former king of Thebes
Creon, king of Thebes, uncle of Antigone and Ismene
Haimon (hī′mən), Creon's son, engaged to Antigone
Eurydice (yo͞o-rĭd′ə-sē′), wife of Creon
Teiresias (tī-rē′sē-əs), a blind prophet
Chorus, made up of about fifteen elders of Thebes
Choragos (kə-rā′gəs), leader of the Chorus
A Boy, who leads Teiresias
A Sentry
Guards
Servants
A Messenger

Scene: *Before the palace of* Creon, *king of Thebes. A central double door, and two doors at the side. A platform extends the length of the stage, and from this platform three steps lead down into the orchestra, or chorus-ground.*
Time: *Dawn of the day after the repulse of the Argive army from the assault on Thebes.*

Prologue

[Antigone *and* Ismene *enter from the central door of the palace.*]

Antigone. Ismene, dear sister,
 You would think that we had already suffered enough

For the curse on Oedipus:
I cannot imagine any grief
That you and I have not gone through. And now— 5
Have they told you of the new decree of our King Creon?

Ismene. I have heard nothing: I know
That two sisters lost two brothers, a double death
In a single hour; and I know that the Argive army
Fled in the night; but beyond this, nothing. 10

Antigone. I thought so. And that is why I wanted you
To come out here with me. There is something we must do.

Ismene. Why do you speak so strangely?

Antigone. Listen, Ismene:
Creon buried our brother Eteocles 15
With military honors, gave him a soldier's funeral,
And it was right that he should; but Polyneices,
Who fought as bravely and died as miserably—
They say that Creon has sworn
No one shall bury him, no one mourn for him, 20
But his body must lie in the fields, a sweet treasure
For carrion birds to find as they search for food.
That is what they say, and our good Creon is coming here
To announce it publicly; and the penalty—
Stoning to death in the public square!

 There it is, 25
And now you can prove what you are:
A true sister, or a traitor to your family.

Ismene. Antigone, you are mad! What could I possibly do?

Antigone. You must decide whether you will help me or not.

Ismene. I do not understand you. Help you in what? 30

Antigone. Ismene, I am going to bury him. Will you come?

Ismene. Bury him! You have just said the new law forbids it.

Antigone. He is my brother. And he is your brother, too.

Ismene. But think of the danger! Think what Creon will do!

Antigone. Creon is not strong enough to stand in my way. 35

Ismene. Ah sister!
Oedipus died, everyone hating him
For what his own search brought to light, his eyes
Ripped out by his own hand; and Iocaste died,
His mother and wife at once: she twisted the cords 40
That strangled her life; and our two brothers died,
Each killed by the other's sword. And we are left:
But oh, Antigone,
Think how much more terrible than these

Our own death would be if we should go against Creon 45
And do what he has forbidden! We are only women,
We cannot fight with men, Antigone!
The law is strong, we must give in to the law
In this thing, and in worse. I beg the dead
To forgive me, but I am helpless: I must yield 50
To those in authority. And I think it is dangerous business
To be always meddling.

Antigone. If that is what you think,
I should not want you, even if you asked to come.
You have made your choice, you can be what you want to be.
But I will bury him; and if I must die, 55
I say that this crime is holy: I shall lie down
With him in death, and I shall be as dear
To him as he to me.
 It is the dead,
Not the living, who make the longest demands:
We die forever . . .
 You may do as you like, 60
Since apparently the laws of the gods mean nothing to you.

Ismene. They mean a great deal to me; but I have no strength
To break laws that were made for the public good.

Antigone. That must be your excuse, I suppose. But as for me,
I will bury the brother I love.

Ismene. Antigone, 65
I am so afraid for you!

Antigone. You need not be:
You have yourself to consider, after all.

Ismene. But no one must hear of this, you must tell no one!
I will keep it a secret, I promise!

Antigone. Oh tell it! Tell everyone!
Think how they'll hate you when it all comes out 70
If they learn that you knew about it all the time!

Ismene. So fiery! You should be cold with fear.

Antigone. Perhaps. But I am doing only what I must.

Ismene. But can you do it? I say that you cannot.

Antigone. Very well: when my strength gives out, I shall do no more. 75

Ismene. Impossible things should not be tried at all.

Antigone. Go away, Ismene:
I shall be hating you soon, and the dead will, too,
For your words are hateful. Leave me my foolish plan:
I am not afraid of the danger; if it means death, 80
It will not be the worst of deaths—death without honor.

Ismene. Go then, if you feel that you must.
 You are unwise,
 But a loyal friend indeed to those who love you.

[*Exit into the palace.* Antigone *goes off, left. Enter the* Chorus *and* Choragos.]

Parados°

Chorus. Now the long blade of the sun, lying 85
 Level east to west, touches with glory
 Thebes of the Seven Gates. Open, unlidded
 Eye of golden day! O marching light
 Across the eddy and rush of Dirce's stream,°
 Striking the white shields of the enemy 90
 Thrown headlong backward from the blaze of morning!
Choragos. Polyneices their commander
 Roused them with windy phrases,
 He the wild eagle screaming
 Insults above our land, 95
 His wings their shields of snow,
 His crest their marshaled helms.

Chorus. Against our seven gates in a yawning ring
 The famished spears came onward in the night;
 But before his jaws were sated with our blood, 100
 Or pinefire took the garland of our towers,
 He was thrown back; and as he turned, great Thebes—
 No tender victim for his noisy power—
 Rose like a dragon behind him, shouting war.
Choragos. For God hates utterly 105
 The bray of bragging tongues;
 And when he beheld their smiling,
 Their swagger of golden helms,
 The frown of his thunder blasted
 Their first man from our walls.° 110

Chorus. We heard his shout of triumph high in the air
 Turn to a scream; far out in a flaming arc
 He fell with his windy torch, and the earth struck him.

°**Parados:** the song accompanying the entrance of the Chorus. 89. **Dirce's stream:** Dirce, an early queen of Thebes, was murdered and her body thrown into the stream that bears her name. 105–110. **For God . . . walls:** Zeus threw a thunderbolt that killed the first Argive attackers.

And others storming in fury no less than his
　　Found shock of death in the dusty joy of battle. 115
Choragos. Seven captains at seven gates
　　Yielded their clanging arms to the god
　　That bends the battle line and breaks it.
　　These two only, brothers in blood,
　　Face to face in matchless rage, 120
　　Mirroring each the other's death,
　　Clashed in long combat.

Chorus. But now in the beautiful morning of victory
　　Let Thebes of the many chariots sing for joy!
　　With hearts for dancing we'll take leave of war: 125
　　Our temples shall be sweet with hymns of praise,
　　And the long night shall echo with our chorus.

Scene 1

Choragos. But now at last our new king is coming:
　　Creon of Thebes, Menoikeus'° son.
　　In this auspicious dawn of his reign
　　What are the new complexities
　　That shifting fate has woven for him? 5
　　What is his counsel? Why has he summoned
　　The old men to hear him?

　　　　[*Enter* Creon *from the palace, center. He addresses the* Chorus *from the top step.*]

Creon. Gentlemen: I have the honor to inform you that our ship of state, which recent
storms have threatened to destroy, has come safely to harbor at last, guided by the
merciful wisdom of heaven. I have summoned you here this morning because I know 10
that I can depend upon you: your devotion to King Laios was absolute; you never
hesitated in your duty to our late ruler Oedipus; and when Oedipus died, your loyalty
was transferred to his children. Unfortunately, as you know, his two sons, the princes
Eteocles and Polyneices, have killed each other in battle, and I, as the next in blood,
have succeeded to the full power of the throne. 15
　　I am aware, of course, that no ruler can expect complete loyalty from his subjects
until he has been tested in office. Nevertheless, I say to you at the very outset that I
have nothing but contempt for the kind of governor who is afraid, for whatever reason,
to follow the course that he knows is best for the state; and as for the man who sets
private friendship above the public welfare—I have no use for him, either. I call God 20

2. **Menoikeus** (mĕ-noi′kē-əs).

to witness that if I saw my country headed for ruin, I should not be afraid to speak out plainly; and I need hardly remind you that I would never have any dealings with an enemy of the people. No one values friendship more highly than I; but we must remember that friends made at the risk of wrecking our ship are not real friends at all. 25

These are my principles, at any rate, and that is why I have made the following decisions concerning the sons of Oedipus: Eteocles, who died as a man should die, fighting for his country, is to be buried with full military honors, with all the ceremony that is usual when the greatest heroes die; but his brother Polyneices, who broke his exile to come back with fire and sword against his native city and the shrines of his 30 fathers' gods, whose one idea was to spill the blood of his blood and sell his own people into slavery—Polyneices, I say, is to have no burial: no man is to touch him or say the least prayer for him; he shall lie on the plain, unburied; and the birds and the scavenging dogs can do with him whatever they like.

This is my command, and you can see the wisdom behind it. As long as I am king, 35 no traitor is going to be honored with the loyal man. But whoever shows by word and deed that he is on the side of the state—he shall have my respect while he is living and my reverence when he is dead.

Choragos. If that is your will, Creon, son of Menoikeus,
You have the right to enforce it: we are yours. 40
Creon. That is my will. Take care that you do your part.
Choragos. We are old men: let the younger ones carry it out.
Creon. I do not mean that: The sentries have been appointed.
Choragos. Then what is it that you would have us do?
Creon. You will give no support to whoever breaks this law. 45
Choragos. Only a crazy man is in love with death!
Creon. And death it is; yet money talks, and the wisest
Have sometimes been known to count a few coins too many.

[*Enter* Sentry *from left.*]

Sentry. I'll not say that I'm out of breath from running, King, because every time I stopped to think about what I have to tell you, I felt like going back. And all the time a voice 50 kept saying, "You fool, don't you know you're walking straight into trouble?"; and then another voice: "Yes, but if you let somebody else get the news to Creon first, it will be even worse than that for you!" But good sense won out, at least I hope it was good sense, and here I am with a story that makes no sense at all; but I'll tell it anyhow, because, as they say, what's going to happen's going to happen, and— 55
Creon. Come to the point. What have you to say?
Sentry. I did not do it. I did not see who did it. You must not punish me for what someone else has done.
Creon. A comprehensive defense! More effective, perhaps,
If I knew its purpose. Come: what is it? 60
Sentry. A dreadful thing . . . I don't know how to put it—

Creon. Out with it!

Sentry. Well, then;
 The dead man—
 Polyneices—

[*Pause. The* Sentry *is overcome, fumbles for words.* Creon *waits impassively.*]

 out there—
 someone—
New dust on the slimy flesh!

[*Pause. No sign from* Creon.]

Someone has given it burial that way, and 65
Gone . . .

[*Long pause.* Creon *finally speaks with deadly control.*]

Creon. And the man who dared do this?

Sentry. I swear I
 Do not know! You must believe me!
 Listen:
 The ground was dry, not a sign of digging, no,
 Not a wheeltrack in the dust, no trace of anyone. 70
 It was when they relieved us this morning; and one of them,
 The corporal, pointed to it.
 There it was,
 The strangest—
 Look:
 The body, just mounded over with light dust: you see?
 Not buried really, but as if they'd covered it 75
 Just enough for the ghost's peace. And no sign
 Of dogs or any wild animal that had been there.

 And then what a scene there was! Every man of us
 Accusing the other: we all proved the other man did it,
 We all had proof that we could not have done it. 80
 We were ready to take hot iron in our hands,
 Walk through fire, swear by all gods,
 It was not I!
 —I do not know who it was, but it was not I!

[Creon's *rage has been mounting steadily, but the* Sentry *is too intent upon his story to notice it.*]

Photographs for *Antigone* are from a production by The Repertory Theater of Lincoln Center.
Photographs by Martha Swope

And then, when this came to nothing, someone said 85
A thing that silenced us and made us stare
Down at the ground: You had to be told the news,
And one of us had to do it! We threw the dice,
And the bad luck fell to me. So here I am,
No happier to be here than you are to have me: 90
Nobody likes the man who brings bad news.
Choragos. I have been wondering, King: can it be that the gods have done this?
Creon (*furiously*). Stop!
Must you doddering wrecks
Go out of your heads entirely? "The gods!" 95
Intolerable!
The gods favor this corpse? Why? How had he served them?

Tried to loot their temples, burn their images,
Yes, and the whole state, and its laws with it!
Is it your senile opinion that the gods love to honor bad men? 100
A pious thought!—
 No, from the very beginning
There have been those who have whispered together,
Stiff-necked anarchists,° putting their heads together,
Scheming against me in alleys. These are the men,
And they have bribed my own guard to do this thing. 105

(*Sententiously*°) Money!
There's nothing in the world so demoralizing as money.
Down go your cities,
Homes gone, men gone, honest hearts corrupted,
Crookedness of all kinds, and all for money!
 (*To* Sentry) But you—! 110
I swear by God and by the throne of God,
The man who has done this thing shall pay for it!
Find that man, bring him here to me, or your death
Will be the least of your problems: I'll string you up
Alive, and there will be certain ways to make you 115
Discover your employer before you die;
And the process may teach you a lesson you seem to have missed:
The dearest profit is sometimes all too dear:
That depends on the source. Do you understand me?
A fortune won is often misfortune. 120
Sentry. King, may I speak?
Creon. Your very voice distresses me.
Sentry. Are you sure that it is my voice, and not your conscience?
Creon. By God, he wants to analyze me now!
Sentry. It is not what I say, but what has been done, that hurts you.
Creon. You talk too much.
Sentry. Maybe; but I've done nothing. 125
Creon. Sold your soul for some silver: that's all you've done.
Sentry. How dreadful it is when the right judge judges wrong!
Creon. Your figures of speech
 May entertain you now; but unless you bring me the man,
 You will get little profit from them in the end. [*Exit* Creon *into the palace.*] 130

Sentry. "Bring me the man"—!

103. **anarchists:** people who believe that law and organized government should be done away with. S.D. **Sententiously:**
speaking in a way that is especially trite or moralistic.

I'd like nothing better than bringing him the man!
But bring him or not, you have seen the last of me here.
At any rate, I am safe! [*Exit* Sentry.]

Ode 1°

Chorus. Numberless are the world's wonders, but none
 More wonderful than man; the storm-gray sea
 Yields to his prows, the huge crests bear him high;
 Earth, holy and inexhaustible, is graven
 With shining furrows where his plows have gone 5
 Year after year, the timeless labor of stallions.

 The lightboned birds and beasts that cling to cover,
 The lithe fish lighting their reaches of dim water,
 All are taken, tamed in the net of his mind;
 The lion on the hill, the wild horse windy-maned, 10
 Resign to him; and his blunt yoke has broken
 The sultry shoulders of the mountain bull.

 Words also, and thought as rapid as air,
 He fashions to his good use; statecraft is his,
 And his the skill that deflects the arrows of snow, 15
 The spears of winter rain: from every wind
 He has made himself secure—from all but one:
 In the late wind of death he cannot stand.

 O clear intelligence, force beyond all measure!
 O fate of man, working both good and evil! 20
 When the laws are kept, how proudly his city stands!
 When the laws are broken, what of his city then?
 Never may the anarchic man° find rest at my hearth,
 Never be it said that my thoughts are his thoughts.

Scene 2

[*Reenter* Sentry, *leading* Antigone.]

Choragos. What does this mean? Surely this captive woman
 Is the princess, Antigone. Why should she be taken?

°**Ode:** a song chanted by the Chorus. An ode separates one scene from the next. (There was no curtain in the Greek theater.) 23. **anarchic** (ăn-är′kĭk) **man:** an anarchist.

Sentry. Here is the one who did it! We caught her
 In the very act of burying him.—Where is Creon?
Choragos. Just coming from the house.

 [*Enter* Creon, *center.*]

Creon. What has happened? 5
 Why have you come back so soon?
Sentry (*expansively*). O King,
 A man should never be too sure of anything:
 I would have sworn
 That you'd not see me here again: your anger
 Frightened me so, and the things you threatened me with; 10
 But how could I tell then
 That I'd be able to solve the case so soon?

 No dice-throwing this time: I was only too glad to come!

 Here is this woman. She is the guilty one:
 We found her trying to bury him. 15
 Take her, then; question her; judge her as you will.
 I am through with the whole thing now, and glad of it.
Creon. But this is Antigone! Why have you brought her here?
Sentry. She was burying him, I tell you!
Creon (*severely*). Is this the truth?
Sentry. I saw her with my own eyes. Can I say more? 20
Creon. The details: Come, tell me quickly!
Sentry. It was like this:
 After those terrible threats of yours, King,
 We went back and brushed the dust away from the body.
 The flesh was soft by now, and stinking,
 So we sat on a hill to windward and kept guard. 25
 No napping this time! We kept each other awake.
 But nothing happened until the white round sun
 Whirled in the center of the round sky over us:
 Then, suddenly,
 A storm of dust roared up from the earth, and the sky 30
 Went out, the plain vanished with all its trees
 In the stinging dark. We closed our eyes and endured it.
 The whirlwind lasted a long time, but it passed;
 And then we looked, and there was Antigone!
 I have seen 35
 A mother bird come back to a stripped nest, heard

Her crying bitterly a broken note or two
For the young ones stolen. Just so, when this girl
Found the bare corpse, and all her love's work wasted,
She wept, and cried on heaven to damn the hands 40
That had done this thing.
 And then she brought more dust
And sprinkled wine three times for her brother's ghost.

We ran and took her at once. She was not afraid,
Not even when we charged her with what she had done.
She denied nothing.
 And this was a comfort to me, 45
And some uneasiness: for it is a good thing
To escape from death, but it is no great pleasure
To bring death to a friend.
 Yet I always say
There is nothing so comfortable as your own safe skin!
Creon (*slowly, dangerously*). And you, Antigone, 50
You with your head hanging—do you confess this thing?
Antigone. I do. I deny nothing.
Creon (*to* Sentry). You may go. [*Exit* Sentry.]
(*To* Antigone) Tell me, tell me briefly:
Had you heard my proclamation touching this matter?
Antigone. It was public. Could I help hearing it? 55
Creon. And yet you dared defy the law.
Antigone. I dared.
It was not God's proclamation. That final justice
That rules the world below makes no such laws.

Your edict, King, was strong,
But all your strength is weakness itself against 60
The immortal unrecorded laws of God.
They are not merely now: they were, and shall be,
Operative forever, beyond man utterly.

I knew I must die, even without your decree:
I am only mortal. And if I must die 65
Now, before it is my time to die,
Surely this is no hardship: can anyone
Living, as I live, with evil all about me,
Think death less than a friend? This death of mine
Is of no importance; but if I had left my brother 70
Lying in death unburied, I should have suffered.

Now I do not.
　　　　　You smile at me. Ah Creon,
Think me a fool, if you like; but it may well be
That a fool convicts me of folly.

Choragos. Like father, like daughter: both headstrong, deaf to reason!　　　75
She has never learned to yield.

Creon.　　　　　　　　　She has much to learn.
The inflexible heart breaks first, the toughest iron
Cracks first, and the wildest horses bend their necks
At the pull of the smallest curb.
　　　　　　　　Pride? In a slave?
This girl is guilty of a double insolence,　　　　　80
Breaking the given laws and boasting of it.
Who is the man here,
She or I, if this crime goes unpunished?
Sister's child, or more than sister's child,
Or closer yet in blood—she and her sister　　　　　85
Win bitter death for this!
　　　　　(*To* Servants) Go, some of you,
Arrest Ismene. I accuse her equally.
Bring her: You will find her sniffling in the house there.

Her mind's a traitor: crimes kept in the dark
Cry for light, and the guardian brain shudders;　　　　　90
But how much worse than this
Is brazen boasting of barefaced anarchy!

Antigone. Creon, what more do you want than my death?
Creon.　　　　　　　　　　　　　Nothing.
That gives me everything.

Antigone.　　　　　Then I beg you: kill me.
This talking is a great weariness: your words　　　　　95
Are distasteful to me, and I am sure that mine
Seem so to you. And yet they should not seem so:
I should have praise and honor for what I have done.
All these men here would praise me
Were their lips not frozen shut with fear of you.　　　　　100

(*Bitterly*) Ah the good fortune of kings,
Licensed to say and do whatever they please!

Creon. You are alone here in that opinion.
Antigone. No, they are with me. But they keep their tongues in leash.
Creon. Maybe. But you are guilty, and they are not.　　　　　105
Antigone. There is no guilt in reverence for the dead.

Creon. But Eteocles—was he not your brother too?

Antigone. My brother too.

Creon. And you insult his memory?

Antigone (*softly*). The dead man would not say that I insult it.

Creon. He would: for you honor a traitor as much as him. 110

Antigone. His own brother, traitor or not, and equal in blood.

Creon. He made war on his country. Eteocles defended it.

Antigone. Nevertheless, there are honors due all the dead.

Creon. But not the same for the wicked as for the just.

Antigone. Ah Creon, Creon, 115
　　Which of us can say what the gods hold wicked?

Creon. An enemy is an enemy, even dead.

Antigone. It is my nature to join in love, not hate.

Creon (*finally losing patience*). Go join them, then; if you must have your love,
　　Find it in hell! 120

Choragos. But see, Ismene comes:

[*Enter* Ismene, *guarded.*]

　　Those tears are sisterly, the cloud
　　That shadows her eyes rains down gentle sorrow.

Creon. You too, Ismene,
　　Snake in my ordered house, sucking my blood 125
　　Stealthily—and all the time I never knew
　　That these two sisters were aiming at my throne!
　　　　　　　　　　　　　　　　　　　　Ismene,
　　Do you confess your share in this crime, or deny it?
　　Answer me.

Ismene. Yes, if she will let me say so. I am guilty. 130

Antigone (*coldly*). No, Ismene. You have no right to say so.
　　You would not help me, and I will not have you help me.

Ismene. But now I know what you meant; and I am here
　　To join you, to take my share of punishment.

Antigone. The dead man and the gods who rule the dead 135
　　Know whose act this was. Words are not friends.

Ismene. Do you refuse me, Antigone? I want to die with you:
　　I too have a duty that I must discharge to the dead.

Antigone. You shall not lessen my death by sharing it.

Ismene. What do I care for life when you are dead? 140

Antigone. Ask Creon. You're always hanging on his opinions.

Ismene. You are laughing at me. Why, Antigone?

Antigone. It's a joyless laughter, Ismene.

Ismene. But can I do nothing?

Antigone. Yes. Save yourself. I shall not envy you.

There are those who will praise you; I shall have honor, too. 145

Ismene. But we are equally guilty!

Antigone. No more, Ismene.

You are alive, but I belong to death.

Creon (*to the* Chorus). Gentlemen, I beg you to observe these girls:

One has just now lost her mind; the other,

It seems, has never had a mind at all. 150

Ismene. Grief teaches the steadiest minds to waver, King.

Creon. Yours certainly did, when you assumed guilt with the guilty!

Ismene. But how could I go on living without her?

Creon. You are.

She is already dead.

Ismene. But your own son's bride!

Creon. There are places enough for him to push his plow. 155

I want no wicked women for my sons!

Ismene. O dearest Haimon, how your father wrongs you!

Creon. I've had enough of your childish talk of marriage!

Choragos. Do you really intend to steal this girl from your son?

Creon. No; death will do that for me.

Choragos. Then she must die? 160

Creon (*ironically*). You dazzle me.

—But enough of this talk!

(*To* Guards) You, there, take them away and guard them well:

For they are but women, and even brave men run

When they see death coming. [*Exeunt* Ismene, Antigone, *and* Guards.]

Ode 2

Chorus. Fortunate is the man who has never tasted God's vengeance!

Where once the anger of heaven has struck, that house is shaken

Forever: damnation rises behind each child

Like a wave cresting out of the black northeast,

When the long darkness under sea roars up 5

And bursts drumming death upon the windwhipped sand.

I have seen this gathering sorrow from time long past

Loom upon Oedipus' children: generation from generation

Takes the compulsive rage of the enemy god.

So lately this last flower of Oedipus' line 10

Drank the sunlight! but now a passionate word

And a handful of dust have closed up all its beauty.

What mortal arrogance
Transcends the wrath of Zeus?
Sleep cannot lull him,° nor the effortless long months 15
Of the timeless gods: but he is young forever,
And his house is the shining day of high Olympos.°
　　And that is and shall be,
　　And all the past, is his.
No pride on earth is free of the curse of heaven. 20

The straying dreams of men
May bring them ghosts of joy:
But as they drowse, the waking embers burn them;
Or they walk with fixed eyes, as blind men walk.
But the ancient wisdom speaks for our own time: 25
　　Fate works most for woe
　　With folly's fairest show.
Man's little pleasure is the spring of sorrow.

Scene 3

Choragos. But here is Haimon, King, the last of all your sons.
　　Is it grief for Antigone that brings him here,
　　And bitterness at being robbed of his bride?

　　　　　　　　　　[*Enter* Haimon.]

Creon. We shall soon see, and no need of diviners.°
　　　　　　　　　　　　—Son,
　　You have heard my final judgment on that girl: 5
　　Have you come here hating me, or have you come
　　With deference and with love, whatever I do?
Haimon. I am your son, Father. You are my guide.
　　You make things clear for me, and I obey you.
　　No marriage means more to me than your continuing wisdom. 10
Creon. Good. That is the way to behave: subordinate
　　Everything else, my son, to your father's will.
　　This is what a man prays for, that he may get
　　Sons attentive and dutiful in his house,
　　Each one hating his father's enemies, 15
　　Honoring his father's friends. But if his sons

15. **him:** Zeus, king of the gods.　17. **Olympos:** a mountain in northern Greece, legendary home of the gods and goddesses.
　4. **diviners:** persons who could predict the future.

Fail him, if they turn out unprofitably,
What has he fathered but trouble for himself
And amusement for the malicious?
 So you are right
Not to lose your head over this woman. 20
Your pleasure with her would soon grow cold, Haimon,
And then you'd have a hellcat in bed and elsewhere.

Let her find her husband in hell!
Of all the people in this city, only she
Has had contempt for my law and broken it. 25

Do you want me to show myself weak before the people?
Or to break my sworn word? No, and I will not.
The woman dies.
I suppose she'll plead "family ties." Well, let her.
If I permit my own family to rebel, 30
How shall I earn the world's obedience?
Show me the man who keeps his house in hand,
He's fit for public authority.
 I'll have no dealings
With lawbreakers, critics of the government:
Whoever is chosen to govern should be obeyed— 35
Must be obeyed, in all things, great and small,
Just and unjust! O Haimon,
The man who knows how to obey, and that man only,
Knows how to give commands when the time comes.
You can depend on him, no matter how fast 40
The spears come: He's a good soldier, he'll stick it out.

Anarchy, anarchy! Show me a greater evil!
This is why cities tumble and the great houses rain down,
This is what scatters armies!

No, no: Good lives are made so by discipline. 45
We keep the laws then, and the lawmakers,
And no woman shall seduce us. If we must lose,
Let's lose to a man, at least! Is a woman stronger than we?
Choragos. Unless time has rusted my wits,
What you say, King, is said with point and dignity. 50
Haimon (*boyishly earnest*). Father:
Reason is God's crowning gift to man, and you are right
To warn me against losing mine. I cannot say—
I hope that I shall never want to say!—that you
Have reasoned badly. Yet there are other men 55
Who can reason, too; and their opinions might be helpful.
You are not in a position to know everything
That people say or do, or what they feel:
Your temper terrifies them—everyone
Will tell you only what you like to hear. 60
But I, at any rate, can listen; and I have heard them

Muttering and whispering in the dark about this girl.
They say no woman has ever, so unreasonably,
Died so shameful a death for a generous act:
"She covered her brother's body. Is this indecent? 65
She kept him from dogs and vultures. Is this a crime?
Death?—She should have all the honor that we can give her!"

This is the way they talk out there in the city.

You must believe me:
Nothing is closer to me than your happiness. 70
What could be closer? Must not any son
Value his father's fortune as his father does his?
I beg you, do not be unchangeable:
Do not believe that you alone can be right.
The man who thinks that, 75
The man who maintains that only he has the power
To reason correctly, the gift to speak, the soul—
A man like that, when you know him, turns out empty.

It is not reason never to yield to reason!

In flood time you can see how some trees bend, 80
And because they bend, even their twigs are safe,
While stubborn trees are torn up, roots and all.
And the same thing happens in sailing:
Make your sheet fast, never slacken—and over you go,
Head over heels and under: and there's your voyage. 85
Forget you are angry! Let yourself be moved!
I know I am young; but please let me say this:
The ideal condition
Would be, I admit, that men should be right by instinct;
But since we are all too likely to go astray, 90
The reasonable thing is to learn from those who can teach.
Choragos. You will do well to listen to him, King,
 If what he says is sensible. And you, Haimon,
 Must listen to your father—both speak well.
Creon. You consider it right for a man of my years and experience 95
 To go to school to a boy?
Haimon. It is not right
 If I am wrong. But if I am young, and right,
 What does my age matter?
Creon. You think it right to stand up for an anarchist?

Haimon. Not at all. I pay no respect to criminals. 100
Creon. Then she is not a criminal?
Haimon. The city would deny it, to a man.
Creon. And the city proposes to teach me how to rule?
Haimon. Ah. Who is it that's talking like a boy now?
Creon. My voice is the one voice giving orders in this city! 105
Haimon. It is no city if it takes orders from one voice.
Creon. The state is the king!
Haimon. Yes, if the state is a desert.

[Pause]

Creon. This boy, it seems, has sold out to a woman.
Haimon. If you are a woman: My concern is only for you.
Creon. So? Your "concern"! In a public brawl with your father! 110
Haimon. How about you, in a public brawl with justice?
Creon. With justice, when all that I do is within my rights?
Haimon. You have no right to trample on God's right.
Creon (*completely out of control*). Fool, adolescent fool! Taken in by a woman!
Haimon. You'll never see me taken in by anything vile. 115
Creon. Every word you say is for her!
Haimon (*quietly, darkly*). And for you.
 And for me. And for the gods under the earth.
Creon. You'll never marry her while she lives.
Haimon. Then she must die—But her death will cause another.
Creon. Another? 120
 Have you lost your senses? Is this an open threat?
Haimon. There is no threat in speaking to emptiness.
Creon. I swear you'll regret this superior tone of yours!
 You are the empty one!
Haimon. If you were not my father,
 I'd say you were perverse.° 125
Creon. You girlstruck fool, don't play at words with me!
Haimon. I am sorry. You prefer silence.
Creon. Now, by God—!
 I swear, by all the gods in heaven above us,
 You'll watch it, I swear you shall!
 (*To the* Servants) Bring her out!
 Bring the woman out! Let her die before his eyes! 130
 Here, this instant, with her bridegroom beside her!
Haimon. Not here, no; she will not die here, King.

125. **perverse:** here, stubbornly refusing to yield to reason.

And you will never see my face again.
Go on raving as long as you've a friend to endure you.

[*Exit* Haimon.]

Choragos. Gone, gone. 135
　　Creon, a young man in a rage is dangerous!
Creon. Let him do, or dream to do, more than a man can.
　　He shall not save these girls from death.
Choragos. These girls?
　　You have sentenced them both?
Creon. No, you are right.
　　I will not kill the one whose hands are clean. 140
Choragos. But Antigone?
Creon (*somberly*). I will carry her far away
　　Out there in the wilderness and lock her
　　Living in a vault of stone. She shall have food,
　　As the custom is, to absolve the state of her death.
　　And there let her pray to the gods of hell: 145
　　They are her only gods:
　　Perhaps they will show her an escape from death,
　　Or she may learn,
　　　　　　　　　though late,
　　That piety shown the dead is pity in vain. [*Exit* Creon.]

Ode 3

Chorus. Love, unconquerable
　　Waster of rich men, keeper
　　Of warm lights and all-night vigil
　　In the soft face of a girl:
　　Sea-wanderer, forest-visitor! 5
　　Even the pure Immortals cannot escape you,
　　And mortal man, in his one day's dusk,
　　Trembles before your glory.

　　Surely you swerve upon ruin
　　The just man's consenting heart, 10
　　As here you have made bright anger
　　Strike between father and son—
　　And none has conquered but love!
　　A girl's glance working the will of Heaven:
　　Pleasure to her alone who mocks us, 15
　　Merciless Aphrodite.°

16. **Aphrodite** (ăf'rə-dī'tē): goddess of love and beauty.

Scene 4

Choragos (*as* Antigone *enters, guarded*). But I can no longer stand in awe of this,
 Nor, seeing what I see, keep back my tears.
 Here is Antigone, passing to that chamber
 Where all find sleep at last.

Antigone. Look upon me, friends, and pity me 5
 Turning back at the night's edge to say
 Goodbye to the sun that shines for me no longer;
 Now sleepy death
 Summons me down to Acheron,° that cold shore:
 There is no bridesong there, nor any music. 10

Chorus. Yet not unpraised, not without a kind of honor,
 You walk at last into the underworld;
 Untouched by sickness, broken by no sword.
 What woman has ever found your way to death?

Antigone. How often I have heard the story of Niobe,° 15
 Tantalos'° wretched daughter, how the stone
 Clung fast about her, ivy-close; and they say
 The rain falls endlessly
 And sifting soft snow; her tears are never done.
 I feel the loneliness of her death in mine. 20

Chorus. But she was born of heaven, and you
 Are woman, woman-born. If her death is yours,
 A mortal woman's, is this not for you
 Glory in our world and in the world beyond?

Antigone. You laugh at me. Ah, friends, friends, 25
 Can you not wait until I am dead? O Thebes,
 O men many-charioted, in love with fortune,
 Dear springs of Dirce, sacred Theban grove,
 Be witnesses for me, denied all pity,
 Unjustly judged! and think a word of love 30
 For her whose path turns
 Under dark earth, where there are no more tears.

Chorus. You have passed beyond human daring and come at last
 Into a place of stone where justice sits.
 I cannot tell 35
 What shape of your father's guilt appears in this.

9. **Acheron** (ăk′ə-rŏn): in Greek mythology, one of the rivers surrounding Hades. 15. **Niobe** (nī′ə-bē): an ancient queen of Thebes who boasted that she was greater than the goddess Leto because she had seven sons and seven daughters while Leto had only two children. To punish her for her arrogance, the gods killed all of Niobe's children, and Zeus turned the weeping woman into a column of stone from which her tears, in the form of a stream, continued to flow. 16. **Tantalos** (tăn′tə-ləs): Niobe's father, who suffered eternal hunger and thirst in the underworld. In Greek mythology, the underworld was not primarily a place of punishment. All dead souls wandered there as ghosts, or shades.

Antigone. You have touched it at last: that bridal bed
 Unspeakable, horror of son and mother mingling:
 Their crime, infection of all our family!
 O Oedipus, father and brother! 40
 Your marriage strikes from the grave to murder mine.
 I have been a stranger here in my own land:
 All my life
 The blasphemy of my birth has followed me.

Chorus. Reverence is a virtue, but strength 45
 Lives in established law: That must prevail.
 You have made your choice,
 Your death is the doing of your conscious hand.

Antigone. Then let me go, since all your words are bitter,
 And the very light of the sun is cold to me. 50
 Lead me to my vigil, where I must have
 Neither love nor lamentation; no song, but silence.

[Creon *interrupts impatiently.*]

Creon. If dirges and planned lamentations could put off death,
 Men would be singing forever.
 (*To the* Servants) Take her, go!
 You know your orders: take her to the vault 55
 And leave her alone there. And if she lives or dies,
 That's her affair, not ours: Our hands are clean.

Antigone. O tomb, vaulted bride-bed in eternal rock,
 Soon I shall be with my own again
 Where Persephone° welcomes the thin ghosts underground: 60
 And I shall see my father again, and you, Mother,
 And dearest Polyneices—
 dearest indeed
 To me, since it was my hand
 That washed him clean and poured the ritual wine;
 And my reward is death before my time! 65

 And yet, as men's hearts know, I have done no wrong,
 I have not sinned before God. Or if I have,
 I shall know the truth in death. But if the guilt
 Lies upon Creon who judged me, then, I pray,
 May his punishment equal my own.

60. **Persephone** (pər-sĕf′ə-nē): queen of Hades, or the underworld.

Choragos. O passionate heart, 70
 Unyielding, tormented still by the same winds!
Creon. Her guards shall have good cause to regret their delaying.
Antigone. Ah! That voice is like the voice of death!
Creon. I can give you no reason to think you are mistaken.
Antigone. Thebes, and you my fathers' gods, 75
 And rulers of Thebes, you see me now, the last
 Unhappy daughter of a line of kings,
 Your kings, led away to death. You will remember
 What things I suffer, and at what men's hands,
 Because I would not transgress the laws of heaven. 80
 (*To the* Guards, *simply*) Come: let us wait no longer.

 [*Exit* Antigone, *left, guarded.*]

 Antigone Scene 4 **519**

Ode 4

Chorus. All Danae's beauty° was locked away
 In a brazen cell where the sunlight could not come:
 A small room, still as any grave, enclosed her.
 Yet she was a princess, too,
 And Zeus in a rain of gold poured love upon her. 5
 O child, child,
 No power in wealth or war
 Or tough sea-blackened ships
 Can prevail against untiring destiny!

 And Dryas' son° also, that furious king, 10
 Bore the god's prisoning anger for his pride:
 Sealed up by Dionysos in deaf stone,
 His madness died among echoes.
 So at the last he learned what dreadful power
 His tongue had mocked: 15
 For he had profaned the revels,
 And fired the wrath of the nine
 Implacable Sisters° that love the sound of the flute.

 And old men tell a half-remembered tale°
 Of horror done where a dark ledge splits the sea 20
 And a double surf beats on the gray shores:
 How a king's new woman, sick
 With hatred for the queen he had imprisoned,
 Ripped out his two sons' eyes with her bloody hands
 While grinning Ares° watched the shuttle plunge 25
 Four times: four blind wounds crying for revenge,

 Crying, tears and blood mingled—piteously born,
 Those sons whose mother was of heavenly birth!
 Her father was the god of the North Wind
 And she was cradled by gales, 30
 She raced with young colts on the glittering hills

1. **Danae's beauty:** Danae (dăn′ə-ē′) was a princess whose father imprisoned her in a bronze tower because it was predicted that the son she would one day bear would kill him. Zeus loved Danae, visited her in the form of a shower of gold, and gave her a son. 10. **Dryas' son:** a king named Lycurgos, who disapproved of the worship of Dionysos, god of wine and revelry. Lycurgos attacked the god, who, as punishment, drove him mad and imprisoned him in stone. 17–18. **nine Implacable Sisters:** the Muses, goddesses of the arts and sciences. *Implacable* means that once offended, they cannot be appeased. 19. **a half-remembered tale:** The details that follow refer to an ancient myth about King Phineus of Thrace, who imprisoned his first wife, Cleopatra, daughter of the North Wind god. Cleopatra's two sons were blinded by the king's new wife. 25. **Ares** (âr′ēz′): god of war and strife.

And walked untrammeled in the open light;
But in her marriage deathless Fate found means
To build a tomb like yours for all her joy.

Scene 5

[*Enter blind* Teiresias, *led by a* Boy. *The opening speeches of* Teiresias *should be in singsong contrast to the realistic lines of* Creon.]

Teiresias. This is the way the blind man comes, Princes, Princes,
 Lock-step, two heads lit by the eyes of one.
Creon. What new thing have you to tell us, old Teiresias?
Teiresias. I have much to tell you: Listen to the prophet, Creon.
Creon. I am not aware that I have ever failed to listen. 5
Teiresias. Then you have done wisely, King, and ruled well.
Creon. I admit my debt to you.° But what have you to say?
Teiresias. This, Creon: You stand once more on the edge of fate.
Creon. What do you mean? Your words are a kind of dread.
Teiresias. Listen, Creon: 10
 I was sitting in my chair of augury,° at the place
 Where the birds gather about me. They were all a-chatter,
 As is their habit, when suddenly I heard
 A strange note in their jangling, a scream, a
 Whirring fury; I knew that they were fighting, 15
 Tearing each other, dying
 In a whirlwind of wings clashing. And I was afraid.
 I began the rites of burnt-offering at the altar,
 But Hephaistos° failed me: Instead of bright flame,
 There was only the sputtering slime of the fat thigh-flesh 20
 Melting: The entrails dissolved in gray smoke,
 The bare bone burst from the welter. And no blaze!

 This was a sign from heaven. My boy described it,
 Seeing for me as I see for others.

 I tell you, Creon, you yourself have brought 25
 This new calamity upon us. Our hearths and altars
 Are stained with the corruption of dogs and carrion birds
 That glut themselves on the corpse of Oedipus' son.

7. **my debt to you:** Teiresias served as an instrument of the gods in foretelling Oedipus' fate and was thus indirectly responsible for Creon's ascension to the throne. 11. **chair of augury:** the place where Teiresias interpreted omens. Among the omens he interpreted were certain sounds from birds. 19. **Hephaistos** (hĭ-fīs′təs): Greek god of fire.

The gods are deaf when we pray to them, their fire
Recoils from our offering, their birds of omen 30
Have no cry of comfort, for they are gorged
With the thick blood of the dead.

 O my son,
These are no trifles! Think: all men make mistakes,
But a good man yields when he knows his course is wrong,
And repairs the evil. The only crime is pride. 35

Give in to the dead man, then: Do not fight with a corpse—
What glory is it to kill a man who is dead?
Think, I beg you:
It is for your own good that I speak as I do.
You should be able to yield for your own good. 40

Creon. It seems that prophets have made me their especial province.
All my life long
I have been a kind of butt for the dull arrows
Of doddering fortunetellers!

 No, Teiresias:
If your birds—if the great eagles of God himself 45
Should carry him stinking bit by bit to heaven,
I would not yield. I am not afraid of pollution:
No man can defile the gods.

 Do what you will,
Go into business, make money, speculate
In India gold or that synthetic gold from Sardis,° 50
Get rich otherwise than by my consent to bury him.
Teiresias, it is a sorry thing when a wise man
Sells his wisdom, lets out his words for hire!

Teiresias. Ah Creon! Is there no man left in the world—
Creon. To do what?—Come, let's have the aphorism!° 55
Teiresias. No man who knows that wisdom outweighs any wealth?
Creon. As surely as bribes are baser than any baseness.
Teiresias. You are sick, Creon! You are deathly sick!
Creon. As you say: It is not my place to challenge a prophet.
Teiresias. Yet you have said my prophecy is for sale. 60
Creon. The generation of prophets has always loved gold.
Teiresias. The generation of kings has always loved brass.
Creon. You forget yourself! You are speaking to your king.
Teiresias. I know it. You are a king because of me.

50. **Sardis:** In Sardis, the capital of ancient Lydia, the first metal coins were produced from a natural alloy of gold that contained 20 to 35 percent silver. 55. **aphorism** (ăf'ə-rĭz'əm): wise saying, used ironically here.

Creon. You have a certain skill; but you have sold out. 65

Teiresias. King, you will drive me to the words that—

Creon. Say them, say them!

Only remember: I will not pay you for them.

Teiresias. No, you will find them too costly.

Creon. No doubt. Speak:

Whatever you say, you will not change my will.

Teiresias. Then take this, and take it to heart! 70

The time is not far off when you shall pay back
Corpse for corpse, flesh of your own flesh.
You have thrust the child of this world into living night,
You have kept from the gods below the child that is theirs:
The one in a grave before her death, the other, 75
Dead, denied the grave. This is your crime;
And the Furies° and the dark gods of hell
Are swift with terrible punishment for you.

Do you want to buy me now, Creon?

 Not many days,
And your house will be full of men and women weeping, 80
And curses will be hurled at you from far
Cities grieving for sons unburied, left to rot
Before the walls of Thebes.

These are my arrows, Creon: They are all for you.

(*To* Boy) But come, child: Lead me home. 85
Let him waste his fine anger upon younger men.
Maybe he will learn at last
To control a wiser tongue in a better head. [*Exit* Teiresias.]

Choragos. The old man has gone, King, but his words
Remain to plague us. I am old, too, 90
But I cannot remember that he was ever false.

Creon. That is true . . . It troubles me.
Oh it is hard to give in! But it is worse
To risk everything for stubborn pride.

Choragos. Creon: Take my advice.

Creon. What shall I do? 95

Choragos. Go quickly: free Antigone from her vault
And build a tomb for the body of Polyneices.

77. **Furies:** three winged goddesses who avenge unpunished crimes, especially those that go against the ties of kinship.

Creon. You would have me do this?

Choragos. Creon, yes!
 And it must be done at once: God moves
 Swiftly to cancel the folly of stubborn men. 100

Creon. It is hard to deny the heart! But I
 Will do it: I will not fight with destiny.

Choragos. You must go yourself, you cannot leave it to others.

Creon. I will go.
 —Bring axes, servants:
 Come with me to the tomb. I buried her, I 105
 Will set her free.
 Oh quickly!
 My mind misgives—
 The laws of the gods are mighty, and a man must serve them
 To the last day of his life! [*Exit* Creon.]

Exodos°

[*Enter* Messenger, *left.*]

Messenger. Men of the line of Kadmos,° you who live
 Near Amphion's° citadel:
 I cannot say
 Of any condition of human life "This is fixed,
 This is clearly good, or bad." Fate raises up,
 And fate casts down the happy and unhappy alike: 5
 No man can foretell his fate.
 Take the case of Creon:
 Creon was happy once, as I count happiness;
 Victorious in battle, sole governor of the land,
 Fortunate father of children nobly born.
 And now it has all gone from him! Who can say 10
 That a man is still alive when his life's joy fails?
 He is a walking dead man. Grant him rich,
 Let him live like a king in his great house:
 If his pleasure is gone, I would not give
 So much as the shadow of smoke for all he owns. 15

Choragos. Your words hint at sorrow; what is your news for us?

Messenger. They are dead. The living are guilty of their death.

°**Exodos:** the final, or exit, scene. 1. **Kadmos:** the founder of Thebes. 2. **Amphion** (ăm-fī′ən): Niobe's husband, former ruler of Thebes.

Choragos. Who is guilty? Who is dead? Speak!
Messenger. Haimon.
 Haimon is dead; and the hand that killed him
 Is his own hand.
Choragos. His father's? or his own? 20
Messenger. His own, driven mad by the murder his father had done.
Choragos. Teiresias, Teiresias, how clearly you saw it all!
Messenger. This is my news; you must draw what conclusions you can from it.
Choragos. But look: Eurydice, our queen:
 Has she overheard us? 25

[*Enter* Eurydice *from the palace, center.*]

Eurydice. I have heard something, friends:
 As I was unlocking the gate of Pallas'° shrine,
 For I needed her help today, I heard a voice
 Telling of some new sorrow. And I fainted
 There at the temple with all my maidens about me. 30
 But speak again; whatever it is, I can bear it:
 Grief and I are not strangers.°
Messenger. Dearest lady,
 I will tell you plainly all that I have seen.
 I shall not try to comfort you: What is the use,
 Since comfort could lie only in what is not true? 35
 The truth is always best.
 I went with Creon
 To the outer plain where Polyneices was lying,
 No friend to pity him, his body shredded by dogs.
 We made our prayers in that place to Hecate°
 And Pluto,° that they would be merciful. And we bathed 40
 The corpse with holy water, and we brought
 Fresh-broken branches to burn what was left of it,
 And upon the urn we heaped up a towering barrow
 Of the earth of his own land.
 When we were done, we ran
 To the vault where Antigone lay on her couch of stone. 45
 One of the servants had gone ahead,
 And while he was yet far off he heard a voice
 Grieving within the chamber, and he came back
 And told Creon. And as the king went closer,

27. **Pallas:** Pallas Athena, goddess of wisdom. 32. **Grief . . . strangers:** Megareus, the older son of Eurydice and Creon, had died in the battle for Thebes. 39–40. **Hecate** (hĕk′ə-tē) and **Pluto:** divinities associated with the dead and the underworld.

The air was full of wailing, the words lost, 50
And he begged us to make all haste. "Am I a prophet?"
He said weeping. "And must I walk this road,
The saddest of all that I have gone before?
My son's voice calls me on. Oh quickly, quickly!
Look through the crevice there, and tell me 55
If it is Haimon, or some deception of the gods!"

We obeyed; and in the cavern's farthest corner
We saw her lying:
She had made a noose of her fine linen veil
And hanged herself. Haimon lay beside her, 60
His arms about her waist, lamenting her,
His love lost under ground, crying out
That his father had stolen her away from him.

When Creon saw him the tears rushed to his eyes
And he called to him: "What have you done, child? Speak to me. 65
What are you thinking that makes your eyes so strange?
O my son, my son, I come to you on my knees!"
But Haimon spat in his face. He said not a word,
Staring—
 And suddenly drew his sword
And lunged. Creon shrank back, the blade missed; and the boy, 70
Desperate against himself, drove it half its length
Into his own side and fell. And as he died
He gathered Antigone close in his arms again,
Choking, his blood bright red on her white cheek.
And now he lies dead with the dead, and she is his 75
At last, his bride in the houses of the dead. [*Exit* Eurydice *into the palace.*]

Choragos. She has left us without a word. What can this mean?
Messenger. It troubles me, too; yet she knows what is best.
Her grief is too great for public lamentation,
And doubtless she has gone to her chamber to weep 80
For her dead son, leading her maidens in his dirge.
Choragos. It may be so; but I fear this deep silence.

 [*Pause.*]

Messenger. I will see what she is doing. I will go in. [*Exit* Messenger *into the palace.*]

 [*Enter* Creon *with attendants, bearing* Haimon's *body.*]

Choragos. But here is the king himself: oh look at him,
 Bearing his own damnation in his arms. 85
Creon. Nothing you say can touch me any more.
 My own blind heart has brought me
 From darkness to final darkness. Here you see
 The father murdering, the murdered son—
 And all my civic wisdom! 90

 Haimon my son, so young, so young to die,
 I was the fool, not you; and you died for me.
Choragos. That is the truth; but you were late in learning it.
Creon. This truth is hard to bear. Surely a god
 Has crushed me beneath the hugest weight of heaven, 95
 And driven me headlong a barbaric way
 To trample out the thing I held most dear.

 The pains that men will take to come to pain!

 [*Enter* Messenger *from the palace.*]

Messenger. The burden you carry in your hands is heavy,
 But it is not all: You will find more in your house. 100
Creon. What burden worse than this shall I find there?
Messenger. The queen is dead.
Creon. O port of death, deaf world,
 Is there no pity for me? And you, angel of evil,
 I was dead, and your words are death again. 105
 Is it true, boy? Can it be true?
 Is my wife dead? Has death bred death?
Messenger. You can see for yourself.

 [*The doors are opened, and the body of* Eurydice *is disclosed within.*]

Creon. Oh pity!
 All true, all true, and more than I can bear! 110
 O my wife, my son!
Messenger. She stood before the altar, and her heart
 Welcomed the knife her own hand guided,
 And a great cry burst from her lips for Megareus° dead,
 And for Haimon dead, her sons; and her last breath 115
 Was a curse for their father, the murderer of her sons.
 And she fell, and the dark flowed in through her closing eyes.
Creon. O God, I am sick with fear.
 Are there no swords here? Has no one a blow for me?

114. **Megareus** (mĕg′ə-rəs, mə-găr′ē-əs).

Messenger. Her curse is upon you for the deaths of both. 120

Creon. It is right that it should be. I alone am guilty.
 I know it, and I say it. Lead me in
 Quickly, friends.
 I have neither life nor substance. Lead me in.

Choragos. You are right, if there can be right in so much wrong. 125
 The briefest way is best in a world of sorrow.

Creon. Let it come,
 Let death come quickly, and be kind to me.
 I would not ever see the sun again.

Choragos. All that will come when it will; but we, meanwhile, 130
 Have much to do. Leave the future to itself.

Creon. All my heart was in that prayer!

Choragos. Then do not pray any more: the sky is deaf.

Creon. Lead me away. I have been rash and foolish.
 I have killed my son and my wife. 135
 I look for comfort; my comfort lies here dead.
 Whatever my hands have touched has come to nothing.
 Fate has brought all my pride to a thought of dust.

[*As* Creon *is being led into the house, the* Choragos *advances and speaks directly to the audience.*]

Choragos. There is no happiness where there is no wisdom;
 No wisdom but in submission to the gods. 140
 Big words are always punished,
 And proud men in old age learn to be wise.

For Study and Discussion

Analyzing and Interpreting the Play

Prologue

1. The action of the play begins immediately with a conflict between Antigone and Ismene. What is the cause of the conflict?

2. Ismene and Antigone are strongly contrasted in this scene. **a.** What can you tell of Antigone's character? **b.** Of Ismene's?

3. The speeches of the Chorus and Choragos interrupt the action of the play to describe the battle to the audience. What do these city elders look forward to in the futue?

Scene 1

1a. What have we learned about Creon before he appears onstage? **b.** What is revealed of Creon's character in this scene? (Remember that characters may reveal their own motives in the motives they attribute to others.)

2a. What reason does Creon give for his ruling concerning the bodies of Polyneices and Eteocles? **b.** How does the Chorus react?

3. The Sentry is a very ordinary person, even somewhat humorous. What does he want Creon to think about him?

Ode 1

1. This ode presents a portrait of human existence—its wonders and its limitations. Restate its main idea in your own words.

2. How does the ode comment on the problem of the play as it has been developed so far?

Scene 2

1. Since Greek dramas usually do not move from one setting to another, many of their important actions take place offstage. **a.** What major event has taken place before this scene opens? **b.** How does Sophocles help the audience picture what has happened?

2. How does Antigone defend her actions?

3. Look back at the comments of the Choragos in this scene. Does he seem to side with Antigone or with Creon? Explain.

4a. How has Ismene changed since we first saw her in the Prologue? **b.** How does Antigone treat her?

Ode 2

1. What grave fears for Oedipus' children does this ode express?

2. How would you explain the ancient wisdom in line 28: "Man's little pleasure is the spring of sorrow"?

Scene 3

1. Haimon is caught in a conflict of loyalties in this scene. What methods and arguments does he use to try to persuade Creon to change his mind? For example, how does he appeal to his father's self-interest?

2a. How does Creon react to Haimon's arguments? **b.** What attitudes does Creon seem to take toward women?

3. What function does the Choragos have in this scene? Whose side, if any, is he on?

Ode 3

The first ode was about human strengths and limitations, the second was about fate and the

vengeance of the gods. **a.** What is the subject of this ode? **b.** Which lines allude to specific characters in the play?

Scene 4

1a. What comfort does the Chorus offer Antigone in this scene? **b.** Antigone thinks (in line 25) that the Chorus is making fun of her. Do you agree or disagree? Explain.

2. As Antigone faces her death, does she seem in any way changed from the way she has been in previous scenes? Explain your answer.

3. Antigone is not to be stoned to death as originally planned. Why does the form of her punishment suit Creon?

Ode 4

In this ode the Chorus alludes to three Greek myths that were familiar to the ancient Greek audiences. How are the fates of the characters in these myths related to Antigone's fate?

Scene 5

1. Creon has refused to yield to the arguments of Antigone and Haimon, and at first he refuses to listen to Teiresias. Of what does he accuse Teiresias?

2. Teiresias tells Creon that the only crime is pride. How has Creon shown that he is guilty of pride?

3a. Why does Creon finally give in? **b.** What part does the Choragos play in Creon's decision?

4a. How has the character of the Chorus (or its leader, the Choragos) changed throughout the play? **b.** Where in the play do you think the Chorus speaks for Sophocles himself?

Exodos

1. Violence is certainly a part of Greek drama, but it was never portrayed onstage. How does Sophocles tell us what happens to Antigone, Haimon, and Eurydice?

2. How is Teiresias' prophecy from Scene 5 fulfilled in this scene?

3a. How has Creon changed since the beginning of the play? **b.** What does he finally come to recognize?

The Play as a Whole

1. In his last words, the Choragos states one of the major themes of the play:

> There is no happiness where there is no wisdom;
> No wisdom but in submission to the gods.
> Big words are always punished,
> And proud men in old age learn to be wise.

What other lines in the play also refer to the idea that human pride can be destructive?

2. Other important themes appear in *Antigone*. **a.** Try to state in a few sentences what the play says about the individual conscience in conflict with the authority of the state. **b.** What does the play say about the conflict between human and divine laws? **c.** About loyalty to the family versus loyalty to the state?

3. The conflict in a tragedy is rarely between absolute good and absolute evil. How can Creon's conflict be seen as a conflict between two choices that seem equally "good"—that is, between the stability of the state and obedience to divine law?

4a. What errors in judgment does Creon make in the course of the play? **b.** By the end of the play, do you find him a sympathetic or an unsympathetic character? Tell why.

5a. Discuss whether Antigone is admirable and worthy to be honored, or whether she is foolish and just as proud as Creon. **b.** Where in the play does the Chorus accuse Antigone of pride?

6. Discuss the idea of fate as it is expressed in *Antigone*. Are Antigone and Creon the helpless victims of fate, or do they freely choose their own destinies? Explain your answer.

The Tragic Hero or Heroine

The Greek philosopher Aristotle (384–322 B.C.) formulated ideas about tragedy that have influenced writers and critics for centuries. Aristotle based his ideas on the tragedies produced in his own day.

Aristotle defines the tragic hero as a person who is neither completely virtuous nor utterly villainous. The downfall of this tragic figure is brought about "not by vice or depravity but by some error in judgment or frailty." The tragic hero or heroine is "highly renowned or prosperous" so that the fall from good fortune to disaster will arouse strong emotions in the audience.

Aristotle felt that it was good to arouse these strong feelings in the audience. He thought that the release of these upsetting emotions—called **catharsis** (or "cleansing")—was helpful politically because it cleansed people of their urges to defy authority the way the tragic hero or heroine did.

Who is the tragic figure in *Antigone?* Some critics argue that Creon is the real tragic hero. To support their position, they offer the following evidence: Creon undergoes a dramatic change, whereas Antigone's fate is determined in the first scene and she disappears from stage halfway through the play. The deaths of Haimon and Eurydice are meaningful only to Creon, not to Antigone. And it is the body of Creon's son that is carried onstage, not Antigone's body.

The classical scholar H. D. F. Kitto has suggested that *Antigone* is built on a "double foundation," and that the play's "center of gravity does not lie in one person, but between two." Kitto says that "of the two, the significant one to Sophocles was always Creon." What do you think? Are there two tragic figures in this play, or only one? If you think there is only one, who is it?

To help you decide, apply each of the following questions to Antigone and to Creon:

1. What error in judgment or frailty in character did the tragic figure display?
2. At what point in the play might the character have saved himself or herself from a tragic downfall?
3. Define the character's downfall. How did he or she change during the course of the play?
4. What emotions did the character's downfall arouse in you?

Language and Vocabulary

Recognizing Analogies

Vocabulary questions that ask you to identify synonyms or antonyms usually involve a pair of words. Some other vocabulary questions, called *analogies,* involve two pairs of words. You must first decide what relationship exists between the words in the first pair. The same relationship applies to the second pair.

An analogy question has a special format and uses special symbols:

industrious : busy :: arrogant : _____

a. quiet **b.** haughty **c.** sly **d.** artless

The two dots (:) stand for "is to"; the four dots (::) stand for "as." The example, therefore, reads "Industrious *is to* busy *as* arrogant *is to* _____." Since the first two words, *industrious* and *busy,* are synonyms, the correct answer is **b.** The word that means the same thing as *arrogant* is *haughty.*

Complete the following analogies:

Synonyms

1. decree : order :: garland : _____
 a. judgment **c.** wreath
 b. deception **d.** flower

2. lithe : graceful :: comprehensive : _____
 a. inclusive **c.** enthusiastic
 b. reckless **d.** listless
3. sate : satisfy :: demoralize : _____
 a. wreck **c.** struggle
 b. bewilder **d.** corrupt
4. naive : childlike :: sultry : _____
 a. shameful **c.** uncertain
 b. hot **d.** abundant

Antonyms

5. curt : polite :: impassive : _____
 a. possible **c.** artificial
 b. free **d.** emotional
6. synthetic : natural :: insolent : _____
 a. shy **c.** rash
 b. respectful **d.** impertinent
7. absolve : blame :: profane : _____
 a. revere **c.** release
 b. defile **d.** deflect
8. auspicious : unfavorable :: malicious : _____
 a. mischievous **c.** benevolent
 b. evil **d.** charming

Writing About Literature

Supporting an Opinion

The characters in *Antigone* make many statements that sound like proverbs, or wise sayings. If you look closely, you will see that these statements express the speaker's view about life. None are factual statements that can be definitely proved or disproved, though they do invite agreement or disagreement. Choose one of the following statements from the play and in a brief essay tell whether you agree or disagree with it. Support your opinion with at least three good reasons.

We are only women, we cannot fight with men, Antigone!

Impossible things should not be tried at all.

Good lives are made so by discipline.

Money! There's nothing in the world so demoralizing as money.

The only crime is pride.

There is no happiness where there is no wisdom.

Focus on Persuasive Writing

Choosing a Topic for Persuasion

The goal of **persuasion** is to get your audience to agree with a certain opinion, to take a certain action, or both. Starting with the first scene, Sophocles' tragedy *Antigone* presents a series of confrontations in which characters attempt to persuade each other.

A suitable topic for persuasion is one on which people can hold conflicting or opposing positions. When you choose a topic for your own persuasive writing, follow these steps:

1. Make sure that the topic is important to you and to others—in short, that it is worth arguing about.
2. Be sure that the topic is a matter of opinion, rather than a matter of fact.
3. Identify the audience you want to convince.
4. State your opinion or point of view in one or two sentences.

Look through some recent issues of newspapers and browse through the editorial section. After reading some of the editorials, choose two national or local issues that you care about. Write an **opinion statement** in one or two sentences, giving your point of view on each issue. Save your notes.

THE TRAGEDY OF JULIUS CAESAR

At the beginning of *Julius Caesar*, the Roman Republic is at peace after three years of civil war. By the end of the play, one man has been assassinated in public, another has been torn to pieces by an angry mob, a woman has killed herself by swallowing hot coals, thousands of soldiers lie dead on a battlefield, a government has changed hands, and several of Rome's most respected citizens have killed themselves rather than face dishonor.

These are historical events of the first century B.C., which William Shakespeare used to write *Julius Caesar*. The facts of this story can be found in an encyclopedia. In 1599, when Shakespeare was writing the play, he found his facts in a translation of *Plutarch's Lives of the Noble Greeks and Romans*. (Plutarch was a Greek historian who wrote during the first century A.D.) But the play *Julius Caesar* is more than a collection of facts. Historians can tell you about facts; playwrights must find ways of dramatizing and re-creating events before your eyes.

Scene from a 1953 film of *Julius Caesar*.

Shakespeare's Life and Times

Since his death nearly four hundred years ago, Shakespeare has been regarded as the greatest writer in the English language. Not only did he express himself in language unsurpassed for richness and beauty, but perhaps better than any other writer before or after him, Shakespeare understood human concerns—the joys, fears, hopes, passions, and weaknesses common to all of us, in all ages.

Few facts are known about Shakespeare's life. In April 1564, in the early part of Queen Elizabeth's reign, William Shakespeare was

Title page of the First Folio. The works of Shakespeare were published in The First Folio of 1623, seven years after the playwright's death. Shown here are prefatory verses by a contemporary, Ben Jonson, and a portrait of Shakespeare by Martin Droesbout.
Folger Shakespeare Library, Washington, D.C.

To the Reader.

This Figure, that thou here feeſt put,
 It vvas for gentle Shakeſpeare cut ;
VVherein the Grauer had a ſtrife
 with Nature, to out-doo the life :
O, could he but haue dravvne his vvit
 As vvell in braſſe, as he hath hit
His face ; the Print would then ſurpaſſe
 All, that vvas euer vvrit in braſſe.
But, ſince he cannot, Reader, looke
 Not on his Picture, but his Booke.

B. I.

MR. WILLIAM
SHAKESPEARES
COMEDIES, HISTORIES, & TRAGEDIES.

Publiſhed according to the True Originall Copies.

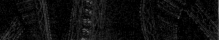

LONDON
Printed by Iſaac Iaggard, and Ed. Blount. 1623.

born at Stratford-on-Avon, a small market town in the county of Warwickshire. William was the oldest son of John Shakespeare, one of the most prosperous men of Stratford, and of Mary Arden, the daughter of a gentleman. At the age of eighteen, William Shakespeare married Anne Hathaway, the daughter of a nearby farmer, and within a few years their three children were born. Sometime after this, Shakespeare left Stratford for London. By 1592, when he was twenty-eight, he was firmly established as an actor and a playwright. Two years later, Shakespeare became a full sharer in the profits of the acting company known as the Lord Chamberlain's Company. By the time he was thirty-two, he was generally considered "the most excellent" of the writers of both tragedy and comedy for the stage. By the time he was thirty-six, he had behind him such masterpieces as *Romeo and Juliet* (a tragedy), *A Midsummer Night's Dream* (a comic farce and fantasy), and *As You Like It* (a mixture of comedy and satire—to be taken "as you like it").

Early in 1599 the Chamberlain's Men moved into a new theater, built to their own specifications, just south of London. One of the first plays performed in this theater (called the Globe) was *The Tragedy of Julius Caesar*. Within a few years, Shakespeare produced a series of great tragedies: *Hamlet, Othello, King Lear, Macbeth,* and *Antony and Cleopatra*. Many of these plays were performed at the royal court, for when Queen Elizabeth died in 1603, Shakespeare's company received the enthusiastic patronage of her successor, King James I. Known thereafter as the King's Men, the company at the Globe rose to even greater prominence.

In his mid-forties, Shakespeare retired from the stage and returned to his home in Stratford-on-Avon, a prosperous man and one of the town's most honored citizens. He died in Stratford on April 23, 1616.

Shakespeare lived near the end of the historical period called the Renaissance, which lasted from about 1350 to 1600. During the Renaissance (a French word meaning "rebirth"), Europeans made their first great expeditions to the New World, technology advanced at an unprecedented rate, the arts flourished, and the great classical civilizations of Greece and Rome were rediscovered. The grammar school of Shakespeare's day taught the Bible, Latin grammar, and Ovid's *Metamorphoses*, and educated its students to look to the past for lessons about their own times.

During the reign of Queen Elizabeth (1558–1603), England developed into one of the great powers of the world. This was the age of growing English sea power, of English exploration, and of continuing growth in English scholarship. Nevertheless, most Englishmen had

little reliable information about life beyond their own island, much less of life in ancient Rome in the first century B.C. Thus, in *Julius Caesar,* you will find many details of Elizabethan life mixed in with Roman history. Such out-of-place objects, customs, and beliefs are called *anachronisms,* which means literally "out of time." Shakespeare's Romans mention striking clocks, nightcaps, chimneys, hats, and doublets (which are heavy Elizabethan jackets). None of these existed in ancient Rome. There are also references to bearbaiting, an Elizabethan sport in which chained bears were attacked by dogs. Even Elizabethan and Roman superstitions are mixed in *Julius Caesar.*

Shakespeare's Theater

In September of 1599, a Swiss doctor visiting London wrote in his diary that he crossed the river Thames "and there in the house with the thatched roof witnessed an excellent performance of the tragedy of the first emperor Julius." The house with the thatched roof was the Globe, a theater which had just opened that summer. Fourteen years later that thatch caught fire and the Globe burned to the ground. The Swiss doctor's diary entry is one of the few pieces of information about the original Globe that has survived.

The Globe opened only twenty-three years after the first permanent theater had been built in England. Before that, plays had been performed in the courtyards of inns and on wagons in the street. The Globe contained many reminders of its courtyard origins. It was an eight-sided building with a central yard. About a third of the yard was occupied by a six-foot-high platform stage. The spectators paid one penny to stand in the yard around the stage, two pennies to sit in the second- or third-floor galleries that surrounded the yard, or three pennies to sit in the first-floor galleries. Those who paid the least and stood in the yard were called *groundlings*—the noisiest and perhaps most vocally critical members of the audience.

The stage of the Globe had no front curtain and no artificial lighting. (Performances took place in the afternoon.) The back wall of the stage had at least two doors for entrances and exits. There was a balcony, used for scenes that took place on a hilltop, on the walls of a town, or on a second story.

From various bills and receipts that have survived, we know that Elizabethan theaters used many props: swords, lanterns, trees, rocks, and even a Mouth of Hell. The heavier props were probably raised and lowered through trapdoors in the stage. But there were no settings of the sort used in any modern theaters. The realistic, boxlike

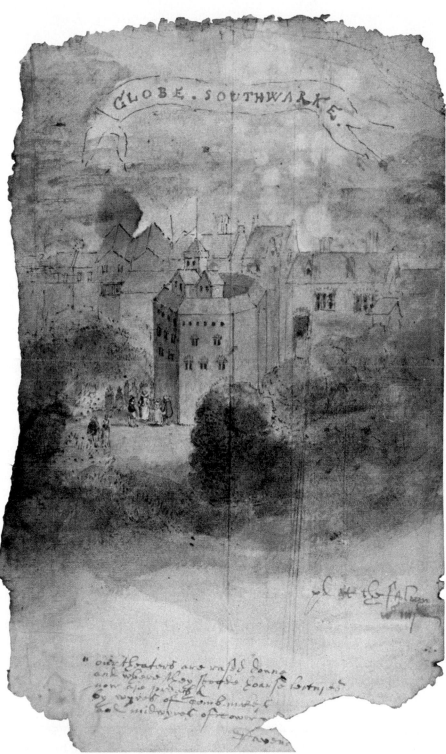

The Globe.
Watercolor drawing, after an eighteenth-century engraving
The Granger Collection,
New York

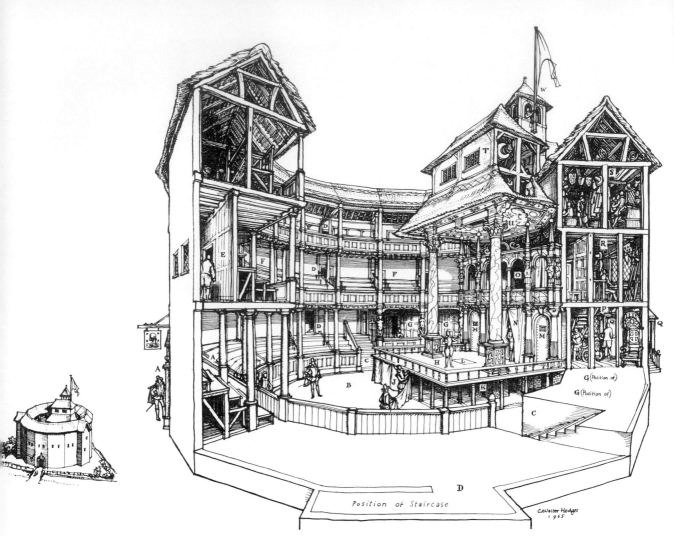

Position of Staircase

C. Walter Hodges
1965

A conjectural reconstruction drawing of The Globe Playhouse by C. Walter Hodges. A Main entrance B The Yard C Entrances to lowest gallery D Entrances to staircase and upper galleries E Corridor F Middle gallery ("Twopenny Rooms") G "Gentlemen's" or "Lords' Rooms" H The stage J Curtain K The area under the stage L Trap door M Entrance doors for actors N Curtained area behind the stage O Gallery used for musicians, spectators, or as actors' balcony P Backstage area (prop room) Q Entrance to prop room R Dressing rooms S Wardrobe and storage T The "hut" with machinery U The "Heavens" W Playhouse flag

set with the audience spying through an imaginary fourth wall did not come into being until the late nineteenth century. Because there were no elaborate sets or a curtain in Shakespeare's time, each scene could follow the other with little interruption. To make up for the lack of scenery, Elizabethan costumes were lavish and expensive. Having costumes appropriate to the historical period of a play is also

a modern idea: for example, Shakespeare's Caesar wore an Elizabethan doublet, not a Roman toga.

A performance of *Julius Caesar* included realistic sound effects for thunder and battle noises. The actor playing Caesar probably had a pig's bladder filled with blood hidden in his costume; when he was stabbed, he and the conspirators were drenched with gore.

Plays at the Globe were performed in the repertory system. A different play was presented every afternoon, and the company kept on its program a series of plays to which it was constantly adding. The average life of a play was about ten performances, although popular plays were generally acted more often. In a given season, an actor might have had to memorize half a dozen or more parts. About fifteen men played all the roles in *Julius Caesar,* with the women's parts taken by boy apprentices. The senior actors were also shareholders in the company. Since the Puritans of Elizabethan England considered the theater sinful, an acting company often had to seek the legal protection of a noble patron. Shakespeare's company was protected by the Lord Chamberlain at first, and later by King James I.

The picture you now have of a performance at the Globe may seem a little unusual. How could the plays be convincing without actresses and sets?

But no play, movie, or television show is truly realistic. Imagine how Shakespeare would have felt if he could have seen a fade-out in a modern movie. He might have thought that the actor or actress was a disappearing ghost. Because we have seen movies all our lives, we understand that a fade-out indicates the passage of time. In a way, we have made a silent agreement with the filmmakers that in this make-believe world a fade-out will stand for a time lapse. These agreements between the artist and audience are called *conventions.* Shakespeare and his audience also accepted certain conventions.

One of these conventions involves the use of *verse.* The characters in *Julius Caesar* express themselves in poetry. Occasionally, Shakespeare will have his characters speak in prose, often for coarse, comic effects. Casca, in Act One, for example, is addressed in poetry, but he answers in prose because he wants to be blunt. When a character speaks alone on the stage, we call the speech a *soliloquy.* The soliloquy is used to convey a character's thoughts directly to the audience. Sometimes a character will make a remark during a scene that is meant to be heard by the audience and perhaps by one other character, but by no one else onstage. These remarks are called *asides.* Asides are often used for an ironic effect, informing the audience of something that another character is ignorant of.

Historical Background of the Play

Julius Caesar (100?–44 B.C.) was the foremost Roman of his day and, because of the great influence of Rome, one could say he was then the most powerful man in the known world. He was born into a prominent family and was for most of his career close to the centers of power. He led an active and adventuresome life. As a young man, he had been banished from Rome because of an unpopular marriage. After he had been pardoned, he decided to prepare for a political career by studying oratory or rhetoric, the usual training for public life in his day. On his way to Rhodes to study, he was captured by pirates. After his ransom was paid, Caesar manned ships, set out in pursuit of the pirates, overtook and overcame them, and had them executed.

When he returned to Rome, he set about systematically to win the favor of the people. Caesar spent great sums of money on popular causes and was rewarded with a succession of high offices. He used these high offices to cement his relationship with the people. He raised many persons to positions of wealth and power—Marcus Brutus was one. Caesar also became a brilliant military strategist. His conquests in Gaul and Britain made him even more popular with the people and gained him the loyalty of the army as well. All of these favors and gifts, however, made him unpopular with his former political allies, who became jealous of him. United under Pompey, these enemies persuaded the Roman Senate to pass a resolution commanding Caesar to disband his army and return to Rome as a private citizen. Caesar refused to comply. Instead, he marched on Rome with his army. Many members of the force sent to stop him deserted their commander, Pompey, and joined Caesar's army. Pompey fled to Greece, and then to Egypt, where he was murdered before Caesar could capture him.

Caesar then did battle in Asia Minor, announcing his victory to the Senate with the now famous words: "*Veni. Vidi. Vici.*" ("I came. I saw. I conquered.") After defeating the remaining Pompeian forces in Africa and Spain, he returned to Rome, the undisputed master of the Roman world. Caesar was made dictator for life and probably wanted to be named king, though he was uncertain about how popular this would be with the people. In the sixth century B.C., the Romans had expelled their last king and set up a republic.

This is the situation as Shakespeare's play begins. On the one hand is Caesar, recently arrived in Rome with great favor among the populace. On the other hand are those who envy him and who fear for the republic should he be named king.

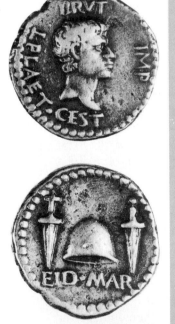

Coin commemorating the death of Caesar. On one side is a profile that appears to be that of Brutus. The reverse side shows the daggers of the assassins.

Julius Caesar

WILLIAM SHAKESPEARE

Characters

Julius Caesar
Octavius (ŏk-tā′vē-əs) Caesar } triumvirs after the death of Julius Caesar
Marcus Antonius
M. Aemilius Lepidus (lĕp′ə-dəs)

Cicero
Publius (pōōb′lē-əs) } Senators
Popilius Lena (pō-pĭl′ē əs lē′nə)

Marcus Brutus
Cassius (kăsh′əs)
Casca
Trebonius (trə-bō′nē-əs)
Ligarius (lĭ-gâr′ē-əs)
Decius (dē′shəs) Brutus
Metellus Cimber (mə-tĕl′əs sĭm′bər)
Cinna (sĭn′ə) } conspirators against Julius Caesar

Flavius (flā′vē-əs) and Marullus (mə-rŭl′əs), tribunes of the people
Artemidorus (är′tə-mə-dō′rəs) of Cnidos (nī′dəs), a teacher of rhetoric

Senators, Citizens, Guards, Attendants, etc.

A Soothsayer
Cinna, a poet
Another Poet

Lucilius (lōō-sĭl′ē-əs)
Titinius (tĭ-tĭn′ē-əs)
Messala (mə-sä′lə) } friends of Brutus and Cassius
Young Cato
Volumnius (vō-lŭm′nē-əs)

Varro (văr′ō)
Clitus (klī′təs)
Claudius (klô′dē-əs)
Strato (strā′tō) } servants of Brutus
Lucius (lōō′shəs)
Dardanius (där-dā′nē-əs)

Pindarus (pĭn′də-rəs), servant of Cassius

Calpurnia (kăl-pûr′nē-ə), wife of Caesar
Portia (pôr′shə), wife of Brutus

Scene: Rome: the neighborhood of Sardis; the neighborhood of Philippi (fĭ-lĭp′ī)

Act One

Scene 1

[*A street in Rome. It is the fifteenth of February, Lupercalia, a Roman festival celebrated with dancing, feasting, and public games.* Caesar *has recently returned to Rome.*

As the play opens, Flavius *and* Marullus, *tribunes of the people, meet a group of* Commoners *on their way to the Forum. The tribunes are angered by the people's eagerness to celebrate* Caesar's *triumph.*]

Flavius. Hence! Home, you idle creatures, get you home.
Is this a holiday? What! Know you not,
Being mechanical,° you ought not walk
Upon a laboring day without the sign
Of your profession?° [*Stopping one*] Speak, what trade art thou? 5
First Commoner. Why, sir, a carpenter.
Marullus. Where is thy leather apron and thy rule?
What dost thou with thy best apparel on?
[*To another*] You, sir, what trade are you?
Second Commoner. Truly, sir, in respect of a fine workman,° I am but, as you would say, 10
a cobbler.°
Marullus. But what trade art thou? Answer me directly.
Second Commoner. A trade, sir, that I hope I may use with a safe conscience, which is
indeed, sir, a mender of bad soles.
Marullus. What trade, thou knave? Thou naughty knave, what trade? 15
Second Commoner. Nay, I beseech you, sir, be not out° with me. Yet if you be out, sir, I
can mend you.
Marullus. What mean'st thou by that? Mend me, thou saucy fellow!
Second Commoner. Why, sir, cobble you.
Flavius. Thou art a cobbler, art thou? 20
Second Commoner. Truly, sir, all that I live by is with the awl. I meddle with no tradesman's
matters, nor women's matters, but with awl. I am indeed, sir, a surgeon to old shoes.
When they are in great danger, I re-cover them. As proper men as ever trod upon
neat's leather° have gone upon my handiwork.
Flavius. But wherefore art not in thy shop today? Why dost thou lead these men about 25
the streets?
Second Commoner. Truly, sir, to wear out their shoes, to get myself into more work. But
indeed, sir, we make holiday, to see Caesar and to rejoice in his triumph.

3. **mechanical:** workmen. 4–5. **sign . . . profession:** tools and work clothes. 10. **in . . . workmen:** as far as good
work is concerned. 11. **cobbler:** a shoemaker. (In Shakespeare's time, the word also meant "bungler.") 16. **out:** This
first *out* means "out of temper, angry." The next one means "down at the heel." 24. **neat's leather:** oxhide.

Marullus. Wherefore rejoice? What conquest brings he home?
 What tributaries° follow him to Rome, 30
 To grace in captive bonds his chariot wheels?
 You blocks, you stones, you worse than senseless things!
 O you hard hearts, you cruel men of Rome,
 Knew you not Pompey? Many a time and oft
 Have you climbed up to walls and battlements, 35
 To towers and windows, yea, to chimney tops,
 Your infants in your arms, and there have sat
 The livelong day with patient expectation
 To see great Pompey pass the streets of Rome.
 And when you saw his chariot but appear, 40
 Have you not made a universal shout,
 That Tiber° trembled underneath her banks
 To hear the replication° of your sounds
 Made in her concave shores?
 And do you now put on your best attire? 45
 And do you now cull out° a holiday?
 And do you now strew flowers in his way
 That comes in triumph over Pompey's blood?°
 Be gone!
 Run to your houses, fall upon your knees, 50
 Pray to the gods to intermit° the plague
 That needs must light on this ingratitude.
Flavius. Go, go, good countrymen, and for this fault
 Assemble all the poor men of your sort.
 Draw them to Tiber banks and weep your tears 55
 Into the channel till the lowest stream
 Do kiss the most exalted shores of all. [*Exeunt all the* Commoners.]
 See whether their basest metal° be not moved.
 They vanish tongue-tied in their guiltiness.
 Go you down that way toward the Capitol, 60
 This way will I. Disrobe the images°
 If you do find them decked with ceremonies.°
Marullus. May we do so?
 You know it is the feast of Lupercal.°
Flavius. It is no matter. Let no images 65
 Be hung with Caesar's trophies. I'll about,
 And drive away the vulgar° from the streets.

30. **tributaries:** captives, prisoners. 42. **Tiber:** the river that runs through Rome. 43. **replication:** echo. 46. **cull out:** choose to take. 48. **Pompey's blood:** Caesar has killed Pompey's sons in Spain. 51. **intermit:** prevent. 58. **metal:** material, stuff of which they are made. 61. **Disrobe the images:** strip the statues. 62. **ceremonies:** decorations. 64. **Lupercal** (loō′pər-kăl): Roman god of fertility. 67. **vulgar:** common people.

So do you too, where you perceive them thick.
These growing feathers plucked from Caesar's wing
Will make him fly an ordinary pitch,° 70
Who else would soar above the view of men
And keep us all in servile fearfulness. [*Exeunt.*]

Scene 2

[*A public square near the Forum. A flourish of trumpets announces the approach of* Caesar. *A crowd
of* Commoners *gathers, among them an old man, a* Soothsayer. *Enter* Caesar, *his wife* Cal-
purnia, Portia, Decius, Cicero, Brutus, Cassius, Casca, *and* Antony, *who is stripped for
running in the games.*]

Caesar. Calpurnia!
Casca. Peace, ho! Caesar speaks.
Caesar. [*Music ceases.*] Calpurnia!
Calpurnia. Here, my lord.
Caesar. Stand you directly in Antonius'° way
 When he doth run his course. Antonius!
Antonius. Caesar, my lord? 5
Caesar. Forget not, in your speed, Antonius,
 To touch Calpurnia, for our elders say
 The barren, touchèd in this holy chase,
 Shake off their sterile curse.°
Antonius. I shall remember:
 When Caesar says "Do this," it is performed. 10
Caesar. Set on, and leave no ceremony out.

 [*Flourish of trumpets.* Caesar *starts to leave.*]

Soothsayer. Caesar!
Caesar. Ha! Who calls?
Casca. Bid every noise be still—peace yet again!
Caesar. Who is it in the press° that calls on me? 15
 I hear a tongue, shriller than all the music,
 Cry "Caesar." Speak. Caesar is turned to hear.
Soothsayer. Beware the ides of March.°
Caesar. What man is that?

70. **pitch:** height of a soaring falcon. Flavius is saying that without the common people ("these growing feathers"), Caesar
will not be able to soar so high.
 3. **Antonius:** Mark Antony is sometimes referred to as Marcus Antonius. 7–9. **Calpurnia . . . curse:** Caesar's wife has
been unable to bear children. The Romans believed that women would bear children if touched by a whip of goat's hide
carried by a racer during this feast in celebration of the return of spring. Caesar asks Antony to touch Calpurnia with
his whip, hoping that this will enable her to give him a son. 15. **press:** crowd. 18. **ides of March:** March 15.

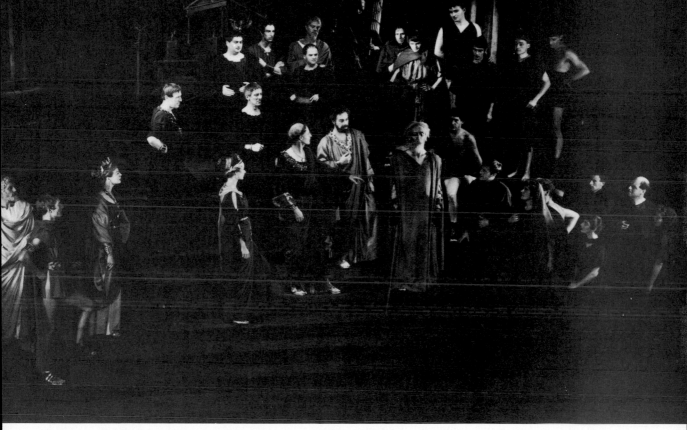

Photographs for *Julius Caesar* are from a production by The Old Vic Company.
Photographs by Desmond Tripp

Brutus. A soothsayer bids you beware the ides of March.
Caesar. Set him before me. Let me see his face. 20
Cassius. Fellow, come from the throng. Look upon Caesar.
Caesar. What say'st thou to me now? Speak once again.
Soothsayer. Beware the ides of March.
Caesar. He is a dreamer. Let us leave him—pass.

[*Trumpets sound. Exeunt all but* Brutus *and* Cassius.]

Cassius. Will you go see the order of the course? 25
Brutus. Not I.
Cassius. I pray you, do.

Julius Caesar Act One, Scene 2 **547**

Brutus. I am not gamesome.° I do lack some part
 Of that quick spirit that is in Antony.
 Let me not hinder, Cassius, your desires. 30
 I'll leave you.
Cassius. Brutus, I do observe you now of late.
 I have not from your eyes that gentleness
 And show of love as I was wont to° have.
 You bear too stubborn and too strange a hand 35
 Over your friend that loves you.
Brutus. Cassius,
 Be not deceived. If I have veiled my look,
 I turn the trouble of my countenance
 Merely upon myself. Vexèd I am
 Of late with passions of some difference,° 40
 Conceptions only proper to myself,
 Which give some soil° perhaps to my behaviors.
 But let not therefore my good friends be grieved—
 Among which number, Cassius, be you one—
 Nor cónstrue° any further my neglect 45
 Than that poor Brutus, with himself at war,
 Forgets the shows of love to other men.
Cassius. Then, Brutus, I have much mistook your passion,
 By means whereof° this breast of mine hath buried
 Thoughts of great value, worthy cogitations. 50
 Tell me, good Brutus, can you see your face?
Brutus. No, Cassius, for the eye sees not itself
 But by reflection, by some other things.
Cassius. 'Tis just.°
 And it is very much lamented, Brutus, 55
 That you have no such mirrors as will turn
 Your hidden worthiness into your eye,
 That you might see your shadow.° I have heard
 Where many of the best respect in Rome,
 Except immortal° Caesar, speaking of Brutus, 60
 And groaning underneath this age's yoke,
 Have wished that noble Brutus had his eyes.
Brutus. Into what dangers would you lead me, Cassius,
 That you would have me seek into myself
 For that which is not in me? 65
Cassius. Therefore, good Brutus, be prepared to hear.

28. **gamesome:** fond of games. 34. **was wont to:** used to. 40. **passions . . . difference:** conflicting feelings. 42. **soil:** blemish, stain. 45. **cónstrue:** interpret, guess at. 49. **By means whereof:** because of which. 54. **just:** true. 58. **shadow:** reflection. 60. **immortal:** Cassius speaks sarcastically.

And since you know you cannot see yourself
So well as by reflection, I your glass°
Will modestly discover to yourself
That of yourself which you yet know not of. 70
And be not jealous on° me, gentle Brutus.
Were I a common laugher, or did use
To stale with ordinary oaths my love
To every new protester;° if you know
That I do fawn on men and hug them hard, 75
And after scandal them; or if you know
That I profess° myself in banqueting
To all the rout°—then hold me dangerous.

[*Flourish and shout.*]

Brutus. What means this shouting? I do fear the people
 Choose Caesar for their king.
Cassius. Aye, do you fear it? 80
 Then must I think you would not have it so.
Brutus. I would not, Cassius, yet I love him well.
 But wherefore do you hold me here so long?
 What is it that you would impart to me?
 If it be aught towárd the general good, 85
 Set honor in one eye and death i' the other,
 And I will look on both indifferently;
 For let the gods so speed me° as I love
 The name of honor more than I fear death.
Cassius. I know that virtue to be in you, Brutus, 90
 As well as I do know your outward favor.°
 Well, honor is the subject of my story.
 I cannot tell what you and other men
 Think of this life, but for my single self
 I had as lief not be° as live to be 95
 In awe of such a thing as I myself.
 I was born free as Caesar; so were you.
 We both have fed as well, and we can both
 Endure the winter's cold as well as he.
 For once, upon a raw and gusty day, 100
 The troubled Tiber chafing with her shores,

68. **glass:** mirror. 71. **jealous on:** suspicious of. 72–74. **Were . . . protester:** if I were an ordinary jester (laugher), in the habit of swearing common oaths to everyone who swears them to me, and thereby cheapening my gift of friendship. 77. **profess:** proclaim friendship. 78. **rout:** mob. 88. **speed me:** give me good fortune. 91. **favor:** appearance. 95. **I . . . be:** I would prefer not to exist.

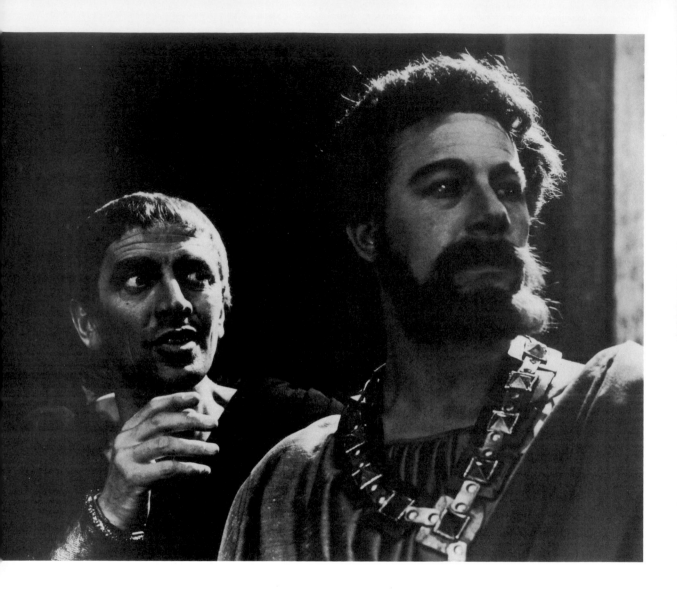

Caesar said to me "Darest thou, Cassius, now
Leap in with me into this angry flood
And swim to yonder point?" Upon the word,
Accoutered° as I was, I plungèd in 105
And bade him follow. So indeed he did.
The torrent roared, and we did buffet it
With lusty sinews, throwing it aside
And stemming it with hearts of controversy.°

105. **Accoutered:** dressed in armor. 109. **controversy:** competition.

But ere we could arrive the point proposed, 110
Caesar cried, "Help me, Cassius, or I sink!"
I, as Aeneas° our great ancestor
Did from the flames of Troy upon his shoulder
The old Anchises bear, so from the waves of Tiber
Did I the tired Caesar—and this man 115
Is now become a god, and Cassius is
A wretched creature, and must bend his body
If Caesar carelessly but nod on him.
He had a fever when he was in Spain,
And when the fit was on him, I did mark 120
How he did shake. 'Tis true, this god did shake.
His coward lips did from their color fly,°
And that same eye whose bend doth awe the world
Did lose his luster. I did hear him groan.
Aye, and that tongue of his that bade the Romans 125
Mark him and write his speeches in their books,
Alas, it cried, "Give me some drink, Titinius,"
As a sick girl. Ye gods! It doth amaze me
A man of such a feeble temper should
So get the start of° the majestic world 130
And bear the palm° alone.

 [*Shout. Flourish.*]

Brutus. Another general shout!
 I do believe that these applauses are
 For some new honors that are heaped on Caesar.
Cassius. Why, man, he doth bestride the narrow world 135
 Like a Colossus,° and we petty men
 Walk under his huge legs and peep about
 To find ourselves dishonorable graves.
 Men at some time are masters of their fates.
 The fault, dear Brutus, is not in our stars, 140
 But in ourselves, that we are underlings.
 Brutus, and Caesar. What should be in that Caesar?
 Why should that name be sounded more than yours?
 Write them together, yours is as fair a name.
 Sound them, it doth become the mouth as well. 145

112. **Aeneas:** according to legend, the founder of Rome. As the Greeks destroyed Troy, Aeneas escaped, carrying his aged father, Anchises, on his back. 122. **His . . . fly:** Caesar's lips lost their color. 130. **get . . . of:** get a headstart on. 131. **palm:** prize of victory. 136. **Colossus:** The Colossus of Rhodes, one of the seven wonders of the ancient world, was a gigantic statue whose legs straddled the entrance of the harbor of Rhodes.

Weigh them, it is as heavy. Conjure° with 'em,
Brutus will start a spirit as soon as Caesar.
Now, in the names of all the gods at once,
Upon what meat doth this our Caesar feed
That he is grown so great? Age, thou art shamed! 150
Rome, thou has lost the breed of noble bloods!
When went there by an age, since the great flood,
But it was famed with more than with one man?
When could they say till now that talked of Rome
That her wide walls encompassed but one man? 155
Now is it Rome indeed, and room° enough,
When there is in it but one only man.
Oh, you and I have heard our fathers say
There was a Brutus° once that would have brooked°
The eternal Devil to keep his state in Rome 160
As easily as a king.
Brutus. That you do love me, I am nothing jealous.°
What you would work me to, I have some aim.°
How I have thought of this and of these times,
I shall recount hereafter; for this present, 165
I would not, so with love I might entreat you,
Be any further moved. What you have said
I will consider. What you have to say
I will with patience hear, and find a time
Both meet° to hear and answer such high things. 170
Till then, my noble friend, chew upon this:
Brutus had rather be a villager
Than to repute himself a son of Rome
Under these hard conditions as this time
Is like to lay upon us. 175
Cassius. I am glad that my weak words
Have struck but thus much show of fire from Brutus.

[*Voices and music are heard approaching.*]

Brutus. The games are done, and Caesar is returning.
Cassius. As they pass by, pluck Casca by the sleeve,
And he will, after his sour fashion, tell you 180
What hath proceeded worthy note today.

146. **Conjure:** call up spirits. 156. **Rome . . . room:** a pun. Both words were pronounced and spelled alike in Shakespeare's time. 159. **a Brutus:** Lucius Junius Brutus expelled the last king from Rome and established the Republic in the sixth century B.C. Marcus Brutus believed he was descended from this patriot. **brooked:** put up with. 162. **am . . . jealous:** have no doubt. 163. **aim:** idea. 170. **meet:** appropriate.

[Reenter Cacsar *and his train of followers.]*

Brutus. I will do so. But look you, Cassius.
 The angry spot doth glow on Caesar's brow,
 And all the rest look like a chidden train.°
 Calpurnia's cheek is pale, and Cicero° 185
 Looks with such ferret° and such fiery eyes
 As we have seen him in the Capitol,
 Being crossed in conference by some Senators.
Cassius. Casca will tell us what the matter is.

[Caesar looks at Cassius *and turns to* Antony.]*

Caesar. Antonius! 190
Antonius. Caesar?
Caesar. Let me have men about me that are fat,
 Sleek-headed men, and such as sleep o' nights.
 Yond Cassius has a lean and hungry look.
 He thinks too much, such men are dangerous. 195
Antonius. Fear him not, Caesar. He's not dangerous,
 He is a noble Roman, and well given.°
Caesar. Would he were fatter! But I fear him not.
 Yet if my name were liable to fear,
 I do not know the man I should avoid 200
 So soon as that spare Cassius. He reads much,
 He is a great observer, and he looks
 Quite through the deeds of men. He loves no plays
 As thou dost, Antony; he hears no music.
 Seldom he smiles, and smiles in such a sort 205
 As if he mocked himself, and scorned his spirit
 That could be moved to smile at anything.
 Such men as he be never at heart's ease
 While they behold a greater than themselves,
 And therefore are they very dangerous. 210
 I rather tell thee what is to be feared
 Than what I fear, for always I am Caesar.
 Come on my right hand, for this ear is deaf,
 And tell me truly what thou think'st of him.

[Trumpets sound. Exeunt Caesar *and all his train except* Casca, *who stays behind.]*

184. **a chidden train:** scolded followers. 185. **Cicero:** a Roman senator. 186. **ferret:** a weasel-like animal with tiny red eyes; here, sharp, nervous. 197. **well given:** well disposed (toward Caesar).

Casca. You pulled me by the cloak. Would you speak with me? 215

Brutus. Aye, Casca. Tell us what hath chanced today
 That Caesar looks so sad.°

Casca. Why, you were with him, were you not?

Brutus. I should not then ask Casca what had chanced.

Casca. Why, there was a crown offered him; and being offered him, he put it by with the 220
 back of his hand, thus. And then the people fell a-shouting.

Brutus. What was the second noise for?

Casca. Why, for that too.

Cassius. They shouted thrice. What was the last cry for?

Casca. Why, for that too. 225

Brutus. Was the crown offered him thrice?

Casca. Aye, marry,° was 't, and he put it by thrice, every time gentler than other. And at
 every putting-by mine honest neighbors shouted.

Cassius. Who offered him the crown?

Casca. Why, Antony. 230

Brutus. Tell us the manner of it, gentle Casca.

Casca. I can as well be hanged as tell the manner of it. It was mere foolery—I did not
 mark it. I saw Mark Antony offer him a crown, yet 'twas not a crown neither, 'twas
 one of these coronets;° and, as I told you, he put it by once. But for all that, to my
 thinking, he would fain° have had it. Then he offered it to him again, then he put it 235
 by again. But, to my thinking, he was very loath to lay his fingers off it. And then he
 offered it the third time, he put it the third time by. And still as he refused it the
 rabblement° hooted and clapped their chopped° hands and threw up their sweaty
 nightcaps and uttered such a deal of stinking breath because Caesar refused the crown
 that it had almost choked Caesar; for he swounded° and fell down at it. And for mine 240
 own part, I durst not laugh, for fear of opening my lips and receiving the bad air.

Cassius. But, soft,° I pray you. What, did Caesar swound?

Casca. He fell down in the market place and foamed at mouth and was speechless.

Brutus. 'Tis very like—he hath the falling sickness.°

Cassius. No, Caesar hath it not. But you, and I, 245
 And honest Casca, we have the falling sickness.

Casca. I know not what you mean by that, but I am sure Caesar fell down. If the tagrag°
 people did not clap him and hiss him according as he pleased and displeased them,
 as they use to do the players in the theater, I am no true man.

Brutus. What said he when he came unto himself? 250

Casca. Marry, before he fell down, when he perceived the common herd was glad he
 refused the crown, he plucked me ope his doublet° and offered them his throat to
 cut. An I had been a man of any occupation,° if I would not have taken him at a

217. **sad:** serious. 227. **marry:** indeed. 234. **coronets:** small crowns wreathed with laurel. 235. **fain:** gladly.
238. **rabblement:** common people. **chopped:** chapped. 240. **swounded:** fainted. 242. **soft:** slowly. 244. **falling sick-ness:** epilepsy. Cassius picks up the term and gives it quite another meaning. 247. **tagrag:** shabbily dressed. 252. **ope his doublet:** open his short coat. Note that the actors were dressed in Elizabethan costumes. 253. **An . . . occupation:** if I had been a craftsman who carried cutting tools.

word, I would I might go to Hell among the rogues. And so he fell. When he came to himself again, he said if he had done or said anything amiss, he desired Their Worships to think it was his infirmity. Three or four wenches where I stood cried, "Alas, good soul!" and forgave him with all their hearts: but there's no heed to be taken of them. If Caesar had stabbed their mothers, they would have done no less.

Brutus. And after that, he came, thus sad, away?

Casca. Aye.

Cassius. Did Cicero say anything?

Casca. Aye, he spoke Greek.

Cassius. To what effect?

Casca. Nay, an I tell you that, I'll ne'er look you i' the face again. But those that understood him smiled at one another and shook their heads—but for mine own part, it was Greek to me. I could tell you more news too. Marullus and Flavius, for pulling scarfs off Caesar's images, are put to silence.° Fare you well. There were more foolery yet, if I could remember it.

Cassius. Will you sup with me tonight, Casca?

Casca. No, I am promised forth.

Cassius. Will you dine with me tomorrow?

Casca. Aye, if I be alive, and your mind hold, and your dinner worth the eating.

Cassius. Good, I will expect you.

Casca. Do so. Farewell, both. [*Exit*]

Brutus. What a blunt fellow is this grown to be!
He was quick mettle° when he went to school.

Cassius. So is he now in execution
Of any bold or noble enterprise,
However he puts on this tardy form.°
This rudeness is a sauce to his good wit,
Which gives men stomach to digest his words
With better appetite.

Brutus. And so it is. For this time I will leave you.
Tomorrow, if you please to speak with me,
I will come home to you, or, if you will,
Come home to me and I will wait for you.

Cassius. I will do so. Till then, think of the world. (*Exit* Brutus.)
Well, Brutus, thou art noble. Yet I see
Thy honorable mettle may be wrought
From that it is disposed.° Therefore it is meet
That noble minds keep ever with their likes,
For who so firm that cannot be seduced?
Caesar doth bear me hard,° but he loves Brutus.

255

260

265

270

275

280

285

290

267. **put to silence:** banished. 276. **quick mettle:** lively spirited. 279. **tardy form:** appearance of stupidity. 289–290. **wrought . . . disposed:** changed from its natural inclinations. 293. **bear me hard:** dislikes me.

If I were Brutus now and he were Cassius,
He should not humor° me. I will this night, 295
In several hands,° in at his windows throw,
As if they came from several citizens,
Writings, all tending to the great opinion
That Rome holds of his name, wherein obscurely
Caesar's ambition shall be glancèd° at. 300
And after this let Caesar seat him° sure,
For we will shake him, or worse days endure. [*Exit.*]

Scene 3

[*A street. Thunder and lightning. Enter, from opposite sides,* Casca, *with his sword drawn, and*
Cicero. *It is the night before the ides of March.*]

Cicero. Good even, Casca. Brought you Caesar home?
 Why are you breathless? And why stare you so?
Casca. Are not you moved, when all the sway° of earth
 Shakes like a thing unfirm? O Cicero,
 I have seen tempests when the scolding winds 5
 Have rived° the knotty oaks, and I have seen
 The ambitious ocean swell and rage and foam,
 To be exalted with° the threatening clouds.
 But never till tonight, never till now,
 Did I go through a tempest dropping fire. 10
 Either there is a civil strife in Heaven,
 Or else the world too saucy with the gods
 Incenses° them to send destruction.
Cicero. Why, saw you anything more wonderful?
Casca. A common slave—you know him well by sight— 15
 Held up his left hand, which did flame and burn
 Like twenty torches joined, and yet his hand,
 Not sensible of fire, remained unscorched.
 Besides—I ha' not since put up my sword—
 Against the Capitol I met a lion, 20
 Who glazed° upon me and went surly by
 Without annoying me. And there were drawn
 Upon a heap° a hundred ghastly women
 Transformèd with their fear, who swore they saw
 Men all in fire walk up and down the streets. 25

295. **humor:** influence, persuade. 296. **several hands:** several different handwritings. 300. **glancèd:** hinted. 301.
him: himself.
 3. **sway:** natural order. 6. **rived:** split. 8. **exalted with:** raised up to the level of. 13. **Incenses:** angers. 21. **glazed:**
glared. 22–23. **drawn . . . heap:** huddled together.

And yesterday the bird of night° did sit
Even at noonday upon the market place,
Hooting and shrieking. When these prodigies°
Do so conjointly meet, let not men say
"These are their reasons, they are natural." 30
For I believe they are portentous things
Unto the climate that they point upon.°
Cicero. Indeed, it is a strange-disposèd time.
But men may cónstrue things after their fashion,
Clean from the purpose° of the things themselves. 35
Comes Caesar to the Capitol tomorrow?
Casca. He doth, for he did bid Antonius
Send word to you he would be there tomorrow.
Cicero. Good night then, Casca. This disturbèd sky
Is not to walk in.
Casca. Farewell, Cicero. [*Exit* Cicero.] 40

[*Enter* Cassius.]

Cassius. Who's there?
Casca. A Roman.
Cassius. Casca, by your voice
Casca. Your ear is good. Cassius, what night is this!
Cassius. A very pleasing night to honest men.
Casca. Who ever knew the heavens menace so?
Cassius. Those that have known the earth so full of faults. 45
For my part, I have walked about the streets,
Submitting me unto the perilous night,
And thus unbraced,° Casca, as you see,
Have bared my bosom to the thunder stone.°
And when the cross° blue lightning seemed to open 50
The breast of Heaven, I did present myself
Even in the aim and very flash of it.
Casca. But wherefore did you so much tempt the heavens?
It is the part of men to fear and tremble
When the most mighty gods by tokens send 55
Such dreadful heralds to astonish us.
Cassius. You are dull, Casca, and those sparks of life
That should be in a Roman you do want,°
Or else you use not. You look pale and gaze

26. **bird of night:** screech owl 28. **prodigies:** wonders. 31–32. **portentous . . . upon:** ominous things, foretelling disaster for Rome. 35. **Clean . . . purpose:** opposite to the real meaning. 48. **unbraced:** with clothes blowing open. 49. **thunder stone:** thunderbolt. 50. **cross:** forked. 58. **want:** lack.

And put on fear and cast yourself in wonder, 60
To see the strange impatience of the heavens.
But if you would consider the true cause
Why all these fires, why all these gliding ghosts,
Why birds and beasts from quality and kind,°
Why old men fool and children calculate,° 65
Why all these things change from their ordinance,°
Their natures and preformèd faculties,
To monstrous quality, why, you shall find
That Heaven hath infused them with these spirits
To make them instruments of fear and warning 70
Unto some monstrous state.
Now could I, Casca, name to thee a man
Most like this dreadful night
That thunders, lightens, opens graves, and roars
As doth the lion in the Capitol— 75
A man no mightier than thyself or me
In personal action, yet prodigious grown
And fearful, as these strange eruptions are.

Casca. 'Tis Caesar that you mean, is it not, Cassius?

Cassius. Let it be who it is. For Romans now 80
 Have thews° and limbs like to their ancestors.
 But, woe the while!° our fathers' minds are dead,
 And we are governed with our mothers' spirits,
 Our yoke and sufferance show us womanish.

Casca. Indeed they say the Senators tomorrow 85
 Mean to establish Caesar as a king,
 And he shall wear his crown by sea and land
 In every place save here in Italy.

Cassius. I know where I will wear this dagger then.
 Cassius from bondage will deliver Cassius. 90
 Therein, ye gods, you make the weak most strong.
 Therein, ye gods, you tyrants do defeat.
 Nor stony tower, nor walls of beaten brass,
 Nor airless dungeon, nor strong links of iron,
 Can be retentive to the strength of spirit; 95
 But life, being weary of these worldly bars,
 Never lacks power to dismiss itself.
 If I know this, know all the world besides,
 That part of tyranny that I do bear
 I can shake off at pleasure.

64. **from . . . kind:** acting contrary to their natures. 65. **calculate:** prophesy. 66. **ordinance:** natural order. 81. **thews:** sinews, strength. 82. **woe the while:** alas for our time.

Casca. So can I. 100
So every bondman in his own hand bears
The power to cancel his captivity.

Cassius. And why should Caesar be a tyrant, then?
Poor man! I know he would not be a wolf
But that he sees the Romans are but sheep. 105
He were no lion were not Romans hinds.°
Those that with haste will make a mighty fire
Begin it with weak straws. What trash is Rome,
What rubbish and what offal,° when it serves
For the base matter to illuminate 110
So vile a thing as Caesar! But, O Grief,
Where hast thou led me? I perhaps speak this
Before a willing bondman;° then I know
My answer must be made. But I am armed,
And dangers are to me indifferent. 115

Casca. You speak to Casca, and to such a man
That is no fleering° telltale. Hold, my hand
Be factious for redress of all these griefs,°
And I will set this foot of mine as far
As who goes farthest.

Cassius. There's a bargain made. 120
Now know you, Casca, I have moved already
Some certain of the noblest-minded Romans
To undergo with me an enterprise
Of honorable-dangerous consequence.
And I do know, by this they stay° for me 125
In Pompey's porch;° for now, this fearful night,
There is no stir or walking in the streets,
And the complexion of the element
In favor's° like the work we have in hand,
Most bloody, fiery, and most terrible. 130

[*Enter* Cinna.]

Casca. Stand close° awhile, for here comes one in haste.
Cassius. 'Tis Cinna, I do know him by his gait—
He is a friend. Cinna, where haste you so?

106. **hinds:** female deer. 109. **offal** (ŏ′fəl): garbage. 113. **bondman:** slave (that is, of Caesar). 117. **fleering:** sneering. 118. **Be factious . . . griefs:** Form a faction, or conspiracy, with me to right these wrongs. 125. **stay:** wait. 126. **Pompey's porch:** the covered entrance to the theater built by Pompey. 128–129. **element in favor's:** sky (element) in appearance (favor) is. 131. **close:** hidden.

Cinna. To find out you. Who's that? Metellus Cimber?

Cassius. No, it is Casca, one incorporate 135
 To our attempts.° Am I not stayed for, Cinna?

Cinna. I am glad on 't.° What a fearful night is this!
 There's two or three of us have seen strange sights.

Cassius. Am I not stayed for? Tell me.

Cinna. Yes, you are.
 O Cassius, if you could 140
 But win the noble Brutus to our party——

Cassius. Be you content. Good Cinna, take this paper,
 And look you lay it in the praetor's chair,°
 Where Brutus may but find it, and throw this
 In at his window; set this up with wax 145
 Upon old Brutus'° statue. All this done,
 Repair to Pompey's porch, where you shall find us.
 Is Decius Brutus and Trebonius there?

Cinna. All but Metellus Cimber, and he's gone
 To seek you at your house. Well, I will hie,° 150
 And so bestow these papers as you bade me.

Cassius. That done, repair to Pompey's theater. [*Exit* Cinna.]
 Come, Casca, you and I will yet ere day
 See Brutus at his house. Three parts of him
 Is ours already, and the man entire 155
 Upon the next encounter yields him ours.

Casca. Oh, he sits high in all the people's hearts,
 And that which would appear offense in us
 His countenance, like richest alchemy,°
 Will change to virtue and to worthiness. 160

Cassius. Him and his worth and our great need of him
 You have right well conceited.° Let us go,
 For it is after midnight, and ere day
 We will awake him and be sure of him. [*Exeunt.*]

135–136. **incorporate . . . attempts:** involved in our conspiracy. 137. **I . . . on 't;** that is, that Casca is involved. 143. **praetor's** (prē′tərz) **chair:** Brutus was a praetor, a high-ranking Roman judge, second in power only to Caesar's rank of consul. 146. **old Brutus:** Brutus' ancestor, Lucius Junius Brutus. 150. **hie:** hurry. 159. **alchemy** (ăl′kə-mē): an ancient science that attempted to change lesser metals into gold. 162. **conceited:** understood.

Reading Check

1. What actions do the tribunes Flavius and Marullus take to restrain popular support of Caesar?
2. How are Flavius and Marullus punished?
3. Why have Caesar and his attendants gathered in a public square near the Forum?
4. What warning does Caesar receive from a soothsayer?
5. What reason does Brutus give for not attending the games?
6. How did Cassius once save Caesar's life?
7. What is Antony's opinion of Cassius?
8. Brutus and Cassius hear the crowd shout three times. What does the shouting mean?
9. On the night of the storm, what unnatural events does Casca report?
10. Whom does Cassius win over to the conspiracy at the end of the first act?

For Study and Discussion

Analyzing and Interpreting the Play

1. The play begins with a humorous scene that provides important background information. **a.** How are the conflicting attitudes toward Caesar shown? **b.** What information about Caesar and Pompey is revealed?

2. The commoners (the mob) are a major force in the play. **a.** What does Scene 1 tell you about how fickle the mob is in its loyalty? **b.** How does it show that the mob is easily influenced by people in authority?

3. In line 46 of Scene 2, Brutus says that he is at war with himself. What are the two sides of the "war" that is going on in Brutus' mind?

4. In the early part of Scene 2, Cassius attempts to get Brutus to join the conspiracy against Caesar. Why doesn't he ask Brutus directly? What tactics does he use?

5a. What is Caesar's emotional state when he reenters in Scene 2? **b.** What do you think he means by the word *hungry* in line 194?

6a. What personal defects and weaknesses of Caesar does Shakespeare emphasize in Act One? **b.** Do you think these frailties make him unsuitable as a leader? Explain.

7a. According to lines 162–170 of Scene 2, how eager is Brutus to continue his conversation with Cassius? **b.** Brutus' attitude has changed by lines 283–286. Why?

8a. What does Cassius do and say that makes us suspicious of his motives and his cause? **b.** Do his actions seem to support Caesar's opinion of him?

9. In what ways is Cassius the opposite of Brutus?

10a. Scene 3 begins with a frightening storm. What attitude does each of the following characters have toward the storm and its causes: Cicero, Casca, Cassius? **b.** How does Cassius use the storm to support his political views?

11. In Scene 3 Cassius sounds out Casca on joining the conspiracy, just as in Scene 2 he sounded out Brutus. **a.** How is his approach to Casca different from his approach to Brutus? **b.** How is it similar?

12. Why is it necessary to the conspirators that Brutus join them? Cite lines from Scene 3 that show their attitudes toward Brutus.

13. What is the mood of Scene 3?

Literary Elements

Dramatic Structure: Characterization

In Act One, Scene 2, Shakespeare brings all of his major characters onstage. By the end of this scene, we have come to know them as individuals with distinct traits, beliefs, and ways of speaking. Even characters with little to say in this scene—Antony and Casca, for example—are distinct persons in a way that the minor characters Flavius and Marullus are not.

The playwright's basic method for building several characterizations economically is this: when a character speaks, he or she will often give information about three people: the character being discussed, the character being addressed, and the character speaking.

To illustrate, look at one of Caesar's early speeches:

> Forget not, in your speed, Antonius,
> To touch Calpurnia, for our elders say
> The barren, touchèd in this holy chase,
> Shake off their sterile curse.
>
> (2, 6–9)

Caesar is discussing Calpurnia, his wife, and we learn that Antony is a friend of Caesar's: the words "Forget not" make it clear that Antony and Caesar have already had a conversation on the subject.

And what does Caesar tell us about himself? First, we learn that he is superstitious and concerned about his public image. It is "our elders" who believe in this magic cure, he says, not me; nevertheless, he is saying, don't forget to touch my wife in case the magic works. Second, Caesar gives us what may be a clue about his ambitions. One of the differences between a king and a dictator is that a king passes on his title to his offspring. If Caesar wants to be a king, he will also want to have an heir.

Read again each of the following speeches in its context. What does each tell about its speaker, its subject, and its listener?

> **Brutus.** I am not gamesome. I do lack some part
> Of that quick spirit that is in Antony.
> Let me not hinder, Cassius, your desires.
> I'll leave you.
>
> (2, 28–31)

> **Cassius.** I have heard
> Where many of the best respect in Rome,
> Except immortal Caesar, speaking of Brutus,
> And groaning underneath this age's yoke,
> Have wished that noble Brutus had his eyes.
>
> (2, 58–62)

> **Caesar.** I rather tell thee what is to be feared
> Than what I fear, for always I am Caesar.
> Come on my right hand, for this ear is deaf,
> And tell me truly what thou think'st of him.
>
> (2, 211–214)

Language and Vocabulary

Understanding the Function of Puns

"Truly, sir, in respect of a fine workman, I am but, as you would say, a cobbler." Ten lines into *Julius Caesar*, Shakespeare has his cobbler make the first of several puns. Some puns are jokes that depend for their humor on words that sound alike but mean different things. Other puns play on different meanings of a single word. In the line quoted above, *cobbler* means both "shoemaker" and "bungler." It is hard for us to understand this pun because in the years since Shakespeare wrote this line, "bungler" as a meaning for *cobbler* has become archaic, that is, gone out of use.

Puns have a practical purpose in getting an audience into a good-humored mood. From accounts of Shakespeare's time, we know that his audiences were rowdier and more vocal in their approval and disapproval than a typical theater audience is today. Look back at Casca's remarks in Act One, Scene 2, lines 247–249; they describe an Elizabethan audience as well as a Roman one.

Shakespeare's use of puns at the start of his play is also a way of alerting his audience to

the fact that words are tricky. As the play continues, words get trickier and soon become treacherous. Even in the first scene, puns are used by the cobbler to undercut the authority of the tribunes.

Puns have a metaphoric use as well. The cobbler lives by the *awl,* a tool for punching holes, which also sounds like the *All,* that is, the universe. The cobbler calls himself "a mender of bad soles" (souls). To what occupation is he comparing his own? The cobbler also says that he is a "surgeon" to old shoes. Where do the ideas of a body in bad health and souls in trouble come up again in Cassius' speeches to Brutus in Scene 2?

Writing About Literature

Explaining the Significance of a Passage

These lines from Scene 2 are often quoted:

> Let me have men about me that are fat,
> Sleek-headed men, and such as sleep o' nights.
> Yond Cassius has a lean and hungry look.
> He thinks too much, such men are dangerous.
> (lines 192–195)

Write a paragraph in which you explain the meaning of these lines and their importance to the drama. For assistance see the model essay in the section called *Writing About Literature* at the back of this textbook.

Focus on Persuasive Writing

Considering Your Audience

At the end of Act One, Cassius says he is confident that the conspirators can win Brutus to their cause. Cassius is shrewd enough to adjust his persuasive arguments and techniques to make the maximum appeal to Brutus' beliefs and personality.

Similarly, when you plan a persuasive speech or essay, you should consider your **audience** carefully. Remain alert to their interests and concerns, as well as to their prior knowledge of the topic. Ask yourself what your audience's views are likely to be. What group might strongly disagree with your opinion on the issue, and why?

Choose one of the topics identified earlier in this unit (see page 534), or explore a new topic. Fill out an audience chart like the one below. When you have finished, get together with a partner and compare notes. Save your writing.

Audience Chart

Topic: _____

Position/Opinion: _____

Audience: _____

Interests/Concerns: _____

Prior Knowledge: _____

Possible Opposing Opinions: _____

Reasons for Opposition: _____

Act Two

Scene 1

[*Rome.* Brutus' *orchard.*]

Brutus. What, Lucius, ho! [*To himself*]
 I cannot, by the progress of the stars,
 Give guess how near to day. [*Calling*] Lucius, I say!
 I would it were my fault to sleep so soundly.
 When, Lucius, when? Awake, I say! What, Lucius! 5

[*Enter* Lucius *from the house.*]

Lucius. Called you, my lord?
Brutus. Get me a taper° in my study, Lucius.
 When it is lighted, come and call me here.
Lucius. I will, my lord. [*Exit.*]

[Brutus *returns to his brooding.*]

Brutus. It must be by his° death and for my part 10
 I know no personal cause to spurn at him,
 But for the general.° He would be crowned.
 How that might change his nature, there's the question.
 It is the bright day that brings forth the adder,°
 And that craves wary walking. Crown him?—That— 15
 And then, I grant, we put a sting in him,
 That at his will he may do danger with.
 The abuse of greatness is when it disjoins
 Remorse° from power; and to speak truth of Caesar
 I have not known when his affections swayed° 20
 More than his reason. But 'tis a common proof
 That lowliness is young ambition's ladder,
 Whereto the climber-upward turns his face.
 But when he once attains the upmost round,°
 He then unto the ladder turns his back, 25
 Looks in the clouds, scorning the base degrees
 By which he did ascend. So Caesar may.
 Then, lest he may, prevent.° And since the quarrel

7. **taper:** candle. 10. **his:** Caesar's. 12. **the general:** the general good. 14. **adder:** poisonous snake. 19. **Remorse:** pity. 20. **his affections swayed:** his personal desires ruled. 24. **round:** rung. 28. **prevent:** he must be stopped.

Will bear no color° for the thing he is,
Fashion it thus: that what he is, augmented, 30
Would run to these and these extremities.
And therefore think him as a serpent's egg
Which hatched would as his kind grow mischievous,
And kill him in the shell.

[*Reenter* Lucius *with a letter.*]

Lucius. The taper burneth in your closet,° sir, 35
 Searching the window for a flint, I found
 This paper thus sealed up, and I am sure
 It did not lie there when I went to bed.

[*Gives him the letter.*]

Brutus. Get you to bed again. It is not day.
 Is not tomorrow, boy, the ides of March? 40
Lucius. I know not, sir.
Brutus. Look in the calendar and bring me word.
Lucius. I will, sir. [*Exit.*]
Brutus. The exhalations° whizzing in the air
 Give so much light that I may read by them. 45

[*Opens the letter and reads.*]

"Brutus, thou sleep'st. Awake and see thyself.
Shall Rome, etc.° Speak, strike, redress."°
"Brutus, thou sleep'st. Awake."
Such instigations have been often dropped
Where I have took them up. 50
"Shall Rome, etc." Thus must I piece it out—
Shall Rome stand under one man's awe? What, Rome?
My ancestors did from the streets of Rome
The Tarquin° drive, when he was called a king.
"Speak, strike, redress." Am I entreated 55
To speak and strike? O Rome, I make thee promise,
If the redress will follow, thou receivest
Thy full petition at the hand of Brutus!

29. **Will . . . color:** is unconvincing. 35. **closet:** a small room. 44. **exhalations:** meteors. 47. **etc.:** The letter continues, but Shakespeare did not include it in the manuscript. **redress:** right a wrong. 54. **Tarquin:** the last king of Rome, expelled by Brutus' ancestor.

[Reenter Lucius.]

Lucius. Sir, March is wasted fifteen days.

[Knocking within.]

Brutus. 'Tis good. Go to the gate. Somebody knocks. *[Exit Lucius.]* 60
 Since Cassius first did whet me against Caesar
 I have not slept.
 Between the acting of a dreadful thing
 And the first motion,° all the interim is
 Like a phantasma or a hideous dream. 65
 The Genius and the mortal instruments°
 Are then in council, and the state of man,
 Like to a little kingdom, suffers then
 The nature of an insurrection.°

[Reenter Lucius.]

Lucius. Sir, 'tis your brother° Cassius at the door, 70
 Who doth desire to see you.
Brutus. Is he alone?
Lucius. No, sir, there are moe° with him.
Brutus. Do you know them?
Lucius. No, sir. Their hats are plucked about their ears,
 And half their faces buried in their cloaks,
 That by no means I may discover them 75
 By any mark of favor.°
Brutus. Let 'em enter. *[Exit Lucius.]*
 They are the faction. O Conspiracy,
 Shamest thou to show thy dangerous brow by night,
 When evils are most free? Oh, then by day
 Where wilt thou find a cavern dark enough 80
 To mask thy monstrous visage? Seek none, Conspiracy—
 Hide it in smiles and affability.
 For if thou path, thy native semblance on,°
 Not Erebus° itself were dim enough
 To hide thee from prevention.° 85

[Enter the conspirators, Cassius, Casca, Decius, Cinna, Metellus Cimber, *and* Trebonius.]

64. **motion:** hint of the idea. 66. **The Genius . . . mortal instruments:** the mind (Genius) and the body. 69. **insurrection:** revolution, civil war. 70. **brother:** brother-in-law. Cassius had married Brutus' sister. 72. **moe:** more. 76. **favor:** appearance. 83. **path . . . on:** walk openly in your usual way. 84. **Erebus** (ĕr′ə-bəs): in Greek mythology, a dim region of the underworld. 85. **prevention:** discovery.

Cassius. I think we are too bold upon your rest.
　　Good morrow, Brutus. Do we trouble you?
Brutus. I have been up this hour, awake all night.
　　Know I these men that come along with you?
Cassius. Yes, every man of them, and no man here　　　　　90
　　But honors you, and every one doth wish
　　You had but that opinion of yourself
　　Which every noble Roman bears of you.
　　This is Trebonius.
Brutus. 　　　　　　　He is welcome hither.
Cassius. This, Decius Brutus.
Brutus. 　　　　　　　　　He is welcome too.　　　　　95
Cassius. This, Casca, this, Cinna, and this, Metellus Cimber.
Brutus. They are all welcome.
　　What watchful cares do interpose themselves
　　Betwixt your eyes and night?
Cassius. Shall I entreat a word?　　　　　　　　　　　100

[They whisper.]

Decius. Here lies the east. Doth not the day break here?
Casca. No.
Cinna. Oh, pardon, sir, it doth, and yon gray lines
　　That fret° the clouds are messengers of day.
Casca. You shall confess that you are both deceived.　　105
　　Here, as I point my sword, the sun arises,
　　Which is a great way growing on the south,
　　Weighing° the youthful season of the year.
　　Some two months hence up higher toward the north
　　He first presents his fire, and the high east　　　　　　110
　　Stands as the Capitol, directly here.

[Brutus and Cassius rejoin the others.]

Brutus. Give me your hands all over, one by one.
Cassius. And let us swear our resolution.
Brutus. No, not an oath. If not the face of men,
　　The sufferance of our souls, the time's abuse—　　　　115
　　If these be motives weak, break off betimes,°
　　And every man hence to his idle bed.
　　So let high-sighted° tyranny range on

104. **fret:** lace, ornament.　108. **Weighing:** considering.　116. **betimes:** right now.　118. **high-sighted:** proud-eyed.

Till each man drop by lottery.° But if these,
As I am sure they do, bear fire enough 120
To kindle cowards and to steel with valor
The melting spirits of women, then, countrymen,
What need we any spur but our own cause
To prick us to redress? What other bond
Than secret Romans that have spoke the word, 125
And will not palter?° And what other oath
Than honesty to honesty engaged
That this shall be or we will fall for it?
Swear priests and cowards and men cautelous,°
Old feeble carrions° and such suffering souls 130
That welcome wrongs; unto bad causes swear
Such creatures as men doubt; but do not stain
The even virtue of our enterprise,
Nor the insuppressive mettle of our spirits,
To think that or our cause or° our performance 135
Did need an oath when every drop of blood
That every Roman bears, and nobly bears,
Is guilty of a several bastardy°
If he do break the smallest particle
Of any promise that hath passed from him. 140

Cassius. But what of Cicero? Shall we sound him?
 I think he will stand very strong with us.

Casca. Let us not leave him out.

Cinna. No, by no means.

Metellus. Oh, let us have him, for his silver hairs
 Will purchase us a good opinion 145
 And buy men's voices to commend our deeds.
 It shall be said his judgment ruled our hands.
 Our youths and wildness shall no whit appear,
 But all be buried in his gravity.

Brutus. Oh, name him not. Let us not break with him,° 150
 For he will never follow anything
 That other men begin.

Cassius. Then leave him out.

Casca. Indeed he is not fit.

Decius. Shall no man else be touched but only Caesar?

Cassius. Decius, well urged. I think it is not meet 155
 Mark Antony, so well beloved of Caesar,
 Should outlive Caesar. We shall find of him

119. **lottery:** chance. 126. **palter:** play false. 129. **cautelous:** crafty, cunning. 130. **carrions:** carcasses. 135. **or . . . or:** either . . . or. 138. **several bastardy:** individual betrayal. 150. **break with him:** disclose our plot to him.

A shrewd contriver;° and you know his means,
If he improve them, may well stretch so far
As to annoy° us all. Which to prevent 160
Let Antony and Caesar fall together.
Brutus. Our course will seem too bloody, Caius Cassius,
To cut the head off and then hack the limbs,
Like wrath in death and envy afterward.
For Antony is but a limb of Caesar. 165
Let us be sacrificers, but not butchers, Caius.
We all stand up against the spirit of Caesar,
And in the spirit of men there is no blood.
Oh, that we then could come by Caesar's spirit,
And not dismember Caesar! But, alas, 170
Caesar must bleed for it! And, gentle° friends,
Let's kill him boldly, but not wrathfully.
Let's carve him as a dish fit for the gods,
Not hew him as a carcass fit for hounds.
And let our hearts, as subtle masters do, 175
Stir up their servants° to an act of rage
And after seem to chide 'em. This shall make
Our purpose necessary and not envious,°
Which so appearing to the common eyes,
We shall be called purgers, not murderers. 180
And for Mark Antony, think not of him,
For he can do no more than Caesar's arm
When Caesar's head is off.
Cassius. Yet I fear him,
For in the ingrafted love he bears to Caesar——
Brutus. Alas, good Cassius, do not think of him. 185
If he love Caesar, all that he can do
Is to himself, take thought and die for Caesar.
And that were much he should, for he is given
To sports, to wildness and much company.
Trebonius. There is no fear° in him. Let him not die, 190
For he will live and laugh at this hereafter.

[*Clock strikes.*]

Brutus. Peace! Count the clock.
Cassius. The clock hath stricken three.
Trebonius. 'Tis time to part.

158. **contriver:** plotter. 160. **annoy:** harm. 171. **gentle:** noble. 176. **their servants:** our hands. 178. **envious:** full of malice. 190. **no fear:** nothing to fear.

Cassius. But it is doubtful yet
 Whether Caesar will come forth today or no,
 For he is superstitious grown of late, 195
 Quite from the main opinion he held once
 Of fantasy, of dreams and ceremonies.°
 It may be these apparent prodigies,
 The unaccustomed terror of this night
 And the persuasion of his augurers,° 200
 May hold him from the Capitol today.
Decius. Never fear that. If he be so resolved,
 I can o'ersway him. For he loves to hear
 That unicorns may be betrayed with trees
 And bears with glasses, elephants with holes, 205
 Lions with toils° and men with flatterers—
 But when I tell him he hates flatterers,
 He says he does, being then most flattered.
 Let me work,
 For I can give his humor the true bent,° 210
 And I will bring him to the Capitol.
Cassius. Nay, we will all of us be there to fetch him.
Brutus. By the eighth hour.° Is that the uttermost?°
Cinna. Be that the uttermost, and fail not then.
Metellus. Caius Ligarius doth bear Caesar hard, 215
 Who rated° him for speaking well of Pompey.
 I wonder none of you have thought of him.
Brutus. Now, good Metellus, go along by him.
 He loves me well, and I have given him reasons.
 Send him but hither and I'll fashion° him. 220
Cassius. The morning comes upon 's. We'll leave you, Brutus.
 And friends. disperse yourselves, but all remember
 What you have said, and show yourselves true Romans.
Brutus. Good gentlemen, look fresh and merrily.
 Let not our looks put on our purposes, 225
 But bear it as our Roman actors do,
 With untired spirits and formal constancy.°
 And so, good morrow to you every one. [*Exeunt all but* Brutus.]
 Boy! Lucius! Fast asleep! It is no matter.
 Enjoy the honey-heavy dew of slumber. 230

197. **ceremonies:** supernatural signs. 200. **augurers:** officials who predicted the future by means of signs and omens. 204–206. **unicorns . . . toils:** It was believed that unicorns could be trapped by having a hunter stand in front of a tree, provoke the unicorn into charging, and then step quickly aside. Bears were supposed to be vain and easily lured by mirrors. Elephants can still be caught in pits and lions in snares (toils). 210. **humor . . . bent:** put him in the right mood. 213. **eighth hour:** the hour that business usually started in Shakespeare's day. **uttermost:** latest. 216. **rated:** rebuked. 220. **fashion:** mold. 227. **formal constancy:** calm self-control.

Thou hast no figures° nor no fantasies
Which busy care draws in the brains of men,
Therefore thou sleep'st so sound.

[*Enter* Portia, Brutus' *wife*.]

Portia. Brutus, my lord!
Brutus. Portia, what mean you? Wherefore rise you now?
 It is not for your health thus to commit 235
 Your weak condition to the raw cold morning.
Portia. Nor for yours neither. You've ungently, Brutus,
 Stole from my bed. And yesternight at supper
 You suddenly arose and walked about,
 Musing and sighing, with your arms across, 240
 And when I asked you what the matter was,
 You stared upon me with ungentle looks.
 I urged you further, then you scratched your head,
 And too impatiently stamped with your foot.
 Yet I insisted, yet you answered not, 245
 But with an angry wafture° of your hand
 Gave sign for me to leave you. So I did,
 Fearing to strengthen that impatience
 Which seemed too much enkindled, and withal°
 Hoping it was but an effect of humor,° 250
 Which sometime hath his hour with every man.
 It will not let you eat, nor talk, nor sleep,
 And, could it work so much upon your shape
 As it hath much prevailed on your condition,
 I should not know you, Brutus. Dear my lord, 255
 Make me acquainted with your cause of grief.
Brutus. I am not well in health, and that is all.
Portia. Brutus is wise, and were he not in health,
 He would embrace the means to come by it.
Brutus. Why, so I do. Good Portia, go to bed. 260
Portia. Is Brutus sick, and is it physical°
 To walk unbraced and suck up the humors°
 Of the dank morning? What, is Brutus sick,
 And will he steal out of his wholesome bed
 To dare the vile contagion of the night,° 265
 And tempt the rheumy and unpurgèd air

231. **figures:** dreams, visions. 246. **wafture:** motion. 249. **withal:** in addition. 250. **humor:** moodiness. 261. **physical:** good for your health. 262. **humors:** mists. 265. **contagion . . . night:** It was thought that night air was unhealthy, since it was moist (rheumy) and unpurified (unpurged) by the sun.

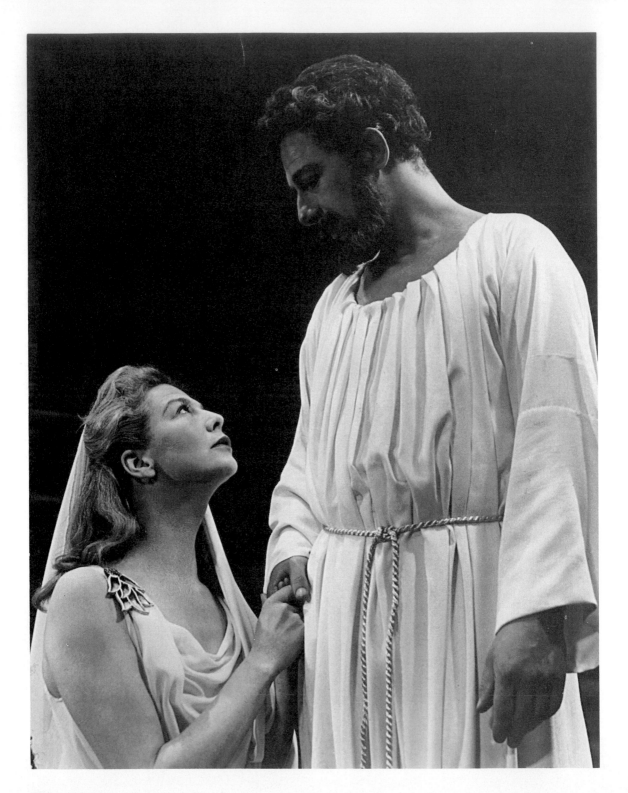

To add unto his sickness? No, my Brutus;
You have some sick offense within your mind,
Which by the right and virtue of my place
I ought to know of. And, upon my knees, 270
I charm you, by my once commended beauty,
By all your vows of love and that great vow
Which did incorporate and make us one,
That you unfold me, yourself, your half,
Why you are heavy, and what men tonight 275
Have had resort to you; for here have been
Some six or seven who did hide their faces
Even from darkness.
Brutus. Kneel not, gentle Portia.
Portia. I should not need if you were gentle Brutus.
 Within the bond of marriage, tell me, Brutus, 280
 Is it excepted I should know no secrets
 That appertain to you? Am I yourself°
 But,° as it were, in sort or limitation,
 To keep with you at meals, comfort your bed,
 And talk to you sometimes? Dwell I but in the suburbs 285
 Of your good pleasure? If it be no more,
 Portia is Brutus' harlot, not his wife.
Brutus. You are my true and honorable wife,
 As dear to me as are the ruddy drops°
 That visit my sad heart. 290
Portia. If this were true, then should I know this secret.
 I grant I am a woman, but withal
 A woman that Lord Brutus took to wife.
 I grant I am a woman, but withal
 A woman well reputed, Cato's daughter.° 295
 Think you I am no stronger than my sex,
 Being so fathered and so husbanded?
 Tell me your counsels, I will not disclose 'em.
 I have made strong proof of my constancy,
 Giving myself a voluntary wound 300
 Here in the thigh. Can I bear that with patience
 And not my husband's secrets?
Brutus. O ye gods,
 Render me worthy of this noble wife!

282. **yourself:** part of you (by marriage). 283. **But:** only. 289. **ruddy drops:** blood. 295. **Cato's daughter:** Cato of Utica, Portia's father. Famous for his honesty and courage, Cato killed himself after Caesar defeated Pompey because he would not live under a tyrant's rule.

[*Knocking within.*]

Hark, hark! One knocks. Portia, go in awhile,
And by and by thy bosom shall partake 305
The secrets of my heart.
All my engagements I will construe° to thee,
All the charáctery° of my sad brows.
Leave me with haste. [*Exit* Portia.] Lucius, who's that knocks?

[*Reenter* Lucius *with* Ligarius.]

Lucius. Here is a sick man that would speak with you. 310
Brutus. Caius Ligarius, that Metellus spake of.
 Boy, stand aside. Caius Ligarius? How?
Ligarius. Vouchsafe° good morrow from a feeble tongue.
Brutus. Oh, what a time you have chose out, brave Caius,
 To wear a kerchief!° Would you were not sick! 315
Ligarius. I am not sick if Brutus have in hand
 Any exploit worthy the name of honor.
Brutus. Such an exploit have I in hand, Ligarius,
 Had you a healthful ear to hear of it.
Ligarius. By all the gods that Romans bow before, 320
 I here discard my sickness! Soul of Rome!
 Brave son, derived from honorable loins!
 Thou, like an exorcist,° hast conjured up
 My mortified spirit. Now bid me run,
 And I will strive with things impossible, 325
 Yea, get the better of them. What's to do?
Brutus. A piece of work that will make sick men whole.
Ligarius. But are not some whole that we must make sick?
Brutus. That must we also. What it is, my Caius,
 I shall unfold to thee as we are going 330
 To whom it must be done.
Ligarius. Set on your foot,
 And with a heart new-fired I follow you,
 To do I know not what, it sufficeth
 That Brutus leads me on.
Brutus. Follow me, then. [*Exeunt.*]

307. **construe:** explain. 308. **charáctery:** written lines. 313. **Vouchsafe:** please accept. 315. **kerchief:** a muffler, worn by the sick. 323. **exorcist:** summoner of dead (mortified) spirits to walk again.

Scene 2

[*Caesar's house. Thunder and lightning. Enter* Caesar *in his nightgown.*]

Caesar. Nor Heaven nor earth have been at peace tonight.
 Thrice hath Calpurnia in her sleep cried out,
 "Help, ho! They murder Caesar!" [*Calling.*] Who's within?

[*Enter a* Servant.]

Servant. My lord?
Caesar. Go bid the priests do present° sacrifice, 5
 And bring me their opinions of success.
Servant. I will, my lord. [*Exit.*]

[Calpurnia, Caesar's *wife, enters, alarmed.*]

Calpurnia. What mean you, Caesar? Think you to walk forth?
 You shall not stir out of your house today.
Caesar. Caesar shall forth. The things that threatened me 10
 Ne'er looked but on my back. When they shall see
 The face of Caesar, they are vanishèd.
Calpurnia. Caesar, I never stood on ceremonies,°
 Yet now they fright me. There is one within,
 Besides the things that we have heard and seen, 15
 Recounts most horrid sights seen by the watch.°
 A lioness hath whelpèd° in the streets.
 And graves have yawned and yielded up their dead.
 Fierce fiery warriors fight upon the clouds,
 In ranks and squadrons and right form of war, 20
 Which drizzled blood upon the Capitol.
 The noise of battle hurtled in the air,
 Horses did neigh and dying men did groan,
 And ghosts did shriek and squeal about the streets.
 O Caesar! these things are beyond all use,° 25
 And I do fear them.
Caesar. What can be avoided
 Whose end is purposed by the mighty gods?
 Yet Caesar shall go forth, for these predictions
 Are to the world in general as to Caesar.

5. **present:** immediate. 13. **stood on ceremonies:** paid much attention to omens. 16. **the watch:** night watchmen. 17. **whelpèd:** given birth. 25. **use:** custom, usual events.

Calpurnia. When beggars die, there are no comets seen. 30
The heavens themselves blaze forth the death of princes.
Caesar. Cowards die many times before their deaths,
The valiant never taste of death but once.
Of all the wonders that I yet have heard,
It seems to me most strange that men should fear, 35
Seeing that death, a necessary end,
Will come when it will come.

<center>[Reenter Servant.]</center>

<center>What say the augurers?</center>

Servant. They would not have you to stir forth today.
Plucking the entrails of an offering forth,
They could not find a heart within the beast.° 40
Caesar. The gods do this in shame of cowardice.
Caesar should be a beast without a heart
If he should stay at home today for fear.
No, Caesar shall not. Danger knows full well
That Caesar is more dangerous than he, 45
We are two lions littered° in one day,
And I the elder and more terrible.
And Caesar shall go forth.
Calpurnia. Alas, my lord,
Your wisdom is consumed in confidence.
Do not go forth today. Call it my fear 50
That keeps you in the house, and not your own.
We'll send Mark Antony to the Senate House,
And he shall say you are not well today.
Let me, upon my knee, prevail in this.
Caesar. Mark Antony shall say I am not well, 55
And, for thy humor° I will stay at home.

<center>[Enter Decius.]</center>

Here's Decius Brutus. He shall tell them so.
Decius. Caesar, all hail! Good morrow, worthy Caesar.
I come to fetch you to the Senate House.
Caesar. And you are come in a very happy time, 60
To bear my greetings to the Senators

40. **heart . . . beast:** Roman augurers predicted the future by examining the insides of animals killed for sacrifice. In this case, the lack of the heart, the most important organ, suggests that the state soon will lack its most important citizen. Caesar, however, finds another explanation. 46. **littered:** born. 56. **humor:** whim, wish.

And tell them that I will not come today.
Cannot is false, and that I dare not, falser—
I will not come today. Tell them so, Decius.
Calpurnia. Say he is sick.
Caesar. Shall Caesar send a lie? 65
Have I in conquest stretched mine arm so far,
To be afeared to tell graybeards the truth?
Decius, go tell them Caesar will not come.
Decius. Most mighty Caesar, let me know some cause,
Lest I be laughed at when I tell them so. 70
Caesar. The cause is in my will—I will not come.
That is cnough to satisfy the Senate.
But, for your private satisfaction,
Because I love you, I will let you know.

Calpurnia here, my wife, stays me at home. 75
She dreamt tonight she saw my statuë,°
Which like a fountain with a hundred spouts
Did run pure blood, and many lusty Romans
Came smiling and did bathe their hands in it.
And these does she apply for warnings and portents 80
And evils imminent, and on her knee
Hath begged that I will stay at home today.
Decius. This dream is all amiss interpreted.
It was a vision fair and fortunate.
Your statue spouting blood in many pipes, 85
In which so many smiling Romans bathed,
Signifies that from you great Rome shall suck
Reviving blood, and that great men shall press
For tinctures, stains, relics, and cognizance.°
This by Calpurnia's dream is signified. 90
Caesar. And this way have you well expounded° it.
Decius. I have, when you have heard what I can say.
And know it now—the Senate have concluded
To give this day a crown to mighty Caesar.
If you shall send them word you will not come, 95
Their minds may change. Besides, it were a mock
Apt to be rendered, for someone to say
"Break up the Senate till another time,
When Caesar's wife shall meet with better dreams."
If Caesar hide himself, shall they not whisper 100
"Lo, Caesar is afraid"?
Pardon me, Caesar, for my dear dear love
To your proceeding bids me tell you this,
And reason to my love is liable.°
Caesar. How foolish do your fears seem now, Calpurnia! 105
I am ashamèd I did yield to them.
Give me my robe, for I will go.

[*Enter* Publius, Brutus, Ligarius, Metellus, Casca, Trebonius, *and* Cinna.]

And look where Publius is come to fetch me.
Publius. Good morrow, Caesar.
Caesar. Welcome, Publius.
What, Brutus, are you stirred so early too? 110
Good morrow, Casca. Caius Ligarius,

76. **statuë:** pronounced as three syllables here. 89. **tinctures . . . cognizance:** souvenirs of your greatness. 91. **expounded:** explained. 104. **And reason . . . liable:** and my love requires that I speak the truth to you.

Caesar was ne'er so much your enemy°
As that same ague° which hath made you lean.
What is 't o'clock?
Brutus. Caesar, 'tis strucken eight.
Caesar. I thank you for your pains and courtesy. 115

[*Enter* Antony.]

See! Antony, that revels long o' nights,
Is notwithstanding up. Good morrow, Antony.
Antony. So to most noble Caesar.
Caesar. Bid them prepare within.
I am to blame to be thus waited for.
Now, Cinna, now, Metellus. What, Trebonius! 120
I have an hour's talk in store for you.
Remember that you call on me today.
Be near me, that I may remember you.
Trebonius. Caesar, I will. [*Aside*] And so near will I be
That your best friends shall wish I had been further. 125
Caesar. Good friends, go in and taste some wine with me,
And we like friends will straightway go together.
Brutus. [*Aside*] That every like is not the same, O Caesar,
The heart of Brutus yearns° to think upon! [*Exeunt.*]

Scene 3

[*A street near the Capitol. Enter* Artemidorus, *reading a paper.*]

Artemidorus. "Caesar, beware of Brutus; take heed of Cassius; come not near Casca; have
an eye to Cinna; trust not Trebonius; mark well Metellus Cimber; Decius Brutus loves
thee not; thou hast wronged Caius Ligarius. There is but one mind in all these men,
and it is bent against Caesar. If thou beest not immortal, look about you. Security°
gives way to conspiracy. The mighty gods defend thee! 5
 Thy lover,° Artemidorus."

Here will I stand till Caesar pass along,
And as a suitor° will I give him this.
My heart laments that virtue cannot live
Out of the teeth of emulation.° 10
If thou read this, O Caesar, thou mayst live;
If not, the Fates with traitors do contrive.° [*Exit.*]

112. **Caesar . . . enemy:** Ligarius sided with Pompey during the civil war. 113. **ague:** feverish sickness. 129. **yearns:**
grieves.
 4. **Security:** overconfidence. 6. **lover:** friend. 8. **suitor:** one who seeks a favor. 10. **emulation:** envy. 12. **contrive:**
plot.

Scene 4

[*Another part of the same street, before the house of* Brutus. *Enter* Portia *and* Lucius.]

Portia. I prithee,° boy, run to the Senate House.
 Stay not to answer me, but get thee gone.
 Why dost thou stay?
Lucius. To know my errand, madam.
Portia. I would have had thee there, and here again.
 Ere I can tell thee what thou shouldst do there. 5
 O Constancy, be strong upon my side!
 Set a huge mountain 'tween my heart and tongue!
 I have a man's mind, but a woman's might.
 How hard it is for women to keep counsel!
 Art thou here yet?
Lucius. Madam, what should I do? 10
 Run to the Capitol, and nothing else?
 And so return to you, and nothing else?
Portia. Yes, bring me word, boy, if thy lord look well,
 For he went sickly forth. And take good note
 What Caesar doth, what suitors press to him. 15
 Hark, boy! What noise is that?
Lucius. I hear none, madam.
Portia. Prithee, listen well.
 I heard a bustling rumor like a fray,°
 And the wind brings it from the Capitol.
Lucius. Sooth,° madam, I hear nothing.

[*Enter the* Soothsayer.]

Portia. Come hither, fellow. 20
 Which way hast thou been?
Soothsayer. At mine own house, good lady.
Portia. What is 't o'clock?
Soothsayer. About the ninth hour, lady.
Portia. Is Caesar yet gone to the Capitol?
Soothsayer. Madam, not yet. I go to take my stand
 To see him pass on to the Capitol. 25
Portia. Thou hast some suit to Caesar, hast thou not?
Soothsayer. That I have, lady. If it will please Caesar
 To be so good to Caesar as to hear me,
 I shall beseech him to befriend himself.

1. **prithee:** pray thee. 18. **rumor . . . fray:** noise like a battle. 20. **Sooth:** truly.

Portia. Why, know'st thou any harm's intended toward him? 30
Soothsayer. None that I know will be, much that I fear may chance.
 Good morrow to you. Here the street is narrow,
 The throng that follows Caesar at the heels,
 Of Senators, of praetors, common suitors,
 Will crowd a feeble man almost to death. 35
 I'll get me to a place more void,° and there
 Speak to great Caesar as he comes along. *[Exit.]*
Portia. I must go in. Aye me, how weak a thing
 The heart of women is! O Brutus,
 The heavens speed thee in thine enterprise! 40
 Sure, the boy heard me. Brutus hath a suit
 That Caesar will not grant. Oh, I grow faint.
 Run, Lucius, and commend me to my lord.
 Say I am merry. Come to me again,
 And bring me word what he doth say to thee. *[Exeunt severally.°]* 45

36. **void:** empty. S.D. **severally:** by different exits.

For Study and Discussion

Analyzing and Interpreting the Play

1. As Brutus begins his soliloquy in Scene 1, it is clear he has already decided that Caesar must die. **a.** What reasons does he give for his decision? **b.** From what you have seen of Caesar, are they good reasons? Tell why or why not.

2. Lucius is the only important character in the play whom Shakespeare did not find in Plutarch's *Lives*. What function does Lucius serve in Scene 1? Watch for Lucius again in Act Four, and see if you can decide why Shakespeare put him in the play.

3a. Why does Brutus believe there is no need for the conspirators to swear an oath? **b.** What does this suggest about his character?

4a. In Scene 1, what two changes does Brutus make in the plans of the conspirators? **b.** Are his reasons noble and high-minded? Are they realistic and practical? Explain.

5. Portia appears at the end of Scene 1 right after the conspirators leave. What does the scene reveal about the characters of Brutus and Portia and about their relationship?

6. Brutus follows a philosophy called Stoicism. Stoics believed that individuals should lead lives of virtue, reason, and duty, mastering all emotions and submitting to fate. **a.** So far in the play, how does Brutus show his Stoicism? **b.** How does Portia show she is a Stoic?

7a. In Scene 2, what impression do you get of Caesar? **b.** What strengths does he show? What weaknesses?

8. Scene 2 focuses on the question of whether or not Caesar will attend the Senate. **a.** How does Shakespeare build suspense? **b.** What feelings do you have as you watch Caesar try to make up his mind?

9. Both Portia and Calpurnia try to exert influence on their husbands. **a.** How do their methods differ? **b.** How does Caesar's treatment of Calpurnia differ from Brutus' treatment of Portia?

10. Reread lines 58–107 in Scene 2. To what aspects of Caesar's personality is Decius appealing as he tries to persuade him to go to the Senate?

11. Lines 32–37 in Scene 2 contain one of the most famous speeches in all of Shakespeare's work. **a.** Explain what Caesar means in this speech. **b.** Why is this speech ironic to the audience?

12. How does Scene 3 add to the suspense of the play?

13a. In Scene 4, why does Portia send Brutus the message that she is merry? **b.** Describe her actual state of mind in this scene and tell how you know what it is.

14a. Why do you think Shakespeare has the soothsayer reappear in Scene 4? **b.** In line 29 he says that Caesar is his own enemy. How is this so?

Literary Elements

Dramatic Structure: Suspense and Action

Film director Alfred Hitchcock has said that the difference between surprise and suspense is that surprise makes you wonder *what* will happen, but suspense makes you wonder *how* it will happen. You know that Julius Caesar will be dead before the play is over. What questions remain unanswered at this point in the play to keep you in suspense? Put your answer in the form of a list of questions, each beginning with "How."

What is the *action* of this play? Clearly, there will be some violence before it is over. Violence is action. But other things are action too. There has been no violence in the first two acts, but this does not mean that nothing has happened. Action is whatever keeps a play moving forward. Thinking can be action. Talking can be action. But if characters think and do not change their minds, if characters talk but do not reach a decision, then the play stops moving.

Make a list of the people who have changed their minds thus far in the play. Jot down what they thought before the change and what they thought afterward. (Think of the citizens as one person.)

Have you changed your mind about anything so far? Has your impression of certain characters changed? How does this make you part of the action, in a way?

Imagery

One of Shakespeare's greatest talents is his ability to take a simple, familiar image and give it many shades of meaning and feeling. Let's look at the way the image of *blood* is used in Act Two, Scene 1:

In line 136, *blood* means "the honor of a Roman."

In line 162, *bloody* means "senselessly brutal."

In line 168, *blood* means "red fluid in the body."

In line 171, *bleed* means "die."

Notice that one image—blood—pulls together the contradictory concepts of life and death, honor and brutality. How do these contradictions reflect the moral problem of the assassination?

Shakespeare also uses images of *sleep, sickness,* and *fire.* Select one of these words, locate its appearances (including its variants) in Act Two, and prepare a list similar to the one above.

Writing About Literature

Comparing Characters

In Act Two we are introduced to Brutus' wife, Portia, and to Caesar's wife, Calpurnia, in scenes that are interesting dramatic parallels. What do you learn about each woman and her relationship with her husband? What is revealed about Brutus and Caesar in the scenes with their respective wives? What admirable qualities do both women possess? How does each one influence or fail to influence her husband? Write an essay in which you compare the two characters as figures in the drama.

Act Three

Scene 1

[*Rome. Before the Capitol, a great crowd. On a higher level, the Senate sits, waiting for* Caesar *to appear. The* Soothsayer *and* Artemidorus *are among the crowd.*

A flourish of trumpets. Enter Caesar, Brutus, Cassius, Casca, Decius, Metellus, Trebonius, Cinna; Antony, Lepidus, Popilius, Publius, *and others.* Caesar *stops in front of the* Soothsayer *and smiles.*]

Caesar. The ides of March are come.
Soothsayer. Aye, Caesar, but not gone.

[Artemidorus *steps up to* Caesar *with his warning.*]

Artemidorus. Hail, Caesar! Read this schedule.°

[Decius *steps forward quickly with another paper.*]

Decius. Trebonius doth desire you to o'erread,
 At your best leisure, this his humble suit. 5
Artemidorus. O Caesar, read mine first, for mine's a suit
 That touches Caesar nearer. Read it, great Caesar.
Caesar. What touches us ourself shall be last served.

[Caesar *pushes the paper aside and turns away.*]

Artemidorus. Delay not, Caesar. Read it instantly.
Caesar. What, is the fellow mad?
Publius. Sirrah,° give place. 10

[Publius *and the other conspirators force* Artemidorus *away from* Caesar.]

Cassius. What, urge you your petitions in the street?
 Come to the Capitol.

[Caesar *goes up into the Senate House, the rest following.* Popilius *speaks to* Cassius *in a low voice.*]

Popilius. I wish your enterprise today may thrive.
Cassius. What enterprise, Popilius?
Popilius. Fare you well.

3. **schedule:** paper. 10. **Sirrah:** an insulting way of addressing an inferior.

[Advances to Caesar.]

Brutus. What said Popilius Lena? 15
Cassius. He wished today our enterprise might thrive.
 I fear our purpose is discovered.
Brutus. Look how he makes to° Caesar. Mark him.
Cassius. Casca,
 Be sudden, for we fear prevention.
 Brutus, what shall be done? If this be known, 20
 Cassius or Caesar never shall turn back,
 For I will slay myself.
Brutus. Cassius, be constant.
 Popilius Lena speaks not of our purposes,
 For look he smiles and Caesar doth not change.
Cassius. Trebonius knows his time, for look you, Brutus, 25
 He draws Mark Antony out of the way. *[Exeunt* Antony *and* Trebonius.]
Decius. Where is Metellus Cimber? Let him go,
 And presently prefer his suit to Caesar.
Brutus. He is addressed.° Press near and second him.
Cinna. Casca, you are the first that rears your hand. 30

[Caesar seats himself in his high Senate chair.]

Caesar. Are we all ready? What is now amiss
 That Caesar and his Senate must redress?
Metellus. Most high, most mighty, and most puissant° Caesar,
 Metellus Cimber throws before thy seat
 A humble heart—— *[Kneeling.]*
Caesar. I must prevent thee, Cimber. 35
 These couchings° and these lowly courtesies
 Might fire the blood of ordinary men,
 And turn preordinance and first decree
 Into the law of children.° Be not fond,°
 To think that Caesar bears such rebel blood 40
 That will be thawed from the true quality
 With that which melteth fools—I mean sweet words,
 Low-crookèd° curtsies, and base spaniel fawning.
 Thy brother by decree is banished.
 If thou dost bend and pray and fawn for him, 45
 I spurn thee like a cur out of my way.

18. **makes to:** goes toward. 29. **addressed:** ready. 33. **puissant** (pwĭs′ənt): powerful. 36. **couchings:** low bowings.
38–39. **And . . . children:** and turn established laws (preordinance) and penalties (first decree) into laws or rules that
change at whim. 39. **fond:** foolish. 43. **Low-crookèd:** low-bending.

Know, Caesar doth not wrong, nor without cause
 Will he be satisfied.
Metellus. Is there no voice more worthy than my own,
 To sound more sweetly in great Caesar's ear 50
 For the repealing of my banished brother?
Brutus. I kiss thy hand, but not in flattery, Caesar,
 Desiring thee that Publius Cimber may
 Have an immediate freedom of repeal.
Caesar. What, Brutus!
Cassius. Pardon, Caesar, Caesar, pardon. 55
 As low as to thy foot doth Cassius fall,
 To beg enfranchisement° for Publius Cimber.
Caesar. I could be well moved, if I were as you.
 If I could pray to move, prayers would move me;
 But I am constant as the Northern Star, 60
 Of whose true-fixed and resting quality
 There is no fellow in the firmament.°
 The skies are painted with unnumbered sparks,
 They are all fire, and every one doth shine,
 But there's but one in all doth hold his place. 65
 So in the world. 'Tis furnished well with men,
 And men are flesh and blood, and apprehensive;°
 Yet in the number I do know but one
 That unassailable holds on his rank,
 Unshaked of motion. And that I am he, 70
 Let me a little show it, even in this,
 That I was constant Cimber should be banished,
 And constant do remain to keep him so.
Cinna. O Caesar——
Caesar. Hence! Wilt thou lift up Olympus?°
Decius. Great Caesar——
Caesar. Doth not Brutus bootless° kneel? 75
Casca. Speak, hands, for me!

[Casca *first, then the other conspirators and* Marcus Brutus *stab* Caesar.]

Caesar. *Et tu, Brute?*° Then fall, Caesar! [*Dies.*]
Cinna. Liberty! Freedom! Tyranny is dead!
 Run hence, proclaim, cry it about the streets.

57. **enfranchisement:** restoration of rights as a citizen. 62. **no . . . firmament:** no equal in the heavens. 67. **apprehensive:** capable of thought and feeling. 74. **Olympus:** a mountain in Greece, the legendary home of the gods. 75. **bootless:** in vain. 77. **Et tu, Brute?** (brōō´tā): Latin for "And you (too), Brutus?"

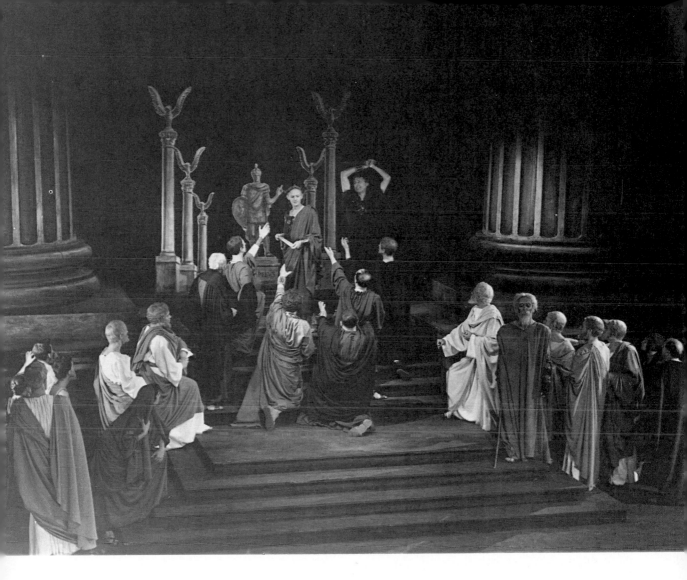

Cassius. Some to the common pulpits, and cry out 80
 "Liberty, freedom, and enfranchisement!"
Brutus. People, and Senators, be not affrighted.
 Fly not, stand still. Ambition's debt is paid.
Casca. Go to the pulpit, Brutus.
Decius. And Cassius too.
Brutus. Where's Publius?° 85
Cinna. Here, quite confounded° with this mutiny.
Metellus. Stand fast together, lest some friend of Caesar's
 Should chance——

85. **Publius:** an elderly senator; not Publius Cimber who is in exile. 86. **confounded:** confused.

Brutus. Talk not of standing. Publius, good cheer.

There is no harm intended to your person,

Nor to no Roman else. So tell them, Publius. 90

Cassius. And leave us, Publius, lest that the people

Rushing on us should do your age some mischief.

Brutus. Do so, and let no man abide° this deed

But we the doers.

[*Reenter* Trebonius.]

Cassius. Where is Antony? 95

Trebonius. Fled to his house amazed.

Men, wives, and children stare, cry out, and run

As it were Doomsday.

Brutus. Fates, we will know your pleasures.

That we shall die, we know; 'tis but the time,

And drawing days out, that men stand upon.° 100

Casca. Why, he that cuts off twenty years of life

Cuts off so many years of fearing death.

Brutus. Grant that, and then is death a benefit.

So are we Caesar's friends that have abridged

His time of fearing death. Stoop, Romans, stoop, 105

And let us bathe our hands in Caesar's blood

Up to the elbows, and besmear our swords.

Then walk we forth, even to the market place,

And waving our red weapons o'er our heads,

Let's all cry "Peace, freedom, and liberty!" 110

Cassius. Stoop then, and wash. How many ages hence

Shall this our lofty scene be acted over

In states unborn and accents yet unknown!

Brutus. How many times shall Caesar bleed in sport,

That now on Pompey's basis lies along° 115

No worthier than the dust!

Cassius. So oft as that shall be,

So often shall the knot of us be called

The men that gave their country liberty.

Decius. What, shall we forth?

Cassius. Aye, every man away.

Brutus shall lead, and we will grace his heels 120

With the most boldest and best hearts of Rome.

94. **abide:** pay the penalty for. 100. **stand upon:** worry about. 115. **Pompey's . . . along:** lies stretched out on the base of Pompey's statue.

Brutus. Soft! Who comes here? A friend of Antony's.

Servant. Thus, Brutus, did my master bid me kneel,
 Thus did Mark Antony bid me fall down,
 And, being prostrate, thus he bade me say: 125
 Brutus is noble, wise, valiant, and honest,
 Caesar was mighty, bold, royal, and loving.
 Say I love Brutus and I honor him,
 Say I feared Caesar, honored him, and loved him.
 If Brutus will vouchsafe° that Antony 130
 May safely come to him and be resolved°
 How Caesar hath deserved to lie in death,
 Mark Antony shall not love Caesar dead
 So well as Brutus living, but will follow
 The fortunes and affairs of noble Brutus 135
 Thorough° the hazards of this untrod state
 With all true faith. So says my master Antony.

Brutus. Thy master is a wise and valiant Roman—
 I never thought him worse.
 Tell him, so please him come unto this place, 140
 He shall be satisfied and, by my honor,
 Depart untouched.

Servant. I'll fetch him presently.° [*Exit.*]

Brutus. I know that we shall have him well to friend.°

Cassius. I wish we may, but yet have I a mind
 That fears him much, and my misgiving still 145
 Falls shrewdly to the purpose.°

[*Reenter* Antony.]

Brutus. But here comes Antony. Welcome, Mark Antony.

Antony. O mighty Caesar, dost thou lie so low?
 Are all thy conquests, glories, triumphs, spoils,
 Shrunk to this little measure? Fare thee well. 150
 I know not, gentlemen, what you intend,
 Who else must be let blood, who else is rank.°
 If I myself, there is no hour so fit
 As Caesar's death's hour, nor no instrument

130. **vouchsafe:** permit. 131. **resolved:** convinced. 136. **Thorough:** through. 142. **presently:** immediately. 143. **well to friend:** as a good friend. 145–146. **my misgiving . . . purpose:** my worries are usually justified. 152. **rank:** in need of bleeding to cure an illness.

Of half that worth as those your swords, made rich 155
With the most noble blood of all this world.
I do beseech ye, if you bear me hard,
Now, whilst your purpled hands do reek and smoke,
Fulfill your pleasure. Live a thousand years,
I shall not find myself so apt to die. 160
No place will please me so, no mean° of death,
As here by Caesar, and by you cut off,
The choice and master spirits of this age.

Brutus. O Antony, beg not your death of us.
Though now we must appear bloody and cruel, 165
As by our hands and this our present act
You see we do. Yet see you but our hands
And this the bleeding business they have done.
Our hearts you see not. They are pitiful,
And pity to the general wrong of Rome— 170
As fire drives out fire, so pity pity—
Hath done this deed on Caesar. For your part,
To you our swords have leaden° points, Mark Antony.
Our arms in strength of malice,° and our hearts
Of brothers' temper, do receive you in 175
With all kind love, good thoughts, and reverence.

Cassius. Your voice shall be as strong as any man's
In the disposing of new dignities.°

Brutus. Only be patient till we have appeased
The multitude, beside themselves with fear, 180
And then we will deliver you the cause
Why I, that did love Caesar when I struck him,
Have thus proceeded.

Antony. I doubt not of your wisdom.
Let each man render me his bloody hand.
First, Marcus Brutus, will I shake with you. 185
Next, Caius Cassius, do I take your hand.
Now, Decius Brutus, yours, now yours, Metellus;
Yours, Cinna, and, my valiant Casca, yours—
Though last, not least in love, yours, good Trebonius.
Gentlemen all—alas, what shall I say? 190
My credit° now stands on such slippery ground
That one of two bad ways you must conceit° me,
Either a coward or a flatterer.
That I did love thee, Caesar, oh, 'tis true.

161. **mean:** means, method. 173. **leaden:** blunt. 174. **in . . . malice:** with power to hurt you. 178. **disposing . . . dignities:** deciding who should hold high public office. 191. **credit:** reputation. 192. **conceit:** think of.

If then thy spirit look upon us now, 195
Shall it not grieve thee dearer than thy death
To see thy Antony making his peace,
Shaking the bloody fingers of thy foes,
Most noble! in the presence of thy corse?° 200
Had I as many eyes as thou hast wounds,
Weeping as fast as they stream forth thy blood,
It would become me better than to close
In terms of friendship with thine enemies.
Pardon me, Julius! Here wast thou bayed,° brave hart,°
Here didst thou fall, and here thy hunters stand, 205
Signed in thy spoil° and crimsoned in thy lethe.°
O world, thou wast the forest to this hart,
And this, indeed, O world, the heart of thee.
How like a deer strucken by many princes
Dost thou here lie! 210
Cassius. Mark Antony——
Antony. Pardon me, Caius Cassius.
The enemies of Caesar shall say this;
Then, in a friend, it is cold modesty.
Cassius. I blame you not for praising Caesar so,
But what compact mean you to have with us? 215
Will you be pricked in number° of our friends,
Or shall we on, and not depend on you?
Antony. Therefore I took your hands, but was indeed
Swayed from the point by looking down on Caesar.
Friends am I with you all and love you all, 220
Upon this hope that you shall give me reasons
Why and wherein Caesar was dangerous.
Brutus. Or else were this a savage spectacle.
Our reasons are so full of good regard
That were you, Antony, the son of Caesar, 225
You should be satisfied.
Antony. That's all I seek.
And am moreover suitor that I may
produce his body to the market place,
And in the pulpit, as becomes a friend,
Speak in the order of his funeral. 230
Brutus. You shall, Mark Antony.
Cassius. Brutus, a word with you.
[*Aside to* Brutus] You know not what you do. Do not consent

199. **corse:** corpse. 204. **bayed:** brought to bay, surrounded by hounds. **hart:** deer. 206. **Signed . . . spoil:** stained with your slaughter. **lethe:** blood, death. 216. **pricked in number:** marked in the list, counted on.

That Antony speak in his funeral.
Know you how much the people may be moved
By that which he will utter?
Brutus. By your pardon, 235
I will myself into the pulpit first,
And show the reason of our Caesar's death.
What Antony shall speak, I will protest
He speaks by leave and by permission,
And that we are contented Caesar shall 240
Have all true rites and lawful ceremonies.
It shall advantage more than do us wrong.
Cassius. I know not what may fall. I like it not.
Brutus. Mark Antony, here, take you Caesar's body.
You shall not in your funeral speech blame us, 245
But speak all good you can devise of Caesar,
And say you do 't by our permission.
Else shall you not have any hand at all
About his funeral. And you shall speak
In the same pulpit whereto I am going— 250
After my speech is ended.
Antony. Be it so.
I do desire no more.
Brutus. Prepare the body then, and follow us.

> [*Exeunt all but* Antony, *who looks down at* Caesar's *body.*]

Antony. O, pardon me, thou bleeding piece of earth,
That I am meek and gentle with these butchers! 255
Thou art the ruins of the noblest man
That ever livèd in the tide of times.
Woe to the hand that shed this costly blood!
Over thy wounds now do I prophesy,
Which like dumb mouths do ope their ruby lips 260
To beg the voice and utterance of my tongue,
A curse shall light upon the limbs of men.
Domestic fury and fierce civil strife
Shall cumber° all the parts of Italy.
Blood and destruction shall be so in use, 265
And dreadful objects so familiar,
That mothers shall but smile when they behold
Their infants quartered° with the hands of war,
All pity choked with custom of fell° deeds.
And Caesar's spirit ranging for revenge, 270

264. **cumber:** encumber, weigh down. 268. **quartered:** torn apart. 269. **fell:** cruel.

With Até° by his side come hot from Hell,
Shall in these confines with a monarch's voice
Cry "Havoc,"° and let slip the dogs of war,
That this foul deed shall smell above the earth
With carrion men, groaning for burial. 275

[*Enter a* Servant.]

 You serve Octavius Caesar,° do you not?
Servant. I do, Mark Antony.
Antony. Caesar did write for him to come to Rome.
Servant. He did receive his letters and is coming,
 And bid me say to you by word of mouth—— 280
 [*Seeing the body*] O Caesar!
Antony. Thy heart is big. Get thee apart and weep.
 Passion, I see, is catching, for mine eyes,
 Seeing those beads of sorrow stand in thine,
 Began to water. Is thy master coming? 285
Servant. He lies tonight within seven leagues of Rome.
Antony. Post° back with speed, and tell him what hath chanced.
 Here is a mourning Rome, a dangerous Rome,
 No Rome of safety for Octavius yet.
 Hie hence, and tell him so. Yet stay awhile. 290
 Thou shalt not back till I have borne this corse
 Into the market place. There shall I try,°
 In my oration, how the people take
 The cruel issue° of these bloody men,
 According to the which, thou shalt discourse 295
 To young Octavius of the state of things.
 Lend me your hand. [*Exeunt with* Caesar's *body.*]

Scene 2

[*The Forum. Enter* Brutus *and* Cassius, *and a throng of* Citizens, *disturbed by the death of*
 Caesar.]

Citizens. We will be satisfied. Let us be satisfied.
Brutus. Then follow me, and give me audience, friends.
 Cassius, go you into the other street,

271. **Até:** Greek goddess of vengeance and strife. 273. **"Havoc":** a signal for general slaughter, meaning that no
prisoners be taken but all enemies killed. 276. **Octavius Caesar:** the grandson of Caesar's sister, adopted by Caesar as
his official heir. 287. **Post:** ride. 292. **try:** test, find out. 294. **issue:** action, deed.

And part the numbers.°
Those that will hear me speak, let 'em stay here, 5
Those that will follow Cassius, go with him,
And public reasons shall be rendered
Of Caesar's death.
First Citizen. I will hear Brutus speak.
Second Citizen. I will hear Cassius, and compare their reasons
When severally° we hear them rendered. [*Exit* Cassius, *with some of the* Citizens.] 10

[Brutus *goes into the pulpit.*]

Third Citizen. The noble Brutus is ascended. Silence!
Brutus. Be patient till the last.
 Romans, countrymen, and lovers! Hear me for my cause, and be silent, that you may
 hear. Believe me for mine honor, and have respect to mine honor, that you may
 believe. Censure° me in your wisdom, and awake your senses, that you may the better 15
 judge. If there be any in this assembly, any dear friend of Caesar's, to him I say that
 Brutus' love to Caesar was no less than his. If then that friend demand why Brutus
 rose against Caesar, this is my answer—not that I loved Caesar less, but that I loved
 Rome more. Had you rather Caesar were living, and die all slaves, than that Caesar
 were dead, to live all freemen? As Caesar loved me, I weep for him; as he was 20
 fortunate, I rejoice at it; as he was valiant, I honor him. But as he was ambitious, I slew
 him. There is tears for his love, joy for his fortune, honor for his valor, and death
 for his ambition. Who is here so base that would be a bondman?° If any, speak, for
 him have I offended. Who is here so rude° that would not be a Roman? If any, speak,
 for him have I offended. Who is here so vile that will not love his country? If 25
 any, speak, for him have I offended. I pause for a reply.
All. None, Brutus, none.
Brutus. Then none have I offended. I have done no more to Caesar than you shall do to
 Brutus. The question of his death is enrolled in the Capitol,° his glory not extenuated,°
 wherein he was worthy, nor his offenses enforced,° for which he suffered death. 30

[*Enter* Antony *and others, with* Caesar's *body.*]

 Here comes his body, mourned by Mark Antony, who, though he had no hand in his
 death, shall receive the benefit of his dying, a place in the commonwealth—as which
 of you shall not? With this I depart—that, as I slew my best lover for the good of
 Rome, I have the same dagger for myself when it shall please my country to need my
 death. 35

4. **part the numbers:** divide the crowd. 10. **severally:** separately. 15. **Censure:** judge. 23. **bondman:** slave. 24.
rude: uncivilized. 29. **The question . . . Capitol:** The reasons for Caesar's death are written in the public ar-
chives. **extenuated:** belittled. 30. **enforced:** exaggerated.

All. Live, Brutus! Live, live!

First Citizen. Bring him with triumph home unto his house.

Second Citizen. Give him a statue with his ancestors.

Third Citizen. Let him be Caesar.

Fourth Citizen. Caesar's better parts

Shall be crowned in Brutus. 40

First Citizen. We'll bring him to his house with shouts and clamors.

Brutus. My countrymen——

Second Citizen. Peace! Silence! Brutus speaks.

First Citizen. Peace, ho!

Brutus. Good countrymen, let me depart alone,

And, for my sake, stay here with Antony. 45

Do grace to Caesar's corpse, and grace his speech

Tending to Caesar's glories, which Mark Antony

By our permission is allowed to make.

I do entreat you, not a man depart,

Save I alone, till Antony have spoke. [*Exit.*] 50

First Citizen. Stay, ho, and let us hear Mark Antony!

Third Citizen. Let him go up into the public chair.

We'll hear him. Noble Antony, go up.

Antony. For Brutus' sake, I am beholding° to you.

[*Goes into the pulpit.*]

Fourth Citizen. What does he say of Brutus?

Third Citizen. He says, for Brutus' sake, 55

He finds himself beholding to us all.

Fourth Citizen. 'Twere best he speak no harm of Brutus here.

First Citizen. This Caesar was a tyrant.

Third Citizen. Nay, that's certain.

We are blest that Rome is rid of him.

Second Citizen. Peace! Let us hear what Antony can say. 60

Antony. You gentle Romans——

All. Peace, ho! Let us hear him.

Antony. Friends, Romans, countrymen, lend me your ears.

I come to bury Caesar, not to praise him.

The evil that men do lives after them,

The good is oft interrèd° with their bones. 65

So let it be with Caesar. The noble Brutus

Hath told you Caesar was ambitious.

If it were so, it was a grievous fault.

54. **beholding:** indebted. 65. **interrèd:** buried.

And grievously hath Caesar answered it.
Here, under leave of Brutus and the rest— 70
For Brutus is an honorable man,
So are they all, all honorable men—
Come I to speak in Caesar's funeral.
He was my friend, faithful and just to me.
But Brutus says he was ambitious, 75
And Brutus is an honorable man.
He hath brought many captives home to Rome,
Whose ransoms did the general coffers° fill.
Did this in Caesar seem ambitious?

78. **general coffers:** public treasury.

When that the poor have cried, Caesar hath wept— 80
Ambition should be made of sterner stuff.
Yet Brutus says he was ambitious,
And Brutus is an honorable man.
You all did see that on the Lupercal
I thrice presented him a kingly crown, 85
Which he did thrice refuse. Was this ambition?
Yet Brutus says he was ambitious,
And, sure, he is an honorable man.
I speak not to disprove what Brutus spoke,
But here I am to speak what I do know. 90
You all did love him once, not without cause.
What cause withholds you then to mourn for him?
O judgment, thou art fled to brutish beasts,
And men have lost their reason! Bear with me,
My heart is in the coffin there with Caesar, 95
And I must pause till it come back to me.

First Citizen. Methinks there is much reason in his sayings.

Second Citizen. If thou consider rightly of the matter,
Caesar has had great wrong.

Third Citizen. Has he, masters?
I fear there will a worse come in his place. 100

Fourth Citizen. Marked ye his words? He would not take the crown,
Therefore 'tis certain he was not ambitious.

First Citizen. If it be found so, some will dear abide it.°

Second Citizen. Poor soul! His eyes are red as fire with weeping.

Third Citizen. There's not a nobler man in Rome than Antony. 105

Fourth Citizen. Now mark him, he begins again to speak.

Antony. But yesterday the word of Caesar might
Have stood against the world. Now lies he there,
And none so poor to do him reverence.°
O masters, if I were disposed to stir 110
Your hearts and minds to mutiny and rage,
I should do Brutus wrong and Cassius wrong,
Who, you all know, are honorable men.
I will not do them wrong; I rather choose
To wrong the dead, to wrong myself and you, 115
Than I will wrong such honorable men.
But here's a parchment with the seal of Caesar—
I found it in his closet—'tis his will.
Let but the commons hear this testament—

103. **dear abide it:** pay for it dearly. 109. **And . . . reverence:** And you think that honoring Caesar is beneath your dignity.

Which, pardon me, I do not mean to read— 120
And they would go and kiss dead Caesar's wounds
And dip their napkins° in his sacred blood,
Yea, beg a hair of him for memory,
And, dying, mention it within their wills,
Bequeathing it as a rich legacy 125
Unto their issue.°

Fourth Citizen. We'll hear the will. Read it, Mark Antony.

All. The will, the will! We will hear Caesar's will.

Antony. Have patience, gentle friends. I must not read it.
It is not meet you know how Caesar loved you. 130
You are not wood, you are not stones, but men;
And, being men, hearing the will of Caesar,
It will inflame you, it will make you mad
'Tis good you know not that you are his heirs,
For if you should, oh, what would come of it! 135

Fourth Citizen. Read the will. We'll hear it, Antony.
You shall read us the will, Caesar's will.

Antony. Will you be patient? Will you stay awhile?
I have o'ershot myself to tell you of it.
I fear I wrong the honorable men 140
Whose daggers have stabbed Caesar. I do fear it.

Fourth Citizen. They were traitors—honorable men!

All. The will! The testament!

Second Citizen. They were villains, murderers. The will! Read the will.

Antony. You will compel me then to read the will? 145
Then make a ring about the corpse of Caesar.
And let me show you him that made the will.
Shall I descend? And will you give me leave?

All. Come down.

Second Citizen. Descend. 150

[*He comes down from the pulpit.*]

Third Citizen. You shall have leave.

Fourth Citizen. A ring. Stand round.

First Citizen. Stand from the hearse, stand from the body.

Second Citizen. Room for Antony, most noble Antony.

Antony. Nay, press not so upon me. Stand far off. 155

All. Stand back. Room! Bear back.

Antony. If you have tears, prepare to shed them now.

122. **napkins:** handkerchiefs. 126. **issue:** children.

You all do know this mantle. I remember
The first time ever Caesar put it on.
'Twas on a summer's evening, in his tent, 160
That day he overcame the Nervii.°
Look, in this place ran Cassius' dagger through.
See what a rent the envious Casca made.
Through this the well-belovèd Brutus stabbed,
And as he plucked his cursèd steel away, 165
Mark how the blood of Caesar followed it,
As rushing out of doors, to be resolved
If Brutus so unkindly knocked, or no.
For Brutus, as you know, was Caesar's angel.
Judge, O you gods, how dearly Caesar loved him! 170
This was the most unkindest cut of all,
For when the noble Caesar saw him stab,
Ingratitude, more strong than traitors' arms,
Quite vanquished him. Then burst his mighty heart,
And, in his mantle muffling up his face, 175
Even at the base of Pompey's statuë,
Which all the while ran blood, great Caesar fell.
Oh, what a fall was there, my countrymen!
Then I, and you, and all of us fell down,
Whilst bloody treason flourished over us. 180
Oh, now you weep, and I perceive you feel
The dint° of pity. These are gracious drops.
Kind souls, what weep you when you but behold
Our Caesar's vesture wounded?° Look you here—
Here is himself, marred, as you see, with traitors. 185

[*He pulls the cloak off* Caesar's *body.*]

First Citizen. Oh, piteous spectacle!
Second Citizen. Oh, noble Caesar!
Third Citizen. Oh, woeful day!
Fourth Citizen. Oh, traitors, villains!
First Citizen. Oh, most bloody sight! 190
Second Citizen. We will be revenged.
All. Revenge! About! Seek! Burn! Fire! Kill! Slay!
 Let not a traitor live!
Antony. Stay, countrymen.
First Citizen. Peace there! Hear the noble Antony. 195

161. **Nervii:** fierce tribe in Belgium, conquered in 57 B.C. 182. **dint:** blow. 184. **vesture wounded:** clothing torn.

Second Citizen. We'll hear him, we'll follow him, we'll die with him.
Antony. Good friends, sweet friends, let me not stir you up
 To such a sudden flood of mutiny.
 They that have done this deed are honorable.
 What private griefs they have, alas, I know not, 200
 That made them do it. They are wise and honorable,
 And will, no doubt, with reasons answer you.
 I come not, friends, to steal away your hearts.
 I am no orator, as Brutus is,
 But, as you know me all, a plain blunt man 205
 That love my friend; and that they know full well
 That gave me public leave to speak of him.
 For I have neither wit, nor words, nor worth,
 Action, nor utterance, nor the power of speech,

To stir men's blood. I only speak right on, 210
I tell you that which you yourselves do know,
Show you sweet Caesar's wounds, poor poor dumb mouths,
And bid them speak for me. But were I Brutus,
And Brutus Antony, there were an Antony
Would ruffle up your spirits, and put a tongue 215
In every wound of Caesar that should move
The stones of Rome to rise and mutiny.

All. We'll mutiny.

First Citizen. We'll burn the house of Brutus.

Third Citizen. Away, then! Come, seek the conspirators. 220

Antony. Yet hear me, countrymen, yet hear me speak.

All. Peace, ho! Hear Antony. Most noble Antony!

Antony. Why, friends, you go to do you know not what.
 Wherein hath Caesar thus deserved your loves?
 Alas, you know not. I must tell you, then— 225
 You have forgot the will I told you of.

All. Most true, the will! Let's stay and hear the will.

Antony. Here is the will, and under Caesar's seal.
 To every Roman citizen he gives,
 To every several° man, seventy-five drachmas.° 230

Second Citizen. Most noble Caesar! We'll revenge his death.

Third Citizen. Oh, royal Caesar!

Antony. Hear me with patience.

All. Peace, ho!

Antony. Moreover, he hath left you all his walks, 235
 His private arbors and new-planted orchards.
 On this side Tiber. He hath left them you,
 And to your heirs forever—common pleasures,
 To walk abroad and recreate yourselves.
 Here was a Caesar! When comes such another? 240

First Citizen. Never, never. Come, away, away!
 We'll burn his body in the holy place,
 And with the brands fire the traitors' houses.
 Take up the body.

Second Citizen. Go fetch fire. 245

Third Citizen. Pluck down benches.

Fourth Citizen. Pluck down forms, windows,° anything.

[*Exeunt* Citizens *with the body.*]

Antony. Now let it work. Mischief, thou art afoot,
 Take thou what course thou wilt.

230. **several:** individual. **drachmas:** Greek silver coins. 247. **forms, windows:** benches and shutters.

[Enter a Servant.]

How now, fellow!

Servant. Sir, Octavius is already come to Rome. 250

Antony. Where is he?

Servant. He and Lepidus° are at Caesar's house.

Antony. And thither will I straight to visit him.
 He comes upon a wish.° Fortune is merry,
 And in this mood will give us anything. 255

Servant. I heard him say Brutus and Cassius
 Are rid like madmen through the gates of Rome.

Antony. Belike° they had some notice of the people,
 How I had moved them. Bring me to Octavius. *[Exeunt.]*

Scene 3

[A street. Enter Cinna *the poet.]*

Cinna. I dreamt tonight that I did feast with Caesar,
 And things unluckily charge my fantasy.°
 I have no will to wander forth of doors,
 Yet something leads me forth.

[A mob of Citizens, *armed with sticks, spears, and swords, enters and surrounds him.]*

First Citizen. What is your name? 5

Second Citizen. Whither are you going?

Third Citizen. Where do you dwell?

Fourth Citizen. Are you a married man or a bachelor?

Second Citizen. Answer every man directly.

First Citizen. Aye, and briefly. 10

Fourth Citizen. Aye, and wisely.

Third Citizen. Aye, and truly, you were best.

Cinna. What is my name? Whither am I going? Where do I dwell? Am I a married man
 or a bachelor? Then, to answer every man directly and briefly, wisely and truly, wisely
 I say I am a bachelor. 15

Second Citizen. That's as much as to say they are fools that marry. You'll bear me a bang°
 for that, I fear. Proceed, directly.

Cinna. Directly, I am going to Caesar's funeral.

First Citizen. As a friend or an enemy?

252. **Lepidus:** one of Caesar's generals and one of the three chief leaders of Caesar's party. 254. **upon a wish:** just
when I wanted him. 258. **Belike:** probably.
 2. **unluckily charge my fantasy:** ominously fill my imagination. 16. **bear me a bang:** get a wallop from me.

Cinna. As a friend. 20

Second Citizen. That matter is answered directly.

Fourth Citizen. For your dwelling, briefly.

Cinna. Briefly, I dwell by the Capitol.

Third Citizen. Your name, sir, truly.

Cinna. Truly, my name is Cinna. 25

First Citizen. Tear him to pieces. He's a conspirator.

Cinna. I am Cinna the poet, I am Cinna the poet.

Fourth Citizen. Tear him for his bad verses, tear him for his bad verses.

Cinna. I am not Cinna the conspirator.

Fourth Citizen. It is no matter, his name's Cinna. Pluck but his name out of his heart, and 30
turn him going.

Third Citizen. Tear him, tear him! Come, brands. Ho, firebrands—to Brutus', to Cassius'!
Burn all. Some to Decius' house, and some to Casca's, some to Ligarius'. Away, go!

[Exeunt.]

Reading Check

1. Why does Caesar push aside the paper Artemidorus asks him to read?
2. Who is the first conspirator to strike Caesar?
3. Why does Antony shake hands with the conspirators?
4. What two requests does Antony make of Brutus?
5. What prediction does Antony make about the consequences of Caesar's death?
6. Why does Antony send word to Octavius?
7. What does Brutus give the citizens as his reason for killing Caesar?
8. According to Antony, what are the terms of Caesar's will?
9. What news does Antony receive of Brutus and Cassius?
10. What does the mob do in revenge for Caesar's death?

For Study and Discussion

Analyzing and Interpreting the Play

1. You have seen Caesar three times onstage and heard many characters talk about him. **a.** What is your opinion of him? **b.** Is he likable?

2a. What are Caesar's dying words? **b.** How did you feel as these words were spoken?

3a. Describe the mood of the conspirators immediately after the assassination. **b.** What is the idea they claim to have killed?

4. In lines 116–118 of Scene 1, what side of Cassius' character is seen for the first time?

5. With Caesar murdered, Antony's position is perilous. Look carefully at his words in Scene 1. **a.** What impression does he wish to give the conspirators? **b.** Where in the scene do you learn how he really feels?

6. Cassius' loyalty to Brutus, like his resentment of Caesar, is personal. Does Brutus have any personal loyalties? Explain your answer.

7. Notice that Brutus' speech in Scene 2 is in prose whereas Antony's is in verse. **a.** How does Brutus' speech show that he addresses himself more to the citizens' reason than to their emotions? **b.** What values does he assume the citizens cherish?

8. Which remarks by the citizens show that they have not understood Brutus at all?

9a. What does Antony say in his speech to make the crowd feel (a) sorry for him? (b) guilty about having thought Caesar a tyrant? (c) angry at the conspirators? **b.** What props does he use to produce these reactions?

10. By the end of Scene 2, whose personal leadership has replaced Caesar's?

11. What does Scene 3 show about the nature of a mob?

12a. In what way is Scene 3 humorous? **b.** Does the use of humor increase or lessen the horror of the mob's attack on an innocent man? Explain your answer.

Literary Elements

Dramatic Structure: Plot

Act One of *Julius Caesar* presents the basic conflict of the play, the conflict between Caesar and his party and a group of dissatisfied citizens who either resent or fear Caesar's great power. This conflict is obvious from the first scene between the tribunes, Flavius and Marullus, and the citizens who are celebrating Caesar's triumph. Most of the major characters are presented in this act. Because this act ex-

poses or sets forth the problem in the play, we say it contains the **exposition.**

Acts Two and Three constitute the **rising action** of the play, which means the action that leads us to the **turning point,** the crisis of the play, when the fate of the hero is sealed. Brutus joins the dissatisfied citizens, a full-scale conspiracy is planned, and Caesar is assassinated. All of these complications come finally to the turning point. In Shakespeare's plays, the turning point almost always takes place in the third act, and *Julius Caesar* is no exception. Here, in Act Three, it is decided that Mark Antony will *not* be assassinated, but that he will be allowed to deliver a funeral oration for his dead friend. Find the moment when this fact becomes clear. This marks the turning point of the play because in this decision lie the seeds of destruction for the conspirators. We know now that Caesar's power will be passed on not to the high-minded and naive Brutus, but to the shrewd and revengeful Antony and those who join him.

Acts Four and Five will constitute the **falling action** of the play. Watch for a reversal of roles and the final inevitable catastrophe.

Irony

When Antony in his famous funeral oration for Caesar says one thing and means something else ("Brutus is an honorable man"), he is using **verbal irony.** Antony's words are ironic rather than deceptive, because his true meaning is clear to his audience.

Another type of irony is **irony of situation.** This occurs when a situation turns out differently from the way we expect it to turn out. Brutus expects that Antony will not blame the conspirators in his oration. Ironically, while Antony does not literally break his promise to Brutus, the result of his speech is the same as if he had.

A third type of irony is **dramatic irony.** Dramatic irony occurs in a story or play when the reader or audience has a better understanding of what is going on than the individual characters do. When Caesar calls the conspirators "good friends" near the end of Scene 2 in Act Two, we in the audience find this ironic, even though Caesar means exactly what he says. We know better than he does how "good" his friends are.

Tell why the following passages are ironic:

Brutus. And for Mark Antony, think not of him,
For he can do no more than Caesar's arm
When Caesar's head is off.

(II, 1, 181–183)

Antony. I come to bury Caesar, not to praise him.
(III, 2, 63)

Antony. O masters, if I were disposed to stir
Your hearts and minds to mutiny and rage,
I should do Brutus wrong and Cassius wrong,
Who, you all know, are honorable men.
I will not do them wrong . . .

(III, 2, 110–114)

Focus on Persuasive Writing

Appealing to Emotion

Antony succeeds in turning the crowd against Caesar's assassins because his powerful speech appeals to his listeners' emotions: grief, love, hatred, and gratitude. Brutus' speech, by contrast, is somewhat dry and analytical.

Emotional appeals in persuasion are especially effective when they include specific examples or personal experiences: see, for example, Antony's words about the crown (III, 2, 84–86) and his memories about Caesar's mantle (III, 2, 158–161).

Write an **opinion statement** of one or two sentences on an issue that is important to you. Then jot down notes for two or three emotional appeals you could make in a speech to support your opinion. Compare notes with a partner. Save your writing.

Act Four

Scene 1

[*A house in Rome.* Antony, Octavius, *and* Lepidus, *seated at a table.*]

Antony. These many then shall die, their names are pricked.°
Octavius. Your brother too must die. Consent you, Lepidus?
Lepidus. I do consent.
Octavius. Prick him down, Antony.
Lepidus. Upon condition Publius shall not live,
 Who is your sister's son, Mark Antony. 5
Antony. He shall not live. Look, with a spot I damn him.
 But, Lepidus, go you to Caesar's house.
 Fetch the will hither, and we shall determine
 How to cut off some charge in legacies.°
Lepidus. What, shall I find you here? 10
Octavius. Or here or at the Capitol. [*Exit* Lepidus.]
Antony. This is a slight unmeritable man,
 Meet to be sent on errands. Is it fit,
 The threefold world divided, he should stand
 One of the three to share it?
Octavius. So you thought him. 15
 And took his voice who should be pricked to die
 In our black sentence and proscription.°
Antony. Octavius, I have seen more days than you.
 And though we lay these honors on this man,
 To ease ourselves of divers slanderous loads, 20
 He shall but bear them as the ass bears gold,
 To groan and sweat under the business,
 Either led or driven, as we point the way.
 And having brought our treasure where we will,
 Then take we down his load and turn him off, 25
 Like to the empty ass, to shake his ears
 And graze in commons.°
Octavius. You may do your will.
 But he's a tried and valiant soldier.
Antony. So is my horse, Octavius, and for that
 I do appoint him store of provender.° 30

1. **pricked:** marked (on a wax tablet) by punching a hole next to the names. 9. **cut . . . legacies:** reduce the amount of money given in some bequests. 17. **proscription:** accusation of treason, the death list. 27. **in commons:** on public pastures. 30. **store of provender:** supply of food.

It is a creature that I teach to fight,
To wind,° to stop, to run directly on,
His corporal° motion governed by my spirit.
And, in some taste,° is Lepidus but so.
He must be taught, and trained, and bid go forth, 35
A barren-spirited fellow, one that feeds
On abjects, orts,° and imitations,
Which, out of use and staled by other men,
Begin his fashion. Do not talk of him
But as a property.° And now, Octavius, 40
Listen great things. Brutus and Cassius
Are levying powers.° We must straight make head.°
Therefore let our alliance be combined,
Our best friends made, our means stretched,
And let us presently go sit in council 45
How covert matters may be best disclosed,
And open perils surest answered.
Octavius. Let us do so, for we are at the stake,°
And bayed about with many enemies.
And some that smile have in their hearts, I fear, 50
Millions of mischiefs. *[Exeunt.]*

Scene 2

[*A camp near Sardis, in Greece. In front of* Brutus' *tent. A sound of drums. Enter* Brutus,
Lucilius, Lucius, *and* Soldiers. Titinius *and* Pindarus, *from* Cassius' *army, meet them.*
Brutus *halts his men.*]

Brutus. Stand, ho!
Lucilius. Give the word, ho, and stand!
Brutus. What now, Lucilius! Is Cassius near?
Lucilius. He is at hand, and Pindarus is come
To do you salutation from his master. 5
Brutus. He greets me well.° Your master, Pindarus,
In his own change, or by ill officers,°
Hath given me some worthy cause to wish
Things done undone. But if he be at hand,
I shall be satisfied.° 10

32. **wind:** turn. 33. **corporal:** bodily. 34. **in some taste:** to some extent. 37. **abjects, orts:** worthless things, scraps.
40. **property:** tool. 42. **levying powers:** gathering armies. **make head:** make headway. 48. **at the stake:** like a bear
tied to a stake and "bayed about" by dogs.
 6. **greets me well:** sends his greetings with a worthy man. 7. **In . . . officers:** because of some change of heart in
himself or because of the deeds of unworthy subordinates. 10. **be satisfied:** find out the truth.

Pindarus. I do not doubt 10
 But that my noble master will appear
 Such as he is, full of regard and honor.
Brutus. He is not doubted. A word, Lucilius,
 How he received you. Let me be resolved.
Lucilius. With courtesy and with respect enough, 15
 But not with such familiar instances.°
 Nor with such free and friendly conference,
 As he hath used of old.
Brutus. Thou hast described
 A hot friend cooling. Ever note, Lucilius,
 When love begins to sicken and decay, 20
 It useth an enforcèd ceremony.
 There are no tricks in plain and simple faith.
 But hollow men, like horses hot at hand,°
 Make gallant show and promise of their mettle;
 But when they should endure the bloody spur, 25
 They fall their crests° and like deceitful jades°
 Sink in the trial. Comes his army on?
Lucilius. They mean this night in Sardis to be quartered.
 The greater part, the horse in general,°
 Are come with Cassius.

[Low march within.]

Brutus. Hark! He is arrived. 30
 March gently on to meet him.

[Enter Cassius and his army.]

Cassius. Stand, ho!
Brutus. Stand, ho! Speak the word along.
First Soldier. Stand!
Second Soldier. Stand! 35
Third Soldier. Stand!
Cassius. Most noble brother, you have done me wrong.
Brutus. Judge me, you gods! Wrong I mine enemies?
 And if not so, how should I wrong a brother?
Cassius. Brutus, this sober° form of yours hides wrongs, 40
 And when you do them——

16. **familiar instances:** friendly behavior. 23. **hot at hand:** eager before the race begins. 26. **crests:** proud necks. **jades:** worn-out nags. 29. **the horse in general:** all the cavalry. 40. **sober:** composed.

Brutus. Cassius, be content,
 Speak your griefs softly. I do know you well.
 Before the eyes of both our armies here,
 Which should perceive nothing but love from us,
 Let us not wrangle. Bid them move away, 45
 Then in my tent, Cassius, enlarge your griefs,
 And I will give you audience.
Cassius. Pindarus,
 Bid our commanders lead their charges off
 A little from this ground.
Brutus. Lucilius, do you the like, and let no man 50
 Come to our tent till we have done our conference.
 Let Lucius and Titinius guard our door. [*Exeunt.*]

Scene 3

 [*Inside* Brutus' *tent. Enter* Brutus *and* Cassius.]

Cassius. That you have wronged me doth appear in this:
 You have condemned and noted° Lucius Pella
 For taking bribes here of the Sardians,
 Wherein my letters, praying on his side,
 Because I knew the man, were slighted off. 5
Brutus. You wronged yourself to write in such a case.
Cassius. In such a time as this it is not meet
 That every nice offense should bear his comment.°
Brutus. Let me tell you, Cassius, you yourself
 Are much condemned to have an itching palm, 10
 To sell and mart your offices° for gold
 To undeservers.
Cassius. I an itching palm!
 You know that you are Brutus that speaks this,
 Or, by the gods, this speech were else your last.
Brutus. The name of Cassius honors this corruption, 15
 And chastisement doth therefore hide his head.
Cassius. Chastisement!
Brutus. Remember March, the ides of March remember.
 Did not great Julius bleed for justice' sake?
 What villain touched his body that did stab, 20
 And not for justice? What, shall one of us,
 That struck the foremost man of all this world

2. **noted:** publicly disgraced. 7–8. **not meet . . . comment:** not necessary for every trivial offense to be strictly punished. 11. **mart your offices:** trade your services.

But for supporting robbers, shall we now
Contaminate our fingers with base bribes,
And sell the mighty space of our large honors 25
For so much trash as may be graspèd thus?
I had rather be a dog and bay the moon
Than such a Roman.

Cassius. Brutus, bait° not me,
I'll not endure it. You forget yourself,
To hedge me in. I am a soldier, I, 30
Older in practice, abler than yourself
To make conditions.°

Brutus. Go to. You are not, Cassius.

Cassius. I am.

Brutus. I say you are not.

Cassius. Urge me no more, I shall forget myself. 35
Have mind upon your health, tempt me no farther.

Brutus. Away, slight man!

Cassius. Is 't possible?

Brutus. Hear me, for I will speak.
Must I give way and room to your rash choler?°
Shall I be frighted when a madman stares? 40

Cassius. O ye gods, ye gods! Must I endure all this?

Brutus. All this! Aye, more. Fret till your proud heart break.
Go show your slaves how choleric you are,
And make your bondmen tremble. Must I budge?
Must I observe you? Must I stand and crouch 45
Under your testy humor?° By the gods,
You shall digest the venom of your spleen,°
Though it do split you; for, from this day forth,
I'll use you for my mirth, yea, for my laughter,
When you are waspish.

Cassius. Is it come to this? 50

Brutus. You say you are a better soldier.
Let it appear so, make your vaunting° true
And it shall please me well. For mine own part,
I shall be glad to learn of noble men.

Cassius. You wrong me every way, you wrong me, Brutus. 55
I said an elder soldier, not a better.
Did I say better?

Brutus. If you did, I care not.

Cassius. When Caesar lived, he durst° not thus have moved me.

28. **bait:** antagonize. 32. **conditions:** rules. 39. **choler:** anger. 46. **testy humor:** bad temper. 47. **spleen:** rage,
temper. 52. **vaunting:** boasting. 58. **durst:** dared.

Brutus. Peace, peace! You durst not so have tempted him.

Cassius. I durst not! 60

Brutus. No.

Cassius. What, durst not tempt him!

Brutus. For your life you durst not.

Cassius. Do not presume too much upon my love.

 I may do that I shall be sorry for.

Brutus. You have done that you should be sorry for. 65

 There is no terror, Cassius, in your threats,

 For I am armed so strong in honesty

 That they pass by me as the idle wind

 Which I respect not. I did send to you

 For certain sums of gold, which you denied me. 70

 For I can raise no money by vile means—

 By heaven, I had rather coin my heart,

 And drop my blood for drachmas, than to wring

 From the hard hands of peasants their vile trash

 By any indirection.° I did send 75

 To you for gold to pay my legions,

 Which you denied me. Was that done like Cassius?

 Should I have answered Caius Cassius so?

 When Marcus Brutus grows so covetous,

 To lock such rascal counters° from his friends, 80

 Be ready, gods, with all your thunderbolts,

 Dash him to pieces!

Cassius. I denied you not.

Brutus. You did.

Cassius. I did not. He was but a fool

 That brought my answer back. Brutus hath rived° my heart.

 A friend should bear his friend's infirmities. 85

 But Brutus makes mine greater than they are.

Brutus. I do not, till you practice them on me.

Cassius. You love me not.

Brutus. I do not like your faults.

Cassius. A friendly eye could never see such faults.

Brutus. A flatterer's would not, though they do appear 90

 As huge as high Olympus.

Cassius. Come, Antony, and young Octavius, come,

 Revenge yourselves alone° on Cassius,

 For Cassius is aweary of the world—

 Hated by one he loves, braved° by his brother, 95

75. **indirection:** underhanded means. 80. **rascal counters:** filthy coins. 84. **rived:** split. 93. **alone:** only. 95. **braved:** mocked.

Checked like a bondman,° all his faults observed,
Set in a notebook, learned and conned by rote,°
To cast into my teeth. Oh, I could weep
My spirit from mine eyes! There is my dagger,
And here my naked breast; within, a heart 100
Dearer than Plutus' mine,° richer than gold.
If that thou be'st a Roman, take it forth,
I, that denied thee gold, will give my heart.
Strike, as thou didst at Caesar; for I know
When thou didst hate him worst, thou lovedst him better 105
Than ever thou lovedst Cassius.

Brutus. Sheathe your dagger.
Be angry when you will, it shall have scope;°
Do what you will, dishonor shall be humor.°
O Cassius, you are yokèd with a lamb
That carries anger as the flint bears fire, 110
Who, much enforcèd, shows a hasty spark
And straight is cold again.

Cassius. Hath Cassius lived
To be but mirth and laughter to his Brutus,
When grief and blood ill-tempered vexeth him?

Brutus. When I spoke that, I was ill-tempered too. 115

Cassius. Do you confess so much? Give me your hand.

Brutus. And my heart too.

Cassius. O Brutus!

Brutus. What's the matter?

Cassius. Have not you love enough to bear with me
When that rash humor which my mother gave me
Makes me forgetful?

Brutus. Yes, Cassius, and from henceforth, 120
When you are overearnest with your Brutus,
He'll think your mother chides, and leave you so.

Poet. [*Within*] Let me go in to see the generals.
There is some grudge between 'em, 'tis not meet
They be alone. 125

Lucilius. [*Within*] You shall not come to them.

Poet. [*Within*] Nothing but death shall stay me.

[*Enter* Poet, *followed by* Lucilius, Titinius, *and* Lucius.]

96. **Checked like a bondman:** scolded like a slave. 97. **conned by rote:** learned by heart. 101. **Plutus' mine:** Plutus was the Greek god of wealth and precious metals. 107. **scope:** free range. 108. **dishonor . . . humor:** your insults shall be considered just a mood or whim.

Cassius. How now! What's the matter?

Poet. For shame, you generals! What do you mean?
Love and be friends, as two such men should be,　　　　　130
For I have more years, I'm sure, than ye.

Cassius. Ha, ha! How vilely doth this cynic° rhyme!

Brutus. Get you hence, sirrah. Saucy fellow, hence!

Cassius. Bear with him, Brutus. 'Tis his fashion.

Brutus. I'll know his humor when he knows his time.°　　　　　135
What should the wars do with these jigging fools?
Companion,° hence!

Cassius.　　　　　　　　Away, away, be gone!　　　　　[*Exit* Poet.]

Brutus. Lucilius and Titinius, bid the commanders
Prepare to lodge their companions tonight.

Cassius. And come yourselves, and bring Messala with you　　　　　140
Immediately to us.　　　　　　[*Exeunt* Lucilius *and* Titinius.]

Brutus.　　　　　　　　Lucius, a bowl of wine!　　　　　[*Exit* Lucius.]

Cassius. I did not think you could have been so angry.

Brutus. O Cassius, I am sick of many griefs.

Cassius. Of your philosophy you make no use
If you give place to accidental evils.　　　　　145

Brutus. No man bears sorrow better. Portia is dead.

Cassius. Ha! Portia!

Brutus. She is dead.

Cassius. How 'scaped I killing when I crossed you so?
Oh, insupportable and touching loss!　　　　　150
Upon what sickness?

Brutus.　　　　　　　Impatient of my absence,
And grief that young Octavius with Mark Antony
Have made themselves so strong—for with her death
That tidings came—with this she fell distract,°
And, her attendants absent, swallowed fire.　　　　　155

Cassius. And died so?

Brutus.　　　　　　Even so.

Cassius.　　　　　　　　O ye immortal gods!

[*Reenter* Lucius, *with wine and taper.*]

Brutus. Speak no more of her. Give me a bowl of wine.
In this I bury all unkindness, Cassius. [*Drinks.*]

132. **cynic:** ill-mannered fellow.　　135. **I'll . . . time:** I'll be patient with his whims if he knows the right time to speak.　　137.
Companion: fellow, used with contempt.　　154. **distract:** mad.

Cassius. My heart is thirsty for that noble pledge.
 Fill, Lucius, till the wine o'erswell the cup. 160
 I cannot drink too much of Brutus' love. [*Drinks.*]
Brutus. Come in, Titinius! [*Exit* Lucius.]

[*Reenter* Titinius, *with* Messala.]

 Welcome, good Messala.
 Now sit we close about this taper here,
 And call in question our necessities.°
Cassius. Portia, art thou gone?
Brutus. No more, I pray you. 165
 Messala, I have here receivèd letters
 That young Octavius and Mark Antony
 Come down upon us with a mighty power,
 Bending their expedition toward Philippi.°
Messala. Myself have letters of the selfsame tenor. 170
Brutus. With what addition?
Messala. That by proscription and bills of outlawry
 Octavius, Antony, and Lepidus
 Have put to death a hundred Senators.
Brutus. Therein our letters do not well agree. 175
 Mine speak of seventy Senators that died
 By their proscriptions, Cicero being one.
Cassius. Cicero one!
Messala. Cicero is dead,
 And by that order of proscription.
 Had you your letters from your wife, my lord? 180
Brutus. No, Messala.
Messala. Nor nothing in your letters writ of her?
Brutus. Nothing, Messala.
Messala. That, methinks, is strange.
Brutus. Why ask you? Hear you aught of her in yours?
Messala. No, my lord. 185
Brutus. Now, as you are a Roman, tell me true.
Messala. Then like a Roman bear the truth I tell—
 For certain she is dead, and by strange manner.
Brutus. Why, farewell, Portia. We must die, Messala.
 With meditating that she must die once 190
 I have the patience to endure it now.

164. **call . . . necessities:** discuss what must be done. 169. **Philippi:** city in northern Greece.

Messala. Even so great men great losses should endure.

Cassius. I have as much of this in art° as you,
But yet my nature could not bear it so.

Brutus. Well, to our work alive. What do you think 195
Of marching to Philippi presently?

Cassius. I do not think it good.

Brutus. Your reason?

Cassius. This it is:
'Tis better that the enemy seek us.
So shall he waste his means, weary his soldiers,
Doing himself offense, whilst we lying still 200
Are full of rest, defense, and nimbleness.

Brutus. Good reasons must of force give place to better.
The people 'twixt Philippi and this ground
Do stand in a forced affection,
For they have grudged us contribution. 205
The enemy, marching along by them,
By them shall make a fuller number up,
Come on refreshed, new-added, and encouraged.
For which advantage shall we cut him off
If at Philippi we do face him there, 210
These people at our back.

Cassius. Hear me, good brother——

Brutus. Under your pardon. You must note beside
That we have tried the utmost of our friends,
Our legions are brimful, our cause is ripe.
The enemy increaseth every day, 215
We, at the height, are ready to decline.
There is a tide in the affairs of men
Which taken at the flood leads on to fortune;
Omitted, all the voyage of their life
Is bound in shallows and in miseries. 220
On such a full sea are we now afloat,
And we must take the current when it serves,
Or lose our ventures.

Cassius. Then, with your will, go on.
We'll along ourselves and meet them at Philippi.

Brutus. The deep of night is crept upon our talk, 225
And nature must obey necessity,
Which we will niggard° with a little rest.
There is no more to say?

193. **art:** theory, philosophical belief. 227. **niggard:** satisfy reluctantly.

Cassius. No more. Good night.
Early tomorrow will we rise and hence.

Brutus. Lucius! [*Reenter* Lucius.] My gown. [*Exit* Lucius.] Farewell, good Messala. 230
Good night, Titinius. Noble, noble Cassius,
Good night, and good repose.

Cassius. O my dear brother!
This was an ill beginning of the night.
Never come such division 'tween our souls!
Let it not, Brutus.

Brutus. Everything is well. 235

Cassius. Good night, my lord.

Brutus. Good night, good brother.

Titinius *and* **Messala.** Good night, Lord Brutus.

Brutus. Farewell, everyone.

[*Exeunt all but* Brutus.]

[*Reenter* Lucius, *with the gown.*]

Give me the gown. Where is thy instrument?

Lucius. Here in the tent.

Brutus. What, thou speak'st drowsily?
Poor knave,° I blame thee not, thou art o'erwatched.° 240
Call Claudius and some other of my men.
I'll have them sleep on cushions in my tent.

Lucius. Varro and Claudius!

[*Enter* Varro *and* Claudius.]

Varro. Calls my lord?

Brutus. I pray you, sirs, lie in my tent and sleep. 245
It may be I shall raise you by and by
On business to my brother Cassius.

Varro. So please you, we will stand and watch your pleasure.°

Brutus. I will not have it so. Lie down, good sirs.
It may be I shall otherwise bethink me. 250
Look, Lucius, here's the book I sought for so,
I put it in the pocket of my gown.

[Varro *and* Claudius *lie down.*]

Lucius. I was sure your lordship did not give it me.

240. **knave:** servant boy. **o'erwatched:** worn out from too much watching. 248. **watch your pleasure:** await your command.

Brutus. Bear with me, good boy, I am much forgetful.
 Canst thou hold up thy heavy eyes awhile, 255
 And touch thy instrument a strain or two?
Lucius. Aye, my lord, an 't please you.
Brutus. It does, my boy.
 I trouble thee too much, but thou art willing.
Lucius. It is my duty, sir.
Brutus. I should not urge thy duty past thy might— 260
 I know young bloods look for a time of rest.
Lucius. I have slept, my lord, already.
Brutus. It was well done, and thou shalt sleep again,
 I will not hold thee long. If I do live,
 I will be good to thee. 265

[*Music, and a song.* Lucius *falls asleep as he sings.*]

This is a sleepy tune. O murderous slumber,
Lay'st thou thy leaden mace° upon my boy,
That plays thee music? Gentle knave, good night.
I will not do thee so much wrong to wake thee.
If thou dost nod, thou break'st thy instrument, 270
I'll take it from thee, and, good boy, good night.
Let me see, let me see, is not the leaf turned down
Where I left reading? Here it is, I think. [*Sits down and begins to read.*]

[*Enter the* Ghost of Caesar.]

How ill this taper burns! Ha! Who comes here?
I think it is the weakness of mine eyes 275
That shapes this monstrous apparition.
It comes upon me. Art thou anything?
Art thou some god, some angel, or some devil,
That makest my blood cold, and my hair to stare?°
Speak to me what thou art. 280
Ghost. Thy evil spirit, Brutus.
Brutus. Why comest thou?
Ghost. To tell thee thou shalt see me at Philippi.
Brutus. Well, then I shall see thee again?
Ghost. Aye, at Philippi.
Brutus. Why, I will see thee at Philippi then. [*Exit* Ghost.] 285
 Now I have taken heart, thou vanishest.

267. **mace:** club. Morpheus, Greek god of dreams, was said to carry a leaden mace that caused sleep. 279. **stare:** stand up.

Ill spirit, I would hold more talk with thee.
Boy, Lucius! Varro! Claudius! Sirs, awake!
Claudius!

Lucius. [*Sleepily*] The strings, my lord, are false. 290
Brutus. He thinks he still is at his instrument.
Lucius, awake!
Lucius. My lord?
Brutus. Didst thou dream, Lucius, that thou so criedst out?
Lucius. My lord, I do not know that I did cry. 295
Brutus. Yes, that thou didst. Didst thou see anything?
Lucius. Nothing, my lord.
Brutus. Sleep again, Lucius. Sirrah Claudius!
[*To* Varro] Fellow thou, awake!
Varro. My lord? 300
Claudius. My lord?
Brutus. Why did you so cry out, sirs, in your sleep?
Varro *and* **Claudius.** Did we, my lord?
Brutus. Aye. Saw you anything?
Varro. No, my lord, I saw nothing.
Claudius. Nor I, my lord.
Brutus. Go and commend me to my brother Cassius. 305
Bid him set on his powers betimes before,°
And we will follow.
Varro *and* **Claudius.** It shall be done, my lord. [*Exeunt.*]

306. **set . . . before:** lead his army on ahead of ours right away.

Reading Check

1. Why does Antony send Lepidus to Caesar's house?
2. What is Antony's opinion of Lepidus?
3. What does Octavius say in defense of Lepidus?
4. Why has Brutus asked Cassius for money?
5. Why does the poet ask to see Brutus and Cassius?
6. Why has Portia taken her own life?
7. What has happened to Cicero?
8. Where will Brutus and Cassius face the legions of Antony and Octavius?
9. How does the ghost identify itself?
10. What is the ghost's reason for visiting Brutus?

For Study and Discussion

Analyzing and Interpreting the Play

1a. Find the lines in Scene 1 that indicate Antony has decided to change Caesar's will. **b.** What new aspect of his character does this reveal?

2. How does Antony's behavior in Scene 1 affect your opinion of him?

3a. What does Scene 1 reveal about Octavius? **b.** Of the three men in power, which do you think is the most worthy leader? Why?

4. In Scene 2, what do we learn of the relationship between Brutus and Cassius?

5. Brutus and Cassius are so different that conflict between them seems inevitable. **a.** State briefly the concrete issues that Brutus and Cassius quarrel about in Scene 3. **b.** What accusations does each one make?

6. Being forced from Rome is the first great loss Brutus suffers in the play. Portia's death is the second. Is Brutus' reaction to Portia's death characteristic or uncharacteristic of his behavior throughout the play so far? Explain your answer.

7a. Compare the meeting of Brutus and Cassius in Scene 3 with the meeting of the Triumvirate in the first scene of this act. Look for similarities as well as differences. For example, what does Cassius say that is similar to Antony's "Octavius, I have seen more days than you"? **b.** Which characters in each scene are shown to be corrupt?

8. Once again a course of action must be decided, and Brutus and Cassius have different opinions. **a.** So far in the play what have we learned about Brutus' judgment? **b.** Why does Cassius yield to Brutus' opinion?

9a. Although Caesar has been dead for more than two years, in what sense does he still have an important role in the play? **b.** What do you think the appearance of his ghost in Scene 3 signifies? **c.** What does his reaction to the ghost reveal about Brutus?

10. Scene 3, one of the longest in the play, begins with an argument and ends with the visitation of Caesar's ghost. **a.** Describe the mood (or moods) of this scene. **b.** What details of setting and action contribute to the mood?

Literary Elements

Metaphor

A **metaphor** is a figure of speech that compares two things which are basically dissimilar. The purpose of a metaphor is to give added meaning to one of the things being compared.

An **extended metaphor** extends the points of comparison throughout several lines of a

poem. Here is an extended metaphor from Act Two, Scene 1, where Brutus is talking about Caesar's ambition. Note that he starts by directly stating that lowliness is a ladder.

> But 'tis a common proof
> That lowliness is young ambition's ladder,
> Whereto the climber-upward turns his face.
> But when he once attains the upmost round,
> He then unto the ladder turns his back,
> Looks in the clouds, scorning the base degrees
> By which he did ascend.
>
> (21–27)

The two terms of the metaphor are lowliness and a ladder. The overall similarity is that they both reach for a higher place. Shakespeare extends the metaphor by saying that when the ambitious person gets to the top rung, he turns his back on the ladder and the lowliness it helped him escape.

Identify the metaphors in the following lines from *Julius Caesar*. What is being compared in each one? Are any of these metaphors extended to show several points of comparison?

> **Caesar.** Caesar should be a beast without a heart
> If he should stay at home today for fear.
> No, Caesar shall not. Danger knows full well
> That Caesar is more dangerous than he,
> We are two lions littered in one day,
> And I the elder and more terrible.
>
> (II, 2, 42–47)

> **Brutus.** There is a tide in the affairs of men
> Which taken at the flood leads on to fortune;
> Omitted, all the voyage of their life
> Is bound in shallows and in miseries.
> On such a full sea are we now afloat,
> And we must take the current when it serves,
> Or lose our ventures.
>
> (IV, 3, 217–223)

Writing About Literature

Discussing Sleep Imagery

The critic G. Wilson Knight has pointed out the importance of sleep imagery in *Julius Cae-*sar. In his soliloquy in the first scene of Act Two, Brutus speaks of his sleeplessness:

> Since Cassius first did whet me against Caesar
> I have not slept.

Brutus' soul is divided. He believes the only way to save Rome is to assassinate Caesar, yet murder is repellent to his nature.

Study the sleep imagery in the first four acts of the play. How does it emphasize Brutus' loneliness and inner conflict? Write an essay in which you discuss your findings. Be sure to cite specific evidence.

Focus on Persuasive Writing

Appealing to Reason

When Brutus wants to persuade Cassius to march to Philippi immediately, he tells him, "Good reasons must of force give place to better" (IV, 3, 202). Brutus then gives several **logical appeals,** or reasons, to support his opinion.

Most successful persuasion combines appeals to emotion with logical appeals. The list below shows logical appeals that you can use in a persuasive essay or speech.

Logical Appeals

Reasons (telling why)
Evidence (giving proof or support)
Facts (verifiable statements)
Expert opinions (statements by recognized authorities on the topic)

Choose a position or opinion you would like to support in a persuasive speech to an audience of adults in your community. Write an opinion statement of one or two sentences. Then list as many reasons, facts, and expert opinions as you can to support your view. Save your writing.

Act Five

Scene 1

[*The plains of Philippi in Greece. Enter* Octavius, Antony, *and their* Army.]

Octavius. Now, Antony, our hopes are answerèd.
 You said the enemy would not come down,
 But keep the hills and upper regions.
 It proves not so, their battles° are at hand,
 They mean to warn° us at Philippi here, 5
 Answering before we do demand of them.
Antony. Tut, I am in their bosoms,° and I know
 Wherefore they do it. They could be content
 To visit other places, and come down
 With fearful bravery,° thinking by this face 10
 To fasten in our thoughts that they have courage.
 But 'tis not so.

[*Enter a* Messenger.]

Messenger. Prepare you, generals.
 The enemy comes on in gallant show.
 Their bloody sign° of battle is hung out,
 And something to be done immediately. 15
Antony. Octavius, lead your battle softly on,
 Upon the left hand of the even field.
Octavius. Upon the right hand I. Keep thou the left.
Antony. Why do you cross me in this exigent?°
Octavius. I do not cross you, but I will do so. 20

[*March. Drum. Enter from the other side of the stage* Brutus, Cassius, *and their* Army; Lucilius,
 Titinius, Messala, *and others.*]

Brutus. They stand, and would have parley.
Cassius. Stand fast, Titinius. We must out and talk.
Octavius. Mark Antony, shall we give sign of battle?
Antony. No, Caesar, we will answer on their charge.
 Make forth, the generals would have some words. 25
Octavius. Stir not until the signal.

 4. **battles:** armies drawn up for battle. 5. **warn:** challenge. 7. **bosoms:** inner thoughts. 10. **bravery:** brave show. 14.
bloody sign: red flag. 19. **exigent** (ĕk′sə·jənt): critical moment.

[*Brutus, Cassius, Octavius, and* Antony *meet in the center of the stage.*]

Brutus. Words before blows. Is it so, countrymen?

Octavius. Not that we love words better, as you do.

Brutus. Good words are better than bad strokes, Octavius.

Antony. In your bad strokes, Brutus, you give good words. 30
 Witness the hole you made in Caesar's heart,
 Crying "Long live! Hail, Caesar!"

Cassius. Antony,
 The posture of your blows are yet unknown,
 But for your words, they rob the Hybla° bees,
 And leave them honeyless.

Antony. Not stingless too. 35

Brutus. Oh, yes, and soundless too,
 For you have stol'n their buzzing, Antony,
 And very wisely threat before you sting.

Antony. Villains, you did not so when your vile daggers
 Hacked one another in the sides of Caesar. 40
 You showed your teeth like apes, and fawned like hounds,
 And bowed like bondmen, kissing Caesar's feet,
 Whilst damnèd Casca, like a cur, behind
 Struck Caesar on the neck. O you flatterers!

Cassius. Flatterers! Now, Brutus, thank yourself. 45
 This tongue had not offended so today
 If Cassius might have ruled.°

Octavius. Come, come, the cause. If arguing make us sweat,
 The proof of it will turn to redder drops.
 Look, 50
 I draw a sword against conspirators.
 When think you that the sword goes up° again?
 Never, till Caesar's three and thirty wounds
 Be well avenged, or till another Caesar
 Have added slaughter to the sword of traitors. 55

Brutus. Caesar, thou canst not die by traitors' hands,
 Unless thou bring'st them with thee.

Octavius. So I hope.
 I was not born to die on Brutus' sword.

Brutus. Oh, if thou wert the noblest of thy strain,
 Young man, thou couldst not die more honorable. 60

Cassius. A peevish schoolboy, worthless of such honor,
 Joined with a masker° and a reveler!

34. **Hybla:** a mountain in Sicily famous for the honey produced there. 47. **ruled:** had his way in wanting to slay Antony. 52. **up:** back in its scabbard. 62. **masker:** actor.

Antony. Old Cassius still!

Octavius. Come, Antony, away!
 Defiance, traitors, hurl we in your teeth.
 If you dare fight today, come to the field; 65
 If not, when you have stomachs.° [*Exeunt* Octavius, Antony, *and their* Army.]

Cassius. Why, now, blow wind, swell billow, and swim bark!°
 The storm is up, and all is on the hazard.°

Brutus. Ho, Lucilius! Hark, a word with you.

Lucilius. [*Standing forth*] My lord?

66. **stomachs:** appetites. 67. **bark:** ship. 68. **on the hazard:** at stake.

[Brutus *and* Lucilius *converse apart.*]

Cassius. Messala!

Messala. [*Standing forth*] What says my general? 70

Cassius. Messala,

This is my birthday, as this very day
Was Cassius born. Give me thy hand, Messala.
Be thou my witness that, against my will,
As Pompey was, am I compelled to set 75
Upon one battle all our liberties.
You know that I held Epicurus° strong,
And his opinion. Now I change my mind,
And partly credit things that do presage.°
Coming from Sardis, on our former ensign° 80
Two mighty eagles fell, and there they perched,
Gorging and feeding from our soldiers' hands,
Who to Philippi here consorted° us.
This morning are they fled away and gone,
And in their steads do ravens, crows, and kites° 85
Fly o'er our heads and downward look on us.
As we were sickly prey. Their shadows seem
A canopy most fatal, under which
Our army lies, ready to give up the ghost.

Messala. Believe not so.

Cassius. I but believe it partly, 90
For I am fresh of spirit and resolved
To meet all perils very constantly.

[Brutus *and* Lucilius *end their conversation.*]

Brutus. Even so, Lucilius.

Cassius. Now, most noble Brutus,
The gods today stand friendly, that we may,
Lovers in peace, lead on our days to age! 95
But since the affairs of men rest still incertain,
Let's reason with the worst that may befall.
If we do lose this battle, then is this
The very last time we shall speak together.
What are you then determinèd to do? 100

Brutus. Even by the rule of that philosophy
By which I did blame Cato° for the death

77. **Epicurus:** a philosopher who taught that supernatural omens were simply superstition. 79. **presage** (prĭ-sāj'): foretell what is to come. 80. **former ensign:** foremost battle flag. 83. **consorted:** accompanied. 85. **kites:** hawks. 102. **Cato:** Portia's father, a Stoic, killed himself when Caesar defeated Pompey.

Which he did give himself—I know not how,
But I do find it cowardly and vile,
For fear of what might fall, so to prevent 105
The time of life°—arming myself with patience
To stay° the providence of some high powers
That governs us below.

Cassius. Then, if we lose this battle,
You are contented to be led in triumph
Thorough the streets of Rome? 110

Brutus. No, Cassius, no. Think not, thou noble Roman,
That ever Brutus will go bound to Rome.
He bears too great a mind. But this same day
Must end that work the ides of March begun,
And whether we shall meet again I know not. 115
Therefore our everlasting farewell take.
Forever and forever, farewell, Cassius!
If we do meet again, why, we shall smile;
If not, why then this parting was well made.

Cassius. Forever, and forever farewell, Brutus! 120
If we do meet again, we'll smile indeed;
If not, 'tis true this parting was well made.

Brutus. Why then, lead on. Oh, that a man might know
The end of this day's business ere it come!
But it sufficeth that the day will end, 125
And then the end is known. Come, ho! Away! [*Exeunt.*]

Scene 2

[*The field of battle. Alarum.° Enter* Brutus *and* Messala.]

Brutus. Ride, ride, Messala, ride, and give these bills°
Unto the legions on the other side.

[*Loud alarum.*]

Let them set on at once, for I perceive
But cold demeanor° in Octavius' wing,
And sudden push gives them the overthrow. 5
Ride, ride, Messala. Let them all come down. [*Exeunt.*]

105–106. **prevent . . . life:** anticipate the natural end of life. 107. **stay:** await.
S.D. **Alarum:** drum or trumpet call to arms. 1. **bills:** orders. 4. **cold demeanor:** lack of spirit.

Scene 3

[Another part of the field. Alarums. Enter Cassius *and* Titinius, *dismayed.]*

Cassius. Oh, look, Titinius, look, the villains fly!
 Myself have to mine own turned enemy.
 This ensign° here of mine was turning back.
 I slew the coward, and did take it from him.
Titinius. O Cassius, Brutus gave the word too early, 5
 Who, having some advantage on Octavius,
 Took it too eagerly. His soldiers fell to spoil°
 Whilst we by Antony are all enclosed.

[Enter Pindarus.]

Pindarus. Fly further off, my lord, fly further off.
 Mark Antony is in your tents, my lord. 10
 Fly, therefore, noble Cassius, fly far off.
Cassius. This hill is far enough. Look, look, Titinius,
 Are those my tents where I perceive the fire?
Titinius. They are, my lord.
Cassius. Titinius, if thou lovest me,
 Mount thou my horse and hide thy spurs in him 15
 Till he have brought thee up to yonder troops
 And here again, that I may rest assured
 Whether yond troops are friend or enemy.
Titinius. I will be here again, even with° a thought. *[Exit.]*
Cassius. Go, Pindarus, get higher on that hill— 20
 My sight was ever thick.° Regard Titinius,
 And tell me what thou notest about the field.

[Pindarus *ascends the hill.*]

 This day I breathèd first. Time is come round,
 And where I did begin, there shall I end,
 My life is run his compass. Sirrah, what news? 25
Pindarus. *[Above.]* O my lord!
Cassius. What news?
Pindarus. *[Above.]* Titinius is enclosèd round about
 With horsemen that make to him on the spur,
 Yet he spurs on. Now they are almost on him. 30

3. **ensign:** flag bearer. 7. **spoil:** looting. 19. **even with:** as quickly as. 21. **thick:** weak.

Now, Titinius! Now some light.° Oh, he lights too.
He's ta'en. [*Shout*] And, hark! They shout for joy.
Cassius. Come down, behold no more.
 Oh, coward that I am, to live so long,
 To see my best friend ta'en before my face! 35

[Pindarus *descends.*]

Come higher, sirrah.
In Parthia° did I take thee prisoner,
And then I swore thee, saving of thy life.
That whatsoever I did bid thee do
Thou shouldst attempt it. Come now, keep thine oath. 40
Now be a free man, and with this good sword,
That ran through Caesar's bowels, search this bosom.
Stand not to answer. Here, take thou the hilts,
And when my face is covered, as 'tis now,
Guide thou the sword.

[Pindarus *stabs him.*]

 Caesar, thou art revenged, 45
Even with the sword that killed thee. [*Dies.*]
Pindarus. So, I am free, yet would not so have been,
 Durst I have done my will. O Cassius!
 Far from this country Pindarus shall run,
 Where never Roman shall take note of him. 50

[*He throws down the sword and runs. Reenter* Titinius *with* Messala.]

Messala. It is but change,° Titinius, for Octavius
 Is overthrown by noble Brutus' power,
 As Cassius' legions are by Antony.
Titinius. These tidings will well comfort Cassius.
Messala. Where did you leave him?
Titinius. All disconsolate, 55
 With Pindarus his bondman, on this hill.
Messala. Is not that he that lies upon the ground?
Titinius. He lies not like the living. Oh, my heart!
Messala. Is not that he?
Titinius. No, this was he, Messala,

31. **light:** dismount. 37. **Parthia:** ancient country in Asia. 51. **change:** even exchange.

But Cassius is no more. O setting sun, 60
As in thy red rays thou dost sink to night,
So in his red blood Cassius' day is set,
The sun of Rome is set! Our day is gone,
Clouds, dews, and dangers come. Our deeds are done!
Mistrust of my success hath done this deed. 65
Messala. Mistrust of good success hath done this deed.
O hateful error, melancholy's child,
Why dost thou show to the apt° thoughts of men
The things that are not? O error, soon conceived,
Thou never comest unto a happy birth, 70
But kill'st the mother that engendered thee!
Titinius. What, Pindarus! Where art thou, Pindarus?
Messala. Seek him, Titinius, whilst I go to meet
The noble Brutus, thrusting this report
Into his ears. I may say "thrusting" it, 75
For piercing steel and darts envenomèd
Shall be as welcome to the ears of Brutus
As tidings of this sight.
Titinius. Hie you, Messala,
And I will seek for Pindarus the while. [*Exit* Messala.]

[Titinius *looks at* Cassius.]

Why didst thou send me forth, brave Cassius? 80
Did I not meet thy friends? And did not they
Put on my brows this wreath of victory,
And bid me give it thee? Didst thou not hear their shouts?
Alas, thou hast miscónstrued° everything!
But hold thee, take this garland on thy brow. 85
Thy Brutus bid me give it thee, and I
Will do his bidding. Brutus, come apace,°
And see how I regarded Caius Cassius.
By your leave, gods, this is a Roman's part.
Come, Cassius' sword, and find Titinius' heart. [*Kills himself*.] 90

[*Alarum. Reenter* Messala, *with* Brutus, *young* Cato, Lucilius, *and others*.]

Brutus. Where, where, Messala, doth his body lie?
Messala. Lo, yonder, and Titinius mourning it.
Brutus. Titinius' face is upward.

68. **apt:** ready to be deceived. 84. **miscónstrued:** misinterpreted. 87. **apace:** quickly.

Cato. He is slain.

Brutus. O Julius Caesar, thou art mighty yet!

 Thy spirit walks abroad, and turns our swords 95

 In our own proper entrails.

 [*Low alarums.*]

Cato. Brave Titinius!

 Look whether he have not crowned dead Cassius!

Brutus. Are yet two Romans living such as these?

 The last of all the Romans, fare thee well!

 It is impossible that ever Rome 100

 Should breed thy fellow. Friends, I owe moe tears

 To this dead man than you shall see me pay.

 I shall find time, Cassius, I shall find time.

 Come therefore, and to Thasos° send his body.

 His funerals shall not be in our camp, 105

 Lest it discomfort us.° Lucilius, come,

 And come, young Cato. Let us to the field.

 Labeo and Flavius, set our battles on.

 'Tis three o'clock, and, Romans, yet ere night

 We shall try fortune in a second fight. [*Exeunt.*] 110

Scene 4

[*Another part of the field. Alarum. Enter, fighting,* Soldiers *of both armies; then* Brutus, *young* Cato, Lucilius, *and others in retreat.*]

Brutus. Yet, countrymen, oh, yet hold up your heads!

Cato. What bastard doth not? Who will go with me?

 I will proclaim my name about the field.

 I am the son of Marcus Cato, ho!—

 A foe to tyrants, and my country's friend. 5

 I am the son of Marcus Cato, ho!

 [*He runs off, followed by several* Soldiers.]

Brutus. And I am Brutus, Marcus Brutus, I—

 Brutus, my country's friend. Know me for Brutus!

[*He runs off in another direction, followed by all but* Lucilius, *who looks off in the direction taken by young* Cato. *A loud cry offstage.*]

104. **Thasos:** Greek island in the Aegean Sea. 106. **discomfort us:** make us all lose heart.

Lucilius. O young and noble Cato, art thou down?
　　Why, now thou diest as gravely as Titinius,　　　　　　　　　　10
　　And mayst be honored, being Cato's son.

　　　　　　[Soldiers *of Antony's army enter behind him with drawn swords.*]

First Soldier. Yield, or thou diest.
Lucilius.　　　　　　　　　　Only I yield to die.
　　[*Offering money*] There is so much that thou wilt kill me straight.
　　Kill Brutus, and be honored in his death.
First Soldier. We must not. A noble prisoner!　　　　　　　　　15
Second Soldier. Room, ho! Tell Antony, Brutus is ta'en.
First Soldier. I'll tell the news. Here comes the general.

　　　　　　　　　　[*Enter* Antony.]

　　Brutus is ta'en, Brutus is ta'en, my lord.
Antony. Where is he?
Lucilius. Safe, Antony, Brutus is safe enough　　　　　　　　　20
　　I dare assure thee that no enemy
　　Shall ever take alive the noble Brutus.
　　The gods defend him from so great a shame!
　　When you do find him, or alive or dead,
　　He will be found like Brutus, like himself.　　　　　　　　　　25
Antony. This is not Brutus, friend, but, I assure you,
　　A prize no less in worth. Keep this man safe,
　　Give him all kindness. I have rather have
　　Such men my friends than enemies. Go on,
　　And see whether Brutus be alive or dead,　　　　　　　　　　30
　　And bring us word unto Octavius' tent
　　How everything is chanced.　　　　　　　　　[*Exeunt.*]

Scene 5

[*Another part of the field. Enter* Brutus, Dardanius, Clitus, Strato, *and* Volumnius, *weary and defeated.*]

Brutus. Come, poor remains of friends, rest on this rock.
Clitus. Statilius showed the torchlight,° but, my lord,
　　He came not back. He is or ta'en or slain.
Brutus. Sit thee down, Clitus. Slaying is the word,
　　It is a deed in fashion. Hark thee, Clitus. [*Whispering*]　　　5

2. **showed the torchlight:** gave the signal.

Clitus. What, I, my lord? No, not for all the world.

Brutus. Peace then, no words.

Clitus. I'll rather kill myself.

Brutus. Hark thee, Dardanius. [*Whispering*]

Dardanius. Shall I do such a deed?

Clitus. O Dardanius!

Dardanius. O Clitus! 10

Clitus. What ill request did Brutus make to thee?

Dardanius. To kill him, Clitus. Look, he meditates.

Clitus. Now is that noble vessel full of grief,

 That it runs over even at his eyes.

Brutus. Come hither, good Volumnius, list° a word. 15

Volumnius. What says my lord?

Brutus. Why, this, Volumnius.

 The ghost of Caesar hath appeared to me

 Two several° times by night—at Sardis once,

 And this last night here in Philippi fields.

 I know my hour is come.

Volumnius. Not so, my lord. 20

Brutus. Nay, I am sure it is, Volumnius.

 Thou seest the world, Volumnius, how it goes,

 Our enemies have beat us to the pit.°

 [*Low alarums.*]

 It is more worthy to leap in ourselves

 Than tarry till they push us. Good Volumnius, 25

 Thou know'st that we two went to school together.

 Even for that our love of old, I prithee

 Hold thou my sword hilts whilst I run on it.

Volumnius. That's not an office for a friend, my lord.

 [*Alarum still.*]

Clitus. Fly, fly, my lord, there is no tarrying here. 30

Brutus. Farewell to you, and you, and you, Volumnius.

 Strato, thou hast been all this while asleep—

 Farewell to thee too, Strato. Countrymen,

 My heart doth joy that yet in all my life

 I found no man but he was true to me. 35

 I shall have glory by this losing day,

15. **list:** listen to. 18. **several:** different. 23. **Our . . . pit:** a reference to the method hunters used, encircling and driving their prey into a pit.

More than Octavius and Mark Antony
By this vile conquest shall attain unto.
So, fare you well at once, for Brutus' tongue
Hath almost ended his life's history. 40
Night hangs upon mine eyes, my bones would rest
That have but labored to attain this hour.

[*Alarum. Cry within, "Fly, fly, fly!"*]

Clitus. Fly, my lord, fly!
Brutus. Hence! I will follow.

[*Exeunt* Clitus, Dardanius, *and* Volumnius.]

I prithee, Strato, stay thou by thy lord.
Thou art a fellow of a good respect, 45
Thy life hath had some smatch° of honor in it.
Hold then my sword, and turn away thy face
While I do run upon it. Wilt thou, Strato?
Strato. Give me your hand first. Fare you well, my lord.
Brutus. Farewell, good Strato. [*Runs on his sword.*] Caesar, now be still. 50
I killed not thee with half so good a will. [*Dies.*]

[*Alarum. Retreat. Enter* Octavius, Antony, Messala, Lucilius, *and the* Army.]

Octavius. What man is that?
Messala. My master's man. Strato, where is thy master?
Strato. Free from the bondage you are in, Messala.
The conquerors can but make a fire of him, 55
For Brutus only overcame himself,
And no man else hath honor by his death.
Lucilius. So Brutus should be found. I thank thee, Brutus,
That thou hast proved Lucilius' saying true.
Octavius. All that served Brutus, I will entertain them.° 60
Fellow, wilt thou bestow thy time with me?
Strato. Aye, if Messala will prefer° me to you.
Octavius. Do so, good Messsala.
Messala. How died my master, Strato?
Strato. I held the sword, and he did run on it. 65
Messala. Octavius, then take him to follow thee
That did the latest° service to my master.
Antony. This was the noblest Roman of them all.
All conspirators, save only he,

46. **smatch:** taste. 60. **entertain them:** give them a place in my service. 62. **prefer:** recommend. 67. **latest:** last.

Did that they did in envy of great Caesar. 70
He only, in a general honest thought
And common good to all, made one of them.
His life was gentle, and the elements
So mixed in him that Nature might stand up
And say to all the world, "This was a man." 75
Octavius. According to his virtue let us use° him,
With all respect and rites of burial.
Within my tent his bones tonight shall lie,
Most like a soldier, ordered honorably.
So call the field to rest, and let's away, 80
To part° the glories of this happy day. [*Exeunt.*]

76. **use:** treat. 81. **part:** divide up.

Reading Check

1. During the parley before the battle, Cassius refers to "a peevish schoolboy" and "a masker and a reveler." Identify both persons.
2. What has changed Cassius' belief in the philosophy of Epicurus?
3. What mistake leads Cassius to take his own life?
4. How is Lucilius treated by Antony?
5. What convinces Brutus that his hour has come?

For Study and Discussion

Analyzing and Interpreting the Play

1. In Scene 1, the enemies meet to talk before they fight. Evaluate the behavior of the four main characters: Antony and Octavius versus Brutus and Cassius. **a.** What has united the two pairs on either side? **b.** Which of the four seem most in control of their emotions?

2. Who is the other Caesar that Octavius mentions in line 54 of Scene 1?

3. In lines 77–89 of Scene 1, Cassius reports some omens which, for the first time in his life, he "partly credits." How do these omens, together with Brutus' and Cassius' parting speeches, affect the mood of the scene?

4a. What function does Scene 2 have? **b.** How does it affect your expectation of the battle's outcome?

5. Explain how Messala's speech on error and melancholy (Scene 3, lines 67–71) applies to Cassius' death.

6. In lines 94–96 of Scene 3, Brutus addresses Julius Caesar. How is Caesar present in this scene?

7. What does Scene 4 reveal about the progress of the battle offstage?

8. Look back at the actions of Cassius, Pindarus, and Titinius in Scene 3, and at the actions of Lucilius in Scene 4. How does each one deal with what seems to be defeat at the hands of the enemy?

9a. What are the reasons for the suicides of

Cassius and Brutus? **b.** Who dies for loyalty? Who for honor?

10a. Is Antony's speech in Scene 5 an accurate description of Brutus' character? **b.** Is Antony being sincere or ironic? Explain.

11a. How does Octavius show himself to be a good politician in Scene 5? **b.** Why do you think Shakespeare gives him the closing lines of the play?

The Play as a Whole

1. Suppose you were going to direct a production of *Julius Caesar*. You would want to decide which character (if any) should be the focus of the play. Who is the tragic hero in this play?

2. Some critics have suggested that *Julius Caesar* tends to be misinterpreted by modern audiences because of their belief in democracy and liberty. According to these critics, Shakespeare had quite a different point of view, living as he did under a legitimate and respected ruler in a time of peace and prosperity, not so long after a series of bloody civil wars. Shakespeare, these critics say, intended Brutus to be the villain of his play, not the hero, since he kills a popular ruler and disrupts the social order. Do you agree? What evidence is there in the play that Shakespeare thought of Brutus as a hero? As a villain?

3. Brutus is an idealist; he desires perfection in himself and in the society he lives in. Brutus is also the only character in the play who consistently says what he really thinks. What do Brutus' actions and decisions show about the virtues and shortcomings of idealism? Are there any occasions where Cassius seems more likable and human than Brutus?

4. *Julius Caesar* is a play about politics and power. What kind of person, does the play suggest, is most likely to come out on top in a power struggle? Discuss whether or not you think this is necessarily true.

Literary Elements

Dramatic Structure: Tragedy

Everyone has some idea of what tragedy means when it applies to something other than plays. Tragic plays, however, are so called because they have similar structures. The Greeks called tragic characters "dying ones," a term which is much more vivid than our term *mortal,* though it means the same thing. The simplest ingredient of a tragic structure is an unhappy ending. In this respect, tragedy is the opposite of comedy. In comedy, events go from bad to worse, but finally there is an upturn and a happy ending. By contrast, most tragedies start with a hero or heroine at the height of power and prestige and then plunge that person into defeat.

Many people who have written about tragedy refer to the hero's or heroine's **tragic flaw.** This may be pride, arrogance, lust for power, or something else. In many tragedies, the flaw is lack of insight, the inability to see circumstances as they really are, or to understand one's own nature properly. Frequently, this flaw, combined with ill luck or blind fate, brings about the downfall of the principal character, called the **protagonist.** The protagonist is usually opposed by the **antagonist,** who also may contribute to the downfall.

Generally, along with suffering, the protagonist comes to a **recognition,** a discovery, insight, enlightenment, or understanding. The suffering that the protagonist goes through is the price that must be paid and the means by which enlightenment comes.

Elizabethan audiences particularly liked a kind of tragedy that dealt with **revenge.** These plays often dealt with personal vendettas in which the protagonist, revenging a murder, brought about general destruction. Shakespeare's revenge plays are almost always set in a larger social context. In his plays, there is usually a strong **ruling figure** who is brought down by a **rebel,** or usurping figure, who in turn is defeated by an **avenger.**

You might want to consider what characters or group of characters in *Julius Caesar* take these three roles of ruling figure, rebel, and avenger. You might also want to consider the following questions in your discussion:

Is this Caesar's tragedy, the story of a man whose ambition brings about his fall? Is this Brutus' tragedy, the story of a man whose lack of insight brings chaos to his society and his own death? Is this a revenge tragedy, the story of a man who avenges the death of his friend?

Blank Verse

English is an accented language, which means that its speakers put more stress on some words and syllables than on others. In English, meaning is often determined by accent: "Did you ASK?" is one question, but "Did YOU ask?" is another. English poetry, as you know, makes deliberate use of accents, and many poems are worked out so that they have a regular pattern of stressed and unstressed syllables.

In this line from *Julius Caesar*, an unstressed syllable is regularly followed by a stressed syllable. The unstressed syllable is marked (˘) and the stressed ('):

 Whý, mán, hĕ dóth bĕstríde thĕ nárrŏw wórld

This unit of rhythm—an unstressed syllable followed by a stressed one—is called an **iamb.** Unrhymed poetry that uses five iambs to a line is called **blank verse.** Blank verse is the verse form used by Shakespeare as well as by other major English poets. The natural cadence of the English language lends itself to the rhythm of the iamb, which might explain its widespread use in English poetry.

In reading blank verse aloud, actors and actresses must not overemphasize the iambs, or the speeches will take on a singsong rhythm and their meaning will be blunted. The best way to read blank verse is to look first for meaning, and then read each speech to bring the meaning out. The forceful iambs will take care of themselves, in the background, as steady and essential as a heartbeat.

Poetry, of course, can be read in different ways, with accents placed on different words, depending on how individual readers interpret the meaning. In the line quoted above, for example, some readers might stress the word *he*. In what different ways could the rest of this speech be recited aloud?

Cassius. Why, man, he doth bestride the narrow
 world
 Like a Colossus, and we petty men
 Walk under his huge legs and peep about
 To find ourselves dishonorable graves.
 Men at some time are masters of their fates.
 The fault, dear Brutus, is not in our stars,
 But in ourselves, that we are underlings.
 (1, 2, 135–141)

Writing About Literature

Comparing Two Literary Works

Shakespeare based his play *The Tragedy of Julius Caesar* largely on what he read in Plutarch's history (page 290). In a short essay, compare Shakespeare's dramatization of Calpurnia's dream (Act Two, Scene 2); of the attempts of Artemidorus to warn Caesar (Act Two, Scene 3); and of the assassination scene (Act Three, Scene 1) with what you have read in Plutarch. What specific facts has Shakespeare taken from Plutarch? What additions has Shakespeare made to Plutarch's story? Discuss how Shakespeare has developed Plutarch's narrative to suit his own dramatic purposes.

Literature and History

The Coup d'État

Julius Caesar tells the story of political struggle and overthrow. Such power struggles are constantly occurring all over the globe. As in *Julius Caesar,* there is more than one side to the issue. According to your stance, you may view certain participants as heroes, villains, or something in between.

Making Connections: Activities

Pick a conflict in recent years in which a coup d'état, or the sudden overthrow of a ruler or government, has been staged. These incidents may include unsuccessful attempts to oust a ruling party, as in the case of the opposition in Russia that tried to oust Boris Yeltsin in 1991. Other coups in recent years include those in Haiti, Guatemala, Panama, and Burundi, Africa. Using microfilm or microfiche at a library, consult back issues of newspapers with a strong international section, such as the *New York Times* or the *Washington Post,* to find out about one political conspiracy or coup. What were the issues at stake? What were the different points of view? In your opinion, who appeared to be right? Why? How do the conflicts reflect the cultural background and history of the place involved? Are Shakespeare's insights into political rivalry still relevant? Write an editorial for one of the newspapers you consulted expressing your views.

I NEVER SANG FOR MY FATHER

The Modern Theater

One major trend that has developed in the modern theater is the trend toward realism. Realism in drama, like realism in novels and short stories, attempts to present life as it actually is, not as we wish it would be. Realism explores in detail the characters of ordinary people and the world they live in. Another trend in modern drama is experimentalism. Modern playwrights have experimented with traditional dramatic elements, trying to find new ways of presenting action and character on the stage. Some playwrights have abandoned plot altogether. Some have only a few planks of wood for scenery. One playwright has his characters speak while sitting inside trash cans.

Robert Anderson's *I Never Sang for My Father* is a realistic play that uses certain experimental touches. Anderson's play has no scenery but uses lighting as the chief means for setting the stage. It makes sudden shifts in time and place, and it has a character who steps out of the action to speak directly to the audience. Anderson has stripped away all the nonessentials in order to focus our attention on the real problem faced by one American family. As you remember, the tragedies of ancient Greece and Elizabethan England were concerned with the downfall of noble characters, and with how their downfall affected a larger society. Anderson's play is different: it is about ordinary people involved in a very personal problem. The characters do not speak in verse but in the ordinary language and disjointed rhythms of everyday conversation. When death comes to characters in realistic dramas like Anderson's, it does not come from the avenging gods or from the designs of fate; it comes from things like old age or car accidents.

In many modern dramas, the conflict is caused by social or emotional factors—war, sickness, poverty, loneliness, and so on. Some modern plays do not even present any resolution to the conflict. Unlike the endings of the Greek or Shakespearean tragedies, the conflict in a modern play might remain unresolved, even as the last curtain is coming down.

What the modern theater shares with the theater of the past is a basic concern with the ideas, needs, fears, and joys that matter to all of us. Sophocles, in *Antigone,* and Shakespeare, in *Julius Caesar,* were

interested in the universal problems of power, authority, and the conscience of the individual. Robert Anderson, in *I Never Sang for My Father,* is interested in our need for love.

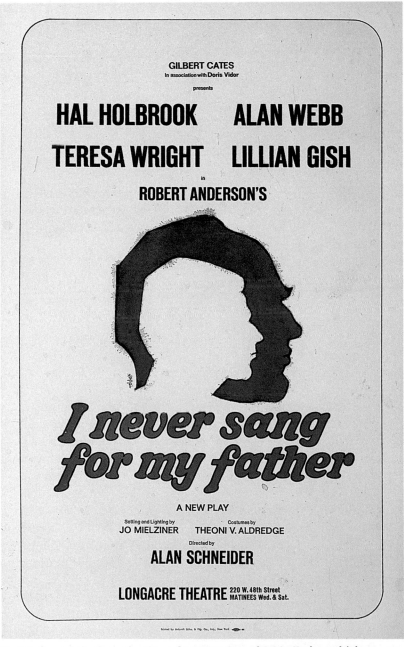

Poster for original production of *I Never Sang for My Father,* which opened on January 25, 1968.

I Never Sang for My Father

ROBERT ANDERSON

Characters

Gene Garrison	
Porter	Reverend Pell
Tom Garrison	Marvin Scott
Margaret Garrison	Waiter
Mary	Dr. Mayberry
Nurse	Alice

The time is the present and the past. The places are New York City and a town in Westchester County.

There are no sets. Lighting is the chief means for setting the stage.

Act One

A man comes from the shadows in the rear. He is Gene Garrison, *age forty. He checks his watch. A* Porter *passes through with a baggage cart.*

Gene. I wonder if you could help me. (*The* Porter *stops.*) My father and mother are coming in on the Seaboard Express from Florida. I'd like a wheelchair for my mother if I could get one.
Porter. You have the car number?
Gene. Yes. (*He checks a slip of paper.*) One-oh-seven.
Porter. Due in at three ten. I'll meet you on the platform.

Gene. Thank you. (*The* Porter *moves away and off.* Gene *comes down and addresses the audience.*) Death ends a life, but it does not end a relationship, which struggles on in the survivor's mind toward some final resolution, some clear meaning, which it perhaps never finds. (*He changes the mood.*) Pennsylvania Station, New York, a few years ago. My mother and father were returning from Florida. They were both bored in Florida, but they had been going each winter for a number of years. If they didn't go, my father came down with pneumonia and my mother's joints stiffened cruelly with arthritis. My mother read a great deal, liked to play bridge and chatter and laugh gaily with "the girls" . . . make her eyes sparkle in a way

she had and pretend that she had not had two operations for cancer, three heart attacks and painful arthritis . . . She used to say, "Old age takes courage." She had it. My father, though he had never been in the service, had the air of a retired brigadier general. He read the newspapers, all editions, presumably to help him make decisions about his investments. He watched Westerns on television and told anyone who would listen the story of his life. I loved my mother . . . I wanted to love my father . . .

[*The lights come up on another area of the stage, where the* Porter *is already standing with the wheelchair and baggage cart.* Tom Garrison *is standing amid the suitcases which have been piled up on the platform. He is a handsome man, almost eighty, erect in his bearing, neat in his dress. He speaks distinctly, and when he is irritated, his voice takes on a hard, harsh edge. At the moment he is irritated, slightly bewildered, on the brink of exasperation.*]

Tom. We had four bags. I don't see any of them. We had one in the compartment with us. That can't have been lost.

[*He fumes for a moment. As* Gene *watches his father for a moment, we can see in his face something of his feelings of tension. On the surface he shows great kindness and consideration for the old man. Underneath there is usually considerable strain.*]

Gene. Hello, Dad.
Tom (*beaming*). Well, Gene, as I live and breathe. This is a surprise.
Gene. I wrote you I'd be here.
Tom. Did you? Well, my mind is like a sieve. (*They have shaken hands and kissed each other on the cheek.*) Am I glad to see you! They've lost all our bags.
Gene. I'm sure they're somewhere, Dad.
Tom (*firmly*). No. I've looked. It's damnable!

Gene. Well, let's just take it easy. I'll handle it. (*He looks around at the luggage piled on the platform.*)
Tom. I'm confident we had four bags.
Gene (*quietly showing the redcap*). There's one . . . They'll show up. Where's Mother?
Tom. What? . . . Oh, she's still on the train. Wait a minute. Are you sure that's ours? (*He looks around for bags, fussing and fuming. He shakes his head in exasperation with the world.*)
Gene. Yes, Dad. You just relax now.

[Tom *is seized with a fit of coughing.*]

Tom (*is exasperated at the cough*). Damnable cough. You know the wind never stops blowing down there.
Gene. Don't worry about anything now, Dad. We've got a porter, and everything's under control. (Tom *snorts at this idea. The redcap proceeds in a quiet, efficient and amused way to work the luggage.*) I brought a wheelchair for Mother.
Tom. Oh. That's very considerate of you.
Gene. I'll go get her.
Tom. I didn't hear you.
Gene (*raising his voice*). I said I'll go get Mother.
Tom. Yes, you do that. I've got to get these bags straightened out. (*His rage and confusion are rising.*)
Gene (*to the* Porter). There's one. The gray one.
Tom. That's not ours.
Gene (*patient but irritated*). Yes, it is, Dad.
Tom. No. Now wait. We don't want to get the wrong bags. Mine is brown.
Gene. The old one was brown, Dad. I got you a new one this year for the trip.
Tom (*smiling reasonably*). Now. Gene. I've had the bag in Florida all winter. I should know.
Gene. Dad. Please . . . Please let me handle this.

Tom (*barks out an order to his son without looking at him*). You go get your mother. I'll take care of the bags.

[*Gene's mouth thins to a line of annoyance. He points out another bag to the* Porter, *who is amused. Gene moves with the wheelchair to another area of the stage, where his mother,* Margaret Garrison, *is sitting. Margaret is waiting patiently. She is seventy-eight, still a pretty woman. She has great spirit and a smile that lights up her whole face. She is a good sport about her problems. When she is put out, she says "darn." She is devoted to her son, but she is not the possessive and smothering mother. She is wearing a white orchid on her mink stole.*]

Gene. Hello, Mother.
Margaret (*Her face lights up*). Well, Gene. (*She opens her arms, but remains seated. They embrace.*) Oh, my, it's good to see you. (*This with real feeling as she holds her son close to her.*)
Gene (*when he draws away*). You look wonderful.
Margaret. What?
Gene (*raises his voice slightly. His mother wears a hearing aid*). You look wonderful.
Margaret (*little-girl coy*). Oh . . . a little rouge . . . This is your Easter orchid. I had them keep it in the icebox in the hotel. This is the fourth time I've worn it.
Gene. You sure get mileage out of those things.
Margaret (*raising her voice slightly*). I say it's the fourth time I've worn it . . . Some of the other ladies had orchids for Easter, but mine was the only white one. (*She knows she is being snobbishly proud and smiles as she pokes at the bow.*) I was hoping it would last so you could see it.
Gene. How do you feel?
Margaret (*serious, pouting*). I'm all right, but your father . . . did you see him out there?
Gene. Yes.
Margaret. He's sick and he won't do anything about it.

Gene. I heard his cough.
Margaret. It makes me so darned mad. I couldn't get him to see a doctor.
Gene. Why not?
Margaret. Oh, he's afraid they'd send him a big bill. He says he'll see Mayberry tomorrow . . . But I can't tell you what it's been like. You tell him. Tell him he's got to see a doctor. He's got me sick with worry. (*She starts to cry.*)
Gene (*comforts her*). I'll get him to a doctor, Mother. Don't you worry.
Margaret. He makes me so mad. He coughs all night and keeps us both awake. Poor man, he's skin and bone . . . And he's getting so forgetful. This morning he woke up here on the train and he asked me where we were going.
Gene. Well, Mother, he's almost eighty.
Margaret. Oh, I know. And he's a remarkable man. Stands so straight. Everyone down there always comments on how handsome your father is . . . But I've given up. You get him to a doctor.
Gene. I've got a wheelchair for you, Mother. Save you the long walk up the ramp.
Margaret. Oh, my precious. What would we ever do without you?
Gene (*He is always embarrassed by these expressions of love and gratitude*). Oh, you manage pretty well.

[*He helps her up from the chair, and she gives him a big hug as she stands . . . and looks at him.*]

Margaret. Oh, you're a sight for sore eyes.
Gene (*embarrassed by the intensity*). It's good to see you.
Margaret (*She sits in the wheelchair*). You know, much as we appreciate your coming to meet us . . . I say, much as we appreciate your coming like this, the last thing in the world I'd want to do is take you away from your work.
Gene. You're not, Mother.

[*Father coughs his hacking cough.*]

Margaret. Do you hear that? I'm so worried and so darned mad.

[*They arrive at the platform area.*]

Tom. Oh, Gene, this is damnable. They've lost a suitcase. We had four suitcases.
Gene. Let's see, Dad. There are four there.
Tom. Where?
Gene. Under the others. See?
Tom. That's not ours.
Gene. Yes. Your new one.
Tom. Well, I'm certainly glad you're here. My mind's like a sieve. (*Low, to* Gene) It's the confusion and worrying about your mother.

Gene. Well, everything's under control now, Dad, so let's go. We'll take a cab to my apartment, where I've got the car parked, and then I'll drive you out home.
Tom. Your mother can't climb the stairs to your apartment.
Gene. She won't have to. We'll just change from the cab to my car.
Tom. But she might have to use the facilities.
Margaret. No. No. I'm all right.
Tom (*with a twinkle in his eye . . . the operator*). You know, if you handle it right, you can get away with parking right out there in front of the station. When I used to come to meet the Senator . . .
Gene. I know, but I'd prefer to do it this way. I'm not very good at that sort of thing.

Photographs for *I Never Sang for My Father* are from the original Broadway production.
Photographs by Martha Swope

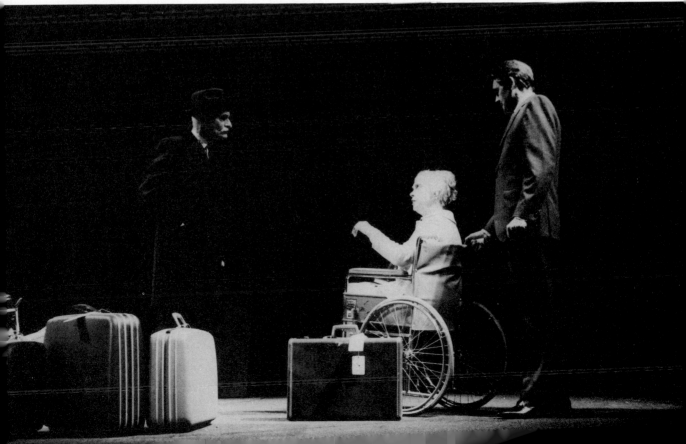

Tom. Well, all right. You're the boss. It's just that you can get right on the West Side Drive.
Gene. It's easier for me to go up the Major Deegan.
Tom. Rather than the Cross County?
Gene. Yes.
Tom. I don't like to question you, old man, but I'm sure if you clocked it, you'd find it shorter to go up the West Side Drive and——
Margaret (*annoyed with him*). Father, now come on. Gene is handling this.
Tom. All right. All right. Just a suggestion.
Gene. Come on, Dad.
Tom. You go along with your mother. I'll keep an eye on this luggage.
Gene (*trying to be patient*). It will be all right.
Tom (*clenching his teeth and jutting out his jaw, sarcastic*). You don't mind if I want to keep an eye on my luggage, do you? I've traveled a good deal more than you have in my day, old man, and I know what these guys will do if you let them out of your sight. (Gene *is embarrassed. The* Porter *smiles and starts moving off.*) Hey, not so fast there.

[*And he strides after the* Porter *and the bags.* Gene *moves to the front of the stage again, as the lights dim on the retreating wheelchair and luggage, and on* Tom *and* Margaret.]

Gene. My father's house was in a suburb of New York City, up in Westchester County. It had been a quiet town with elms and chestnut trees, lawns and old sprawling houses with a certain nondescript elegance. My father had been mayor of this town, a long time ago . . . Most of the elms and chestnut trees had gone, and the only elegance left was in the pretentious names of the developments and ugly apartment houses . . . Parkview Meadows Estates . . . only there was no meadow, and no park, and no view except of the neon signs of the chain stores. Some old houses remained, like slightly frowzy dowagers. The lawns were not well kept, and the houses were not painted as often as they should have been, but they remained. My father's house was one of these.

[Tom *and* Margaret *have now started coming in from the back.*]

Tom. Just look at this town.
Margaret. What, dear?
Tom (*raises his voice in irritation*). Do you have that thing turned on?
Margaret. Yes.
Tom. I said just look at this town.
Margaret. I know, dear, but time marches on.
Tom. Junky, ugly mess. When we came here . . .
Margaret. Don't get started on that. You can't play the show over again.
Tom. I can make a comment, can't I?
Margaret. But you always dwell on the gloomy side. Look at the good things.
Tom. Like what? . . . I'll bet you Murphy didn't bring the battery back for the Buick. I wrote him we'd be home today. (*He heads for the garage.*)
Margaret (*to* Gene). I don't know what we're going to do about that car. Your father shouldn't be driving any more. But they just keep renewing his license by mail. (*She moves stiffly, looking at her garden and trees and lawn.*) I must say, there's no place like home. *Mmmmm.* Just smell the grass.
Gene (*taking his mother's arm*). You all right?
Margaret. It's just my mean old joints getting adjusted. I want to look at my garden. I think I see some crocuses. (*And she moves into the shadows to see her garden.*)
Tom (*coming back*). Well, he did bring it back.
Gene. Good.
Tom. Can't count on anyone these days. Where's your mother?
Gene. She's walking around her garden.

Tom. What?

Gene. She's walking around her garden.

Tom. You know, Gene, I don't mean to criticize, but I notice you're mumbling a great deal. It's getting very difficult to understand you.

Gene (*friendly, his hand on his father's shoulder*). I think you need a hearing aid, Dad.

Tom. I can hear perfectly well if people would only enunciate. "Mr. Garrison, if you would only *E-NUN-CIATE*." Professor Aurelio, night school. Didn't you ever have to take any public speaking?

Gene. No, Dad.

Tom. All your education. Well . . . Where did you say your mother was?

Gene. Walking around her garden.

Tom (*intense. He has been waiting for someone to say this to*). I tell you, the strain has been awful.

Gene. She looks well.

Tom. I know. But you never know when she might get another of those damnable seizures. (*He looks at the ground and shakes his head at the problem of it all.*)

Gene (*pats his father's shoulder*). It's rough. I know.

Tom. Well, we'll manage. She's a good soldier. But you know, she eats too fast. The doctor said she must slow down. But not your mother. Incidentally, don't forget she has a birthday coming up.

Gene (*who knows his mother's birthday and hates being reminded of it each year*). Yes, I know.

Tom. Before you go, I want to give you some money. Go get something nice for me to give her. Handkerchiefs. You know what she likes.

Gene (*who has done this every Christmas and birthday for years . . . smiles*). All right. (Tom *coughs, deep and thick.*) We're going to have to get that cough looked into.

Tom. I fully intend to, now I'm home. But I wasn't going to let them get their hands on me down there. If you're a tourist, they just soak you.

Gene. With the problems you've had with pneumonia . . .

Tom. I can take care of myself. Don't worry about me.

Gene. Let's go see if Dr. Mayberry can see you.

Tom. First thing tomorrow.

Gene. Why not make the appointment today?

Tom (*irked*). Now, look, I'm perfectly able to take care of myself.

Gene. Mother would feel better if——

Tom (*that smile again*). Now, Gene, don't you think I have the sense to take care of myself?

Gene (*smiling, but a little angry*). Sometimes, no.

Tom (*considers this, but is mollified by the smile*). Well, I appreciate your solicitude, old man. Why don't you stay for supper?

Gene. I was planning to take you to Schrafft's.

Tom. Hooray for our side! (Gene *starts out toward the garden.*) Oh, Gene. I want to talk to you a minute. We received your four letters from California . . .

Gene. I'm sorry I didn't write more often.

Tom. Well, we *do* look forward to your letters. But this girl, this woman you mentioned several times . . .

Gene. Yes?

Tom. You seemed to see a lot of her.

Gene. Yes. I did.

Tom. Carol's been dead now, what is it? . . .

Gene. About a year.

Tom. And there's no reason why you shouldn't go out with other women. (Gene *just waits.*) I was in California with the Senator, and before that. It's a perfectly beautiful place. I can understand your enthusiasm for it. Gorgeous place.

Gene. Yes. I like it a lot.

Tom. But listen, Gene . . . (*He bites his upper lip, and his voice is heavy with emotion.*) If you were to go out there, I mean, to live, it would kill your mother. (*He looks at his son with piercing eyes, tears starting. This has been in the nature of a plea and an order. Gene says nothing. He is angry*

at this order, that his father would say such a thing.)
You know you're her whole life. (Gene *is further
embarrassed and troubled by this statement of what
he knows to be the truth from his father.*) Yes, you
are! Oh, she likes your sister. But you . . . are
. . . her . . . life!

Gene. Dad, we've always been fond of each
other, but——

Tom. Just remember what I said.

[Margaret *can now be heard reciting to herself,
very emotionally.*]

Margaret. "Loveliest of trees, the cherry now /
Is hung with bloom along the bough, / And
stands about the woodland ride, / Wearing
white for Eastertide."[1] (*She opens her eyes.*) Oh,
Gene, I've just been looking at your garden.
Give me a real hug. You haven't given me a
real hug yet. (Gene *hugs her, uncomfortable, but
loving and dutiful. It is, after all, a small thing.*
Margaret *looks at him, then kisses him on the lips.*)
Mmmmmmm. (*She smiles, making a playful thing
of it.*) Oh, you're a sight for sore eyes.

[Tom *has watched this, and looks significantly at*
Gene.]

Tom (*moving off*). Gene is staying for dinner.
We're going to Schrafft's.

Margaret. Oh. Can you give us all that time?

Tom. He said he would. Now come along. You
shouldn't be standing so long. You've had a
long trip. (*He exits.*)

Margaret. He worries so about me. I suppose
it is a strain, but he makes me nervous re-
minding me I should be sitting or lying down
. . . Oh, well . . . (*She takes* Gene's *arm.*) How
are you, my precious?

Gene. Fine.

1. **"Loveliest . . . Eastertide":** lines from a poem called
"Loveliest of Trees" by A. E. Housman.

Margaret. We haven't talked about your trip
to California.

Gene. No.

Margaret (*raising her voice*). I say, we haven't
talked about your trip.

Gene. We will.

Margaret (*low*). Did you speak to your father
about seeing a doctor?

Gene. He promised me tomorrow.

Margaret. I'll believe it when I see it. He's so
darned stubborn. Alice takes after him.

Gene. Oh, I got a piece of it too.

Margaret (*her tinkling laugh*). You? You don't
have a stubborn bone in your body.

[*We fade, as they move up and into the shadows.*
 *Immediately the lights come up on another part of
the stage—Schrafft's.*]

Mary (*A pretty Irish waitress, she is just finishing
setting up her table as* Tom *enters*). Well, good
evening, Mr. Garrison. Welcome back.

Tom (*the charmer*). Greetings and salutations.

Mary. We've missed you.

Tom. It's mutual. Is this your table?

Mary. Yes.

Tom. Is there a draft here? I like to keep Mrs.
Garrison out of drafts.

[*He looks around for windows.* Margaret *and*
Gene *come into the area. He is helping her, as she
moves slowly and deliberately.*]

Mary. Good evening, Mrs. Garrison. Nice to
have you back.

Tom. You remember Mary?

Margaret (*polite but reserved*). Yes. Good eve-
ning, Mary.

Mary. You're looking well, Mrs. Garrison.

Margaret (*as* Tom *holds the chair for her*). But
look at him. (*She nods at* Tom.)

Mary. We'll fatten him up.

Tom (*smiling, flirtatiously*). Will you do that

now? Oh, we've missed you. We've had a girl down there in Florida, no sense of humor. Couldn't get a smile out of her.

Mary. Well, we'll have some jokes. Dry martini?

Tom (*a roguish twinkle*). You twist my arm. Six to one. (*He says this as though he were being quite a man to drink his martini so dry. Gene finds all this byplay harmless, but uncomfortable.*) You remember my son, Gene.

Mary (*smiles*). Yes.

[Gene *smiles back.*]

Tom. What's your pleasure, Gene . . . Dubonnet?

Gene. I'll have a martini too, please.

Tom. But not six to one.

Gene. Yes. The same.

Tom. Well!

Gene. Mother?

Margaret. No, nothing. My joints would be stiff as a board.

Tom (*with a twinkle in his eye*). You said you'd be stiff?

Margaret. What?

Tom (*raising his voice*). You said you'd be stiff?

Margaret. My joints. My joints.

Tom. Oh, wouldn't want you stiff. (*He thinks he's being very funny, and tries to share his laugh with* Gene, *who smiles reluctantly.* Mary *exits. To* Gene) Have I ever shown you this ring?

Margaret. Oh, Tom, you've shown it to him a hundred times.

Tom (*ignoring her reminder*). I never thought I'd wear a diamond ring, but when the Senator died, I wanted something of his. Last time I had it appraised, they told me it was worth four thousand.

Margaret. It's his favorite occupation, getting that ring appraised.

Tom (*again ignoring her*). Don't let anyone ever tell you it's a yellow diamond. It's a golden diamond. Of course, when I go to see a doctor,

I turn it around. (*He gives a sly smile. The others look embarrassed.*)

Margaret (*looking at the menu*). What are you going to have?

Tom (*taking out his glasses*). Now, this is my dinner, understand?

Gene. No. I invited you.

Tom. Uh-uh. You had all the expenses of coming to get us.

Gene. No, it's mine. And order what you want. Don't go reading down the prices first.

Tom (*smiles at the idea, though he knows he does it*). What do you mean?

Gene. Whenever I take you out to dinner, you always read down the prices first.

Margaret. Oh, he does that anyway.

Tom. I do not. But I think it's ridiculous to pay, look, three seventy-five for curried shrimp.

Gene. You like shrimp. Take the shrimp.

Tom. If you'll let me pay for it.

Gene (*getting annoyed*). No! Now, come on.

Tom. Look, I appreciate it, Gene, but on what you make . . .

Gene. I can afford it. Now let's not argue.

Margaret. Tell me, lovey, do you get paid your full salary on your sabbatical?[2]

Gene. No. Fifty percent.

Tom. Well, then, look . . .

Margaret. Now, Father, he wants to pay. Let him pay. (*They consult their menus.*) Incidentally, Tom, you should go over and say hello to Bert Edwards. Gene and I stopped on our way in.

Tom. Why?

Margaret. While we were gone, he lost his wife.

Tom. Where'd he lose her?

Margaret. Tom!

Tom. Just trying to get a rise.

Margaret. And Mrs. Bernard. She looks terrible.

Tom. Always did.

2. **sabbatical:** leave of absence.

Margaret. She lost her husband six months ago. She told me, just before we left for Florida, "I hope I go soon."

Tom. Why are you so morbid tonight?

Margaret. I'm not morbid. They're just there. We really should see them, have them in.

Tom. Phooey! Who needs them?

Margaret. Oh, Tom! I can't have anyone in. Your father won't play bridge or do anything. He just wants to watch Westerns or tell the story of his life.

Tom. Now, wait a minute.

Margaret. I can't invite people to come over to watch Westerns or to listen to you go on and on. You embarrass me so. You insist on going into the most gruesome details of your life.

Tom. People seem to be interested.

Margaret. What?

Tom. Have you got that turned up?

Margaret. Yes. (*She adjusts the volume.*)

Tom. I said they seem to be interested.

[*He tries to take* Gene *in on an exasperated shaking of the head, but* Gene *looks the other way.*]

Margaret. I admit it's a remarkable story, your life. But there are other things to talk about. People want to talk about art or music or books.

Tom. Well, let them.

Margaret. He keeps going over and over the old times. Other people have had miserable childhoods, and they don't keep going over and over them . . . That story of your mother's funeral. And you say I'm morbid.

Gene. What was that? I don't remember that.

Margaret. Oh, don't get him started.

Tom. Your mother wants me to play cards with a lot of women who just want to gossip and chatter about styles. That's why I won't play.

Margaret. You won't play because you can't follow the play of the cards any more.

Tom. I beg to disagree.

Gene. Please! Don't fight . . . don't fight. (*He's said this in a mock-serious singsong.*)

Margaret. He kept telling everyone how he wouldn't allow his father to come to his mother's funeral.

Tom (*defensively angry*). Are you implying that I should have let him?

Margaret. I'm not saying——

Tom. He'd run out on us when we were kids, and I told him——

Margaret. I'm not saying you were wrong. You're so defensive about it. I'm saying you're wrong to keep bringing it up.

Tom. You brought it up this time.

Margaret. Well, I'm sorry. Imagine going around telling everyone he shoved his father off the funeral coach. (*She is consulting the menu.*)

Tom. And I'd do it again. I was only ten, but I'd do it again. We hadn't seen him in over a year, living, the four of us, in a miserable two-room tenement, and suddenly he shows up weeping and begging, and drunk, as usual. And I shove him off! (*He almost relives it.*) I never saw him again till some years later when he was dying in Bellevue . . . of drink. (*The hatred and anger are held in, but barely.*)

Margaret (*She has been studying the menu*). What looks good to you?

Tom (*a hard, sharp edge to his voice*). I have not finished! I went down to see him, to ask him if he wanted anything. He said he wanted an orange. I sent him in a half-dozen oranges. I would have sent more, except I knew he was dying, and there was no point in just giving a lot of oranges to the nurses. The next morning he died.

[*There is a silence for a moment, while* Gene *and* Margaret *look at the menu, and* Tom *grips and ungrips his hand in memory of his hatred for his father.*]

Margaret (*gently*). Look at your menu now, Father. What are you going to eat?

Tom. I don't feel like anything. I have no appetite. (*He lights a cigarette.*)

Margaret (*to Gene*). This is the way it's been.

Gene. He'll see a doctor tomorrow. Don't get upset.

[Mary *arrives with the martinis.*]

Tom. Ah, here we are.

Mary. Six to one. (*She puts the martini in front of him.*)

Tom. Oh . . . ! (*He shakes his head in exasperation and fishes out the lemon peel.*)

Mary. But you always ask for lemon peel.

Tom (*demonstrating*). Twisted over it, not dumped in it. It's all right. It's all right. (*With an Irish accent*). Well, to your smilin' Irish eyes.

Mary. He hasn't changed, has he?

Tom. What county are you from, did you say?

Mary. Armagh.

Tom. I knew there was something I liked about you. That's where my people came from, County Armagh. (*He drinks.*) Do you have any burnt ice cream tonight?

Mary. Ah, you.

Tom (*smiling*). No, I mean it. (*To* Gene) They have burnt ice cream here.

Mary. I'll be back. (*And she exits.* Margaret *sits embarrassed and piqued by this kind of flirtation which has gone on all their lives.*)

Tom (*the sport, to* Gene). I like to get a rise out of them. If they kid with me, I give them a good tip. If they don't, a straight ten percent. (*He draws a line on the tablecloth to emphasize this. He looks at* Margaret.) What's the matter?

Margaret. If you want to make a fool of yourself, go right ahead.

[Tom *is angry, hurt and exasperated. He looks at her, and then tries to include* Gene, *to make him share his anger. But* Gene *looks away and to the menu.* Tom *stares at his glass, and his jaw muscles start to work. The scene dims in the Schrafft's area, and* Gene *moves from the table to another side of the stage.*]

Gene. We hurried through the last part of our dinner. My father ate only his dessert, burnt almond ice cream. We hurried through to rush home to one of my father's rituals, the television Western. He would sit in front of them hour after hour, falling asleep in one and waking up in the middle of the next one, never knowing the difference. When my father fell in love with a program, it was forever. All during my childhood we ate our dinner to the accompaniment of Lowell Thomas and Amos and Andy.[3] If anyone dared to talk, Father would storm away from the table and have his dinner served at the radio . . . I say, we rushed away from Schrafft's. Actually, my father rushed. We just lived down the street. I walked my mother home very slowly, stopping every fifty yards or so.

3. **Lowell Thomas and Amos and Andy:** radio shows popular in the 1930s and 1940s. Lowell Thomas was a commentator, and Amos and Andy were comics.

[Margaret *has joined* Gene *and taken his arm.*]

Margaret. I don't know how he can sit through hour after hour of those Westerns.

Gene. I think he always wished he'd been a cowboy. "Take 'em out and shoot 'em!"

Margaret. He won't listen to the things I want to hear. Down in Florida there's only one TV in the lounge, and he rode herd on it. And then he'd fall asleep in three minutes . . . Still, he's a remarkable man.

Gene. Good old Mom.

Margaret. Well, he is. Not many boys have fathers they could be as proud of.

Gene. I know that, Mom. I'm very . . . proud of him.

Margaret (*She catches his tone*). Everything he's done, he's done for his family. (Gene *just looks at her, smiling.*) So he didn't dance with me at parties. (*She smiles at* Gene.) You took care of that.

Gene. You were just a great dancer, Mother.

Margaret. I was a terrible dancer. You just couldn't stand seeing me sitting alone at a table at the club while your father was . . . (*She stops, realizing she's about to make* Gene's *point.*)

Gene. . . . off dancing with various other people, table-hopping or playing poker with the boys in the locker room.

Margaret. What a shame that children can't see their parents when they're young and courting, and in love. All they see them being is tolerant, sympathetic, forbearing and devoted. All the qualities that are so unimportant to passionate young people.

[Tom *appears.*]

Tom. Gene . . . Gene . . . Come watch this one. This is a real shoot-'em-up.

Gene. In a minute, Dad.

Margaret. Gene. I want to talk to you.

Gene. You should be in bed. You've had a big day. (*They move to another part of the stage.*)

Margaret. I took another nitro.[4] And I've had something on my mind for a long time now. You remember you gave me that heart-shaped pillow when I was in the hospital once, when you were a boy? (*She sits on the chaise longue.*)

Gene. Yes.

Margaret. Fidget used to curl up here. (*She indicates the crook in her leg.*) And you'd sit over there, and we'd listen to the Metropolitan Opera broadcasts.

[Gene *is made uncomfortable by this attempt to evoke another time, another kind of relationship, but he doesn't show it.*]

Gene. Yes. I remember.

Margaret. You'd dress up in costumes and act in front of that mirror. I remember you were marvelous as D'Artagnan in *The Three Musketeers*. (*For the fun of it, a forty-year-old man, he assumes the dueling stance, and thrusts at his image in an imaginary mirror. Gene sits on a footstool and watches her adjust herself in her chaise. After a moment*) Tell me about California.

Gene (*a little taken by surprise. Here is the subject*). I loved it.

Margaret. And the girl, the woman with the children? The doctor? (*Gene doesn't say anything. He frowns, wondering what to say.*) You love her too, don't you?

Gene. I think so.

Margaret. I know when Carol died, you said you'd never marry again. But I hoped you would. I know it's hard, but I think Carol would have wanted you to.

Gene. I don't know.

Margaret. Gene, your sabbatical is over soon, isn't it?

Gene. A few more months.

Margaret. I think you want to move to California and get a job teaching there and marry this woman.

Gene (*after a moment*). Yes. I think I do. I wasn't sure while I was there. I suddenly felt I should get away and think. But when I walked into my old apartment, with all Carol's things there . . .

Margaret. I think it would be the best thing in the world for you to get away, to marry this girl.

Gene (*touched . . . very simply*). Thanks.

Margaret. A new place, a new wife, a new life. I would feel just terrible if you didn't go because of me. There are still planes, trains and telephones, and Alice comes from Chicago once or twice a year and brings the children.

Gene. Thanks, Mother. You've always made things very easy. I think you'll like Peggy.

Margaret. I'm sure I will. You have good taste in women. And they have good taste when they like you.

Gene. I'm not so sure. I never really knew if I made Carol happy . . . If I did make her happy, I wish she'd let me know it.

Margaret. I guess a lot of us forget to say thank you until it's too late. (*She takes his hand and smiles at him.*) Thank you . . . You have such nice hands. I've always loved your hands . . . You've been so good to me, Gene, so considerate. Perhaps I've let you be too considerate. But it was your nature, and your father just withdrew behind his paper and his investments and his golf. And our interests seem to go together. You liked to sing, and I played the piano, oh, miserably, but I played. (*She strokes his hand.*) I tried not to be one of those possessive mothers, Gene. If I did things wrong, I just did the best I knew how.

Gene. You did everything just fine. (*He pats his mother's hand before he draws his own away.*)

Margaret. And your father has done the best he knew how.

Gene (*with no conviction*). Yes.

4. **nitro:** short for nitroglycerine, a medication that relieves heart pains.

[*This is her old song. She knows that* Gene *knows it's probably true, but he gets no satisfaction from the knowledge.*]

Margaret. Of course you know your father will object to your going away.

Gene. He already has. He said it would kill you.

Margaret. How sad. Why can't he say it would kill *him*? He doesn't think it would hold you or mean anything to you. (*She shakes her head.*) He dotes on your letters down there. Reads them and rereads them. Tells everyone what a fine relationship he has with you. "My door is always open . . . Anything he wants, he can have . . . We have always had each other's confidence . . ." (Gene *smiles at this and sadly shakes his head.*) Well, you go to California. Your father and I can take care of each other. I'll remember where he put his checkbook, and he'll make the beds, which is the only thing I'm really not supposed to do. And, for your information, I have my old-lady's home all picked out. That's what I want, so I won't be a burden to any of you.

Gene. You a burden!

Margaret (*wisely*). Oh, yes! Now don't mention this business to your father tonight. He's not well, and it's been such a nice day. In the next few days I'll talk to him, tell him it's important for you to——

Gene. No, I'll do it. (*He kisses her on the cheek.*)

Margaret. Good night, my precious.

Gene. Where would you like to celebrate your birthday?

Margaret. Oh, lovey, you've already given me so much time. Just call me on the phone.

Gene. No . . . We can at least have dinner . . . I'll make some plans.

Margaret. Gene, if your father gives you money to buy his present for me, please, no more handkerchiefs.

Gene. He always says handkerchiefs.

Margaret. I know, but I've got dozens and dozens from my past birthdays and Christmases.

Gene. What would you like?

Margaret. Get me some perfume. You choose the kind, except I don't like lily of the valley, or gardenia.

Gene. You're a hard woman to please . . . Good night . . . You look great.

Margaret. Oh, a little rouge and lipstick. Thanks for coming to meet us. Tell your father I've gone to bed, and don't let him keep you there to all hours watching television. (*Calling after him*) I don't like carnation either.

[Gene *waves back affectionately and moves away, as the lights dim on* Margaret's *area.* Gene *moves, then stands and looks at the back of his father's chair as the TV sounds come up, and lights come on in that area.* Gene *moves to his father's chair and gently touches his arm while turning the knob of the TV volume.*]

Tom (*stirring*). What? . . . What? (*He comes to slowly, shakes his head and looks at* Gene, *bewildered.*)

Gene (*gently*). I'm going now, Dad.

Tom. Oh, so soon?

Gene (*controls his irritation. This has always been his father's response, no matter how long he has been with him*). Yes. I have to go.

Tom. Where's your mother?

Gene. She's upstairs. She's fine. (Tom *starts to cough.*) You see about that in the morning, Dad.

Tom (*getting up, steadying himself*). I fully intend to. I would have done it down there, but I wasn't going to be charged outrageous prices. (*He glances at the TV screen.*) Oh, this is a good one. Why don't you just stay for this show?

Gene (*the anger building*). No, Dad. I've got to run along.

Tom. Well, all right. We see so little of you.

Gene. I'm up at least once a week, Dad.

Tom. Oh, I'm not complaining. (*But he is.*) There just doesn't seem to be any time. And when you are here, your mother's doing all the talking. The way she interrupts. She just doesn't listen. And I say, "Margaret, please." . . . But she goes right on . . . Well, "all's lost, all's spent, when we our desires get without content . . . 'tis better to be that which we destroy, than by destruction dwell with doubtful joy."[5]

Gene (*He is always puzzled by his father's frequent use of this quotation. It never is immediately appropriate, but it indicates such unhappiness that it is sad and touching to him*). We'll get a chance to talk, Dad. (*He moves toward the porch.*)

Tom. I can't tell you what a comfort it is knowing you are just down in the city. Don't know what we'd do without you. No hat or coat?

Gene. No.

Tom. It's still chilly. You should be careful.

Gene (*kissing his father on the cheek*). Good night, Dad. I'll call you tomorrow to see if you've gone to the doctor's.

Tom. Well, I may and I may not. I've looked after myself pretty well for almost eighty years. I guess I can judge if I need to see the doctor or not.

Gene (*angry*). Look, Dad . . .

Tom. Seventy years ago, when I was a snot-nosed kid up in Harlem, a doctor looked at me and said if I were careful, I'd live to be twenty. That's what I think about doctors. Ten dollars to look at your tongue. Phooey! Out! Who needs them?

Gene. Look, Dad, you're worrying Mother to death with that cough.

Tom. All right, all right. I'll go. I'll be a good soldier . . . You're coming up for your mother's birthday, aren't you?

Gene. Yes.

5. **"all's lost . . . doubtful joy":** These lines expressing tragic regret are spoken by Lady Macbeth in Act Three, Scene 2, of William Shakespeare's *Macbeth*.

Tom. And don't forget, Mother's Day is coming up.

Gene. Well . . .

Tom. Why don't we make reservations at that restaurant in Connecticut where you took us last Mother's Day?

Gene. We'll see.

Tom. It will be my party. And, Gene, remember what I said about California!

Gene (*straining to get away from all the encirclements*). Good night, Dad. (*He moves off.*)

Tom. Drive carefully. I noticed you were inclined to push it up there a little. (Gene *burns.*) Make a full stop going out the driveway, then turn right.

Gene (*angry, moves further down*). Yes, Dad.

Tom (*calling after him*). Traffic is terrible out there now. Used to be a quiet little street. Take your first left, and your second right.

Gene (*He has driven this route for many years*). Yes.

Tom. Then left under the bridge. It's a little tricky down there. (*When he gets no response, he calls.*) Gene?

Gene (*in a sudden outburst*). Dad, I've driven this road for twenty years! (*He is immediately sorry, and turns away from his father's direction.*)

Tom. Just trying to be helpful.

[*The lights fade on* Tom *as he goes back into the house.* Gene *is now downstage.*]

Gene. Take your first left and your second right. Then turn left under the bridge. But do not go as far as California, because it would kill your mother . . . I hated him for that, for sending up warning flares that if I left, it would not be with his blessing, but with a curse . . . as he had banished my sister Alice years ago for marrying someone he didn't approve of . . . and the scene so terrified me at fourteen, I was sick . . . He knew his man . . . that part of me at least . . . a gentleman who gave way

at intersections . . . And yet, when I looked at those two old people, almost totally dependent on me for their happiness . . . This is the way the world ends, all right . . .

[*A phone rings. A light picks out* Tom *holding the phone.*]

Tom. I was downstairs in the kitchen, and suddenly I heard your mother scream . . . "Tom! Tom!" . . . I ran up the stairs . . . (*He is seized with a fit of coughing.*) I ran up the stairs, and there she was stretched out on the floor of the bedroom . . . "Nitro" . . . "nitro" . . . That's all she could say. You know we have nitroglycerine all over the house.

[*A Nurse* comes to Tom *as the lights come up; she leads him into a hospital waiting-room area.* Gene *joins them.*]

Gene. Dad. (*He shakes his hand and kisses him on the cheek.*)
Tom. Am I glad to see you! Have you seen your mother?
Gene. Yes. She's sleeping.

[Tom *starts to cough.*]

Gene. That doesn't sound any better.
Tom. Well, I've had a shot. After your mother got settled over here, the doctor took me to his office and gave me a shot. I *would* have gone down there in Florida, you know, but . . . well . . . (*shakes his head*) I just don't know. I was in the kitchen getting breakfast . . . You know I've been getting the breakfasts, when suddenly I heard her scream, "Tom, Tom." I went running up the stairs, and there she was stretched out on the floor. She'd had an attack. "Nitro," she whispered. We've got it all over the house, you know. She'd had attacks before, but I knew at once that this was something more. I gave her the pills and called the doctor

. . . "This is an emergency. Come quick." . . . The doctor came, gave her a shot . . . and called the ambulance . . . and here we are. (*He shakes his head, partly in sorrow, but also partly in exasperation that such a thing could happen.*) She had a good time in Florida. I don't understand it. She ate too fast, you know. And the doctor had said she should do everything more slowly.
Gene. There's no explaining these things, Dad.
Tom. I suppose I could have seen more of her down there. But she just wanted to play bridge, and I didn't play, because the ladies just chattered all the time about styles and shops . . . And I met some very interesting people. Oh, some of them were bores and just wanted to tell you the story of their life. But there were others. You know, I met a man from Waterbury, Connecticut, used to know Helen Moffett . . . I've told you about Helen Moffett, haven't I? When I was a kid, when the clouds were low and dark, my grandfather'd take me up there sometimes on Sundays . . . a city slum kid in that lovely country . . . And Helen and I . . . oh . . . it never amounted to much. We'd go to church, and then we'd take a walk and sit in a hammock or under an apple tree. I think she liked that. But I didn't have any money, and I couldn't go up there often. Her mother didn't like me . . . "That young man will end up the same way as his father." . . . And that scared her off . . . This man in Florida, I've got his name somewhere . . . (*He fishes out a notebook and starts to go through it.*) He said Helen had never married . . . Said she'd been in love as a kid . . . and had never married. (*Tears come to his eyes.*) Well, I can't find it. No matter. (Gene *doesn't know what to say. He is touched by this naked and unconscious revelation of an early and deeply meaningful love. But it seems so incongruous under the circumstances.*) Someday we might drive out there and look him up . . . Helen's dead now, but it's nice country. I was a kid with nothing . . . living with my grand-

father . . . Maybe if she hadn't been so far away . . . Well, that's water over the dam.

Gene (*After a long pause, he touches his father*). Yes.

Tom (*just sits for a few moments, then seems to come back to the present, and takes out his watch*). You know, I'd like to make a suggestion.

Gene. What, Dad?

Tom. If we move right along, we might be able to make the Rotary Club for dinner. (Gene *frowns in bewilderment.*) I've been away for three months. They don't like that very much if you're absent too often. They drop you or fine you. How about it? (*He asks this with a cocked head and a twinkle in his eye.*)

Gene. I thought we might eat something around here in the hospital.

Tom. I had lunch in the coffee shop downstairs, and it's terrible. It will only take a little longer. We won't stay for the speeches, though sometimes they're very good, very funny. We'll just say hello to the fellows and get back . . . Your mother's sleeping now. That's what they want her to do.

Gene (*bewildered by this, but doesn't want to get into an argument*). Let's drop by and see Mother first.

Tom. They want her to rest. We'd only disturb her.

Gene. All right.

Tom (*As they turn to go, he puts his arm around Gene's shoulder*). I don't know what I'd do without you, old man.

[*As the lights shift, and* Tom *and* Gene *head away, we move to the Rotary gathering, held in the grill room of one of the local country clubs. A piano is heard offstage, playing old-fashioned singing-type songs—badly. A tinkle of glasses . . . a hum of men talking and laughing. This area is presumably an anteroom with two comfortable leather chairs. A man enters, wearing a large name button and carrying a glass. This is the minister,* Reverend Pell, *a straightforward, middle-aged man.*]

Reverend Pell. Hello, Tom, good to see you back.

Tom (*His face lights up in a special "greeting the fellows" type grin*). Hello, Sam.

Reverend Pell. Did you have a good trip?

Tom. All except for that damnable wind down there. You know my son, Gene. Reverend Pell.

Reverend Pell. Yes, of course. Hello, Gene. (*They shake hands.*)

Tom. Gene was a Marine. (Gene *frowns.*) You were a Marine, weren't you, Sam?

Reverend Pell. No. Navy.

Tom. Well, same thing.

Reverend Pell. Don't say that to a Marine.

[Gene *and* Reverend Pell *smile.*]

Tom. Gene saw the flag go up on Iwo.[6]

Gene (*embarrassed by all this inappropriate line*). Let's order a drink, Dad.

Tom. Sam, I've been wanting to talk to you. Now is not the appropriate time, but some bozo has been crowding into our pew at church. You know Margaret and I sit up close because she doesn't hear very well. Well, this guy has been there in our pew. I've given him a pretty sharp look several times, but it doesn't seem to faze him. Now, I don't want to seem unreasonable, but there is a whole church for him to sit in.

Reverend Pell. Well, we'll see what we can do, Tom.

Tom (*calling to a bartender*). A martini, George. Six to one. (*To Gene*) Dubonnet?

Gene. A martini.

Tom. Six to one?

Gene. Yes. Only make mine vodka.

Tom. Vodka? Out! Phooey!

Reverend Pell. What have you got against vodka, Tom?

6. **Iwo:** Iwo Jima, a tiny island in the Pacific, taken in March 1945 by the United States Marines after fierce fighting.

Tom. It's Russian, isn't it? However, I don't want to influence you. Make his vodka. Six to one, now! These fellows like to charge you extra for a six to one, and then they don't give you all the gin you've got coming to you.

Reverend Pell. I hope you don't drink many of those, Tom, six to one.

Tom. My grandmother used to give me, every morning before I went to school, when I was knee-high to a grasshopper . . . she used to give me a jigger of gin with a piece of garlic in it, to keep away colds. I wonder what the teacher thought. Phew. I must have stunk to high heaven . . . She used to put a camphor ball in my necktie too. That was for colds, too, I think . . . But they were good people. They just didn't know any better. That's my grandfather and my grandmother. I lived with them for a while when I was a little shaver, because my father . . . well, that's another story . . . but my grandfather——

Reverend Pell (*He puts his hand on* Tom's *arm*). I don't mean to run out on you, Tom, but I was on my way to the little boy's room. I'll catch up with you later.

Tom. Go ahead. We don't want an accident.

Reverend Pell (*as he is going, to* Gene). You got a great dad there. (*And he disappears.*)

Tom. I don't really know these fellows any more. (*Indicating people offstage*) All new faces. Most of them are bores. All they want to do is tell you the story of their lives. But sometimes you hear some good jokes . . . Now, here's someone I know. Hello, Marvin.

[Marvin Scott, *a man about sixty-five, enters.*]

Marvin Scott. Hello, Tom. Good to see you back.

Tom. You remember my son, Gene.

Marvin Scott. Yes. Hello.

Gene. Hello, Mr. Scott.

Marvin Scott (*to* Tom). Well, young feller, you're looking great!

Tom. Am I? Well, thank you.

Marvin Scott. How's Margaret?

[Tom *goes very dramatic, pauses for a moment and bites his lip.* Marvin *looks at* Gene.]

Gene. Mother's . . .

Tom. Margaret's in an oxygen tent in the hospital.

Marvin Scott (*Surprised that* Tom *is here, he looks at* Gene, *then at* Tom). I'm terribly sorry to hear that, Tom.

Tom. Heart. (*He shakes his head and starts to get emotional.*)

Gene (*embarrassed*). We're just going to grab a bite and get back. Mother's sleeping, and if we were there, she'd want to talk.

Marvin Scott. I'm sorry to hear that, Tom. When did it happen?

Tom (*striving for control. His emotion is as much anger that it could happen, and self-pity, as anything else*). This morning . . . I was in the kitchen, getting something for Margaret, when suddenly I heard her scream . . . "Tom . . . Tom . . ." and I ran upstairs . . . and there she was, stretched out on the bedroom floor . . . "Nitro . . . nitro" . . . she said . . . We have nitrogly-

cerin all over the house, you know . . . since her last two attacks . . . So, I get her the nitro and call the doctor . . . and now she's in an oxygen tent in the hospital . . . (*The bell starts to ring to call them to dinner.*)

Marvin Scott. Well, I hope everything's all right, Tom.

Gene. Thank you.

Tom. What happened to those martinis? We've got to go in to dinner and we haven't gotten them yet.

Gene. We can take them to the table with us.

Tom. I have to drink mine before I eat anything. It brings up the gas. Where are they? (*And he heads off.*)

Marvin Scott (*to* Gene). He's quite a fella.

[*And they move off as Rotarians start singing to the tune of "Auld Lang Syne," "We're awfully glad you're here," etc.*

As the lights fade on this group they come up on the hospital bed and Margaret. *The* Nurse *is sitting there, reading a movie magazine. The oxygen tent has been moved away.* Tom *and* Gene *enter quietly, cautiously. The* Nurse *gets up.* Gene *approaches the bed.*]

Gene (*whispers to the* Nurse). Anything?

Nurse. The doctor was just here. He said things looked much better.

Tom (*too loud*). Hooray for our side.

Margaret (*stirs*). Hm . . . What? (*She looks around.*)

Gene. Hello, Mother.

Margaret. Oh, Gene. (*She reaches as though to touch him.*) Look where I ended up.

Gene. The doctor says you're better tonight.

Margaret (*her eyes flashing*). You know how this happened, don't you? Why it happened? (*She nods her head in the direction of* Tom, *who is at the foot of the bed chatting with the* Nurse.)

Gene (*quieting*). Now, Mother. Take it easy. He's seen the doctor. He's had his shot.

Margaret. Well!

Gene. You should be sleeping.

Margaret. That's all I've been doing. (*She takes his hand.*) It makes me so mad. I was feeling so well. All the ladies down in Florida said I've never looked so well.

Gene. You've had these before, Mother. Easy does it.

Margaret. He's seen the doctor for himself?

Gene. Yes. Just a bad cold. He's had a shot.

Margaret. Why wouldn't he have that down there?

Gene. Mother, we'll have to go if you talk like this, because you should be resting.

Tom (*leaving the* Nurse, *cheerful*). Well, how goes it?

Margaret. How do I know?

Tom (*takes her hand and smiles*). You look better.

Margaret. You know I came without anything. I've still got my stockings on.

Tom (*kidding. Very gentle*). Well, it all happened pretty quick, my darling.

Margaret. I'll need some things.

Tom. Your wish is our command.

Gene. I'll write it down. But don't talk too much.

Margaret. Toothbrush . . . some night clothes. I'm still in my slip . . . a hairbrush.

Tom. We'll collect some things.

Margaret (*joshing*). Oh, you. You wouldn't know what to bring. Gene, you look around.

Gene. Yes. Now, take it easy.

Margaret. I hate being seen this way.

Tom. We think you look beautiful.

Gene. Mother, we're just going to sit here now, because you're talking too much. You're being a bad girl. (*Margaret makes a childlike face at him, puckering her lips and wrinkling her nose. She reaches out for his hand.*) Those are lovely flowers Alice sent. She knows your favorites. I called her. I'll keep in touch with her. She said she'd come on, but I said I didn't think she had to.

Margaret. Did you have any dinner?

Tom. We went to Rotary. Everyone asked for you.

Margaret. That's nice.

[Dr. Mayberry *comes into the room, in the shadows of the entrance.* Gene *spots him and goes to him.*]

Dr. Mayberry. Hello, Gene. How are you?

Gene (*trying to catch him before he enters the room entirely*). I'd like to——

Dr. Mayberry (*pleasant and hearty*). We can talk right here. She seems to be coming along very well.

Gene. Good.

Tom. That's wonderful news.

Dr. Mayberry (*kidding her*). She's tough. (Margaret *smiles and makes a face at him.*) We won't know the extent of it until we're able to take a cardiogram tomorrow. It was nothing to toss off lightly, but it looks good now.

Gene. Well . . . thank you. (Tom *coughs.*) What about that?

Dr. Mayberry. He'll be all right. Just a deep cough. He'll get another shot tomorrow.

Gene (*low*). You don't think we should . . . stay around?

Dr. Mayberry. I wouldn't say so. And she should rest.

Gene. Thanks, Doctor. (*They shake hands.*)

Dr. Mayberry. Do I have your number in New York? I'll keep in touch with you. Your dad's a little vague about things. (Gene *jots the number on a slip of paper.*) Good night, Mrs. Garrison. I'm going to kick your family out now so that you can get some rest.

Margaret (*smiles and makes a small wave of the fingers*). Take care of Tom.

Dr. Mayberry. He's going to be fine. (*To* Tom) Drop into the office for another shot tomorrow.

Tom (*kidding*). Will you ask that girl of yours to be a little more considerate next time?

Dr. Mayberry. Oh, you can take it.

Tom. Oh, I'm a good soldier. But, wow! (*He indicates a sore rump.*)

Dr. Mayberry. Good night. (*He waves his hand and disappears.*)

Gene. We'll run along now, Mother.

[*She reaches her hand out.*]

Margaret. My precious.

Gene (*leans down and kisses her hand*). Good night. Sleep well.

Tom. Well, my dearest, remember what we used to say to the children. "When you wake up, may your cheeks be as red as roses and your eyes bright as diamonds."

Margaret (*pouts, half-kidding*). Just you take care of yourself. And get the laundry ready for Annie tomorrow.

Tom (*with a flourish*). Your wish is my command.

Margaret. I put your dirty shirts from Florida in the hamper in the guest bathroom, and my things are——

Gene (*trying to stop her talking*). We'll find them.

Margaret (*to* Gene). Thanks for coming. Don't bother to come tomorrow. Father will keep in touch with you.

Gene. We'll see. Good night.

[*He stops at the door for a little wave. She wiggles her fingers in a small motion. The lights dim on the hospital scene as* Tom *and* Gene *move away.*]

Tom. Well, that's good news.

Gene. Yes.

Tom. She looks a lot better than when they brought her in here this morning, I can tell you that.

Gene. She looked pretty good.

Tom. She's a good soldier. Do you remember what she asked us to bring her? My mind is like a sieve.

Gene. I'll come along and get the bag ready and round up the laundry.

Tom. We should get the laundry ready tonight because Annie arrives at eight sharp, and she starts getting paid the minute she enters the door. But we could leave the bag till morning.

Gene (*uneasy*). I've got an early appointment at college tomorrow, Dad. I'll have to run along after we have a nightcap.

Tom. Oh, I thought you might spend the night.

Gene. I . . . uh . . . I've got an early appointment at college tomorrow.

Tom. I thought you were on your sabbatical.

Gene. I am . . . But I arranged a meeting with someone there, Dad.

Tom. You could stay and still make it.

Gene. It's very early, Dad.

Tom. We've got an alarm. Alarm clocks all over the house.

Gene. I want to change before the appointment . . . Shirt . . .

Tom. I've got plenty of shirts . . . underwear . . . socks . . .

Gene (*more uncomfortable*). I don't wear your sizes, Dad.

Tom. I could get you up earlier, then. I don't sleep beyond five these days.

Gene (*tense*). No, Dad . . . I just . . . No. I'll come by and ——

Tom. There may be something good on television . . . Wednesday night. I think there is . . .

Gene. . . . We'll watch a little television, Dad . . . and have some drinks . . . But then I'll have to go.

Tom (*after a moment*). All right, old man.

[Gene *instinctively reaches out to touch his father's arm, to soften the rejection. They look at each other a moment; then* Tom *drifts off into the dark, as* Gene *moves directly downstage.*]

Gene. I sat with my father much longer than I meant to . . . Because I knew I should stay the night. But . . . I couldn't . . . We watched television. He slept on and off . . . and I went home . . . The next morning, around nine thirty, my mother died . . . (Gene *turns and walks upstage, as the lights dim.*)

[*Curtain.*]

Reading Check

1. Where have Tom and Margaret Garrison spent the winter?
2. Why has Tom Garrison refused to see a doctor despite his bad cough?
3. Why does Tom object to Gene's going to California?
4. Why is Tom eager to get home after the dinner at Schrafft's?
5. Why is Gene unable to stay with his father while Margaret is in the hospital?

For Study and Discussion

Analyzing and Interpreting the Play

1. This play is told mainly from the point of view of Gene. He functions as a narrator, guiding us through the action and commenting on it. Look at Gene's first speech to the audience (page 642). What problem central to the play is introduced in this speech?

2. The characters of Tom and Margaret Garrison are revealed in a succession of scenes, which move from a railroad station, to their home, to Schrafft's restaurant, to a hospital, to a Rotary Club meeting. **a.** What actions show that Tom can be bossy and self-centered? **b.** Do you feel sympathy for Tom in any of these scenes? Explain.

3. In the stage directions on page 644, the playwright tells us that Margaret Garrison is "devoted to her son." **a.** Which of Margaret's actions reveal this characteristic? **b.** How does Margaret serve as a contrast to Tom?

4. The stage directions often tell us that Gene is irritated or angry with his father. Where does Gene also show sympathy for the older man?

5. The playwright lets Tom Garrison tell about his childhood for certain purposes. **a.** What have you learned in Act One of Tom's relationship with his own father? **b.** How do these details affect the way you feel about Tom?

6. At the end of Act One, Margaret Garrison dies. What new problems do you think this will introduce into the play?

7a. What are your feelings for each of these characters at this stage of the action? **b.** Did your feelings about any of them change as the action progressed?

Focus on Persuasive Writing

Avoiding Fallacies

A **fallacy** is an error in thinking or reasoning. When you evaluate your reasoning for a persuasive speech or essay, be sure that you avoid statements that look like reasons but really aren't. Here are five types of fallacies to watch out for.

1. **Attacking the person:** name-calling to discredit the opposition, rather than dealing with the issue
2. **False cause and effect:** assuming that **A** caused **B** simply because **A** preceded **B** in time order
3. **Hasty generalization:** basing a conclusion on insufficient evidence
4. **Circular reasoning:** merely restating your opinion in different words, rather than supporting it with a reason
5. **Either-or:** limiting your analysis of an issue or situation to two extreme alternatives and suggesting that there is only a single correct choice

Analyze some television or magazine ads and see if you can identify examples of some or all of these logical fallacies. Jot down some notes about each example you find. Then join with a small group of classmates to share and discuss your findings. Save your writing.

Act Two

Gene *and* Dr. Mayberry *enter from the rear.* Gene *is carrying a small overnight case containing his mother's things.*

Gene. Thank you for all you've done for her over the years. It's been a great comfort to her, to us all.

Dr. Mayberry. I was very fond of her.

Gene. She was terribly worried about my father's health. Yesterday she said to me, "You know what put me here."

Dr. Mayberry. Well, Gene, I think that's a little too harsh. She's been living on borrowed time for quite a while, you know.

Gene. Yes . . . Where's Dad?

Dr. Mayberry. He's gone along to the undertaker's. He wanted to wait for you, but since we couldn't reach you this morning, he went along. We sent your mother's nurse to be with him till you arrived.

Gene. Thank you.

Dr. Mayberry. He's all right. You know, Gene, old people live with death. He's been prepared for this for years. It may in some way be a relief. He's taken wonderful care of her.

Gene. Yes, he has.

Dr. Mayberry. Alice will be coming on, I suppose.

Gene. I've called her.

Dr. Mayberry. He shouldn't be staying in that house alone. (Gene *nods.*) Now, you have the suitcase and the envelope with your mother's things.

Gene. Yes. I think she should have her wedding ring.

Dr. Mayberry. Maybe you ought to check with your father . . .

Gene. No . . . Will you? . . .

[*He hands the ring to* Dr. Mayberry *and moves away. The lights come up on the undertaker's office.* Tom *and the Nurse are there.*]

Tom. I find that constant wind down there very annoying. Every year I think it's going to be different, but it isn't. You get a little overheated in the sun, and when you walk out from behind some shelter, it knifes into you.

Gene (*He has stood looking at his father for a moment. He now comes to him with tenderness, to share the experience*). Dad.

Tom (*looks up in the middle of his story*). Oh, Gene.

[*He gets up shakily. They embrace.* Gene *pats him on the back.* Tom *steps away and shakes his head. His mouth contorts, showing emotion and anger that this should have happened. He looks at the floor in moments like this.*]

Nurse. We've given him a little sedative.

Tom (*looks up*). What?

Nurse. I said we'd given you a little sedative.

Tom (*at once the charmer*). Oh, yes. This lovely lady has taken wonderful care of me.

Gene (*to the* Nurse). Thank you.

Tom. It turns out she's been to Florida, very near to where we go.

Gene (*a little surprised at this casual conversation, but playing along*). Oh, really?

Tom. I was telling her it was too bad we didn't have the pleasure of meeting her down there. But she goes in the summer. Isn't it terribly hot down there in the summer?

Nurse. The trade winds are always blowing.

Tom. Oh, yes, those damnable winds. We wanted this young man to come join us there, but he went to California instead. (*To* Gene) You'll have to come down to Florida sometime. See what lovely girls you'd meet there!

Gene (*baffled and annoyed by this chatter, but passes it off*). I will.

Tom. What was your name again? My mind's like a sieve.

Nurse. Halsey.

Tom (*courtly*). Miss Halsey . . . My son, Gene.

Gene. How do you do?

Tom. Miss Halsey and I are on rather intimate terms. She . . . uh . . . gave me my shot.

Gene. Good.

Tom (*to the* Nurse). I had this terrible cough down there. The winds. But I'll be all right. Don't worry about me. If I can get some regular exercise, get over to the club.

[*For a moment they all just sit there. Obviously there is to be no sharing of the experience of the mother's death.*]

Gene. I called Alice.

Tom. Oh. Thank you. (*To the* Nurse) Alice was my daughter. She . . . uh . . . lives in Chicago.

Nurse (*shaking his hand, kindly*). Goodbye, Mr. Garrison.

Tom. Oh, are you going?

Nurse. Yes. Take good care of yourself.

Tom. Oh, well. Thank you very much my dear. You've been very kind.

Gene. Thank you.

[*The* Nurse *exits.*]

Marvin Scott (*entering with some forms and papers*). Now, Tom, all we have to do is—(*He looks up from papers and sees* Gene.) Oh, hello, Gene.

Gene. Mr. Scott.

Marvin Scott. I'm terribly sorry.

Gene. Thank you.

Marvin Scott. Now, the burial is to be where, Tom? (*Throughout he is simple, considerate and decent.*)

Tom. The upper burial ground. I've got the deed at home in my file cabinet, if I can ever find it. For years I've meant to clean out that file cabinet. But I'll find it.

Marvin Scott (*to* Gene). Will you see that I get it? At least the number of the plot?

Gene. It's 542.

Marvin Scott. You're sure of that?

Gene. My wife was buried there last year.

Tom (*suddenly remembering*). That's right. (*He reaches out and puts his hand on Gene's arm, implying that they have something to share. Gene doesn't really want to share his father's kind of emotionalism.*)

Marvin Scott (*He has been making notes*). We'll need some clothes . . . uh . . .

Gene (*quickly*). Yes, all right. I'll take care of that.

Marvin Scott. Do you want the casket open or closed while she's resting here?

[*There is a pause.*]

Gene. Dad?

Tom. What was that?

Gene. Do you want the casket open or closed?

Tom. Oh . . . open, I think.

[Gene *would have preferred it closed.*]

Marvin Scott. Now, an obituary. Perhaps you would like to prepare something, Tom.

Tom. Yes. Well . . . Gene? Gene was very close to his mother.

[Marvin Scott *looks at* Gene.]

Gene. Yes, I'll work something up.

Marvin Scott. If you could come by this afternoon, so that it would catch the——

Tom. She was my inspiration. When I met her the clouds hung low and dark. I was going to night school, studying shorthand and typing and *elocution* . . . and working in a lumberyard in the daytime . . . wearing a cutaway coat, if you please, someone at the church had given me . . . I was making a home for my brother

and sister . . . My mother had died, and my father had deserted us . . . (*He has gone hard on his father . . . and stops a moment.*) "He did not know the meaning of the word 'quit.' " They said that some years ago when The Schoolboys of Old Harlem gave me an award. You were there, Gene.

Gene. Yes.

Tom. "Obstructions, yes. But go through them or over them, but never around them." Teddy Roosevelt said that. I took it down in shorthand for practice . . . Early in life I developed a will of iron . . . (*You can feel the iron in the way he says it.*) Any young man in this country who has a sound mind and a sound body, who will set himself an objective, can achieve anything he wants, within reason. (*He has said all this firmly, as though lecturing or giving a speech. He now looks at his cigarette.*) Ugh . . . Filthy habit. Twenty years ago a doctor told me to give these things up, and I did. But when things pile up . . . Well . . . All's lost, all's spent, when we our desires get without content . . . (*He looks around. There is a pause.*)

Gene. I'll write something.

Tom. About what?

Gene. Mother. For an obituary.

Tom. Oh, yes, you do that. He's the lit'ry member of the family. You'll use the church, won't you? Not the chapel. I imagine there'll be hundreds of people there . . . Garden Club . . . Woman's Club . . . Mother's Club.

Marvin Scott. I'm sure that Reverend Pell will use whichever you want. (*He shuffles some papers.*) Now, Tom, the only thing that's left is the most difficult. We have to choose a coffin.

Tom. Do we have to do that now?

Marvin Scott. It's easier now, Tom. To get it over with.

Tom (*firm*). I want the best. That's one thing. I want the best!

Marvin Scott (*moves across the stage with* Tom *and* Gene). There are many kinds.

Tom (*As he takes a few steps, he takes* Gene's *arm*). I don't know what I'd do without this young fellow. (*This kind of word-bribery disturbs* Gene. *In the coffin area, overhead lights suddenly come on. Shafts of light in the darkness indicate the coffins.* Tom *claps his hand to his forehead.*) Do I have to look at all these?

Marvin Scott (*gently*). It's the only way, Tom. The best way is to just let you wander around alone and look at them. The prices are all marked on the cards inside the caskets. (*He lifts an imaginary card.*)

Tom (*puts on his glasses to look*). Nine hundred? For the casket?

Marvin Scott. That includes everything, Tom. All our services, and one car for the mourners. Other cars are extra.

Tom (*to* Gene, *who is standing back*). Well, we'll have your car, so we shouldn't need another. Anybody else wants to come, let them drive their own car. (*Looks back at the caskets*) Oh, dear . . . Gene! (Gene *comes alongside. He is tender and considerate to the part of his father that is going through a difficult time, though irritated by the part that has always angered him. They walk silently among the caskets for a few moments.* Tom *lifts a price tag and looks at it.*) Two thousand! (*He taps an imaginary casket.*) What are these made of?

Marvin Scott (*coming forward*). They vary, Tom . . . Steel, bronze . . . wood.

Tom. What accounts for the variation in prices?

Marvin Scott. Material . . . workmanship . . . The finish inside. You see, this is all silk.

Tom. I suppose the metal stands up best.

Marvin Scott. Well, yes. (Tom *shakes his head, confused.*) Of course the casket does not go directly into the ground. We first sink a concrete outer vault.

Tom. Oh?

Marvin Scott. That prevents seepage, et cetera.

Tom. That's included in the price?

Marvin Scott. Yes.

[Tom *walks on.* Gene *stays in the shadows.*]

Tom. How long do any of these stand up?

[Gene *closes his eyes.*]

Marvin Scott. It's hard to say, Tom. It depends on the location. Trees, roots, and so on.

Tom. I suppose these metal ones are all welded at the seams?

Marvin Scott. Oh, yes.

Tom. Our plot up there is on a small slope. I suppose that's not so good for wear. I didn't think of that when I bought it . . . And the trees looked so lovely . . . I never thought.

Marvin Scott (*gently*). I don't think it makes that much difference, Tom.

Tom (*moves along, stops*). For a child?

Marvin Scott. Yes.

Tom (*shakes his head, moved*). My mother would have fit in that. She was a little bit of a thing . . . Died when I was ten. (*Tears come to his eyes.*) I don't remember much about her funeral except my father . . . He'd run out on us, but he came back when she died . . . and I wouldn't let him come to the cemetery. (*He gets angry all over again . . . then*) Oh, well . . . water over the dam. But this made me think of her . . . a little bit of a thing. (Gene *is touched by his father's memory of his own mother, but still upset at this supermarket type of shopping.*) Five hundred. What do you think of this one, Gene? (Gene *comes up.*) I like the color of the silk. Did you say that was silk or satin?

Marvin Scott. Silk.

Gene. I don't think it makes much difference, Dad. Whatever you think.

Tom. I mean, they all go into this concrete business. (*He senses some disapproval on* Gene's *part and moves on, then adjusts his glasses.*) This

one is eight hundred. I don't see the difference. Marvin, what's the difference?

Marvin Scott. It's mostly finish and workmanship. They're both steel.

Tom. I don't like the browns or blacks. Gray seems less somber. Don't you agree, Gene?

Gene. Yes, I do.

Tom. Eight hundred. Is there a tax, Marvin?

[Gene *turns away.*]

Marvin Scott. That includes the tax, Tom.

Tom. All right. Let's settle for that, then, and get out of here. (*He shivers.*)

Marvin Scott. Fine. (*To* Gene) And you'll send some clothes over?

Gene. Yes. (Gene *bobs his head up and down, annoyed with the details, though* Marvin *has been considerate and discreet.*)

Marvin Scott. I'd estimate that Mrs. Garrison should be . . . that is, if people want to come pay their respects, about noon tomorrow.

Gene. All right.

Marvin Scott. Would you like to see where Mrs. Garrison will be resting?

Gene (*definite*). No, thank you. I think we'll be moving along.

Marvin Scott. I assume your sister Alice will be coming on?

Gene. She arrives this evening. (*He looks around for his father and sees him standing in front of the child's coffin, staring at it. He goes over to his father and takes him gently by the arm.*) Shall we go, Dad?

Tom (*nods his head, far away*). She was just a little bit of a thing.

[*And they start moving out of the room, as the lights dim out.*

As the lights come up again on another part of the stage, Alice, Gene's *older sister, is coming on. She is in her early forties, attractive, brisk, realistic, unsentimental.*]

Alice. Shouldn't we be getting home to Dad?

Gene (*carrying two highballs. He is blowing off steam*). I suppose so, but I'm not ready to go home yet . . . Let's sit over here, where we can get away from the noise at the bar.

Alice. You've had quite a day.

Gene. I'm sorry for blowing off, but . . . (*shakes his head*) Alice, our mother died this morning, and I've wanted to talk about her, but she hasn't been mentioned except as "my inspiration," which is his cue to start the story of his life.

Alice. I'm sorry you've had to take it all alone.

Gene. Well, I'm glad you're here, and I'm glad of the chance to get out of the house to come to meet you . . . I'm so tired of hearing about "when the clouds hung low and dark" . . . I'm so tired of people coming up to me and saying, "Your dad's a remarkable man." Nobody talks about Mother. Just "He's a remarkable man." You'd think he died! . . . I want to say to them, "My mother was a remarkable woman . . . You don't know my father. You only know the man in the newspapers. He's a selfish man who's lived on the edge of exasperation all his life. You don't know the bite of his sarcasm. The night he banished my sister for marrying someone he didn't approve of did not get into the papers."

Alice. *Shhh* . . .

Gene. What a night that was! Mother running from the room sobbing. You shouting at him and storming out, and the two of us, father and son, left to finish dinner, in silence. Afterward I threw up.

Alice. I shouted and you threw up. That was pretty much the pattern.

Gene. I know I'm being unfair. But I'm in the mood to be unfair. I've wanted to turn to him all day and say, "Will you for once shut up about your miserable childhood and say something about Mother?" (*A little ashamed of his outburst*) But I can't say that. He's an old man

and my father, and his wife has died, and he may be experiencing something, somewhere, I know nothing about. (*He shakes his head for going on like this.*) I'm sorry.

Alice. It's all right.

Gene. No. (*He touches her arm, smiles.*) Mother loved your flowers.

Alice. I've felt guilty about Mother all the way coming here. I should have seen her more, invited her more often, brought the kids more often. Instead I sent flowers.

Gene. I guess that's an inevitable feeling when a person dies. I feel the same way.

Alice. But you were so good to her. You made her life.

Gene (*He has always hated that phrase. Slowly, quietly*). A son is not supposed to make his mother's life ... Oh, I loved Mother. You know that. But to be depended on to make her life ... Dad says, he boasts, he never knew the meaning of the word *quit*. Well, he quit on her all right. And I ... I was just there. (*Alice looks at this sudden revelation of his feelings, his resentment that he was left to save his mother from loneliness and unhappiness.*) Still, wait till you see him. There's something that comes through

. . . the old Tiger. Something that reaches you and makes you want to cry . . . He'll probably be asleep when we get home, in front of the television. And you'll see. The Old Man . . . the Father. But then he wakes up and becomes Tom Garrison, and I'm in trouble . . . Last night he asked me to stay with him, and I didn't . . . I couldn't. I'm ashamed of that now.
Alice (*Touched by the complexity of* Gene's *feelings, she looks at him a long moment, then*). Have you called California?
Gene (*frowns. A problem*). No. (*He takes a drink, wanting to avoid the subject.*)
Alice. I suppose we have enough problems for the next few days, but . . .
Gene. After?
Alice. Yes. We'll have to start thinking about Dad, about what we're going to do.
Gene (*nods his head*). I don't know. (*They look at each other a moment, then*) Well, let's go home. (*He rises.*) Thanks for listening to all this, Alice. You had to pay good money to get someone to listen to you. I appreciate it. (*He smiles.*) I thought I wanted to talk to you about Mother, but all I've done is talk about him, just like the others.
Alice. We'll talk. There'll be time.

[*And they leave. The lights dim out on the bar area and come up on the home area.* Tom *is asleep, his head forward, his glasses on, some legal papers in his lap. Quiet like this, he is a touching picture of old age. The strong face . . . the good but gnarled hands. He is the symbol of* Father. *The television is on. As* Gene *and* Alice *come in, they pause and look. They are impressed by the sad dignity. Finally* Gene *approaches and gently puts his hand on his father's arm, then turns down the television.*]

Gene. Dad?
Tom (*barely stirs*). Hm?
Gene. Dad?
Tom. Mm? Margaret? (*Coming to a little more and looking up at* Gene) . . . Oh, Gene . . . I must have dozed off.
Gene. Alice is here.
Tom. Alice? . . . What for? (*He is genuinely confused.*)
Alice (*comes from the shadows*). Hello, Dad.
Tom (*looks around, a bit panicky, confused. Then he remembers*). Oh . . . Oh, yes.

[*He bites his upper lip, and with his gnarled hand grips theirs for a moment of affection and family strength.* Alice *kisses him on the cheek. They help him from the chair and start putting on his coat. As the lights dim on the home area, they come up on a graveyard area.* Tom, Gene *and* Alice *and all the people we have met, are gathering as* Reverend Pell *starts his eulogy.*]

Reverend Pell. Margaret Garrison was a loving wife and a kind and generous mother, and a public-spirited member of the community. The many people who were touched by her goodness can attest to the pleasure and joy she brought them through her love of life and her power to communicate this love to others. The many children, now grown . . .
Gene (*turns from the family group*). Only a dozen or so people were at my mother's funeral. Most of her friends were dead, or had moved to other cities, or just couldn't make it. Fifteen years earlier the church would have been filled. There were a few men sent from Rotary, a few women from the Garden Club, the Mother's Club, the Woman's Club, and a few of the members of her bridge club were there . . . The hundreds of children who had listened to her tell stories year after year on Christmas Eve were all gone, or had forgotten . . . Perhaps some of them who were still in the neighborhood looked up from their evening papers to say, "I see Mrs. Garrison died. She was nice . . . Well, she was an old lady." (*He turns to rejoin the family group.*)

Reverend Pell. Earth to earth . . . ashes to ashes . . . dust to dust . . . The Lord giveth and the Lord taketh away . . . Blessed be the name of the Lord . . . Amen.

[Tom *comes to shake hands with* Reverend Pell. *The others drift about, exchanging nods, and gradually leave during the following.*]

Tom. Well, it's a nice place up here.
Gene (*who has wandered over to look at another grave*). Yes.
Tom. Your mother and I bought it soon after we were married. She thought it a strange thing to do, but we bought it. (*He looks at the grave* Gene *is looking at.*) Now, let's see, that's . . .
Gene. Carol.
Tom. Who?
Gene. Carol. My wife.
Tom. Oh, yes. (*He reaches out a sympathetic hand toward* Gene, *then moves away.*) There's room for three more burials up here, as I remember. There . . . there . . . and there. I'm to go there, when the time comes. (*He looks around for a moment.*) This plot is in terrible shape . . . I paid three hundred dollars some years ago for perpetual care, and now look at it. Just disgraceful . . . I'm going to talk to that superintendent.

[*And he strides off. The lights change.* Alice *and* Gene *move into another area, what might be a garden with a bench. For a moment neither says anything.* Gene *lights a cigarette and sits on the grass.*]

Alice. I don't know how you feel, but I'd like to figure out some kind of memorial for Mother . . . Use some of the money she left.
Gene. Yes, definitely.
Alice. Maybe some shelves of books for the children's library. Christmas books with the stories she liked to tell.

Gene. That's a good idea.

[*There is a long and awkward pause.*]

Alice. Well, Gene, what are we going to do?
Gene (*frowns*). Mother always said to put her in an old-people's home. She had one all picked out.
Alice. Sidney's mother and father saw it coming and arranged to be in one of those cottage colonies for old people.
Gene. Mother and Dad didn't.
Alice. I think you should go ahead and get married and move to California . . . But . . . I might as well get this off my chest, it would be murder if he came to live with us. In the first place, he wouldn't do it, feeling as he does about Sid, and the kids can't stand how he tells them how to do everything.
Gene. I think you're right. That would never work. (*There is a pause.* Gene *looks out at the garden.*) I can't tell you what it does to me as a man . . . to see someone like that . . . a man who was distinguished, remarkable . . . just become a nuisance.
Alice (*She is disturbed at what her brother may be thinking*). I know I sound hard, but he's had his life . . . and as long as we can be assured that he's taken care of . . . Oh, I'll feel some guilt, and you, maybe more. But my responsibility is to my husband and my children.
Gene. Yes. That's *your* responsibility.
Alice. And your responsibility is to yourself . . . to get married again, to get away from memories of Carol and her whole world. Have you called California?
Gene (*frowns*). No.
Alice. If I were the girl you were planning to marry, and you didn't call me to tell me your mother had died . . .
Gene (*gets up, disturbed*). I just haven't wanted to go into it all with her.
Alice (*understanding, but worried*). Gene, my

friend . . . my brother . . . Get out of here!

Gene. Look, Alice, your situation is quite different. Mine is very complex. You fortunately see things very clearly, but it's not so easy for me. (Alice *looks at* Gene, *troubled by what his thinking seems to be leading to. After a moment . . . reflective*) We always remember the terrible things about Dad. I've been trying to remember some of the others . . . How much he *did* do for us.

Alice. I'm doing a lot for my kids. I don't expect them to pay me back at the other end. (Gene *wanders around, thinking, scuffing the grass.*) I'm sure we could find a full-time housekeeper. He can afford it.

Gene. He'd never agree.

Alice. It's that or finding a home. (Gene *frowns.*) Sidney's folks like where they are. Also, we might as well face it, his mind's going. Sooner or later, we'll have to think about powers of attorney, perhaps committing him to an institution.

Gene (*shaking his head*). It's all so ugly.

Alice (*smiling*). Yes, my gentle Gene, a lot of life is.

Gene. Now, look, don't go trying to make me out some softhearted . . . (*He can't find the word.*) I know life is ugly.

Alice. Yes. I think you know it. You've lived through a great deal of ugliness. But you work like a Trojan to deny it, to make it not so. (*After a moment, not arguing*) He kicked me out. He said he never wanted to see me again. He broke Mother's heart over that for years. He was mean, unloving. He beat you when you were a kid . . . You've hated and feared him all your adult life . . .

Gene (*cutting in*). Still he's my father, and a man. And what's happening to him appalls me as a man.

Alice. We have a practical problem here.

Gene. It's not as simple as all that.

Alice. To me it is. I don't understand this mystical haze you're casting over it. I'm going to talk to him tomorrow, after the session with the lawyer, about a housekeeper. (Gene *reacts but says nothing.*) Just let me handle it. He can visit us, and we can take turns coming to visit him. Now, I'll do the dirty work. Only when he turns to you, don't give in.

Gene. I can't tell you how ashamed I feel . . . not to say with open arms, "Poppa, come live with me . . . I love you, Poppa, and I want to take care of you." . . . I need to love him. I've always wanted to love him.

[*He drops his arms and wanders off.* Alice *watches her brother drift off into the garden as the lights go down in that area. The lights come up in the living-room area.* Tom *is seated in his chair, writing.* Alice *comes into the room. Small packing boxes are grouped around.*]

Alice. How are you coming?

Tom. Oh, Alice, I've written out receipts for you to sign for the jewelry your mother left you. And if you'll sign for the things she left the children.

Alice. All right.

[*Signs.* Gene *comes into the room carrying a box full of his mother's things. He exchanges a look with* Alice, *knowing the time has come for the discussion.*]

Tom. It may not be necessary, but as executor, I'll be held responsible for these things.

Alice. Dad, I'd like to talk a little . . . with you . . . about——

Tom. Yes, all right. But first I'd like to read you this letter I've written to Harry Hall . . . He and I used to play golf out in New Jersey . . . He wrote a very nice letter to me about your mother . . . and I've written him as follows . . . It will only take a minute . . . If I can read my own shorthand . . . (*He adjusts his glasses.*) "Dear Harry . . . How thoughtful of

you to write me on the occasion of Margaret's death. It was quite a blow. As you know, she was my inspiration, and had been ever since that day fifty-five years ago when I met her . . . when the clouds hung low and dark for me. At that time I was supporting my younger brother and my sister and my aged grandfather in a two-room flat . . . going to work every day in a lumber mill. Providence, which has always guided me, prompted me to take a night course in shorthand and typing, and also prompted me to go to the Underwood Typewriting Company seeking a position as stenographer. They sent me, God be praised, to the office of T. J. Parks . . . and a job that started at five dollars a week, ended in 1929 when I retired, at fifty thousand a year . . ." That's as far as I've gotten at the moment. (*He looks up for approval.*)

Gene. Dad, I don't think financial matters are particularly appropriate in answering a letter of condolence.

Tom. Oh? (*He looks at the letter.*) But it's true. You see, it follows. I'm saying she was my inspiration . . . and it seems entirely appropriate to explain that.

Gene. Well, it's your letter, Dad.

Tom (*looks it over*). Well . . .

Alice. Dad, I'm leaving tomorrow . . . and . . .

Tom (*looking up*). What?

Alice. I'm going home tomorrow.

Tom (*formal*). Well, Alice, I'm grateful you came. I know it was difficult for you, leaving home. Your mother would have appreciated it. She was very fond of you, Alice.

Alice. I think we ought to talk over, maybe, what your plans are.

Tom. My plans? I have many letters to answer, and a whole mess in my files and accounts. If the income-tax people ever asked me to produce my books . . .

Gene. They're not likely to, Dad. Your income is no longer of that size.

Tom (*with a twinkle in his eye*). Don't be too sure.

Alice. I didn't mean exactly that kind of plans. I meant . . . Well, you haven't been well.

Tom (*belligerent*). Who said so?

Alice. Mother was worried to death about—— (*She stops.*)

Tom. I was under a strain. Your mother's health . . . never knowing when it might happen. Trying to get her to take care of herself, to take it easy. You know, the doctor said if she didn't eat more slowly, this might happen.

Alice. You plan to keep the house?

Tom. Oh, yes. All my things are here . . . It's a . . . It's a . . . I'll be back on my feet, and my . . . (*Points to his head*) . . . will clear up. Now this strain is over, I'm confident I'll be in shape any day now.

Alice. I worry, leaving you in this house . . . alone, Dad.

Tom (*looks around, very alert, defensively*). I'm perfectly all right. Now don't worry about me . . . either of you. Why, for the last year, since your mother's first attack, I've been getting the breakfast, making the beds, using a dust rag . . . (*He makes quite a performance of this. It is a gallant struggle.*) And the laundress comes in once a week and cleans up for me . . . And Gene here . . . if Gene will keep an eye on me, drop in once or twice a week . . .

Alice. That's the point.

Gene (*low*). Alice.

Alice. We think you should have a full-time housekeeper, Dad. To live here.

Tom (*trying to kid it off, but angry*). Alone here with me? That wouldn't be very proper, would it?

Alice (*smiling*). Nevertheless . . .

Tom. No. Now that's final!

Alice. Dad, Gene and I would feel a lot better about it if——

Tom. Look, you don't have to worry about me.

Alice. Dad, you're forgetting things more and more.

Tom. Who says so?

Alice. Mother wrote me, and——

Tom. I was under a strain. I just finished telling you. Look, Alice, you can go, leave with a clear mind. I'm all right. (Gene *is touched and moved by his father's effort, his desperate effort to maintain his dignity, his standing as a functioning man.*) Of course, I will appreciate Gene's dropping in. But I'm all right.

Alice. We still would like to get a full-time housekeeper.

Tom (*bristling*). What do you mean, you would get? I've hired and fired thousands of people in my day. I don't need anyone *getting* someone for me.

Alice. Will you do it yourself, then?

Tom. No, I told you. No! (*He gets very angry. His voice sharpens and hardens.*) Since I was eight years old I've taken care of myself. What do you two know about it? You were given everything on a platter. At an age when you two were swinging on that tree out there, breaking the branches, I was selling newspapers five hours a day, and at night dancing a jig in saloons for pennies . . . And you're trying to tell me I can't take care of myself . . . If I want a

housekeeper, and I don't, I'll hire one . . . I've hired and fired thousands of people in my time. When I was vice president of Colonial Brass at fifty thousand a year . . . Two thousand people. And you tell me I'm incompetent . . . to hire a housekeeper. And how many people have you hired? (*To* Gene) You teach . . . Well, all right. That's your business, if that's what you want to do. But don't talk to me about hiring and firing.

[*The children are saddened and perhaps a little cowed by this naked outburst, the defense of a man who knows that he is slipping, and an angry outburst of hatred and jealousy for his own children. Everyone is quiet for a moment . . . then.*]

Alice. Dad, you might fall down.
Tom. Why fall down? There's nothing wrong with my balance.

[Gene *is sick at this gradual attempt to bring to a man's consciousness the awareness that he is finished.*]

Alice. Sometimes, when you get up, you're dizzy.
Tom. Nonsense. (*He gets up abruptly. He makes great effort and stands for a moment, then one foot moves slightly to steady his balance . . . and the children both look away.*) Now, I appreciate your concern . . . (*Very fatherly*) But I'm perfectly able to carry on by myself. As I said, with Gene's help from time to time. I imagine we could have dinner every once in a while, couldn't we, Gene . . . once a week or so? Take you up to the Rotary. Some of the speakers are quite amusing.

[Alice *looks at* Gene *to see if he is going to speak up.*]

Gene. Sure, Dad.

Tom. Give us some time together at last. Get to know each other.
Alice (*quietly but firmly*). Gene wants to get married.
Gene. Alice!
Tom. What?
Alice. Gene wants to move to California and get married.
Gene. Alice, shut up.
Alice (*almost in tears*). I can't help it. You've never faced up to him. You'd let him ruin your life.
Gene (*angry*). I can take care of my own life.
Alice. You can't!
Tom (*loud*). Children! . . . Children! (*They stop arguing and turn to their father at his command.* Tom *speaks with a note of sarcasm.*) I have no desire to interfere with either of your lives. I took care of myself at eight. I can take care of myself at eighty. I have never wanted to be a burden to my children.
Gene. I'm going to hang around, Dad.
Tom. There's no need to.
Gene. I'll move in here at least till you're feeling better.

[Alice *turns away, angry and despairing.*]

Tom (*sarcastically*). I don't want to ruin your life.
Gene (*angry now at his father*). I didn't say that.
Tom. I have long gotten the impression that my only function in this family is to supply the money to ——
Gene (*anguished*). Dad!
Tom. ——to supply the funds for your education, for your——
Gene. Dad, stop it.

[Tom *staggers a little, dizzy.* Gene *goes to his side to steady him.* Tom *breathes heavily in and out in rage. The rage of this man is a terrible thing to see, old as he is. He finally gets some control of himself.*]

Tom. As far as I am concerned, this conversation is ended. Alice, we've gotten along very well for some years now without your attention.

Gene (*protesting, but hating the fight*). Dad!

Alice. You sent me away. Don't forget that.

Tom. You chose to lead your own life. Well, we won't keep you now.

Gene. Dad . . .

Tom (*rage again*). I was competent to go into the city year after year to earn money for your clothes, your food, the roof over your head. Am I now incompetent? Is that what you're trying to tell me?

[*He looks at* Alice *with a terrible look. He breathes heavily for a moment or two; then, shaking his head, he turns away from both of them and leaves, disappearing into the shadows.*]

Gene (*angry, troubled*). Alice!

Alice. I'm only trying to get a practical matter accomplished.

Gene. You don't have to destroy him in the process.

Alice. I wasn't discussing his competence. Although that will be a matter for discussion soon.

Gene. Look, Alice, just leave it now, the way it is. Don't say any more.

Alice. With you staying on.

Gene. Yes. You can go with a clear conscience.

Alice. My conscience is clear.

Gene. I am doing this because I want to.

Alice. You're doing it because you can't help yourself.

Gene. Look, when I want to be analyzed, I'll pay for it.

Alice (*pleading*). But I saw you. Didn't you see yourself there, when he started to rage? Didn't you feel yourself pull in? You shrank.

Gene. I shrank at the ugliness of what was happening.

Alice. You're staying because you can't stand his wrath the day you say, "Dad, I'm leaving." You've never been able to stand up to his anger. He's cowed you.

Gene. Look, Alice . . .

Alice. He'll call you ungrateful, and you'll believe him. He'll lash out at you with his sarcasm, and that will kill this lovely, necessary image you have of yourself as the good son. Can't you see that?

Gene (*lashing out*). What do you want us to do? Shall we get out a white paper?[1] Let it be known that we, Alice and Gene, have done all that we can to make this old man happy in his old age, without inconveniencing ourselves, of course. And he has refused our help. So, if he falls and hits his head and lies there until he rots, it is not our fault. Is that it?

Alice. You insist on——

Gene (*running on*). Haven't you learned on the couch[2] that people do *not* always do what you want them to do? It is sometimes *we* who have to make the adjustments?

Alice. The difference between us is that I accept the inevitable sadness of this world without an acute sense of personal guilt. You don't. I don't think anyone expects either of us to ruin our lives for an unreasonable old man.

Gene. It's not going to ruin my life.

Alice. It is.

Gene. A few weeks, a month.

Alice. Forever!

Gene. Alice, let's not go on discussing it. I know what I am going to do. Maybe I can't explain my reasons to you. I just know I can't do anything else. Maybe there isn't the same thing between a mother and a daughter, but the "old man" in me feels something very deep, wants to extend some kind of mercy to that old man. I never had a father. I ran away from him. He ran away from me. Maybe he's

1. **white paper:** official report.
2. **on the couch:** on the psychiatrist's couch.

right. Maybe it is time we found each other.

Alice. Excuse me for saying so, but I find that sentimental slop! I think this is all rationalization to make tolerable a compulsion you have to stay here. You hate the compulsion, so you've dressed it up to look nice.

Gene. How do you know what you're saying isn't a rationalization to cover up a callousness, a selfishness, a coldness in yourself? To make *it* smell nice?

Alice. What do you think you'll find?

Gene. I don't know.

Alice. You hope to find love. Couldn't you tell from what he just said what you're going to find? Don't you understand he's got to hate you? He may not think it in his head or feel it in his heart, but you are his enemy! From the moment you were born a boy, you were a threat to this man and his enemy.

Gene. That sounds like the textbooks, Alice.

Alice. He wanted your guts, and he's had them! When has he ever regarded you as a man, an equal, a male? When you were a Marine. And that you did for him. Because even back there you were looking for his love. You didn't want to be a Marine. "Now, Poppa, will you love me?" And he did. No, not love. But he was proud and grateful because you gave him an extension of himself he could boast about, with his phony set of values. When was

he ever proud about the things *you* do? The things *you* value? When did he ever mention your teaching or your books, except in scorn?

Gene. You don't seem to have felt the absence of a father. But I feel incomplete, deprived. I just do not want to let my father die a stranger to me.

Alice. You're looking for something that isn't there, Gene. You're looking for a mother's love in a father. Mothers are soft and yielding. Fathers are hard and rough, to teach us the way of the world, which is rough, which is mean, which is selfish and prejudiced.

Gene. All right. That's your definition. And because of what he did to you, you're entitled to it.

Alice. I've always been grateful to him for what he did. He taught me a marvelous lesson, and has made me able to face a lot. And there has been a lot to face, and I'm grateful to him. Because if I couldn't get the understanding and compassion from a father, who could I expect it from in the world? Who in the world, if not from a father? So I learned, and didn't expect it, and I've found very little, and so I'm grateful to him. I'm grateful to him. (*The growing intensity ends in tears, and she turns her head.*)

Gene (*looks in pity at the involuntary revelation of her true feeling. He moves to her and touches her*). I'll stay, Alice . . . for a while, at least . . . for whatever reasons. Let's not argue any more.

Alice. And Peggy?

Gene. She'll be coming in a week or two, we'll see.

Alice. Don't lose her, Gene. Maybe I'm still fouled up on myself, but I think I've spoken near the truth about you.

Gene. I keep wondering why I haven't called her, or wanted to call her. Why I seem so much closer to Carol at the moment.

Alice (*gently, tentatively*). The image . . . of the eternally bereaved husband . . . forgive me . . . the dutiful son . . . They're very appealing and seductive . . . But they're not living. (*Gene just stands, looking at her, thinking about what she has said. Alice kisses him on the cheek.*) Good night, Gene.

Gene (*his hands on her shoulders*). Good night.

Alice (*She suddenly puts her head tight against his shoulder and holds him*). Suddenly I miss Mother so. (*She sobs. He just holds her and strokes her back.*)

Gene. Yes. (*And he holds her, comforting her, as the lights dim.*)

[*After a few moments of darkness the lights come up on* Tom *in his bedroom in pajamas and bathrobe, kneeling by his bed, praying. On his bed is a small top drawer of a bureau, filled with mementos.* Gene *comes in. He stands in the shadows and watches his father at his prayers.* Gene *does not pray any more, and he has always been touched by the sight of his father praying.* Tom *gets up and starts to untie his bathrobe.*]

Gene. You ready to be tucked in?

Tom (*smiling*). Yes. (*Loosening his robe*) Look at the weight I've lost.

Gene (*troubled at the emaciated body, which is pathetic. The face is ruddy and strong, the body that of an old man*). Since when?

Tom. Oh, I don't know.

Gene (*tapping his father's stomach*). Well, you had quite a little pot there, Dad.

Tom (*smiling*). Did I?

Gene. Yes.

Tom. But look, all through here, through my chest.

Gene. Well, we'll put some back on you. You've been eating pretty well this last week.

Tom (*looking at his own chest*). You know, I never had hair on my chest. I don't understand it. You have hair on your chest. I just didn't have any. Well, I'm confident if I could get some exercise . . . Do you remember when I used to get you up in the morning, and we'd go down and do calisthenics to the radio?

Gene (*smiling*). Yes.

Tom (*stands very straight, swings his arms*). One-two-three-four . . . One-two-three-four . . .

Gene. Hey, take it easy.

Tom. I used to swing the Indian clubs every day at lunchtime. I gave you a set once, didn't I?

Gene. I think so.

Tom. We'll have to dig them out. (*Starts bending exercises*) One-two-three-four . . . one-two-three-four.

Gene. Why don't you wait till morning for that?

Tom. Remember when we used to put on the gloves and spar down on the side porch? . . . I don't think you ever liked it very much. (*He crouches in boxing position.*) The manly art of self-defense . . . Gentleman Jim Corbett . . . Now it's something else again . . . Oh, well, things to worry about. But I intend to get over to the club, play some golf, sit around and swap stories with the boys. Too bad you never took up golf. Alice could have played a good game of golf. But she had a temper. Inherited it from your mother's father. (*He fishes in the bureau drawer on the bed.*) I was looking through my bureau drawer . . . I don't know, just going over things . . . Did you ever see this? (*He takes out a small revolver.*)

Gene. Yes.

Tom. Never had occasion to use it. Oh, I took it out West one winter when we went to Arizona instead of Florida. Shot at rattlesnakes in a rock pile. (*Takes potshots*) I don't have a permit for this any more. (*Starts putting it back in its box*) I suppose they wouldn't give me one. I don't know anyone up there any more. When I was Mayor, cops on every corner would wave . . . "Hello, Mr. Garrison . . . 'Morning, Mr. Garrison." Now, one of the young whipper-snappers gave me a ticket, just before we left for Florida. Said I'd passed a full-stop sign. That's what *he* said. First ticket I had in forty or more years of driving, so keep this quiet. (*He takes out a packet of photographs wrapped in tissue paper.*) Pictures . . . I think you've seen most of them . . . The family.

Gene (*very tentatively*). You know, Dad, I've never seen a picture of your father. (Tom *looks at him a long time. Then finally, with his hatred showing on his face, he unwraps another tissue and hands over a small picture.* Gene *looks at it a long moment.*) He's just a boy.

Tom. That was taken about the time he was married.

Gene. I'd always thought of him as . . . the way you talked about him . . . as . . . (Gene *is obviously touched by the picture.*)

Tom. Oh, he was a fine-looking man before he started to drink. Big, square, high color. But he became my mortal enemy . . . Did I ever show you that? (*He takes out a small piece of paper.*) Careful . . . When I set up a home for my brother and sister, one day we were all out, and he came around and ripped up all my sister's clothes and shoes. Drunk, of course. A few days later he came around to apologize and ask for some money, and I threw him out . . . The next day he left this note . . . "You are welcome to your burden."

Gene. And you kept it?

Tom. Yes. I never saw him again until many years later he was dying, in Bellevue, and someone got word to me, and I went down and asked him if he wanted anything. He said he'd like some fruit. So I sent him in a few oranges. He died the next day.

Gene. There must have been something there to love, to understand.

Tom. In my father? (*Shakes his head "no." Then he shows* Gene *another card.*) Do you remember this? (*He reads.*) "To the best dad in the world on Father's Day." That was in . . . (*Turns over and reads the notation*) 1946 . . . Yes. (*Emotional*) I appreciate that, Gene. That's a lovely tribute. I think I have all your Father's Day cards here.

I Never Sang for My Father Act Two **679**

You know, your mother used to talk of you children as her jewels. Maybe because my interests were different, I've always said you were my dividends . . . You know, I didn't want children, coming from the background I did . . . and we didn't have Alice for a long time. But your mother finally persuaded me. She said they would be a comfort in our old age. And you are, Gene.

Gene (*touched, but embarrassed and uncomfortable*). Well . . .

Tom (*fishes in the drawer and brings out a sheet of paper*). A program of yours from college . . . some glee club concert . . . I've got everything but the kitchen stove in here. (*Looks over the program*) Do you still sing?

Gene (*smiling*). Not in years.

Tom. That's too bad. You had a good voice. But we can't do everything . . . I remember your mother would sit at the piano, hour after hour, and I'd be up here at my desk, and I'd hear you singing.

Gene. You always asked me to sing "When I Grow Too Old to Dream."

Tom. Did I? . . . I don't remember your ever singing that . . . You always seemed to be just finishing when I came into the room . . . (*Looks at* Gene) Did you used to sing that for me?

Gene (*not a joke any more*). No . . . But you always asked me to sing it for you.

Tom. Oh . . . (*Puts the program away*) Well, I enjoyed sitting up here and listening. (*He pokes around in his box and takes something out . . . in tissue paper. He unwraps a picture carefully.*) And that's my mother.

Gene (*gently*). Yes. I've seen that, Dad. It's lovely.

Tom. She was twenty-five when that was taken. She died the next year . . . I carried it in my wallet for years . . . And then I felt I was wearing it out. So I put it away . . . Just a little bit of a thing . . . (*He starts to cry, and the deep, deep, sobs finally come and his emaciated body is wracked by them. It is a terrible, almost soundless sobbing. Gene comes to his father and puts his arms around him and holds him. After moments*) I didn't think it would be this way . . . I always thought I'd go first. (*He sobs again, gasping for air. Gene continues to hold him, inevitably moved and touched by this genuine suffering. Finally,* Tom *gets a stern grip on himself.*) I'm sorry . . . (*Tries to shake it off*) It just comes over me . . . It'll pass . . . I'll get a hold of myself.

Gene. Don't try, Dad . . . Believe me, it's best.

Tom (*angry with himself*). No . . . It's just that . . . I'll be all right. (*He turns and blows his nose.*)

Gene. It's rough, Dad . . . It's bound to be rough.

Tom (*shakes his head to snap out of it*). It'll pass . . . it'll pass . . . (*Starts to wrap up the picture of his mother*)

Gene. Can I help you put these things away, Dad?

Tom. No . . . No . . . I can . . . (*He seems to be looking for something he can't find.*) Well, if you would. (Gene *helps him wrap the pictures.*) I don't know what we'd do without you . . .

[*And together they put the things back in the box. As they do so,* Gene *is deeply moved with feelings of tenderness for his father. After a few moments he starts, with great consideration.*]

Gene. Dad?

Tom. Yes?

Gene (*carefully*). You remember . . . I wrote you about California . . . and Peggy?

Tom. What?

Gene. The girl . . . in California.

Tom (*on guard*). Oh, yes.

Gene (*putting it carefully, and slowly*). I'm thinking very seriously, Dad . . . of going there . . . to marry . . . and to live. (Tom *straightens up a little.*) Now, I know this is your home, where you're used to . . . But I'd like you to come out there with me, Dad . . . It's lovely out there, as

you said, and we could find an apartment for you, near us. (*This is the most loving gesture* Gene *has made to his father in his life.*)

Tom (*thinks for a moment, then looks at* Gene *with a smile*). You know, I'd like to make a suggestion . . . Why don't you all come live here?

Gene (*explaining calmly*). Peggy has a practice out there.

Tom. A what?

Gene. She's a doctor. I told you. And children with schools and friends.

Tom. We have a big house here. You always liked this house. It's wonderful for children.

You used to play baseball out back, and there's that basketball thing.

Gene. Dad, I'd like to get away from this part of the country for a while. It's been rough here ever since Carol died. It would be good for you too, getting away.

Tom. Your mother would be very happy to have the house full of children again. I won't be around long, and then it would be all yours.

Gene. That's very kind of you, Dad. But I don't think that would work. Besides her work and the children, all Peggy's family is out there.

Tom. Your family is here.

Gene. Yes, I know.

Tom. Just me, of course.

Gene. You see, the children's father is out there, and they're very fond of him and see him a lot.

Tom. Divorced?

Gene. Yes.

Tom. You know, Gene, I'm only saying this for your own good, but you went out there very soon after Carol's death, and you were exhausted from her long illness, and well, naturally, very susceptible . . . I was wondering if you've really waited long enough to know your own mind.

Gene. I know my own mind.

Tom. I mean, taking on another man's children. You know, children are far from the blessing they're supposed to be . . . And then there's the whole matter of discipline, of keeping them in line. You may rule them with a rod of iron, but if this father——

Gene (*cutting in*). I happen to love Peggy.

Tom (*looks at* Gene *a long moment*). Did you mention this business of California to your mother?

Gene (*gets the point, but keeps level*). She mentioned it to me, and told me to go ahead, with her blessings.

Tom. She would say that, of course . . . But I warned you.

Gene (*turns away*). For God's sake——

Tom (*giving up, angry*). All right, go ahead. I can manage . . . (*His sarcasm*) Send me a Christmas card . . . if you remember.

Gene (*enraged*). Dad!

Tom. What?

Gene. I've asked you to come with me!

Tom. And I've told you I'm not going.

Gene. I understand that, but not this "send me a Christmas card, if you remember."

Tom. I'm very sorry if I offended you. Your mother always said I mustn't raise my voice to you. (*Suddenly hard and vicious*) Did you want

me to make it easy for you the way your mother did? Well, I won't. If you want to go, go!

Gene. Dad!

Tom (*running on*). I've always known it would come to this when your mother was gone. I was tolerated around this house because I paid the bills and——

Gene. Shut up!

Tom (*coming at him*). Don't you——

Gene (*shouting*). Shut up! I asked you to come with me. What do you want? For God's sake, what do you want? If I lived here the rest of my life, it wouldn't be enough for you. I've tried, I've tried to be the dutiful son, to maintain the image of the good son . . . Commanded into your presence on every conceivable occasion . . . Easter, Christmas, birthdays, Thanksgiving . . . Even that Thanksgiving when Carol was dying, and I was staying with her in the hospital. "We miss you so. Our day is nothing without you. Couldn't you come up for an hour or two after you leave Carol?" You had no regard for what was really going on . . . My wife was dying!

Tom. Is it so terrible to want to see your own son?

Gene. It is terrible to want to possess him . . . entirely and completely!

Tom (*coldly . . . after a moment*). There will be some papers to sign for your mother's estate. Be sure you leave an address with my lawyer . . .

Gene (*cutting in*). Dad!

Tom (*cutting, with no self-pity*). From tonight on, you can consider me dead. (*Turns on him in a rage of resentment*) I gave you everything. Since I was a snot-nosed kid I've worked my fingers to the bone. You've had everything and I had nothing. I put a roof over your head, clothes on your back——

Gene. Food on the table.

Tom. ——things I never had.

Gene. I know!

Tom. You ungrateful . . . !

Gene (*seizes him, almost as though he would hit him*). What do you want for gratitude? Nothing, nothing would be enough. You have resented everything you ever gave me. The orphan boy in you has resented everything. I'm sorry about your miserable childhood. When I was a kid, and you told me those stories, I used to go up to my room at night and cry. But there is nothing I can do about it . . . and it does not excuse everything . . . I *am* grateful to you. I also admire you and respect you, and stand in awe of what you have done with your life. I will never be able to touch it. (Tom *looks at him with contempt*.) But it does not make me love you. And I wanted to love you. (Tom *snorts his disbelief*.) You hated your father. I saw what it did to you. I did not want to hate you.

Tom. I don't care what you feel about me.

Gene. I do! (*He moves away from his father.*) I came so close to loving you tonight . . . I'd never felt so open to you. You don't know what it cost me to ask you to come with me . . . when I have never been able to sit in a room alone with you . . . Did you really think your door was always open to me?

Tom. It was not my fault if you never came in.

Gene (*starts to move out*). Goodbye, Dad. I'll arrange for someone to come in.

Tom (*shouting*). I don't want anyone to come in! I can take care of myself! I have always had to take care of myself. Who needs you? Get out!

[*This last, wildly at* Gene. *The lights dim out quickly, except for a lingering light on* Gene.]

Gene (*after a few moments*). That night I left my father's house forever . . . I took the first right and the second left . . . and this time I went as far as California . . . Peggy and I visited him once or twice . . . and then he came to California to visit us, and had a fever and swollen ankles, and we put him in a hospital, and he never left . . . The reason we gave, and which he could accept, for not leaving . . . the swollen ankles. But the real reason . . . the arteries

were hardening, and he gradually over several years slipped into complete and speechless senility . . . with all his life centered in his burning eyes. (*A Nurse wheels in* Tom, *dressed in a heavy, warm bathrobe, and wearing a white linen golf cap to protect his head from drafts. The* Nurse *withdraws into the shadows.*) When I would visit him, and we would sit and look at each other, his eyes would mist over and his nostrils would pinch with emotion . . . But I never could learn what the emotion was . . . anger . . . or love . . . or regret . . . One day, sitting in his wheelchair and staring without comprehension at television . . . he died . . . alone . . . without even an orange in his hand. (*The light fades on* Tom.) Death ends a life . . . but it does not end a relationship, which struggles on in the survivor's mind . . . toward some resolution, which it never finds. Alice said I would not accept the sadness of the world . . . What did it matter if I never loved him, or if he never loved me? . . . Perhaps she was right . . . But, still, when I hear the word *father* . . . (*He cannot express it . . . there is still the longing, the emotion. He looks around . . . out . . . as though he would finally be able to express it, but he can only say . . .*) It matters. (*He turns and walks slowly away, into the shadows . . . as the lights dim.*)

[*Curtain.*]

Reading Check

1. What makes Tom think of his own mother when he is inspecting the caskets in the funeral home?
2. Why has Tom always thought of his father as his enemy?
3. What memorial does Alice want for her mother?
4. What suggestion does Alice make for her father's care?
5. What causes Gene to leave his father's house?

For Study and Discussion

Analyzing and Interpreting the Play

1. The tension between Tom and Gene mounts steadily in Act Two. How do Tom's reactions to Margaret's death differ from Gene's?

2a. Why do Tom's actions make Gene angry? b. Where do you also learn that Gene is sometimes touched by his father and wants to feel love for him?

3. Although she is mentioned in Act One, Alice does not appear in the play until Act Two. a. How is Alice's character a contrast, or a **foil**, to Gene's? b. What new problem does Alice force into the open?

4. In the scene beginning on page 672, Tom is angry and hurt by his children's attempts to arrange for his care. a. What do you think of each character in this important scene? b. What truths are revealed about each one?

5. The major conflict in this play takes place between Gene and his father, but there is also a conflict between Gene and his sister. Look at the scene that begins on page 676, where Alice tries to make Gene see their father the way she

sees him. **a.** What does Alice want Gene to think of his father? **b.** What is Gene's response?

6a. At what points in the final scene of the play does it seem that Gene and his father might be able to change and begin to show their love for each other? **b.** When does the play reach its **climax**—that point when you know that this will not happen as Gene hopes it will?

7. Find the lines in which the play's title is explained.

8. What is the significance of Gene's saying that his father died "without even an orange in his hand"?

The Play as a Whole

1. In classical Greek tragedies, a father and a son like Tom and Gene might have suffered because they were cursed by the gods. Modern dramatists often look for other explanations for human problems. **a.** How is Tom's basic problem explained in this play? **b.** How is Tom's feeling for his own father like a "curse" that is passed on to another generation?

2. This play, like many works of literature, is about a search. On page 676, Gene says:

> . . . the "old man" in me feels something very deep, wants to extend some kind of mercy to that old man. I never had a father. I ran away from him. He ran away from me. . . . Maybe it is time we found each other.

a. How would you explain Gene's statement in your own words? **b.** What has happened to Gene's search by the end of the play, and how does this ending make you feel?

3. In Act One (page 652), Margaret makes this speech to Gene:

> What a shame that children can't see their parents when they're young and courting, and in love. All they see them being is tolerant, sympathetic, for-

bearing and devoted. All the qualities that are so unimportant to passionate young people.

a. In what ways are Gene and Alice able to show tolerance, sympathy, forbearing, and devotion to their father? **b.** In what ways do they fail? **c.** What do you think accounts for their failure?

4. How would you define the **theme** of this play—the central truth about life that the playwright is revealing?

For Dramatization

Reading Dialogue

Imagine that you are an actor or actress in *I Never Sang for My Father.* You must convey to the audience the characters' feelings and thoughts as they speak these lines of dialogue:

Gene (*the anger building*). No, Dad, I've got to run along.

Gene (*bewildered by this, but doesn't want to get into an argument*). Let's drop by and see Mother first.

Alice (*almost in tears*). I can't help it. You've never faced up to him. You'd let him ruin your life.

Tom (*sarcastically*). I don't want to ruin your life.

Alice (*pleading*). But I saw you. Didn't you see yourself there, when he started to rage? Didn't you feel yourself pull in? You shrank.

How can you use your voice to convey emotion? Practice reading aloud each of these lines from the play, experimenting with volume, pitch, emphasis, and pauses. Then choose one scene from the play, and work with another student (or other students) in reading aloud the dialogue to convey the feelings you think the author intends.

Writing About Literature

Discussing a Key Statement

At the beginning of the play, and again at the end, Gene says, "Death ends a life, but it does not end a relationship." Consider this statement from the point of view of Tom Garrison. What do you learn about his unresolved relationship with his parents? What does the play show about Gene's failure to find a resolution? In what way does Alice's relationship with her father remain unresolved?

Focus on Persuasive Writing

Organizing a Persuasive Essay

Use an **outline** like the one below to organize a persuasive essay on a topic of your choice. After you have completed your outline, ask a partner to review it and to offer you some comments. Save your writing.

 I. Introduction
 A. Attention grabber
 B. Background (if necessary)
 C. Opinion Statement
 II. Body
 A. Reason with explanation/evidence
 Emotional appeal (if appropriate)
 B. Reason with explanation/evidence
 Emotional appeal (if appropriate)
 C. Additional reasons/emotional appeals (if appropriate)
 D. Discussion of/response to main opposing arguments
 III. Conclusion
 A. Restatement of opinion
 B. Call to action (if needed)

About the Author

Robert Anderson (1917–)

Robert Anderson was born in New York City. After earning a B.A. and M.A. from Harvard University, he studied drama at the New School for Social Research in New York. He has been an important American dramatist since 1953, when his play *Tea and Sympathy* became a Broadway hit. Called "the dramatist of loneliness," Anderson has written many plays for the stage, radio, and television. He has also taught courses in drama and playwriting and advises aspiring dramatists to follow his example: "All I can tell you—if you really want to learn to do something, try teaching it. That's how I learned to write plays." Anderson's notable successes include a comedy called *You Know I Can't Hear You When the Water's Running* and the screenplay for the movie *The Sand Pebbles*.

THE THIRD MAN

The Third Man, shot on location in Vienna, in 1949, is generally considered to be one of the finest films ever made. In his introduction to the published film script, Andrew Sinclair writes that this film "set a particular style for British films, a combination of realism of background and penetration of character, based on the two main qualities of the British wartime cinema, a feeling for documentary detail and social purpose."

After World War II Austria was divided into zones of occupation: American, British, French, and Russian. Vienna, the setting for *The Third Man*, was divided into four zones, but the center of the city was under joint occupation and administration. This occupation ended in 1955.

The screenplay is based on Graham Greene's novel of the same name. Greene worked closely with Carol Reed, the director, who made a number of changes as the film was shot and edited. The result of this collaboration was highly successful. *The Third Man* was named the best feature film at the 1949 International Film Festival at Cannes.

Elements of Screenplays

Like the other dramas you have read, a screenplay makes use of plot, characterization, setting, and theme. The director's use of the camera corresponds to the writer's point of view. Think of all the visual elements that can be manipulated by the filmmaker: angle, composition, background, light, distance, and focus.

On the page a screenplay looks quite different from a stage play. Instead of acts and scenes, the drama is divided into *shots*. The shot refers to any sequence or view taken by the camera in a single run. A shot may be long or short; it may or may not contain dialogue. In the screenplay a shot is often identified by its location and time (*staircase and lobby, night*). A screenplay also contains more narrative than most stage plays. These passages of narrative are similar to lengthy stage directions.

As you read *The Third Man*, you will recognize familiar conventions from films you have seen. You will find that scenes are sometimes shot in quick succession and that some scenes dissolve into each other. Ask yourself what dramatic effects are achieved by these visual techniques.

Here for your reference are some filmmaking terms you will come across in the screenplay of *The Third Man:*

back projection
A background scene projected onto a translucent screen behind the actors

close-up
Any close shot, particularly the subject's face

dissolve
A fade-out of one scene with a fade-in of a new scene superimposed

foreshortened
Distortion caused by a telephoto lens shooting the depth from the lens to the subject

montage
A sequence of rapidly alternating shots or scenes, superimposed on one another or juxtaposed

shot
A long or short take on film without cuts

top shot
A shot taken from above the action, looking downward on the subject

track
Movement of a camera from one point to another, often sideways on tracks

voice-over
The voice of an unseen narrator

The Third Man

GRAHAM GREENE AND CAROL REED

Cast

Holly Martins	*Joseph Cotten*	Popescu	*Siegfried Breuer*
Anna	*Alida Valli*	Dr. Winkel	*Erich Ponto*
Harry Lime	*Orson Welles*	Crabbit	*Wilfrid Hyde-White*
Major Calloway	*Trevor Howard*	Anna's landlady	*Hedwig Bleibtreu*
Sergeant Paine	*Bernard Lee*	Hansl	*Herbert Halbik*
Porter	*Paul Hoerbiger*	Brodsky	*Alexis Chesnakov*
Porter's Wife	*Annie Rosar*	Hall Porter at Sacher's	*Paul Hardtmuth*
"Baron" Kurtz	*Ernst Deutsch*		

Credits roll out over a huge close up of a zither. Sound of the "Harry Lime" theme playing. Many different shots of Vienna.

Voice *over.* I never knew the old Vienna before the war, with its Strauss music, its glamor and easy charm—Constantinople suited me better. I really got to know it in the classic period of the Black Market[1]—*Shots of boots and stockings changing hands*—we'd run anything, if people wanted it enough and had the money to pay. Of course, a situation like that does tend to amateurs—*Shot of a body floating in an icy river*—but you know they can't stay the course like a professional. *Shot of a poster:* "YOU ARE NOW ENTERING THE AMERICAN ZONE." Now the city is divided into four zones, each occupied by a power—*Shots of British, Russian, and French posters*—the Americans, the British, the Russians, and the French. But the center of the city—that's international, policed by an International Patrol. *Shot of guard duty being changed.* One member of each of the four powers. What a hope they had, all strangers to the place and none of them could speak the same language, except for a sort of smattering of German. *Shot of jeep-load of mixed guards, all silent.* Good fellows on the whole, even if it doesn't look any worse than a lot of other European cities, bombed about a bit . . . Oh wait, I was going to tell you—*Shots of bomb sites*—I was going to tell you about Holly Martins from America—he came all the way here to visit a friend of his—*Shot of soldiers standing on parade in a square.* The name was Lime, Harry Lime. *Soldiers are now seen marching.* Now Martins was broke and Lime had offered him—I don't

1. **Black Market:** a system of illegal trade, in violation of price controls or rationing.

know—some sort of a job. Anyway, there he was, poor chap, happy as a lark and without a cent. *Shot of a train pulling into the station. The theme music swells with the train pulling in.* Holly Martins *gets off the train and walks through the barrier, looking for someone.*

Guards from the four zones wait at the barrier.

American Guard. Passports please . . .
British Officer (*to* Martins, *as they glance over his papers*). What is the purpose of your visit, Mr. Martins?
Martins. I've been offered a job by a friend of mine . . .
British Officer. Where are you staying?
Martins. With him . . . Stiftgasse 15.
British Officer. His name?

[Martins *has had to repeat this too many times.*]

Martins. Lime—Harry Lime.
British Officer (*lets* Martins *through*). Okay.
Martins. I thought he'd be here to meet me.

[Martins *arrives at a flat and looks up at the entrance, comparing the address to the one on a paper in his hand. The address on the door reads 15 Stiftgasse. He hurries in.*]

15 STIFTGASSE STAIRCASE. PART LOCATION (DAY):

[Martins *is making his way as rapidly as he can with his bag up the stairs. He rings the bell of* Harry Lime's *flat, which he can recognize on the third floor by the nameplate, and opening the letter box, he whistles. While he waits, he examines such things as the hooks for brushing the clothes outside the doors and the spy holes to observe people. There is no reply to his ring and no answer comes. He rings a second and then a third time. Suddenly a voice speaks to him in German. The* Porter *is standing two floors above.*]

Porter. Es hat keinen Zweck so zu läuten, es ist niemand hier.[2]
Martins. Huh? Speak English?
Porter (*in bad English, shouting to make himself understood*). You have missed them.
Martins. Missed who?
Porter. His friends and the coffin.

[Martins *looks up with surprise and apprehension.*]

Martins. Coffin?
Porter. Mr. Lime's.

[Martins *stares at the* Porter, *who realizes his mistake.*]

Porter. Didn't you know? . . . An accident . . . run over by a car . . . saw it myself . . . on his own doorstep . . . bang, bowled down like a rabbit. Killed at once. They'll have a difficult time burying him in this frost.

[*On the* Porter's *voice and the look of distress on* Martins' *face, slowly dissolve.*]

CENTRAL CEMETERY. LOCATION (DAY):

[Martins *is looking about him—he speaks to an official who points down the huge snowbound park. Avenues of graves, each avenue numbered and lettered, stretching out like spokes of an enormous wheel. A long way away a small group seems to be gathered together on some very private business.* Martins *is walking down the avenue towards them still carrying his bag. Still further away stands a man in a mackintosh. He stands there more like an observer than a participant in the scene. He is* Calloway. Martins *comes up to him.*]

Martins (*quietly*). Could you tell me . . . is this . . .?

2. **Es hat . . . hier:** "There's no reason to make noise; there's no one here."

Photographs are from the film production of *The Third Man*.

National Film Archive, London

Calloway (*not at all moved*). A fellow called Lime.

[*As* Martins *approaches the group, we can see a coffin is on the point of being lowered into a grave and we hear a passage of prayer the* Priest *is saying at the grave.*]

Priest (*mumbling rapidly*). *Anima ejus, et animae omnium fidelium defunctorum, per misericordium Dei requiescant in pace.*[3]

[*Two men in heavy overcoats stand close to the grave. One carries a wreath that he has obviously forgotten*

3. ***Anima . . . pace:*** Latin prayer for repose of the soul.

to lay on the coffin, until his companion touches his elbow, and he comes to with a start. A girl stands a little distance away from them and she puts her hands over her face as the coffin is lowered. We shall know her later as Anna Schmidt.

Martins *stands watching the scene with tears gathering in his eyes. The* Priest *puts a spoon of earth on the coffin, and then the two men do the same. One of the men approaches the girl and offers her the spoon. The girl shakes her head and turns away with tears in her eyes. The man is left holding the spoon uncertainly.* Martins *approaches him and takes the spoon from him and adds his earth to the others. All the time* Calloway *watches the scene from a distance. The two men, whom we know later as* Kurtz *and* Winkel, *stand side by side, watching* Martins, *whom they have never seen before; they*

The Third Man **691**

are uneasy and puzzled. As he turns away from the grave, they say something to each other in low voices. The Priest *goes up to them, speaks a few words, and shakes their hands; he turns to* Martins, *but Martins is walking rapidly away. He stumbles on a loose stone as he walks.* Calloway *follows him, catching him up.*]

Calloway (*loudly*). I've got a car here. Like a lift to town?

[Martins *stares at this man who offers him a lift as if they were leaving a party.*]

Martins. Thanks.

[*He starts to walk ahead, then changes his mind and returns to the taxi. As they get in, a jeep in the background, driven by a sergeant (*Paine, *whom we meet later) who is watching. He starts up and follows.*]

INTERIOR TAXI. BACK PROJECTION (DAY):

[Calloway *looks back towards the group by the grave, but* Martins *stares straight ahead.*]

Calloway. My name's Calloway.

[Martins *does not at first answer; his thoughts are elsewhere.*]

Calloway. You a friend of Lime? (Martins *will not answer.*) Been here long?
Martins. No.

[Calloway *sees someone out of the window of the taxi and leans forward to get a better view.*]

MAIN ROAD. LOCATION (DAY):

[*The girl who was at the graveside is walking towards the city by the wall of the cemetery, with the*

trams running beside it. Behind are rows of monumental masons and flower shops, gravestones waiting for the owners and wreaths for mourners.]

TAXI. BACK PROJECTION (DAY):

[Calloway *is now looking out of the back window at the receding figure. He turns to* Martins, *who is staring straight ahead, and speaks with a voice out of mood with the situation.*]

Calloway. You've had a bit of a shock, haven't you? (*No notice taken.*) You need a drink.

[*For the first time, at the word* drink, *he gets a reaction.*]

Martins. Could you buy me one? I haven't any Austrian money.
Calloway. Of course.

[*As he leans forward to give the driver instructions, dissolve.*]

KARNTNERSTRASSE BAR (DAY):

[*A small bar consisting of two rooms. A self-absorbed courting couple sit in the first room.* Calloway *and* Martins *with his back to the entrance. A bottle of cognac is on the table and at intervals* Calloway *fills* Martins' *glass, always giving him a little more than he does himself.* Martins *is already half-drunk. He twirls the bottom of his glass through the drink spilt on the table.*]

Martins. I guess there's nobody knew Harry like he did . . . (*Corrects himself*) like I did.

[Calloway's *lighter stays a moment halfway to his cigarette.*]

Calloway. How long ago?
Martins. First term at school. Never felt so

damned lonely in my life—and then Harry showed up . . .

Calloway. When did you see him last?

Martins. September '39.

Calloway. When the business started.[4] See much of him before that?

Martins. Once in a while. Best friend I ever had.

Calloway. That sounds like a cheap novelette.

Martins. I *write* cheap novelettes.

Calloway. I've never heard of you. What's your name again?

Martins. Holly Martins.

Calloway. No. Sorry.

Martins (*as English as possible*). Ever heard of *The Lone Rider of Santa Fe?*

Calloway. No.

Martins (*very American*). *Death at Double X Ranch?*

Calloway. No.

Martins. Must have known I was broke—even sent me an aeroplane ticket. It's a damned shame.

Calloway. What?

Martins. Him dying like that.

Calloway. The best thing that ever happened to him.

[Martins *at last sees that there is a hidden meaning in* Calloway's *words. He becomes quieter and more dangerous. His right hand lets go of the brandy glass and lies on the table ready for action.*]

Martins. What are you trying to say?

[Calloway *knows what is coming. He moves his chair very slowly back, calculating* Martins' *reach.*]

Calloway. You see, he'd have served a long spell—if it hadn't been for the accident.

Martins. What for?

Calloway. He was about the worst racketeer

4. **When . . . started:** World War II.

who ever made a dirty living in this city. Have another drink.

Martins. You some sort of a policeman?

Calloway (*sitting back*). Mmm. Have another drink.

Martins. I don't like policemen.

[Martins *edges his chair round to block* Calloway's *way out;* Calloway *catches the waiter's eye. The waiter obviously knows what is expected of him and goes out.*]

Martins (*gently with a surface smile*). I have to call them sheriffs.

Calloway. Ever seen one?

Martins. You're the first. I guess there was some petty racket going on with gasoline and you couldn't pin it on anyone, so you picked a dead man. Just like a cop. You're a real cop, I suppose?

Calloway. Yes, but it wasn't petrol.

Martins. So it wasn't petrol? So it was tires? . . . Saccharine? . . . Why don't you catch a few murderers for a change?

Calloway. Well, you could say that murder was part of his racket.

[Martins *pushes the table over with one hand and makes a dive at* Calloway *with the other: the drink confuses his calculations. Before he can try, his arms are caught behind him. Neither we nor* Martins *have seen the entrance of* Sergeant Paine, *who has been summoned by the waiter and who now pinions* Martins.]

Calloway. That's all right, Paine. He's only a scribbler with too much drink in him. (*With contempt*) Take Mr. Holly Martins home.

Paine (*impressed*). Holly Martins, sir? (Martins *struggles. To* Calloway) The writer? *The Lone Rider of Santa Fe?*

[Calloway *nods and moves away to collect his mackintosh.*]

Martins. Listen, Callaghan, or whatever your name is . . .

Calloway. Calloway. I'm English, not Irish.

Martins. There's one dead man you aren't going to pin your unsolved crimes on.

Calloway. Going to find me the real criminal? It sounds like one of your stories.

Martins. You can let me go, Callaghan. If I gave you a black eye, you'd only go to bed for a few days. When I've finished with you—you'll leave Vienna, you'll look so silly.

[Calloway *takes out a couple of pounds' worth of* Bafs[5] *and sticks them in* Martins' *breast pocket.*]

Calloway. This is Army money. Should see you through tonight at Sacher's Hotel if you don't spend too much in the bar. We'll keep a seat for you on tomorrow's plane.

[Martins *slashes out at* Calloway. *Before* Martins *can try again,* Paine, *who has been greatly impressed by meeting* Martins, *has to land him on the mouth. He comes up bleeding from a cut lip.*
Paine *lifts him up and dusts him down again.*]

Paine. Please be careful, sir. Up we come. Written anything lately?

[Martins *wipes some of the blood away with his sleeve.* Calloway *has had a long day and is tired of* Martins.]

Calloway. Take him to Sacher's. Don't hit him again if he behaves. You go carefully there—it's a Military Hotel.

[Calloway *turns away from both of them and leaves the bar.*]

Paine (*still dusting* Martins *down*). I'm so glad to have met you, sir. (*He leads* Martins *towards*

5. **Bafs:** scrip, or paper money, issued for temporary use.

the door—he holds his arm—he carries his bag and smiles to him.) We read quite a few of your books. I like a good Western. That's what I like about them, sir, pick them up and put them down any time.

[*Dissolve.*]

SACHER'S HOTEL LOUNGE (DAY):

[*Sacher's Hotel, which may roughly be compared to Brown's Hotel in London, has been taken over by the British Army, but this has not altered its atmosphere of red plush and Edwardian[6] pictures, nor the old world courtesy of the porter who treats every subaltern[7] like a grand duke.*]

SACHER'S RECEPTION HALL (DAY):

[Paine *leads* Martins *to the hall porter's desk. He is carrying* Martins' *bag for him, and* Martins *has a handkerchief pressed to his mouth.*]

Paine (*to the* Porter). Major Calloway says this gentleman is to have a bed for the night.

[*As* Martins *is producing his passport,* Paine *moves over to* Crabbit *who is staring at this strange-looking tourist.*]

Paine. Holly Martins, sir, the writer. Thought you'd be interested.

Crabbit. Did you say *writer*, Paine?

Paine. Of books, sir. Yes, Westerns, sir. He's very good, sir. We read quite a few of his books.

Crabbit. Mr. Martins, isn't it?

Martins. Yes.

Crabbit. The name's Crabbit. I represent the C.R.S. of G.H.Q., you know.

6. **Edwardian** (ĕd-wôr'dē-ən, ĕd-wär'-): of the period of the English king Edward VII (1901–1910).
7. **subaltern** (sŭb'ŏl'tərn, sŭb'əl-tûrn'): a subordinate military officer.

Martins. You do?

Crabbit. Cultural Reeducation Section. Propaganda—very important in a place like this. We do a little show each week—last week we had *Hamlet*. Week before we had—um . . . something . . .

Paine. The dancers, sir.

Crabbit. Oh yes, the Hindu Dancers, thank you, Sergeant. This is the first opportunity we've had of making an American author welcome.

Martins. Welcome?

Crabbit. I'll tell you what, on Wednesday night at our Institute, we're having a little lecture on the—er—contemporary novel. Perhaps you'd like to speak?

Martins. They wouldn't know me.

Crabbit. Oh nonsense, your novels are very popular here, aren't they, Sergeant?

Paine. Very popular.

Crabbit. Very popular. Are you staying long?

Martins (*showing Bafs*). How long can you stay on a couple of pounds of this funny money?

Crabbit. We'd like you to be our guest, sir. Glad to have you here.

Martins. Did you say . . . guest?

Crabbit. As long as you care to stay.

Paine. But he's due to leave tomorrow, sir.

Crabbit. Got toothache, sir? I know a very good dentist.

Martins. I don't need a dentist. Somebody hit me, that's all.

Crabbit. Trying to rob you?

Martins. Just a soldier.

[Martins *removes the handkerchief and gives them a view.*]

Martins. I was trying to punch his major in the eye.

Crabbit (*smiling*). Really, a major?

Martins. Heard of Harry Lime? I came here to stay with him. And he died last Thursday—then . . .

Crabbit. Goodness, that's awkward.

Martins. Is that what you say to people after a death? Goodness, that's awkward!

Porter (*holding up telephone*). Mr. Martins, excuse me, Baron von Kurtz.

Martins. It's a mistake.

[*But he takes the telephone.* Crabbit *and* Paine *move a little away and converse together in undertones.*]

Martins. Yes.

Voice. I was a friend of Harry Lime.

Martins (*his attitude changing*). I would much like to meet you, Baron. Come around.

Voice. Austrians aren't allowed in Sacher's. May we meet at the Mozart Café? Just around the corner.

Martins. How will I know you?

Voice. I'll carry a copy of one of your books. (*He sniggers.*) Harry gave it to me.

Martins. Be there in a moment.

[*He hangs up and goes over to* Crabbit.]

Martins. If I do this lecture business, I can be your guest for a week? Can I?

Crabbit. Certainly. You're just the man we need.

Martins. Fine. It's a deal. (*He starts for the door, excited, then turns.*) Ever read a book of mine called *The Lone Rider of Santa Fe*?

Crabbit. No . . . (*Trying to remember*) . . . Not that one.

Martins. The story is about a rider who hunted down a sheriff who was victimizing his best friend.

Crabbit. Sounds exciting.

Martins. It is. I'm gunning just the same way for your Major Callaghan.

[*As* Martins *turns to the door,* Paine *speaks uneasily to* Crabbit.]

Paine. Sounds anti-British.

MOZART CAFÉ. PART LOCATION (DAY):

[Martins *enters the café and examines the occupants. Several are reading newspapers—they do not interest him. He passes over a group playing cards, but there remain two or three, reading books, and the audience is given time to decide for themselves which of these is* Kurtz: *the young man with the arrogant Hitler Jugend[8] look about him?* Martins *passes by to catch his eye—looks as if ready to smile— he gets no reaction. He turns away and at that moment* Kurtz *enters the café.* Martins *recognizes him at once because he holds well to the fore the gaudy paper-covered Western with a picture of a cowboy leaping from a horse onto the horns of a galloping steer. He wears a toupee, flat and yellow with the hair out straight at the back and not fitting close. He carries a stick with an ivory top.* Martins *meets him.*]

Martins. Baron Kurtz?
Kurtz. Martins? Delighted to meet you.

[*His English accent is really too good. A man ought not to speak a foreign language so well.*]

Kurtz. Let us sit here.

[*His clothes are shabby, but not too shabby. His overcoat looks quite adequate compared with the poor clothes of the other men. When they are seated, he calls a waiter and orders coffee. That done, he leans back with a sigh.*]

Kurtz. It's wonderful how you keep the tension.
Martins. Tension?
Kurtz. Suspense. At the end of every chapter, you are left guessing . . . what he'll be up to next.

8. **Hitler Jugend** (yo͞o′gənd): an organization of youth in Nazi Germany.

Martins. So you were a friend of Harry's?
Kurtz. I think his best. (*A small pause in which his brain must have registered the error*) Except you, of course.
Martins. The police have a crazy notion that he was mixed up in some racket.
Kurtz. Everyone in Vienna is—we all sell cigarettes and that kind of thing. Why, I have done things that would have seemed unthinkable before the war. Once when I was hard up, I sold some tires on the black market. I wonder what my father would have said.
Martins. The police meant something worse.
Kurtz. They get rather absurd ideas sometimes. He's somewhere now he won't mind about that.
Martins. Well, anyway, I'm not going to leave it at this—will you help me?

[Kurtz *has a cup of coffee halfway to his lips; he takes a slow sip.*]

Kurtz. I wish I could. You know I am an Austrian—I have to be careful with the police; no, I can't help you—except with advice, of course, advice.
Martins. Well, anyway, show me how it happened.

[*Dissolve.*]

OUTSIDE LIME'S FLAT. LOCATION (DAY):

[Kurtz *is standing at the door of* Lime's *flat, and is holding* Martins' *arm.*]

Kurtz. You see, you might be Harry. We came out like this and were walking this way . . .

[*He points to a doorway on the other side of the road; the camera follows imaginary figures while the voice continues.*]

Kurtz. A friend of his, Popescu, called to him

from over there. Harry went across, and from up there . . . (*Points down the road*) . . . came the truck. It was Harry's fault, really, not the driver's. (*Looking down on the ground*) It was just about here. These military cars aren't safe.
Martins. It was here?

[*He kicks with his foot at a broken stone on the curb. From out of the doorway to* Harry's *flat comes the* Porter *sweeping the steps. They nod to each other.* Kurtz *sees this.*]

Kurtz. Popescu and I carried him across to the doorway over there.

[*He leads* Martins *to the other side of the road. The* Porter *continues sweeping with his eyes on the two of them.*]

IN THE MIDDLE OF THE SQUARE, NEAR A STATUE OF THE EMPEROR FRANZ JOSEF (DAY):

Kurtz. And this is where he died. Even at the end his thoughts were of you.
Martins (*greatly moved*). What did he say?
Kurtz. I can't remember the exact words. Holly—I may call you Holly, mayn't I?—he always called you that to us—he was anxious I should look after you when you arrived—to see that you got safely home. Tickets, you know, and all that.
Martins (*indicating* Porter). He told me he died instantaneously.
Kurtz. No. But he died before the ambulance could reach us.
Martins. So you were here, and this man Popescu. I'd like to talk to him.
Kurtz. He's left Vienna.

[Martins *walks across to the* Porter.]

Martins. You remember me?
Porter. Yes.

Martins. I wanted to ask you some questions about Harry Lime.

[*The* Porter's Wife *has come out and gives an angry look at* Martins *and* Kurtz.]

Martins. Who used to visit Mr. Lime?

[*The* Porter *speaks to* Kurtz *in German.*]

Martins. What's he say?
Kurtz. He says he doesn't know everybody.
Porter's Wife (*in German*). Don't stand there gossiping.

[*She hustles him in.* Martins *returns thoughtfully to* Kurtz.]

Martins. Who was at the funeral besides you?
Kurtz. Only his doctor, Dr. Winkel.
Martins. The girl?
Kurtz. Oh, you know what Harry was. Some girl from the Josefstadt Theater. (*He sees an intention in* Martins' *face.*) You oughtn't to speak to her. It would only cause her pain.
Martins. We don't have to think about her. We've got to think about Harry.
Kurtz. What's the good of another post-mortem?[9] Suppose you dig up something—well, discreditable to Harry?

[Martins *shakes his head. It is not an idea he will entertain.*]

Martins. Could I have your address?
Kurtz. I live in the Russian Sector. But you'll find me at the Casanova Club every night.
Martins. What was the girl's name?
Kurtz. I don't know. I don't think I ever heard it.
Martins. But the theater where she works?

9. **post-mortem** (pōst-môr'təm): an examination after death.

Kurtz. The Josefstadt. I still think it won't do Harry any good. You'd do better to think of yourself.
Martins. I'll be all right.

[*They turn to go.*]

Kurtz. I'm glad to have met you, Holly.

[Kurtz *holds up the book showing the cowboy on the cover.*]

Kurtz. A master of suspense. Such a good cover, I think.

[*Dissolve.*]

SACHER'S HOTEL. RECEPTION DESK (DAY):

[Martins *comes in and finds* Sergeant Paine *waiting.* Paine *advances to meet him and holds out an envelope.*]

Paine. Major Calloway sent this, with his compliments. It's the ticket for the plane tomorrow. He said I was to drive you out to the airfield or take you to the bus, whichever you prefer.
Martins. Tell Major Calloway I won't need it. Didn't you hear Mister Crabbit offer me the hospitality of the H.Q.B.M.C.? (*He hands the ticket back to the sergeant and turns to the porter.*) Please get me a ticket for the Josefstadt Theater tonight.

[*He walks slowly up the staircase one step at a time—feeling he has started to put* Calloway *in his place. Dissolve.*]

JOSEFSTADT THEATER (NIGHT):

[Martins *is seated in the stalls. A play is in progress. The actors all wear eighteenth-century costume. He* cannot understand a word of it, and gazes bewilderedly at his neighbors when they rock with laughter at a situation which visually seems serious enough. On the stage an elderly man and a woman are storming at a girl—the girl from the cemetery—who protests something, he does not know what. At every sentence, the audience howls with laughter. He looks at his program and we see the name of Anna Schmidt. As he looks up at the stage again, the curtain falls. The audience remain in their seats, but *Martins* scrambles out and through the small door at one side of the stage.*]

BACKSTAGE. LOCATION (NIGHT):

[*A quick change of scene is taking place on the stage.* Martins *watches from the wings the scene-shifters at work.* Anna Schmidt *comes up hurriedly and stands near him, doing up her dress: the clasps will not fasten—she does not notice him.*]

Martins. I was a friend of Harry Lime.

[Anna *stops and stares at him. The curtain is rising and her entrance has to be on the rise of the curtain.*]

Anna (*quickly*). Afterwards. Afterwards.

[*She goes onto the stage and, playing her first lines towards him, watches with an expression, puzzled and distressed, the stranger who has broken into her grief. For the first time we really take her in: an honest face: a wide forehead, a large mouth which does not try to charm, the kind of face which you can recognize at once as a friend's. The opening lines of this scene demand that she should approach the wings. Dissolve.*]

ANNA'S DRESSING ROOM (NIGHT):

[Anna *opens the door to* Martins. *On the only easy chair, a tin of half-used paints and grease. A kettle hums softly on a gas ring.*]

Martins (*at the door*). Miss Schmidt?

Anna. Come in.

Martins. I enjoyed the play very much. You were awfully good.

Anna. You understand German?

Martins. No—no—I . . . excuse me, I could follow it fine. My name's Holly Martins. Perhaps Harry told you about me.

Anna. No. He never told me about his friends. Would you like a cup of tea? Someone threw me a packet last week—sometimes the British do, instead of flowers, you know, on the first night.

[*She opens a cupboard under the dressing table to get the tea and shows a bottle of Canadian Club.*]

Anna. That was a bouquet too, from an American. (*Reluctantly*) Would you rather have a whiskey?

Martins. Tea's okay.
Anna. Good. (*She closes the cupboard.*) I wanted to sell it.

[*He watches her while she makes the tea. All wrong: the water not on the boil, the teapot unheated, too few leaves. She pours it out immediately.*]

Martins. You'd known him some time?

[*Her mouth stiffens to meet the dreaded conversation.*]

Anna. Yes.
Martins. I knew him twenty years. (*Gently*) I want to talk to you about him . . .

[Anna *stares back at him.*]

Anna. There's nothing really to talk about, is there? Nothing.

[*He drinks his cup quickly like a medicine and watches her gingerly and delicately sip at hers.*]

Martins. I saw you at the funeral.
Anna. I'm sorry . . . I didn't notice much.
Martins. You loved him, didn't you?
Anna. I don't know. You can't know a thing like that—afterwards. I don't know anything anymore except . . . (*She hesitates;* Martins *looks at her.*) I want to be dead too. (*There is silence for a while.*) Another cup of tea?
Martins (*too promptly*). No, no thank you . . . Cigarette? (*He offers a Lucky Strike packet.*)
Anna. Thank you . . . I like Americans.

[*He lights it, but during the following scene she lets it go out.*]

Martins. I've been talking to a friend of Harry's. Baron Kurtz. Do you know him?
Anna. No.

Martins. He wears a *toupee*. I can't understand what Harry saw in him.
Anna. Oh, yes. (*She does not like him.*) That was the man who brought me some money when Harry died. He said Harry had been anxious— at the last moment.
Martins. He must have been very clear in his head at the end: he remembered about me too. It seems to show there wasn't really any pain.
Anna. Doctor Winkel told me that . . .
Martins. Who's he?
Anna. A doctor Harry used to go to. He was passing just after it happened.
Martins. Harry's own doctor?
Anna. Yes.
Martins. Did you go to the inquest?
Anna. Yes. They said it wasn't the driver's fault. Harry had often said what a careful driver he was.
Martins (*astonished*). He was Harry's driver?
Anna. Yes.
Martins. I don't get this. Kurtz and the Rumanian—his own driver knocking him down— his own doctor—not a single stranger.

[*He is brooding on this new fact.*]

Anna. I've wondered about it a hundred times—if it really was an accident. (Martins *is astonished.*) What difference does it make? He's dead.
Voice (*from outside*). Fräulein Schmidt.
Anna. They don't like us to use the light. It uses up their electricity.

[Martins *up to this point had never thought of murder.*]

Martins. The porter saw it happen. It couldn't have been . . . You know that porter?
Anna. Yes.

[*Dissolve.*]

HARRY'S FLAT. SITTING ROOM (NIGHT):

[*The* Porter *throws open the window.* Martins *stands behind him.* Anna *is a little distance away, examining the room as though it was a home to which she had returned after many years.*]

Porter. It happened right down there.

[*He leans out and we look down with him to the pavement five stories below.* Anna *turns abruptly away and walks through an open door into the bedroom.*]

Martins. And you saw it?
Porter. Well, not saw. I heard it though. I heard the brakes put on and the sound of the skid and I got to the window and saw them carry the body to the other side of the Emperor Josef statue (*He points*) . . . over there.

[*While the* Porter *is talking,* Martins *turns and watches* Anna *in the next room.*]

BEDROOM (NIGHT):

[*She stands beside the bed with her head down, and every now and then she raises it and takes a quick look here and there.*]

SITTING ROOM. (NIGHT):

[Martins *says in a low voice so as not to carry to the next room . . .*]

Martins. Could he have been conscious?
Porter. Oh no, he was quite dead.
Martins. I've been told he *didn't* die at once.
Porter. He couldn't have been alive, not with his head in the state it was. (*Trying to explain*) Wait a moment, Fräulein Schmidt. (*He asks her a question in German.*)
Anna. He was quite dead.

Porter. He was quite dead.
Martins. But this sounds crazy. If he was killed at once, how could he have talked about me and this lady after he was dead?

BEDROOM (NIGHT):

[Anna *moves from the bed. Twice she puts out her hand and touches the wall. She comes to the dressing table. In the mirror is stuck a snapshot. It is of herself, laughing into the camera. Above it she sees her face in the mirror with tousled hair and hopeless eyes. Automatically she puts her hand down to the right-hand drawer. She does not have to look. She opens the drawer and pulls out a comb. Still only half-conscious of what she is doing, she raises it to her head and is just going to use the comb when her eye falls on something in the drawer belonging to* Harry. *She drops the comb, slams the drawer to, and puts her hand over her face.*]

SITTING ROOM (NIGHT):

Martins. Why didn't you say all this at the Inquest?
Porter. It's better not to be mixed up in things like that.
Martins. Things like what?
Porter. I was not the only one who did not give evidence.
Martins. What do you mean?
Porter. Three men helped to carry your friend to the statue.
Martins. No—only Kurtz and the Rumanian.
Porter. There was a third man. He didn't give evidence.
Martins. *Three* men carried the body?
Porter. Yes. The third one held his head.
Martins. You don't mean the doctor?
Porter. Oh no, he didn't arrive till after they got him to the doorway.
Martins. Can't you describe this—third man?
Porter. No. He didn't look up. He was just—ordinary. He might have been anybody.

[Martins *looks down at the pavement. At the Porter's last sentence,* Martins *looks down at two or three people passing foreshortened on the pavement.*]

Martins (*almost to himself*). Just anybody. But I think he murdered Harry.

[*A telephone rings in the bedroom.*]

BEDROOM (NIGHT):

[Anna *picks up the receiver.*]

Anna. Hallo, wer ist da? (Hello, who is there?)

[*There is no reply, but whoever it is remains on the line.*]

Anna. Warum antworten Sie nicht? (Why don't you answer?)

[*She puts the receiver down and turns to* Martins.]

Anna. Nobody.

[Martins *turns back into the other room.*]

Martins. But I was told there were only two men there.

Museum of Modern Art Film Stills Archive

SITTING ROOM (NIGHT):

[*The* Porter *does not want to continue the discussion.*]

Martins. You've got to tell the police your story.

[*Through the open door of the room from the landing outside trickles a child's ball—nobody sees it.*]

Porter. Nonsense. It is all nonsense. It was an accident. I saw it happen.

[*A child (little* Hansl) *comes to the door and looks in—the ball is too far across the floor for him to reach it unobserved—and he skulks there, watching the scene, waiting his opportunity.*]

Martins. Be accurate. You saw a dead man and three men carrying him.

[*The* Porter *is working himself up from self-protection into rage.*]

Porter. You have no business forcing your way in here and talking nonsense. I ought to have listened to my wife. She said you were up to no good. Gossip.
Martins. Don't you see your evidence is important?
Porter. I have no evidence. I saw nothing. I'm not concerned. You must go at once please. Fräulein Anna.

[Anna Schmidt *comes in from the bedroom.*]

Anna. What is it?
Porter. I have always liked you, Fräulein Anna, whatever my wife may say, but you must not bring this gentleman again.

[*The* Porter *shepherds them towards the door. The child backs out of sight onto the landing—as the*

Porter *reaches the ball and kicks it angrily through the door—it bounces into the corridor and off down the stairs. The child follows it. Dissolve.*]

ANNA'S STREET. LOCATION (NIGHT):

[Anna *and* Martins *walk up to the door of an ancient bombed house where* Anna *has a room—she looks in her bag for the key.*]

Anna. You shouldn't get mixed up in this.
Martins. Well, if I do find out something, can I look you up again?
Anna. Why don't you leave this town—go home?

DOORWAY. PART LOCATION (NIGHT):

[*The door of the house has been broken away and a makeshift door has been made out of planks nailed roughly together. Between the planks can be seen an* Old Woman *hurrying towards the door. She starts to talk to* Anna *excitedly in German. Through the cracks in the door,* Anna *steps back on the pavement and looks up to a lighted window.*]

Martins. What is it?
Anna. The Police. They are searching my room.

HALLWAY AND STAIRCASE (NIGHT):

[*A once grand house, badly bombed, and with half the walls out—a large staircase leads upstairs. The* Old Woman *follows behind* Anna *and* Martins, *to whom she behaves like a hostess; muttering all the time and not able to keep up with them; and stops on the first landing, watching up . . .*]

STAIRCASE AND LANDING (NIGHT):

[Anna's *bedroom had once been a reception room; it is large with a high ceiling, but is now a cheaply*

furnished room with the bare necessities. Anna *and* Martins *can see nobody through the half-opened door, but the drawers of a chest are open, and her things are piled in neat heaps on top. Photographs have been removed from frames, etc. Reaction of bewilderment and fear on* Anna's *face.* Martins *swings the door open with his foot.*]

ANNA'S BEDROOM (NIGHT):

[*The opening of the door has taken no one by surprise.* Calloway *stands inside while* Paine *and two Austrian* Policemen, *paying no attention whatever to the arrival of* Anna *and* Martins, *continue their search.*]

Martins. What the devil?
Calloway. Getting around, Martins?
Martins. Pinning things on girls now?
Calloway (*ignoring him*). I want to see your papers, Miss Schmidt.

[Anna *opens her bag, hands over her papers.*]

Calloway. Thank you.

[*He begins to turn them over.*]

Calloway. You were born in Graz, of Austrian parents? . . .
Anna (*in a low voice*). Yes.

[Calloway *lifts the document to the light and examines it at the level of his eyes.*]

Calloway. Paine. (Paine *repeats the action.*) See what I mean?
Paine. Yes, sir. It's very good, sir, isn't it?
Calloway. How much did you pay for this? I'll have to keep these for a while, Miss Schmidt.

[*She is too scared to protest.* Martins *does it for her.*]

Martins. You can't go that far, Callaghan. She can't live in this city without papers.

Calloway. Write her out a receipt, Paine. That will serve. Give her a receipt for the other things too.
Paine. This way, miss.

[*He leads the way through into the sitting room.*]

Martins. I suppose it doesn't interest you to hear Harry Lime was murdered?

ANNA'S SITTING ROOM (NIGHT):

[Paine *seats himself at a table where a number of objects are already stacked, including a bundle of letters.*]

Anna. You aren't taking those?
Paine (*writing on a leaf of his notebook*). They'll be returned, miss.
Anna. They are private letters.
Paine. Don't worry, miss. We are used to it. Like doctors.

[Anna *leaves him and goes to the doorway.*]

ANNA'S BEDROOM (NIGHT):

[Martins *is in the middle of a tirade.* Anna *listens.*]

Martins. And there was a third man there. I suppose that doesn't sound peculiar to you.
Calloway. I'm not interested in whether a racketeer like Lime was killed by his friends or in an accident. The only important thing is that he's dead.

[*As he speaks the last words, he turns and sees* Anna *in the doorway.*]

Calloway. I'm sorry.
Martins. Tactful too, aren't we, Callaghan?
Calloway (*with good humor*). Calloway.
Anna. Must you take those letters?

Calloway. Yes, I'm afraid so.

Anna. They are Harry's.

Calloway. That's the reason.

Anna. You won't learn anything from them. They are only—love letters. There are not many of them . . .

Calloway. They'll be returned, Miss Schmidt, after they've been examined.

Anna. There's nothing in them. Harry never did anything. (*She hesitates.*) Only a small thing, once, out of kindness.

Calloway. What was that?

Anna (*turning to the other room*). You've got it in your hand.

[Calloway *lifts his hand with* Anna's *papers in them.* Paine *comes through from the other room.*]

Calloway (*to Austrian* Policeman *in German*). Finished?

Policeman (*in German*). Nearly.

Calloway. You'll have to come with us, Miss Schmidt. Martins, go home like a sensible chap. You don't know what you are mixing in. Get the next plane.

Martins. You can't order me around, Callaghan. I'm going to get to the bottom of this.

Calloway. Death's at the bottom of everything, Martins. Leave death to the professionals.

Martins (*to* Calloway). Mind if I use that line in my next Western? You can't chuck me out, my papers are in order.

Paine. (*to* Anna). Your receipt for the letters, miss.

Anna. I don't want it.

Paine. Well, I've got it when you want it, miss.

[Calloway *crosses to* Paine, *where some of* Anna's *belongings are being put back.* Anna *goes to the chest and begins to put one of the photographs back in its frame.* Martins *watches it, and her. The photograph of a man grinning with great gaiety and vitality at the camera.*]

Martins. That's him all right. He would have known how to handle that . . . (*Whispers*) . . . Why did they take your papers?

Anna. They are forged.

Martins. Why?

Anna. The Russians would claim me. I come from Czechoslovakia.

[*In the open doorway stands the* Old Woman. *She does not come in.*]

Old Woman (*in German*). The way they behave—breaking in like this. I am so sorry . . .

[Anna *takes no notice—the* Woman *goes on talking in German to* Martins.]

Martins. What's she say?

Anna. Only complaining about the way they behave—it's her house.

Martins (*looking around*). Is it . . .

Anna. Give her some cigarettes.

[Martins *gives her four cigarettes, which she will not at first accept, but finally does so with great grace.* Martins *goes back to* Anna.]

Calloway. Ready, Miss Schmidt?

Martins. Don't be scared. If I can only clear up this mess about Harry—you'll be okay.

Anna (*glancing up at the picture*). Sometimes he said I laughed too much. (*To* Calloway) Yes.

Martins. What was that doctor's name?

Anna (*spelling it*). Winkel.

Calloway. What do you want to see a doctor for?

[Martins *touches his mouth where* Paine *hit him.*]

Martins. A bruised lip.

[*The* Old Woman *watches them downstairs. Dissolve.*]

INTERNATIONAL POLICE HEADQUARTERS (NIGHT):

[Anna's letters are being gone through in detail and photographed.]

DR. WINKEL'S FLAT. DINING ROOM (NIGHT):

[A chicken being carefully dissected. The bell rings.]

DR. WINKEL'S FLAT. PASSAGE (NIGHT):

[A Maid passes along and opens the door. Martins stands outside.]

Martins. Is Dr. Winkel in?
Maid. Die Sprechstund ist von drei bis fünf. (His consulting hours are 3 till 5).

[She prepares to close the door.]

Martins. I want Dr. Winkel. Don't you speak any English?
Maid. Nein.
Martins. Dr. Winkel, I . . . (He points at himself) . . . want to see Dr. Winkel. Tell him a friend of Harry Lime.

DR. WINKEL'S DINING ROOM (NIGHT):

[We cut back to the hands carving the chicken. They suddenly stay still. The knife is put down. A voice calls out something in German.]

Voice (in German). Show him into the waiting room, Hilda.

DR. WINKEL'S WAITING ROOM (NIGHT):

[The Maid shows Martins into the waiting room and leaves him there. Dr. Winkel's waiting room reminds one of an antique shop that specializes in religious objets d'art.[10] There are more crucifixes hanging on the walls and perched on the cupboards and occasional tables than one can count, none of later date than the seventeenth century. There are statues in wood and ivory. There are a number of reliquaries: little bits of bone marked with saints' names and set in oval frames on a background of tinfoil. Even the high-backed, hideous chairs look as if they had been sat in by cardinals. Through the open doorway can be seen the stick with the ivory top that Kurtz was carrying earlier. A sneeze disturbs him.

Dr. Winkel is very small, neat, very clean, in a black tail coat and a high stiff collar; his little black mustache is like an evening tie. He sneezes again. Perhaps he is cold because he is so clean.]

Winkel (in German). Good evening.
Martins. Dr. Winkel?

[Martins always pronounces this name wrong, as though it were the name of the shellfish, so that the "W" is pronounced like an English "W" and not as in German as a "V." This annoys Winkel.]

Winkel. Vinkel.

[When he bows there is a very slight creak as though his shirt front is celluloid. Or does he wear stays?]

Martins. You have an interesting collection here.
Winkel. Yes.

[A small and disgusting little dog barks and Winkel marshals it out of the room with a great rigmarole[11] in German.]

Martins. That your dog?
Winkel. Yes. Would you mind, Mr. Martins, coming to the point? I have guests waiting.

10. **objets d'art** (ôb′zhĕ där′): objects valued for their artistry.
11. **rigmarole** (rĭg′mə-rōl): fussy business.

Martins. You and I were both friends of Harry Lime.

Winkel (*unyieldingly*). I was his medical adviser.

Martins. I want to find out all I can.

Winkel. Find out?

Martins. Hear the details.

Winkel. I can tell you very little. He was knocked over by a car. He was dead when I arrived.

Martins. Who was there?

Winkel. Two friends of his.

Martins. You're sure . . . Two?

Winkel. Quite sure.

Martins. Would he have been conscious at all?

Winkel. I understand he was . . . yes . . . for a short time . . . while they carried him into the house.

Martins. In great pain?

Winkel. Not necessarily.

Martins. Would he have been capable of . . . well, making plans to look after me and others? In those few moments?

[Winkel *looks at the nails on one hand.*]

Winkel. I cannot give an opinion. I was not there.

[Winkel *studies a statuette.*]

Winkel. My opinion is limited to the causes of death. Have you any reason to be dissatisfied?

Martins. Could his death have been . . . not accidental?

[Dr. Winkel *puts out a hand and straightens a crucifix on the wall, and flicks some imaginary dust off the feet.*]

Martins (*trying to make himself clear*). Could it have been . . .

Winkel. Yes?

Martins. Could he have been pushed, Dr. Winkel?

Winkel (*stonily correcting him*). Vinkel, Vinkel.

[Dr. Winkel *is a very cautious doctor. His statements are so limited that you cannot for a moment doubt their veracity.*]

Winkel. I cannot give an opinion. The injuries to the head and skull would have been the same.

[*Dissolve.*]

CALLOWAY'S OFFICE (NIGHT):

[Anna *paces up and down* Calloway's office. Calloway *enters, but is called back by a Russian Officer,* Brodsky.]

Brodsky. Major, major, could I see you for a moment, please?

Calloway. Certainly, Brodsky. What is it?

Brodsky. These forgeries, very clever . . . we too are interested in this case. Have you arrested the girl? Please, keep this passport to yourself until I make some inquiries, will you, major?

Calloway. Yes, of course.

Brodsky. Thank you.

[Calloway *reenters his office and indicates* Anna's *letters on his desk.*]

Calloway. I can let you have these back, Miss Schmidt. Will you look through, see that they are right, and sign the receipt?

[He *pushes the receipt across to her, watching her closely.*]

Anna. But my passport?

Calloway. We need that for a while longer. Miss Schmidt, you were intimate with Lime, weren't you?

Anna. We loved each other. Do you mean that?

[Calloway *is looking through the window.*]

Calloway (*turning from the window and picking a photograph from the desk*). Know this man?

Anna (*after a quick look at the photograph*). I've never seen him.
Calloway. But you've heard of him—Joseph Harbin. He works in a military hospital.
Anna. No.
Calloway. It's stupid to lie to me, Miss Schmidt. I am in a position to help you.
Anna. I am not lying. You are wrong about Harry. You are wrong about everything.
Calloway. In the letter we've kept, Lime asked you to telephone a good friend of his called Joseph. He gave you the number of the Casanova Club. That's where a lot of friends of Lime used to go.
Anna. Oh, that. Yes, I remember that. It wasn't important.
Calloway. What was the message?
Anna. Something about meeting Harry at his home.
Calloway. Harbin disappeared the day you telephoned—I want to find him. (*He picks up the passport and turns it over in his hands.*) You can help us.
Anna. What can I tell you but . . . (Calloway *looks up.*) You've got everything upside down. (Calloway *gets up.*)
Calloway. Right, Miss Schmidt. We'll send for you when we want you. That friend of yours is waiting for you—a rather troublesome fellow.

[*Dissolve.*]

THE CASANOVA CLUB (NIGHT):

[*A dance floor with tables round it; up a short flight of stairs, a bar and a cloakroom.* Kurtz, *playing a violin with two other players, is going from table to table. As he passes one table, we see* Crabbit. *He goes up the stairs to the bar and cloakroom. As he reaches the cloakroom, the street door opens and* Martins *and* Anna *enter.* Anna *goes up to the bar.* Crabbit *sees* Martins *as he turns, struggling to get into his overcoat.*]

Crabbit. Hello, Mr. Martins. Goodness, I'm glad I ran into you.
Martins. Good evening.
Crabbit. I've been looking all over town for you, Mr. Martins. I've arranged that lecture for tomorrow.
Martins. What about?
Crabbit. On the modern novel, you remember what we arranged. They want you to talk on the Crisis of Faith.
Martins. What does that mean?
Crabbit. We thought you'd know. You're a writer, old chap. We'll talk again after the discussion. I'll let you know the time.

[Anna *is at the bar.* Martins *comes up.*]

Martins. Drink?

[*He takes out his army money.*]

Anna. And they won't take that stuff here. (*To* Barman) Two whiskeys. (*She opens her bag.*)

[Martins *turning round on his stool sees* Kurtz *playing at a table below, where a fat woman is sitting with an elderly man. He is pouring it out with great emotion—eyes slit and swimming, his shoulders move with the slow rhythm and his head nods with appreciation.* Martins *watches him with suspicion.* Kurtz *has not yet seen him.*]

Anna. Your whiskey.

[*He half-turns back to the bar.* Anna, *who has turned her bag out, is putting her change back. She*

picks up a snapshot and is about to put it back in her bag.]

Martins. Harry?

[*She gives it to him—they stare at it together.*]

Anna. He moved his head, but the rest is good.

[Kurtz *is playing from table to table, followed by a double bass and second violin—sees* Martins *and* Anna—*leaves the others and moves to the bar. He seems completely unperturbed and comes up the stairs to the bar. He bows to* Anna.]

Kurtz. Miss Schmidt. You've found out my little secrct. A man must live. (*To* Martins) How goes the investigation? Have you proved the policeman wrong?
Martins. Not yet.

[Kurtz, *who is aware he has carried off a tricky situation well, has been a little over-exhilarated, but this plain statement damps him.*]

Kurtz. Our friend Winkel said you had called. Perhaps he was helpful? (*He cannot avoid a shade of anxiety.*)
Martins. No.
Kurtz. Mr. Popescu is here tonight.
Martins. I thought he left Vienna.
Kurtz. He's back now.
Martins. I want to meet all Harry's friends.
Kurtz. I'll bring him to you.

[Kurtz *goes back to the dance floor.*]

Anna. Haven't you done enough today? (*She is worn out with reminders of* Harry.)
Martins. That porter said three men carried the body, and two of them are here.

[Martins *turns from the bar and sees* Popescu: *a*

man with tousled gray hair, a worried, kindly, humanitarian face and long-sighted eyes.*]

Kurtz. Mr. Popescu, Mr. Martins.
Popescu. Any friend of Harry is a friend of mine.
Kurtz. I'll leave you together. (*He goes.*)
Popescu. Good evening, Miss Schmidt. You remember me?
Anna. Yes. (*The memory is obviously not pleasant.*)
Popescu. I helped Harry fix her papers, Mr. Martins. Not the sort of thing I should confess to a stranger, but you have to break the rules sometimes. Humanity's a duty. Cigarette, Miss Schmidt? Keep the pack.

[Martins *is growing impatient with all this talk.*]

Martins. I understand you were with Harry . . .

[Anna Schmidt *takes her glass and moves away down the bar. She cannot bear any more of this. She sits there, during the ensuing scene, smoking cigarette after cigarette.*]

Popescu (*to* Barman). Two large whiskeys and a small one for the lady. (*To* Martins) It was a terrible thing. I was just crossing the road to go to Harry. He and the Baron were on the sidewalk.

[Martins' *eyes go to* Kurtz *who has come into sight below, playing at a table as before. He glances towards* Martins *and nods at him with a smile.*]

Popescu. Maybe if I hadn't started across the road, it wouldn't have happened. I can't help blaming myself and wishing things had been different. Anyway he saw me and stepped off the sidewalk to meet me, and the truck . . . it was terrible, Mr. Martins, terrible. (*He swallows his whiskey.*) I've never seen a man killed before.

Martins. There was something wrong about Harry's death.

Popescu. Of course, there was.

Martins. You think so too?

Popescu. It was so damned stupid for a man like Harry to be killed in a street accident.

Martins. That's all you meant?

Popescu. What else?

Martins. Who was the third man?

[Popescu *takes up his glass.*]

Popescu. I oughtn't to drink it. It makes me acid. What man would you be referring to, Mr. Martins?

Martins. I was told a third man helped you and Kurtz with the body.

Popescu. I don't know how you got that idea. You'll find all about it in the Inquest report. There was just the two of us. Me and the Baron. Who could have told you a story like that?

Martins. I was talking to the porter at Harry's place. He was cleaning the window and looked out.

Popescu (*with great calm*). And saw the accident?

Martins. No. Three men carrying the body, that's all.

Popescu. Why wasn't he at the Inquest?

Martins. He didn't want to get involved.

Popescu. You'll never teach these Austrians to be good citizens. It was his duty to give the evidence, even though he remembered wrong. What else did he tell you?

Martins. That Harry was dead when he was carried into the house. Somebody's lying.

Popescu. Not necessarily.

Martins (*watching the other man's reactions*). The police say Harry was mixed up in some racket.

Popescu. That's quite impossible. He had a great sense of duty.

Martins. Kurtz seemed to think it was possible.

Popescu. The Baron doesn't understand how an Anglo-Saxon mind feels.

Martins. He seems to have been around a bit. Do you know a man called Harbin . . . Joseph Harbin?

Popescu. No.

[*He looks across at* Anna *and finishes his drink.*]

Popescu. That's a nice girl, that. But she ought to be careful in Vienna. Everybody ought to be careful in a city like this.

[*Dissolve.*]

POPESCU'S ROOM (DAWN):

[Popescu *is finishing a telephone call.*]

Popescu. He will meet us at the bridge, good.

[*Dissolve.*]

KURTZ'S HOUSE. EXTERIOR (DAWN):

[Kurtz *leaves his house surreptitiously. Dissolve.*]

WINKEL'S HOUSE. EXTERIOR (DAWN):

[Winkel *wheels out an old bicycle and rides away. Dissolve.*]

POPESCU'S FRONT DOOR (DAWN):

[Popescu, *dressed in an overcoat, steps out. Dissolve.*]

REICHSBRÜCKE. EXTERIOR. LOCATION (DAWN):

[*A man with his back turned to the camera waits on the bridge. He is joined one after the other by* Popescu, Kurtz, *and* Winkel. *They talk together out of hearing.*]

HARRY'S FLAT. EXTERIOR. LOCATION (DAY):

[Martins *is pacing out the distance from the door to the point where* Harry *was killed, and various other distances. Then he paces back along the pavement where the body was carried, and looks up to the window of* Harry's *flat, from which the* Porter *had seen the third man. Staring down at him is the* Porter, *duster in hand.*]

Porter (*calling softly down*). Mein Herr.
Martins. Yes?
Porter. I am not a bad man, mein Herr. Not a bad man. Is it really so important?
Martins. Very important.
Porter. Come this evening when my wife is out then.
Martins. I'll come, but tell me now. Was the car . . .
Porter Shsh. (*He slams the window.*)

HARRY'S FLAT (DAY):

[*The* Porter *slams the window and turns towards camera. He stays still, listening. The sound of squeaking shoes approaching from the next room. As they come close, there is a look of horror on the* Porter's *face. Dissolve.*]

ANNA'S ROOM (DAY):

[*The gray early evening time before it is quite dark enough to switch on the lights.* Anna *is standing by the table on which are the roneoed*[12] *sheets of a play. She has been trying to learn a new part. She turns and the camera turns with her to pick up* Martins *in the doorway, in a wet mackintosh. For a moment, because her mind is in the past, she almost thinks it is* Harry. *She makes a motion towards him and then turns away.*]

12. **roneoed** (rōn′ē-ōd): duplicated on a machine that makes many copies.

Anna. Come in.
Martins. The porter's going to talk to us to-night.
Anna. Need we go through it all again?
Martins. I can manage alone. (*He picks up the play.*) Busy?
Anna. Another part I've got to learn.
Martins. Shall I hear you?
Anna (*skeptically*). In German?
Martins. I can try. Tragedy or comedy?
Anna. Comedy. I'm not the right shape for tragedy.

[*She hands him the part and shows him the cue, which he ludicrously mispronounces. They go on for a few lines, but she is obviously getting them wrong.*]

Anna. It's no good.
Martins. One of the bad days?
Anna. It's always bad about this time. He used to look in round six. I've been frightened, I've been alone, I've been without friends and money, but I've never known anything like this.

[Anna *plunks herself down on a hard chair opposite him. It is as if she had been fighting for days not to say this, and now surrenders.*]

Anna. Please talk. Tell me about him; tell me about the Harry you knew.

[Martins *takes a long look at her. All the grace she may have had seems to have been folded up with her dresses and put away for professional use. This* Anna *is for everyday. Suddenly it is he who is less willing to talk of Harry.*]

Martins. What kind of things?
Anna. Anything. Just talk. Where did you see him last? When? What did you do?
Martins. We drank too much. We quarreled. I thought he was making a pass at my girl.

Anna. Where's she?

Martins. I don't know. That was nine years ago.

Anna. Tell me more.

Martins. It's difficult. You knew Harry; we didn't do anything terribly amusing—he just made it all seem such fun.

Anna. I know what you mean. Was he clever when he was a boy?

[*He gets up restlessly and looks out of the window.*]

Martins. I suppose so. He could fix anything.

Anna. Tell me.

Martins. Oh, little things—how to put up your temperature before an exam—the best crib—how to avoid this and that.

Anna. He fixed my papers for me. He heard the Russians were repatriating[13] people like me who came from Czechoslovakia. He knew the right man straight away for forging stamps.

Martins. When he was only fourteen, he taught me the three-card trick. That was growing up fast.

Anna. He never grew up. The world grew up round him, that's all—and buried him.

Martins. You'll fall in love again.

[Anna *turns to the sink with the remains of a dinner.*]

Anna. Don't you see I don't want to. I don't ever want to.

[Martins *moving away from the window, passes her and sympathetically scratches the top of her head.*]

Martins. Come out and have a drink.

[Anna *looks quickly up.*]

13. **repatriating** (rē-pā′trē-āt′əng): sending back to the country of one's birth.

Anna. Why did you say that?

Martins. It seemed like a good idea.

Anna. It was just what he used to say.

Martins. Well, I didn't learn that from him.

[*They laugh for a moment.*]

Anna. If we've got to see the porter, we'd better go . . .

[*She picks up her part and starts for the door.*]

Martins. I thought you didn't want . . .

Anna. We're both in it, Harry.

Martins. The name's Holly.

Anna. I'm sorry.

Martins. You needn't be. You might get my name right.

[*In the doorway she turns and speaks with the first real friendliness.*]

Anna. You know, you ought to find yourself a girl.

[*Dissolve.*]

HARRY'S STREET. PART LOCATION (NIGHT):

[*As Anna and Martins walk along the street, lights go on. At the end of the road a group of people are gathered in spite of thin icy rain. The lights are reflected in the puddles. Anna is staring down the road with some uneasiness, trying to make out what is happening.*]

Martins. Isn't that Harry's?

Anna (*She stops altogether*). Let's go away.

Martins. Stay here. I'll see what it's about.

[Martins *walks slowly on alone. It is not a political meeting, for no one is making a speech. Heads turn to watch him come, as though he is somebody ex-*

pected. Martins *reaches the fringe of the little crowd and speaks to a* Man *there.*]

Martins (*trying out some bad German*). Was ist? (*He waves his hand at the crowd.*)
Man. They wait to see him brought out.
Martins. Who?
Man. The porter.
Martins. What's he done?
Man. Nobody knows yet. They can't make their minds up in there—it might be suicide, you see, but why should he have cut his own throat . . .?

[*The small child, called* Hansl, *whom* Martins *saw on his visit to* Harry's *flat, comes up to his informant and pulls at his hand.*]

Hansl. Papa, papa.

[*His face is pinched and blue with cold and more unpleasant than ever.*]

Hansl (*in German*). Papa, I heard the big man say, "Can you tell me what the foreigner looked like?"
Man (*to* Martins). Ha. He had a row with a foreigner, they think he did it . . .
Hansl. Papa, papa.
Man. Ja, Hansl?
Hansl. Wie ich durch's Gitter geschaut habe, hab' ich Blut auf'm Koks gesehen. (When I looked through the grating, I could see some blood on the coke.)
Man (*admiringly to* Martins). What imagination! He thought when he looked through the grating, he could see blood on the coke.

[*The child stares solemnly up at* Martins.]

Hansl. Papa.
Man. Ja, Hansl?

Hansl (*in German*). Das ist der Fremde. (That's the foreigner.)

[*The* Man *gives a big laugh that causes a dozen heads to turn.*]

Man. Listen to him, sir. He thinks you did it because you are a foreigner. There are more foreigners here these days than Viennese.
Hansl. Papa, papa.
Man. Yes, Hansl?

[Hansl *points. A knot of police surrounds the covered stretcher which they lower down the steps. The* Porter's *wife comes out at the tail of the procession; she has a shawl over her head and an old sackcloth coat. Somebody gives her a hand and she looks round with a lost, hopeless gaze at this crowd of strangers. If there are friends there, she does not recognize them, looking from face to face. To avoid her look,* Martins *bends to do up his shoelace, but kneeling there, he finds himself on a level with* Hansl's *scrutinizing gaze. Walking back up the street towards* Anna, Martins *looks behind him once. The child is pulling at his father's hand, and he can see the lips forming round those syllables, "Papa, papa . . ."*]

Martins. The porter's been murdered. Let's get away from here. They're asking about the foreigner who called on him.

[*They hurry away. Unknown to them, they are followed at a distance by little* Hansl, *who drags his father after him.* Anna *and* Martins *walk as naturally as they can, but sometimes hurrying too much, and then slowing too much.*]

Anna. Then what he said was true. There *was* a third man.

[Martins *does not reply. The tram cars flash like icicles at the end of the street.* Martins *turns round*

and sees Hansl *and his father following with a few of the men who were outside the* Porter's *doorway.*]

Martins. Anna. (*He indicates their pursuers.*)
Anna. That child?

[Martins *nods. They hurry round the corner.*]

CINEMA. LOCATION (NIGHT):

[*Outside a cinema a small queue[14] is just moving in.*]

Martins. Come in here.

[Anna *takes money from her bag, and they buy tickets. They go into the dark cinema.*]

CINEMA. INTERIOR. LOCATION (NIGHT):

[*The film which is being shown is a well-known Hope-Crosby-Lamour film with voices dubbed in German. Big laughs come from the audience. Crosby begins to sing in German.*]

Anna. Be careful. The porter knew so little and they murdered him. You know as much . . .
Martins. You can't be careful of someone you don't know.

[*The camera takes in the anonymous, shadowy faces sitting round them.*]

Martins. Go on to the theater. I'd better not come near you again till this is fixed.

[Anna *gets up.*]

Anna. What are you going to do?
Martins (*with harassed bewilderment*). I wish I knew. (*He looks back at the screen.*)

14. **queue** (kyo͞o): a line of people.

Anna. Be sensible. Tell Major Calloway.

[*Dissolve.*]

SACHER'S RECEPTION DESK (NIGHT):

[*A* Man, *with a chauffeur's cap and a shifty expression, is just leaving the desk as* Martins *comes hurriedly in. The* Man *turns and stares at him as he passes.* Martins' *mind is made up.*]

Martins (*to* Porter). Get Major Callaghan on the phone.
Porter. I don't know him, sir.
Martins. Calloway then. I don't care what his name is. Get him quickly. It's urgent.
Porter. Do you know his number, sir?
Martins. Of course, I don't. Is there a car I can use?
Porter. There's one right here for you, sir.
Martins. Fine.

[*He strides out, followed by a sub-porter.*]

SACHER'S HOTEL. LOCATION (NIGHT):

[*The sub-porter opens the door of a car driven by the shifty* Man *in the chauffeur's cap.*]

CAR. BACK PROJECTION (NIGHT):

[*As* Martins *sits down, the car immediately begins to move off.*]

Martins. International Police Headquarters. Major Calloway's Office.

[*The* Man *does not reply and the car gathers speed. It plunges into ill-lit streets.* Martins *peers anxiously out.*]

CAR. STREET. LOCATION (NIGHT):

[*The taxi speeds around a corner—it almost mounts the curb—it is driving to a more deserted part of the city.*]

CAR. BACK PROJECTION (NIGHT):

Martins. Slower. Slower. You don't know where to take me yet. (*The* Driver *pays no attention.*) This isn't the way to the International Police. Where are we going?

[*The* Driver *turns his head and speaks in German, with a malevolent ring.* Martins *makes a joke which sounds hollow to his own ears . . .*]

Martins. Have you got orders to kill me?
Driver. Ich kann nicht Englisch. (I do not speak English.)

CULTURAL CENTER. LOCATION (NIGHT):

[*The car pulls through the open gates of a courtyard and drives around to the rear of a house, stopping with a jerk alongside a big doorway. The* Driver *opens the door.*]

Driver. Bitte. (Please.)
Martins. This isn't police headquarters.
Driver. Bitte.

[*The* Driver *puts his hand into the car to help* Martins *out, and* Martins *shakes it off.*]

Driver. Bitte.

[*The* Driver *turns towards the big doors and starts to push them open.* Martins *edges out of the car and turns to try to escape, but the car blocks his way. The light from the now open doorway falls across him.*]

Voice. Oh, Mr. Martins.

[*He looks up startled.*]

CULTURAL CENTER. HALLWAY (NIGHT):

[*Bright lights shine out.* Martins *sees* Crabbit *advancing through a throng of women.*]

Crabbit. Better late than never. (*He draws* Martins *inside.*)

CULTURAL CENTER. RECEPTION AND ANTE-ROOM (NIGHT):

[*Hemmed in by* Crabbit *and the attendant women,* Martins *is hustled like a Führer[15] through the anteroom which is being used as a cloakroom. His mackintosh is drawn off him as he walks. In the large inner room where the discussion will be held, the uncomfortable chairs are arranged in rows; a buffet has been set up laden with nothing more exhilarating than cocoa; an urn steams; a woman's face is shiny with exertion; and huddled in the background, like faces in a family album, the earnest and dreary features of constant readers.* Martins *looks behind him, but the door has closed. There is no escape.*]

Crabbit. Ladies and Gentlemen, we have with us tonight Mr. Holly Martins, one of the great writers from the other side. Here he is. We've all of us read his books. Wonderful stuff. Literature depends on character—I've read that somewhere—and Mr. Martins' characters—well, there's nothing quite like them, is there? You know what I mean. We ought to give him a great welcome.

[*The faces of the listeners watch with avid expectancy; one figure jumps up to ask a question. Dissolve.*]

POPESCU ON THE TELEPHONE. INTERIOR (NIGHT):

Popescu. . . . Bring the car and anyone else who would like to come. Don't be long . . .

15. **Führer** (fyo͞or′ər): a leader, particularly a tyrant.

[*Dissolve.*]

RECEPTION ROOM (NIGHT):

[*It is some time later and* Martins *already looks harried and confused by the questions.* Crabbit *is worried.*]

Austrian Woman. Do you believe in the stream of consciousness?
Martins (*to* Crabbit). Stream of what?

[Crabbit *gives a gesture of despair. Two ladies leave the audience.*]

Man in Audience. What author has chiefly influenced you?
Martins. Gray.
Lady in Audience. Grey? Which Grey?
Martins. Zane Gray.
Crabbit. That's Mr. Martins' little joke, of course. As we all know perfectly well, Zane Gray wrote what we call "Westerns"—cowboys and baddies.
Another Man. This—er—James Joyce now, where would you put him?

[Popescu *has come in and caught* Martins' *attention.*]

Martins. Would you mind repeating that question?
Man (*viciously*). Where would you put James Joyce—in what category?
Popescu. Can I ask Mr. Martins if he's engaged on a new book?

[Martins *and* Crabbit *look at the doorway.* Popescu *stands there.* Martins *takes him in for a moment of silence. He recognizes the challenge.*]

Martins. Yes . . . yes . . . It's called *The Third Man.*

Woman. A novel, Mr. Martins?
Martins. It's founded on fact. It's a murder story.
Crabbit (*quickly interjects*). I'm so glad you were able to come, Mr. Popescu. (*To* Martins) Mr. Popescu is a very great supporter of one of our medical charities.
Martins. I've just started it.
Popescu. Are you a slow writer, Mr. Martins?
Martins. Pretty quick when I get interested.
Popescu. I'd say you were doing something pretty dangerous this time.
Martins. Yes?
Popescu. Mixing fact and fiction, like oil and water.
Martins. Should I write it as straight fact?
Popescu. Why no, Mr. Martins. I'd say stick to fiction, straight fiction.
Martins. I've gone too far with the book, Mr. Popescu.
Popescu. Haven't you ever scrapped a book, Mr. Martins?
Martins. Never.

[Popescu *gets lazily up from the edge of the buffet. He touches the urn with his finger.*]

Popescu. Pity. (*He goes out.*)
Crabbit (*after everybody has shuffled out in dissatisfaction*). Well, if there are no more questions for Mr. Martins, I think I can call the meeting officially closed.

ANTEROOM (NIGHT):

[Popescu *speaks quietly to two men, and we do not hear what is said, but the three men now stand in the narrow hallway obviously waiting for* Martins *to come down. They look up the stairs towards him.* Martins *looks above him and sees a narrow staircase that leads along a corridor. He makes a dash for this.* Popescu *and the two men have seen him vanish and start up the stairs.*]

CORRIDOR (NIGHT):

[Martins *opens the door at random and shuts it behind him. We can hear the three men go by. The room where he stands is in darkness: a curious moaning sound makes him turn and face whatever room it is. He can see nothing and the sound has stopped. He makes a tiny movement and once more it starts, like an impeded breath. He remains still and the sound dies away. Outside somebody calls.*]

Popescu's Voice. Mr. Martins . . .

[*Then a new sound starts. It is like somebody whispering—a long continuous monologue in the darkness.*]

Martins. Is anybody there?

[*The sound stops again. He can stand no more of it. He takes out his lighter. Footsteps go up and down the stairs. He scrapes and scrapes at his lighter in the dark and something rattles in midair like a chain.*]

Martins (*with the anger of fear*). Is anybody there?

[*He turns the light switch, and the eyes of a parrot chained to a perch stare beadily at him. Somebody turns the handle of the door, and Martins has only just time to turn the key. A hand beats on the door.*

Martins *sees an open window behind the parrot. He tries to avoid the parrot, who snaps at him as he squeezes by and wounds his hand. Martins reaches the window and gets out, just as the door is forced open.*]

EVADING. STREETS. LOCATION (NIGHT):

[*These shots show Martins evading his pursuers. He manages to get to International Police Headquarters over bomb sites.*]

CALLOWAY'S OFFICE (NIGHT):

[Martins *sits gloomily in front of* Calloway. *He has bound up his left hand, where the parrot bit him, with a handkerchief.*]

Calloway (*furiously*). I told you to go away, Martins. This isn't Santa Fe, I'm not a sheriff, and you aren't a cowboy . . . You've been wanted for murder, you've been associating with suspicious characters . . .
Martins. Put down drunk and disorderly too.
Calloway. I have. What's the matter with your hand?
Martins. A parrot bit me.

[Calloway *looks sharply up and then lets it go. He rings a bell.* Paine *enters.*]

Calloway. Give me the Harry Lime file, Paine, and better give Mr. Martins a double whiskey.

[Paine *very efficiently does both.*]

Martins. I don't need your drinks, Callaghan.
Calloway. You will. I don't want another murder in this case, and you were born to be murdered, so you're going to hear the facts.
Martins. You haven't told me a single one yet.
Calloway. You're going to hear plenty now. I suppose you've heard of penicillin.
Martins. Well?
Calloway. In Vienna there hasn't been enough penicillin to go round. So a nice trade started here. Stealing penicillin from the military hospitals, diluting it to make it go further, selling it to patients. Do you see what that means?
Martins. So you're too busy chasing a few tubes of penicillin to investigate a murder.
Calloway. These *were* murders. Men with gangrened legs, women in childbirth. And there were children too. They used some of this di-

luted penicillin against meningitis.[16] The lucky children died, the unlucky ones went off their heads. You can see them now in the mental ward. That was the racket Harry Lime organized.

Martins. Callaghan, you haven't shown me one shred of evidence.

Calloway. We're coming to that. (*He crosses and pulls a curtain over the window.*) A magic lantern show, Paine.

[Paine *fetches a lantern, pulls down a sheet, and turns out the light. While he is doing this,* Calloway *cheerfully changes the subject.*]

Calloway. You know Paine's one of your devoted readers. He's promised to lend me— what is it? *The Lone Rider?*

[Martins *does not reply.*]

Paine. I'd like to see Texas before I die, sir.

[Martins' *nerves give way.*]

Martins. Show me what you've got to show and let me get out.

[Paine *works the slides. The first slide is of a man caught unawares by the camera*—Harbin. *He is talking to some friends.*]

Calloway. See this man here? Fellow called Harbin, a medical orderly at the General Hospital. He worked for Lime and helped to steal the stuff from the laboratory. We forced him to give information, which led us as far as Kurtz and Lime, but we didn't arrest them as our evidence wasn't complete and it might have spoiled our chances of getting the others. Next.

16. **meningitis** (měn´ĭn-jī´tĭs): inflammation of the membranes around the brain and the spinal cord.

Martins. I'd like a word with your agent, Harbin.

Calloway. So would I.

Martins. Bring him in then.

Calloway. I can't. He disappeared a week ago.

Martins. That's convenient. This is more like a mortuary than a Police H.Q.

Calloway. We have better witnesses.

[*Dissolve.*]

MONTAGE (NIGHT):

[*Microscope—fingerprints, threads from coat, files about Lime—still photographs—and* Martins' *reaction to all this. dissolve.*]

CALLOWAY'S OFFICE (NIGHT):

[Calloway *is dropping a pile of photographs on his desk.* Martins *is sunk in a chair. He has nothing, at first, to say; he is convinced.*]

Martins. How could he have done it?

Calloway (*kindly*). You see how it is, Martins. (Martins *gets up and drinks his whiskey.*) Go back to bed, and keep out of trouble. You're all right in the hotel, and I'll try to fix things with the Austrian police, but I can't be responsible for you on the streets.

Martins. I'm not asking you to be.

Calloway. I'm sorry, Martins.

Martins. I'm sorry, too. (*To* Paine) Still got that aeroplane ticket on you?

Calloway. We'll send it to the hotel in the morning.

[*He goes.* Calloway *picks up the receiver.*]

Calloway. Get me the Austrian Police H.Q.

[*While he waits for the call to come through,* Brodsky *enters.*]

Brodsky. Can I have that passport? The Schmidt one?

[*It lies on* Calloway's *desk. He pushes it with a ruler towards* Brodsky.]

Calloway. We're not going to pick her up for that, are we?
Brodsky. We treat these things more seriously, and your colleagues have agreed.

[Brodsky *exits with passport. Dissolve.*]

A CABARET BAR (NIGHT):

[Martins *sits in a sleazy cabaret bar, drinking and watching the floor show. Hostesses watch him, and a waiter brings him another drink. An old flower seller persuades him to buy two huge bunches of chrysanthemums. Dissolve.*]

ANNA'S LANDING (NIGHT):

[*There is a knock at the door and* Anna *stirs.*]

Anna. Who's that?
Martins. It's me.

[*She opens the door.* Martins *removes his hat, still holding the bunches of flowers.*]

The Third Man **719**

Anna. What is it? What happened to you?
Martins. Just came to see you.

ANNA'S ROOM (NIGHT):

Anna. Now, what is it? I thought you were going to keep away. Are the police after you?
Martins. I don't know.
Anna. You're drunk, aren't you?
Martins (*sulkily*). A bit. (*Angrily*) I'm sorry. I did want to say goodbye before I pushed off back home.
Anna. Why?
Martins. It's what you've always wanted, all of you. (*Dangles a string to the cat on the bed.*) Kitty. (*The cat jumps off the bed.*) Not very sociable, is he?
Anna. No, he only likes cats. What made you decide so suddenly?
Martins. I brought you these . . . (*Offers flowers*) They got a little wet, but . . .
Anna. What happened to your hand?
Martins. A parrot . . .
Anna. Have you seen Calloway?
Martins. Imagine a parrot nipping a man.
Anna. Have you?
Martins. Oh . . . I've been saying goodbye all over.
Anna. He told you, didn't he?
Martins. Told me?
Anna. About Harry.
Martins. You know?
Anna. I've seen Major Calloway today.

[*Camera tracks to the window and shows the square outside. He goes to the window, and turns again to her. Over his shoulder we look down into the dark street.*]

ANNA'S STREET. LOCATION (NIGHT):

[*Somebody looks up at the lighted window. The shadow of a bombed building falls across his face so that we cannot see it. He walks towards a door and*

stands in the shadow—we cannot see him—a cat walks across from the other side of the road in his direction—it is mewing.*]

DOORWAY. LOCATION (NIGHT):

[*The cat comes to the man's legs—purring and rubs itself around the bottom of his trouser leg—it is hungry.*]

ANNA'S ROOM (NIGHT):

Anna. He's better dead. I thought perhaps he was mixed up . . . but not that.
Martins (*getting up and walking about*). For twenty years—I knew him—the drinks he liked, the girls he liked. We laughed at the same things. He couldn't bear the color green. But it wasn't true. He never existed, we dreamed him. Was he laughing at fools like us all the time?
Anna (*sadly*). He liked to laugh.
Martins (*bitterly*). Seventy pounds a tube. And he asked me to write about his great medical charity. I suppose he wanted a Press Agent. Maybe I could have raised the price to eighty pounds.
Anna. There are so many things you don't know about a person you love, good things, bad things.
Martins. But to cash in like that . . .
Anna (*angrily*). For heaven's sake, stop making him in *your* image. Harry was real. He wasn't just your friend and my lover. He was Harry.
Martins. Don't talk wisdom at me. You make it sound as if his manners were occasionally bad . . . I don't know . . . I'm just a bad writer who drinks too much and falls in love with girls . . . you.
Anna. Me?
Martins. Don't be such a fool—you know I love you?
Anna. If you'd rung me up and asked me,

were you dark or fair or had a mustache, I wouldn't have known.

Martins. Can't you get him out of your head?

Anna. No.

Martins. I'm leaving Vienna. I don't care if Kurtz killed Harry or Popescu—or the third man. Whoever killed him, it was justice. Maybe I'd have killed him myself.

Anna. A man doesn't alter because you find out more.

Martins. I hate the way you talk. I've got a splitting headache, and you talk and talk . . . You make me cross.

[*Suddenly* Anna *laughs.*]

Anna. You come here at three in the morning—a stranger—and say you love me. Then you get angry and pick a quarrel. What do you expect me to do?

Martins. I haven't seen you laugh before. Do it again. I like it.

Anna (*staring through him*). There isn't enough for two laughs.

[Martins *takes her by the shoulder and shakes her gently.*]

Martins. I'd make comic faces all day long. I'd stand on my head and grin at you between my legs. I'd learn a lot of jokes from the books on After Dinner Speaking . . . I'd . . .

[Anna *stares at him without speaking.*]

Martins (*hopelessly*). You still love Harry, don't you? You told me to find a girl.

[*Dissolve.*]

ANNA'S STREET. LOCATION (NIGHT).

[Martins *walks rapidly away. Passing along the street, he becomes aware of a figure in a doorway on* the opposite side of the street. The whole figure is in darkness except for the points of the shoes. Martins stops and stares and the silent motionless figure in the dark street stares back at him. Martins' nerves are on edge. Is this one of* Calloway's *men, or* Popescu's, *or the Austrian police?*]

Martins. Have you been following me? Who's your boss? (*Still no reply.* Martins *is irascible with drink. He calls out sharply*) What kind of a spy do you think you are, satchel-foot? Can't you answer? (*Chanting childishly*) Come out, come out, whoever you are.

[*A window curtain opposite is drawn back and a sleepy voice shouts angrily to him.*]

Woman. Seien Sie ruhig. Gehen Sie weiter. (Be quiet. Go away.)

[*The light shines across straight on the other man's face.*]

Martins. Harry!

[Martins, *in his amazement, hesitates on the edge of the pavement. The woman has slammed down the window and the figure is again in darkness, except for the shoecaps. Then it begins to emerge, but before* Martins *has a chance of seeing the face again, an International Police car approaches down the street. The figure steps back, and as the car comes between them, the figure makes off in the dark. By the time the car has passed, there is no sign of the stranger— only the sound of footsteps.* Martins *pursues, but the sound dies out. He passes a kiosk[17] and comes out into a fairly well-lighted square which is completely empty. He stands around in bewilderment, unable to decide whether he was drunk or whether he had seen a ghost, or indeed* Harry. *Dissolve.*]

KIOSK SQUARE. LOCATION (NIGHT):

17. **kiosk** (kē-ŏsk′, kē′ŏsk′): a cylindrical structure on which advertisements are posted.

[Calloway *stands looking at the square with Martins and* Paine.]

Martins. You don't believe me . . .
Calloway. No.
Martins. It ran up here and vanished.

[*They stare at the empty moonlit square.* Paine *and* Calloway *exchange glances.*]

Calloway. Where were you when you saw it first?
Martins. Down there—fifty yards away.

[Calloway *turns his back on the square and looks down the street past the kiosk.*]

Calloway. Which side of the road?
Martins. This one. And there aren't any side turnings.

[*They begin to walk down the street.*]

Calloway. Doorways . . .
Martins. But I could hear it running ahead of me.

[*They reach the kiosk.*]

Calloway. And it vanished with a puff of smoke, I suppose, and a clap of . . . (*He breaks off as his eye lights on the kiosk, and he walks across to it, pulls open the door. We see the little curling staircase going down.*) It wasn't the German gin, Paine.

[Calloway *leads the way down, shining a torch ahead.*]

THE SEWERS. LOCATION (NIGHT):

[*A strange world unknown to most of us lies under our feet: a cavernous land of waterfalls and rushing rivers, where tides ebb and flow as in the world above. The main sewer, half as wide as the Thames,*[18] *rushes by under a huge arch, fed by tributary streams: these streams have fallen in waterfalls from higher levels and have been purified in their falls, so that only in these side channels is the air foul. The main stream smells sweet and fresh with a faint tang of ozone, and everywhere in the darkness is the sound of falling and rushing water.*]

Martins. What is it?

[Calloway *without replying moves ahead, across a bridge which spans a waterfall.*]

Paine. It's only the main sewer, sir. Smells sweet, don't it? Runs right into the blue Danube.

[*They come up with* Calloway, *who is leaning over the bridge.*]

Calloway. I've been a fool. We should have dug deeper than a grave.

[*Dissolve.*]

CENTRAL CEMETERY. LOCATION (DAWN):

[*One of the men comes over to* Calloway *and speaks in German.*]

Man. Wir sind jetzt am Sarg. (We've reached the coffin.)
Calloway (*to* Official). Tell them to take off the lid.

[Calloway *and the* Official, *still under the same umbrella, go up to the graveside and stand looking down. The* Official *moves round the side of the grave to examine the body from another angle. He*

18. **Thames** (tĕmz): a river in England that flows past London.

turns across the grave to Calloway *and shrugs his shoulders.* Calloway *takes one look and moves away, passing* Martins. *He nods to* Martins *to take a look.* Martins *reluctantly does so, then quietly joins* Calloway *as they walk away.*]

Official. Did you know him, Colonel?
Calloway. Yes. Joseph Harbin, medical orderly at the 43rd General Hospital. (*To* Junior Officer) Next time we'll have a foolproof coffin.

[*Dissolve.*]

INTERNATIONAL POLICE H.Q. (DAWN):

[*A doorway marked International Police in three languages. Through the door comes* Brodsky *with* Anna's *passport. He crosses over the hallway and out into the yard where the International Police car is waiting. He goes up to the car and the* Russian *member of the patrol gets out and joins him. He speaks to him. Dissolve.*]

ANNA'S STREET. LOCATION (DAWN):

[*The International Police Patrol drives up and, leaving an Austrian policeman in the car, enters the building.*]

STAIRCASE AND LANDING (DAWN):

[*The four men run up the stairs, the* British M.P.[19] *leading. At* Anna's *door, the* British M.P. *tries the handle. The* Russian M.P. *pushing forward, puts his shoulder to it and breaks in.* Anna *has not had time to get out of bed.*]

ANNA'S ROOM (DAWN):

Anna. Was ist es? (What is it?)
Russian M.P. Internationale Polizei. Sie müs-

sen mit uns kommen. (You must come with us.)
Anna (*to the* British *and* American M.P.'s). Have I got to go?
British M.P. Sorry, miss, it's orders.
Russian M.P. (*in bad German*). These your papers? Your papers?

[*He shows* Anna's *passport.* Anna *looks at them and up to the four men, realizing there is nothing she can do.* Anna *leaves the room to dress.*]

ANNA'S LANDING (DAWN):

[*The* British M.P. *stands by the wall, yawning. The* Woman *who owns the house comes up and speaks to him in German.*]

Woman (*in German*). This happens every day. I am getting tired of the police.

[*He does not understand a word and to escape from her goes back into the room.*]

ANNA'S ROOM (DAWN):

[Anna *has finished dressing as the* British M.P. *enters.*]

Anna. Where are you taking me?
American M.P. International Police Headquarters for a checkup. The Russkies are claiming the body.
Anna. Body?
American M.P. Just an expression.

[*The* Russian M.P. *listens suspiciously to their conversation.*]

British M.P. It's the law, miss. We can't go against the protocol.[20]

20. **protocol** (prō′tə-kôl, -kōl′, -kŏl′): correct and proper procedures according to diplomats or officials.

19. **M.P.:** military police.

Anna. I don't even know what protocol means.
British M.P. I don't either, miss.
Russian M.P. Wir müssen gehen. (*We must go.*)

[*Anna picks up her bag. The Russian M.P. takes it away from her and looks rapidly through the contents, and then hands it back.*]

HALL. INTERNATIONAL POLICE H.Q. (DAWN):

[*Martins is by the stairs when the International Patrol brings Anna in.*]

Martins (*with astonishment*). Anna.
American M.P. You can't talk to the prisoner, son.
Martins. Why are you here? (*Anna shrugs her shoulders.*) I've got to talk to you. I've just seen a dead man walking.

[*Anna looks up sharply. They begin to move up the stairs and Martins follows.*]

Martins. I saw him buried, and now I've seen him alive.
American M.P. Please, Jock . . . I don't want no trouble with you . . .

[*Anna looks at Martins with excitement. She cannot bring herself to believe him.*]

Anna. You're drunk?
Martins. No.

[*They come to the head of the stairs. Calloway is about to enter his office—he sees the group who are about to pass on.*]

Calloway. One moment . . . Bring the prisoner in here.

[*He motions to the patrol to wait outside. The* British

M.P. *jerks his hand for* Anna *to enter and* Martins *tries to follow.*]

American M.P. Not you.

[*He pushes him away and the door is slammed on him.*]

CALLOWAY'S OFFICE (DAY):

[*Anna is brought in.* Paine *is in the office.*]

Calloway. Sit down, Miss Schmidt. The Russians have asked for you, but I'm not interested in your forged papers.

[*She sits down. She is strung up with excitement at what she has heard from* Martins. *She is waiting to have her hopes confirmed or darkened.*]

Calloway. When did you last see Lime?
Anna. Two weeks ago. (*She waits hungrily for his next question.*)
Calloway. We want the truth, Miss Schmidt . . . We know he's alive.
Anna (*with excitement and joy*). It *is* true, then?
Calloway. The body of another man, Joseph Harbin, was found in the coffin.

[*Anna cannot attend to anything but this news.*]

Anna. What did you say? I didn't hear you. I'm sorry.
Calloway. I said another man was buried in his place.
Anna. Another man? Oh, yes . . . where's Harry?
Calloway. That's what we want to find out.
Anna. I'm sorry. I don't seem able to understand anything you say. But nothing matters now. He's alive.
Calloway. We are pretty sure, Miss Schmidt, that he's somewhere in the Russian sector,

across the canal. Sooner or later we'll get him, even if the Russians don't cooperate. You may as well help us.

Anna. Help you? Why?

Calloway. The next man you have to deal with is Colonel Brodsky. Tell me where Lime is?

Anna. I don't know . . .

Calloway. If you help us, we are prepared to help you.

Anna. Martins always said you were a fool.

Calloway. Miss Schmidt, Vienna is a closed city. A rat would have more chance in a closed room without a hole and a pack of terriers loose.

Anna. Poor Harry. (*All her joy has gone now.*) I wish he *was* dead. He'd be safe from all of you then.

Calloway. Better think about it. (*He goes to the door and out.*)

[*Dissolve.*]

THE STREET OUTSIDE KURTZ'S HOUSE (DAY):

[Martins *comes across the courtyard to the house and rings the doorbell.* Kurtz *comes onto the balcony in his dressing gown.*]

Kurtz. Why, that's you! Come up! . . . Winkel, look who's here.

[Winkel *comes out and joins him on the balcony.*]

Martins. I want to speak to you, Kurtz.

Kurtz. Of course . . . Come up.

Martins. I'll wait here.

Kurtz. I don't understand . . .

Martins. I want to talk to Harry, Kurtz.

Kurtz. Are you mad?

Martins. I've seen a ghost. But you tell Harry I want to see him.

Kurtz. Be reasonable. Come up and talk.

Martins. I like the open. Tell him I'll wait by the Wheel for an hour. Or do ghosts only rise by night? Have you an opinion on that, Dr. Winkel?

[Dr. Winkel *takes out his handkerchief and blows his nose.* Martins *walks away toward the Great Wheel. Dissolve.*]

THE GREAT WHEEL. PART LOCATION (DAY):

[*The Wheel on this cold autumn day is not popular, and the Prater[21] itself has not recovered sufficiently from the shelling and bombing to attract crowds. A wrecked pleasure place, weeds growing up round the foundations of merry-go-rounds. In the enclosure one stall is selling big thin flat cakes like cartwheels, and the children queue with coupons. A few courting couples wait and wait on the platform of the wheel, and then are packed into a single car and revolve slowly above the city with empty cars above and below them. As the loaded car reaches the highest point of the Wheel, the machinery stops for a couple of minutes and leaves them suspended. Looking up,* Martins *can see the tiny faces pressed like flies against a glass. He walks up and down to keep warm. He looks at his watch. The time is nearly up. Somewhere behind the cake stall, someone is whistling.* Martins *turns quickly. He watches for him to come into sight with fear and excitement. Life to* Martins *has always quickened when* Harry *came, as he comes now, as though nothing much has really happened: with an amused geniality, a recognition that his happiness will make the world's day. Only sometimes the cheerfulness will be suddenly clouded; a melancholy beats through his guard; a memory that this life does not go on. Now he does not make the mistake of offering a hand that might be rejected, but instead just pats* Martins *on his bandaged hand.*]

Harry. How are things? They seem to have been messing you about a bit.

21. **Prater:** a long park along the Danube.

Martins. We've got to talk, Harry.

Harry. Of course, old man. This way.

[*He walks straight on towards the platform in the absolute confidence that* Martins *will follow.*]

Martins. Alone.

[*The Wheel has come round again and one lot of passengers is getting out on the opposite platform as another enters the same car from their platform. Harry has always known the ropes everywhere, so now he speaks apart to the* Portress *and money passes. The car with the passengers moves slowly up, an empty car passes, and then the Wheel stops long enough for them to get into the third car, which they have to themselves.*]

GREAT WHEEL. BACK PROJECTION (DAY):

Harry. We couldn't be more alone. Lovers used to do this in the old days, but they haven't the money to spare, poor devils, now.

TOP SHOT FROM GREAT WHEEL (DAY):

[*He looks out of the window of the swaying, rising car at the figures diminishing below them with what looks like genuine commiseration. Very slowly, on one side of them, the city sinks: very slowly on the other, the great cross girders of the Wheel rise into sight. As the horizon slides away, the Danube becomes visible, and the piers of the Reichsbrücke lift above the houses.*]

GREAT WHEEL. BACK PROJECTION (DAY):

[Harry *turns from the window.*]

Harry. It's good to see you, Holly.

Martins. I was at your funeral.

Harry. That was pretty smart, wasn't it?

Martins. You know what's happened to Anna? They've arrested her.

Harry. Tough, very tough, but don't worry, old man. They won't hurt her.

Martins. They are handing her to the Russians. Can't you help her?

Harry (*unconvincingly*). What can I do, old man? I'm dead—aren't I? Who have you told about me?

Martins. The police—and Anna.

Harry. Unwise, Holly, unwise. Did they believe you?

Martins. You don't care a damn about her, do you?

Harry. I've got a lot on my mind.

Martins. You won't do a thing to help her?

Harry. What can I do, Holly? Be reasonable. Give myself up? This is a far far better thing. The old limelight and the fall of the curtain. We aren't heroes, Holly, you and I. The world doesn't make heroes outside your books.

Martins. You have your contacts.

Harry. I've got to be so careful. These Russians, Holly,—well, I'm safe so long as I have my uses.

Martins (*with sudden realization*). You informed on her.

Harry (*with a smile*). Don't become a policeman, old man.

Martins. I didn't believe the police when they told me about you. Were you going to cut me in on the spoils?

Harry. I've never kept you out of anything, old man, yet.

[Harry *stands with his back to the door as the car swings upward and smiles back at* Martins.]

Martins. I remember that time at the Club "The 43," when the police raided it. You'd learned a safe way out. Absolutely safe for you. It wasn't safe for me.

Harry. You should never have gone to the police, you know. You should have left this thing alone.

Martins. You've never grown up, Harry.

Harry. Well, we shall be old for a very long time.

Martins. Have you ever seen any of your victims?

[Harry *takes a look at the toy landscape below and comes away from the door.*]

Harry. I never feel quite safe in these things. (*He feels the door with his hands.*) Victims? Don't be melodramatic. Look down there.

TOP SHOT FROM GREAT WHEEL. LOCATION (DAY):

[*He points through the window at the people moving like black flies at the base of the Wheel.*]

GREAT WHEEL. BACK PROJECTION (DAY):

Harry. Would you really feel any pity if one of those dots stopped moving forever? If I said you can have twenty thousand pounds for every dot that stops, would you really, old man,

tell me to keep my money—or would you calculate how many dots you could afford to spare? Free of income tax, old man. Free of income tax. (*He gives his boyish, conspiratorial smile.*) It's the only way to save nowadays.

Martins. You're finished now. The police know everything.

Harry. But they can't catch me, Holly. They can't come in the Russian Zone.

[*The car swings to a standstill at the highest point of the curve.*]

Martins (*looking out of the window*). I should be pretty easy to get rid of.

Harry. Pretty easy.

Martins. Don't be too sure.

Harry. I carry a gun. You don't think they'd look for a bullet wound after you hit *that* ground.

Martins. They dug up your coffin.

Harry. Found Harbin? Pity.

[*Again the car begins to move, sailing slowly down, until the flies are midgets, are recognizable human beings.*]

Harry. What fools we are, Holly, talking like this, as if I'd do that to you—or you to me. (*Deliberately he turns his back and leans his face against the glass.*) In these days, old man, nobody thinks in terms of human beings. Governments don't so why should we? They talk of the people and the proletariat, and I talk of the mugs. It's the same thing. They have their five year plans and so have I.

Martins. You used to believe in a God.

[*That shade of melancholy crosses Harry's face.*]

Harry. Oh, I still *believe,* old man. In God and Mercy and all that. The dead are happier dead. They don't miss much here, poor devils.

[*As he speaks the last words with the odd touch of genuine pity, the car reaches the platform and the faces of the doomed-to-be victims peer in at them.*]

Martins. What do you believe in?

Harry. If you ever get Anna out of this mess, be kind to her. You'll find she's worth it. I wish I'd asked you to bring some of those tablets.

[*They get off the Wheel.*]

Harry. I'd like to cut you in, you know. We always did things together, Holly. I've no one left in Vienna I can really trust. When you make up your mind, send me a message—I'll meet you any place, any time, and when we do meet, old man, it's you I want to see, not the police . . . and don't be so gloomy . . . After all, it's not that awful—you know what the fellow said—In Italy for thirty years under the Borgias they had warfare, terror, murder, bloodshed—they produced Michelangelo, Leonardo da Vinci and the Renaissance. In Switzerland they had brotherly love, five hundred years of democracy and peace, and what did that produce . . .? The cuckoo clock. So long, Holly.

[*Dissolve.*]

CALLOWAY'S OFFICE (DAY):

[Calloway *is standing with his back to* Martins *studying a map of Vienna.*]

Calloway. Look here, Martins, you can always arrange to meet him in some little café . . . Say here, . . . (*pointing at the map*) . . . in the International Zone.

Martins. It wouldn't work.

Calloway. We'll never get him in the Russian Zone.

Martins. You expect too much, Callaghan. Oh, I know he deserves to hang. You've proved

your stuff. But twenty years is a long time. Don't ask me to tie the rope.
Calloway. Okay, forget it.

[Martins *moves up and down as he speaks. The door opens and* Colonel Brodsky *enters.*]

Calloway. Evening, Brodsky. Anything I can do?
Brodsky. We've identified the girl.
Calloway. I've questioned her. We've got nothing against her.
Brodsky. We shall apply for her at the Four Power meeting tomorrow. This is her report.

[*During their talk we watch* Martins' *reactions.*]

Calloway. I've asked your people to help with Lime.
Brodsky. This is a different case. It is being looked into. She has no right to be here.

[*As he goes he drops* Anna's *passport on* Calloway's *desk and smiles.*]

Calloway. In the last war a general would hang his opponent's picture on the wall. He got to know him that way. I'm beginning to know Lime, and I think this would have worked. With your help.
Martins. What price would you pay?
Calloway. Name it.

[*Dissolve.*]

VIENNA RAILWAY STATION BUFFET. BACK PROJECTION (NIGHT):

[*A clock shows 8:15* P.M. *Atmosphere and description must be left for location.* Martins *begins by standing at the station barrier. He moves to the buffet to avoid* Anna *and* Paine, *who sees her onto the train, and finds a compartment for her.*]

Paine. Here we are, you'll be all right here, miss.
Anna. I'm afraid I don't understand Major Calloway.
Paine. I expect he's got a soft spot for you, miss.
Anna. Why has he done it?
Paine. Don't you worry, miss, you're well out of things. There we are, miss.
Anna. Thank you, you've been so kind.
Paine. Well, I'll be saying good night.

[Paine *leaves, while* Anna *inspects her ticket and papers. She looks out of the train window, sees* Martins *in the buffet, and gets off the train to accost him there.*]

Anna. Are you going too?
Martins. I wanted to see you safely off. (*Defiantly*) There's no harm in that, is there?
Anna. How did you know I'd be here?

[Martins *sees he has made a mistake and becomes evasive.*]

Martins. Oh, I heard something about it at Police H.Q.
Anna. Have you been seeing Major Calloway?
Martins. No. I don't live in his pocket.
Anna. Harry, what is it?
Martins. For heaven's sake, don't call me Harry again.
Anna. I'm sorry.
Loudspeaker. Passengers for Klagenfurt[22] take their seats, please.

[*The loudspeaker repeats it in French, German and Russian, while the dialogue goes on.*]

Martins. It's time to be off, Anna.
Anna. What's on your mind, Holly? Why did you avoid me just now?

22. **Klagenfurt** (kläg′ən-fûrt): an Austrian city near the Yugoslav border.

Martins. I didn't see you. Anna, you *must* come along.

[*He urges her through the buffet door.*]

RAILWAY PLATFORM. BACK PROJECTION (NIGHT):

[*Reluctantly, scenting a mystery,* Anna *follows* Martins *towards the train.*]

Martins. Only six hours. It's going to be cold. Take my coat.
Anna. I shall be all right.

[Martins *begins to take off his coat.*]

Martins. Send me a wire from Klagenfurt when you are safe.
Anna. Are you staying in Vienna?
Martins (*evasively*). A day or two. (*He puts his coat round* Anna *and opens a compartment door.*) Jump in, my dear.
Anna. What's going to happen? Where is he?
Martins. Safe in the Russian Zone. I saw him today.
Anna. You saw him?
Martins. Oh yes, we talked and he laughed a lot. Like the old days.
Anna. How is he?
Martins. He can look after himself. Don't worry.
Anna. Did he say anything about me?
Martins. Oh, the usual things.
Anna. What?
Martins. Goodbye, Anna.
Anna. I don't want to go.
Martins. You must.
Anna. There's something wrong. Did you tell Calloway about your meeting?
Martins. No. Of course not.
Anna. Why should Calloway be helping me like this? The Russians will make trouble.

Martins. That's his headache. We're getting you out of here.
Anna. I'm not going.
Martins. You must. (*He puts his hand on her arm as though to force her into the carriage.*) Anna, don't you recognize a good turn when you see one?
Anna. You have seen Calloway. What are you two doing?
Martins (*angrily, his nerves breaking*). They want me to help take him.
Anna. Poor Harry.
Martins. Poor Harry? Poor Harry wouldn't even lift a finger to help you.
Anna. Oh, you've got your precious honesty, and don't want anything else.
Martins (*fiercely*). I suppose you still want him.
Anna. I don't want him any more. I don't want to see him, hear him. But he's in me—that's a fact. I wouldn't do a thing to harm him.
Martins. Oh, Anna, why do we always have to quarrel?

[*The train pulls out past the buffet window.*]

Anna. If you want to sell yourself, I'm not willing to be the price.

[*She takes the ticket and her papers and tears them into scraps.* Martins *watches her with gloomy acquiescence.*]

Anna. I loved him. You loved him, and what good have we done him? Oh love! Look at yourself in the window—they have a name for faces like that . . .

[Anna *leaves the buffet, and* Martins *stares at the swinging door, while his coat lies discarded on the floor.*]

CALLOWAY'S OFFICE (NIGHT):

[Calloway *and* Martins *together.* Calloway *stands with his back to* Martins *and his eyes on the map of Vienna.*]

Martins. I want to catch the first plane out of here.
Calloway. So she talked you round?
Martins (*holding out the scraps of paper*). She gave me these.
Calloway (*sourly*). A girl of spirit.
Martins. She's right. It's none of my business.
Calloway. It won't make any difference in the long run. I shall get him.
Martins. I won't have helped.
Calloway. That will be a fine boast to make. (*He puts his finger on the map as though he is still planning* Lime's *capture. Then he shrugs and turns to* Martins.) Oh, well, I always wanted you to catch that plane, didn't I?
Martins. You all did.
Calloway (*going to the telephone*). I'd better see if anyone's at the terminus still. You may need a priority.

[*Dissolve.*]

CALLOWAY'S CAR. BACK PROJECTION (NIGHT):

[Paine *is driving.* Calloway *is sitting in silence,* Martins *beside him.*]

Calloway. Mind if I drop off somewhere on the way? I've got an appointment. Won't take five minutes.

[Martins *nods. They draw up outside a large public building.*]

Calloway. Why don't you come in too! You're a writer: it should interest you.

[*Dissolve.*]

CHILDREN'S HOSPITAL (NIGHT):

[*As they come through the doors, a* Nurse *passes and* Martins *realizes he has been* shanghaied,[23] *but it is too late to do anything.*]

CHILDREN'S WARD (NIGHT):

[*He pushes open a door and, with a friendly hand, propels* Martins *down the ward, talking as he goes in a cheerful, professional, apparently heartless way. We take a rapid view of the six small beds, but we do not see the occupants, only the effect of horror on* Martins' *face.*]

Calloway. This is the biggest children's hospital in Vienna. All the kids in here are the results of Lime's penicillin racket . . .

[*He and* Martins *inspect the beds.* Martins' *face is full of anxiety and compassion, as* Calloway *indicates a particular child's bed.*]

Calloway (*offhandedly*). Had meningitis . . . Gave it some of Lime's penicillin. Awful pity, isn't it?

[*As they continue their walk past the small beds, dissolve.*]

CALLOWAY'S CAR. BACK PROJECTION (NIGHT):

[*They are driving together again in* Calloway's *car.* Martins *is not speaking.*]

Calloway. For a good read I like a Western. Paine's lent me several of your books. *The Lone Rider* seemed a bit drawn out—you don't mind my talking frankly, do you? But I thought the plot of *Dead Man's Ranch* was pretty good. You certainly know how to tell an exciting story.
Martins (*sullenly*). All right, Callaghan, you win.

23. **shanghaied** (shăng-hīd′): here, compelled or persuaded to do something through trickery.

Calloway. I didn't know they had snake charmers in Texas.
Martins. I said you win.
Calloway. Win what?
Martins. I'll be your dumb decoy duck.

[*Dissolve.*]

CAFÉ (NIGHT):

[*A thin drizzling rain falls and the windows of the café continually cloud with steam. Martins sits gloomily, drinking cup after cup of coffee, and the clock in the café points to a quarter past midnight. There are only two other people in the café. Once, as somebody opens the door of the café, we see Martins put a hand to his pocket and we are aware that he has a revolver there.*]

CAFÉ STREET. LOCATION (NIGHT):

[*Outside the café preparations are being made for Harry's capture; the kiosk and the empty rain-wet street, and then at discreet intervals, well away from the scene, groups of Police.*]

SQUARE (WITH MANHOLE IN DISTANCE). LOCATION (NIGHT):

[*Last, under the trees of a square, sheltering as well as they can from the rain, Calloway, Paine, and a group of Sewer Police; men with peaked caps, rather like lumberjacks, with big thigh-length boots; one man has a small searchlight hung on his chest; all carry revolvers. A manhole in the square is ready open.*

A huge shadow looms against a house front near the café. Paine, Calloway, and the soldiers stiffen and signal to each other. An aged Balloon-Seller shuffles into shot. While they are distracted, Anna dives into the café.]

Paine. Look sir!

CAFÉ (NIGHT):

Anna (*sits down. To* Martins). How much longer are you going to sit here?

CAFÉ SQUARE (NIGHT):

[*Return to the waiting men.*]

Paine. Shall I go over there, sir?
Calloway. No, leave them for a while.

[*The* Balloon-Seller *shuffles and sways towards* Calloway *and* Paine, *who try to sink into the shadows. But the old man pesters them until* Paine *rapidly makes a purchase to get him out of the way.*]

ROOFTOP. LOCATION (NIGHT):

[*We see* Harry *beside a chimney stack, silhouetted by bombed ruins against the sky, looking grimly down. From this angle, the square seems deserted. Then he turns and watches the window of the café.*]

CAFÉ (NIGHT):

Martins. You should have gone. How did you know I was here, anyway?
Anna. From Kurtz. They've just been arrested . . . But Harry won't come. He's not a fool.
Martins. I wonder.

CAFÉ SQUARE (NIGHT):

[*The* Policemen *wait.*]

Calloway. Yes, Paine, slip across and see what she's up to.

[Paine *leaves.*]

CAFÉ (NIGHT):

[Anna *is speaking bitterly to* Martins.]

Anna. What's your price this time?

[*The back door of the café opens.*]

Martins. No price, Anna.
Anna. Honest, sensible, sober Holly Martins. Holly, what a silly name. You must feel very proud to be a police informer.

[Harry *has entered quietly, overhears the word* informer, *and frowns.* Anna *turns away from Martins and catches sight of* Harry.]

Anna. Harry, get away, the police are outside!

[Harry, *drawing his gun, signals* Anna *out of the line of fire between himself and* Martins, *but* Paine *is already making for the main door, so* Harry *dashes out of the back door.*]

THE RUINS OF VIENNA (NIGHT):

[Harry *runs across bomb sites, as the chase is raised with shrill whistles and shouts. Dogs bark and sirens hoot.*]

A SQUARE (NIGHT):

[Harry *clatters across a square to an open manhole and leaps in.* Paine, Calloway, Martins *and the* Policeman *quickly catch up. The party begin to file down the manhole.*]

WINDING IRON STAIRCASE FROM THE KIOSK. LOCATION (NIGHT):

[Paine *goes first, shining a torch, and* Martins *follows.*]

MANHOLES ON THE RIM OF THE CITY. LOCATION (NIGHT):

[*The* Police *pour down every available manhole.*]

THE SEWERS (NIGHT):

[*The* Police *search, watch and shout in the echoing tunnels. They spot the fleeing* Harry *several times. Various shots of* Harry *hiding on a gallery. Other shots of him hiding as the* Police *pass.*]

THE SEWERS. LOCATION (NIGHT):

[*It is just past high tide when* Martins *and* Paine *reach the river; first the curving iron staircase, then a short passage so low they have to stoop, and then the shallow edge of the water laps at their feet.* Paine *shines his torch along the edge of the current.*]

Martins. Harry.

[*The name sets up an echo,* "Harry, Harry, Harry," *that travels down the stream and wakes a whole chorus of whistles in the darkness. He calls again.*]

Martins. Harry. Come out. It's no use.

[*A voice startlingly close makes them hug the wall.*]

Harry's Voice (*off*). Is that you, old man? What do you want me to do?
Martins. Come out. And put your hands above your head.

[Paine *dashes out to warn* Martins.]

Paine. Get back, get back, sir!

[Paine *is standing right in the middle of the tunnel and does not realize where* Harry *is hiding.* Harry *shoots him down. The shot echoes round and round as* Paine *subsides onto the cobbles.* Calloway *strides out of the shadows and shoots* Harry, *as the latter makes another break.* Harry *falls, and scrambles away.*

Martins *is wading upstream to find* Harry. *He is afraid to lift the torch. He does not want to tempt*

The Third Man **735**

him to shoot again. Harry *scrambles with difficulty out of the water, falls on his knees, and begins to crawl up a side passage. He reaches the foot of the iron stairs. Thirty feet above his head is a manhole, but he would not have the strength to lift it, and even if he succeeded the police are waiting above. He knows all that, but he is in great pain, and cannot think rationally. He begins to pull himself up the stairs, but then the pain takes him and he cannot go on.* Martins *wades through the dark.*]

A GRILL AT STREET LEVEL (NIGHT):

[*The wounded* Harry *reaches a grill at street level. His fingers clutch and claw at the heavy grating, unable to move it.*]

THE SEWERS (NIGHT):

[Martins *follows* Harry *up to the foot of the iron stairway and sees him struggling with the grill.* Harry *is in great pain and fear.*

Calloway *and his men reach the end of the passage behind the searchlight. They hear a shot and halt, turning on the light.* Martins *comes out into the beams with hanging head. Dissolve.*]

THE CENTRAL CEMETERY. LOCATION (DAY):

[*The coffin of* Harry Lime *is being lowered into the grave, just as in the first sequence except that now only three figures stand around the grave:* Anna, Martins, Calloway. *But* Kurtz *and* Popescu *are missing.*]

Priest. *Anima ejus, et animae omnium fidelium defunctorum, per misericordiam Dei requiescant in pace.*
Anna. Amen.

[*The* Priest, *again as in the previous sequence, takes a spoon of earth and drops it onto the coffin. He hands the spoon to* Martins *who does the same. This*

time Anna *takes it, and she drops the earth too. Then, as before, she walks away without a word.* Martins *and* Calloway *walk together in silence towards the jeep, down one of the long avenues.*]

Calloway. What time do you make it?
Martins. Three-thirty.
Calloway. We'll have to step on it, if you're going to catch that plane.
Martins. A man's not dead because you put him underground.

[*We watch the worried reaction on* Calloway's *face. He glances over his shoulder towards the grave, remembering only too well that the first time* Harry Lime *was not dead. They reach the car and climb in. There is no* Paine *to drive them now.* Calloway *takes the wheel.*]

CAR. BACK PROJECTION (DAY):

[Calloway *pushes at the starter.* Martins *is looking ahead down the road towards the receding figure of* Anna.]

Martins. What about Anna, Calloway?
Calloway. I'll do what I can—if she'll let me.

[*They drive out of the cemetery. This time it is* Martins *who looks out at* Anna.]

CEMETERY STREET. LOCATION (DAY):

[Anna *is on her way to the tram stop, walking down the long dreary road.*]

CAR. BACK PROJECTION (DAY):

Martins. Put me down a moment, Calloway.
Calloway. There's not much time.
Martins. I can't just leave . . .

[Calloway *slows the car and brings it to a stop.*]

CEMETERY STREET. LOCATION (DAY):

Calloway. Be sensible, Martins.
Martins (*as he stands beside the jeep*). I haven't got a sensible name . . . Callaghan.

[*He begins to walk down the road.* Calloway *turns and watches.* Anna *is approaching.* Martins *stops and waits for her. She pays no attention, walking right past him and on into the distance.* Martins *follows her with his eyes.*]

The End

The Third Man **737**

Reading Check

1. Why does Holly Martins come to Vienna?
2. Where does he first see Anna Schmidt?
3. What kind of books does Martins write?
4. How is Martins able to stay in Vienna although he has no money?
5. According to the Porter, who was with Harry Lime at the time of his accident?
6. Why does Calloway take Anna's papers?
7. According to Calloway, who was Lime's accomplice in stealing penicillin from military hospitals?
8. How does Lime make his escape when Martins catches sight of him in the doorway?
9. Why is Lime confident that he is safe from the police?
10. Why does Martins agree to help Calloway trap Lime?

For Study and Discussion

Analyzing and Interpreting the Play

Plot

1a. What does the title, *The Third Man,* refer to? **b.** At what point in the drama does the existence of a "third man" become known? **c.** Judging from the outcome of events, who must have been the third man?

2a. How is Holly Martins instrumental in exposing Harry Lime's plan to deceive the police? **b.** How does he help to trap Harry?

3. Along with the main plot, which deals with Harry Lime, there is a subplot dealing with Anna Schmidt. **a.** At what point or points in the drama do Anna's actions affect the main plot? **b.** Where does she almost succeed in interfering with the pursuit of Harry?

Character

4. Holly Martins is a finely realized, complex character who defies easy classification. **a.** Where does he show himself to be inept or meddlesome? **b.** What admirable traits does he possess? **c.** What impression are you left with of his character?

5. There are two **foils,** or dramatic contrasts, to Martins in the characters of Major Calloway and Harry Lime. In what way does Calloway offer a contrast to Martins?

6. Although Harry Lime appears in only a few scenes, his presence is felt throughout the film in his influence upon others. Before we actually meet him, we get to know him through the comments of other characters. **a.** How is he perceived by Holly Martins? **b.** By Anna Schmidt? **c.** By Major Calloway?

7a. What is Harry Lime's attitude toward his own crimes? **b.** Despite his corrupt nature, how does he manage to exert charm? **c.** Why does his charm make him even more dangerous?

8. Even after Anna learns what Harry has done, she is unwavering in her love and devotion to him. Do you find her behavior and attitudes credible? Explain.

Setting

9. The action is set in postwar Vienna, and most of the scenes take place at night amid stark buildings and reminders of the devastation of war. **a.** How is this setting appropriate to the story? **b.** Why is the sewer system a fitting setting for the climactic scenes?

10. One of the key scenes takes place when Martins and Lime ride to the top of the Great Wheel. **a.** How is this setting used dramati-

cally to reveal the corruption in Lime's character? **b.** How is the relationship between the two men altered irrevocably by the events of that ride?

Theme

11. *The Third Man* deals with the tragic consequences of greed and corruption in the postwar world. But as Holly Martins' story, it tells of the loss of a certain kind of innocence. **a.** How are his memories of the friendship with Harry tarnished by his insight into Harry's character? **b.** How is he made to betray his old friend?

12. At Harry's real funeral, Martins comments, "A man's not dead because you put him underground." In what ways is Harry Lime and what he meant to other characters still alive?

Writing About Literature

Analyzing Character

In much of modern literature the central character does not possess the stature of a traditional hero. That is, the individual is not dignified, noble, or virtuous, but is often a failure. Such a character is called an **antihero.**

Consider the character of Holly Martins. In what way is he the antithesis, or opposite, of a traditional hero? If you wish, compare him with a traditional heroic figure such as Brutus in *Julius Caesar.*

About the Authors

Graham Greene (1904–1991)

Graham Greene was born in Hertfordshire, England. After graduating from Oxford University, he worked as a journalist and then as a film critic before devoting himself to his own writing projects. An avid traveler, Greene believed: "What one reads doesn't influence one as much as where one is." Greene's novels take place in many lands, from West Africa to Vietnam. Politics and religion are themes that run through much of his work. In addition to twenty-four novels, Greene wrote plays, essays, short stories, and an autobiography. Though many of his stories were adapted into movies, Greene believed that the films rarely preserved the qualities of the original novels. Among his most popular books are *The Power and the Glory* (1940), *The Heart of the Matter* (1948), and *The Quiet American* (1956).

Carol Reed (1906–1976)

The family of Carol Reed sent him to King's School at Canterbury and expected him to become a farmer, but after six months on an American chicken farm, he returned to England determined to become an actor. After several minor roles, Reed became a stage manager and then a director. He directed many films in the thirties and forties, including *Odd Man Out* (1947), *The Fallen Idol* (1948), and *The Third Man* (1949)—all three based on material written by Graham Greene. Later Reed directed *Trapeze* (1956) and *The Agony and the Ecstasy* (1965). He won an Academy Award as best director for the musical *Oliver!* in 1962.

The Third Man **739**

DISTINGUISHING FACT FROM OPINION

*I*f you are reading or writing persuasion, it is important to distinguish fact from opinion. Facts are statements that can be verified as true or false. Opinions are beliefs or attitudes that vary from person to person.

Persuasive writers usually mingle facts with opinions. Whether persuasion takes the form of an editorial, an advertisement, a campaign speech, or an essay, a writer's opinion derives its force from the facts, examples, and arguments that support it.

Read the following excerpt from an essay by Roger Angell. After you have finished, respond to the exercise that follows.

On the Ball

It weighs just over five ounces and measures between 2.86 and 2.94 inches in diameter. It is made of a composition-cork nucleus encased in two thin layers of rubber, one black and one red, surrounded by 121 yards of tightly wrapped blue-gray wool yarn, 45 yards of white wool yarn, 53 more yards of blue-gray wool yarn, 150 yards of fine cotton yarn, a coat of rubber cement, and a cowhide (formerly horsehide) exterior, which is held together with 216 slightly raised red cotton stitches. . . . Baseballs are assembled and hand-stitched in Taiwan (before this year the work was done in Haiti, and before 1973 in Chicopee, Massachusetts), and contemporary pitchers claim that there is a tangible variation in the size and feel of the balls that now come into play in a single game; a true peewee is treasured by hurlers, and its departure from the premises, by fair means or foul, is secretly mourned. But never mind: any baseball is beautiful. No other small package comes as close to the ideal in design and utility. It is a perfect object for a man's hand. Pick it up and it instantly suggests its purpose; it is meant to be thrown a considerable distance—thrown hard and with precision. Its feel and heft are the beginning of the sport's critical dimensions; if it were a fraction of an inch larger or smaller, a few centigrams heavier or lighter, the game of baseball would be utterly different. Hold a baseball in your hand. . . . Feel the ball, turn it over in your hand; hold it across the seam or the other way, with the seam just to the side of your middle finger. Speculation stirs. You want to go outdoors and throw this spare and sensual object to somebody, or, at the very least, watch somebody else throw it. The game has begun.

Distinguishing Fact from Opinion

- Get together with a small group of classmates. Make a chart of facts and opinions in this essay. Then sum up the essay's main idea in a sentence or two.

WRITING A PERSUASIVE ESSAY

*I*n **persuasive writing** you state your opinion about a topic and then support this point of view as convincingly as you can. You may use reasons and evidence, as well as emotional appeals, to win your audience over. Persuasive writing appears in many contexts: advertisements, political speeches, letters to the editor, editorials, and opinion columns. As you have seen in this unit, persuasion also appears in literature when one character tries to convince another to act or think in a certain way. Now that you have examined some of the key elements of persuasion, you will have the chance to write a persuasive essay on a topic of your choice.

Prewriting

1. What are some of the issues that matter to you? Explore topics for your essay by listing some topics you care about. Make sure that these subjects are genuine matters of opinion—that is, people can have conflicting or opposing points of view about them. For example, you may think that living in a small town is better than living in a city, or that dogs make better pets than cats. These topics, however, are primarily matters of taste or personal preference, rather than genuinely arguable issues.

2. Write an **opinion statement** of one or two sentences to express your view on the issue you have selected. This statement will serve as the **thesis** or **main idea** for your essay. [See **Focus** assignment on page 534.]

3. Analyze the **audience** you want to convince. Is it composed of people in general, or does it consist of one or more special groups?

What are the needs and interests of your audience? What opinions are they likely to hold on the issue? Build a profile of your audience by filling out a chart like the one that follows.

Audience Chart
Topic: _____
Position/Opinion: _____
Audience: _____
Audience's Interests and Concerns: _____
Possible Opposing Opinions: _____
Reasons for Opposition: _____
Ways to Respond to Opposition: _____

[See **Focus** assignment on page 563.]

4. Develop support for your opinion. Remember that effective persuasion usually combines **appeals to logic** with **appeals to emotion.** The chart below lists several examples of each kind of appeal.

Logic	Emotion
reasons and facts	examples
statistics	personal experiences
expert opinions	word connotations

[See **Focus** assignments on pages 606 and 623.]

5. Evaluate your reasoning for logical soundness. Avoid **fallacies**—thinking or reasoning

errors that do not support your argument and may even detract from it. Here are five fallacies to watch out for:

- **attacking the person:** name-calling to smear the opposition, rather than dealing honestly with the issue
- **false cause and effect:** asserting that one event caused another just because the first preceded the second
- **hasty generalization:** basing a conclusion on insufficient evidence
- **circular reasoning:** merely restating your opinion in different words
- **either-or:** unfairly limiting the choices on an issue to two extreme alternatives

[See **Focus** assignment on page 663.]

Writing ~~

1. Follow an **outline** like the one below when you write your first draft:

 I. Introduction
 A. Attention grabber
 B. Background (if needed)
 C. Opinion statement
 II. Body
 A. Reason with explanation/evidence + emotional appeal (if appropriate)
 B. Reason with explanation/evidence + emotional appeal (if appropriate)
 C. Additional reasons + emotional appeals (if appropriate)
 D. Discussion of/response to main opposing arguments
 III. Conclusion
 A. Restatement of opinion
 B. Call to action (if needed)

[See **Focus** assignment on page 686.]

2. Maintain a balance between logical and emotional appeals. Don't swing too far in one direction or the other, or you may lose part of your audience. Refer to your audience chart as you write. See if you can anticipate which arguments will best satisfy the concerns of your readers or listeners.

3. In persuasive writing you may find it helpful to arrange your supporting material in **order of importance.** This means placing your most important support either first or last in the body of your paper.

Evaluating and Revising ~~

1. When you have finished your first draft, put it aside for a while, so that you can return to it in the evaluating and revising stage with a fresh perspective. As you look over your draft, focus on your language and style. Be sure that you have used the connotations of words effectively. Also check to see that you have used active-voice verbs to present your arguments as forcefully as possible.

 The persuasive paragraph below combines a reason with an expert opinion. Notice the writer's revisions.

Writer's Model

The most
~~An~~ important reason for making a

 a requirement
drivers' training course ~~something~~

~~required~~ for graduation is that

teenagers who take driver's training

courses those
are safer drivers than ~~the teenagers~~

who do not. Pedro Ramirez,

Commissioner of Motor Vehicles, has stated, "There's no substitute for quality instruction from professionals in a school setting."

2. Either on your own or with a partner, use the following checklist to evaluate and revise your essay.

Checklist for Evaluation and Revision

✓ Do I capture the audience's attention at the beginning?

✓ Do I clearly identify the issue and state my position?

✓ Do I use both logical and emotional appeals to support my opinion?

✓ Have I been careful to avoid logical fallacies?

✓ Have I organized my support in a logical way?

✓ Is the tone of my essay suitable for the subject matter and audience?

✓ Do I end with a strong conclusion?

Proofreading and Publishing 〰

1. Proofread your essay to correct errors in grammar, usage, and mechanics. (Here you may find it helpful to refer to the **Handbook for Revision** on pages 928–971.) Then prepare a final version of your paper by making a clean copy.

2. Here are some methods you can consider for publishing and sharing your essay:

- send your essay to the school or community paper as a letter to the editor
- present your essay as a speech to the class
- create an "opinion forum" with a group of classmates and discuss one another's essays
- send your essay to the organization that is concerned with the topic

Portfolio If your teacher approves, you may wish to keep a copy of your work in your writing folder or portfolio.

THE LEGEND OF KING ARTHUR

The legend of King Arthur and the Knights of the Round Table has appealed not only to generations of readers but also to artists, novelists, poets, and dramatists. Can you think of movies, musicals, and television plays that are based on the stories of medieval knights?

The tapestry reproduced at the left shows one artist's interpretation of the quest for the Holy Grail. Write the story of what you see. Attend to these details in your narrative:

1. Who are the knight and the lady in the left foreground of the tapestry? How are they different from other figures in the scene?
2. What weapons do the knights carry on their quest?
3. What qualities of the knights and ladies of King Arthur's court are emphasized in this work?

Save your story. Compare it with the adventures you will read in this unit.

The Arming and Departure of the Knights of the Round Table on the Quest of the Holy Grail. Tapestry designed by Edward Burne-Jones (1833–1898). Wool and silk on cotton warp.
Published by permission of the Birmingham Museum and Art Gallery

745

There are many versions of the legend of King Arthur, a cycle of stories that has been shaped and passed down through over fourteen hundred years of English history. The Arthur legend tells of the adventures of an early king of Britain and the knights and ladies who made up his royal court at Camelot. It recalls a world of mounted warriors armed with lance, sword, and coat of mail. It tells of jousts, tournaments, and falconry, of wizards, enchantresses, and damsels in distress, of wars, quests, and the medieval code of chivalry. It tells of a great king who came to the throne from obscurity and of a noble idea that came to a tragic end. It is a legend that has fascinated readers throughout the world and inspired great writers to retell it.

"Did King Arthur actually live?" This question cannot be answered with a simple yes or no. It is unlikely that Arthur was ever a real king. Modern historians believe that he was a *dux bellorum* (war chief) of the Welsh. Arthur was trained in war by the Romans, and in 517 he led his cavalry to a great victory against Saxon invaders from Germany. It is thought that Arthur fought more battles against the Saxons but met with less success. His people were eventually driven back into Wales and Scotland. Medieval historians reported that Arthur was killed in the battle of Glastonbury in southwestern England and secretly buried there by his knights.

Stories of Arthur's exploits soon sprang up among his comrades in arms, and were passed from generation to generation by word of mouth. These early storytellers spoke a Celtic language, far different from the English language that was to develop centuries later. As the Celts told and retold the stories of Arthur, they began to shape a legend. Semiprofessional storytellers—singers, bards, or minstrels, as they were called—mingled their own imaginations with their memories to make the tale satisfy the hopes and dreams of their listeners. The Celts were a defeated people. Arthur had brought them momentary glory. He was not dead, they sang. He would return someday to drive out the Saxons. Hope was fading for the Celts, however, and Arthur's tale seemed destined to die with their dreams.

In 817, however, a monk named Nennius, who was educated in Latin, wrote a chronicle of the life of Arthur that was a mixture of history and legend. In this account Arthur was revealed as a hero who had almost singlehandedly turned back the invaders. Perhaps more than any other, this account put Arthur on his way to everlasting fame. During the next three hundred years, chiefly through the skill of the minstrels who entertained in the manor halls of the nobles, the legend began to take shape. The familiar characters appeared: Kay, Gawain, Bedivere, Gareth, and Gwynevere. The Arthur stories gradually came to the attention of the whole of England.

Arthur depicted on a fifteenth-century tapestry as
one of the Nine Worthies.

The twelfth-century writer Geoffrey of Monmouth, who also wrote in Latin, became the first famous shaper of the Arthur legend. Geoffrey was writing a history of British kings. Geoffrey's history was actually not a history at all but an attempt to give England, now composed of many peoples—Normans, Saxons, Angles, Celts, and others—a beginning which would link it to ancient civilizations. Geoffrey made Arthur a descendant of Aeneas, the legendary founder of Rome. In this account Arthur began to lose some of the rough ways of the Celtic hero. Geoffrey wrote of him as a Norman king, modeled after Charlemagne, the great emperor of ninth-century Europe. Geoffrey was also the first to describe Arthur as a fifteen-year-old boy king and to tell about Arthur's magician-tutor, Merlyn. Geoffrey, too, told of Arthur's marriage to Gwynevere and of the betrayal of Arthur by the knight Modred.

Wace, a Norman who wrote in French, also retold the legend of Arthur, and he based his account on Geoffrey's. Wace added the famous Round Table, "ordained by Arthur that, when his fair fellowship sat to meat, their chairs should be alike, their service equal, and none before or after his fellow."

For the next two centuries, Arthur's story changed and spread. What had been a purely British legend found its way into France, Spain, Germany, and Italy. Courtly romances and knightly adventures added a new cast of characters, among them Launcelot, Tristram, Mark, Isolde, Galahad, Percivale, and many others.

Thomas Malory

The King Arthur legend belonged to England, however, and in 1470 one of the most important shapers of the legend, Sir Thomas Malory, a knight himself, made it forever English. Malory, writing in English, gathered together and retold many of the French romances dealing with Arthur and the knights. A printer, William Caxton, gave these stories an order and unified the whole in one work which he called *Le Morte Darthur* (*The Death of Arthur*).

By Malory's time, feudalism and knighthood were dying out. People were flocking to live in the cities, gunpowder was putting the knights out of work, and a wealthy merchant class was replacing the knights and nobles as the most influential group in England. Perhaps Malory was like the old warrior, trying to recapture the grandeur of the good old days. Or perhaps he was trying to give the institution of knighthood an order and virtue that it never had. Although the

A page from the only existing manuscript of *Le Morte Darthur*. This fifteenth-century manuscript, which is not Malory's original, was discovered at Winchester College in 1934.
British Library

Church and the powerful kings and nobles had set down a code of conduct for knights, many disregarded it. Most knights were trained for fighting, and not much else. Unless they were kept busy, they could be a menace. Malory himself was a good example of a knight who took the law into his own hands. In fact, he wrote his stories about Arthur while serving time in prison.

Alfred, Lord Tennyson

Since Malory's time, scores of writers have used the Arthurian legends to please readers and to express their own views of what society should be like. The most prominent of these writers is Alfred, Lord Tennyson, the nineteenth-century English poet. Tennyson selected several popular Arthurian tales, changed them to suit his purpose, and retold them as poetry. He called this work the *Idylls of the King*. An idyll is characterized by its rural setting, and in Camelot, Arthur's fabled court and countryside, Tennyson found a peaceful background against which a high-minded Arthur and his knights played out a tragic story. Tennyson made his Arthur a great moral leader. Tennyson's Arthur conquers his enemies when he must, but his greatness is not in war but in moral superiority, specifically in the gathering of knights who serve him by bringing order and justice to the world.

T. H. White

In our own time, the English writer T. H. White found the Arthur legend a proper setting in which to search for new hope for a world wracked by war. White's own telling of the Arthur story, in four short novels, is humorous and human. Though he shows his appreciation for the past, White's viewpoint is modern. His portrayal of Arthur as a boy shows us a boy much like those we may know. With the help of Merlyn, who introduces him to wisdom, White's Arthur grows up to be a wise, judgelike king who gropes for a solution to his world's problems. His great idea is to use the skill and valor of his knights for good—for the high ideal of a peaceful, ordered, and just world. White's four novels about King Arthur are combined in one volume with the title *The Once and Future King*.

Why have writers continued to tell the story of King Arthur? Is it the romance and adventure, the classic struggle between good and evil, or the appeal of the story of the good king who will return to save his people? Perhaps we go to the story of King Arthur, as we do to all great legends, not to find historical facts, but to find what kind of dreams people dream; not, as the critic Northrop Frye has said, "to find out what a king *is*, or even what a king *could be*, but what we *would like* a king to be." In this sense, the King Arthur legend belongs to us all.

Guidelines for Close Reading

1. Read for pleasure and for understanding. Take note of the qualities that hold the reader's interest.

2. Become familiar with principal characters. Consult the table on page 751 whenever necessary.

3. Form a concept of the ideals of chivalry. Determine in what way these ideals still appeal to modern readers.

4. Identify the characteristics of the medieval romance. Consider where these characteristics survive in present-day stories and novels.

5. Compare interpretations of the legend. Ask yourself how writers reflect the concerns of their own age.

People and Places in the Legend of King Arthur

King Arthur	Son of Uther Pendragon; King of Britain; founder of the Knights of the Round Table
Avalon (Avilion)	Island in the western seas where King Arthur goes at his death
Sir Bedivere	Last of the Knights of the Round Table
Camelot	City where Arthur's court is established
Sir Ector	Arthur's foster father
Excalibur	Arthur's sword
Sir Galahad	Son of Sir Launcelot and purest of Arthur's knights; succeeds in the quest for the Holy Grail
Sir Gareth	Gawain's brother and Arthur's nephew; assumes disguise as Beaumains
Sir Gawain	Nephew to King Arthur; son of Morgana; most courteous of Arthur's knights
Queen Guinevere (Gwynevere)	Daughter of King Lodegreaunce; Arthur's wife
Holy Grail (Sangreal)	Cup used at Last Supper; object of quests of Knights of the Round Table
Sir Kay	Arthur's foster brother and steward
Lady of the Lake	Gives Arthur his sword
Sir Launcelot (Lancelot) du Lake	Greatest of the Knights of the Round Table; father of Sir Galahad
Merlyn (Merlin)	A magician; counselor to Arthur
Sir Modred	Arthur's nephew; plots to overthrow the king
Morgan le Fay	Arthur's half sister; a sorceress
Round Table	A wedding gift from Arthur's father-in-law; provided seats for 150 knights

According to T. H. White's lively retelling of the legend, Arthur is an orphan of unknown parentage, who lives with his guardian, Sir Ector. Sir Ector has a son named Kay, a disagreeable boy, who gives Arthur the nickname "Wart" because it more or less rhymes with "Art." Kay soon becomes a knight, but Arthur must be Kay's servant—his squire.

Although Arthur seems very ordinary, the magician Merlyn knows who he really is: the trueborn king of England. Merlyn thus takes the boy's education in hand and prepares him for the future Arthur knows nothing about. Under Merlyn's guidance, Arthur even learns the secret language of the animals and is given the chance to fly as a bird.

When Arthur is fifteen, England's king dies with no heir to succeed him. All of England's knights and barons journey to London to compete in a great jousting tournament on New Year's Day, each hoping to be acclaimed king. But at this time, a mysterious object appears in London: a sword stuck hilt-deep in an anvil on a slab of stone. On the sword are these words: "Whoso Pulleth Out This Sword of this Stone and Anvil, is Rightwise King Born of All England."

As this part of the story opens, Sir Ector, Sir Kay, Arthur (the Wart), and two old friends, Sir Grummore and Sir Pellinore, are setting out for London. Sir Kay can hardly wait to show off at the tournament—and maybe have a try at the sword.

A tournament depicted in a fifteenth-century manuscript. Ms. Fr. Harley 4431, f 150.

Arthur Becomes King

T. H. WHITE

Perhaps, if you happen not to have lived in the Old England of the twelfth century, or whenever it was, and in a remote castle on the borders of the Marches[1] at that, you will find it difficult to imagine the wonders of their journey.

The road, or track, ran most of the time along the high ridges of the hills or downs, and they could look down on either side of them upon the desolate marshes where the snowy reeds sighed, and the ice crackled, and the duck in the red sunsets quacked loud on the winter air. The whole country was like that. Perhaps there would be a moory marsh on one side of the ridge, and a forest of a hundred thousand acres on the other, with all the great branches weighted in white. They could sometimes see a wisp of smoke among the trees, or a huddle of buildings far out among the impassable roads, and twice they came to quite respectable towns which had several inns to boast of, but on the whole it was an England without civilization. The better roads were cleared of cover for a bowshot on either side of them, lest the traveler should be slain by hidden thieves.

They slept where they could, sometimes in the hut of some cottager who was prepared to welcome them, sometimes in the castle of a brother knight who invited them to refresh themselves, sometimes in the firelight and fleas of a dirty little hovel with a bush tied to a pole outside it—this was the sign board used at that time by inns—and once or twice on the open ground, all huddled together for warmth between their grazing chargers. Wherever they went and wherever they slept, the east wind whistled in the reeds, and the geese went over high in the starlight, honking at the stars.

London was full to the brim. If Sir Ector had not been lucky enough to own a little land in Pie Street, on which there stood a respectable inn, they would have been hard put to it to find a lodging. But he did own it, and as a matter of fact drew most of his dividends[2] from that source, so they were able to get three beds among the five of them. They thought themselves fortunate.

On the first day of the tournament, Sir Kay managed to get them on the way to the lists[3] at least an hour before the jousts could possibly begin. He had lain awake all night, imagining how he was going to beat the best barons in England, and he had not been able to eat his breakfast. Now he rode at the front of the

1. **Marches:** boundaries that are in dispute.

2. **dividends:** White is having fun with history. Today, of course, a dividend is paid to stockholders in a corporation. Sir Ector would have received feudal tithes.
3. **lists:** fields where the tournament is held.

cavalcade, with pale cheeks, and Wart wished there was something he could do to calm him down.

For country people, who only knew the dismantled tilting ground[4] of Sir Ector's castle, the scene which met their eyes was ravishing. It was a huge green pit in the earth, about as big as the arena at a football match. It lay ten feet lower than the surrounding country, with sloping banks, and the snow had been swept off it. It had been kept warm with straw, which had been cleared off that morning, and now the close-worn grass sparkled green in the white landscape. Round the arena there was a world of color so dazzling and moving and twinkling as to make one blink one's eyes. The wooden grandstands were painted in scarlet and white. The silk pavilions[5] of famous people, pitched on every side, were azure and green and saffron and checkered. The pennons and pennoncels[6] which floated everywhere in the sharp wind were flapping with every color of the rainbow, as they strained and slapped at their flagpoles, and the barrier down the middle of the arena itself was done in chessboard squares of black and white. Most of the combatants and their friends had not yet arrived, but one could see from those few who had come how the very people would turn the scene into a bank of flowers, and how the armor would flash, and the scalloped sleeves of the heralds jig in the wind, as they raised their brazen trumpets to their lips to shake the fleecy clouds of winter with joyances and fanfares.

"Good heavens!" cried Sir Kay. "I have left my sword at home."

"Can't joust without a sword," said Sir Grummore. "Quite irregular."

4. **tilting ground:** grounds where the knights practice tilting, or charging with lances. Tilts are the same as jousts.
5. **pavilions:** tents.
6. **pennons and pennoncels:** flags bearing the knights' emblems. A pennoncel is smaller than a pennon.

"Better go and fetch it," said Sir Ector. "You have time."

"My squire will do," said Sir Kay. "What a mistake to make! Here, squire, ride hard back to the inn and fetch my sword. You shall have a shilling if you fetch it in time."

The Wart went as pale as Sir Kay was, and looked as if he were going to strike him. Then he said, "It shall be done, master," and turned his ambling palfrey[7] against the stream of newcomers. He began to push his way toward their hostelry as best he might.

"To offer me money!" cried the Wart to himself. "To look down at this beastly little donkey-affair off his great charger and to call me squire! Oh, Merlyn, give me patience with the brute, and stop me from throwing his filthy shilling in his face."

When he got to the inn it was closed. Everybody had thronged to see the famous tournament, and the entire household had followed after the mob. Those were lawless days and it was not safe to leave your house—or even to go to sleep in it—unless you were certain that it was impregnable. The wooden shutters bolted over the downstairs windows were two inches thick, and the doors were double-barred.

"Now what do I do," asked the Wart, "to earn my shilling?"

He looked ruefully at the blind little inn, and began to laugh.

"Poor Kay," he said. "All that shilling stuff was only because he was scared and miserable, and now he has good cause to be. Well, he shall have a sword of some sort if I have to break into the Tower of London.

"How does one get hold of a sword?" he continued. "Where can I steal one? Could I waylay some knight even if I am mounted on an ambling pad, and take his weapons by

7. **palfrey:** saddle horse, usually a small and gentle one.

force? There must be some swordsmith or armorer in a great town like this, whose shop would be still open."

He turned his mount and cantered off along the street. There was a quiet churchyard at the end of it, with a kind of square in front of the church door. In the middle of the square there was a heavy stone with an anvil on it, and a fine new sword was stuck through the anvil.

"Well," said the Wart, "I suppose it is some sort of war memorial, but it will have to do. I am sure nobody would grudge Kay a war memorial, if they knew his desperate straits."

He tied his reins round a post of the lych gate,[8] strode up the gravel path, and took hold of the sword.

"Come, sword," he said. "I must cry your mercy and take you for a better cause.

"This is extraordinary," said the Wart. "I feel strange when I have hold of this sword, and I notice everything much more clearly. Look at the beautiful gargoyles of the church, and of the monastery which it belongs to. See how splendidly all the famous banners in the aisle are waving. How nobly that yew[9] holds up the red flakes of its timbers to worship God. How clean the snow is. I can smell something like fetherfew and sweet briar—and is it music that I hear?"

It was music, whether of panpipes or of recorders, and the light in the churchyard was so clear, without being dazzling, that one could have picked a pin out twenty yards away.

"There is something in this place," said the Wart. "There are people. Oh, people, what do you want?"

Nobody answered him, but the music was loud and the light beautiful.

"People," cried the Wart, "I must take this sword. It is not for me, but for Kay. I will bring it back."

8. **lych gate:** roofed gate leading into a churchyard.
9. **yew:** evergreen tree with wide-spreading limbs.

There was still no answer, and Wart turned back to the anvil. He saw the golden letters, which he did not read, and the jewels on the pommel,[10] flashing in the lovely light.

"Come, sword," said the Wart.

He took hold of the handles with both hands, and strained against the stone. There was a melodious consort[11] on the recorders, but nothing moved.

The Wart let go of the handles, when they were beginning to bite into the palms of his hands, and stepped back, seeing stars.

"It is well fixed," he said.

He took hold of it again and pulled with all his might. The music played more strongly, and the light all about the churchyard glowed like amethysts; but the sword still stuck.

"Oh, Merlyn," cried the Wart, "help me to get this weapon."

There was a kind of rushing noise, and a long chord played along with it. All round the churchyard there were hundreds of old friends. They rose over the church wall all together, like the Punch and Judy ghosts of remembered days, and there were badgers and nightingales and vulgar crows and hares and wild geese and falcons and fishes and dogs and dainty unicorns and solitary wasps and corkindrills[12] and hedgehogs and griffins[13] and the thousand other animals he had met. They loomed round the church wall, the lovers and helpers of the Wart, and they all spoke solemnly in turn. Some of them had come from the banners in the church, where they were painted in heraldry, some from the waters and the sky and the fields about—but all, down to the smallest shrew mouse, had

10. **pommel:** the rounded, ornamental knob on the handle of the sword.
11. **consort:** harmony.
12. **corkindrills:** beasts feared in medieval times, now identified as crocodiles.
13. **griffins:** huge, mythical animals, half lion and half eagle.

Two scenes from Arthur's life are combined. *(Above)* Arthur proves his right to the throne by pulling the sword out of the stone. *(Below)* Arthur offers his sword on the altar at his coronation. Thirteenth-century French illumination. Ms. Fr. 95, f 159 v.
Bibliothèque Nationale, Paris

come to help on account of love. Wart felt his power grow.

"Put your back into it," said a Luce (or pike) off one of the heraldic banners, "as you once did when I was going to snap you up. Remember that power springs from the nape of the neck."

"What about those forearms," asked a Badger gravely, "that are held together by a chest? Come along, my dear embryo, and find your tool."

A Merlin[14] sitting at the top of the yew tree cried out, "Now then, Captain Wart, what is the first law of the foot? I thought I once heard something about never letting go?"

"Don't work like a stalling woodpecker," urged a Tawny Owl affectionately. "Keep up a steady effort, my duck, and you will have it yet."

A White-front said, "Now, Wart, if you were once able to fly the great North Sea, surely you can coordinate a few little wing muscles here and there? Fold your powers together, with the spirit of your mind, and it will come out like butter. Come along, Homo sapiens, for all we humble friends of yours are waiting here to cheer."

The Wart walked up to the great sword for the third time. He put out his right hand softly and drew it out as gently as from a scabbard.

There was a lot of cheering, a noise like a hurdy-gurdy which went on and on. In the middle of this noise, after a long time, he saw Kay and gave him the sword. The people at the tournament were making a frightful row.

"But this is not my sword," said Sir Kay.

"It was the only one I could get," said the Wart. "The inn was locked."

"It is a nice-looking sword. Where did you get it?"

"I found it stuck in a stone, outside a church."

Sir Kay had been watching the tilting nervously, waiting for his turn. He had not paid much attention to his squire.

"That is a funny place to find one," he said.

"Yes, it was stuck through an anvil."

"What?" cried Sir Kay, suddenly rounding upon him. "Did you just say this sword was stuck in a stone?"

"It was," said the Wart. "It was a sort of war memorial."

Sir Kay stared at him for several seconds in amazement, opened his mouth, shut it again, licked his lips, then turned his back and plunged through the crowd. He was looking for Sir Ector, and the Wart followed after him.

"Father," cried Sir Kay, "come here a moment."

"Yes, my boy," said Sir Ector. "Splendid falls these professional chaps do manage. Why, what's the matter, Kay? You look as white as a sheet."

"Do you remember that sword which the King of England would pull out?"

"Yes."

"Well, here it is. I have it. It is in my hand. I pulled it out."

Sir Ector did not say anything silly. He looked at Kay and he looked at the Wart. Then he stared at Kay again, long and lovingly, and said, "We will go back to the church."

"Now then, Kay," he said, when they were at the church door. He looked at his firstborn kindly, but straight between the eyes. "Here is the stone, and you have the sword. It will make you the King of England. You are my son that I am proud of, and always will be, whatever you do. Will you promise me that you took it out by your own might?"

Kay looked at his father. He also looked at the Wart and at the sword.

14. **Merlin:** European falcon.

Then he handed the sword to the Wart quite quietly.

He said, "I am a liar. Wart pulled it out."

As far as the Wart was concerned, there was a time after this in which Sir Ector kept telling him to put the sword back into the stone—which he did—and in which Sir Ector and Kay then vainly tried to take it out. The Wart took it out for them, and stuck it back again once or twice. After this, there was another time which was more painful.

He saw that his dear guardian was looking quite old and powerless, and that he was kneeling down with difficulty on a gouty[15] knee.

"Sir," said Sir Ector, without looking up, although he was speaking to his own boy.

"Please do not do this, Father," said the Wart, kneeling down also. "Let me help you up, Sir Ector, because you are making me unhappy."

"Nay, nay, my lord," said Sir Ector, with some very feeble old tears. "I was never your father nor of your blood, but I wote well ye are of an higher blood than I wend ye were."

"Plenty of people have told me you are not my father," said the Wart, "but it does not matter a bit."

"Sir," said Sir Ector humbly, "will ye be my good and gracious lord when ye are king?"

"Don't!" said the Wart.

"Sir," said Sir Ector, "I will ask no more of you but that you will make my son, your foster brother, Sir Kay, seneschal[16] of all your lands?"

Kay was kneeling down too, and it was more than the Wart could bear.

"Oh, do stop," he cried. "Of course he can be seneschal, if I have got to be this king, and, oh, Father, don't kneel down like that, because it breaks my heart. Please get up, Sir Ector, and don't make everything so horrible. Oh,

dear, oh, dear, I wish I had never seen that filthy sword at all."

And the Wart also burst into tears.

After Arthur becomes king, he is plunged into war with a number of local rulers of England and Scotland who do not accept his right to rule them. England in the Middle Ages, like most of Europe, was governed according to the feudal system. This meant that the King of England did not rule the whole land directly. He ruled it through local leaders, each of whom was all-powerful in his own territory but was also bound to the king by an oath of obedience. Lot, mentioned in this selection, is the leader of those who are fighting against Arthur.

In the following selection we see Arthur as the King of England. He is preparing to unite his kingdom and establish a new order—one that will emphasize peace and good deeds.

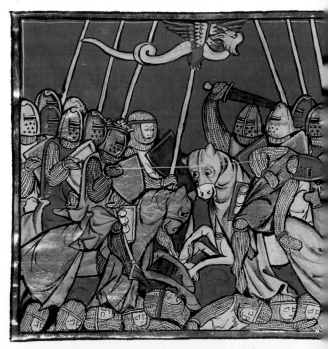

In this illumination, Arthur, shown at the left, unhorses one of the rebels. Ms. Fr. 95, f. 173 v.
Bibliothèque Nationale, Paris

15. **gouty:** afflicted with gout, a disease that causes a painful swelling of the joints.
16. **seneschal** (sĕn′ə-shəl): chief administrator of a medieval noble's estate.

The King of England painfully climbed the two hundred and eight steps which led to Merlyn's tower room, and knocked on the door. The magician was inside, with Archimedes[17] sitting on the back of his chair, busily trying to find the square root of minus one. He had forgotten how to do it.

"Merlyn," said the king, panting, "I want to talk to you."

He closed his book with a bang, leaped to his feet, seized his wand of lignum vitae,[18] and rushed at Arthur as if he were trying to shoo away a stray chicken.

"Go away!" he shouted. "What are you doing here? What do you mean by it? Aren't you the King of England? Go away and send for me! Get out of my room! I never heard of such a thing! Go away at once and send for me!"

"But I am here."

"No, you're not," retorted the old man resourcefully. And he pushed the king out of the door, slamming it in his face.

"Well!" said Arthur, and he went off sadly down the two hundred and eight stairs.

An hour later, Merlyn presented himself in the Royal Chamber, in answer to a summons which had been delivered by a page.

"That's better," he said, and sat down comfortably on a carpet chest.

"Stand up," said Arthur, and he clapped his hands for a page to take away the seat.

Merlyn stood up, boiling with indignation. The whites of his knuckles blanched as he clenched them.

"About our conversation on the subject of chivalry," began the king in an airy tone. . . .

"I don't recollect such a conversation."

"No?"

"I have never been so insulted in my life!"

"But I am the king," said Arthur. "You can't sit down in front of the king."

"Rubbish!"

Arthur began to laugh more than was seemly, and his foster brother, Sir Kay, and his old guardian, Sir Ector, came out from behind the throne, where they had been hiding. Kay took off Merlyn's hat and put it on Sir Ector, and Sir Ector said, "Well, bless my soul, now I am a necromancer.[19] Hocus-Pocus." Then everybody began laughing, including Merlyn eventually, and seats were sent for so that they could sit down, and bottles of wine were opened so that it should not be a dry meeting.

"You see," he said proudly, "I have summoned a council."

There was a pause, for it was the first time that Arthur had made a speech, and he wanted to collect his wits for it.

"Well," said the king. "It is about chivalry. I want to talk about that."

Merlyn was immediately watching him with a sharp eye. His knobbed fingers fluttered among the stars and secret signs of his gown, but he would not help the speaker. You might say that this moment was the critical one in his career—the moment towards which he had been living backward for heaven knows how many centuries, and now he was to see for certain whether he had lived in vain.

"I have been thinking," said Arthur, "about Might and Right. I don't think things ought to be done because you are *able* to do them. I think they should be done because you *ought* to do them. After all, a penny is a penny in any case, however much Might is exerted on either side, to prove that it is or is not. Is that plain?"

Nobody answered.

"Well, I was talking to Merlyn on the battlements one day, and he mentioned that the last battle we had—in which seven hundred kerns[20] were killed—was not so much fun as I

17. **Archimedes:** Merlyn's owl.
18. **lignum vitae:** Latin for "wood of life."

19. **necromancer:** magician.
20. **kerns:** lowborn foot soldiers.

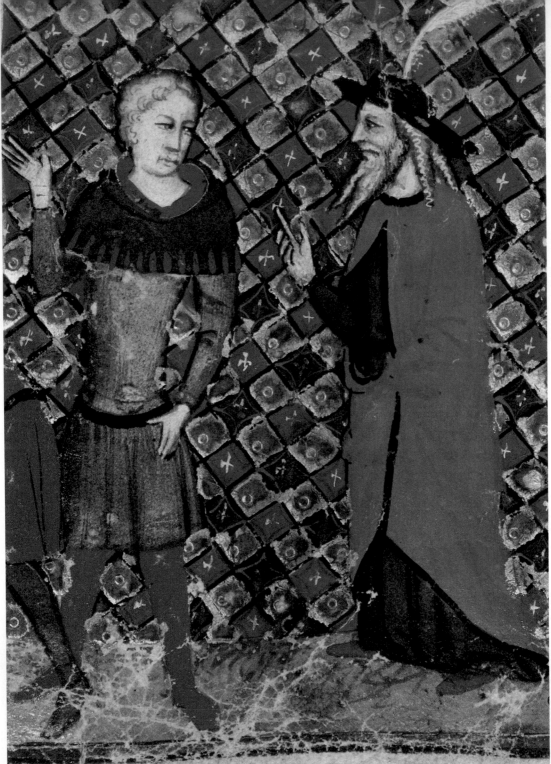

Merlin is the figure at the right in this fourteenth-century illuminated man-
uscript. Ms. Add. Meladius 12228 f 202 v.

had thought it was. Of course, battles are not fun when you come to think about them. I mean, people ought not to be killed, ought they? It is better to be alive.

"Very well. But the funny thing is that Merlyn was helping me to win battles. He is still helping me, for that matter, and we hope to win the battle of Bedegraine together, when it comes off."

"We will," said Sir Ector, who was in the secret.[21]

"That seems to me to be inconsistent. Why does he help me to fight wars, if they are bad things?"

There was no answer from anybody, and the king began to speak with agitation.

"I could only think," said he, beginning to blush, "I could only think that I—that we—that he—that he wanted to win them for a reason."

He paused and looked at Merlyn, who turned his head away.

"The reason was—was it?—the reason was that if I could be the master of my kingdom by winning these two battles, I could stop them afterwards and then do something about the business of Might. Have I guessed? Was I right?"

The magician did not turn his head, and his hands lay still in his lap.

"I was!" exclaimed Arthur.

And he began talking so quickly that he could hardly keep up with himself.

"You see," he said, "Might is not Right. But there is a lot of Might knocking about in this world, and something has to be done about it. It is as if People were half horrible and half nice. Perhaps they are even more than half horrible, and when they are left to themselves they run wild. You get the average baron that we see nowadays, people like Sir Bruce Sans

Pitié, who simply go clod-hopping round the country dressed in steel, and doing exactly what they please, for sport. It is our Norman idea about the upper classes having a monopoly of power, without reference to justice. Then the horrible side gets uppermost, and there is thieving and plunder and torture. The people become beasts.

"But, you see, Merlyn is helping me to win my two battles so that I can stop this. He wants me to put things right.

"Lot and Uriens and Anguish[22] and those—they are the old world, the old-fashioned order who want to have their private will. I have got to vanquish them with their own weapons—they force it upon me, because they live by force—and then the real work will begin. This battle at Bedegraine is the preliminary, you see. It is *after* the battle that Merlyn is wanting me to think about."

Arthur paused again for comment or encouragement, but the magician's face was turned away. It was only Sir Ector, sitting next to him, who could see his eyes.

"Now what I have thought," said Arthur, "is this. Why can't you harness Might so that it works for Right? I know it sounds nonsense, but, I mean, you can't just say there is no such thing. The Might is there, in the bad half of people, and you can't neglect it. You can't cut it out, but you might be able to direct it, if you see what I mean, so that it was useful instead of bad."

The audience was interested. They leaned forward to listen, except Merlyn.

"My idea is that if we can win this battle in front of us, and get a firm hold of the country, then I will institute a sort of order of chivalry. I will not punish the bad knights, or hang Lot, but I will try to get them into our Order. We shall have to make it a great honor, you see,

21. **in the secret:** Merlyn has devised a secret plan to win the battle.

22. **Lot and Uriens and Anguish:** local rulers in Britain before Arthur.

and make it fashionable and all that. Everybody must want to be in. And then I shall make the oath of the order that Might is only to be used for Right. Do you follow? The knights in my order will ride all over the world, still dressed in steel and whacking away with their swords—that will give an outlet for wanting to whack, you understand, an outlet for what Merlyn calls the foxhunting spirit—but they will be bound to strike only on behalf of what is good, to restore what has been done wrong in the past and to help the oppressed and so forth. Do you see the idea? It will be using the Might instead of fighting against it, and turning a bad thing into a good. There, Merlyn, that is all I can think of. I have thought as hard as I could, and I suppose I am wrong, as usual. But I did think. I can't do any better. Please say something!"

The magician stood up as straight as a pillar, stretched out his arms in both directions, looked at the ceiling and said the first few words of the Nunc Dimittis.[23]

23. **Nunc Dimittis:** the title of the Song of Simeon (Luke 2: 29–32), from its first words in Latin. The Nunc Dimittis begins: "Lord, now lettest thou thy servant depart in peace . . . For mine eyes have seen thy salvation." According to the Biblical account, Simeon was an old man who had been allowed by God to live long enough to see the Messiah. When the child Jesus was brought to him, he uttered these words and was ready to die.

Reading Check

1. Why have Sir Ector and the two boys come to London?
2. Why does Sir Kay send his squire back to the inn?
3. What problem does Arthur find when he reaches the inn?
4. What does Arthur assume about the sword in the stone when he first sees it?
5. What kind of help does Arthur get in drawing the sword out of the stone?
6. How does Sir Ector test Arthur?
7. Why does Merlyn send the king away from his room in the tower?
8. Why does Arthur have Merlyn's seat removed?
9. What does Arthur intend to do about the rebels after he conquers them?
10. What is Arthur's idea about Might and Right?

For Study and Discussion

Analyzing and Interpreting the Selection

1. In this episode, how does White show us that Arthur was not a very likely person to become the King of England?

2. White's main source for his novel was Thomas Malory's *Le Morte Darthur*. But Malory tells us very little about the thoughts or feelings of the main characters. White, on the other hand, makes his characters seem like real people, so that we can identify with them. **a.** What thoughts and feelings does Arthur express after Sir Kay has rather rudely ordered him to find his sword? **b.** In this incident, what kind of person does White show the young Arthur to be?

3a. How does the character of Kay contrast with the character of Arthur? **b.** What are you supposed to think of Kay?

4. What details in the account of Arthur's "trial" with the sword show that he has extraordinary abilities that set him apart from others?

5. In the last part of this story, Arthur is changing and becoming "kingly." **a.** What is Arthur's vision of the future? **b.** What do you think he means by "the foxhunting spirit"?

6. Merlyn has been a key figure in Arthur's early life. **a.** Why do you think the old magician remains silent during Arthur's speech about Might and Right? **b.** Why does Merlyn finally react to the speech the way he does?

Literary Elements

Anachronisms

An **anachronism** is an object, an event, a person, or a thing that is chronologically out of place, often something appropriate to a later period of time. For example, White refers to football in this selection. The sport of football was not known in medieval England, so football is an anachronism in this story. Writers sometimes create anachronisms as a result of carelessness or poor research. White, however, uses anachronisms intentionally, as a way of modernizing an old story and as a means of creating humor.

See if you can find other anachronisms in this selection. Which ones make the story humorous?

Language and Vocabulary

Recognizing Word Origins

The word *chivalry* comes from an old French word, *chevaler*, meaning "knight." The French word is also the source for our word *cavalry*.

Both words can be traced back to a Latin word meaning "horse."

In a dictionary find the origins of these words:

 tournament joust pavilion tilt

Creative Writing

Modernizing a Legend

The story you have just read is an example of an ancient legend that has been modernized. Choose a part of White's story to modernize in your own way. Provide thoughts and feelings for your Arthur that reflect the boys you have known and have grown up with. If you wish, claim artistic license and make Arthur a girl. You may want to use anachronisms for humor. Give your story a recognizable modern setting.

About the Author

T. H. White (1906–1964)

Terence Hansbury (T. H.) White was born in Bombay, India, but went to England for his education. His first book, a collection of poems, was published when he was only nineteen. Later he wrote a number of detective stories. White was tremendously interested in a wide variety of subjects, including flying, movie-making, sailing, and falconry (a medieval sport still practiced by some people today). His novels about Arthur, combined in *The Once and Future King,* took almost twenty years to write. White visited America for the first time in 1960 when *Camelot,* a musical comedy based on *The Once and Future King,* opened on Broadway.

Focus on Comparison and Contrast

Choosing a Subject

Comparison focuses on the similarities of two or more subjects. **Contrast** focuses on the differences of the subjects. In a **comparison/contrast essay,** you examine the relationships and patterns of two or more subjects and discuss the similarities, the differences, or both. The purpose of a comparison/contrast essay can be to inform, to persuade, or to express yourself.

When you choose subjects for this kind of essay, be sure that

a. the subjects have some basic similarities

b. the subjects are different enough to be interesting

c. information about the subjects can be easily obtained

d. the subjects are limited enough so that you can handle them adequately in a short essay

Brainstorm for essay subjects by looking at notes you have made for your literature assignments, by scanning recent issues of newspapers and magazines, or by talking with a small group of classmates. Arrange your subjects in pairs. For example:

Arthur—Kay
legendary heroes—modern heroes
classical concerts—pop concerts
color film—black and white

Freewrite some notes on each pair of subjects you list. Save your notes.

Connecting Cultures

Heroic Figures Around the World

Many cultures have great heroes and heroines who appear in myths, legends, and epics. Some of these heroes and heroines are Gilgamesh, a legendary Sumerian king; the goddess Isis in ancient Egyptian mythology; Siegfried and Brunhild in medieval German legend; Sundiata, founder of the Empire of Mali; and Rama, hero of the Indian epic *Ramayana.* There are also many modern fictional heroes and heroines.

Making Connections: Activities

1. Research the stories of several heroic figures. What qualities do they have in common? How are they different? What makes them heroic? What legends have sprung up around them? Create a short story or play in which two or more heroic characters from different cultures meet. Present it to the class.

2. Explore fictional heroes or heroines in movies, such as Superman, Wonder Woman, Indiana Jones, Robin Hood, and Princess Leia. Compare and contrast this hero's or heroine's development with that of King Arthur. Where does the character get his or her power? How does he or she evolve into a champion? What are his or her heroic qualities? Who are the major enemies, and how are they vanquished? Do you think this character will be remembered, as Arthur is, hundreds of years from now? Why or why not?

Arthur subdues the feudal lords of Britain and establishes his court at Camelot. Once peace is established, Arthur marries the beautiful Gwynevere, daughter of King Lodegreaunce. As a wedding present, King Lodegreaunce gives Arthur the Round Table.

The bravest and most skillful of all King Arthur's knights is Launcelot. He has come from France (as chivalry itself had come to England from France), and represents chivalry at its height. But there is another reason why Launcelot is so well known. Launcelot, who is Arthur's closest friend, eventually falls in love with Arthur's queen, Gwynevere, and she falls in love with him. For years Launcelot is torn between an undying friendship for Arthur and an undying love for Gwynevere. Eventually, this love breaks out into the open and helps to bring Arthur's brilliant court to ruin.

But here you will read about Launcelot at the height of his career, at a time when all is well at Camelot.

Round Table at Winchester Castle. This oaken table is painted to show King Arthur encircled by the names of certain Knights of the Round Table. It was probably painted during the reign of Henry VII (1485–1509), who claimed to be a descendant of Arthur.

The Tale of Sir Launcelot du Lake

SIR THOMAS MALORY

Retold by Keith Baines

Sir Tarquine Captures Sir Lyonel

When King Arthur returned from Rome,[1] he settled his court at Camelot, and there gathered about him his knights of the Round Table, who diverted themselves with jousting and tournaments. Of all his knights one was supreme, both in prowess at arms and in nobility of bearing, and this was Sir Launcelot, who was also the favorite of Queen Gwynevere, to whom he had sworn oaths of fidelity.

One day Sir Launcelot, feeling weary of his life at the court, and of only playing at arms, decided to set forth in search of adventure. He asked his nephew Sir Lyonel to accompany him, and when both were suitably armed and mounted, they rode off together through the forest.

At noon they started across a plain, but the intensity of the sun made Sir Launcelot feel sleepy, so Sir Lyonel suggested that they should rest beneath the shade of an apple tree

that grew by a hedge not far from the road. They dismounted, tethered their horses, and settled down.

"Not for seven years have I felt so sleepy," said Sir Launcelot, and with that fell fast asleep, while Sir Lyonel watched over him.

Soon three knights came galloping past, and Sir Lyonel noticed that they were being pursued by a fourth knight, who was one of the most powerful he had yet seen. The pursuing knight overtook each of the others in turn, and, as he did so, knocked each off his horse with a thrust of his spear. When all three lay stunned he dismounted, bound them securely to their horses with the reins, and led them away.

Without waking Sir Launcelot, Sir Lyonel mounted his horse and rode after the knight, and, as soon as he had drawn close enough, shouted his challenge. The knight turned about and they charged at each other, with the result that Sir Lyonel was likewise flung from his horse, bound, and led away a prisoner.

The victorious knight, whose name was Sir Tarquine, led his prisoners to his castle, and there threw them on the ground, stripped

1. **Rome:** According to legend, when the Roman Emperor Lucius demanded his annual tribute from Britain, King Arthur refused to pay. Instead, he led his armies into Italy, defeated the Roman army, and killed Lucius.

them naked, and beat them with thorn twigs. After that he locked them in a dungeon where many other prisoners, who had received like treatment, were complaining dismally.

Meanwhile, Sir Ector de Marys,[2] who liked to accompany Sir Launcelot on his adventures, and finding him gone, decided to ride after him. Before long he came upon a forester.

"My good fellow, if you know the forest hereabouts, could you tell me in which direction I am likely to meet with adventure?"

"Sir, I can tell you: Less than a mile from here stands a well-moated castle. On the left of the entrance you will find a ford where you can water your horse, and across from the ford a large tree from which hang the shields of many famous knights. Below the shields hangs a caldron of copper and brass: strike it three times with your spear, and then surely you will meet with adventure—such, indeed, that if you survive it, you will prove yourself the foremost knight in these parts for many years."

"May God reward you!" Sir Ector replied.

The castle was exactly as the forester had described it, and among the shields Sir Ector recognized several as belonging to knights of the Round Table. After watering his horse, he knocked on the caldron and Sir Tarquine, whose castle it was, appeared.

They jousted, and at the first encounter Sir Ector sent his opponent's horse spinning twice about before he could recover.

"That was a fine stroke; now let us try again," said Sir Tarquine.

This time Sir Tarquine caught Sir Ector just below the right arm and, having impaled him on his spear, lifted him clean out of the saddle, and rode with him into the castle, where he threw him on the ground.

"Sir," said Sir Tarquine, "you have fought better than any knight I have encountered in the last twelve years; therefore, if you wish, I will demand no more of you than your parole as my prisoner."

"Sir, that I will never give."

"Then I am sorry for you," said Sir Tarquine, and with that he stripped and beat him and locked him in the dungeon with the other prisoners. There Sir Ector saw Sir Lyonel.

"Alas, Sir Lyonel, we are in a sorry plight. But tell me, what has happened to Sir Launcelot? for he surely is the one knight who could save us."

"I left him sleeping beneath an apple tree, and what has befallen him since I do not know," Sir Lyonel replied; and then all the unhappy prisoners once more bewailed their lot.

While Sir Launcelot still slept beneath the apple tree, four queens started across the plain. They were riding white mules and accompanied by four knights who held above them, at the tips of their spears, a green silk canopy to protect them from the sun. The party was startled by the neighing of Sir Launcelot's horse and, changing direction, rode up to the apple tree, where they discovered the sleeping knight. And as each of the queens gazed at the handsome Sir Launcelot, so each wanted him for her own.

"Let us not quarrel," said Morgan le Fay.[3] "Instead, I will cast a spell over him so that he remains asleep while we take him to my castle and make him our prisoner. We can then oblige him to choose one of us for his paramour."

Sir Launcelot was laid on his shield and borne by two of the knights to the Castle Charyot, which was Morgan le Fay's stronghold. He awoke to find himself in a cold cell, where a young noblewoman was serving him supper.

2. **Sir Ector de Marys:** Sir Launcelot's younger brother, not to be confused with the Sir Ector who was Arthur's foster father.

3. **Morgan le Fay:** Arthur's half sister, an enchantress.

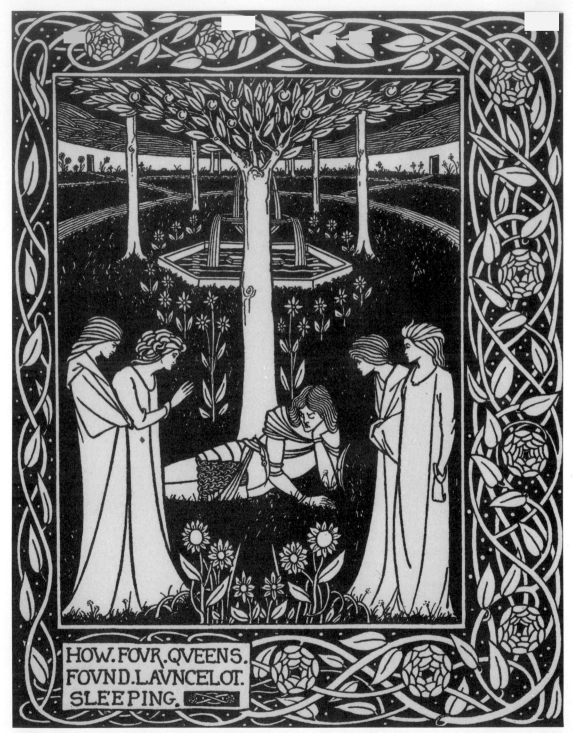

HOW·FOVR·QVEENS·
FOVND·LAVNCELOT·
SLEEPING·

Illustration by Aubrey Beardsley (1872–1898) for a nineteenth-century edition of Sir Thomas Malory's *Le Morte Darthur*.

THE LEGEND OF KING ARTHUR

"What cheer?" she asked.

"My lady, I hardly know, except that I must have been brought here by means of an enchantment."

"Sir, if you are the knight you appear to be, you will learn your fate at dawn tomorrow." And with that the young noblewoman left him. Sir Launcelot spent an uncomfortable night but at dawn the four queens presented themselves and Morgan le Fay spoke to him:

"Sir Launcelot, I know that Queen Gwynevere loves you, and you her. But now you are my prisoner, and you will have to choose: either to take one of us for your paramour, or to die miserably in this cell—just as you please. Now I will tell you who we are: I am Morgan le Fay, Queen of Gore; my companions are the Queens of North Galys, of Estelonde, and of the Outer Isles. So make your choice."

"A hard choice! Understand that I choose none of you, lewd sorceresses that you are; rather will I die in this cell. But were I free, I would take pleasure in proving it against any who would champion you that Queen Gwynevere is the finest lady of this land."

"So, you refuse us?" asked Morgan le Fay.

"On my life, I do," Sir Launcelot said finally, and so the queens departed.

Sometime later, the young noblewoman who had served Sir Launcelot's supper reappeared.

"What news?" she asked.

"It is the end," Sir Launcelot replied.

"Sir Launcelot, I know that you have refused the four queens, and that they wish to kill you out of spite. But if you will be ruled by me, I can save you. I ask that you will champion my father at a tournament next Tuesday, when he has to combat the King of North Galys, and three knights of the Round Table, who last Tuesday defeated him ignominiously."

"My lady, pray tell me, what is your father's name?"

"King Bagdemagus."

"Excellent, my lady, I know him for a good king and a true knight, so I shall be happy to serve him."

"May God reward you! And tomorrow at dawn I will release you, and direct you to an abbey which is ten miles from here, and where the good monks will care for you while I fetch my father."

"I am at your service, my lady."

As promised, the young noblewoman released Sir Launcelot at dawn. When she had led him through the twelve doors to the castle entrance, she gave him his horse and armor, and directions for finding the abbey.

"God bless you, my lady; and when the time comes, I promise I shall not fail you."

Sir Launcelot rode through the forest in search of the abbey, but at dusk had still failed to find it, and coming upon a red silk pavilion, apparently unoccupied, decided to rest there overnight, and continue his search in the morning.

Launcelot Enters a Tournament

As soon as it was daylight, Sir Launcelot armed, mounted, and rode away in search of the abbey, which he found in less than two hours. King Bagdemagus' daughter was waiting for him, and as soon as she heard his horse's footsteps in the yard ran to the window, and, seeing that it was Sir Launcelot, herself ordered the servants to stable his horse. She then led him to her chamber, disarmed him, and gave him a long gown to wear, welcoming him warmly as she did so.

King Bagdemagus' castle was twelve miles away, and his daughter sent for him as soon as she had settled Sir Launcelot. The king arrived with his retinue and embraced Sir Launcelot, who then described his recent enchantment, and the great obligation he was under to his daughter for releasing him.

Detail of a fourteenth-century manuscript illumination showing Sir Launcelot fighting for King Bagdemagus, with Gwynevere watching on the tower with her attendants. Ms. Fr. 806, f 262.

"Sir, you will fight for me on Tuesday next?"

"Sire, I shall not fail you; but please tell me the names of the three Round Table knights whom I shall be fighting."

"Sir Modred, Sir Madore de la Porte, and Sir Gahalantyne. I must admit that last Tuesday they defeated me and my knights completely."

"Sire, I hear that the tournament is to be fought within three miles of the abbey. Could you send me three of your most trustworthy knights, clad in plain armor, and with no device, and a fourth suit of armor which I myself shall wear? We will take up our position just outside the tournament field and watch while you and the King of North Galys enter into combat with your followers; and then, as soon as you are in difficulties, we will come to your rescue and show your opponents what kind of knights you command."

This was arranged on Sunday, and on the following Tuesday Sir Launcelot and the three

knights of King Bagdemagus waited in a copse,[4] not far from the pavilion which had been erected for the lords and ladies who were to judge the tournament and award the prizes.

The King of North Galys was the first on the field, with a company of ninescore knights; he was followed by King Bagdemagus with fourscore knights, and then by the three knights of the Round Table, who remained

4. **copse:** group of small trees or bushes.

apart from both companies. At the first encounter King Bagdemagus lost twelve knights, all killed, and the King of North Galys six.

With that, Sir Launcelot galloped onto the field, and with his first spear unhorsed five of the King of North Galys' knights, breaking the backs of four of them. With his next spear he charged the king, and wounded him deeply in the thigh.

"That was a shrewd blow," commented Sir Madore, and galloped onto the field to chal-

The Tale of Sir Launcelot du Lake **771**

lenge Sir Launcelot. But he too was tumbled from his horse, and with such violence that his shoulder was broken.

Sir Modred was the next to challenge Sir Launcelot, and he was sent spinning over his horse's tail. He landed head first, his helmet became buried in the soil, and he nearly broke his neck, and for a long time lay stunned.

Finally Sir Gahalantyne tried; at the first encounter both he and Sir Launcelot broke their spears, so both drew their swords and hacked vehemently at each other. But Sir Launcelot, with mounting wrath, soon struck his opponent a blow on the helmet which brought the blood streaming from eyes, ears, and mouth. Sir Gahalantyne slumped forward in the saddle, his horse panicked, and he was thrown to the ground, useless for further combat.

Sir Launcelot took another spear, and unhorsed sixteen more of the King of North Galys' knights, and with his next, unhorsed another twelve; and in each case with such violence that none of the knights ever fully recovered. The King of North Galys was forced to admit defeat, and the prize was awarded to King Bagdemagus.

That night Sir Launcelot was entertained as the guest of honor by King Bagdemagus and his daughter at their castle, and before leaving was loaded with gifts.

"My lady, please, if ever again you should need my services, remember that I shall not fail you."

The Battle of Sir Launcelot and Sir Tarquine

The next day Sir Launcelot rode once more through the forest, and by chance came to the apple tree where he had previously slept. This time he met a young noblewoman riding a white palfrey.[5]

5. **palfrey:** horse.

"My lady, I am riding in search of adventure; pray tell me if you know of any I might find hereabouts."

"Sir, there are adventures hereabouts if you believe that you are equal to them; but please tell me, what is your name?"

"Sir Launcelot du Lake."

"Very well, Sir Launcelot, you appear to be a sturdy enough knight, so I will tell you. Not far away stands the castle of Sir Tarquine, a knight who in fair combat has overcome more than sixty opponents whom he now holds prisoner. Many are from the court of King Arthur."

"My lady, please lead me to Sir Tarquine."

When they arrived at the castle, Sir Launcelot watered his horse at the ford, and then beat the caldron until the bottom fell out. However, none came to answer the challenge, so they waited by the castle gate for half an hour or so. Then Sir Tarquine appeared, riding toward the castle with a wounded prisoner slung over his horse, whom Sir Launcelot recognized as Sir Gaheris, Sir Gawain's brother and a knight of the Round Table.

"Good knight," said Sir Launcelot, "it is known to me that you have put to shame many of the knights of the Round Table. Pray allow your prisoner, who I see is wounded, to recover, while I vindicate the honor of the knights whom you have defeated."

"I defy you, and all your fellowship of the Round Table," Sir Tarquine replied.

"You boast!" said Sir Launcelot.

At the first charge the backs of the horses were broken and both knights stunned. But they soon recovered and set to with their swords, and both struck so lustily that neither shield nor armor could resist, and within two hours they were cutting each other's flesh, from which the blood flowed liberally. Finally they paused for a moment, resting on their shields.

"Worthy knight," said Sir Tarquine, "pray hold your hand for a while, and if you will, answer my question."

"Sir, speak on."

"You are the most powerful knight I have fought yet, but I fear you may be the one whom in the whole world I most hate. If you are not, for the love of you I will release all my prisoners and swear eternal friendship."

"What is the name of the knight you hate above all others?"

"Sir Launcelot du Lake; for it was he who slew my brother, Sir Carados of the Dolorous Tower, and it is because of him that I have killed a hundred knights, and maimed as many more, apart from the sixty-four I still hold prisoner. And so, if you are Sir Launcelot, speak up, for we must then fight to the death."

"Sir, I see now that I might go in peace and good fellowship, or otherwise fight to the death; but being the knight I am, I must tell you: I am Sir Launcelot du Lake, son of King Ban of Benwick, of Arthur's court, and a knight of the Round Table. So defend yourself!"

"Ah! this is most welcome."

Now the two knights hurled themselves at each other like two wild bulls; swords and shields clashed together, and often their swords drove into the flesh. Then sometimes one, sometimes the other, would stagger and fall, only to recover immediately and resume the contest. At last, however, Sir Tarquine grew faint, and unwittingly lowered his shield. Sir Launcelot was swift to follow up his advantage, and dragging the other down to his knees, unlaced his helmet and beheaded him.

Reading Check

1. Why does Sir Launcelot leave Camelot?
2. How is Launcelot brought to Morgan le Fay's stronghold?
3. How does he escape from Castle Charyot?
4. Why does no one recognize Launcelot during the tournament?
5. Why has Sir Tarquine sworn vengeance against Launcelot?

For Study and Discussion

Analyzing and Interpreting the Selection

1. In Sir Thomas Malory's *Le Morte Darthur*, Launcelot is the ideal knight. Three of the principal duties of a knight, according to the code of chivalry, were to correct wrongs, to honor his word, and to serve his "lady." Find examples from this selection that show how Launcelot fulfills these knightly duties.

2a. Why might Launcelot have felt divided in his loyalties when he fought for King Bagdemagus? b. Which loyalty did Launcelot obviously put first? c. Why do you think he did this?

3. Malory writes that Launcelot was first among the knights of the Round Table not only in arms but in "nobility of bearing" as well. How does Launcelot show "nobility of bearing" in this selection?

4. Malory's reading public liked duels and tournaments just as people today like the action in Westerns. a. What other kinds of stories popular today are similar to these knightly adventures—in characterization as well as in plot? b. How do you account for their appeal?

5a. What aspects of these knightly stories lend themselves to parody? **b.** What parodies have you seen or read of such chivalrous tales?

Language and Vocabulary

Identifying Word Origins

After the Normans from France conquered England in 1066, French was instituted as the official language of the ruling classes in England. For two centuries, French was used in court, government, military affairs, commerce, the arts, and religion. The result is that thousands of words in English today are French in origin.

Because it was the language of the ruling classes, French was considered more "elegant" than plain English. This might be one reason why this story was called "Le Morte Darthur," instead of "The Death of Arthur." *Death* is an English word that goes back to Old Saxon; *morte* is French. You can see how strong the French influence has been when you consider all the other English words related to *morte: mortality, mortal, mortify, mortgage.*

It is interesting to look at the French influence on words used to name foods. While they were in the barnyard, animals kept their plain English names, but they became French when they were served on the table. In a dictionary, look up the derivations of the following words. Which are French in origin, and which are English? Could they be used interchangeably?

swine, pig, boar, pork, bacon
cow, beef
sheep, lamb, mutton
deer, venison
veal, calf

Focus on Comparison and Contrast

Analyzing Relevant Features

When you analyze the **relevant features** of subjects for comparison and contrast, you explore ways in which the subjects are alike as well as ways in which they are different. This kind of analysis helps you focus on the specific parts of your topic. It also helps give you a sense of the ratio or proportion of similarities to differences.

For example, if you were comparing and contrasting Malory's "Tale of Sir Launcelot du Lake" with current forms of adventure and romance, you might choose action sequences, ideals of chivalry, and the conflict of good versus evil as relevant features. You would then examine the likenesses and differences between your subjects for each feature.

Choose one of the pairs of subjects identified for comparison and contrast earlier in this unit (see **Focus** assignment on page 764), or identify a new pair of subjects. Analyze the relevant features of your subjects by making a chart like the one below. Save your notes.

	Subject 1	Subject 2
Feature 1:	_____	_____
	_____	_____
Feature 2:	_____	_____
	_____	_____
Feature 3:	_____	_____
	_____	_____

Besides the tales of King Arthur and Sir Launcelot, Sir Thomas Malory's *Le Morte Darthur* includes tales of other knights who gallop off to slay monsters, rescue women in danger, and search, as Sir Galahad does, for the Holy Grail. "The Tale of Sir Gareth," which follows, is a story of one knight's trial and adventure. Gareth's story is enlivened with touches of robust humor. As with many heroes of the Arthurian legends, Gareth is in disguise when he first appears on the scene.

The Knights Set Out to Seek the Holy Grail. Fourteenth-century Italian manuscript illumination. Ms. Fr. 343, f 8 v.
Bibliothèque Nationale, Paris

The Tale of Sir Gareth

SIR THOMAS MALORY

Retold by Keith Baines

It happened one Pentecost[1] when King Arthur and his knights of the Round Table had all assembled at the castle of Kynke Kenadonne and were waiting, as was customary, for some unusual event to occur before settling down to the feast, that Sir Gawain saw through the window three gentlemen riding toward the castle, accompanied by a dwarf. The gentlemen dismounted, and giving their horses into the care of the dwarf, started walking toward the castle gate.

"My lords," Sir Gawain shouted, "we can sit down to the feast, for here come three gentlemen and a dwarf who are certain to bring strange tidings."

The king and his knights sat down at the great Round Table, which provided seats for a hundred and fifty knights; but this year, as in most, several were vacant because their owners had either been killed in the course of their adventures, or else taken prisoner.

The three gentlemen entered the hall, and there was complete silence as they approached the king. All three were richly clothed; and the one who walked in the center was obviously young, but taller than his companions by eighteen inches, strongly built, of noble features, and with large and beautiful hands. He leaned

heavily on his companions' shoulders and did not stand up to his full height until he was confronting the king. Then he spoke:

"Most noble king, may God bless you and your knights of the Round Table! I come to ask you for three gifts, and none of them is unreasonable or such as to give you cause to repent. The first of the gifts I will ask for now, the other two at the next Pentecost."

"The three gifts shall be yours for the asking," Arthur replied.

"Sire, today I ask that you shall give me food and drink for twelve months, until the next Pentecost, when I shall ask for the other two."

"My dear son, this is a simple thing to ask for. I have never denied food and drink either to my friends or to my enemies. Can you ask for no worthier gift? For you have the appearance of a man nobly born and bred."

"Sire, for the present I ask nothing more."

"Very well, then; but ·pray tell me your name."

"Sire, that I cannot tell you."

"It is strange indeed that you should not know your name."

King Arthur then commanded Sir Kay, his steward, to serve the young gentleman with the best fare available throughout the coming year, and to treat him with the courtesy due to a nobleman.

1. **Pentecost:** a Christian festival held on the seventh Sunday after Easter.

"Sire, that is unnecessary," Sir Kay answered sourly, "for were he of noble birth he would have asked for a horse and for armor. No! he is nothing but a great loafer born of a serving wench, you may be sure. However, I will keep him in the kitchen and feed him until he is as fat as any pig, and the kitchen shall be his sty. And since he has neither name nor purpose, I shall call him Beaumains."[2]

And so Beaumains' companions duly delivered him into the charge of Sir Kay, who lost no opportunity to gibe and jeer at him. Both Sir Gawain and Sir Launcelot were deeply ashamed of Sir Kay's cavalier behavior, and Sir Launcelot spoke his mind:

"Sir Kay, take warning! Beaumains may yet prove to be of noble birth, and win fame for himself and for our liege."

Throughout the next twelve months, while Sir Kay remained irate and contemptuous, both Sir Launcelot and Sir Gawain treated Beaumains with the greatest courtesy, inviting him frequently to their quarters to dine, and urging him to accept money for his needs. With Sir Launcelot this was due to his habitually gentle nature; but with Sir Gawain it was more, for he had an unexplained feeling of kinship with Beaumains. However, Beaumains always refused them, remaining in the kitchen to work and eat with the servants, and meekly obedient to Sir Kay. Only when the knights were jousting would he leave the kitchen to watch them, or when games were played, then he participated, and by virtue of his natural strength and skill, was always the champion; and only then would Sir Kay take pride in his charge, and say: "Well, what do you think of my kitchen lad now?"

Once more the feast of Pentecost came around, and once more King Arthur and his knights waited for an unusual occurrence before sitting down to the banquet. This time a

2. **Beaumains** (bō-mănz'): in French, "Fair Hands."

squire came running into the hall, and straight up to Arthur:

"Sire, you may take your seats at the Round Table, for a lady is approaching the castle, with strange tidings to relate."

As soon as the king and his knights were seated at the table the lady entered the hall, and kneeling before Arthur, begged his aid.

"Lady, pray tell us your story," Arthur responded.

"Sire, I have a sister, of noble birth and wide dominion, who for two years has been held captive by a most audacious and tyrannical knight; so now I beseech Your Majesty, who is said to command the flower of the chivalry, to dispatch one of your knights to her rescue."

"My lady, pray tell me her name and where she lives, also the name of the knight who holds her prisoner."

"Sire, I may not reveal her name or where she lives; I can only plead that she is a lady of great worth. The knight who holds her prisoner while extorting wealth from her estates is known as the Red Knight of the Red Lands."

"Then I do not know him."

"Sire, I do!" cried Sir Gawain. "He is a knight who is said to have the strength of seven men, and I can believe it, because I fought him once and barely escaped with my life."

"My lady," said Arthur, "I can send a knight to rescue your sister only if I know her name and where she lives; otherwise you can have no help from this court."

"Alas! I thought you would not fail me; so now I must resume my search."

But then Beaumains spoke up: "Sire, for twelve months I have eaten in your kitchen; now the time has come for me to ask you for the other two gifts."

"You ask at your peril, Beaumains," said the king.

"The first is that I pursue the quest besought by this lady, for I believe that it is my appointed

one. The second, that Sir Launcelot should follow us, and when I have proved myself worthy, make me a knight, for it is only by him, who is peerless among all knights, that I should wish to be sworn into the order."

"I grant you both gifts, Beaumains."

"Sire, you shame me! To send a kitchen boy on such a noble quest! I will have none of it," said the lady, and walked angrily from the hall.

Meanwhile Beaumains' two companions and the dwarf had arrived, leading a fine charger with gold trappings, and an excellent sword and suit of armor; only a spear and shield were lacking. Beaumains armed at once and mounted; and Arthur's knights were astonished to discover him the possessor of such fine equipment and to see how nobly he bore himself, once clad in it. Beaumains returned to the hall, took his leave of Arthur and of Sir Gawain, and then set off after the lady, followed by Sir Launcelot.

Just as they were leaving the court, Sir Kay appeared, fully armed and mounted. "I too am going to follow this kitchen lout," he said grimly.

"Sir Kay, you would do better to remain here," said Sir Launcelot.

But Sir Kay was not to be dissuaded, and he galloped up to Beaumains and shouted: "Well, Beaumains, do you still recognize your master?"

"I know you for the most ungracious knight at the court, Sir Kay, so now beware!"

Sir Kay couched his spear and charged at him. Beaumains, having neither shield nor spear, drew his sword, and as Sir Kay bore down on him, made two rapid strokes. With the first he knocked the spear out of Sir Kay's grasp, and with the second lunged at Sir Kay and drove the sword into his side, wounding him deeply so that he fell to the ground as though dead.

Beaumains dismounted, took possession of Sir Kay's spear and shield, and then remounted and instructed his dwarf to take the spare horse. At this point Sir Launcelot rode up to him, and Beaumains asked if he would like to joust, to which Sir Launcelot agreed.

They drew apart and then galloped together, and the collision sent both men and horses tumbling to the ground. Recovering quickly, both drew their swords and attacked each other with the ferocity of wild boars. Sir Launcelot, who had hitherto been unmatched, was astonished at Beaumains' strength and skill, and felt as if he were fighting a giant rather than an ordinary man. Each succeeded in delivering blows that sent his opponent staggering to the ground, only to recover immediately. After a while, however, Sir Launcelot began to realize that his strength was not equal to that of Beaumains, and fearing an ignominious defeat, called a halt.

"My friend, pray hold off! for we have no quarrel," he said.

"That is true, Sir Launcelot, yet it does me good to feel your strength, though I have not yet fought to my uttermost."

"Then you are matchless: I called a halt just now for fear that I should be shamed into begging for mercy!"

"Sir Launcelot, will you make me a knight?"

"Certainly, but first you must reveal to me your true name, and of whom you were born."

"Sir, if you will pledge yourself to absolute secrecy, I will tell you."

"I shall not betray you."

"My name is Gareth of Orkney; I am Sir Gawain's brother, born of the same parents."

"Gareth, that gladdens my heart, for I guessed that you were of noble birth."

Sir Launcelot then knighted Gareth and left him. Sir Kay was still lying senseless, so he laid him on his shield and brought him to the court, where the other knights, especially Sir Gawain, taunted him without mercy. However,

Knighting on the Field of Battle. Illustration from a thirteenth-century French manuscript. Ms. Fr. 343, f 79.
Bibliothèque Nationale, Paris

Sir Launcelot excused Sir Kay on the grounds that he was young and ignorant of Beaumains' birth and of his purpose in serving in the kitchen for a year.

Sir Gareth, meanwhile, had ridden after the lady, and as soon as he caught up with her she rounded on him:

"Why do you follow me, you wretched lackey? Your clothes still stink of tallow and grease; and I know from Sir Kay that you are nameless and have to be called Beaumains, and how treacherously you overcame that excellent knight! Now leave me, I command you; have done!"

"Madame, I have come to serve you, and your words shall not deter me."

"Lewd little knave! Well, before long we shall meet a knight who will frighten you back to your kitchen quickly enough."

At this moment a man came running frantically out of the forest.

"My good fellow, what is your trouble?" asked Sir Gareth.

"My lord, six thieves have attacked my master; they have him bound and at any moment will kill him."

"Pray lead me to them."

Sir Gareth killed three of the thieves as soon as they came upon them. The other three fled, and Sir Gareth chased them until they turned about and attacked him fiercely, but before long he had killed them all. Returning to the knight, he released him from his bonds, and the knight begged Sir Gareth to accompany him to his castle, where he would be able to reward him as he deserved.

"Sir, I need no reward for doing as a knight should; and today I have been knighted by

the peerless Sir Launcelot, so I am content enough. Pray forgive me now if I return to my lady, whose quest I am pursuing."

Sir Gareth returned to the lady, and she turned on him again:

"Misshapen wretch! What pleasure do you expect me to take in your cumbrous deeds? Now leave me, get back to your kitchen, I say!"

The knight whom Sir Gareth had rescued now rode up to them both and offered them hospitality for the night. It was already dusk, and the lady accepted. At dinner she found herself sitting opposite to Sir Gareth, and protested at once: "Sir, forgive me, but I cannot possibly dine in company with this stinking kitchen knave; why, he is fit only for sticking pigs."

Thereupon the knight set Sir Gareth at a side table, and excusing himself, removed his own place there as well.

In the morning, after thanking their host, Sir Gareth and the lady resumed their journey. Soon they came to a broad stream, and on the further bank were two knights.

"Now," said the lady, "I think you had better fly, and save your bacon."

"My lady, were there six knights, I should not fly."

The first of the knights and Sir Gareth galloped their horses into the stream, and both broke their spears as they collided. They drew their swords, and soon Sir Gareth stunned his opponent with a blow on the helmet, and he fell into the water and was drowned. Urging his horse through the stream, Sir Gareth met the second knight on the far bank; and again

Jousts of St. Inglevert from Froissart's *Chronicles,* fourteenth-century manuscript. In May, 1390, English knights went to St. Inglevert to tilt with three French champions. Ms. Fr. 2646, f 43 v.

Bibliothèque Nationale Service Photographique, Paris

both spears were broken, and again Sir Gareth struck his opponent on the helmet, this time with a blow that killed him outright.

"It is strange," said the lady when Sir Gareth had joined her once more, "that fortune should favor so vile a wretch as you. But do not suppose for one moment that it was either by skill or daring that you overcame those two excellent knights. No, I watched you closely. The first was thrown into the water by his horse stumbling, and so unhappily drowned. The second you won by a cowardly blow when he was not expecting it. However, had you not better turn back now? For the next knight we meet will certainly cut you down without mercy or remorse."

"My lady, I shall not turn back. So far I have fought with such ability as God gave me, and trusting in His protection. My only discouragement has been your own extraordinary abuse."

All day they rode together, and the lady's villainous tongue never ceased to wag. In the evening they came to the Black Land. By a black hawthorne on which was hung a black shield, and by the side of which was a black rock, stood a black standard. Under the tree stood a knight in black armor, who was Knight of the Black Lands.

"Now fly," said the lady to Gareth, "for here is a knight before whom even the brave might tremble."

"I am not a coward, my lady."

"My lady!" shouted the Black Knight, "are you come with your champion from King Arthur's court?"

"Sir, unhappily not! This ill-gotten lout has pursued me from King Arthur's kitchen, and continues to force his odious presence upon me. Purely by mischance, and by treachery, he has overcome a few knights on the way; but I beg you to rid me of him."

"My lady, that I will happily do. I thought for a moment that since he was accompanying you, he must be of noble birth. Now let us see: it would be degrading to fight him, so I will just strip him of his armor and horse, and then he can run back to his kitchen."

"Sir, I shall pass through this country as it pleases me, and whether you will or no. It appears that you covet my horse and my armor. Very well, let us see if you can win them! Now—defend yourself!"

And with that, both knights, in a black rage, galloped thunderously at each other. Both broke their spears, but while Sir Gareth was unharmed, the point of his own spear was embedded deeply in the body of his opponent. They fought with their swords, and for an hour and a half the Black Knight held out, but then he fell dead from his horse.

Noticing the fine quality of the Black Knight's armor, Sir Gareth stripped him of it, and exchanged it for his own. He then remounted and joined his lady.

"Alas! the lackey still lives. Shall I never be rid of him? Tell me, cockroach, why do you not run off now? You could boast to everyone that you have overcome all these knights, who, entirely through misfortune, have fallen to you."

"My lady, I shall accompany you until I have accomplished my quest or died in the attempt. This, whether you will or no."

Next they came upon the Green Knight, clad in green armor, who, seeing Sir Gareth's black armor, inquired if it were not his brother, the Black Knight.

"Alas! no," the lady replied. "This is but a fat pauper from King Arthur's kitchen, who has treacherously murdered your noble brother. I pray you, avenge him!"

"My lady, this is most shameful; certainly I will avenge him."

"This is slander," said Sir Gareth. "I killed him in fair combat; so now defend yourself!"

The Green Knight blew three times on his horn, and two maids appeared, who handed him his green spear and green shield.

They jousted and both broke their spears, then continued the fight with swords, still on horseback, until Sir Gareth wounded his op-

It Hung upon a Thorn and There He Blew Three Deadly Notes. Illustration by N. C. Wyeth (1882–1945) for *The Boy's King Arthur* (1917). Oil on canvas. Private Collection.

ponent's horse and it collapsed under him. They both leaped clear and resumed the fight on foot. The Green Knight was powerful, and both were soon liberally wounded. At last the lady spoke up:

"Why, sir, for shame! Does it take so long to dispatch a mere scullery boy! Surely you can finish him off; this is the weed overshooting the corn!"

The Green Knight, deeply ashamed, redoubled his blows, and succeeded in splintering Sir Gareth's shield. Sir Gareth then exerted his full strength, and striking his opponent on the helmet, sent him reeling to the ground, where he unlaced his helmet in order to behead him; and the Green Knight cried for mercy.

"Mercy you shall not have, unless this lady pleads for you," Sir Gareth replied.

"And that I should be beholden to a servant? Never!" the lady replied.

"Very well, sweet lady, he shall die."

"Not so fast, knave!"

"Good knight, I pray you, do not kill me for want of a good word from the lady. Spare me, and not only shall I forgive you the death of my brother, but I will myself swear you allegiance, together with that of the thirty knights at my command."

"In the devil's name! The Green Knight and his thirty followers at the command of a scullery boy! For shame, I say!"

For answer, Sir Gareth raised his sword, and made as if to behead the Green Knight.

"Hold, you dog, or you will repent it!" said the lady.

"My lady's command is a pleasure, and I shall obey her in this as in all things; for surely I would do nothing to displease her."

With that Sir Gareth released the Green Knight, who at once swore him homage.

The two knights and the lady rode to the Green Knight's castle, and as ever, the lady unbridled her flow of invective against Sir Gareth, and once more refused to dine at the same table with him. The Green Knight removed both his own and Sir Gareth's places to a side table, and the two knights ate merrily together. Then the Green Knight addressed the lady:

"My lady, it astonishes me that you can behave in such unseemly fashion before this noble knight, who has proved himself worthier than I—and believe me, I have encountered the greatest knights of my time. He is surely rendering you an honorable service, and I warn you that whatever mystery he pretends concerning his birth, it will be proved in the end that he is of noble, if not royal, blood."

"My lord, you make me sick," the lady responded.

Before retiring to their chambers, the Green Knight commanded thirty of his retainers to watch over Sir Gareth while he slept, and to be on their guard against treachery.

In the morning, after Mass and breakfast, the Green Knight accompanied Sir Gareth and the lady through the forest, and when he came to take leave of them, spoke to Sir Gareth:

"Noble knight, please remember that I and my thirty knights are sworn to your service, to command when you will."

"Sir, I thank you; when the time comes, I shall request you to make your allegiance to King Arthur."

"Sir, we shall be ready at all times," said the Green Knight.

"For shame! For shame!" cried the lady.

They parted, and then the lady spoke to Sir Gareth:

"Now, you greasy knave, surely you have run to the end of your leash. Ahead of us lies the Passage Perelous, and it would take a trueborn knight, and one of the quality of Sir Launcelot, Sir Tristram, or Sir Lamerok, to pass through this stage of the journey without losing courage. And so I advise you to run for it now!"

Peasants harvest grapes in the fields before the Duc de Berry's castle at Saumur. Manuscript illumination.

Musée Condé, Chantilly

the castle, seeing Sir Gareth approach with the lady and his dwarf, decided to challenge him, so he clad himself in puce[4] armor, for he was the Puce Knight, and then rode out to meet them.

"Sir, are you not my brother, the Black Knight?" he asked.

"Sir, indeed he is not. He is a nameless servant from King Arthur's kitchen, called Beaumains. Purely by treachery and mischance he has killed your brother the Black Knight, and obtained the allegiance of your excellent brother the Green Knight. I beg you to avenge them, and rid me of his odious presence once and for all."

"My lady, it shall be done," the Puce Knight replied.

They jousted and both horses collapsed, and they continued the fight on foot. After two hours the lady could contain herself no longer:

"Sir, for shame that you should dally so long with a mere scullery boy. Pray do me the goodness to finish him off."

The Puce Knight was duly ashamed, and redoubled his strokes, but to no avail; for Sir Gareth, using only a little more strength, struck him to the ground, then, straddling him, dragged off his helmet to behead him. The Puce Knight pleaded for mercy.

"Mercy you shall not have unless my lady pleads for you."

"Leave him be, Beaumains; he is a noble knight," said the lady.

"Then, my lady, he shall thank you for his life," said Sir Gareth.

The Puce Knight rose, and begged them to accept hospitality in his castle for the night. The lady accepted and that evening they dined well and then went to bed; but as ever she continued to abuse Sir Gareth. Distrusting her, the Puce Knight commanded his sixty knights

"Perhaps, my lady, I shall not run," Sir Gareth replied.

They were approaching a castle comprising a fine white tower, surrounded by machicolated walls[3] and double ditches. Leading up to the gate was a large jousting field, with a pavilion in process of erection for a coming tournament; and hung above the gate were fifty shields bearing different devices. The lord of

3. **machicolated** (mə-chĭk′ə-lāt′ĭd) **walls:** castle walls with openings (machicolations) through which stones or hot liquids could be dropped upon attackers.

4. **puce** (pyo͞os): brownish purple or dull red.

to keep watch over him while he slept. In the morning, after hearing Mass and breakfasting, the lady and Sir Gareth took leave of their host; and before parting the Puce Knight swore his allegiance, and that of his sixty knights, to Sir Gareth, who, as before, said that in due course he would require him to make his allegiance to King Arthur.

They resumed their journey, and by noon had come in sight of a beautiful city. Before it stretched a plain, the grass was newly mown, and many splendid pavilions had been erected. But one in particular caught the eye, being the color of indigo, and arranged about it were armor and equipment of the same color; so also were the adornments of the ladies who passed to and fro.

"Yonder lies the pavilion of Sir Persaunte, the Indigo Knight, and lord of this city. But for one, he is the greatest knight living, and when the weather is good he pitches his pavilions on the plain and spends his time in jousting and tournaments, and other pastimes suitable to the nobility. He has at his command a hundred and fifty knights, and it is his custom to challenge every knight who passes through his terrain. And so now, filthy knave, had you not better think twice and flee, before Sir Persaunte chastises you with the ignominy that you deserve?"

"My lady, if he is noble, as you say he is, he will not dispatch his knights to murder me, but fight with me in single combat; and if he has won honor as you say he has, the greater glory will be mine if I overcome him. Before each combat you yourself chasten me with your abuse; and after each you deny flatly what I have truly accomplished, distorting the event so that it serves only to augment the hatred you bear me!"

"Sir, your courteous speech and brave deeds astound me. I have with my own eyes witnessed what you have already accomplished, and I am becoming convinced that you must indeed be of noble birth. But this time I would save you, so please offer no challenge to the Indigo Knight, for both you and your horse have already suffered much in your previous combats. Up to now we have come safely through this difficult journey, but here we are within seven miles of the castle where my sister is held captive; and to combat the knight who holds her, you will need all your strength, for his is seven times that of ordinary men."

"My lady, I should be ashamed to withdraw from combat with the Indigo Knight now; but with God's grace, we shall be able to continue our journey in two hours."

"Ah Jesu!" exclaimed the lady. "Worthy knight, you must indeed be of noble blood to have borne for so long and with such courtesy the terrible way in which I have reviled you."

"My lady, it would be an unworthy knight indeed who was unable to bear the chastisement of a lady. The anger your insults inspired in me I turned against my opponents, and so overcame them more readily. Always have I been determined to prove my own worth: I served in King Arthur's kitchen in order to discover who were my true friends, and who my enemies. What my blood may be shall be revealed in due course; but at present I wish to prove myself by my deeds alone. And so, my lady, I shall continue to serve you as I have already."

"I beg you, gentle knight, can you forgive me my terrible words?"

"My lady, you are forgiven; and if formerly anger made me strong, may joy now make me invincible!"

Meanwhile, the Indigo Knight had seen Sir Gareth and the lady approach, and sent a messenger to inquire whether they came in war or in peace. Sir Gareth replied that he offered a challenge only if the Indigo Knight wished to receive one. The Indigo Knight decided to

accept the challenge and fight to his uttermost, so he mounted and rode out to meet Sir Gareth.

They charged at each other with equal determination, and both broke their spears into three pieces, while their horses tumbled to the ground.

The sword fight lasted for two hours, and in the course of it Sir Gareth wounded the Indigo Knight deeply in the side; however, he continued to fight bravely. At last, though somewhat loath because of his opponent's bravery, Sir Gareth delivered his crushing blow on the helmet, and the Indigo Knight was sent spinning to the ground. Once more Sir Gareth straddled his opponent and unlaced his helmet to behead him, and the Indigo Knight yielded. The lady at once begged that Sir Gareth should spare his life.

"My lady, that I will gladly do, for he is a noble knight."

"May God reward you!" said the Indigo Knight. "Now I understand well enough how it was that you killed my brother Sir Perarde the Black Knight, and won the allegiance of my other two brothers, Sir Pertolope the Green Knight and Sir Perymones the Puce Knight."

Sir Persaunte then led Sir Gareth and the lady to his pavilion, where he refreshed them with wine and spices, and insisted that Sir Gareth should rest both before and after supper.

In the morning Sir Persaunte asked the lady where she was leading Sir Gareth.

"To the Castle Dangerous."

"Ah ha! that is where the Red Knight of the Red Lands lives, and holds the Lady Lyoness prisoner, is it not? But tell me, you are surely her sister, Lady Lynet?"

"Sir, that is my name," the lady replied.

"Well, sir, you must prepare yourself for an ordeal, for it is said that the Red Knight has the strength of seven ordinary men. But you will be fighting for a worthy cause, for this knight has held the Lady Lyoness prisoner for two years now. He has been waiting for a challenge from one of four knights from King Arthur's court: Sir Launcelot, the most powerful of all, Sir Tristram, Sir Gawain, or Sir Lamerok. And although many other knights have achieved much fame—for example, Sir Palomides, Sir Safere, Sir Bleobris, Sir Blamoure, Sir Bors, Sir Ector, Sir Percivale, and so on—it is one of these four he wishes to fight. So, now, let me wish you God's speed, and strength for the coming battle."

"Sir Persaunte, would you have the goodness of heart to make my companion a knight? It would please me greatly to see this done before he fights the Red Knight of the Red Lands."

"My lady, I will gladly, if he will accept the order from so simple a man as I."

"Sir, I thank you for your gracious offer, but I have already been knighted by Sir Launcelot, for I wished it to be from no other hands than his. And if you will both swear to keep the secret, I will now reveal to you my name, and of whom I was born."

"We swear," they said together.

"I am Sir Gareth, Sir Gawain's brother, and the youngest son of King Lot of Lowthean and Orkney; my mother is Margawse, King Arthur's sister. But neither King Arthur, Sir Gawain, nor any other at his court, with the exception of Sir Launcelot, knows who I am."

In the morning, after Mass and breakfast, Sir Gareth and the lady rode through the forest, and then across a wide plain, to the Castle Dangerous, which stood on the seashore. The Red Knight had pitched his pavilions beneath the walls of the castle, and to one side Sir Gareth noticed a copse of tall trees, and from the branches hung forty knights. They were in full armor, with their swords in their hands, shields, and spurs at their heels. Sir Gareth was horrified.

"Tell, my lady, what is the meaning of this?"

"Sir Gareth, those are the knights who hitherto have attempted to rescue my sister, so take heed! The Red Knight is a formidable warrior, and lord of many marches,[5] but once he has overcome a knight in battle, he always puts him to this murderous end; and that is one reason why no gentlewoman can love him."

"May Jesu preserve me from such a death! Certainly I should prefer to die fighting. But how strange that no knight from King Arthur's court has yet defeated him!"

"My lord, take courage; he is a powerful knight."

The castle moats were formed by two dikes which ran around from the sea. Several ships were at anchor and everywhere were signs of activity. On board the ships, in the Red Knight's pavilions, and from within the castle could be heard the merry sounds of minstrelsy,[6] while lords and their ladies walked upon the castle walls. Just by the gate grew a large sycamore tree, and on this was hung an elephant's horn for those who wished to challenge the Red Knight. Sir Gareth was about to blow it when the lady cautioned him:

"Sir Gareth, do not sound your challenge yet. Until noon the Red Knight's strength increases, after then it wanes, so if you will wait for a little the advantage will be yours."

"My lady, I should be ashamed not to challenge him at his greatest strength." And with that Sir Gareth blew a tremendous blast on the horn.

Immediately knights and ladies came running from all directions, to the castle walls and windows, or out of their pavilions, in order to witness the coming battle. The Red Knight hastily armed, assisted by his earls and barons. One of them laced on his helmet while another

5. **marches:** borderlands.
6. **sounds of minstrelsy:** music (sounds made by minstrels, or musicians).

buckled on his spurs and a third handed him his blood-red shield and spear. He then mounted, rode out to a small hollow which could be easily viewed from the castle, and awaited his challenger.

"My lord, here comes your mortal enemy, and at the tower window stands your lady."

"Pray, tell me where," asked Sir Gareth.

The lady pointed with her finger, and Sir Gareth looked up and saw a lady whose beauty filled him with awe. She curtsied to him, and then held out her hands in supplication.

"Truly, she is the most beautiful lady on earth. My quarrel could not be better chosen," he said.

"Sir, you may cease looking at the lady, and look to your arms instead. She is not for you,

Jousts in London from Froissart's *Chronicles*, a fifteenth-century French manuscript. Ms. Fr. 2646, f 92v.
Bibliothèque Nationale, Paris

nor shall she be," said the Red Knight grimly.

"Sir, it would seem that although you hold the lady, she is not yours, and therefore your love for her is nothing but folly. Now that I have seen her and I know that I love her, by the grace of God, I shall win her for myself."

"Sir, are you not warned by the array of corpses hung from the trees—your predecessors, who spoke as you do?"

"No, I am not. Rather am I filled with anger and contempt, and understand well why the lady does not love you. And for myself, I wish only to fight you to the death and put an end to your murderous ways. Nor shall I feel any of that remorse in overcoming you which I have felt in the past for more honorable opponents."

"Sir, make ready—enough of your words!"

They jousted, and both crashed to the ground with such violence, and lay stunned for so long, that the onlookers supposed that they had broken their necks. However, they recovered, and drawing their swords, chopped at each other with heavy, deliberate blows, beneath which one or the other would occasionally stagger. So they fought until well past noon, when they paused for a moment to recover their breath. Both were streaming with blood from their wounds, panting, and momentarily exhausted as they leaned on their shields.

Beneath the steady rain of blows their shields were chipped and their armor and mail had given way in many places; and Sir Gareth soon learned, to his cost, to defend them from the shrewd blows of his opponent. Several times one or the other fell to the ground, half stunned by a blow, whereon the other would leap on top of him; and more than once in the ensuing scuffle they exchanged swords.

At eventide they agreed to rest, and sat on two molehills while their pages unlaced their helmets so that they should be refreshed by the cool breeze. Sir Gareth looked up to the tower, and seeing the lady, was inspired with fresh courage:

"Sir, let us continue; to the death!"

"To the death!" the Red Knight responded.

Despite their many wounds, they continued the fight with fresh vigor, until with two skillful blows the Red Knight first knocked the sword from Sir Gareth's hand, and then sent him spinning to the ground. Leaping on top of him, the Red Knight started unlacing his helmet, when suddenly Lady Lynet cried out:

"Alas! Sir Gareth, your lady weeps with despair, and my own heart is heavy."

Sir Gareth responded with a tremendous thrust of his body and succeeded in overturning his opponent, then, reaching swiftly for his sword, confronted him once more. A new and desperate battle ensued, as each strained to the limits of his strength to overmatch the other. Then it was Sir Gareth who sent his opponent's sword flying from his hand, and following it up with a hail of blows on the helmet, knocked him senseless to the ground, where he sprang on top of him. He had just unlaced his helmet to behead him when the Red Knight cried aloud:

"Most noble knight, I beg for mercy!"

"Sir, how can I honorably spare you, when you have murdered so many courageous knights who yielded to you?"

"Sir, there was a reason for that, if you will only allow me to tell you."

"Speak on."

"Once I loved a lady whose brethren had all been killed by Sir Launcelot or Sir Gawain; and it was at her bidding that I fought with every knight who passed this way from King Arthur's court, and hung by the neck those whom I overcame. And to this day I have been waiting for either Sir Launcelot or Sir Gawain to mete[7] her final revenge. And to accomplish

7. **mete:** dole out.

Beaumains shown defeating the Red Knight, an illustration by Arthur Rackham (1867–1939) for *The Romance of King Arthur and His Knights of the Round Table* (1917).

this purpose, I have been enchanted, so that each day my strength increases until noon, when it is seven times that of other men, after which it wanes again."

Meanwhile the Red Knight's earls and barons had gathered round, and now they threw themselves on their knees and begged Sir Gareth to spare him:

"Sir, surely nothing can be gained by his death, nor can the dead be brought to life again. But spare him and he shall pay you homage, and learn to atone for his misdeeds."

"My lords, for your asking I will spare the Red Knight; and in my heart I can find some room for forgiveness, since what he did was at his lady's bidding. But these are my conditions: that first he shall yield to Lady Lyoness, making full redress for the damage done to her, and then go to King Arthur's court and yield to Sir Launcelot and Sir Gawain, confessing his enmity toward them."

"Sir, I thank you, and will most certainly fulfill your conditions."

For the next ten days, the Red Knight entertained Sir Gareth and the lady in his pavilion, where the lady treated their wounds. Then, in accordance with his oath, he first yielded to Lady Lyoness and then rode to King Arthur's court, where, in the presence of all, he yielded to Sir Launcelot and Sir Gawain, recounting fully his own misdeeds and defeat at the hands of Sir Gareth, whose progress through the Passage Perelous he also described.

"I wonder," said Arthur, "of whose blood he was born, for certainly he has proved himself a noble knight since he ate in our kitchen."

"Sire, it is no marvel, for such courage and endurance as his surely stem from noble blood," said Sir Launcelot.

"Sir Launcelot, it would seem that you already know the secret of his birth?"

"Sire, I must admit that I do. I demanded

to know before making him a knight, but I have been sworn to secrecy."

Sir Gareth, meanwhile, had asked Lady Lynet if he could not see her sister.

"Sir, most certainly you shall," she replied.

Sir Gareth armed and mounted and rode toward the castle, but as he did so, he was astonished to see the gate being closed and the drawbridge raised. Then Lady Lyoness spoke to him from one of the castle windows:

"Go your way, good knight, for you shall not have my love until you have won further fame; therefore you must strive for another year. Return to me then, and I will tell you more."

"My lady, I had not expected such thanks from one for whom I have already striven so hard, and for whom, alas! I was willing to shed the last drop of my blood."

"Worthy knight, be assured that I love you for your brave deeds, and go forth with a glad heart. Soon the twelve months will pass, and, in the meantime, do not doubt that I shall be faithful to you."

Sir Gareth rode into the forest, bitterly unhappy and careless of direction, his dwarf following. That night he lodged in a humble cottage, but was unable to sleep. He continued his aimless journey all the next day, and that night came to a marsh where, feeling sleepy, he lay on his shield, while his dwarf watched over him.

As soon as Sir Gareth had ridden into the forest, the Lady Lyoness had summoned her brother, Sir Gryngamour.

"My dear brother, I need your help. Would you ride after Sir Beaumains, and when you find an opportunity, kidnap his dwarf? I am in difficulties because I do not know whether or not Sir Beaumains is of noble birth, and until I know, naturally, I cannot love him. But I feel certain that we can frighten his dwarf into telling us."

Sir Gryngamour prepared to do as his sister

asked, and cladding himself entirely in black armor, and mounting a black horse, followed them faithfully until they came to the marsh. Then, as soon as Sir Gareth was asleep, he crept up on the dwarf, seized him suddenly, and tucked him under his arm. However, the dwarf roared lustily, and Sir Gareth awoke in time to see him disappearing in the arms of a black knight.

Arming himself hastily, Sir Gareth mounted and pursued them as best he could, but with great difficulty, owing to his ignorance of the lay of the land. All night he rode across wild moors, over steep hills, and through dense forest, and frequently his horse stumbled, nearly throwing him. But at dawn he came to a woodland path, and seeing a forester, asked him if he had seen a black knight riding that way, with a dwarf behind him.

"Sir, I have. It was Sir Gryngamour, whose castle lies two miles further on. But I should beware of him, for once provoked he is a dangerous enemy."

Meanwhile Sir Gryngamour had taken the dwarf to his castle, where Lady Lyoness was cross-examining him.

"Dwarf, we wish to know the secret of your master's birth; and if you would prefer not to starve in the castle dungeon, you had better tell us. Who was his father, and who his mother, and whence does he come?"

"My lady, I am not ashamed to tell you that my master is Sir Gareth, the son of King Lot of Orkney and Queen Margawse, King Arthur's sister. Furthermore he is such a knight that he will soon destroy your lands and bring this castle tumbling about your ears if you do not release me."

"As for that, I think we need not trouble ourselves," said Lady Lyoness. "But let us go now and dine."

In honor of his sister's visit, Sir Gryngamour had ordered a splendid banquet, so they all sat down and dined merrily.

"My dear sister," said Lady Lynet, "you know I can well believe that your paramour is of noble birth, for throughout our journey through the Passage Perelous, in scorn of what I assumed to be his low birth, I taunted him unmercifully, and never once did he rebuke me. And certainly, as you yourself have witnessed, his feats at arms are unexampled."

At this moment Sir Gareth rode up to the castle gate with his sword drawn, and shouted in a tremendous voice:

"Sir Gryngamour, treacherous knight that you are, deliver my dwarf to me at once."

"Sir, that I shall not," Sir Gryngamour replied through the window.

"Coward! Come out and fight for him, then."

"Very well," Sir Gryngamour said.

"My dear brother, not so fast!" said Lady Lyoness. "I think Sir Gareth could have his dwarf. Now that I know who he is, I can love him, and certainly I am indebted to him for releasing me from the Red Knight. Therefore let us entertain him, but I shall disguise myself so that he will not know me."

"My dear sister, just as you wish," said Sir Gryngamour, and then to Sir Gareth: "Sir, I beg your pardon for taking your dwarf. Now we know that your name, as well as your deeds, commends you, we invite you to accept hospitality at the castle."

"And my dwarf?" Sir Gareth shouted.

"Most certainly you shall have him," Sir Gryngamour replied; and then, accompanied by the dwarf, he went to the castle gate and, taking Sir Gareth by the hand, led him into the hall, where his wife welcomed him.

"Ah, my good dwarf, what a hunt I have had for you!" said Sir Gareth.

Presently Lady Lynet appeared with her sister, who had dressed in all her finery, and disguised herself as a princess. Minstrels were summoned, and amid dancing and singing

Lady Lyoness dressed in her finery, an illustration by Arthur Rackham.

Lady Lyoness set out to win the love of Sir Gareth. She succeeded, and was herself enraptured by him, so that before long ardent looks and tender words passed between them. Sir Gareth was completely deceived by her disguise, and several times wished secretly to himself that his paramour at the Castle Dangerous were as beautiful and as gracious.

At supper neither of the young lovers could eat, both being hungry only for the looks and words of the other. Sir Gryngamour noticed this, and after supper took Lady Lyoness aside and spoke to her:

"Dear sister, it appears that you love the young Sir Gareth, and certainly his noble blood and valor commend him. If you wish to pledge yourself to him, and I could think of none worthier, I will persuade him to stay at my castle."

"Dear brother, not only is what you say true, but also I am beholden to him more than to any man living."

Then Sir Gryngamour went to Sir Gareth and spoke to him:

"Sir, I could not but observe the semblance of love between you and my sister; and if this should be founded on true feeling on your part, as it is on hers, I should like to welcome you to stay in my castle for as long as it please you."

"Sir, you make me the happiest man on earth; I thank you."

"Good! Then that is arranged; and I can promise you that my sister will be here to entertain you, both day and night."

"Sir, again I thank you. In fact I have sworn to remain in this country for twelve months, and your castle has the advantage that should King Arthur, my liege, wish to find me, he will be able to do so readily."

Sir Gareth returned to Lady Lyoness, and she now revealed to him her true identity, and admitted that it was at her instigation that his dwarf had been kidnapped, so that she could discover the secret of his birth before declaring herself. Sir Gareth was overjoyed, and there followed an exchange of vows.

At Pentecost, each of the knights whom Sir Gareth had overcome went to Caerleon to surrender to Arthur: Sir Pertolope, the Green Knight, with his fifty retainers; Sir Perymones, the Puce Knight, with his sixty retainers; Sir Persaunte, the Indigo Knight, with his hundred and fifty retainers; and Sir Ironside, the Red Knight, with his five hundred retainers.

Arthur's amazement grew as each of the brothers in turn related how he had been overcome by the knight called Beaumains; also Ar-

thur was delighted, for the five brothers had been among his most implacable enemies. Then he noticed that Sir Perarde, the Black Knight, had not come, and the Green Knight went on to describe how Beaumains had killed him in combat; also the two brothers, Sir Arnolde and Sir Gerarde le Brewse, whom Beaumains had killed at the river. The death of the Black Knight was regretted by all, and Arthur promised to make the four remaining brothers fellows of the Round Table as soon as Sir Beaumains returned.

The whole company now sat down to enjoy the banquet, but no sooner were they seated than Queen Margawse of Orkney arrived, attended by her royal suite. Her sons—Sir Gawain, Sir Aggravayne, and Sir Gaheris—at once left their places and knelt down to receive her blessing, as none of them had seen her for twelve years.

When all were seated once more, Queen Margawse inquired after her youngest son, Sir Gareth, and told Arthur frankly that word had reached her that he had been kept in the kitchen for a year in the charge of Sir Kay, who had dubbed him Beaumains and treated him with the utmost disrespect.

It was now clear to Arthur that Beaumains was none other than Sir Gareth, and so he described to his sister how Sir Gareth had come without revealing his identity and asked for the three gifts: to eat in his kitchen, to pursue the quest of Lady Lyoness, and to be knighted by Sir Launcelot.

"Dear brother," said Queen Margawse, "I can well believe it of him, for even as a child he always displayed a remarkable wit, and was wont to go his own way. And perhaps Sir Kay's scornful name is not so inept after all, for certainly since he was knighted he has won great honor by the use of his hands. But now how shall we find him again?"

"I pray you, let me go in search of him,"

cried Sir Gawain, "for I too was in complete ignorance of the fact that he was my brother."

"I think that will not be necessary," said Sir Launcelot. "Surely our best plan would be to send for Lady Lyoness, who is certain to know his whereabouts."

On Michaelmas Day[8] the Archbishop of Canterbury married Sir Gareth to Lady Lyoness and, at Arthur's request, Sir Gaheris to Lady Lynet (or Lady Saveage), and Sir Aggravayne to their niece, Lady Lawrell. When the triple wedding was over, the knights whom Sir Gareth had overcome arrived with their followers to swear him allegiance.

8. **Michaelmas** (mĭk′ĕl-məs) **Day:** feast of the archangel Michael, held on September 29.

Reading Check

1. What gift does the young stranger ask of King Arthur?
2. Why does Sir Kay assume that the young man is of inferior birth?
3. Which two knights befriend Beaumains?
4. What request does Beaumains make at the second feast of Pentecost?
5. What secret does Beaumains entrust to Launcelot?
6. What is the result of Sir Gareth's battle with the Green Knight?
7. Why does Gareth spare the Puce Knight?
8. At what point does the lady show a change in attitude toward Gareth?
9. Where is the Lady Lyoness being held prisoner?
10. Why does the Lady Lyoness ask her brother to kidnap the dwarf?

The Tale of Sir Gareth **793**

For Study and Discussion

Analyzing and Interpreting the Selection

1. According to the code of chivalry, a knight was expected at all times to be courteous. **a.** How do Launcelot and Gawain fulfill this requirement by their treatment of Beaumains? **b.** How does Kay show himself, by his treatment of Beaumains, to be unchivalrous?

2. Even as a mere scullery boy, Beaumains demonstrates abilities that hint at his true identity. What noble traits of character and physical prowess does the young Beaumains exhibit?

3. One aspect of medieval society pictured in this tale is the sharp division that existed between social classes. The upper class, made up of knights, ladies, and royalty, was the master of the lower class, made up of common working people. Socializing and marriage between classes was almost never allowed. How is this division between classes illustrated by the attitudes of Sir Kay, Lady Lynet, and Lady Lyoness toward Beaumains?

4a. What other stories or films can you name in which the hero or heroine disguises his or her true identity? **b.** Why do you think this kind of story has such wide appeal?

5. What is comic about this old story?

Literary Elements

The Medieval Romance

Malory's tales are **romances,** a form of literature popular throughout Europe during the Middle Ages. Certain features characterize the medieval romance:

1. A romance is about the adventures of knights and the institution of chivalry. Romances are concerned with the exploits of kings, queens, and knights—not with common, ordinary people.
2. A romance does not take place in a realistic setting, but in idealized worlds—in imaginary castles, gardens, and forests. (No one in a romance has to worry about the price of potatoes or catching a cold.)
3. A romance contains mysterious, magical, and supernatural events.
4. A romance hero or heroine is braver, nobler, and more honorable than an ordinary human. Often the hero or heroine has the use of magic or other extraordinary powers.
5. A romance hero or heroine will often put on a lowly disguise to conceal his or her true identity.
6. A romance hero or heroine is often motivated by romantic love.
7. A romance pits the forces of good against the forces of evil.

Look back at the two excerpts you have just read from Malory's *Le Morte Darthur.* See if you can find examples in the text of each of these characteristics.

Some of these characteristics of the medieval romance survive even today. Perhaps you can name some present-day stories or movies that reflect the qualities of a medieval romance.

Language and Vocabulary

Reading Midland Dialect

When Sir Thomas Malory wrote the story of King Arthur, he used the language spoken by the people of London during the fifteenth century. These people spoke a form of Midland dialect. For several centuries before Malory's time, English was divided into several dialects. By writing in the Midland dialect, Malory helped that dialect become the basis for modern English.

William Caxton, the first Englishman to use the new printing press, published an edition of *Le Morte Darthur* in 1485. Here is a sample of Malory's prose as Caxton printed it.

It befel in the dayes of Vther Pendragon when he was kynge of all Englond/and fo regned that there was a myȝty duke of Cornewaill that helde warre ageynft hym long tyme/ And the duke was called the duke of Tyntagil/ and fo by meanes kynge Vther fend for this duk/

Read this paragraph aloud, if you can. Then try to rewrite it in modern English. Note that the writers of the Midland dialect used an alphabet somewhat different from ours. They wrote a *v* for *u,* f for *s,* and a *ʒ* for *gh.*

Writing About Literature

Explaining the Idea of Chivalry

These two selections by Malory give an ideal picture of chivalry. The idea of chivalry was developed in France as a code of conduct for horse soldiers, or cavalry. Chivalry in practice did not always work as ideally as Malory pictures it. Malory's tales, however, do give the modern reader a good idea of the civilizing goals that chivalry stood for. The idea of chivalry was kept alive even after the medieval world vanished, and was glorified in the works of later writers such as Edmund Spenser, Sir Walter Scott, and Alfred, Lord Tennyson.

Drawing upon what you have learned from these tales by Malory, write a short essay in which you explain what you think chivalry meant. If you wish to look further into the subject, refer to an encyclopedia or history book. Tell which aspects of chivalry, if any, you think are still alive today. Which aspects of chivalry do you think are gone forever?

Focus on Comparison and Contrast

Developing a Thesis Statement

The **thesis statement** of a comparison/contrast essay identifies your subjects and presents your main idea. In your thesis statement you can emphasize similarities, differences, or both. For example, a thesis statement for an essay comparing Malory's style with that of T. H. White might emphasize both the similarities and the differences in the two authors' uses of humor: "Both Malory and White employ humor in their Arthurian narratives, but each author has his own distinctive repertory of humorous techniques."

Review the chart made for a pair of subjects earlier in this unit (see page 774), or choose a new pair of subjects and make a chart to analyze their relevant features. Evaluate the relative importance of similarities and differences between the subjects. Then write a thesis statement of one or two sentences for an essay of comparison and contrast. Save your notes.

About the Author

Sir Thomas Malory (?–1471)

Sir Thomas Malory, who led an adventurous life but apparently not a chivalrous one, has been the subject of considerable research. Modern scholars have been able to piece together a number of the facts of his life. They have found, for example, that he was a knight who fought in the Hundred Years' War in France, and that he was a member of the British Parliament in 1445.

The greatest impact on Malory's life came from the series of disastrous civil wars fought from 1455 to 1485 between the supporters of the two great families that claimed the right to rule all of England, the House of Lancaster and the House of York. Malory was caught up in the violence of this political conflict. In 1451 he was imprisoned for a long list of offenses. Though he escaped twice, he spent the last years of his life in prison, and there, in 1469–1470, he compiled *Le Morte Darthur.*

Each age has read its own concerns into the King Arthur legend, and a main concern of Victorian England—Tennyson's England—was morality. It is not surprising, then, that when Tennyson wrote about Arthur in *Idylls of the King,* he told the story as the rise and fall of a moral hero and of a moral idea.

In Tennyson's version of the legend, as in Malory's, the fall of the Round Table begins when the love between Launcelot and Guinevere is discovered. For Tennyson, this disloyal love is a destructive force that undermines the high moral standards of Arthur's court. How can others keep the faith, Tennyson asks, if the noblest man and woman do not? The knights begin to quarrel among themselves, and Arthur's nephew, Sir Modred, plots to overthrow him. Launcelot and Guinevere are forced to flee, he to his castle in France and she to a convent. Arthur is challenged by the rebel Modred and goes forth to meet him in his last great battle.

This selection takes up the story after Arthur's battle with Modred. All the knights of the Round Table have been killed except the faithful Sir Bedivere. Arthur has killed Modred in combat but has himself been mortally wounded. Close to death, Arthur is moved by Bedivere to a chapel near a lake. The selection begins when Arthur commands Sir Bedivere to take his sword Excalibur and throw it into the water. This brilliant sword had been given to Arthur by a magical Lady of the Lake.

Detail from *The Spirit of War* (1851) by Jasper Francis Cropsey (1823–1900).
Oil on canvas.
National Gallery of Art, Washington, Avalon Fund

The Passing of Arthur

ALFRED, LORD TENNYSON

"Thou therefore take my brand° Excalibur,
Which was my pride; for thou rememberest how
In those old days, one summer noon, an arm
Rose up from out the bosom of the lake,
Clothed in white samite,° mystic, wonderful, 5
Holding the sword—and how I rowed across
And took it, and have worn it, like a king;
And, wheresoever I am sung or told
In aftertime, this also shall be known.
But now delay not; take Excalibur, 10
And fling him far into the middle mere;°
Watch what thou seest, and lightly bring me word."

To him replied the bold Sir Bedivere:
"It is not meet,° Sir King, to leave thee thus,
Aidless, alone, and smitten through the helm— 15
A little thing may harm a wounded man;
Yet I thy hest° will all perform at full,
Watch what I see, and lightly bring thee word."

 So saying, from the ruined shrine he stepped,
And in the moon athwart° the place of tombs, 20
Where lay the mighty bones of ancient men,
Old knights, and over them the sea-wind sang
Shrill, chill, with flakes of foam. He, stepping down
By zigzag paths, and juts of pointed rock,
Came on the shining levels of the lake. 25

1. **brand:** sword.

5. **samite:** heavy silk cloth woven with gold and silver.

11. **mere:** body of water.

14. **meet:** right.

17. **hest:** command.

20. **athwart:** across.

There drew he forth the brand Excalibur,
And o'er him, drawing it, the winter moon,
Brightening the skirts of a long cloud, ran forth
And sparkled keen with frost against the hilt;
For all the haft° twinkled with diamond sparks, 30
Myriads of topaz-lights, and jacinth°-work
Of subtlest jewelry. He gazed so long
That both his eyes were dazzled as he stood,
This way and that dividing the swift mind,
In act to throw: but at the last it seemed 35
Better to leave Excalibur concealed
There in the many-knotted waterflags,°
That whistled stiff and dry about the marge.°
So strode he back slow to the wounded King.

Then spake King Arthur to Sir Bedivere: 40
"Hast thou performed my mission which I gave?
What is it thou hast seen? or what hast heard?"

And answer made the bold Sir Bedivere:
"I heard the ripple washing in the reeds,
And the wild water lapping on the crag." 45

To whom replied King Arthur, faint and pale:
"Thou hast betrayed thy nature and thy name,
Not rendering true answer, as beseemed
Thy fealty,° nor like a noble knight;
For surer sign had followed, either hand, 50
Or voice, or else a motion of the mere.
This is a shameful thing for men to lie.
Yet now, I charge thee, quickly go again,
As thou art lief° and dear, and do the thing
I bade thee, watch, and lightly bring me word." 55

Then went Sir Bedivere the second time
Across the ridge, and paced beside the mere,
Counting the dewy pebbles, fixed in thought;
But when he saw the wonder of the hilt,
How curiously° and strangely chased,° he smote 60
His palms together, and he cried aloud:

"And if indeed I cast the brand away,
Surely a precious thing, one worthy note,

30. **haft:** handle.

31. **jacinth:** semiprecious stone, orange in color.

37. **waterflags:** a kind of iris.

38. **marge:** margin (edge) of the lake.

49. **fealty:** duty.

54. **lief:** loved.

60. **curiously:** wondrously; skillfully. **chased:** decorated with a raised design.

Should thus be lost for ever from the earth,
Which might have pleased the eyes of many men. 65
What good should follow this, if this were done?
What harm, undone? Deep harm to disobey,
Seeing obedience is the bond of rule.
Were it well to obey then, if a king demand
An act unprofitable, against himself? 70
The King is sick, and knows not what he does.
What record, or what relic of my lord
Should be to aftertime, but empty breath
And rumors of a doubt? But were this kept,
Stored in some treasure-house of mighty kings, 75
Someone might show it at a joust of arms,
Saying: 'King Arthur's sword, Excalibur,
Wrought by the lonely maiden of the Lake.
Nine years she wrought it, sitting in the deeps
Upon the hidden bases of the hills.' 80
So might some old man speak in the aftertime
To all the people, winning reverence.
But now much honor and much fame were lost."

 So spake he, clouded with his own conceit,° **84. conceit:** idea; thought.
And hid Excalibur the second time, 85
And so strode back slow to the wounded King.

 Then spoke King Arthur, breathing heavily:
"What is it thou hast seen? or what hast heard?"

 And answer made the bold Sir Bedivere:
"I heard the water lapping on the crag, 90
And the long ripple washing in the reeds."

 To whom replied King Arthur, much in wrath:
"Ah miserable and unkind, untrue,
Unknightly, traitor-hearted! Woe is me!
Authority forgets a dying king, 95
Laid widowed of the power in his eye
That bowed the will. I see thee what thou art,
For thou, the latest-left of all my knights,
In whom should meet the offices of all,
Thou wouldst betray me for the precious hilt; 100
Either from lust of gold, or like a girl
Valuing the giddy pleasure of the eyes.

Yet, for a man may fail in duty twice,
And the third time may prosper, get thee hence;
But, if thou spare to fling Excalibur, 105
I will arise and slay thee with my hands."

 Then quickly rose Sir Bedivere, and ran,
And, leaping down the ridges lightly, plunged
Among the bulrush beds, and clutched the sword,
And strongly wheeled and threw it. The great brand 110
Made lightnings in the splendor of the moon,
And flashing round and round, and whirled in an arch,
Shot like a streamer of the northern morn,°
Seen where the moving isles of winter shock°
By night, with noises of the Northern Sea. 115
So flashed and fell the brand Excalibur:
But ere he dipped the surface, rose an arm
Clothed in white samite, mystic, wonderful,
And caught him° by the hilt, and brandished him
Three times, and drew him under in the mere. 120
And lightly went the other to the King.

113. **streamer . . . morn:** the aurora borealis, or "northern lights."
114. **where . . . shock:** where the icebergs collide.

119. **him:** Excalibur.

Excalibur is retrieved by the Lady of the Lake. Illuminated French manuscript (c. 1316). Ms. Add. 10294, f 94.
British Library

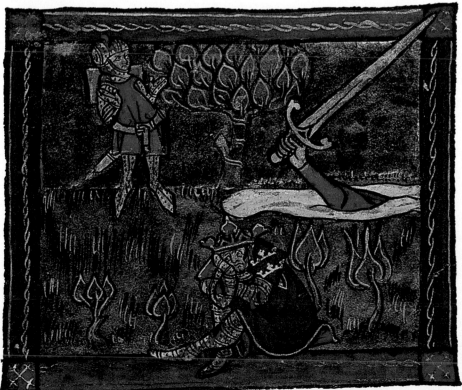

Then spoke King Arthur, drawing thicker breath:
"Now see I by thine eyes that this is done.
Speak out: what is it thou hast heard, or seen?"

And answer made the bold Sir Bedivere: 125
"Sir King, I closed mine eyelids, lest the gems
Should blind my purpose, for I never saw,
Nor shall see, here or elsewhere, till I die,
Not though I live three lives of mortal men,
So great a miracle as yonder hilt. 130
Then with both hands I flung him, wheeling him;
But when I looked again, behold an arm,
Clothed in white samite, mystic, wonderful,
That caught him by the hilt, and brandished him
Three times, and drew him under in the mere." 135

And answer made King Arthur, breathing hard:
"My end draws nigh; 'tis time that I were gone.
Make broad thy shoulders to receive my weight,
And bear me to the margin; yet I fear
My wound hath taken cold, and I shall die." 140

So saying, from the pavement he half rose,
Slowly, with pain, reclining on his arm,
And looking wistfully with wide blue eyes
As in a picture. Him Sir Bedivere
Remorsefully regarded through his tears, 145
And would have spoken, but he found not words;
Then took with care, and kneeling on one knee,
O'er both his shoulders drew the languid hands,
And rising bore him through the place of tombs.

But, as he walked, King Arthur panted hard, 150
Like one that feels a nightmare on his bed
When all the house is mute. So sighed the King,
Muttering and murmuring at his ear, "Quick, quick!
I fear it is too late, and I shall die."
But the other swiftly strode from ridge to ridge, 155
Clothed with his breath, and looking, as he walked,
Larger than human on the frozen hills.
He heard the deep° behind him, and a cry 158. **deep:** open sea.
Before. His own thought drove him like a goad.

Dry clashed his harness° in the icy caves 160

160. **harness:** armor and other equipment.

Dry clashed his harness° in the icy caves 160
And barren chasms, and all to left and right
The bare black cliff clanged round him, as he based
His feet on juts of slippery crag that rang
Sharp-smitten with the dint° of armèd° heels—
And on a sudden, lo, the level lake, 165
And the long glories of the winter moon!

164. **dint:** blow. **armèd:** He wore steel boots.

Then saw they how there hove° a dusky barge,
Dark as a funeral scarf from stem to stern,
Beneath them; and descending they were ware
That all the decks were dense with stately forms, 170
Black-stoled, black-hooded, like a dream—by° these
Three Queens with crowns of gold—and from them rose
A cry that shivered to the tingling stars,
And, as it were one voice, an agony
Of lamentation, like a wind that shrills 175
All night in a waste land, where no one comes,
Or hath come, since the making of the world.

167. **hove:** moved into sight.

171. **by:** beside.

Then murmured Arthur, "Place me in the barge."
So to the barge they came. There those three Queens
Put forth their hands, and took the King, and wept. 180
But she that rose the tallest of them all
And fairest, laid his head upon her lap,
And loosed the shattered casque,° and chafed his hands,
And called him by his name, complaining loud.
And dropping bitter tears against a brow 185
Striped with dark blood: for all his face was white
And colorless, and like the withered moon
Smote by the fresh beam of the springing east;
And all his greaves° and cuisses° dashed with drops
Of onset;° and the light and lustrous curls— 190
That made his forehead like a rising sun
High from the dais-throne°—were parched with dust;
Or, clotted into points and hanging loose,
Mixed with the knightly growth that fringed his lips.
So like a shattered column lay the King; 195
Not like that Arthur who, with lance in rest,
From spur to plume a star of tournament,
Shot through the lists° at Camelot, and charged
Before the eyes of ladies and of kings.

183. **casque:** helmet.

189. **greaves:** armor that covers the shins. **cuisses** (kwĭs′əz): armor that covers the thighs.
190. **onset:** blood, or the "onset" of death.
192. **dais-throne:** throne raised on a low platform.

198. **lists:** here, the jousting field.

Then loudly cried the bold Sir Bedivere: 200
"Ah! my Lord Arthur, whither shall I go?
Where shall I hide my forehead and my eyes?
For now I see the true old times are dead,
When every morning brought a noble chance,
And every chance brought out a noble knight. 205
Such times have been not since the light that led
The holy Elders° with the gift of myrrh.
But now the whole Round Table is dissolved
Which was an image of the mighty world;
And I, the last, go forth companionless, 210
And the days darken round me, and the years,
Among new men, strange faces, other minds."

 And slowly answered Arthur from the barge:
"The old order changeth, yielding place to new,
And God fulfills himself in many ways, 215
Lest one good custom should corrupt the world.
Comfort thyself; what comfort is in me?
I have lived my life, and that which I have done
May He within himself make pure! but thou,
If thou shouldst never see my face again, 220
Pray for my soul. More things are wrought by prayer
Than this world dreams of. Wherefore, let thy voice
Rise like a fountain for me night and day.
For what are men better than sheep or goats
That nourish a blind life within the brain, 225
If, knowing God, they lift not hands of prayer
Both for themselves and those who call them friend?
For so the whole round earth is every way
Bound by gold chains about the feet of God.
But now farewell. I am going a long way 230
With these thou seest—if indeed I go
(For all my mind is clouded with a doubt)—
To the island-valley of Avilion;°
Where falls not hail, or rain, or any snow,
Nor ever wind blows loudly; but it lies 235
Deep-meadowed, happy, fair with orchard lawns
And bowery hollows crowned with summer sea,
Where I will heal me of my grievous wound."

 So said he, and the barge with oar and sail
Moved from the brink, like some full-breasted swan 240

207. **The holy Elders:** the Magi, who brought gold and frankincense and myrrh to the infant Jesus (see Matthew 2:1–12).

233. **Avilion:** Paradise, in Celtic mythology.

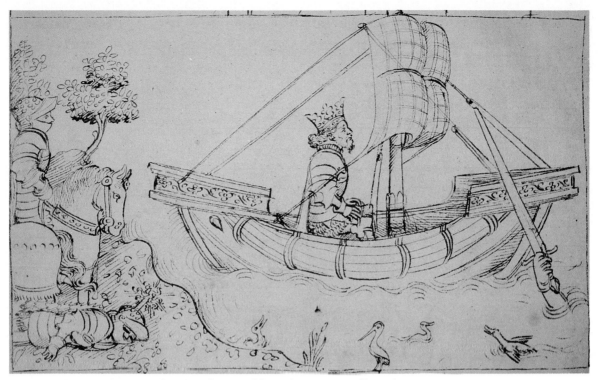

Arthur Sails to Avalon. Pen drawing from a fifteenth-century Italian manuscript. Cod. PAL. 556.
National Library, Florence

That, fluting a wild carol° ere her death,
Ruffles her pure cold plume, and takes the flood°
With swarthy webs. Long stood Sir Bedivere
Revolving many memories, till the hull
Looked one black dot against the verge of dawn, 245
And on the mere the wailing died away.

But when that moan had passed for evermore,
The stillness of the dead world's winter dawn
Amazed him, and he groaned, "The King is gone."
And therewithal came on him the weird rhyme, 250
"From the great deep to the great deep he goes."

Whereat he slowly turned and slowly clomb
The last hard footstep of that iron crag;
Thence marked the black hull moving yet, and cried,
"He passes to be King among the dead, 255
And after healing of his grievous wound

241. **wild carol:** The swan is believed to sing just before death.
242. **flood:** deep water.

The Passing of Arthur **805**

He comes again; but—if he come no more—
O me, be yon dark Queens in yon black boat,
Who shrieked and wailed, the three whereat we gazed
On that high day, when, clothed with living light, 260
They stood before his throne in silence, friends
Of Arthur, who should help him at his need?"

 Then from the dawn it seemed there came, but faint
As from beyond the limit of the world,
Like the last echo born of a great cry, 265
Sounds as if some fair city were one voice
Around a king returning from his wars.

 Thereat once more he moved about, and clomb
Ev'n to the highest he could climb, and saw,
Straining his eyes beneath an arch of hand, 270
Or thought he saw, the speck that bare the King,
Down that long water opening on the deep
Somewhere far off, pass on and on, and go
From less to less and vanish into light.
And the new sun rose bringing the new year. 275

Analyzing and Interpreting the Selection

1a. What reasons does Bedivere give for not throwing Excalibur into the lake? **b.** What motives does Arthur accuse Bedivere of having? **c.** How close to the truth is Arthur?

2. After Bedivere fails a second time to carry out Arthur's command, Arthur laments: "Authority forgets a dying king." **a.** What emotion does this line convey? **b.** How does it represent a major point of the poem?

3. As Tennyson describes Arthur being placed in the barge, he writes: "So like a shattered column lay the King." How is the wounded Arthur like a "shattered column"?

4a. What does Bedivere fear will be lost when Arthur dies? **b.** What does Arthur say to comfort him?

5. In the next to last line of the excerpt, Tennyson says that the barge bearing Arthur vanished into light. This light then becomes a new sun, in the last line, bringing in a new year. With this image, what does the poet suggest about the future of Arthur and the ideals he stood for?

Language and Vocabulary

Identifying Archaisms

An **archaism** (är′kē-ĭs′əm) is a word or expression that is no longer in use. Writers use archaisms to give the flavor of the past to their work. One of the first English poets to use archaisms in his work was Edmund Spenser (1552–1599). In his long poem *The Faerie Queene,* he deliberately used archaic words in order to evoke the spirit of an earlier age of chivalry.

Tennyson similarly uses archaic language to give a sense of the past and the atmosphere of the chivalric world. The word *hest* in line 17, for example, is an archaic form of *behest.* The word *lief* in line 54 is an archaic word meaning "loved."

Find other examples of archaic language in the excerpt. Check your answers in a dictionary. What is lost by substituting modern words for these archaisms?

Writing About Literature

Supporting an Opinion

In early Celtic legend it was said that Arthur would someday return to lead his people in battle once again against their enemies. This idea of the leader who will return is echoed in lines 255–257 of Tennyson's poem, where Bedivere says:

> "He passes to be King among the dead,
> And after healing of his grievous wound
> He comes again . . ."

These lines express a feeling of optimism about the future that has always been a part of the Arthur legend. But many readers have pointed out that a strong note of pessimism or doubt is also struck in Tennyson's poem.

Write a short essay in which you give your overall impression of this story of the death of Arthur. Is it optimistic, or pessimistic and doubtful? Quote lines from the poem to support your opinion. Consider specifically the implications of lines 214–215, 246, and 257.

Focus on Comparison and Contrast

Arranging Information

In a comparison/contrast essay, arranging information clearly and logically will help your readers understand the patterns and relationships of your subjects. You will find the following two methods of organization helpful.

Block method: Present all the relevant features for the first subject and then all the relevant features for the second subject. Make sure you discuss the features in the same order for each subject.

Point-by-point method: Discuss one feature at a time as it relates to both of your subjects. Make sure you present the two subjects in the same order for each feature.

The chart below shows how each method might work for an essay comparing Tennyson's version of the death of Arthur with Malory's account of the same subject (see pages 809–810). S = Subject; F = Feature.

Block	Point-by-point
S1: Malory	F1: Heroic ideals
F1: Heroic ideals	S1: Malory
F2: Characters	S2: Tennyson
F3: Magic	
	F2: Characters
S2: Tennyson	S1: Malory
F1: Heroic ideals	S2: Tennyson
F2: Characters	
F3: Magic	F3: Magic
	S1: Malory
	S2: Tennyson

Use one of these methods to organize notes for a comparison/contrast essay on a topic of your choice. Save your outline.

About the Author

Alfred, Lord Tennyson (1809–1892)

Alfred, Lord Tennyson was brought up, with his seven brothers and four sisters, in the comfortable rectory of an English country town. The children were encouraged to draw on the family's extensive library, and they grew up knowing far more about knights, giants, and princesses than about the busy world a few miles distant.

At seven, young Alfred was sent to a grammar school. He was unhappy there and later returned home, where his father prepared him for college. At Cambridge, Tennyson was not an exceptional student, and in fact never received a degree, but he read widely and soon established himself as a masterful poet.

All his life Tennyson tended to withdraw from society. He devoted himself to reading, to enjoying nature, but above all, to writing poetry. Besides *Idylls of the King,* Tennyson wrote such great poems as *In Memoriam,* "The Lady of Shalott," and "Ulysses." Eight years before his death he was made a lord, a title he valued highly. Tennyson was England's chief spokesman during the reign of Queen Victoria, and was poet laureate for over forty years.

Reading and Critical Thinking

COMPARING AND CONTRASTING VERSIONS OF A LEGEND

*T*ennyson's version of the death of Arthur is based on the account given in Book 21 of Malory's *Le Morte Darthur,* which is reprinted here. Working in small groups, compare the Tennyson selection on pages 798–806 with the following excerpt in terms of heroic ideals, characterization, and supernatural elements. Divide the questions in the margin among members of your group. After writing your answers, pool them with other members' responses and discuss your comparisons and contrasts.

"Therefore," said Arthur unto Sir Bedevere, "take thou Excalibur, my good sword, and go with it to yonder water side, and when thou comest there I charge thee throw my sword in that water, and come again and tell me what thou there seest."

See lines 1–12. What is Malory's focus? What is Tennyson's focus?

"My lord," said Bedevere, "your commandment shall be done, and lightly bring you word again."

So Sir Bedevere departed, and by the way he beheld that noble sword, that the pommel and the haft was all of precious stones; and then he said to himself, "If I throw this rich sword in the water, thereof shall never come good, but harm and loss." And then Sir Bedevere hid Excalibur under a tree.

See lines 20–37. What does Tennyson add to the setting? What does he add to Bedevere's characterization?

And so, as soon as he might, he came again unto the king, and said he had been at the water, and had thrown the sword in the water.

"What saw thou there?" said the king.

"Sir," he said, "I saw nothing but waves and winds."

"That is untruly said of thee," said the king, "therefore go thou lightly again, and do my commandment; as thou art to me leve and dear, spare not, but throw it in."

See lines 46–55. What does Tennyson stress in Arthur's character?

Then Sir Bedevere returned again, and took the sword in his hand; and then him thought sin and shame to throw away that noble sword, and so eft[1] he hid the sword, and returned again, and told to the king that he had been at the water and done his commandment.

See lines 62–86. How does Tennyson intensify Bedevere's conflict?

"What saw thou there?" said the king.

"Sir," he said, "I saw nothing but the waters wap and the waves wan."[2]

"Ah, traitor untrue," said King Arthur, "now hast thou betrayed me twice. Who would have weened that thou that hast been to me so leve and dear, and thou art named a noble knight, and would

1. **eft:** again.
2. **wap . . . wan:** lap . . . grow dark.

betray me for the riches of the sword? But now go again lightly, for thy long tarrying putteth me in great jeopardy of my life, for I have taken cold. And but if thou do now as I bid thee, if ever I may see thee, I shall slay thee with mine own hands; for thou wouldst for my rich sword see me dead.''

See lines 92–106. What change does Tennyson make in his source? What does he retain?

Then Sir Bedevere departed, and went to the sword, and lightly took it up, and went to the water side; and there he bound the girdle about the hilts, and then he threw the sword as far into the water as he might; and there came an arm and an hand above the water and met it, and caught it, and so shook it thrice and brandished, and then vanished away the hand with the sword in the water. So Sir Bedevere came again to the king, and told him what he saw.

See lines 107–121. What elements in the original does Tennyson expand?

''Alas,'' said the king, ''help me hence, for I dread me I have tarried over long.''

Then Sir Bedevere took the king upon his back, and so went with him to that water side. And when they were at the water side, even fast by the bank hoved a little barge with many fair ladies in it, and among them all was a queen, and all they had black hoods, and all they wept and shrieked when they saw King Arthur.

See lines 167–238. What interpretation does Tennyson give to this scene?

''Now put me into the barge,'' said the king.

And so he did softly; and there received him three queens with great mourning; and so they set them down, and in one of their laps King Arthur laid his head.

And then that queen said, ''Ah, dear brother, why have ye tarried so long from me? Alas, this wound on your head hath caught overmuch cold.''

And so then they rowed from the land, and Sir Bedevere beheld all those ladies go from him.

Then Sir Bedevere cried, ''Ah my lord Arthur, what shall become of me, now ye go from me and leave me here alone among mine enemies?''

''Comfort thyself,'' said the king, ''and do as well as thou mayest, for in me is no trust for to trust in; for I will into the vale of Avilion to heal me of my grievous wound: and if thou hear never more of me, pray for my soul.''

What new material does Tennyson introduce and why?

But ever the queens and ladies wept and shrieked, that it was pity to hear. And as soon as Sir Bedevere had lost the sight of the barge, he wept and wailed, and so took the forest; and so he went all that night, and in the morning he was ware betwixt two holts[3] hoar, of a chapel and an hermitage.

3. **holt:** small wood.

WRITING A COMPARISON/CONTRAST ESSAY

A **comparison/contrast essay** examines the relationships and patterns of two or more subjects. In this kind of essay, you may focus on similarities between the subjects, on differences, or on both. You can use comparison and contrast for many writing projects: for example, book and movie reviews, essays of extended definition, biographical sketches, and historical reports. Now that you have seen some of the key elements in a comparison/contrast essay, you will have the chance to write this kind of paper on a topic of your choice.

Prewriting ✍

1. Identify a topic for comparison/contrast writing by using one of the following strategies:

- brainstorm with a small group of classmates
- skim recent issues of newspapers and magazines
- browse through encyclopedia articles
- review notes you have made for your literature assignments during this unit

Make a list of pairs of subjects that interest you: for example, architecture in New York and in Chicago, or two kinds of exercise equipment for home use. Remember that the two or more subjects for this kind of essay should have some significant differences as well as some points in common. [See **Focus** assignment on page 764.]

2. Consider your purpose and audience. Although you can use comparison/contrast to persuade others or express yourself, assume that your **purpose** in this essay is to inform.

Think about what your **audience** may already know about your topic. What background will they need to understand your essay? How can you present unfamiliar information clearly and logically?

3. Analyze the **relevant features** of your subjects by making a chart like the following one. List the ways in which your subjects are similar feature by feature. Also list the ways in which they are different.

	Subject 1	Subject 2
Feature 1:	_____	_____
	_____	_____
Feature 2:	_____	_____
	_____	_____
Feature 3:	_____	_____
	_____	_____

[See **Focus** assignment on page 774.]

4. After you have evaluated the balance or ratio of similarities to differences on your chart, state the main idea for your essay in a **thesis statement** of one or two sentences. In this thesis statement focus on similarities, on differences, or on both.

Writing ✍

1. Capture your reader's attention in your **introduction** by using one of the following:

- a question
- a striking detail
- a quotation
- an anecdote
- a controversial statement

You should also state your thesis in the introduction to your essay.

2. Use one of the two methods below to arrange your information in the **body** of your essay.

Block Method

Present all the relevant features for the first subject and then all the relevant features for the second. Be sure to treat the features in the same order for each subject.

Subject 1: _____
 Feature 1: _____
 Feature 2: _____
 Feature 3: _____
Subject 2: _____
 Feature 1: _____
 Feature 2: _____
 Feature 3: _____

Point-by-Point Method

Present one feature at a time as it relates to both subjects. Be sure to present the two subjects in the same order for each feature.

Feature 1: _____
 Subject 1: _____
 Subject 2: _____
Feature 2: _____
 Subject 1: _____
 Subject 2: _____
Feature 3: _____
 Subject 1: _____
 Subject 2: _____

[See **Focus** assignment on page 808.]

3. In your **conclusion** restate your thesis. If appropriate, add an evaluation, a question, or a fresh thought in the final paragraph.

4. Use **transitional words and phrases** to show the relationship of information and ideas in your essay. The chart below lists some useful transitions for comparison and contrast.

Comparison		Contrast	
also	and	but	despite
another	like	however	instead
likewise	similarly	yet	

Evaluating and Revising

1. After you have finished your first draft, put it aside for a while so that you can gain some perspective. Then evaluate your draft as objectively as you can. Be sure you have not omitted any important information about your subjects. Also check to see that you have used degrees of comparison correctly.

Below is a revised introductory paragraph for an essay of comparison/contrast.

Writer's Model

Two reference books that ~~are~~ ~~absolutely essential for the~~ a writer
needs good desk
~~are~~ a dictionary and a thesaurus.
help
Both books ~~give~~ writers ~~assistance~~
~~in~~ finding the right word for a
particular context. A thesaurus
storehouse of
contains a ~~great many~~ synonyms
whereas college or an unabridged
and antonyms. A dictionary provides
definitions and often shows how
words are used.

2. You may find the following checklist helpful at this stage of the writing process.

Checklist for Evaluation and Revision

✓ Does the introduction capture the reader's attention?

✓ Are the subjects similar enough to compare and different enough to be interesting?

✓ Do I clearly state my thesis in the introduction?

✓ Is the essay organized logically by the block method or the point-by-point method?

✓ Are the features of the two subjects handled in the same order?

✓ Does my essay include all the important information about the subjects?

✓ Do I end with a strong conclusion?

Proofreading and Publishing

1. Proofread your essay to identify and correct errors in grammar, punctuation, capitalization, and usage. Correct any sentence fragments or run-on sentences that you find. Also check your word order to make sure you have not used misplaced or dangling modifiers. (You may find it helpful at this stage to refer to the **Handbook for Revision** on pages 928–971.) Prepare a final version of your essay by making a clean copy.

2. Consider some of the following ways of sharing your essay:

- share your essay with students in another class, for example, history or physical education
- submit your essay to the school paper or magazine
- combine your essay with those of other students to make a mini-encyclopedia
- present your essay as an oral report to the class

Portfolio If your teacher approves, you may wish to keep a copy of your work in your writing folder or portfolio.

Many people today can listen to books that have been recorded on cassette or compact disc. There are a great many pleasures in listening to a skillful interpreter tell a story. For most people, however, nothing can take the place of doing their own reading.

What story does the painting below tell? Have you ever been caught up in a good book? Free-write for about ten minutes to explore your personal responses to a book you enjoyed. Tell something about the plot and characters. What parts of the book did you like the most? Did

The New Novel (1877) by Winslow Homer (1836–1910). Watercolor.
Museum of Fine Arts, Springfield, Massachusetts, the Horace P. Wright Collection

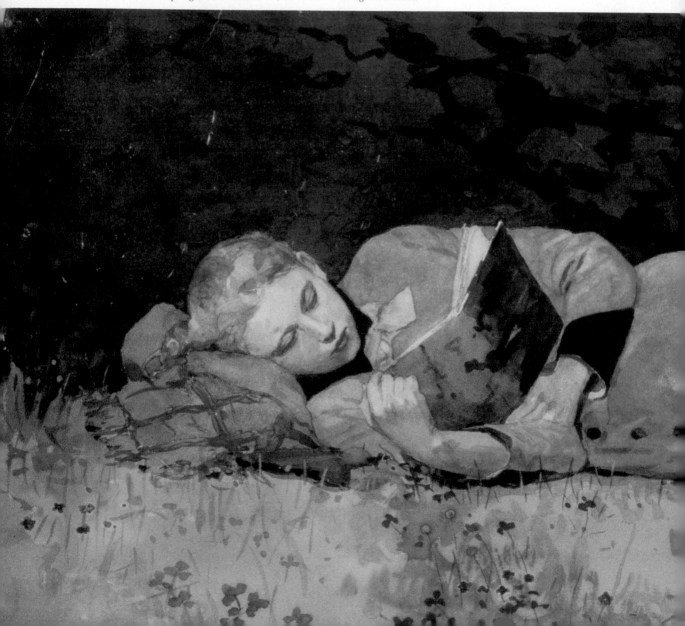

the book leave you feeling satisfied? curious? eager to read more?

Imagine a contemporary painting with the title *The New Novel*. How might it be different from Winslow Homer's painting?

THE NOVEL

HOMER 1877

The novel is one of the most popular and familiar of all literary forms. Down through the ages, people have always enjoyed a good story. The novel—a long, fictional prose narrative which usually has many characters and a strong plot or story line—has allowed readers the pleasure of becoming involved with new people and identifying with problems and feelings that are very much like their own.

The novel is a comparative newcomer to English literature. It appeared in England after a major political and social revolution that took place in the mid-seventeenth century. In the course of that revolution, the English monarchy in the person of King Charles I was overthrown by the followers of Oliver Cromwell, who sought a more democratic form of government. Though the monarchy was restored in 1660, a new social class—the middle class of merchants, bankers, and shopkeepers—had started its rise to power. This new social class firmly established itself by the eighteenth century.

Before this, only a handful of the population could read, and the art of printing was crude and expensive. But by the eighteenth century, education had spread, and printing was so vastly improved that books could be produced more rapidly and inexpensively. Up to this time, most stories in English literature had been about elevated characters—kings, queens, princes, knights, and larger-than-life heroes—and the dominant writing style had been poetic, dignified, and often elaborate. The new middle class was more interested in stories of ordinary people like themselves, and they wanted the stories told in the language of their own everyday speech.

Engraved frontispiece and title page of the first edition of Daniel Defoe's *Robinson Crusoe* (London, 1719).

THE
LIFE
AND
STRANGE SURPRIZING
ADVENTURES
OF
ROBINSON CRUSOE,
Of YORK, MARINER:

Who lived Eight and Twenty Years, all alone in an un-inhabited Island on the Coast of AMERICA, near the Mouth of the Great River of OROONOQUE;

Having been cast on Shore by Shipwreck, wherein all the Men perished but himself.

WITH
An Account how he was at last as strangely deliver'd by PYRATES.

Written by Himself.

LONDON:
Printed for W. TAYLOR at the *Ship* in *Pater-Noster-Row.* MDCCXIX.

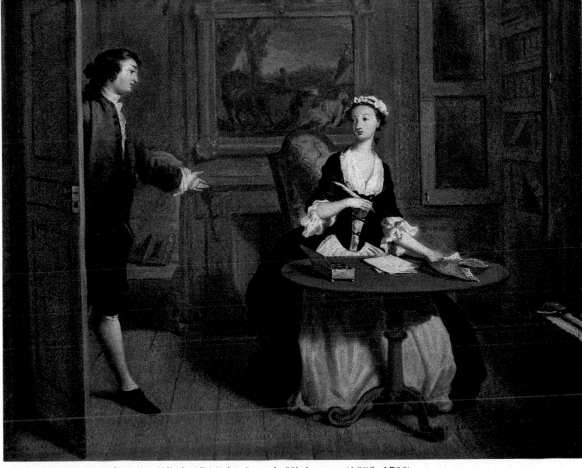

Mr. B. Finds Pamela Writing (1743–1744) by Joseph Highmore (1692–1780).
Richardson's *Pamela* inspired a series of twelve paintings illustrating scenes
from the novel.

One of the first writers to meet this demand was Daniel Defoe.
The hero of his story *Robinson Crusoe* (1719) is an ordinary trader
who tells about his adventures in the everyday language of the shop,
street, and trading ship. Defoe's books are basically adventure or
travel stories, in which the hero or heroine becomes involved in one
episode after another. There is little or no plot—that is, there is no
development of a major conflict, with a beginning, a middle, and an
end.

In 1740 a printer named Samuel Richardson published a pious,
sentimental story called *Pamela; or Virtue Rewarded.* The story is told
as a series of letters which a servant girl writes to her friends. The
letters tell how the master pursues the girl, how she succeeds in foiling
his schemes, and how she eventually reforms him and marries him.
Pamela is often regarded as the first English novel. It has a definite
shape or plot, in which a single theme—here, the idea of virtue
getting its reward—is introduced, developed, and resolved.

Introduction to the Novel **817**

Elements of the Novel

The novel has taken on many variations since Richardson's day, but it has retained certain fundamental elements. The *plot* is the pattern of related events that make up the story. The plot entangles the characters in a *conflict*—a struggle that might take place between two characters, or within a character's mind. As the conflict becomes more involved, the story moves toward a *climax*, or moment of great emotional intensity. The novel ends with a *resolution*, or disentanglement of the conflict. In long and complex novels, you will find related plots and conflicts in operation, though one plot and its conflict are usually dominant.

Effective *characterization*, the creation of interesting, believable characters, is another important element of the novel. One way to

James Lackington's London bookshop and lending library (c. 1800), called the "Temple of the Muses."

create characters is to describe their physical appearance and give each person a single outstanding trait. Generally, however, novelists have the leisure to create characters in more depth—by looking inside them, by examining their thoughts, feelings, and motivations. Novelists can create characters by describing their actions, their gestures, their talk, and sometimes their physical surroundings. For example, the people in the novels of Ernest Hemingway are characterized mainly by what they say, rather than by detailed physical descriptions.

Like all major works of literature, the novel has a *theme*—the idea or truth about life that the story reveals. For example, the theme of Mark Twain's great novel *Adventures of Huckleberry Finn* might be expressed in this way: the spirit of youth will break down social and physical boundaries to discover new ideas and uncharted territories. In some novels, theme is immediately apparent and may even be stated directly by the writer. In others, theme is introduced and developed more subtly. Sometimes the reader can get a hint of the theme from the images or symbols used over and over again by the writer. In *Adventures of Huckleberry Finn,* for example, the Mississippi River—exciting, untamed, and free—can be seen as a symbol of Huck's restless desire to "light out" for new territories.

Novelists approach and write their stories in many different ways. They will select techniques that best suit their own particular skills, as well as the content and nature of their own particular stories. For example, they can make use of one or more of the three major *points of view.* In the *omniscient,* or all-knowing, point of view, the writer stands outside the novel and reveals the unspoken thoughts and feelings of all the characters. In the *first-person* point of view, the writer pretends to be a character in the story and narrates the events through the voice of this character. In the *limited third-person* point of view, the writer stands outside the story but narrates all events from the vantage point of one character only.

A writer's characteristic form of expression is known as his or her *style.* Some writers use an elaborate, formal style; others may write in plain, informal language or even in slang. Some novelists include long poetic passages of description; some use a great deal of dialogue.

To some extent, style determines a novel's *tone*—the attitude the writer takes toward the story and its characters. Satiric novelists may ridicule their characters in a scornful, biting manner. Comic novelists, on the other hand, tend to laugh sympathetically with their characters, rather than at them. Other writers may be detached and objective or nostalgic and personal. Style and tone are closely linked. Together they make up the writer's voice, a personal signature tying the work together and making it unmistakably the writer's own.

Guidelines for Close Reading

1. Read actively, asking questions as you read. For example, as you read, try to predict how some incident or event will turn out. Try to determine the author's purpose as you work through the novel.

2. Become aware of information that establishes the setting or background of the novel. The language of characters, for example, can help to set the time and place of the action.

3. Look for clues that reveal what characters are like: key speeches, important actions, or descriptive details. Discover how characters develop and change as the novel progresses.

4. Determine what forms the major action of the novel. As you read, consider how individual episodes are connected to the main plot.

5. Note the point of view of the novel. Seek to understand the author's reason in selecting this point of view.

6. Consider how all the elements of the novel contribute to its theme. Try to clarify your own understanding of the author's underlying idea.

Two qualities mark the work of American writer John Steinbeck: a deep feeling for nature and a profound sympathy for people. With the detachment of a scientist, Steinbeck can view his characters as living on a purely instinctual level, moved by forces they can hardly understand or control. But we also find his characters striving toward wisdom, struggling, even under the most brutal conditions, to realize their decency and dignity as human beings.

Steinbeck was born in Salinas, California, a state that has provided the settings for many of his stories. He attended Stanford University where he specialized in marine biology. He worked at odd laboring jobs after he left college, and he wrote. Until the publication of *Tortilla Flat* in 1935, however, his writing earned him little money. In 1937 Steinbeck achieved literary success with *Of Mice and Men,* which he followed two years later with his masterpiece, *The Grapes of Wrath. The Grapes of Wrath,* a novel set in the Great Depression, depicts the tragic plight of the "Okies"—Oklahoma farmers who fled from the Dust Bowl and migrated to California to seek jobs as fruit pickers. It is a work of epic scope and was quickly recognized as one of the great American novels. *The Grapes of Wrath* was awarded the Pulitzer Prize and made Steinbeck one of the most widely known writers of our time. His career was capped in 1962, when he was awarded the Nobel Prize for literature. In announcing the award, the Swedish Academy said of Steinbeck: ". . . he had no mind to be an unoffending comforter and entertainer. Instead, the topics he chose were serious and denunciatory. . . ."

In 1940, Steinbeck sailed in a sardine boat with his friend the biologist Edward F. Ricketts to collect marine invertebrates from the beaches of the Gulf of California. The expedition was described by the two men in a book called *The Sea of Cortez.* In one part of *The Sea of Cortez,* Steinbeck describes how, while stopping off in the harbor town of La Paz in Mexico, he heard a story about a poor Indian boy who found a magnificent pearl. Steinbeck later transformed this story into a novel that he calls a *parable*—a tale that is told to present a moral lesson of universal significance, a story that speaks to all people, everywhere.

The Pearl

JOHN STEINBECK

Sunrise on the Sea of Cortez.

"In the town they tell the story of the great pearl—how it was found and how it was lost again. They tell of Kino, the fisherman, and of his wife, Juana, and of the baby, Coyotito.[1] And because the story has been told so often, it has taken root in every man's mind. And, as with all retold tales that are in people's hearts, there are only good and bad things and black and white things and good and evil things and no in-between anywhere.

"If this story is a parable, perhaps everyone takes his own meaning from it and reads his own life into it. In any case, they say in the town that . . ."

I

Kino awakened in the near dark. The stars still shone and the day had drawn only a pale wash of light in the lower sky to the east. The roosters had been crowing for some time, and the early pigs were already beginning their ceaseless turning of twigs and bits of wood to see whether anything to eat had been overlooked. Outside the brush house in the tuna[2] clump, a covey of little birds chittered and flurried with their wings.

Kino's eyes opened, and he looked first at the lightening square which was the door and

1. **Kino** (kē′nō); **Juana** (hwä′nä); **Coyotito** (kō′yō-tē′tō).

2. **tuna:** a prickly-pear plant found in the tropics.

then he looked at the hanging box where Coyotito slept. And last he turned his head to Juana, his wife, who lay beside him on the mat, her blue head shawl over her nose and over her breasts and around the small of her back. Juana's eyes were open too. Kino could never remember seeing them closed when he awakened. Her dark eyes made little reflected stars. She was looking at him as she was always looking at him when he awakened.

Kino heard the little splash of morning waves on the beach. It was very good—Kino closed his eyes again to listen to his music. Perhaps he alone did this and perhaps all of his people did it. His people had once been great makers of songs so that everything they saw or thought or did or heard became a song. That was very long ago. The songs remained; Kino knew them, but no new songs were added. That does not mean that there were no personal songs. In Kino's head there was a song now, clear and soft, and if he had been able to speak it, he would have called it the Song of the Family.

His blanket was over his nose to protect him from the dank air. His eyes flicked to a rustle beside him. It was Juana arising, almost soundlessly. On her bare feet she went to the hanging box where Coyotito slept, and she leaned over and said a little reassuring word. Coyotito looked up for a moment and closed his eyes and slept again.

Juana went to the fire pit and uncovered a coal and fanned it alive while she broke little pieces of brush over it.

Now Kino got up and wrapped his blanket about his head and nose and shoulders. He slipped his feet into his sandals and went outside to watch the dawn.

Outside the door he squatted down and gathered the blanket ends about his knees. He saw the specks of Gulf clouds flame high in the air. And a goat came near and sniffed at him and stared with its cold yellow eyes. Behind him Juana's fire leaped into flame and threw spears of light through the chinks of the brush-house wall and threw a wavering square of light out the door. A late moth blustered in to find the fire. The Song of the Family came now from behind Kino. And the rhythm of the family song was the grinding stone where Juana worked the corn for the morning cakes.

The dawn came quickly now, a wash, a glow, a lightness, and then an explosion of fire as the sun arose out of the Gulf. Kino looked down to cover his eyes from the glare. He could hear the pat of the corncakes in the house and the rich smell of them on the cooking plate. The ants were busy on the ground, big black ones with shiny bodies, and little dusty quick ants. Kino watched with the detachment of God while a dusty ant frantically tried to escape the sand trap an ant lion[3] had dug for him. A thin, timid dog came close and, at a soft word from Kino, curled up, arranged its tail neatly over its feet, and laid its chin delicately on the pile. It was a black dog with yellow-gold spots where its eyebrows should have been. It was a morning like other mornings and yet perfect among mornings.

Kino heard the creak of the rope when Juana took Coyotito out of his hanging box and cleaned him and hammocked him in her shawl in a loop that placed him close to her breast. Kino could see these things without looking at them. Juana sang softly an ancient song that had only three notes and yet endless variety of interval. And this was part of the family song too. It was all part. Sometimes it rose to an aching chord that caught the throat, saying this is safety, this is warmth, this is the *Whole*.

Across the brush fence were other brush houses, and the smoke came from them too,

3. **ant lion:** a large insect whose larvae trap ants in pits.

Delfina and Dimas (1935) by Diego Rivera (1886–1957). Tempera on masonite.
Private Collection

and the sound of breakfast, but those were other songs, their pigs were other pigs, their wives were not Juana. Kino was young and strong and his black hair hung over his brown forehead. His eyes were warm and fierce and bright and his mustache was thin and coarse. He lowered his blanket from his nose now, for the dark poisonous air was gone and the yellow sunlight fell on the house. Near the brush fence two roosters bowed and feinted at each other with squared wings and neck feathers ruffed out. It would be a clumsy fight. They were not game chickens. Kino watched them for a moment, and then his eyes went up to a flight of wild doves twinkling inland to the hills. The world was awake now, and Kino arose and went into his brush house.

As he came through the door Juana stood up from the glowing fire pit. She put Coyotito back in his hanging box and then she combed her black hair and braided it in two braids and tied the ends with thin green ribbon. Kino squatted by the fire pit and rolled a hot corncake and dipped it in sauce and ate it. And he drank a little pulque[4] and that was breakfast. That was the only breakfast he had ever known outside of feast days and one incredible fiesta on cookies that had nearly killed him. When Kino had finished, Juana came back to the fire and ate her breakfast. They had spoken once, but there is not need for speech if it is only a habit anyway. Kino sighed with satisfaction— and that was conversation.

The sun was warming the brush house, breaking through its crevices in long streaks. And one of the streaks fell on the hanging box where Coyotito lay, and on the ropes that held it.

It was a tiny movement that drew their eyes to the hanging box. Kino and Juana froze in their positions. Down the rope that hung the baby's box from the roof support a scorpion moved slowly. His stinging tail was straight out behind him, but he could whip it up in a flash of time.

Kino's breath whistled in his nostrils and he opened his mouth to stop it. And then the startled look was gone from him and the rigidity from his body. In his mind a new song had come, the Song of Evil, the music of the enemy, of any foe of the family, a savage, secret, dangerous melody, and underneath, the Song of the Family cried plaintively.

The scorpion moved delicately down the rope toward the box. Under her breath Juana repeated an ancient magic to guard against such evil, and on top of that she muttered a Hail Mary[5] between clenched teeth. But Kino was in motion. His body glided quietly across the room, noiselessly and smoothly. His hands were in front of him, palms down, and his eyes were on the scorpion. Beneath it in the hanging box Coyotito laughed and reached up his hand toward it. It sensed danger when Kino was almost within reach of it. It stopped, and its tail rose up over its back in little jerks and the curved thorn on the tail's end glistened.

Kino stood perfectly still. He could hear Juana whispering the old magic again, and he could hear the evil music of the enemy. He could not move until the scorpion moved, and it felt for the source of the death that was coming to it. Kino's hand went forward very slowly, very smoothly. The thorned tail jerked upright. And at that moment the laughing Coyotito shook the rope and the scorpion fell.

Kino's hand leaped to catch it, but it fell past his fingers, fell on the baby's shoulder, landed and struck. Then, snarling, Kino had it, had it in his fingers, rubbing it to a paste in his hands. He threw it down and beat it into the earth floor with his fist, and Coyotito screamed with

4. **pulque** (pōol′kä′): a fermented, milky drink made from the juice of a desert plant.

5. **Hail Mary:** a prayer to the Virgin Mary.

pain in his box. But Kino beat and stamped the enemy until it was only a fragment and a moist place in the dirt. His teeth were bared and fury flared in his eyes and the Song of the Enemy roared in his ears.

But Juana had the baby in her arms now. She found the puncture with redness starting from it already. She put her lips down over the puncture and sucked hard and spat and sucked again while Coyotito screamed.

Kino hovered; he was helpless, he was in the way.

The screams of the baby brought the neighbors. Out of their brush houses they poured—Kino's brother Juan Tomás and his fat wife Apolonia and their four children crowded in the door and blocked the entrance, while behind them others tried to look in, and one small boy crawled among legs to have a look. And those in front passed the word back to those behind—"Scorpion. The baby has been stung."

Juana stopped sucking the puncture for a moment. The little hole was slightly enlarged and its edges whitened from the sucking, but the red swelling extended farther around it in a hard lymphatic mound.[6] And all of these people knew about the scorpion. An adult might be very ill from the sting, but a baby could easily die from the poison. First, they knew, would come swelling and fever and tightened throat, and then cramps in the stomach, and then Coyotito might die if enough of the poison had gone in. But the stinging pain of the bite was going away. Coyotito's screams turned to moans.

Kino had wondered often at the iron in his patient, fragile wife. She, who was obedient and respectful and cheerful and patient, she could arch her back in child pain with hardly a cry. She could stand fatigue and hunger al-

6. **lymphatic mound:** a swelling caused by infection.

most better than Kino himself. In the canoe she was like a strong man. And now she did a most surprising thing.

"The doctor," she said. "Go to get the doctor."

The word was passed out among the neighbors where they stood close packed in the little yard behind the brush fence. And they repeated among themselves, "Juana wants the doctor." A wonderful thing, a memorable thing, to want the doctor. To get him would be a remarkable thing. The doctor never came to the cluster of brush houses. Why should he, when he had more than he could do to take care of the rich people who lived in the stone and plaster houses of the town.

"He would not come," the people in the yard said.

"He would not come," the people in the door said, and the thought got into Kino.

"The doctor would not come," Kino said to Juana.

She looked up at him, her eyes as cold as the eyes of a lioness. This was Juana's first baby—this was nearly everything there was in Juana's world. And Kino saw her determination and the music of the family sounded in his head with a steely tone.

"Then we will go to him," Juana said, and with one hand she arranged her dark blue shawl over her head and made of one end of it a sling to hold the moaning baby and made of the other end of it a shade over his eyes to protect him from the light. The people in the door pushed against those behind to let her through. Kino followed her. They went out of the gate to the rutted path and the neighbors followed them.

The thing had become a neighborhood affair. They made a quick soft-footed procession into the center of town, first Juana and Kino, and behind them Juan Thomás and Apolonia, her big stomach jiggling with the strenuous

The Mexican Family (1940) by Rufino Tamayo (1899–1991). Gouache on heavy paper.

pace, then all the neighbors with the children trotting on the flanks. And the yellow sun threw their black shadows ahead of them so that they walked on their own shadows.

They came to the place where the brush houses stopped and the city of stone and plaster began, the city of harsh outer walls and inner cool gardens where a little water played and the bougainvillea[7] crusted the walls with purple and brick-red and white. They heard from the secret gardens the singing of caged birds and heard the splash of cooling water on hot flagstones. The procession crossed the blinding plaza and passed in front of the church. It had grown now, and on the outskirts the hurrying newcomers were being softly informed how the baby had been stung by a scorpion, how the father and mother were taking it to the doctor.

And the newcomers, particularly the beggars from the front of the church who were great experts in financial analysis, looked quickly at Juana's old blue skirt, saw the tears in her shawl, appraised the green ribbon on her braids, read the age of Kino's blanket and the thousand washings of his clothes, and set them down as poverty people and went along to see what kind of drama might develop. The four beggars in front of the church knew everything in the town. They were students of the expressions of young women as they went into confession, and they saw them as they came out and read the nature of the sin. They knew every little scandal and some very big crimes. They slept at their posts in the shadow of the church so that no one crept in for consolation without their knowledge. And they knew the doctor. They knew his ignorance, his cruelty, his avarice, his appetites, his sins. They knew his clumsy abortions and the little brown pennies he gave sparingly for alms. They had

seen his corpses go into the church. And, since early Mass was over and business was slow, they followed the procession, these endless searchers after perfect knowledge of their fellow men, to see what the fat lazy doctor would do about a indigent baby with a scorpion bite.

The scurrying procession came at last to the big gate in the wall of the doctor's house. They could hear the splashing water and the singing of caged birds and the sweep of the long brooms on the flagstones. And they could smell the frying of good bacon from the doctor's house.

Kino hesitated a moment. This doctor was not of his people. This doctor was of a race which for nearly four hundred years had beaten and starved and robbed and despised Kino's race, and frightened it too, so that the indigene[8] came humbly to the door. And as always when he came near to one of this race, Kino felt weak and afraid and angry at the same time. Rage and terror went together. He could kill the doctor more easily than he could talk to him, for all of the doctor's race spoke to all of Kino's race as though they were simple animals. And as Kino raised his right hand to the iron ring knocker in the gate, rage swelled in him, and the pounding music of the enemy beat in his ears, and his lips drew tight against his teeth—but with his left hand he reached to take off his hat. The iron ring pounded against the gate. Kino took off his hat and stood waiting. Coyotito moaned a little in Juana's arms and she spoke softly to him. The procession crowded close the better to see and hear.

After a moment the big gate opened a few inches. Kino could see the green coolness of the garden and little splashing fountain through the opening. The man who looked out at him was one of his own race. Kino spoke to him in the old language. "The little one—

7. **bougainvillea** (boo′gən-vĭl′ē-ə): a vine covered with bright flowers.

8. **indigene** (ĭn′də-jən): a native or original inhabitant of an area.

Campesino con sombrero (*Peasant with Sombrero*) (1926) by Diego Rivera. Tempera on linen.

the firstborn—has been poisoned by the scorpion," Kino said. "He requires the skill of the healer."

The gate closed a little, and the servant refused to speak in the old language. "A little moment," he said. "I go to inform myself," and he closed the gate and slid the bolt home. The glaring sun threw the bunched shadows of the people blackly on the white wall.

In his chamber the doctor sat up in his high bed. He had on his dressing gown of red watered silk that had come from Paris, a little tight over the chest now if it was buttoned. On his lap was a silver tray with a silver chocolate pot and a tiny cup of eggshell china, so delicate that it looked silly when he lifted it with his big hand, lifted it with the tips of thumb and forefinger and spread the other three fingers wide to get them out of the way. His eyes rested in puffy little hammocks of flesh and his mouth drooped with discontent. He was growing very stout, and his voice was hoarse with the fat that pressed on his throat. Beside him on a table was a small Oriental gong and a bowl of cigarettes. The furnishings of the room were heavy and dark and gloomy. The pictures were religious, even the large tinted photograph of his dead wife, who, if Masses willed and paid for out of her own estate could do it, was in Heaven. The doctor had once for a short time been a part of the great world and his whole subsequent life was memory and longing for France. "That," he said, "was civilized living"—by which he meant that on a small income he had been able to keep a mistress and eat in restaurants. He poured his second cup of chocolate and crumbled a sweet biscuit in his fingers. The servant from the gate came to the open door and stood waiting to be noticed.

"Yes?" the doctor asked.

"It is a little Indian with a baby. He says a scorpion stung it."

The doctor put his cup down gently before he let his anger rise.

"Have I nothing better to do than cure insect bites for 'little Indians'? I am a doctor, not a veterinary."

"Yes, Patron,"[9] said the servant.

"Has he any money?" the doctor demanded. "No, they never have any money. I, I alone in the world am supposed to work for nothing—and I am tired of it. See if he has any money!"

At the gate the servant opened the door a trifle and looked out at the waiting people. And this time he spoke in the old language.

"Have you money to pay for the treatment?"

Now Kino reached into a secret place somewhere under his blanket. He brought out a paper folded many times. Crease by crease he unfolded it, until at last there came to view eight small misshapen seed pearls,[10] as ugly and gray as little ulcers, flattened and almost valueless. The servant took the paper and closed the gate again, but this time he was not gone long. He opened the gate just wide enough to pass the paper back.

"The doctor has gone out," he said. "He was called to a serious case." And he shut the gate quickly out of shame.

And now a wave of shame went over the whole procession. They melted away. The beggars went back to the church steps, the stragglers moved off, and the neighbors departed so that the public shaming of Kino would not be in their eyes.

For a long time Kino stood in front of the gate with Juana beside him. Slowly he put his suppliant hat on his head. Then, without warning, he struck the gate a crushing blow with his fist. He looked down in wonder at his split knuckles and at the blood that flowed down between his fingers.

9. **Patron** (pä-trōn′): master; boss.
10. **seed pearls:** very small, irregularly shaped pearls.

For Study and Discussion

Analyzing and Interpreting the Novel

1. Steinbeck introduces his major characters and their setting in this first chapter. What details suggest that Kino and Juana are good people who live in harmony with their world?

2. Kino's songs are used to reveal his emotions. For example, the Song of the Family says to Kino: "this is the *Whole*." What do you think the word *whole* signifies here?

3. A new song intrudes into the Song of the Family when the scorpion appears above the hanging box. **a.** What does Kino identify the scorpion with? **b.** What events does the scorpion bite set into motion?

4. The doctor is introduced on page 830. **a.** How does he contrast with Kino in appearance, in way of life, and in values? **b.** What details does Steinbeck use to make the doctor seem evil?

5a. What larger social conflict has existed for centuries between the doctor's people and Kino's? **b.** How is this larger conflict underscored by the doctor's saying, "I am a doctor, not a veterinary" (page 830)?

II

The town lay on a broad estuary,[1] its old yellow plastered buildings hugging the beach. And on the beach the white and blue canoes that came from Nayarit[2] were drawn up, canoes preserved for generations by a hard shell-like waterproof plaster whose making was a secret of the fishing people. They were high and graceful canoes with curving bow and stern and a braced section midships where a mast could be stepped to carry a small lateen sail.[3]

The beach was yellow sand, but at the water's edge a rubble of shell and algae took its place. Fiddler crabs bubbled and sputtered in their holes in the sand, and in the shallows little lobsters popped in and out of their tiny homes in the rubble and sand. The sea bottom was rich with crawling and swimming and growing things. The brown algae waved in the gentle currents and the green eel grass swayed and little sea horses clung to its stems. Spotted botete,[4] the poison fish, lay on the bottom in the eel-grass beds, and the bright-colored swimming crabs scampered over them.

On the beach the hungry dogs and the hungry pigs of the town searched endlessly for any dead fish or sea bird that might have floated in on a rising tide.

Although the morning was young, the hazy mirage was up. The uncertain air that magnified some things and blotted out others hung over the whole Gulf so that all sights were unreal and vision could not be trusted; so that sea and land had the sharp clarities and the vagueness of a dream. Thus it might be that the people of the Gulf trust things of the spirit

1. **estuary:** an inlet of the sea.
2. **Nayarit** (nä′yä-rēt′): a small state in western Mexico, northwest of Mexico City.
3. **lateen** (lă-tēn′) **sail:** a triangular sail hung from a long pole attached to a short mast.
4. **botete** (bō-tä′tā).

and things of the imagination, but they do not trust their eyes to show them distance or clear outline or any optical exactness. Across the estuary from the town one section of mangroves stood clear and telescopically defined, while another mangrove clump was a hazy black-green blob. Part of the far shore disappeared into a shimmer that looked like water. There was no certainty in seeing, no proof that what you saw was there or was not there. And the people of the Gulf expected all places were that way, and it was not strange to them. A copper haze hung over the water, and the hot morning sun beat on it and made it vibrate blindingly.

The brush houses of the fishing people were back from the beach on the right-hand side of the town, and the canoes were drawn up in front of this area.

Kino and Juana came slowly down to the beach and to Kino's canoe, which was the one thing of value he owned in the world. It was very old. Kino's grandfather had brought it from Nayarit, and he had given it to Kino's father, and so it had come to Kino. It was at once property and source of food, for a man with a boat can guarantee a woman that she will eat something. It is the bulwark against starvation. And every year Kino refinished his canoe with the hard shell-like plaster by the secret method that had also come to him from his father. Now he came to the canoe and touched the bow tenderly as he always did. He laid his diving rock and his basket and the two ropes in the sand by the canoe. And he folded his blanket and laid it in the bow.

Juana laid Coyotito on the blanket, and she placed her shawl over him so that the hot sun could not shine on him. He was quiet now, but the swelling on his shoulder had continued up his neck and under his ear and his face was puffed and feverish. Juana went to the water and waded in. She gathered some brown sea-

weed and made a flat damp poultice[5] of it, and this she applied to the baby's swollen shoulder, which was as good a remedy as any and probably better than the doctor could have done. But the remedy lacked his authority because it was simple and didn't cost anything. The stomach cramps had not come to Coyotito. Perhaps Juana had sucked out the poison in time, but she had not sucked out her worry over her firstborn. She had not prayed directly for the recovery of the baby—she had prayed that they might find a pearl with which to hire the doctor to cure the baby, for the minds of people are as unsubstantial as the mirage of the Gulf.

Now Kino and Juana slid the canoe down the beach to the water, and when the bow floated, Juana climbed in, while Kino pushed the stern in and waded beside it until it floated lightly and trembled on the little breaking waves. Then in coordination Juana and Kino drove their double-bladed paddles into the sea, and the canoe creased the water and hissed with speed. The other pearlers were gone out long since. In a few moments Kino could see them clustered in the haze, riding over the oyster bed.

Light filtered down through the water to the bed where the frilly pearl oysters lay fastened to the rubbly bottom, a bottom strewn with shells of broken, opened oysters. This was the bed that had raised the King of Spain to be a great power in Europe in past years, had helped to pay for his wars, and had decorated the churches for his soul's sake. The gray oysters with ruffles like skirts on the shells, the barnacle-crusted oysters with little bits of weed clinging to the skirts and small crabs climbing over them. An accident could happen to these oysters, a grain of sand could lie in the folds of muscle and irritate the flesh until in self-

5. **poultice** (pōl′tĭs): a soft, moist substance applied to the body as a remedy.

protection the flesh coated the grain with a layer of smooth cement. But once started, the flesh continued to coat the foreign body until it fell free in some tidal flurry or until the oyster was destroyed. For centuries men had dived down and torn the oysters from the beds and ripped them open, looking for the coated grains of sand. Swarms of fish lived near the bed to live near the oysters thrown back by the searching men and to nibble at the shining inner shells. But the pearls were accidents, and the finding of one was luck, a little pat on the back by God or the gods or both.

Kino had two ropes, one tied to a heavy stone and one to a basket. He stripped off his shirt and trousers and laid his hat in the bottom of the canoe. The water was oily smooth. He took his rock in one hand and his basket in the other, and he slipped feet first over the side and the rock carried him to the bottom. The bubbles rose behind him until the water cleared and he could see. Above, the surface of the water was an undulating mirror of brightness, and he could see the bottoms of the canoes sticking through it.

Kino moved cautiously so that the water would not be obscured with mud or sand. He hooked his foot in the loop on his rock and his hands worked quickly, tearing the oysters loose, some singly, others in clusters. He laid them in his basket. In some places the oysters clung to one another so that they came free in lumps.

Now, Kino's people had sung of everything that happened or existed. They had made songs to the fishes, to the sea in anger and to the sea in calm, to the light and the dark and the sun and the moon, and the songs were all in Kino and in his people—every song that had ever been made, even the ones forgotten. And as he filled his basket the song was in Kino, and the beat of the song was his pounding heart as it ate the oxygen from his held breath, and the melody of the song was the gray-green water and the little scuttling animals and the clouds of fish that flitted by and were gone. But in the song there was a secret little inner song, hardly perceptible, but always there, sweet and secret and clinging, almost hiding in the countermelody, and this was the Song of the Pearl That Might Be, for every shell thrown in the basket might contain a pearl. Chance was against it, but luck and the gods might be for it. And in the canoe above him Kino knew that Juana was making the magic of prayer, her face set rigid and her muscles hard to force the luck, to tear the luck out of the god's hands, for she needed the luck for the swollen shoulder of Coyotito. And because the need was great and the desire was great, the little secret melody of the pearl that might be was stronger this morning. Whole phrases of it came clearly and softly into the Song of the Undersea.

Kino, in his pride and youth and strength, could remain down over two minutes without strain, so that he worked deliberately, selecting the largest shells. Because they were disturbed, the oyster shells were tightly closed. A little to his right a hummock of rubbly rock stuck up, covered with young oysters not ready to take. Kino moved next to the hummock, and then, beside it, under a little overhang, he saw a very large oyster lying by itself, not covered with its clinging brothers. The shell was partly open, for the overhang protected this ancient oyster, and in the liplike muscle Kino saw a ghostly gleam, and then the shell closed down. His heart beat out a heavy rhythm and the melody of the maybe pearl shrilled in his ears. Slowly he forced the oyster loose and held it tightly against his breast. He kicked his foot free from the rock loop, and his body rose to the surface and his black hair gleamed in the sunlight. He reached over the side of the canoe and laid the oyster in the bottom.

Then Juana steadied the boat while he climbed in. His eyes were shining with excitement, but in decency he pulled up his rock, and then he pulled up his basket of oysters and lifted them in. Juana sensed his excitement, and she pretended to look away. It is not good to want a thing too much. It sometimes drives the luck away. You must want it just enough, and you must be very tactful with God or the gods. But Juana stopped breathing.

Los remeros (*The Rowers*) (1944) by Rufino Tamayo. Gouache on paper.

Very deliberately Kino opened his short strong knife. He looked speculatively at the basket. Perhaps it would be better to open *the* oyster last. He took a small oyster from the basket, cut the muscle, searched the folds of flesh, and threw it in the water. Then he seemed to see the great oyster for the first time. He squatted in the bottom of the canoe, picked up the shell and examined it. The flutes were shining black to brown, and only a few small barnacles adhered to the shell. Now Kino was reluctant to open it. What he had seen, he knew, might be a reflection, a piece of flat shell accidentally drifted in or a complete illusion. In this Gulf of uncertain light there were more illusions than realities.

But Juana's eyes were on him and she could not wait. She put her hand on Coyotito's covered head. "Open it," she said softly.

Kino deftly slipped his knife into the edge of the shell. Through the knife he could feel the muscle tighten hard. He worked the blade leverwise and the closing muscle parted and the shell fell apart. The liplike flesh writhed up and then subsided. Kino lifted the flesh, and there it lay, the great pearl, perfect as the moon. It captured the light and refined it and gave it back in silver incandescence. It was as large as a sea gull's egg. It was the greatest pearl in the world.

Juana caught her breath and moaned a little. And to Kino the secret melody of the maybe pearl broke clear and beautiful, rich and warm and lovely, glowing and gloating and triumphant. In the surface of the great pearl he could see dream forms. He picked the pearl from the dying flesh and held it in his palm, and he turned it over and saw that its curve was perfect. Juana came near to stare at it in his hand, and it was the hand he had smashed against the doctor's gate, and the torn flesh of the knuckles was turned grayish white by the sea water.

Instinctively Juana went to Coyotito where he lay on his father's blanket. She lifted the poultice of seaweed and looked at the shoulder. "Kino," she cried shrilly.

He looked past his pearl, and he saw that the swelling was going out of the baby's shoulder, the poison was receding from its body. Then Kino's fist closed over the pearl and his emotion broke over him. He put back his head and howled. His eyes rolled up and he screamed and his body was rigid. The men in the other canoes looked up, startled, and then they dug their paddles into the sea and raced toward Kino's canoe.

Reading Check

1. What is the effect of the haze that hangs over the Gulf?
2. What is Kino's sole valuable possession?
3. What is Kino's occupation?
4. Describe his equipment.
5. How does Juana cure Coyotito?

For Study and Discussion

Analyzing and Interpreting the Novel

1. In this chapter, Steinbeck describes the story's setting. How has the setting become part of the people's ways of seeing and thinking?

2a. Why does Juana feel that it is "not good to want a thing too much"? b. What does this reveal about the villagers' attitude toward life?

3. Two of Kino's and Juana's desires seem to be fulfilled at the end of this chapter. One is the finding of the pearl. a. What other "miracle" has accompanied the discovery of the pearl? b. Do you think that Kino links the two events? Why or why not?

III

A town is a thing like a colonial animal. A town has a nervous system and a head and shoulders and feet. A town is a thing separate from all other towns, so that there are no two towns alike. And a town has a whole emotion. How news travels through a town is a mystery not easily to be solved. News seems to move faster than small boys can scramble and dart to tell it, faster than women can call it over the fences.

Before Kino and Juana and the other fishers had come to Kino's brush house, the nerves of the town were pulsing and vibrating with the news—Kino had found the Pearl of the World. Before panting little boys could strangle out the words, their mothers knew it. The news swept on past the brush houses, and it washed in a foaming wave into the town of stone and plaster. It came to the priest walking in his garden, and it put a thoughtful look in his eyes and a memory of certain repairs necessary to the church. He wondered what the pearl would be worth. And he wondered whether he had baptized Kino's baby, or married him for that matter. The news came to the shop-keepers, and they looked at men's clothes that had not sold so well.

The news came to the doctor where he sat with a woman whose illness was age, though neither she nor the doctor would admit it. And when it was made plain who Kino was, the doctor grew stern and judicious at the same time. "He is a client of mine," the doctor said. "I'm treating his child for a scorpion sting." And the doctor's eyes rolled up a little in their fat hammocks and he thought of Paris. He remembered the room he had lived in there as a great and luxurious place, and he remembered the hard-faced woman who had lived with him as a beautiful and kind girl, although she had been none of these three. The doctor looked past his aged patient and saw himself sitting in a restaurant in Paris and a waiter was just opening a bottle of wine.

The news came early to the beggars in front of the church, and it made them giggle a little with pleasure, for they knew that there is no almsgiver in the world like a poor man who is suddenly lucky.

Kino has found the Pearl of the World. In the town, in little offices, sat the men who bought pearls from the fishers. They waited in their chairs until the pearls came in, and then they cackled and fought and shouted and threatened until they reached the lowest price the fisherman would stand. But there was a price below which they dared not go, for it had happened that a fisherman in despair had given his pearls to the church. And when the buying was over, these buyers sat alone and their fingers played restlessly with the pearls, and they wished they owned the pearls. For there were not many buyers really—there was only one, and he kept his agents in separate offices to give a semblance of competition. The news came to these men, and their eyes squinted and their fingertips burned a little, and each one thought how the patron could not live forever and someone had to take his place. And each one thought how with some capital he could get a new start.

All manner of people grew interested in Kino—people with things to sell and people with favors to ask. Kino had found the Pearl of the World. The essence of pearl mixed with essence of men and a curious dark residue was precipitated. Every man suddenly became related to Kino's pearl, and Kino's pearl went into the dreams, the speculations, the schemes, the plans, the futures, the wishes, the needs, the lusts, the hungers, of everyone, and only one person stood in the way and that was Kino, so that he became curiously every man's enemy. The news stirred up something infinitely black and evil in the town; the black

distillate was like the scorpion, or like hunger in the smell of food, or like loneliness when love is withheld. The poison sacs of the town began to manufacture venom, and the town swelled and puffed with the pressure of it.

But Kino and Juana did not know these things. Because they were happy and excited they thought everyone shared their joy. Juan Tomás and Apolonia did, and they were the world too. In the afternoon, when the sun had gone over the mountains of the Peninsula to sink in the outward sea, Kino squatted in his

Vendedores de maiz en el mercado (Corn Vendors in the Marketplace) (1934) by Diego Rivera. Tempera on linen.

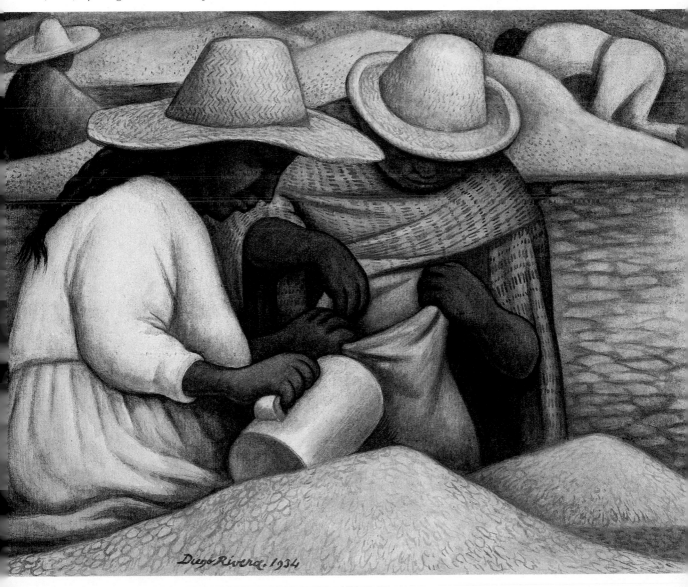

house with Juana beside him. And the brush house was crowded with neighbors. Kino held the great pearl in his hand, and it was warm and alive in his hand. And the music of the pearl had merged with the music of the family so that one beautified the other. The neighbors looked at the pearl in Kino's hand and they wondered how such luck could come to any man.

And Juan Tomás, who squatted on Kino's right hand because he was his brother, asked, "What will you do now that you have become a rich man?"

Kino looked into his pearl, and Juana cast her eyelashes down and arranged her shawl to cover her face so that her excitement could not be seen. And in the incandescence of the pearl the pictures formed of the things Kino's mind had considered in the past and had given up as impossible. In the pearl he saw Juana and Coyotito and himself standing and kneeling at the high altar, and they were being married now that they could pay. He spoke softly, "We will be married—in the church."

In the pearl he saw how they were dressed— Juana in a shawl stiff with newness and a new skirt, and from under the long skirt Kino could see that she wore shoes. It was in the pearl— the picture glowing there. He himself was dressed in new white clothes, and he carried a new hat—not of straw but of fine black felt— and he too wore shoes—not sandals but shoes that laced. But Coyotito—he was the one—he wore a blue sailor suit from the United States and a little yachting cap such as Kino had seen once when a pleasure boat put into the estuary. All of these things Kino saw in the lucent[1] pearl and he said, "We will have new clothes."

And the music of the pearl rose like a chorus of trumpets in his ears.

Then to the lovely gray surface of the pearl

came the little things Kino wanted: a harpoon to take the place of one lost a year ago, a new harpoon of iron with a ring in the end of the shaft; and—his mind could hardly make the leap—a rifle—but why not, since he was so rich. And Kino saw Kino in the pearl, Kino holding a Winchester carbine. It was the wildest daydreaming and very pleasant. His lips moved hesitantly over this—"A rifle," he said. "Perhaps a rifle."

It was the rifle that broke down the barriers. This was an impossibility, and if he could think of having a rifle whole horizons were burst and he could rush on. For it is said that humans are never satisfied, that you give them one thing and they want something more. And this is said in disparagement, whereas it is one of the greatest talents the species has and one that has made it superior to animals that are satisfied with what they have.

The neighbors, close pressed and silent in the house, nodded their heads at his wild imaginings. And a man in the rear murmured, "A rifle. He will have a rifle."

But the music of the pearl was shrilling with triumph in Kino. Juana looked up, and her eyes were wide at Kino's courage and at his imagination. And electric strength had come to him now the horizons were kicked out. In the pearl he saw Coyotito sitting at a little desk in a school, just as Kino had once seen it through an open door. And Coyotito was dressed in a jacket, and he had on a white collar and a broad silken tie. Moreover, Coyotito was writing on a big piece of paper. Kino looked at his neighbors fiercely. "My son will go to school," he said, and the neighbors were hushed. Juana caught her breath sharply. Her eyes were bright as she watched him, and she looked quickly down at Coyotito in her arms to see whether this might be possible.

But Kino's face shone with prophecy. "My son will read and open the books, and my son

1. **lucent** (loo′sənt): shiny; luminous.

will write and will know writing. And my son will make numbers, and these things will make us free because he will know—he will know and through him we will know." And in the pearl Kino saw himself and Juana squatting by the little fire in the brush hut while Coyotito read from a great book. "This is what the pearl will do," said Kino. And he had never said so many words together in his life. And suddenly he was afraid of his talking. His hand closed down over the pearl and cut the light away from it. Kino was afraid as a man is afraid who says, "I will,"[2] without knowing.

Now the neighbors knew they had witnessed a great marvel. They knew that time would now date from Kino's pearl, and that they would discuss this moment for many years to come. If these things came to pass, they would recount how Kino looked and what he said and how his eyes shone, and they would say, "He was a man transfigured. Some power was given to him, and there it started. You see what a great man he has become, starting from that moment. And I myself saw it."

And if Kino's planning came to nothing, those same neighbors would say, "There it started. A foolish madness came over him so that he spoke foolish words. God keep us from such things. Yes, God punished Kino because he rebelled against the way things are. You see what has become of him. And I myself saw the moment when his reason left him."

Kino looked down at his closed hand and the knuckles were scabbed over and tight where he had struck the gate.

Now the dusk was coming. And Juana looped her shawl under the baby so that he hung against her hip, and she went to the fire hole and dug a coal from the ashes and broke a few twigs over it and fanned a flame alive. The little flames danced on the faces of the neighbors. They knew they should go to their own dinners, but they were reluctant to leave.

The dark was almost in, and Juana's fire threw shadows on the brush walls when the whisper came in, passed from mouth to mouth. "The Father is coming—the priest is coming." The men uncovered their heads and stepped back from the door, and the women gathered their shawls about their faces and cast down their eyes. Kino and Juan Tomás, his brother, stood up. The priest came in—a graying, aging man with an old skin and a young sharp eye. Children, he considered these people, and he treated them like children.

"Kino," he said softly, "thou are named after a great man—and a great Father of the Church."[3] He made it sound like a benediction. "Thy namesake tamed the desert and sweetened the minds of thy people, didst thou know that? It is in the books."

Kino looked quickly down at Coyotito's head, where he hung on Juana's hip. Some day, his mind said, that boy would know what things were in the books and what things were not. The music had gone out of Kino's head, but now, thinly, slowly, the melody of the morning, the music of evil, of the enemy sounded, but it was faint and weak. And Kino looked at his neighbors to see who might have brought this song in.

But the priest was speaking again. "It has come to me that thou hast found a great fortune, a great pearl."

Kino opened his hand and held it out, and the priest gasped a little at the size and beauty of the pearl. And then he said, "I hope thou wilt remember to give thanks, my son, to Him who has given thee this treasure, and to pray for guidance in the future."

Kino nodded dumbly, and it was Juana who

2. **"I will"**: the promise made in the wedding ceremony.

3. **Father of the Church:** Kino is named after Eusebius Kino, a great seventeenth-century missionary-explorer.

spoke softly. "We will, Father. And we will be married now. Kino has said so." She looked at the neighbors for confirmation, and they nodded their heads solemnly.

The priest said, "It is pleasant to see that your first thoughts are good thoughts. God bless you, my children." He turned and left quietly, and the people let him through.

But Kino's hand had closed tightly on the pearl again, and he was glancing about suspiciously, for the evil song was in his ears, shrilling against the music of the pearl.

The neighbors slipped away to go to their houses, and Juana squatted by the fire and set her clay pot of boiled beans over the little flame. Kino stepped to the doorway and looked out. As always, he could smell the smoke from many fires, and he could see the hazy stars and feel the damp of the night air so that he covered his nose from it. The thin dog came to him and threshed itself in greeting like a windblown flag, and Kino looked down at it and didn't see it. He had broken through the horizons into a cold and lonely outside. He felt alone and unprotected, and scraping crickets and shrilling tree frogs and croaking toads seemed to be carrying the melody of evil. Kino shivered a little and drew his blanket more tightly against his nose. He carried the pearl still in his hand, tightly closed in his palm, and it was warm and smooth against his skin.

Behind him he heard Juana patting the cakes before she put them down on the clay cooking sheet. Kino felt all the warmth and security of his family behind him, and the Song of the Family came from behind him like the purring of a kitten. But now, by saying what his future was going to be like, he had created it. A plan is a real thing, and things projected are experienced. A plan once made and visualized becomes a reality along with other realities—never to be destroyed but easily to be attacked. Thus Kino's future was real, but having set it up, other forces were set up to destroy it, and this he knew, so that he had to prepare to meet the attack. And this Kino knew also—that the gods do not love men's plans, and the gods do not love success unless it comes by accident. He knew that the gods take their revenge on a man if he be successful through his own efforts. Consequently Kino was afraid of plans, but having made one, he could never destroy it. And to meet the attack, Kino was already making a hard skin for himself against the world. His eyes and his mind probed for danger before it appeared.

Standing in the door, he saw two men approach; and one of them carried a lantern which lighted the ground and the legs of the men. They turned in through the opening of Kino's brush fence and came to his door. And Kino saw that one was the doctor and the other the servant who had opened the gate in the morning. The split knuckles on Kino's right hand burned when he saw who they were.

The doctor said, "I was not in when you came this morning. But now, at the first chance, I have come to see the baby."

Kino stood in the door, filling it, and hatred raged and flamed in back of his eyes, and fear too, for the hundreds of years of subjugation were cut deep in him.

"The baby is nearly well now," he said curtly.

The doctor smiled, but his eyes in their little lymph-lined hammocks did not smile.

He said, "Sometimes, my friend, the scorpion sting has a curious effect. There will be apparent improvement, and then without warning—pouf!" He pursed his lips and made a little explosion to show how quick it could be, and he shifted his small black doctor's bag about so that the light of the lamp fell upon it, for he knew that Kino's race love the tools of any craft and trust them. "Sometimes," the doctor went on in a liquid tone, "sometimes

there will be a withered leg or a blind eye or a crumpled back. Oh, I know the sting of the scorpion, my friend, and I can cure it."

Kino felt the rage and hatred melting toward fear. He did not know, and perhaps this doctor did. And he could not take the chance of putting his certain ignorance against this man's possible knowledge. He was trapped as his people were always trapped, and would be until, as he had said, they could be sure that the things in the books were really in the books. He could not take a chance—not with the life or with the straightness of Coyotito. He stood aside and let the doctor and his man enter the brush hut.

Juana stood up from the fire and backed away as he entered, and she covered the baby's face with the fringe of her shawl. And when the doctor went to her and held out his hand, she clutched the baby tight and looked at Kino where he stood with the fire shadows leaping on his face.

Kino nodded, and only then did she let the doctor take the baby.

"Hold the light," the doctor said, and when the servant held the lantern high, the doctor looked for a moment at the wound on the baby's shoulder. He was thoughtful for a moment and then he rolled back the baby's eyelid and looked at the eyeball. He nodded his head while Coyotito struggled against him.

"It is as I thought," he said. "The poison has gone inward and it will strike soon. Come look!" He held the eyelid down. "See—it is blue." And Kino, looking anxiously, saw that indeed it was a little blue. And he didn't know whether or not it was always a little blue. But the trap was set. He couldn't take the chance.

The doctor's eyes watered in their little hammocks. "I will give him something to try to turn the poison aside," he said. And he handed the baby to Kino.

Then from his bag he took a little bottle of white powder and a capsule of gelatine. He filled the capsule with the powder and closed it, and then around the first capsule he fitted a second capsule and closed it. Then he worked very deftly. He took the baby and pinched its lower lip until it opened its mouth. His fat fingers placed the capsule far back on the baby's tongue, back of the point where he could spit it out, and then from the floor he picked up the little pitcher of pulque and gave Coyotito a drink, and it was done. He looked again at the baby's eyeball and he pursed his lips and seemed to think.

At last he handed the baby back to Juana, and he turned to Kino. "I think the poison will attack within the hour," he said. "The medicine may save the baby from hurt, but I will come back in an hour. Perhaps I am in time to save him." He took a deep breath and went out of the hut, and his servant followed him with the lantern.

Now Juana had the baby under her shawl, and she stared at it with anxiety and fear. Kino came to her, and he lifted the shawl and stared at the baby. He moved his hand to look under the eyelid, and only then saw that the pearl was still in his hand. Then he went to a box by the wall, and from it he brought a piece of rag. He wrapped the pearl in the rag, then went to the corner of the brush house and dug a little hole with his fingers in the dirt floor, and he put the pearl in the hole and covered it up and concealed the place. And then he went to the fire where Juana was squatting, watching the baby's face.

The doctor, back in his house, settled into his chair and looked at his watch. His people brought him a little supper of chocolate and sweet cakes and fruit, and he stared at the food discontentedly.

In the houses of the neighbors the subject that would lead all conversations for a long time to come was aired for the first time to see

how it would go. The neighbors showed one another with their thumbs how big the pearl was, and they made little caressing gestures to show how lovely it was. From now on they would watch Kino and Juana very closely to see whether riches turned their heads, as riches turned all people's heads. Everyone knew why the doctor had come. He was not good at dissembling and he was very well understood.

Out in the estuary a tight-woven school of small fishes glittered and broke water to escape a school of great fishes that drove in to eat them. And in the houses the people could hear the swish of the small ones and the bouncing splash of the great ones as the slaughter went on. The dampness arose out of the Gulf and was deposited on bushes and cacti and on little trees in salty drops. And the night mice crept about on the ground and the little night hawks hunted them silently.

The skinny black puppy with flame spots over his eyes came to Kino's door and looked in. He nearly shook his hind quarters loose when Kino glanced up at him, and he subsided when Kino looked away. The puppy did not enter the house, but he watched with frantic interest while Kino ate his beans from the little pottery dish and wiped it clean with a corncake and ate the cake and washed the whole down with a drink of pulque.

Kino was finished and was rolling a cigarette when Juana spoke sharply. "Kino." He glanced at her and then got up and went quickly to her for he saw fright in her eyes. He stood over her, looking down, but the light was very dim. He kicked a pile of twigs into the fire hole to make a blaze, and then he could see the face of Coyotito. The baby's face was flushed and his throat was working and a little thick drool of saliva issued from his lips. The spasms of the stomach muscles began, and the baby was very sick.

Kino knelt beside his wife. "So the doctor knew," he said, but he said it for himself as well as for his wife, for his mind was hard and suspicious and he was remembering the white powder. Juana rocked from side to side and moaned out the little Song of the Family as though it could ward off the danger, and the baby vomited and writhed in her arms. Now uncertainty was in Kino, and the music of evil throbbed in his head and nearly drove out Juana's song.

The doctor finished his chocolate and nibbled the little fallen pieces of sweet cake. He brushed his fingers on a napkin, looked at his watch, arose, and took up his little bag.

The news of the baby's illness traveled quickly among the brush houses, for sickness is second only to hunger as the enemy of poor people. And some said softly, "Luck, you see, brings bitter friends." And they nodded and got up to go to Kino's house. The neighbors scuttled with covered noses through the dark until they crowded into Kino's house again. They stood and gazed, and they made little comments on the sadness that this should happen at a time of joy, and they said, "All things are in God's hands." The old women squatted down beside Juana to try to give her aid if they could and comfort if they could not.

Then the doctor hurried in, followed by his man. He scattered the old women like chickens. He took the baby and examined it and felt its head. "The poison it has worked," he said. "I think I can defeat it. I will try my best." He asked for water, and in the cup of it he put three drops of ammonia, and he pried open the baby's mouth and poured it down. The baby spluttered and screeched under the treatment, and Juana watched him with haunted eyes. The doctor spoke a little as he worked. "It is lucky that I knew about the poison of the scorpion, otherwise——" and he shrugged to show what could have happened.

But Kino was suspicious, and he could not take his eyes from the doctor's open bag, and from the bottle of white powder there. Gradually the spasms subsided and the baby relaxed under the doctor's hands. And then Coyotito sighed deeply and went to sleep, for he was very tired with vomiting.

The doctor put the baby in Juana's arms. "He will get well now," he said. "I have won the fight." And Juana looked at him with adoration.

The doctor was closing his bag now. He said, "When do you think you can pay this bill?" He said it even kindly.

"When I have sold my pearl I will pay you," Kino said.

"You have a pearl? A good pearl?" the doctor asked with interest.

And then the chorus of the neighbors broke in. "He has found the Pearl of the World," they cried, and they joined forefinger with thumb to show how great the pearl was.

"Kino will be a rich man," they clamored. "It is a pearl such as one has never seen."

The doctor looked surprised. "I had not heard of it. Do you keep this pearl in a safe place? Perhaps you would like me to put it in my safe?"

Kino's eyes were hooded now, his cheeks were drawn taut. "I have it secure," he said. "Tomorrow I will sell it and then I will pay you."

The doctor shrugged, and his wet eyes never left Kino's eyes. He knew the pearl would be buried in the house, and he thought Kino might look toward the place where it was buried. "It would be a shame to have it stolen before you could sell it," the doctor said, and he saw Kino's eyes flick involuntarily to the floor near the side post of the brush house.

When the doctor had gone and all the neighbors had reluctantly returned to their houses, Kino squatted beside the little glowing coals in the fire hole and listened to the night sound, the soft sweep of the little waves on the shore and the distant barking of dogs, the creeping of the breeze through the brush house roof and the soft speech of his neighbors in their houses in the village. For these people do not sleep soundly all night; they awaken at intervals and talk a little and then go to sleep again. And after a while Kino got up and went to the door of his house.

He smelled the breeze and he listened for any foreign sound of secrecy or creeping, and his eyes searched the darkness, for the music of evil was sounding in his head and he was fierce and afraid. After he had probed the night with his senses he went to the place by the side post where the pearl was buried, and he dug it up and brought it to his sleeping mat, and under his sleeping mat he dug another little hole in the dirt floor and buried his pearl and covered it up again.

And Juana, sitting by the fire hole, watched him with questioning eyes, and when he had buried his pearl she asked, "Who do you fear?"

Kino searched for a true answer, and at last he said, "Everyone." And he could feel a shell of hardness drawing over him.

After a while they lay down together on the sleeping mat, and Juana did not put the baby in his box tonight, but cradled him on her arms and covered his face with her head shawl. And the last light went out of the embers in the fire hole.

But Kino's brain burned, even during his sleep, and he dreamed that Coyotito could read, that one of his own people could tell him the truth of things. And in his dream, Coyotito was reading from a book as large as a house, with letters as big as dogs, and the words galloped and played on the book. And then darkness spread over the page, and with the darkness came the music of evil again, and Kino

stirred in his sleep; and when he stirred, Juana's eyes opened in the darkness. And then Kino awakened, with the evil music pulsing in him, and he lay in the darkness with his ears alert.

Then from the corner of the house came a sound so soft that it might have been simply a thought, a little furtive movement, a touch of a foot on earth, the almost inaudible purr of controlled breathing. Kino held his breath to listen, and he knew that whatever dark thing was in his house was holding its breath too, to listen. For a time no sound at all came from the corner of the brush house. Then Kino might have thought he had imagined the sound. But Juana's hand came creeping over to him in warning, and then the sound came again! the whisper of a foot on dry earth and the scratch of fingers in the soil.

And now a wild fear surged in Kino's breast, and on the fear came rage, as it always did. Kino's hand crept into his breast where his knife hung on a string, and then he sprang like an angry cat, leaped striking and spitting for the dark thing he knew was in the corner of the house. He felt cloth, struck at it with his knife and missed, and struck again and felt his knife go through cloth, and then his head crashed with lightning and exploded with pain. There was a soft scurry in the doorway, and running steps for a moment, and then silence.

Kino could feel warm blood running down from his forehead, and he could hear Juana calling to him. "Kino! Kino!" And there was terror in her voice. Then coldness came over him as quickly as the rage had, and he said, "I am all right. The thing has gone."

He groped his way back to the sleeping mat. Already Juana was working at the fire. She uncovered an ember from the ashes and shredded little pieces of cornhusk over it and blew a little flame into the cornhusks so that a tiny light danced through the hut. And then from a secret place Juana brought a little piece of consecrated candle and lighted it at the flame and set it upright on a fireplace stone. She worked quickly, crooning as she moved about. She dipped the end of her head shawl in water and swabbed the blood from Kino's bruised forehead. "It is nothing," Kino said, but his eyes and his voice were hard and cold and a brooding hate was growing in him.

Now the tension which had been growing in Juana boiled up to the surface and her lips were thin. "This thing is evil," she cried harshly. "This pearl is like a sin! It will destroy us," and her voice rose shrilly. "Throw it away, Kino. Let us break it between stones. Let us bury it and forget the place. Let us throw it back into the sea. It has brought evil. Kino, my husband, it will destroy us." And in the firelight her lips and her eyes were alive with her fear.

But Kino's face was set, and his mind and his will were set. "This is our one chance," he said. "Our son must go to school. He must break out of the pot that holds us in."

"It will destroy us all," Juana cried. "Even our son."

"Hush," said Kino. "Do not speak any more. In the morning we will sell the pearl, and then the evil will be gone, and only the good remain. Now hush, my wife." His dark eyes scowled into the little fire, and for the first time he knew that his knife was still in his hands, and he raised the blade and looked at it and saw a little line of blood on the steel. For a moment he seemed about to wipe the blade on his trousers but then he plunged the knife into the earth and so cleansed it.

The distant roosters began to crow and the air changed and the dawn was coming. The wind of the morning ruffled the water of the estuary and whispered through the mangroves, and the little waves beat on the rubbly beach with an increased tempo. Kino raised

the sleeping mat and dug up his pearl and put it in front of him and stared at it.

And the beauty of the pearl, winking and glimmering in the light of the little candle, cozened[4] his brain with its beauty. So lovely it was, so soft, and its own music came from it— its music of promise and delight, its guarantee of the future, of comfort, of security. Its warm lucence promised a poultice against illness and a wall against insult. It closed a door on hunger. And as he stared at it Kino's eyes softened and his face relaxed. He could see the little image of the consecrated candle reflected in the soft surface of the pearl, and he heard again in his ears the lovely music of the undersea, the tone of the diffused green light of the sea bottom. Juana, glancing secretly at him, saw him smile. And because they were in some way one thing and one purpose, she smiled with him.

And they began this day with hope.

4. **cozened** (kŭz'ənd): beguiled, deluded.

Reading Check

1. What name has been given to Kino's pearl?
2. What does Kino wish to buy for himself?
3. What are his plans for his son?
4. Who are the two outsiders who come to Kino's brush house?
5. Why does Kino change the hiding place for his pearl?

For Study and Discussion

Analyzing and Interpreting the Novel

1. The poison of the scorpion infected Coyotito in the first chapter, but another kind of poison now infects the town. Steinbeck describes this evil with a metaphor: "the town swelled and puffed with the pressure of it." How would you describe what is actually happening in the town?

2. What are the reactions of these people to Kino's discovery: the priest, the shopkeepers, the doctor, the beggars, the pearl buyers?

3. How do Kino's dreams for the pearl differ from those of the townspeople?

4. Why do you think Kino hears the evil song when the first outsider, the priest, comes to see the pearl?

5. On page 840 we read of the first changes taking place in Kino: "He had broken through the horizons," and he "was already making a hard skin for himself against the world." **a.** What do these metaphors mean? **b.** How would you explain what is causing the change in Kino?

6a. Why does the doctor come to Kino's house after refusing to see the baby that morning? **b.** What do you think he actually does to Coyotito?

7. What experiences make Kino realize that his innocence and lack of knowledge have put him at the mercy of other people?

IV

It is wonderful the way a little town keeps track of itself and of all its units. If every single man and woman, child and baby, acts and conducts itself in a known pattern and breaks no walls and differs with no one and experiments in no way and is not sick and does not endanger the ease and peace of mind or steady unbroken flow of the town, then that unit can disappear and never be heard of. But let one man step out of the regular thought or the known and trusted pattern, and the nerves of the towns-people ring with nervousness and communication travels over the nerve lines of the town. Then every unit communicates to the whole.

Thus, in La Paz, it was known in the early morning through the whole town that Kino was going to sell his pearl that day. It was known among the neighbors in the brush huts, among the pearl fishermen; it was known among the Chinese grocery-store owners; it was known in the church, for the altar boys whispered about it. Word of it crept in among the nuns; the beggars in front of the church spoke of it, for they would be there to take the tithe[1] of the first fruits of the luck. The little boys knew about it with excitement, but most of all the pearl buyers knew about it, and when the day had come, in the offices of the pearl buyers, each man sat alone with his little black velvet tray, and each man rolled the pearls about with his fingertips and considered his part in the picture.

It was supposed that the pearl buyers were individuals acting alone, bidding against one another for the pearls the fishermen brought in. And once it had been so. But this was a wasteful method, for often, in the excitement of bidding for a fine pearl, too great a price had been paid to the fishermen. This was ex-

travagant and not to be countenanced. Now there was only one pearl buyer with many hands, and the men who sat in their offices and waited for Kino knew what price they would offer, how high they would bid, and what method each one would use. And although these men would not profit beyond their salaries, there was excitement among the pearl buyers, for there was excitement in the

1. **tithe** (tīth): literally a tenth, but popularly any small portion given to charity.

The White Village (1961) by Fletcher Martin (1904–1979). Oil on canvas.

hunt, and if it be a man's function to break down a price, then he must take joy and satisfaction in breaking it as far down as possible. For every man in the world functions to the best of his ability, and no one does less than his best, no matter what he may think about it. Quite apart from any reward they might get, from any word of praise, from any promotion, a pearl buyer was a pearl buyer, and the best and happiest pearl buyer was he who bought for the lowest prices.

The sun was hot yellow that morning, and it drew the moisture from the estuary and from the Gulf and hung it in shimmering scarves in the air so that the air vibrated and vision was insubstantial. A vision hung in the air to the north of the city—the vision of a mountain that was over two hundred miles

away, and the high slopes of this mountain were swaddled with pines and a great stone peak arose above the timber line.

And the morning of this day the canoes lay lined up on the beach; the fishermen did not go out to dive for pearls, for there would be too much happening, too many things to see when Kino went to sell the great pearl.

In the brush houses by the shore Kino's neighbors sat long over their breakfasts, and they spoke of what they would do if they had found the pearl. And one man said that he would give it as a present to the Holy Father in Rome. Another said that he would buy Masses for the souls of his family for a thousand years. Another thought he might take the money and distribute it among the poor of La Paz; and a fourth thought of all the good things one could do with the money from the pearl, of all the charities, benefits, of all the rescues one could perform if one had money. All of the neighbors hoped that sudden wealth would not turn Kino's head, would not make a rich man of him, would not graft onto him the evil limbs of greed and hatred and coldness. For Kino was a well-liked man; it would be a shame if the pearl destroyed him. "That good wife Juana," they said, "and the beautiful baby Coyotito, and the others to come. What a pity it would be if the pearl should destroy them all."

For Kino and Juana this was the morning of mornings of their lives, comparable only to the day when the baby was born. This was to be the day from which all other days would take their arrangement. Thus they would say, "It was two years before we sold the pearl," or, "It was six weeks after we sold the pearl." Juana, considering the matter, threw caution to the winds, and she dressed Coyotito in the clothes she had prepared for his baptism, when there would be money for his baptism. And Juana combed and braided her hair and tied the ends

with two little bows of red ribbon, and she put on her marriage skirt and waist. The sun was quarter high when they were ready. Kino's ragged white clothes were clean at least, and this was the last day of his raggedness. For tomorrow, or even this afternoon, he would have new clothes.

The neighbors, watching Kino's door through the crevices in their brush houses, were dressed and ready too. There was no self-consciousness about their joining Kino and Juana to go pearl selling. It was expected, it was an historic moment, they would be crazy if they didn't go. It would be almost a sign of unfriendship.

Juana put on her head shawl carefully, and she draped one end under her right elbow and gathered it with her right hand so that a hammock hung under her arm, and in this little hammock she placed Coyotito, propped up against the head shawl so that he could see everything and perhaps remember. Kino put on his large straw hat and felt it with his hand to see that it was properly placed, not on the back or side of his head, like a rash, unmarried, irresponsible man, and not flat as an elder would wear it, but tilted a little forward to show aggressiveness and seriousness and vigor. There is a great deal to be seen in the tilt of a hat on a man. Kino slipped his feet into his sandals and pulled the thongs up over his heels. The great pearl was wrapped in an old soft piece of deerskin and placed in a little leather bag, and the leather bag was in a pocket in Kino's shirt. He folded his blanket carefully and draped it in a narrow strip over his left shoulder, and now they were ready.

Kino stepped with dignity out of the house, and Juana followed him, carrying Coyotito. And as they marched up the freshet-washed alley toward the town, the neighbors joined them. The houses belched people; the doorways spewed out children. But because of the

El reto (*The Threat* or *The Challenge*) (1954) by David Alfaro Siqueiros
(1896–1974). Pyroxylin on masonite.

seriousness of the occasion, only one man walked with Kino, and that was his brother, Juan Tomás.

Juan Tomás cautioned his brother. "You must be careful to see they do not cheat you," he said.

And, "Very careful," Kino agreed.

"We do not know what prices are paid in other places," said Juan Thomás. "How can we know what is a fair price, if we do not know what the pearl buyer gets for the pearl in another place?"

"That is true," said Kino, "but how can we know? We are here, we are not there."

As they walked up toward the city the crowd grew behind them, and Juan Thomás, in pure nervousness, went on speaking.

"Before you were born, Kino," he said, "the old ones thought of a way to get more money for their pearls. They thought it would be better if they had an agent who took all the pearls to the capital and sold them there and kept only his share of the profit."

Kino nodded his head. "I know," he said. "It was a good thought."

"And so they got such a man," said Juan Tomás, "and they pooled the pearls, and they started him off. And he was never heard of again and the pearls were lost. Then they got another man, and they started him off, and he was never heard of again. And so they gave the whole thing up and went back to the old way."

"I know," said Kino. "I have heard our father tell of it. It was a good idea, but it was against religion, and the Father made that very clear. The loss of the pearl was a punishment visited on those who tried to leave their station. And the Father made it clear that each man and woman is like a soldier sent by God to guard some part of the castle of the Universe. And some are in the ramparts and some far deep in the darkness of the walls. But each one must remain faithful to his post and must not go running about, else the castle is in danger from the assaults of Hell."

"I have heard him make that sermon," said Juan Tomás. "He makes it every year."

The brothers, as they walked along, squinted their eyes a little, as they and their grandfathers and their great-grandfathers had done for four hundred years, since first the strangers came with arguments and authority and gunpowder to back up both. And in the four hundred years Kino's people had learned only one defense—a slight slitting of the eyes and a slight tightening of the lips and a retirement. Nothing could break down this wall, and they could remain whole within the wall.

The gathering procession was solemn, for they sensed the importance of this day, and any children who showed a tendency to scuffle, to scream, to cry out, to steal hats and rumple hair, were hissed to silence by their elders. So important was this day that an old man came to see, riding on the stalwart shoulders of his nephew. The procession left the brush huts and entered the stone and plaster city where the streets were a little wider and there were narrow pavements beside the buildings. And as before, the beggars joined them as they passed the church; the grocers looked out at them as they went by; the little saloons lost their customers and the owners closed up shop and went along. And the sun beat down on the streets of the city and even tiny stones threw shadows on the ground.

The news of the approach of the procession ran ahead of it, and in their little dark offices the pearl buyers stiffened and grew alert. They got out papers so that they could be at work when Kino appeared, and they put their pearls in the desks, for it is not good to let an inferior pearl be seen beside a beauty. And word of the loveliness of Kino's pearl had come to them. The pearl buyers' offices were clustered to-

gether in one narrow street, and they were barred at the windows, and wooden slats cut out the light so that only a soft gloom entered the offices.

A stout slow man sat in an office waiting. His face was fatherly and benign, and his eyes twinkled with friendship. He was a caller of good mornings, a ceremonious shaker of hands, a jolly man who knew all jokes and yet who hovered close to sadness, for in the midst of a laugh he could remember the death of your aunt, and his eyes could become wet with sorrow for your loss. This morning he had placed a flower in a vase on his desk, a single scarlet hibiscus, and the vase sat beside the black velvet-lined pearl tray in front of him. He was shaved close to the blue roots of his beard, and his hands were clean and his nails polished. His door stood open to the morning, and he hummed under his breath while his right hand practiced legerdemain.[2] He rolled a coin back and forth over his knuckles and made it appear and disappear, made it spin and sparkle. The coin winked into sight and as quickly slipped out of sight, and the man did not even watch his own performance. The fingers did it all mechanically, precisely, while the man hummed to himself and peered out the door. Then he heard the tramp of feet of the approaching crowd, and the fingers of his right hand worked faster and faster until, as the figure of Kino filled the doorway, the coin flashed and disappeared.

"Good morning, my friend," the stout man said. "What can I do for you?"

Kino stared into the dimness of the little office, for his eyes were squeezed from the outside glare. But the buyer's eyes had become as steady and cruel and unwinking as a hawk's eyes, while the rest of his face smiled in greeting. And secretly, behind his desk, his right

2. **legerdemain** (lĕj′ər-də-mān′): tricks or magic done with the hands.

hand practiced with the coin.

"I have a pearl," said Kino. And Juan Tomás stood beside him and snorted a little at the understatement. The neighbors peered around the doorway, and a line of little boys clambered on the window bars and looked through. Several little boys, on their hands and knees, watched the scene around Kino's legs.

"You have a pearl," the dealer said. "Sometimes a man brings in a dozen. Well, let us see your pearl. We will value it and give you the best price." And his fingers worked furiously with the coin.

Now Kino instinctively knew his own dramatic effects. Slowly he brought out the leather bag, slowly took from it the soft and dirty piece of deerskin, and then he let the great pearl roll into the black velvet tray, and instantly his eyes went to the buyer's face. But there was no sign, no movement, the face did not change, but the secret hand behind the desk missed in its precision. The coin stumbled over a knuckle and slipped silently into the dealer's lap. And the fingers behind the desk curled into a fist. When the right hand came out of hiding, the forefinger touched the great pearl, rolled it on the black velvet; thumb and forefinger picked it up and brought it near to the dealer's eyes and twirled it in the air.

Kino held his breath, and the neighbors held their breath, and the whispering went back through the crowd. "He is inspecting it—No price has been mentioned yet—They have not come to a price."

Now the dealer's hand had become a personality. The hand tossed the great pearl back to the tray, the forefinger poked and insulted it, and on the dealer's face there came a sad and contemptuous smile.

"I am sorry, my friend," he said, and his shoulders rose a little to indicate that the misfortune was no fault of his.

"It is a pearl of great value," Kino said.

The dealer's fingers spurned the pearl so that it bounced and rebounded softly from the sides of the velvet tray.

"You have heard of fool's gold," the dealer said. "This pearl is like fool's gold. It is too large. Who would buy it? There is no market for such things. It is a curiosity only. I am sorry. You thought it was a thing of value, and it is only a curiosity."

Now Kino's face was perplexed and worried. "It is the Pearl of the World," he cried. "No one has ever seen such a pearl."

"On the contrary," said the dealer, "it is large and clumsy. As a curiosity it has interest; some museum might perhaps take it to place in a collection of seashells. I can give you, say, a thousand pesos."[3]

Kino's face grew dark and dangerous, "It is worth fifty thousand," he said. "You know it. You want to cheat me."

And the dealer heard a little grumble go through the crowd as they heard his price. And the dealer felt a little tremor of fear.

"Do not blame me," he said quickly. "I am only an appraiser. Ask the others. Go to their offices and show your pearl—or better let them come here, so that you can see there is no collusion.[4] Boy," he called. And when his servant looked through the rear door, "Boy, go to such a one, and such another one and such a third one. Ask them to step in here and do not tell them why. Just say that I will be pleased to see them." And his right hand went behind the desk and pulled another coin from his pocket, and the coin rolled back and forth over his knuckles.

Kino's neighbors whispered together. They had been afraid of something like this. The pearl was large, but it had a strange color.

They had been suspicious of it from the first. And after all, a thousand pesos was not to be thrown away. It was comparative wealth to a man who was not wealthy. And suppose Kino took a thousand pesos. Only yesterday he had nothing.

But Kino had grown tight and hard. He felt the creeping of fate, the circling of wolves, the hover of vultures. He felt the evil coagulating about him, and he was helpless to protect himself. He heard in his ears the evil music. And on the black velvet the great pearl glistened, so that the dealer could not keep his eyes from it.

The crowd in the doorway wavered and broke and let the three pearl dealers through. The crowd was silent now, fearing to miss a word, to fail to see a gesture or an expression. Kino was silent and watchful. He felt a little tugging at his back, and he turned and looked in Juana's eyes, and when he looked away he had renewed strength.

The dealers did not glance at one another nor at the pearl. The man behind the desk said, "I have put a value on this pearl. The owner here does not think it fair. I will ask you to examine this—this thing and make an offer. Notice," he said to Kino, "I have not mentioned what I have offered."

The first dealer, dry and stringy, seemed now to see the pearl for the first time. He took it up, rolled it quickly between thumb and forefinger, and then cast it contemptuously back into the tray.

"Do not include me in the discussion," he said dryly. "I will make no offer at all. I do not want it. This is not a pearl—it is a monstrosity." His thin lips curled.

Now the second dealer, a little man with a shy soft voice, took up the pearl, and he examined it carefully. He took a glass from his pocket and inspected it under magnification. Then he laughed softly.

3. **a thousand pesos:** eighty dollars. The peso was then worth about eight cents.
4. **collusion:** secret agreement made for the purpose of fraud; conspiracy.

"Better pearls are made of paste," he said. "I know these things. This is soft and chalky, it will lose its color and die in a few months. Look—." He offered the glass to Kino, showed him how to use it, and Kino, who had never seen a pearl's surface magnified, was shocked at the strange-looking surface.

The third dealer took the pearl from Kino's hands. "One of my clients likes such things," he said. "I will offer five hundred pesos, and perhaps I can sell it to my client for six hundred."

Kino reached quickly and snatched the pearl from his hand. He wrapped it in the deerskin and thrust it inside his shirt.

The man behind the desk said, "I'm a fool, I know, but my first offer stands. I still offer one thousand. What are you doing?" he asked, as Kino thrust the pearl out of sight.

"I am cheated," Kino cried fiercely. "My pearl is not for sale here. I will go, perhaps even to the capital."

Now the dealers glanced quickly at one another. They knew they had played too hard; they knew they would be disciplined for their failure, and the man at the desk said quickly, "I might go to fifteen hundred."

But Kino was pushing his way through the crowd. The hum of talk came to him dimly, his rage blood pounded in his ears, and he burst through and strode away. Juana followed, trotting after him.

When the evening came, the neighbors in the brush houses sat eating their corncakes and beans, and they discussed the great theme of the morning. They did not know, it seemed a fine pearl to them, but they had never seen such a pearl before, and surely the dealers knew more about the value of pearls than they. "And mark this," they said. "Those dealers did not discuss these things. Each of the three knew the pearl was valueless."

"But suppose they had arranged it before?"

"If that is so, then all of us have been cheated all of our lives."

Perhaps, some argued, perhaps it would have been better if Kino took the one thousand five hundred pesos. That is a great deal of money, more than he has ever seen. Maybe Kino is being a pigheaded fool. Suppose he should really go to the capital and find no buyer for his pearl. He would never live that down.

And now, said other fearful ones, now that he had defied them, those buyers will not want to deal with him at all. Maybe Kino has cut off his own head and destroyed himself.

And others said, Kino is a brave man, and a fierce man; he is right. From his courage we may all profit. These were proud of Kino.

In his house Kino squatted on his sleeping mat, brooding. He had buried his pearl under a stone of the fire hole in his house, and he stared at the woven tules[5] of his sleeping mat until the crossed design danced in his head. He had lost one world and had not gained another. And Kino was afraid. Never in his life had he been far from home. He was afraid of strangers and of strange places. He was terrified of that monster of strangeness they called the capital. It lay over the water and through the mountains, over a thousand miles, and every strange terrible mile was frightening. But Kino had lost his old world and he must clamber on to a new one. For his dream of the future was real and never to be destroyed, and he had said "I will go," and that made a real thing too. To determine to go and to say it was to be halfway there.

Juana watched him while he buried his pearl, and she watched him while she cleaned Coyotito and nursed him, and Juana made the corncakes for supper.

Juan Tomás came in and squatted down be-

5. **tules** (tōō'lēs): reeds or rushes.

side Kino and remained silent for a long time, until at last Kino demanded, "What else could I do? They are cheats."

Juan Tomás nodded gravely. He was the elder, and Kino looked to him for wisdom. "It is hard to know," he said. "We do know that we are cheated from birth to the overcharge on our coffins. But we survive. You have defied not the pearl buyers, but the whole structure, the whole way of life, and I am afraid for you."

"What have I to fear but starvation?" Kino asked.

But Juan Tomás shook his head slowly. "That we must all fear. But suppose you are correct—suppose your pearl is of great value—do you think then the game is over?"

"What do you mean?"

"I don't know," said Juan Tomás, "but I am afraid for you. It is new ground you are walking on, you do not know the way."

"I will go. I will go soon," said Kino.

"Yes," Juan Tomás agreed. "That you must do. But I wonder if you will find it any different in the capital. Here, you have friends and me, your brother. There, you will have no one."

"What can I do?" Kino cried. "Some deep outrage is here. My son must have a chance. That is what they are striking at. My friends will protect me."

"Only so long as they are not in danger or discomfort from it," said Juan Tomás. He arose, saying, "Go with God."

And Kino said, "Go with God," and did not even look up, for the words had a strange chill in them.

Long after Juan Tomás had gone Kino sat brooding on his sleeping mat. A lethargy had settled on him, and a little gray hopelessness. Every road seemed blocked against him. In his head he heard only the dark music of the enemy. His senses were burningly alive, but his mind went back to the deep participation with all things, the gift he had from his people. He heard every little sound of the gathering night, the sleepy complaint of settling birds, the love agony of cats, the strike and the withdrawal of little waves on the beach, and the simple hiss of distance. And he could smell the sharp odor of exposed kelp from the receding tide. The little flare of the twig fire made the design on his sleeping mat jump before his entranced eyes.

Juana watched him with worry, but she knew him and she knew she could help him best by being silent and by being near. And as though she too could hear the Song of Evil, she fought it, singing softly the melody of the family, of the safety and warmth and wholeness of the family. She held Coyotito in her arms and sang the song to him, to keep the evil out, and her voice was brave against the threat of the dark music.

Kino did not move nor ask for his supper. She knew he would ask when he wanted it. His eyes were entranced, and he could sense the wary, watchful evil outside the brush house; he could feel the dark creeping things waiting for him to go out into the night. It was shadowy and dreadful, and yet it called to him and threatened him and challenged him. His right hand went into his shirt and felt his knife; his eyes were wide; he stood up and walked to the doorway.

Juana willed to stop him; she raised her hand to stop him, and her mouth opened with terror. For a long moment Kino looked out into the darkness and then he stepped outside. Juana heard the little rush, the grunting struggle, the blow. She froze with terror for a moment, and then her lips drew back from her teeth like a cat's lips. She set Coyotito down on the ground. She seized a stone from the fireplace and rushed outside, but it was over by then. Kino lay on the ground, struggling to rise, and there was no one near him. Only the

Untitled painting (1963) by Eduardo Kingman (1911–). Oil on canvas.
Private Collection

shadows and the strike and rush of waves and the hiss of distance. But the evil was all about, hidden behind the brush fence, crouched beside the house in the shadow, hovering in the air.

Juana dropped her stone, and she put her arms around Kino and helped him to his feet and supported him into the house. Blood oozed down from his scalp and there was a long deep cut in his cheek from ear to chin, a deep, bleeding slash. And Kino was only half conscious. He shook his head from side to side. His shirt was torn open and his clothes half pulled off. Juana sat him down on his sleeping mat and she wiped the thickening blood from his face with her skirt. She brought him pulque to drink in a little pitcher, and still he shook his head to clear out the darkness.

"Who?" Juana asked.

"I don't know," Kino said. "I didn't see."

Now Juana brought her clay pot of water and she washed the cut on his face while he stared dazed ahead of him.

"Kino, my husband," she cried, and his eyes stared past her. "Kino, can you hear me?"

"I hear you," he said dully.

"Kino, this pearl is evil. Let us destroy it before it destroys us. Let us crush it between two stones. Let us—let us throw it back in the sea where it belongs. Kino, it is evil, it is evil!"

And as she spoke the light came back in Kino's eyes so that they glowed fiercely and his muscles hardened and his will hardened.

"No," he said. "I will fight this thing. I will win over it. We will have our chance." His fist pounded the sleeping mat. "No one shall take our good fortune from us," he said. His eyes softened then and he raised a gentle hand to Juana's shoulder. "Believe me," he said. "I am a man." And his face grew crafty.

"In the morning we will take our canoe and we will go over the sea and over the mountains to the capital, you and I. We will not be cheated. I am a man."

"Kino," she said huskily, "I am afraid. A man can be killed. Let us throw the pearl back into the sea."

"Hush," he said fiercely. "I am a man. Hush." And she was silent, for his voice was command. "Let us sleep a little," he said. "In the first light we will start. You are not afraid to go with me?"

"No, my husband."

His eyes were soft and warm on her then, his hand touched her cheek. "Let us sleep a little," he said.

Reading Check

1. Who is the only man Kino trusts?
2. How much is Kino offered for his pearl?
3. Where does Kino hide the pearl?
4. Why does Juana believe the pearl is evil?
5. What is Kino's plan to sell the pearl?

For Study and Discussion

Analyzing and Interpreting the Novel

1. What details reveal how the pearl buyers have deceived the pearl divers for centuries?

2. The pearl buyer's face is described as "fatherly and benign," but one detail—the way the buyer plays tricks with a coin—reveals the true nature of his character. a. What does this detail suggest about the pearl buyer? b. After Kino shows him the pearl, what happens to the coin? c. How does this show the reader—but not Kino—the buyer's true reaction?

3. By the end of the chapter, how has Kino broken "walls" and stepped out of "known and trusted patterns"?

V

The late moon arose before the first rooster crowed. Kino opened his eyes in the darkness, for he sensed movement near him, but he did not move. Only his eyes searched the darkness, and in the pale light of the moon that crept through the holes in the brush house Kino saw Juana arise silently from beside him. He saw her move toward the fireplace. So carefully did she work that he heard only the lightest sound when she moved the fireplace stone. And then like a shadow she glided toward the door. She paused for a moment beside the hanging box where Coyotito lay, then for a second she was back in the doorway, and then she was gone.

And rage surged in Kino. He rolled up to his feet and followed her as silently as she had gone, and he could hear her quick footsteps going toward the shore. Quietly he tracked her, and his brain was red with anger. She burst clear of the brush line and stumbled over the little boulders toward the water, and then she heard him coming and she broke into a run. Her arm was up to throw when he leaped at her and caught her arm and wrenched the pearl from her. He struck her in the face with his clenched fist and she fell among the boulders, and he kicked her in the side. In the pale light he could see the little waves break over her, and her skirt floated about and clung to her legs as the water receded.

Kino looked down at her and his teeth were bared. He hissed at her like a snake, and Juana stared at him with wide unfrightened eyes, like a sheep before the butcher. She knew there was murder in him, and it was all right; she had accepted it, and she would not resist or even protest. And then the rage left him and a sick disgust took its place. He turned away from her and walked up the beach and through the brush line. His senses were dulled by his emotion.

He heard the rush, got his knife out and lunged at one dark figure and felt his knife go home, and then he was swept to his knees and swept again to the ground. Greedy fingers went through his clothes, frantic fingers searched him, and the pearl, knocked from his hand, lay winking behind a little stone in the pathway. It glinted in the soft moonlight.

Juana dragged herself up from the rocks on the edge of the water. Her face was a dull pain and her side ached. She steadied herself on her knees for a while and her wet skirt clung to her. There was no anger in her for Kino. He had said, "I am a man," and that meant certain things to Juana. It meant that he was half insane and half god. It meant that Kino would drive his strength against a mountain and plunge his strength against the sea. Juana, in her woman's soul, knew that the mountain would stand while the man broke himself; that the sea would surge while the man drowned in it. And yet it was this thing that made him a man, half insane and half god, and Juana had need of a man; she could not live without a man. Although she might be puzzled by these differences between man and woman, she knew them and accepted them and needed them. Of course she would follow him, there was no question of that. Sometimes the quality of woman, the reason, the caution, the sense of preservation, could cut through Kino's manness and save them all. She climbed painfully to her feet, and she dipped her cupped palms in the little waves and washed her bruised face with the stinging salt water, and then she went creeping up the beach after Kino.

A flight of herring clouds had moved over the sky from the south. The pale moon dipped in and out of the strands of clouds so that Juana walked in darkness for a moment and in light the next. Her back was bent with pain and her head was low. She went through the

line of brush when the moon was covered, and when it looked through she saw the glimmer of the great pearl in the path behind the rock. She sank to her knees and picked it up, and the moon went into the darkness of the clouds again. Juana remained on her knees while she considered whether to go back to the sea and finish her job, and as she considered, the light came again, and she saw two dark figures lying in the path ahead of her. She leaped forward and saw that one was Kino and the other a stranger with dark shiny fluid leaking from his throat.

Kino moved sluggishly, arms and legs stirred like those of a crushed bug, and a thick muttering came from his mouth. Now, in an instant, Juana knew that the old life was gone forever. A dead man in the path and Kino's knife, dark bladed beside him, convinced her. All of the time Juana had been trying to rescue something of the old peace, of the time before the pearl. But now it was gone, and there was no retrieving it. And knowing this, she abandoned the past instantly. There was nothing to do but to save themselves.

Her pain was gone now, her slowness. Quickly she dragged the dead man from the pathway into the shelter of the brush. She went to Kino and sponged his face with her wet skirt. His senses were coming back and he moaned.

"They have taken the pearl. I have lost it. Now it is over," he said. "The pearl is gone."

Juana quieted him as she would quiet a sick child. "Hush," she said. "Here is your pearl. I found it in the path. Can you hear me now? Here is your pearl. Can you understand? You have killed a man. We must go away. They will come for us, can you understand? We must be gone before the daylight comes."

"I was attacked," Kino said uneasily. "I struck to save my life."

"Do you remember yesterday?" Juana asked.

"Do you think that will matter? Do you remember the men of the city? Do you think your explanation will help?"

Kino drew a great breath and fought off his weakness. "No," he said. "You are right." And his will hardened and he was a man again.

"Go to our house and bring Coyotito," he said, "and bring all the corn we have. I will drag the canoe into the water and we will go."

He took his knife and left her. He stumbled toward the beach and he came to his canoe. And when the light broke through again he saw that a great hole had been knocked in the bottom. And a searing rage came to him and gave him strength. Now the darkness was closing in on his family; now the evil music filled the night, hung over the mangroves, skirled[1] in the wave beat. The canoe of his grandfather, plastered over and over, and a splintered hole broken in it. This was an evil beyond thinking. The killing of a man was not so evil as the killing of a boat. For a boat does not have sons, and a boat cannot protect itself, and a wounded boat does not heal. There was sorrow in Kino's rage, but this last thing had tightened him beyond breaking. He was an animal now, for hiding, for attacking, and he lived only to preserve himself and his family. He was not conscious of the pain in his head. He leaped up the beach, through the brush line toward his brush house, and it did not occur to him to take one of the canoes of his neighbors. Never once did the thought enter his head, any more than he could have conceived breaking a boat.

The roosters were crowing and the dawn was not far off. Smoke of the first fires seeped out through the walls of the brush houses, and the first smell of cooking corncakes was in the air. Already the dawn birds were scampering in the bushes. The weak moon was losing its

1. **skirled** (skûrld): made a shrill, piercing sound.

light and the clouds thickened and curdled to the southward. The wind blew freshly into the estuary, a nervous, restless wind with the smell of storm on its breath, and there was change and uneasiness in the air.

Kino, hurrying toward his house, felt a surge of exhilaration. Now he was not confused, for there was only one thing to do, and Kino's hand went first to the great pearl in his shirt and then to his knife hanging under his shirt.

He saw a little glow ahead of him, and then without interval a tall flame leaped up in the dark with a crackling roar, and a tall edifice of fire lighted the pathway. Kino broke into a run; it was his brush house, he knew. And he knew that these houses could burn down in a very few moments. And as he ran a scuttling figure ran toward him—Juana, with Coyotito in her arms and Kino's shoulder blanket clutched in her hand. The baby moaned with fright, and Juana's eyes were wide and terrified. Kino could see the house was gone, and he did not question Juana. He knew, but she said, "It was torn up and the floor dug—even the baby's box turned out, and as I looked they put the fire to the outside."

The fierce light of the burning house lighted Kino's face strongly. "Who?" he demanded.

"I don't know," she said. "The dark ones."

The neighbors were tumbling from their houses now, and they watched the falling sparks and stamped them out to save their own houses. Suddenly Kino was afraid. The light made him afraid. He remembered the man lying dead in the brush beside the path, and he took Juana by the arm and drew her into the shadow of a house away from the light, for light was danger to him. For a moment he considered and then he worked among the shadows until he came to the house of Juan Tomás, his brother, and he slipped into the doorway and drew Juana after him. Outside, he could hear the squeal of children and the shouts of neighbors, for his friends thought he might be inside the burning house.

The house of Juan Tomás was almost exactly like Kino's house; nearly all of the brush houses were alike, and all leaked light and air, so that Juana and Kino, sitting in the corner of the brother's house, could see the leaping flames through the wall. They saw the flames tall and furious, they saw the roof fall and watched the fire die down as quickly as a twig fire dies. They heard the cries of warning of their friends, and the shrill, keening[2] cry of Apolonia, wife of Juan Tomás. She, being the nearest woman relative, raised a formal lament for the dead of the family.

Apolonia realized that she was wearing her second-best head shawl and she rushed to her house to get her fine new one. As she rummaged in a box by the wall, Kino's voice said quietly, "Apolonia, do not cry out. We are not hurt."

"How do you come here?" she demanded.

"Do not question," he said. "Go now to Juan Tomás and bring him here and tell no one else. This is important to us, Apolonia."

She paused, her hands helpless in front of her, and then, "Yes, my brother-in-law," she said.

In a few moments Juan Tomás came back with her. He lighted a candle and came to them where they crouched in a corner and he said, "Apolonia, see to the door, and do not let anyone enter." He was older, Juan Tomás, and he assumed the authority. "Now, my brother," he said.

"I was attacked in the dark," said Kino. "And in the fight I have killed a man."

"Who?" asked Juan Tomás quickly.

"I do not know. It is all darkness—all darkness and shape of darkness."

"It is the pearl," said Juan Tomás. "There is

2. **keening**: wailing.

a devil in this pearl. You should have sold it and passed on the devil. Perhaps you can still sell it and buy peace for yourself."

And Kino said, "Oh, my brother, an insult has been put on me that is deeper than my life. For on the beach my canoe is broken, my house is burned, and in the brush a dead man lies. Every escape is cut off. You must hide us, my brother."

And Kino, looking closely, saw deep worry come into his brother's eyes and he forestalled him in a possible refusal. "Not for long," he said quickly. "Only until a day has passed and the new night has come. Then we will go."

"I will hide you," said Juan Tomás.

"I do not want to bring danger to you," Kino said. "I know I am like leprosy. I will go tonight and then you will be safe."

"I will protect you," said Juan Tomás, and he called, "Apolonia, close up the door. Do not even whisper that Kino is here."

They sat silently all day in the darkness of the house, and they could hear the neighbors speaking of them. Through the walls of the house they could watch their neighbors raking the ashes to find the bones. Crouching in the house of Juan Tomás, they heard the shock go into their neighbors' minds at the news of the broken boat. Juan Tomás went out among the neighbors to divert their suspicions, and he gave them theories and ideas of what had happened to Kino and to Juana and to the baby. To one he said, "I think they have gone south along the coast to escape the evil that was on them." And to another, "Kino would never leave the sea. Perhaps he found another boat." And he said, "Apolonia is ill with grief."

And in that day the wind rose to beat the Gulf and tore the kelps and weeds that lined the shore, and the wind cried through the brush houses and no boat was safe on the water. Then Juan Tomás told among the neighbors, "Kino is gone. If he went to the sea, he is drowned by now." And after each trip among the neighbors Juan Tomás came back with something borrowed. He brought a little woven straw bag of red beans and a gourd full of rice. He borrowed a cup of dried peppers and a block of salt, and he brought in a long working knife, eighteen inches long and heavy, as a small ax, a tool and a weapon. And when Kino saw this knife his eyes lighted up, and he fondled the blade and his thumb tested the edge.

The wind screamed over the Gulf and turned the water white, and the mangroves plunged like frightened cattle, and a fine sandy dust arose from the land and hung in a stifling cloud over the sea. The wind drove off the clouds and skimmed the sky clean and drifted the sand of the country like snow.

Then Juan Tomás, when the evening approached, talked long with his brother. "Where will you go?"

"To the north," said Kino. "I have heard that there are cities in the north."

"Avoid the shore," said Juan Tomás. "They are making a party to search the shore. The men in the city will look for you. Do you still have the pearl?"

"I have it," said Kino. "And I will keep it. I might have given it as a gift, but now it is my misfortune and my life and I will keep it." His eyes were hard and cruel and bitter.

Coyotito whimpered and Juana muttered little magics over him to make him silent.

"The wind is good," said Juan Tomás. "There will be no tracks."

They left quietly in the dark before the moon had risen. The family stood formally in the house of Juan Tomás. Juana carried Coyotito on her back, covered and held in by her head shawl, and the baby slept, cheek turned sideways against her shoulder. The head shawl covered the baby, and one end of it came across Juana's nose to protect her from the evil

night air. Juan Tomás embraced his brother with the double embrace and kissed him on both cheeks. "Go with God," he said, and it was like a death. "You will not give up the pearl?"

"This pearl has become my soul," said Kino. "If I give it up I shall lose my soul. Go thou also with God."

Reading Check

1. Why does Juana remove the pearl from its hiding place?
2. What happens to the pearl during Kino's struggle with his attackers?
3. How do his enemies prevent Kino's flight over the sea?
4. Why are Kino and Juana forced to flee?

For Study and Discussion

Analyzing and Interpreting the Novel

1. At the opening of the novel, Kino and Juana were "one thing and one purpose." But the pearl has changed all this. What event dramatizes how greatly they have been divided?

2. Steinbeck frequently uses animal imagery in this story to suggest a cruel world where people prey on one another. What animals are Kino and Juana compared to in the scene on the beach (page 857)?

3. The **turning point** of a story is that moment when the fate of the main character is sealed, when the events of the story must turn in one direction or another. What event marks the turning point of this novel?

4. Kino says that the pearl has become his "soul." **a.** What do you think "soul" means here? **b.** If Kino really believes this at this point in the story, what does it reveal about him?

VI

The wind blew fierce and strong, and it pelted them with bits of sticks, sand, and little rocks. Juana and Kino gathered their clothing tighter about them and covered their noses and went out into the world. The sky was brushed clean by the wind and the stars were cold in a black sky. The two walked carefully, and they avoided the center of town where some sleeper in a doorway might see them pass. For the town closed itself in against the night, and anyone who moved about in the darkness would be noticeable. Kino threaded his way around the edge of the city and turned north, north by the stars, and found the rutted sandy road that led through the brushy country toward Loreto where the miraculous Virgin has her station.[1]

Kino could feel the blown sand against his ankles and he was glad, for he knew there would be no tracks. The little light from the stars made out for him the narrow road through the brushy country. And Kino could hear the pad of Juana's feet behind him. He went quickly and quietly, and Juana trotted behind him to keep up.

Some ancient thing stirred in Kino. Through his fear of dark and the devils that haunt the night, there came a rush of exhilaration; some animal thing was moving in him so that he was cautious and wary and dangerous; some ancient thing out of the past of his people was alive in him. The wind was at his back and the stars guided him. The wind cried and whisked in the brush, and the family went on monotonously, hour after hour. They passed no one and saw no one. At last, to their right, the waning moon arose, and when it came up the wind died down, and the land was still.

1. **station:** shrine.

Now they could see the little road ahead of them, deep cut with sand-drifted wheel tracks. With the wind gone there would be footprints, but they were a good distance from the town and perhaps their tracks might not be noticed. Kino walked carefully in a wheel rut, and Juana followed in his path. One big cart, going to the town in the morning, could wipe out every trace of their passage.

All night they walked and never changed their pace. Once Coyotito awakened, and Juana shifted him in front of her and soothed him until he went to sleep again. And the evils of the night were about them. The coyotes cried and laughed in the brush, and the owls screeched and hissed over their heads. And once some large animal lumbered away, crackling the undergrowth as it went. And Kino gripped the handle of the big working knife and took a sense of protection from it.

The music of the pearl was triumphant in Kino's head, and the quiet melody of the family underlay it, and they wove themselves into the soft padding of sandaled feet in the dusk. All night they walked, and in the first dawn Kino searched the roadside for a covert to lie in during the day. He found his place near to the road, a little clearing where deer might have lain, and it was curtained thickly with the dry brittle trees that lined the road. And when Juana had seated herself and had settled to nurse the baby, Kino went back to the road. He broke a branch and carefully swept the footprints where they had turned from the roadway. And then, in the first light, he heard the creak of a wagon, and he crouched beside the road and watched a heavy two-wheeled cart go by, drawn by slouching oxen. And when it had passed out of sight, he went back to the roadway and looked at the rut and found that the footprints were gone. And again he swept out his traces and went back to Juana.

She gave him the soft corncakes Apolonia had packed for them, and after a while she slept a little. But Kino sat on the ground and stared at the earth in front of him. He watched the ants moving, a little column of them near to his foot, and he put his foot in their path. Then the column climbed over his instep and continued on its way, and Kino left his foot there and watched them move over it.

The sun arose hotly. They were not near the Gulf now, and the air was dry and hot so that the brush cricked[2] with heat and a good resinous smell came from it. And when Juana awakened, when the sun was high, Kino told her things she knew already.

"Beware of that kind of tree there," he said, pointing. "Do not touch it, for if you do and then touch your eyes, it will blind you. And beware of the tree that bleeds. See, that one over there. For if you break it the red blood will flow from it, and it is evil luck." And she nodded and smiled at him, for she knew these things.

"Will they follow us?" she asked. "Do you think they will try to find us?"

"They will try," said Kino. "Whoever finds us will take the pearl. Oh, they will try."

And Juana said, "Perhaps the dealers were right and the pearl has no value. Perhaps this has all been an illusion."

Kino reached into his clothes and brought out the pearl. He let the sun play on it until it burned in his eyes. "No," he said, "they would not have tried to steal it if it had been valueless."

"Do you know who attacked you? Was it the dealers?"

"I do not know," he said. "I didn't see them."

He looked into his pearl to find his vision. "When we sell it at last, I will have a rifle," he said, and he looked into the shining surface for his rifle, but he saw only a huddled dark

2. **cricked:** turned or twisted.

Paisaje con volcanes (*Landscape with Volcanoes*) by Dr. Atl (1875–1964). Atl color on board.
Private Collection, Santo Domingo

body on the ground with shining blood dripping from its throat. And he said quickly, "We will be married in a great church." And in the pearl he saw Juana with her beaten face crawling home through the night. "Our son must learn to read," he said frantically. And there in the pearl Coyotito's face, thick, and feverish from the medicine.

And Kino thrust the pearl back into his clothing, and the music of the pearl had become sinister in his ears and it was interwoven with the music of evil.

The hot sun beat on the earth so that Kino and Juana moved into the lacy shade of the brush, and small gray birds scampered on the ground in the shade. In the heat of the day Kino relaxed and covered his eyes with his hat and wrapped his blanket about his face to keep the flies off, and he slept.

But Juana did not sleep. She sat quiet as a stone and her face was quiet. Her mouth was still swollen where Kino had struck her, and big flies buzzed around the cut on her chin. But she sat as still as a sentinel, and when Coyotito awakened she placed him on the ground in front of her and watched him wave his arms and kick his feet, and he smiled and gurgled at her until she smiled too. She picked

up a little twig from the ground and tickled him, and she gave him water from the gourd she carried in her bundle.

Kino stirred in a dream, and he cried out in a guttural voice, and his hand moved in symbolic fighting. And then he moaned and sat up suddenly, his eyes wide and his nostrils flaring. He listened and heard only the cricking heat and the hiss of distance.

"What is it?" Juana asked.

"Hush," he said.

"You were dreaming."

"Perhaps." But he was restless, and when she gave him a corncake from her store he paused in his chewing to listen. He was uneasy and nervous; he glanced over his shoulder; he lifted the big knife and felt its edge. When Coyotito gurgled on the ground Kino said, "Keep him quiet."

"What is the matter?" Juana asked.

"I don't know."

He listened again, an animal light in his eyes. He stood up then, silently; and crouched low, he threaded his way through the brush toward the road. But he did not step into the road; he crept into the cover of a thorny tree and peered out along the way he had come.

And then he saw them moving along. His body stiffened and he drew down his head and peeked out from under a fallen branch. In the distance he could see three figures, two on foot and one on horseback. But he knew what they were, and a chill of fear went through him. Even in the distance he could see the two on foot moving slowly along, bent low to the ground. Here, one would pause and look at the earth, while the other joined him. They were the trackers, they could follow the trail of a bighorn sheep in the stone mountains. They were as sensitive as hounds. Here, he and Juana might have stepped out of the wheel rut, and these people from the inland, these hunters, could follow, could read a broken straw or a little tumbled pile of dust. Behind them, on a horse, was a dark man, his nose covered with a blanket, and across his saddle a rifle gleamed in the sun.

Kino lay as rigid as the tree limb. He barely breathed, and his eyes went to the place where he had swept out the track. Even the sweeping might be a message to the trackers. He knew these inland hunters. In a country where there is little game they managed to live because of their ability to hunt, and they were hunting him. They scuttled over the ground like animals and found a sign and crouched over it while the horseman waited.

The trackers whined a little, like excited dogs on a warming trail. Kino slowly drew his big knife to his hand and made it ready. He knew what he must do. If the trackers found the swept place, he must leap for the horseman, kill him quickly and take the rifle. That was his only chance in the world. And as the three drew near on the road, Kino dug little pits with his sandaled toes so that he could leap without warning, so that his feet would not slip. He had only a little vision under the fallen limb.

Now Juana, back in her hidden place, heard the pad of the horse's hoofs, and Coyotito gurgled. She took him up quickly and put him under her shawl and gave him her breast and he was silent.

When the trackers came near, Kino could see only their legs and only the legs of the horse from under the fallen branch. He saw the dark horny feet of the men and their ragged white clothes, and he heard the creak of leather of the saddle and the clink of spurs. The trackers stopped at the swept place and studied it, and the horseman stopped. The horse flung his head up against the bit and the bit-roller clicked under his tongue and the horse snorted. Then the dark trackers turned and studied the horse and watched his ears.

Kino was not breathing, but his back arched a little and the muscles of his arms and legs stood out with tension and a line of sweat formed on his upper lip. For a long moment the trackers bent over the road, and they moved on slowly, studying the ground ahead of them, and the horseman moved after them. The trackers scuttled along, stopping, looking, and hurrying on. They would be back, Kino knew. They would be circling and searching, peeping, stooping, and they would come back sooner or later to his covered track.

He slid backward and did not bother to cover his tracks. He could not; too many little signs were there, too many broken twigs and scuffed places and displaced stones. And there was a panic in Kino now, a panic of flight. The trackers would find his trail, he knew it. There was no escape, except in flight. He edged away from the road and went quickly and silently to the hidden place where Juana was. She looked up at him in question.

"Trackers," he said. "Come!"

And then a helplessness and a hopelessness swept over him, and his face went black and his eyes were sad. "Perhaps I should let them take me."

Instantly Juana was on her feet and her hand lay on his arm. "You have the pearl," she cried hoarsely. "Do you think they would take you back alive to say they had stolen it?"

His hand strayed limply to the place where the pearl was hidden under his clothes. "They will find it," he said weakly.

"Come," she said. "Come!"

And when he did not respond, "Do you think they would let me live? Do you think they would let the little one here live?"

Her goading struck into his brain; his lips snarled and his eyes were fierce again. "Come," he said. "We will go into the mountains. Maybe we can lose them in the mountains."

Frantically he gathered the gourds and the little bags that were their property. Kino carried a bundle in his left hand, but the big knife swung free in his right hand. He parted the brush for Juana and they hurried to the west, toward the high stone mountains. They trotted quickly through the tangle of the undergrowth. This was panic flight. Kino did not try to conceal his passages; he trotted, kicking the stones, knocking the telltale leaves from the little trees. The high sun streamed down on the dry creaking earth so that even vegetation ticked in protest. But ahead were the naked granite mountains, rising out of erosion rubble and standing monolithic against the sky. And Kino ran for the high place, as nearly all animals do when they are pursued.

This land was waterless, furred with the cacti which could store water and with the great-rooted brush which could reach deep into the earth for a little moisture and get along on very little. And underfoot was not soil but broken rock, split into small cubes, great slabs, but none of it water-rounded. Little tufts of sad dry grass grew between the stones, grass that had sprouted with one single rain and headed,[3] dropped its seed, and died. Horned toads watched the family go by and turned their little pivoting dragon heads. And now and then a great jackrabbit, disturbed in his shade, bumped away and hid behind the nearest rock. The singing heat lay over this desert country, and ahead the stone mountains looked cool and welcoming.

And Kino fled. He knew what would happen. A little way along the road the trackers would become aware that they had missed the path, and they would come back, searching and judging, and in a little while they would find the place where Kino and Juana had rested. From there it would be easy for them— these little stones, the fallen leaves and the

3. **headed:** grew to a head.

Copalli (1937) by Diego Rivera. Oil on canvas.
The Brooklyn Museum, Augustus A. Healy Fund (38.36)

whipped branches, the scuffed places where a foot had slipped. Kino could see them in his mind, slipping along the track, whining a little with eagerness, and behind them, dark and half disinterested, the horseman with the rifle. His work would come last, for he would not take them back. Oh, the music of evil sang loud in Kino's head now, it sang with the whine of heat and with the dry ringing of snake rattles.

It was not large and overwhelming now, but secret and poisonous, and the pounding of his heart gave it undertone and rhythm.

The way began to rise, and as it did the rocks grew larger. But now Kino had put a little distance between his family and the trackers. Now, on the first rise, he rested. He climbed a great boulder and looked back over the shimmering country, but he could not see his ene-

mies, not even the tall horseman riding through the brush. Juana had squatted in the shade of the boulder. She raised her bottle of water to Coyotito's lips; his little dried tongue sucked greedily at it. She looked up at Kino when he came back; she saw him examine her ankles, cut and scratched from the stones and brush, and she covered them quickly with her skirt. Then she handed the bottle to him, but he shook his head. Her eyes were bright in her tired face. Kino moistened his cracked lips with his tongue.

"Juana," he said, "I will go on and you will hide. I will lead them into the mountains, and when they have gone past, you will go north to Loreto or to Santa Rosalia.[4] Then, if I can escape them, I will come to you. It is the only safe way."

She looked full into his eyes for a moment. "No," she said. "We go with you."

"I can go faster alone," he said harshly. "You will put the little one in more danger if you go with me."

"No," said Juana.

"You must. It is the wise thing and it is my wish," he said.

"No," said Juana.

He looked then for weakness in her face, for fear or irresolution, and there was none. Her eyes were very bright. He shrugged his shoulders helplessly then, but he had taken strength from her. When they moved on it was no longer panic flight.

The country, as it rose toward the mountains, changed rapidly. Now there were long outcroppings of granite with deep crevices between, and Kino walked on bare unmarkable stone when he could and leaped from ledge to ledge. He knew that wherever the trackers lost his path they must circle and lose time before they found it again. And so he did not go

4. **Santa Rosalia** (sän'tä rō-zä'lē-ä): a town on the west coast of Baja California.

straight for the mountains anymore; he moved in zigzags, and sometimes he cut back to the south and left a sign and then went toward the mountains over bare stone again. And the path rose steeply now, so that he panted a little as he went.

The sun moved downward toward the bare stone teeth of the mountains, and Kino set his direction for a dark and shadowing cleft in the range. If there were any water at all, it would be there where he could see, even in the distance, a hint of foliage. And if there were any passage through the smooth stone range, it would be by this same deep cleft. It had its danger, for the trackers would think of it too, but the empty water bottle did not let that consideration enter. And as the sun lowered, Kino and Juana struggled wearily up the steep slope toward the cleft.

High in the gray stone mountains, under a frowning peak, a little spring bubbled out of a rupture in the stone. It was fed by shade-preserved snow in the summer, and now and then it died completely and bare rocks and dry algae were on its bottom. But nearly always it gushed out, cold and clean and lovely. In the times when the quick rains fell, it might become a freshet and send its column of white water crashing down the mountain cleft, but nearly always it was a lean little spring. It bubbled out into a pool and then fell a hundred feet to another pool, and this one, overflowing, dropped again, so that it continued, down and down, until it came to the rubble of the upland, and there it disappeared altogether. There wasn't much left of it then anyway, for every time it fell over an escarpment the thirsty air drank it, and it splashed from the pools to the dry vegetation. The animals from miles around came to drink from the little pools, and the wild sheep and the deer, the pumas and raccoons, and the mice—all came to drink. And the birds which spent the day in the

brushland came at night to the little pools that were like steps in the mountain cleft. Beside this tiny stream, wherever enough earth collected for root-hold, colonies of plants grew, wild grape and little palms, maidenhair fern, hibiscus, and tall pampas grass with feathery rods raised above the spike leaves. And in the pool lived frogs and water-skaters, and water-worms crawled on the bottom of the pool. Everything that loved water came to these few shallow places. The cats took their prey there, and strewed feathers and lapped water through their bloody teeth. The little pools were places of life because of the water, and places of killing because of the water, too.

The lowest step, where the stream collected before it tumbled down a hundred feet and disappeared into the rubbly desert, was a little platform of stone and sand. Only a pencil of water fell into the pool, but it was enough to keep the pool full and to keep the ferns green in the underhang of the cliff, and wild grape climbed the stone mountain and all manner of little plants found comfort here. The freshets had made a small sandy beach through which the pool flowed, and bright green watercress grew in the damp sand. The beach was cut and scarred and padded by the feet of animals that had come to drink and to hunt.

The sun had passed over the stone mountains when Kino and Juana struggled up the steep broken slope and came at last to the water. From this step they could look out over the sunbeaten desert to the blue Gulf in the distance. They came utterly weary to the pool, and Juana slumped to her knees and first washed Coyotito's face and then filled her bottle and gave him a drink. And the baby was weary and petulant, and he cried softly until Juana gave him her breast, and then he gurgled and clucked against her. Kino drank long and thirstily at the pool. For a moment, then, he stretched out beside the water and relaxed all his muscles and watched Juana feeding the baby, and then he got to his feet and went to the edge of the step where the water slipped over, and he searched the distance carefully. His eyes set on a point and he became rigid. Far down the slope he could see the two trackers; they were little more than dots or scurrying ants and behind them a larger ant.

Juana had turned to look at him and she saw his back stiffen.

"How far?" she asked quietly.

"They will be here by evening," said Kino. He looked up the long steep chimney of the cleft where the water came down. "We must go west," he said, and his eyes searched the stone shoulder behind the cleft. And thirty feet up on the gray shoulder he saw a series of little erosion caves. He slipped off his sandals and clambered up to them, gripping the bare stone with his toes, and he looked into the shallow caves. They were only a few feet deep, wind-hollowed scoops, but they sloped slightly downward and back. Kino crawled into the largest one and lay down and knew that he could not be seen from the outside. Quickly he went back to Juana.

"You must go up there. Perhaps they will not find us there," he said.

Without question she filled her water bottle to the top, and then Kino helped her up to the shallow cave and brought up the packages of food and passed them to her. And Juana sat in the cave entrance and watched him. She saw that he did not try to erase their tracks in the sand. Instead, he climbed up the brush cliff beside the water, clawing and tearing at the ferns and wild grape as he went. And when he had climbed a hundred feet to the next bench, he came down again. He looked carefully at the smooth rock shoulder toward the cave to see that there was no trace of passage, and last he climbed up and crept into the cave beside Juana.

"When they go up," he said, "we will slip away, down to the lowlands again. I am afraid only that the baby may cry. You must see that he does not cry."

"He will not cry," she said, and she raised the baby's face to her own and looked into his eyes and he stared solemnly back at her.

"He knows," said Juana.

Now Kino lay in the cave entrance, his chin braced on his crossed arms, and he watched the blue shadow of the mountain move out across the brushy desert below until it reached the Gulf, and the long twilight of the shadow was over the land.

The trackers were long in coming, as though they had trouble with the trail Kino had left. It was dusk when they came at last to the little pool. And all three were on foot now, for a horse could not climb the last steep slope. From above they were thin figures in the evening. The two trackers scurried about on the little beach, and they saw Kino's progress up the cliff before they drank. The man with the rifle sat down and rested himself, and the trackers squatted near him, and in the evening the points of their cigarettes glowed and receded. And then Kino could see that they were eating, and the soft murmur of their voices came to him.

Then darkness fell, deep and black in the mountain cleft. The animals that used the pool came near and smelled men there and drifted away again into the darkness.

He heard a murmur behind him. Juana was whispering, "Coyotito." She was begging him to be quiet. Kino heard the baby whimper, and he knew from the muffled sounds that Juana had covered his head with her shawl.

Down on the beach a match flared, and in its momentary light Kino saw that two of the men were sleeping, curled up like dogs, while the third watched, and he saw the glint of the rifle in the match light. And then the match died, but it left a picture on Kino's eyes. He could see it, just how each man was, two sleeping curled and the third squatting in the sand with the rifle between his knees.

Kino moved silently back into the cave. Juana's eyes were two sparks reflecting a low star. Kino crawled quietly close to her and he put his lips near to her cheek.

"There is a way," he said.

"But they will kill you."

"If I get first to the one with the rifle," Kino said, "I must get to him first, then I will be all right. Two are sleeping."

Her hand crept out from under her shawl and gripped his arm. "They will see your white clothes in the starlight."

"No," he said. "And I must go before moonrise."

He searched for a soft word and then gave it up. "If they kill me," he said, "lie quietly. And when they are gone away, go to Loreto."

Her hand shook a little, holding his wrist.

"There is no choice," he said. "It is the only way. They will find us in the morning."

Her voice trembled a little. "Go with God," she said.

He peered closely at her and he could see her large eyes. His hand fumbled out and found the baby, and for a moment his palm lay on Coyotito's head. And then Kino raised his hand and touched Juana's cheek, and she held her breath.

Against the sky in the cave entrance Juana could see that Kino was taking off his white clothes, for dirty and ragged though they were, they would show up against the dark night. His own brown skin was a better protection for him. And then she saw how he hooked his amulet[5] neck-string about the horn handle of his great knife, so that it hung down in front of him and left both hands free. He

5. **amulet** (ăm′yə-lĭt): a charm or magic ornament, usually worn around the neck.

did not come back to her. For a moment his body was black in the cave entrance, crouched and silent, and then he was gone.

Juana moved to the entrance and looked out. She peered like an owl from the hole in the mountain, and the baby slept under the blanket on her back, his face turned sideways against her neck and shoulder. She could feel his warm breath against her skin, and Juana whispered her combination of prayer and magic, her Hail Marys and her ancient intercession, against the black unhuman things.

The night seemed a little less dark when she looked out, and to the east there was a lightning in the sky, down near the horizon where the moon would show. And, looking down, she could see the cigarette of the man on watch.

Kino edged like a slow lizard down the smooth rock shoulder. He had turned his neck-string so that the great knife hung down from his back and could not clash against the stone. His spread fingers gripped the mountain, and his bare toes found support through contact, and even his chest lay against the stone so that he would not slip. For any sound, a rolling pebble or a sign, a little slip of flesh on rock, would rouse the watchers below. Any sound that was not germane to the night would make them alert. But the night was not silent; the little tree frogs that lived near the stream twittered like birds, and the high metallic ringing of the cicadas filled the mountain cleft. And Kino's own music was in his head, the music of the enemy, low and pulsing, nearly asleep. But the Song of the Family had become as fierce and sharp and feline as the snarl of a female puma. The family song was alive now and driving him down on the dark enemy. The harsh cicada seemed to take up its melody, and the twittering tree frogs called little phrases to it.

And Kino crept silently as a shadow down the smooth mountain face. One bare foot moved a few inches and the toes touched the stone and gripped, and the other foot a few inches, and then the palm of one hand a little downward, and then the other hand, until the whole body, without seeming to move, had moved. Kino's mouth was open so that even his breath would make no sound, for he knew that he was not invisible. If the watcher, sensing movement, looked at the dark place against the stone which was his body, he could see him. Kino must move so slowly he would not draw the watcher's eyes. It took him a long time to reach the bottom and to crouch behind a little dwarf palm. His heart thundered in his chest and his hands and face were wet with sweat. He crouched and took slow long breaths to calm himself.

Only twenty feet separated him from the enemy now, and he tried to remember the ground between. Was there any stone which might trip him in his rush? He kneaded his legs against cramp and found that his muscles were jerking after their long tension. And then he looked apprehensively to the east. The moon would rise in a few moments now, and he must attack before it rose. He could see the outline of the watcher, but the sleeping men were below his vision. It was the watcher Kino must find—must find quickly and without hesitation. Silently he drew the amulet string over his shoulder and loosened the loop from the horn handle of his great knife.

He was too late, for as he rose from his crouch the silver edge of the moon slipped above the eastern horizon, and Kino sank back behind his bush.

It was an old and ragged moon, but it threw hard light and hard shadow into the mountain cleft, and now Kino could see the seated figure of the watcher on the little beach beside the pool. The watcher gazed full at the moon, and then he lighted another cigarette, and the

match illumined his dark face for a moment. There could be no waiting now; when the watcher turned his head, Kino must leap. His legs were as tight as wound springs.

And then from above came a little murmuring cry. The watcher turned his head to listen and then he stood up, and one of the sleepers stirred on the ground and awakened and asked quietly, "What is it?"

"I don't know," said the watcher. "It sounded like a cry, almost like a human—like a baby."

The man who had been sleeping said, "You can't tell. Some coyote bitch with a litter. I've heard a coyote pup cry like a baby."

The sweat rolled in drops down Kino's forehead and fell into his eyes and burned them. The little cry came again and the watcher looked up the side of the hill to the dark cave.

"Coyote maybe," he said, and Kino heard the harsh click as he cocked the rifle.

"If it's a coyote, this will stop it," the watcher said as he raised the gun.

Kino was in midleap when the gun crashed and the barrel-flash made a picture on his eyes. The great knife swung and crunched hollowly. It bit through neck and deep into chest, and Kino was a terrible machine now. He grasped the rifle even as he wrenched free his knife. His strength and his movement and his speed were a machine. He whirled and struck the head of the seated man like a melon. The third man scrabbled away like a crab, slipped into the pool, and then he began to climb frantically, to climb up the cliff where the water penciled down. His hands and feet threshed in the tangle of the wild grapevine, and he whimpered and gibbered as he tried to get up. But Kino had become as cold and deadly as steel. Deliberately he threw the lever of the rifle, and then he raised the gun and aimed deliberately and fired. He saw his enemy tumble backward into the pool, and Kino strode to the water. In the moonlight he could see the

frantic frightened eyes, and Kino aimed and fired between the eyes.

And then Kino stood uncertainly. Something was wrong, some signal was trying to get through to his brain. Tree frogs and cicadas were silent now. And then Kino's brain cleared from its red concentration and he knew the sound—the keening, moaning, rising hysterical cry from the little cave in the side of the stone mountain, the cry of death.

Everyone in La Paz remembers the return of the family; there may be some old ones who saw it, but those whose fathers and whose grandfathers told it to them remember it nevertheless. It is an event that happened to everyone.

It was late in the golden afternoon when the first little boys ran hysterically in the town and spread the word that Kino and Juana were coming back. And everyone hurried to see them. The sun was settling toward the western mountains and the shadows on the ground were long. And perhaps that was what left the deep impression on those who saw them.

The two came from the rutted country road into the city, and they were not walking in single file, Kino ahead and Juana behind, as usual, but side by side. The sun was behind them and their long shadows stalked ahead, and they seemed to carry two towers of darkness with them. Kino had a rifle across his arm and Juana carried her shawl like a sack over her shoulder. And in it was a small limp heavy bundle. The shawl was crusted with dried blood, and the bundle swayed a little as she walked. Her face was hard and lined and leathery with fatigue and with the tightness with which she fought fatigue. And her wide eyes stared inward on herself. She was as remote and as removed as Heaven. Kino's lips were thin and his jaws tight, and the people say that he carried fear with him, that he was as dan-

gerous as a rising storm. The people say that the two seemed to be removed from human experience; that they had gone through pain and had come out on the other side; that there was almost a magical protection about them. And those people who had rushed to see them crowded back and let them pass and did not speak to them.

Kino and Juana walked through the city as though it were not there. Their eyes glanced neither right nor left nor up nor down, but stared only straight ahead. Their legs moved a little jerkily, like well-made wooden dolls, and they carried pillars of black fear about them. And as they walked through the stone and plaster city brokers peered at them from barred windows and servants put one eye to a slitted gate and mothers turned the faces of their youngest children inward against their skirts. Kino and Juana strode side by side through the stone and plaster city and down among the brush houses, and the neighbors stood back and let them pass. Juan Tomás raised his hand in greeting and did not say the greeting and left his hand in the air for a moment uncertainly.

In Kino's ears the Song of the Family was as fierce as a cry. He was immune and terrible, and his song had become a battle cry. They trudged past the burned square where their house had been without even looking at it. They cleared the brush that edged the beach and picked their way down the shore toward the water. And they did not look toward Kino's broken canoe.

And when they came to the water's edge they stopped and stared out over the Gulf. And then Kino laid the rifle down, and he dug among his clothes, and then he held the great pearl in his hand. He looked into its surface and it was gray and ulcerous. Evil faces peered from it into his eyes, and he saw the light of burning. And in the surface of the pearl he saw the frantic eyes of the man in the pool. And in the surface of the pearl he saw Coyotito lying in the little cave with the top of his head shot away. And the pearl was ugly; it was gray, like a malignant growth. And Kino heard the music of the pearl, distorted and insane. Kino's hand shook a little, and he turned slowly to Juana and held the pearl out to her. She stood beside him, still holding her dead bundle over her shoulder. She looked at the pearl in his hand for a moment and then she looked into Kino's eyes and said softly, "No, you."

And Kino drew back his arm and flung the pearl with all his might. Kino and Juana

Drawing for the 1947 edition of *The Pearl* by José Clemente Orozco (1883–1949).

watched it go, winking and glimmering under the setting sun. They saw the little splash in the distance, and they stood side by side watching the place for a long time.

And the pearl settled into the lovely green water and dropped toward the bottom. The waving branches of the algae called to it and beckoned to it. The lights on its surface were green and lovely. It settled down to the sand bottom among the fernlike plants. Above, the surface of the water was a green mirror. And the pearl lay on the floor of the sea. A crab scampering over the bottom raised a little cloud of sand, and when it settled the pearl was gone.

And the music of the pearl drifted to a whisper and disappeared.

Reading Check

1. How does Kino attempt to erase his trail?
2. Who are Kino's pursuers?
3. How does Kino try to lose them?
4. Where do Kino and Juana find shelter in the mountains?
5. Why does Kino decide to attack his pursuers?

For Study and Discussion

Analyzing and Interpreting the Novel

1. In the midst of his perilous journey, Kino looks into the pearl for "his vision." But the pearl reflects only nightmares. What does each nightmare reveal about what has happened to Kino?

2. Is Kino in any way responsible for his little son's death? Why, or why not?

3a. What is significant about the fact that the Song of the Family becomes "a battle cry" when Kino and Juana return with the pearl

and the body of their son? **b.** What images now make the pair seem noble and powerful?

4a. How does the melody of the pearl in Chapter 2 (page 835) compare with what Kino now sees in the pearl? **b.** What has caused Kino to associate the pearl with evil?

5. Kino at first saw the pearl as a means of gaining a kind of freedom. **a.** What would you say he finally gains from his tragic experience? **b.** How does Kino change? **c.** What does his final act reveal about his values?

6. Why do you think Kino and Juana throw the pearl away?

The Novel as a Whole

Plot

1. The plot of *The Pearl* consists of a series of connected incidents, all related in chronological order. **a.** Trace the major events of the plot. **b.** What are the **conflicts** in the story? **c.** What is the **climax**—that moment of greatest emotional intensity? **d.** How are the conflicts finally resolved? **e.** Would you describe the **resolution** as satisfying, or as something else?

2. To create suspense and tension, storytellers often use **foreshadowing**—that is, they drop hints about what is to happen later. Steinbeck often uses imagery from the natural world to foreshadow human conflicts. **a.** What human conflict is foreshadowed by the description of the ant lion on page 823? **b.** What human conflict is foreshadowed in the passage on page 842 that begins with the slaughter of the fish?

Irony

3. To show us that life is unpredictable and not always comprehensible, writers often use **irony.** Ironic situations turn out to be just the reverse of what we expect or of what we think would be appropriate. **a.** What is ironic about

the fact that it is Coyotito who is killed in this story? **b.** How did this irony affect you?

4. When Kino and Juana set out to sell the pearl at the opening of Chapter 4, they feel that it is "the morning of mornings of their lives, comparable only to the day when their baby was born. This was to be the day from which all other days would take their arrangement." **a.** Given what happens later, what is ironic about the parents' hopes? **b.** In what unexpected way does this turn out to be the "morning of mornings"?

5. Kino hoped to win freedom and knowledge through his son. He hoped that Coyotito would "break out of the pot that holds us in" (page 844). **a.** Ironically, how does Coyotito help his parents win a kind of "freedom"? **b.** What do Kino and Juana come to realize through the baby's death?

Imagery

6. Kino and Juana are often compared to animals. After Kino finds the pearl, for example, he "howls," as a dog or a wolf would. **a.** What images in Chapter 6 compare Kino and Juana, as well as their trackers, to animals? **b.** In contrast, what images describe the pair when they return to La Paz after their ordeal is over? **c.** How have they changed? **d.** What would you compare them to now?

Symbol

7. A **symbol** is any object, action, person, or place that has a meaning in itself and that also stands for something broader than itself. The pearl in this story seems to stand for more than just an actual pearl. Steinbeck tells us on page 833 that the pearl is an accident, a "coated grain of sand." **a.** Find passages that reveal what the pearl symbolizes to various people at various times in the story. **b.** Does Steinbeck finally make us see the pearl again for what it really is—a beautiful "accident" of the sea? Explain.

Theme

8. At the opening of the novel, Steinbeck says that everyone takes his or her own meaning from this story. *The Pearl* is a simple story, but what it means is anything but simple. One of the themes of the story might be illuminated by this statement on page 838:

> For it is said that humans are never satisfied, that you give them one thing and they want something more. And this is said in disparagement, whereas it is one of the greatest talents the species has and one that has made it superior to animals that are satisfied with what they have.

a. How does this statement apply to Kino and Juana and their quest? **b.** What desires eventually distinguish Kino and Juana from everyone else in La Paz? **c.** Are there other passages in the story supporting this as a theme?

9. The theme of *The Pearl* also might have something to do with tragic experience, and with the wisdom that can be gained from it. **a.** What tragic experience do Kino and Juana undergo? **b.** How do they change as a result of the experience? **c.** What wisdom do they gain?

10. Many people see the theme of the story as one concerning the dehumanizing nature of greed. **a.** In what passages is greed depicted as an evil? **b.** Tell specifically how it has dehumanized certain characters. **c.** Are there any major characters in the story who are not tainted at one time or another with greed? **d.** Is there a force in the story that finally triumphs over greed?

11. Throughout the story, Steinbeck develops the theme that the rich and powerful can dominate the poor and uneducated. **a.** What episodes dramatize this theme? Consider why Kino is unable to deal with the doctor and the pearl buyers. **b.** How does the priest's yearly sermon (page 850) relate to this theme? **c.** What do you think Steinbeck is saying about

those people who attempt to overcome this situation?

Style

12. Because Steinbeck wanted this novel to serve as a parable, he wrote it in a style that is suggestive of a folk tale. Folk literature is usually told in simple, straightforward language; it makes use of repetition, which gives the prose a rhythmic effect; and its characters are often presented as either good or bad—they are not usually the complex individuals we know in actual life. Look back at the final scene of the novel, where Kino and Juana return to La Paz. How does the style here reflect some of the characteristics of a folk tale?

Tone

13. **Tone** is the attitude that a writer takes toward the characters and events in a story. It is important to recognize a writer's tone, because if we misinterpret tone, we might misinterpret the entire story. **a.** How would you described Steinbeck's tone in *The Pearl?* **b.** What does he think of the events that take place in La Paz? **c.** How does he feel about the various characters in the story?

Language and Vocabulary

Using Precise Diction

Steinbeck's diction is simple, but he makes each word do exactly what he wants it to do. Look at his use of the word *lacy:*

> The hot sun beat on the earth so that Kino and Juana moved into the *lacy* shade of the brush....

The word *lacy* means "like lace, having a delicate, open pattern." The word makes us visualize a shady area streaked with a delicate pattern of gentle sunlight. The word itself has a soft sound quality that adds to the impression of gentleness.

Using the dictionary when necessary, define the italicized words in the following sentences.

Consider the precise meaning of each word, what the word makes you see, hear, or feel, and the word's sound quality. Notice that some of these words are used metaphorically. For such words, tell what comparisons they make and if you think the comparisons are effective.

> Kino had wondered often at the *iron* in his patient, fragile wife.

> His eyes rested in puffy little *hammocks* of flesh and his mouth drooped with discontent.

> It [the canoe] is the *bulwark* against starvation.

> Then in coordination Juana and Kino drove their double-bladed paddles into the sea, and the canoe *creased* the water and *hissed* with speed.

> The *liplike flesh* [of the oyster] *writhed* up and then *subsided*.

> "Kino will be a rich man," they *clamored*.

> He felt the evil *coagulating* about him, and he was helpless to protect himself.

> High slopes of the mountain are *swaddled* with pines.

> The third man *scrabbled* away like a crab, slipped into the pool, and then he began to climb frantically, to climb up the cliff where the water *penciled* down.

Writing About Literature

Analyzing the Theme

Using one of the discussion topics under the heading **Theme** (page 874), write an essay in which you analyze the theme of *The Pearl*. In your essay, state clearly and in detail what you believe is the major theme of the novel—what truth or insight about life and human behavior is Steinbeck revealing in his story? Cite specific passages from the novel to support your statement.

Focus on Literary Analysis

Analyzing Prose Fiction

In a **literary analysis** you use a thesis statement to present your main idea about at least one element in a literary work. You then include quotations and other details from the work to support your thesis.

As you plan a literary analysis, here are some questions to ask:

1. What external and internal conflicts do the characters face?
2. What is the climax of the story?
3. What is the setting of the story?
4. Is the setting related to the story's overall mood and tone?
5. What are the main characters like?
6. How does point of view affect what you know and feel about the characters?
7. Does foreshadowing help prepare for later events?
8. Does irony help to shape your reactions to the events in the story?
9. How does the author use symbolism?
10. What point about life and human nature does the author express or imply?

In a literary analysis you can examine individual story elements or you can compare and contrast elements. If you focus on comparison and contrast, be sure that the elements you choose to discuss share one or more important features (see page 764).

Choose one of your favorite short stories. Reread the story carefully. Using the questions above, make prewriting notes for a literary analysis of this story. Then write your main idea in a **thesis statement** of one or two sentences. Save your notes.

Connecting Cultures

Parables

At the beginning of *The Pearl*, the narrator says that the story is a parable and that "everyone takes his own meaning from it and reads his own life into it." A parable is a brief allegorical story that teaches a moral or religious lesson about life. Parables occur in many cultures. The New Testament contains moral lessons in short tales about everyday life. "The Good Samaritan," "The Prodigal Son," "The Sower, "The Fig," and "The Talents" are among the most well known. In Japanese culture the Zen sect of Buddhism used the simple tales of parables to teach monks about profound truths. Some of the more famous Zen parables are "The Muddy Road," "The Thief Who Became a Disciple," "Publishing the Sutras," and "The Taste of Banzo's Sword!" Parables written by Africans and African Americans include "Parable of the Broom" and "The Parable of the Eagle."

Making Connections: Activities

1. Read several of the parables cited above or others that you find. What are their messages? How are their symbolic meanings embedded in their literal ones? How are the parables appropriate to modern life? See if you can find where the messages of parables overlap across boundaries of culture and race.

2. Select one of the parables that you read and rewrite it, using language, situations, and references that today's reader can easily relate to. When planning your modern version of the parable, make a list of the details of the original parable and the symbolic meaning of those details. Then decide how you will change the details in your updated parable. The symbolic meaning should remain the same.

FOCUS ON Reading and Critical Thinking

ANALYZING LITERATURE

*L*iterary critics use a variety of arguments and evidence to support their ideas. This evidence may consist of quotations and inferences from the work being analyzed, references to other works by the same author, facts about the author and the era in which the work was written, expert opinions, and material from other sources.

Read the following excerpt from an essay about *The Pearl* by critic Richard Astro. Notice how Astro skillfully combines plot summary with analysis. Also notice the techniques the writer uses to incorporate smoothly a variety of quotations from and references to Steinbeck's novel.

At the beginning of Steinbeck's fable, Kino is a poor but mildly satisfied pearl fisherman. A devoted husband and father, his song is the "Song of the Family," which rises "to an aching chord that caught the throat, saying this is safety, this is warmth, this is the *Whole*." He is a man who . . . "enjoys a deep participation with all things, the gift he had from his people."

He heard every little sound of the gathering night, the sleepy complaint of settling birds, the love agony of cats, the strike and withdrawal of little waves on the beach, and the simple hiss of distance. And he could smell the sharp odor of exposed kelp from the receding tide.

But, despite his sense of participation with the land and with his family, Kino is victimized by his poverty and exploited because of his ignorance. "He was trapped as his people were always trapped and would be until . . . they could be sure that the things in the books were really in the books." When, therefore, Kino finds "the pearl of the world," he sees in it an end to the poverty and exploitation which heretofore he has been forced to accept. Gradually, the "Song of the Pearl" merges with the "Song of the Family," Steinbeck points out, "so that the one beautified the other." And Kino envisages a day when he will be able to afford to send his child to school so that "one of his own people could tell him the truth of things." Kino tells his wife, Juana, "This is our one chance. Our son must go to school. He must break out of the pot that holds us in."

But Kino's thinking about the future becomes cloudy; his vision becomes as hazy as the mirage of the Gulf. "There was no certainty in seeing, no proof that what you saw was there or was not there." And Kino looks down into the surface of his fabulous pearl and forms misty, insubstantial dreams that will never come true. For "in this Gulf of uncertain light there were more illusions than realities."

As a member of a village of pearl fishermen, Kino is a member-unit of the organism of the greater community of La Paz. Steinbeck describes the town organismically as a "thing like a colonial animal. A town has a nervous system and a head and shoulders and feet. A town is a thing separate from all other towns, so that there are not two towns alike. And a town has a whole emotion." Thus, when Kino finds his great pearl, the organism of the town stirs to life and an interest develops in Kino—

"people with things to sell and people with favors to ask." . . .

When he senses the greed of the envious villagers, Kino, who "had broken through the horizons into a cold and lonely outside" (Steinbeck's choice of words is significant here), hardens and "his eyes and his voice were hard and cold and a brooding hate was growing in him." And as attempts are made first to cheat him of his wealth and later to steal his pearl, the "Song of the Pearl" becomes a "Song of Evil" as Kino fights to save himself, his family, and his newfound wealth. Kino admits that "This pearl has become my soul. . . . If I give it up I shall lose my soul." . . .

Kino saves his pearl from those who would steal it, but he pays dearly for it with the destruction of his house and canoe, and ultimately with the death of his baby. Finally, Kino begins to see the pearl as a "grey, malignant growth," and he chooses the "region of inward adjustments" over the "region of outward possessions" by throwing the pearl back into the Gulf. And though he has lost his canoe, his home, and his child, and so is even poorer than before, his choice has been made possible only because he has "gone through the pain" and "come out on the other side." Kino's story is the parable of the human condition; a parable of that two-legged paradox, man, growing accustomed to "the tragic miracle of consciousness," struggling, and finally succeeding, to forge the design of his microcosmic history.

—from "Intimations of a Wasteland"

Analyzing Literature

- List an example from the passage for each of the following:

 1. a quotation of part of a sentence from the novel
 2. a quotation of one or more complete sentences
 3. a quotation in which ellipsis points signal that some material has been omitted
 4. an indented quotation of a longer excerpt
 5. ellipsis points that signal omissions from Astro's critical essay

WRITING A LITERARY ANALYSIS

*W*hen you write about literature, your purpose may be to evaluate a literary work, provide information about it, share your responses to it, or a combination of all three. In a **literary analysis,** you examine at least one of the major elements of a work, present a thesis or main idea, and support that idea with quotations and other details from the text. In this assignment, you will have the chance to write a literary analysis of a work of your own choice.

Prewriting

1. Begin with your own personal responses to a short story, novel, play, or poem. Jot down some active-reading thoughts and reactions to a work while you read it. Use your own experience and knowledge as well as questions and predictions.

2. After you have "listened" to yourself read a literary work, move on to a more objective, critical analysis of what makes the work tick. If you have chosen a novel or short story to analyze, examine the major elements of prose fiction below:

- plot
- setting
- characters
- point of view
- foreshadowing
- irony
- symbol
- theme

If you have chosen a play, think about these elements of drama:

- plot
- setting
- dialogue
- stage directions
- dramatic conventions
- theme

If you have chosen a poem, here are some elements to consider:

- speaker
- diction
- imagery
- figures of speech
- theme
- tone
- musical devices
- rhythm and meter
- structure

Use **questioning** to analyze the elements of a work. Here are some questions you can ask yourself about a work of prose fiction:

- What are the major external/internal conflicts?
- What is the climax of the story?
- What is the setting?
- Is the setting related to the story's mood and tone?
- What are the main characters like? What are their motivations? Do they change or stay the same?
- How does the point of view affect the impact of the events and characters?
- Does the author use foreshadowing to prepare for later events?
- Does the author use symbolism?
- What theme does the story suggest?

3. Focusing on one or two elements for closer analysis, jot down notes to identify a **main idea** or overall thesis for your essay. For example, if you have chosen *The Pearl,* you might want to concentrate on Steinbeck's use of foreshadowing or on the relationship of setting to mood in the novel. State your thesis clearly in one or two sentences. [See **Focus** assignment on page 876.]

4. Consider your purpose, audience, and tone. The **purpose** of a literary analysis is to enrich your readers' understanding of a work

by sharing your ideas about it. Your **audience** for an analysis is often your teacher and your classmates. Assume that your audience has read the work you have chosen. You will need to include details from the work to support your thesis, but you should avoid confining your analysis to a summary of the plot. Use a relatively formal **tone** for your essay—one that shows you've given the literature some careful thought.

5. Collect **support** for your thesis by gathering specific details from the literary work. Here are some types of details you can use:

- plot events
- details of setting
- structure
- dialogue
- choice of words
- poetic devices

At this stage, try to gather as much evidence as possible for your main idea. You can evaluate your support later, selecting only the clearest and most convincing details for inclusion in your essay. As you list references to the text of the work, remember to include the page or line number for each reference.

Writing ᴧᴧᴡ

1. A literary analysis usually consists of three parts:

I. Introduction
 A. Capture reader's attention
 B. Identify work by title and author
 C. State thesis
II. Body
 Support main idea with details, quotations, and other evidence
III. Conclusion
 A. Summarize major points
 B. Restate main idea

In the body of your essay, organize your support in a logical fashion. For example, if your focus is on plot structure, you will probably want to use **chronological order.** If you focus on character or theme, you may want to use **order of importance.** If you concentrate on setting, you may find **spatial order** helpful. For comparison and contrast, see the organizational methods outlined on page 812.

2. As you write your first draft, be careful not to fall into two common errors:

 a. writing a plot summary (as opposed to an analysis)
 b. presenting only your personal feelings about the work

Your analysis should share ideas and insights, not just give information about the work. Likewise, even though your personal responses were your starting point, your essay should go beyond these reactions to offer objective support for your main idea about the work.

Evaluating and Revising ᴧᴧᴡ

1. When you have finished your first draft, set it aside for a while. Then try to evaluate it as objectively as you can. You may want to trade papers with a classmate at this stage. Offer each other suggestions about how to improve your essays. Make sure that you have presented your material in a logical way and that you have used **transitions** to help readers follow your ideas. Also check to see that you have incorporated support from the work smoothly and grammatically into your sentences. Verify your quotations by matching them against the original. If you have paraphrased or summarized events or descriptions, be sure you have done so accurately.

Below is an example of an opening paragraph of a literary analysis. The thesis statement is underlined. Notice the writer's revisions.

Writer's Model

In *The Pearl*, John Steinbeck uses simple ~straightforward~ language, as well as repetition, uncomplicated characters, and *haunting* imagery. <u>The style of ~the~ *Steinbeck's* ~author's~ *parable* ~story~ about good and evil suggests the style of a *traditional* folk tale.</u>

2. You may find the following checklist helpful.

Checklist for Evaluation and Revision

✓ Does the introduction include the author and title of the literary work?
✓ Do I state my thesis in the introduction?
✓ Do I support my main idea with specific examples, quotations, and other evidence?
✓ Do I organize my analysis clearly?
✓ Do I incorporate supporting evidence smoothly?
✓ Have I considered my purpose, audience, and tone?
✓ Does the conclusion bring the essay to a satisfying close?

Proofreading and Publishing

1. Proofread your essay to correct any errors in grammar, usage, and mechanics. (Here you may find it helpful to refer to the **Handbook for Revision** on pages 928–971.) Prepare a final version by making a clean copy.
2. Here are some ideas for sharing your analysis:

- hold a round-table discussion with other students who have analyzed the same or a similar work
- send your essay to a literary magazine
- present your essay orally as a review
- make a class file of essays, arranged by topic, title, or author

Portfolio If your teacher approves, you may wish to keep a copy of your work in your writing folder or portfolio.

WRITING ABOUT LITERATURE

Developing Skills in Critical Thinking

In English class you will often be asked to write about the literature you read. The writing may be in response to a homework assignment, an examination question, or a research project. At times you may be assigned a topic to work on; at other times you may be instructed to choose your own subject.

In writing about literature your object is to demonstrate your understanding of a literary work or group of works by focusing on some specific aspect of the literature under study. For example, you may analyze the central character or characters in a short story. You may discuss the use of dramatic irony in a play. You may compare techniques or ideas in two poems. Such writing assignments are an important part of literary study, which aims at greater understanding and appreciation of the works you read.

The effort involved in writing about a literary work actually helps you get to know it better. Before you write, you must read carefully. You must think about what you have read, gather and weigh the evidence, and come to conclusions. In putting your thoughts down on paper, you become more fully involved with the literature.

In your studies you will become familiar with a great many elements that are useful in analyzing literary works. You can safely assume that your readers will understand what you mean when you refer to a character as the *protagonist* or *antagonist,* or when you use such terms as *satire* and *tone.* These words are part of a common vocabulary used in writing about literature. (See *Literary Terms and Techniques,* page 904.)

The material on the following pages offers help in planning and writing papers about literature. Here you will find suggestions for answering examination questions, choosing topics, gathering evidence, organizing essays, and writing, evaluating, and revising papers. Also included are several model essays.

The Writing Process

We often refer to writing an essay as a *process,* which consists of several key stages or phases: **prewriting, writing a first draft, evaluating and revising, and proofreading and publishing.** In this process, much of the critical work—the thinking and planning—precedes the actual writing of the paper.

In the **prewriting** stage, the writer makes decisions about what to say and how to say it. Prewriting activities include choosing and limiting a subject; considering purpose, audience, and tone; gathering ideas and organizing them into a plan; and developing a *thesis*—the controlling idea for the paper. In **writing a first draft,** the writer uses the working plan to get ideas down on paper. In the **evaluating and revising** stage, the writer judges the first draft to identify strengths and weaknesses in content, organization, and style. The writer then makes changes to eliminate the weaknesses identified through evaluating. The writer can revise by adding, cutting, reordering, or replacing ideas and details. In the **proofreading and publishing** stage, the writer checks the revised draft to correct errors in grammar, usage, and mechanics. The writer then prepares a clean copy and proofreads it to catch any omissions or errors. Finally, the completed paper is shared with others.

The stages of the writing process depend upon one another, which results in a "back and forth" movement among the stages. Few writers complete one stage entirely before moving to another, nor do they progress in a straight line from one stage to the next. For example, new ideas may emerge as the first draft is written, requiring a restatement of the thesis or additional evidence. This interplay among stages is a natural part of writing—for all writers.

The amount of time devoted to each stage will vary with individual assignments. During a classroom examination, you will have limited time to plan your essay and to proofread your paper. For a term paper, you may have weeks or months to prepare your essay.

On the following pages the steps in this process are illustrated through the development of several model papers.

Answering Examination Questions

From time to time you will be asked to demonstrate your understanding of a literary work or topic by writing a short essay in class. Usually, your teacher will select the subject of the essay. How well you do will depend not only on how carefully you have prepared for the examination but on how carefully you read and interpret the essay question.

Before you begin to answer an examination question, be sure you understand what the question calls for. Suppose you are asked to discuss the different kinds of irony in a particular short story. Should you limit yourself to one type of irony, your essay will not fulfill the requirements of the question. If you are asked to state the theme of a novel and you give instead a summary of its plot, your answer will be unacceptable. No matter how good your essay is, it will be unsatisfactory if you do not respond to the question accurately. Always take some time to read the essay question carefully in order to determine how it should be answered.

Remember that you are expected to demonstrate specific knowledge of the literature. Any general statement should be supported by evidence. If you wish to demonstrate the tone of a poem, refer to individual words, sounds, images, and any other elements of style that make up the writer's voice. If you are allowed to use your textbook during the examination, you may occasionally quote short passages or refer to a specific page in order to provide supporting evidence.

At the start, it may be helpful to jot down some notes to guide you in writing the essay. If you have several points to make, decide what the most effective order of presentation will be. You might build up to your strongest point, or you might present your points to develop a striking contrast. Aim for a logical organization that helps your reader follow your thinking.

Also remember that length alone is not satisfactory. Your answer must be relevant, and it must be presented in acceptable, correct English. Always take time to proofread your paper.

The key word in examination questions is the *verb*. Let us look briefly at some common instructions used in examinations.

ANALYSIS A question may ask you to *analyze* some aspect of a literary work or topic. When you analyze something, you take it apart to see how each part works. On an examination, you will generally be directed to focus on some limited but essential aspect of a work in order to

demonstrate your knowledge and understanding. A common type of exercise is *character analysis,* in which you draw on the most significant details of characterization in order to reach conclusions about a specific figure. For example, you might be asked to analyze the character of Anton Rosicky in "Neighbor Rosicky" (page 48). You might be asked to analyze the ballad conventions in "Johnny Armstrong" (page 443). You might be asked to analyze the theme of *The Pearl* (page 822). Analysis may be applied to form, technique, or ideas.

COMPARISON CONTRAST A question may ask that you *compare* (or *contrast*) two things, such as techniques, ideas, characters, or works. When you *compare,* you point out likenesses; when you *contrast,* you point out differences. If you are asked to *compare and contrast,* you will have to deal with similarities and differences. You might be asked to compare characters in two stories: Barry in "Shaving" (page 195) and Jerry in "Through the Tunnel" (page 202). You might be asked to compare points of view toward childhood in two selections: "A Child's Christmas in Wales" (page 306) and *Aké* (page 339). You might be asked to contrast the moods of two poems: "The Lake Isle of Innisfree" (page 377) and "Above Pate Valley" (page 380). You might be asked to compare and contrast the images in two poems. Sometimes the instruction to *compare* implies both comparison and contrast. Always check with your teacher to make sure how inclusive the term *compare* is intended to be.

DEFINITION A question may ask you to *define* a literary term—to answer the question "What is it?" To define a term, first classify it, or assign it to a larger class or group. Then discuss the specific features that make it different from other members of the same class. You should also provide specific examples that illustrate the term. For example, if asked to define the term *metaphor,* you would first identify it as a figure of speech (general class) and then indicate that it is used to compare two unlike things (specific feature). You might then use "Dreams," the poem by Langston Hughes (page 388), as a specific example of metaphor.

DESCRIPTION If a question asks you to *describe* a setting or a character, you are expected to give a picture in words. In describing a setting, include details that establish the historical period as well as the locale. Be sure also to include details that establish mood or build emotional intensity. In describing a character, deal with both direct and indirect methods of characterization (see page 73). You might be asked to describe details in the story "The Alligator War" (page 185) that render the

flavor of its particular setting. You might be asked to describe the seven rooms of Prince Prospero's palace in "The Masque of the Red Death" (page 120) to point out how Poe creates atmosphere.

DISCUSSION The word *discuss* in a question is much more general than the other words we've looked at. When you are asked to discuss a subject, you are expected to examine it in detail. If you were directed to discuss the characteristics of the medieval romance as illustrated in "The Tale of Sir Gareth" (page 776), you would be obligated to stress its chivalric exploits, since the code of chivalry is primary in the Arthurian legends. In discussing the moral issues in *Antigone* (page 494), you would have to take into account not only the position of the heroine but that of her adversary, Creon. If you were asked to discuss Shakespeare's use of superstition in *Julius Caesar* (page 543), you would need to include such important instances as the prophecy of the Soothsayer and the tempest in Act One, Calpurnia's dream in Act Two, and the appearance of Caesar's ghost in Act Four.

EVALUATION If a question asks you to *evaluate* a literary work or some aspect of one or more works, you are expected to determine if a writer has successfully achieved his or her purpose, and how important that purpose is. To evaluate, you must apply criteria, or standards of judgment, which may relate to both literary content and form. You must also supply evidence from the literary work or works to support your judgment. You might be asked to evaluate Keats's use of the ballad form and tradition in "La Belle Dame sans Merci" (page 446). Your object would be to determine how effectively Keats adapts the conventions of the folk ballad to his literary ballad.

EXPLANATION A question may ask you to *explain* something. When you explain, you give reasons for something being the way it is. You make clear a character's actions, or you show how something has come about. You might, for example, be asked to explain how the author uses point of view in "The Handsomest Drowned Man in the World" (page 223) to control the reader's reaction to characters and events. You might be asked to explain how May Swenson uses language in "Ornamental Sketch with Verbs" (page 373) to transform an ordinary scene into something magical. You might be asked to explain the anachronistic references in "Arthur Becomes King" (page 753). You might be asked to explain a title, an allusion, or a convention.

ILLUSTRATION The word *illustrate*, *demonstrate*, or *show* asks that you provide examples to support a point. You might be asked to provide examples of

images in *The Pearl* (page 822) that depict characters in terms of animals. You might be asked to illustrate Antony's skill in manipulating the conspirators and the mob in *Julius Caesar* (page 543). You might be asked to demonstrate musical effects in "Summer Remembered" (page 419). Or you might be asked to show the kinds of poetic license that E. E. Cummings uses in "i thank You God for most this amazing" (page 464).

INTERPRETATION

The word *interpret* in a question asks that you give the meaning or significance of something. For example, you might be asked to provide an interpretation for a particular symbol, such as the sheet of yellow paper in "Contents of the Dead Man's Pockets" (page 98). You might be asked to interpret the meaning of a satire such as "Learn with BOOK" (page 266). Sometimes you will be asked to agree or disagree with a stated interpretation of a work, giving specific evidence to support your position. For example, see the essay topics on page 895.

You will find that there is frequent overlapping of approaches. In discussing a subject, you will draw upon illustration, explanation, analysis, or any other approach that is useful. In comparing or contrasting two works, you may rely on description or interpretation. However, an examination question generally will have a central purpose, and it is important that you focus on this purpose in preparing your answer.

Using the Writing Process to Answer an Essay Question

Even if you are well prepared for an examination, you may not develop your essay effectively unless you manage your time well. Although you may have to work quickly, you should nevertheless devote some time to each stage of the writing process. The following suggestions indicate how you can use the writing process to develop an answer to an essay question. Once you become familiar with this pattern, you will have a plan that enables you to work quickly and efficiently.

PREWRITING

The examination question itself often establishes the topic and, through its key verb (*analyze*, *compare*, *interpret*, etc.) suggests an approach for developing an answer. Several prewriting steps remain:

1. *Formulate a thesis statement.* A *thesis statement* is a sentence that represents the main point of your paper. It generally appears at the beginning of an essay and establishes the position you are going to support.

2. *Develop points that support the thesis statement.* There should always be at least two supporting points. In a short essay all the points may be presented in a single paragraph. In a longer paper each point may be stated as the topic sentence of a separate paragraph. Each point should clearly support the idea expressed in the thesis.

3. *Locate supporting evidence in the literary work(s).* Evidence can include specific details, direct quotations, incidents, or images that support each point.

4. *Organize the major points and evidence.* Arrange your ideas and details logically so that your plan includes an introduction, a body, and a conclusion.

WRITING A FIRST DRAFT

Using your prewriting plan as a guide, write your essay. In the **introduction,** identify the work(s) under study and state your thesis. In the **body** present your major points with supporting evidence. In the **conclusion** restate your thesis and summarize what you have demonstrated. As you write, adopt a tone appropriate for your purpose (to convey ideas) and for your audience (your teacher, in most cases). Use straightforward language that is serious without being affected, and include transitional expressions (connecting words or phrases, such as *nevertheless, finally,* and *by contrast*) to make clear the relationships among ideas.

EVALUATING AND REVISING

Quickly evaluate, or judge, your answer by asking the following questions:

Purpose	**1.** Have I answered the specific assignment or questions?
Introduction	**2.** Have I included a thesis statement that specifies what the answer will discuss?
Body	**3.** Have I developed at least two major points that support the thesis statement?
	4. Have I included enough evidence from the literary work to support each major point?
	5. Is the order of ideas in the essay clear and logical?
Conclusion	**6.** Have I included a conclusion that summarizes findings or restates the main idea?

Using your evaluation, improve your essay by *adding, cutting, reordering,* or *replacing* ideas and details.

PROOFREADING AND PUBLISHING Review your answer to locate and correct errors in grammar, usage, and mechanics. If your teacher indicates that you have time to do so, prepare a clean copy of your answer and proofread it again to catch any errors or omissions.

Sample Examination Questions and Answers

On the following pages you will find some sample examination questions and answers for study and discussion. Note that the questions or assignments (shown in italics) may be phrased as essay topics.

I

QUESTION *In a paragraph, explain the significance of the following lines that Cassius speaks in* Julius Caesar:

> *Men at some time are masters of their fates.*
> *The fault, dear Brutus, is not in our stars*
> *But in ourselves, that we are underlings.*
> *(I, 2, 139–141)*

DEVELOPING AN ANSWER This assignment asks you to explain the significance of some key lines in the play. What you need to demonstrate in your answer is that you understand not only the meaning of the lines, but their importance to the drama. Since you are instructed to write a single paragraph, the opening sentence should state the *thesis*—the controlling idea of your essay.

Before you write the essay, jot down some prewriting notes to guide you. Be sure that you understand exactly what Cassius is saying. If necessary, paraphrase the lines in your notes.

Paraphrase
 Cassius tells Brutus that human beings control their own destiny. He does not believe that the stars influence human behavior. If human beings are inferior, it is their own fault.

Cassius' Motives

Cassius wishes to have Brutus join the conspiracy. He knows that Brutus will not act out of base or selfish motives. Therefore, he appeals to Brutus' pride as a Roman. He suggests that the Romans are cowards who willingly subject themselves to the tyranny of Caesar. He implies that they can control what happens by taking matters into their own hands.

Conclusion

This is one example of Cassius' skill in manipulating people.

WRITING AN ANSWER

Here is a model paragraph developed from the notes. The topic sentence of this paragraph states the *thesis*—the central idea that gives focus to the essay. Although the thesis appears at the opening of the essay, it represents the end product of thinking.

Topic Sentence

Supporting Statements

This brief passage is one example of Cassius' persuasive tactics as master conspirator. A shrewd judge of character, he knows that Brutus will not act out of base or selfish motives, so he appeals to Brutus' pride as a Roman. Denying a superstitious belief in the influence of the stars, Cassius urges Brutus to take control of his own destiny. He suggests that the Romans are cowards who willingly accept their role as "underlings" to Caesar. Without naming the conspiracy, he implies that Romans can free themselves from Caesar's tyranny by becoming "masters of their fates."

Length: 96 words

II

QUESTION

Analyze the character of the speaker in Browning's "The Laboratory" (page 456).

DEVELOPING AN ANSWER

This is an exercise in *character analysis*. This assignment is more demanding than the first assignment because you have to exercise your own judgment in setting limits to your answer. You may need one paragraph or several paragraphs. The assignment also requires that you supply a thesis statement. Your thesis statement should be formulated *after* you have examined the evidence and come to a conclusion about the subject.

Assuming that you have the text of the poem to work from, you might go through it line by line, noting explicit and implicit clues to the speaker's character. You might jot down line references alongside your notes to guide you in writing your paper. As you work, look for major characteristics that will provide a focus for your paper.

This is one way to plan your answer.

Character of Speaker

Speaker is a "minion"—petite and delicate (29).
Men find her attractive since they are waiting for her at the court (12).
She is sure of her charms and offers the apothecary a kiss (46).
She possesses many jewels and gold (45).

> **APPEARANCE:**
> **BEAUTY**
> **GRACE**
> **WEALTH**

She has been spurned by the King and is enraged (5).
She wants revenge against her rival, who has "ensnared" the King (27–30).
She furiously imagines the King and his new favorite laughing at her (7).
She takes pleasure in contemplating her rival's death; she wants her to die hideously and in agony (37–40).
She entertains fantasies of killing other women with poison carried in innocent-looking ornaments (17–24).
She feels no remorse about her crime or pity for her intended victim (43–44).
Her sole concern is whether the poison will be effective (29).

> **PASSIONS:**
> **JEALOUSY**
> **ANGER**
> **HATRED**
> **CRUELTY**

She shows a will of iron in planning the murder.
She shows no dread of the apothecary shop, which is compared to hell—"devil's smithy" (3).
She does not shrink from the sight of the poisons—she ties on a glass mask (1).
She takes an interest in the different poisons and in the apothecary's art (9–16).
She even instructs him in changing the color of the poison (25–28).
She has the dust brushed from her clothing so that no one will suspect where she has been (47–48).

> **NERVES OF**
> **STEEL**

What you might conclude from this set of notes is that the speaker is a diabolically evil woman whose monstrous nature is hidden beneath a façade of beauty and grace. Each of the overall characteristics shown in the notes can become the subject of a paragraph.

This is what the final essay might look like.

WRITING AN ANSWER

INTRODUCTION
Thesis Statement

In "The Laboratory," Browning creates a portrait of a diabolically evil woman whose monstrous nature is hidden beneath a façade of beauty and grace. Because she has been spurned by the King, she decides to be revenged by murdering the woman who has supplanted her in the King's affections.

BODY
Topic Sentence

Her physical appearance belies the ugly, raging emotions that drive her to commit murder. She is petite and delicate, by her own description a "minion" (line 29). Men find her desirable, for they are waiting to dance with her at the court. We get an image of her coquettish nature when she offers the apothecary one of her favors— a kiss on the mouth. She is sure of her charms. No doubt the jewels she offers as payment for the poison are gifts from her admirers.

Supporting Evidence

Topic Sentence	**Underneath this veneer, she is consumed by jealousy, anger, and hatred.** Her overwhelming desire is to destroy the woman who has
Supporting Evidence	"ensnared" the King (line 30). She furiously imagines the two of them laughing at her. She takes pleasure in contemplating her rival's death; she wants her to die hideously and in agony. She entertains fantasies of killing other women, perhaps potential rivals, with poison carried in innocent-looking ornaments. Although the apothecary looks "morose" (line 41), she is lighthearted. She feels no remorse about her crime or pity for her intended victim. Her sole concern is whether the poison will be effective.
Topic Sentence	**She shows great daring in planning and carrying out the murder.** She has no dread of the apothecary shop, which is compared to hell—the "devil's smithy" (line 3). She does not shrink from the sight of the poisons; she calmly ties on a glass mask for protection against
Supporting Evidence	the vapors. She takes an interest in the different poisons and in the apothecary's art. Moreover, she instructs him in changing the color of the poison so that it will make the fatal drink more enticing. She takes care to have the dust brushed from her clothing so that no one will suspect where she has been.
CONCLUSION	Although the events of the poem are set in the *"Ancien Régime,"* the period before the French Revolution, the poem has immediacy and relevance. The corrupt passions of the speaker are not confined to any age but are found throughout history.

Length: 384 words

III

QUESTION	*Some critics argue that the tragic figure in* Antigone *(page 494) is not the heroine for whom the play is named, but Creon. Other critics argue that there are two tragic figures in the play. Are there two tragic figures in the play or only one? If there is only one, who is it? Write an essay stating your opinion.*
DEVELOPING AN ANSWER	This is an exercise in *interpretation*. There is no "right" answer. The effectiveness of your essay will depend on how well you build your case and how much supporting evidence you use. Note that the key term in the assignment is *tragic figure*. You must be clear about how you use this term in your essay.
	Let us suppose that you wish to argue that Creon is the tragic hero of the play. You might arrange your notes under three headings, in the following manner:

Aristotle's Definition of Tragic Figure	Creon as Tragic Figure
Character must be a person of stature.	Creon is foremost figure in Thebes—King.
Character must be neither totally good nor evil.	Creon wishes to preserve peace.
An error in judgment or weakness in character causes misfortune.	Creon suffers from overweening pride and rashness.
Character must be responsible for tragic events.	Creon brings about the deaths of 3 people.
Action involves a change in fortune from happiness to misery.	Creon loses both his son and his wife.
Character undergoes a change.	Creon gains knowledge of his own character.

Creon at Center of Drama

Action focuses on Creon's dilemma, rather than on Antigone's.

She disappears after the fourth scene of the play.

Creon is seen in conflict with Antigone, with Haimon, and with Teiresias.

Whereas Antigone does not undergo a change, there is a significant change in Creon's character.

He understands that his own pride and rashness have been responsible for tragic events.

At end of play, he is a broken figure who longs for death.

WRITING AN ANSWER

Thesis Statement

Creon is the tragic figure in *Antigone. He exemplifies the tragic protagonist defined by Aristotle, and it is he rather than Antigone who is at the center of Sophocles' drama.*

Topic Sentence

If we examine Aristotle's concept of the tragic hero, we see that Creon meets all the criteria of the role. Creon is a person of stature; as King, he is the foremost figure in Thebes. He is neither totally good nor evil. He takes stern measures in order to preserve peace in

Supporting Evidence

Thebes. He brings about the tragic events in the play through his own pride and rashness. His own downfall involves a change from relative happiness to misery. Finally, through suffering, he gains insight into his own character.

Topic Sentence

The action of the play focuses on Creon's dilemma rather than on Antigone's. She disappears after the fourth scene of the play. Creon, on the other hand, is dominant throughout the play. He is

Supporting Evidence

seen in conflict with Antigone, with Haimon, and with Teiresias. Whereas Antigone undergoes no change, there is a significant change in Creon's character. He comes to understand that his own pride and rashness have been responsible for the tragic deaths of three people. At the end of the play, he is a broken figure who longs for death.

CONCLUSION Despite Antigone's central role in the play, it is Creon who is the true focus of the drama and who most embodies the characteristics of Aristotle's tragic hero.

Length: 239 words

Writing on a Topic of Your Own

Prewriting: Choosing a Topic

At times you may be asked to write an essay on a topic of your own choosing. Often it will be necessary to read a work or group of works more than once before a suitable topic presents itself.

Although any literary subject that interests you is usually acceptable as a topic for study, it is a good idea to steer away from broad subjects that invite generalizations and sweeping statements. You may be interested in the attitude toward women in the Arthurian legend, but in a 350–500 word essay, you would be forced to cover the subject too superficially to demonstrate any real mastery of the material. It might be better to restrict yourself to one tale, such as "The Tale of Sir Gareth."

What the writer must often do is to limit a broad subject to a narrow topic—one that can be discussed in the time and space available. You might have to divide a subject into several parts and select only one part as the focus of your essay.

Students sometimes worry that if they choose a narrow topic, they won't have enough to say. This will seldom present a problem if you have developed the habit of digging into a selection and examining it in depth.

A topic may focus on one element or technique in a work. If you are writing about fiction, you might concentrate on some aspect of plot, such as conflict. Or you might concentrate on character, setting, or theme. If you are writing about poetry, you might choose to analyze imagery or figurative language. In writing about drama, you might focus on dramatic irony or stage conventions. A topic may deal with more than one aspect of a work. You might, for example, discuss several elements of a short story in order to show how an idea or theme is developed. Keep the key verbs, such as *analyze, compare, illustrate*, in mind (see pages 884–887) as guides in limiting a topic.

Once you have a topic in mind, your object is to form it into a *thesis*, a controlling idea that represents the conclusion of your findings. This thesis, of course, will appear at the opening of your paper. It may be necessary to read a work several times before you can formulate a thesis. You would then need to present the evidence supporting your position. Here are some examples showing how a thesis differs from a topic:

Topic The Central Conflict in "Chee's Daughter" (page 211)

Thesis The central conflict is a clash between two sets of values—the traditional humanizing values embraced by Chee and the materialistic values adopted by his in-laws.

Topic The Object of the Author's Satire in "Learn with BOOK" (page 266)

Thesis The author's satire is directed against the modern addiction to electronic gadgets and our reliance on jargon.

Topic Tone in "Blue Girls" (page 418)

Thesis The poem opens on a lightly mocking tone in which the poet identifies with the carefree, irreverent attitudes of youth and then shifts to a harsh, bitter tone when he contemplates the ravages of age.

Gathering Evidence/Formulating Major Points

It is a good idea to take notes as you read, even if you do not yet have a topic in mind. Later on, when you have settled on a topic, you can discard any notes that are not relevant. Some people prefer a worksheet, others index cards. In the beginning, you should record all your reactions. A topic may emerge during this early stage.

When you take notes, make an effort to state ideas in your own words. If a specific phrase or line is so important that it deserves to be quoted directly, be sure to enclose the words in quotation marks. When you transfer your notes to your final paper, be sure to copy quotations exactly.

If you cite lines in a poem, you should enclose the line numbers in parentheses following the quotation. The following note, which is for "The Passing of Arthur" (page 798), shows you how to incorporate two lines of a poem into your own text:

Reluctant to cast Excalibur into the lake, Sir Bedivere finds an excuse to disobey Arthur: "Were it well to obey then, if a king demand/An act unprofitable, against himself?" (lines 69–70)

The slash (/) shows the reader where line 69 ends and line 70 begins. If you cite three or more lines, you should separate the quotation from your own text in this way:

> When Bedivere, the last of Arthur's knights, laments that the Round Table is dissolved and that he is now alone, Arthur replies, expressing a belief in the future:
>
>> "The old order changeth, yielding place to new,
>> And God fulfills himself in many ways,
>> Lest one good custom should corrupt the world."
>> (lines 214–216)

When a quotation is separated from your own text, you do not need quotation marks unless the lines cited are dialogue, as in this excerpt from Tennyson's poem.

Sometimes a direct quotation from a literary work can be the springboard to a topic. In "The Life of Caesar," Plutarch says that the "great divine power or genius" that had watched over Caesar remained active even after his death (page 297). You might investigate how Shakespeare's play makes use of this idea. It is perfectly all right to use another person's idea as long as you give credit and acknowledge your source.

Let us suppose that you have just concluded the unit on Poetry in this textbook (pages 359–471). You are instructed to write an essay of approximately 500 words on a topic of your own choice. You realize that you must choose a relatively limited topic if you are to treat it thoroughly.

You haven't any ideas at the outset so you skim through the unit, refreshing your memory of poems studied in class and reading additional poems that interest you. You reread introductions and headnotes, sifting through this material for approaches and ideas. You become aware that two poems in the unit deal with a similar subject: May Swenson's "Ornamental Sketch with Verbs" (page 373) and Emily Dickinson's "She Sweeps with Many-Colored Brooms" (page 392). You wonder whether a comparison of subject matter and technique would help to illuminate both works. You decide to investigate.

You read each poem several times, paraphrasing lines for clarity wherever necessary. You might work out a chart of this kind for recording your notes, letting the letter A stand for "Ornamental Sketch with Verbs" and B stand for "She Sweeps with Many-Colored Brooms":

SUBJECT	Both poems describe the beauty of a sunset.	Setting of A is a city scene.
		Focus is on mundane objects transformed into things rare and beautiful.
	Both unite the commonplace and the sublime.	Setting of B is a New England countryside.
		Focus is on the grandeur of the western sky at sunset.
TECHNIQUE	Both poems are rich in visual images, particularly images of color.	A uses many vivid images; e.g., "gilded stagger," "salamander-red," "brindled light," "golden sled."
		B uses an extended metaphor from domestic life to describe the colors of the sky: e.g., "many-colored brooms," "purple raveling," "amber thread," "duds of emerald."
	Both use diction with suggestive meanings and associations.	A uses words that have romantic or exotic associations: e.g., *salamander, flamingos, urns*.
		B uses common words: e.g., *sweeps, purple*.
TONE	Both poems have a whimsical tone.	In A, there is humor in the incongruity, or contrast, between the object and what it becomes: e.g., pigeons to flamingos, ash cans to urns.
		In B, the comparison of sunset to an absent-minded, untidy housewife who forgets to dust and keeps dropping things is both playful and fantastic.

Organizing Ideas

Before you begin writing, organize your main ideas to provide for an introduction, a body, and a conclusion. The introduction should identify the authors, the works, or the problem that is under study. It should contain a statement of your thesis as well. The body of your paper should present the evidence supporting your thesis. The conclusion should restate or bring together your main ideas briefly.

This is one kind of plan you might use for a short paper. It indicates the main idea of each paragraph.

INTRODUCTION

Paragraph 1 *Thesis* Through the gift of observation and imagination, both poets invest ordinary scenes with magic.

BODY

Paragraph 2 Both poems unite the commonplace and the sublime.

Paragraph 3 Both poems are rich in visual images, particularly images of color. Swenson sees the sunset creating decorative patterns along the street.

Paragraph 4 Like Swenson, Dickinson captures the dramatic splendor of the sunset, but she focuses on the brilliant colors of the sky.

Paragraph 5 Both poets use diction with suggestive meanings and associations.

Paragraph 6 Both poets adopt a whimsical tone toward their subject.

CONCLUSION

Paragraph 7 Although there are differences in the settings chosen by the poets and in their styles, both poems convey a sense of wonder and delight to be found in the simple, everyday beauty of nature.

Writing the Essay

Use your prewriting plan as a guide in writing your paper. Focus on expressing clearly the major points and evidence supporting your thesis statement. Include a topic sentence and supporting sentences in each paragraph. As you write, use language that is appropriate in tone. Include transitional expressions to make clear the relationships among your ideas.

Here is a model essay developing the thesis statement. For an earlier draft of this essay, see pages 901–903.

TITLE

A COMPARISON OF "ORNAMENTAL SKETCH WITH VERBS" AND "SHE SWEEPS WITH MANY-COLORED BROOMS"

INTRODUCTION
Identify works by title and author.

Thesis Statement

May Swenson, in "Ornamental Sketch with Verbs," and Emily Dickinson, in "She Sweeps with Many-Colored Brooms," have taken as their subject the beauty of a sunset. *Through the gift of observation and imagination, both poets invest ordinary scenes with magic.*

BODY

Topic Sentence

Both poems unite the commonplace and the sublime. The setting of Swenson's poem is an ordinary city street. Sunset spilling over the street transforms such common sights as a girl on skates, an iceman, gutters, and sooty roofs into a golden and fabulous scene. The setting of Dickinson's poem is a New England countryside, where the glorious colors of the western sky are compared to precious gems—amber and emerald.

Supporting Evidence

Topic Sentence

Both poems are rich in visual images, particularly images of color. Swenson sees the sunset creating decorative patterns along the street. The street becomes a "gilded stagger" as the light zigzags across it. The golden light covers the walls of buildings with spots of sunlight that look like shiny "salamander-red" scales. The spotted and streaked light falls across the gutter in fine, hairlike lines. It covers the tops of cars and boys' heads with "helmets." The coal truck is ringed with light that looks like a halo. Even the coal sliding down its chute is transformed into "nuggets" racing "from a golden sled." Lampposts are wreathed with light so that they look like "fantastic trees." Ordinary creatures like pigeons and dogs are transformed into exotic flamingos and chows; ash cans become urns; and homely fire escapes are changed to elegant balconies.

Supporting Evidence

Transitional Sentence

Like Swenson, Dickinson captures the dramatic splendor of the sunset, but she focuses on the brilliant colors of the sky. She compares the sunset to a housewife who sweeps the sky with multicolored brooms. As she sweeps, she leaves streaks of color across the sky. She is inefficient and leaves "shreds" of her brooms behind her. She forgets to "dust the pond," and she drops purple and amber threads. She litters the eastern sky with her clothing, "duds of emerald." The clouds become her aprons, which fly as she works. She continues to sweep until the sun settles behind the horizon and the stars come out.

Supporting Evidence

Topic Sentence

Both poets use diction with suggestive meanings and associations. Swenson uses language with romantic or exotic associations. The word *salamander*, for example, calls to mind the mythological creature that lives in fire; *urn* has connotations of elegance and dignity. Dickinson, on the other hand, uses common words with rich connotative meanings. The word *sweeps*, for example, carries with it not only the commonplace meaning of clearing a surface, but that of a flowing, majestic movement. *Purple* is the imperial color used to symbolize royalty.

Supporting Evidence

Topic Sentence

Both poets adopt a whimsical tone toward their subject. The underlying humor in Swenson's poem arises from the incongruity between each object and what it becomes: pigeons to flamingos; ash cans to urns. There is something playful and fantastic also in Dick-

Supporting Evidence

inson's notion of sunset as an absent-minded, untidy housewife who neglects to dust and who litters the sky.

CONCLUSION Although there are differences in the settings chosen by the poets and in their styles, both poems convey a sense of wonder and delight to be found in the simple, everyday beauty of nature.

Length: 534 words

Evaluating and Revising Papers

When you write an essay in class, you have a limited amount of time to plan and develop your essay. Nevertheless, you should save a few minutes to read over your work and make necessary improvements. When an essay is assigned as homework, you have more time to prepare it carefully. Get into the habit of evaluating and revising your work. A first draft of an essay should be treated as a rough copy of your manuscript. Chances are that thinking about and reworking your first draft will result in a clearer and stronger paper.

To evaluate an essay, you judge its content, organization, and style by applying a set of criteria, or standards. Your goal in evaluating is to identify the strengths and weaknesses of the paper. Knowing this, you will be able to make the changes that will improve the essay. To evaluate an essay about literature, ask yourself the following questions:

Guidelines for Evaluating an Essay

Introduction
1. Have I included an introduction that identifies the subject of the paper? Have I identified the author(s) and literary work(s) the paper will deal with?

Thesis Statement
2. Have I included a thesis statement that clearly expresses the controlling idea for the paper?

Thesis Development
3. Have I included convincing main points that develop the thesis in the body of the paper?
4. Have I included sufficient evidence from the work to support each main point?

Conclusion
5. Have I included a conclusion that synthesizes the main ideas or that suggests additional ideas for study?

Coherence
6. Have I arranged ideas logically and related them clearly to one another?

Style
7. Have I varied sentence beginnings and sentence structure? Have I defined any unfamiliar words or unusual terms? Have I used vivid and specific words?

Tone
8. Have I used language that is appropriate for my purpose and audience?

Having identified the strengths and weaknesses of your essay, you can then revise it. Writers usually revise by using any one of four basic techniques: *adding, cutting, reordering,* and *replacing.* For example, if the relationship of ideas is unclear, you can *add* transitional expressions (such as *first, finally,* and *by contrast*). If your language is not appropriate, you can *replace* slang, contractions, and informal expressions with more formal language. You can *cut* unrelated evidence, and you can *reorder,* or rearrange, ideas that are difficult to follow.

On the following pages you will find a revised draft of the essay that appears on pages 898–900. The annotations in the margins indicate which revising techniques were used to make the changes. Compare the two versions of this paper, noting where the writer has made vague or general statements more specific, clear, and concise.

cut	~~The beauty of nature is a popular subject with poets.~~ Two poems that deal
cut; replace	~~with the beauty of a sunset~~ are May Swenson's "Ornamental Sketch with Verbs",
replace; add	and Emily Dickinson's "She Sweeps with Many-Colored Brooms" *have taken as their subject the beauty of a sunset.* Through the
	gift of observation and imagination, both poets invest ordinary scenes with
	magic.
add	Both poems unite the commonplace and the sublime. *The setting of* Swenson's poem ~~uses~~ *is*
replace; replace	an ordinary city setting, ~~where we see~~ *street. Sunset spilling over the street transforms such common sights as* a girl on skates, an iceman, gutters, and
cut; add; add	sooty roofs. ~~The street is transformed~~ *golden and* into a fabulous scene ~~by the sunset.~~ *The setting of*
replace; add; add	Dickinson ~~uses~~ *'s poem is* a New England countryside, where the *glorious western* colors of the sky are
	compared to precious gems—amber and emerald.
cut	~~Both poems are rich in visual images, particularly images of color.~~ In
replace; replace	Swenson's ~~poem~~ *sees* the sunset ~~creates~~ *creating* decorative patterns along the street. ~~It~~ *The street*

The golden light covers ... *with spots of sunlight that*

add; add becomes a "gilded stagger" as the light zigzags across it. ∧ The walls of buildings ∧

spotted and streaked

add look like shiny "salamander-red" scales. The ∧ light falls across the gutter in fine,

hairlike lines. It covers the tops of cars and boys' heads with "helmets."

exotic

reorder; add Ordinary creatures like pigeons and dogs are transformed into ∧ flamingos

homely

add and chows; ash cans become urns; and ∧ fire escapes are changed to elegant

is ringed with light that ... *sliding down its chute*

add; cut; add balconies.) The coal truck ∧ looks like ~~it has~~ a halo. Even the coal ∧ is transformed

are wreathed with light so that they

cut; add into "nuggets" racing "from a golden sled." The lampposts ∧ look like "fantastic"

trees." ∧

Like Swenson, Dickinson captures the dramatic splendor of the sunset, but

she focuses on the brilliant colors of the sky. She compares the sunset to a

who sweeps the sky with multi-colored brooms.

add housewife ∧ As she sweeps, she leaves streaks of color across the sky. She is

She forgets to "dust the pond," and she drops purple and amber threads.

add inefficient and leaves "shreds" of her brooms behind her. ∧ She litters the eastern

her clothing

add sky with ∧ "duds of emerald." The clouds become her aprons, which fly as she

works. She continues to sweep until the sun settles behind the horizon and the

stars come out.

Both poets use diction with suggestive meanings and associations.

Swenson uses language with romantic or exotic associations. The word

for ... *calls to mind the*

replace; replace salamander ~~is one example.~~ ~~A salamander is a~~ mythological creature that lives

cut; replace; add

reorder; cut; replace; cut

cut; add; replace

has connotations of elegance and dignity. *on the other hand,*

in fire, ~~The word~~ urn ~~is another example.~~ Dickinson uses (words) that are

common *with* ~~but that have~~ rich connotative meanings. ~~One example is~~ the word *for example, carries with it not only the*

sweeps. ~~It has a~~ commonplace meaning *of* clearing a surface, ~~It also stands~~ *but that of* for a

flowing, majestic movement. Purple is the imperial color used to symbolize

royalty.

cut

replace; add; cut

cut

reorder; add; add; add; cut

add

Both poets adopt a whimsical tone toward their subject. ~~There is~~

The underlying humor in Swenson's poem arises from the

incongruity between each object and what it becomes, *:* ~~in Swenson's poem:~~ pigeons

to flamingos; ash cans to urns, ~~resulting in an underlying humor.~~ (Dickinson's)

There is something also of

(notion) is playful and fantastic, in ~~that~~ sunset ~~is treated~~ as an absent-minded,

who

untidy housewife who neglects to dust and litters the sky.

Although there are differences in the settings chosen by the poets and in

their styles, both poems convey a sense of wonder and delight to be found in the

simple, everyday beauty of nature.

Proofreading and Publishing

After you have revised your draft, proofread your essay to locate and correct any errors in grammar, usage, and mechanics. Pay particular attention to the correct capitalization and punctuation of any direct quotations you cite as evidence. Then prepare a final version of your essay by following correct manuscript form or your teacher's instructions for the assignment. After writing this clean copy, proofread once more to catch any errors or omissions made in copying. Share your essay with others.

Literary Terms AND Techniques

ALLITERATION *The repetition of consonant sounds in a group of words close together.* Most often, alliteration comes at the beginning of words, although it can appear in the middle and at the end of words as well.

One important function of alliteration is to give special emphasis to the words alliterated. Our ear hears them as having special value. This is one reason why advertising jingles use alliteration frequently. Advertisers and politicians have discovered that alliteration helps people remember what they have said. Abraham Lincoln once alliterated the beginning, middle, and end of two words: "Among free men there can be no successful appeal from the ballot to the bullet."

Alliteration is most commonly used in poetry. An example of a heavily alliterated passage is this, from Ted Hughes's "The Lake":

Snuffles at my feet for what I might drop or kick up,
Sucks and slobbers the stones, snorts through its lips

See **Assonance, Onomatopoeia.**
See also pages 314, 413, 420.

ALLUSION *A reference to a work of literature or to a well-known historical event, person, or place.* The purpose of an allusion is to give us a fuller understanding of one thing by helping us to see it in comparison with something else we may know better.

Allusions to the Bible and to the works of Shakespeare are common because so many people have had exposure to both. Allusions to famous people and historical events are also common.

In older literature, allusion to Greek and Roman deities is common because classical literature was once basic to everyone's education. Apollo, when alluded to, implies the values of moderation, reason, and the arts. Dionysos implies passion and abandon, since he was associated with the use of wine. Aphrodite implies beauty, while her son, Eros, suggests love.

An allusion to the Ark would suggest the story of Noah and the Flood in the Bible. An allusion to Cain would suggest murder, since, according to Genesis, Cain was the first person to take another's life. An allusion to Jonah would suggest God's trial of Jonah, who was swallowed by a whale but restored to the world of the living. In his poem "A Black Man Talks of Reaping," Arna Bontemps alludes to a statement in the Bible that people reap what they sow, or get back what they put into something—or, at least they ought to.

Historical events yield many sources of allusions. "Crossing the Rubicon," for example, refers to Julius Caesar's decision to defy Pompey by crossing the river that was to have been the limit of his territory. When he declared defiantly, but triumphantly, *"Veni. Vidi. Vici.,"* Caesar gave us another source of allusion—his statement "I came. I saw. I conquered."

See pages 228, 399.

ANACHRONISM *An event or a detail that is chronologically out of its proper time in history.* Anachronism comes from a Greek word meaning "out of time." If a character in an ancient Greek tragedy were shown driving off in a car, that would be an anachronism. Obviously, there were no cars in ancient Greece. Sometimes an anachronism is unintentional, with no particular effect, as when the clock strikes in William Shakespeare's play *Julius Caesar.* (There were, of course, no striking clocks in ancient Rome.)

See pages 538, 763.

ANALOGY *A comparison of two things, stressing their similarities.* Often analogies are used in arguments to convince someone of a point, but analogies are used in other types of writing and speaking as well. Emily Dickinson uses an analogy in her famous poem called "I Never Saw a Moor." She says that just as she believes in moors and the sea, though she has never seen them, so does she also believe in God and Heaven.

ANTAGONIST *A person or force that opposes the protagonist in a story or drama; an enemy of the hero or*

904 LITERARY TERMS AND TECHNIQUES

heroine. *Antagonist* comes from a Greek word meaning "to struggle against." Famous antagonists in literature include the evil Professor Moriarty, in Arthur Conan Doyle's stories about Sherlock Holmes; and the great white whale, Captain Ahab's antagonist in Herman Melville's novel *Moby-Dick*.

See **Protagonist.**
See also page 637.

ARGUMENT *A kind of speaking or writing which uses reason to try to change the way people think.* The most famous arguments in literature are the carefully reasoned arguments of the philosopher Socrates. We usually think of good argument as being like Socrates' discourses: he advanced from point to point according to logical principles of reasoning, in order to convince someone of the truth of a certain point of view. The word *argument* is also used for a summary that precedes a novel, a long poem or a lengthy chapter in a literary work.

ARTISTIC LICENSE *Freedom to depart from known facts to create a story.* By the use of artistic license, a writer treating a historical person or event can change details to suit the purposes of his or her own work of literature. In their play *The Diary of Anne Frank*, dramatists Frances Goodrich and Albert Hackett use artistic license when they have Anne write an entry in her diary describing how the Nazis stormed her hiding place. In actual fact, the diary ends on August 1, and the Nazis arrived on August 4. There is no entry in Anne's diary recording the tragic events of August 4.

ASIDE *A dramatic convention in which a character turns "aside" to speak a few words directly to the audience or to another character, but is not supposed to be heard by others on the stage.* An aside allows the character to reveal plans or feelings unknown to others on the stage, or to make secret comments about other characters. For instance, in William Shakespeare's play *Othello*, the villain, Iago, has been working on a plan to ruin Othello. When Iago delivers the following speech, his plans are close to being realized, as he reminds the audience in an aside:

Emilia, run you to the citadel,
And tell my lord and lady what hath happed!
Will you go on? I pray. [*Aside*] This is the night
That either makes me or fordoes me quite.

See **Monologue, Soliloquy.**
See also page 541.

ASSONANCE *The repetition of vowel sounds in a group of words close together.* Assonance is used most frequently in poetry, both within a single line or within a group of lines.

Assonance differs from full rhyme in that in assonance only the vowels repeat; in full rhyme, the vowels and consonants repeat. *Find* and *mind* are an example of full rhymes, but *find* and *hive*, because of their repeated "i" sound, are an example of assonance. Another example of assonance appears in this line from Edgar Allan Poe's poem "The Bells," where the "o" sound is repeated three times:

From the molten golden notes

See **Alliteration, Onomatopoeia.**
See also pages 413, 420.

ATMOSPHERE *The general mood or feeling established in a work of literature.* Atmosphere is usually produced by careful **description.** Landscapes, especially places like dark, dank moors, are effective in producing atmosphere.

See pages 97, 126.

AUTOBIOGRAPHY *Someone's account of his or her own life.* Generally, an autobiography is a narrative account, often chronological, of the important events of a person's life. Such accounts often relate the person's life story to crucial historical events that are happening at the same time. They also offer personal evaluation of actions, as well as some speculation on the significance of certain actions and events. People in the public eye frequently offer autobiographies as a way of setting the record straight as they see it. Benjamin Franklin's *Autobiography* and Winston Churchill's *My Early Life* are two classic autobiographies.

See **Biography.**
See also page 276.

BALLAD *A narrative poem that depends on regular verse patterns and strong rhymes for its effect.* **Folk ballads,** such as "Johnny Armstrong," originate as anonymous songs and are passed on orally before being written down. The so-called **literary ballad** is composed by a known writer, and it may or may not be sung. John Keats's "La Belle Dame sans Merci" is an example of a literary ballad. Most ballads have lots of action and adventure, and most

are tragic. Desperadoes, such as Jesse James or Billy the Kid, are favorite ballad subjects.

See pages 442, 445.

BIOGRAPHY *An account of someone's life, written by another person.* Most libraries have an entire section devoted to biography because it is among the most popular forms of nonfiction. The biographical portrait of Peter the Great by Robert K. Massie shows that the art of writing biography is anything but matter-of-fact. A history book might state that Peter the Great instituted change in seventeenth-century Russia. Massie says that at a banquet "Peter was there to box the ears of any who showed reluctance" about being relieved of his beard.

See **Autobiography.**
See also pages 276, 283.

BLANK VERSE *Verse written in unrhymed iambic pentameter—that is, with each line usually containing five iambs, which consist of an unstressed syllable followed by a stressed syllable (˘ ′).* The word *blank* means that the verse is not rhymed. The blank-verse line has become the great line for epic and dramatic poetry in English, perhaps because the English language seems to be strongly iambic. William Shakespeare's plays and John Milton's epics are written in blank verse. Usually a line of blank verse has exactly ten syllables; it almost always has five strong stresses.

When the Queen in William Shakespeare's play *Hamlet* describes the drowning of Ophelia, she uses blank verse:

> When down her weedy trophies and herself
> Fell in the weeping brook. Her clothes spread wide,
> And mermaid-like awhile they bore her up

Modern poets—notably Robert Frost—also use the blank-verse line. Because it has no rhyme, blank verse seems very natural, but with the underlying iambic meter ever present, it also has a tightness and dependability.

See **Iambic Pentameter, Meter.**
See also pages 430, 639.

CATASTROPHE *The conclusion of a tragic drama or story, following the period of falling action.* At the point of catastrophe, the conflicts have been resolved, with disastrous consequences for the tragic hero or heroine, and possibly for others as well. Thus, the catastrophe of William Shakespeare's play *Julius Caesar* occurs when Brutus kills himself. At this point, all the conspirators are dead, the inevitable result of the machinations and decisions made throughout the body of the play.

See page 606.

CATHARSIS *In tragedy, the release of strong emotions in the audience.* The word comes from a Greek word meaning "cleanse." The philosopher Aristotle felt that it was good for people to watch a noble figure fall from power for daring to test fate or the gods. Tragedies were supposed to make people feel pity for the fallen hero or heroine, and terror that such things could happen. Aristotle felt that such tragedies would "cleanse" members of the audience of their own urges to rebel against fate or the gods, as the tragic figure did. Such catharsis, then, would improve the stability of society.

See page 533.

CHARACTERIZATION *The methods used to present the personality of a character in a work of literature.* A writer can develop a character in many ways: by showing the character's actions and speech, by giving a physical description of the character, by revealing the character's thoughts, by revealing what others think about the character, and by commenting directly on the character. Any or all of these methods may be used in a given characterization.

Characterization may be *direct* or *indirect*. In **direct characterization**, the writer tells us explicitly what kind of person the character is. If the character is a disgusting person with disagreeable habits and a past record of mischief making, we will be told. In **indirect characterization**, the writer makes us figure out the character for ourselves. We are allowed to see the character in action, to hear the character speak, and to hear others talk about him or her, but we have to use our own minds to generalize about the *kind* of person we are reading about—whether good, bad, trustworthy, sneaky, cruel, and so on. Most writers use both direct and indirect methods of characterization.

See **Characters.**
See also pages 47, 73, 90, 562, 818.

CHARACTERS *Persons—or animals or natural forces represented as persons—in a work of literature.* Characters may be classified in several ways. For instance, they may be called **static** or **dynamic**, depending on whether they stay the same throughout a work (static) or undergo a change in personality or attitude (dynamic). Leiningen, the plantation owner in Carl Stephenson's story "Leiningen Versus the Ants," is a static character. Though he has great adventures, he does not undergo any change in attitude or in personality in the story. On the other hand, Jerry in Doris Lessing's "Through the Tunnel" is a dynamic character. By reaching his difficult goal of swimming through the underwater tunnel, he attains greater maturity and independence.

Characters may also be classified as **flat** or **round**. *Flat* characters are merely sketched out for us and are not fully developed; they are called "flat" because they have only one dimension, or "side." Like Old Man Fat in Platero and Miller's story "Chee's Daughter," a flat character may be a **stereotype**, with one recognizable personality trait. *Round* characters are more fully developed; we see many sides of their personality and we come to appreciate their complexity, as if they were actual persons. For example, because we see many sides of the father in Woiwode's story "The Beginning of Grief," we recognize him as a fully developed, complex individual.

See **Characterization**.
See also pages 47, 82, 95, 96.

CLIMAX *The moment of highest emotional intensity in a plot, when the outcome of the conflict is finally made clear to us.* While the term may refer to any of several moments of intensity, it usually refers to the climax of the main conflict. The climax of William Shakespeare's play *Julius Caesar* takes place in the last act, when we watch the noble Brutus die.

In Jack Finney's story "Contents of the Dead Man's Pockets," the climax occurs four paragraphs from the end, when the man has succeeded in inching his way along the ledge of the building to the point where he can shoot his arm forward and break the glass of his apartment window. It is at this very suspenseful and tense moment that we know for certain that the man has won his conflict and that he will *not* plunge to his death in the street below.

See **Plot**.
See also pages 28, 818.

COMEDY *A literary work, generally amusing, which usually ends happily because the hero or heroine is able to overcome obstacles and get what he or she wants.* Though comedy and tragedy are often associated with drama, both terms can also apply to novels and short stories.

Comedy is distinct from **tragedy** in that the comic characters normally find a satisfactory resolution of their difficulties. The focus of most comedies is not on a single figure, as is the case with tragedies, but a group of figures, placed in a recognizable society. Very frequently, a comedy will have several plots, each with a group of central characters. Part of the humor comes from seeing how these plots interact.

Comedy often seeks to poke fun at the social customs and "rules" held by some of the characters—quite often the very same customs and "rules" held by the audience. Such comedies often include a young couple (or several) who defy the conventions and "rules," and whose marriage is delayed because of the shortsightedness of their elders. Usually the older adults reform, see the error of their ways, and permit the youngsters to marry. One of the great masters of dramatic comedy, apart from William Shakespeare, is George Bernard Shaw, whose comedies have also been popular as movies and as Broadway musicals.

Modern comedy seems to have developed from the Greek comedies of the fifth and sixth centuries B.C.

See page 478.

CONFLICT *A struggle between two opposing forces in a piece of literature.* Conflict may take many forms, and it may be **external** or **internal**.

1. Conflict may take place between two or more characters, as in Platero and Miller's "Chee's Daughter," in which Chee opposes his father-in-law for custody of his daughter.

2. Conflict may occur between a character and society, as in Kurt Vonnegut's "Harrison Bergeron," in which Harrison challenges the rules of a society which forces everyone to be the same.

3. Conflict may occur between a character and nature, as in Carl Stephenson's "Leiningen Versus the Ants," where the main character struggles against an army of flesh-eating ants.

4. Conflict may take place within a character's own mind, as in Eugenia Collier's "Marigolds," where the narrator, Lizabeth, struggles with her feelings of despair.

Longer narratives may contain several conflicts, which are usually interrelated in some way. William Shakespeare's play *Julius Caesar* includes the following conflicts: a conflict within Brutus about whether to take action against Caesar or not; a conflict between the ruler, Caesar, and the conspirators; and a conflict between the conspirators and Antony for the rule of Rome. All these conflicts are resolved by the last scene of the play, when each form of disorder, within and between characters and groups, is resolved into order.

It is the staging of conflict, and its resolution or lack of resolution, that often provides the impetus behind a work of literature.

See **Plot.**
See also pages 11, 28, 605, 818.

CONNOTATION *The suggested meanings of a word or phrase; the meanings and feelings that have become associated with the word, in addition to its explicit meaning.* The dictionary explicitly defines *rat*, for example, as a long-tailed rodent. But the connotations of the word *rat* go beyond this literal meaning; the word suggests dirt, disease, and danger. When applied to a person, the word *rat* suggests someone untrustworthy, dangerous, and unable to keep a secret. The word *autumn* is defined explicitly as the season that comes between summer and winter. But *autumn* suggests more than this: it suggests the beginning of decay, the end of youth, the death of the year. Advertisers are very sensitive to the connotations of words. In advertising an apartment, for example, the owner would probably not call the rooms "small," but would describe them as "cozy," a word with pleasant connotations.

See **Denotation.**
See also pages 126, 374, 448.

CONVENTIONS *Certain practices or methods that are accepted by a reader or an audience even though they are not realistic.* For example, one of the conventions of the Elizabethan theater was the use of verse in speech, something that is no longer a convention in drama today.

See pages 445, 541.

COUPLET *A pair of successive rhymed lines of poetry.* The following poem is written in couplets:

A Recollection
Frances Cornford

My father's friend came once to tea.
He laughed and talked. He spoke to me.
But in another week they said
That friendly pink-faced man was dead.

"How sad . . ." they said, "the best of men . . ."
So I said too, "How sad"; but then
Deep in my heart I thought, with pride,
"I know a person who has died."

Couplets usually emphasize a completed thought. The rhyme establishes a tight sense of closure. This is particularly true in the **Shakespearean sonnet,** as in this final couplet from Sonnet 73:

This thou perceivest, which makes thy love more strong,
To love that well which thou must leave ere long.

See pages 415, 437.

DENOTATION *The explicit meaning of a word, as listed in a dictionary.* We distinguish denotation as a special quality because many writers also use the **connotations** of words to intensify meaning. Connotation differs from denotation in that connotation depends on associated or related meanings in addition to, or in place of, the strict, explicit definition of a word. The word *informer*, for example, has a denotation of one who gives information. However, its connotation is that of a person who sells out friends and is a kind of traitor.

See **Connotation.**
See also pages 126, 374, 448.

DESCRIPTION *A kind of writing that uses sensory details to re-create a person, a place, a thing, or an event.* Description usually tells how something looks, but it might also describe how it sounds, tastes, smells, or feels to the touch. The details in some descriptive passages work together to produce a strong impression: perhaps of evil or innocence, or of horror, danger, comfort. The details in a descriptive passage are often arranged in some logical sequence, chronological, spatial, or some other order.

See page 97.

DIALECT *Speech that is flavored by the usages of particular regional, social, or cultural groups.* Formal writing usually uses a variant of English known as standard English. Most people, however, speak an English which is characteristic of their region or their associations. Mark Twain, for example, represented the diction and the pronunciation of the Mississippi Valley in *Adventures of Huckleberry Finn* and other writings.

See pages 151, 463, 794.

DIALOGUE *Conversation or speech among two or more characters.* Plays are usually constructed entirely out of dialogue.

The use of dialogue is especially prominent in modern fiction, perhaps because it makes a story seem more natural and fast-moving. Modern writers use dialogue to reveal character, to establish the conflict, to build suspense, and to move the action forward.

See page 200.

DICTION *A writer's choice of words.* One of the prime ingredients of a writer's style is *words.* The French master of the novel, Gustave Flaubert, often struggled for half a day trying to get *"le mot juste"*: the precisely correct word for what he wanted to say.

An old song uses two forms of diction to show what a difference words make:

Show me the way to go home,
I'm tired and I want to go to bed . . .

Indicate the way to my habitual abode,
I'm fatigued and I want to retire . . .

Writers use an informal diction to produce a natural-sounding easiness, as contemporary poet Mari Evans does in these opening lines from "When in Rome":

Mattie dear
the box is full . . .
take
whatever you like
to eat . . .

Phillis Wheatley, on the other hand, writing in the eighteenth century, used formal diction to produce a more "literary" effect, as in these lines from her poem written to the Earl of Dartmouth:

Should you, my lord, while you pursue my song
Wonder from whence my love of Freedom
sprung,
Whence flow these wishes for the common good,
By feeling hearts alone best understood,
I, young in life, by seeming cruel fate
Was snatch'd from Afric's fancied happy seat

See pages 367, 372, 875.

DRAMA *A story written to be acted out on a stage.* The playwright usually emphasizes character, conflict, and action, which are developed by the use of dialogue. Stage directions are provided to help the actors and the director bring the characters and the action to life. When the play is presented, additional elements—such as the set, props, and lighting effects—are used to enhance the emotional impact of the story. Thus, drama is truly a living form of literature; the same drama can take on new shape and nuance each time it is represented on the stage by different actors, under different direction.

See **Comedy, Tragedy.**
See also page 474.

DRAMATIC IRONY *A device which allows an audience or a reader to know something that a character in a drama or story is unaware of.* When we understand something that a character does not yet know, we are drawn into the play or story, and we usually feel a heightened sense of suspense, anxiety, or secret pleasure.

One of the most famous examples of extended dramatic irony occurs in Sophocles' play *Oedipus the King.* Throughout the play, Oedipus tries to discover the murderer of the previous king, threatening to destroy the murderer once he is found. But it is Oedipus himself who has killed the king, though he does not know it. Ironically, every time he speaks in condemnation of the murderer, Oedipus is condemning himself.

In the third act of William Shakespeare's *Julius Caesar*, Decius finally convinces Caesar to accompany him to the Senate House to be crowned. We feel the dramatic irony here very sharply because *we* know that the conspirators are actually planning to execute him.

See **Irony.**
See also pages 159, 320, 606.

DRAMATIC POETRY *Poetry in which one or more characters speak.* Dramatic poetry allows the writer to reveal character directly through dialogue, just as a playwright does. For example, Robert Frost's poem "Death of the Hired Man" is written mainly as a conversation between a husband and wife. The dialogue reveals their personalities, their differences of opinion, and the plight and life story of the hired man who has worked for them over the years and has come home to die. John Keats's poem "La Belle Dame sans Merci" is a dramatic poem, written as a conversation between a traveler and sickly knight encountered on the roadside.

One type of dramatic poem is the **dramatic monologue,** in which only one character speaks; the listener's replies are suggested but not quoted. Robert Browning is the most famous writer of dramatic monologues. His poem "The Laboratory" is spoken by a jealous woman. The entire poem consists of her speech to a chemist as he mixes a deadly poison which she plans to use on her rival.

See page 455.

ELEGY *A lyric poem which expresses mourning, usually over the death of an individual.* An elegy may also be a lament over the passing of life and beauty, or a meditation on the nature of death. An elegy is usually formal in language and structure, and solemn or even melancholy in tone. Most elegies are long. Famous elegies in our language include Thomas Gray's 128-line "Elegy Written in a Country Churchyard" and Walt Whitman's "When Lilacs Last in the Dooryard Bloom'd," a 16-part elegy mourning the assassination of President Lincoln.

See page 466.

EPIC *A long narrative poem that usually centers on a single important character who embodies the values of a particular society.* The term is often misused to mean anything huge in scope. However, the literary meaning of **epic** implies a heroic character, an action of great importance, and a range of adventures that often span hell (or the underworld), earth, and heaven (or the upper world of the gods). Some of the oldest known stories are told in epic form.

See page 442.

EPITHET *An adjective phrase used to set apart, describe, and characterize a person, place, or thing.* Some of the most well-known epithets are from literature: "wine-dark sea," "ox-eyed Hera," "rosy-fingered Dawn." All of these are from Homer's *Odyssey.* But many popular expressions, such as "Catherine the Great" or "America the Beautiful," are also useful epithets.

ESSAY *A brief examination of a subject in prose, usually expressing a personal or limited view of the topic.* The essay is a modern literary form, probably dating back to Michel de Montaigne's *Essais,* written in the sixteenth century. Along with Francis Bacon in the seventeenth century and Ralph Waldo Emerson in the nineteenth century, Montaigne gave us an approach that has remained standard for years. It is an approach that takes a single subject, such as "Friendship," "Style," or "Duty," and examines it from a personal point of view.

We expect that modern essays will reveal almost as much about the writer as about the subject. This is one of the qualities that helps keep the essay distinct from journalism and from the kinds of reports that scholars and scientists prepare from their research.

See pages 238, 354.

EXAGGERATION *Saying more than what is literally true, usually for humor or for emphasis.* Other terms for exaggeration are **overstatement** and **hyperbole.** We use exaggeration all the time in everyday conversation: "I'm so hungry I could eat a bear." "She hit the ball a mile." "It's raining cats and dogs." Exaggeration is a stock device used by humorists. Mark Twain uses exaggeration often, as in this statement from "A Genuine Mexican Plug":

. . . but the first dash the creature made was over a pile of telegraph poles half as high as a church . . . when the Speaker got to the Capitol he said he had been in the air so much he felt as if he had made the trip on a comet.

Twain is describing a ride on a horse.

See **Hyperbole.**

EXPOSITION *The kind of writing that explains a subject or provides information.* The most familiar form of exposition is probably the informative magazine article, or the news account in the daily papers. The parts of Harry Crews's essay called "The Hawk Is Flying" in which he explains the process of hooding a hawk are exposition. R. J. Heathorn's entire essay

"Learn with BOOK" is expository: it explains how this imaginary new product, BOOK, works. Other examples of exposition include the introductions to parts of this book.

In drama and novels and some short stories, exposition is the part of the **plot** that provides information about setting and about what has happened to the characters before the story starts. A remarkable use of exposition is made in William Shakespeare's play *The Tempest.* Just after the play opens, we are on an island, and Prospero starts to explain to his daughter Miranda (and to the audience) how they came to be living on this empty island. Prospero's exposition is so long and clumsy that Miranda begins to doze. Shakespeare, in providing this traditional bit of exposition, is having some fun with his audience and himself. A skillful writer manages to work background information into the dialogue without interrupting the action of the play or making the exposition obvious.

See pages 248, 259, 354, 606.

FABLE *A very brief story told to teach a moral or lesson.* Often the characters in fables are animals who speak and act like humans. The best-known fables are those of Aesop, who may have been a slave in Greece, living around 600 B.C. Aesop's shrewd, satirical fables are still told today. "Belling the Cat" is one of his most famous:

The mice gathered to solve the problem of the cat who was making their lives miserable. All the mice agreed that the best solution was to place a noisy bell around the cat's neck, so that they could hear its approach and run away. Then came the terrible problem: Who would volunteer to put the bell on the cat? The moral is "It is easy to propose impossible remedies."

The seventeenth-century writer Jean de La Fontaine also wrote fables, including the favorite called "The Fox and the Grapes."

The American humorist James Thurber's fables continue in the Aesop tradition. His *Fables for Our Time* use barbed wit to puncture our modern pretensions.

FALLING ACTION *All the action in a play that follows the turning point.* In William Shakespeare's *Julius Caesar,* the **turning point** takes place in Act Three,

when Antony delivers his emotional speech persuading the populace to see Caesar as a martyr and the conspirators as their enemies. The people do believe Antony, and from this moment Brutus and the other conspirators are doomed. From here on, the action is called "falling action" because it is falling toward a **catastrophe**, the deaths of the conspirators that take place in Act Five. The terms "rising" and "falling" action make us see the plot of tragic plays as being something like a pyramid: the rising action leads toward a peak, or turning point; the falling action takes place after this, and leads down toward a catastrophe (usually death) for the tragic hero.

See **Rising Action.**
See also page 606.

FARCE *A type of comic play in which ridiculous situations and characters, coarse wit, and physical buffoonery are used to make us laugh.* The American movies starring Abbott and Costello, Laurel and Hardy, and the Three Stooges are farces. Farce is used all the time in popular television comedies—such as when characters walk into doors, slip on banana peels, or hide under beds or in closets.

Serious plays, even tragedies, often use farcical elements for comic relief. William Shakespeare, who had a genius for farce, often puts his commoners into hilarious farcical situations. These scenes contrast with the more serious problems that his noble characters find themselves faced with. See the conversation of the workmen that opens his play *Julius Caesar.*

See page 481.

FICTION *Any work of literature that includes material that is invented or imagined, that is not a record of things as they actually happened.* In literature, the term *fiction* usually refers to the **novel** or the **short story.** Much fiction is based on actual personal experience, but it almost always involves invented characters, or invented actions or settings, or other details which are made up for the sake of the story itself.

In *The House of the Seven Gables,* Nathaniel Hawthorne uses a real setting, that of a house in Salem, Massachusetts. He also mentions some historical incidents, such as the Salem witch trials. But the main characters and events of his novel are fictional, created for the sake of developing the novel's themes.

John Steinbeck's novel *The Pearl* is set in an actual place, and it is based on a true story. Steinbeck, however, simply uses this true account and the actual setting as the springboard for a novel that is obviously fictional.

FIGURATIVE LANGUAGE *Language that is used to describe one thing in terms of something else; language that is not intended to be taken literally.* Figurative language depends upon a comparison made between two or more things that are basically unlike.

Figurative language is used in everyday conversation. For example, we might refer to someone as a "turkey." This is not suggesting that the person gobbles and would make a good meal; it is simply a way of insulting someone because turkeys are not very bright, nor very industrious. To say that someone is a "shrimp" does not mean that the person is an edible sea animal; it simply means, figuratively, that the person is rather small (as a shrimp is, compared with a whale).

Metaphor is the main form of figurative language. Metaphor is an identification of two things that can be directly stated ("My love *is* a red rose"), or that can be implied or suggested ("My love has a rosy bloom"). Neither of these descriptions is meant to be taken literally (no one *is* a rose, nor does anyone bloom and open petals). Each description is figurative.

Simile is another common form of figurative language. A simile is straightforward. It always makes its comparison by using a specific word, such as *like*, *as*, *than*, or an equivalent ("My love is *like* a red rose").

Personification—speaking of an animal or an inanimate thing as if it were human—is a special form of metaphor. When Isabella Gardner in "Summer Remembered" speaks of the "quarreling of oarlocks," she is personifying the oarlocks as people. She is comparing the sounds made by the wooden oars to the noise of human argument.

A **symbol** is something (such as a dove, or a rose, or a journey) that is used to stand for itself and for something more than itself as well (such as peace, or love, or life).

See **Metaphor, Personification, Simile, Symbol.**
See also pages 144, 199, 314, 387.

FIGURE OF SPEECH *Any expression that uses language figuratively, not literally.* **Metaphors, similes, personification,** and **symbols** are all figures of speech.

See **Figurative Language.**

FLASHBACK *A scene in a story or play that interrupts the present action to tell about events that happened at an earlier time.* Most narratives are told in chronological order—that is, the order in which they occur in time. But often a flashback is needed to make the present action more understandable to the reader. Willa Cather uses flashback in her story "Neighbor Rosicky." In Part One Dr. Burleigh recalls a past visit to the Rosicky farm. In Part Three Rosicky thinks back to the conflicts of his youth. These flashbacks provide insight into Rosicky's life and character.

See pages 165, 338.

FOIL *A character (or a place or an event) that is used to contrast with another character (or place or event).* For example, in William Shakespeare's play *Julius Caesar*, the character of Cassius—a scheming and ambitious man—is used as a foil to the character of Brutus—an idealistic and unselfish man. *Foil* is also the word for a metallic material that gives off a reflection (as in *tinfoil*). A character who is a foil to someone else sets the other person off, and brings out his or her particular characteristics.

FORESHADOWING *The use of clues that hint at important plot developments that are to follow in a story or drama.* While foreshadowing is primarily used as a plot device, it may also help in the creation of mood, causing us to feel suspense and anxiety. Charles Dickens is a master of this technique. In his novel *Oliver Twist* he hints many times at the true parentage of Oliver, who is an orphan. Soon after Oliver is born in a workhouse, his mother dies. She never tells anyone who she is or where she comes from. When Mr. Brownlow (who turns out later to be Oliver's grandfather) sees Oliver for the first time, he mutters to himself: "There is something in that boy's face. . . . Where have I seen something like that before?" When Oliver goes to Mr. Brownlow's house and sees the picture of a lady (who turns out later to be Oliver's dead mother), he feels "as if it was alive, and wanted to speak to me, but couldn't." These and other foreshadowings in the

story help to create a mood of suspense and doubt. They intrigue us as readers, so that we anxiously read on to find out whether Oliver will discover his true identity and be rescued from his perilous situation.

See pages 39, 873.

FRAME STORY *A story that contains another story within it or that serves to unify different narratives.* A famous early example of the frame story is Boccaccio's *Decameron*, written in the fourteenth century. In the frame story, ten Florentines who have retreated to a villa to escape the Black Death (probably bubonic plague) pass the time by telling stories. The result is a hundred tales.

FREE VERSE *Poetry that doesn't have a fixed line length, stanza form, rhyme scheme, or meter.* Free verse is an important modern verse technique and has caused some confusion. Older poetry was always written in regular form, with meter and rhyme, and many people still expect poets to follow this tradition. But modern poets, in order to strike out in new directions, often employ free verse to give expression to their own thoughts and to reorganize our expectations. Sometimes free verse relies on the kinds of pauses we hear in conversation, thus giving an easiness to the poetry. Although it does not use fixed rhymes or fixed rhythms, free verse may make use of rhyme and rhythm, as well as other poetic techniques, such as **alliteration, figurative language,** and **onomatopoeia.**

Marge Piercy uses free verse in this short poem, which is about love. Notice how rhythm in the poem is created by the use of repetition.

Simple-Song
Marge Piercy

When we are going toward someone we say
you are just like me
your thoughts are my brothers
word matches word
how easy to be together.

When we are leaving someone we say
how strange you are
we cannot communicate
we can never agree
how hard, hard and weary to be together.

We are not different nor alike
but each strange in his leather body

sealed in skin and reaching out clumsy hands
and loving is an act
that cannot outlive
the open hand
the open eye
the door in the chest standing open.

See pages 425, 433.

HYPERBOLE *A figure of speech that uses exaggeration or overstatement for effect.* In these opening lines from her poem "Notes Written on a Damp Veranda," Phyllis McGinley uses hyperbole to emphasize how often it rains on her vacation.

Do they need any rain
In Portland, Maine?
 Does Texas pray for torrents,
The water supply
Run dry, run dry,
 From the ancient wells of Florence?
Is the vintage grape
In perilous shape
 On the slopes of Burgundy?
Let none despair
At the arid air—
 They've only to send for me,
Invite me to stay for a holiday
 And the rain will follow me.

See **Exaggeration.**
See also pages 440, 462.

IAMBIC PENTAMETER *Five iambs (�‿ ′) in a line of poetry.* An **iamb** is an unaccented syllable followed by an accented syllable (�‿ ′). **Iambic pentameter** is one of the most basic and natural of English verse lines. *Penta-* is the Greek prefix for "five"; *meter* is the Greek for "measure." Most of Shakespeare's plays, all of Milton's *Paradise Lost*, and a great deal of modern poetry is written in iambic pentameter. Anne Bradstreet, the first American poet of note, uses iambic pentameter in her poem "To My Dear and Loving Husband":

Mў lo′ve iŝ su′ch thăt ri′věrš ca′nnŏt que′nch

See **Meter.**
See also pages 425, 430.

IMAGERY *Words or phrases that use description to create pictures, or images, in the reader's mind.* Most images appeal directly to our sense of sight, but

images can also appeal to our senses of sound, taste, smell, or touch.

The purpose of imagery is to help us re-create in our own minds the situation which the writer imagines, so that we can react as we would to the thing or the experience itself.

In these final lines from her poem "Venus Transiens," Amy Lowell describes a beautiful woman in several striking images that appeal to our senses of sight, sound, and touch:

> For me,
> You stand poised
> In the blue and buoyant air,
> Cinctured by bright winds,
> Treading the sunlight.
> And the waves which precede you
> Ripple and stir
> The sands at my feet.

See pages 376, 583, 874.

INVERSION *The reversal of the usual order of words in a sentence.* Emily Dickinson, in the first stanza of her poem "For Each Ecstatic Instant," inverts the normal order of the verb *pay* and of its object *anguish*. This inversion emphasizes the word *anguish*—what the poet feels we must pay for the intense moments we experience:

> For each ecstatic instant
> We must an anguish pay
> In keen and quivering ratio
> To the ecstasy.

Sometimes the inversion is used for technical reasons. Edgar Allan Poe, for instance, in his poem "The Raven," almost certainly inverted words in the following sentence to get a rhyme for the word *nevermore* (which appears in a preceding line):

> But the Raven, sitting lonely on the placid bust, spoke only
> That one word, as if his soul in that one word he did outpour.

See page 372.

IRONY *A contrast or discrepancy between what is stated and what is really meant, or between what is expected to happen and what actually does happen.* Three kinds of irony are (1) **verbal irony**, in which a writer or speaker says one thing and means something en-

tirely different; (2) **dramatic irony,** in which a reader or an audience perceives something that a character in the story or play does not know; and (3) **irony of situation,** in which the writer shows a discrepancy between the expected result of some action or situation and its actual result.

The character Antony in William Shakespeare's play *Julius Caesar* uses **verbal irony** when he keeps repeating in his funeral oration over Caesar's body: "For Brutus is an honorable man." Antony is a political enemy of Brutus and does not think his participation in Caesar's murder was honorable.

Examples of **dramatic irony** are also found throughout *Julius Caesar.* For example, the audience knows from history that Caesar will be murdered by members of the Senate, but Caesar himself does not know this. The audience also hears the conspirators actually planning to murder Caesar, but Caesar himself is ignorant of the plot.

An example of **irony of situation** is found in Maupassant's "The Piece of String." We would expect Hauchecorne to be cleared of all charges after the pocketbook is found by a farmhand and returned to its owner. But the peasants refuse to believe that Hauchecorne is innocent and accuse him of using an accomplice. The irony lies in the fact that the more Hauchecorne protests his innocence, the greater skepticism he creates among the villagers.

See pages 159, 166, 172, 320, 606, 873.

LITERAL LANGUAGE *Language that states facts or ideas directly.* Literal language means exactly what it says; it does not depend on hidden meanings. Literal language is the opposite of **figurative language.** We expect to find literal language used in factual writings, where precision and clarity are important.

LOCAL COLOR *The use of specific details describing the speech, dress, customs, and scenery associated with a particular region or section of a country.* The purpose of local color is to suggest the unique flavor of a specific locale. In the years following the Civil War, stories of local color flourished in the United States. Bret Harte uses the local color of the West in such stories as "The Outcasts of Poker Flat." Mark Twain re-creates the local color of a small town along the Mississippi in his novels *The Adventures of Tom Sawyer*

and *Adventures of Huckleberry Finn.* Sarah Orne Jewett and Mary Wilkins Freeman are known for their stories of New England life. Local colorists are sometimes called *regionalists.*

LYRIC POETRY *Verse, usually brief, which focuses on the emotions or thoughts of the speaker.* Originally, the term **lyric** derived from the fact that in ancient Greece certain poems were recited to the strumming of a lyre—a guitar-like instrument. The musical accompaniment helped intensify the emotional quality of the poem.

It is usual, as in John Crowe Ransom's lyric "Blue Girls," for the lyric poet to express a single or primary emotion, to which we relate as readers. It is also usual, as in Ransom's poem, for the emotion to be implied, rather than stated or named directly.

See **Poetry.**
See also page 461.

METAPHOR *A comparison made between two things which are basically dissimilar, with the intent of giving added meaning to one of them.* Metaphor is one of the most important forms of **figurative language.** Gwendolyn Brooks uses a metaphor in the opening lines of her poem "The Ballad of Rudolph Reed," when she says:

Rudolph Reed was oaken.
His wife was oaken too.

This metaphor compares two people to oak trees. On one level, this metaphor suggests that Rudolph Reed and his wife are dark-skinned. But it suggests much more than this. Rudolph Reed and his wife, the metaphor suggests, also have the solidity and the strength of the oak tree.

Many metaphors are not directly stated but implied, or suggested. An **implied metaphor** does not directly tell us that one thing *is* another different thing. When Walt Whitman exclaims, "Old age superbly rising!" he uses an implied metaphor. The word *rising* implies that he is comparing the onset of age with the rising of the sun. This is a particularly rich metaphor because it reverses our usual notion that age is a decline; according to this metaphor, old age is a new beginning.

Marianne Moore uses implied metaphors in the following poem about an American dancer, director

of the Harlem Dance Theater. Three metaphors basic to this poem are the comparisons of the dancer to a dragon-fly, to a gem, and to a peacock:

Arthur Mitchell
Marianne Moore

Slim dragon-fly
 too rapid for the eye
 to cage.

contagious gem of virtuosity
make visible, mentality.
Your jewels of mobility

reveal
 and veil
 a peacock-tail.

An **extended metaphor** is a metaphor that is extended throughout a poem. In "She Sweeps with Many-Colored Brooms" by Emily Dickinson, the metaphor comparing the sunset to a housewife is extended throughout the entire poem.

A **dead metaphor** is a metaphor which has become so commonplace that it has lost its force, and we forget that it is not literally true. Some examples are the *foot* of a hill, the *head* of the class, and the *eye* of the needle.

A **mixed metaphor** is the use of two or more inconsistent metaphors in one expression. When they are examined, mixed metaphors make no sense. Mixed metaphors are often unintentionally humorous: "To hold the fort, he'd have to shake a leg" or "We're skating on a very gray area."

See **Figurative Language.**
See also pages 29, 199, 387, 388, 391, 393, 622.

METER *The regular pattern of rhythm—that is, of stressed and unstressed syllables in a line of verse.* Most poetry respects the normal stress that words ordinarily have. For example, we know that the accent should fall on the second syllable of *indeed.* This is the way most English-speaking people pronounce the word. In a line of poetry, the word would also be sounded to respect this pronunciation.

In metrical analysis the sign (�‿) means the syllable is unstressed. The sign (′) means the syllable receives stress. The sign (‖) is used to separate metrical feet. A **metrical foot** usually consists of one stressed syllable and one or more unstressed syllables. Some

of the principal metrical feet in English (with their adjectival forms in parentheses) are the following:

Iamb (iambic): ˘ ´ as in indéed.

Trochee (trochaic): ´ ˘ as in hárkĕn.

Anapest (anapestic): ˘ ˘ ´ as in comprĕhénd.

Dactyl (dactylic): ´ ˘ ˘ as in fávŏrĭtĕ.

Spondee (spondaic): ´ ´ as in úpsét.

Iambic pentameter is one of the basic meters in English. Verse in iambic pentameter has five feet (*penta-* is the Greek prefix for "five"), most of which are iambs (˘ ´). The following line from "On Hearing a Symphony of Beethoven" by Edna St. Vincent Millay uses absolutely regular iambic pentameter:

Thĭs mómĕnt ĭs thĕ bést thĕ wórld căn gíve

A metrical line is named for its pattern and number of feet: **iambic pentameter** has five iambs; **iambic tetrameter** has four iambs; **trochaic trimeter** has three trochees; and so on.

There are several "secrets" to keep in mind when you are **scanning** a line, or determining its metrical pattern. First, look for the most important words. They usually get an accent. Second, speak the line aloud, listening to where you give emphasis. Third, rely on a good dictionary to help with difficult words.

> See **Iambic Pentameter, Rhythm.**
> See also pages 425, 427.

MONOLOGUE *A long speech in a play or story, delivered by a single person.* A monologue is delivered in the presence of one or more other characters; a **soliloquy** is delivered while the speaker is alone.

In William Shakespeare's play *Julius Caesar*, the characters frequently use monologues. An example is Cassius' speech in Act One, Scene 2, beginning "Why, man, he doth bestride the narrow world."

In poetry, a monologue may constitute the entire poem. This is called a **dramatic monologue**, a technique Robert Browning often uses. In his poem "The Laboratory," a woman talks to a silent chemist, revealing her twisted character as she watches poison being made for her rival.

> See page 455.

MORAL *A practical lesson about right and wrong conduct, often stated at the conclusion of an instructive story*

such as a fable. Morals usually instruct us to "do" or "not do" certain things.

> See page 201.

MORALITY PLAY *A dramatization of the spiritual struggle between the forces of good and evil for the human soul.* Morality plays evolved during the Middle Ages and were closely related to Mystery and Miracle plays.

> See page 474.

MOTIVATION *The reasons, either stated or implied, for a character's behavior.* To make a story believable, a writer must provide characters with motivation that explains what they do. Characters may be motivated by outside events, or they may be motivated by inner needs or fears.

> See page 90.

MYTH *A story, often about gods and goddesses and sometimes connected with religious rituals, that attempts to explain the mysteries of the world.* The body of related myths that is accepted by a people is known as its **mythology.** Almost every society has myths that explain the beginnings of the world and of the human race.

NARRATION *The kind of writing or speaking that relates a series of events (a narrative).* Narration explains what happened, when it happened, and to whom it happened. While narration is usually associated with fiction, it may also be used in nonfiction, such as in an essay or a biography. A narrative may be of almost any length, from short anecdotes, fables, and ballads; to longer narrative poems and short stories; to lengthy works such as epics and novels.

> See page 233.

NARRATIVE POETRY *Poetry that tells a story.* A narrative poem can be as long as an **epic,** that is, several thousand lines, or it can be as short as a popular **ballad.** Homer's *Odyssey,* Keats's "La Belle Dame sans Merci," and Tennyson's "The Passing of Arthur" are all narrative poems.

> See page 442.

NARRATOR *One who narrates, or tells, a story.* A writer may choose to have a story told by a **first-**

person narrator, someone who is either a major or minor character in the story. Or a writer may choose to use a **third-person narrator,** someone who is not in the story at all. In this case, we think of the author of the story as being the narrator. Third-person narrators are often **omniscient,** or "all-knowing"— that is, they are able to enter into the minds of all the characters in the story.

William Maxwell's short story "Love" is related in the first person by a narrator who is one of the major characters in the story.

Maurice Walsh's short story "The Quiet Man" is told by a third-person narrator. This narrator, who is not in the story at all, is omniscient and so can tell us what any one of the characters is thinking and feeling.

The word *narrator* can also refer to a character in a drama who guides the audience through the play, often commenting on the action and sometimes participating in it. Thornton Wilder uses such a narrator in his play *Our Town.*

An awareness of who the narrator is, of what the narrator's attitudes are, and of whether the narrator is trustworthy is of key importance in understanding any short story. For instance, in Toni Cade Bambara's story "Blues Ain't No Mockin Bird," the reader must keep in mind that the events of the story are being narrated by a character who is a young girl. We can only guess at the way the adults in that story feel about the conflict with the cameramen, but we are able to gain a vivid insight into the way the adults' behavior affects the children who are looking on.

See **Point of View.**
See also page 128.

NONFICTION *Prose that deals with real events and people, not with imagined events and imagined people.* In nonfiction, the characters, settings, and actions must conform to what is true; they cannot be manipulated by the imagination of the writer.

Two of the most popular forms of nonfiction are **biography** and **autobiography,** which narrate the events of someone's life. **Essays** are another form, as are newspaper articles, journals, diaries, and magazine articles.

Nonfiction relies on all major forms of discourse: **description,** which gives sensory information; **narration,** which tells of a series of events; **exposition,** which explains a process or situation; and **persuasion** or **argument,** which tries to change the way a reader acts or thinks about something.

See pages 238, 276.

NOVEL *A long fictional narrative written in prose, usually having many characters and a strong plot.* Because it is longer than a short story, the novel usually allows for greater complexity of character and plot development. However, since the novel is a relatively new form of literature, first taking shape in the eighteenth century, it is constantly being redefined as writers continue to experiment with the form.

The broad term **novel** includes a variety of subclassifications or types. The **Gothic novel** is one of the earliest forms, and it remains popular today. Gothic novels create an atmosphere of mystery and danger in a picturesque setting, usually involving a threat combined with love intrigue for a romantic young heroine. Charlotte Brontë's *Jane Eyre* is an early example of a Gothic novel. The **historical novel** creates the atmosphere, customs, and events of an actual historical period, and may even include actual historical figures. William Thackeray's *Vanity Fair* is an early example of a historical novel; James Michener's *Chesapeake* is a more recent one. The **psychological novel** explores the complex emotional lives of the characters. *Crime and Punishment* by the Russian writer Fyodor Dostoyevsky is an example. Other popular forms of the novel include **detective stories, spy thrillers, science fiction,** and **fantasies.**

See page 816.

OCTAVE *A grouping of eight lines of verse, as in the first eight lines of a Petrarchan (or Italian) sonnet.* The eight lines are usually grouped together because they develop a single subject. The last six lines of a Petrarchan sonnet are also a group, called a **sestet.**

See **Petrarchan Sonnet.**

ODE *A complex and often lengthy lyric poem, written in a dignified, formal style on some serious subject.* Odes are used in Sophocles' Greek drama *Antigone* to conclude each scene, where they comment on such profound topics as the wonders of human creation, the workings of fate, and the power of love.

ONOMATOPOEIA *The use of a word whose sound imitates or reinforces its meaning.* In everyday speech, words such as *whoosh, tick-tock, zoom,* and *purr* are onomatopoetic. Another example is *popcorn,* which is named to echo its peculiar behavior.

See pages 304, 413, 420.

PARABLE *A short, simple tale, usually about an ordinary, familiar event, from which a moral or religious lesson is drawn.* The Zen masters in Japan frequently use parables for religious or moral instruction. Some of the most famous parables are those used by Jesus in the New Testament. John Steinbeck considered his short novel *The Pearl* a kind of parable that reveals something about the nature of good and evil.

PARADOX *A statement that reveals a kind of truth, although it seems at first to be self-contradictory and untrue.* In the following poem, Countee Cullen presents a paradox. Though his grandmother is dead, he believes she will grow again.

For My Grandmother
Countee Cullen

This lovely flower fell to seed;
Work gently sun and rain;
She held it as her dying creed
That she would grow again.

See pages 264, 325.

PARALLELISM *The repetition of words, phrases, or clauses that are similar in structure or in meaning.* Parallelism is used extensively in the Psalms in the Bible, where the meaning of one statement is often repeated, in a different way, in the next. This example is from Psalm 34:

I will bless the Lord at all times:
his praise shall continually be in my mouth.

Several famous uses of parallelism are found in Abraham Lincoln's Gettysburg Address. In this sentence from the speech, the repetition of the subject and part of the verb emphasizes Lincoln's point and gives his words a stately rhythm:

But, in a larger sense, we cannot dedicate—we cannot consecrate—we cannot hallow—this ground.

Christina Rossetti uses parallelism in this poem:

Song
Christina Rossetti

When I am dead, my dearest,
 Sing no sad songs for me;
Plant thou no roses at my head,
 Nor shady cypress tree:
Be the green grass above me
 With showers and dewdrops wet;
And if thou wilt, remember,
 And if thou wilt, forget.
I shall not see the shadows,
 I shall not feel the rain;
I shall not hear the nightingale
 Sing on, as if in pain;
And dreaming through the twilight
 That doth not rise nor set,
Haply I may remember,
 And haply may forget.

PARAPHRASE *A rewording of a text or of a passage from a text, often for the purpose of clarification or simplification.* A paraphrase differs from a summary in that it may be as long as, or even longer than, the original text. While the paraphrase may help us to understand more clearly what happens in the passage at hand, it does so at the expense of style, or atmosphere, or ambiguity—effects that may have been an important part of the original work. For example, here is a poem by Emily Dickinson, and a paraphrase:

My Life Closed Twice Before Its Close
Emily Dickinson

My life closed twice before its close;
It yet remains to see
If Immortality unveil
A third event to me,

So huge, so hopeless to conceive
As these that twice befell.
Parting is all we know of heaven,
And all we need of hell.

I have felt as if I had died twice in my life, when I parted from a person I loved, and I am wondering whether my own death will reveal such deep emotions, impossible to put into words, as these previous "deaths" did. When we part from someone we love, our memory of why we loved that person, of the happiness we shared, can help us understand what heaven might be like; at the

same time, our grief and pain at losing the loved one make us feel that we know what hell might be like.

The paraphrase might help someone who is reading the poem for the first time to understand what the poem "says," but it loses the impact and possibilities of meaning contained in the original.

See page 391.

PARODY *The imitation of a piece of literature or music or art, for amusement or instruction.* Literary parodies are ways of poking fun at the high seriousness of some writers and of some forms of literature. Parodies are also ways of poking fun at those who take the literature too seriously.

Dorothy Parker's poem "One Perfect Rose" opens with the kind of language used in some poems celebrating love. The parody begins when the poet shifts her tone and suggests that a limousine might be a better gift than a rose.

The more pronounced and distinct a style is, the easier it is to write a parody. "Sea Fever" by John Masefield is a case in point, as this parody of the opening lines suggests:

C Fever: Bringing Home the Report Card

I must go down to the living room, to face
 the music go I,
And all I ask is a feeble excuse and some
 luck to get me by,
And my mom is miffed and I can't speak up
 and my knees are shaking,
And a gray mist's on my dad's face, and my
 voice starts quaking.

PERSONIFICATION *A figure of speech in which something nonhuman is given human characteristics or feelings.* Elizabeth Bishop personifies factories in the opening lines of her poem "Varick Street." She describes the factories as if they were people who have to work at night.

At night the factories
struggle awake,
wretched uneasy buildings
veined with pipes
attempt their work.
Trying to breathe,
the elongated nostrils

haired with spikes
give off such stenches, too.

See **Figurative Language.**
See also pages 252, 387.

PERSUASION *A kind of speaking or writing that is intended to influence people's actions.* Newspaper editorials and other essays that present a particular opinion on an issue, commercials and other advertisements, propaganda and other kinds of political speeches, and handbills are all forms of persuasion. Persuasion makes use of both logical appeals, such as reasons and evidence, and emotional appeals, such as words with powerful connotations.

PETRARCHAN SONNET *A lyric poem of fourteen lines, written in iambic pentameter, with an octave (first eight lines) that establishes a position or problem, and a sestet (last six lines) that resolves it.* Usually the **octave** is rhymed *abbaabba* and the **sestet** *cdecde; cdccdc;* or *cdedce.* The form was popularized by the Italian poet Francesco Petrarch in the fourteenth century. It is also called the **Italian sonnet.**

The American poet Edna St. Vincent Millay became an expert at the sonnet form. The following poem is written in the Petrarchan style, though Millay has departed from the traditional rhyme scheme in the sestet.

I Shall Go Back Again to the Bleak Shore
Edna St. Vincent Millay

a I shall go back again to the bleak shore
b And build a little shanty on the sand,
b In such a way that the extremist band
a Of brittle seaweed will escape my door
a But by a yard or two; and nevermore
b Shall I return to take you by the hand;
b I shall be gone to what I understand,
a And happier than I ever was before.

c The love that stood a moment in your eyes,
d The words that lay a moment on your tongue,
c Are one with all that in a moment dies,
d A little under-said and over-sung.
c But I shall find the sullen rocks and skies
d Unchanged from what they were when I was
 young.

See **Sonnet.**
See also page 437.

PLOT *The sequence of related events that make up a story or a drama.* It is important to remember that a plot shows us a *relationship* among events. Plots may be very simple, or, as in many novels, they may be complex and consist of a major plot plus one or more **subplots.** The major element in most plots is **conflict.**

In the past, plot has been of greater importance in the novel or short story than it often is today. A traditional plot structure might have the following elements: a section of **exposition,** which gives background information on such things as character and setting; a series of complications that develop the **conflict;** a **climax,** the point where the main conflict is finally solved; and a **denouement,** or a final unraveling of all the complications of the plot. A traditional plot of this sort is found in Maurice Walsh's short story "The Quiet Man," where our interest focuses on what happens in the conflict between the bully and the quiet man.

In more modern writings, however, plot is often minor, and might be almost nonexistent; in such a case, character and the inner states of the mind are dominant. This kind of minimal plot can be seen in Woiwode's story "The Beginning of Grief," where our major interest is not in what happens but in what the characters are experiencing emotionally.

See pages 11, 605, 818, 873.

POETIC LICENSE *A writer's freedom to break conventional rules in order to use language playfully and creatively, usually to create mood or enhance meaning.* The American poet E. E. Cummings is famous for the liberties he takes with capitalization and punctuation.

See page 367.

POETRY *Traditionally, poetry is language arranged in lines with a regular rhythm and often with a definite rhyme scheme. Experimental poetry often does away with regular patterns of meter and rhyme, but it usually is set up in lines.* The density of meaning suggested by **imagery,** by **figurative language,** and by **rhythm** distinguishes poetry from other uses of language. As with many things, it is more difficult to define poetry than it is to recognize it. It surprises many people to discover that poetry is a very old form of human expression; prose, on the other hand, is fairly recent.

Poetry can tell a story (**narrative poetry**) or it can express an emotion or idea (**lyric poetry**). We often expect poetry to be set up in groups of lines called **stanzas.** Some of the common poetic forms are the **ballad,** the **epic,** and the **sonnet.**

See page 359.

POINT OF VIEW *The vantage point from which a narrative is told.* There are numerous possibilities for point of view, but three are most frequent: (1) **omniscient point of view,** (2) **limited third-person point of view,** and (3) **first-person point of view.**

In the **omniscient point of view** (often called the "all-knowing" point of view), the narrator can take us all over the world, allow us to see into the minds of all the characters, and help us to see events from several points of view. Ursula Le Guin, in her fantasy novel *A Wizard of Earthsea,* writes from an omniscient point of view:

> The island of Gont, a single mountain that lifts its peak a mile above the storm-racked Northeast Sea, is a land famous for wizards. From the towns in its high valleys and the ports on its dark narrow bays many a Gontishman has gone forth to serve the Lords of the Archipelago in their cities as wizard or mage, or, looking for adventure, to wander working magic from isle to isle of all Earthsea. Of these some say the greatest, and surely the greatest voyager, was the man called Sparrowhawk, who in his day became both dragonlord and Archmage. His life is told of in the *Deed of Ged* and in many songs, but this is a tale of the time before his fame, before the songs were made.

In the **limited third-person point of view,** the writer tells the story from the vantage point of one character. In her novel *A Tree Grows in Brooklyn,* Betty Smith tells a story from the vantage point of her main character, a young girl named Francie. This helps us feel as if we are inside Francie's mind, participating in events in just the way she does:

> The library was a little old shabby place. Francie thought it was beautiful. The feeling she had about it was as good as the feeling she had about church. She pushed open the door and went in. She liked the combined smell of worn leather bindings, library paste and freshly inked stamping pads better than she liked the smell of burning incense at High Mass.

In the **first-person point of view**, an "I" tells the story. This "I" is usually a character in the story. Our perception of all the other characters and events in the story is limited to the way this one character sees them and tells us about them. Richard Wright uses the first-person point of view to tell the story of his own life in *Black Boy:*

> One winter morning in the long-ago, four-year-old days of my life I found myself standing before a fireplace, warming my hands over a mound of glowing coals, listening to the wind whistle past the house outside. All morning my mother had been scolding me, telling me to keep still, warning me that I must make no noise. And I was angry, fretful, and impatient. In the next room Granny lay ill and under the day and night care of a doctor and I knew that I would be punished if I did not obey. I crossed restlessly to the window and pushed back the long fluffy white curtains—which I had been forbidden to touch—and looked yearningly out into the empty street.

See **Narrator.**
See also pages 128, 143, 151, 157, 819.

PROTAGONIST *The central character in a story or drama, the one whom we, as readers or audience, are supposed to sympathize with.* The protagonist's enemy is the **antagonist.** The protagonist can be admirable and distinguished, such as Brutus in Shakespeare's play *Julius Caesar,* or foolish and very ordinary, such as Tom Benecke in Jack Finney's story "Contents of the Dead Man's Pockets."

See **Antagonist.**
See also page 637.

PUN *A humorous play on words, using either (1) two or more different meanings of the same word, or (2) two or more words that are spelled and pronounced somewhat the same but have different meanings.* William Shakespeare uses puns frequently. In his play *Romeo and Juliet,* a character named Mercutio, who is always joking, is fatally wounded and knows he does not have long to live. Punning on the word *grave,* Mercutio says, "Ask for me tomorrow and you shall find me a grave man."

In the following poem, Arthur Guiterman puns on the words *pause / paws* and on the different meanings of the word *bark:*

Motto for a Dog House
Arthur Guiterman

I love this little house because
 It offers, after dark,
A pause for rest, a rest for paws,
 A place to moor my bark.

See page 562.

QUATRAIN *A group of four lines of verse which are unified in thought and sometimes in rhyme.* Quatrains are commonly rhymed *abab, abba,* or *abcb.* Sometimes quatrains are set apart as **stanzas.** Sometimes, as in the case of Shakespeare's sonnets, they are run together. A **Shakespearean sonnet** is made up of three quatrains and a concluding **couplet.**

See **Sonnet, Stanza.**
See also page 437.

REFRAIN *One or more words, phrases, or lines that are repeated regularly in a poem, usually at the end of each stanza.* Refrains are especially common in ballads and in songs meant to be sung by groups. Refrains can aid memory and emphasize an idea. An example of a refrain in modern poetry is found in the first stanza of Elizabeth Bishop's poem to a Brooklyn poet, "Invitation to Miss Marianne Moore":

> From Brooklyn, over the Brooklyn Bridge, on
> this fine morning, please come flying.
> In a cloud of fiery pale chemicals,
> please come flying,
> to the rapid rolling of thousands of small blue
> drums
> descending out of the mackerel sky
> over the glittering grandstand of harbor-water
> please come flying.

The invitation "please come flying" is repeated in each of the remaining eight stanzas. Doubtless, Miss Moore got the message.

See **Repetition.**
See also pages 413, 422.

REPETITION *The reappearance of a word, phrase, stanza, or structure in any literary work.* Repetition is one of the most reliable and widely used means of bringing intensity to a piece of literature. It takes an enormous number of forms. Three common

Literary Terms and Techniques **921**

forms used in poetry are **refrain, rhyme,** and **alliteration. Parallelism,** which is the repetition of structures or ideas, is useful in both poetry and prose.

One of the most famous examples of repetition occurs at the end of Robert Frost's poem "Stopping by Woods on a Snowy Evening." Not only is an entire line repeated, but also the meter is repetitive and so is the rhyme:

> The woods are lovely, dark, and deep,
> But I have promises to keep,
> And miles to go before I sleep.
> And miles to go before I sleep.

The daring quality of these lines, with the total repetition of one line, has often caught readers' attention. The repetition has a calming effect, in one sense. But it also is a way of forcing us to reflect more deeply on the poet's words, and we sense that they may mean more than they seem to.

See **Alliteration, Parallelism, Refrain, Rhyme.**

RHYME *The repetition of accented vowel sounds and all succeeding sounds in words that appear close together in verse.*

End rhyme, the most common form of rhyme, places the rhyme sound at the end of the line of verse. The effect is one of closure, rest, and a sense of completion and fulfillment of expectation. An end rhyme is used in this short poem (a **couplet**), called "Epigram":

> O, God of dust and rainbows, help us see
> That without dust the rainbow would not be.
>
> *Langston Hughes*

Internal rhyme repeats sounds within the lines of verse. A famous use of internal rhyme occurs in the first line of Edgar Allan Poe's poem "The Raven":

> Once upon a midnight dreary, while I pondered weak and weary

Approximate rhyme is very popular with modern poets. In approximate rhyme, the final rhyming sounds are close, but not the same. Emily Dickinson often uses approximate rhyme. Her approximate rhymes surprise us and add a slightly discordant note to a poem, as a flat or sharp note does to music. Here is an example:

Lightly Stepped a Yellow Star
Emily Dickinson

> Lightly stepped a yellow star
> To its lofty place,
> Loosed the Moon her silver hat
> From her lustral face.
>
> All of the evening softly lit
> As an astral hall—
> "Father," I observed to Heaven,
> "You are punctual!"

The approximate rhyme here occurs in the words *hall* and *punctual*—they sound nearly alike, but they are slightly different.

One of the chief functions of rhyme is to insure the unity of a poem. The repetition of rhyming sounds emphasizes the relationship of certain lines. Another function of rhyme is to build our anticipation, which can be either satisfied or frustrated. Finally, a very happy function of rhyme is that it can produce humor, as in this verse from Gilbert and Sullivan's operetta *Iolanthe.* The lines describe someone who has had a bad night:

> You're a regular wreck, with a crick in your neck; and no wonder you snore, for your head's on the floor, and you're needles and pins from your soles to your shins; and your flesh is a-creep, for your left leg's asleep; and you've cramps in your toes, and a fly on your nose, and some fluff in your lung, and a feverish tongue, and a thirst that's intense, and a general sense that you haven't been sleeping in clover. . . .

See **Rhyme Scheme.**
See also pages 413, 415, 417, 418.

RHYME SCHEME *The pattern of rhymes in a stanza or poem.* A rhyme scheme is usually indicated by using small letters to stand for each rhyme, starting with *a* for the first rhyme. Each *a* indicates the first rhyme, each *b* indicates the second rhyme, and so on. Letters indicating the rhyme scheme of this lovely "inside-out" poem appear on the left.

Slowly
Mary Coleridge

a	Heavy is my heart,
b	Dark are thine eyes.
a	Thou and I must part
b	Ere the sun rise.

b	Ere the sun rise
a	Thou and I must part.
b	Dark are thine eyes,
a	Heavy is my heart.

When analyzing a rhyme scheme, be sure to give the same rhyme sound the same letter, even if, as in the above poem, it appears in a different position in subsequent stanzas.

See **Rhyme.**
See also pages 417, 437.

RHYTHM *In language, the arrangement of stressed and unstressed syllables.* Rhythm is natural in all speech. Rhythm in poetry, as in music, can be fast, slow, soothing, disturbing, and so on.

When rhythm follows a generally regular pattern, we call it **meter.** Rhythm is used to lend musicality to a poem and to support the meaning of its lines. Occasionally, a tension between meter and rhythm will be felt, particularly in lines where meter makes us want to stop, but rhythm and meaning push us onward. An example of this appears in the beginning stanzas of Marya Zaturenska's poem "Song":

> Life with her weary eyes,
> Smiles, and lifts high her horn
> Of plenty and surprise,
> Not so where I was born
>
> In the dark streets of fear,
> In the damp houses where greed
> Grew sharper every year
> Through hunger and through need.

The reader expects the word *horn* to have a rhyme, and the tendency to want to stop at that word is strong. But the phrase is not meaningfully complete until the next line, so we move on. The break between stanzas is also surprsing. We want to stop because the expectation of meter tells us to. But meaning tells us to go on. The effect here is to force us to pay close attention to what the poet is saying about life.

See **Meter.**
See also pages 425, 427.

RISING ACTION *The series of events in a drama that lead up to a turning point, where the central character's fate is sealed.* In William Shakespeare's play *Julius Caesar*, the rising action begins when the con-spiracy is formed to murder Caesar, and it ends after Antony's speech in Act Three, when the populace has turned its back on Brutus. All the action that follows is **falling action.**

See **Falling Action.**
See also page 606.

ROMANCE *Originally, a term used to describe a medieval tale dealing with the loves and adventures of kings, queens, knights, and ladies, and including unlikely or supernatural happenings.* One of the most famous romances is the legend of King Arthur and his Knights of the Round Table.

In a more general sense, a romance is *any work of imaginative literature that is set in an idealized world and that deals with heroic adventures and battles in which brave heroes or heroines struggle against evil villains or monsters.* The conflict in a romance is almost always one of good versus evil. Often the heroes and heroines in a romance are aided by magic, such as a magical sword or a magical ring. The modern trilogy of novels called *The Lord of the Rings*, by J. R. R. Tolkien, is a romance. A movie that uses all the traditional elements of romance and sets its actions in a world of startling technological ("magical") achievements is *Star Wars*.

See pages 774, 794.

SATIRE *A literary work that mocks or ridicules the stupidity or vices of individuals, groups, institutions, or society in general.* Satire is generally of two sorts: that which is gentle, witty, and amusing; and that which is forceful, bitter, and even vicious.

In his novel *The House of the Seven Gables*, Nathaniel Hawthorne gently satirizes the aristocratic pride of one of his main characters, Hepzibah Pyncheon. He shows her affectations in dress, her cringing from the need to earn an honest living as a shopkeeper, and her disdain of what she would call "common folk." But Hawthorne is careful to show that Hepzibah is a sensitive human being as well, and his affection for his character prevents us from viewing her too harshly.

A classic example of bitter satire is found in Jonathan Swift's *Gulliver's Travels*, which mocks the corruption in every revered British institution of the early eighteenth century. Swift ridicules the British Empire, for example, by reducing it to a place called Lilliput, which is twelve miles in circumference,

ruled over by an Emperor who is six inches high and who is addressed as Golbasto Momaren Evlame Gurdilo Shefin Mully Ully Gue.

See pages 172, 267.

SESTET *The final six lines of a Petrarchan (or Italian) sonnet.* The sestet (from the Italian for "six") has a rhyme scheme of *cdecde, cdccdc, cdedce,* or a variant. The first eight lines of the Petrarchan sonnet (the **octave**) usually state a thought, theme, or idea which is developed and resolved in the sestet. Sometimes the sestet is set apart as a **stanza**, and sometimes it is run together with the octave.

See **Petrarchan Sonnet.**

SETTING *The time and place in which the events of a literary work take place.* In short stories, novels, poetry, and nonfiction, the setting is generally created by **description**. In drama, setting is usually established by stage sets and dialogue.

Setting can be very important in establishing atmosphere or in making a comment about character. In his novel *Tess of the D'Urbervilles,* Thomas Hardy emphasizes the fall of his heroine, from a period of happiness to one of bleak despair, by changing her environment. At her happiest time, Tess lives on a prosperous dairy farm, in summer, at the height of the land's luxuriant fruitfulness; in her despair, she lives on a poor vegetable farm in the north of England, in the winter, when the land is most bare.

See **Atmosphere.**
See also pages 97, 110, 126, 209.

SHAKESPEAREAN SONNET *A lyric poem of fourteen lines written in iambic pentameter, with three quatrains and a concluding couplet.* Shakespeare inherited the form from other English writers (it is also called the **English sonnet**), but he made the form so much his own that it has been named for him. The rhyme scheme of a Shakespearean sonnet is usually *abab cdcd efef gg.* If you read Shakespeare's "No Longer Mourn for Me When I Am Dead," you can see how each **quatrain** deals with a single thought, which is finally summed up or resolved in the **couplet.**

See **Sonnet.**
See also page 437.

SHORT STORY *A fictional narrative written in prose, which is shorter than a novel.* Because of its relative brevity, the short story often limits itself to one main event and the development of one character or a single aspect of character. A short story lacks the complexity and detail of the novel, but it may gain in impact through the compression of character and events.

See page 1.

SIMILE *A direct comparison made between two unlike things, using a word of comparison such as* like, as, than, such as, *or* resembles. Similes are one of the most frequently used **figures of speech**; not only are they common in prose and poetry, but they are also used in everyday speech. When we say, "His grip was like a vise" or "Her memory was like a computer," we are using a simile. In her poem "A Narrow Fellow in the Grass," Emily Dickinson describes a snake with this homely simile: "The grass divides as with a comb." The simile compares the grass to hair and the snake's path to a part made by a comb. In these lines from his poem "A Youth Mowing," D. H. Lawrence uses a simile to describe the pride of a young boy:

And he sees me bringing the dinner, he lifts
His head as proud as a deer that looks
Shoulder-deep out of the corn.

See **Figurative Language, Metaphor.**
See also pages 199, 387.

SOLILOQUY *A dramatic convention in which a character makes an extended speech while alone on the stage.* This device allows the dramatist to convey a character's most private thoughts to the audience. In fact, soliloquies might be considered "verbalized thoughts."

The convention of the soliloquy was primarily used in the Elizabethan theater, and it is not much used today. In *Hamlet,* for instance, William Shakespeare frequently uses the soliloquy to reveal his hero's uncertainties and innermost feelings. Without the soliloquies, we would not know very much about Hamlet's plans to murder his uncle, nor about his motives for doing so. One of the most famous soliloquies in literature is Hamlet's speech in Act Three, Scene 1, which begins, "To be, or not to be—that is the question."

See **Aside, Monologue.**
See also page 541.

SONNET *A lyric poem having fourteen rhymed lines, usually written in iambic pentameter.* The most important kinds of sonnets are the **Petrarchan** (or **Italian**) and the **Shakespearean** (or **English**). Both forms usually take a single topic and develop it fully. The Petrarchan sonnet has an eight-line beginning called the **octave**, and a six-line conclusion called the **sestet**. The feelings expressed in the octave often contrast with those expressed in the sestet. The Shakespearean sonnet often develops aspects of its topic in each of three **quatrains**, and uses the final **couplet** as a conclusion.

The sonnet form originated in Italy in the thirteenth century. It was very popular for love poems, but it was also popular for any meditation on a limited subject. During the Renaissance, entire books of poems were written using only the sonnet form. Writing a "Century of Sonnets" (100 sonnets) to a loved one was popular for a time in Elizabethan England.

Modern sonnets follow the older patterns, but often with variations.

See **Petrarchan Sonnet**,
Shakespearean Sonnet.
See also page 437.

SPEAKER *The voice in a poem.* The voice of a poem can be the poet, or a character (person, animal, or thing) created by the poet. Except in the most personal of lyric poems, the poet will frequently speak in a voice invented for the poem. This is similar to a playwright who creates a speaker—a dramatic character—to speak lines on stage.

Even when a poem begins with "I," we cannot assume the speaker is the poet. Therefore, it is best to treat the voice in any poem as a speaker invented, like any other literary character, for the sake of the poem.

In the following heroic couplet by Alexander Pope, we know for certain that the speaker is not the poet:

I am his Highness' dog at Kew;
Pray tell me, sir, whose dog are you?

This little verse, engraved on a dog collar, contains a wry bit of humor. The dog himself is the speaker. Of course, we must wonder who the reader is.

See pages 364, 366.

STANZA *A group of related lines that forms a division of a poem or a song.* In some poems, each stanza has the same pattern; in others, each stanza is different.

"Boy with His Hair Cut Short" by Muriel Rukeyser is divided into five stanzas of equal length. Yet there is no rhyme scheme or metrical pattern in the stanzas.

More traditional is Sara Teasdale's "The Long Hill," which has three **quatrains** (groups of four lines) for its stanzas. Each stanza is rhymed in the same pattern, so the rhyme scheme of the entire poem is *abab cdcd efef.* As in many traditional poems, each stanza here states a complete thought that is related to the overall theme.

Isabella Gardner's "Summer Remembered" does not use regular stanza patterns at all. Instead, the poem is broken up into two large stanzas focusing on two aspects of the poem's theme.

Some of the best known of the regular stanza patterns are the **couplet**, the **quatrain**, the **sestet**, and the **octave**—all named for the number of lines they possess.

See page 437.

STYLE *A writer's characteristic way of writing—his or her choice of words, sentence structure, and use of imagery and figurative language.* For example, a writer such as Dylan Thomas coins new words, writes in long, rhythmic sentences, and creates striking images and metaphors. Another writer, such as Joan Didion, uses sentences that are straightforward and very precise in diction. Dylan Thomas' style may remind us of poetry; Joan Didion's may remind us of good journalistic prose.

See pages 239, 274, 314, 819, 875.

SUBPLOT *A plot in a story or play that is secondary to the main plot.* There may, in fact, be several subplots in longer literary forms like dramas or novels.

Usually the subplots are closely related to the main plot and support one general, unified theme. For instance, in Lorraine Hansberry's play *A Raisin in the Sun*, the main plot concerns Walter's struggle to become a responsible person. This plot is supported by two parallel subplots: his mother's desire to move the family to a better house and his sister Beneatha's drive to become a doctor. Each plot develops the general theme of our human need to become the

best people we can become, despite considerable obstacles.

Subplots may also be **counterplots**; that is, they may provide a contrast to the main plot of the narrative. In her novel *Emma*, Jane Austen uses the rather comic subplot of Mrs. Elton's shallow marriage to the vicar as a mild contrast to the main plot of Emma's more meaningful relationship with Mr. Knightly.

See **Plot**.

SUSPENSE *A sense of uncertainty or anxiety about the outcome of events in a story or drama.* Generally, the purpose of suspense is to keep us in a state of high interest, so that we will read on eagerly to find out what happens next.

In the traditional novel, suspense is often most intense at the ends of chapters, where a character may be left at the point of death or in great peril. When novels were published in magazine installments, this made the reader want to buy the next issue to read the next chapter. In traditional drama, suspense has also been most intense at the ends of acts. This maintains the audience's curiosity about the next act, and makes them want to return after intermission. Some short stories concentrate solely on evoking a state of suspense. In "Contents of the Dead Man's Pockets," Jack Finney places his main character in a perilous situation, intensifying our suspense as we read along and increasing our fear and uncertainty until we reach the story's end.

See pages 39, 583.

SYMBOL *Something in a literary work which maintains its own meaning while at the same time standing for something broader than itself.* When a symbol is used in literature, its "double nature" can make it very complex and sometimes difficult to recognize.

There are many common, "reusable" symbols—symbols used over and over again. For example, the rose is often used as a symbol of beauty and love; the west is often used as a symbol of death; the seasons are often used as symbols of the human "seasons" of birth, youth, maturity, and old age; the dove is often used as a symbol of peace; a journey is often used as a symbol of life itself.

An interesting use of a symbol in literature is made in Robert Frost's poem "Birches." In that poem, the birches are themselves: trees that a boy can swing on and that can break under the weight of ice. But the birches also point toward heaven, and so they can be seen as symbolic ladders to the afterlife. Frost says it would be nice to experiment with the birches and "get away from earth awhile." But then he realizes that he must die to have the birches do their symbolic job, and so he worries that his symbol may be taken too literally:

May no fate willfully misunderstand me
And half grant what I wish and snatch me away
Not to return. . . .

He can wait, he decides.

Writers usually let us know through the context when they wish us to interpret something as a symbol. Once we recognize a symbol, its further meanings seem to radiate outward in our imagination like the ripples from a stone dropped in a well.

See **Figurative Language**.
See also pages 180, 387, 397, 875.

THEME *The main idea expressed in a literary work; the central insight that the work gives us about human life.* If the work is relatively brief, such as a short story or a lyric poem, it will probably have only one theme. If it is a longer work, such as a novel or play, it will probably have several themes, which may work together. Theme is different from **plot** and from subject. For example, in the following poem, the subject is joy, but the theme has to do with two human needs: our need to give thanks for the joy that comes from ordinary things, and our need to share joy, lest we lose it:

Welcome Morning
Anne Sexton

There is joy
in all:
in the hair I brush each morning,
in the Cannon towel, newly washed,
that I rub my body with each morning,
in the chapel of eggs I cook
each morning,
in the outcry from the kettle
that heats my coffee
each morning,
in the spoon and the chair
that cry "hello there, Anne"
each morning.

in the godhead of the table
that I set my silver, plate, cup upon
each morning.

All this is God,
right here in my pea-green house
each morning
and I mean,
though often forget,
to give thanks,
to faint down by the kitchen table
in a prayer of rejoicing
as the holy birds at the kitchen window
peck into their marriage of seeds.

So while I think of it,
let me paint a thank-you on my palm
for this God, this laughter of the morning,
lest it go unspoken.

The Joy that isn't shared, I've heard,
dies young.

While a writer may state the theme directly, as is sometimes done in an essay, more often theme is only suggested and requires analysis and thought to be brought out. The theme of a work sometimes is a statement about life, but it often simply is the raising of an important question for which the writer gives no ready answers. Theme does not by any means have to be a **moral** or lesson, giving a prescription for behavior; rather, theme is an exploration of important ideas about human life.

Theme might be compared to a colored thread being woven into a tapestry, it appears, disappears, reappears, perhaps in a different guise, until the final pattern emerges at the end of the work.

See pages 201, 209, 819, 875.

TONE *The attitude a writer takes toward the subject or the reader of a work of literature.* In some cases, such as in Lincoln's Gettysburg Address, the tone is straightforward and serious. In other cases, as in Mark Twain's novel *Adventures of Huckleberry Finn*, the tone shifts from seriousness to humor. At times Twain is amused by some of his characters, while at other times he takes them very seriously. It is always important to recognize tone, because a misunderstanding of tone can distort the entire meaning of a work. For example, many readers have failed to recognize Jonathan Swift's tone in his essay "A Modest Proposal," which suggests that the English solve the Irish problem by serving Irish infants as roasts and stews. Some horrified readers have thought Swift really was serious and have not caught the satire. Thus they have missed Swift's point, which is to show how the English had failed to treat the Irish as human beings.

See pages 166, 402, 819, 875.

TRAGEDY *A literary work dealing with very serious and important themes, in which a dignified tragic figure meets destruction, usually through some personal flaw or weakness.* Although tragedy ends in destruction, its impact may not be depressing, but uplifting, for the hero or heroine often gains a measure of wisdom or self-awareness from failure. Although it is too late for the tragic hero or heroine to change the tragic outcome, he or she faces the catastrophe with dignity and courage.

In classic tragedy the hero is a person of high birth, whose personal destruction is in some way involved with the well-being of the state. The most famous tragedies of this type are those of ancient Greece, such as Sophocles' *Antigone*. Shakespeare's tragedies, such as *Julius Caesar*, also follow this pattern.

See pages 478, 637.

TURNING POINT *That crucial moment in a drama or story in which the fate of the hero or heroine is sealed, when the events of the plot must begin to move toward a happy ending or toward an unhappy one.* For example, in Shakespeare's play *Julius Caesar*, the turning point occurs in Act Three, when Antony manages, through his skillful oratory, to win the people over to his side and away from Brutus and the other conspirators. At this moment, Brutus' fate is sealed, and we know he cannot win over Antony. The remaining acts of the play dramatize the events that lead finally to Brutus' tragic downfall.

See pages 606, 861.

VERSE DRAMA *A play written mostly or entirely in verse.* All of Shakespeare's plays are verse dramas. He uses **blank verse** (poetic lines written in unrhymed **iambic pentameter**) for most of his plays. *Antigone*, like all the Greek dramas, is a verse drama. Maxwell Anderson's *Winterset* is one of the better known examples of modern verse drama. A more recent example is Archibald MacLeish's verse drama *J. B.*, based on the Book of Job.

HANDBOOK FOR *Revision*

Contents

The essays on the following pages are shown in two versions: a rough draft and a final copy. In the draft, the writer has evaluated and revised the essay for logic, clarity, style, and specific support. The writer has also proofread the essay for errors in grammar, usage, punctuation, spelling, and capitalization. The writer's corrections are shown on the draft. The reasons for many of the revisions and corrections are shown in the margin. Marginal notes in the final copy identify important parts of each essay.

Symbols for Revising and Proofreading

Symbol	Example	Meaning of Symbol
≡	Pine street	Capitalize a lowercase letter.
/	Pia's Aunt	Lowercase a capital letter.
/	relitive	Change a letter.
∧	barkiŋ dog	Insert a word, letter, or punctuation mark.
ℒ	Are we we ready?	Delete a word, letter, or punctuation mark.
⌐	Where'is my hat?	Leave out and close up.
(tr)	the first letter of his name (last) (tr)	Transfer the circled material.
(¶)	"Help!" someone cried.	Begin a new paragraph.
⊙	Please stay⊙	Add a period.
∧	Well, why not?	Add a comma.
∨	Tims car	Add an apostrophe.
⊙	as follows ⊙	Add a colon.
∧	Ray Cruz, Sr. ∧ Phil Long, Ph.D.	Add a semicolon.

MODEL 1: A PERSUASIVE ESSAY
Rough Draft

IS TELEVISION TO BLAME?

Comma after prepositional phrases

By the end of elementary school the average American child

will have witnessed more than five thousand murders—on

television. The second leading cause of death in America for

Spelling

persons aged fifteen to twenty-four is homicide. Is there any

Question mark

connection between these two facts ?

Proving this type of cause-and-effect relationship is

However,

Transition

complex. Many research studies, including investigations by the

Title

Surgeon general and the American Medical Association, have

concluded that there is a definite causal link between violence on

TV and off-screen violence. To inform and protect viewers better,

Comma after introductory element

we should set up a rating system for the violence content of all

television and cable programs.

Perhaps the most important

Transition

One reason for a rating system is that it will help to protect

young viewers. Surprisingly, the bulk of television violence is in

Run-on sentence

children's programming for example, cartoons and toy

commercials contain an average of twenty-five violent acts per

MODEL 1: A PERSUASIVE ESSAY
Final Copy

IS TELEVISION TO BLAME?

By the end of elementary school, the average American child will have witnessed more than five thousand murders—on television. The second leading cause of death in America for persons aged fifteen to twenty-four is homicide. Is there any connection between these two facts?

Proving this type of cause-and-effect relationship is complex. However, many research studies, including investigations by the Surgeon General and the American Medical Association, have concluded that there is a definite causal link between violence on TV and off-screen violence. To inform and protect viewers better, we should set up a rating system for the violence content of all television and cable programs.

Perhaps the most important reason for a rating system is that it will help to protect young viewers. Surprisingly, the bulk of television violence is in children's programming. For example, cartoons and toy commercials contain an average of twenty-five

Introduction

Body

Opinion statement

Logical appeal

Supporting evidence

Words needed	hour. Prominent displays of a rating system such as ^{the one} used now for movies would encourage parental guidance as well as industry restraint.
Transition	^{second} An important reason for a rating system is that it might
Spelling	help to reduce the a^ggressive or antisocial behavior that some programs apparently inspire. A particular cause of concern is the
Close quotes	"copycat" phenomenon. In a recent example of this pattern, one teenager was killed and two others were critically injured when
Spelling	they imitated a daredevil stunt in a film by lying down in the middle of a busy highway at night.
	Some people oppose a rating system for television programs
Spelling	because they believe that it would inte^rfere with free speech and artistic creativity. However, over the past twenty-five years the movie rating system does not seem to have had a negative impact
New paragraph	on the art of filmmaking. A rating system for television and cable programs, together with more industry self-restraint and greater parental involvement, might help to reverse the trends of on-screen and off-screen violence in this country. Write your Senator and Representative today in favor of a TV rating system.

violent acts per hour. Prominent displays of a rating system such as the one used now for movies would encourage parental guidance as well as industry restraint.

A second important reason for a rating system is that it might help to reduce the aggressive or antisocial behavior that some programs apparently inspire. A particular cause of concern is the "copycat" phenomenon. In a recent example of this pattern, one teenager was killed and two others were critically injured when they imitated a daredevil stunt in a film by lying down in the middle of a busy highway at night.

Emotional appeal

Some people oppose a rating system for television programs because they believe that it would interfere with free speech and artistic creativity. However, over the past twenty-five years the movie rating system does not seem to have had a negative impact on the art of filmmaking.

Response to opposing arguments

A rating system for television and cable programs, together with more industry self-restraint and greater parental involvement, might help to reverse the trends of on-screen and off-screen violence in this country. Write your Senator and Representative today in favor of a TV rating system.

Conclusion

MODEL 2: AN EXPOSITORY ESSAY
Rough Draft

BATS: FACTS VERSUS FICTION

Apostrophe

Bats are some of nature's most misunderstood and
needlessly threatened creatures. The widespread myths about the
world's only flying mammals are hard to shake off—that they are
rodents, for example, or that they are blind, or that they live on
blood. Actually, not one of these claims is true. Bats are not related

Spelling

to squirrels, rats, or mice but comprise their own order, the
Chiroptera (Greek for "hand wing"). All 900 species of bats can

Comma in compound sentence

see and the majority of them have a built-in sonar system called
echolocation. It is an even better navigating tool than vision. Only
three species of bats are vampires that feed on blood, and these
live in Central and South America.

Contrary to the negative images of myth, bats are vitally

Commas with parenthetical expression

important to life on earth. These creatures of the night for example
are the safest and most efficient known means of insect control.

Wordy

Seventy percent of bats feed on insects. If bats were to ~~vanish and~~
disappear—and many species are currently threatened or

MODEL 2: AN EXPOSITORY ESSAY
Final Copy

BATS: FACTS VERSUS FICTION

Bats are some of nature's most misunderstood and needlessly threatened creatures. The widespread myths about the world's only flying mammals are hard to shake off—that they are rodents, for example, or that they are blind, or that they live on blood. Actually, not one of these claims is true. Bats are not related to squirrels, rats, or mice but comprise their own order, the Chiroptera (Greek for "hand wing"). All 900 species of bats can see, and the majority of them have a built-in sonar system called echolocation. It is an even better navigating tool than vision. Only three species of bats are vampires that feed on blood, and these live in Central and South America.

Contrary to the negative images of myth, bats are vitally important to life on earth. These creatures of the night, for example, are the safest and most efficient known means of insect control. Seventy percent of bats feed on insects. If bats were to disappear—and many species are currently threatened or

Introduction

Body

Thesis statement

Cause and effect

endangered around the world—insect populations might easily

spiral out of control.

Subject-verb agreement

Not all bats eats insects, however. Many species feed on

fruits or nectar and pollen. This diet is related to a second vital

Colon needed

contribution of bats; their role in the pollination and seed dispersal

of plants and flowers. These activities are especially significant in

two very different ecosystems: deserts and tropical rain forests.

Capitalization

For example, the saguaro cactus of the American southwest, whose

flowers open only at night, depends on the Lesser Long-nosed Bat

(Leptonycteris curasoae) for pollination. In the rain forest, where

Subject-verb agreement

there is a high concentration of bat species, the Short-tailed Fruit

More specific fact

Bat (Carollia perspicillata) alone can disperse 60,000 seeds a night.

Besides regenerating the environment, seed dispersal by bats is

essential to the economy of many fruit-producing areas of the

world, notably Southeast Asia.

A third important resource that bats provide is the rich

Sentence fragment

fertilizer made from their droppings, or bat guano. This fertilizer May even have

uses outside of agriculture. Research scientists, for example, are

studying the applications of bacteria in guano for such projects as

endangered around the world—insect populations might easily spiral out of control.

Not all bats eat insects, however. Many species feed on fruits or nectar and pollen. This diet is related to a second vital contribution of bats: their role in the pollination and seed dispersal of plants and flowers. These activities are especially significant in two very different ecosystems: deserts and tropical rain forests. For example, the saguaro cactus of the American Southwest, whose flowers open only at night, depends on the Lesser Long-nosed Bat (Leptonycteris curasoae) for pollination. In the rain forest, where there is a high concentration of bat species, the Short-tailed Fruit Bat (Carollia perspicillata) alone can disperse 60,000 seeds a night. Besides regenerating the environment, seed dispersal by bats is essential to the economy of many fruit-producing areas of the world, notably Southeast Asia.

A third important resource that bats provide is the rich fertilizer made from their droppings, or bat guano. This fertilizer may even have uses outside of agriculture. Research scientists, for example, are studying the applications of bacteria in guano for

Explanation of process

Additional details

Commas in series	detoxifying industrial waste producing gasohol and refining antibiotics. Scientists also continue to study bats' extraordinary system of echolocation. This research may one day result in the
Spelling	discovery of new acçoustic orientation systems for the blind.
	Bats are not likely to become household pets or to replace cats and dogs in popularity. The remarkable contributions that bats make to human life and to the environment, however, should
Pronoun-antecedent agreement	encourage us to understand these creatures better and to protect ~~it~~ them from persecution.

such projects as detoxifying industrial waste, producing gasohol, and refining antibiotics. Scientists also continue to study bats' extraordinary system of echolocation. This research may one day result in the discovery of new acoustic orientation systems for the blind.

Bats are not likely to become household pets or to replace cats and dogs in popularity. The remarkable contributions that bats make to human life and to the environment, however, should encourage us to understand these creatures better and to protect them from persecution.

Conclusion

For definitions of grammatical terms, see the Grammar Reference Guide on pages 961–963.

Part 2: Sentence Structure

- Sentence Fragments
- Run-on Sentences
- Parallel Structure
- Comparisons

SENTENCE FRAGMENTS

A **sentence** is a group of words that expresses a complete thought. A group of words that looks like a sentence but that doesn't make sense by itself is a **sentence fragment.**

1. **Correct a fragment by adding the necessary sentence parts. Usually you will need to add a verb, a subject, or both.**

 Fragment
 Three stately queens at the edge of the lake. [verb missing: what did the queens do?]

 Sentence
 Three stately queens at the edge of the lake **received** Arthur.

 Fragment
 Shows that fate played an important role in Caesar's destiny. [subject missing: who or what shows?]

 Sentence
 Plutarch shows that fate played an important role in Caesar's destiny.

 Fragment
 In Vonnegut's imaginary society in the year 2081. [subject and verb missing]

 Sentence
 In Vonnegut's imaginary society in the year 2081, **television and radio control** people.

2. **Correct a subordinate-clause fragment by connecting it to an independent clause.**

 Fragment
 After Doris Lessing had moved to England at the age of thirty. She continued to write while supporting herself with a variety of odd jobs.

 Sentence
 After Doris Lessing had moved to England at the age of thirty, **s**he continued to write while supporting herself with a variety of odd jobs.

RUN-ON SENTENCES

A **run-on sentence** consists of two complete sentences run together as if they were one sentence. Most run-ons are *comma splices*—or two complete thoughts separated only by a comma. Other run-ons are *fused sentences*—two complete thoughts separated by no punctuation.

1. **Correct a run-on sentence by using a period to form two complete sentences.**

 Run-on
 Juanita Platero and Siyowin Miller have collaborated on several stories, these tales feature a conflict between different values.

 Corrected
 Juanita Platero and Siyowin Miller have collaborated on several stories. **These** tales feature a conflict between different values.

2. **Correct a run-on by using a comma and a coordinating conjunction (such as *and, but,* or *yet*) to create a compound sentence.**

 Run-on
 Edgar Allan Poe attended the United States Military Academy at West Point, he was expelled for disobedience and neglect of duty.

 Corrected
 Edgar Allan Poe attended the United States Military Academy at West Point, **but** he was expelled for disobedience and neglect of duty.

3. **Correct a run-on by using a semicolon to form a compound sentence.**

Run-on

A simile uses a word of comparison such as *like* or *as* to compare two unlike things, a metaphor directly compares two basically dissimilar things.

Corrected

A simile uses a word of comparison such as *like* or *as* to compare two unlike things; a metaphor directly compares two basically dissimilar things.

4. **Correct a run-on by using a semicolon plus a conjunctive adverb (such as *however*, *moreover*, or *nevertheless*) to form a compound sentence.**

Run-on

Creon stubbornly refuses to allow funeral rites for Polyneices Antigone is equally determined to bury her brother.

Corrected

Creon stubbornly refuses to allow funeral rites for Polyneices; **however,** Antigone is equally determined to bury her brother.

PARALLEL STRUCTURE

Parallel structure is the use of the same grammatical form or part of speech for equal ideas.

1. **Balance a noun with a noun, a phrase with a phrase, and a clause with a clause.**

Not Parallel

Besides being a poet, James Weldon Johnson was a high-school **principal,** an **attorney,** and **wrote songs.** [two nouns and a predicate]

Parallel

Besides being a poet, James Weldon Johnson was a high-school **principal,** an **attorney,** and a **songwriter.** [three nouns]

Not Parallel

Writers use exposition for **setting the scene, providing background,** and **characterization.** [two phrases and a noun]

Parallel

Writers use exposition for **setting the scene, providing background,** and **introducing characters.** [three phrases]

Not Parallel

In Chekhov's "The Bet," the prisoner forfeits the money **because he has learned to despise life** and **his scorn for the banker's values.** [clause and phrase]

Parallel

In Chekhov's "The Bet," the prisoner forfeits the money **because he has learned to despise life** and **because he scorns the banker's values.** [two clauses]

2. **Repeat articles, prepositions, or pronouns if they are necessary to make your meaning clear in a parallel construction.**

Unclear

In "A Pair of Silk Stockings," Mrs. Sommers turns out to be more generous to herself than her children.

Clear

In "A Pair of Silk Stockings," Mrs. Sommers turns out to be more generous **to** herself than **to** her children.

COMPARISONS

1. **Be sure that a comparison contains items of the same or a similar kind. Add any words that may be necessary to clarify your meaning.**

Nonstandard

The structure of a Shakespearean sonnet is different from a Petrarchan sonnet.

Standard

The structure of a Shakespearean sonnet is different from **that of** a Petrarchan sonnet.

2. **Include the word *other* or *else* when comparing one member of a group with the rest of the members.**

Nonstandard

Dinesh enjoyed "A Child's Christmas in Wales" more than any essay.

Standard

Dinesh enjoyed "A Child's Christmas in Wales" more than any **other** essay.

Nonstandard

More than anyone, Edgar Allan Poe laid the foundations of the modern detective story.

Standard

More than anyone **else,** Edgar Allan Poe laid the foundations of the modern detective story.

3. **Avoid double comparisons.**

Nonstandard

At the end of his life, Rosicky seemed never to have been **more happier.**

Standard

At the end of his life, Rosicky seemed never to have been **happier.**

Nonstandard

Sophocles was one of the three **most greatest** tragedians of ancient Athens.

Standard

Sophocles was one of the three **greatest** trage-dians of ancient Athens.

4. **Avoid using absolute modifiers in illogical comparisons. Common absolute modifiers include** *entirely, final, identical, never, perfect,* **and** *unique.*

Nonstandard

Very few versions of a folk ballad are **completely identical.**

Standard

Very few versions of a folk ballad are **identical.**

Nonstandard

In the eyes of Socrates' followers, the philoso-pher was **rather uniquely** wise.

Standard

In the eyes of Socrates' followers, the philoso-pher was **uniquely** wise.

Part 3: Pronouns

- Pronoun-Antecedent Agreement
- Pronoun Reference
- Case Forms of Personal Pronouns

PRONOUN-ANTECEDENT AGREEMENT

The noun or pronoun to which a pronoun refers is called its **antecedent.**

1. **A pronoun must agree with its antecedent in number and in gender.**

Nonstandard

The **atmosphere** in many of Poe's short stories is notable for **their** ominous effect.

Standard

The **atmosphere** in many of Poe's short stories is notable for **its** ominous effect.

2. **Use a singular pronoun to refer to an ante-cedent that is a singular indefinite pronoun.**

Use a plural pronoun to refer to an anteced-ent that is a plural indefinite pronoun.

Nonstandard

Each of these women writers has **their** distinctive style.

Standard

Each of these women writers has **her** distinctive style.

Nonstandard

Some of the authors we read, like Guy de Mau-passant, are famous for **his** surprise endings.

Standard

Some of the authors we read, like Guy de Mau-passant, are famous for **their** surprise endings.

3. **When the antecedent may be either masculine or feminine, rephrase the sentence to avoid an awkward construction, or use both the masculine and the feminine forms.**

Standard
All the major characters in *Antigone* are made to suffer from **their** choices and conflicts.

Standard
Each of the major characters in *Antigone* is made to suffer from **his** or **her** choices and conflicts.

4. **Use a plural pronoun to refer to two or more antecedents joined by *and*.**

Nonstandard
John Keats and **Alfred, Lord Tennyson** wrote **his** poems in the nineteenth century.

Standard
John Keats and **Alfred, Lord Tennyson** wrote **their** poems in the nineteenth century.

5. **Use a singular pronoun to refer to two or more singular antecedents joined by *or* or *nor*.**

Nonstandard
In Woiwode's "The Beginning of Grief," neither **Stanion** nor **Kevin** has been able to deal successfully with **their** internal conflicts.

Standard
In Woiwode's "The Beginning of Grief," neither **Stanion** nor **Kevin** has been able to deal successfully with **his** internal conflicts.

Sentences of this type can sound awkward if the antecedents are of different genders. If a sentence sounds awkward, revise it to avoid the problem.

Awkward
Each of these writers created suspense in **his** or **her** stories.

Revised
All these writers created suspense in **their** stories.

PRONOUN REFERENCE

1. **Avoid *ambiguous reference*, which occurs when a pronoun can refer to either of two antecedents.**

Ambiguous
In Act Four, Cassius confronts Brutus in **his** tent.

Clear
In Act Four, when **Brutus** is in **his** tent, Cassius confronts him.

2. **Avoid *general reference*, which occurs when a pronoun refers to a general idea rather than to a specific word or group of words.**

General
In "Blues Ain't No Mockin Bird," the cameramen invade Granny's privacy, **which** is offensive to her.

Clear
In "Blues Ain't No Mockin Bird," **Granny is offended because** the cameramen invade her privacy.

3. **Avoid *weak reference*, which occurs when a pronoun refers to an antecedent that has not been expressed.**

Weak
Tamara writes plays, and she hopes to make **it** on her career.

Clear
Tamara writes plays, and she hopes to make **writing** her career.

4. **In formal writing, avoid the indefinite use of the pronouns *you*, *it*, and *they*.**

Indefinite
In the article, **it** says that Wole Soyinka won the Nobel Prize in 1986.

Clear
The article says that Wole Soyinka won the Nobel Prize in 1986.

CASE FORMS OF PERSONAL PRONOUNS

1. **Be sure to use the correct case for personal pronouns that are part of compound constructions. To choose the right form, try each pronoun of the compound construction separately.**

Nonstandard

In 1949 Carol Reed directed the film *The Third Man,* which was based on a story by Graham Greene; in fact, both Greene and **him** wrote the screenplay for the film.

Standard

In 1949 Carol Reed directed the film *The Third Man,* which was based on a story by Graham Greene; in fact, both Greene and **he** wrote the screenplay for the film.

Nonstandard

Did Mr. Otero give you and **he** a copy of the program?

Standard

Did Mr. Otero give you and **him** a copy of the program?

Nonstandard

Between you and **I,** did you understand the symbolism of *The Pearl?*

Standard

Between you and **me,** did you understand the symbolism of *The Pearl?*

2. **A pronoun following *than* or *as* in an incomplete (or elliptical) construction is in the same case as it would be if the construction were completed.**

Nonstandard

Julius Caesar was a brilliant general and a gifted politician; few figures had as great an impact on Roman history as **him.**

Standard

Julius Caesar was a brilliant general and a gifted politician; few figures had as great an impact on Roman history as **he** [did].

3. **Use the possessive case of a personal pronoun before a gerund. Use the objective case of a personal pronoun before a participle.**

Nonstandard

Jerry sinks to the bottom, and then Lessing describes every stage of **him swimming** through the tunnel.

Standard

Jerry sinks to the bottom, and then Lessing describes every stage of **his swimming** through the tunnel. [gerund]

Nonstandard

When Polly sees **his staggering** in pain, she rushes to help Rosicky into the house.

Standard

When Polly sees **him staggering** in pain, she rushes to help Rosicky into the house. [participle]

Part 4: Verbs

- Missing or Incorrect Verb Endings
- Subject-Verb Agreement
- Sequence of Tenses

MISSING OR INCORRECT VERB ENDINGS

1. A *regular verb* forms the past and past participle by adding *-d* or *-ed* to the infinitive form. Don't make the mistake of leaving off or doubling the *-d* or *-ed* ending.

Nonstandard

By order of Peter the Great, only the clergy and the peasants were **suppose** to wear beards

Standard

By order of Peter the Great, only the clergy and the peasants were **supposed** to wear beards.

Nonstandard

If Beryl Markham's plane had crashed, she would almost certainly have **drownded.**

Standard

If Beryl Markham's plane had crashed, she would almost certainly have **drowned.**

2. **An *irregular verb* forms the past and past participle in some other way than by adding *-d* or *-ed* to the infinitive form. Irregular verbs form their past and past participle by**
 - changing a vowel
 - changing consonants
 - adding *-en*
 - making no change at all

Examples

Infinitive	Past	Past Participle
begin	began	(have) begun
bring	brought	(have) brought
burst	burst	(have) burst
let	let	(have) let
throw	threw	(have) thrown
write	wrote	(have) written

When you proofread your writing, check your sentences to determine which form—past or past participle—is called for. Remember that many nonstandard verb forms sound quite natural. Keep a dictionary handy to check any verb forms you're not sure about.

Nonstandard

Do you think that Kino should have **saw** earlier that he had to get rid of the pearl?

Standard

Do you think that Kino should have **seen** earlier that he had to get rid of the pearl?

Nonstandard

Maybe Sergeant Major Morris thinks he should not have **brung** the monkey's paw to the Whites' house.

Standard

Maybe Sergeant Major Morris thinks he should not have **brought** the monkey's paw to the Whites' house.

SUBJECT-VERB AGREEMENT

1. **A verb must agree with its subject in number—either singular or plural. The number of a subject is not changed by a phrase or clause intervening between the subject and the verb.**

Nonstandard

In Kurt Vonnegut's "Harrison Bergeron," the **agents** of the Handicapper General's Office **makes** sure that everyone is equal to everyone else.

Standard

In Kurt Vonnegut's "Harrison Bergeron," the **agents** of the Handicapper General's Office **make** sure that everyone is equal to everyone else.

2. **The number of the subject remains unchanged even when the subject is followed by a phrase beginning with expressions like *along with*, *as well as*, *in addition to*, and *together with*.**

Nonstandard

Sir Kay, along with Sir Grummore and Sir Ector, **ride** to the lists on the first day of the tournament.

Standard

Sir Kay, along with Sir Grummore and Sir Ector, **rides** to the lists on the first day of the tournament.

3. **Use a singular verb to agree with the following singular indefinite pronouns: *anybody, anyone, anything, each, either, everybody, everyone, everything, neither, nobody, no one, nothing, one, somebody, someone,* and *something.***

Nonstandard

According to Cassius, **everyone** in Rome **are** threatened by tyranny if Caesar becomes king.

Standard

According to Cassius, **everyone** in Rome **is** threatened by tyranny if Caesar becomes king.

Nonstandard

Mario likes these poems because he thinks that **each** of them **explore** an interesting theme.

Verbs **945**

Standard

Mario likes these poems because he thinks that **each** of them **explores** an interesting theme.

4. **Use a plural verb to agree with the following plural indefinite pronouns:** *both, few, many,* **and** *several.*

Nonstandard

Many of Wole Soyinka's works **presents** aspects of life in modern Africa.

Standard

Many of Wole Soyinka's works **present** aspects of life in modern Africa.

Nonstandard

Unfortunately, **few** of my classmates **has** read the novels of Willa Cather.

Standard

Unfortunately, **few** of my classmates **have** read the novels of Willa Cather.

5. **The following indefinite pronouns are singular when they refer to singular words and plural when they refer to plural words:** *all, any, most, none,* **and** *some.*

Nonstandard

All of the manuscript **have** been carefully edited.

Standard

All of the manuscript **has** been carefully edited.

Nonstandard

All of Shakespeare's plays **is** now available on CD-ROM.

Standard

All of Shakespeare's plays **are** now available on CD-ROM.

6. **Compound subjects joined by** *and* **usually take a plural verb.**

Nonstandard

In Act Three, **Brutus** and **Antony delivers** funeral orations.

Standard

In Act Three, **Brutus** and **Antony deliver** funeral orations.

When the elements of a compound subject joined by *and* may be considered a single item or refer to the same thing, the compound subject takes a singular verb.

Nonstandard

Wole's best **friend** and unofficial **guardian were** Osiki.

Standard

Wole's best **friend** and unofficial **guardian was** Osiki.

7. **Singular subjects joined by** *or* **or** *nor* **take a singular verb.**

Nonstandard

Neither **Edna St. Vincent Millay** nor **Hart Crane were** a British poet.

Standard

Neither **Edna St. Vincent Millay** nor **Hart Crane was** a British poet.

When a singular subject and a plural subject are joined by *or* or *nor,* the verb agrees with the subject nearer the verb.

Nonstandard

Neither **Malandain** nor the other **villagers seems** to trust Hauchecorne.

Standard

Neither **Malandain** nor the other **villagers seem** to trust Hauchecorne.

8. **When the subject follows the verb, as in questions and in sentences beginning with** *here* **and** *there,* **identify the subject and make sure that the verb agrees with it.**

Nonstandard

Here **are** a **list** of valid analogies.

Standard

Here **is** a **list** of valid analogies.

Nonstandard

Where **is Athens** and **Thebes** on this map of ancient Greece?

Standard

Where **are Athens** and **Thebes** on this map of ancient Greece?

9. **A collective noun takes a singular verb when the noun refers to the group as a unit. A collective noun takes a plural verb when the noun refers to the parts or members of the group.**

Examples

Wole's **family is** amazed when he announces at the age of three that he is going to school.

The **class were** disagreeing with one another about Brutus' motivations.

10. **The title of a creative work (such as a book, song, film, or painting) and the name of a country (even if it is plural in form) take a singular verb.**

Examples

"Reapers" **is** a poem by Jean Toomer.

The **United Arab Emirates is** a federation of seven sheikdoms on the southern shore of the Persian Gulf.

11. **A verb should always agree with its subject, not with its predicate nominative.**

Nonstandard

For the speaker in James Wright's poem, the two Indian **ponies** that he meets just off the highway **is** a blessing.

Standard

For the speaker in James Wright's poem, the two Indian **ponies** that he meets just off the highway **are** a blessing.

12. **Subjects preceded by *every* or *many a(n)* take singular verbs.**

Examples

Every storyteller and **poet knows** the importance of vivid details.

Many an actor has wanted to play the role of Antony in *Julius Caesar*.

SEQUENCE OF TENSES

1. **Changing verb tense in mid-sentence or from sentence to sentence without good reason creates awkwardness and confusion. Be sure that the verb tenses in a single sentence or in a group of related sentences are consistent.**

Awkward

Barry **says** that his father **was** not going to get better.

Better

Barry **says** that his father **is** not going to get better.

Barry **said** that his father **was** not going to get better.

2. **The past perfect tense with *had* is used to express an action that was completed before another action in the past.**

Nonstandard

Jerry **did** not **tell** his mother that he **swum** through the tunnel.

Standard

Jerry **did** not **tell** his mother that he **had swum** through the tunnel.

Part 5: Word Order

- Misplaced Modifiers - Dangling Modifiers

MISPLACED MODIFIERS

Avoid a *misplaced modifier*, which is a modifying phrase or clause that is placed too far from the word it sensibly modifies.

Misplaced

We learned that the twelfth-century author Geoffrey of Monmouth, who wrote in Latin, was the first famous shaper of the Arthur legend **in our English class.**

Clear

In our English class, we learned that the twelfth-century author Geoffrey of Monmouth, who wrote in Latin, was the first famous shaper of the Arthur legend.

Misplaced

The speaker in Adrienne Rich's "Transit" says that she halts beside the fence **haunted by the image of the skier.**

Clear

Haunted by the image of the skier, the speaker in Adrienne Rich's "Transit" says that she halts beside the fence.

DANGLING MODIFIERS

Avoid *dangling modifiers*, which are phrases or clauses that do not sensibly modify any word or group of words in the sentence.

Dangling

To become a successful playwright, training, practice, and luck are needed.

Clear

To become a successful playwright, a person needs training, practice, and luck.

Part 6: Comma Usage

- Compound Structure
- Items in a Series
- Two or More Adjectives
- Nonessential Elements
- Introduction Elements
- Interrupters

COMPOUND STRUCTURE

Use a comma before a coordinating conjunction (*and, but, or, nor, for, so,* and *yet*) that joins two independent clauses. If the clauses are very short, you may omit the comma.

Examples

Her voice was muffled**, and** he knew her head and shoulders were in the bedroom closet.

—Finney, "Contents of the Dead Man's Pockets" (p. 98)

After supper they sat round in the kitchen**, and** the younger boys were saying how sorry they were it hadn't snowed.

—Cather, "Neighbor Rosicky" (p. 63)

Five minutes passed **and** the prisoner did not once stir.

—Chekhov, "The Bet" (p. 164)

Chee started to protest **but** his mother shook her head slowly.

—Platero and Miller, "Chee's Daughter" (p. 213)

ITEMS IN A SERIES

Use commas to separate words, phrases, and clauses in a series.

Examples

Hardly had he seized it when a horde of infuriated ants flowed over his **hands, arms, and shoulders.**

—Stephenson, "Leiningen Versus the Ants" (p. 25)

And to save his life he concentrated on **holding on to consciousness, drawing deliberate deep breaths of cold air into his lungs, fighting to keep his senses aware.**

—Finney, "Contents of the Dead Man's Pockets" (p. 103)

Soon the biggest of the boys **poised himself, shot down into the water, and did not come up.**

—Lessing, "Through the Tunnel" (p. 204)

TWO OR MORE ADJECTIVES

Use a comma to separate two or more adjectives

preceding a noun. However, do not use a comma before the final adjective in a series if the adjective is thought of as being part of a noun. Determine if the adjective and noun form a unit by inserting the word *and* between the adjectives. If *and* fits sensibly, use a comma.

Examples

After passing among them and exchanging embraces, Peter suddenly produced a **long, sharp** barber's razor and with his own hands began shaving off their beards.

—Massie, from *Peter the Great* (p. 277)

He was a **tall, lean, dark-haired** young man in a pullover sweater, who looked as though he had played not football, probably, but basketball in college.

—Finney, "Contents of the Dead Man's Pockets" (p. 98)

Polly was in a **short-sleeved gingham** dress, clearing away the supper dishes.

—Cather, "Neighbor Rosicky" (p. 59)

That was how they came to hold the most splendid funeral they could conceive of for an **abandoned drowned man.**

—García Márquez, "The Handsomest Drowned Man in the World" (p. 226)

NONESSENTIAL ELEMENTS

A *nonessential* (or *nonrestrictive*) clause or participial phrase contains information that is not necessary to the meaning of the sentence. Use commas to set off nonessential clauses and nonessential participial phrases. An *essential* (or *restrictive*) clause or participial phrase is not set off by commas, because it contains information that is necessary to the meaning of the sentence.

Nonessential Clause

She brought the stranger**, who seemed ill at ease,** into the room.

—Jacobs, "The Monkey's Paw" (p. 34)

Essential Clause

Another thing **which caused offense** was his insulting treatment of the tribunes.

—Plutarch, from *The Life of Caesar* (p. 291)

Nonessential Phrase

The long table**, covered with a bright oilcloth,** was set out with dishes waiting for them, and the warm kitchen was full of the smell of coffee and hot biscuit and sausage.

—Cather, "Neighbor Rosicky" (p. 50)

Essential Phrase

The snow **melting in the sunlight** reminded her that spring would be starting soon.

Some clauses and participial phrases may be either nonessential or essential. The presence or absence of commas tells the reader how the clause or phrase relates to the main idea of the sentence.

Examples

Sandy's uncle**, who lives in Sri Lanka,** sent her a charm bracelet. [nonessential clause—the commas tell you that Sandy has only one uncle; he sent the bracelet.]

Sandy's uncle **who lives in Sri Lanka** sent her a charm bracelet. [essential clause—the lack of commas tells you that Sandy has more than one uncle; the one who lives in Sri Lanka sent the bracelet.]

Our former neighbor**, now living in Houston,** sent us a card. [nonessential phrase—We have only one former neighbor; that person sent the card.]

Our former neighbor **now living in Houston** sent us a card. [essential phrase—We have more than one former neighbor; the one living in Houston sent the card.]

INTRODUCTORY ELEMENTS

Use a comma after *yes, no,* or any mild exclamation such as *well* or *why* at the beginning of a sentence. Also use a comma after an introductory participial phrase, after two or more introductory prepositional phrases, and after an introductory adverb clause.

Examples

"**No,** you ain't," she said.

—Baldwin, "The Rockpile" (p. 118)

"**Well,** my good fellow, you understand these things; what ought I to do?"

—Plato, "The Death of Socrates" (p. 287)

Distracted by the episode, some defenders had turned away from the ditch. [introductory participial phrase]

—Stephenson, "Leiningen Versus the Ants" (p. 17)

By a kind of instinct, he instantly began making his intention acceptable to himself by laughing at it. [introductory prepositional phrases]

—Finney, "Contents of the Dead Man's Pockets" (p. 101)

When George could open his eyes again, the photograph of Harrison was gone. [introductory adverb clause]

—Vonnegut, "Harrison Bergeron" (p. 170)

INTERRUPTERS

1. **Appositives and appositive phrases are usually set off by commas.**

A friend of Shawn's, **Matt Tobin the thresher,** heard that and lifted his voice . . .

—Walsh, "The Quiet Man" (p. 136)

All the carriage aristocracy was eating here at the table of Maît' Jourdain, **innkeeper and horse dealer, a sly man who had a knack for making money.**

—Maupassant, "The Piece of Yarn" (p. 175)

2. **Words used in direct address are set off by commas.**

"**Stranger,** you've been taken in."

—Twain, "A Genuine Mexican Plug" (p. 318)

"**My dear Jailer,** I write you these lines in six languages."

—Chekhov, "The Bet" (p. 163)

"But come, **Crito,** let us do as he says."

—Plato, "The Death of Socrates" (p. 287)

"Report from the signal officer, **sir.**"

—Knight, "The Rifles of the Regiment" (p. 94)

3. **Use commas to set off parenthetical expressions.**

Examples

When I just skipped those words, **of course,** I really ended up with little idea of what the book said.

—Malcolm X, from *The Autobiography* (p. 322)

The future of the demolition derby, **then,** stretches out over the face of America.

—Wolfe, "Clean Fun at Riverhead" (p. 274)

December, **in my memory,** is white as Lapland, though there were no reindeer.

—Thomas, "A Child's Christmas in Wales" (p. 306)

Some of the pictures, **however,** are disturbingly strange.

—Abbey, from *Desert Images* (p. 261)

Part 7: Style

- Sentence Variety
- Stringy Sentences
- Active and Passive Voice
- Overwriting
- Creative Use of Synonyms
- Vivid Words
- Clichés
- Levels of Language

SENTENCE VARIETY

1. **Create sentence variety in length and rhythm by using compound, complex, and compound-complex sentences, as well as simple sentences.**

Little Variation

The District Commissioner warns Leiningen. He talks excitedly about a horde of army ants. According to the official, the ants are headed toward Leiningen's plantation. The ants can eat a full-grown buffalo to the bones. They can do

this before a man can spit three times. Leiningen thanks the District Commissioner for the warning. Leiningen refuses to leave. He says he has planned for every possible contingency.

More Variation

Talking excitedly, the District Commissioner warns Leiningen of the approach of a horde of army ants, which are headed toward Leiningen's plantation. According to the official, the ants can eat a full-grown buffalo to the bones before a man can spit three times. Leiningen thanks the District Commissioner for the warning, but he refuses to leave, saying he has planned for every possible contingency.

2. **Expand short, choppy sentences by adding details.**

Choppy

W. W. Jacobs was born in London. In his youth, he passed an exam and then worked for the government. He never enjoyed this work, however. He preferred to write instead. Many of his books are about the sea.

More Detailed

W. W. Jacobs was born and grew up near the Thames River in London, where his father was a dockworker. In his youth, Jacobs passed a Civil Service examination and then worked for several government departments, including the General Post Office. He never enjoyed this work, however, and he preferred to write instead. Many of his books, such as *More Cargoes* and *Captains All,* are about the sea.

3. **Vary sentence openers by using appositives, single-word modifiers, phrase modifiers, and clause modifiers.**

Little Variation

Beryl Markham describes her solo flight. She gives her description in *West with the Night.* The flight was across the Atlantic from England to Nova Scotia. The flight took place in September 1936. Markham was the first person to fly alone across the ocean from east to west. She tells in her book about events leading up to the flight. She decided to make the attempt when June Carberry suggested at a London dinner party that Markham go for a record.

More Variation

In *West with the Night,* Beryl Markham describes her solo flight across the Atlantic. **Taking off from England in September 1936,** Markham became the first person to fly alone across the ocean from east to west. **At one point in her autobiography,** she tells about events leading up to the flight. **When June Carberry suggested at a London dinner party that Markham go for a record,** she decided to make the attempt.

4. **Simplify long, rambling sentences by breaking them up and regrouping ideas.**

Rambling

The meter in Masefield's "Sea Fever," which uses seven heavily accented syllables in each line, produces a musical quality that is similar to the sound of nursery rhymes, and this pronounced rhythm, as well as the repetition of certain structures, makes the poem easy to memorize, besides being suggestive of the rocking motion of waves.

Better

The meter in Masefield's "Sea Fever," which uses seven heavily accented syllables in each line, produces a musical quality. The sound of the poem resembles the sound of nursery rhymes. This pronounced rhythm, as well as the repetition of certain structures, makes the poem easy to memorize. The rhythm also suggests the rocking motion of waves.

STRINGY SENTENCES

Simplify stringy sentences by writing concisely. Pare down your use of prepositional phrases. Reduce clauses to phrases, if possible. If you can, reduce clauses and phrases to single words.

Stringy

The Merlyn of the King Arthur legend in the version of T. H. White is living in a reverse order of time: He was born in modern times and grows older as he goes back in time, so he can give excellent advice about all sorts of subjects to

Wart, because he has witnessed the mistakes that people have made in their lives.

Better

White's Merlyn is living in a reverse time order: He was born in modern times and grows older as he goes back in time. He can therefore give Wart excellent advice about all sorts of subjects, because he has witnessed people's mistakes.

ACTIVE AND PASSIVE VOICE

Voice is the form a transitive verb takes to indicate whether the subject of the verb performs or receives the action. In general, the passive voice is less direct, less forceful, and less concise than the active voice. Whenever possible, revise passive verbs so that they are active.

Passive

Caesar **is entreated** by Calpurnia not to go to the Senate House.

Active

Calpurnia **entreats** Caesar not to go to the Senate House.

Passive

The letter **was taken** home by the banker and **was locked** up in the fireproof safe.

Active

The banker **took** the letter home and **locked** it up in the fireproof safe.

OVERWRITING

1. **Eliminate unnecessary words.**

Wordy

Sophocles' *Antigone* explores what happens when civil law **conflicts and clashes** with religious law.

Better

Sophocles' *Antigone* explores what happens when civil law **conflicts** with religious law.

Wordy

In "Recuerdo" Edna St. Vincent Millay creates striking **images and word pictures.**

Better

In "Recuerdo" Edna St. Vincent Millay creates striking **images.**

2. **Avoid pretentious, complicated words where plain, simple ones will do.**

Pretentious

John Steinbeck **utilizes symbolization** in *The Pearl.*

Simpler

John Steinbeck **uses symbolism** in *The Pearl.*

3. **Avoid unnecessary repetition and unnecessary intensifiers.**

Repetitious

Sophocles was an ancient Greek **playwright and tragedian.**

Better

Sophocles was an ancient Greek **tragedian.**

Repetitious

Prince Prospero becomes **angrily enraged** at the presence of the masked figure.

Better

Prince Prospero becomes **enraged** at the presence of the masked figure.

CREATIVE USE OF SYNONYMS

Avoid awkward repetition by using synonyms.

Awkward

Chee wants to **regain his daughter.** He is finally able to **regain** custody of **his daughter** by trading food for her.

Better

Chee wants to **regain his daughter.** He is finally able to **win** custody of **the little girl** by trading food for her.

VIVID WORDS

1. **Whenever possible, replace vague words with specific ones.**

Vague

Each Saturday morning John and Roy sat outside and watched the street.

Specific

Each Saturday morning John and Roy sat **on the fire escape** and watched the **forbidden** street below.

—Baldwin, "The Rockpile" (p. 112)

2. **Replace abstract words with vivid, concrete words that appeal to the senses.**

Abstract

She stopped in the parlor, gave us a peculiar look, and then went to the kitchen, from where I could hear noises.

Concrete/Sensory

She stopped in the parlor, took a long look at my friends, looked at me again, shook her head repeatedly and passed through to the kitchen from where I heard her giving rapid orders to the welcome ring of pots and pans and the creak of the kitchen door.

—Soyinka, from *Aké* (p. 346)

CLICHÉS

A **cliché** is a tired expression. Replace clichés in your writing with fresh, vivid expressions.

Cliché

The shades of twilight are closing in on the meadow.

Vivid

Twilight bounds softly forth on the grass.

—Wright, "A Blessing" (p. 404)

LEVELS OF LANGUAGE

Depending on your purpose, audience, and form of writing, you should use an appropriate level of language. For example, *formal English* is ap-propriate for serious essays, reports, and speeches on solemn occasions. *Informal English* is suitable for personal letters, journal entries, and many articles. The following chart gives an outline of the features of formal and informal language.

	Formal	Informal
WORDS	longer, rare, specialized	shorter, colloquial
SPELLING	in full	contractions
GRAMMAR	complex, complete	compound, fragmentary

Formal English usually creates a serious tone. Informal English tends to have a friendlier, more personal tone.

Formal

Not long after Peter compelled his boyars to shave their beards, he also began to insist they change from traditional Russian clothing to Western dress. Some had already done so; Polish costume had appeared at court and was regularly worn by progressive figures such as Vasily Golitsyn.

—Massie, from *Peter the Great* (p. 279)

Informal

The camera man ducking and bendin and runnin and fallin, jigglin the camera and scared. And Smilin jumpin up and down swipin at the huge bird, tryin to bring the hawk down with just his raggedy ole cap. Granddaddy Cain straight up and silent, watchin the circles of the hawk, then aimin the hammer off his wrist. The giant bird fallin, silent and slow.

—Bambara, "Blues Ain't No Mockin Bird" (p. 149)

a, an Use the indefinite article *a* before words beginning with a consonant sound. Use the indefinite article *an* before words beginning with a vowel sound.

Example
As Leiningen discovered, *an* army of ants can be *a* dangerous adversary.

accept, except *Accept* is a verb meaning "to receive." *Except* may be either a verb or a preposition. As a verb, *except* means "to leave out." As a preposition, *except* means "excluding."

Examples
In Chekhov's story, the young man *accepts* the banker's challenge and agrees to remain confined for fifteen years. [verb]

Arlyne read all the nonfiction writers *except* R. J. Heathorn. [preposition]

None of the conspirators was *excepted* from Antony's revenge. [verb]

adapt, adopt *Adapt* means "to change or adjust something in order to make it fit or to make it suitable." *Adopt* means "to take something and make it one's own."

Examples
Over the centuries, many writers have *adapted* the legend of King Arthur into romances, novels, and poems.

In his funeral oration, Antony *adopts* the pose of a humble, plain-spoken citizen of Rome.

affect, effect *Affect* is a verb meaning "to influence." As a verb, *effect* means "to bring about" or "to accomplish." As a noun, *effect* means "the result of an action."

Examples
Kino's newfound wealth *affects* the townspeople's attitudes toward him.

In "The Hawk Is Flying," Harry Crews tells how

his careful nursing and training *effected* a cure for an injured bird. [verb]

The jailer tells Socrates to walk around until he feels the *effect* of the poison in his legs. [noun]

all, all of The word *of* can usually be omitted, except before some pronouns.

Examples
All of us wanted to see the film of *Julius Caesar.*

Do *all* your friends enjoy stories by Edgar Allan Poe?

allusion, illusion An *allusion* is an indirect reference to something. An *illusion* is a mistaken idea or a misleading appearance.

Examples
The last line of Frost's poem "Once by the Pacific" contains an *allusion* to Shakespeare's play *Othello.*

In *I Never Sang for My Father,* Alice is presented as a down-to-earth character with few *illusions.*

among, between Use *between* when you are referring to two things at a time, or to more than two when each item is being compared individually with each of the others.

Examples
Jeff could not decide *between* Lucille Clifton and James Weldon Johnson as the subject for his report.

Premila's report explored differences *between* the treatments of the King Arthur legend by T. H. White, Sir Thomas Malory, and Alfred, Lord Tennyson.

Use *among* when you are referring to more than two items.

Examples
Among the poems by Robert Frost, which was Paula's favorite?

There was no agreement *among* the hospital staff about the new schedule of visiting hours.

The judge decided to divide the prize money *among* several contestants.

as, like *Like* is a preposition. In formal situations, do not use *like* for the conjunction *as* to introduce a subordinate clause.

Examples

Characters *like* Stanion and Kevin in L. Woiwode's "The Beginning of Grief" are complex and cannot be pigeonholed.

In Poe's story, did Prince Prospero's masquerade end *as* you expected?

assure, ensure *Assure* means "to give confidence to" or "promise." *Ensure* means "to make sure" or "to guarantee."

Examples

Mrs. Sommers *assures* the clerk that the price of the boots is not important.

In Guy de Maupassant's "The Piece of Yarn," Maître Hauchecorne's innocence does not *ensure* freedom from suspicion.

awhile, a while *Awhile* is an adverb meaning "for a short time." *A while* is made up of an article and a noun and means "a period or space of time."

Examples

Are you going to practice *awhile* with the band after school?

James Weldon Johnson served for *a while* as a diplomat in Latin America.

bad, badly *Bad* is an adjective. *Badly* is an adverb. In standard English, only the adjective form should follow a sense verb, such as *feel, see, hear, taste, look,* or other linking verb.

Examples

Cassius argues that to let Antony address the people would be a *bad* decision.

The cameramen in "Blues Ain't No Mockin Bird" behave *badly* to the elderly couple.

Kevin tells Stanion that his head feels *bad.*

because In formal situations, do not use the construction *reason . . . because.* Instead, use *reason . . . that.*

Informal

The reason for the conspirators' distrust of Caesar was *because* they thought he wanted to become king.

Formal

The reason for the conspirators' distrust of Caesar was *that* they thought he wanted to become king.

beside, besides *Beside* is a preposition meaning "by the side of" or "next to." *Besides* may be used as either a preposition or an adverb. As a preposition, *besides* means "in addition to" or "also." As an adverb, *besides* means "moreover."

Examples

Did Jorge sit *beside* you at the concert?

Besides Alfred, Lord Tennyson, which other poets did you enjoy reading? [preposition]

E. B. White wrote editorials, magazine features, and children's books; he was a well-known essayist, *besides.* [adverb]

between See **among, between.**

bring, take *Bring* means "to come carrying something." *Take* means "to go carrying something."

Examples

Can someone *bring* a tape recorder to class tomorrow?

Please *take* this issue of *Sports Illustrated* to Ms. Ramirez in Room 142.

compare to, compare with Use *compare to* when you want to stress either the similarities or the differences between two things. Use *compare with*

when you wish to stress both similarities and differences.

Examples

In his poem, Robert Francis *compares* a base stealer *to* a tightrope-walker.

Debra presented a report that *compared* Sherley Anne Williams' "North Country" *with* Gary Snyder's "Above Pate Valley."

continual, continuous *Continual* means "happening over and over again," "repeated often." *Continuous* means "going on without interruption," "unbroken."

Examples

In "The Piece of Yarn," the villagers' *continual* mockery leads eventually to Hauchecorne's illness and death.

In Chekhov's story, the banker bets that the young man will not be able to tolerate *continuous* confinement.

convince, persuade *Convince* means "to win someone over through argument." *Convince* is usually followed by *that* and a subordinate clause. *Persuade* means to move someone to act in a certain way. *Persuade* is often followed by *to.*

Examples

Antony's speech *convinces* the Roman mob *that* Caesar's assassins are really traitors.

The District Commissioner fails to *persuade* Leiningen *to* abandon the plantation.

could of Do not write *of* with the helping verb *could.* Write *could have.* Also avoid *had of, ought to of, should of, would of, might of,* and *must of.*

Example

No one except the true king *could have* [not *of*] pulled the sword from the stone.

different from, different than Use *different from,* not *different than.*

Example

Tennyson's tone in "The Passing of Arthur" is quite *different from* that of T. H. White in "Arthur Becomes King."

disinterested, uninterested *Disinterested* means "impartial." *Uninterested* means "unconcerned," "inattentive."

Examples

Ethical appeals are intended to make a persuasive speaker seem *disinterested* and fair.

In Dorothy Parker's "One Perfect Rose," the speaker implies that she is *uninterested* in romantic love.

due to the fact that Replace this wordy phrase with *because.*

Wordy

Due to the fact that Kino has found the pearl, he expects that his son Coyotito will enjoy a better future.

Better

Because Kino has found the pearl, he expects that his son Coyotito will enjoy a better future.

effect See **affect, effect.**

emigrate, immigrate *Emigrate* means "to leave a country or a region to settle elsewhere." *Immigrate* means "to come into a country or region to settle there." *Emigrate* is used with *from; immigrate* is used with *to.*

Examples

When Doris Lessing was thirty, she *emigrated* from Southern Rhodesia.

Many of the characters in Willa Cather's stories and novels *immigrated* to America from Europe and settled in the Midwest.

ensure See **assure, ensure.**

everyday, every day *Everyday* is an adjective meaning "daily" or "common." *Every day* is an adverbial phrase meaning "each day."

Examples

On the surface, Kate Chopin's story "A Pair of Silk Stockings" is about *everyday* events.

Every day during the vacation, Jerry thought about trying to swim through the tunnel.

everyone, every one *Everyone* is an indefinite pronoun. *Every one* consists of an adjective and a pronoun and means "every person or thing of those named."

Examples

Does *everyone* know that Socrates lived in the fifth century B.C.?

Shawna surprised the class with her knowledge of *every one* of King Arthur's adventures.

except See **accept, except.**

farther, further *Farther* refers to geographical distance. *Further* means "in addition to" or "to a greater degree."

Examples

The sturgeon liked the saltwater, so he went *farther* out into the ocean than the old alligator did.

The *further* Malcolm X read in the dictionary, the more fascinated he became.

fewer, less Use *fewer,* which tells "how many," to modify a plural noun. Use *less,* which tells "how much," to modify a singular noun.

Examples

At the end of "The Handsomest Drowned Man in the World," the captain makes his announcement in no *fewer* than fourteen languages.

Does the advent of electronics mean that books have *less* value?

good, well *Good* is an adjective. *Well* may be used as an adjective or an adverb. The expressions *feel good* and *feel well* mean different things. *Feel good* means "to feel happy or pleased." *Feel well* means "to feel healthy."

Examples

It is clear that Sergeant Major Morris does not feel *good* about the power of the monkey's paw.

Rosicky protests to Dr. Burleigh that he feels *well* enough.

Avoid using *good* to modify an action verb. Instead, use *well* as an adverb meaning "capably" or "satisfactorily."

Nonstandard

Few authors have written personal essays as *good* as E. B. White did.

Standard

Few authors have written personal essays as *well* as E. B. White did.

had of See **could of.**

hanged, hung Use *hanged* to refer to an execution by hanging. Use *hung* to refer to pictures and other things that can be suspended.

Examples

Were criminals *hanged* for serious offenses in medieval England?

In "The Masque of the Red Death," the tapestries that *hung* on the walls of the second chamber were purple.

hopefully Be sure that this adverb modifies a specific verb. Do not use this word loosely as a modifier for the entire sentence.

Vague

Hopefully, readers will appreciate the traditional values that Cather emphasizes in "Neighbor Rosicky."

Specific

We can *hopefully* suppose that readers will appreciate the traditional values Cather emphasizes in "Neighbor Rosicky."

illusion See **allusion, illusion.**

imply, infer *Imply* means "to suggest something

indirectly." *Infer* means "to interpret" or "to get a certain meaning from a remark or an action."

Examples

In "The Handsomest Drowned Man in the World," García Márquez *implies* that everyone needs heroes.

Can we *infer* from the final lines of Frost's poem "Birches" that the speaker wants to test and explore as much as he can?

in, into, in to *In* means "within." *Into* means "from the outside to the inside." *In to* refers to motion with a purpose.

Examples

John Steinbeck set his novel *The Pearl in* a small fishing village.

Alfred, Lord Tennyson transformed the legend of King Arthur *into* an epic poem entitled *Idylls of the King.*

At line 57, Decius Brutus comes *in to* accompany Caesar to the Senate House.

its, it's *Its* is a possessive pronoun. *It's* is the contraction for *it is* or *it has.*

Examples

Wen's favorite story was "Harrison Bergeron"; he especially liked *its* verbal irony.

It's clear that Ellen's unpaid dowry comes to mean something different to each of the major characters in "The Quiet Man."

kind(s), sort(s), type(s) With the singular form of each of these nouns, use *this* or *that.* With the plural form, use *these* or *those.*

Examples

That type of story could easily be made into a film.

Those kinds of details are sensory and factual, rather than narrative.

lay, lie The verb *lay* means "to put (something) in a place." *Lay* usually takes an object. The past tense of *lay* is *laid.* The verb *lie* means "to rest"

or "to stay, to recline, or to remain in a certain state or position." *Lie* never takes an object. The past tense of *lie* is *lay.*

Examples

Please *lay* those books on the desk. [present tense of *lay*]

Caesar *lies* bleeding at the foot of Pompey's statue. [present tense of *lie*]

leave, let *Leave* means "to go away." *Let* means "to permit" or "to allow." Do not use *leave* for *let.*

Nonstandard
Leave us buy tickets for the concert!

Standard
Let us buy tickets for the concert!

Standard
The bus was scheduled to *leave* at 11:30 A.M.

less See **fewer, less.**

might of, must of See **could of.**

number See **amount, number.**

on, onto, on to *On* refers to position and means "upon," "in contact with," or "supported by." *Onto* implies motion and means "to a position on." Do not confuse *onto* with *on to.*

Examples

In the excerpt from *Desert Images,* Edward Abbey discusses the petroglyphs and pictographs *on* the canyon walls.

Tom climbs out *onto* the ledge to retrieve the paper with his notes.

When Antony has aroused the crowd's pity, he goes *on to* mention Caesar's will.

or, nor Use *or* with *either.* Use *nor* with *neither.*

Examples

Peter will write his report *either* on Edna St. Vincent Millay *or* on Muriel Rukeyser.

Neither Robert Browning *nor* John Masefield was an American poet.

oral, verbal *Oral* refers to that which is spoken, as distinguished from that which is written. *Verbal* refers to anything using words, either oral or written.

Examples
Oral readings of poetry can bring out assonance and alliteration very effectively.

In screenplays, *verbal* elements are often subordinate to images.

ought to of See **could of.**

relation, relationship *Relation* refers to a person connected to another by kinship. *Relationship* refers to a connection between thoughts or meanings.

Examples
Chee is determined to get his daughter back from his wife's *relations.*

One important element in "Chee's Daughter" is the *relationship* of the Navaho people to the land.

respectfully, respectively *Respectfully* means "with respect" or "full of respect." *Respectively* means "each in the order indicated."

Examples
The speaker in John Updike's poem refers *respectfully* to Flick's basketball ability.

Eugenia Collier and James Baldwin are the authors of "Marigolds" and "The Rockpile," *respectively.*

rise, raise *Rise* means "to go up" or "to get up." *Rise* never takes an object. The past tense of *rise* is *rose. Raise* means "to cause (something) to rise" or "to lift up." *Raise* usually takes an object. The past tense of *raise* is *raised.*

Examples
When Brutus stabs him, Caesar falls, never to *rise* again.

Raise your hand if you have seen the 1940 film version of John Steinbeck's *The Grapes of Wrath.*

should of See **could of.**

sit, set *Sit* means "to rest in an upright, seated position." *Sit* seldom takes an object. The past tense of *sit* is *sat. Set* means "to put (something) in a place." *Set* usually takes an object. The past tense of *set* is *set.*

Examples
The aristocratic villagers *sit* at the table of Jourdain, the innkeeper and horse dealer.

Morris *sets* his empty glass on the table and sighs.

some, somewhat In writing, do not use *some* for *somewhat* as an adverb.

Nonstandard
At the beginning of Elizabeth Bowen's "The Demon Lover," the appearance of the letter puzzles Mrs. Drover *some.*

Standard
At the beginning of Elizabeth Bowen's "The Demon Lover," the appearance of the letter puzzles Mrs. Drover *somewhat.*

than, then *Than* is a conjunction used in comparisons. *Then* is an adverb telling *when.*

Examples
In Robert Anderson's play, Gene Garrison feels that he is less close to his father *than* he would like to be.

Lucille Clifton first describes Miss Rosie's deterioration; she *then* reveals that Rosie was once the best-looking woman in Georgia.

that See **who, which, that.**

this here, that there The words *here* and *there* are unnecessary after *this* and *that.*

Example
This [not *this here*] sonnet is a lyric poem, and *that* [not *that there*] ballad is a narrative poem.

Glossary of Usage **959**

verbal See **oral, verbal.**

well See **good, well.**

when, where Do not use *when* or *where* to begin a definition.

Nonstandard
A flashback is *when* an author interrupts the present action with a scene that shows events from an earlier time.

Standard
A flashback is a scene that interrupts the present action and shows events from an earlier time.

Nonstandard
Personification is *where* a writer gives human characteristics or feelings to something nonhuman.

Standard
Personification is a figure of speech that gives human characteristics or feelings to something nonhuman.

where Do not use *where* for *that.*

Nonstandard
Santos read *where* Robert Frost was born in San Francisco, California, in 1874.

Standard
Santos read *that* Robert Frost was born in San Francisco, California, in 1874.

who, which, that *Who* refers to persons only. *Which* refers to things only. *That* may refer to either persons or things.

Examples
The poet *who* wrote "Women" was Alice Walker.

Socrates' execution, *which* occurred in 399 B.C., had a profound impact on the young Plato.

One poet *that* our whole class liked immensely was James Weldon Johnson.

The episode *that* I remember most vividly from "The Demon Lover" is the final scene.

who, whom *Who* is used as the subject of a verb or as a predicate nominative. *Whom* is used as an object of a verb or as an object of a preposition. The use of *who* or *whom* in a subordinate clause depends on how the pronoun functions within the clause.

Examples
Who warns Caesar to beware of the Ides of March?

Socrates was a philosopher *who* challenged people to seek the truth.

The essayist *whom* Lee most enjoyed reading was Harry Crews.

To *whom* does the ghost of Caesar appear in Act Four of Shakespeare's play?

whose, who's *Whose* is the possessive form of *who. Who's* is a contraction for *who is* or *who has.*

Examples
John Updike, *whose* novels have been widely praised, is also a poet and an essayist.

Who's presenting a report tomorrow on the life of Malcolm X?

without, unless Do not use the preposition *without* in place of the conjunction *unless.*

Example
Kino finally realizes that he can never be happy *unless* [not *without*] he gives up the pearl.

would of See **could of.**

Handbook for Revision

NOUNS

A **noun** is a word used to name a person, place, thing, or idea. Nouns can function in sentences as subjects, direct objects, indirect objects, objects of prepositions, predicate nominatives, and appositives.

> The first **children** who saw the dark and slinky **bulge** approaching through the **sea** let themselves think it was an enemy **ship.**
> > —García Márquez, "The Handsomest Drowned Man in the World" (p. 223)

> The **villagers** gave **Esteban,** the drowned **man,** a splendid **funeral.**

PRONOUNS

A **pronoun** is a word used in place of a noun or of more than one noun. **Personal pronouns** refer to the person speaking (first person), the person spoken to (second person), or the person, place, or thing spoken about (third person).

	Singular	**Plural**
First Person	I, my, mine, me	we, our, ours, us
Second Person	you, your, yours	you, your, yours
Third Person	he, his, him	they, their, theirs,
	she, her, hers	them
	it, its	

> **You** have no business forcing **your** way in here and talking nonsense. **I** ought to have listened to **my** wife. **She** said **you** were up to no good.
> > —Greene and Reed, *The Third Man* (p. 703)

A **reflexive pronoun** ends in *-self* or *-selves* and refers back to the subject of a verb.

> He lost **himself** at once in the shrill and slow-moving crowd, keyed up by long-drawn-out bargaining.
> > —Maupassant, "The Piece of Yarn" (p. 175)

An **intensive pronoun** ends in *-self* or *-selves* and adds emphasis to a noun or pronoun in the same sentence.

> Antigone tells Creon that she **herself** dared to disobey his order.

A **relative pronoun** is used to introduce adjective and noun clauses.

> The artist Paul Klee, **whose** surreal work resembles some of this desert rock art, wrote in his *Diaries 1898–1918:* "There are two mountains on **which** the weather is bright and clear, the mountain of the animals and the mountain of the gods."
> > —Abbey, from *Desert Images* (p. 262)

> Great waves looked over others coming in,
> And thought of doing something to the shore
> **That** water never did to land before.
> > —Frost, "Once by the Pacific" (p. 414)

An **interrogative pronoun** is used to begin questions.

> **"Who** dares?" he demanded hoarsely of the courtiers who stood near him. . . .
> > —Poe, "The Masque of the Red Death" (p. 124)

A **demonstrative pronoun** is used to point out a specific person or thing.

> Pretty soon, I would have quit even **these** motions, unless I had received the motivation that I did.
> > —Malcolm X, from *The Autobiography* (p. 322)

An **indefinite pronoun** is used to refer to people or things in general.

> Thurber devotes **some** of his essay to describing the Get-Ready Man.

> Numberless are the world's wonders, but **none** More wonderful than man . . .
> > —Sophocles, *Antigone* (p. 503)

VERBS

A **verb** is a word that expresses action or a state of being. An **action verb** tells what action someone or something is performing.

He **stopped** his horse at the stream and **sat** looking across the narrow ribbon of water to the bare-branched peach trees.

> —Platero and Miller, ''Chee's Daughter'' (p. 211)

A **linking verb** helps to make a statement by serving as a link between two words. The most commonly used linking verbs are forms of the verb *be.*

As she called the roll, her voice **was** as gentle as the expression in her beautiful dark brown eyes.

> —Maxwell, ''Love'' (p. 181)

A **helping verb** is a verb that can be added to another verb to make a verb phrase.

Another time she **would have** stilled the cravings for food until reaching her own home, where she **would have** brewed herself a cup of tea and taken a snack of anything that was available.

> —Chopin, ''A Pair of Silk Stockings'' (p. 156)

ADJECTIVES

An **adjective** is a word used to modify a noun or pronoun. Adjectives tell *what kind, which one,* or *how many.*

I feel again the **chaotic** emotions of adolescence, **illusive** as smoke, yet as **real** as the **potted** geranium before me now.

> —Collier, ''Marigolds'' (p. 75)

The articles *the, a,* and *an* are adjectives. *An* is used before a word beginning with a vowel sound or with an unsounded *h.*

ADVERBS

An **adverb** is a word used to modify a verb, an adjective, or another adverb. Adverbs tell *how, when, where,* and *to what extent.*

The young girl talking to the soldier in the garden had **not ever completely** seen his face.

> —Bowen, ''The Demon Lover'' (p. 43)

PREPOSITIONS

A **preposition** is a word that shows the relationship of a noun or a pronoun to some other word in the sentence. Prepositions are almost always followed by nouns or pronouns. A group of words that begins with a preposition and ends with a noun or pronoun is called a **prepositional phrase.**

It was a very big river **in a region of South America** that had never been visited **by white men;** and **in it** lived many, many alligators—perhaps a hundred, perhaps a thousand.

> —Quiroga, ''The Alligator War'' (p. 185)

CONJUNCTIONS

A **conjunction** is a word used to join words or groups of words. **Coordinating conjunctions** join equal parts of a sentence or similar groups of words.

Then he knew that he would not faint, **but** he could not stop shaking **nor** open his eyes.

> —Finney, ''Contents of the Dead Man's Pockets'' (p. 103)

Correlative conjunctions are used in pairs to join similar words or groups of words.

Both Countee Cullen **and** Jean Toomer were members of the Harlem Renaissance.

A **subordinating conjunction** is used to introduce a clause that has less importance than the main clause in a sentence.

When you are inside the jungle, away from the river, the trees vault out of sight.

> —Dillard, ''In the Jungle'' (p. 245)

A **conjunctive adverb** is an adverb used as a conjunction to connect ideas.

At three hundred feet, the motor was still dead; **nevertheless,** Beryl Markham did not panic.

INTERJECTIONS

An **interjection** is a word that expresses emotion and has no grammatical relation to other words in the sentence.

Oh, he's afraid they'd send him a big bill.

> —Anderson, *I Never Sang for My Father* (p. 644)

SUBJECT-VERB AGREEMENT

A verb should agree with its subject in number—singular or plural.

> Yet the demolition **derbies keep** growing on word-of-mouth publicity. The **"nationals" were held** last month at Langhorne, Pa., with 50 cars in the finals, and demolition-derby **fans** everywhere **know** that **Don McTavish,** of Dover, Mass., **is** the new world's champion.
>
> —Wolfe, "Clean Fun at Riverhead" (p. 271)

PHRASES

A **phrase** is a group of words that does not contain a subject and a verb.

A **prepositional phrase** is a group of words that begins with a preposition and ends with a noun or pronoun.

> **across** the water **beside** us
> **down** the street **in front of** my school

An **appositive** is a noun or pronoun placed beside another noun or pronoun to identify or explain it. An **appositive phrase** is made up of an appositive and its modifiers.

> Aristophanes, **the ancient Greek comic playwright,** was two generations younger than the tragedian Sophocles.

A **participial phrase** consists of a participle and its complements or modifiers. The entire participial phrase acts as an adjective.

> **Clinging tight to the anchor of stone,** he lay on his side and looked in under the dark shelf at the place where his feet had gone.
>
> —Lessing, "Through the Tunnel" (p. 205)

An **infinitive phrase** consists of an infinitive together with its modifiers and complements. The entire phrase can be used as a noun, an adjective, or an adverb.

> With Mary, **to feed creatures** was the natural expression of affection . . . [infinitive phrase used as subject]
>
> —Cather, "Neighbor Rosicky" (p. 51)

CLAUSES

A **clause** is a group of words that has a subject and a verb. An **independent clause** expresses a complete thought and can stand by itself as a sentence.

> Tinu became even more smug.
>
> —Soyinka, from *Aké* (p. 341)

A **subordinate clause** does not express a complete thought and cannot stand alone.

> Sir Gareth killed three of the thieves **as soon as they came upon them.**
>
> —Malory, "The Tale of Sir Gareth" (p. 779)

Part 10: Mechanics

■ Capitalization ■ Punctuation

CAPITALIZATION

1. FIRST WORDS

▌ Capitalize the first word of every sentence.

Example

The symbolic meaning of the automobile tones down but by no means vanishes in adulthood.

—Wolfe, "Clean Fun at Riverhead" (p. 271)

▌ Capitalize the first word of a direct quotation when the word begins with a capital letter in the original. If the original writer has not used a capital letter, do not capitalize the first word of the quotation.

Examples

"**W**hat is it?" shouted Big Liam again, his voice

breaking in astonishment. "What is that you say?"

<div align="right">—Walsh, "The Quiet Man" (p. 140)</div>

"That's all right—" Hazel said of the announcer, "he tried."

<div align="right">—Vonnegut, "Harrison Bergeron" (p. 169)</div>

■ **Traditionally, the first word in a line of poetry is capitalized, although some writers do not follow this rule for reasons of style.**

Examples

"**O**, what can ail thee, knight-at-arms,
 Alone and palely loitering?
The sedge is withered from the lake,
 And no birds sing."

<div align="right">—Keats, "La Belle Dame sans Merci" (p. 446)</div>

When I watch you
wrapped up like garbage
sitting, surrounded by the smell
of too old potato peels . . .

<div align="right">—Clifton, "Miss Rosie" (p. 403)</div>

2. THE PRONOUN *I* AND THE INTERJECTION *O*

■ **Capitalize the pronoun *I* and the interjection *O*.**

Examples

I saw the ship and the daybreak, and then **I** saw the cliffs of Newfoundland wound in ribbons of fog.

<div align="right">—Markham, "West with the Night" (p. 333)</div>

O, hark, **O**, hear! how thin and clear,
 And thinner, clearer, farther going!
O, sweet and far from cliff and scar
 The horns of Elfland faintly blowing!

<div align="right">—Tennyson, "The Splendor Falls" (p. 416)</div>

3. PROPER NOUNS AND PROPER ADJECTIVES

■ **A *proper noun* names a particular person, place, or thing. A *proper adjective* is formed from a proper noun. Capitalize proper nouns and proper adjectives.**

Examples

Colombia	Korea	China	Africa
Columbian	Korean	Chinese	African

■ **In proper nouns consisting of two or more words, do not capitalize articles (*a, an, the*), short prepositions (those with fewer than five letters, such as *at, of, for, with*), and coordinating conjunctions (*and, but, for, nor, or, so, yet*).**

Examples

Nobel Prize	Cape Breton Island
Los Angeles	President Nixon
Mayor Ruiz	Bridge of Sighs

■ **Some proper nouns and proper adjectives have lost their capitals after long usage. Others may be written with or without capitals.**

Examples

diesel engine 100-watt bulb bologna sandwich

If you are not sure whether to capitalize a word, check in an up-to-date dictionary.

4. NAMES OF PEOPLE

■ **Capitalize the names of people. Some names contain more than one capital letter.**

Examples

L. Woiwode	Sean O'Faolain
Edna St. Vincent Millay	Countee Cullen

5. GEOGRAPHICAL NAMES

■ **Capitalize geographical names, such as towns, cities, counties, townships, states, regions, countries, continents, islands, mountains, bodies of water, parks, roads, highways, and streets.**

Examples

Dallas	Route 95
Australia	the Painted Desert
Lake Huron	Interstate 10
Pacific Palisades	State Street
Key Largo	the Cascades
Central Park	Long Island

■ Note that words such as *south, east,* and *north-west* are not capitalized when they indicate direction.

Examples

east of the Rockies north of town

■ These words are capitalized, however, when they name a particular place.

Examples

In the summer of 1993, there were disastrous floods in the Midwest.

Have you ever visited the far North?

■ A word such as *city, island, river, park,* or *street* is capitalized only when it is part of a proper noun.

Examples

Have you seen Liberty Island in New York Harbor?

We went on a picnic in the park.

Hector spent the afternoon at the Bronx Zoo.

Monica jogged beside the East River.

6. ORGANIZATIONS

■ Capitalize the names of organizations, teams, businesses, institutions, buildings, and government bodies.

Examples

National Honor Society	Regency Hotel
Museum of Fine Arts	Delta Airlines
Clemson University	Xerox Corporation
Houston Oilers	the Senate
Fox Theater	

■ A word such as *hotel, theater, college, post office,* or *high school* is not capitalized unless it is part of a proper noun.

Examples

Is the Hyatt a convenient hotel?
We'll take a cab to the theater.
Can you direct me to the nearest post office?
Twyla goes to Jefferson High School.

7. HISTORICAL EVENTS

■ Capitalize the names of historical events and periods, special events, and calendar items.

Examples

Great Depression	Thanksgiving
the Battle of Antietam	the Iowa State Fair
Earth Day	the All-Star Game
Memorial Day	the Boston Marathon

8. NATIONALITIES, RACES, AND RELIGIONS

■ Capitalize the names of nationalities, races, and peoples.

Examples

Vietnamese	Arab
Aztec	Cherokee
Native American	Japanese

■ Capitalize the names of religions and their followers, holy days and celebrations, holy writings, and specific deities.

Examples

Buddhism	Ramadan	Taoist
Baptist	the Talmud	the Koran
Muslim	Vishnu	the Holy Spirit
Hanukkah	Vedas	Allah
Pentecost	Deuteronomy	God

9. BRAND NAMES

■ Capitalize the brand names of business products. Do not capitalize the noun that often follows a brand name.

Examples

Buick Skylark	Mongol pencils
Kodak cameras	Zenith radio

10. PARTICULAR PLACES, THINGS, AND EVENTS

■ Capitalize the names of ships, trains, aircraft, spacecraft, monuments, buildings, awards, planets, and any other particular places, things, or events.

Examples

Titanic	*Gemini*	Bronze Star
Orient Express	Lincoln Memorial	Neptune
Maine	Sears Tower	Election Day

11. SPECIFIC COURSES, LANGUAGES

▎ Do *not* capitalize the names of school subjects, except for languages and for course names followed by a number.

Examples

chemistry	social studies
Spanish	physics
Hebrew	Computer Science 101

▎ Do *not* capitalize the class name *senior, junior, sophomore,* or *freshman* unless it is part of a proper noun.

Examples

The freshmen will hold their class dinner tomorrow night.

The Sophomore Singers will perform at dinner.

12. TITLES OF PEOPLE

▎ Capitalize a title belonging to a particular person when it comes before a person's name.

Examples

President Ford	Miss Simpson
General Zakowski	Principal Leone
Professor Kantor	Dr. Sankhala

▎ Do *not* capitalize a title used alone or following a person's name, especially if the title is preceded by *a* or *the*.

Examples

Peter Martinez, mayor of Albuquerque
the governor's order
the duke's castle

▎ Capitalize a word showing a family relationship when the word is used with a person's name but *not* when it is preceded by a possessive.

Examples

Uncle Sidney	Aunt Teresa	my aunt Teresa

13. TITLES OF LITERARY AND OTHER CREATIVE WORKS

▎ Capitalize the first and last words and all important words in titles of books, periodicals, poems, stories, plays, historical documents, movies, radio and television programs, works of art, and musical compositions.

Unimportant words within titles are articles (*a, an, the*), short prepositions (fewer than five letters, such as *of, to, for, from*), and coordinating conjunctions (*and, but, for, nor, or, so, yet*).

Examples

One of Ours	"Once by the Pacific"
"In the Jungle"	*Publishers Weekly*
Idylls of the King	"The Piece of Yarn"
Declaration of	*Batteries Not Included*
Independence	*Eroica Symphony*
Hogan of a Farmer	

▎ The words *a, an,* and *the* written before a title are capitalized only when they are the first word of a title.

Examples

The Pearl	"A Birthday"	*The New Yorker*

PUNCTUATION

1. END MARKS

▎ End marks—*periods, question marks,* and *exclamation points*—are used to indicate the purpose of a sentence. (A period is also used at the end of many abbreviations.)

Use a period to end a statement (or declarative sentence).

Example

Perhaps the fact that his own youth was well over before he began to have a family was one reason why Rosicky was so fond of his boys.

—Cather, "Neighbor Rosicky" (p. 59)

▎ A question (or interrogative sentence) is followed by a question mark. Note that a direct question may have the same word order as a

declarative sentence. Since it is a question, however, it is followed by a question mark.

Examples

"What would you do if you saw *two* hippos?"
—Thomas, "A Child's Christmas in Wales" (p. 312)

"Today is really your birthday?" she asked.

■ **Do *not* use a question mark after a declarative sentence containing an indirect question.**

Example

"I don't know what people are thinking about."
—Jacobs, "The Monkey's Paw" (p. 30)

■ **Use an exclamation point to end an exclamation.**

Examples

"Agreed! You stake your millions and I stake my freedom!" said the young man.
—Chekhov, "The Bet" (p. 161)

How good was the touch of the raw silk to her flesh!
—Chopin, "A Pair of Silk Stockings" (p. 154)

"Fire!" cried Mrs. Prothero, and she beat the dinner gong.
—Thomas, "A Child's Christmas in Wales" (p. 306)

And she wept, "God bless you!" for the apples and pears,
And we gave her all our money but our subway fares.
—Millay, "Recuerdo" (p. 382)

■ **An imperative sentence may be followed by either a period or an exclamation point.**

Examples

"Just drink it," he said, "and then walk about until you feel a weight in your legs, and then lie down."
—Plato, "The Death of Socrates" (p. 287)

"Trackers," he said. "Come!"
—Steinbeck, *The Pearl* (p. 865)

■ **Use a period after an abbreviation.**

Examples

Personal Names: W. W. Jacobs
Titles Used with Names: Mr., Mrs., Ms., Dr., Capt., Rev.

States and Countries: R.I., Fla., U.K.
Time of Day: A.M., P.M.
Years: B.C., A.D.
Addresses: Blvd., P.O. Box
Organizations: Corp., Org., Co.
Units of Measure: lb., oz., in., ft., yd., sq. mi.

■ **No periods are used in abbreviations with states when the zip code is included: CA 90049**

■ **Abbreviations in the metric system are often written without periods: for example, km for kilometer, kg for kilogram, ml for milliliter. Abbreviations for government agencies and international organizations and some other frequently used abbreviations are written without periods: for example, USDA, VCR, TV, YWCA.**

2. COMMAS: CONVENTIONAL USES

■ **Use a comma to separate items in dates and addresses.**

Examples

She received my letter on May 10, 1995.
I wrote to Glynnis at 40 Oxford St., Boulder, CO 80306.

■ **Notice that a comma also separates the final item in a date and in an address from the words that follow it. A comma does *not* separate the month from the day, the house number from the street name, or the state name from the ZIP code.**

■ **Use a comma after the salutation of a friendly letter and after the closing of any letter.**

Examples

Dear Ms. Costas, My dear Kim,
Sincerely yours, Yours truly,

■ **A comma often appears after a name followed by an abbreviation such as *Jr.*, *Sr.*, and *M.D.***

Examples

Anita Visone, M.D. Martin Sanders, Jr.
Milos Čapek, Ph.D. B. B. Russo, M.A.

For other uses of commas, see **Part 6** (pp. 948–950).

3. SEMICOLONS

■ **Use a semicolon between independent clauses that are closely related in thought and that are not joined by** *and, but, or, nor, for, so,* **or** *yet.*

EXAMPLES

There was no reply; the old woman's face was white, her eyes staring, and her breath inaudible; on the husband's face was a look such as his friend the sergeant might have carried into his first action.

—Jacobs, "The Monkey's Paw" (p. 35)

The wind was plucking at her new purple blouse and wide green skirt; it freed truant strands of soft dark hair from the meager queue into which it had been tied with white yarn.

—Platero and Miller, "Chee's Daughter" (p. 215)

■ **Use a semicolon between independent clauses joined by a conjunctive adverb or a transitional expression.**

Examples

This was in spite of the fact that Caesar was a follower of the doctrines of Epicurus; yet the moment of crisis, so it would seem, and the very imminence of the dreadful deed made him forget his former rationalistic views and filled him with an emotion that was intuitive or divinely inspired.

—Plutarch, from *The Life of Caesar* (p. 294)

That looked promising; any moment now I expected our mother to rush through the doors, making up for the delay with all sorts of unexpected delights.

—Soyinka, from *Aké* (p. 345)

■ **Use a semicolon (rather than a comma) before a coordinating conjunction to join independent clauses that contain commas.**

Example

The new boat, like the other one, stopped some distance below the dam; and again a little boat came rowing toward them.

—Quiroga, "The Alligator War" (p. 189)

■ **Use a semicolon between items in a series if the items contain commas.**

Example

We visited Lima, Peru; Santiago, Chile; and Buenos Aires, Argentina.

4. COLONS

■ **Use a colon before a list of items, especially after expressions like** *as follows* **and** *the following.*

Example

Miyoki's favorite poets were the following: May Swenson, Gary Snyder, and Robert Frost.

■ **Use a colon before a long quotation.**

Example

The opening lines of Jean Toomer's "Reapers" are as follows:

> Black reapers with the sound of steel on stones
> Are sharpening scythes. I see them place the hones
> In their hip-pockets as a thing that's done . . .

■ **Use a colon in certain conventional situations: between the hour and the minute, between chapter and verse in a Biblical citation, and after the salutation of a business letter.**

Examples

10:45 A.M. Genesis 3:3 Dear Prof. Cruz:

5. ITALICS

■ **When writing or typing, indicate italics by underlining. Use italics for titles of books, plays, periodicals, works of art, films, long musical compositions, television series, ships, aircraft, and spacecraft.**

Examples

BOOK: *Desert Images*
PLAY: *Antigone*
PERIODICAL: *Sports Illustrated*
WORK OF ART: *Crossing the Brook*
FILM: *Tootsie*
LONG MUSICAL COMPOSITION: *Peter and the Wolf*
TELEVISION SERIES: *The Waltons*
SHIP: *Andrea Doria*
AIRCRAFT: *Concorde*
SPACECRAFT: *Apollo*

Handbook for Revision

■ **Use italics for words, letters, and figures referred to as such and for foreign words not yet adopted into English.**

Examples

The word *principal* may be a noun or an adjective.

Is *7* your lucky number?

Montana's state motto is *oro y plata,* Spanish for "gold and silver."

6. QUOTATION MARKS

■ **Use quotation marks to enclose a direct quotation—a person's exact words.**

Example

Old Man Fat sighed, his voice dropping to an injured tone. "He says he and his wife are going to rest this winter; then after that he'll build a place up on the new highway."

—Platero and Miller, "Chee's Daughter" (p. 219)

■ **Do *not* use quotation marks to enclose an indirect quotation—a rewording of a direct quotation.**

Example

She wanted an excellent and stylish fit, she told the young fellow who served her, and she did not mind the difference of a dollar or two more in the price so long as she got what she desired.

—Chopin, "A Pair of Silk Stockings" (p. 155)

■ **Begin a direct quotation with a capital letter. If the direct quotation is obviously a fragment of the original quotation, it may begin with a small letter.**

Examples

"Well, lads," he began, "we've lost the first round. But we'll smash the beggars yet, don't you worry."

—Stephenson, "Leiningen Versus the Ants" (p. 21)

In the first stanza of Keats's poem, the speaker asks the knight why he is "palely loitering."

■ **When an expression identifying the speaker interrupts a quoted sentence, the second part of the quotation begins with a small letter.**

Example

"Oh, Merlyn," cried the Wart, "help me to get this weapon."

—White, "Arthur Becomes King" (p. 755)

■ **A direct quotation is set off from the rest of the sentence by commas or by a question mark or an exclamation point.**

Examples

"We could cut south and find a better spot—the men still have fight left," the colonel said desperately.

—Knight, "The Rifles of the Regiment" (p. 93)

"You have a pearl? A good pearl?" the doctor asked with interest.

—Steinbeck, *The Pearl* (p. 843)

"Fifteen? Done!" cried the banker. "Gentlemen, I stake two millions!"

—Chekhov, "The Bet" (p. 161)

■ **Commas and periods are always placed inside closing quotation marks.**

Examples

"We shall try our best to do as you say," said Crito.

—Plato, "The Death of Socrates" (p. 285)

Yet, walking down the path with her, he blurted out, "I'd like to go and have a look at those rocks down there."

—Lessing, "Through the Tunnel" (p. 202)

■ **Semicolons and colons are always placed outside closing quotation marks.**

Examples

Willa Cather wrote "Neighbor Rosicky"; she was also the author of *The Song of the Lark* and *My Ántonia.*

"Friends, Romans, countrymen, lend me your ears": This is how Antony begins his funeral oration.

■ **Question marks and exclamation points are placed inside closing quotation marks if the quotation is a question or an exclamation. Otherwise, they are placed outside.**

Examples

"Well, why don't you have three, sir?" said Herbert White, cleverly.

—Jacobs, "The Monkey's Paw" (p. 31)

"Leiningen!" he shouted. "You're insane!"

—Stephenson, "Leiningen Versus the Ants" (p. 12)

Did you know that Annie Dillard wrote "In the Jungle"?

I really enjoy Poe's "The Masque of the Red Death"!

∎ **When you write dialogue, begin a new paragraph every time the speaker changes, and enclose each speaker's words in quotation marks.**

Example

"Don't now," Stanion said. "Don't carry on so. Please. Sit up."

"I'm sorry!"

"I know. Now don't."

—Woiwode, "The Beginning of Grief" (p. 88)

∎ **When a quoted passage consists of more than one paragraph, place quotation marks at the beginning of each paragraph and at the end of only the last paragraph in the passage.**

∎ **Use single quotation marks to enclose a quotation within a quotation.**

Example

"Let's write, 'Mr. Daniel looks like a spaniel' all over his lawn."

—Thomas, "A Child's Christmas in Wales" (p. 312)

∎ **Use quotation marks to enclose titles of short works, such as short stories, short poems, essays, articles, songs, episodes of television series, and chapters and other parts of books.**

Examples

SHORT STORY: "Love"

SHORT POEM: "Miss Rosie"

ESSAY: "Cold Weather"

ARTICLE: "Company Rejects Call for Mediation"

SONG: "White Christmas"

TV EPISODE: "An Unexpected Guest"

CHAPTER: "Twentieth-Century Playwrights"

∎ **Use quotation marks to enclose slang, technical terms, and other unusual uses of words.**

What's the name of the new "in" restaurant?
Did your computer come with a "mouse"?

7. APOSTROPHES

POSSESSIVE CASE

∎ **To form the possessive of a singular noun, add an apostrophe and an *s*. Add only the apostrophe to a proper name ending in an *s* sound if the name has two or more syllables or if the addition of *'s* would make the name awkward to pronounce.**

Examples

a **rose's** petals	Dr. **Gonzalez'** coat
the **child's** hat	**Euripides'** plays

∎ **To form the possessive of a plural noun ending in *s*, add only the apostrophe.**

Examples

the **farmers'** fields the **actors'** costumes

∎ **Do *not* use an apostrophe with possessive personal pronouns or with the possessive pronoun *whose*.**

Examples

I thought this present was **ours.**
Whose keys are those?

∎ **To form the possessive of an indefinite pronoun, add an apostrophe and an *s*.**

Examples

Anyone's suggestions are welcome.
Someone's bike is lying on the sidewalk.

∎ **Form the possessive of only the last word in a compound word, in the name of an organization or a business firm, or in a word group showing joint possession.**

Examples

her **father-in-law's** opinion
the **Urban League's** membership
Kimi and Tanaki's house

∎ **When a possessive pronoun is part of a word**

group showing joint possession, each noun in the word group is also possessive.

Example
Kimi's and **her** house

▮ When two or more persons possess something individually, make each of their names possessive in form.

Example
Lila's and **Katie's** toys

CONTRACTIONS

▮ Use an apostrophe to show where letters, numbers, or words have been omitted in a contraction.

Examples
I've forgotten. four **o'clock**
 (I have) (of the clock)
We're right. (We are) in the **'90s** (1990s)

PLURALS

▮ Use an apostrophe and an *s* to form the plurals of all lowercase letters, some capital letters, and some words referred to as words.

Examples
Write your *w*'s more distinctly.
Do you know any words that start with *X*'s?
I revised some of the *when*'s and *so*'s in that paragraph.

8. HYPHENS

▮ Use a hyphen in some compound words.

Examples
great-grandfather six-year-old
ice-cold half-pint container

▮ Use a hyphen to divide a word at the end of a line.

Example
John Crowe Ransom was born in 1888 in **Pulaski,** Tennessee.

▮ Do not divide a one-syllable word.

Incorrect
The central character in a short story is called the protagonist.

Correct
The central character in a short story is **called** the protagonist.

▮ Use a hyphen with compound numbers from *twenty-one* to *ninety-nine* and with fractions used as modifiers.

Examples
forty-nine years a **two-thirds** vote

▮ Hyphenate a compound adjective when it precedes the word it modifies. Do not use a hyphen, however, if one of the modifiers is an adverb ending in *-ly*.

a **world-renowned** poet an **after-school** job
a **well-delivered** speech a **poorly assembled**
 computer

▮ Use a hyphen with the prefixes *ex-*, *self-*, *all-*, with the suffix *-elect*, and with all prefixes before a proper noun or proper adjective.

Examples
our **ex**-mayor a **self**-indulgent outlook
the **all**-important issue the president-**elect**
pre-Revolutionary **pro**-American policy
 America

9. DASHES

▮ Use a dash to indicate an abrupt break in thought or speech or an unfinished statement or question.

Example
"Why, darling, would you rather not come with me? Would you rather—" She frowned, conscientiously worrying over what amusements he might secretly be longing for . . .
 —Lessing, "Through the Tunnel" (p. 202)

10. PARENTHESES

▮ Use parentheses to enclose informative or explanatory material of minor importance.

Example
Rudolph, the oldest one (he was still living at home then), said: "The last time I was over there, she was lifting them big heavy milk cans, and I knew she oughtn't to be doing it."
 —Cather, "Neighbor Rosicky" (p. 51)

Glossary

Strictly speaking, the word *glossary* means a collection of technical, obscure, or foreign words found in a certain field of work. The words in this glossary are not "technical, obscure, or foreign," but are those that might present difficulty as you read the selections in this textbook.

Many words in the English language have several meanings. In this glossary, the meanings given are the ones that apply to the words as they are used in the selections in the textbook. Words closely related in form and meaning are generally listed together in one entry (**abstemious** and **abstemiousness**), and the definition is given for the first form. Related words that generally appear as separate entries in dictionaries are listed separately (**apathetic** and **apathy**). Regular adverbs (ending in *-ly*) are defined in their adjective form, with the adverb form shown at the end of the definition.

For complete definitions of these words, a good dictionary must be consulted.

The following abbreviations are used:

adj. adjective	*n.* noun	*v.* verb
adv. adverb	*prep.* preposition	

A

abate (ə-bāt′) *v.* To lessen.

aberration (ăb′ə-rā′shən) *n.* A deviation from the normal or usual.

abhorrence (ăb-hôr′əns) *n.* Loathing.

abhorrent (ăb-hôr′ənt, -hŏr′ənt) *adj.* Hateful; disgusting. —**abhorrently** *adv.*

aboriginal (ăb′ə-rĭj′ə-nəl) *adj.* Native; original.

abrasive (ə-brā′sĭv, -zĭv) *adj.* Harsh; rough.

absolve (ăb-zŏlv′, -sŏlv′) *v.* To free from blame or guilt.

abstemious (ăb-stē′mē-əs) *adj.* Moderate in eating and drinking. —**abstemiousness** *n.*

abstract (ăb-străkt′, ăb′străkt′) *adj.* **1.** Difficult to understand; theoretical. **2.** Removed from reality; dreamy.

abyss (ə-bĭs′) *n.* A bottomless, empty space.

accelerate (ăk-sĕl′ə-rāt′) *v.* To increase the speed of.

accentuate (ăk-sĕn′chōō-āt′) *v.* to emphasize.

accord (ə-kôrd′) *n.* Agreement.

accredit (ə-krĕd′ĭt) *v.* To authorize; appoint.

accrue (ə-krōō′) *v.* To increase.

acrid (ăk′rĭd) *adj.* Harsh; bitter.

administer (ăd-mĭn′ĭs-tər) *v.* To give; dispense.

admonish (ăd-mŏn′ĭsh) *v.* To scold mildly.

advent (ăd′vĕnt) *n.* A coming or arrival, as of an important event or person.

affable (ăf′ə-bəl) *adj.* Friendly. —**affability** *n.*

affiliate (ə-fĭl′ē-āt′) *v.* To associate with.

affront (ə-frŭnt′) *n.* Offense; insult.

agitation (ăj′ə-tā′shən) *n.* **1.** A violent movement or stirring. **2.** Emotional disturbance.

aimless (ām′lĭs) *adj.* Without purpose. —**aimlessly** *adv.*

ajar (ə-jär′) *adv.* or *adj.* Open slightly.

alacrity (ə-lăk′rə-tē) *n.* Quickness and liveliness in movement; eagerness.

alight (ə-līt′) *v.* to get off or down.

alms (ämz) *n. pl.* Money or goods given to the needy. —**almsgiver** *n.*

ambiguous (ăm-bĭg′yōō-əs) *adj.* Uncertain or doubtful.

amble (ăm′bəl) *v.* To walk in a slow, relaxed way.

amenity (ə-mĕn′ə-tē, ə-mē′nə-) *n.* Something that makes a place more pleasant or comfortable.

amiable (ā′mē-ə-bəl) *adj.* Friendly. —**amiably** *adv.*

ample (ăm′pəl) *adj.* Plentiful.

amulet (ăm′yə-lĭt) *n.* A charm against evil or injury.

animosity (ăn′ə-mŏs′ə-tē) *n.* Hatred.

anthropologist (ăn′thrə-pŏl′ə-jist) *n.* One who studies the origin and behavior of human beings.

antics (ăn′tĭks) *n. pl.* Funny, playful behavior.

antiquated (ăn′tə-kwā′tĭd) *adj.* Very old; outmoded.

apathetic (ăp′ə-thĕt′ĭk) *adj.* Without emotion; indifferent. **—apathetically** *adv.*

apathy (ăp′ə-thē) *n.* The absence of emotion; indifference.

aperture (ăp′ər-chər) *n.* An opening such as a slit or gap.

aphorism (ăf′ə-rĭz′əm) *n.* A short and wise or clever statement.

apocalypse (ə-pŏk′ə-lĭps′) *n.* A revelation or prophecy, particularly of destruction.

appall (ə-pôl′) *v.* **1.** To shock; horrify. **2.** To fill with dismay or fear.

appalling (ə-pô′lĭng) *adj.* Horrifying.

apparition (ăp′ə-rĭsh′ən) *n.* **1.** A ghost. **2.** A sudden appearance of an unusual sight or form.

appease (ə-pēz′) *v.* To soothe; satisfy.

appellation (ăp′ə-lā′shən) *n.* Name.

appertain (ăp′ər-tān′) *v.* To have to do with.

apprehend (ăp′rĭ-hĕnd′) *v.* To anticipate, generally with fear or uneasiness.

apprehension (ăp′rĭ-hĕn′shən) *n.* Dread; expectation of something bad.

apprehensive (ăp′rĭ-hĕn′sĭv) *adj.* Fearful. **—apprehensively** *adv.*

apropos (ăp′rə-pō′) *adj.* Relevant. **—apropos of** With regard to.

arabesque (ăr′ə-bĕsk′) *adj.* Fanciful; with elaborate designs.

arbiter (är′bə-tər) *n.* A person who settles a dispute.

arbitrary (är′bə-trĕr′ē) *adj.* Determined by whim or personal preference. **—arbitrarily** *adv.*

arbor (är′bər) *n.* An area shaded by trees.

arboreal (är-bôr′ē-əl) *adj.* Relating to trees.

archaeologist (är′kē-ŏl′ə-jĭst) *n.* One who studies evidence of the past.

ardent (är′dənt) *adj.* Enthusiastic.

arid (ăr′ĭd) *adj.* Dry.

aridity (ə-rĭd′ə-tē) *n.* Dryness; dullness.

array (ə-rā′) *n.* **1.** A large display. **2.** An orderly grouping.

arrogant (ăr′ə-gənt) *adj.* Excessively self-important and proud. **—arrogantly** *adv.* **—arrogance** *n.*

ascent (ə-sĕnt′) *n.* The act of moving upward.

ascertain (ăs′ər-tān′) *v.* To discover.

aspiration (ăs′pə-rā′shən) *n.* High ambition.

assail (ə-sāl′) *v.* To attack. **—assailable** *adj.*

assent (ə-sĕnt′) *n.* Agreement; acceptance.

assimilate (ə-sĭm′ə-lāt′) *v.* To absorb; make part of one's thinking.

assumption (ə-sŭmp′shən) *n.* An act of arrogance or forwardness.

astound (ə-stound′) *v.* To amaze; bewilder.

attain (ə-tān′) *v.* To arrive at; reach.

attendant (ə-tĕn′dənt) *adj.* Accompanying.

audacious (ô-dā′shəs) *adj.* Fearless; daring.

audible (ô′də-bəl) *adj.* Able to be heard.

aught (ôt) *n.* Anything at all.

augment (ôg-mĕnt′) *v.* To increase; make greater.

augur (ô′gər) *v.* To predict the future from signs or omens. **—augurer** (ô′gyər-ər) *n.*

august (ô-gŭst′) *adj.* Dignified; majestic.

auspicious (ô-spĭsh′əs) *adj.* Favorable; boding well.

austere (ô-stîr′) *adj.* Solemn; dignified.

authenticate (ô-thĕn′tĭ-kāt′) *v.* To confirm as true or genuine.

avaricious (ăv′ə-rĭsh′əs) *adj.* Greedy.

avert (ə-vûrt′) *v.* To turn away.

avid (ăv′ĭd) *adj.* Eager.

awry (ə-rī′) *adv.* Twisted toward one side.

B

ballast (băl′əst) *n.* Heavy material kept in a ship's hold to help maintain stability.

banter (băn′tər) *n.* Quick, witty conversation.

baroque (bə-rōk′) *adj.* Irregular or odd in shape.

base (bās) *adj.* Dishonorable; mean. **—basely** *adv.*

bay (bā) *v.* To force into being cornered so that escape is impossible.

beguile (bĭ-gīl′) *v.* To divert.

beleaguer (bĭ-lē′gər) *v.* To attack by surrounding on all sides.

belligerent (bə-lĭj′ər-ənt) *adj.* Ready to fight or argue. **—belligerently** *adv.*

bellow (bĕl′ō) *v.* To roar.

benediction (bĕn′ə-dĭk′shən) *n.* A blessing.

benefactor (bĕn′ə-făk′tər) *n.* Someone who gives help, particularly financial help.

benevolent (bə-nĕv′ə-lənt) *adj.* Kind; doing good.

benign (bĭ-nīn′) *adj.* Not harmful.

bequeath (bĭ-kwēth′, -kwēth′) *v.* To leave to someone by will; hand down.

ă pat/ā pay/âr care/ä father/b bib/ ch church/d deed/ĕ pet/ē be/f fife/g gag/h hat/hw which/ĭ pit/ī pie/îr pier/j judge/k kick/ l lid, needle/m mum/n no, sudden/ng thing/ŏ pot/ō toe/ô paw, for/oi noise/ou out/ŏŏ took/ōō boot/p pop/r roar/s sauce/ sh ship, dish/t tight/th thin, path/*th* this, bathe/ŭ cut/ûr urge/v valve/w with/y yes/z zebra, size/zh vision/ə about, item, edible, gallop, circus/à *Fr.* ami/ œ *Fr.* feu, *Ger.* schön/ü *Fr.* tu, *Ger.* über/KH *Ger.* ich, *Scot.* loch/N *Fr.* bon.

berate (bǐ-rāt′) v. To scold.

bereave (bǐ-rēv′) v. To leave sad or forlorn, as by death. —**bereavement** n.

beseech (bǐ-sēch′) v. To ask seriously; beg.

bestow (bǐ-stō) v. To give; grant.

bestowal (bǐ-stō′əl) n. Gift.

betide (bǐ-tīd′) v. To happen to.

betimes (bǐ-tīmz′) adv. Archaic. Early; quickly.

blanch (blănch, blänch) v. To become pale or white.

bland (blănd) adj. Mild; dull.

blasphemy (blăs′fə-mē) n. Any irreverent or contemptuous act or remark. —**blasphemous** adj.

blithe (blīth, blīth) adj. Carefree; cheerful. —**blitheness** n.

blunderbuss (blŭn′dər-bŭs′) n. A short musket, formerly used for shooting at close range.

bodice (bŏd′ĭs) n. The fitted upper part of a dress.

bouffant (bōō-fänt′) adj. Full; puffed out.

bountiful (boun′tə-fəl) adj. Generous; kind.

bower (bou′ər) n. A leafy, shaded place. —**bowery** adj.

brackish (brăk′ĭsh) adj. Containing some salt (describing water).

brand (brănd) n. A burning stick.

brandish (brăn′dĭsh) v. To wave in a threatening way.

brazen (brā′zən) adj. 1. Made of or like brass in color and hardness. 2. Shameless.

brazier (brā′zhər) n. An open pan used to hold burning coals.

brisk (brĭsk) adj. Energetic; active.

broach (brōch) v. To bring up a topic for discussion.

brood (brōōd) v. To cover in a protective way, as birds do with their young.

brusque (brŭsk) adj. Abrupt; rude.

buffet (bŭf′ĭt) v. To struggle against.

bulwark (bōōl′wərk, bŭl′-, -wôrk′) n. Someone or something that acts as a defense or protection.

buttress (bŭt′rĭs) v. To reinforce or support.

C

cad (kăd) n. An ill-bred man.

caftan (kăf′tăn′, kăf-tăn′) n. A long robe or tunic.

caldron (kôl′drən) n. A large kettle or vat.

calibrate (kăl′ə-brāt′) v. To mark the measure or capacity of something.

callous (kăl′əs) adj. Unfeeling; pitiless. —**callousness** n.

cameo (kăm′ē-ō′) n. A raised, carved design on a gemstone or shell.

camphor (kăm′fər) n. A chemical substance generally used to protect fabric against moths, but sometimes used in medicine as a stimulant.

candelabrum (kăn′də-lă′brəm) n. A large, branched candleholder.

candor (kăn′dər) n. Sincerity; frankness.

canopy (kăn′ə-pē) n. A high covering.

canter (kăn′tər) v. To ride at a slow gallop.

cape (kāp) n. A piece of land projecting into a body of water.

caper (kā′pər) v. To jump about playfully.

caprice (kə-prēs′) n. A sudden, impulsive change of mind or way of thinking.

capricious (kə-prĭsh′əs, -prē′shəs) adj. Fickle; subject to whim.

cardiogram (kär′dē-ə-grăm′) n. A tracing of the contractions of the heart, used in diagnosing heart disease.

carrion (kăr′ē-ən) adj. 1. Rotten or decaying. 2. Feeding on decaying flesh.

cassock (kăs′ək) n. A long garment worn by members of the clergy.

catapult (kăt′ə-pŭlt′) v. To leap up suddenly.

cataract (kăt′ə-răkt′) n. A large waterfall.

cavalcade (kăv′əl-kād′, kăv′əl-kād′) n. A formal parade of horsemen.

cavalier (kăv′ə-lîr′) adj. Arrogant; haughty.

cavernous (kăv′ər-nəs) adj. Vast; like a cavern.

celestial (sə-lĕs′chəl) adj. Relating to heaven.

celluloid (sĕl′yə-loid′) n. A hard plastic substance.

cessation (sĕ-sā′shən) n. A stopping, either permanent or temporary.

chafe (chāf) v. 1. To rub in order to stimulate. 2. To wear away by rubbing.

chafer (chā′fər) n. A beetle.

chaff (chăf) n. Straw or hay used to feed animals.

chaise longue (shāz′ lông′) A "long chair," having an extended seat to support the sitter's legs.

chaos (kā′ŏs′) n. Extreme confusion or disorder.—**chaotic** adj.

chary (châr′ē) adj. Careful; cautious; not giving freely.

chasm (kăz′əm) n. A narrow, deep opening in the earth's surface.

chasten (chā′sən) v. 1. To punish in order to make better. 2. To purify; refine.

chastise (chăs-tīz′) v. To punish; condemn. —**chastisement** n.

chide (chīd) v. To scold mildly.

chortle (chôrt′l) v. To chuckle with a snorting sound.

cinch (sĭnch) *v.* To fasten something tightly around another thing.

circuit (sûr′kĭt) *n.* A regular route taken by someone in the performance of his or her duties.

circumscribe (sûr′kəm-skrīb′) *v.* To limit; restrict.

circumvent (sûr′kəm-vĕnt′) *v.* To overcome.

citadel (sĭt′ə-dəl, -dĕl′) *n.* A fort that protects a city.

citron (sĭt′rən) *n.* The candied rind of a lemonlike fruit, used in baking.

clamant (klā′mənt) *adj.* Noisy.

clamber (klăm′ər, klăm′bər) *v.* To climb with difficulty, on all fours; scramble. —**clambering** *adj.*

cleave (klēv) *v.* To split; pierce.

cleft (klĕft) *adj.* Split; divided.

clique (klēk, klĭk) *n.* A small, select group of people sharing a common interest.

clod (klŏd) *n.* A lump of soil or clay.

cogitation (kŏj′ə-tā′shən) *n.* Serious thought.

coherent (kō-hîr′ənt, kō-hĕr′-) *adj.* Orderly and logical.

comeliness (kŭm′lē-nĕs) *n.* Attractiveness.

commend (kə-mĕnd′) *v.* **1.** To make a favorable impression. **2.** To be praiseworthy. **3.** To express praise. **4.** To transmit regards.

commiseration (kə-mĭz′ə-rā′shən) *n.* Pity; sympathy.

compartment (kəm-pärt′mənt) *n.* A separate room or section.

complacence (kəm-plā′səns) *n.* Satisfaction, especially self-satisfaction.

composure (kəm-pō′zhər) *n.* Calmness.

compound (kŏm′pound) *n.* An enclosed area or group of buildings where people live.

comprehensive (kŏm′prĭ-hĕn′sĭv) *adj.* Including all necessary details; extensive.

computation (kŏm′pyoo-tā′shən) *n.* Determination of amount or number by mathematical calculation.

concave (kŏn-kāv′) *adj.* Curved inward.

conceivable (kən-sēv′ə-bəl) *adj.* Able to be thought of or imagined.

conceive (kən-sēv′) *v.* To think of or develop, as an idea.

concentric (kən-sĕn′trĭk) *adj.* Having a common center.

conception (kən-sĕp′shən) *n.* An idea; thought.

condole (kən-dōl′) *v.* To sympathize.

confer (kən-fûr′) *v.* To give; grant.

confinement (kən-fīn′mənt) *n.* A woman's lying-in during childbirth.

confirmation (kŏn′fər-mā′shən) *n.* Verification; corroboration.

conform (kən-fôrm′) *v.* To comply; to act in accordance with rules or customs.

confront (kən-frŭnt′) *v.* To come face to face with.

congenial (kən-jēn′yəl) *adj.* **1.** Friendly. **2.** Sharing similar tastes or habits.

conjecture (kən-jĕk′chər) *n.* A conclusion based on guesswork or insufficient evidence. —**conjectural** *adj.*

conjoint (kən-joint′) *adj.* United. —**conjointly** *adv.*

conjunction (kən-jŭngk′shən) *n.* An association; union.

conjure (kŏn′jər, kən-joor′) *v.* To bring a particular image to mind (used with **up**).

conscientious (kŏn′shē-ĕn′shəs) *adj.* Dutiful; persevering.

consecrate (kŏn′sə-krāt′) *v.* **1.** To make holy. **2.** To dedicate to a special service or goal.

conservatory (kən-sûr′və-tôr′ē, -tōr′ē) *n.* A glass-enclosed room used to grow plants.

console (kən-sōl′) *v.* To comfort.

constancy (kŏn′stən-sē) *n.* Steadfastness; firmness of purpose.

consternation (kŏn′-stər-nā′shən) *n.* Sudden fear or confusion.

construe (kən-stroo′) *v.* To interpret.

consul (kŏn′səl) *n.* In ancient Rome, a high-ranking judge.

contemplate (kŏn′təm-plāt′) *v.* To look at thoughtfully and intently.

contemplation (kŏn′təm-plā′shən) *n.* Thoughtful consideration.

contemplative (kən-tĕm′plə-tĭv) *adv.* Thoughtful; pensive.

contempt (kən-tĕmpt′) *n.* Scorn; disdain.

contemptuous (kən-tĕmp′choo-əs) *adj.* Scornful.

contend (kən-tĕnd′) *v.* To struggle with.

continuity (kŏn′tə-noo′ə-tē, kŏn′tə-nyoo′-) *n.* Uninterrupted course.

contort (kən-tôrt′) *v.* To twist into an unusual shape.

contour (kŏn′toor) *n.* The outline or form of a figure or piece of land.

contrition (kən-trĭsh′ən) *n.* A feeling of regret for wrongdoing.

ă pat/ā pay/âr care/ä father/b bib/ ch church/d deed/ĕ pet/ē be/f fife/g gag/h hat/hw which/ĭ pit/ī pie/îr pier/j judge/k kick/ l lid, needle/m mum/n no, sudden/ng thing/ŏ pot/ō toe/ô paw, for/oi noise/ou out/oo took/oo boot/p pop/r roar/s sauce/ sh ship, dish/t tight/th thin, path/*th* this, bathe/ŭ cut/ûr urge/v valve/w with/y yes/z zebra, size/zh vision/ə about, item, edible, gallop, circus/à *Fr.* ami/ œ *Fr.* feu, *Ger.* schön/ü *Fr.* tu, *Ger.* über/KH *Ger.* ich, *Scot.* loch/N *Fr.* bon.

contrive (kən-trīv′) *v.* To plan cleverly; scheme.

conventional (kən-věn′shən-əl) *adj.* Conforming to accepted standards; customary.

converge (kən-vûrj′) *v.* To come to the same point or to move to the same conclusion.

converse (kən-vûrs′) *v.* To talk.

conviction (kən-vĭk′shən) *n.* Strong belief.

convoluted (kŏn-və-lōō′tĭd) *adj.* Twisted; intricate.

convulse (kən-vŭls′) *v.* To agitate; cause to shake.

coquette (kō-kět′) *n.* A flirt. —**coquettish** *adj.*

cordial (kôr′jəl) *adj.* Friendly.

cordon (kôr′dən) *n.* A line or circle of individuals.

correlate (kôr′ə-lāt′, kŏr′-) *v.* To bring into relation.

corrugated (kôr′ə-gāt′ĭd) *adj.* Made of metal or paper that is furrowed or ridged for added strength.

counsel (koun′səl) *n.* **1.** A private thought; secret. **2.** An intention; purpose.

countenance (koun′tə-nəns) *n.* **1.** The expression on a person's face. **2.** The face. —*v.* To tolerate.

counteract (koun′tər-ăkt′) *v.* To act against; offset.

covert (kŭv′ərt, kō′vərt) *n.* A covered place. —*adj.* hidden; secret.

covet (kŭv′ĭt) *v.* To have a strong desire for something, especially something belonging to another.

covey (kŭv′ē) *n.* A small flock of birds.

cow (kou) *v.* To subdue by instilling fear.

cower (kou′ər) *v.* To shrink away or fall down in fear.

cowl (koul) *n.* Hood.

cranny (krăn′ē) *n.* A small, narrow opening in a rock or wall.

credulity (krĭ-dōō′lə-tē, -dyōō′lə-tē) *n.* A tendency to believe something too quickly and without sufficient evidence.

crest (krĕst) *n.* **1.** The peak or highest point of something. **2.** A bunch of feathers or growth on the head of some birds. —*v.* To reach the highest level.

crevice (krĕv′ĭs) *n.* **1.** A narrow crack. **2.** A deep opening in the earth's surface.

cryptic (krĭp′tĭk) *adj.* Mysterious; obscure.

cumbersome (kŭm′bər-səm) *adj.* Clumsy; burdensome; troublesome. —also **cumbrous.**

cunning (kŭn′ĭng) *adj.* Clever; skillful.

curate (kyōōr′ĭt) *n.* A clergyman who is in charge of a parish or who assists a clergyman of higher rank.

cursory (kûr′sə-rē) *adj.* Hasty; not thorough.

curt (kûrt) *adj.* Rude; blunt. —**curtly** *adv.*

D

dank (dăngk) *adj.* Unpleasantly damp and chilly.

daub (dôb) *v.* To apply paint or coloring crudely.

daunt (dônt, dänt) *v.* To make afraid.

dauntless (dônt′lĭs, dänt′-) *adj.* Fearless; bold.

decorous (děk′ər-əs, dĭ-kôr′əs, -kōr′-) *adj.* Polite; mannerly. —**decorously** *adv.*

decorum (dĭ-kôr′əm, -kōr′-) *n.* Conformity to standards of good taste in behavior, dress, etc.

decree (dĭ-krē′) *n.* An official order.

decrepitude (dĭ-krĕp′ĭ-tōōd′, -tyōōd′) *n.* Weakness.

deface (dĭ-fās′) *v.* To mar; spoil.

default (dĭ-fôlt′) *n.* Failure.

deference (děf′ər-əns) *n.* **1.** Submission to the wishes of another. **2.** Respect; courtesy.

defile (dĭ-fīl′) *v.* To make unclean or impure; soil.

deflect (dĭ-flĕkt′) *v.* To turn aside.

deft (děft) *adj.* Skillful in a quick and sure way. —**deftly** *adv.* —**deftness** *n.*

degenerate (dĭ-jěn′ə-rāt′) *v.* To decline or be reduced to a lower state.

deign (dān) *v.* To think it proper to one's dignity to behave in a certain way.

deluge (děl′yōōj) *n.* A flood. *v.* To flood.

delusion (dĭ-lōō′zhən, dĭ-lyōō′-) *n.* A false belief.

dementia (dĭ-měn′shə, -shē-ə) *n.* Insanity.

demolition (děm′ə-lĭsh′ən) *n.* The act of wrecking or destroying.

demoralize (dĭ-môr′əl-īz′, dĭ-mŏr′-) *v.* To corrupt.

demure (dĭ-myōōr′) *adj.* Modest; reserved.

denizen (děn′ə-zən) *n.* A resident; inhabitant.

denotation (dē′nō-tā′shən) *n.* Explicit meaning.

depend (dĭ-pěnd′) *v.* To hang down from.

deplorable (dĭ-plôr′ə-bəl, dĭ-plōr′-) *adj.* Worthy of condemnation. —**deplorably** *adv.*

deploy (dĭ-ploi′) *v.* To spread out troops.

depraved (dĭ-prāvd′) *adj.* Corrupt; wicked.

depravity (dĭ-prăv′ə-tē) *n.* The state of being morally evil.

deprivation (děp′rə-vā′shən) *n.* The condition of being denied the means of comfort or enjoyment.

derision (dĭ-rĭzh′ən) *n.* ridicule; contempt.

derisive (dĭ-rī′sĭv) *adj.* Contemptuous; mocking. —**derisively** *adv.*

destitute (děs′tĭ-tōōt′, -tyōōt′) *adj.* Impoverished.

deter (dĭ-tûr′) *v.* To prevent someone from acting through fear or doubt.

device (dĭ-vīs′) *n.* A decorative figure or design.

dewlap (dōō′lăp′, dyōō′-) *n.* Loose skin hanging from the neck. —**dewlapped** *adj.*

diaphanous (dī-ăf′ə-nəs) *adj.* So fine that light can shine through; airy.

diffident (dĭf′ə-dənt, -dĕnt′) *adj.* Without confidence; shy. —**diffidently** *adv.*

dilatory (dĭl′ə-tôr′ē, -tōr′ē) *adj.* Slow; delaying.

dilute (dī-lōōt′, dĭ-) *v.* To thin or weaken.

diminutive (dĭ-mĭn′yə-tĭv) *adj.* Very small; tiny.

dirge (dûrj) *n.* A funeral hymn.

disapprobation (dĭs-ăp′rə-bā′shən) *n.* Disapproval.

disarm (dĭs-ärm′) *v.* To make friendly; overcome hostility.

disconcert (dĭs′kən-sûrt′) *n. Archaic.* Discord; confusion.

disconsolate (dĭs′kŏn′sə-lĭt) *adj.* Hopelessly unhappy.

discourse (dĭs′kôrs′, -kōrs′) *v.* To carry on a conversation about something.

discredit (dĭs-krĕd′ĭt) *v.* To disgrace; dishonor.

discreditable (dĭs-krĕd′ĭ-tə-bəl) *adj.* Disgraceful; damaging.

discreet (dĭs-krēt′) *adj.* **1.** Careful. **2.** Quiet; modest. —**discreetly** *adv.*

discretion (dĭs-krĕsh′ən) *n.* Caution.

disembark (dĭs′ĭm-bärk′) *v.* To go ashore.

disjoin (dĭs-join′) *v.* To separate.

dismantle (dĭs-mănt′l) *v.* To take apart.

dismember (dĭs-mĕm′bər) *v.* To remove the limbs from a body; to cut or tear to pieces.

disparage (dĭs-păr′ĭj) *v.* To belittle. —**disparagement** *n.*

dispassionate (dĭs-păsh′ən-ĭt) *adj.* Impartial; unemotional.

dispatch (dĭs-păch′) *v.* To send off or out quickly.

disperse (dĭs-pûrs′) *v.* **1.** To scatter in various directions. **2.** To cause to disappear.

dissemble (dĭ-sĕm′bəl) *v.* To disguise one's true feelings or motives.

dissipate (dĭs′ə-pāt′) *v.* To cause to disappear.

dissolution (dĭs′ə-lōō′shən) *n.* **1.** Disintegration. **2.** Death.

dissuade (dĭ-swād′) *v.* To stop someone from doing something through persuasion.

distend (dĭs-tĕnd′) *v.* To become swollen.

distillate (dĭs′tə-lāt′, dĭs-tĭl′ĭt) *n.* The concentrated, purified liquid left after the refining process; essence.

diversion (dĭ-vûr′zhən, -shən, dī-) *n.* Something that causes one's attention to be turned away.

divert (dĭ-vûrt′, dī-) *v.* **1.** To cause to turn aside. **2.** To entertain.

divine (dĭ-vīn′) *v.* To guess.

docile (dŏs′əl) *adj.* Tame; easily handled.

doctrine (dŏk′trĭn) *n.* A belief; principle.

dodder (dŏd′ər) *v.* To shake; tremble.

dogged (dô′gĭd, dŏg′ĭd) *adj.* Persistent; stubborn. —**doggedly** *adv.*

dogmatic (dôg-măt′ĭk) *adj.* Authoritative.

domesticate (də-mĕs′tĭ-kat′) *v.* To make something strange or foreign familiar.

dominion (də-mĭn′yən) *n.* **1.** Power; supreme authority. **2.** Territory ruled; realm.

dote (dōt) *v.* To be extremely fond of something (used with **on**).

doughty (dou′tē) *adj.* Brave.

dour (dōōr, dour) *adj.* Ill-tempered.

dowager (dou′ə-jər) *n.* A well-to-do, elderly woman, especially a widow.

down (doun) *n.* Soft feathers used to stuff pillows.

dowry (dour′ē) *n.* Money or property brought by a woman to her husband at marriage.

drawn (drôn) *adj.* Haggard.

droll (drōl) *adj.* Humorous in a whimsical way.

drub (drŭb) *v.* To beat.

dubious (dōō′bē-əs, dyōō′-) *adj.* Doubtful. —**dubiously** *adv.*

ducal (dōō′kəl) *adj.* Belonging to a duke or dukedom.

dullard (dŭl′ərd) *n.* A stupid person.

duly (dōō′lē) *adv.* In a fitting manner; rightfully.

E

ebb (ĕb) *n.* A gradual decrease in intensity or strength.

eccentric (ĕk-sĕn′trĭk, ĭk-) *n.* An odd or unusual person. —*adj.* Strange; straying from the usual. —**eccentrically** *adv.*

ecstasy (ĕk′stə-sē) *n.* Great joy.

eddy (ĕd′ē) *v.* To move in a whirling motion against the current.

edict (ē′dĭkt′) *n.* An official order or decision.

edifice (ĕd′ə-fĭs) *n.* A large building or something resembling one.

Glossary

effete (ĭ-fēt′) *adj.* Weak; unproductive.

egress (ē′grĕs) *n.* A way out; exit.

ejaculate (ĭ-jăk′yə-lāt′) *v.* To exclaim suddenly.

eject (ĭ-jĕkt′) *v.* To throw out.

elation (ĭ-lā′shən) *n.* A feeling of great joy.

elocution (ĕl′ə-kyōō′shən) *n.* The art of reading or speaking in public.

elude (ĭ-lōōd′) *v.* To avoid.

elusive (ĭ-lōō′sĭv) *adj.* Able to avoid being seen or caught.

emaciate (ĭ-mā′shē-āt′) *v.* To become abnormally thin.

emanate (ĕm′-ə-nāt′) *v.* To come forth; flow out; spring from a source.

embellishment (ĕm-bĕl′ĭsh-mənt) *n.* An ornament; decoration.

emergent (ĭ-mûr′jənt) *adj.* Coming into view.

emigrant (ĕm′ĭ-grənt) *n.* One who leaves a country to settle somewhere else.

eminent (ĕm′ə-nənt) *adj.* Outstanding. —**eminently** *adv.*

emissary (ĕm′ə-sĕr′ē) *n.* Someone sent out as a messenger or representative.

emulate (ĕm′yə-lāt′) *v.* To try to equal someone through imitation.

encompass (ĕn-kŭm′pəs) *v.* To surround.

encounter (ĕn-koun′tər, ĭn-) *v.* To come upon.

engender (ĕn-jĕn′dər) *v.* To produce.

engross (ĕn-grōs′) *v.* To occupy one's attention completely. —**engrossing** *adj.*

enigmatic (ĕn′ĭg-măt′ĭk) *adj.* Puzzling.

enkindle (ĕn-kĭnd′l) *v.* To arouse; stir up.

enmity (ĕn′mə-tē) *n.* Hostility.

enshroud (ĕn-shroud′) *v.* To wrap so as to hide from view; conceal.

ensue (ĕn-sōō′) *v.* To follow immediately.

enthrall (ĕn-thrôl′) *v.* To spellbind; fascinate.

entity (ĕn′tə-tē) *n.* Something that has a definite and separate existence; something real.

entrails (ĕn′trālz′, -trəlz) *n. pl.* The internal organs of a human or an animal.

entrance (ĕn-trăns′) *v.* To fill with delight.

entreat (ĕn-trēt′, ĭn-) *v.* To ask for earnestly; beg; plead.

enunciate (ĭ-nŭn′sē-āt) *v.* To pronounce words clearly.

equine (ē′kwīn) *adj.* Belonging to or characteristic of a horse.

escarpment (ĕ-skärp′mənt) *n.* A steep slope.

esoteric (ĕs′ə-tĕr′ĭk) *adj.* Mysterious; open to or understood by only a select few.

essence (ĕs′əns) *n.* **1.** The most basic or important element of something. **2.** An extract containing a concentrated fragrance or flavor.

estrange (ĕs-trānj′) *v.* **1.** To put at a distance; separate. **2.** To alienate or disrupt affections.

ethereal (ĭ-thîr′ē-əl) *adj.* **1.** Having to do with the upper regions of space. **2.** Light and airy.

eulogy (yōō′lə-jē) *n.* **1.** A speech delivered at a funeral in praise of the deceased person.

evanescent (ĕv′ə-nĕs′ənt) *adj.* Fleeting; short-lived.

evocative (ĭ-vŏk′ə-tĭv) *adj.* Tending to call forth memories, thoughts, and feelings.

exalted (ĕg-zôl′tĭd) *adj.* Noble; sublime.

exasperate (ĕg-zăs′pə-rāt′) *v.* To irritate or anger.

exasperation (ĕg-zăs′pə-rā′shən) *n.* Extreme annoyance.

excruciating (ĕk-skrōō′shē-ā′tĭng) *adj.* Intensely painful.

executor (ĕg-zĕk′yə-tər) *n.* Someone appointed to carry out the instructions in a will.

exhalation (ĕks′hə-lā′shən) *n.* Something given off, as air or steam.

exhilaration (ĕg-zĭl′ə-rā′shən) *n.* Stimulation; liveliness; high spirits.

exhortation (ĕg′zôr-tā′shən, ĕk′sôr-) *n.* Earnest request.

exhume (ĕg-zyōōm′, ĭg-, ĕks-hyōōm′) *v.* To uncover or dig up.

exotic (ĕg-zŏt′ĭk) *adj.* Foreign or unfamiliar.

expansive (ĕk-spăn′sĭv) *adj.* Behaving in a grand or self-important way. —**espansively** *adv.*

expedient (ĕk-spē′dē-ənt) *n.* A quick or convenient means of accomplishing a desired result.

exploit (ĕk′sploit′, ĭk-sploit′) *n.* A bold or remarkable action.

exploitation (ĕks′ploi-tā′shən) *n.* The use of another person or a thing for selfish or improper reasons.

extort (ĕk-stôrt′) *v.* To get money from someone through threats, violence, or misuse of authority.

exultant (ĕg-zŭl′tənt, ĭg-) *adj.* Joyful; triumphant.

exultation (ĕg′zŭl-tā′shən) *n.* Rejoicing, especially in triumph.

F

facilitate (fə-sĭl′ə-tāt′) *v.* To make easy.

faction (făk′shən) *n.* A group within an organization working together against the main body or other groups.

fastidious (fă-stĭd′ē-əs, fə-) *adj.* Extremely careful or precise in details.

fatuous (făch′ōō-əs) *adj.* Foolish or silly. —**fatuously** *adv.*

fawn (fôn) *v.* To get attention or favor through flattery or excessive humility, as a dog will show friendliness by licking hands.

feign (fān) *v.* To pretend.

feint (fānt) *v.* To deliver pretended blows to confuse an opponent; to pretend to attack.

fervent (fûr′vənt) *adj.* Intense in feeling. —**fervently** *adv.*

fervid (fûr′vĭd) *adj.* Intensely enthusiastic. —**fervidly** *adv.*

festoon (fĕs-tōōn′) *n.* A wreath of flowers, leaves, and ribbons. —*v.* To hang such a wreath around.

fetter (fĕt′ər) *n.* Something attached to the body to prevent freedom of movement; a chain.

fey (fā) *adj.* Appearing as if under a spell.

fidget (fĭj′ĭt) *v.* To move in a restless or nervous way.

filigree (fĭl′ə-grē′) *adj.* Delicate and lacelike.

flagstone (flăg′stōn′) *n.* A hard stone used for paving.

flail (flāl) *v.* To strike.

flange (flănj) *n.* A protruding edge.

flank (flăngk) *n.* A side part of anything.

flatulent (flăch′ōō-lənt) *adj.* Full of or resembling gas.

flaunt (flônt) *v.* To show off.

flaw (flô) *n.* A gust of wind.

fleur-de-lys (flûr′də-lē′, flōōr′-) *n.* A three-petaled flower design, used as an emblem of the kings of France.

flint (flĭnt) *n.* A small stone used to start a fire.

flotsam (flŏt′səm) *n.* Floating wreckage from a sunken ship.

flounce (flouns) *v.* To move in quick, exaggerated movements.

flounder (floun′dər) *v.* To struggle or move with great difficulty.

floweret (flou′ər-ĭt) *n.* *Poetic.* A small flower.

fluctuate (flŭk′chōō-āt′) *v.* To change continuously; rise and fall.

flute (flōōt) *n.* A vertical groove with a rounded inner surface.

forage (fôr′ĭj, fŏr′-) *n.* Food for cattle, sheep, or horses.

foray (fôr′ā′) *n.* A raid.

forbear (fôr-bâr′) *v.* To be patient or tolerant.

ford (fôrd, fōrd) *n.* A place in a river that is shallow enough to cross on foot.

foreboding (fôr-bō′dĭng, fōr-) *n.* A feeling that something harmful is going to happen.

foresight (fôr′sīt′, fōr′) *n.* Preparation for the future.

forestall (fôr-stôl′, fōr-) *v.* To prevent.

formidable (fôr′mə-də-bəl) *adj.* **1.** Causing fear. **2.** Very impressive because of strength or skill.

fraternity (frə-tûr′nə-tē) *n.* Circle or group, often referring specifically to men.

frenzy (frĕn′zē) *n.* Agitation; excitement.

freshet (frĕsh′ĭt) *n.* A stream flowing into the sea.

fretful (frĕt′fəl) *adj.* Irritable. —**fretfully** *adv.*

frivolity (frĭ-vŏl′ĭ-tē) *n.* Foolishness; triviality.

frivolous (frĭv′ə-ləs) *adj.* Not serious; playful; silly.

frond (frŏnd) *n.* A leaf or leaflike part of a plant.

frowzy (frou′zē) *adj.* Untidy; shabby.

frugal (frōō′gəl) *adj.* Thrifty. —**frugally** *adv.*

furrow (fûr′ō) *n.* **1.** A rut or groove made by a plow. **2.** A deep wrinkle, as in the skin.

furtive (fûr′tĭv) *adj.* Sly; secret. —**furtively** *adv.*

fusillade (fyōō′sə-lād′, läd′) *n.* A rapid and continuous barrage of gunfire; any rapid outburst or attack of something.

futile (fyōōt′l, fyōō′tīl′) *adj.* Useless.

G

gait (gāt) *n.* A manner of walking.

gaiter (gā′tər) *n.* Covering for the leg.

gall (gôl) *v.* To irritate; annoy.

galleon (găl′ē-ən, găl′yən) *n.* A large sailing ship of the 15th and 16th centuries.

galvanize (găl′və-nīz′) *v.* To coat with rust-resistant zinc.

gambol (găm′bəl) *v.* To skip about playfully.

gargoyle (gär′goil′) *n.* A carved, jutting-out decoration on a building, featuring a fantastic and grotesque animal or human.

garish (gâr′ĭsh) *adj.* Overly showy; gaudy.

garland (gär′lənd) *n.* A wreath of flowers.

garner (gär′nər) *v.* To gather; acquire.

garnish (gär′nĭsh) *v.* To decorate; trim.

gaudy (gô′dē) *adj.* Showy; tasteless.

gaunt (gônt) *adj.* Extremely thin.

ă pat/ā pay/âr care/ä father/b bib/ ch church/d deed/ĕ pet/ē be/f fife/g gag/h hat/hw which/ĭ pit/ī pie/îr pier/j judge/k kick/ l lid, needle/m mum/n no, sudden/ng thing/ŏ pot/ō toe/ô paw, for/oi noise/ou out/ōō took/ōō boot/p pop/r roar/s sauce/ sh ship, dish/t tight/th thin, path/*th* this, bathe/ŭ cut/ûr urge/v valve/w with/y yes/z zebra, size/zh vision/ə about, item, edible, gallop, circus/à *Fr.* ami/ œ *Fr.* feu, *Ger.* schön/ü *Fr.* tu, *Ger.* über/ᴋʜ *Ger.* ich, *Scot.* loch/ɴ *Fr.* bon.

Glossary

gauntlet (gônt′lĭt, gänt′-) *n.* **1.** A long protective glove. **2.** An ordeal once used as a means of punishment, in which the guilty person had to run between two rows of men who struck him with clubs or other weapons. **3.** A severe trial; an ordeal.

gelatin (jĕl′ə-tən) *n.* A thin, transparent, soluble material used in the preparation of food, medicine capsules, etc.

geniality (jē′nē-ăl′ə-tē) *n.* Friendliness.

gentry (jĕn′trē) *n.* A class of landowners below the nobility.

germane (jər-mān′) *adj.* Naturally related to the subject at hand.

ghoulish (gōōl′ĭsh) *adj.* Devilish.

gibe (jīb) *v.* To make sarcastic remarks.

glean (glēn) *v.* To gather grain from a field that has been reaped.

glen (glĕn) *n.* A valley.

glint (glĭnt) *v.* To sparkle.

gloaming (glō′mĭng) *n.* Twilight.

globular (glŏb′yə-lər) *adj.* Globe-shaped; round.

goad (gōd) *n.* A pointed stick used to drive cattle. —*v.* To urge into action.

gorge (gôrj) *v.* **1.** To fill oneself. **2.** To eat greedily.

gourd (gôrd, gōrd, gōōrd) *n.* The dried, hollow shell of a kind of plant (like a pumpkin), used as a container.

gout (gout) *n.* **1.** A disease that affects the joints. **2.** A spurt or splash.

gramophone (grăm′ə-fōn′) *n.* A phonograph.

granary (grăn′ə-rē, grā′nə-) *n.* A storage place for grain that is ready to be used.

graphic (grăf′ĭk) *adj.* Vivid and detailed. —**graphically** *adv.*

grapple (grăp′əl) *v.* To wrestle; struggle hand to hand.

grave (grāv) *adj.* Serious; solemn. —**gravely** *adv.*

grimace (grĭ-mās′, grĭm′ĭs) *n.* A facial expression of disgust or pain.

gringo (grĭng′gō) *n.* In Latin America, a term for a foreigner, especially an English or American person.

grope (grōp) *v.* To feel one's way.

grotesque (grō-tĕsk′) *adj.* Distorted; fantastic or strange. —**grotesquely** *adv.*

guileless (gīl′lĭs) *adj.* Simple; naive.

guttural (gŭt′ər-əl) *adj.* Coming from the throat.

H

habiliments (hə-bĭl′ə-mənts) *n. pl.* Clothing and accessories suitable to a particular occasion.

haggard (hăg′ərd) *adj.* Worn or exhausted-looking.

haggle (hăg′əl) *v.* To argue about the price or terms of a deal.

halcyon (hăl′sē-ən) *adj.* Calm, peaceful.

half-bred (hăf brĕd) *n.* An animal having one parent of good stock and one of unknown or inferior stock.

haply (hăp′lē) *adv. Archaic.* Perhaps.

harbinger (här′bən-jər) *n.* Forerunner.

harry (hăr′ē) *v.* To torment, worry.

haul (hôl) *v.* To change course.

hawk (hôk) *n.* **1.** Any of a large group of birds of prey. **2.** A small board used to hold plaster.

hearken (här′kən) *v.* To listen carefully.

hectic (hĕk′tĭk) *adj.* Flushed; feverish.

helpmeet (hĕlp′mēt′) *n.* Helpmate; spouse.

heraldry (hĕr′əl-drē) *n.* Coats of arms or other family insignia. —**heraldic** (hə-răl′dĭk) *adj.*

herbage (ûr′bĭj, hûr′-) *n.* Green plant growth, especially grass.

hermitage (hûr′mə-tĭj) *n.* A place to live that is far away from other people.

hew (hyōō) *v.* To chop or cut.

hilarity (hĭ-lăr′ə-tē, hī-) *n.* Extreme merriment or laughter.

hinterland (hĭn′tər-lănd′) *n.* A remote, outlying region.

hoary (hôr′ē, hōr′ē) *adj.* White with age; ancient.

holocaust (hŏl′ə-kôst′, hō′lə-) *n.* A large and destructive fire.

homage (hŏm′ĭj, ŏm′-) *n.* Honor and loyalty.

horde (hôrd, hōrd) *n.* A swarm.

hostelry (hŏs′təl-rē) *n.* An inn.

hove (hōv) *v.* Headed into the wind, like a ship.

hovel (hŭv′əl, hŏv′-) *n.* A small, poor dwelling.

hover (hŭv′ər, hŏv′-) *v.* To move around while staying over a particular place.

humane (hyōō-mān′) *adj.* Merciful; kind.

hummock (hŭm′ək) *n.* A small hill.

I

ignominy (ĭg′nə-mĭn′ē) *n.* Dishonor; shame.

illimitable (ĭ-lĭm′ĭ-tə-bəl) *adj.* Unlimited; boundless.

illusive (ĭ-lōō′sĭv) *adj.* Deceptive; based on an illusion.

illusory (ĭ-lōō′sə-rē, -zə-rē) *adj.* Unreal.

imbibe (ĭm-bīb′) *v.* To absorb (into the mind).

immerse (ĭ-mûrs′) *v.* To involve completely.

imminent (ĭm′ə-nənt) *adj.* About to happen. —**imminence** *n.*

immolate (ĭm′ə-lāt′) *v.* To kill, as if for a sacrifice.

impale (ĭm-pāl′) *v.* To pierce through and fix on something pointed.

impalpable (ĭm-păl′pə-bəl) *adj.* Unable to be felt.

impart (ĭm-pärt′) *v.* To tell; reveal.

impassive (ĭm-păs′ĭv) *adj.* Showing no emotion. —**impassively** *adv.*

impede (ĭm-pēd′) *v.* To block; hinder.

impediment (ĭm-pĕd′ə-mənt) *n.* Obstacle.

imperative (ĭm-pĕr′ə-tĭv) *adj.* Commanding; urgent. —*n.* A compelling force.

imperceptible (ĭm′pər sĕp′tə-bəl) *adj.* Not or barely noticeable. —**imperceptibly** *adv.*

imperial (ĭm-pîr′ē-əl) *adj.* Of great size and outstanding quality; majestic.

impetuous (ĭm-pĕch′oo-əs) *adj.* Acting suddenly without thinking; reckless. —**impetuosity** (ĭm-pĕch′oo-ŏs′ə-tē) *n.*

implicit (ĭm-plĭs′ĭt) *adj.* Characteristic of but not directly expressed; suggested.

implore (ĭm-plôr′, -plōr′) *v.* To beg.

imposture (ĭm-pŏs′chər) *n.* Deception, trickery.

impotent (ĭm′pə-tənt) *adj.* Weak; powerless.

impoverish (ĭm-pŏv′ər ĭsh) *v.* To make poor.

imprecation (ĭm′prə-kā′shən) *n.* A curse.

impregnable (ĭm-prĕg′nə-bəl) *adj.* Incapable of being captured or entered; unyielding.

improvise (ĭm′prə-vīz′) *v.* To create or invent from materials at hand, without preparation beforehand.

impudent (ĭm′pyə-dənt) *adj.* Boldly disrespectful.

impute (ĭm-pyoot′) *v.* To attribute.

inanimate (ĭn-ăn′ə-mĭt) *adj.* Not containing or showing life.

inarticulate (ĭn-är-tĭk′yə-lĭt) *adj.* **1.** Uttered without the distinct sounds of speech. **2.** Speechless.

inaudible (ĭn-ô′də-bəl) *adj.* Unable to be heard. —**inaudibly** *adv.*

inauspicious (ĭn′ô-spĭsh′əs) *adj.* Boding ill; unlucky.

incandescent (ĭn-kən-dĕs′ənt) *adj.* Very bright; brilliant. —**incandescence** *n.*

incapacitate (ĭn′kə-păs′ə-tāt′) *v.* To take away strength or ability from.

incendiary (ĭn-sĕn′dē-ĕr′ē) *adj.* Capable of causing a fire.

incessant (ĭn-sĕs′ənt) *adj.* Unceasing; continuous. —**incessantly** *adv.*

incite (ĭn-sīt′) *v.* To urge on to action.

incompetent (ĭn-kŏm′pə-tənt) *adj.* Not capable.

incomprehensible (ĭn′kŏm-prĭ-hĕn′sə-bəl) *adj.* Not understandable.

incongruous (ĭn-kong′groo-əs) *adj.* Lacking in suitability, harmony, or logic. —**incongruity** (ĭn′kong-groo′ə-tē, ĭn′kən-) *n.*

incorporate (ĭn-kôr′pə-rāt′) *v.* To combine; bring together into a single unit.

incredulous (ĭn-krĕj′ə-ləs) *adj.* Unable to believe.

indifference (ĭn-dĭf′ər-əns, -dĭf′rəns) *n.* Lack of concern or interest.

indigent (ĭn′də-jənt) *adj.* Very poor.

indignant (ĭn-dĭg′nənt) *adj.* Angry at something that is unfair or unjust.

indigo (ĭn′dĭ-gō′) *n.* A deep purplish-blue.

indiscreet (ĭn′dĭs-krēt′) *adj.* Showing poor judgment.

indiscriminate (ĭn′dĭs-krĭm′ə-nĭt) *adj.* Haphazard; random. —**indiscriminately** *adv.*

indolent (ĭn′də-lənt) *adj.* Lazy. —**indolence** *n.*

indomitable (ĭn dŏm′ə-tə-bəl) *adj.* Unconquerable.

inducement (ĭn-doos′mənt, ĭn-dyoos′-) *n.* Incentive.

indulge (ĭn-dŭlj′) *v.* To give in to an urge or whim.

indulgence (ĭn-dŭl′jəns) *n.* Leniency; tolerance.

indulgent (ĭn-dŭl′jənt) *adj.* Lenient; kind.

ineffable (ĭn-ĕf′ə-bəl) *adj.* Indescribable.

inert (ĭn-ûrt′) *adj.* Not moving or unable to move.

inevitable (ĭn-ĕv′ə-tə-bəl) *adj.* Unavoidable. —**inevitably** *adv.*

infallible (ĭn-făl′ə-bəl) *adj.* Incapable of error; certain. —**infallibly** *adv.*

infirmity (ĭn-fûr′mə-tē) *n.* Bodily weakness.

infuse (ĭn-fyooz′) *v.* To fill, as if by pouring.

ingenious (ĭn-jēn′yəs) *adj.* Clever; inventive. —**ingeniously** *adv.*

inherent (ĭn-hîr′ənt) *adj.* Built-in; essential.

ingress (ĭn′grĕs) *n.* A way in; entrance.

inscrutable (ĭn-skroo′tə-bəl) *adj.* Mysterious.

insensible (ĭn-sĕn′sə-bəl) *adj.* Unconscious. —**insensibility** *n.*

insolent (ĭn′sə-lənt) *adj.* Shamelessly disrespectful. —**insolence** *n.*

instigate (ĭn′stĭ-gāt′) *v.* To urge on to action. —**instigation** (ĭn′stĭ-gā′shən) *n.*

ă pat/ā pay/âr care/ä father/b bib/ ch church/d deed/ĕ pet/ē be/f fife/g gag/h hat/hw which/ĭ pit/ī pie/îr pier/j judge/k kick/ l lid, needle/m mum/n no, sudden/ng thing/ŏ pot/ō toe/ô paw, for/oi noise/ou out/oo took/oo boot/p pop/r roar/s sauce/ sh ship, dish/t tight/th thin, path/th this, bathe/ŭ cut/ûr urge/v valve/w with/y yes/z zebra, size/zh vision/ə about, item, edible, gallop, circus/à Fr. ami/ œ Fr. feu, Ger. schön/ü Fr. tu, Ger. über/KH Ger. ich, Scot. loch/N Fr. bon.

insupportable (ĭn′sə-pôr′tə-bəl, -pōr′-) *adj.* Intolerable; unbearable.

integrity (ĭn-tĕg′rə-tē) *n.* The quality of being complete or sound, especially morally.

intercession (ĭn′tər-sĕsh′ən) *n.* Prayer or pleading on behalf of another.

interim (ĭn′tər-ĭm) *n.* The time between one event and another.

interminable (ĭn-tûr′mə-nə-bəl) *adj.* Seeming to be endless.

interpose (ĭn′tər-pōz′) *v.* To introduce an interruption of speech or motion.

interrogate (ĭn-tĕr′ə-gāt′) *v.* To question.

intimidate (ĭn′tĭm′ĭ-dāt′) *v.* To frighten.

intolerable (ĭn-tŏl′ər-ə-bəl) *adj.* Unbearable. —**intolerably** *adv.*

intone (ĭn-tōn′) *v.* To speak or recite.

intricate (ĭn′trĭ-kĭt) *adj.* Having many parts or details; complicated.

intriguing (ĭn′trēg′ĭng) *adj.* Fascinating; exciting curiosity.

intuitive (ĭn-tōō′ə-tĭv, ĭn-tyōō′-) *adj.* Understood or known without conscious reasoning.

inundate (ĭn′ŭn-dāt′) *v.* To flood. —**inundation** (ĭn′ŭn-dā′shən) *n.*

invective (ĭn-vĕk′tĭv) *n.* Strong verbal abuse characterized by curses and insults.

invest (ĭn-vĕst′) *v.* To provide or endow with some particular quality.

invigorate (ĭn-vĭg′ə-rāt′) *v.* To fill with strength and energy.

irascible (ĭ-răs′ə-bəl, ī-răs′-) *adj.* Easily angered.

irate (ī′rāt, ī-rāt′) *adj.* Very angry.

iridescent (îr′ə-dĕs′ənt) *adj.* Rainbowlike.

irrelevant (ĭ-rĕl′ə-vənt) *adj.* Without application.

irresolute (ĭ-rĕz′ə-lōōt′) *adj.* Unable to make a decision. —**irresolution** (ĭ-rĕz′ə-lōō′shən) *n.*

irrevocable (ĭ-rĕv′ə-kə-bəl) *adj.* Incapable of being undone or brought back. —**irrevocably** *adv.*

J

jagged (jăg′ĭd) *adj.* Rough-edged; ragged.

jar (jär) *v.* To shock; irritate.

jest (jĕst) *n.* Something said or done to amuse; a joke.

jettison (jĕt′ ĭ-sən, -zən) *v.* To cast off or discard.

jostle (jŏs′əl) *v.* To bump and shove.

jounce (jouns) *v.* To bounce or shake; jolt.

joust (joust, jŭst, jōōst) *n.* A fight with lances between two people on horseback.

jubilant (jōō′bə-lənt) *adj.* Elated; exultant.

judicious (jōō-dĭsh′əs) *adj.* Showing good judgment; wise. —**judiciously** *adv.*

juncture (jŭng′chər) *n.* A point in time, especially a decisive moment.

juxtapose (jŭk′stə-pōz′) *v.* To place side by side.

K

kelp (kĕlp) *n.* Brown seaweed.

kindle (kĭnd′l) *v.* To inflame; excite.

kindred (kĭn′drĭd) *adj.* Similar; related.

knave (nāv) *n.* **1.** *Archaic.* A male servant; a man of humble status. **2.** A dishonest, deceitful person.

knead (nēd) *v.* To rub or press with the hands.

knoll (nōl) *n.* A small hill.

L

labyrinth (lăb′ə-rĭnth′) *n.* A maze; a complicated, interconnecting series of passages.

lacerate (lăs′ə-rāt′) *v.* To cut or tear jaggedly.

laconic (lə-kŏn′ĭk) *adj.* Using few words.

lament (lə-mĕnt′) *v.* To grieve; mourn. —*n.* An expression of grief. —also **lamentation** (lăm′ən-tā′shən) *n.*

languid (lăng′gwĭd) *adj.* Without spirit; listless.

languish (lăng′gwĭsh) *v.* To become weak or slow.

languor (lăng′gər) *n.* An air of softness or gentleness. —**languorous** *adj.*

lap (lăp) *v.* To make a light, splashing sound.

latent (lāt′nt) *adj.* Present but inactive.

laurel (lô′rəl) *n.* A plant with large leaves that are woven into a wreath to crown the victor in a contest. —*v.* To crown a victor with such a wreath.

leer (lîr) *v.* To look from the side with an expression of spite or ill will.

leeward (lē′wərd, lōō′ərd) *adj.* In the direction toward which the wind blows.

legacy (lĕg′ə-sē) *n.* Anything inherited through a will.

legend (lĕj′ənd) *n.* **1.** A story handed down from generation to generation, believed to have a historical basis. **2.** An inscription on a coin, etc. **3.** A caption or key for an illustration or a map.

legion (lē′jən) *n.* In ancient Rome, a major division of an army.

leprous (lĕp′rəs) *adj.* Diseased; resembling leprosy, a disease marked by skin lesions, sores, and decay.

lethargy (lĕth′ər-jē) *n.* A condition of extreme sluggishness.

lewd (lōōd) *adj.* **1.** *Obsolete.* Ignorant; uncouth. **2.** Wicked; lustful.

license (lī'səns) *n.* Excessive, undisciplined freedom.

liege (lēj) *n.* A lord in medieval times.

limber (lĭm'bər) *adj.* Able to move easily.

linguist (lĭng-gwĭst) *n.* **1.** A person who speaks many languages. **2.** A language specialist.

lintel (lĭnt'l) *n.* The horizontal beam over a door or window.

listless (lĭst'lĭs) *adj.* Not showing interest or enthusiasm. —**listlessly** *adv.*

lithe (līth) *adj.* Easily graceful; limber.

loath (lōth, lōth) *adj.* Unwilling.

loiter (loi'tər) *v.* To linger or walk about aimlessly.

loll (lŏl) *v.* To hang or droop.

lope (lōp) *n.* A steady, easy stride.

lore (lôr, lōr) *n.* The accumulated information on a particular subject.

lout (lout) *n.* A stupid, awkward person.

lubber (lŭb'ər) *n.* A slow, clumsy person. —**lubberly** *adj.*

lucent (loō'sənt) *adj.* Bright. —**lucency** *n.*

lucid (loō'sĭd) *adj.* Clear.

ludicrous (loō'dĭ-krəs) *adj.* Absurd; ridiculous. —**ludicrously** *adv.*

lumber (lŭm'bər) *v.* To move clumsily.

luminous (loō'mə-nəs) *adj.* **1.** Giving off light. **2.** Clear.

lurch (lûrch) *v.* To pitch forward suddenly.

lurid (loōr'ĭd) *adj.* **1.** Glowing. **2.** Vivid, in a shocking way.

lush (lŭsh) *adj.* Characterized by rich, abundant growth.

lustrous (lŭs'trəs) *adj.* Bright.

lusty (lŭs'te) *adj.* Full of intense enthusiasm. —**lustily** *adv.*

M

mace (mās) *n.* An aromatic spice made from the outer covering of the nutmeg.

machete (mə-shĕt'ē, -chĕt'ē) *n.* A large knife with a broad blade.

mail (māl) *n.* A flexible protective body covering, made of overlapping metal rings.

maim (mām) *v.* To cripple.

maize (māz) *n.* Corn.

malaise (măl-āz') *n.* A feeling of physical or mental discomfort.

malevolent (mə-lĕv'ə-lənt) *adj.* Showing ill will; wishing harm to others. —**malevolence** *n.*

malice (măl'ĭs) *n.* Ill will; spite.

malign (mə-līn') *v.* To speak evil of. —*adj.* Harmful.

malignant (mə-lĭg'nənt) *adj.* Very harmful; likely to cause death.

mandible (măn'də-bəl) *n.* The jaw.

manifest (măn'ə-fĕst) *adj.* Obvious. —**manifestly** *adv.*

mantle (măn'təl) *n.* A sleeveless cloak or cape.

marshal (mär'shəl) *v.* To arrange in order.

martial (mär'shəl) *adj.* Pertaining to war or the military.

mastodon (măs'tə-dŏn') *n.* An extinct mammal resembling the elephant.

materialize (mə-tîr'ē-ə-līz') *v.* To take form.

matriarch (mā'trē-ärk') *n.* A woman who is the head of a family or tribe.

mattock (măt'ək) *n.* A digging tool similar to a pickax.

maul (môl) *n.* A heavy hammer with a long handle.

melodramatic (mĕl'ə-drə'-măt'ĭk) *adj.* Overly emotional or sentimental.

memento (mə-mĕn'tō) *n.* A souvenir.

mentor (mĕn'tôr', -tər) *n.* Teacher or counselor.

methodize (mĕth'ə-dīz') *v.* To systematize.

meticulous (mə-tĭk'yə-ləs) *adj.* Extremely precise concerning details; fussy.

mettle (mĕt'l) *n.* An extremely fine character, especially in regard to courage.

milch (mĭlch) *adj.* Giving milk (describing a cow).

milliner (mĭl'ə-nər) *n.* A person who makes or sells women's hats.

minute (mī-noōt') *adj.* Tiny.

missive (mĭs'ĭv) *n.* Something that is sent; letter.

mollify (mŏl'ə-fī') *v.* To soothe.

moniker (mŏn'ĭ-kər) *n. Slang.* A person's name or nickname.

monocle (mŏn'ə-kəl) *n.* An eyeglass for one eye.

monologue (mŏn'ə-lôg', -lŏg') *n.* A long speech by one person.

monosyllable (mŏn'ə-sĭl'ə-bəl) *n.* A word with one syllable.

morbid (môr'bĭd) *adj.* Concerned with gloomy or gruesome matters.

mordant (môr'dənt) *adj.* Biting; cutting.

morose (mə-rōs′, mô-) *adj.* Gloomy or ill-humored. —**morosely** *adv.*

mortal (môrt′l) *adj.* **1.** Human; not able to live forever. **2.** To the point of death; extreme. —**mortally** *adv.*

mortality (môr-tăl′ə-tē) *n.* The condition of being subject to death.

mortify (môr′tə-fī′) *v.* **1.** *Obsolete.* To deprive of life or strength. **2.** To humiliate; embarrass.

motif (mō′tēf′) *n.* The main idea or most distinctive quality of a work of art.

myriad (mîr′ē-əd) *n.* A vast number. —*adj.* Countless.

myrrh (mûr) *n.* A fragrant plant fluid used in making incense or perfume.

mystic (mĭs′tĭk) *adj.* Mysterious; beyond human understanding. —also **mystical.**

mysticism (mĭs′tə-sĭz′əm) *n.* The belief that certain basic truths can be known or understood by intuition alone, without the use of reason.

N

naive (nä-ēv′) *adj.* Childlike; not worldly-wise.

nape (nāp) *n.* The back of the neck.

nocturnal (nŏk-tûr′nəl) *adj.* Occurring at night.

nomadic (nō-măd′ĭk) *adj.* Wandering.

nonchalant (nŏn′shə-länt′) *adj.* Cool; casual.

nondescript (nŏn′dĭ-skrĭpt′) *adj.* Not having any distinguishing qualities or characteristics.

nonrepresentational (nŏn′rĕp-rĭ-zĕn-tā′shən-əl) *adj.* Not depicted as occurring in nature.

nostalgia (nŏ′stăl′jə, nə-) *n.* A longing to return to the past.

not by a long chalk (chôk) *Brit.* Not by any means.

notorious (nō-tôr′ē-əs, -tōr′ē-əs) *adj.* Known unfavorably.

novelty (nŏv′əl-tē) *n.* Something new or recently invented.

novice (nŏv′ĭs) *n.* Beginner.

nubbin (nŭb′ĭn) *n.* Anything small and not yet developed.

nullity (nŭl′ə-tē) *n.* Nonentity; something that doesn't exist.

O

oblique (ō-blēk′, ə-) *adj.* Not straightforward; unclear in meaning.

obsolete (ŏb′sə-lēt′, ŏb′sə-lēt′) *adj.* Out of fashion; no longer in use.

oddments (ŏd′mənts) *n. pl.* Various, miscellaneous items.

odious (ō′dē-əs) *adj.* Hateful; disgusting.

omen (ō′mən) *n.* Something that foretells the future.

ominous (ŏm′ə-nəs) *adj.* Threatening. —**ominously** *adv.*

opaque (ō-pāk′) *adj.* Not reflecting light; not transparent.

oppressive (ə-prĕs′ĭv) *adj.* Difficult to bear.

optical (ŏp′tĭ-kəl) *adj.* Having to do with the sense of sight. —**optically** *adv.*

opulent (ŏp′yə-lənt) *adj.* Lavish; rich.

oracle (ôr′ə-kəl, ŏr′-) *n.* A person believed in ancient times to be in contact with the gods.

ordain (ôr-dān′) *v.* To determine beforehand.

orient (ôr′ē-ĕnt′, ŏr′-) *v.* To get one's bearings.

orthodox (ôr′thə-dŏks) *adj.* Traditional; accepted.

ostentatious (ŏs′tĕn-tā′shəs, ŏs′tən-) *adj.* Extremely showy.

outback (out′băk′) *n.* Back country of Australia or New Zealand.

P

paling (pāl′ĭng) *n.* A piece of wood that is part of a fence.

pallid (păl′ĭd) *adj.* Extremely pale.

palmy (päm′ē) *adj.* Prosperous; flourishing.

palpable (păl′pə-bəl) *adj.* Capable of being easily grasped mentally; obvious.

panacea (păn′ə-sē′ə) *n.* A supposed remedy; a cure-all.

pandemonium (păn′də-mō′nē-əm) *n.* Wild noise and disorder.

parabolic (păr′ə-bŏl′ĭk) *adj.* Bowl-shaped.

paradox (păr′ə-dŏks′) *n.* A situation or statement that seems self-contradictory but is nevertheless true.

paramour (păr′ə-mŏŏr′) *n.* A lover.

parley (pär′lē) *n.* A discussion or conference.

passive (păs′ĭv) *adj.* Not active; making no effort.

patent (păt′ənt) *adj.* Obvious. —**patently** *adv.*

patrimony (păt′rə-mō′nē) *n.* Anything inherited from ancestors.

patronize (pā′trə-nīz′, păt′rə-) *v.* To treat others with an air of superiority. —**patronizing** *adj.* —**patronizingly** *adv.*

peal (pēl) *n.* The ringing of bells or chimes.

pedestrian (pə-dĕs′trē-ən) *adj.* Ordinary; not distinguished.

peerless (pîr′lĭs) *adj.* Without an equal; unmatched.

pelt (pĕlt) *v.* To pound steadily and heavily.

pendulum (pĕn'jŏŏ-ləm, dyə-, də-) *n.* Something that swings freely back and forth.

peon (pē'ŏn') *n.* In Latin America or the southwestern United States, a laborer or a farm worker.

perceptible (pər-sĕp'tə-bəl) *adj.* Noticeable; recognizable.

perception (pər-sĕp'shən) *n.* Understanding or insight; awareness.

periphery (pə-rĭf'ə-rē) *n.* The outside boundary of a particular area.

permeate (pûr'mē-āt') *v.* To penetrate or spread throughout.

perpetual (pər-pĕch'ŏŏ-əl) *adj.* Lasting forever.

perplex (pər-plĕks') *v.* To confuse.

perturbation (pûr'tər-bā'shən) *n.* A confusion or disturbance.

perverse (pər-vûrs') *adj.* Contrary to what is considered to be correct thinking or behavior.

pestilence (pĕs'tə-ləns) *n.* An epidemic of a contagious, deadly disease; plague.

petulant (pĕch'ŏŏ-lənt) *adj.* Irritable; impatient.

phantasm (făn'tăz'əm) *n.* Something that seems to exist but actually has no physical reality; phantom. —also **phantasma.**

phenomenon (fĭ-nŏm'ə-nŏn') *n.* Something that can be seen but is difficult to understand; an unusual occurrence.

phosphorescence (fŏs'fə-rĕs'əns) *n.* A continuous giving off of light.

phosphoric (fŏs-fôr'ĭk, -fŏr'ĭk) *adj.* Giving off light; gleaming.

piazza (pē-ăz'ə) *n.* A wide porch.

picturesque (pĭk'chə-rĕsk') *adj.* Charming; attractive. —**picturesquely** *adv.*

pinion (pĭn'yən) *v.* To restrain someone by binding the arms.

pinnacle (pĭn'ə-kəl) *n.* Summit; highest point.

pious (pī'əs) *adj.* **1.** Devout; religious. **2.** Falsely devout or hypocritical.

piquant (pē'kənt, -känt', pē-känt') *adj.* Stimulating; exciting. —**piquancy** *n.*

pique (pēk) *n.* Resentment due to injured pride. —*v.* To provoke such resentment by offending someone's pride.

pirouette (pĭr'ŏŏ-ĕt') *n.* A spinning movement on tiptoe.

pith (pĭth) *n.* The soft, spongy tissue in the center of the stems of most plants.

placate (plā'kāt', plăk'āt') *v.* To pacify.

placid (plăs'ĭd) *adj.* Calm. —**placidly** *adv.*

plaintive (plān'tĭv) *adj.* Sad.

plight (plīt) *v.* To promise or bind by solemn oath, especially to promise to marry.

plume (plŏŏm) *n.* A cluster of feathers on a helmet worn as a decoration or symbol of rank.

plunder (plŭn'dər) *v.* To rob or take by force. —**plunderer** *n.*

plunge (plŭnj) *n.* A downward leap or fall.

ply (plī) *v.* **1.** To work diligently at an occupation requiring a particular skill. **2.** To travel back and forth between places.

pneumatic (nŏŏ-măt'ĭk, nyŏŏ-) *adj.* Using air.

poignant (poin'yənt) *adj.* Emotionally touching. —**poignantly** *adv.*

poise (poiz) *v.* To balance or remain steady in a certain position. —*n.* The state of being calm and self-assured.

poll (pōl) *n.* The head, especially the top of the head, where the hair is.

pommel (pŭm'əl, pŏm'-) *n.* The rounded front part of a saddle.

pompous (pŏm'pəs) *adj.* Self-important; pretentious.

ponderous (pŏn'dər-əs) *adj.* Huge; heavy.

porous (pôr'əs, pōr'-) *adj.* **1.** Full of pores. **2.** Having tiny openings that allow liquids, gases, or odors to pass through.

portal (pôrt'l, pōrt'l) *n.* A point of entry, especially a large, imposing doorway or gate.

portent (pôr'tĕnt', pōr'-) *n.* Something that predicts an event that is about to happen, usually an unfortunate one.

portly (pôrt'lē, pōrt'-) *adj.* Large; heavy.

posterior (pŏ-stîr'ē-ər, pō-) *n.* The rear end of the body or, figuratively, a part of something in a similar position.

posterity (pŏ-stĕr'ə-tē) *n.* All of a person's descendants.

poultice (pōl'tĭs) *n.* A hot pack applied to an inflamed part of the body.

praetor (prē'tər) *n.* In ancient Rome, an elected judge ranking just below a consul.

ă pat/ā pay/âr care/ä father/b bib/ ch church/d deed/ĕ pet/ē be/f fife/g gag/h hat/hw which/ĭ pit/ī pie/îr pier/j judge/k kick/ l lid, needle/m mum/n no, sudden/ng thing/ŏ pot/ō toc/ô paw, for/oi noise/ou out/ŏŏ took/ŏŏ boot/p pop/r roar/s sauce/ sh ship, dish/t tight/th thin, path/th this, bathe/ŭ cut/ûr urge/v valve/w with/y yes/z zebra, size/zh vision/ə about, item, edible, gallop, circus/à *Fr.* ami/ œ *Fr.* feu, *Ger.* schön/ü *Fr.* tu, *Ger.* über/KH *Ger.* ich, *Scot.* loch/N *Fr.* bon.

precarious (prĭ-kâr′ē-əs) *adj.* Uncertain; risky. —**precariously** *adv.*

precede (prĭ-sēd′) *v.* To come before.

precincts (prē-sĭngkts) *n. pl.* A neighborhood or particular area.

precipitate (prĭ-sĭp′ə-tāt′) *v.* **1.** To cause to happen sooner than expected; bring on. **2.** To cause a substance to separate and fall. —**precipitately** *adv.*

precipitous (prĭ-sĭp′ə-təs) *adj.* Steep.

premise (prĕm′ĭs) *v.* To state by way of introduction.

premonition (prē′mə-nĭsh′ən, prĕm′ə-) *n.* A feeling that a particular thing will happen.

preoccupy (prē-ŏk′yə-pī′) *v.* To completely fill one's thoughts.

preposterous (prĭ-pŏs′tər-əs) *adj.* Absurd.

presentiment (prĭ-zĕn′tə-mənt) *n.* Premonition; uneasy feeling about what is to come.

preside (prĭ-zīd′) *v.* To be in charge or exercise control.

presumptuous (prĭ-zŭmp′chōō-əs) *adj.* Overconfident; arrogant.

pretext (prē′tĕkst′) *n.* A false reason; an excuse.

prevail (prĭ-vāl′) *v.* **1.** To be or remain in force. **2.** To have an effect. **3.** To have the greatest authority.

prevalent (prĕv′ə-lənt) *adj.* Generally accepted; widespread.

prime (prīm) *n.* The period of an individual's peak physical and mental condition.

prink (prĭngk) *v.* To primp; dress up in a fussy way.

priority (prī-ôr′ə-tē, -ŏr′ə-tē) *n.* Something given importance or prior attention.

privation (prī-vā′shən) *n.* A deprivation, especially of a basic need or comfort of life.

procession (prə-sĕsh′ən) *n.* A group of people moving in an orderly way, as in a parade.

procure (prō-kyŏŏr′, prə-) *v.* To acquire; get.

prodigious (prə-dĭj′əs) *adj.* Enormous.

prodigy (prŏd′ə-jē) *n.* **1.** *Archaic.* An unusual happening, thought to foretell the future. **2.** An extraordinary person or thing.

profane (prō-fān′, prə-) *v.* To treat sacred things with contempt.

proffer (prŏf′ər) *v.* To offer.

profuse (prə-fyōōs′, prō-) *adj.* Abundant.

profusion (prə-fyōō′zhən, prō-) *n.* A great deal.

progressive (prə-grĕs′ĭv) *adj.* Favoring reform.

proletariat (prō′lə-târ′ē-ĭt) *n.* The class of working people.

promontory (prŏm′ən-tôr′ē, -tōr′ē) *n.* A high ridge of land jutting out into a body of water.

prone (prōn) *adj.* Having a natural tendency (used with to).

propriety (prə-prī′ə-tē) *n.* The quality of being in accordance with what is accepted as proper in taste and behavior.

prosaic (prō-zā′ĭk) *adj.* Matter-of-fact; straightforward.

proscription (prō-skrĭp′shən) *n.* In ancient Rome, the publication of the name of someone condemned to death. Such a person was "fair game" and could be killed by anyone.

prospect (prŏs′pĕkt′) *n.* Anticipation; a looking forward to something.

prosperity (prŏ-spĕr′ĭ-tē) *n.* Good fortune; financial success.

prostrate (prŏs′trāt′) *adj.* Lying face down, especially in humility.

protestation (prŏt′ĭs-tā′shən, prō′tĭs-) *n.* A strong protest or assertion.

protrude (prō-trōōd′) *v.* To jut out.

provender (prŏv′ən-dər) *n.* Food, especially for livestock.

providence (prŏv′ə-dəns, -dĕns′) *n.* **1.** God's care or guidance. **2.** *cap.* God.

prudent (prōōd′ənt) *adj.* Careful; wise.

pugnacious (pŭg-nā′shəs) *adj.* Quarrelsome.

pulsate (pŭl′sāt′) *v.* To beat or throb.

punctilious (pŭngk-tĭl′ē-əs) *adj.* Very strict in carrying out details, especially details of proper behavior.

pungent (pŭn′jənt) *adj.* Sharp; penetrating.

purge (pûrj) *v.* To make clean by removing impurities. —**purger** *n.*

putrefactive (pyōō′trə-făk′tĭv) *adj.* Causing decay or rotting.

pyre (pīr) *n.* A pile or structure, usually of wood, on which a dead body is burned as part of a funeral.

Q

quadrilateral (kwŏd′rə-lăt′ər-əl) *n.* A four-sided figure.

quaint (kwānt) *adj.* Pleasing in an unusual or old-fashioned way.

qualm (kwäm, kwôm) *n.* A sudden feeling of physical or mental discomfort or uneasiness.

quarry (kwôr′ē, kwŏr′ē) *n.* A place where building stone is taken from the ground.

quest (kwĕst) *n.* A search for something.

quicksilver (kwĭk′sĭl′vər) *adj.* Fast-moving, like mercury.

R

rail (rāl) *v.* To complain bitterly; scold.

raiment (rā′mənt) *n.* Clothing.

rakish (rā′kĭsh) *adj.* Dashing; carefree.

rampant (răm′pənt) *adj.* Wild in behavior; unrestrained.

rampart (răm′pärt) *n.* **1.** A protective wall encircling a fortress or city. **2.** Any structure that serves as a defense.

ramshackle (răm′shăk′əl) *adj.* Rickety; in a state of deterioration.

rancor (răng′kər) *n.* Hatred.

range (rānj) *v.* To wander about.

rankle (răng′kəl) *v.* To cause resentment.

rant (rănt) *v.* To speak wildly.

rapacious (rə-pā′shəs) *adj.* Greedy.

rapport (ră-pôr′, -pōr′) *n.* A harmonious relationship.

rapt (răpt) *adj.* Completely absorbed; engrossed.

rational (răsh′ən-əl) *adj.* **1.** Able to reason. **2.** Sane. —**rationally** *adv.*

rationalism (răsh′ən-əl-ĭz′əm) *n.* The belief that reason is the only authority in determining truth. — **rationalistic** (răsh′ən-əl-ĭs′tĭk) *adj.*

rationalize (răsh′ən-əl-īz′) *v.* To think up self-satisfying but untrue reasons or excuses for one's behavior or beliefs. —**rationalization** (răsh′ən-əl-ə-zā′shən) *n.*

raze (rāz) *v.* **1.** *Rare.* To erase. **2.** To tear down completely.

rebuke (rĭ-byook′) *v.* To scold; reprimand.

recede (rĭ-sēd′) *v.* To move or fade away.

reckless (rĕk′lĭs) *adj.* Heedless of danger.

recluse (rĕk′loos′, rĭ-kloos′) *n.* A person who lives alone and shut off from other people.

recoil (rĭ-koil′) *v.* To shrink away from.

reconnoiter (rē′kə-noi′tər, rĕk′ə-) *v.* To explore an area to get to know what it is like or what is happening there.

recount (rĭ-kount′) *v.* To tell in detail; narrate.

redeem (rĭ-dēm′) *v.* To deliver from sin.

redress (rĭ-drĕs′) *v.* To set right; make amends. —(rĭ-drĕs′, rē′drĕs) *n.* Correction of or compensation for something wrong.

reel (rēl) *v.* To spin or stagger; fall back.

reflective (rĭ-flĕk′tĭv) *adj.* Thoughtful.

relapse (rĭ-lăps′) *v.* To slip back into a former state after showing improvement.

relentless (rĭ-lĕnt′lĭs) *adj.* Not letting up; persistent. —**relentlessly** *adv.*

relic (rĕl′ĭk) *n.* Something from the past valued for its historic interest or personal association.

reluctant (rĭ-lŭk′tənt) *adj.* Unwilling. —**reluctantly** *adv.*

remnant (rĕm′nənt) *n.* Something left over, especially something indicating what has been; a remaining trace.

remorse (rĭ-môrs′) *n.* A feeling of guilt or regret for having done something wrong. —**remorseful** *adj.* —**remorsefully** *adv.*

rend (rĕnd) *v.* To pull at or rip forcefully.

render (rĕn′dər) *v.* **1.** To make a formal, public declaration. **2.** To deliver a personal expression or interpretation of something already written or said.

rent (rĕnt) *n.* A hole or opening made by ripping or tearing.

repeal (rĭ-pēl′) *v. Obsolete.* To recall from exile. —*n. Obsolete.* The act of recalling from exile.

repel (rĭ-pĕl′) *v.* To cause someone to turn away; disgust.

repent (rĭ-pĕnt′) *v.* To feel sorry and eager to make amends for something one has done.

repercussion (rē′pər-kŭsh′ən) *n.* Recoil; act of springing back.

repose (rĭ-pōz′) *v.* To lie quietly. —*n.* Sleep or rest; relaxation.

reprieve (rĭ-prēv′) *n.* The postponement of punishment or trouble; temporary relief.

reproach (rĭ-prōch′) *v.* To blame; criticize.

reprove (rĭ-proov′) *v.* To scold.

residue (rĕz′ə-doo′, -dyoo′) *n.* Something remaining after the major part has beeen removed.

resolute (rĕz′ə-loot′) *adj.* Determined.

resolve (rĭ-zŏlv′) *v.* To make a decision.

resonant (rĕz′ə-nənt) *adj.* Deep and rich in sound.

ă pat/ā pay/âr care/ä father/b bib/ ch church/d deed/ĕ pet/ē be/f fife/g gag/h hat/hw which/ĭ pit/ī pie/îr pier/j judge/k kick/ l lid, needle/m mum/n no, sudden/ng thing/ŏ pot/ō toe/ô paw, for/oi noise/ou out/oo took/oo boot/p pop/r roar/s sauce/ sh ship, dish/t tight/th thin, path/th this, bathe/ŭ cut/ûr urge/v valve/w with/y yes/z zebra, size/zh vision/ə about, item, edible, gallop, circus/ä *Fr.* ami/ œ *Fr.* feu, *Ger.* schön/ü *Fr.* tu, *Ger.* über/кн *Ger.* ich, *Scot.* loch/N *Fr.* bon.

Glossary

resound (rĭ-zound′) *v.* To make a loud, echoing sound.

respite (rĕs′pĭt) *n.* An interval of relief.

restive (rĕs′tĭv) *adj.* Nervous; restless.

retain (rĭ′tān′) *v.* To hold or keep in a particular place or condition.

retainer (rĭ′tā′nər) *n.* Someone in the service of another, especially of one of the nobility in the Middle Ages.

retentive (rĭ′tĕn′tĭv) *adj.* Having the ability to keep or hold.

reticent (rĕt′ə-sənt) *adj.* Not inclined to speak; silent.

retinue (rĕt′n-ō̄o′, -yō̄o′) *n.* A group of people in the service of a person of high status.

retort (rĭ-tôrt′) *v.* To answer in a sharp, quick way.

retribution (rĕt′-rə-byō̄o′shən) *n.* Punishment for having done something evil.

revel (rĕv′l) *v.* To engage in lively festivities. —*n.* A celebration; noisy merrymaking. —**reveler** *n.*

reverberate (rĭ-vûr′bə-rāt′) *v.* To reecho.

reverie (rĕv′ər-ē) *n.* Fanciful thinking; a daydream.

revile (rĭ-vīl′) *v.* To speak to with abusive language; insult.

rhetorical (rĭ-tôr′ĭ-kəl, rĭ-tōr′-) *adj.* Showy or complicated in one's style of writing or speaking.

rheum (rō̄om) *n.* A watery discharge from the eyes or nose, as from a cold. —**rheumy** *adj.*

riffle (rĭf′əl) *v.* To thumb through the pages of.

rigid (rĭj′ĭd) *adj.* Stiff; unbending.

rigor (rĭg′ər) *n.* **1.** Strictness. **2.** Extreme difficulty. —**rigorous** *adj.*

rile (rīl) *v.* To anger.

rite (rīt) *n.* A ceremony for a special occasion, especially a religious ceremony.

ritual (rĭch′ō̄o-əl) *n.* A ceremony or practice performed according to set rules and at regular intervals. —**ritualistic** *adj.* —**ritualize** *v.*

rivulet (rĭv′yə-lĭt) *n.* A stream or brook.

robust (rō-bŭst′, rō′bŭst′) *adj.* Strong; healthy.

roil (roil) *v.* To become muddy.

root (rō̄ot, rŏŏt) *v.* To dig in the earth as a pig does with its snout.

rout (rout) *n. Poetic.* A group of people; crowd.

row (rou) *n.* A noisy dispute.

rueful (rō̄o′fəl) *adj.* Sorrowful. —**ruefully** *adv.*

rummage (rŭm′ĭj) *v.* To make a hasty search.

S

sable (sā′bəl) *adj.* Black or dark in color.

sack (săk) *v.* To loot a captured area.

saffron (săf′rən) *adj.* Orange-yellow.

sagacious (sə-gā′shəs) *adj.* Wise.

salutation (săl′yə-tā′shən) *n.* An expression or gesture of greeting.

sanctimonious (săngk′tə-mō′nē-əs) *adj.* Pretending to be righteous.

sanctuary (săngk′chō̄o-ĕr-ē) *n.* A place of safety.

sanitarium (săn′ə-târ′ē-əm) *n.* An institution for the care of people with long-term illnesses.

sate (sāt) *v.* To satisfy to the fullest extent.

saunter (sôn′tər) *v.* To stroll.

scabbard (skăb′ərd) *n.* A container for a sword.

scallop (skŏl′əp, skăl′-) *v.* To make a decorative edging out of a series of curved projections.

scavenge (skăv′ĭnj) *v.* To search through rubbish heaps for something useful or edible.

scoff (skôf, skŏf) *v.* To mock; scorn.

scrabble (skrăb′əl) *v.* To scrape frantically with the hands.

scrutinize (skrō̄ot′n-īz′) *v.* To examine carefully.

scud (skŭd) *v.* **1.** To skim. **2.** To be driven by the wind.

scullery (skŭl′ə-rē) *n.* A room where the dirty dishes are washed; kitchen.

scurry (skûr′ē) *v.* To hurry.

scuttle (skŭt′l) *n.* To run quickly.

seclusion (sĭ-klō̄o′zhən) *n.* Being separated from others; isolation.

sedan (sĭ-dăn′) *n.* A closed automobile with wide front and back seats.

sedate (sĭ-dāt′) *adj.* Calm; unemotional.

sedative (sĕd′ə-tĭv) *adj.* Medication that calms and relaxes.

seduce (sĭ-dō̄os′, -dyō̄os′) *v.* **1.** To persuade a person to do something wrong or to be disobedient. **2.** To win someone over to one's side.

seductive (sĭ-dŭk′tĭv) *adj.* Tending to lead astray; enticing; charming.

semblance (sĕm′bləns) *n.* An outward appearance.

senile (sē′nīl′, sĕn′īl) *adj.* Showing mental deterioration associated with old age. —**senility** (sĭ-nĭl′ə-tē) *n.*

sensibilities (sĕn′sə-bĭl′ə-tēz) *n. pl.* The ability to respond to stimuli with great feeling.

sensibility (sĕn′sə-bil′ə-tē) *n.* Awareness or responsiveness.

sentinel (sĕnt′n-əl) *n.* Someone who stands guard, usually a soldier.

serpentine (sûr′pən-tēn′, -tīn′) *adj.* Winding, like a serpent.

servile (sûr′vəl, -vīl′) *adj.* Slavish; submissive.

shamble (shăm-bəl) *v.* To walk in a shuffling way.

shepherd (shĕp'ərd) v. To lead, guard, or care for.

shiftless (shĭft'lĭs) adj. Lacking the will or ability to do anything; lazy. —**shiftlessness** n.

shoal (shōl) n. A sand bar or other elevation that creates a shallow place in a body of water.

shroud (shroud) v. To cover completely, as with a burial cloth.

sickle (sĭk'əl) n. A cutting tool with a rounded blade and a short handle.

sidereal (sī-dîr'ē-əl) adj. Having to do with the stars or constellations.

sidle (sīd'l) v. To move sideways, especially in a sly manner.

siesta (sē-ĕs'tə) n. A rest, usually in the afternoon.

simultaneous (sī'məl-tā'nē-əs, sĭm'əl-) adj. Happening at the same time. —**simultaneously** adv.

sinew (sĭn'yōō) n. **1.** A tendon. **2.** Muscular power.

singular (sĭng'gyə-lər) adj. Extraordinary; remarkable. —**singularly** adv.

skein (skān) n. A complex tangle.

skeptical (skĕp'tĭ-kəl) adj. Doubting; disbelieving.

skitter (skĭt'ər) v. To move quickly or skip along a surface.

slake (slāk) v. To make less intense; quench.

slattern (slăt'ərn) n. An untidy or dirty woman.

slaver (slăv'ər) v. To dribble saliva; drool.

sleazy (slē'zē) adj. Flimsy; cheap.

slinky (slĭng'kē) adj. Sleek; sinuous.

sloop (slōōp) n. A small sailing vessel.

slovenly (slŭv'ən-lē) adj. Untidy; sloppy.

sluggard (slŭg'ərd) n. A lazy person.

snood (snōōd) n. A net worn over the back of the head to keep the hair in place.

snuffle (snŭf'əl) v. To breathe noisily; sniffle.

sojourn (sō'jûrn, sō-jûrn') v. To stay somewhere temporarily.

solicitous (sə-lĭs'ə-təs) adj. Showing concern; anxious.

solicitude (sə-lĭs'ə-tōōd, -tyōōd') n. Concern

sophisticated (sə-fĭs'tĭ-kā'tĭd) adj. Worldly-wise.

sordid (sôr'dĭd) adj. **1.** Depressingly drab; very shabby. **2.** Morally low; vile. **3.** Greedy; selfish.

sovereign (sŏv'ər-ən) adj. Supreme; chief.

spar (spär) n. A pole supporting a sail of a ship.

spasmodic (spăz-mŏd'ĭk) adj. Happening intermittently; on and off.

spawn (spôn) n. One of numerous young offspring, as from the eggs produced by some fish.

spectral (spĕk'trəl) adj. Ghostly.

spectroscope (spĕk'trə-skōp') n. An optical instrument used to record bands of colored light coming from stars or other sources of radiant energy.

speculation (spĕk'yə-lā'shən) n. **1.** The pursuit of a risky financial venture. **2.** Serious thought or consideration.

speculative (spĕk'yə-lə-tĭv, -lā'tĭv) adj. In a reflective, wondering way. —**speculatively** adv.

spew (spyōō) v. To vomit; spit out.

sphere (sfîr) n. A globe-shaped object.

spurn (spûrn) v. To reject scornfully.

stalk (stôk) v. To move or advance in a menacing or grim manner.

stance (stăns) n. A person's attitude or feelings concerning a particular situation.

steadfast (stĕd'făst') adj. Not moving or changing; steady.

stealthy (stĕl'thē) adj. Moving or acting in secret.

steed (stēd) n. A spirited horse.

sterile (stĕr'əl, -ĭl') adj. Incapable of producing vegetation.

steward (stōō'ərd, styōō') n. A person in charge of someone's property or household affairs.

stint (stĭnt) v. To restrict in giving.

stock (stŏk) n. Supply; amount on hand.

strategist (străt'ə-jĭst) n. One skilled in making plans or schemes toward a certain end.

strident (strīd'ənt) adj. Shrill; harsh. —**stridently** adv.

stupendous (stōō-pĕn'dəs, styōō-) adj. Immense; enormous.

stupor (stōō'pər, styōō-) n. A state of mental dullness or numbness.

suave (swäv, swâv) adj. Gracious in manner; polished.

subjugate (sŭb'jə-gāt') v. To keep under control; subdue. —**subjugation** (sŭb'jə-gā'shən) n.

sublime (sə-blīm') adj. Inspiring awe; extremely impressive.

sublimity (sə-blĭm'ə-te) n. Nobility; grandeur.

subordinate (sə-bôr'də-nāt') v. To put in a less important position.

ă pat/ā pay/âr care/ä father/b bib/ ch church/d deed/ĕ pet/ē be/f fife/g gag/h hat/hw which/ĭ pit/ī pie/îr pier/j judge/k kick/ l lid, needle/m mum/n no, sudden/ng thing/ŏ pot/ō toe/ô paw, for/oi noise/ou out/ōō took/ōō boot/p pop/r roar/s sauce/ sh ship, dish/t tight/th thin, path/th this, bathe/ŭ cut/ûr urge/v valve/w with/y yes/z zebra, size/zh vision/ə about, item, edible, gallop, circus/à Fr. ami/ œ Fr. feu, Ger. schön/ü Fr. tu, Ger. über/КН Ger. ich, Scot. loch/N Fr. bon.

sufferance (sŭf′ər-əns, sŭf′rəns) *n.* The ability to endure pain or distress; tolerance.

suffice (sə-fīs′) *v.* To be enough; to satisfy the needs.

suitor (sōō′tər) *n.* Someone who requests or petitions.

sullen (sŭl′ən) *adj.* Depressing; gloomy; dismal.

sultry (sŭl′trē) *adj.* **1.** Hot and humid; muggy. **2.** Very hot; fiery.

superficial (sōō′pər-fĭsh′əl) *adj.* On the surface.

superfluity (sōō′pər-flōō′ə-tē) *n.* Something not needed.

suppliant (sŭp′lē-ənt) *adj.* Beggarly; humble.

supplication (sŭp′lĭ-kā′shən) *n.* A humble prayer or request.

supposition (sŭp′ə-zĭsh′ən) *n.* Something supposed.

surge (sûrj) *v.* To rise up or increase suddenly.

surmise (sər-mīz′) *v.* To guess.

surmount (sər-mount′) *v.* To overcome.

surreal (sə-rē′əl) *adj.* Dreamlike.

surreptitious (sûr′əp-tĭsh′əs) *adj.* Secret; stealthy. — **surreptitiously** *adv.*

susceptible (sə-sĕp′tə-bəl) *adj.* Very sensitive; easily influenced or affected.

sustain (sə-stān′) *v.* To support; strengthen.

swath (swäth, swôth) *n.* A broad strip.

swathe (swä*th*) *v.* To wrap.

sweltering (swĕl′tər-ĭng) *adj.* Very hot and humid.

swivel (swĭv′əl) *v.* To turn or rotate easily. **shark swivel** *n.* A fastening device of rings or clips joined by a ball bearing, allowing attached parts to turn freely.

symmetrical (sĭ-mĕt′rĭ-kəl) *adj.* Having equivalent or identical form.

synthetic (sĭn-thĕt′ĭk) *adj.* Artificial.

T

tableau (tăb′lō, tă-blō′) *n.* A picturesque scene.

talisman (tăl′ĭs-mən, tăl′ĭz-) *n.* Something supposed to have magical power, particularly to bring good luck.

tallow (tăl′ō) *n.* Animal fat used in preparing food or in making candles or soap.

tangible (tăn′jə-bəl) *adj.* Capable of being touched or felt; real.

tarnish (tär′nĭsh) *v.* To discolor; to spoil.

tarry (tăr′ē) *v.* To linger.

taut (tôt) *adj.* Tightly stretched; tense.

teeter (tē′tər) *v.* To move unsteadily; wobble.

temperate (tĕm′pər-ĭt, tĕm′prĭt) *adj.* Neither hot nor cold (describing weather).

tempered (tĕm′pərd) *adj.* Strengthened, toughened.

temporizing (tĕm′pə-rīz′əng) *n.* Compromising.

tenor (tĕn′ər) *n.* General drift or meaning.

terminus (tûr′mə-nəs) *n.* **1.** Final point. **2.** Station at the end of a line.

terra cotta (tĕr′ə kŏt′ə) *n.* Reddish brown or deep orange.

terrain (tə-rān′, tĕ-) *n.* A particular stretch of land or the physical features of it.

testament (tĕs′tə-mənt) *n.* A will.

testimony (tĕs′tə-mō′nē) *n.* Evidence or proof of something.

testy (tĕs′tē) *adj.* Irritable.

tether (tĕth′ər) *v.* To confine an animal to a certain area by tying or chaining it.

theology (thē-ŏl′ə-jē) *n.* The study of religious doctrines or beliefs.

throng (thrŏng) *n.* A very large group of people or things. —*v.* To crowd together.

thwart (thwôrt) *v.* To block.

tidings (tī′dĭngz) *n. pl.* News.

tincture (tĭngk′chər) *n.* A quality that colors or distinguishes something.

tine (tīn) *n.* A slender, pointed projecting part; prong.

tirade (tī′rād′, tī-rād′) *n.* A long, vehement or denouncing speech.

tolerable (tŏl′ər-ə-bəl) *adj.* Bearable.

tonic (tŏn′ĭk) *adj.* Something that refreshes or restores.

torrent (tôr′ənt, tŏr′-) *n.* A violent flow, especially of water. —**torrential** (tô-rĕn′shəl, tə-) *adj.*

tragicomic (trăj′ĭ-kŏm′ĭk) *adj.* Combining sad and funny elements.

transcend (trăn-sĕnd′) *v.* To go beyond; surpass; excel.

transcendental (trăn′sĕn-dĕnt′l) *adj.* Rising above or going beyond common thought or experiences; mystical.

transfigure (trăns-fĭg′yər) *v.* To change the form or appearance of something.

transfix (trăns-fĭks′) *v.* To make motionless with terror or awe.

transgress (trăns-grĕs′, trănz-) *v.* To go beyond the limits of something.

transient (trăn′shənt, -zhənt) *adj.* Not permanent; existing or lasting for only a short time.

transit (trăn′sĭt, -zĭt) *n.* **1.** Passage. **2.** Transition or change.

translucent (trăns-lōō′sənt, trănz-) *adj.* Letting light pass through, but not enough to make objects on the other side clear.

transverse (trăns-vûrs′, trănz-) *adj.* Going crosswise.

traverse (trăv′ərs, trə-vûrs′) *v.* To go through or across.

travesty (trăv′ĭ-stē) *v.* To imitate in a ridiculing way.

treatise (trē′tĭs) *n.* A formal and lengthy written discussion of some subject.

tremor (trĕm′ər) *n.* A shivering or trembling movement.

tremulous (trĕm′yə-ləs) *adj.* **1.** Trembling; quivering. **2.** Fearful. —**tremulousness** *n.*

trice (trīs) *n.* An instant.

truculent (trŭk′yə-lənt) *adj.* Inclined to fight; fierce. —**truculently** *adv.* —**truculence** *n.*

tumultuous (tə-mŭl′chōō-əs). *adj.* Noisy in a wild and disorderly way.

tureen (tōō-rēn′, tyōō-) *n.* A deep, covered dish for serving soup or stew.

turgid (tûr′jĭd) *adj.* Swollen.

tympany (tĭm′pə-nē) *n.* The resounding sound coming from two objects striking against each other.

U

unabashed (ŭn′ə-băsht′) *adj.* Not ashamed or embarrassed.

unabated (ŭn′ə-bā′tĭd) *adj.* With full strength.

unalterable (ŭn-ôl′tər-ə-bəl) *adj.* Without possibility of change.

unassailable (ŭn′ə-sā′lə-bəl) *adj.* Unable to be denied or attacked.

unbraced (ŭn′brāst′) *adj.* Unprotected; weakened.

unbridle (ŭn′brī′dəl) *v.* To release.

uncanny (ŭn′kăn′ē) *adj.* Weird; mysterious. —**uncannily** *adv.*

undeciphered (ŭn′dĭ-sī′-fərd) *adj.* Not understood or interpreted.

undulate (ŭn′jōō-lāt′, ŭn′dyə-, ŭn′də-) *v.* To move in a wavelike manner.

unfathomable (ŭn-făth′əm-ə-bəl) *adj.* Not capable of being measured; too deep to be sounded.

unkempt (ŭn′kĕmpt′) *adj.* Untidy.

unobtrusive (ŭn′əb-trōō′sĭv) *adj.* Not calling attention to itself.

unperturbed (ŭn′pər-tûrbd′) *adj.* Not upset or disturbed.

unremitting (ŭnr′ĭ-mĭt′ĭng) *adj.* Persistent; not slackening.

unseemly (ŭn′sēm′lē) *adj.* Not decent; improper.

unsubstantial (ŭn′səb-stăn′shəl) *adj.* Not real or solid; flimsy.

untrammeled (ŭn′trăm′əld) *adj.* Not hindered or confined; free.

uproarious (ŭp-rôr′ē-əs, -rōr-) *adj.* Loud and boisterous. —**uproariously** *adv.*

urchin (ûr′chĭn) *n.* A mischievous youngster.

usurer (yōō′zhər-ər) *n.* Someone who lends money, usually at a high interest rate.

V

vagrant (vā′grənt) *adj.* Wandering.

vair (vâr) *n.* Squirrel fur used to decorate clothes during the Middle Ages.

valor (văl′ər) *n.* Bravery.

vanguard (văn′gärd′) *n.* The part of an army that advances before the rest.

vanquish (văng′kwĭsh, văn′-) *v.* To defeat in battle.

variable (vâr′ē-ə-bəl) *adj.* Changeable.

veer (vîr) *v.* To change direction.

vehement (vē′ə-mənt) *adj.* With great force; violent. —**vehemently** *adv.*

veldt (fĕlt, vĕlt) *n.* Grassland in southern Africa.

veracity (və-răs′ə-tē) *n.* Truthfulness.

verifiable (vĕr′ə-fī′ə-bəl) *adj.* Capable of being proved.

verify (vĕr′ə-fī) *v.* To substantiate.

veritable (vĕr′ə-tə-bəl) *adj.* Actual; real.

versatile (vûr′sə-təl) *adj.* Able to be used in many different ways.

vestment (vĕst′mənt) *n.* A robe worn by a clergyman. —**vestmented** *adj.*

vesture (vĕs′chər) *n.* **1.** Clothing. **2.** Something that covers or wraps.

vex (vĕks) *v.* To irritate.

vibrant (vī′brənt) *adj.* Very energetic; lively.

victualize (vĭt′l-īz′) *v.* To supply with food. —also **victual.**

vigilance (vĭj′ə-ləns) *n.* Watchfulness.

villa (vĭl′ə) *n.* A large country house.

vindicate (vĭn′dĭ-kāt′) *v.* To clear of guilt or criticism.

virile (vîr′əl, -īl′) *adj.* Manly.

visage (vĭz′ĭj) *n.* The face.

vise (vīs) *n.* A clamping object used by carpenters or metal-workers to keep something in position.

ă pat/ā **pay**/âr c**are**/ä **father**/b **bib**/ ch **church**/d **deed**/ē p**e**t/ē b**e**/f **f**i**f**e/g **g**a**g**/h **h**at/hw **which**/ĭ p**i**t/ī p**ie**/îr p**ier**/j **j**u**dg**e/k **k**i**ck**/ l **l**i**d**, need**le**/m **m**u**m**/n **n**o, sudde**n**/ng thi**ng**/ŏ p**o**t/ō t**oe**/ô p**aw**, f**or**/oi n**oi**se/ou **ou**t/ōō t**oo**k/ōō b**oo**t/p **p**o**p**/r **r**oar/s **s**auce/ sh **sh**ip, di**sh**/t **t**igh**t**/th **th**in, pa**th**/th **th**is, ba**th**e/ŭ c**u**t/ûr **ur**ge/v **v**al**v**e/w **w**ith/y **y**es/z **z**ebra, si**z**e/zh vi**si**on/ə **a**bout, it**e**m, **e**d**i**ble, g**a**ll**o**p, c**i**rc**u**s/à *Fr.* **a**mi/ œ *Fr.* f**eu**, *Ger.* sch**ö**n/ü *Fr.* t**u**, *Ger.* **ü**ber/κн *Ger.* i**ch**, *Scot.* lo**ch**/ɴ *Fr.* bo**n**.

Glossary **991**

vista (vĭs′tə) *n.* An extended view.
vocation (vō-kā′-shən) *n.* Profession or occupation.
voluptuous (və-lŭp′chŏŏ-əs) *adj.* Luxurious; giving sensual pleasure.
voracious (vô-rā′shəs, vō-, və-) *adj.* Greedy; devouring.
vouchsafe (vouch′saf′) *v.* To be gracious enough to give or grant.
vulnerable (vŭl′nər-ə-bəl) *adj.* Easily hurt or wounded.

W

wake (wāk) *n.* The watch kept over a corpse before burial.
wallow (wŏl′ō) *v.* To roll about in something wet or dirty, especially mud. —*n.* A wet and muddy place.
wane (wān) *v.* To decrease gradually in size, intensity, or amount.
wanton (wŏn′tən) *adj.* Unrestrained; extravagant. — **wantonly** *adv.*
wary (wâr′ē) *adj.* Cautious.
waver (wāv′ər) *v.* To start giving way.
weir (wîr) *n.* An obstruction built in a river to change the direction of the flow of water.
welter (wĕl′tər) *n.* A jumbled mass.
wend (wĕnd) *v. Archaic.* Thought; imagined. —also **weened.**

whelp (hwĕlp, wĕlp) *n.* **1.** The young of various animals. **2.** A young child.
whet (hwĕt, wĕt) *v.* To sharpen.
whimsy (hwĭm′zē, wĭm′-) *n.* An imaginative or playful idea.
whisk (hwĭsk, wĭsk) *v.* To move rapidly.
wistful (wĭst′fəl) Full of vague yearning; wishful. — **wistfully** *adv.*
wizened (wĭz′ənd) *adj.* Shriveled.
wote (wōt) *v. Archaic.* Knew. —also **wot.**
wrack (răk) *n.* To torture.
wrath (răth, räth) *n.* Extreme anger.
writhe (rīth) *v.* To twist and turn, as in agony.
wrought (rôt) *v. Archaic.* Created; performed. —*adj.* Formed; shaped by hammering.

Y

yawl (yôl) *n.* A small boat, with oars.
yoke (yōk) *n.* **1.** A wooden bar fitted around the necks of a pair of work animals to harness them together. **3.** Bondage; submission.

Z

zealous (zĕl′əs) *adj.* Enthusiastic; earnest. —**zealously** *adv.*
zither (zĭth′ər, zĭth′-) *n.* A musical instrument which has thirty to forty strings stretched over a flat sounding box.

Outline OF *Concepts* AND *Skills*

Page numbers in italics refer to entries in Literary Terms and Techniques

LITERARY ELEMENTS

Action 583
Allegory 194
Alliteration 314, 413, 420, *904*
Allusion 228, 399, *904*
Anachronism 538, 763, *904*
Analogy 533, *904*
Anecdote 305
Antagonist 637, *904*
Antihero 739

Approximate Rhyme 413, 418
Archaism 463, 807
Argument *905*
Artistic License *905*
Aside 541, *905*
Assonance 413, 420, *905*
Atmosphere 39, 97, 126, *905*
Autobiography 276, *905*
Avenger (in Tragedy) 638
Ballad 442, 445, *905*
Ballad Stanza 445
Biography 276, 283, *906*
Blank Verse 430, 638, *906*
Burlesque 267
Caricature 267

Outline of Concepts and Skills

Outline of Concepts and Skills **993**

LANGUAGE AND VOCABULARY

Analogies

Archaic Words

Connotation

Context

Dialect

Diction

Etymology

Meaning

Puns

Sentence Structure

Style

Word Structure

WRITING ABOUT LITERATURE

Outline of Concepts and Skills

CREATIVE WRITING

FOR ORAL READING

FOR DRAMATIZATION

FOCUS ON WRITING

Analyzing Literature

Comparison and Contrast

Descriptive Writing

Expository Writing

Narrative Writing

Persuasive Writing

FOCUS ON READING AND CRITICAL THINKING

Index OF Titles BY Themes

Index of Fine Art and Illustrations

Photo Credits

Title page and back cover, William S. Nawrocki/Nawrocki Stock Photos; page viii, Scala/AR; ix, Tate Gallery, London/AR; xi, Henry J. Drewel; xii, Advertisement for Pierce-Arrow, from Vogue, April 15, 1926/NYPL; xv, Dennis Stock/MP; xvii, Jen and Des Bartlett/BC; xviii, Bill Binzen; xix, Constantine Manos/MP; 2, HRW; 13, Will Wilkins/PR; 20, Townsend P. Dickinson/PR; 40, GC; 46, AP/WW; 49, AS; 50, Alan Pitcairn/GH; 53, John Colwell/GH; 68, AS; 71, David E. Scherman, LIFE; 72, John E. Carter © 1978/NSHS; 74, CP; 90, TV; 92, Victor Englebert/PR; 96, NYPL; 99, Tom Hollyman/PR; 106, Brett H. Froomer/TIB; 113, Ernie Baxter/BS; 114, John Laundis/BS; 119, AP/WW; 120, By permission of The Houghton Library, Harvard University; 123, Photograph © 1994 The Museum of Modern Art, New York; 131, 142, CP; 152, © Nikky Finney/courtesy Random House; 158, Missouri Historical Society; 166, BA; 171, Geoffrey Gove/TIB; 172, BA; 179, CP; 184, David R. Godine, Publisher; 187, © Dennis Stock/MP; 188, Amanda Clement/TIB; 191, © Gary Braasch/A; 194, From La Republica, back cover. © 1990. Instituto Nacional del Libro/Photo courtesy of the Consulate of Uruguay, New York; 200, Courtesy Leslie Norris; 210, FG; 229, © Miriam Berkley; 239, HRW; 242, Benjamin Franklin Collection, Sterling Memorial Library, Yale University Library; 245, Bob Kelly/PR; 248, RM; 253, BA; 254, Ernest Haas/MP; 257, Jim Goodwin/PR; 259, © Hank Rowland; 260(l)(r), 261(l), David Muench; 261(r), Polly Schaafsma; 265, C. Jay Dusard; 272, Tony Ray Jones/MP; 275, Bruce Davidson/MP; 278, from Russian Folk Prints by Dmitri Rovinski, 1881, NYPL; 279, State Historical Museum, Moscow. Photograph: Novosti/Sovfoto; 284, © Jerry Bauer; 289, GC; 291, MC; 297, Ray Manley/SS; 301, 302, © 1933, 1961 by James Thurber. From "My Life and Hard Times", published by Harper & Row; 305, Henri Cartier Bresson/MP; 309, from "Dylan Thomas" by Paul Ferris, Hodder & Stoughton, London, Reprinted by permission of DHAL/NYPL; 311, RM; 321, LC; 327, 335, from the jacket of "West With the Night" by Beryl Markham. Published by North Point Press. Reprinted with permission.; 332, 337, © 1936 by the New York Times Company. Reprinted with permission.; 340, RC; 342, Bruno Barbey/MP; 347, 349(b), Margaret Thompson Drewel; 349(l)(b), Henry J. Drewel; 352, RC; 358-9, Paul Wheeler/SS; 360, HRW; 362, © Carr Clifton/A; 366, Courtesy Harcourt Brace Jovanovich, San Diego; 366, RM; 369, Photo by Frank Stewart/courtesy The Studio Museum in Harlem, NY; 371, Advertisement for Pierce-Arrow, from Vogue, April 15, 1926/NYPL; 373, Bill Binzen/PR; 375(l), UPI/BA; 375(br), TV; 375(mr), GC; 375(tr), MC; 385, GC; 385, Jean Toomer Papers, Yale Collection of American Literature, Beinecke Library; 386(tl)(bl), TV; 386(tr)(br), GC; 389, Photograph courtesy the artist; 392-3, Bob O'Shaunessy/SM; 395, Hans Halberstadt, Very Moving Pictures, San Jose, CA.; 400(tl), reprinted from FROST: A TIME TO TALK: CONVERSATIONS & INDISCRETIONS recorded by Robert Frost Francis (Amherst: The University of Massachusetts Press, 1972), © 1972 by Robert Francis; 400(bl), NPG/AR; 400(tr), FG; 400(br), GC; 401(tl), Burt Glinn/MP; 401(bl), Archive Photos; 401(tr), © Kelly Wise; 401(br), UPI/BA; 405, Lightscapes/SM; 407, Nancy Brown/TIB; 408, Chris Luneski/PR; 412(tl), LaVerne H. Clark; 412(bl), CP; 412(tr), Richard Kalvar/MP; 412(br), TV; 415, Al Lowry/PR; 423, RM; 424(rc), Bill Swersey/GL; 424(tl), NPG; 424(bl), UPI/BA; 424(tr), TV; 424(br), Dan Labbey/courtesy Harper & Row, Publishers; 428-9, Michael P. Gadomski/PR; 432, AR; 436(tl), GC; 436(bl), BA; 436(tr), CP; 436(br), Courtesy of Teresa Palomo Acosta; 441(bl), By permission of The FSL; 441(tr), Winold Reiss/GC; 441(br), RM; 450, Photograph by Dawoud Bey/courtesy The Studio Museum in Harlem, NY; 454, NPG; 454(tr), Winold Reiss/GC; 454(br),

Photo Credits

Index of *Authors* and *Titles*

The page numbers in italics indicate where a brief biography of the author is located.

Index of Authors and Titles